Mastery & Elegance

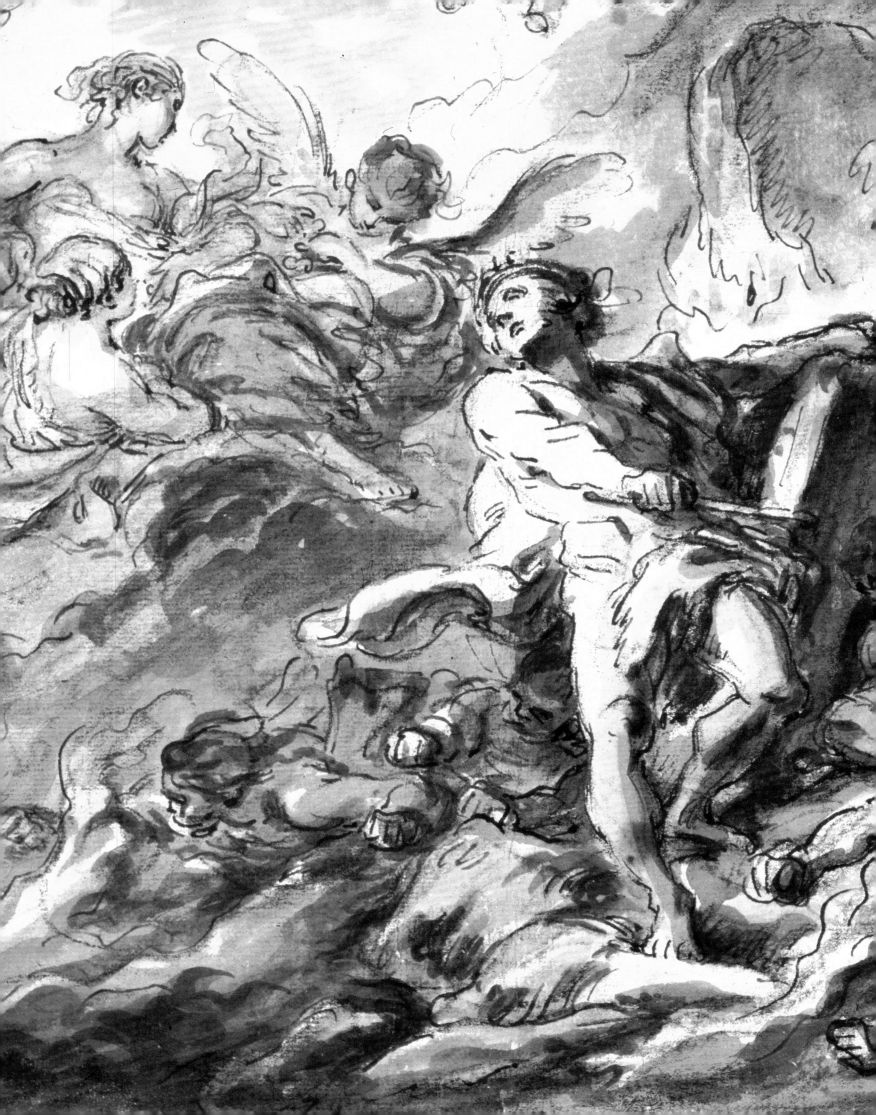

Mastery & Elegance

TWO CENTURIES OF FRENCH DRAWINGS
FROM THE
COLLECTION OF JEFFREY E. HORVITZ

Edited by
Alvin L. Clark, Jr.

with

Margaret Morgan Grasselli
Jean-François Méjanès
William W. Robinson

Foreword by
Pierre Rosenberg de l'Académie française

HARVARD UNIVERSITY ART MUSEUMS

CAMBRIDGE, MASSACHUSETTS

Mastery & Elegance: Two Centuries of French Drawings from the Collection of Jeffrey E. Horvitz is the catalogue of an exhibition organized by the Harvard University Art Museums, Cambridge, Massachusetts.

EXHIBITION TOUR:

Harvard University Art Museums, Cambridge
5 December 1998–31 January 1999

Art Gallery of Ontario, Toronto
20 February–18 April 1999

Musée Jacquemart-André, Paris
1 May–25 June 1999

National Gallery of Scotland, Edinburgh
9 July–5 September 1999

National Academy Museum and School of Fine Arts, New York
8 October–12 December 1999

Los Angeles County Museum of Art, Los Angeles
24 February–24 April 2000

Manager of publications: Evelyn Rosenthal
Copy editors: Jennifer Barber and Carolann Barrett
 with Elizabeth Allen and Nicole Chaison
Translators: Maria Ascher with the assistance of Alvin L. Clark, Jr.,
 and William W. Robinson
Designer: Christopher Kuntze
Printer: The Stinehour Press
Composed in Minion and Poetica types and printed on
 Mead Moistrite Matte, an acid-free paper
Printed in the United States

COVER ILLUSTRATION: Jean-Baptiste Greuze, *Head of a Woman in Profile*,
cat. 78.

FRONTISPIECE: François Boucher, *Juno Commanding Aeolus to Release the Storm Winds*, cat. 61, detail

Distributed by the University of Washington Press
PO Box 50096, Seattle, WA 98145

LIBRARY OF CONGRESS CATALOGUING-IN-PUBLICATION DATA

Mastery & elegance : two centuries of French drawings from the collection of
 Jeffrey E. Horvitz / edited by Alvin L. Clark, Jr. with Margaret Morgan
 Grasselli, Jean-François Méjanès, William W. Robinson : foreword by
 Pierre Rosenberg.
 p. cm.
 Exhibition tour: Harvard University Art Museums, Cambridge,
 5 December 1998 – 31 January 1999 and others.
 Includes bibliographical references and index.
 ISBN 1-891771-01-9 (hard : alk. paper). — ISBN 1-891771-02-7
(soft : alk. paper)
 1. Drawing, French—Exhibitions. 2. Drawing—17th century—
France—Exhibitions. 3. Drawing—18th century—France—Exhibitions.
4. Horvitz, Jeffrey E.—Art collections—Exhibitions.
5. Drawing—Private collections—United States—Exhibitions.
I. Horvitz, Jeffrey E. II. Clark, Alvin L. III. Harvard University. Art
Museums. IV. Title: Mastery and elegance.
NC246.M38 1998
741.944'09'0320747444—dc21 98-45290
 CIP

CONTENTS

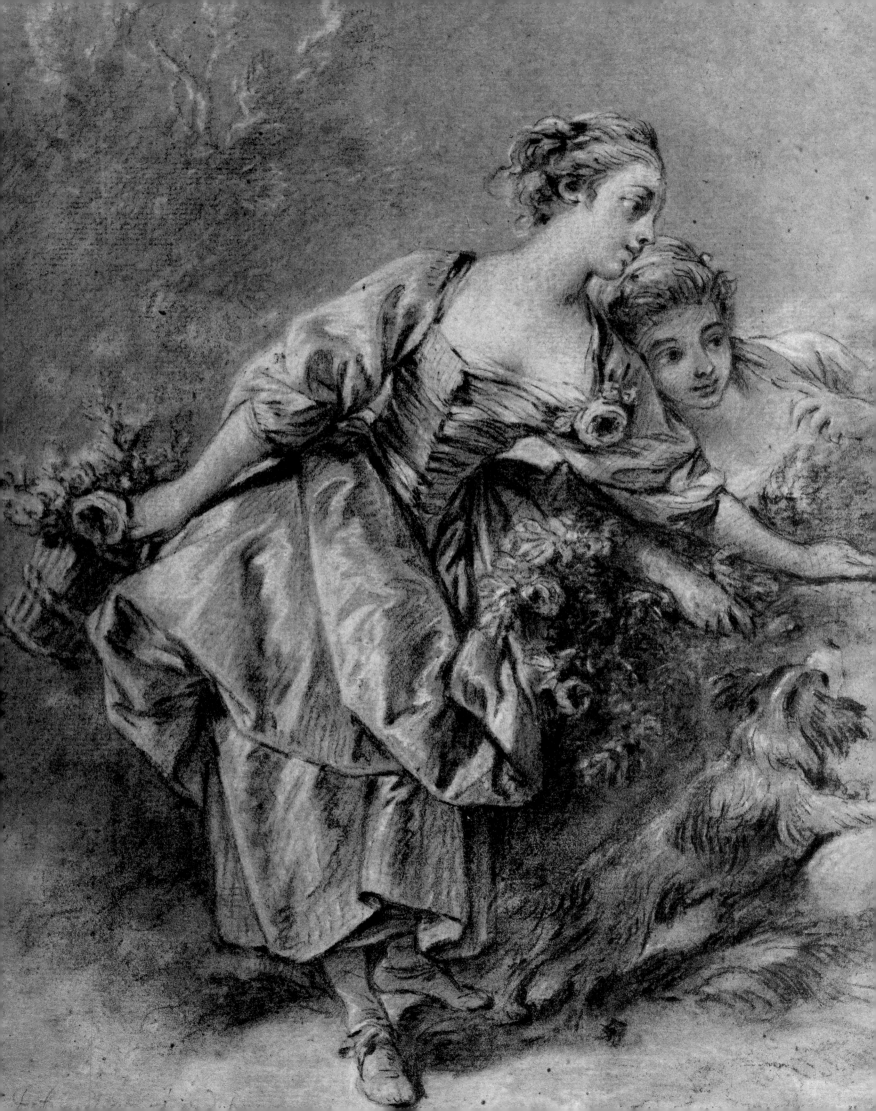

In Memory of

AGNES MONGAN

$(1905-1996)$

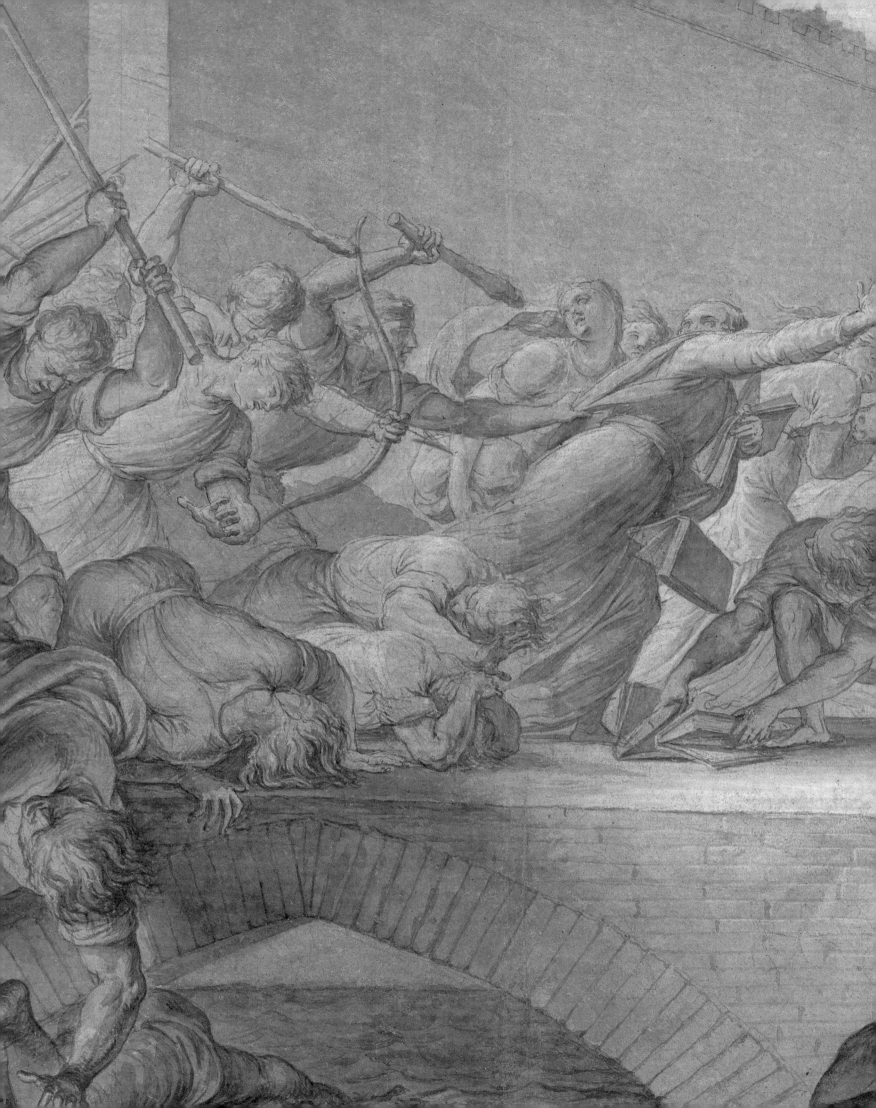

DIRECTOR'S FOREWORD

Since the time of Paul J. Sachs, the Fogg Art Museum has been one of the world's leaders in the acquisition, exhibition, and study of old master drawings. Sachs, who first came to the Fogg as its assistant director in 1915 and retired as associate director in 1944, was responsible for securing many of its most important drawings, including those bequeathed by Charles A. Loeser and Grenville L. Winthrop, not to mention those Sachs himself gave or left to the museum. Since then, the Fogg's Department of Drawings has been led by such distinguished scholars as Agnes Mongan and Konrad Oberhuber, and has been the inspiration for curators like Victor Carlson of the Los Angeles County Museum of Art, Suzanne Folds McCullagh of the Art Institute of Chicago, and Margaret Morgan Grasselli of the National Gallery of Art, Washington—all contributors to the present volume, who did graduate work in Harvard's Department of History of Art and Architecture on Hubert Robert, Gabriel-Jacques de Saint-Aubin, and Jean-Antoine Watteau, respectively.

This legacy of distinguished curatorial leadership and the training of students is embodied in our current curator, William W. Robinson, who received his Ph.D. from Harvard and has been in charge of the Fogg's Department of Drawings since 1988. During the past ten years, Bill has curated or supervised nine loan exhibitions, including shows devoted to drawings by Guercino and Tiepolo in North American collections, French Renaissance drawings, and the Maida and George Abrams collection of seventeenth-century Dutch drawings, each of which was accompanied by a major scholarly catalogue. The current exhibition is only the most recent project of this most productive and distinguished curatorial department.

The Fogg's proven commitment to the exhibition and study of old master drawings no doubt attracted Jeffrey Horvitz. It is a perfect fit with his own intentions for his collection and for the exhibition he graciously permitted the Fogg to organize from it. As the interview published in this catalogue attests, he has rigorous standards for both the quality and historical importance of the drawings he collects, as well as a high regard for the contributions of scholarship and graduate training in the field. In this respect, over the past three years, Jeffrey has generously supported research undertaken by the Fogg's Drawing Department and has formalized that support with the funding of the Jeffrey

E. Horvitz Research Curator for French Drawings. For his continuing support, and indeed for his many gifts of drawings to the Fogg's collection, including works by Edme Bouchardon, Charles-Nicolas Cochin le jeune, Antoine Coypel, Eustache Le Sueur, Nicolas Mignard, Augustin Pajou, Jean-François-Pierre Peyron, and Joseph-Marie Vien—some thirty-one drawings in this year alone, many of which represent the first work by the artist in the Fogg's collection—we are enormously grateful. Jeffrey has been a model patron. Through the six years during which we have worked on this exhibition, he has asked only one thing of us: that we spare nothing in pursuit of the highest quality of professionalism and scholarship in the organization of the exhibition and the publication of the catalogue. We hope we have risen to the challenge.

Alvin L. Clark, Jr., the first Jeffrey E. Horvitz Research Curator, conceived and coordinated this exhibition and edited its catalogue. One cannot imagine an exhibition curator more dedicated or better organized than Larry Clark. He left nothing to chance and marshaled the thirty-six authors of this catalogue with discipline and sensitivity. The success of this exhibition is Larry's and we are grateful to him for his dedicated work on our behalf.

Joining Larry as coeditors of this catalogue are Jean-François Méjanès, conservateur-en-chef in the Département des Arts Graphiques, Musée du Louvre, and Margaret Morgan Grasselli, curator of old master drawings, National Gallery of Art, Washington. We thank them for their many contributions. We also wish to acknowledge Pierre Rosenberg de l'Académie française, Président-Directeur of the Musée du Louvre, for his foreword to the catalogue, and Eunice Williams for her thoughtful advice on many issues pertaining to this project.

The staff members of the Harvard University Art Museums who contributed significantly to the exhibition and catalogue are acknowledged in the preface. It leaves me to thank our colleagues Jean-Pierre Babelon, membre l'Institut, and Nicolas Sainte-Fare-Garnot at the Musée Jacquemart-André; Timothy Clifford and Michael Clarke at the National Gallery of Scotland; Graham Beale, Victor Carlson, and Leslie Bowman at the Los Angeles County Museum of Art; Annette Blaugrund, David Dearinger, and former chief curator Dita Amory at the National Academy Museum and School of Fine Arts; and Matthew Teitelbaum, former direc-

tor Maxwell Anderson, Katherine Lochnan, and Linda Milrod at the Art Gallery of Ontario. It is a sign of the importance of the Horvitz Collection and of the significance of the Fogg's Department of Drawings that the exhibition is traveling to these prominent national and international venues, and we are most grateful for their support and participation.

Finally, it gives me great pleasure to note that this catalogue is dedicated to the memory of Agnes Mongan, former curator of drawings and director of the Fogg Museum, who first came to work as Paul Sachs's assistant in 1929, and whose last publication, the catalogue of our French drawings from David to Corot, appeared just a few months before her death in 1996. Like Sachs before her, Agnes held the Fogg's Department of Drawings to the highest standard. With this exhibition and catalogue, as with the other projects directed by our curator William Robinson, we believe we have met that standard.

James Cuno
Elizabeth and John Moors Cabot Director

HOMAGE TO A COLLECTOR

&

A PLEA FOR RESEARCH

In Memory and Admiration of Bernice Davidson (1927–1998)

Sometimes it's enough to make you lose hope and become discouraged. The history of seventeenth- and eighteenth-century French drawings is still summed up by a handful of well-known and often repeated names—Poussin and Claude, Watteau and Boucher, Fragonard and Robert—plus a few more, such as Vouet, Le Brun, Greuze, and Saint-Aubin, which are only uttered with a certain condescension and reluctance. Occasionally, however, despondence gives way to hope: along comes a collector who, with his curiosity and tenacity, shakes up the old standards and refuses to be satisfied with the same old names. He strives to paint a more nuanced portrait of these two centuries of French draftsmanship by also including the works of artists who, though less famous today, are in many cases surprising for their inspiration, originality, and technique. The present catalogue embodies the results of this adventurous approach.

≈

Not without a degree of pride (or perhaps vanity), I occasionally consult *French Master Drawings of the Seventeenth and Eighteenth Centuries in North American Collections*, the bilingual catalogue of an exhibition I organized that traveled to Toronto, Ottawa, San Francisco, and New York in 1972–73. Thanks to the generosity of more than forty museums and a few illustrious private collections, the 157 drawings included in that volume offer a relatively complete and varied panorama of French drawing from Jacques-Charles Bellange at the very beginning of the seventeenth century, to Louis-Léopold Boilly at the beginning of the nineteenth. The show was quite successful. It was ardently supported by Mario Amaya and by Walter Vitzthum—the twentieth century's most brilliant connoisseur of drawings—who died in Paris in 1971 at the age of forty-three. Someday, I hope that Vitzthum's thought-provoking essays will be collected and published, because younger generations will be surprised by the originality and boldness of his ideas. Of course, the exhibition was far from perfect and not without flaws: a formerly incontestable Vouet has since been

reliably reattributed to Le Brun, and we now know that a significant number of the drawings thought to be by Bellange should be given to Jean de Saint-Igny. It should also be noted that a number of paintings previously ascribed to Saint-Igny have recently been assigned correctly to Justus van Egmont. But the goal of the exhibition was to emphasize the richness and variety of two centuries of French draftsmanship by rehabilitating forgotten artists and acquainting the public with little-known drawings and with draftsmen that—more out of ignorance than ill will—had generally been disdained by scholars and lay enthusiasts. It is gratifying to note those efforts were not entirely in vain. Some European and American museums and private collectors have endeavored to acquire the finest seventeenth- and eighteenth-century French drawings on the market and build collections that, in themselves, could rival the 1972–73 exhibition in the quality of the works and in the number of artists represented.

Still, one must admit that most French draftsmen of the seventeenth and eighteenth centuries—overshadowed by the illustrious names of the Italian Renaissance, the great French artists of the nineteenth and twentieth centuries from Ingres to Matisse, and those of the Northern Renaissance and Baroque (Dürer and Holbein, Rubens and Rembrandt)—leave one, if you will pardon the expression, somewhat underwhelmed. To be sure, the taste for the eighteenth century's more or less sprightly minor artists has endured, and the market value of exceptionally fine sheets by masters such as Simon Vouet and François-André Vincent has risen. On the other hand, artists such as Grégoire Huret and Michel-François Dandré-Bardon, both of whom are magnificently represented in the Horvitz Collection, have not yet won the hearts of the most knowledgeable connoisseurs and major collectors of drawings in Europe and the Americas.

≈

I referred above to collectors with an enthusiasm, love, and passion for French drawings. Preeminent among them is

one name that justifies this brief preface to the present catalogue, which will be indispensable to every collector of drawings and every scholar and *amateur* of French art: Mathias Polakovits (1921–1987). His important and stimulating collection of more than 3,000 French drawings is now in the Ecole nationale supérieure des Beaux-Arts in Paris—an institution whose holdings in this area were already extensive (see Paris 1989a). Unfortunately, the great majority of drawings in the Polakovits Collection have never been photographed. Thanks to the generosity of Jeffrey E. Horvitz and to the kind assistance of this exhibition's curator, Alvin L. Clark, Jr.—whose work on François Perrier is eagerly and even impatiently awaited in published form (it's no surprise that Perrier is included in the Horvitz Collection!)—the French drawings in the Polakovits Collection are now assured photographic reproduction.

~

Of all the admirable writings by Bernard Berenson, which is the one that remains in constant use by specialists even today, and whose importance and scientific interest are universally acknowledged? The answer is easy. It is his famous inventory of fifteenth- and sixteenth-century Florentine drawings, published in the first years of this century. Berenson undertook to list and to reproduce, in city after city, museum by museum, all of the drawings he knew by artists such as Fra Bartolommeo and Jacopo da Pontormo. This inventory made it possible to identify and distinguish the graphic styles of a great many artists of the period, to recognize their hand, to distinguish their artistic personality—in short, to understand them more fully.

Let us indulge in a dream, or at least consider a personal wish that, to my mind, is not utopian. Why not compile an inventory of all the known drawings by French artists of the seventeenth century (for the eighteenth century, the task is probably too unwieldy)? Although the drawings of Claude and Poussin have already been the focus of scholarly studies, only a few dozen sheets are known today by artists like Thomas Blanchet and Louis Chéron. No one today could confuse François Verdier (there's scarcely a museum in the world that does not have drawings from his hand) with Charles Le Brun, or Michel Corneille with Pierre Mignard, and while important essays have been devoted to Nicolas de Plattemontagne, Charles-Alphonse Dufresnoy, Charles Mellin, and Noël Coypel, these are incomplete and much remains to be done for a number of other artists. It's true that quite often, too often, standing before a fine drawing in which "everything" (a word that needs closer analysis) indicates its French origin, the viewer is at a loss and can say nothing conclusive about its authorship. But the balance between drawings with solid attributions and those that remain anonymous is swinging more and more toward the former. The catalogue of the Horvitz Collection will help the young researcher endeavoring to compile that inventory of French seventeenth-century drawings (in private as well as public collections) that the field so sorely needs. Thus we will rehabilitate a century and a school that produced great masters, but whose "second string" deserves to be brought, at long last, out of the shade.

Pierre Rosenberg de l'Académie française
Président-Directeur, Musée du Louvre, Paris

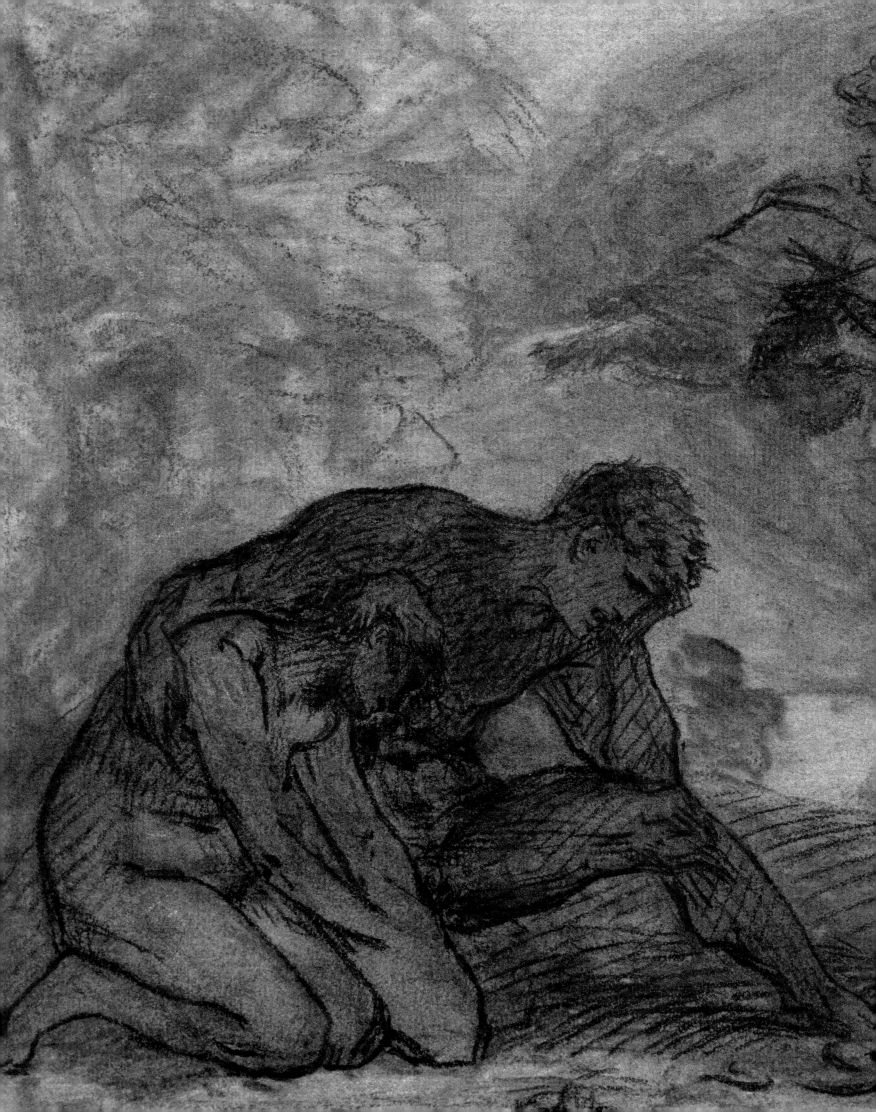

PREFACE & ACKNOWLEDGMENTS

In France … from the closing years of the fourteenth century to our own day there have been, in every generation, artists whose drawings fuse freshness and sensitivity of perception, deep human understanding and irreproachable technical mastery.

Agnes Mongan

This catalogue is dedicated to the memory of Agnes Mongan, our former director and curator of drawings who, along with Paul Sachs, began the Fogg's longstanding tradition of collecting, studying, and exhibiting French drawings. An internationally respected authority on European art and a prolific author of books, articles, reviews, and exhibition catalogues, Miss Mongan was associated with the Fogg for more than sixty years. Her long career as curator of drawings was punctuated by several distinguished scholarly and curatorial contributions to the French field, including the landmark *Ingres Centennial Exhibition 1867–1967; French Drawings from American Collections: Clouet to Matisse* (1958–59), a loan exhibition that traveled to Rotterdam, Paris, and New York; her permanent collection catalogue, *David to Corot: French Drawings in the Fogg Art Museum* (1996); and innumerable acquisitions of works by French masters ranging from François Clouet to Poussin, Fragonard, Delacroix, Degas, and Matisse. The perceptive observations quoted above, from her preface to the French volume of *Great Drawings of All Time* (1963), provide an important lens through which to view the two centuries of French drawings presented in this exhibition from the collection of Jeffrey E. Horvitz.

~

This publication originated as a research project in the winter of 1992–93, when the Horvitz Collection consisted of about 160 French drawings. The exhibition and catalogue began to take shape in 1995–96. This volume begins with essays that elaborate in some detail on the context in which these drawings—many by unfamiliar and understudied artists—came into being and on the history of collecting in this field in the United States. These essays are followed by an interview with Jeffrey E. Horvitz in which he discusses his specific goals and interests as a collector. All of the 117 exhibited drawings are reproduced in color within 115 detailed catalogue entries that are supplemented by a number of black-and-white comparative illustrations. These are followed by biographies of exhibited artists and a partially illustrated appendix that lists the more than 350 other pre-nineteenth-century works in the collection. Reproductions of many of these sheets are also included throughout the entries, the essays, and the interview. Finally, the catalogue also includes indices of the subjects and provenances of the early French sheets in the Horvitz Collection and an index of drawings from other collections cited or reproduced in the text.

This exhibition of French drawings and its accompanying catalogue provide the visitor and reader with examples of works that reveal both the concurrent and successive styles of two centuries of French draftsmen from the late Mannerist works of the early seventeenth century (Jacques-Charles Bellange, cat. 1) to the lyricism of Simon Vouet and his extensive circle during the second quarter of the century (cats. 5, 6, and 17); the refined, classicizing mode referred to as Parisian Atticism that was popular from the 1640s through the 1650s (Eustache Le Sueur, cat. 16); the cerebral austerity of Poussin (cat. 8); and the ethereal and seamless vistas of Claude at mid-century (cat. 11). The heavy, full-blown Baroque classicism of Le Brun and his enormous group of students and followers that emerged in the late 1650s is followed by the softer, coloristic works of his students such as Charles de La Fosse and Louis de Boullogne at the end of the century (cats. 23 and 27). The drawings of their students and followers such as Louis Galloche (cat. 32) and François Le Moyne (cats. 40–42)—combined with the effortless, harmonious elegance and the refined delicacy of touch evident in the works of Jean-Antoine Watteau (cats. 34–36)—dominated artistic expression at the very beginning of the eighteenth century. The remarkably talented generation of artists born around 1700 took the French school to its early maturity in what we now refer to as the Rococo style (c. 1720–60). François Boucher (cats. 60–62) and Charles-Joseph Natoire (cats. 55–58), as well as their students and followers like Jean-Honoré Fragonard (cats. 86–89), developed

and expanded upon the urbane, sophisticated, and curvilinear elegance of this mode with a level of technical brilliance that led to the hegemony of French art and culture in Europe, matching her new political and military might. The extravagance of the Rococo was tempered by artists such as Joseph-Marie Vien (cat. 74) and Jean-Baptiste Greuze (cats. 78–81) in more sober works that looked back to the classicizing works of seventeenth-century artists like Poussin and Le Sueur. This style, often referred to as the Reform (c. 1750–80), also comprised experimental works by lesser known and more independent talents like Gabriel-François Doyen (cat. 82) and Jean-Baptiste Deshays (cat. 84), who endeavored to move away from the Rococo in a less restrained way. However, the influence of Vien and his numerous students—François-André Vincent (cats. 98–99) and Jacques-Louis David (cat. 100)—prevailed and led to what we now refer to as Neoclassicism (c. 1780–1815), with which this exhibition concludes.

This brief chronological summary has focused on successive generations of artists whose careers were centered in Paris. Indeed, one of the merits of the Horvitz collection is that the line of teacher–student relationships can be traced through two centuries: from Vouet to Le Brun, La Fosse, Le Moyne, Natoire, Vien, David, and Girodet. However, despite the artistic and political importance of the French capital, many provincial schools—such as those in Nancy (Bellange and Callot), Lyon (Stella, Blanchet, Huret), Rouen (Deshays), and above all, Provence and Languedoc in the south of France, with the important centers of Aix-en-Provence, Montpellier, and Toulouse (Bourdon, Rigaud, Rivalz, Natoire, and Vien)—made significant contributions to the formation of the French grand manner and often developed a pronounced, though understudied regional flavor that many of these artists brought with them to Paris. A few works that reveal some of the characteristics of these provincial schools (cats. 1, 31, 54, and 92) are included in the exhibition.

The milieu of seventeenth- and eighteenth-century French artists was shaped not only by chronology and region but also by family. Many came from dynasties of successful artists that spanned more than a century. These included the Boullognes (Bon and Louis); the Corneilles (Michel the elder, Jean-Baptiste, and Michel the younger); the Coypels (Noël, Antoine, Charles-Antoine, and Noël-Nicolas); the Dumonstiers (Pierre the elder, Daniel, and Pierre the younger); the Fragonards (Jean-Honoré and Alexandre-Evariste); the Mignards (Nicolas and Pierre); the Parrocels (Pierre, Charles, Etienne, and Jean-François); the Vanloos (Jacob, Carle, Jean-Baptiste, and Jules-César)—to name only some of the members of a few of these families. Moreover, these artists often lived and worked together, intermarried, and served as godparents to one another's children (in an age when this responsibility often led to surrogate parenthood because of illness and early death). In addition to issues of generation and regional heritage, the bonds among these interrelated families should also cause some measure of reflection when considering issues of stylistic similarity, diversity, and change.

Although a large proportion of the drawings in the present exhibition is related to various stages in the genesis of complex historical, religious, and mythological works that were considered to be at the apex of academic hierarchy—including a number of highly finished composition studies—the variety of different kinds of drawings in the Horvitz Collection (academic studies, portrait drawings, designs for book illustration, landscapes, and animal and nature studies) is reflected in both the exhibition and in the appendix. It is my hope that the public will have an opportunity to see and enjoy many of the other worthy sheets in this ever-expanding collection in future exhibitions devoted to specific periods, types, and genres of French drawings.

~

A large number of people made this project and exhibition possible. First among the many who should be thanked is the collector himself, who parted with hundreds of his drawings for more than five years, enabling them to be studied and enjoyed by students, scholars, and other visitors. He inspired us with his energy and enthusiasm; allowed me complete freedom to select the drawings for the exhibition and never interfered with the enterprise; enabled and encouraged my participation in the fast-paced growth of the collection (more than five hundred French and Italian drawings in five years); and provided the means for the necessary research, the participation of other scholars, and the production of this beautiful catalogue and exhibition. It has been a pleasure and a privilege to work with him and his collection.

I am grateful to William W. Robinson, curator of drawings, for first suggesting me for this project, welcoming me as a member of his department, and then patiently guiding me through the various stages of the organization and presentation of the exhibition, the selection of the authors, and the translating and editing of the catalogue. I also owe an enormous debt to Miriam Stewart, assistant curator of drawings, who answered scores of questions related to the storage and basic cataloguing of hundreds of drawings as I integrated them into the collection for frequent use by visitors and entered them into the Fogg's new database. Her kind and keen assistance as a proofreader in the final stages of publication is also reflected in many pages of this text.

Marjorie B. Cohn, Carl A. Weyerhaeuser Curator of Prints, and Deborah Martin Kao, Charles C. Cunningham,

Sr., Associate Curator of Photographs, made considerable space for this project available in the Fogg's new Agnes Mongan Center for the Study of Prints, Drawings and Photographs, always in a cordial and collegial manner. Kristen Collins, Erika Enright (who transcribed the interview with Mr. Horvitz), and Michael T. Dumas, administrative assistants in the Mongan Center, fielded a constant barrage of calls, faxes, and receipts; and Mary Ann Trulli, curatorial assistant, diligently helped me to see to the needs of a number of visitors who arrived specifically to see drawings in the this collection. I owe warm thanks to Eunice Williams—former assistant curator of drawings and still a consultant in the department—for her advice and guidance, as I (formerly a fervent scholar of the *dix-septième*) expanded my vision to incorporate the charms of the *dix-huitième*.

I am grateful to the project's three industrious assistants. Patrick Murphy, Anne R. Leonard, and Mark Roglan Kelley assisted in the preparation of the appendix, the biographies of artists, and the indices and helped to shoulder communications within the museums and with the more than thirty contributors to this catalogue in Europe and North America. Their efforts ensured the project's timely completion.

The scale of this project and exhibition involved a number of departments in the Art Museums. I am greatly indebted to Craigen Bowen, Philip and Lynn Straus Conservator of Works of Art on Paper, and her staff: Anne Driesse, Norene Leddy, Caroline Clawson, Ellen Young and—by extension—Eric Harrington and others. They unframed and analyzed the media of a constant flow of large drawings, provided the staff time necessary for their conservation, and handsomely rematted and reframed them for the exhibition. I owe a similarly great debt to the staff of the registrar's office, particularly to Rachel Vargas, senior associate registrar. They arranged for safe and efficient shipping of more than six hundred drawings and several loans from France, England, Switzerland, and various parts of the United States during the past five years, and the planning for this exhibition's complicated itinerary is already underway. Words are insufficient to thank Elizabeth Gombosi and her staff in the Museums' department of photographic services: Michael Nedzweski, David Mathews, Rick Stafford, and Liz Hansen. They shot nearly two hundred slides; they also produced more than seven hundred black-and-white photographs for documentation and study (as well as developing and labeling several prints of each for the benefit of scholars and potential venues) and then made more than 150 color transparencies for this catalogue in the midst of other projects and exhibitions. Stephanie Schilling, financial officer, and her staff handled the steady torrent of invoices and receipts that kept the project running. Evelyn Rosenthal, manager of publications, offered the patience and encouragement—both greatly appreciated—that made this catalogue possible.

The proficient designer (Christopher Kuntze) and the diligent copyeditors (Jennifer Barber, Carolann Barrett, Nicole Chaison, and Elizabeth Allen) she chose made the publication a pleasure to look at and read and made the process itself enjoyable. Danielle Hanrahan and her staff in the exhibitions department put forth an immense effort to accommodate many large works in an inventive and attractive way. The assistance of the staff of the Fogg's Fine Arts Library, which supported my research, is gratefully recognized. I also thank James Cuno, Elizabeth and John Moors Cabot Director, who was involved at every stage of the exhibition; Frances Beane, deputy director for finance and administration; and Rebecca Wright, manager of grants and traveling exhibitions, all of whom helped to ensure that the exhibition would be shown at venues that met the standards that they and Mr. Horvitz desired.

One of my largest debts of gratitude is to Maria Ascher, translator of most of the French texts submitted for the catalogue; she worked brilliantly under enormous pressure. Her role as a senior editor at the Harvard University Press also guaranteed that the translations arrived in elegant English. During the preparation of this catalogue, the office wing of Edgewater House, Mr. Horvitz's residence, also became a virtual extension of the Fogg. I offer my thanks to his secretaries Joyce Griffin and Milissa Putman, who fielded hundreds of telephone calls, saw to a wealth of administrative details, and helped to unearth several important documents from the files stored there.

Outside of the Harvard University Art Museums, my greatest debt is to my two coeditors, Margaret Morgan Grasselli, curator of old master drawings at the National Gallery of Art in Washington, and Jean-François Méjanès, conservateur-en-chef au Département des Arts Graphiques, Musée du Louvre, Paris. They received constant calls, faxes, and reams of paper—at home, at work, and while traveling—and despite their already busy schedules, they always managed to respond. Their frank discussions, advice, visits, their many entries, and the myriad number of other ways in which they have contributed during the past two and a half years have proved invaluable.

Pierre Rosenberg de l'Académie française, Président-Directeur of the Musée du Louvre, Paris, has been involved at various points in this project's development. I thank him for his foreword, his entry, his rapid responses to dozens of questions, and his constant support. I am also grateful to the authors of the essays: Marianne Roland Michel, director emeritus of Galerie Cailleux, Paris, and a noted scholar of early French drawings; Professor Alain Mérot at the Université de Lille; and Sophie Raux-Carpentier, maître-de-

conférences at the same institution: their essays provide excellent introductions to the array of topics included here. The quality of the scholarship in the entries of this catalogue would not have been possible without the nearly thirty other contributors listed on the pages following these acknowledgments. The coeditors and I thank all of them for their submissions.

The exhibition opens in Cambridge during the showing of two other important exhibitions supported by Jeffrey Horvitz. The first is *Lines of Inquiry: Ancien Régime Book Illustration from the Department of Printing and Graphic Arts* at Harvard's Houghton Library, organized by Graham Larkin, a Ph.D. candidate in Harvard's department of the history of art and architecture and a former Horvitz project assistant. Graham worked under the supervision of Anne Anninger, Philip A. Hofer Curator of Printing and Graphic Arts, and I thank her for allowing him to implement my idea of a related exhibition. *French Printmaking in the Age of the Musketeers*, organized by Sue Welsh Reed at the Museum of Fine Arts, Boston, with Maxime Préaud, conservateur-en-chef de la Réserve du Département des Estampes, Bibliothèque nationale de France, Paris, is a long-awaited exhibition that relates to the first third of the material in the present catalogue. I have enjoyed collaborating with these colleagues on the joint symposium that encompasses all three exhibitions.

The rapid growth of the Horvitz Collection necessitates our acknowledging the discoveries, assistance, and preliminary research of a number of dealers and their assistants (all of whose galleries are listed in the index of provenance), as well as the staffs of the departments of old master drawings at Christie's, Sotheby's, and Phillip's in London and New York. Historically, for the early French drawings in the collection, Mr. Horvitz and I owe a particular debt of gratitude to Thérèse and Bruno de Bayser of Galerie de Bayser, Paris; Mark Brady of W. M. Brady and Co., New York; Marianne Roland Michel and Emmanuelle de Koenigswarter of Galerie Cailleux, Paris; Didier Aaron, Hervé Aaron, Alan Salz, Isabelle Mayer-Michalon, and Bruno Demarest of Galerie Didier Aaron in Paris, London, and New York; Nicolas Joly, formerly of Galerie Yves Mikaeloff, Paris; and Emmanuel Moatti, Galerie Emmanuel Moatti, Paris. We would also like to thank: Olivier Aaron, Guy and Hélène d'Aldecoa, Marcello Aldega, Joseph Baillio, Jean-François Baroni, Jean-Luc Baroni, Jean-Christophe Baudequin, Patrice Bellanger, Katrin Bellinger, Laura Bennett, Siegfried Billesberger, Philippe Bismuth, François Borne, Etienne Bréton, Nicolo Brooker, Hélène Bucaille, Antoine Cahen, Marie-Christine Carlioz, Alexandra Chaldecott, Eric Coatalem, Kevin Dacey, Richard Day, Catherine Doubs, Annamaria Edelstein, Neal A. Fiertag, Jacques Fischer, Kate Ganz, Bertrand Gautier, Michel Gierzod, Margo Gordon, Jean-

François Heim, Penelope Hunter-Stiebel, Marianne Joannides, David Jones, Rénaud Jouslin de Noray, Chantal Kiener, Jack Kilgore, Guy Ladrière, Thomas and Jana Le Claire, Robert M. Light, Bruce and Angelika Livie, Elizabeth Llewellyn, James MacKinnon, Pippa Mason, Annie Martinez-Prouté, Patrick Matthiesen, Yves Mikaeloff, Michael Miller, Alain Moatti, John Morton-Morris, Gabrielle Naughton, Stephen Ongpin, Flavia Ormond, Patrick Perrin, Hubert and Michèle Prouté, Patrick Ramade, Crispian Riley-Smith, Françoise Risso, Christopher Robinson, Cristiana Romalli, Kate de Rothschild, Gregory Rubenstein, Scott Schaefer, Nicolas Schwed, Jean-Pierre Selz, Guy Stair Sainty, Bertrand Talabardon, Yvonne Tan Bunzl, Gabriel Terrades, Sylvie Tocci-Prouté, Lucy Vivante, Paul Weis, Clovis Whitfield, Thomas Williams, Samuel Wythe, David and Constance Yates, Anna Zablocki, and Pascal Zuber.

Extensive travel to conduct the research necessary to complete this project and exhibition, as well as last-minute requests for information and photographs, has left me with a large number of curators, collectors, scholars, and others to thank. First among these are Françoise Viatte, conservateur-en-chef du Département des Arts Graphiques at the Musée du Louvre; Jacques Foucart, conservateur-en-chef au Département des Peintures et chef de la Documentation at the same institution; and Maxime Préaud of the Département des Estampes, Bibliothèque nationale de France, Paris. My work was made possible by their constant and much-appreciated hospitality and the assistance of their staffs. I would also like to thank: Sigrid Achenbach, Véronique Alémany-Desaint, Dita Amory, Rocio Arnaez, David Barquist, Gert Bartoschek, Sylvie Béguin, Maria van Berge, Holm Bevers, Suzanne Boorsch, Catherine Bossis, Barbara Brejon de Lavergnée, Emmanuelle Brugerolles, Hans Buijs, Jacqueline Burns, André Cariou, Victor Carlson, Ulf Cederlöf, Daniel Chol, Gilles Chomer, Michael Clarke, Martin Clayton, Mauro Coen, Emmanuel Coquery, Jean-Pierre Cuzin, Gail Davidson, Cara Dufour Denison, Derick Dreher, Roswitha Erbslöh, Luigi Ficacci, Richard S. Field, Chris Fischer, Glaubrecht Friedrich, Thomas Gaeghtgens, Ulrike Gauss, Ugo Giamborella, Michel Gierzod, Hilliard Goldfarb, William Griswold, Stefan Hautekeete, George L. Hersey, Michel Hilaire, Sara Hyde, John Ittmann, Adrienne Jeske, Hana Karkanova, Annick Kyriazis, Alastair Laing, Jean Lavit, Jacques La Motte des Broöns, Christophe Léribault, Sally Lorensen Conant, José Luis de Los Llanos, Dietmar Ludke, Peter Märker, Harold Marx, Manuela Mena-Marqués, Henrietta McBurney, Suzanne Folds McCullagh, A.W.F.M. Meij, Christian Michel, Hermann Mildenberger, Vitaly A. Mishin, Eric Moinet, Jennifer Montagu, Christiane Nicq, Konrad Oberhuber, Hal Opperman, Paola Pächt-Bassani, Jean Penent, Ann Percy, Louis-Antoine Prat, Michael Prokopow, Patrick Ramade, Barbara Ross, Martin Royalton-Kisch,

Vadim Sadkov, Nicolas Sainte-Fare-Garnot, Xavier Salmon, Helena Santiago, Scott Schaefer, Peter Schatborn, Guilhem Scherf, Erich Schleier, Antoine Schnapper, Stephen Shutt, Bonnie Solomon, Françoise Soulié-François, Emmanuel Starcky, Perrin Stein, Claudio Strinati, Margret Stuffmann, Marilyn Symmes, Almamaria Tantillo, Jacques Thuillier, Carel van Tuyll, Catherine Whistler, Heinz Widauer, Henri Zerner, and the staffs responsible for the drawings, prints, and research materials in the many museums here and abroad whose works are represented in these pages.

Last, but not least, I would like to thank my parents, Catherine D. and Alvin L. Clark, Sr., for their continued love, understanding, and support—without which this publication would never have been completed. ALC

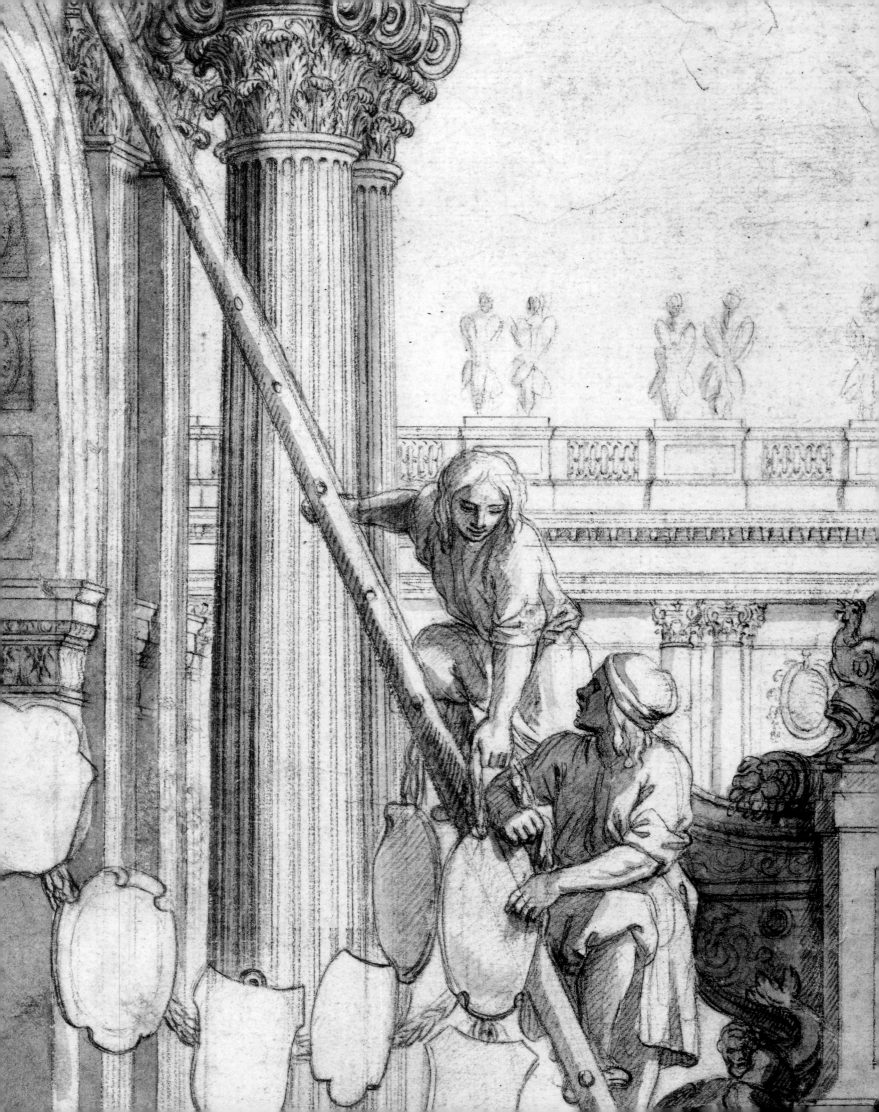

LIST OF CONTRIBUTORS

SB Sylvain Bellenger, directeur du Château et conservateur des Musées de Blois [cats. 108, 109, 110]

BBL Barbara Brejon de Lavergnée, chargée de conservation, Palais des Beaux-Arts, Lille [cat. 5]

EB Emmanuelle Brugerolles, conservateur, Département des Arts Graphiques, Ecole nationale supérieure des Beaux-Arts, Paris [cat. 3]

VC Victor Carlson, senior curator of prints and drawings, Los Angeles County Museum of Art [cats. 90, 91, 105, 113]

ALC Alvin L. Clark, Jr., Jeffrey E. Horvitz Research Curator, Department of Drawings, Fogg Art Museum, Harvard University Art Museums, Cambridge [primary organizer and coeditor/ Preface, Interview with WWR, cats. 4, 6, 8, 9, 10, 12, 14, 17, 20, 26, 29, 31, 43, 51, 52, 54, 70, 82, 95, 96, 97, 98, 99, 107, 115, Appendix, Biographies of Artists, and Indices with PM and ARL and Bibliography with MRK]

PF Peter Fuhring, independent art historian, Paris and Amsterdam [cat. 50]

HG Hilliard Goldfarb, chief curator, Isabella Stewart Gardner Museum, Boston [cats. 2, 19]

MMG Margaret Morgan Grasselli, curator of old master drawings, Division of Prints, Drawings, and Photographs, National Gallery of Art, Washington [coeditor/ cats. 24, 25, 27, 28, 33, 34, 35, 36, 39, 47, 71, 106, 114]

JH Jo Hedley, curator of paintings before 1800, The Wallace Collection, London [cat. 23]

AL Alastair Laing, advisor for paintings and sculpture, The National Trust, London [cats. 60, 61, 62]

SL Sylvain Laveissière, conservateur-en-chef au Département des Peintures, Musée du Louvre, Paris [cats. 101, 102, 103, 104]

TL Thierry Lefrançois, conservateur, Musées d'Art et d'Histoire, La Rochelle [cats. 45, 46]

ARL Anne R. Leonard, Ph.D. candidate, Department of History of Art and Architecture, Harvard University, and graduate student assistant, Department of Drawings, Fogg Art Museum [Biographies of Artists, Indices, and Illustration Credits with ALC]

SFM Suzanne Folds McCullagh, curator of earlier prints and drawings, The Art Institute of Chicago [cat. 77]

JFM Jean-François Méjanès, conservateur-en-chef au Département des Arts Graphiques, Musée du Louvre, Paris [coeditor/ cats. 21, 22, 40, 41, 42, 55, 56, 57, 58, 59, 63, 67, 68, 69, 74, 83, 84, 93, 94, 111]

AM Alain Mérot, professeur, Département d'Histoire de l'Art, Université de Lille III-Charles de Gaulle [Essay with SRC and cat. 16]

CM Christian Michel, professeur, Département d'Histoire de l'Art et Archéologie, Université de Paris X-Nanterre [cats. 72, 73]

OM Olivier Michel, librarian emeritus, Ecole Française de Rome [cat. 92]

JM Jennifer Montagu, curator emeritus, Photograph Collection, Warburg Institute, University of London [cat. 18]

EM Edgar Munhall, curator, The Frick Collection, New York [cats. 78, 79, 80, 81]

PM Patrick Murphy, M.A. candidate, Department of Art and Art History, Tufts University, and graduate student assistant, Department of Drawings, Fogg Art Museum [primary project assistant and Appendix with ALC]

HO Hal Opperman, professor, Department of the History of Art, University of Washington, Seattle [cats. 37, 38]

SRC Sophie Raux-Carpentier, maître de conférences, Département d'Histoire de l'Art, Université de Lille III-Charles de Gaulle [Essay with AM]

SWR Sue Welsh Reed, associate curator, Department of Prints and Drawings, Museum of Fine Arts, Boston [cat. 1]

WWR William W. Robinson, curator, Department of Drawings, Fogg Art Museum, Harvard University Art Museums, Cambridge [Coeditor and coorganizer/ Interview with ALC]

MR Marcel Roethlisberger, professor emeritus, Département d'Histoire de l'Art, Université de Genève [cat. 11]

MRK Mark Roglan Kelley, Ph.D. candidate, Universidad de Madrid [assisted with Bibliography and Index of Cited Drawings]

MRM Marianne Roland Michel, independent art historian and director emeritus, Galerie Cailleux, Paris [Essay and cat. 76]

PR Pierre Rosenberg de l'Académie française, Président-Directeur, Musée du Louvre, Paris [Foreword and cat. 53]

MCS Marie-Catherine Sahut, conservateur-en-chef au Département des Peintures, Musée du Louvre, Paris [cats. 32, 64, 65, 66]

XS Xavier Salmon, conservateur des peintures du XVIII siècle et du Cabinet des Arts Graphiques, Musée national des Châteaux de Versailles et de Trianon [cats. 44, 48, 49]

GS Guilhem Scherf, conservateur-en-chef au Département des Sculptures, Musée du Louvre, Paris [cats. 75, 85]

ALS Anne L. Schroder, visiting assistant professor, University of Florida, Gainesville [cat. 89]

AS Arlette Sérullaz, conservateur-en-chef au Département des Arts Graphiques, Musée du Louvre, et conservateur chargée du Musée Delacroix, Paris [cat. 100]

DT Daniel Ternois, professor emeritus, Département d'Histoire de l'Art, Université de Paris I-Sorbonne, Paris [cat. 7]

HW Heinz Widauer, research associate, Graphische Sammlung Albertina, Vienna [cat. 15]

EW Eunice Williams, independent art historian, Cambridge, MA [cats. 86, 87, 88, 112]

ACADEMICISM & ANTI-ACADEMICISM

Drawing in France in the Seventeenth and Eighteenth Centuries

Alain Mérot and Sophie Raux-Carpentier

*I*n France today, the word "academy," with its double meaning of a school of drawing and a method of instruction focused on life studies of the human figure, has a decidedly pejorative ring. The French academic system, increasingly stagnant during the nineteenth century, gradually lost the dynamic role it had played under the ancien regime, especially in its early years. But in a country where the importance of institutions and the centralization of power and artistic life reinforced each other during the seventeenth and eighteenth centuries, one cannot approach the study of the theory and practice of drawing without considering these institutions as both a starting point and nucleus. In this essay, we hope to show how education in drawing was conceived and developed, what was at stake behind the scenes, and how academic doctrine—to the extent that, with the aid of texts used at the time, one can distinguish a set of precepts—never held absolute sway but rather coexisted with alternative or openly dissident notions.

The Académie royale de Peinture et de Sculpture, hereafter referred to as the Académie, was founded in Paris in 1648, primarily under the initiative of young, ambitious artists eager to free themselves from the vexations and confining strictures of the old guild of painters and sculptors.[1] Protected by the crown, the Académie was conceived from the outset as a school and as a locus for exchanges and discussions. The founders' goal was to provide students with the most complete education possible in both theory and practice, and also to provide a forum for reflecting on the "difficulties of the arts." This, they felt, would enable French artistic standards to approach those that had been defined in Italy—specifically in Florence and Rome—in the preceding century.[2] They hoped that the inauguration of a series of *conférences* (lecture-seminars) in 1667, with the encouragement of the king's first minister, Jean-Baptiste Colbert, would foster debates and establish a body of doctrine while furthering the social and intellectual advancement of artists.[3] Thus painting and sculpture, which in France had long been viewed as simple "mechanical" occupations, could theoretically attain the status of the "liberal arts," in which the mind played at least as much of a part as the hand.

The academy founded in Florence in 1563 under the aegis of Cosimo de' Medici was called the Accademia del Disegno.[4] The French of the seventeenth century translated *disegno* by the term *dessein* (today spelled *dessin*). This word, like the English word *design,* had two meanings: both an idea that conceives and organizes, and a drawing (or *pourtraict,* as it was then called in French) that fixes and clarifies this conception.[5] As in Giorgio Vasari's time, the "arts of design" included painting, sculpture, and architecture. In these three disciplines, marks on paper were the realization of careful thought and a manifestation of the process through which the original conception of the planned work was elaborated, refined, and finally presented in what was considered to be a complete and finished work of art. This all-determining power of the preliminary stage assured drawing a central role within the fine arts, and allows the historian of French art to evoke a real convergence between monarchical authority, the Académie, and drawing. The king protected the Académie, and the Académie in turn guided the various arts by means of drawing, which it strove to acquire the sole right to teach. The universality of drawing thus mirrored the universality of an institution that controlled artistic life, within the harmonious hierarchy of the God-created universe and human society.

Though academies devoted to literature had first appeared in France in the late sixteenth and early seventeenth centuries, none had yet been formed in the realm of the visual arts.[6] But the notion of an academy was already present to some extent in the training offered by the workshop. Traditionally, students were educated in the atelier of a recognized master, where they could learn the rudiments of drawing by studying the examples given to them. Copying prints, plaster casts, statues, and drawings, and rendering draped mannequins and live models, constituted essential preparation for the practice of painting and sculpture. This preparation was more or less guaranteed, depending on the atelier, but was rarely conducted methodically. What mattered most was the rapid acquisition of a skill, a practical knowledge that would allow the apprentices, once they became journeymen, to help the master paint the altarpieces, decorative interiors, and portraits for which he had

received commissions. Occasionally effective, but sometimes brief in duration, this early form of training was scarcely at all concerned with imparting theoretical knowledge or a true education to the young artist. Poussin, who visited a few Parisian ateliers around 1620, reportedly thought little of them.[7]

The idea that this education could also take place within a wider, structured framework while providing an exemplum that offered its traditions and its models was a new one in France. The two Schools of Fontainebleau—the first active under François I^er and Henri II in the middle of the sixteenth century, and the second under Henri IV at the beginning of the seventeenth century—occupy an important place in the history of French art. First the Italians and then the Flemings played an essential role at Fontainebleau. Drawings were widely circulated among masters and students; Rosso Fiorentino and Francesco Primaticcio in the first instance, and later Ambroise Dubois and Toussaint Dubreuil, created a veritable tradition in this way. The large workshops, which brought together teams under the direction of these masters, encouraged copying and competition. The royal collections introduced young artists to the beauties of classical sculpture and Italian Renaissance painting. Talented engravers disseminated their masters' inventions to other centers, and thus contributed to the diffusion of a style.[8] To a lesser extent, the court of the semi-independent duchy of Lorraine at Nancy, which welcomed foreign influences, played an analogous role at the beginning of the seventeenth century.[9] Certain elements of an academic culture were thus already in place, but still scattered. They lacked the coherence that the later Parisian institution would try to establish.

The workshops had more or less established a pedagogy of drawing. It was characterized by two major tendencies that would come into conflict in future debates: the perpetuation of a manner, on the one hand; and the faithful rendering of nature on the other. The easiest and quickest way to educate beginners was to have them copy prints and drawings. They were encouraged to imitate well-known modern examples: Michelangelo, the printmakers active at Fontainebleau, certain Flemish masters, and so on. Thus "drawing" came to mean acquiring a skill (often at a virtuoso level), which included learning techniques that were difficult to unlearn. This accounts for the persistent traits evident in the work of the students of Georges Lallemant (Laurent de La Hyre), of Simon Vouet (Charles Poerson and Michel Dorigny), and of Charles Le Brun (Louis Licherie and François Verdier).[10]

The Académie strove to combat this danger of "mannerism"—a pitfall for every school—by centering its curriculum on the study of the living human form and the imitation of nature. In this respect, it was the heir of the Car-racci Academy in Bologna, which had been formed in reaction to the overintellectualism of the Florentine academy and other Italian drawing classes,[11] such as that formed by Domenichino in Rome, which Poussin doubtless frequented.[12] Early on, Jean Boucher, who had been to Rome several times and had studied classical sculpture, engaged men as well as women to pose as models in his atelier in Bourges (see cat. 4).[13] His drawings are remarkable for their directness and lack of affectation. Their concern for truth was an antidote to the formulas and the caprices of Jacques Bellange and Georges Lallemant, as well as the liberties that Martin Fréminet took with Michelangelo's work (see cats. 1 and 2).[14] This "anti-Mannerism" can also be seen in Flemish drawings such as those by Frans Pourbus the Younger and Philippe de Champaigne: their tranquil, staid compositions and their full, rounded forms, indifferent to elegance, turned their back on a style that was exhausting itself in ever more disappointing iterations.

Two conceptions that were very different but in which the observation of nature was combined with a certain idea of "the beautiful" dominated in the second quarter of the century. Simon Vouet and Nicolas Poussin both left a large number of drawings: the study of the work of these two contemporaries allows us to better distinguish the foundational principles of the Académie's systematic instruction in drawing.

For Vouet, who returned to Paris from Italy late in 1627 and was immediately offered major commissions for decorative painting, a large workshop was a necessity. As his slightly older contemporary Annibale Carracci had done when completing his commission to decorate the famous ceiling of the gallery in the Palazzo Farnese in Rome, Vouet undertook to direct a team of student-collaborators, whom he had to educate and, at the same time, make use of in the best way that their abilities would allow. In Vouet's atelier, they spent a good deal of time sketching the nude and draped human figure. The human form, in a multitude of poses, was the basis for his ample and fluid compositions (cat. 6). Master and students produced an enormous number of these highly recognizable drawings, executed in black chalk and heightened with white chalk on beige paper, in which the figure turns easily in space and the beauty of line and the fullness of form balance each other. The attention to detail, the numerous redrawings of a face, a hand, a curtain, or a garment, have their source in the working method. Vouet's finished composition drawings, which were often squared, or overlaid with a carefully measured grid (cat. 5), enabled his collaborators to paint the specific portion of the altarpiece or wall decoration that had been assigned to them. It was easy for Vouet, often working at the easel himself on the central elements of the commission, to intervene frequently, correcting and refining the students' work.

This taste for fine drawing, a legacy of the Bolognese artists, was initially based on the study of nature. But Vouet's skill and his authority over his students gave rise to a new mannerism.[15] Compositions consisted increasingly of a montage of figures in established poses, arranged in a decorative but not very logical arabesque. Only the foreground figures and some bits of architecture gave a suggestion of spatial depth. The prevailing fashion for pleasing curves and elegant effects permitted deformations (in hands, for example) that were like a signature, and were endlessly repeated in the works of devoted disciples such as Michel Dorigny, Charles Poerson, and the young Eustache Le Sueur (see cats. 16 and 17). Thus, between 1627 and 1649 Vouet's atelier became the first important school of drawing in France since Fontainebleau. It was a school in which blind imitation of a style engendered techniques that in the end became trite. Nevertheless, it was the elderly and infirm Vouet whom the Guild of St. Luke for painters and sculptors (later renamed the Academy of St. Luke) invited to establish a program of instruction in drawing, as part of the fledgling Académie in 1648. Students came in great numbers, but Vouet scarcely had time to engage models and set up the classes: he died the following year. Still, his appointment testifies to the prestige of the longtime master painter, who was also an incomparable teacher.

The solitary achievement of Nicolas Poussin, who had neither atelier nor collaborators (except when he supervised the decoration of the Grande Galerie of the Louvre, 1641–42), is different in every respect from the work of Vouet. For him, drawing did not serve to transmit knowledge or a skill to disciples, nor was its purpose to furnish assistants with sketches to be executed as paintings in a group enterprise. Rather, following the example of artists such as Domenichino, Poussin saw drawing as having two principal aims: first, to record casual observations made while taking walks or reading learned texts and to compile a repertoire of designs, costumes, and details for the enhancement of compositions; second, to make visible the development of a thought, of the *idea* of a painting, after it had been patiently worked out in his mind.[16] Poussin also used figurines that he could pose as he liked and place on a miniature stage.[17] Can this technique alone explain the fact that, among the graphic works by Poussin that have come down to us, there are no figure studies from life or from draped mannequins? Rather, it would seem that the drawings of this type have been lost, for the artist surely must have done some in his youth, especially after coming to Rome and entering the circle of Domenichino. He probably produced others every time he found it necessary to refine a figural pose and felt that figurines or classical statuary would not suffice as models.

Poussin's method stands in sharp contrast to Vouet's.

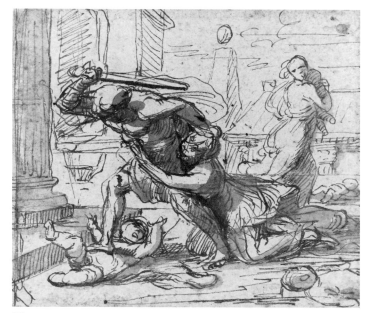

Figure 1

Vouet carefully prepared the individual elements of each composition, but surviving evidence suggests that he was much less concerned with studies of the whole (see cat. 5). Nonetheless, he did leave a certain number of such preparatory works, effortlessly conceived and organized, boldly sketched, and sometimes enhanced with touches of wash to evoke the effects of light in the finished painting. Conversely, Poussin took a good deal of time and trouble to find the best possible arrangement. The spark of inspiration was revealed in his first few strokes: the best examples of this are the vigorous drawings from his early years in Rome, such as the *Massacre of the Innocents* in the Palais des Beaux-Arts, Lille (fig. 1),[18] and the sketches from his old age. But he was rarely satisfied with his first attempts and never ceased revising his compositions. For a single painting we often have several drawings that correspond to successive arrangements of his miniature stage, whose apparatus enabled him to adjust simultaneously the perspective, the poses of the figures, and the lighting.

Poussin's exacting method made it impossible to work quickly or collaboratively, and it goes without saying that great decorative painters such as Annibale Carracci, Vouet, and Charles Le Brun did not make use of it. But it must have been a valuable teaching device for the Académie. This method encouraged a logical thinking through of the design and progression only on the basis of solid reason, without relying too heavily on manual skill. Poussin, like the masters of the Italian Renaissance, was convinced that one of the chief difficulties of painting lay in achieving the accurate representation of the human figure in space. To accomplish this, an artist had to practice rendering fully illuminated forms, beginning with the simplest.[19] As a consequence of this principle, in drawings such as his *Moses Defending the*

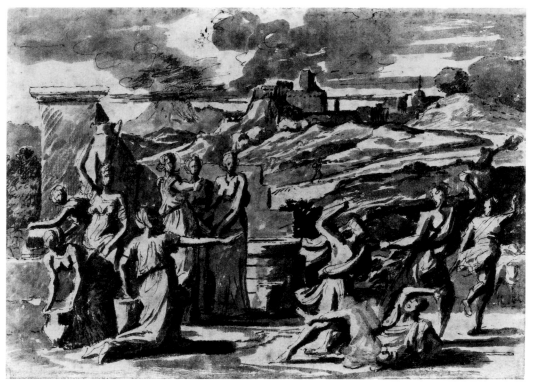

Figure 2

Daughters of Jethro of c. 1647 in the Fogg Art Museum (fig. 2),[20] the rendering of the bold and simplified forms of the wax figurines creates an almost disturbing effect with the chiaroscuro of the wash.

Poussin never ceased to insist on the importance of representing figures in relief. He relied on a profound knowledge of sculpture, acquired from contact with friends such as the Flemish sculptor François Duquesnoy, but also with earlier masters such as Giulio Romano, whose work he studied in the form of engravings soon after his arrival in Paris. Unlike his contemporary, François Perrier, who was renowned for his two books of etchings after famous antique sculptures and bas-reliefs in Rome, which were often used in academic collections as didactic tools, Poussin did not set about making faithful copies of ancient art. Instead, he understood such classical works "from the inside," by measuring them and by distinguishing the various aesthetic norms of the ancient Greeks and Romans. In doing so, he allied himself with a fundamental academic precept: nature, which was inherently imperfect, had to be corrected by reference to Greco-Roman works. In order to accomplish this rectification, one had to memorize the proportions of the most famous classical statues (fig. 3). Thus, Poussin compiled a large repertoire of figural types to represent a diversity of characteristics (age, sex, class, appearance), figures that the painter of biblical and historical scenes could use freely as a source to generate compositions.[21]

Paradoxically, this learned and ideal conception was not accompanied by the concern for "finish" generally associated with academic practice. Poussin was not in the least a virtuosic or even skillful draftsman. His hand, soon afflicted with tremors because of illness, strove to follow his thought by making successive attempts to render logically conceived and slightly abstracted figures. He did not try to rival nature or to exalt the flesh. After the sensuality of his earliest "neo-Venetian" canvases, which often corresponded to studies in wash depicting similarly lithe and fluid forms, came a more severe style with figures that would later be criticized for their dry, lapidary quality.

Vouet and Poussin thus embodied, even before the founding of the Académie, two tendencies that had been present in the Italian academies of the late sixteenth century. The first was more sensual, a legacy of the northern Italian ideas exemplified by the painterly art of Venice and the Bolognese Carracci. The second was more cerebral. Central Italian in origin—and incorporated in the works of Florentine and Roman painters such as Vasari and Federico Zuccaro—it was linked with the spirit of Leonardo's Treatise on Painting. Vouet reminded French artists of the need to follow nature in their drawings, and to look closely at the model, even if its beauty was subsequently enhanced. Poussin, in contrast, emphasized the mind's control over the hand and the superiority of a logically composed vision (the prospect) over the simple first glance (the aspect).[22]

Around 1640, we see a reaction against the style of Vouet, then dominant in Paris, and against a practice that had come to be viewed as lacking in rigor. This movement, in fact, was led by some of Vouet's students, including Le Brun and Le Sueur. These two artists, especially the first, would play a major role in the founding of the Académie. The return from Italy of painters such as Perrier,

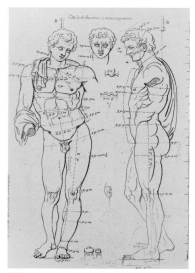

Figure 3

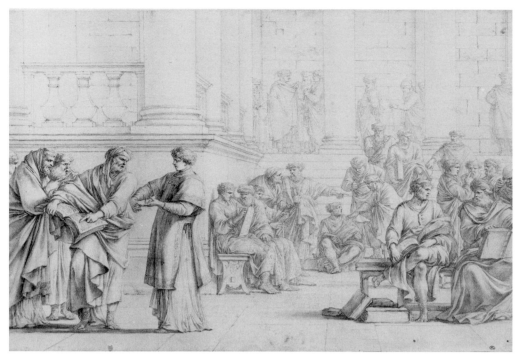

Figure 4

Jacques Stella, and Rémy Vuibert, and Poussin's brief but decisive stay in the French capital (1640–42), helped to promote a Rome-inspired classicism in which the principal elements and sources were clear: the importance of classical sculpture; the model of Raphael and other artists of the High Renaissance; and finally, the example of a few modern masters such as the Carracci, Domenichino, Andrea Sacchi, and Poussin, whose conservative choices differed radically from those of the newer trends of the Baroque seen in the works of artists such as Gian Lorenzo Bernini, Giovanni Lanfranco, and Pietro da Cortona. Of course this new classicism, which contrasted in so many ways with the graceful, but more facile lyricism of Vouet, did not gain the upper hand all at once. Poussin's altarpiece for the Jesuit Novitiate and his plans for the classical-style decoration of the Grande Galerie of the Louvre were not by any means greeted with universal approval.[23] Nonetheless, between 1645 and 1655 we see the emergence of an elegant, purist style in the French capital that has sometimes been called "Parisian Atticism."[24] Its foremost practitioners were Stella, La Hyre, and Le Sueur, but one could also add Perrier, Vuibert, Sébastien Bourdon, and a few others. Whether or not they spent time in Italy, all relied on similar major sources and expressed themselves with deliberate care and clarity, banishing indistinctness, superfluous ornament, and exaggerated movement. They attached equal importance to drawings of the whole composition and to studies of individual figures. In their composition drawings, the artists strove for patient refinement of the idea, a gradual perfecting of the design, balanced in all its parts and set into perspective through the use of skillfully graduated architecture. In their individual figure studies,

they emphasized the clarity of the forms, the fine draperies with delicate folds, and the natural expressions. In both, the contours were sharp and the shading relatively light, whether the artist used cross-hatching and touches of chalk or a light wash (see cats. 10 and 15). The compositional studies by La Hyre for his *Life of St. Stephen* (fig. 4, *St. Stephen in Discussion with Members of the Synagogue*, Musée du Louvre, Paris),[25] or those by Le Sueur for his *St. Paul at Ephesus* and his decorations for the Cabinet des Muses of the Hôtel Lambert (fig. 5, *Clio, Muse of History*, Musée du Louvre, Paris),[26] clearly illustrate how the practitioners of Atticism placed drawing and its capacity for mimetic precision squarely at the heart of the creative process.[27]

In 1663 the Académie acquired the sole right to teach drawing. Successive regulations established the course of study.[28] The twelve professors, referred to as *anciens*, each taught for one month of the year, in rotation. The classes became progressively more difficult. First, the students copied prints and drawings of works by these masters or of classical statues; next, they practiced drawing the various parts of the human figure, before rendering it in its entirety; then, they moved on to group compositions. At the second level, the students worked from sculpture and followed a similar gradation of difficulty. Since the students had moved into the third dimension during the second stage, this level also included exercises in perspective. Finally, they were allowed to progress to life studies of the human figure (always male). The professor in charge would engage a model for the class several days a week, and he would choose the poses and the lighting. He would also correct drawings made during these sessions, as seen in the well-known eighteenth-century depiction by Charles-Joseph Natoire in the Courtauld Institute, London (fig. 6). Unfortunately, there are no seventeenth-century

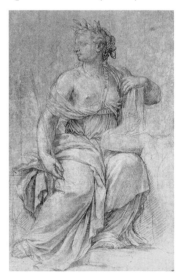

Figure 5

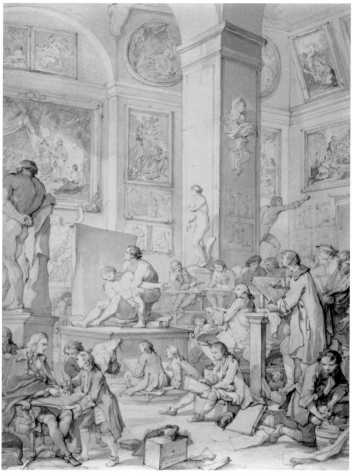

Figure 6

renderings of the institution and its process. Prizes were established to encourage emulation and stimulate competition. This ideal course of instruction was not implemented without difficulties. During the winter of 1670–71, for example, the students wanted to begin with life studies right away and vigorously protested the rule that forbade them to do so.[29] In 1694, a lack of funds nearly forced the Académie to suspend its activities.[30] But the machine had been set in motion, and the school of drawing became the heart of the institution, reaching its apogee in the eighteenth century and continuing to this day, through good times and bad.

The goal of the graduated process initiated by the new Académie was to train not only the students' hands but also their judgment. They were given both pragmatic exercises and instruction in theory. The latter met with variable success but was declared necessary from the earliest days of the institution. As we have mentioned, the practical lessons included a course in perspective, but they also comprised related studies of geometry, and a course in anatomy that was initially taught by a surgeon. Each of these courses presented quantities of precise, scientific knowledge to guide and control the artist as he drew. The inauguration of *conférences* (lecture-seminars) in 1667, the first of which were published through the efforts of André Félibien in 1668,

completed the academic edifice by supplying it with the doctrinal capstone that certain of its founders desired.[31] But in the final analysis, such lectures did more to promote free discussion—and even argument—than to elaborate a true doctrine, as evident in the dispute between Le Brun and Abraham Bosse over perspective, and in the famous "Quarrel of Color versus Line" (often referred to as the *Rubénistes* vs. the *Poussinistes*).[32]

At the instigation of Le Brun, between 1675 and 1679 Henri Testelin gave a series of lectures, illustrated with "lists of precepts" that were generally considered the epitome of academic orthodoxy.[33] In one of these lectures, "On the Uses of Line and Drawing," Testelin declared that line was "the father of all arts and all surfaces, which cannot exist without a boundary" and that its "most glorious and most difficult subject is the human form."[34] These maxims justified the preeminence assigned to life studies.

At the Académie, it was important to distinguish, in practice, between drawing *by eye* and drawing *by rule*. Thus, students initially copied what was in front of their eyes; but to finish and correct their work, they relied on the ruler and the compass, as well as on the disciplines taught at the Académie: anatomy, geometry, and perspective. Testelin's lectures reflected the debates that were taking place within the Académie between those who advocated the *simple imitation of nature* and those who favored beautification by reinforcing the contours according to the *grand goût* (noble taste). Although somewhat cumbersome, these terms are more precise than "Classicism" and "Baroque," which are so unsatisfactory and problematic when applied to French art. But we should remember that these two notions of drawing were applied with particular reference to students. If beginners were told to imitate the model exactly in order to "accustom the eye and hand to accuracy and precision," those who became more advanced were invited to join theory to practice by correcting the imperfections in what they saw with the application of what they knew, for the ultimate aim of these exercises was the grandly decorated interior, the history painting, or the bas-relief and sculptural group in which each figure had to have the character appropriate to it. The contemporary concern for *decorum* and the *affetti,* or what we now refer to as propriety and the expression of the passions, was given the greatest weight. It is here that we see the effect of the science of proportion, based on assiduous study of Greco-Roman art, which would prevent the artist from taking too many liberties by the development of a false, ill-conceived manner on the one hand, and an overly slavish imitation of nature on the other.[35] The diversity found in the real world was reduced to a limited repertoire of easily recognizable human types—which drawing, above all, allows us to distinguish—whose physical aspect corresponded to their social condition and character.

Figure 7

Figure 8

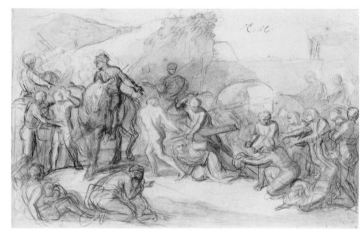

Figure 9

Figure 10

Confronted with the enormous task of satisfying numerous commissions—ranging from cabinet pictures to monumental decorations for great Parisian townhouses, the Château Vaux-le-Vicomte and, of course, the royal Château de Versailles, which contained the gigantic canvases depicting the *Battles of Alexander*—Charles Le Brun gradually learned to conceive and perfect his works methodically through drawing. After the "first idea," impatiently rendered in chalk, came successive stages of refinement and precision. He drew each figure or group of figures in the composition separately, often initially in the nude and then draped; he gave special attention to gestures and particularly to faces, on which the passions could be read.[36] Large-scale versions on board were then made, enabling the collaborators to carry out the master's ideas under the best conditions. The painting and the series of related drawings for Le Brun's *Jesus Carrying the Cross* in the Musée du Louvre, Paris (figs. 7–10), reflect his idea. His later process of transformation from nature to the correction of reality was the essence of the academic method.[37] The composition sketch (fig. 9) shows his indebtedness to Poussin's studies of light and shadow; the other drawings, where the contours circumscribe the figures firmly, with nothing vague or overly sensual about them, reveal his absorption of the art of Vouet and the Carracci, although their supple line has been hardened in the interest of expressive theatricality.

Le Brun's atelier marked the Académie's most successful period. Thanks to immense workshops, a great many artists were able to put into practice what they had learned in the school of drawing and to illustrate noble taste. In this grandiose endeavor, painters, sculptors, and the artisans of the Gobelins tapestry works were pressed into service.[38] Versailles was at once a huge workshop, a studio, an academy, a showcase for the decorative arts, and a school that subsequently made its influence felt throughout Europe. Drawing—*le dessein*—triumphed everywhere, and design no longer dealt only with the human figure but embraced an

entire world of forms. As first painter to the king, and director of the Académie, for several years Le Brun conceived and sketched everything: from doorknobs to painted ceilings, from fountains to tapestries, from staircases to statues. The ornament extended the life and heightened the value of the image. Here we see foreshadowed the "schools of drawing" later formed by artists specializing in ornament; these institutions would help account for France's enduring preeminence in the decorative arts.

By increasing the privileges and supremacy of the Académie, Colbert planned to make Paris a new Rome, a self-sufficient artistic center.[39] The rejection of Bernini's proposal for the Louvre in 1665, in favor of that of a French team, thus took on symbolic importance.[40] In fact, relations with Italy, far from breaking off, grew stronger in the early days of Louis XIV's reign. The creation in 1666 of the Académie de France à Rome (referred to here as the French Academy in Rome), whose first directors, Charles Errard (frontispiece to essay, Horvitz Collection)[41] and Noël Coypel, were skilled at "classical" drawing, certainly enabled young artists to steep themselves in the art of Raphael and the ancients by copying it, but also made them better acquainted with both modern Italian painting in the classical mode and the newer, more ecstatic Roman Baroque, from Pietro da Cortona to Carlo Maratta. The example of Jean-Baptiste Corneille, who produced odd (even bizarre) drawings, if one judges them according to academic criteria, is significant here (fig. 11, Fogg Art Museum, Cambridge).[42]

*I*n the latter half of the seventeenth century, the brilliance of the Académie in Paris, which counted among its members many from the provinces, gave rise to imitations.[43] Sébastien Bourdon had wanted to open an academy in his native Montpellier in the south of France, but it was Jean de Troy who presided over its founding in 1679. In Toulouse, capital of Languedoc in southwestern France, Hilaire Pader—who found time to be a practicing painter, theoretician, and teacher after his return from Italy—attempted unsuccessfully to set up a school for drawing.[44] It was only in 1726 that Antoine Rivalz was able to open an academy in Toulouse that would crown his own achievements in the arts.[45] Toward the end of the seventeenth century, in the north of France at Lille, Arnould de Vuez, a member of the Académie since 1681, held a drawing class once a week.[46] Such initiatives multiplied in the following century, which became the golden age of the regional academies.

In the south of the country, from Lyon to Toulouse, the ties with Italy remained very strong, and the Parisian Atticism and Poussinism that characterized much of the work of the Académie had little influence. Thus, the spirited draw-

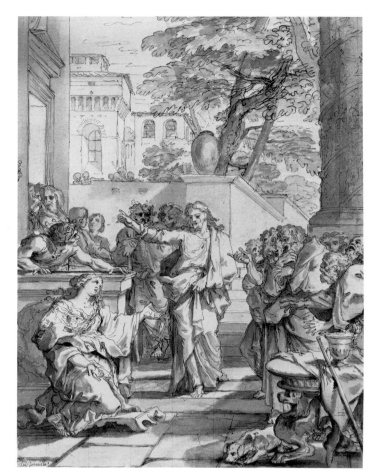

Figure 11

ings of Pierre Puget, like his *Milo of Croton* (fig. 12, Musée des Beaux-Arts, Rennes), remained dependent on the Genoese Baroque.[47] Among the winners of the drawing competition organized by the Accademia di San Luca in Rome were southern French artists like Raymond La Fage (in 1679) and Antoine Rivalz (in 1694). La Fage, who practiced drawing as an end in itself, would hardly have met with praise among those who championed correctness. As his superb *Conversion of St. Paul* (fig. 13)[48] in the Fogg Art Museum reveals, the "fire" of his impulsive yet virtuosic style springs from a "libertinage" of line that in the eighteenth century would evoke diametrically opposed reactions: infatuation on the part of devoted collectors like Pierre Crozat and Jean de Julienne; and censure on the part of contemporary purists like the renowned collector, Pierre-Jean Mariette, and the celebrated amateur, Anne-Claude-Philippe, comte de Caylus.[49] We would have to return to Lorrainese Mannerists such as Jacques Bellange and Jacques Callot—who, like La Fage, produced drawings as well as etchings, or to the sometimes grotesque and freely rendered subjects of Pierre Brébiette—in order to understand the continuity, throughout the seventeenth century, of a current that was resolutely on the margins of official instruction and that even openly made fun of it. Didn't La Fage boast of being able to draw a human

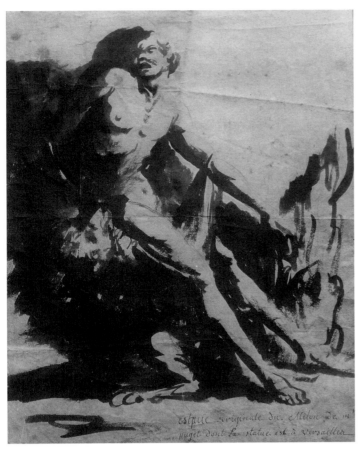

Figure 12

*L*e Brun's official doctrine, based on the primacy of draw-
ing, was again called into question during the Quarrel
of Color versus Line. Criticism of this principle was first
raised, tentatively, by the painter Charles-Alphonse Dufres-
noy in his poem *De Arte Graphica* of 1667. It then took on a
considerably more aggressive tone with the painter Louis-
Gabriel Blanchard,[52] and especially the theorist Roger de
Piles.[53] Whereas Le Brun thought that line was superior to
color because it addressed itself to the mind and not just to
the eye, de Piles maintained that color should be ranked at
least as high as line because it was chiaroscuro that gave the
work of art its perfection. This perfection was not satisfied
with imitating nature, but had to surpass it in order to attain
"perfect truth," understood to be a combination of "simple
truth" and "ideal truth" that only Raphael succeeded in
approaching. But equally great exemplars, according to de
Piles, were Rubens and the Venetians: in his book, *A Course
of Painting by Principles*—which included a pivotal section
entitled the "Balance of Painters"—he accorded them high-
est honors for their use of color.

For de Piles, drawing remained "the key to the fine arts, . . .
the tool of our demonstrations and the light of our under-
standing."[54] The study of anatomy and the science of pro-
portion, based on classical works, were still the basis on

figure on the basis of five points chosen at random?[50] As for
Rivalz, his drawings demonstrate that the Poussinesque and
classically inspired taste that had been the standard at mid-
century was later supplemented with a grandiloquence and
a *terribilità* that harked back to Michelangelo and incorpo-
rated elements of Roman decorative style, from Cortona and
Giovanni Battista Gaulli to Andrea Pozzo (see cat. 31).[51]

The works of a number of landscape draftsmen reveal
that this arena offered relative freedom from excessive regu-
lations. The practice recommended by the academies, begin-
ning with the one formed in Haarlem under Karel van
Mander at the end of the sixteenth century, linked the draw-
ing of the motif sketched from nature and observed by
chance in the course of walks with the carefully thought-out
composition created in the studio. The finished drawing still
depended on the sensory stimulus of the object seen. The
exuberantly animated studies by Claude Lorrain, which
combined line with wash, seem to presage those of Georges
Focus, Jean-Baptiste Forest, and the mysterious Guillerot
(see cat. 22), artists who are known to us through only a few
works, but who constructed their landscapes based on vary-
ing combinations of reality and imagination.

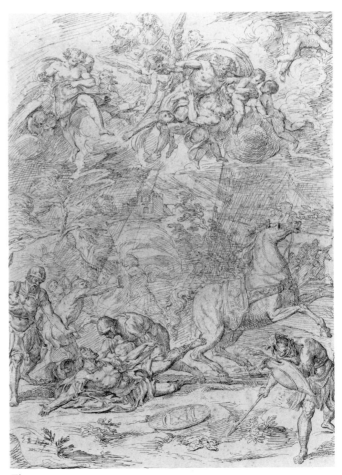

Figure 13

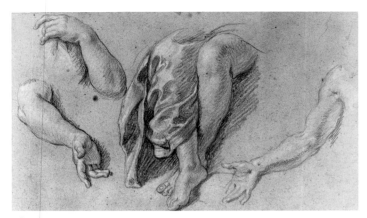

Figure 14

nudes executed by professors and now in the collection of the Ecole nationale supérieure des Beaux-Arts in Paris.[59] If Le Brun and his direct successors such as Alexandre Ubelesqui, Verdier, and Jouvenet (fig. 15, Horvitz Collection)[60] remained staunch defenders of emphatic lines, noble proportions, correctly rendered anatomy, and emotional expressiveness, a new sensibility appeared in the contemporary works of La Fosse (cat. 23), de Troy, Largillière, Louis de Boullogne (cat. 27), and Antoine Coypel. Their figures, which displayed increasing suppleness, evoked those of Rubens and Bernini, and the use of darker papers and the *trois crayons* technique enabled the artist to create the illusion of a delicate play of color and light on the surface of the skin.

This liberating current of colorism found its most radical expression in the realm of ornament. The arabesques sketched by Claude Audran and Jean Bérain (fig. 16, Yale University Art Gallery, New Haven)[61] substituted whim and imagination for reasoned thought, opened the way to the Rococo aesthetic (the art of the delicate line, and the reign of asymmetry and extravagant forms, arabesques, and sinuous curves), and laid the groundwork for the genre of the picturesque, which respectable academicians such as Jacques de

which drawings were corrected. But the classical had to be "tempered with living beauty," or else the artist risked falling into a coldness like that of Poussin, who, for de Piles, "had a taste for stone."[55] Coldness and a mannered style were the dangers that "enthusiasm" and a sense of truth would enable the artist to avoid and that, even with flaws, would always be preferable to a "correct mediocrity."[56] This desire to make academic rules more flexible became ever more widespread, and it finally triumphed in 1699 with the appointment of the architect Jules Hardouin Mansart as surintendant des Bâtiments du roi, and the painter Charles de La Fosse as director of the Académie. Both were supporters of the ideas of de Piles, who set up a curriculum for students that was strongly colorist.[57]

Under the inspiration of these two men, the partisans of color (or *Rubénistes*) moved toward a style of drawing that was freer and more fluid of line, reflecting the new interest in the Flemish and Venetian masters. As his *Sheet of Studies* at the Fogg Art Museum illustrates (fig. 14),[58] La Fosse was a great admirer of Rubens and one of the originators of the *trois-crayons* technique in France, using three colors of chalk (white, black, and red), sometimes on tinted paper. This technique enabled artists to achieve a broad range of tonal contrasts. Antoine Coypel, who copied details of Rubens's *Life of Marie de' Medici* in the Luxembourg Palace, shared the same predilection for this coloristic technique, which Gabriel Blanchard, Michel Corneille the Younger, and Louis Galloche would also use, but more sparingly (see cat. 32). François de Troy and Louis de Boullogne remained loyal to the traditional combination of black and white chalks on colored paper, but nevertheless participated in this stylistic renewal through a more supple and spirited treatment of their subjects (see cat. 27). For all of these artists, drawings still served their traditional academic function as preparatory studies for paintings—records of first inspirations, studies for individual figures and details, and *modelli*.

Even the routine figure studies drawn from life give evidence of these changes, as shown in the series of academic

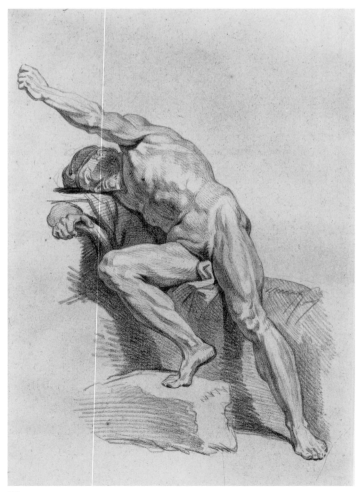

Figure 15

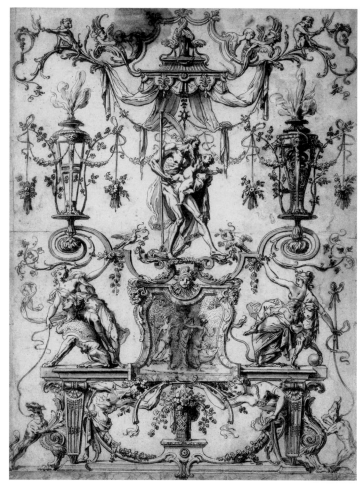

Figure 16

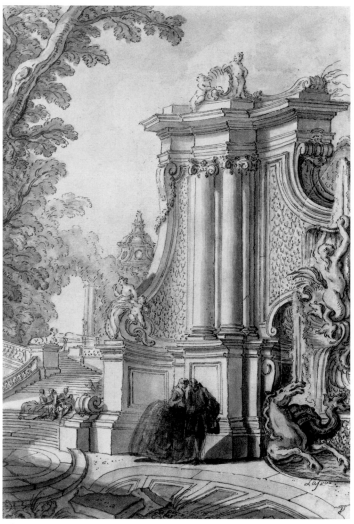

Figure 17

tional hierarchy of subject matter, he elaborated a process of composition that went against hallowed tradition: he produced a large number of figure studies sketched for the most part from life, without any specific purpose. These works, depicting one or several figures or perhaps various details, were gathered into books of sketches and formed repertoires of poses that the artist could use as a source of inspiration for his paintings. Thus, it was not the *idea,* the mental image of a future composition, that guided Watteau when he made his drawings. Instead, it was the impromptu nature of events and the spontaneity of his imagination that imparted the freshness of a new way of seeing to his sketches.[64] Even when Watteau drew from the live model, the pose still looked natural and unconstrained, completely unlike the conventional poses of models at the Académie, and he conveyed a sense of immediacy through the tension and quickness of the line.

After abandoning the rather stiff style he had acquired while working with Gillot, Watteau—then under the influence of Charles de La Fosse and Claude Audran, and inspired by the drawings in the Crozat collection—began using two or three colors of chalk. This became a technique

Lajoüe (fig. 17, Horvitz Collection)[62] and Jean-Baptiste Oudry would cultivate during the reign of Louis XV. In addition, artists introduced or developed subjects that did not belong in the hierarchy of genres established by André Félibien (historical, mythological, and religious paintings at the top, followed by portraits, landscapes, and still lifes). Claude Gillot, for example, drew scenes inspired by the world of the Commedia dell'Arte, fairs, and street shows, rendering them with rapid, clean strokes, and a vigor reminiscent of Callot and Pierre Brébiette.

Thanks to this atmosphere of openness, which promoted freedom from conventions, a talent as singular as Watteau's was able to develop despite the paradox of his situation. He was an artist and academician admired by his peers, but his overall practice betrayed an attitude that was often anti-academic. He matured in Gillot's atelier, where he was influenced by that master's unorthodox subject matter.[63] He spent a great deal of time copying drawings by the masters—notably Flemish and Venetian works in the renowned collection of the financier Pierre Crozat—yet he did so unsystematically, always following his own taste and seeking his own personal artistic enrichment. The creator of the *fête galante,* a new genre of painting that lay outside the tradi-

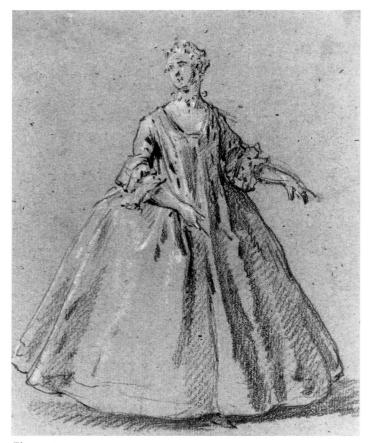

Figure 18

with which he would achieve chromatic effects of matchless refinement and extraordinary variety. An undulating line, which acquired rhythmic regularity through a few bold accents, rendered the essence of a figure, and quick suggestive touches enhanced the vivid luminosity, animating the silken sheen of the fabrics, which shimmered with accidental light. With his elongated proportions, anatomical imprecision, and fluid contours, Watteau's approach stylized nature. This approach was in opposition to the academic strictures of the preceding generation, but Watteau satisfied a basic academic tenet: he escaped the objective reality of forms through his own subjectivity and sense of grace.

Watteau had only one student in the strict sense of the word (Jean-Baptiste Pater, cat. 47), but he exerted a direct and profound influence on a number of artists, including Nicolas Lancret (fig. 18, *Standing Woman,* Horvitz Collection)[65] and Pierre-Antoine Quillard.[66] They adopted his motifs and techniques, but with a more anecdotal approach and mechanical execution, which led them to a "mannered" style. Thanks to Jean de Jullienne, who published etchings of 350 of Watteau's drawings in a two-volume collection,[67] the master's graphic work had a noticeable influence on the drawing of numerous artists in the first half of the eighteenth century, especially on the young François Boucher, who produced the etchings for nearly a third of the plates. Jullienne's compendium enables us to see the evolution in

Watteau's oeuvre of the figure study, which he eventually accorded artistic value in its own right—a development that was enthusiastically praised by Mariette, and that became widespread in the course of the century.[68]

The eclecticism and liberalism that prevailed from then on eventually led to an anti-academic tradition, which spans the eighteenth century, of charming genre drawings by both academicians and independent painters, draftsmen, and engravers such as Michel-Barthélemy Ollivier, Louis-Roland Trinquesse, Jean-Baptiste Chantereau,[69] Jean-Baptiste Mallet, Nicolas-Bernard Lépicié (fig. 19, *Kneeling Boy,* Horvitz Collection),[70] Jacques-Philippe Le Bas (fig. 20, *Scène galante,* Horvitz Collection),[71] Clément-Pierre Marillier, Jacques-André Portail,[72] Gabriel de Saint-Aubin, Jean Touzé, and Louis-Joseph and François-Louis-Joseph Watteau, both known as Watteau de Lille (figs. 21 and 22, *Blindman's Bluff* and *Village Carnival at Night,* Horvitz Collection).[73] Many of these enchanting works were later celebrated by nineteenth-century historians like the Goncourt brothers, who grouped several of these artists under the generic term *petits maîtres.*[74] These works were scarcely conducive to theoretical debates and reflections, and lectures at the Académie became ever more infrequent during the first three or four decades of the eighteenth century.

The contributions of Antoine Coypel provided an important early exception to this anti-academic trend. He believed that the work of art appealed above all to the pleasure of the eye and that its success depended on a skillful compromise between inspiration from past exemplars and the imitation of nature. In his *Lectures on Painting* delivered to the Académie in 1721, Coypel defined the new criteria of beauty, which were quite different from those that had prevailed in Le Brun's day, but which Dufresnoy had formulated as early

Figure 19

Figure 20

as 1667 in his *De Arte Graphica.* Coypel notes that: "In the representation of figures . . . it is a certain elegance of form—indistinct, wavering, much like a flame, one might say—which gives them the spirit that seems to animate them."[75] Undoubtedly inspired by the works of Watteau, this taste for elegant, sinuous, fluid renderings would be shared and incorporated into the works of such younger contemporaries as Oudry and François Le Moyne, and into the works of artists in the next generation like Boucher, Charles-Joseph Natoire, and Carle Vanloo.

*I*n the academic tradition, the work of Le Moyne was an important link between La Fosse and Boucher. Le Moyne embodied the new freedom within this heritage by combining the legacy of academic regulations with a renewed attention to nature, both of which were strongly advocated by Louis Galloche, his professor at the Académie (see cats. 32, and 40–42). But if Watteau, who had never been to Italy, looked more to Flemish exemplars, Le Moyne's vision of

nature was ennobled by the works of the great Italian masters. Under the influence of Venetian artists who visited Paris (Sebastiano Ricci in 1716, and both Giovanni Antonio Pellegrini and Rosalba Carriera in 1720), he adopted a supple, vigorous line and a bright, luminous palette that he passed on to his students, of whom Boucher and Natoire were the most talented. His subsequent sojourn in Italy—where the works of Pietro da Cortona, Federico Barocci, and Correggio were of greatest interest—confirmed his predilection for that "noble taste adorned with charm" that Antoine Coypel had described.[76]

Le Moyne, who in accordance with established institutional methods thought of drawing only as a means of preparation for painting, showed that he cared very little for academic rules (fig. 23, detail of cat. 42). The elongated proportions, sinuous and imprecise contours, and careless anatomy are rendered in an elegant, vibrant figural style in which, as Régis Michel has described it, "grace . . . is born not from adherence to aesthetic norms, but from the line."[77] Le Moyne's contemporaries have left us conflicting testimony regarding his qualities as a teacher.[78] Nevertheless, he exerted an undeniable influence over his pupils, as one can see from the elegant casualness of drawings by Natoire and Boucher.

Boucher, who derived his inspiration from both Watteau and the great Italian masters, was one of the most brilliant and prolific draftsmen of the eighteenth century. He worked in all genres and used all techniques. In his figure studies—notably the female nudes done in chalk—he developed a sensual style focusing on the surface of the skin, which none of his predecessors had perfected to such a degree. He also developed a figural vocabulary in which serpentine poses that lent themselves to intricate arabesques were animated by an energy expressed as much by the rhythm of the fluid line as by the velvety rendering of the flesh. Fine cross-hatching in red and black chalks formed vibrant contrasts with

Figure 21

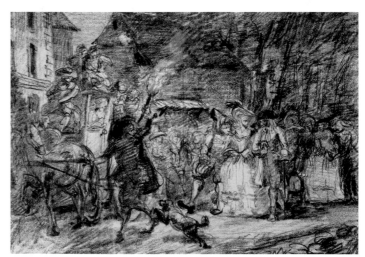

Figure 22

the exposed areas of the colored sheet. His group compositions displayed the same vigor (see cats. 60–62).

If Boucher remained faithful to the academic notion that drawings function as preparatory studies, he also readily understood the expectations of a new category of enthusiasts who were enamored of drawing. In 1732, the comte du Caylus delivered a lecture entitled "On Drawing" at the Académie.[79] In the lecture, which probably helped to foster the growing popularity of this type of art, Caylus confessed to his pleasure at discovering the intimate workings of the creative process, as well as his susceptibility to the sketch's charm—the way a drawing can render its subject with the utmost immediacy—though he reminded his audience that drawing was supposed to be a practice linked to painting and not an activity in itself. Boucher devoted particular care to all of his drawings, especially finished sheets like his *Two Girls and a Dog in a Landscape* (reproduced opposite Dedication),[80] which increasingly acquired value as works of art in their own right. In the course of the 1740s, not only his paintings but several of his drawings were displayed at the Salons, and connoisseurs of drawing contended with each other to obtain the best sheets.[81] Later, new techniques for imitating chalk drawings in engraving (perfected in the late 1750s and approved by the Académie) were used to reproduce the many studies by Boucher and others in order to satisfy a growing market.[82] The prints also promoted the broad diffusion of a style that would leave its mark on Boucher's numerous students, particularly Jean-Baptiste Huet, Jean-Baptiste Deshays, and Jean-Honoré Fragonard in his early years.

~

After this period of liberation, the eclectic style that had dominated for two generations finally lost its appeal toward the middle of the century. A certain weakness and laxness, as much in practice as in theory, was soon evident: for several years in close succession, no Prix de Rome was awarded because the skill of the students was judged insufficient, and there were no new *conférences* after Caylus's lectures of 1732.[83] The directorship of the Bâtiments du roi, which was occupied from 1708 to 1736 by the duc d'Antin and from 1737 to 1745 by Philibert Orry, had established relations with the Académie—condescending in the first case, distant in the second—that fostered a climate of apathy within the institution. The situation changed in 1745, with the appointment of Charles-François Le Normant de Tournehem as surintendant des Bâtiments du roi, who made it his mission to revive history painting in the grand style. This genre was then in crisis, having been vehemently denounced for its shortcomings by the critic Etienne La Font

de Saint Yenne in his negative response to the Salon of 1746.[84] This external pressure caused particular concern among the academicians, who felt exposed to the polemical judgments of laymen, and it spurred them to react.

To attain his objectives, Le Normant de Tournehem appointed Charles-Antoine Coypel (the son of Antoine) to the directorship of the Académie (see cats. 45–46). Their close collaboration and their shared desire to raise the intellectual and artistic level of the Académie are reminiscent (though on a more modest scale) of the cooperation between Colbert and Le Brun in the preceding century. Coypel revived the *conférences*, and the students were urged to attend.[85] Artists and art lovers engaged in much thoughtful discourse on the aesthetic and technical problems involved in the practice of art, without devising any new theoretical direction.[86] To raise the level of the students' performance, Coypel tried to strengthen instruction in drawing by insisting that the curriculum include courses in perspective, anatomy, and classical art.[87] He paid particular attention to the training of the Grand Prize winners, for whom he proposed setting up an advanced school designed to further their general education so that they could better profit from their ensuing stay at the French Academy in Rome. This new advanced institution was the Ecole royale des Elèves Protégés (Royal School of Students Protected by the Crown), founded by Le Normant de Tournehem in 1748, and opened the following year under the brief direction of Jacques Dumont le Romain (cat. 59), then of Carle Vanloo (cats. 63–66).[88] The artistic training was not remarkable for its originality.[89] In contrast, the introduction of a history course—taught first by Nicolas-Bernard Lépicié, then by Michel-François Dandré-Bardon beginning in 1755—clearly encouraged a return to the subject of history and to the genre of history painting, a change that influenced the generation of artists who entered the school in the 1750s. From the first graduating classes, a taste for historical knowledge was evident in the drawings of artists such as Louis Lagrenée, Louis-Félix de La Rue, François-Gabriel Doyen (cat. 82), Jean-Baptiste Deshays (cat. 84), Charles de La Traverse, and Nicolas-Guy Brenet.

In 1747, Coypel's efforts resulted in the formation of a group of eight amateurs, referred to as associates. These elected members played an increasingly influential role within the Académie. The majority of them were important philanthropists and collectors, motivated by an avowed passion for drawing. Among these, Mariette and Caylus deserve mention for being the authors of several key initiatives pertaining to drawing. After Crozat's death, the catalogue Mariette wrote for the sale of the collection of the great *amateur* revealed Mariette to be the foremost French historian of drawing. In this important publication, he devised methods of analysis and classification that would influence laymen

Figure 23 (opposite)

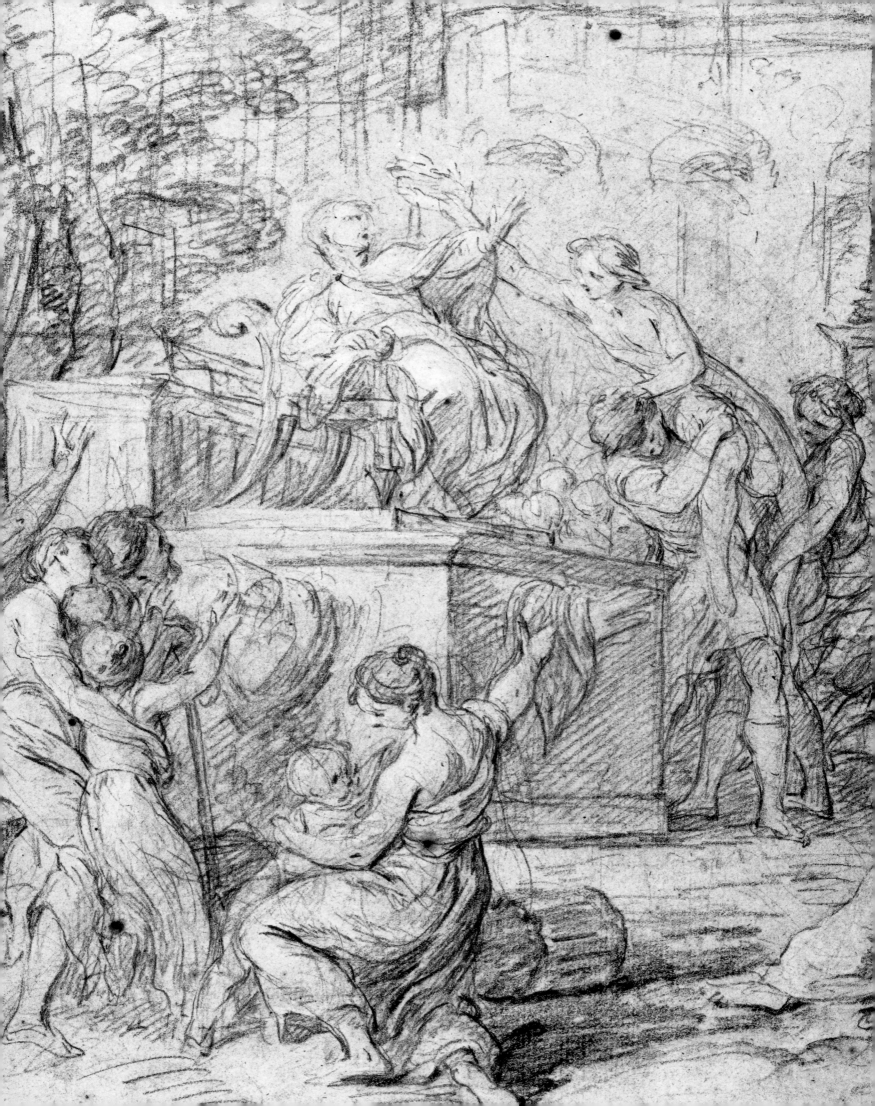

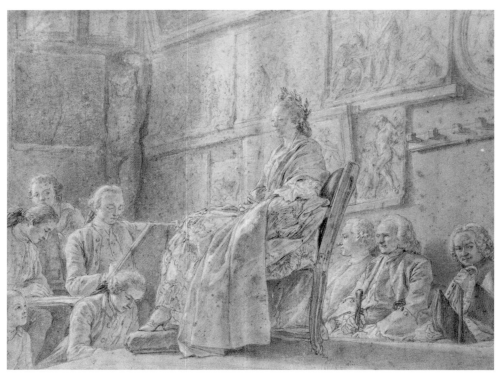

Figure 24

Meissonnier (cat. 50). Nevertheless, Cochin remained a supporter of modified classicism, urging artists to observe nature as closely as the ancient Greeks and Romans had, and rejecting a more "archaeological" approach such as the one advocated by the two most famous German expatriates in Rome, the critic Johann Joachim Winckelmann and the painter Anton Raphael Mengs.[94] Cochin later criticized these two for their influence over young students at the French Academy in Rome, whose style of drawing he described as "slight, dry, and meager."[95] In 1752, foreshadowing the celebrated publications of Winckelmann, Caylus presented the first of the seven volumes of his *Compendium of Egyptian, Etruscan, Greek, and Roman Antiquities* to the Académie.[96] In 1749, con-

and artists alike, and that would serve as a guide for all editors of collection catalogues throughout the century.[90] As for Caylus, in addition to his active participation in the Académie's lecture series, he instituted various competitions to encourage the study of drawing in the purest academic tradition. Among these was the famous Prix de l'Etude des Têtes et de l'Expression (Prize for the Competition in Head and Expression Studies) established in 1759, which led to the first use of female models in the Académie's classes although, as Charles-Nicolas Cochin le jeune's drawing of the competition illustrates (fig. 24, Musée du Louvre, Paris), they remained fully clothed.[91]

The process of change at the Académie gained momentum with the next pair of officials to dominate the world of French art. Abel François Poisson, brother of Madame de Pompadour and later marquis de Marigny, succeeded his uncle, Le Normant de Tournehem, as directeur des Bâtiments in 1746, and the prolific draftsman and engraver Cochin le jeune became secretary of the Académie in 1755 (cats. 72–73). The trip that these two had just made to Italy (1749–51) in the company of the *amateur* abbé Jean-Bernard Le Blanc and the architect Jacques-Germain Soufflot resulted in a marked alteration in the prevailing attitude toward French art. Cochin was a potent voice in the battle of noble taste against the humble manner through his numerous lectures and publications.[92] This battle, already begun under Le Normant de Tournehem's tenure, became noticeably more aggressive in 1754 with the artist's *Appeal to Messieurs the Goldsmiths*,[93] in which he decried the exaggerations of the Rococo style as seen in the work of artists like Juste-Aurèle

vinced that the study of classical art was essential, he had already introduced a new regulation giving students at the Académie free access to sketch the classical works that adorned its chambers.[97] The students, who as yet had little interest in antiquity, did not respond very enthusiastically to this opportunity. Neither did their teachers.[98] Following Caylus's lead, in 1754 Cochin published his *Observations on the Antiquities of the Town of Herculaneum, with Some Reflections on Classical Painting and Sculpture*.[99] These advocates of a return to antiquity "in the French manner" remained loyal to de Piles's principle, which two generations of artists seem to have disregarded: assimilate the lessons of antiquity in order to derive more profit from those of nature.[100] Appreciated as much for his sculpture as for his drawings, Edme Bouchardon appeared to be the one great exception (cats. 51 and 52).

Bouchardon's drawing preparatory to a medal for the Maison de la Reine of 1740, executed in his role as draftsman to the Académie des Inscriptions et Belles Lettres (fig. 25, Horvitz Collection),[101] demonstrates Cochin's belief that Bouchardon was the artist who led the "return to the simple and noble taste for the classical."[102] In the course of his years at the French Academy in Rome, then under the directorship of Nicolas Vleughels, Bouchardon assiduously copied classical and modern sculptures, as well as paintings (especially Raphael and Domenichino), and studied both the nude and draped human form. The rigor of these studies revealed his gift for the acute observation of nature. Whether the works were preparatory studies for his sculptures or drawings apparently made for their own sake, Bouchardon's simplified

Figure 25

modeling and his precision with red chalk, which accentuated the clarity of the contours with long enveloping lines, earned him a rare level of universal esteem. Despite the writings of Caylus and Cochin, and the celebrity of their preferred talents, another image of antiquity would gain ascendance, one that coincided with the return to the *grand genre* of history painting that had already begun. This image was not explicitly elaborated within the Académie, and no new theory was devised to replace the one that had held sway since the early years of the century. Still, two extensions of the academic system fostered its rise: the French Academy in Rome and the Salons, which were finally regularized starting in 1747.

≈

T he artists-in-residence at the French Academy in Rome, then housed in the Palazzo Mancini, were scarcely more enthusiastic about classical art than the students in Paris had been when Caylus attempted to stimulate their interest with new regulations in 1749. Joseph-Marie Vien serves as an instructive example here. It seems that his sojourn in Rome (1744–50) was not the decisive factor in the development of the Greek-inspired style that would make his reputation by the 1760s. On the contrary, it was only after his return to Paris (and thanks to his friendship with Caylus) that Vien actually revealed his study of classical art.[103] Abandoning chalks and colored paper, he adopted pen-and-ink and wash to create a romantic antiquity that marked a true transition between the art of Boucher and that of David. As his *Ancient Sacrifice in an Ionic Temple* in the Fogg Art Museum reveals (fig. 26),[104] his simple arrangements in low-relief,

frieze like compositions, his emphasis on linearity, and his avoidance of coloristic effects led the way to this new style, even though his line remained variable and the elongated proportions, small heads, and tapering limbs of his figures were still indebted to the Rococo aesthetic. Vien went only so far in refining this style. His myriad students—of whom François-André Vincent (cats. 98–99), Jean-François-Pierre Peyron (cats. 96–97), and Jacques-Louis David (cat. 100) were the most talented—were the ones who would take Neoclassical drawing to its peak.

In 1752, Charles-Joseph Natoire replaced Jean-François de Troy as director of the French Academy in Rome. In contrast to his predecessor, Natoire was determined to reinstitute a curriculum solidly grounded in drawing by encouraging the methods he had known in the days of Vleughels: copying works by Renaissance and modern classical masters, and sketching from life (nude and draped figures). The large number of studies by Jean-Honoré Fragonard after earlier masters, such as his *Bargellini Madonna* after Lodovico Carracci commissioned by the Abbé de Saint-Non (Horvitz Collection, fig. 27),[105] and the many studies after earlier masters drawn by his young contemporaries, reveal Natoire's influence. The teaching conducted under his direction also influenced students at the Académie in Paris, indirectly, through the work of the artists at the French Academy in Rome. These works were regularly shipped back to Paris, as the marquis de Marigny had requested, beginning in 1752.[106]

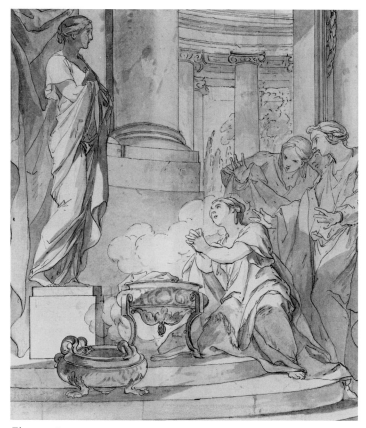

Figure 26

Natoire's most original contribution consisted in the attention he accorded to classical art and to landscape (see cat. 58). The artists-in-residence in Rome in the 1750s, who for the most part had come by way of the Ecole royale des Elèves Protégés, were particularly receptive to his teachings.[107] Certainly artists such as Lagrenée l'aîné and Deshays developed a graphic style that strove for dramatic effects through simple techniques. The same is true for Greuze, their contemporary, who studied in Rome independently (cats. 78–81). Others, such as Fragonard and Hubert Robert, drew superb vistas and landscapes in which they excelled at evoking a sunlit atmosphere, the changeability of the elements, and variable surface textures with limited techniques, such as pen-and-ink with wash or watercolor but usually red chalk alone, shaded through a broad range of tones and brilliantly contrasted with the exposed areas of the paper (see cats. 86, 88, 90–91).

\sim

\mathcal{T}he fashion for classical imitation that prevailed at this time in Rome as a result of the recent archaeological discoveries at Herculaneum and Pompeii—discoveries made known around the world through a variety of publica-

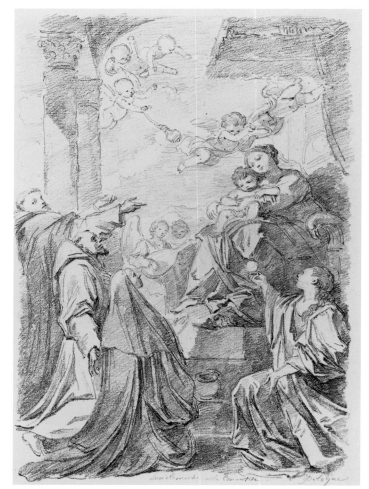

Figure 27

tions—sparked increasing enthusiasm for classical art. Natoire's villa on the Palatine constituted a sort of private annex to the French Academy in Rome: one devoted to the study of classical art and in which he facilitated contacts between the artists-in-residence and the international community of artists, amateurs, and antiquarians that flourished in the Eternal City.

From the 1740s through the 1760s, foreign artists and theoreticians began to exert greater influence on the developing styles of the young artists-in-residence at the Palazzo Mancini. In the 1740s, a first generation of artists that included Jean-Laurent Legeay (cat. 68 and fig. 28, Horvitz Collection), Michel-Ange Challe, Louis-Joseph Le Lorrain, Edmond-Alexandre Petitot and Joseph-Marie Vien (cat. 74), worked with Giovanni Battista Piranesi, who lived directly across from the French Academy in Rome.[108] All of the young French artists were inspired by Piranesi's bold and elliptical graphic style, his penchant for strong chiaroscuro and his grandiose, pre-Romantic image of antiquity reborn. Although this influence continued in the next generation of artists in the 1760s that included Hubert Robert, Etienne de Lavallé-Poussin, Louis-Jean-Jacques Durameau, and Joseph-Benoît Suvée (cat. 93), they made an effort to render their landscapes without the same monumental vision. Instead, this was replaced by a mixture of archaeological and topographical accuracy. For them, ruins were simply a documentable vision of the destroyed past. Many would be won over by Winckelmann's doctrine of the *beau idéal*, which Mengs, then looked upon as the new Raphael, was propounding at the Accademia di San Luca in Rome. For Winckelmann, the exemplar of Greek sculpture was superior to that of nature, and thus supplied the standard that had to be imitated. In his published works, which acquired the authority of manifestoes, he exalted the purity of line, the precise rendering of draperies, and both "noble simplicity" and "quiet grandeur" in poses and expressions. The drawings executed by François-Guillaume Ménageot, Jean-Simon Berthélemy, and Jacques Gamelin (c. 1760–80) again betray a certain hesitation between the supple, elegant style of the first half of the eighteenth century and the severely restrained mode that was becoming the norm.

Winckelmann's ideas were also gaining sympathizers in Paris, thanks to the influence of artists who had returned from Rome and to the activity surrounding the Encyclopédistes, led by Diderot.[109] The development and acceptance of Diderot's own criticism reveals how rapidly the doctrine of the *beau idéal* spread in the course of this decade. In his first reviews of the Salons, Diderot expressed his enthusiasm for the artists who adhered to naturalist values, to emotional expression in the service of moral content, and to a certain simplicity of form. His preferences at first were for Deshays, Vien, Joseph Vernet, Jean-Baptiste-Siméon

Chardin, and especially Jean-Baptiste Greuze, who was for some time his favorite painter. He praised Greuze effusively in his review of the Salon of 1765 for the fire and passion revealed in *The Ungrateful Son* (fig. 29, Palais des Beaux-Arts, Lille). Diderot was attracted to the composition drawing as much by the moral significance of the theme—which he termed "sublime"—as by the dramatic violence of the techniques used to strengthen the force of the argument: simplicity of arrangement, accentuation of the chiaroscuro, heightened rendering of gesture and expression, and free and spirited execution of the pen and wash, revealing the artist's "fire" and "genius." Though Greuze carefully worked out his compositions in myriad preparatory studies that left noth-

Figure 29

ing to chance, his method nevertheless seemed profoundly original: to avoid falling into the "routine" exemplified by the professional atelier, he sketched whatever caught his eye in the city's streets and public places, thus compiling a collection of poses and expressions that he subsequently refined and ennobled with his knowledge of the art of classical antiquity and the best seventeenth-century French masters.[110] But, two years later, in commentary on the Salon

of 1767, Diderot propounded a new approach that accorded with the aesthetic principles of Winckelmann. Thus, in opposition to the impetuosity of genius, the incompleteness of the sketch, and the spirited *fa presto*, he declared the process of patient elaboration, the deliberately thought-out work of art, and the perfection of "finish" as more important. He also exalted the "ideal line," purity of style, and the qualities of correctness and harmony.

Figure 28

⌇

*I*n the 1770s, with the appointment of Jean-Baptiste-Marie Pierre as first painter to the king and director of the Académie, and with Charles Claude Flauhaut de La Billarderie, comte d'Angiviller, at the helm of the Bâtiments, policies became noticeably more rigid. Pierre's success had been assured with elegant and balanced compositions like his *Vulcan Presents Venus with the Arms of Aeneas* in the Horvitz Collection (fig. 30),[111] and he and d'Angiviller shared many of the same views about the future direction of French art. For d'Angiviller, the aim of the liberal arts was to enhance national prestige and to serve as an example of virtue for the nation. History painting, thus confirmed as being at the summit of the hierarchy of genres and allied with monarchical power, was taught in an increasingly strict way, subject to a series of regulations designed to enforce discipline and regular attendance on the part of the students. Adhering to the purest tradition, emphasis was placed on praxis, and theoretical ideas no longer had a forum for public expression. The periodic *conférences* were replaced after 1773 by readings of classical poetry, and they were

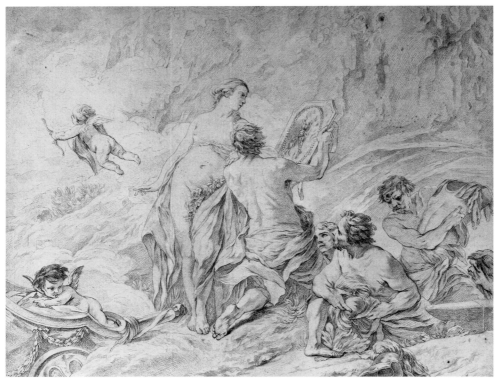

Figure 30

Peyron, Vincent, and, of course, David, chose to study Raphael, the Carracci, Domenichino, and Poussin. Vincent's *Head of a Woman* in the Horvitz Collection, after one of Raphael's figures in the *Expulsion of Heliodorus,* from the Vatican's Stanza di Eliodoro (fig. 31),[114] provides one example of these studies. As another study by Vincent from the Horvitz Collection illustrates (*Antique Male Bust,* fig. 32),[115] these artists also worked assiduously from classical models. Indeed, before long they surpassed their teacher. Greek sculpture, extolled by Winckelmann, acquired the value of a universal standard, which David went so far as to proclaim the best therapy for overcoming the influence of "inept French forms."[116] The students' fascination with marble led them to incorporate an ever-increasing rigor in their drawings. Inspired by the precise arrangements of bas-reliefs, compositions like Peyron's *Lucius Sergius Catalina Inciting Insurrection* from the Horvitz Collection (fig. 33),[117] were realized with simplified modeling, sharp contours designed to reveal the structure of forms, and often accentuated chiaroscuro for greater plasticity. Some of their classmates who were studying sculpture showed them the way—for example, in 1777, Antoine Du Pasquier undertook his *Triumph of Marcus Aurelius,*[118] a gigantic pen-and-ink drawing composed as a frieze. David followed in his footsteps with his astonishing *Classical Frieze,* which he began in 1778.[119] This was his first archaeologically inspired work and signaled his complete adherence to the new style. Around the same time, the sculptor Jacques Lamarie began to experiment with line drawing, inspired by the linear abstraction of Greek vases. He thus presaged the vogue for the aesthetic of the pure line, with its disembodied intellectuality. This was an approach that would become popular in the 1790s with Bénigne Gagneraux, Asmus Jacob Carstens, John Flaxman, Anne-Louis Girodet de Roucy-Trioson (see cat. 110), and many others.

After David returned to Paris, his Italian sketchbooks became an inexhaustible resource and inspiration for his painted compositions. He even felt compelled to return to Rome while working on *The Oath of the Horatii,* so that he could once again immerse himself in an atmosphere suited to his subject. The preparatory studies he completed before executing the painting reveal the stages of his thought, his movement toward an increasingly spare and balanced

discontinued altogether in 1781. This authoritarianism was accompanied by a move to centralize the role of the Académie, with respect both to artistic training and to the organization of public art exhibitions.[112]

When it came to artistic influence, Vien exerted significantly more than Pierre did as a teacher. He was a professor at the Académie in Paris, later the director of the Ecole royale des Elèves Protégés, and then director of the French Academy in Rome beginning in 1775. He had also begun giving a private course in drawing in his atelier as early as the 1750s. His novel methods attracted a number of young artists that included Jacques-Louis David (cat. 100), Jean-François-Pierre Peyron (cats. 96–97), Jean-Baptiste Regnault, Jean-Joseph Taillasson, Joseph-Benoît Suvée (cats. 93–94), François-André Vincent (cats. 98–99) and Julien de Parme. His goal was to bring the French school, both in theory and in practice, back to its old foundations by returning to the close observation of nature, classical exemplars, and the great masters. Vien's instruction differed from the official academic curriculum in the importance it placed on drawing from life: he devoted three days per week to life classes, whereas the Académie, from the outset, had allotted them only two hours per day.[113]

In Rome, Vien strove to accomplish the mission with which d'Angiviller had implicitly entrusted him: to interest young artists in the "new taste" and to revive the tradition of discipline and hard work that had faded away during the last years of Natoire's tenure, which had been characterized by a general negligence. The most promising students, such as

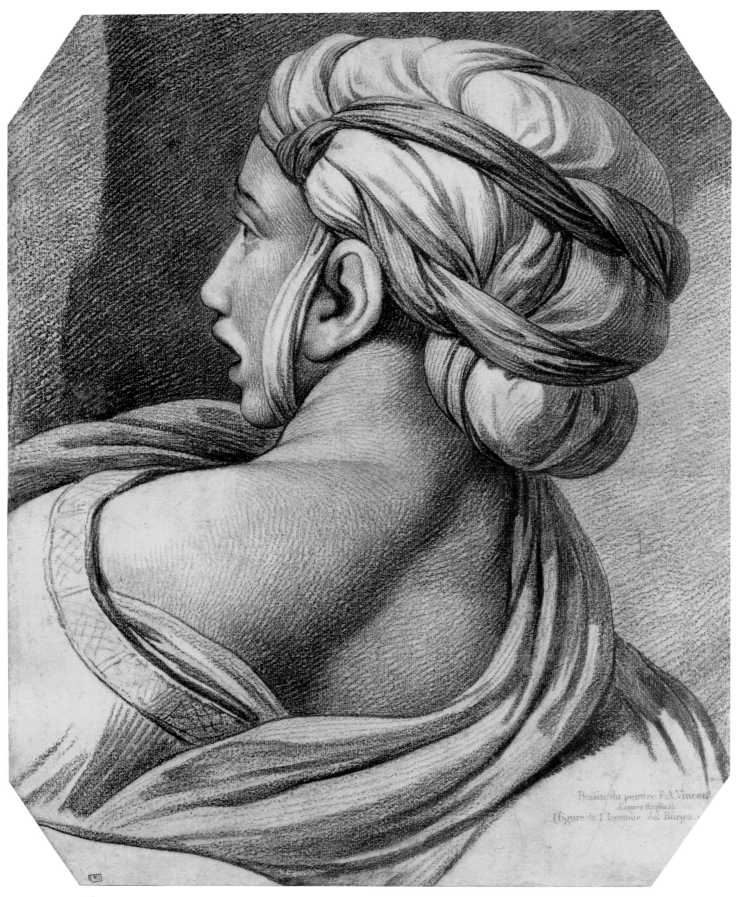

Figure 31

composition. He made sketches for each individual figure, working from life to perfect the anatomy, and from mannequins to perfect the folds of the garments. Nothing was painted without extensive and careful preparations; even accessories such as helmets and swords were rendered from special props. His severity of composition and rigor of line no longer owed anything to the attractions of the Rococo (see cat. 100). The purified drawing was completely subservient to the *idea* and perfectly appropriate to the stoicism of its subject. In effect, it was a pointed return to Poussin, whom David honored by using a soldier from the earlier artist's *Abduction of the Sabines* as the model for the central figure in his group of Horatians. It was also a return to Le Brun, since David emphasized the expression of emotion, though this was no longer concentrated in the face but extended over the entire figure, as Winckelmann recommended.

In the early 1780s, David opened an atelier that met with great success. His early students were Philippe-Auguste Hennequin (fig. 34, *Allegory of Birth*, Horvitz Collection),[120] François-Xavier Fabre, Jean-Baptiste-Joseph Wicar, and Jean-Germain Drouais. Later these were joined by Girodet and Jean-Auguste-Dominique Ingres, as well as Antoine-Jean, baron Gros, and François-Pascal-Simon, baron Gérard, to name only a few of the most well-known. David, who scorned the teachings of the Académie—above all for the conventionality of its approach to life drawing, from which he had encountered such difficulty in freeing himself—strove to inspire his students with his conception of "the beautiful" (based on a synthesis of classical exemplars and study of nature) and his horror of mannered style. Though doctrinaire, his teachings did not stifle the emergence of a less orthodox classicism, which occasionally appeared in the form of a proto-Romanticism in the work of Girodet and Gros.

≈

The prestige of the Académie continued to grow in the latter half of the eighteenth century. Its teachings served as a model for provincial academies, which proliferated throughout the country after 1740.[121] Its methods spread all the more easily as many of its former students were appointed professors or directors, and its figure studies were disseminated to serve as exemplars.[122] Moreover, the academic approach was popularized through a spate of treatises informing students how to draw, which were filled with invariable recipes aimed at an audience of dilettantes.[123] But in the 1760s, as the Académie's influence spread and its instruction became ever more regimented, opposition developed to its repetitive and formulaic program, which turned young artists away from nature and toward a man-

nered style. Jean-Baptiste-Siméon Chardin (cat. 53) was one of the first to express his frustration at the long years spent copying masterworks—training that was revealed as pointless when the artist came face-to-face with nature.[124] Cochin, too, was in favor of shortening this step and of having the students begin life drawing at an earlier stage.[125] Teaching through life studies, on which the Académie held a monopoly, was the target of particular criticism. In phrases heavy with irony, Diderot ridiculed the lengthy drawing sessions in which professional models assumed the conventional poses and simulated the actions and emotions that each professor-of-the-month requested. Diderot urged young artists to avoid distorting their scientific studies of *écorchés* (small statues depicting the underlying muscular structure of the human form) and the antique with contrived or unnatural mannerisms, and to turn away from the Académie—a mere "boutique of mannered styles"—so that they would never lose sight of nature.[126] Cochin likewise thought that professional models could never replace nature, and stressed the rule that Caylus formulated for the Prix de l'Etude des Têtes et de l'Expression: in nature, it is impossible for passion to be expressed for longer than an instant without degenerating into grimace.[127] Pierre voiced the same opinion in a letter he wrote to Marigny a few years

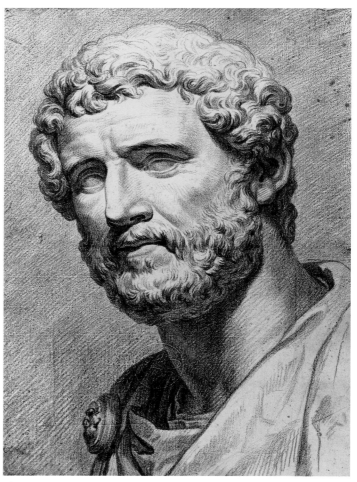

Figure 32

later.[128] The criticism culminated with Antoine-Charles Quatremère de Quincy, who wrote the following words: "The emphasis on figure drawing with professional models, which was the focus of the Académie's teaching, clearly shows its inadequacy and worthlessness."[129]

Soon the very existence of the Académie, an institution charged with normalizing the rules of art, came to seem like a hindrance to creative freedom. "The rules have made art into a routine," declared Diderot. "They have been useful to the ordinary man; they have been harmful to the man of genius."[130] Cochin was convinced that geniuses were not formed in academies. One could expect nothing from such institutions, which were good only for training "a number of artists sufficiently above the mediocre to deserve respect."[131] This anti-academicism found its most radical expression in David's denunciatory lecture *On the Need to Suppress the Academies,* delivered before the National Convention on 8

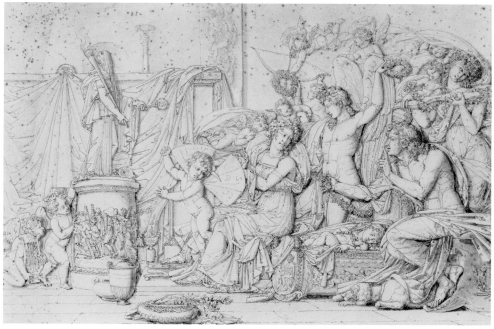

Figure 34

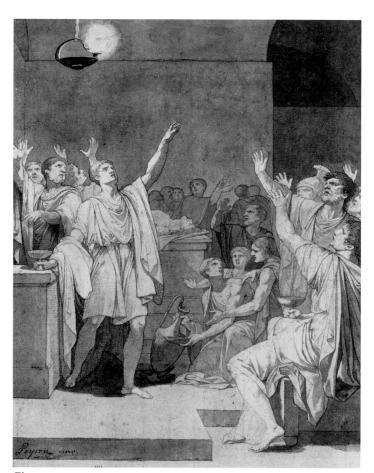

Figure 33

August 1793.[132] Only a few months earlier, the Académie had offered him a post as adjunct professor, which he had deigned to accept. In his lecture, he criticized the Académie's policy of having a monthly succession of professors, which obliged students to change techniques twelve times a year without giving them the time to master any single one. David also inveighed against the sectarianism and professional exclusiveness of the academicians, whom he likened to "monsters," claiming they were jealous of their prerogatives and quick to stifle any overly bold new talent. That same day, the Convention granted David's request and took action against what he termed "the last vestiges of the aristocracy." It abolished the academies. Many aspects of the regulations and the protracted system of instruction in the abrogated Académie were reinstated at the moment of rebirth for the French academic system (the inauguration of the Ecole des Beaux-Arts in 1796). However, the particularized and unprecedented combination of lengthy, circumscribed, and precisely graduated stages of instruction supplemented with specialized classes in perspective, anatomy, history, and mythology, with *conférences* by professors and officially sanctioned associates—all carefully coordinated and supervised by members of the royal bureaucracy for the glory of their Bourbon king—had disappeared forever.

Notes

1. On the circumstances that attended the founding of the Académie, see Vitet 1861; Thuillier 1964a; and Schnapper 1990.

2. In the statutes of 1648, the first academicians are invited to "share their insights" concerning "the difficulties of the arts" (Regulation of 1648, article ix); see Montaiglon 1875, vol. 1, p. 9.

3. See Mérot 1996.

4. For the Accademia del Disegno in Florence, see the recent study by Karen-Edis Barzman, "Perception, Knowledge, and the Theory of *Disegno* in Sixteenth-Century Florence" (with references to most of the earlier literature) in Oberlin et al. 1991, pp. 37–48.

5. In his *Desseins de professions nobles et publiques* (or *Drawings of Noble and Public Professions*), Paris, 1605, Antoine de Laval defined *dessein* as "the goal, the limit, the end, the aim of the action. But it also signifies a project, a plan, a *pourtraict* of several figures, the sketch of what one wishes to render as a painting or a relief. It is a word commonly used by painters, sculptors, and other artists, who used the terms *dessegner* and *griffoner*." See Cordellier, "Le peintre et le poète," in Meaux 1988, pp. 34–46. This vague usage was widespread throughout the seventeenth century (see for example, Furetière's *Dictionnaire* of 1690); however, in 1649, Charles-Alphonse Dufresnoy first defined *le dessin* as "concerned entirely with form" and as one of the three elements of painting (the other two being composition and color). See Thuillier 1965, pp. 193–210.

6. See Yates 1947.

7. Mérot 1990, chap. 1.

8. For more on Fontainebleau, the graphic arts, workshop procedure, and the dissemination of the school via prints, see the introduction by Emmanuelle Brugerolles in Paris et al. 1994; the introduction to Zerner 1969; and Los Angeles et al. 1994, pp. 225–346.

9. See Jacques Thuillier and Michel Sylvestre in Nancy 1992b, pp. 15–20, and 53–59; and Antony Griffiths and Craig Hartley in London 1997, pp. 24–26.

10. In an address to the Académie on 11 June 1672, Philippe de Champaigne spoke scathingly of "copyists with mannered styles"; see Mérot 1996, pp. 224–28.

11. For the Carracci Academy, successively entitled the Accademia degli Desiderosi and the Accademia degli Incamminati, see Dempsey 1989.

12. According to the art theorists and biographers Giovanni Pietro Bellori and Giovanni Battista Passeri, Poussin had frequented Domenichino's "academy." See Spear 1982, vol. 1, pp. 100 and 106.

13. See Bourges and Angers 1988.

14. For Fréminet, see Cordellier 1988.

15. As Roger de Piles noted, "Vouët had this advantage over the other painters: there has never been any artist whose manner was so admired at court and so imitated among his students. But it could be said that if, on the one hand, this manner elevated the insipid taste that prevailed in France when he arrived, on the other hand it was so unnatural, so outlandish, and so facile, and was received with such eagerness, that it infected the thinking of all of his disciples, to the extent that it became a habit with them—one that they had enormous difficulty breaking." See de Piles 1699, p. 467.

16. Such was Domenichino's method: "This was the way he worked: before he took up his brush, he would conceive and skillfully compose in his mind, in finished form, that which he planned; and he would do it by withdrawing into silence, alone, and forming the images of the things he wished to paint." Bellori 1672, p. 347.

17. On this process, see the recent essay by Avigdor Arikha, "De la boîte, des figurines et du mannequin," in Paris and London 1994, pp. 44–47.

18. Nicolas Poussin, *Massacre of the Innocents,* pen and brown ink with brush and brown wash, 147 × 169 mm., Cabinet des Dessins, Palais des Beaux-Arts, Lille; see Rosenberg and Prat 1994, cat. no. 38. Also see Poussin's studies for the *Martyrdom of St. Erasmus* and the *Death of Germanicus,* Rosenberg and Prat 1994, cat. nos. 27 and 39–40.

19. A good example is the drawing (preserved in the Uffizi in Florence, Rosenberg and Prat 1994, cat. no. 292) that depicts an atelier with an artist in the foreground sketching a sphere, a cone, and a cylinder, and another artist standing before a small mannequin (or perhaps a classical miniature). Another case in point is a fully developed preparatory sketch in the Musée Fabre, Montpellier, for *Penitence,* one of the compositions in Poussin's series of the *Seven Sacraments,* destined for Poussin's friend Paul Fréart de Chantelou (Rosenberg and Prat 1994, cat. no. 260).

20. Nicolas Poussin, *Moses Defending the Daughters of Jethro,* pen and brown ink with brush and brown wash on off-white antique laid paper, 186 × 255 mm., The Melvin R. Seiden and Louise Haskell Daly Funds, Department of Drawings, Fogg Art Museum, Harvard University Art Museums, Cambridge, 1984.580; see Rosenberg and Prat 1994, cat. no. 305, and Alvin Clark in Cuno et al. 1996, pp. 214–15.

21. Gérard Audan, *Belverdere Antinous with Measurements,* after Nicolas Poussin, engraving, Department of Printing and Graphic Arts, Houghton Library, Harvard University. Poussin himself gave a demonstration of his typological system in his works depicting multiple figures, such as his *Gathering of the Manna* and his *Rape of the Sabines*; see Pierre Rosenberg in Paris and London 1994, nos. 72 and 78.

22. The distinction between *aspect* and *prospect* (with specific reference to the plans for the vaulted ceiling of the Louvre's Grande Galerie) appears in a letter from Poussin to Sublet de Noyers dated 1672, known through the transcription provided by André Félibien (see Félibien 1725, *Entretien* 4, pp. 282–83).

23. See Mérot 1990, pp. 117–35.

24. The term "Attic" initially designated a way of speaking and writing. For more on the artistic style referred to as Parisian Atticism, see the intro. by Alain Mérot in Dijon and Le Mans 1998.

25. Laurent de La Hyre, *St. Stephen in Discussion with Members of the Synagogue,* black chalk with brush and gray wash, 377 × 555 mm., Département des Arts Graphiques, Musée du Louvre, Paris, inv. no. 27505; see Jacques Thuillier and Pierre Rosenberg in Grenoble et al. 1988, p. 258, cat. no. 214.

26. Eustache Le Sueur, *Clio, Muse of History,* black chalk heightened with white chalk on gray paper, 385 × 285 mm., Département des Arts Graphiques, Musée du Louvre, Paris, inv. no. 30692; see Mérot 1987, pp. 257–80 (for the entire Hôtel Lambert project), and p. 274, cat. no. D.251, fig. 374 (for this sheet).

27. For Dufresnoy, in his *Observations sur la peinture* (manuscript, Bibliothèque nationale de France, Paris) of 1649, the drawing comprises "eurhythmy, anatomy, the harmonious features, the balancing, and the positioning of figures." It "imitates in a pure way, with lines and relief, the form of bodies—as they appear to those with a certain and assured knowledge, as they ought to be in order to be beautiful; and it elucidates them precisely, with spirit, vivacity, and skill, without any ambiguity or confusion about what should appear in the nudity of nature. And even if nature is imperfect in many respects, the drawing is obliged to compensate for this lack, by a prescience that it must have regarding all the parts of the nude; and this requires long study of nature itself, as well as of beautiful things, both classical and modern." See Thuillier 1965, n. 5, p. 200.

28. See Alvin Clark in Cambridge 1994.

29. Charles-Joseph Natoire, *The Drawing Session at the Académie,* 1746, black chalk and watercolor, Witt Collection, Courtauld Institute Galleries, London, inv. no. 3973; for the difficulties at the Académie, see the *Procès-verbal,* 31 January 1671, and Teyssèdre 1965, p. 125.

30. Letter from the surintendant Colbert de Villacerf to the painter Pierre Mignard (22 April 1694). This order of cessation of the Académie's activities because of the financial difficulties caused by the War of the League of Augsburg was prevented with Mignard's assistance. See Teyssèdre 1965, p. 420.

31. Mérot 1996, pp. 11–29.

32. See Mérot 1995, pp. 294–301 for a brief summary; and for a more extensive analysis of this intense debate, see Teyssèdre 1957.

33. On Testelin's pivotal *Sentiments des plus habiles peintres du temps sur la pratique de la peinture et de la sculpture, mis en tables de préceptes, avec plusieurs discours académiques ou conférences tenues en l'académie royale desdits Arts en présence de M. Colbert* (Views of the Most Skillful

Painters of Our Time on the Practice of Painting and Sculpture, Arranged in Lists of Precepts, with Several Academic Lectures or Conférences Delivered at the Royal Academy of the Aforementioned Arts, in the Presence of M. Colbert), Paris, 1696, see Teyssèdre 1965, pp. 201ff.; and Mérot 1996, pp. 297–366.

34. Mérot 1996, pp. 305–11.

35. For the sculptor Gérard van Opstal, copying classical works of art was not an end in itself but an exercise that developed the student's "judgment" and "memory." See his lecture on the *Laocoön* (delivered on 2 July 1667), in Mérot 1996, p. 76. Also important on this topic was the painter Sébastien Bourdon's lecture "Sur les proportions de la figure humaine, expliquées sur l'antique" (On the Proportions of the Human Figure, Explained with Reference to Classical Works), which was delivered on 5 July 1670 and which made frequent mention of Poussin (see Mérot 1996, pp. 247–51).

36. It is known that Le Brun drew diagrams and "masks" of various passions to illustrate the lecture he gave on this topic at the Académie, doubtless in 1668; see Montagu 1994.

37. Charles Le Brun, *Study of Christ Nude for "Jesus Carrying the Cross,"* red chalk on beige paper (fig. 7); Charles Le Brun, *Study of Christ Draped for "Jesus Carrying the Cross,"* black chalk heightened with white chalk on beige paper, 198 × 282 mm., inv. no. 27975 (fig. 8); Charles Le Brun, *Composition Study for "Jesus Carrying the Cross,"* black chalk and brush and gray wash heightened with white chalk on beige paper, 283 × 435 mm., inv. no. 29411 (fig. 9); Charles Le Brun, *Jesus Carrying the Cross,* oil on canvas, painted for Louis XIV in 1688, Département des Peintures, Musée du Louvre, Paris, inv. no. 2879 (fig. 10); see Lydia Beauvais in Paris 1985a, cat. nos. 108–111, pp. 85–89. Other examples of Le Brun's process can be seen in the study for a Muse on the ceiling of the Hôtel La Rivière in Paris. This figure began as a splendidly bearded male figure onto which was grafted a woman's head drawn in the classical style (Département des Arts Graphiques, Musée du Louvre, Paris, inv. no. 29067); as a later example, the Louis XIV that reigns over the Hall of Mirrors at Versailles first appeared in drawings in the heroic nudity of an Apollo, whom the painter then adorned with a cuirass and a peruke (Département des Arts Graphiques, Musée du Louvre, Paris, inv. nos. 29005 and 29213).

38. See the introduction by Lydia Beauvais and Jean-François Méjanès to Paris 1985a, pp. 9–10; and the section on the drawings by Jennifer Montagu in Versailles 1963, pp. 155–415.

39. See Jean-Claude Boyer, "Colbert et les Beaux-Arts," and "Les Académies," in Paris 1983d, pp. 355–72; and Jacques Thuillier, "Réflexions sur la politique artistique de Colbert," in Mousnier 1985, pp. 275–86.

40. For Bernini in France, see the introduction by Anthony Blunt to the recently updated edition of Chantelou 1665, pp. xv–xxvii; Gould 1982; and Nicole Felkay and Dietrich Feldmann, "Le Louvre," in Paris 1983d, pp. 281–94.

41. Charles Errard, *Minerva Seated by a Cartouche with the Emblems of the Arts and Being Crowned by a Putto,* pen and brown ink with brush and brown wash, heightened with white gouache, on tan antique laid paper, 243 × 192 mm., Loan from the Collection of Jeffrey E. Horvitz, Department of Drawings, Fogg Art Museum, Harvard University Art Museums, Cambridge, D-F-96/1.1995.27; for more on Errard, see Thuillier 1978b.

42. Jean-Baptiste Corneille, *Christ and the Woman of Canaan,* pen and brown ink with brush and brown wash over traces of graphite (partially incised) on off-white antique laid paper, 430 × 315 mm., Purchase—The Melvin R. Seiden Fund and Louise Haskell Daly Fund, Department of Drawings, Fogg Art Museum, Harvard University Art Museums, Cambridge, 1984.584; for more on this artist, see Picart 1987.

43. Such members included Nicolas Mignard from Avignon (admitted in 1663); Jean Daret, active in Aix-en-Provence (admitted c. 1663); Thomas Blanchet, born in Paris, but active in Lyon (admitted in 1676); and Hilaire Pader from Toulouse (admitted in 1659).

44. A fine sheet recently identified in the Musée des Beaux-Arts, Besançon, testifies to Pader's interest in executing studies from life. Hilaire Pader, *Male Académie,* red, black, and brown chalks on beige paper, 467 × 389 mm., Cabinet des Dessins, Musée des Beaux Arts et d'Archéologie,

Besançon; see Jean-Claude Boyer in Paris 1993a, no. 106, pp. 210–11, repr.

45. These accomplishments included his imposing studies after the nude, such as the one in the Horvitz Collection first published by Pierre Rosenberg. Antoine Rivalz, *Man Leaning on a Staff Seen from Behind.* See Pierre Rosenberg in Oberhuber—Strauss—Felker 1987, p. 362.

46. For more on de Vuez, see Quarré-Reybourbon 1904; Quinchon-Adam 1993; and Barbara Brejon in Caracciolo 1997, pp. 399–406.

47. Pierre Puget, *Milo of Croton,* brush and brown wash over black chalk, 370 × 280 mm., Saisie des emigrés (marquis de Robien), Cabinet des Dessins, Musée des Beaux-Arts, Rennes, inv. no. c.129-2. For more on Puget as a draftsman, see Klaus Herding and Marie-Paul Viale in Marseille and Genoa 1994, pp. 172–232.

48. Raymond La Fage, *Conversion of St. Paul,* pen and brown ink over graphite on cream antique laid paper, 467 × 316 mm., Purchase—The Melvin R. Seiden Fund and Louise Haskell Daly Fund, Department of Drawings, Fogg Art Museum, Harvard University Art Museums, Cambridge, 1984.607. For more on La Fage, see Jean Penent in Toulouse 1992, pp. 104–17.

49. See the comte de Caylus's "Discours sur les dessins," address to the Académie on 7 June 1732; in Jouin 1883, pp. 368–77. Caylus is critical of "the way in which many painters have let themselves be carried away by the pleasure of drawing." He notes: "This is always a form of libertinage, which should be censured" for in such drawings one finds "neither that fundamental idea nor that careful thought which indicates that the work was composed in the mind before being set down on paper."

50. "He often requested that someone give him five fixed points, which he would then use as a starting point for drawing a human figure, in such a way that the head, the two hands, and the two feet were each placed at one of the given points. M[onsieur] Crozat saw him perform this experiment." Mariette 1750, vol. 3, pp. 36–37.

51. This is particularly true for drawings like his *Fall of the Rebel Angels,* for which he won the prize of the Accademia di San Luca in Rome (a subject he would take up again at a later date); see Jean Penent in Toulouse 1992, nos. 108 and 109.

52. See Blanchard's "Le mérite de la couleur," address to the Académie on 7 November 1671; in Jouin 1883, pp. 206–13.

53. See de Piles 1667; de Piles 1673; and de Piles 1694. The main points of his theories are summarized in de Piles 1708.

54. de Piles 1708, p. 76.

55. de Piles 1677, p. 260.

56. de Piles 1708, p. 75.

57. This curriculum was outlined in de Piles's "De la nécessité d'établir des principes certains à la peinture et des moyens d'y parvenir" (On the Need to Establish Firm Principles for Painting, and the Means for Achieving This), address to the Académie on 6 July 1699 (see Jouin 1883, pp. 389–94); and de Piles 1708.

58. Charles de La Fosse, *Sheet of Studies,* black and red chalks heightened with white chalk on tan paper, 228 × 389 mm., Purchase in Honor of Agnes Mongan's 90th Birthday through the Generosity of Mark Rudkin, Phyllis Hattis, David Daniels, Jean Massengale, Kathryn and William Robinson, Sheldon and Leena Peck, David Leventhal, Melvin R. Seiden, Beverly and John Jacoby, and Robert Erburu through the Ahmanson Foundation, Fogg Art Museum, Harvard University Art Museums, Cambridge, 1995.30; this study is preparatory for the artist's *Bacchus and Ariadne* in the Musée des Beaux-Arts, Dijon; see Clark 1996.

59. See N. Zouaq, "Les académies dessinées des professeurs de l'Académie royale au XVIIe siècle" (Academy Drawings by Professors at the Royal Academy in the Seventeenth Century), unpublished manuscript, University of Paris IV—Sorbonne, 1991.

60. Jean-Baptiste Jouvenet, *Seated Male Nude,* red chalk on light tan antique laid paper, 503 × 308 mm., Loan from the Collection of Jeffrey E. Horvitz, Department of Drawings, Fogg Art Museum, Harvard University Art Museums, Cambridge, inv. no. D-F-140 1.1994.14.

61. Jean I Berain, *Decorative Design,* pen with brown ink and brush with brown and gray wash on light brown antique laid paper, 407 × 286 mm, Everett V. Meeks, B.A. 1901, Fund, Department of Prints, Drawings,

and Photographs, Yale University Art Gallery, New Haven, inv. no. 1961.9.38. It should also be noted that it was Largillière who took the liberating current of colorism furthest in this direction, in contrast to Antoine Coypel, who adhered to a modified Rubenism and retained a strong preference for correction. Largillière did not hesitate to reproduce, without correction, the unique characteristics of the model, to exaggerate the expression, and to set the figure in a more dramatic chiaroscuro.

62. Jacques de Lajoüe, *Garden with Fantastic Architecture*, pen and black ink with brush and gray wash, heightened with white gouache on cream antique laid paper, 332 × 212 mm., Loan from the Collection of Jeffrey E. Horvitz, Department of Drawings, Fogg Art Museum, Harvard University Art Museums, Cambridge, inv. no. D-F-152/ 1.1993.77.

63. See Gaehtgens 1990; the comte du Caylus found fault with him for his lack of academic training. Watteau, he wrote, "possessing no knowledge of anatomy and having almost never drawn the human body from life, did not know how to view *[lire]* it or render it, to the point that depicting the anatomy of an entire figure cost him great effort and hence displeased him." Caylus, "Vie de Watteau," address to the Académie on 3 February 1748; in Fontaine 1910, p. 14.

64. Prior to executing his paintings, Watteau rarely prepared studies of his compositions in their entirety. No *modello* from his hand has survived. At the most, we have a very few compositional sketches. Their schematic nature reveals his first inspiration. An example is the red-chalk study in the Art Institute of Chicago drawn in preparation for his painting, the *Pleasures of Love* of c. 1717, now in the Gemäldegalerie, Dresden. See cat. no. 35 by Margaret Morgan Grasselli.

65. Nicolas Lancret, *Standing Woman*, red chalk heightened with white chalk on blue-gray antique laid paper, 229 × 170 mm., Loan from the Collection of Jeffrey E. Horvitz, Department of Drawings, Fogg Art Museum, Harvard University Art Museums, Cambridge, D-F-371/ 1.1996.40. For more on Lancret as a draftsman, see Grasselli 1985, and Mary Tavener Holmes in New York 1991, pp. 106–43. For Watteau's influence on Lancret, see Ballot de Sovot 1743, p. 16.

66. See Eidelberg 1981.

67. de Jullienne 1726.

68. "Every figure that issues from the hand of this worthy man has such a true and natural aspect that it can hold the viewer's attention all by itself, and has no need to be supported by a composition depicting a larger topic." (Mariette 1750, vol. 4, p. 126).

69. For more on Chanterau, see Bjurström 1971.

70. Nicolas-Bernard Lépicié, *Kneeling Boy,* pen and black ink with brush and gray wash, with touches of red chalk on off-white antique laid paper, 185 × 215 mm., Loan from the Collection of Jeffrey E. Horvitz, Department of Drawings, Fogg Art Museum, Harvard University Art Museums, Cambridge, inv. no. D-F-591/ 1.1998.53.

71. Jacques-Philippe Le Bas, *Scène galante,* red chalk on off-white antique laid paper, 222 × 328 mm., Loan from the Collection of Jeffrey E. Horvitz, Department of Drawings, Fogg Art Museum, Harvard University Art Museums, Cambridge, inv. no. D-F-383/ 1.1996.52.

72. For more on Portail, see Salmon 1996.

73. François-Louis-Joseph Watteau de Lille, *Blindman's Bluff,* red and black chalk on off-white antique laid paper, 352 × 451 mm.; and *Village Carnival at Night,* black and red chalk, heightened with white gouache on off-white laid paper, 346 × 452 mm., both, Loan from the Collection of Jeffrey E. Horvitz, Department of Drawings, Fogg Art Museum, Harvard University Art Museums, Cambridge, inv. nos. D-F-306/ 81.1995, and D-F-307/ 1.1994.34, respectively.

74. Goncourt 1846, pp. 80–81.

75. Antoine Coypel, "Discours sur la peinture," address to the Académie on 7 January 1708; see Mérot 1996, p. 427; and Dufresnoy 1667, pp. 107–9.

76. Coypel as in n. 75, preface.

77. Régis Michel in Paris 1989b, p. 28.

78. If Mariette wrote that Lemoyne "paid little heed to his students," Caylus, in contrast, described Mariette as a very attentive instructor. See Mariette 1750, pp. 165–66; and the "Vie de Lemoyne," address to the Académy on 6 July 1748; in Caylus 1765, p. 46.

79. This lecture by the famous military hero, antiquarian, amateur theorist, and nephew of the marquise de Maintenon was delivered for the first time on 7 June 1732, before a small audience. Charles Coypel thought it deserved a larger one and had it delivered again a few weeks later, on 5 July 1732. Since the lecture remained known to a rather limited number of people, scholars have had difficulty assessing its real impact and the extent to which it anticipated or reflected widespread opinions. See Caylus in Jouin 1883, pp. 368–77.

80. François Boucher, *Two Girls and a Dog in a Landscape,* black chalk heightened with white chalk on faded blue antique laid paper, 352 × 252 mm., Loan from the Collection of Jeffrey E. Horvitz, Department of Drawings, Fogg Art Museum, Harvard University Art Museums, Cambridge, inv. no. D-F-24/ 1.1993.23.

81. "For some time now, our most discerning enthusiasts have been besieging his atelier to discuss his drawings—quickly sketched, and showing only one or two figures, but always so well conceived, so full of grace, so skillfully executed, and so piquant, that they are sure to attract the gaze of everyone present." See Bret, "Eloge historique de M. Boucher," originally published in *Le nécrologue des hommes célèbres de France,* vol. 4; republished in *Le Revue Universelle des Arts* 12 (1860–61), p. 196.

82. For a discussion of these techniques, see John Ittmann in "The Triumph of Color: Technical Innovations in Printmaking," esp. p. 22 and pp. 132–38, in Baltimore et al. 1984.

83. No Prix de Rome were awarded in 1742, 1744, 1746, and 1747.

84. La Font de Saint Yenne 1747.

85. Minutes of the session on 31 May 1748; see Montaiglon 1885, p. 113.

86. Fontaine 1909.

87. A number of lectures were given with this aim in mind: Leclerc, "Discours sur la perspective," 1748; Jean-Jacques Sue, "Dissertation sur l'ostéologie," 1749 (he later published an anatomical guide for the use of artists; see Sue 1788); and Jean-Baptiste Massé, "Discours sur l'antique et l'anatomie," 1749. For these, see Montaiglon 1885, pp. 139, 162, and 180–81. At the session on 6 June 1650, Charles Coypel railed against those who "imagine that the study of geometry, anatomy, and classical art will do nothing but inhibit their alleged genius and deprive them of what they call their natural facility." He gave comparatively low priority to life classes, which is not surprising on the part of an artist who himself had done little sketching from life (for which he was reproached; see Mariette 1750, vol. 2, p. 31.) It is now known that Coypel worked in an atelier using props, mannequins, miniature settings, and plaster casts; see Lefrançois 1994, p. 80. On the problems that the teaching of anatomy and perspective caused at the Académie, see Locquin 1978, pp. 82–87; and Roland Michel 1987, pp. 55–56.

88. Courajod 1874.

89. See Michel 1992.

90. See Mariette 1741. Already in 1744 Edme-François Gersaint adopted Mariette's method as he began compiling the catalogue of the Quentin de Lorangère Collection.

91. Charles-Nicolas Cochin le jeune, *Competition for the Prize in Heads of Expression,* 1760, black chalk heightened with white chalk on gray paper, Département des Arts Graphiques, Musée du Louvre, Paris, inv. no. RF2054.

92. See Michel 1993 for an analysis and complete list, esp. pp. 201–338, and pp. 597–615.

93. *Mercure de France* (December 1754).

94. See Winckelmann 1755, Winckelmann 1764, and Mengs 1762 for their theories.

95. Cochin 1774, letter no. 3, p. 73.

96. Session of 25 November 1752 (published 1752–67).

97. Minutes of the Académie, 29 March 1749; see Montaiglon 1885, p.160.

98. Charles Coypel deplored this at the session of 8 May 1751; see Montaiglon 1885, p. 272.

99. *Mercure de France* (October 1754).

100. See Caylus, "Vie de Bouchardon," 1762, in Fontaine 1910, pp. 78–85.

101. Edme Bouchardon, *TOTO SPARGET IN ORBE: Medal Design for the Maison de la Reine, 1740,* red chalk on off-white antique laid paper, 216 mm. diameter, Loan from the Collection of Jeffrey E. Horvitz, Department of Drawings, Fogg Art Museum, Harvard University Art Museums, Cambridge, inv. no. D-F-539 1.1998.4.

102. Charles-Nicolas Cochin le juene, *Mémoires inédits*; see Jouin 1880, p. 85.

103. See Gaehtgens and Lugand 1988, p. 59.

104. Joseph-Marie Vien, *Ancient Sacrifice in an Ionic Temple,* pen and black ink with brush and gray wash over black chalk on off-white antique laid paper, 314 × 249 mm., Gift of Belinda Lull Randall from the Collection of John Witt Randall, Department of Drawings, Fogg Art Museum, Harvard University Art Museums, Cambridge, 1898.368; see Gaehtgens and Lugand 1988, no. 78, p. 242.

105. Jean-Honoré Fragonard, after Lodovico Carracci, *Bargellini Madonna,* black chalk on off-white antique laid paper, 293 × 204 mm., Loan from the Collection of Jeffrey E. Horvitz, Department of Drawings, Fogg Art Museum, Harvard University Art Museums, Cambridge, inv. no. D-F-432/ 1.1996.88. For the drawings made after other masters during Fragonard's trips to Italy, see Rosenberg and Brejon de Lavergnée 1986.

106. The first shipments were not made until 1754; see Montaiglon and Guiffrey 1900, vol. 10, pp. 381–82, and vol. 11, pp. 32–35.

107. In a letter to Marigny dated 6 February 1754, Natoire wrote—with regard to classical art—that the students "were beginning to realize there was a need for this type of study." See Montaiglon and Guiffrey 1901, p. 10.

108. Jean-Laurent Legeay, *Fantastic Landscape with a Vase*, pen and black ink on off-white antique laid paper, 316 × 238 mm., Loan from the Collection of Jeffrey E. Horvitz, Department of Drawings, Fogg Art Museum, Harvard University Art Museums, Cambridge, inv. no. D-F-379/ 1.1996.48. There is a debate concerning the nature of the relationship between Piranesi and Jean-Laurent Legeay (the oldest member of this group of artists). Who inspired whom? See Kauffman 1952; Kauffman 1954; and Harris 1967.

109. Winckelmann's *Gedanken über die Nachahmung der Griechischen Werke* of 1755 was published in French translation in 1756 in *Le Journal Etranger,* a periodical that had close ties to the *Encyclopédie.*

110. Jean-Baptiste Greuze, *The Ungrateful Son*, brush, brown and gray ink wash, over graphite on off-white paper, 320 x 420 mm., Cabinet des dessins, Palais des Beaux-Arts, Lille. Greuze's blending of nature and the antique is evident here in the pose of the chastised son, which evokes that of the *Laocoön*; and in the friezelike arrangement of *The Ungrateful Son,* which he composed as a deathbed scene and which reminds one of Poussin's *Death of Germanicus;* and again in the care he devoted to the expression of emotion, reflecting the influence of Le Brun. The return to Poussin and realism of expression as applied to history painting were not viewed in the same way by academicians and critics. Greuze broke off all relations with the Académie in 1769, after what he considered to be a humiliating reception as a history painter when he presented his *Septimius Severus.*

111. Jean-Baptiste-Marie Pierre, *Vulcan Presents Venus with the Arms of Aeneas,* red chalk on cream antique laid paper, squared with stylus, 365 × 470 mm., Loan from the Collection of Jeffrey E. Horvitz, Department of Drawings, Fogg Art Museum, Harvard University Art Museums, Cambridge, inv. no. D-F-237/ 1.1993.109.

112. In 1775 Pierre had the Ecole royale des Elèves Protégés abolished. The following year, d'Angiviller succeeded in closing the Academy of St. Luke. D'Angiviller likewise strove to prohibit all private exhibitions and salons that could overshadow those of the Académie. See Locquin 1978, pp. 60–63.

113. Noted in Vien's *Mémoires,* as published in Gaehtgens and Lugand 1988, p. 307.

114. François-André Vincent, *Head of a Woman* after Raphael, red chalk over traces of black chalk, 526 × 412 mm., Loan from the Collection of Jeffrey E. Horvitz, Department of Drawings, Fogg Art Museum, Harvard University Art Museums, Cambridge, inv. no. D-F-290 1.1993.134.

115. François-André Vincent, *Antique Male Bust,* red chalk on cream antique laid paper, 540 × 385 mm., Loan from the Collection of Jeffrey E. Horvitz, Department of Drawings, Fogg Art Museum, Harvard University Art Museums, Cambridge, inv. no. D-F-296 1.1995.57.

116. Manuscript papers of David, Bibliothèque de l'Ecole nationale supérieure des Beaux-Arts, no. 316, 54.

117. Jean-Baptiste Pierre Peyron, *Lucius Sergius Catalina Inciting Insurrection,* pen and gray ink with brush and gray wash on cream laid paper, 255 × 189 mm., Loan from the Collection of Jeffrey E. Horvitz, Department of Drawings, Fogg Art Museum, Harvard University Art Museums, Cambridge, inv. no. 1.1993.189.

118. Antoine Du Pasquier, *Triumph of Marcus Aurelius,* pen and black ink over chalk (squared), 458 × 9,228 mm., Département des Arts Graphiques, Musée du Louvre, Paris, inv. no. RF6087; see Guiffrey and Marcel 1938, vol. 5, p. 59, no. 3832, and Arlette Sérullaz in Paris 1972a, no. 30.

119. Jacques-Louis David, *Classical Frieze,* pen and black ink with brush and gray wash heightened with white gouache over black chalk on gray-blue paper, 260 × 1,530 mm., Department of Drawings, E. B. Crocker Art Gallery, Sacramento, CA, inv. no. 408; also see his slightly later *Two Warriors in Combat* in the Musée des Beaux-Arts, Grenoble (inv. no. D-952-MG-2615). For both, see Arlette Sérullaz in Paris and Versailles 1989, pp. 103–5.

120. Philippe-Auguste Hennequin, *Allegory of Birth,* pen and black ink with brush and brown wash on off-white laid paper, 400 × 570 mm., Loan from the Collection of Jeffrey E. Horvitz, Department of Drawings, Fogg Art Museum, Harvard University Art Museums, Cambridge, inv. no. D-F-131/ 1.1994.16.

121. See Locquin 1978, pp. 115–36.

122. See Roland Michel 1987, p. 70.

123. The content of these works is discussed in Locquin 1978, pp. 71–85; and in Roland Michel 1987, pp. 48, 55–56.

124. Chardin's views are reported by Diderot, in his introduction to the Salon of 1765.

125. Charles-Nicolas Cochin, third lecture delivered to the Academy of Rouen (1779); see Lichtenstein 1995, pp. 767–69.

126. Diderot 1765, p. 384.

127. Letter from Cochin to Marigny, 10 October 1759, in Furey-Raynaud 1903, p. 163.

128. Letter from Pierre to Marigny, 28 September 1770, in Furey-Raynaud, 1903, p. 213.

129. Quatremère de Quincy 1791, p. 126.

130. Diderot 1765, intro. to the commentary for the Salon of 1765.

131. Charles-Nicolas Cochin le jeune, "Sur les avantages que procurent les académies de peinture et de sculpture, et spécialement les écoles académiques" in *Discours prononcés à la séance publique de l'Académie royale des Sciences, Belles Lettres et Arts de Rouen* (Public Lectures Delivered at Rouen's Royal Academy of Sciences, Belles Lettres, and Arts), (1779; orig. pub. 1777), first lecture.

132. Wildenstein and Wildenstein 1973, no. 477, pp. 56–57 and Lichtenstein 1995, pp. 769–71.

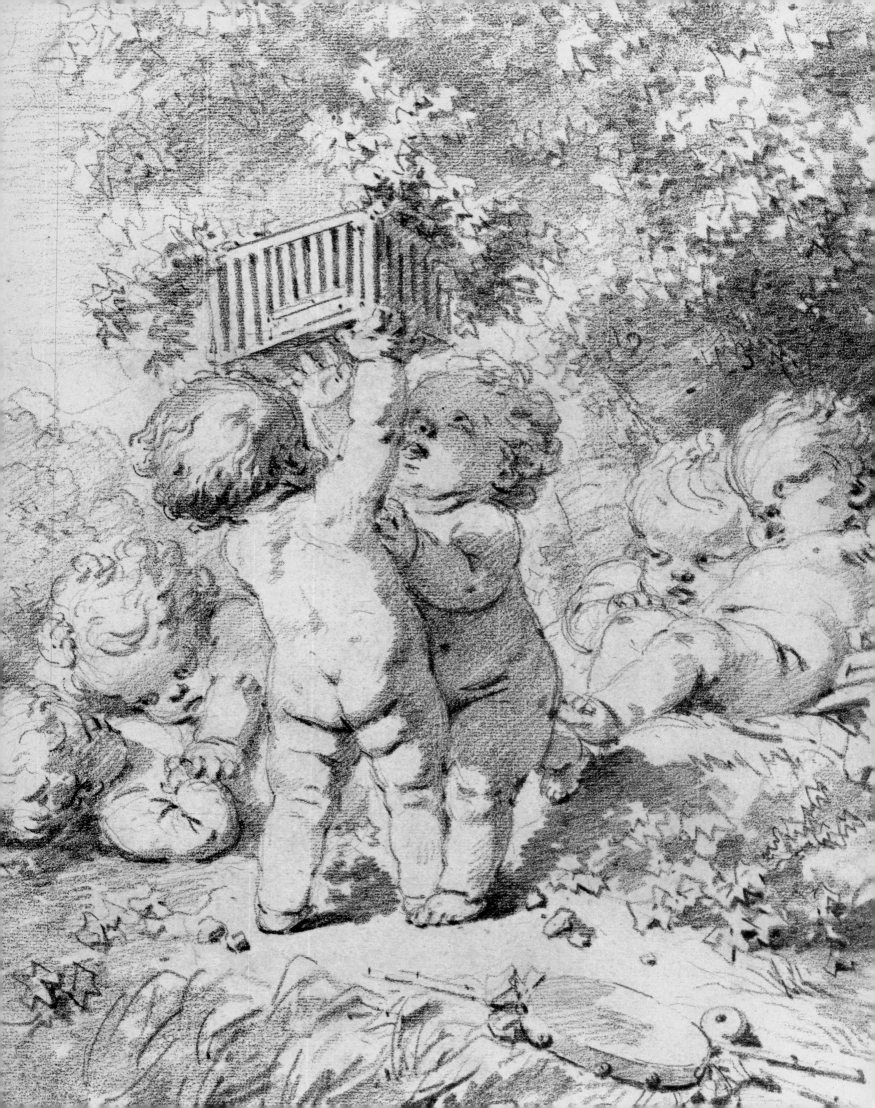

ON SOME COLLECTORS OF EIGHTEENTH-CENTURY FRENCH DRAWINGS IN THE UNITED STATES

Marianne Roland Michel

"Collecting is a journey, not a destination."
—Robert Flynn Johnson, 1989[1]

Today's collector of drawings, usually not a prince, rarely a painter, often a businessman, has the same wish as the collector of the past: to acquire fine drawings. But how difficult it has become. He cannot expect to own, like [Thomas] Lawrence, hundreds of drawings by Rembrandt, Raphael, Rubens, and other great masters. These have largely disappeared from the market. Every day more go to museums, eager collectors themselves, and are thus forever out of his reach. Modern scholarship has added to the scarcity of old master drawings by destroying many a fancy attribution. When a drawing of the first rank comes up for sale, it is now such a rarity that its price is bound to be extremely high. Therefore, today's connoisseur cannot achieve anything like the completeness of the collections of the past. No longer buying drawings en bloc, he chooses each individual item for its appeal to his personal taste.
Thus, the acquisition of each is an event of importance to him.
—Claus Virch, 1962[2]

laus Virch's striking and prophetic assessment of contemporary collecting, from his catalogue of the collection of Walter C. Baker, rings especially true at the end of the 1990s. His consideration of the problems faced by collectors late in the twentieth century reveals his understanding of Baker's way of resolving the difficulties caused by a market that offers ever fewer choices. At the same time, these lines sketch a portrait of those people who enjoy participating in what Robert Flynn Johnson in his catalogue of the Ide Collection aptly described as a journey. In this brief essay, I will discuss some of the approaches taken by American collectors—measures inevitably linked to their diverse personalities and their relationship to the particularities of the American art world—as well as how these individuals relate to the laws of the market. By looking at the choices that collectors of eighteenth-century French drawings made during their journeys, I will address such issues as their definition of boundaries for their collections, their decisions to sell or not to sell, and some of their patterns of patronage. Although this catalogue presents wonderful examples of French draftsmanship from the early seventeenth century through the later phases of Neoclassicism, the eighteenth century has been chosen because it reflects the preference of both Jeffrey Horvitz and this author, and it is the first period of earlier French drawings to generate a documentable and relatively widespread appeal to American taste.[3]

A look at the magnificent exhibition of French drawings from public and private American collections of 1958 organized by Agnes Mongan of the Fogg Art Museum—the person to whom this catalogue is dedicated, and the institution that had so much to do with spawning an American interest in French drawings—will provide us with an opportunity to examine the taste and to witness the notable success of the first two generations of American collectors. That exhibition traveled to Paris, Rotterdam, and New York in 1958–59, little more than a decade after the end of World War II,[4] and was the first in the United States devoted to the topic of French drawings. Jean-Antoine Watteau, whose admirable *Six Studies of Heads* (fig. 1)[5] from the Fogg served as the cover of the French edition of the catalogue, was represented by ten drawings, Jean-Honoré Fragonard by fourteen, and François Boucher by seven. Also exhibited were extremely fine sheets by Jean-Baptiste Greuze, Nicolas Lancret, Hubert Robert, Jean-Michel Moreau le jeune, Gabriel de Saint-Aubin, and others. In short, the selection of eighteenth century drawings reveals the collectors' late-nineteenth-century taste for the great masters and a few charming works by preferred *petits-maîtres*. Among those who lent drawings from their collections were Winslow Ames, Curtis O. Baer, Walter C. Baker, Margaret Blake, John Nicholas Brown, Mrs. Hubert Chandler, Philip Hofer, Siegfried Kramarsky, Robert Lehman, John S. Newberry, Lessing J. Rosenwald, Paul J.

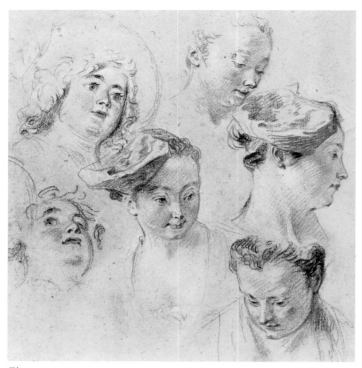

Figure 1

Sachs, Norton Simon, Mrs. C. I. Stralem, Mrs. Herbert N. Straus, Mrs. Jesse Isidor Straus, and Forsyth Wickes.

Many of the works lent to the exhibition by these collectors now enrich institutions in the United States; benefaction to museums is an important aspect of American collecting, one that no longer has a real equivalent in Europe. While it is true, in the case of France, that one must not forget the gifts and bequests of those such as the princesse de Croÿ, Henri and Suzanne Baderou, Mathias Polakovits, and Jacques Petithory, to name only a few,[6] their gifts reflect a different approach or attitude than that of most of their American counterparts. French collectors generally wish to be acknowledged for their taste and for the consistency of their choices, usually at a discreet distance from the officials of the great, historic public collections that surround them. However, while American collectors also seek recognition of their taste, they are aware of the value and importance of their acquisitions and want them to enrich a favorite institution. Often these acquisitions are even made in consultation with the curator or director of their preferred museum. Of course, there are exceptions in both cases, and certain decisions may be the result of legal or financial contingencies. But—to consider the topic covered in this essay and to cite only a few examples—what would the collections at the Art Institute of Chicago be like today without the gifts of Margaret Day Blake and Helen Regenstein; those of the Fogg Art Museum at Harvard without Charles Dunlap, Charles A. Loeser, Philip Hofer, Paul J. Sachs, Melvin R. Seiden, Mrs. Herbert N. Straus, and Grenville L. Winthrop; those of the Metropolitan Museum

in New York without Walter C. Baker, Robert Lehman, Alexandrine Sinsheimer, Mr. and Mrs. Herbert N. Straus, and Mr. and Mrs. Charles Wrightsman; and those of the National Gallery in Washington without Armand Hammer, Lessing J. Rosenwald, Joseph Widener, and Ian Woodner?

While considering collectors who restricted their realm of activity to the French school, as well as those who created important concentrations of earlier French masters, let us, by way of example, look at two senior lenders to the 1958 exhibition: Robert Lehman and Forsyth Wickes. Each in his own way reflects a passion for collecting according to the European pattern.

Robert Lehman surrounded himself with paintings ranging from primitives to twentieth-century works; with drawings from all schools and centuries; with sculptures, antiques, and decorative arts that amounted to some three thousand pieces. These were arranged in his home by the decorator Jansen, whose configuration was—in accordance with Lehman's wishes—recreated in the Metropolitan Museum of Art in the wing that bears the collector's name.[7] Lehman first became interested in drawings in the 1920s and devoted great care to both their framing and their hanging. The eighteenth-century French drawings in his collection

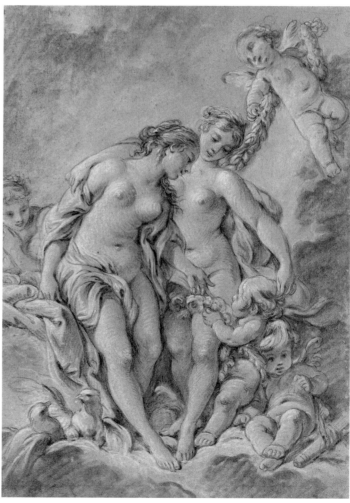

Figure 2

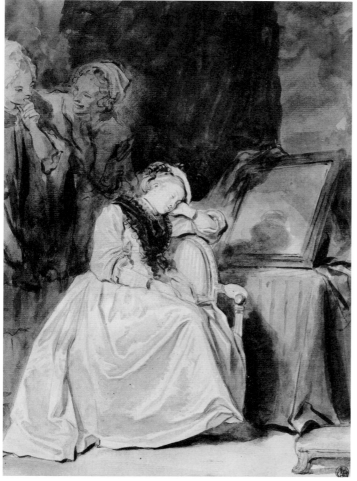

Figure 3

included works by Boucher (*Nymphs and Cupids,* fig. 2),[8] Watteau, Jean-Baptiste Oudry, and Louis Carrogis Carmontelle, as well as several by Saint-Aubin, David, Robert (*Equestrian Statue of Hadrian,* see cat. 90, fig. 2), Charles-Joseph Natoire (his *Orpheus Charming the Nymphs* is a version of the same composition in the Horvitz Collection, see cat. 57, fig. 3), and Fragonard (including the admirable *Fête at Saint-Cloud* and *The Dreamer,* fig. 3).[9]

An almost exact contemporary of Lehman's, the devoted francophile Forsyth Wickes compiled a specifically French eighteenth-century collection of paintings, drawings, furniture, and porcelains that reflected the taste of the Goncourts and that he eventually bequeathed to the Museum of Fine Arts in Boston.[10] Here, too, as the collector had wished, an effort was made to recreate within the museum the interior arrangement of his home. In this case, the installation reflected not only his Parisian townhouse on the rue Weber, but also the Château de Courtmoulins (his residence in the French countryside at Gaillon); his home in Tuxedo Park in New York; and Starbord House, his primary residence in Newport, Rhode Island. Though Wickes surrounded himself with decorative arts of all sorts, the drawings and pastels—along with porcelains and rare books—seem to have

interested him most. He owned a dozen portraits in pastel (Maurice-Quentin de La Tour's *Portrait of a Lady,* fig. 4),[11] and more than fifty other drawings, including works by Boucher, Boilly, Cochin, David, Fragonard (another version of Lehman's *The Dreamer*), Lancret, Watteau, Robert, Saint-Aubin, Moreau le jeune, Pierre-Paul Prud'hon, Jean-Baptiste Le Prince, and Claude Gillot (*Masquerade,* fig. 5).[12]

*I*n contrast to the more European patterns of collecting established by Lehman and Wickes, many of their contemporaries and followers forged pathways that are closer in style to the current American collector. Surely the most influential of these was their friend Paul J. Sachs—Harvard graduate, collector, and eventually professor of fine arts and associate director of the Fogg Art Museum—whose passion and inspiration for collecting, by his own admission, rests between Europe and America. He lent nineteen drawings to the 1958 exhibition. As Agnes Mongan wrote in the preface:

That an interest in drawings has spread throughout the United States is largely due to the contagious enthusiasm, deep knowledge and generosity of . . . Paul J. Sachs . . . [who] combines the qualities of passionate collector, discriminating judge, and infectious teacher. As a collector he has, with his unfailing eye for quality, gathered together a collection now internationally known. . . . As a university professor and museum director, he has spread his influence far and wide.

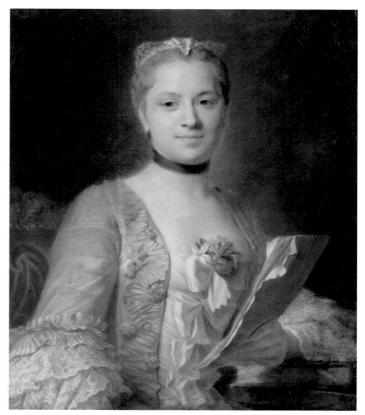

Figure 4

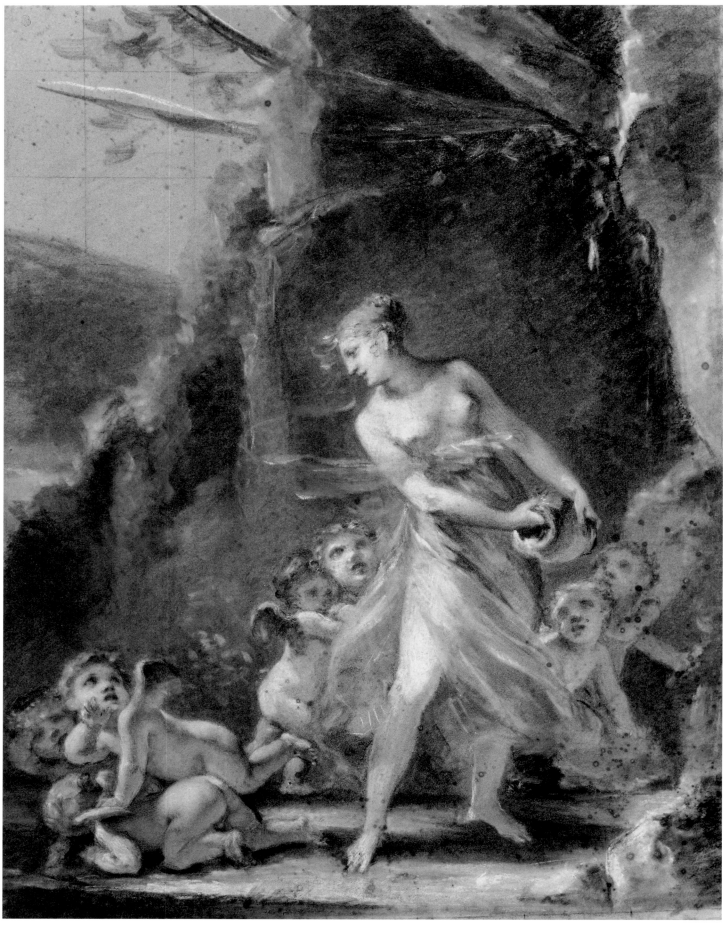

Figure 7

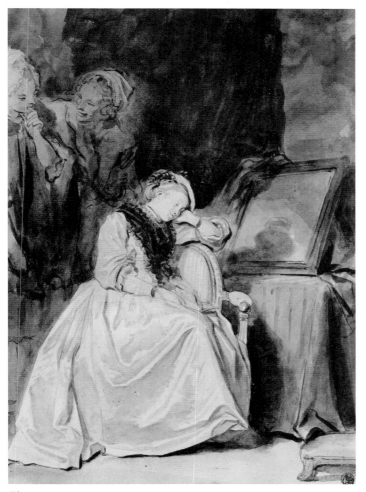

Figure 3

interested him most. He owned a dozen portraits in pastel (Maurice-Quentin de La Tour's *Portrait of a Lady,* fig. 4),[11] and more than fifty other drawings, including works by Boucher, Boilly, Cochin, David, Fragonard (another version of Lehman's *The Dreamer*), Lancret, Watteau, Robert, Saint-Aubin, Moreau le jeune, Pierre-Paul Prud'hon, Jean-Baptiste Le Prince, and Claude Gillot (*Masquerade,* fig. 5).[12]

*I*n contrast to the more European patterns of collecting established by Lehman and Wickes, many of their contemporaries and followers forged pathways that are closer in style to the current American collector. Surely the most influential of these was their friend Paul J. Sachs—Harvard graduate, collector, and eventually professor of fine arts and associate director of the Fogg Art Museum—whose passion and inspiration for collecting, by his own admission, rests between Europe and America. He lent nineteen drawings to the 1958 exhibition. As Agnes Mongan wrote in the preface:

That an interest in drawings has spread throughout the United States is largely due to the contagious enthusiasm, deep knowledge and generosity of . . . Paul J. Sachs . . . [who] combines the qualities of passionate collector, discriminating judge, and infectious teacher. As a collector he has, with his unfailing eye for quality, gathered together a collection now internationally known. . . . As a university professor and museum director, he has spread his influence far and wide.

included works by Boucher (*Nymphs and Cupids,* fig. 2),[8] Watteau, Jean-Baptiste Oudry, and Louis Carrogis Carmontelle, as well as several by Saint-Aubin, David, Robert (*Equestrian Statue of Hadrian,* see cat. 90, fig. 2), Charles-Joseph Natoire (his *Orpheus Charming the Nymphs* is a version of the same composition in the Horvitz Collection, see cat. 57, fig. 3), and Fragonard (including the admirable *Fête at Saint-Cloud* and *The Dreamer,* fig. 3).[9]

An almost exact contemporary of Lehman's, the devoted francophile Forsyth Wickes compiled a specifically French eighteenth-century collection of paintings, drawings, furniture, and porcelains that reflected the taste of the Goncourts and that he eventually bequeathed to the Museum of Fine Arts in Boston.[10] Here, too, as the collector had wished, an effort was made to recreate within the museum the interior arrangement of his home. In this case, the installation reflected not only his Parisian townhouse on the rue Weber, but also the Château de Courtmoulins (his residence in the French countryside at Gaillon); his home in Tuxedo Park in New York; and Starbord House, his primary residence in Newport, Rhode Island. Though Wickes surrounded himself with decorative arts of all sorts, the drawings and pastels—along with porcelains and rare books—seem to have

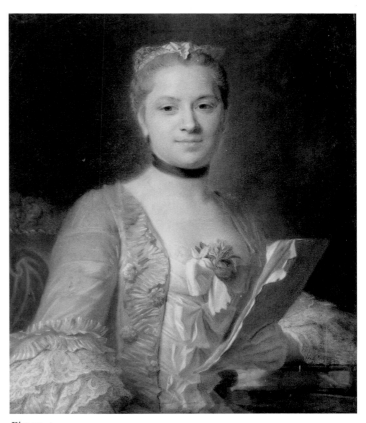

Figure 4

Figure 5

She then described how Sachs depicted collecting:

[As Sachs noted]: 'Every collector is, I believe, stimulated to adventure into new fields . . . through contact with an older, more experienced and enthusiastic collector.' He went on to tell of the deep impression made on him by the French painter Léon Bonnat . . . a very great connoisseur [and collector] of drawings . . . one of those who taught by their brilliant example. The lessons Mr. Sachs learned are reflected not only in the choice of drawings lent from the Fogg Museum, but in many others acquired by those who were in turn influenced by his example.[13]

The important link in America between curators and collectors makes the extraordinary character and example of Sachs especially significant. His tripartite role as a collector, museum professional, and professor introduces a specific kind of Anglo-American collection that has no real equivalent in continental Europe—the university or teaching museum that fosters a multigenerational layer of exchange and commitment between collectors and curators. Modeled after similar institutions at Oxford and Cambridge, teaching museums began at Harvard, Princeton, and Yale, and eventually multiplied to nearly one hundred across the country. As we shall see, they hold a special place in the memories of the collectors and curators who were formed there. Given that the present exhibition has been organized by the Fogg, and that this institution played a pivotal role in the study and collecting of French drawings, we shall take a few examples from its history. In the introduction to the memorial exhibition organized in Sachs's honor not long after his death, Agnes Mongan noted:

Every drawing that entered the Sachs collection was individually and lovingly chosen, and selected with such passion and enthusiasm that a whole generation of . . . collectors and museum curators caught the infection. . . . Many new . . . curators were members of his Museum class or had taken the Print course. When they became active . . . often their first exhibition was of prints and drawings. They turned to Paul Sachs for loans . . . which were almost never refused.[14]

As Sachs's close friends included Grenville L. Winthrop, Charles A. Loeser, and Charles Dunlap (who bequeathed their collections to the Fogg), and because noted museum professionals such as Felice Stampfle, Jacob Bean, William Liebermann, Fiske Kimball, Winslow Ames, Henry McIlhenny, and John S. Newberry were once his students, the influence of Sachs and the Fogg was clearly pervasive. After his death, Sachs's legacy continued through his disciple Agnes Mongan, who eventually became a lecturer in fine arts, curator of drawings, director of the Fogg, and a modest but often shrewd collector of French and Italian drawings that she later gave to Harvard. She developed another generation of donors who continue to benefit the Fogg and other American institutions; she also played a major role in the inauguration of an ambitious tradition of exhibitions devoted to private American collections (in which students participated), and one that has led to the present exhibition. Among the American contributors to this catalogue at least four are her former students.[15]

The list of Sachs's gifts and bequests to the Fogg is remarkable for the number, quality, and variety of objects. If we consider the drawings alone, the schools represented include English, Dutch, Flemish, German, Spanish, and an abundant representation of American, Italian, and, of course, French, a school he admitted to collecting with a special enthusiasm.[16] Among the approximately 120 French sheets, the majority date to the nineteenth century, and the list contains superb works by Degas (perhaps Sachs's preferred artist), Delacroix, and Ingres. French drawings from the eighteenth century account for about one-sixth of the total, and include such magnificent sheets as Watteau's *Six Studies of Heads* (fig. 1), Greuze's superb *Seated Female Nude* (fig. 6),[17] and Prud'hon's *Young Nymph Teased by Cupids* (fig. 7).[18]

The Sachs gifts to the Fogg were admirably complemented by those of Grenville L. Winthrop, a Harvard graduate

Figure 6

Figure 7

and member of a family with constant ties to Harvard since the mid-seventeenth century. Winthrop had received many years of Sachs's advice concerning acquisitions. He began with frequent gifts of prints, but by the late 1930s, he had given a marvelous pastel by Jean-Baptiste-Siméon Chardin (*Portrait of the Painter Jean-Jacques Bachelier,* fig. 8).[19] When his bequest came to the Fogg in 1943, it comprised more than 3,700 objects, including fine early Chinese bronzes and jades, a stunning collection of Pre-Raphaelite paintings and drawings, and a number of other distinguished British and Continental late nineteenth- and early twentieth-century paintings and drawings. It also contained a concentration of hundreds of exquisite French paintings and drawings that traced the line of French classicism from David through Jean-Auguste-Dominique Ingres (*his* preferred artist) and Pierre Puvis de Chavannes. These included David's imposing large composition study for the *Oath of the Tennis Court,* two of David's sketchbooks, and nine wonderful Prud'hons (*Male Nude Figure Resting,* fig. 9).[20] Winthrop's own description of his intentions for his collection attests to the special type of collector generated by a close connection to a university museum:

I am not so interested in the general public as I am in the Younger Generation whom I want to reach in their impressionable years and to prove to them that true art is founded on traditions . . . and that *Beauty* may be found . . . provided the eye be trained to find it.[21]

The Harvard link continues with associates of Sachs, like Loeser, and former students such as Winslow Ames and John S. Newberry. Loeser's primary interest was Italian drawings. After completing his studies at Harvard—where he was in the same class as Winthrop—he settled in Florence. Edward Waldo Forbes, then director of the Fogg, put Sachs in touch with Loeser, thus setting in motion an acquaintance that eventually became a friendship, even if their styles of collecting were quite different. As Loeser, Ames, and Newberry did not focus on the French eighteenth century, these different patterns make them interesting for our discussion. Loeser never wanted his drawings framed, and in fact his bequest of 260 drawings to the Fogg states that they were to be kept in his boxes.[22] Like Winthrop, Ames was a descendant of an old American family. He carefully chose each of his drawings from varying schools while adhering to taste as well as quality; he had set himself a limit of one hundred works, and whenever a purchase led him to exceed this number, he sold a drawing of lesser significance. Some of his collection was left to the Lyman Allyn Museum in New London, Connecticut, where he had been director.[23] Like Sachs and Ames, John S. Newberry combined the roles of museum professional and collector. He formed a noteworthy group of Italian sheets and both nineteenth- and early twentieth-

century French drawings, the bulk of which was left to the Detroit Institute of Arts.[24]

Philip Hofer was another Harvard graduate who credited Paul Sachs with influencing his development as a collector. He inaugurated the Harvard College Library's Department of Printing and Graphic Arts, which eventually became the Houghton Library. He and his wife, Frances, were passionate collectors and donors of many thousands of rare illustrated books, but they also gave scores of drawings to the Fogg and to Houghton.[25] Philip Hofer's advice to fellow collectors of modest means was to boldly buy "nothing by nobody," that is, to buy works by anonymous or underappreciated artists representing less-known or undervalued subjects.[26] Although this advice was often repeated, only a few discerning *amateurs* like Hofer were successful with this system. Given the Hofers' interests, a significant part of their collection was composed of drawings related to book illustration (Charles-Nicolas Cochin le jeune, *Design for the Frontispiece to the Description des principales pierres gravés du cabinet de s.a.s. monseigneur le Duc d'Orléans . . . ,* Houghton Library, fig. 10),[27] but there were also works independent of this focus. The large group of French drawings also included Natoire's charming *Study of a Seated Man Holding Drawing Materials* (fig. 11),[28] and François Le Moyne's *View of Formia from Gaeta* (see cat. 40, fig. 3), both of which were left to the Fogg. Like Winthrop, Philip Hofer's remarks shed light on the special place that the role of teaching and the multigenerational nature of the university museum often hold for

Figure 8

59

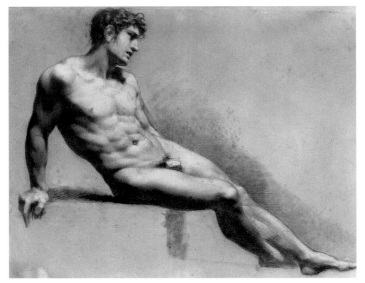

Figure 9

American collectors, even those who eventually give to other institutions:

I began collecting drawings under . . . Paul J. Sachs. I shared these drawings with Frances L. Hofer, my wife. . . . From our collection, drawings related to book illustration have gone to Houghton Library at Harvard. . . . Thus the taste . . . can carry on from generation to generation, just as Professor Sachs hoped it would.[29]

When Henry J. McIlhenny—another Sachs student who cited his teacher's influence—parted with the collection he had formed as a young man, it was acquired by the Philadelphia Museum of Art, where he had been a curator.[30] Primarily composed of nineteenth- and early twentieth-century French masterpieces, his gifts to Philadelphia also included two charming drawings by Trinquesse, and four fine Bouchardons for the fountain on the rue de Grenelle (see cat. 52, fig. 2).

Charles Dunlap was another major collector who was directly associated with Sachs as a student at Harvard. He was also one of the few to restrict himself to earlier French works. His tastes resembled those of his friend Forsyth Wickes (the two often found themselves competing for the same drawing or *objet d'art*). Many of Dunlap's purchases come from the renowned David-Weill Collection.[31] In addition to impressive sheets by Watteau, Moreau l'aîné, and Jacques-André Portail, Dunlap's gifts to the Fogg included Fragonard's amusing *The Servant Girls' Dormitory* (fig. 12),[32] and Le Moyne's elegant *Standing Female Nude* (see cat. 41, fig. 3).

～

The description of Walter C. Baker by his daughter reinforces the one offered in the Claus Virch quotation with which we began this essay:

Neither concentrating on any one particular historical period or type of drawing, nor concerning himself with specialized art historical problems, Mr. Baker has simply relied on his own discerning taste and has bought what he likes. . . . Like most modern collectors, Mr. Baker is on intimate terms with his possessions. He doesn't store his drawings away, but hangs them on his walls and often rearranges them to their best advantage, carefully selecting mats and frames that will best complement each drawing's quality.[33]

Among those works so carefully chosen and framed were a number of masterpieces, such as Watteau's *Male Nude Holding Two Bottles,* Fragonard's *Sultan,* Prud'hon's *Seated Nude Girl,* a *Portrait of Rose and Germain de Saint-Aubin* by their uncle Gabriel, and a fine series by Hubert Robert, including two sheets that give a central place to figures: *Artist Sketching a Young Girl* and *Young Artists in the Studio* (fig. 13).[34] All of these, along with drawings by David, Claude-Louis Châtelet, François-André Vincent, Gilles-Marie Oppenord, and others, were bequeathed by their owner to the Metropolitan Museum of Art.[35]

Just as Sachs traced his inspiration for collecting back to Léon Bonnat, it should come as no surprise that another important collector, Eugene Victor Thaw, traced the beginnings of his interest in art to the influence of Walter C.

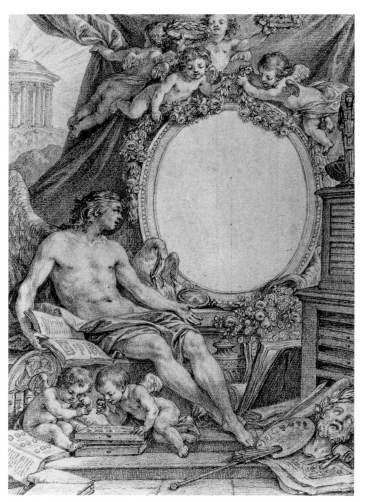

Figure 10

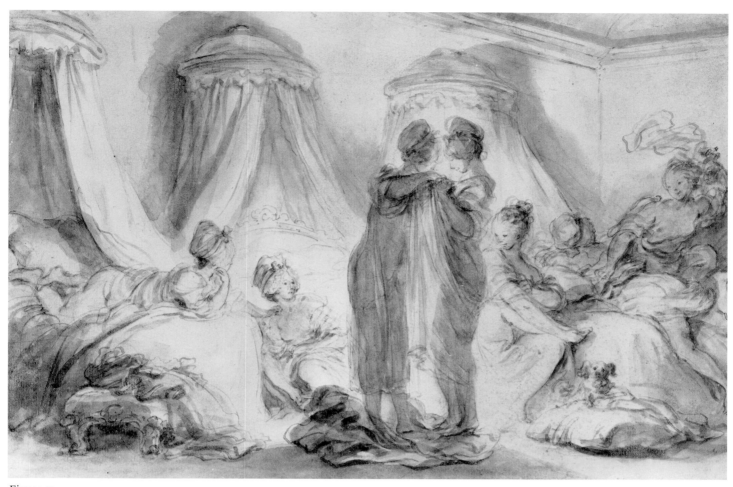

Figure 12

Baker.[36] Baker once said to Thaw, à propos of the Tiepolo drawings he purchased in the early days of his career: "Tiepolo: that is good to begin with. Easy to recognize—no problems there."[37] Like Baker, whom he took as his model, Thaw declared "his taste for putting everything in frames on the wall, [which is] the numerical limitation of such a collection."[38] He, too, a dozen years after Baker had amassed his own exceptional collection, remarked that:

a collection is, of course, very much influenced by the opportunities in the market during the period of one's active collecting. . . . Had I flourished in the era between the two World Wars, when great early Renaissance sheets and Dürer drawings came on the market from time to time, I might have collected differently. As it turned out in my case, very good nineteenth-century material has been available, and eighteenth-century Venetian and French drawings as well, and I have tried to seize some of these opportunities.[39]

A follower of the great American tradition of collector-benefactors, Thaw is not only a major collector and dealer, but also a wise and generous donor. He and his wife, Clare, have chosen the Pierpont Morgan Library as the eventual home of their drawings. As the Thaw Collection spans several schools and periods, only a small fraction of it can be mentioned here: a number of Watteaus, including the *Young*

Man Seen from the Back and Another Study of His Right Arm (fig. 14),[40] and the *Standing Man in Persian Costume* (see cat. 34, fig. 1); many superb Fragonards, including both figure drawings and landscapes, as well as six sheets from the Ariosto series; Roberts; a David; Prud'hons (including a rare

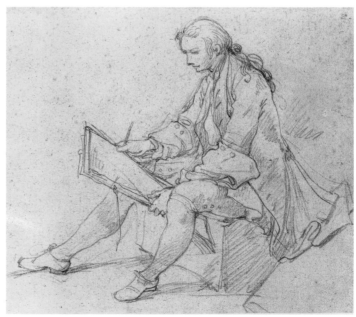

Figure 11

61

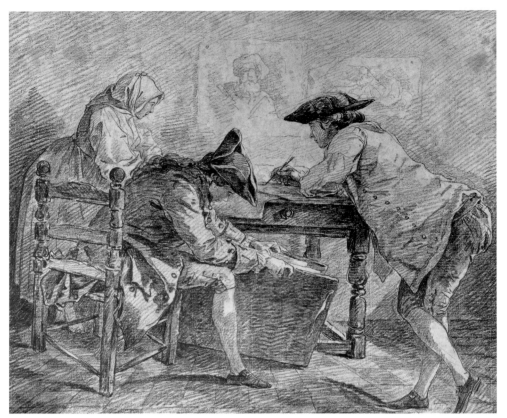

Figure 13

number of the drawings that had belonged to her father, the Honorable Irwin Laughlin, who had a special passion for eighteenth-century France.[45] With regard to Laughlin, Margaret Morgan Grasselli notes:

Drawings were Laughlin's chief delight, for, as his daughter Gertrude Chanler has mentioned, he felt that he could see more clearly the artist's hand and mind at work.[46]

Indeed, the catalogue of the sale sets one dreaming about the purchases Laughlin made between the world wars: twelve drawings by Fragonard (not to mention the series of albums today in the Norton Simon Collection that contain many of the artist's copies of the most significant paintings and sculptures in Italy); twenty-two drawings by Moreau le jeune, including five for the *Monuments du costume* (*Have No Fear, My Good Friend!* is now in the J. Paul Getty Museum, Los Angeles, fig. 17);[47] landscapes by his elder brother, Louis-Gabriel Moreau; seven drawings by Boucher (one of which, *A Reclining Female Nude*, became part of the collection of David Daniels);[48] three Cochins; pastels by La Tour; and more. Mrs. Chanler kept at least six drawings by Boucher, six by Fragonard on the theme of *Don Quixote*, and Watteau's magnificent *Italian Comedians Taking Their Bows*

landscape, portraits of Empress Josephine and Count Sommariva, and a wonderful *Standing Female Nude, Study for Innocence;* see cat. 101, fig. 2); and Louis-Léopold Boilly (*Portraits of the Artist's Family and Servants*).[41]

It is impossible to refer to the Morgan Library without mentioning its founder, John Pierpont Morgan, who was ahead of his time as a collector of drawings in an age when this was not yet the fashion in America. In 1910, he bought an entire collection that Charles Fairfax Murray had amassed in England, one that included significant examples of the work of Watteau, Lancret, Fragonard, Robert, Jean-Jacques de Boissieu, and Greuze.[42] He then acquired additional works by Watteau (*Seated Young Woman*, fig. 15),[43] Fragonard, Portail (*Presumed Portrait of Mme de Lalive de Jully Sketching at a Table*, fig. 16),[44] and Jean-Baptiste Isabey.

Some of the drawings now in museums that have been mentioned so far were included in the 1958 exhibition together with others that appeared in the catalogue under the names of their owners at that time. The inheritance, transfer, or sale of great sheets from one collection to another is an important part of the journey undertaken by collectors of eighteenth-century French drawings. A sample of these keenly sought works, and their collectors, follows.

In 1959, Mrs. Gertrude Chanler offered for sale a large

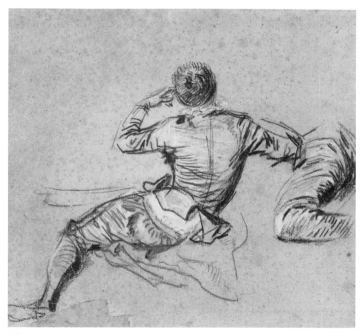

Figure 14

(fig. 18),[49] now promised to the National Gallery of Art in Washington. Because Mrs. Chanler shares many of her father's tastes, the much-reduced collection still reflects the flavor and character of the original quite strongly, covering the same range and variety of artists and subjects.[50] One of Laughlin's sheets by Fragonard came from Mortimer Schiff, a remarkable collector of eighteenth-century drawings who was partial to Fragonard.[51]

Another remarkable collection of drawings was that of Mrs. Jesse Isidor Straus. They were arranged in her Park Avenue apartment and set off by French eighteenth-century woodwork, furniture, and other decorative arts. Their sale in 1970 released a number of exceptional works onto the market.[52] Armand Hammer bought two drawings by Watteau and some extremely fine Fragonards, which are today in the National Gallery in Washington (*Grandfather's Reprimand,* fig. 19).[53] From this same sale, Christian Humann—a collector with highly refined tastes who passed away too soon—acquired important sheets by Boucher, Fragonard, and Niklaus Lafrensen, called Lavreince.[54] Mrs. Straus also sold a superb sheet by Claude Hoin that she had acquired from the collection of Georges Blumenthal through the dealer Robert M. Light and lent to the 1958 exhibition (*Portrait Studies of Two Men,* fig. 20).[55] It was reacquired by Light, a friend of the

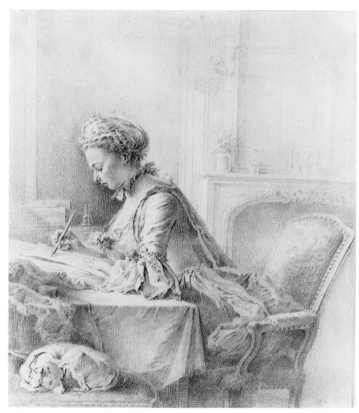

Figure 16

Fogg, who later gave it to the museum in honor of Agnes Mongan.

Among the other important collectors whose drawings passed to other collections, we might mention Mr. and Mrs. Herbert N. Straus, who owned two drawings by Watteau that went to the Metropolitan Museum of Art[56] and a ravishing sheet by Natoire that went to the Fogg (*Mythological Scene, Bacchanal,* fig. 21).[57] Mrs. C. I. Stralem and her son Donald were once owners of Fragonard's *Portrait of a Neapolitan Girl*—today in the Thaw Collection and promised to the Pierpont Morgan Library after passing through the Norton Simon Collection[58]—and Fragonard's *Frolicking Putti,* now in the Horvitz Collection (frontispiece to this essay).[59]

The A. S. W. Rosenbach Company imported a large group of drawings by Jean-Baptiste Oudry for the *Fables* of Jean de La Fontaine, which are now dispersed among many collections. The Rosenbach Company was also the source of Fragonard's drawings for Ariosto's *Orlando Furioso.* Some of these entered the collections of Philip Hofer, John Nicholas Brown, Eugene Victor Thaw, and Jeffrey Horvitz (see cat. 89). Edith Rosenwald gave five drawings from this series to the National Gallery in Washington (*Rinaldo Astride Baiardo Flies Off in Pursuit of Angelica,* fig. 22); one other was given by her husband, Lessing.[60]

In 1971, only a year after the Straus sale, Norton Simon offered a number of his drawings for sale, subsequently

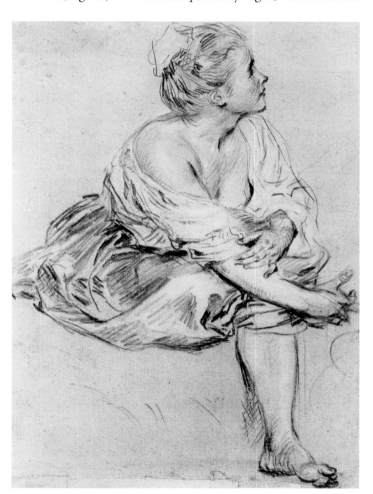

Figure 15

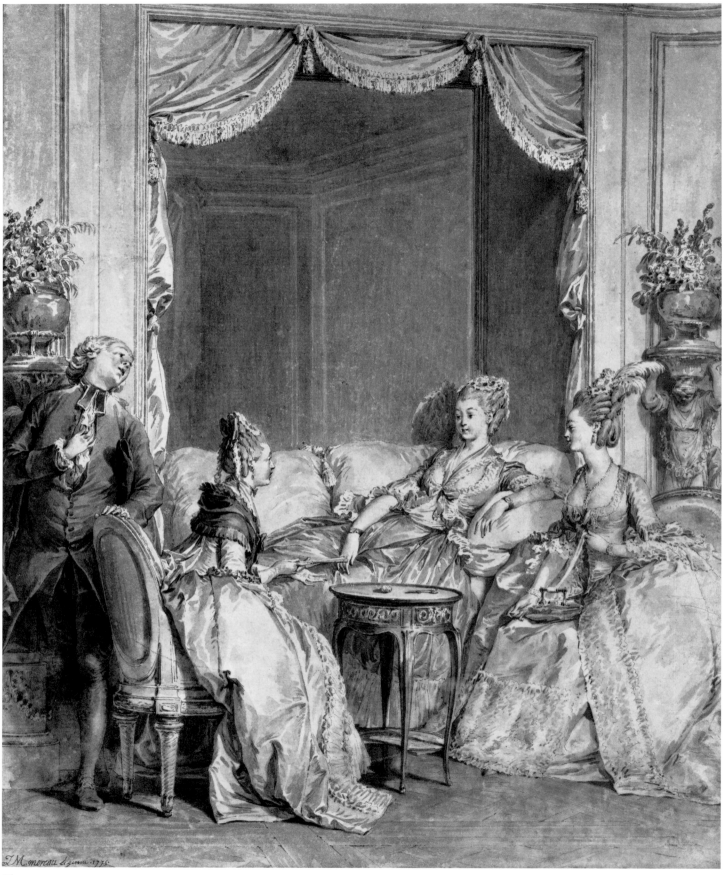

Figure 17

parting with even more in the following years.[61] Two beautiful Bouchers became part of the Hammer Collection.

In many of these cases where collectors were able to part with some or all of their treasures by sale, one thinks of the statement by Edmond de Goncourt that prefaced the catalogue of his sale of 1897:

I do not want my drawings, my prints, my bibelots, my books—all the art objects that were the pleasure of my life—to be entombed in the cold halls of a museum and subjected to the stupid gaze of indifferent passers-by. Rather, I ask that they all be scattered under an auctioneer's hammer and that the joy I took in acquiring each one be given back, with each object, to someone who has inherited my tastes.[62]

*I*n the years between 1970 and 1980, the names of other, newer collectors began to be noted in the catalogues of exhibitions organized in the United States. Thus, in his important exhibition of seventeenth- and eighteenth-century French drawings in 1972, Pierre Rosenberg chose notable drawings from the Suida Mannings, the Bronfmans, John Goelet, Emile Wolfe, Helen Regenstein, and the Homburgers, whose collection—except for Gillot's pivotal *Pilgrimage to the Enchanted Isle,* which was given to the Fogg—is now on deposit in the Portland Museum of Art.[63] The following year, when Regina Slatkin organized an exhibition of Boucher's drawings at the National Gallery in Washington, the list of private lenders included names such as Bronfman, Chanler, Dunlap, Kramarsky, Philips, Sinsheimer, Straus, Stralem, Suida Manning, and last but not least David Daniels, who lent five drawings. In 1978, the National Gallery was also the site of joint monographic exhibitions on Robert, organized by Victor Carlson, and on Fragonard, organized by Eunice Williams. In addition to many of those already listed, the lenders included John Nicholas Brown, Philip Hofer, John M. Schiff, Mrs. Margaret Blake, Mrs. Paul Wick, John and Alice Steiner, and Mrs. Ronald S. Lauder and her son. Some of these collectors, and yet other new names, including Curtis O. Baer and Ian Woodner, were also lenders to the exhibition *The Rococo Age: French Masterpieces of the Eighteenth Century,* organized in 1983 by Eric Zafran at the High Museum of Art in Atlanta.

Figure 18

One of the most remarkable groups of eighteenth-century French drawings assembled by these newcomers was the collection formed by Helen Regenstein in Chicago. Works from this collection were highlighted in exhibitions organized by Harold Joachim and Suzanne Folds McCullagh at the Art Institute of Chicago, to which the drawings were promised. Included in the collection were Watteau's *Landscape with a Chateau, Three Studies of a Woman, Study for "Pleasures of Love"* (see cat. 35, fig. 2), and *Old Savoyard*

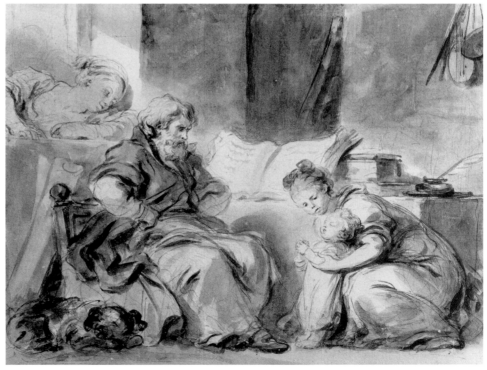

Figure 19

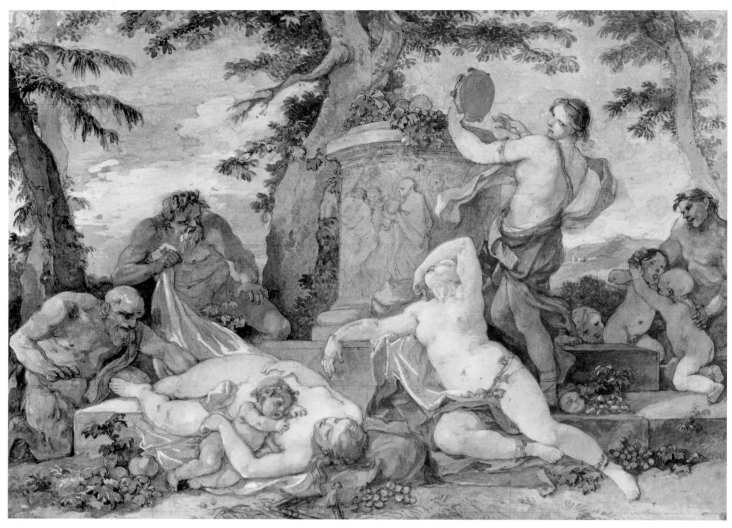

Figure 21

(fig. 23);[64] Oudry's *Swan Attacked by a Dog* (cat. 38, fig. 5); and seven drawings by Boucher, among them his delightful *Young Boy Holding a Carrot* in pastel (fig. 24).[65] In addition to these, there are important drawings by Louis-Gabriel Moreau l'aîné, David, and Anne-Louis Girodet de Roucy-Trioson.[66] Typical of one singularly American approach to collecting that we have already mentioned, this astonishing compilation of great French drawings never adorned the walls of Mrs. Regenstein's home, making the very term "collection" somewhat debatable. Still, it is true that none of the drawings she offered to the Art Institute was bought without her approval, and all were strictly in accord with her taste. The Art Institute also benefited from Tiffany and Margaret Blake, whose donations included a wonderful Watteau, Fragonard's dramatic *The Letter* (fig. 25),[67] and Robert's marvelous *Fountain in a Park* (fig. 26).[68]

Ian Woodner, a great lover of drawings who died in 1990 at the age of eighty-seven, amassed what must doubtless be considered the greatest private collection in recent decades. At the same time, he must be held partially responsible for the increase in their prices. Though Woodner at first sought

advice from several dealers, he rapidly became very sure of his tastes and his choices, purchasing drawings because he liked them, regardless of the period or school, and paying a high price for what he wanted. It was fascinating to see him at public auctions, making ever higher bids for an Albrecht

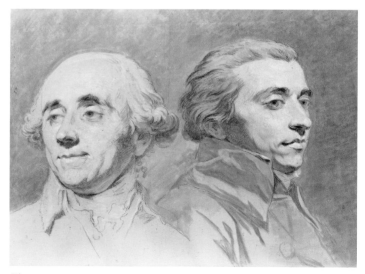

Figure 20

Dürer or a Vittorio Carpaccio, a Pietro Perugino or a Hans Hoffmann, a Tiepolo or a grand *View of Naples* by the little-known Lusieri—not to mention the famous page from Vasari's *Libro de' Disegni* from the Devonshire Collection at Chatsworth, watercolors by Cézanne, and an enormous, unique corpus of sheets by Odilon Redon. If the French eighteenth century was perhaps not his favorite period, he nonetheless purchased a

Figure 22

splendid Gillot, as well as works by Boucher, Greuze, Saint-Aubin, Fragonard (most notably, his marvelously reworked counterproof *Avenue of Cypresses at the Villa d'Este*, fig. 27), and Boilly (*Public in the Salon of the Louvre, Viewing the Painting of the "Sacre,"* fig. 28),[69] all of which have been either given or promised to the National Gallery of Art in Washington. Aside from various masterpieces, Woodner's collection also contained numerous "secondary"—which is not to say mediocre—drawings, such as Pierre-Antoine Baudouin's *Honest Model* (see cat. 76, fig. 2).

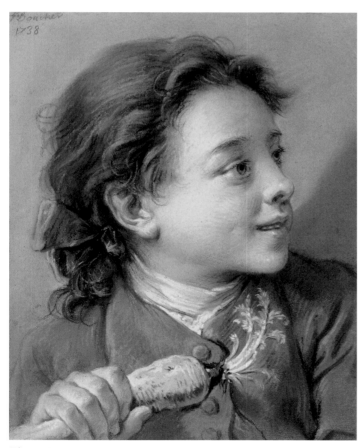

Figure 24

Although my discussion of collectors is necessarily brief here, I cannot end without mentioning Lessing J. Rosenwald, Samuel Kress, and Joseph Widener. Rosenwald's enormous and catholic collection of more than twenty thousand prints—as prodigious in quality as it was in quantity—formed a major part of the National Gallery's collection of graphic arts after its departure from Alverthorpe, his home outside Philadelphia.[70] He also collected paintings and drawings, and these are also in Washington (for example, his elegant Saint-Aubin, *Rendezvous in a Park,* fig. 29),[71] and his amusing sheet by Jean-Baptiste Oudry, *La Scène du grand Baguenaudier,* fig. 30).[72] Samuel Kress was another impressive early donor of hundreds of paintings to the National Gallery. His thousands of other paintings enriched scores of American museums, and he also collected drawings (François-André Vincent, *Park of an Italian Villa,* National Gallery of Art, Washington, fig. 31).[73]

Joseph Widener, another Philadelphian who became a donor to the National Gallery in 1942, amassed an extremely diverse collection that encompassed furniture, tapestries, sculptures, medieval art, and eighteenth-century illustrated books and drawings. He purchased his first drawings in 1916 from yet another Philadelphian, A. S. W. Rosenbach,

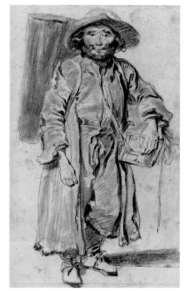

Figure 23

whose impressive library devoted to rare books and to studies for book illustration still maintains an important nucleus of sheets by artists such as Fragonard, Gravelot, Eisen, and Le Prince (*Frontispiece for Travels in Siberia: Urania Informs Louis XV of the Passage of Venus across the Sun,* fig. 32).[74] Rosenbach purchased the Orly-Roederer Collection in 1922. Many already know that he owned another two of Moreau le jeune's drawings for the *Monuments du costume,* two Bouchers, and two drawings by Fragonard and Jean-Jacques Le Barbier for the *Fables* of La Fontaine. But we should not forget the 131 drawings by Hubert-François Bourguignon, called Gravelot, for Boccaccio's *Decameron* (*Title Page Design for Volume One,* fig. 33),[75] as well as drawings by Eisen, Gravelot, Le Prince, Moreau le jeune, and Charles Monnet for Ovid's *Metamorphoses,* or the approximately fifty drawings of theater costumes by the mysterious Brion de La Tour.

We have also only briefly mentioned Georges Blumenthal, David Daniels, and John and Paul Herring. Blumenthal

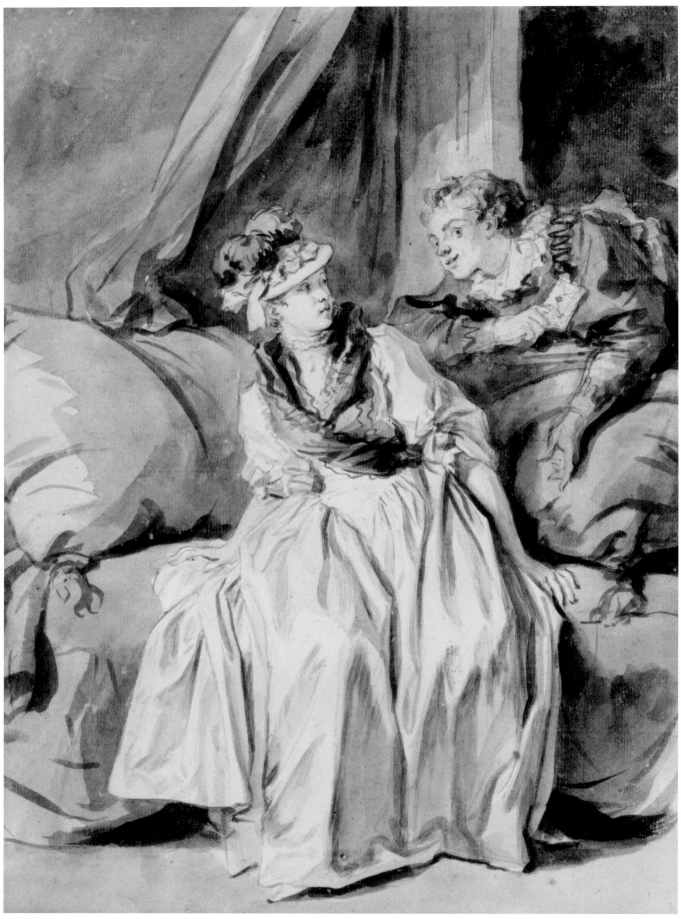

Figure 25

is famous for the patio that bears his name at the Metropolitan Museum of Art, to which he, his wife, and his daughter donated important French drawings, including sheets by Portail, Watteau, Le Moyne (*Valet Pouring Wine*, fig. 34), and Baudouin (see cat. 76, fig. 1).[76] David Daniels built a small collection of masters from all schools—particularly nineteenth-century French—that was exhibited at the Fogg and elsewhere with a catalogue by Agnes Mongan.[77] The discriminating Herring brothers continue to build a highly select collection focused on late eighteenth- and nineteenth-century French drawings with a classic taste resembling that of Paul Sachs and Grenville Winthrop.

Finally, there is a category of drawings that, though usually held in disdain by admirers of Watteau, Fragonard, and David, nevertheless represents an important and inextricable component of eighteenth-century French draftsmanship, both quantitatively and qualitatively. These are often referred to as ornament or architectural drawings. An exemplary collection is now in the Smithsonian's Cooper-Hewitt Museum in New York—founded on the drawings that the Misses Hewitt acquired and donated in the first quarter of the twentieth century. These gifts included superlative sheets by Boucher, Jean-Baptiste-Marie Pierre, Charles de La Fosse, Charles-Michel-Ange Challe, Robert Le Lorrain, Gabriel Huquier, Jean Pillement, Gilles-Paul Cauvet, the Taraval family, and Juste-Aurèle Meissonnier (*The Chariot of Apollo: Ceiling Study for the Salon Bielenski, Warsaw,* fig. 35),[78] to name only a few. There is also a sizable collection of these drawings at the Metropolitan Museum of Art in New York, where, until recently, the ornament drawings were considered distinct from the "real" drawings and were therefore stored and catalogued separately. The donors of these sheets include familiar names such as Baker, Hofer, and Rosenbach, and some new ones like Elisha Whittelsey (who left most of his collection to the museum and established a fund for acquisitions—Alexis Peyrotte, *Ornament Design with Fruit and Flowers,* fig. 36),[79] and Mr. and Mrs. Charles Wrightsman (who not only gave the museum a number of sheets by Lancret, Charles-Antoine Coypel, and Gabriel de Saint-Aubin, but also works by Pierre Contant d'Ivry, Charles de Wailly, Jean-Jacques Huvé, Louis-Félix de La Rue, and Charles Percier). Other lovers of ornament included Donald Oenslager, a stage director and collector of drawings related to theater which he bequeathed to the Pierpont Morgan Library; and especially Richard Wunder, owner of an appealing collection of ornament drawings that was the focus of an exhibition before being offered for sale.[80]

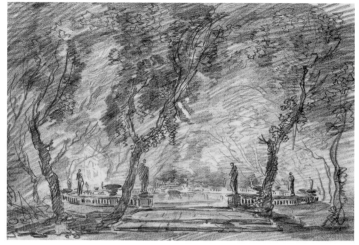

Figure 26

Our conclusion brings us to the Horvitz Collection. Certainly, the collector already has his share of stellar drawings by major masters. These rarities are already being wisely supplemented with impressive sheets by important artists whose talents were extremely well appreciated during their lifetimes, but whose fame has faded in the intervening centuries. As Jeffrey Horvitz's French drawings alone already number more than six hundred, we know that this very active collector does not agree with predecessors like Win-

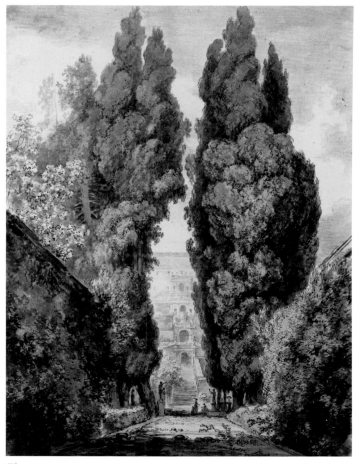

Figure 27

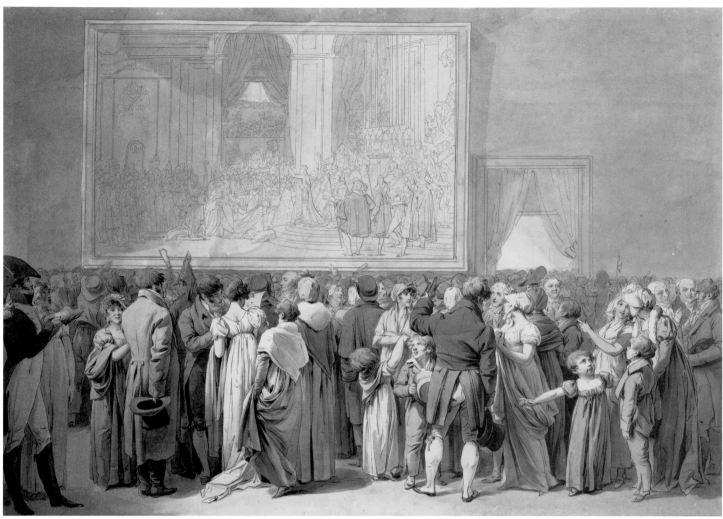

Figure 28

slow Ames, who expressed his desire to sell whenever he reached one hundred sheets! How will this collection expand or be reshaped? Will it be by period, series, or type? Will the eighteenth century continue to predominate? Will nature studies, or drawings for ornament, architecture, and book illustration ever tempt him enough to add them to the significant numbers of figural and compositional studies, portraits, and landscapes? We may be hopeful that the future will offer another opportunity for the public to share in Jeffrey Horvitz's journey and discover some of the answers for themselves.

In this brief survey, many readers will no doubt chide me for having unjustly omitted certain great collectors and great drawings, or for failing to do justice to the richness and variety of the collections mentioned. The topic deserves an entire book, with enough space to go beyond short mentions, passing references, and simple enumeration. Above all, such a study would also give an account of the passionate and sometimes obsessive quest that holds the true collector in its grasp; the desire to add *the* essential missing piece, to complete the series, to surpass what one already possesses, to know how to wait—if necessary, for years—until the coveted object becomes available, and to understand the role of chance, which always holds surprise discoveries in store, in the United States, France, and elsewhere.

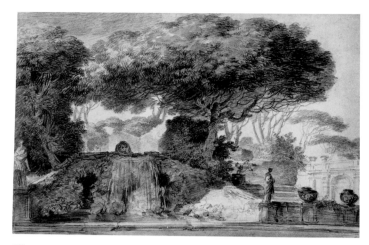

Figure 31

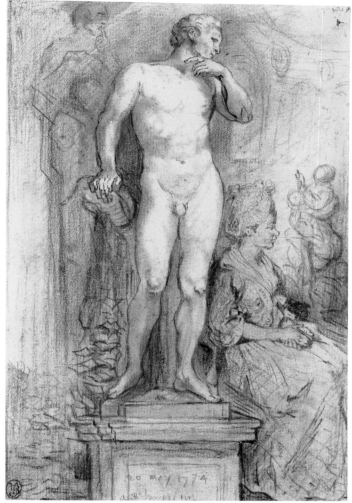

Figure 29

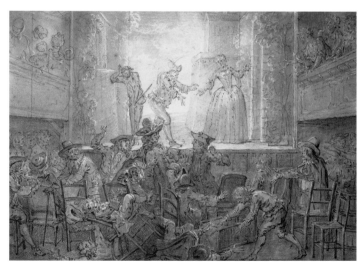

Figure 30

Notes

1. San Francisco 1989, preface.

2. New York 1962, p. 6.

3. I would like to thank Alvin L. Clark, Jr., who added much information and who, together with William W. Robinson, made Maria Ascher's already excellent translation of my text even better. I would also like to thank Cara Dufour Denison, Margaret Morgan Grasselli, Suzanne Folds McCullagh, Mary L. Myers, Innis Shoemaker, and Eunice Williams for their helpful suggestions and their answers to my many questions.

4. Paris et al. 1958.

5. Jean-Antoine Watteau, *Six Studies of Heads,* black and red chalk on light tan antique laid paper, 222 × 217 mm., Bequest of Meta and Paul J. Sachs, Department of Drawings, Fogg Art Museum, Harvard University Art Museums, Cambridge, inv. no. 1965.336.

6. For the Polakovits Collection, bequeathed to the Ecole nationale supérieure des Beaux-Arts, Paris, see Paris 1989a. For the Petithory Collection, bequeathed to the Musée Bonnat, Bayonne, see Paris 1998a. And, for the Baderou Bequest to the Musée des Beaux-Arts, Rouen, see *La Donation Baderou au Musée de Rouen, Ecole française, Etudes de La Revue du Louvre,* vol. 1, 1980.

7. For an overview of the Lehman Collection—left to the Metropolitan Museum in 1969, and officially integrated into the museum in 1975—see Szabo 1975.

8. François Boucher, *Nymphs and Cupids,* black chalk, partially stumped and heightened with white chalk, 322 × 232 mm., The Robert Lehman Collection, Metropolitan Museum of Art, New York; see Szabo 1980, no. 1.

9. Jean-Honoré Fragonard, *The Dreamer,* pen and brown ink with brush and brown wash with watercolor, over an underdrawing in graphite, on cream paper, 305 × 215 mm., The Robert Lehman Collection, Metropolitan Museum of Art, New York; for this, and reproductions and brief descriptions of all of the drawings mentioned, see Szabo 1980.

10. For the drawings in the Forsyth Wickes Collection, see Munger et al. 1992.

11. Maurice-Quentin de La Tour, *Portrait of a Lady (La Dame en Rose),* pastel, 635 × 533 mm., Forsyth Wickes Collection, Department of Prints, Drawings, and Photographs, Museum of Fine Arts, Boston, inv. no. 65.2661; see Eric Zafran in Munger et al. 1992, cat. 28, p. 86.

12. Claude Gillot, *Masquerade,* pen and brown ink, 157 × 200 mm., Forsyth Wickes Collection, Department of Prints, Drawings, and Photographs, Museum of Fine Arts, Boston, inv. no. 65.2572; see Eric Zafran in cat. 63, p. 118.

13. Paris et al. 1958, pp. 23–24.

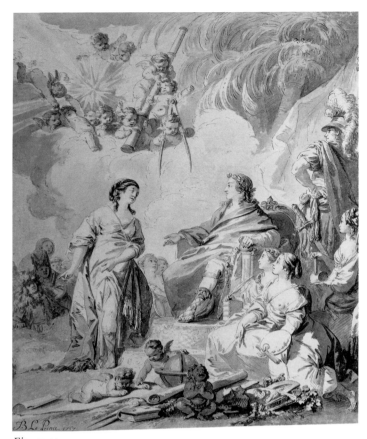

Figure 32

Figure 33

14. Cambridge and New York 1965, p. 11.

15. Victor Carlson, Margaret Morgan Grasselli, Suzanne Folds McCullagh and Eunice Williams. For the exhibitions, see Cambridge and New York 1965; Cambridge 1968; Cambridge 1969; and Cambridge 1971. The tradition continued under the direction of her successor, Konrad Oberhuber, with Cambridge et al. 1977b; Cambridge 1979; and Cambridge and Tampa 1984.

16. Sachs 1961, p. 76.

17. Jean-Baptiste Greuze, *Seated Female Nude,* red chalk on cream paper, 445 × 368 mm., Bequest of Meta and Paul J. Sachs, Department of Drawings, Fogg Art Museum, Harvard University Art Museums, Cambridge, inv. no. 1965.290.

18. Pierre-Paul Prud'hon, *Young Nymph Teased by Cupids* (verso: *Academic Study of a Male Nude*), black chalk heightened with white chalk (recto squared in black chalk) on blue paper, 445 × 368 mm., Bequest of Meta and Paul J. Sachs, Department of Drawings, Fogg Art Museum, Harvard University Art Museums, Cambridge, inv. no. 1965.326.

19. Jean-Baptiste-Siméon Chardin, *Portrait of the Painter Jean-Jacques Bachelier,* 1773, pastel on paper, 544 × 442 mm., Gift of Grenville L. Winthrop, Department of Drawings, Fogg Art Museum, Harvard University Art Museums, Cambridge, 1939.89.

20. Pierre-Paul Prud'hon, *Male Nude Figure Resting,* black and white chalk on blue antique laid paper, 466 × 562 mm., Bequest of Grenville L. Winthrop, Department of Drawings, Fogg Art Museum, Harvard University Art Museums, Cambridge, 1943.886; for this, and other drawings in the Winthrop Bequest, see Cambridge 1969.

21. Cambridge 1969, p. xvii.

22. For Konrad Oberhuber, aside from a few stellar sheets, Loeser's was "clearly a study collection"; see Cambridge 1979, p. 7.

23. He also gave the Fogg a festive sheet by Antoine Caron (*Catherine de'Medici Receiving the Polish Ambassadors in the Garden of the Tuileries Palace, 1573,* 1964.74); see Ehrmann 1986, p. 212, repr. pp. 198 and 212, pls. 176 and 210.

24. See Detroit 1965, and the introduction to Sharp et al. 1992, p. 10. Newberry also gave the Fogg a wonderful Watteau (*Three Studies of a Drummer,* inv. no. 1964.14); and an impressive Albert Cuyp in honor of Paul Sachs's 70th birthday (*View of Rhenen,* 1949.33).

25. See the introductions to Cambridge 1980b and Cambridge and Tampa 1984.

26. Cambridge and Tampa 1984, p. 9.

27. Charles-Nicolas Cochin le jeune, *Design for the Frontispiece to the Description des principales pierres gravés du cabinet de s.a.s. monseigneur le Duc d'Orléans . . . ,* red and black chalk on laid paper, 232 × 171 mm., Department of Printing and Graphic Arts, Houghton Library, Harvard University, Cambridge; see David Becker in Cambridge 1980b, no. 14, pp. 28–29.

28. Charles-Joseph Natoire, *Study of a Seated Man Holding Drawing Materials,* black chalk on buff antique laid paper, 237 × 270 mm., Bequest of Frances L. Hofer, Department of Drawings, Fogg Art Museum, Harvard University Art Museums, Cambridge, 1979.94; see Eunice Williams in Cambridge 1984a, no. 30, pp. 39–40.

29. Cambridge and Tampa 1984, p. 8.

30. See Rishel and Lefton 1987.

31. See Henriot 1928.

32. Jean-Honoré Fragonard, *The Servant Girls' Dormitory,* brown wash and touches of brown ink over graphite on cream antique laid paper, 239 × 367 mm., Gift of Charles E. Dunlap, Department of Drawings, Fogg Art Museum, Harvard University Art Museums, Cambridge, 1954.106; see Pierre Rosenberg in Paris and New York 1987, pp. 238–39, no. 113.

33. New York 1962, p. 6.

34. Hubert Robert, *Young Artists in the Studio,* red chalk with framing lines in pen and brown ink, 352 × 412 mm., Bequest of Walter C. Baker, 1971, Department of Drawings and Prints, Metropolitan Museum of Art, New York, inv. no. 1972.118.231; see Bean and Turčić 1986, no. 262, p. 233.

35. For these others not reproduced here, see Bean and Turčić 1986, nos. 27, 55, 92, 114, 134, 200, 253, 262, 264, 265, 268, 274, 320, 329, 334, 338, 347, 349, and 350.

36. New York 1975, p. 14.

37. New York 1975, p. 14.

38. New York 1975, p. 13.

39. New York 1975, p. 15.

40. Jean-Antoine Watteau, *Young Man Seen from the Back and Another Study of His Right Arm,* black, red, and white chalk on light brown paper, 208 × 227 mm., Collection of Eugene Victor and Clare Thaw on loan to the Pierpont Morgan Library, New York; see Cara Dufour Denison in Paris and New York 1993, no. 35, pp. 84–85.

41. Louis-Léopold Boilly, *Portraits of the Artist's Family and Servants,* black and white chalk on light brown wove paper, 451 × 296 mm., Department of Drawings, Collection of Eugene Victor and Clare Thaw on loan to the Pierpont Morgan Library, New York; see Cara Dufour Denison in Paris and New York 1993, no. 96, pp. 210–11.

42. See Paris and New York 1993.

43. Jean-Antoine Watteau, *Seated Young Woman,* black, red, and white chalk, 255 × 172 mm., Department of Drawings, Pierpont Morgan Library, New York, inv. no. I, 278a; see Cara Dufour Denison in Paris and New York 1993, cat. no. 38, pp. 90–91.

44. Jacques-André Portail, *Presumed Portrait of Mme de Lalive de Jully Sketching at a Table,* black and red chalk, with brush and black and gray wash and touches of pink and blue watercolor, 255 × 212 mm., Department of Drawings, Pierpont Morgan Library, New York, inv. no. III, 98a; see Cara Dufour Denison in New York and Paris 1993, no. 44, pp. 102–3.

45. Sale, Sotheby's, London, 10 June 1959, lots 1–64.

46. Margaret Morgan Grasselli in Washington 1982a, p. 10.

47. Jean-Michel Moreau le jeune, *Have No Fear, My Good Friend!,* 1775, pen and brown ink with brush and brown wash, 267 × 216 mm., Department of Drawings, J. Paul Getty Museum, Los Angeles, inv. no. 85.GG.416; see Goldner—Hendrix—Williams 1988, no. 81, pp. 182–83.

48. See Agnes Mongan in Cambridge 1968, no. 19.

49. Jean-Antoine Watteau, *Italian Comedians Taking Their Bows,* red chalk and graphite on cream paper, 178 × 185 mm., Collection of Mrs. Gertrude Laughlin Chanler, promised to the National Gallery of Art, Washington; see Margaret Morgan Grasselli in Washington 1982a, no. 24, pp. 60–1.

50. Margaret Morgan Grasselli in Washington 1982a, p. 12.

51. Most of Schiff's collection remained in the hands of his son, John, who, on the occasion of Eunice Williams's exhibition devoted to Fragonard's drawings, lent the *Ancient Sacrifice,* which is, in my opinion, one of the most beautiful works in that exhibition (see Washington et al. 1978, no. 19).

52. Sale, Parke Bernet, New York, 21 October 1970.

53. Jean-Honoré Fragonard, *Grandfather's Reprimand,* black chalk with brush and brown wash on beige antique laid paper, 343 × 415 mm., The Armand Hammer Collection, Department of Prints and Drawings, National Gallery of Art, Washington; see Eunice Williams in Washington et al. 1978, no. 46, pp. 120–21.

54. See sale cat., Sotheby Parke Bernet, New York, 30 April 1982.

55. Claude J. Hoin, *Portrait Studies of Two Men,* black and white chalk on blue prepared antique laid paper, 390 × 520 mm., Gift of Robert M.

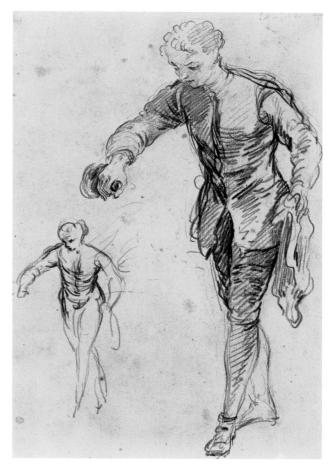

Figure 34

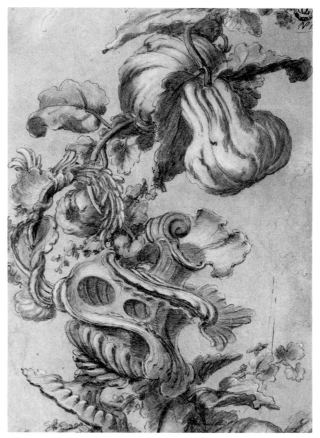

Figure 36

Light as a token of appreciation for the outstanding contributions to Harvard and the Fogg Art Museum of Agnes Mongan, Department of Drawings, Fogg Art Museum, Harvard University Art Museums, Cambridge, inv. no. 1972.324. See Agnes Mongan in Paris et al. 1958, no. 61.

56. See Bean and Turčić 1986, nos. 328 and 332.

57. Charles-Joseph Natoire, *Mythological Scene: Bacchanal,* watercolor and gouache over graphite on tan laid paper, 380 × 527 mm., Gift of Charles E. Dunlap, Department of Drawings, Fogg Art Museum, Harvard University Art Museums, Cambridge, inv. no. 1957.51.

58. See sale cat., Parke Bernet, New York, 7–8 May 1971.

59. Jean-Honoré Fragonard, *Frolicking Putti,* red chalk on off-white antique laid paper, 304 × 244 mm., Loan from the Collection of Jeffrey E. Horvitz, Department of Drawings, Fogg Art Museum, Harvard University Art Museums, Cambridge, inv. no. D-F-343/1.1996.3.

60. Jean-Honoré Fragonard, *Rinaldo Astride Baiardo Flies Off in Pursuit of Angelica,* black chalk, stumped, with brush and brown wash and touches of pen and brown ink on cream antique laid paper, 392 × 262 mm., Rosenwald Collection, Department of Prints and Drawings, National Gallery of Art, Washington, inv. no. 1943.3.9080.(B-11147)/DR.

61. Sale, Parke Bernet, New York, 7–8 May 1971.

62. See Launay 1991, p. 102.

63. See Agnes Mongan in Cambridge 1971, no. 53, pp. 118–121.

64. Jean-Antoine Watteau, *Old Savoyard,* black and red chalk, 360 × 224 mm., Department of Drawings, The Art Institute of Chicago, inv. no. 1964.74; see Harold Joachim and Suzanne Folds McCullagh in Chicago et al. 1976, no. 1.

65. François Boucher, *Young Boy Holding a Carrot,* pastel, 306 × 241 mm., Regenstein Collection, Department of Drawings, The Art Institute of Chicago, inv. no. 1971.22; see Roland Michel 1987, pp. 40–45.

66. See Harold Joachim and Suzanne Folds McCullagh in Chicago et al. 1976 for all of the drawings mentioned; the Girodet is no. 30.

67. Jean-Honoré Fragonard, *The Letter* (*or, The Spanish Conversation*), brush and brown wash over traces of graphite, 399 × 290 mm., Gift of Tiffany and Margaret Blake, Department of Drawings, The Art Institute of Chicago, inv. no. 1945.32; see Harold Joachim and Suzanne Folds McCullagh in Chicago et al. 1976, no. 18.

68. Hubert Robert, *Fountain in a Park,* red chalk, 307 × 435 mm., Gift of Tiffany and Margaret Blake, Department of Drawings, The Art Institute of Chicago, 1962.810; see Harold Joachim and Suzanne Folds McCullagh in Chicago et al. 1976, no. 20.

69. Jean-Honoré Fragonard, *Avenue of Cypresses at the Villa d'Este,* pen and brown and gray ink with brush and gray and brown wash over red chalk counterproof on laid paper, 456 × 342 mm., Woodner Collection on loan to the Department of Prints and Drawings, National Gallery of Art, Washington, and Louis-Léopold Boilly, *Public in the Salon of the Louvre, Viewing the Painting of the "Sacre,"* pen and black ink with brush and watercolor over traces of graphite on laid paper, 595 × 803 mm., Woodner Collection, 1991.182.8. For a selection of the best of the Woodner Collection, see Margaret Morgan Grasselli et al. in Washington 1995a, and for these two drawings, see pp. 313–15, and pp. 355–59, respectively.

70. See Ruth Fine in Washington 1982c.

71. Gabriel-Jacques de Saint-Aubin, *Rendez-vous in a Park,* 1774, black chalk and pen and black ink on laid paper, 224 × 147 mm., Rosenwald Collection, Department of Prints and Drawings, National Gallery of Art, Washington, inv. no. 1961.17.64.(B-22305)/DR. See Victor Carlson, Ellen D'Oench, and Richard S. Field in Middletown and Baltimore 1975, no. 53, pp. 95–96.

72. Jean-Baptiste Oudry, *La Scène du grand Baguenaudier,* black chalk heightened with white chalk on blue laid paper, 330 × 440 mm., Rosenwald Collection, Department of Prints and Drawings, National Gallery of Art, Washington, inv. no. 1952.8.275.(B-20649)/DR. See Hal Opperman in Paris et al. 1982a, no. 55, pp. 124–25.

73. François-André Vincent, *Park of an Italian Villa,* black chalk and brown wash, 248 × 370 mm., Samuel H. Kress Collection, Department of Prints and Drawings, National Gallery of Art, Washington, inv. no. 1963.15.12.(B-22378)/DR. See Cuzin c. 1988, no. 18.

74. Jean-Baptiste Le Prince, *Frontispiece for Travels in Siberia: Urania Informs Louis XV of the Passage of Venus across the Sun,* 1767, pen and black ink with gray wash, 403 × 330 mm., Rosenbach Museum and Library, Philadelphia, inv. no. 54.362; see Kimerly Rorschach in Philadelphia et al. 1986, no. 1, p. 27.

75. Hubert-François Bourguignon, called Gravelot, *Title Page Design for Volume One of Boccaccio's Decameron,* fig. 35, pen and black ink with brush and brown wash over graphite, 120 × 65 mm., Widener Collection, Department of Prints and Drawings, National Gallery of Art, Washington, 1942.9.685.

76. François Le Moyne, *Valet Pouring Wine,* red chalk, 256 × 167 mm., Gift of Anne Payne Blumenthal, 1943, Department of Drawings and Prints, Metropolitan Museum of Art, New York, inv. no. 43.163.22; see Bean and Turčić 1986, no. 166, p. 154.

77. See Agnes Mongan in Cambridge 1968.

78. Juste-Aurèle Meissonnier, *The Chariot of Apollo: Ceiling Study for the Salon Bielenski, Warsaw,* pen and brown ink with brush and watercolor and gouache, 321 × 320 mm., Department of Prints and Drawings, The Cooper-Hewitt Museum, National Museum of Design, Smithsonian Institution, New York, 1911.28.214.

79. Alexis Peyrotte, *Ornament Design with Fruit and Flowers,* black chalk with pastel, 408 × 286 mm., The Elisha Whittelsey Collection, The Elisha Whittelsey Fund, Department of Drawings and Prints, Metropolitan Museum of Art, New York, 1961, inv. no. 61.557.3; see Mary Myers in New York 1991a, no. 102, pp. 167–68.

80. Middlebury 1975.

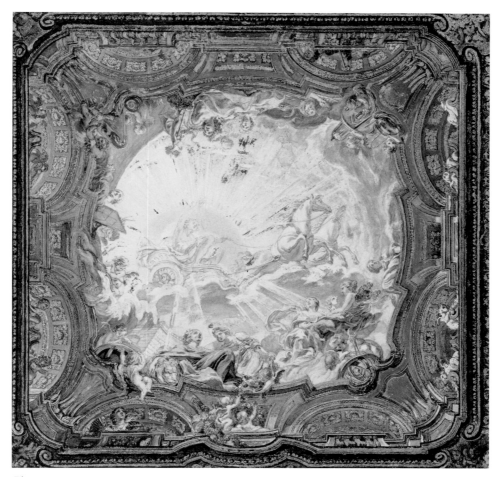

Figure 35

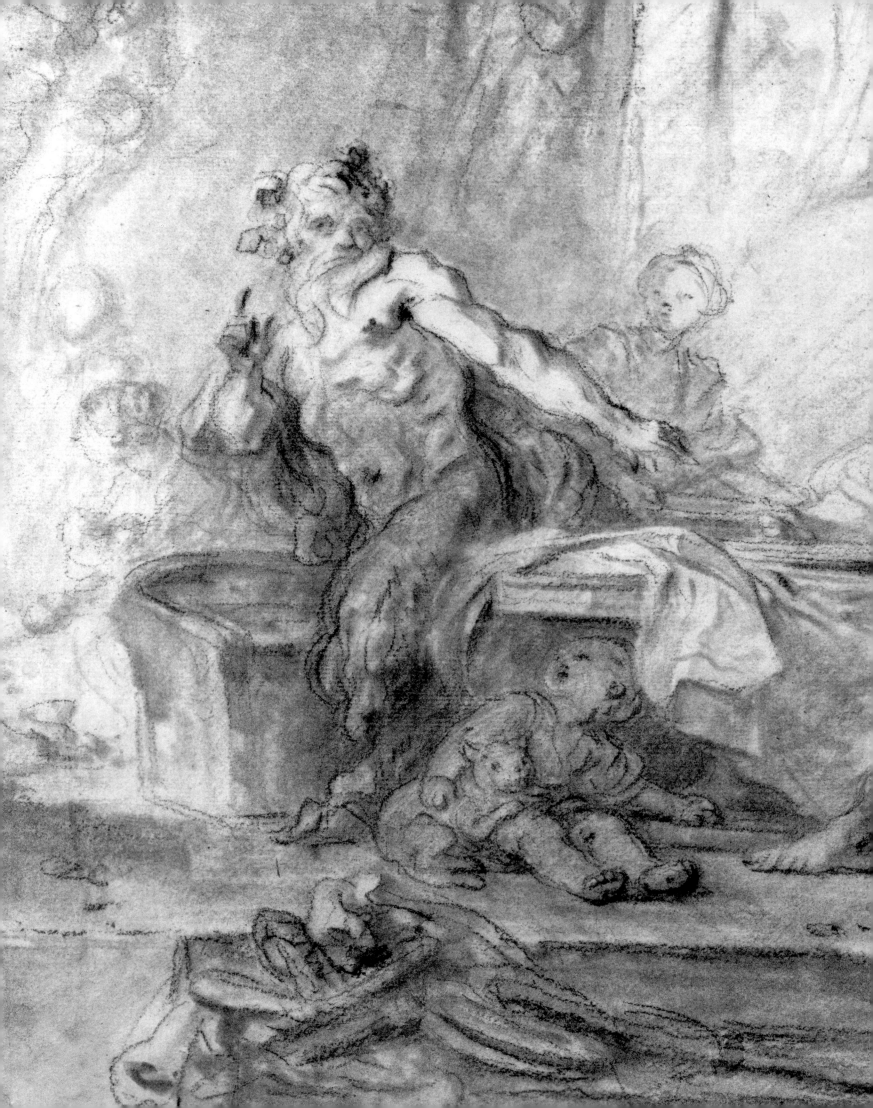

AN INTERVIEW WITH JEFFREY E. HORVITZ

William W. Robinson and Alvin L. Clark, Jr.

*J*effrey E. Horvitz was born in 1950 and grew up in Cleveland. After graduating from the University of Pennsylvania in 1972 with both a B.A. and a master's degree in sociology, he went on to earn a master's in psychology from the University of California at Los Angeles in 1974. He worked as a dealer in modern and contemporary art in Los Angeles from 1974 to 1980, then became a real estate executive in Hollywood, Florida. He now lives outside of Boston, where he is a private investor.

Although he is unabashedly acquisitive and purchases drawings at a hectic pace—more than four hundred during the past four years alone—Jeffrey Horvitz is the least impulsive of collectors. He engages the art market methodically, carefully evaluates the cost of every acquisition, and ponders the contribution of each new drawing to the shape and content of the collection. When contemplating his purchases, he uses a variation of the Venn diagram—devised in 1918 by the English logician John Venn—and thinks of three intersecting sets of criteria: one representing works that he likes, the second standing for drawings esteemed by scholars and other experts, and the third comprising sheets that are priced reasonably. An appropriate acquisition should fall within the intersection of these three sets. In the end, the aesthetic appeal of the object, rather than its rarity or art-historical significance, is his primary criterion for selection.

Mr. Horvitz has clear opinions about the art market and about the purpose of his collection as an instrument of research, education, and visual pleasure. We conducted a loosely structured interview that allowed him the maximum latitude to express his ideas about his goals as a collector, his love of French art, his preference for drawings over other artistic media, his favorite artists, and his aspirations for the present exhibition.

❧

WWR: Jeffrey, having been a dealer and collector in the field of twentieth-century art, why did you decide to specialize in collecting old master drawings?

JEH: I was a dealer in twentieth-century art in Los Angeles in the 1970s, and my experience was that almost all of the

dealers of twentieth-century art that I knew had drawings in their personal collections. I think it has to do with the immediacy of the objects; you can pick them up and handle them easily. Not many had old master drawings. When handling a lot of works of art as a dealer, you want something special in your own collection. Like most dealers, I had a strong preference for works of art on paper, and when I closed my gallery in 1980, I spent a considerable amount of time thinking about what I would like to collect. I definitely wanted to collect something, and it had to be outside of the area in which I had focused as a dealer, which began with late Barbizon works and continued through contemporary. I keep a buffer zone—sort of a DMZ between where my collecting ends and where my dealing started. I eliminated Asian art as a possibility because the aesthetic issues are far too different, although I love Asian art. So, I focused on earlier Western art. I also love sculpture, but given the difficulty and cost to obtain a large number of quality pieces—not to mention the space required for display—this also seemed unfeasible. It was easy to make my decision. When I first started, I was willing to collect European drawings quite broadly: northern, southern, French, German, etc. It didn't take me long to figure out that that was just too broad an area, particularly since I knew nothing about old masters. So, given my preferences and the issue of availability, I settled on French, Italian, and Spanish drawings. Before I had even purchased a Spanish drawing, I realized that there wasn't enough material—and the issues surrounding scholarship were too problematic—so I dropped the Spanish component. In hindsight, this may have been a mistake. I then proceeded with the Italian and French, in roughly equal numbers, and I anticipated buying about half a dozen drawings a year . . . in a big year!

ALC: Once you began to determine your areas of focus, what was the first earlier French drawing you purchased?

JEH: It was a female nude by Prud'hon that I purchased from Galerie Cailleux and Colnaghi when they did an exhibition together in New York (fig. 1).[1] I had seen the same study before in an article in *Architectural Digest* about drawings of nudes that was one of the precipitating influences on

my decision to start collecting old masters. It got me thinking that perhaps I could actually buy earlier drawings of high quality by major masters. Needless to say, I was thrilled that my first purchase was the very same drawing that I found in that article.[2]

WWR: Can you put your finger on what it is about French drawings that particularly appeals to you? Is it the subject matter, the correctness of the draftsmanship, the availability of drawings on the market today?

JEH: It's all of the above. First, it has to do with the fact that basically, at heart, I am a Francophile. The appeal of French art for me has something to do with its balance between the cerebral and the sensual. French art seems to have quite a lot of intellectual refinement, but at the same time, it has a certain *joie de vivre,* and although this is not always evident in the seventeenth century, by the eighteenth century it is there in full force. For me, French drawings are usually more secular in spirit than Italian drawings, and while I am quite fond of the religious passion in Italian drawings, some of it, at least by the seventeenth century, if not forced, seems contrived. There is a Descartian aesthetic reserve that provides a measured balance in French art that doesn't happen anywhere else. German art tends to be very controlled, but it can also be severe, introspective, and even morose. Dutch drawings are fine in their execution, but their subject matter, while interesting for me, keeps it from being quite as broadranging as French art. It is not always that French draftsmen do better work, it is just that French art becomes much broader in its possibilities.

WWR: How about the aspect of the availability of the drawings in today's apparently diminishing old master market?

JEH: I have often mentioned, jokingly, that if French drawings were any rarer, I would be bankrupt. I see an amazing amount of material, and there is a seemingly endless supply of high-quality French drawings. We have often speculated that the dispersion of large holdings during the Revolution, and throughout the political conflicts of the nineteenth century, put vast quantities of drawings in the hands of the bourgeoisie, and that most of these had remained there, fairly well preserved, until the twentieth century. As it was not the first priority of collectors in the first half of the twentieth century, when one could still obtain important Renaissance sheets, they now slowly seep into the marketplace as tastes gradually shift to absorb them.

ALC: Although there are no longer so many sheets available from the late sixteenth and early seventeenth centuries.

JEH: Yes, that's sad, but true.

WWR: During the past twelve years or so, you have been one of the leading collectors of French drawings and you have built a collection of more than seven hundred French and Italian drawings and some French paintings. How do you see the collection developing in the next decade? Will you fill in gaps? Take it as it comes? Move deeper into the nineteenth century, for example? Branch out into other schools?

JEH: The plan for now is more or less to keep doing what I am doing. If there are changes, it will be at the margins. For example, I am beginning to think about moving to earlier material and hence, I am looking at French illuminated manuscripts. These might come to represent earlier centuries, the indigenous source material for later French art. In the nineteenth century, I have already made a large expansion [François-Léon Benouville, *Head of Achilles*; Victor-François-Eloi Biennourry, *Roman Soldier*; William-Adolphe Bouguereau, *Allegory of Winter*; Jean-Léon Gérôme, *Woman*

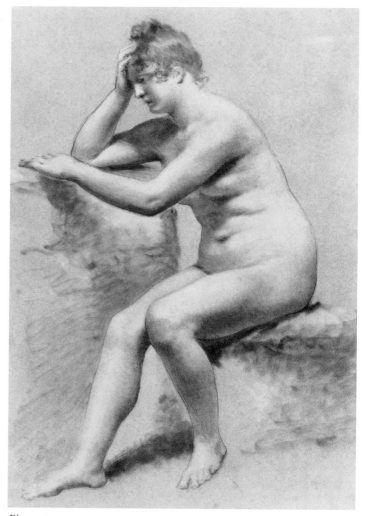

Figure 1

78

Bathing Attended by a Servant; and Jean-Auguste-Dominique Ingres, *Jupiter and Thetis* (figs. 2-6)[3]. At present, the collection follows the earlier academic tradition through to Ingres and his early pupils and associates. The question that remains is whether to break the DMZ and follow the French tradition through the various styles at the end of the nineteenth, or even go to the very beginning of the twentieth century, as Louis-Antoine Prat does.[4] I am resisting that for now, and there is still enough earlier material to keep me busy. As for filling gaps, they get filled when they can be filled. I try not to force it, because I am afraid that if I really force it, both quality and focus would suffer. Sometimes it is just not possible. For example, although I would like to have

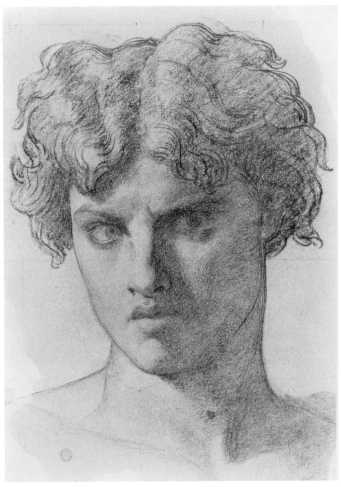

Figure 2

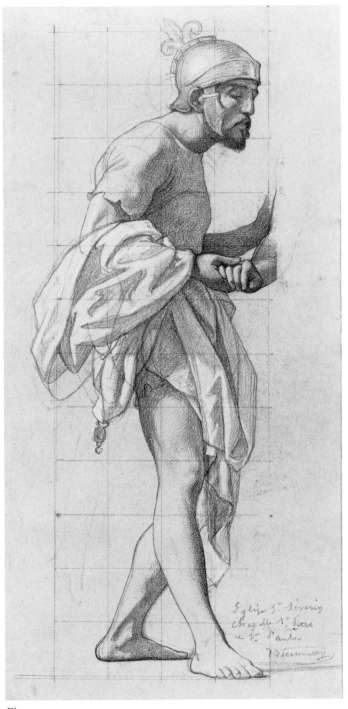

Figure 3

a fine *trois-crayons* Watteau, it just may not be possible in the immediate future given the combined factors of cost, availability, and condition. As for other desiderata, I would have to think through a long list of artists. We have talked about a sort of three-dimensional grid. If you placed the artist on one axis, the subject matter on another, and the media on another, you would have a formidable matrix of cells that could be filled. And if you realize that they can be filled with more than one example, because the number of cells is the number of different media, times the number of different subject matters, times the number of artists, that's a huge amount. So it is probably not possible to fill all of the holes. Some blocks get filled a lot, like Boucher, by whom I have a fairly deep and broad set of holdings, but this is unintentional except that I love Boucher, they are available, and there is no reason *not* to collect them.

WWR: How much do you think your activity now and in the future will be the result of a premeditated strategy or policy and how much is just reacting to the market, reacting to what's out there—what's come along?

JEH: It's actually both, and the way you phrase the question has to do with an approach I use in financial investing. Even

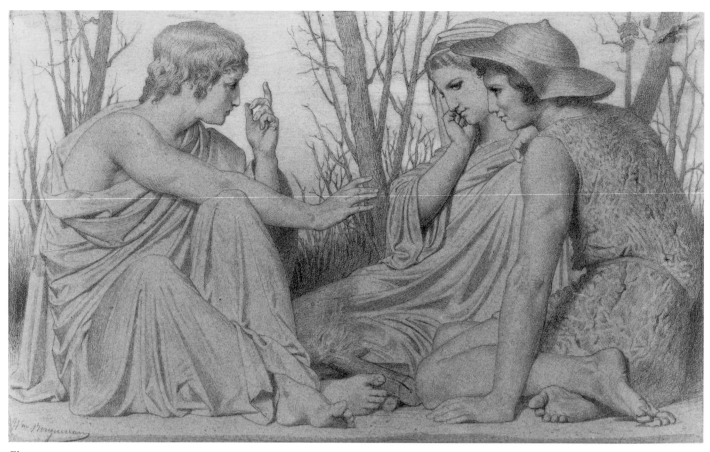

Figure 4

if I have a plan, I still have to have the opportunity to execute it; the material actually has to come up. I suppose in some extreme sense, you could go chasing these things and be willing to pay whatever price is demanded to shake loose the objects that you felt you needed. I don't really do that right now because there is an ample amount on the market. As long as there is the opportunity—meaning that the volume of drawings is flowing and it fits the plan—I am generally content.

ALC: As visitors are often surprised that there are so many elaborately worked and elegantly finished French drawings in your collection, I thought I would ask you to discuss why you often prefer finished sheets to the working sketch.

JEH: I know it has been asked before, but I never had a good answer. Indeed, I probably still don't. First of all, they usually have more total aesthetic quality, and perhaps this is simply because the odds are that with a finished drawing, there is a lot more effort that went into it. Finished drawings also offer more elements of what the artist is working on: a variety of ideas, more complexity, a number of different levels of figural and compositional engagement. At its best, an excellent "finished drawing" presents a type of compromise between the sketched effect and the finish of a painting, where you lose the spontaneity. The immediacy of a work-

ing sketch disappears in the painting; a finished drawing is somewhere between the two. There, at this midpoint, you get most of the instantaneity of the earlier working drawings and most of the complete quality of the painting; quite a lot in the single object. Another way to think about it is that a sketch is like a quick conversation in the hallways, or a short chat on the telephone, whereas a finished drawing is a bit more like a speech, and a painting is more like a book.

WWR: Your response tempts me to ask you to describe how you respond visually to drawings.

JEH: The thing I most respond to in drawings is what I refer to as "energy." Often, the drawings that move me most are very powerful, but they do not have to be. There is something about the combination of line and the effects of light that makes some compositions particularly effective. This quality can be either quiet or strong, and it can be found in both finished drawings and sketches. What appeals to me most is immediacy and a profound sense of movement or tension. This movement goes beyond a mere discussion of line. At its best, it forms a communion between the artist and the viewer. Watteau has this energy, Trinquesse does not.

ALC: We must ask you who your most preferred and least favorite French artists are.

JEH: I thought about this a long time. Unfortunately, the answer is so trite and obvious that I almost hate to say it. Certainly the favorites are Watteau, Fragonard, and Boucher. And, in mulling over the seventeenth century—it's probably Vouet. It is not Le Brun, and it's not Poussin. Indeed, what may be most interesting is who is not my favorite, although this doesn't always mean that I dislike their drawings. Of the major artists who should be obvious candidates for preference, Greuze is not. Although I appreciate Greuze, and have a lot of his drawings, he's not one of my favorites.

WWR: And Claude Lorrain?

JEH: Claude Lorrain is not a favorite. In part, this is a function of the very few drawings that remain in good condition. Claude is, in my view, hypersensitive to condition. If they're in bad shape, you get what is tantamount to a reproduction. The other reason is that he actually draws figures and animals so badly that it compromises a significant portion of his work. For me, his art is about ideas of atmosphere and of light, almost like a conceptual artist today—more about ideas than execution. So when I thought about the question of who I like best, one of the things I did was to differentiate between who I like as a draftsman, and who I like as a painter or overall artist. What is it that I like about Watteau that is unlike anyone else? First, he conceives figures as if they were marionettes held lightly by a string—they seem just slightly lifted. They can have the most remarkable weightlessness or be as dense as he wants them. All of his sheets are executed with a marvelous and effortless quality. In fact, the artists I like the most all possess the gift of effortless draftsmanship that Picasso had: complete control and linkage between mind and hand. Watteau can do that, as can Fragonard. However, Fragonard can also be sloppy, but when he's "dead on," they're terrific. Fragonard understands light, shade, brightness, sparkle, and atmosphere in a way that Watteau really doesn't. Watteau's atmosphere comes out best in his paintings. Boucher is the technician, and probably, in my mind, the finest draftsman in terms of his ability to put anything he wants on paper. Unfortunately, the ideas he put on paper aren't usually that interesting. Other artists—since I like so many—include Prud'hon. To me, his nudes display a cool sensuality that is the most French of all; that synthesis of what is actually a dichotomy. Both the males and the females are palpably sexy, yet distant, and no one else can do that like Prud'hon.

ALC: Do you look for the qualities of your favorite artists in the works of other artists, or do you collect them precisely because they don't have those qualities?

JEH: Each artist has his own gifts. Greuze, for example, has qualities that include a great ability to capture the moment. When he does compositions they can be quirky, or even semi-abstract. Vouet I like because of his crude rough edge, packaged in a slick veneer. I like the "preciousness" of Gabriel de Saint-Aubin. I think preciousness is the best word to describe it. And it's very self-conscious; that's charming in its way. His drawings are like small jewelry.

ALC: Of course, I am curious: why isn't Poussin on your list?

JEH: For me, Poussin is not easily aesthetically accessible. His are mostly working ideas, except for the great drawings where he is blocking out areas of light and shade. In those, I like the way he forms sculptural entities; there, his clear delineations, seemingly without line, are almost Cubist. Although the rest of his drawings are perfectly fine, despite my comprehension of the visual ideas that he is tackling, to me, the drawings fall very short of the paintings. Perhaps this makes sense, because he is essentially about ideas, and color is so important in the paintings. I don't see Poussin's love of drawing in his sheets; he just doesn't come across as a man who likes to draw. He rarely demonstrates his pleasure in it, and thus I get relatively little pleasure.

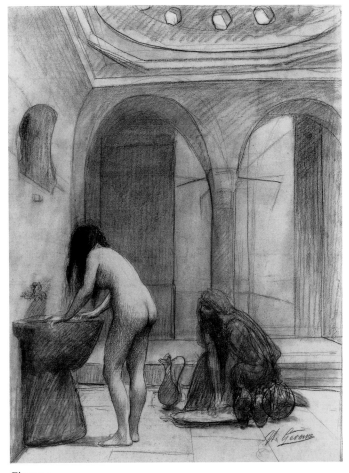

Figure 5

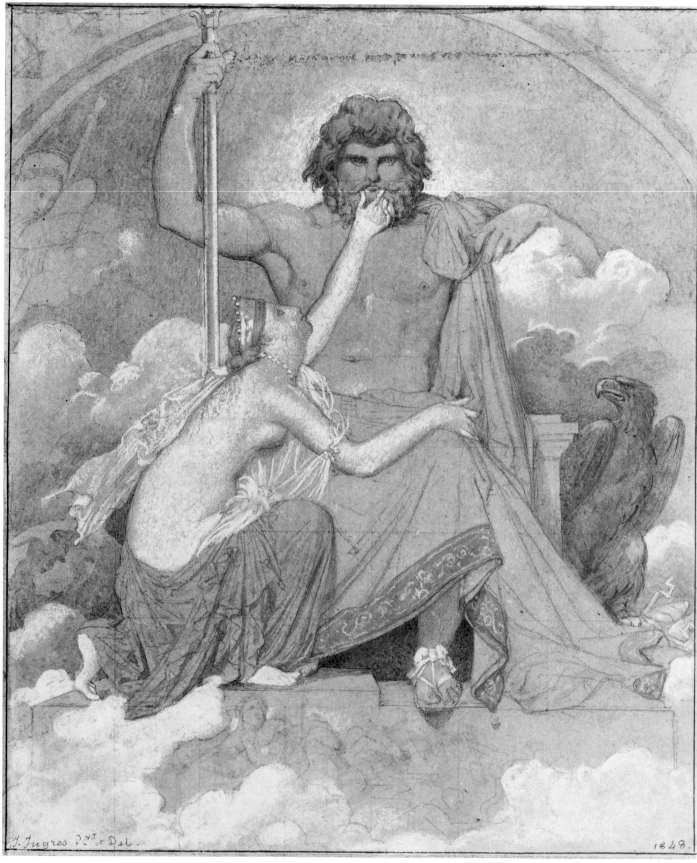

Figure 6

WWR: Let's talk about the mechanics and practical aspects of your collecting: you mentioned that there is an ample supply of French drawings. How do you limit the number of drawings that you acquire in a given year or a given period of time?

JEH: I don't. However, if I had infinite funds I would be buying less than an infinite number of drawings. The number of meritorious purchases that are actually available is probably three to four times what I am actually buying, so I am editing to some extent. I'm editing potential purchases based on my three-factor system for making a purchase, but also if I already have similar things, having duplication doesn't make a lot of sense. I am careful not to fall into what I call the stamp-collecting mentality. I also have other things to do, so probably the single largest limitation is time.

ALC: Even with all of these limitations, how many drawings do you normally purchase in a year?

JEH: It is pretty consistently over a hundred. It comes in spurts. I actually can go as long as sixty days without a purchase!

WWR: One of the conspicuous features of your collecting, as we see it, is the practice of buying groups of drawings from dealers. Do you have a preference about whether you buy from dealers or at auction, or do you see any sort of different opportunities there?

JEH: There are several parts to this. In the first place, I am only buying the drawings I want; otherwise I would buy them one at a time. You can sometimes get better pricing by buying in a group, but with very few exceptions, that doesn't cause me to buy drawings that I don't want, and those exceptions are very, very few, and are either given away or sold. It turns out not to be an important factor to me. As I don't travel every month to make purchases, by the time I get to see a dealer, they have an accumulation of inventory. Only very rarely do they take the trouble to send me a single photo, and that is usually only for an important piece. Unlike the twentieth-century market, dealers are remarkably unaggressive in offering things to someone who they know is a large and consistent buyer. Larry[5] is very good about reminding them to stay in touch. The younger dealers are less entrenched in the tradition of the *amateur* who stops by the gallery at least once a week. But from what I have seen, most old master dealers are slower to think about art dealing as a distribution system than their twentieth-century brethren. If a twentieth-century dealer had a picture, and it was not sold within a year, sometimes less, they are already offering it to other dealers who have different clients. Maybe the old

master field has so few clients that the overlap is much greater, and I am sure that all the old master dealers have their own reasons. I have seen a tendency in the last few years for dealers to own more material together, to offer things to another dealer, to offer to new clients, and basically improve the distribution system. I think that is generally a good thing.

ALC: Could some of this perception just be a factor of your becoming better acquainted with a larger number of dealers specializing in old masters?

JEH: No, to me some of these new developments are clearly driven by the collapsing art market after 1989. Some of the things that we see now were virtually absent before. Many dealers were resisting change, but finally, they were driven by economic necessity. The prices of art went up, but their ability to raise capital had not kept up with it. The difference between, say, pre-1989 and post-1989 is staggering in terms of the economic behavior of dealers. As far as auctions are concerned, when I first started, it was easy one-stop shopping. My impression was that auctions accounted for about 80 percent of my purchases. This is probably down to 20 percent or less now. The result of my getting to know more and more dealers is that a few things get preempted before ever going to auction. Another factor—actually a huge problem—is the lack of warranty in auction houses. If you don't know for sure what you're buying, you are stuck with it. If it were a dealer, in theory, it could go back, although in practice, depending on the individual dealer, this can be a lot more difficult. So, I am learning not to count on the dealers either. Another reason is that for the better objects, auction pricing is quite unpredictable. There's no ability to negotiate, only the ability to bid. It is always a zero-sum game, which is not necessarily true with dealers. For example, when I bought my major Fragonard landscape (cat. 88), it cost me another hundred thousand dollars because of one other collector bidding. If I had purchased the same drawing from a dealer, it may have cost less. Finally, auction purchases are harder to resell, because they have been so widely seen.

ALC: To move away from the auction room and back to your thoughts concerning the shape of your collection since you still collect Italian drawings—despite the concentration on French masters—what are the acquisition criteria you use to differentiate between the two schools?

JEH: The Italian collection is clearly a more personal collection. By that, I don't mean that it is better or worse; it's just more affected by personal taste. The goals are less formidable. Unlike the French collection, the Italian collection has no pretension to be encyclopedic. Although not always

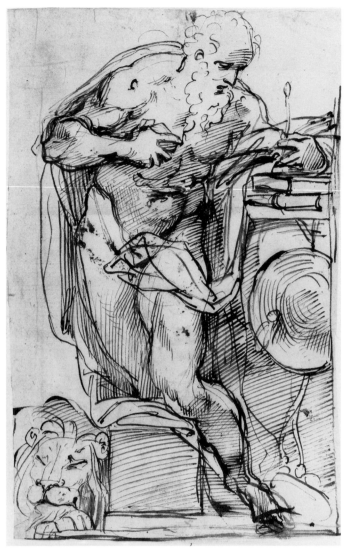

Figure 7

masterpieces, they are almost always of high quality and good condition. The quality has to be good enough to go to a major museum. Clearly, if you look at most major U.S. collections, there are a number of superb Italian drawings that are not masterpieces. Very few things in the world are really masterpieces. It's also no longer possible to assemble an Italian collection equivalent to the French one, so I set realistic goals. To paraphrase Bismarck, I think, "the art of collecting is the art of the possible." However, I can build a very concentrated collection, slowly, one by one, with a focus and some sort of integrity as a whole. The Italian collection has this because my taste for accomplished, powerful, and en-

ergetic draftsmanship predominates (Agostino Carracci, *St. Jerome,* fig. 7).[6] Even the few that are quiet and reflective, like the new Taddeo Zuccaro (*Swooning Magdalen,* fig. 8)[7] or the late eighteenth-century sheets, like the Andrea Appiani (*Assembly of the Gods,* fig. 9),[8] have an underlying blend of tension, refinement, emotion, and energy. These characteristics only define part of the French collection, where I enjoy choices that are sometimes intentionally idiosyncratic.

ALC: If criteria like comprehensiveness are not the same for the French and Italian schools, why do you have multiple examples of the work of some Italian artists?

JEH: Mostly because they fit. There is no reason not to. For example, Giambattista Tiepolo, to me, is one of the great artists of the eighteenth century as a draftsman—and as a painter, too—and they are not that expensive. Gian Domenico is often coarse by comparison, so the number is small (*Miracle in a Grotto,* fig. 10),[9] but Giambattista I like a great deal (*Head of a Man,* fig. 11).[10] Can you have too many? Well, if I can find very, very good examples in very, very good condition, to me, that's terrific, particularly if the compositions are marvelous. I suppose there is some point at which I would have too many, but if I had ten, it wouldn't matter, and if you look at some other collections like the Heinemanns', you see the same idea (although on a grander scale); they had a focused, superb, and very personal collection.[11]

ALC: Do these same criteria apply to the French school?

JEH: The French collection is a more complicated one. The original protocol for the present collection was identical to

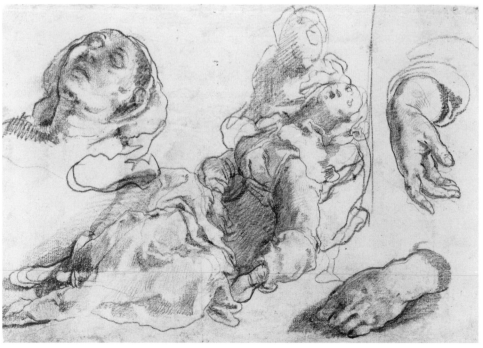

Figure 8

the Italian collection; but it quickly took on a life of its own. It had never occurred to me that I could assemble so much when I started. Obviously the protocol didn't envision the possibilities. Circumstances were such that, as I was able to get more and more, I saw new possibilities; so, not being rigid, I changed the protocol.

WWR: Can you pinpoint when that happened . . . when you had the vision that the French collection would evolve into something more?

JEH: It was about 1993, I guess.

WWR: Did that have something to do with Larry beginning to assist you, or was it prior to that?

JEH: Actually, the idea was emerging a bit earlier. There's probably a period of about two years where I began to see it as a possibility that hadn't really solidified, because by 1989, prices had spiked, so it didn't look feasible to have a major expansion. And then, only a few years later, the art market crashed and a new set of possibilities opened up. As I bought more, more dealers offered me things. And then the affiliation with Larry and the Fogg made it even more feasible to continue and for me to see the relationship of the parts—how this all fits into the realm of French art history—and, in another respect, how my drawings relate to the Fogg's holdings. Now I often see the collection as complementary to the Fogg's, and slowly, I have begun to think of the complementary nature of the collection with other museums, as I begin to understand it more as not a complete entity, but an integrated one. And that has happened over a number of years. I think 1993 was probably when it clicked and I became comfortable that this was going to work, that this was a protocol for the French collection; it was viable and sustainable for quite a number of years to come.

WWR: Earlier, without actually naming it, you briefly mentioned your use of the Venn diagram—the illustration of three intersecting sets, one with the opinions of scholars and other specialists, another with the drawings where the price is right, and the third containing drawings you like, with the intersection being the area where you want to acquire. Do you still consciously refer to that when you're considering a purchase?

JEH: Absolutely. That has been the most helpful conceptualization of buying that I have come up with, although there is a variation that I sometimes use, which is "fuzzy logic," or

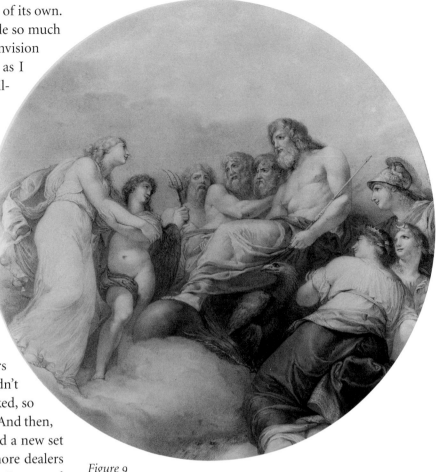

Figure 9

a weighting of variables. The three factors are fixed but their weightings are not. Their relative value is conditional. Thus, for artists such as Poussin, of those three sets, the relative significance of the scholarly factor needs to be heavier. If it were Louis-Félix de La Rue, the relative weighting of the aesthetic factor has to go up, and since they will never be expensive, the price factor is a relatively modest concern. So I have sort of transformed the Venn diagram to account for the specific conditions pertinent to an artist's work.

WWR: We've discussed each of your three areas of concern when it comes to purchases, and you've given us one example of how these might influence your purchase, but how do you go about taking scholarly opinion into account? Do you ever do anything against the opinions of experts?

JEH: Sure, but not very often. If I'm learning anything at all from my exercise in collecting, I should be getting better at this, so my opinions shouldn't vary wildly from those of experts. I'm not trying to prove a point or beat the system. I knew this as an art dealer, and I told my clients the same thing—don't try to beat the system. You can certainly vary from time to time, but to consciously and consistently go against the mainstream is foolish. Use the best information you have. Scholarship has just exploded compared to where

it was before. I expect to see exponential changes in the future, and I will attempt to stay up-to-date. On the matter of sheer taste I am actually happy to go against or outside of the mainstream. For example, my nineteenth-century collection is growing rapidly, particularly in the field of academic artists that are out of favor. For the most part, although we may not always like their paintings today, they are superb draftsmen whose sheets are not much in demand now, and they may never be, but at least I can acquire very good drawings very reasonably, so I see no reason not to take advantage of those circumstances.

WWR: Scholarship is where your relationship with Larry fits in. He has been a research associate in our drawing department and the curator of your collection since 1993–94. Can you characterize how you two interact when something is under consideration, and what his role is in determining what you end up buying?

JEH: In addition to the crucial aspect of authenticity, we talk a lot about the purchase, and we usually agree. We often use a rating system—how good is this work by this artist on a scale from 1 to 10—which enables us to rapidly ascertain how we are both thinking about a drawing. I tend to be a little more severe than Larry is in grading. We tend to be off by about 5–10 percent; it is less likely that he is less enthusiastic,

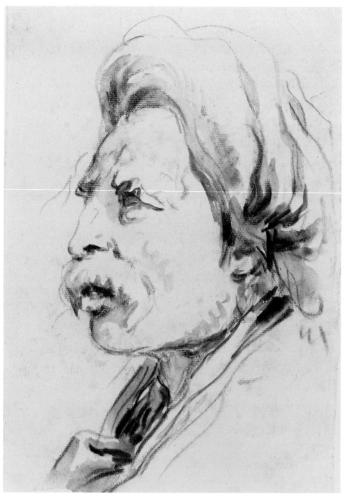

Figure 11

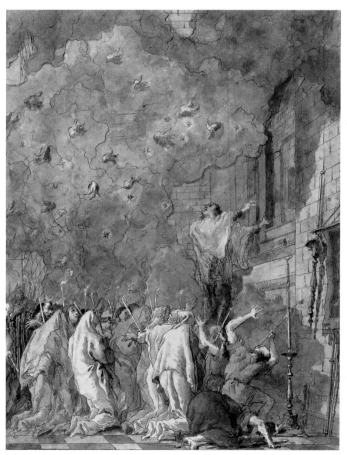

Figure 10

but it does happen. The other huge factor is that I really just don't know enough about the details of art history. So, to understand where things fit, or to know what is a rarity for two to three centuries of artists is a real specialty. For example, drawings by Jérome-François Chantereau are rare. This fact played a role in taking the opportunity to obtain my second sheet by the artist. Knowing how rare an artist's work is does influence whether I buy a second sheet by a charming, but minor talent. There is also the issue of the importance of the drawing. How carefully, for example, does one look at a drawing, especially a seventeenth-century sheet, before rejecting it? Very carefully, given the growing scarcity. The seventeenth-century part of the collection has grown considerably since Larry arrived on the scene. As we work together, he gets to know my taste, and I know his taste. Another factor is time. Art is his primary activity, not mine. He has the time to stay in touch and to bring things to my attention, or to complete research on some potential acquisitions which I might otherwise let pass because of the lack of time necessary to verify a problematic attribution or a potential redundancy in the collection. He also has time to ensure that the public has access. I enjoy contact with scholars, students, and other collectors immensely, but I simply don't have time to see them all and see to their needs.

ALC: What part of collecting do you like best: the negotiating or bidding, making the difficult choices about which sheets to acquire, seeing how various additions benefit or change the collection?

JEH: It is absolutely not the bidding or negotiating. It was very clear to me as I thought about this that the most important element was looking at art. Indeed, if I could rent a room at the Metropolitan Museum and just live there, that would be fine. I don't actually need to own the pieces. The real ownership is not that important to me. I like it, but it's really quite secondary to what I like to do. The second aspect is talking to the dealers and collectors and art historians and sharing the enjoyment of the art, which is not unrelated to looking at the art, because it expands the experience of understanding. It's also very enjoyable to experience someone else's pleasure and excitement in a work of art. Third, I like to make major additions to the collection. This happens by either making a single addition or seeing how, for example, the seventeenth century is finally beginning to shape up after several purchases. Fourth is seeing others use and enjoy the collection, which we are really just now beginning to experience. I would like to see more of this, because I get a lot of pleasure out of scholars—even if I don't always see them—just knowing that they were there, that they found something that was interesting, found something to help

Figure 13

their work. Almost off the list is the mundane activity of buying a drawing. Most people think I love the negotiations. It's the same as driving; it's just a way to get there. What is nice is the social exchange with the dealers. One of my greatest experiences was in Morocco, going through the souks because I understood that negotiation was a form of social intercourse; it was not just to get the price down. Indeed, it was rude not to negotiate. I don't negotiate to win or beat someone. I want reasonable prices and long-term relationships.

ALC: Are there some French artists that you might never collect, despite the comprehensiveness of the collection?

JEH: The answer there is no, and my theory is that every artist had at least one good day. So the trick is to find, even for minor artists, a work produced on that day. One of many examples would be Ursule Boze, who is not exactly a household name. The name Boze is known, but Ursule isn't. The collection includes her impressive trompe l'oeil portrait drawing of her father.[12] Maybe she actually had many good days but we only know of one. Louis-Félix de La Rue was a man of dependably bad days; however, I was able to acquire one sheet from a good day, early in his career, when he drew an extraordinary bacchanal (fig. 12).[13] Its energy and its freedom of execution are quite atypical. Indeed, if you know only his normally tight, compulsive mode, you would get the impression that he, like the followers of Bacchus, was drunk when he did that drawing! Sheets like those are worth having, and I imagine there are probably more of them, so there is almost no artist too small in stature to be included, so long as I can find an example from his best day. That has actually been the most pleasurable part of building the collection, finding those rare examples.

ALC: Let me push the response a bit further: what about an artist like Louis-Roland Trinquesse, who isn't represented in your collection?

JEH: Trinquesse may never be represented, not because I dislike his drawings, but because they are just unreasonably expensive for the quality. Carmontelle is another example. He is an artist who is certainly pleasant enough and who is interesting, but the price is a price of fashion for both of these artists and not necessarily reflective of their level of achievement. But then taste and fashion change, so they might become less expensive one day, and then they will be added. So the only barrier in those examples is price. Bad value, I should say.

ALC: Do you ever buy something that you feel doesn't quite fit comfortably into the collection—or isn't quite the exam-

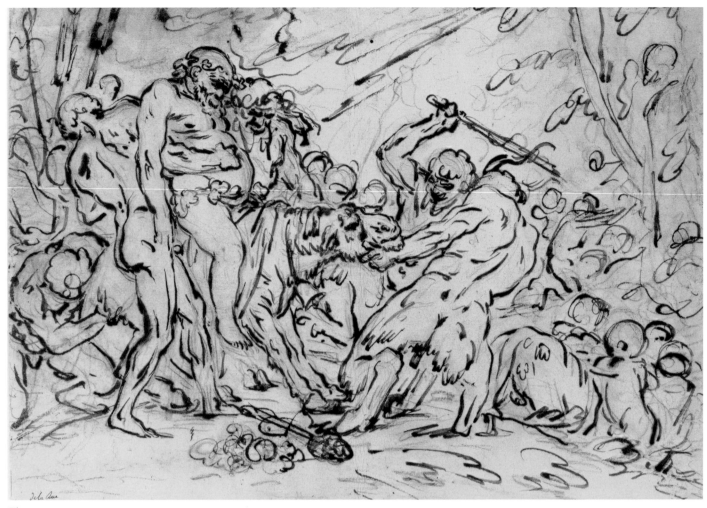

Figure 12

ple you really want by an artist—because of its historical importance?

JEH: Yes; although I try not to do that often, there are examples. One of which is my group of drawings by Eustache Le Sueur. The Le Sueurs don't make me fully satisfied, but he is a very hard artist to find and a very important artist to have represented in a broad-ranging French collection. So here is a case where I slightly bent the rules. But on the other hand, if you think of the conditionality of my three variables, knowing how difficult it is to get a Le Sueur, if I am ever able to find a better one, I don't have to keep all of the others. The most important one in the exhibition is certainly good enough, but just barely to fully satisfy me. Another example of something purchased in large part because of its great rarity is not French, but Italian; the Longhi drawing which was purchased to give to the Fogg (*Kneeling Prelate*, fig. 13).[14] There was no other reason to purchase that. I knew there were only roughly two Longhi drawings in public collections in America. He is not a draftsman I like very much. But, he is a significant artist, and with so few in America, it seemed that I probably better buy it. But in a sense you might reason

that it almost wasn't in the collection; it was for donation.

WWR: Your remarks about Le Sueur raise the possibility of things being jettisoned from the collection.

JEH: Yes, and that is being done on a small scale, but what's maddening is how few I can get rid of. Every time I go through this culling exercise, even asking the advice of dealers who certainly should be motivated for me to be disposing of things that they can sell themselves, they come up with a very short list, and they are lower-value drawings that don't generate large amounts of money. So I'm having a hard time culling very much, and my natural resistance to deaccessioning is very strong, so I put that all together and I get nervous about blowing things out of the collection too readily; I'd rather be a little too cautious. As I own already over six hundred drawings, there will certainly be deaccessions through sales or gift, and there are a lot of drawings being set aside for donations to the Fogg. In fact, as you both know, there have been times when there have been a pair of drawings, and I only own one of them. I don't really want two, but I buy the two because they go together. One sometimes gets

a little bit better price, but more significantly, the idea is that we could have both in the Boston area for someone who would want to see them. The comparative aspect of having them nearby makes a lot of sense.

WWR: I think I'll have to agree with that. Is there anything you want to add to the collection?

JEH: I always wonder who I would add to the collection, if I could find the right one. For the early draftsmen, certainly Primaticcio, Nicolo dell'Abate, Ambroise Dubois are on the list. I remember vividly the charming Dubois in the personal collection of the dealer Jacques Petithory that I often attempted to acquire.[15] Callot would be another. I have a nice Callot, but I don't have nearly the amount or quality that I want. The only time I have been preempted by a museum was during my attempt to buy a Callot landscape.[16] More Claude perhaps, but that's difficult—mostly because of condition. As I mentioned before, I would like to have a *trois-crayons* Watteau, and I would also like to have a late Fragonard red chalk landscape, and a major Boucher female nude—but not the powdered sugar variety. I would also like to have another La Fosse, like the one that I stepped aside to let the Fogg acquire in honor of Agnes Mongan's ninetieth birthday.[17] I get the next one! I am sure there are more things if I thought about it longer, but that is probably a pretty good approximation of the major "missing in action" list.

ALC: I noted that Gericault wasn't on your list; why?

JEH: I like his drawings, I already have one good sheet (*Resurrection of Lazarus,* fig. 14),[18] and he's still on my mental list in the hope that I find a truly superb one, but he's not a favorite, and my list was composed of things that I really want most.

WWR: Let's talk a little bit about the exhibition at hand. You have been extremely supportive in many ways—financially, as well as with your advice—although we have to say that you have kept a certain distance. Larry determined the selection, the format of the book, and which scholars would contribute to the catalogue. This was later supplemented with suggestions from myself and the other coeditors. But I would like to hear what goal you see this exhibition fulfilling—how would you see its role or influence? How does that then fit into your collecting purpose, in your long-term vision for the collection itself?

JEH: What I said when asked to impart a few unrehearsed words when my Italian drawing exhibition opened here at the Fogg, I still believe: I didn't draw the drawings, study them, or discover them, I just bought them, so my role in this is more like a steward than anything else. Except for a very few great masters, earlier French art, which I love dearly, is not much appreciated or thought of—not even in France. So the real purpose of the exhibition is simply another effort to make French old master drawings better known. How would we do this? One of the few areas where I inserted myself was the question of venues. The only criterion I had for a venue was that it have large amounts of traffic, that the drawings be at least potentially viewable by large numbers of people other than just specialists. This was clearly not a blockbuster show. For the larger public, however, I hoped it would be attractive enough to merit attention. Again, the reason for staying out of the whole production is that I'm not an art historian or a museum person. These are serious professional activities. For example, I gather there were significant debates concerning the last ten percent of what should be included in the exhibition between Larry, you, Meg Grasselli, and Jean-François Méjanès. A fifth person was not necessary to do this. In the end, the result is an

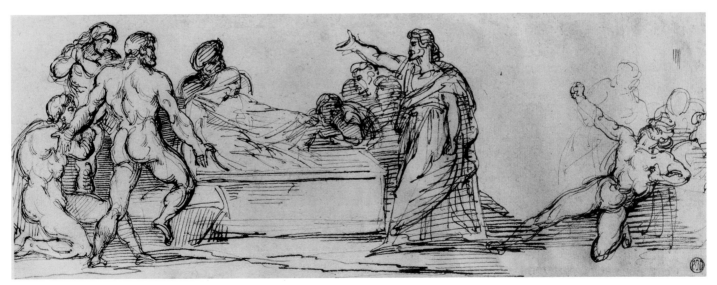

Figure 14

Figure 15

exhibition, not of "greatest hits"—it's not that sort of thing—but a broad selection of some of the finest sheets in my collection where most of the major personalities, types of drawings, and moments in the history of two centuries of French draftsmanship are illustrated. Is it exactly what I would have picked? I doubt it; I can think of one drawing in particular that I might not have added.

WWR: Can you name it?

JEH: Yes, it's the Le Moyne landscape. Not that there aren't others, like the male nude by Jean Boucher. I understand why they are in the show, and they were perfectly good and attractive drawings for me to buy, but if I were making my own selection of what gives me the greatest pleasure, those two wouldn't be included. But the exhibition is for a public purpose, and it gives a good survey of many aspects of French art using about 115 drawings. All the selections, I think, were very well considered to serve that purpose. The catalogue reflects a similar idea. I thought—and this is the only other area where I inserted myself—that it might be best to use specialists on individual masters when possible. When there was a specialist willing and able to write an entry, that is who we used. It was more expensive and time-consuming, but I think it was worth it. We got the best possible scholarship at the moment. This is again part of the public access idea. Then Larry wanted to add something that

Figure 17

is irrelevant to the exhibition, which is the appendix. Why? The museum-going public is not interested in that; it is for scholars. If I could have done it on the Internet, or with a CD-ROM, that would have been better. But for now, Larry had very complete files, as you would expect here, and we hoped that the total catalogue package would allow scholars and interested students to use the collection as a resource.

ALC: You also collect French paintings. Before concluding, why don't you discuss how they fit in—you mentioned some of that before, but maybe you could elaborate. For example, what are the parameters?

JEH: The French paintings are part of a collection in formation, they're still a working project where I have less clear criteria. They date from the late seventeenth through the eighteenth century, and although I have a major Boucher pastoral (fig. 15),[19] the majority of the canvases tend to be very good works by less significant artists [Sébastien Bourdon, *Soldiers at Rest* (fig. 16);[20] Charles de La Fosse, *Adoration of the Shepherds* (fig. 17);[21] Jean-Baptiste Oudry, *Portrait of a Noblewoman* (fig. 18);[22] and François-André Vincent, *St. Jerome* (fig. 19)[23]]. The cost of acquiring a major Fragonard, a major Watteau—actually a Watteau in good condition of any sort—makes it an impossibility for me. But there are all these other artists who are just terrific and who were very important in their lifetimes. They are not exactly forgotten, but they are also not much in vogue. At relatively attractive prices, one can still buy very good examples in extremely good condition. I like to know that the paint that I am seeing was put on by the artist.

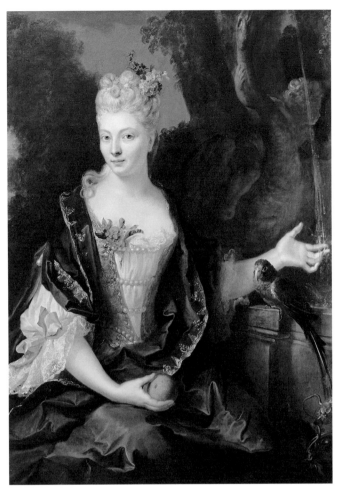

Figure 18

ALC: Why have you mentioned in the past that you would rule out most oil sketches for your paintings collection?

JEH: Actually, there are a couple of unrelated reasons for that. One is that the purpose of the paintings is somewhat different. You don't need to have immediacy in the paintings, because that has already been accomplished in large-scale drawings. The paintings are intended to be what paintings are supposed to be, which is finished. The other reason is that early on, I heard from many dealers that oil sketches were very hard to sell. This may have been a mistake—I realized that if I collected them, it would be nearly impossible to change my mind (this was an important factor early on, because it was originally uncertain what I would do with the paintings collection). I found it was a safer bet to stay with paintings, and I think that proved to be correct overall, although I actually love oil sketches.

ALC: Part of the exhibition was funded by your foundation. What plans do you have for the future connected with French art and the foundation?

JEH: One of the major things I would like to see is subsequent exhibitions that are more specialized, for example,

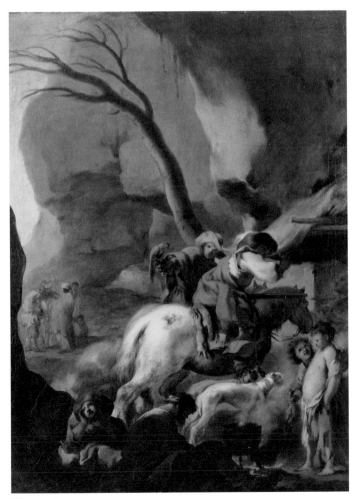

Figure 16

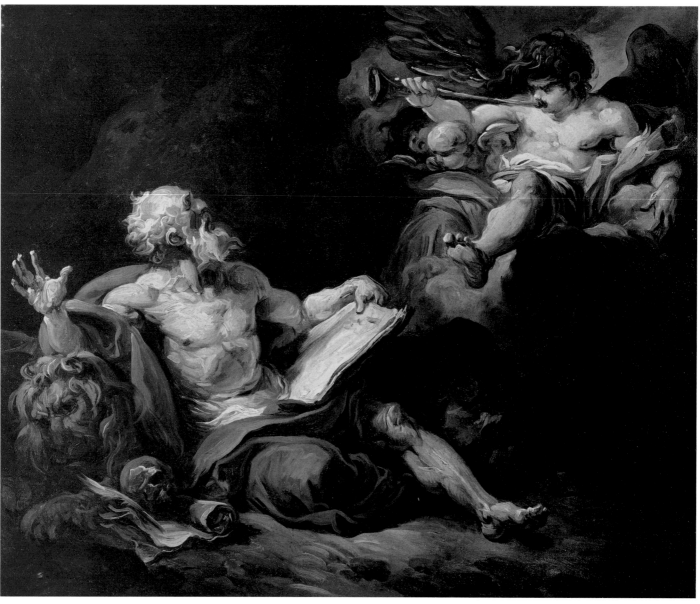

Figure 19

select monographic surveys featuring the greatest extant drawings by key artists, and thematic shows such as French landscape drawings. You and I have already talked about these as exhibitions drawn primarily from North American collections. I think that if we do that, and do it with good scholarship, they will be valuable scholarly and public shows. But given that the current exhibition doesn't open until December 1998 and travels for quite a while, it is going to take some time to get all that organized. As I have come to understand the amount of lead time, paperwork, and preparation necessary for exhibitions, I see that this will not be immediate, but it will be part of an ongoing endeavor.

Jakob Rosenberg Seminar Room, Agnes Mongan Center for the Study of Prints, Drawings, and Photographs, Fogg Art Museum, Harvard University Art Museums Cambridge, Massachusetts

27 October 1997

Notes

1. Pierre-Paul Prud'hon, *Seated Female Nude,* black chalk heightened with white chalk, on faded blue antique laid paper, 424 × 283 mm., Loan from the Collection of Jeffrey E. Horvitz, Department of Drawings, Fogg Art Museum, Harvard University Art Museums, Cambridge, inv. no. D-F-253/ 1.1993.117.

2. Mario Amaya, "Drawings of the Female Nude," *Architectural Digest,* June 1978. The Prud'hon is reproduced on p. 81.

3. François-Léon Benouville, *Head of Achilles,* black chalk with green wash on blue wove paper, 382 × 269 mm., inv. no. D-F-425/ TL35634 (fig. 1); Victor-François-Eloi Biennourry, *Roman Soldier,* black chalk heightened with white chalk on blue wove paper, squared for transfer in red chalk, 420 × 215 mm., inv. no. D-F-463/ TL35787.3 (fig. 2); William-Adolphe Bouguereau, *Allegory of Winter,* graphite on blue-brown wove paper, 240 × 406 mm. D-F-417/ TL35470.1 (fig. 3); Jean-Léon Gérôme, *Woman Bathing Attended by a Servant,* black chalk heightened with white chalk on off-white laid paper, 650 × 460 mm., inv. no., D-F-416/ TL35470.7 (fig. 4); and Jean-Auguste-Dominique Ingres, *Jupiter and Thetis,* pen and black ink and graphite, heightened with brush, watercolor, and white gouache, on tan wove paper, 310 × 240 mm., inv. no. D-F-428/ 1.1996.86 (fig. 5); all are

Loans from the Collection of Jeffrey E. Horvitz, Department of Drawings, Fogg Art Museum, Harvard University Art Museums, Cambridge.

4. See Paris et al. 1995.

5. Alvin L. Clark, Jr., or ALC as noted in this interview as a speaker, is commonly referred to as Larry.

6. Agostino Carracci, *St. Jerome,* pen and brown ink on cream antique laid paper, Loan from the Collection of Jeffrey E. Horvitz, Department of Drawings, Fogg Art Museum, Harvard University Art Museums, Cambridge, inv. no. D-I-14/ 1.1993.180.

7. Taddeo Zuccaro, *Swooning Virgin Supported by a Holy Woman with Subsidiary Studies of the Virgin's Head and Hands,* black chalk on cream antique laid paper, 170 × 250 mm., Loan from the Collection of Jeffrey E. Horvitz, Department of Drawings, Fogg Art Museum, Harvard University Art Museums, Cambridge, inv. no. D-I-79/ TL35339.11.

8. Andrea Appiani, *Assembly of the Gods,* black chalk on off-white wove paper, 300 mm. diameter (sight); Loan from the Collection of Jeffrey E. Horvitz, Department of Drawings, Fogg Art Museum, Harvard University Art Museums, Cambridge, inv. no. D-I-1/ 1.1995.41.

9. Gian Domenico Tiepolo, *Miracle in a Grotto,* pen and brown ink with brush and brown wash on off-white laid paper, 465 × 360 mm., Loan from the Collection of Jeffrey E. Horvitz, Department of Drawings, Fogg Art Museum, Harvard University Art Museums, Cambridge, inv. no. D-I-98/ TL36292.12.

10. Giovanni Battista Tiepolo, *Head of a Man,* red chalk and red chalk wash on off-white antique laid paper, 271 × 185 mm., Loan from the Collection of Jeffrey E. Horvitz, Department of Drawings, Fogg Art Museum, Harvard University Art Museums, Cambridge, inv. no. D-I-81/ TL36292.12.

11. See New York 1973.

12. Ursule Boze, *Portrait of the Artist's Father, Joseph Boze (1744–1826),* black chalk and charcoal with brush and gray wash, heightened with white gouache, on tan wove paper, 460 × 367 mm., Loan from the Collection of Jeffrey E. Horvitz, Department of Drawings, Fogg Art Museum, Harvard University Art Museums, Cambridge, inv. no. D-F-38/ 1.1995.61.

13. Louis Félix de La Rue, *March of Silenus,* pen and brown ink with black and red chalk on cream antique laid paper, 410 × 604 mm., Loan from the Collection of Jeffrey E. Horvitz, Department of Drawings, Fogg Art Museum, Harvard University Art Museums, Cambridge, inv. no. D-F-157/ 1.1993.78.

14. Pietro Longhi, *Kneeling Prelate,* black and white chalk on tan antique laid paper, 370 × 280 mm., Loan from the Collection of Jeffrey E. Horvitz, Department of Drawings, Fogg Art Museum, Harvard University Art Museums, Cambridge, inv. no. D-I-36/ 1.1994.46.

15. On Jacques Petithory as a collector, see Paris 1997c. The drawing by Dubois is cat. no. 154, pp. 149-150.

16. Sale, Christie's, Monaco, 20 June 1994, *Dessins de Maîtres Anciens et du XIXème siècle: Dessins de la Collection de M. Alfred Normand,* lot 42, Jacques Callot, *Vue de village avec une ferme et une église, un paysan portant sa hotte.* This sheet is now in the Musée des Beaux-Arts, Nancy.

17. See Clark 1996.

18. Théodore Gericault, *Resurrection of Lazarus,* pen and brown ink on buff laid paper, 118 × 327 mm., Loan from the Collection of Jeffrey E. Horvitz, Department of Drawings, Fogg Art Museum, Harvard University Art Museums, Cambridge, inv. no. D-F-114/ 1.1995.23.

19. François Boucher, *Farmers at Rest,* oil on canvas, 87 × 136 cm., Collection of Jeffrey E. Horvitz, inv. no. P-F-4.

20. Sébastien Bourdon, *Soldiers at Rest,* oil on canvas, 40 × 29.5 cm., Loan from the Collection of Jeffrey E. Horvitz, Fogg Art Museum, Harvard University Art Museums, inv. no. P-F-5/ TL35203.1.

21. Charles de La Fosse, *Adoration of the Shepherds,* oil on canvas, 110 cm. (diameter), Loan from the Collection of Jeffrey E. Horvitz, Fogg Art Museum, Harvard University Art Museums, Cambridge, inv. no. F-P-20/ TL35488.6.

22. Jean-Baptiste Oudry, *Portrait of a Noblewoman,* oil on canvas, 100 × 90 cm., Collection of Jeffrey E. Horvitz, inv. no. P-F-12.

23. François-André Vincent, *St. Jerome,* oil on canvas, 52.3 × 41 cm., Loan from the Collection of Jeffrey E. Horvitz, Fogg Art Museum, Harvard University Art Museums, inv. no. P-F-19/ TL35552.8.

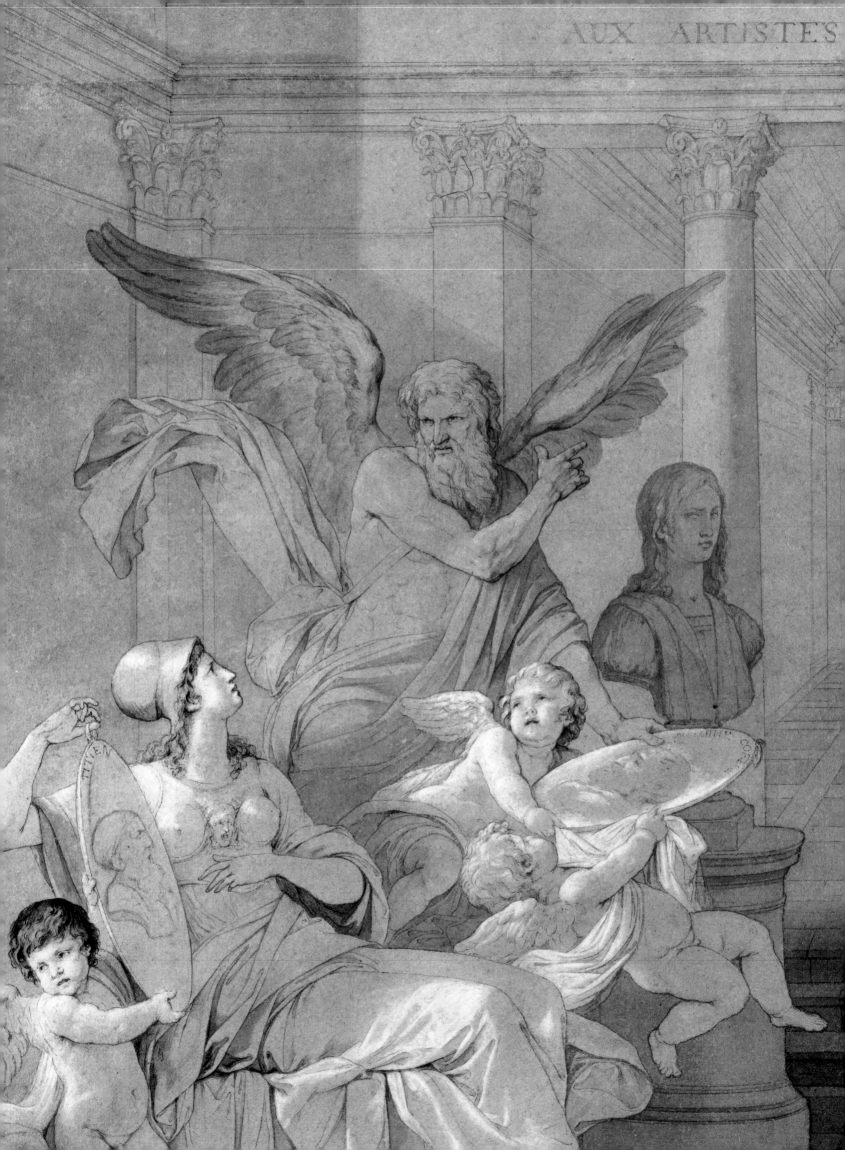

AUX ARTISTES

Catalogue of the Exhibition

NOTES TO THE READER

CATALOGUE NUMBERS—Arabic numerals preceded by *cat.* refer to the 117 drawings catalogued in the 115 entries of this publication. Arabic numerals preceded by an *A.* or *cat. A.* refer to drawings in the Horvitz Collection that are catalogued in the Appendix.

INVENTORY NUMBERS—Each object in the Horvitz Collection is listed with two numbers that appear in the tabular information of each catalogue entry, in the Appendix, and in the notes. The first is the permanent Horvitz inventory number (D-F-# or D-I-#: D = *drawing*; P = *painting*; F = *French*; I = *Italian*). This is usually followed by a solidus (/) and the Harvard University Art Museums TL (temporary loan) or LTL (long-term loan) number, which is used for museum identification, data processing, and photographic negatives.

MEASUREMENTS—Measurements are cited in millimeters (mm.) for drawings and prints and in centimeters (cm.) for paintings. In all cases, height precedes width.

PROVENANCE/COLLECTORS' MARKS—The following abbreviations refer to the standard reference works by Frits Lugt for the marks of collectors and mount makers. These abbreviations appear throughout the provenance sections of the entries, in the Appendix, and in the Index of Former Owners. Complete citations can be found in the Bibliography.

L. Lugt
L.s. Lugt, supplement

SHORT TITLES—The following abbreviated titles to other sections of this publication are used throughout the catalogue [e.g., (MRC ess., fig.#)]:

MRC ess. Essay by Alain Mérot and Sophie Raux-Carpentier
MRM ess. Essay by Marianne Roland Michel
Interview Interview with Jeffrey E. Horvitz by William W. Robinson
 and Alvin L. Clark, Jr.

WATERMARKS—The following abbreviations refer to the standard reference works on watermarks. Complete citations can be found in the Bibliography.

Briquet
Churchill
Gaudriault
Heawood

JACQUES-CHARLES BELLANGE

Active in Lorraine 1595–1616

1 *St. Sebastian Tied to a Tree* (recto)
Studies for St. Sebastian (verso)

Pen and brown ink with brush and brown wash over traces of black chalk (recto); pen and brown ink (verso), on off-white antique laid paper; partially incised for transfer

333 × 215 mm. (four corners cut at angles)

Watermark: Variant of Gaudriault 413 (also see Briquet 5096–98)

Inscriptions: None

Provenance: Private Collection; sale, Christie's, London, 2 July 1996, lot 197; acquired at the sale (D-F-401/ 1.1996.71)

Exhibitions: None

Literature: Unpublished

A gifted and highly individual artist, Jacques Bellange served as court painter to the dukes of Lorraine from 1602 to 1616. His painted oeuvre has almost entirely disappeared; however, his drawings and etchings, imbued with the verve and originality of late Mannerism, have remained popular through the intervening centuries.[1] It is a pleasure to present a newly discovered sheet by the artist. On the verso are several sketches relating to the recto, where Bellange has depicted the Christian martyr St. Sebastian being tied to a tree by three men in preparation for his execution.[2]

According to several early sources, Sebastian was an officer in the army of the Roman emperor Diocletian (ruled A.D. 284–305), whom he openly defied with his belief in Christianity.[3] He was bound to a stake and sentenced to die at the hands of a company of imperial archers. A poignant version of the story states that these archers had been under Sebastian's command. He was taken for burial by a devout woman, Irene, who, on finding that he was still alive, removed the arrows and dressed his wounds. Sebastian confronted the emperor once more, and was immediately beaten to death. His body was recovered by fellow Christians and buried in the catacombs. The Basilica of St. Sebastian was erected at this spot on the Appian Way and became a popular site for medieval pilgrims to Rome. The saint's relics were brought to Soissons, France, in 826, which became the new center of his cult. Because he survived the first attempt to kill him, or perhaps as a result of the similarities between arrow wounds and plague sores, Sebastian is often invoked for protection against the plague.

That Jacques Bellange would design a composition depicting St. Sebastian is not surprising. Lorraine's population suffered from outbreaks of the plague throughout the seventeenth century, and its artists, including Jacques Callot and Georges de La Tour,

depicted the saint in a number of memorable images. Sebastian was named a patron saint of the newly constructed section of the growing capital city of Nancy in 1593 during a period of plague that ravaged the region, and in 1602 some of his relics were relocated there from Soissons. At first they were housed in a hospital chapel, but in 1607 the city purchased an existing church to serve the new parish.[4] Its main altarpiece, depicting St. Sebastian as well as the traditional patron saint of the plague-stricken, St. Roch, was painted by Rémond Constant (c. 1575–1637) in 1610, and is now in the Musée historique lorrain, Nancy (fig. 1).[5]

The Horvitz Bellange probably indicates a topical interest in the subject of St. Sebastian rather than a rival design for a painting. Interestingly, it demonstrates a knowledge of the same print that provided a model for Constant's altarpiece: the *Martyrdom of St. Sebastian,* engraved by Jan Muller (1571–1628) after the Mannerist painter Hans von Aachen (c. 1552–1615); von Aachen was active at the imperial court of Rudolph II in Prague (fig. 2).[6] Bellange freely interprets the saint's pose, altering the position of the arms, shoulders, and neck while closely imitating the torso, stretched up to the right, and the upturned head with its firmly shaded chin. The weight-bearing leg is similarly shaped, though Bellange chooses to depict the saint's right leg as weight-bearing on the

1

2

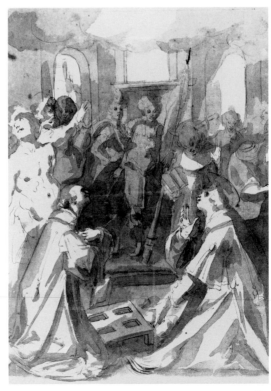

3

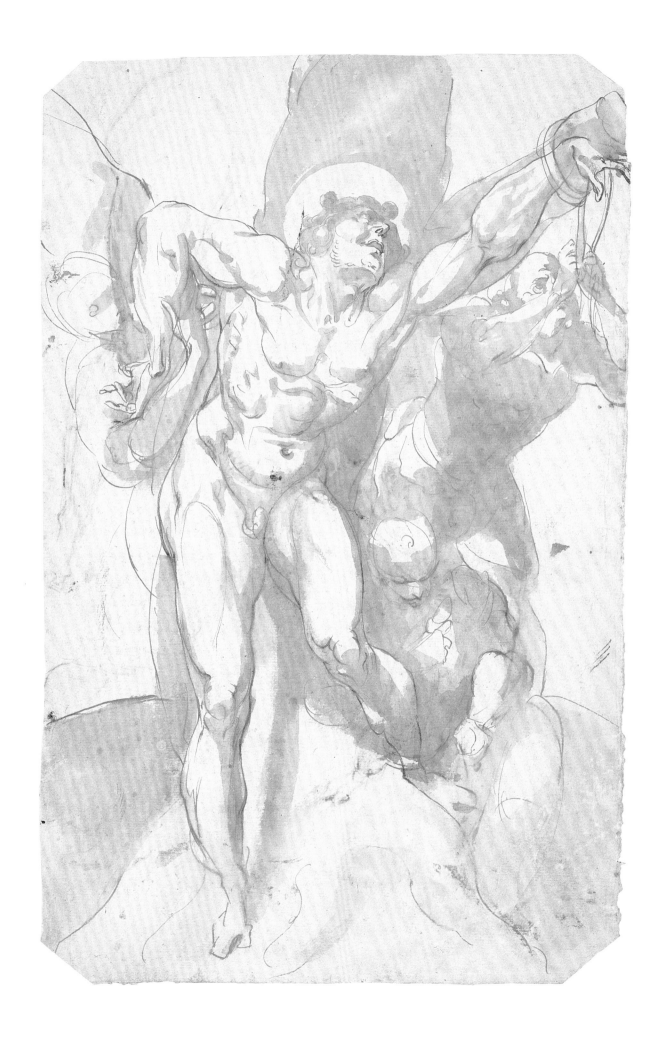

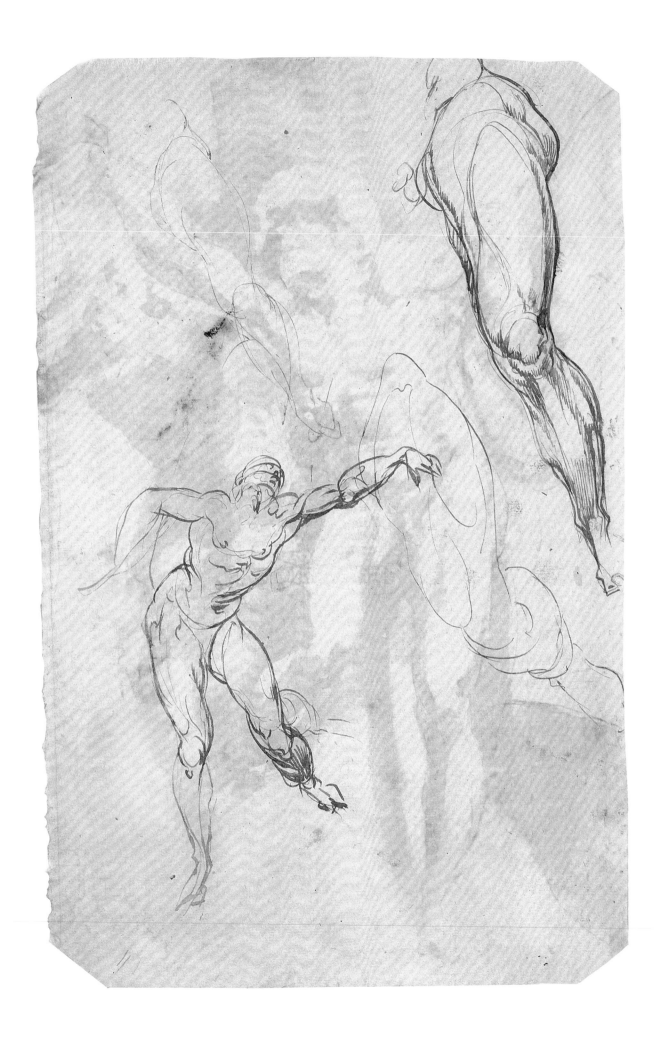

4

5

recto. On the verso of the Horvitz sheet, the fully modeled leg at the upper right replicates the left leg in Muller's print so closely that Bellange was probably looking directly at the print. The contours and shading are very similar in print and drawing, although the free, rhythmic strokes of Bellange's pen were already at work transforming Muller's tightly engraved image.

The taut pectoral muscles of Bellange's St. Sebastian, with their horizontal definition, are more pronounced than in any other of the artist's nude or quasi-nude figures, which include the flaccid torsos of the dead Christ in the etched *Pietà,* of St. Sebastian in the *Martyred Saints Attest to Their Faith* in the Städelsches Kunstinstitut, Frankfurt (fig. 3),[7] and of the central figure in the *Raising of Lazarus* in the Metropolitan Museum of Art, New York.[8] What creates the emotive power in Bellange's St. Sebastian is a combination of the pose, the agony of the facial expression, and, above all, the evocative use of washes. Bellange paints with the wash, creating an active play of light and shade independent of his contour lines to form such aspects of the composition as the saint's halo with the reserved white of the paper against the shaded tree trunk. Other contemporary and similarly

executed wash drawings include the version of his *Martyred Saints Attest to Their Faith* in the Musée du Louvre, Paris,[9] and the version in the Städelsches Kunstinstitut, Frankfurt, just mentioned above (fig. 3); the *Entombment of Christ* in the Musée des Beaux-Arts, Dijon (fig. 4);[10] and the *Cavalier Holding a Lance* in the Musée des Beaux-Arts, Rouen (fig. 5).[11]

The secular equivalent to the exhibited sheet is the Rouen drawing, full of masculine energy, where the cavalier throws his arms wide in a "look-at-me" gesture.[12] Both drawings share sensitively handled lines and expressive washes. Bellange, magician and master of deception, throws up a cloud of wash to disguise his shortcomings in anatomical knowledge. Many years will pass before lessons in drawing the nude human figure are taught in pious Lorraine; even the Académie in Paris was not founded until 1648.[13] As a Mannerist artist, Bellange created wonderfully exuberant images that were filtered through ideals of beauty with little basis in direct observation. In the Horvitz *St. Sebastian Tied to a Tree,* as in many of Bellange's other masterful drawings, the effect is tantalizing and mysterious—like a woman's face hidden by a veil or a body glimpsed behind drapery. SWR

GEORGES LALLEMANT

Nancy (Lorraine) c. 1570–1636 Paris

2 *Standing Man in an Elaborate Costume*

Pen and brown ink with brush and brown wash on off-white antique laid paper (cut to the contour of the subject and laid down onto a sheet of cream antique laid paper)

343 × 157 mm. (sheet)/ 310 × 125 mm. (figure)

Watermark: Laid down—none visible through mount

Inscriptions: In graphite on verso of larger sheet, bottom left: *P. Lugt 205*; in graphite on verso of larger sheet, bottom right: *G 6288/ 79*

Provenance: Jacques Petithory, Paris (his mark—not in Lugt—on recto, lower right); sale, Sotheby's, London, 3 July 1995, lot 115; acquired at the sale (D-F-153/ 1.1995.102)

Exhibitions: Norwich 1987 (as Jacques Bellange)

Literature: Unpublished

Georges Lallemant received his initial training in Nancy, but by 1601 he was already established in Paris. Apart from Rubens's brief visits there between 1622 and 1625, Lallemant's studio was the most prominent artistic presence in the French capital in the second and third decades of the seventeenth century. This would change with the return of Vouet from Rome in 1627. The Lallemant drawing corpus is still disputed, and several hands may be assigned to drawings traditionally attributed to the artist: this is not surprising, given his large and successful Parisian workshop and the few sheets we can securely identify as his. Nonetheless, the increased scholarly attention given to Lallemant over the last decade has helped to clarify his stylistic character.[1]

This handsome, highly finished figure study reflects the enduring influence of Lallemant's origins in Nancy, where Bellange and his studio produced costumes and theater designs for the ducal court. Like the famous *River God* by Lallemant in Stockholm—an ornately costumed and bearded figure in black chalk and gray wash (fig. 1)—the exhibited study has been cut to the contours of the figure.[2] The control and discipline brought to the handling of the pen and brush distinguish this sheet from other studies in pen and ink of costumed figures that were formerly accepted as autograph but are now doubted. It shows none of the self-conscious, mannered profusion of hatching strokes with calligraphic flourishes, nor the

excessively extended proportions and odd anatomies found in these putative sheets.[3] A key to understanding Lallemant is his tendency toward soft, Flemish-inspired modeling over the foundations of a more linear and Mannerist style influenced by the Fontainebleau and Lorraine schools. These qualities are evident in his *Warrior* and his *Holy Family* (both in the Musée du Louvre, Paris), his *Deposition* (Château-Musée, Nemours), his *River God* (Nationalmuseum, Stockholm), and his *Man in a Plumed Hat* (Musée des Beaux-Arts, Rouen).[4] Although it shows substantial reliance on hatching to define drapery and convey shadow, the exhibited drawing is noteworthy for its softly rounded modeling. The use of wash for shading and modeling is comparable to the Stockholm drawing.

The Horvitz figure and his costume and boots are generically similar to those found in several of Lallemant's paintings, including those worn by the magi in the *Adoration of the Magi* in the Palais des Beaux-Arts at Lille (fig. 2), and by several figures in his *Charity of St. Martin* at the Musée Carnavalet in Paris. His *Finding of Jesus in the Temple* in the Musée des Beaux-Arts, Senlis, and his *Abraham and Melchisedech* in Notre-Dame-des-Blancs-Manteaux, Paris, also display a similar handling of figure and dress.[5] Lallemant evidently executed several versions of the theme of the Adoration of the Magi. In addition to the one in Lille, these include compositions in St. Petersburg and a closely related work now lost, but known through an etching by Jean Ganière.[6] Perhaps the Horvitz drawing was for one version of this subject. Alternatively, this sheet could have been a costume design for a court theatrical production or pageant. The finish of this drawing would suggest the latter function. HG

2

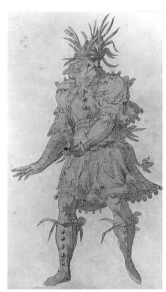

1

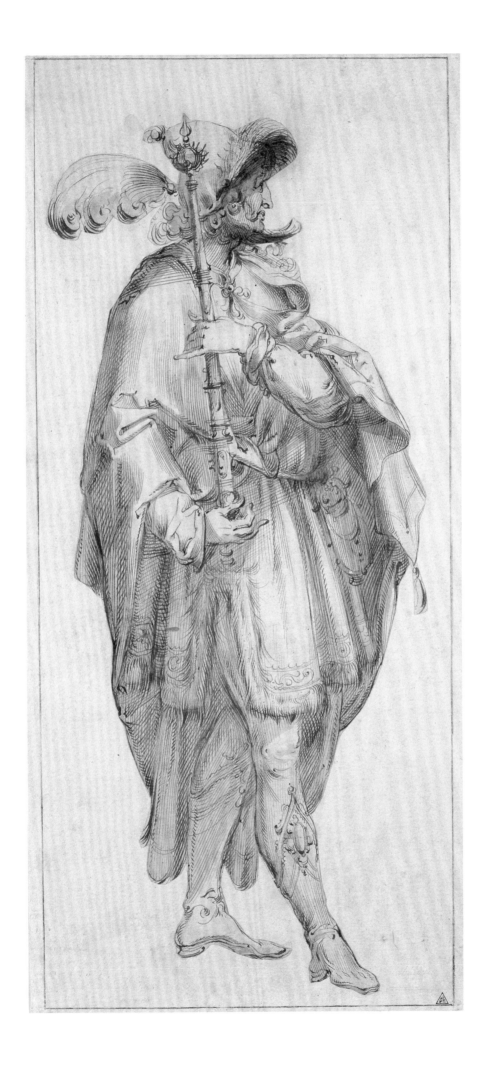

DANIEL DUMONSTIER

Paris 1574–1646 Paris

3 Jean-Jacques de La Grange, Marquis d'Arquien

Colored chalks on tan antique laid paper

485 × 303 mm.

Watermark: Laid down—none visible through mount

Inscriptions: In pen and brown ink heightened with ochre gouache across top: *LEMARQUIS D'ARQUIEN GOUVERNR. DE CALAIS / 1623*

Provenance: Private Collection, Belgium; Renaud Jouslin de Noray, Paris; acquired in 1995 (D-F-89/ 1.1995.80)

Exhibitions: None

Literature: Unpublished

*P*ortrait drawings in chalk began in France with the work of Jean Clouet sometime in the second decade of the sixteenth century, and continued through the beginning of the next century with his son François and painters and draftsmen such as the Quesnel and the Dumonstier families. Although his work enjoyed tremendous success, Daniel Dumonstier was the last exponent of this tradition. Due to the growing popularity of portrait engravings, portraits in chalk were beginning to be considered *retardataire* in the 1620s. Dumonstier's primary contribution to the legacy of chalk portrait drawing was his concern for realism and fidelity to the likeness of his sitters, often at the expense of the subtlety that distinguishes the work of some of his predecessors. His production consisted of bust-length portraits such as the one exhibited here, with the sitters posed nearly frontally, their direct outward gazes and frank expressions providing for strong characterization of their personalities. Although his earliest known drawings, which date from the first decade of the seventeenth century, reveal great sensitivity, his increasing preference for realism led some modern critics, such as the art historian Louis Dimier, to refer to his late production as the "perfect vulgarity of style."[1]

The majority of Dumonstier's patrons were nobles of the French court, and many of their portraits survive today in the Bibliothèque nationale de France, Paris, and the Musée du Louvre, Paris.[2] Like the exhibited drawing, most of these have inscriptions in large capital letters across the top of the sheet that indicate the name and rank of the sitter. Jules Guiffrey and Pierre Marcel considered these to be later additions intended to replace earlier, abraded identifications that may have been in Dumonstier's hand.[3]

The La Grange family is recorded as minor nobility in Berry as early as the mid-fifteenth century. Continuing the efforts to consolidate royal authority that began under the Valois, the family was typical of the minor nobility and upper bourgeois clans that the

early Bourbons elevated to prominence in order to provide allies who would create a political balance between themselves and the enormously powerful princes and dukes.[4] The illustrious La Grange eventually provided France with military officers, a cardinal, and (notable for its diplomatic significance) a queen of Poland. One family member, François de La Grange d'Arquien, maréchal de Montigny (1554–1617)—a distinguished general, premier maître d'Hôtel de sa Majesté, chevalier de l'ordre de Saint-Esprit, gouverneur de Berry, de Paris, et de Metz, and uncle of the younger man in the Horvitz sheet—also had his portrait drawn by Dumonstier (fig. 1).[5] The young man depicted in the exhibited sheet, François's nephew, chevalier Jean-Jacques de La Grange, vicomte de Soulangis et seigneur d'Arquien et de Bréviandes, also had a distinguished career. He was a gentilhomme ordinaire de la chambre du roi, and in 1610, as the title in the inscription above his portrait indicates, he became governor of Calais.[6] However, the date *1623* written in the later inscription may be incorrect. Both the subtle, early style of the drawing, and the costume from the first decade of the century (note the decoratively slashed doublet with reinforced armholes, and the broad stiff collar typical of court dress late in the reign of Henri IV) suggest that a date of c. 1610 is more appropriate for the Horvitz portrait, which may have been commissioned in celebration of the receipt of the marquis's new post.[7] EB

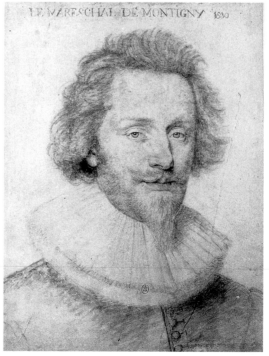

1

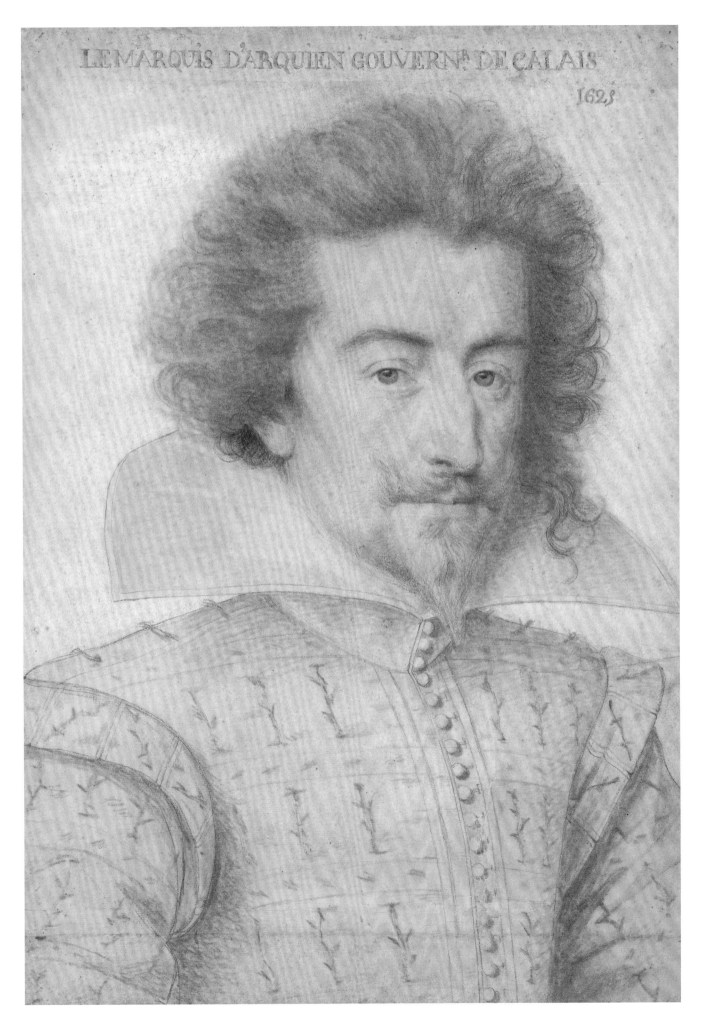

LE MARQUIS D'ARQUIEN GOUVERNᴿ DE CALAIS

1625

JEAN BOUCHER DE BOURGES

Bourges c. 1575–c. 1633 Bourges

4 *Kneeling Male Nude with Arms Crossed*

Black chalk heightened with white chalk on tan prepared antique laid paper

305 × 203 mm.

Watermark: None

Inscriptions: Signed in black chalk, left center: *boucher*; in pen and brown ink on recto of mount, upper right: *73*; in graphite on recto of mount, upper right: *54*; in graphite on recto of mount, under drawing: *77 / cat. Museé B.A. Rouen 1984*; in graphite on verso, top left: *23* (encircled), in graphite on verso, top right: *165*; in graphite on verso of mount, bottom: *Etude pour le Tableau de l'adoration des Bergers à la chapelle St. Joseph / Nicolas-Carthusien de la Cathédrale à Bourges ou plus tôt pour la décolation de St. Jean Baptiste peint en grisaille* [some words have been crossed out] */ sur le revers du Volet du Tableau de St. Jean autrefois à l'Eglise St. Bouvet et aujourd'hui à la cathédrale. / Le revers (côté de la méthode J. Boucher) est actuellement au musée. ou plutot martyr de Paul à St. Bonnet* (the rest, indecipherable)

Provenance: Private Collection, France; sale, Drouot, Paris, 4 February 1987, lot 19; W. M. Brady and Co., Inc., New York; Private Collection, Connecticut; acquired in 1997 via W. M. Brady and Co., Inc., New York (D-F-500/ 1.1997.59)

Exhibitions: Cleveland et al. 1989, no. 51

Literature: Hilliard Goldfarb in Cleveland et al. 1989, pp. 107–8

*P*erhaps because of the devastation caused by the Wars of Religion in France (c. 1562–1629), Jean Boucher, often called Boucher de Bourges, is virtually the only French painter working at the very beginning of the seventeenth century—fully formed in the sixteenth century, but active well into the seventeenth—by whom we possess a relatively abundant, documented, and representative oeuvre of paintings, drawings, and prints.[1] Executed in black and white chalks on tan prepared paper, signed, and laid down onto another sheet numbered at the top right, the Horvitz *Kneeling Male Nude with Arms Crossed* displays all of the characteristics of the artist's studies of nude models seen in the core group of his drawings assembled by the noted scholar and avid collector, Charles-Philippe, marquis de Chennevières-Pointel (who also wrote the fundamental early publication on the artist). These are now in the Musée du Berry in Bourges.[2] Indeed, two similar nude studies in that collection, *Recumbent Male Nude with Elevated Left*

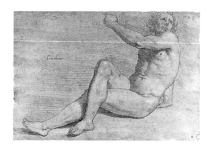

Arm (fig. 1) and *Frontal Standing Seminude Male Holding a Scythe*, may depict the same model (fig. 2).[3] The importance of this type of drawing by Boucher cannot be overstated, for as Jacques Thuillier has discussed, they are probably the earliest studies of the live model produced by a French artist.[4] As Hilliard Goldfarb has suggested, the pose of the nude in the Horvitz drawing could be appropriate for figures in a number of subjects.[5] However, it is probably most directly related, though in reverse, to the figure of the Baptist in the *Beheading of St. John the Baptist* painted on the exterior of the right panel of Boucher's signed and dated *Triptych of St. John the Baptist* of 1630, originally placed in the artist's chapel in the Eglise St. Bonnet and now in the Musée du Berry, Bourges (fig. 3).[6]

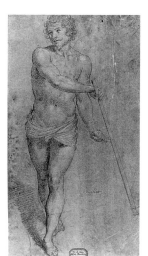

The core group of Boucher's extant drawings in Bourges, as well as others in Rouen, Paris, Grenoble, and New York, display a variety of types, including studies of the antique, anatomy, the nude, draped figures, and compositions.[7] The range of specific types of sheets, both for practice and for building the various stages of a design, is remarkable, given that Boucher's Italianate utilization of the medium precedes Vouet's return to Paris in 1627, traditionally considered to be the moment when this phenomenon took root in France.

Conversely, the advanced nature of Boucher's oeuvre should not be too surprising; we know that the artist visited Paris, Fontainebleau, Italy (at least three times), and perhaps the Low Countries.[8] Rejecting the current French modes of late Mannerism in Paris, Lorraine, and the Second School of Fontainebleau, his graphic style reflects his knowledge of masters such as Cavaliere d'Arpino and other Italian Counter-Reform artists working in Rome at the beginning of the seventeenth century, when the decorative excesses of late Mannerism were displaced by a new interest in naturalism.[9] Despite his attraction to the antique, his nude studies reveal an approach to form and a use of media that eschew the monumental idealism and flamboyance of his Italian contemporaries, as well as oppose the penetrating realism of many northern masters. Instead, as the Horvitz Boucher demonstrates, his firm contours, his systematic hatching, and his calculated use of white heightening suggest a cerebral, distanced, and measured art of balance, reserve, and reflection that would become an essential component of the evolving tradition of French draftsmanship.

ALC

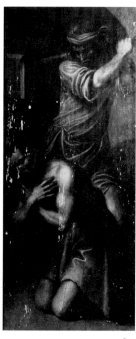

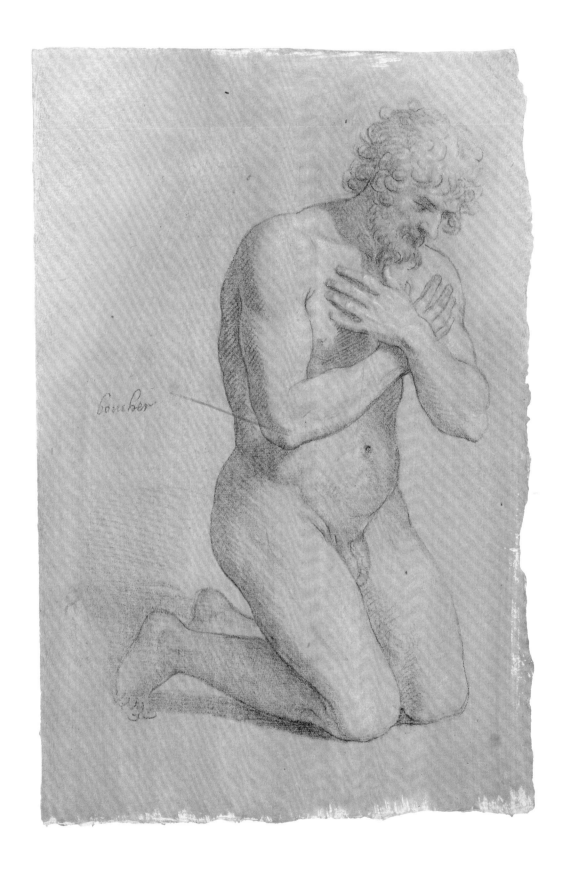

boucher

SIMON VOUET

Paris 1590–1649 Paris

5 *Esther and Ahasuerus*

Black chalk with brush and brown wash, heightened with white gouache on faded blue antique laid paper, squared in black chalk

379 × 268 mm.

Watermark: None

Inscriptions: In pen and dark brown ink on verso, bottom center: *Voitte*; in pen and brown ink on verso, bottom right: *109*

Provenance: Private Collection, France; sale, Christie's, London, 14 April 1992, lot 151; Galerie Moatti, Paris; acquired in 1994 (D-F-299/ 1.1994.29)

Exhibitions: New York 1994b, no. 15

Literature: Emmanuel Moatti in New York 1994b, cat. no. 15 (n.p.)

*T*raditionally, Vouet's great reputation as a draftsman is based on his elegant figure drawings connected with the compositions painted after his return to Paris in 1627. In these impressive sheets, executed with an oily black chalk and heightened with white chalk, both the light and the sense of the forms are rendered with a vigorous naturalism (see cat. 6). This type of study broke completely with the late Mannerist graphic mode then current in Paris and set the tone for the new century. All of Vouet's early biographers underlined the significance of drawing for the artist, and André Félibien specifically insisted on the importance of Vouet's large atelier as a center of teaching, and not only as a means of production.[1] Undoubtedly, the rigor demonstrated by Vouet in his studies after the model was replicated in countless drawings for compositions. However, despite the intense research focused on Simon Vouet in the last decade, composition studies remain a comparatively rare component of his extant oeuvre. Nonetheless, the small number that have been rediscovered in the last few years, like the *Esther and Ahasuerus,* have amplified our understanding of the full range of Vouet's talents as a draftsman. In this sheet, he depicts an episode from the Old Testament Book of Esther, when the young and beautiful Esther, second wife of King Ahasuerus of Persia, reveals her Jewish heritage and successfully intercedes on behalf of her people to prevent their massacre.

The known composition drawings by Vouet punctuate his graphic oeuvre at regular intervals. These include early studies from the end of the 1620s such as the *St. Peter Healing the Sick with His Shadow* in the Princeton Art Museum;[2] the *Last Supper* in the Kupferstichkabinett, Berlin;[3] the *Apotheosis of St. Joseph*(?) in a private Parisian collection (fig. 1);[4] and the *Assumption of the Virgin* in the Musée du Louvre, Paris.[5] These studies continue through the 1630s and the early 1640s with the *Lot and His Daughters,* c. 1633, in the Musée des Beaux-Arts in Reims;[6] the *Greeks at the Table of Circe* in the Fogg Art Museum in Cambridge, c. 1634 (fig. 2);[7] the *St. Peter Delivered from Prison by an Angel* in the Musée des Beaux-Arts in Rennes, from the mid-1630s;[8] the *Assembly of the Gods* in the Musée des Arts Décoratifs in Paris from the end of the 1630s;[9] and the *Virgin and Child with a Basket of Fruit* in the Musée des Beaux-Arts in Besançon, c. 1640.[10] These studies reveal how Vouet evolved the techniques and figural styles with which he generated his compositions. Beginning in Italy, his earlier sheets in Princeton, Berlin, the Louvre, and a private Parisian collection demonstrate his brilliant use of wash in a manner similar to the artists of the Second School of Fontainebleau. However, he gradually abandoned this fluid medium for studies in the early 1630s that focused on contours in black chalk, as in the sheets in Reims and Cambridge.

Elongated figures in complex attitudes, realized with extreme sketchiness and strong contrasts of light and dark between the various planes, suggest that Vouet's *Esther and Ahasuerus* does not date from his maturity. Instead, it must be placed in either his Italian period or in the first years after his return to Paris. Important because it documents an ambitious and previously unrecorded composition, the Horvitz Vouet also justifies the celebrity of the artist as a draftsman.[11] BBL

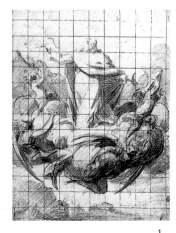

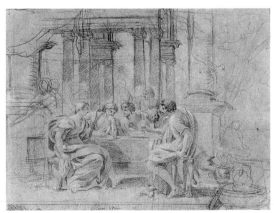

1

2

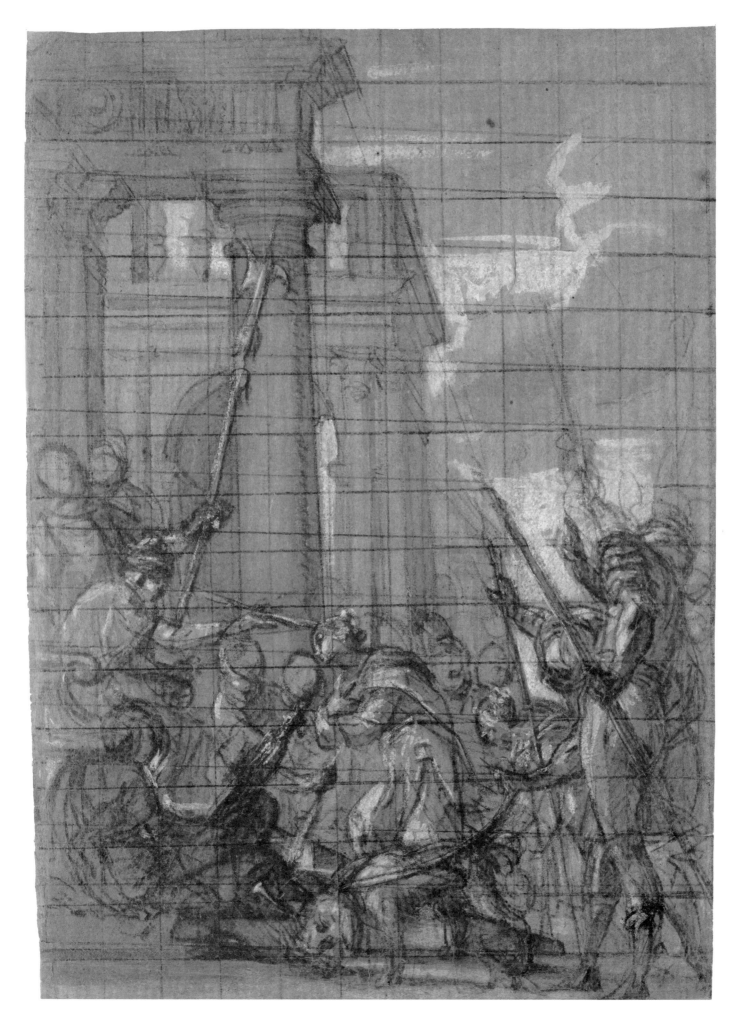

SIMON VOUET

Paris 1590–1649 Paris

6 *Kneeling Woman, with Detail Studies of Drapery and a Foot*

Black chalk heightened with white chalk on light tan antique laid paper

360 × 249 mm.

Watermark: Laid down—none visible through mount

Inscriptions: In pen and dark brown ink, on recto of Mariette mount, in cartouche: *SIMON VOUET*; in graphite on verso of mount, bottom center: *Go86*

Provenance: Pierre-Jean Mariette (L. 1852, at bottom right, and his inscribed attribution); Mariette sale, Paris, 1775, lot 1385; sale, Drouot, Paris, 1 March 1967, lot 42; Jacques Petithory, Paris; British Rail Pension Fund, London; sale, Sotheby's, London, 2 July 1990, lot 1; Galerie Moatti, Paris; acquired in 1995 (D-F-326/ 1.1995.101)

Exhibitions: Norwich 1987

Literature: Brejon 1987, under cat. no. 27, p. 61; Grate 1988, p. 70; Jacques Thuillier in Paris 1990a, p. 326, under cat. no. 58; Emmanuel Moatti in Paris 1992c, cat. no. 1 (n.p.); Olaf Keoster in Copenhagen 1992, under cat. no. 26, p. 224

*B*y the late 1630s, Vouet was at the summit of his career, with a large atelier full of assistants and students to help him complete the countless numbers of prestigious commissions that he received as premier peintre du roi (see cats. 16 and 17). During the last decade of his life, he was also at the height of his powers as a draftsman. The drawing exhibited here dates to this important moment in the master's career. The kneeling woman is a study for the attendant at the right of his *Artemisia Directing the Building of the Mausoleum* of c. 1643, now in the Nationalmuseum in Stockholm; the latter may have been commissioned as a memorial by Anne of Austria after the death of Louis XIII (fig. 1).[1] The subsidiary studies, which endow the sheet with such an elegant *mise-en-page,* are for the proper right foot and the cloak of Queen Artemisia in the same painting. There is another drawing related to this composition in the Städelsches Kunstinstitut, Frankfurt—a study for the figure of the architect at left—that bears a questionable attribution to Vouet (fig. 2).[2]

Although only a few of Vouet's composition drawings are known (see cat. 5), there are a large number of extant figure studies. Like the very representative Horvitz sheet, all of these reveal the artist working out the position and function of each of the participants in a given scene. In these types of drawings (usually executed in black and white chalk on tan paper), the rapidly realized figures spread out across the center of the page, and Vouet often takes the opportunity to reexamine specific details of anatomy or drapery, as he does here with the redrawn foot and the edge of the queen's cloak. Sometimes, significant aspects of the figure—in this case, the facial features—remain

somewhat indeterminate. When necessary, these were resolved in later studies.[3]

In her catalogue of Vouet's drawings, Barbara Brejon de Lavergnée referred to the first half of the 1640s as a privileged period in the artist's career when his figure studies were distinguished by a suppleness of modeling, a stylized plentitude of form, and carefully rendered nuances of light. Conversely, in the last four years of his life, the artist's figure studies reveal a tendency toward a schematization of planes and volumes.[4] This cogent description of Vouet's gradual stylistic shift in the mid-1640s may explain the amalgamation of restraint and ebullience evident in the exhibited drawing and may suggest a slightly later date for both the painting and its related studies.[5] The regularized hatching in black chalk and the heightening with white chalk on the skirt of the kneeling woman endow it with a planar plasticity that is also evident in most of the drapery of the contemporary *Kneeling Draped Figure* in the Bayerische Staatsbibliothek, Munich (fig. 3).[6] This tempered approach to form is dissimilar to the more volumetric and fluid swath of drapery, executed with the same media at the upper right of the Horvitz sheet, that is characteristic of the artist's draftsmanship in the early 1640s. Indeed, the conceptions of the two larger studies in this drawing are so distinct that they create an engaging spatial tension: the figure remains attached to the plane, and the drapery appears to burst into the third dimension. The Horvitz Vouet reflects a critical moment in the artist's evolution of an equally grand, but more reserved and classicizing graphic style that was never fully realized before his death.[7] In addition to the drawing's quality and the freshness of the media, perhaps it is this transitional aspect of the sheet, at once personal and academic, that also appealed to the renowned and perspicacious art critic, biographer, dealer, and collector, Pierre-Jean Mariette, whose elegant mount still serves as its support.[8]

ALC

1

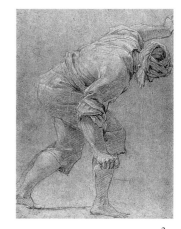

2

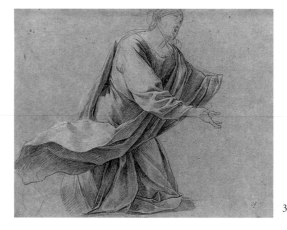

3

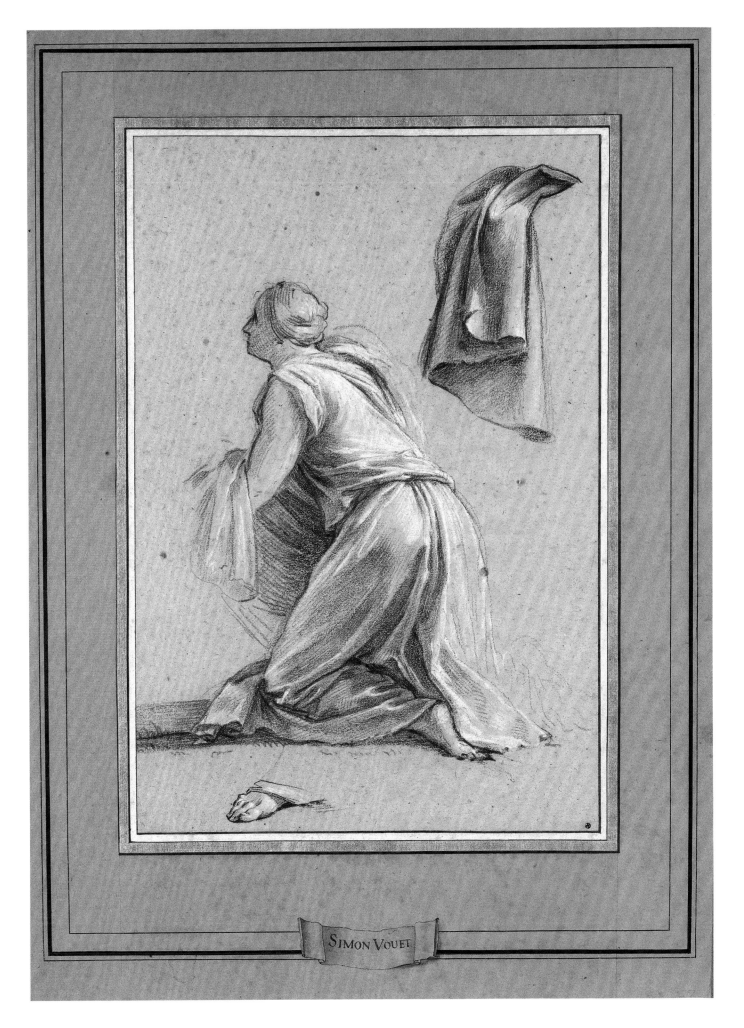

SIMON VOUET

JACQUES CALLOT

Nancy (Lorraine) 1592–1635 Nancy (Lorraine)

7 *Horse Studies and a Groom* (recto)
Head of a Horse (verso)

Pen and brown ink on light tan antique laid paper

226 × 304 mm.

Watermark: None

Inscriptions: In pen and brown ink on recto, bottom center: *135*; in pen and brown ink on recto, bottom right: *212*

Provenance: Nathaniel Hone, London (L. 2793, on verso at bottom right); John Thane, London (L. 1544, on recto toward bottom, right of center, and on verso at bottom left); Unidentified Collector JB (L. 2736, on recto at top left); sale, Sotheby's, London, 11 November 1965, lot 104; Bernard Houthakker, Amsterdam, in 1966; Stichting P. and N. de Boer, Amsterdam; sale, Christie's, London, 4 July 1995, lot 81; acquired at the sale (D-F-41/ 1.1995.107)

Exhibitions: Amsterdam 1966, nos. 8 and 8a

Literature: Pierre Rosenberg in Toronto et al. 1972, under cat. no. 20; Ternois 1973, p. 218 and suppl., cat. no. 8; Ternois 1993, p. 363; Ternois 1998, cat. no. S1460

*T*he recto of this double-sided Callot features six studies of the same horse walking to the right, one of which has been effaced. There is also a minute decorative outline of a horse in profile and another crossed-out study (of a hand?) at the top of the sheet; an indeterminate sketch at the center of the right edge; and a rapid but graceful sketch of a man, possibly a groom, at the lower right. On the verso, there is an elegant and somewhat haunting frontal study of the head of a horse.

This drawing belongs to a series of twenty known sheets of studies with horses that demonstrate Callot's ability to absorb and vary a subject rapidly.[1] They are mostly the same size and format, and they are often double-sided. The exhibited drawing shares an English provenance with three others from the same series (Hone, Thane, and the unidentified collector JB); one of these sheets, *Four Studies of a Horse and the Head of a Horse,* now in the National Gallery, Washington (fig. 1), even has the same made-up corner at the upper right.[2] These similarities suggest that a homogeneous series, one that may have been even larger, was dispersed in the eighteenth century.

Callot's horse studies are spirited, liberal copies after a series of twenty-nine etchings by Antonio Tempesta, entitled *Cavalli di differenti paesi,* published in Florence in 1590.[3] The horse copied six times on the recto of the Horvitz sheet is *Romanus Equus* (fig. 2), the sixth in Tempesta's series, which also appears in other Callot drawings.[4] The head of a horse on the verso is a variant of *Arduus Iberus* (fig. 3), the tenth plate in Tempesta's work.

In contrast to the direct, firm yet sensitive penmanship evident in the horses on the recto of the exhibited drawing, both the groom at the bottom right of the recto and the head of a horse on the verso of this sheet illustrate other aspects of Callot's draftsmanship. For example, the generous contours used to describe the head of the horse on the verso—more inclined in the print, and more vertical and symmetrical in the drawing—are charged with an energy and a liberality that underscore the artist's sheer delight in working freely with pen and ink. In both its style and its execution, the calligraphic sketch of the standing male figure on the recto, seen from behind in a Mannerist *contrapposto* pose, is comparable to Tuscan drawings at the beginning of the seventeenth century. Although one finds analogous sketches in other Callot sheets, such as the *Horse among Figure Studies* in the British Museum, London (fig. 4),[5] these are rarely as open or as elegantly drawn as the groom in the exhibited sheet, which reflects the results of Callot's contemporaneous academic life studies now in the Uffizi in Florence (fig. 5).[6]

The Horvitz Callot was certainly executed during the artist's Florentine period (c. 1612–21). According to the late seventeenth-century biographer and critic Filippo Baldinucci, Callot was a student of Remigio Cantagallina and Giulio Parigi, and during his first years with them, following standard academic practice, he copied prints. However, at the same time, and on the same sheets, he gives free rein to his imagination by quickly sketching fantastic small figures and

2

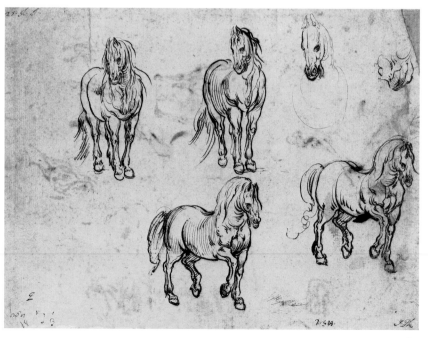

1

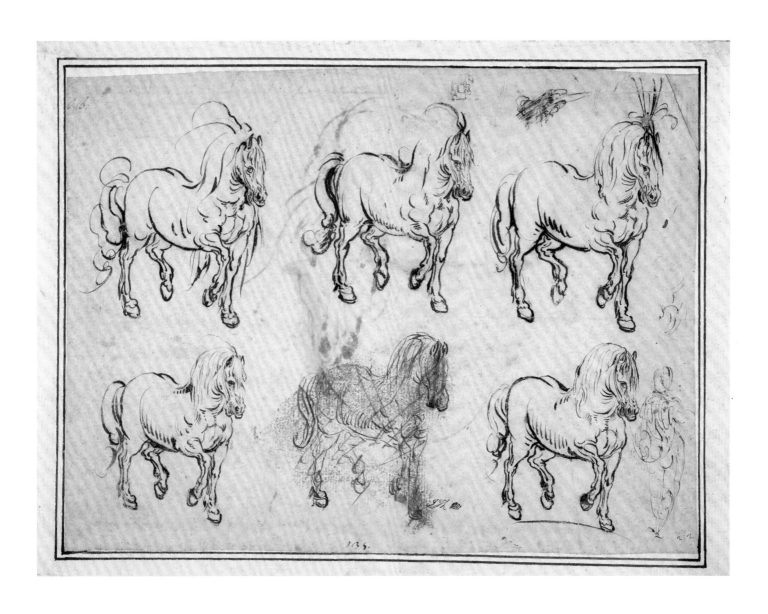

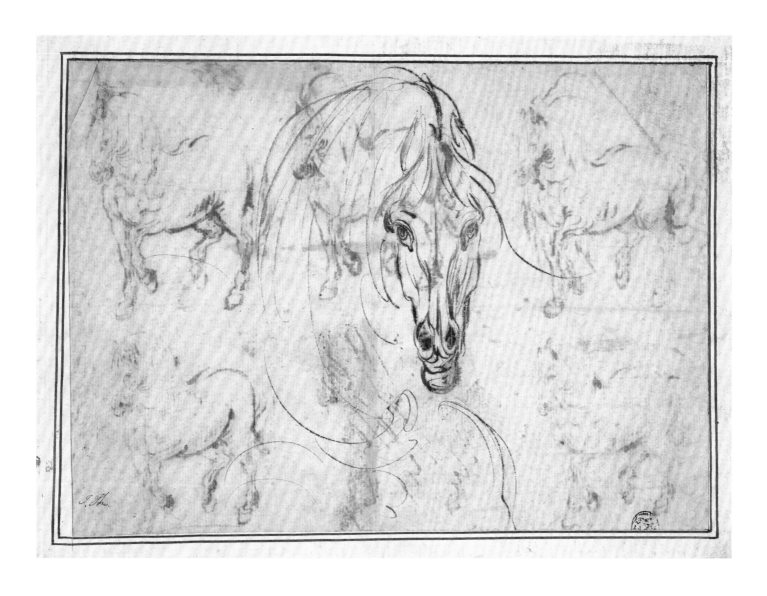

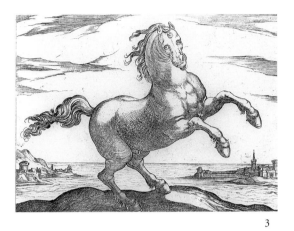

3

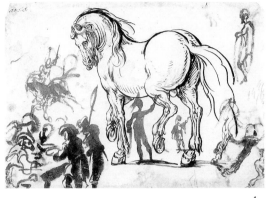

4

vignettes that were neither literal copies nor servile pastiches.[7] One can situate this phase of his early development, in which his originality is clearly affirmed, between 1612 and 1616. More specifically, the Horvitz drawing and the other horse studies date to the time of Callot's etchings after his own designs, such as those based on the *Carousel of the Battle of* *Love,* a pageant given by Cosimo II de' Medici for the Carnival of 1616.[8] Later, in the second half of his period in Florence, the artist would move toward a somewhat more naturalistic mode in which he produced such works as the *Capricci* of c. 1617 and the studies for the *Fair at Impruneta* of 1620. DT

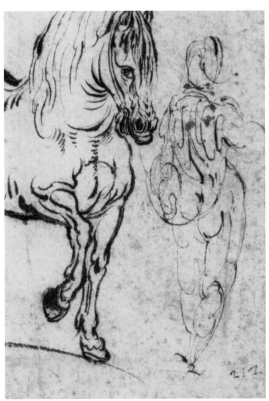

detail of cat. 7 recto

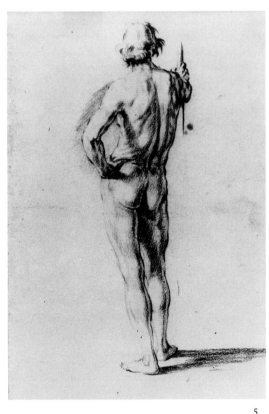

5

NICOLAS POUSSIN

Les Andelys 1594–1665 Rome (Italy)

8 Satyr and Nymphs

Pen and brown ink on cream antique laid paper

105 × 204 mm.

Watermark: Laid down—none visible through mount

Inscriptions: In black chalk on mount, bottom left: *N. Poussin / 218*; in graphite on recto, partially erased, bottom right: *Nicolas Poussin 1596-1665*; in graphite on verso of mount, top left: *foms* (?); in graphite on verso of mount, center: *54/45*; in graphite on mount, bottom right: *30765*

Provenance: A. Strölin, Lausanne, through c. 1974; Private Collection; Galerie de Bayser, Paris, in 1992; Eugene Victor Thaw, New York; Thos. Agnew and Sons, Ltd., London; acquired in 1994, (D-F-41/ 1.1993.173)

Exhibitions: None

Literature: Rosenberg 1991, pp. 212–13, and n. 12; Pierre Rosenberg and Louis-Antoine Prat in Bayonne 1994, p. 36, repr., fig. 5a; Rosenberg and Prat 1994, pp. 274–75, cat. no. 142

*R*eflecting Poussin's growing reputation as an artist of major talent, sometime in the early 1630s Cardinal Richelieu requested a series of Bacchanals to decorate his chateau at Rueil. The first two were sent from Rome in 1636.[1] At least ten drawings dating between 1634 and 1636 can be related to the four extant paintings connected with the prestigious commission, and they demonstrate a marked preference for agitated constructions full of energetic figures.[2] Although unrelated to any known paintings, the exhibited sheet is one of a small group of drawings of slightly later date (c. 1636–38) that fit securely between the Bacchanals and the more static studies for the first series of the Sacraments.[3] This group—which includes another version of the Horvitz design at Bayonne (fig. 1) and the Windsor *Nymph Seated beneath a Tree* (fig. 2)—demonstrates Poussin's continued preoccupation with the lively devotees of Bacchus and other profane topics.[4] The later sheets also reveal the artist's efforts to create sparser, friezelike compositions whose more fully realized figures use their bursts of energy to accomplish specific actions.[5] To aid himself in this endeavor Poussin utilized a number of adjustable models set into an experimental stagelike box so that he could alter their positions and the disposition of light.[6]

In the exhibited sheet, a nymph reaching for a cloak on the rock to her left looks on with concern as she hears the scream of a fellow nymph being abducted by a satyr on the right. One assumes that the force of the satyr's flight with his catch has overturned the large wine vessel in the foreground. The differences between this composition and the more preliminary Bayonne drawing are technically minor, but their visual effect is significant. Omitted in the version shown here are the statue of Diana and the boar's head on top of the tree present in the Bayonne composition (or the decorations in the Windsor drawing), and the fleeing pair are placed closer to the fallen wine vessel. Although the faceless protagonists in the Bayonne sheet are already more rhythmic and more carefully rendered than many of those in the earlier Bacchanal drawings, in the exhibited version the facial expressions are summarily indicated, the contours of all of the forms are redrawn, and the shadows in and around the ewers and the intertwined pair are so densely hatched that they appear to be generated with a dark wash. Poussin's heightened contrasting of lights and darks is a direct result of his experiments with his box and models. In the drawing shown here, the direction of the light has shifted from the right (as in the Bayonne sheet) to the left. This change results in new shadows, like the one beneath the fleeing satyr and his catch that roots them more securely in the composition. The altered effect is further accentuated by boldly hatched diagonal lines in the background that move from top left to bottom right: the right-handed artist probably had to turn the sheet to execute these so carefully.

The impact of Poussin's unusual diagonal hatchings in the Horvitz drawing is twofold. First, they intensify the dramatic action of the sheet by reinforcing the vigorous rightward motion of both the satyr and the screaming nymph, as well as by drawing the eye toward the quieter nymph on the more static left side of the composition who now leans toward the pair on the right. Moreover, these hatchings force the entire composition into the foreground as in a bas-relief, thereby enabling the viewer to read the action of the scene across the sheet—an effective, didactic compositional tool that Poussin would use with increasing frequency throughout his mature years.[7]

ALC

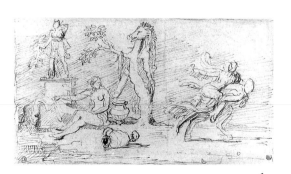

1

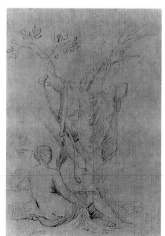

2

114

JACQUES STELLA

Lyon 1596–1657 Paris

9 *Assumption of the Virgin Witnessed by St. Francis of Paola*

Pen and brown ink with brush and brown and gray wash, and traces of heightening in white gouache, on cream antique laid paper; squared for transfer in black chalk

568 × 427 mm.

Watermark: Laid down—none visible through mount

Inscriptions: In blue ink, on verso of mount, center: *Espagnol / Ecole de Sevilla / attr. Valdes Leal*

Provenance: Unidentified collector's mark (at lower left); Galerie Siegfried Billesberger, Munich; acquired in 1996 (D-F-367/ 1.1996.13)

Exhibitions: None

Literature: Unpublished

*B*etween 1622 and 1623, after six years in Florence, Stella moved to Rome, where he lived for more than a decade in the parish of Sant'Andrea delle Fratte.[1] His work there included a number of finished drawings for prints and small cabinet pictures.[2] In 1625 he executed his earliest known *Assumption,* a painting now in the Musée des Beaux-Arts, Nantes (fig. 1).[3] Given what we expect from his later, more classicizing designs, this work, which resonates with the early Baroque energy and lyricism of Annibale Carracci, Giovanni Lanfranco, and Simon Vouet, comes as a surprise.[4] This was the first of a number of documented scenes of either the Assumption or the Virgin's appearance to saints that he continued to generate until the end of his life as paintings or as finished drawings, like his *Assumption* for the *Life of the Virgin* series of c. 1654–56 (fig. 2).[5] For Gilles Chomer, who is completing a monograph on the artist,[6] Stella's large *Assumption Witnessed by St. Francis of Paola* is a magnificent sheet that probably records an important lost altarpiece painted for the Monastery of the Minimes in Abbeville.[7] The subject certainly suggests such a patron, as this saint was the founder of the order in France at the end of the fifteenth century.[8]

Jacques Thuillier has noted that by the 1630s, Stella's style was already marked by traits that would remain with him, including the use of oval faces, rustic details, and a realism curiously blended with a cool approach to form and expression.[9] This description may account for the fusion of restraint and dynamism in the drawing shown here, where the vivacity of the design is arrested by the emphatic gestures of the lightly contoured figures. It also points to the wonderful landscape at the lower right, often found in sheets from the 1630s (see cat. 10, fig. 2).

The Stella exhibited here contains both a tomb, and a *repoussoir* figure at the lower left, similar to those found in the artist's painting of the *Assumption* from 1627. But in the drawing, without the kneeling donor and the apostles of the crowded canvas, there is a graceful clarity in the spatial relationship between the earth-bound saint and his heavenly apparition. The Virgin is now vertical, and the potentially unsightly problem of dangling feet has been creatively resolved by the presence of a tractable and energetic angel who swirls elegantly across the Virgin's lower legs. The drawing was produced with a technique that combined a liberal use of wash with a fluidity of line that is also seen in the artist's sheets for the *Life of St. Philip Neri* (the *Stabbing of Paolo de Bernardis,* Yale University Art Gallery, New Haven, fig. 3).[10] Finally, the figure of God at the upper right here emerges out of a blend of wash and the white of the sheet like St. Philip in the Yale sheet, where the large sweep of the combatants' capes, accentuated with calligraphic hatching strokes, is analogous to St. Francis's bulky robe. All of these similarities with finished composition drawings and paintings achieved during Stella's later years in Italy suggest that the Horvitz *Assumption Witnessed by St. Francis of Paola* was executed between 1630 and 1634, before the artist's return to France via the centers of northern Italy in 1634–35, or within a very short time of his return to France.[11]

ALC

2

3

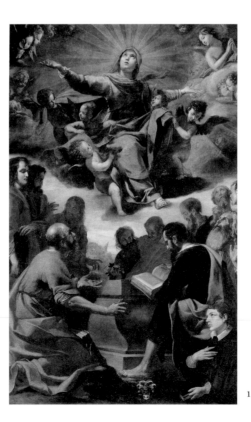

1

116

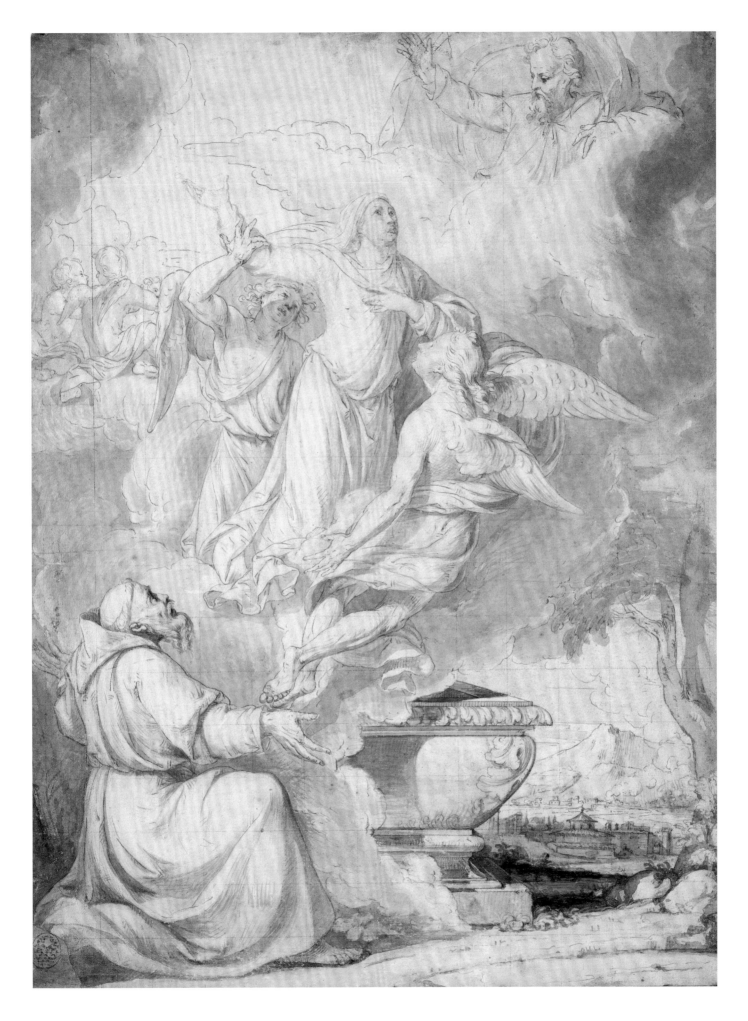

117

JACQUES STELLA

Lyon 1596–1657 Paris

10 *Expulsion of Joachim and Anna from the Temple*

Pen and black ink with brush and gray wash on off-white antique laid paper; partially incised for transfer

345 × 265 mm.

Watermark: Laid down—none visible through mount

Inscriptions: In black chalk, top right: *n*

Provenance: Collection of the artist; by descent to Claudine Bouzonnet-Stella, Paris; by descent to Michel de Maso, Paris; Gaetano Minossi, Rome (c. 1756); purchased as Poussin by Thomas Talbot, Margam Abbey, United Kingdom (c. 1776); by descent to Lady Beythswood, Penrice Castle, Glamorgan, United Kingdom; Christopher Methuen-Campbell, Penrice Castle, Glamorgan, United Kingdom; sale, Christie's, London, 9 December 1986, lot 123 (as the *Presentation in the Temple*); sale, Christie's, New York, 13 January 1987, lot 105 (as the *Sacrifice of Anna*); Yvonne Tan Bunzl, London; acquired in 1994 (D-F-268/ 1.1994.10)

Exhibitions: London 1994

Literature: For this sheet, and the entire series: Bottari 1822, vol. 3, p. 521; Guiffrey 1877, pp. 3–4 and 53–54; Pierre Rosenberg in Toronto et al. 1972, under cat. no. 135, p. 211; Blunt 1974, pp. 746–48; Davidson 1975, pp. 148 and 155, n. 9; Chomer 1989, pp. 72–74; Gilles Chomer in Paris 1989a, under cat. no. 22, pp. 84–85; Hilliard Goldfarb in Cleveland et al. 1989, under cat. no. 68, p. 141; Kerspern 1989, p. 9, n. 23; Pierre Rosenberg in New York et al. 1990, under cat. no. 14, p. 62; Jean-François Méjanès in Paris 1993a, under cat. no. 46, p. 112; Tan Bunzl in London 1994, cat. no. 30 (n.p); Pierre Rosenberg in Paris et al. 1995, under cat. no. 11, p. 56

*A*fter returning from Italy in the suite of the maréchal de Créquy, French ambassador to the Holy See, Stella was named a *peintre du roi*.[1] In addition to numerous commissions for paintings, he continued to make finished drawings for prints.[2] These included frontispieces for deluxe editions published by the new Imprimerie Royale, and two series representing the Life of the Virgin. The first series comprised eight scenes and is usually dated to the early 1650s.[3] The second and larger series consisted of twenty-two drawings and dates to the mid-1650s.[4] The Horvitz *Expulsion of Joachim and Anna from the Temple* is from this second, more comprehensive series, which was engraved three times.[5] The artist's niece, Antoinette Bouzonnet-Stella, produced the rare first set of engravings before the end of the seventeenth century. Francesco Polanzani, who fraudulently inscribed the inventor as Poussin, made the second set in 1756 (fig. 1).[6] The final set, which continued the falsehood, was produced by Alessandro Mochetti at the end of the eighteenth century.[7]

In the drawing studied here, Stella depicted an apocryphal scene from Jacopo da Voragine's *Golden*

Legend. After twenty years of marriage, Joachim and Anna, the parents of the Virgin, were still without children. As a result, their offering of a lamb was refused on a feast day. In this sheet, the seated high priest stops the forward movement of Anna's hands and shoulders with a gentle gesture of restraint while one of his assistants casts her startled husband out of the temple. According to the legend, the disconsolate Joachim then went into the fields, where he was visited by an angel who told him that Anna would soon conceive.

In contrast to his fluid and painterly works of the 1620s and early 1630s, by the late 1630s Stella began to move towards a more classical style. This may have been reinforced by the success of the works of his friend, Nicolas Poussin, who lived in Paris from 1640–42.[8] Indeed, along with Stella, artists such as Champaigne, La Hyre (cat. 12), and Le Sueur (cat. 16) all began to work in a style that is sometimes referred to as Parisian Atticism.[9] Although their efforts in this mode often lacked the sculptured monumentality of form and the purity of structured composition that Poussin himself would generate, their extremely refined works were deliberately less lyric than those that Vouet and his circle continued to produce for grand decorations.

Stella's *Noli me tangere* of 1638 in the Fogg Art Museum, Cambridge (fig. 2) reveals his attempt to master a greater solidity of form than his earlier *Assumption of the Virgin Witnessed by St. Francis of Paola* (cat. 9) by a painterly use of gouache that serves to construct the figures out of the density of the media itself.[10] Later, his *Christ at the Column* of the mid-1640s, also at the Fogg (fig. 3), displays his use of a very thin contour line in tandem with wash and a reduced amount of gouache in an abbreviated foreground, a technique that generates a marvelous sense of form but reduces the design to a bas-relief.[11] In contrast to these highly worked drawings, many of the sheets for the two *Life of the Virgin* series, usually restricted to pen and black ink or chalk with brush and gray wash, are quite sober. In the *Birth of the Virgin* from the first series, again at the Fogg (fig. 4), Stella combined a liveliness of line and touch by using the brush and the wash as much as the pen.[12] However, in the second set, as in the *Assumption* (cat. 9, fig. 2) and the Horvitz drawing—where firmer contours are reinforced with hatching, draperies stiffen, compositions begin to recede into depth, gesture and expression become more impassioned, and there are greater contrasts of lights and dark—Stella often evokes a *gravitas* that parallels the later works of Poussin.

ALC

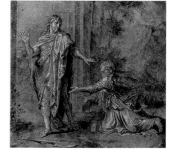

1

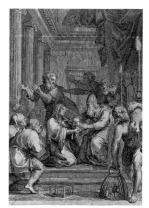

2

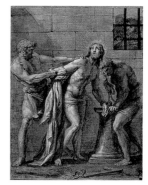

3

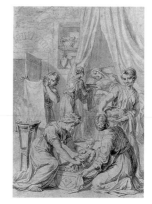

4

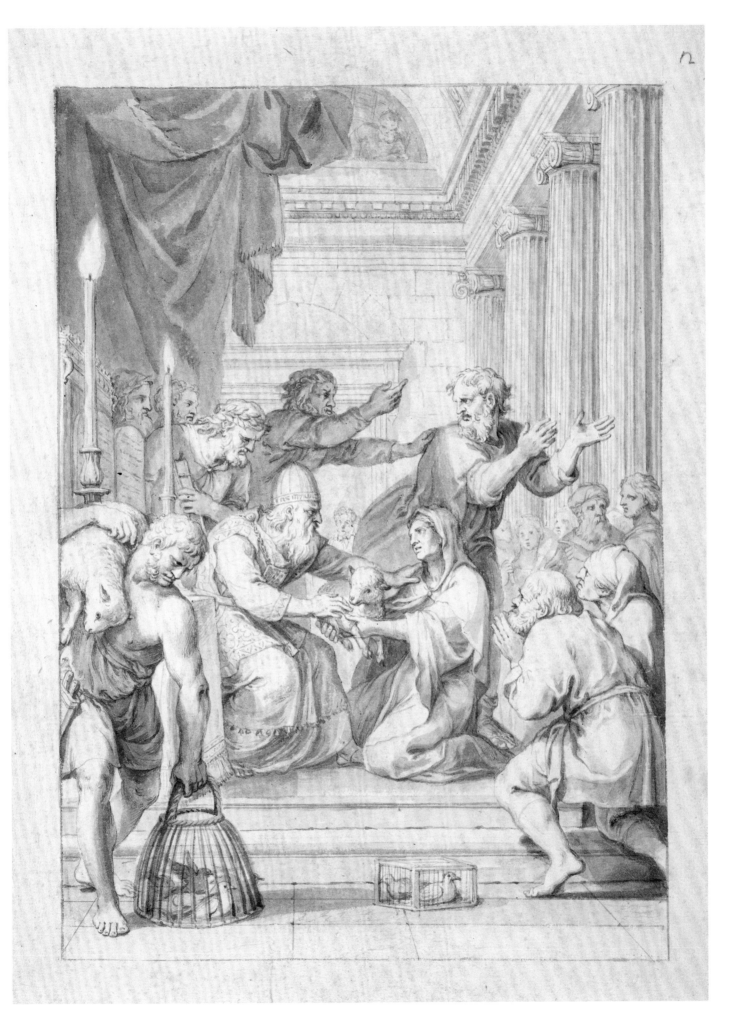

CLAUDE GELLÉE, called LE LORRAIN

Chamagne (Lorraine) 1600–1682 Rome (Italy)

11 *View of the Roman Campagna*

Pen and brown ink with brush and brown wash on cream antique laid paper

207 × 274 mm.

Watermark: Laid down—none visible through mount

Inscriptions: In pen and brown ink on recto, bottom left: *Claudio. Gille(e or s?)*; in graphite, on verso of mount on old customs stamp, top right: *Douane Française / Recette de Paris Nord / 67* (encircled); in graphite on verso of mount, bottom left: *bleu* (first three letters in square label); in graphite on verso of mount, bottom right: *32–37½ cm. / 1577* (in a square); in pen and brown ink on verso of mount, bottom right: *Claud: Lor:*; in graphite on verso of mount, bottom center: *View of the campagna with the Tiber / spanned by a bridge in the middle / distance and the Tivoli mountains in the / background. Pen and wash 8 × 10½ / From the Collection of Hugh Howard / (1675–1737) and the collection of / a Nobleman*

Provenance: Hugh Howard, London (before 1737); sale, Sotheby's, London, 14 December 1932, lot 23; Private Collection, France; Knoedler Gallery, New York (in 1959); Private Collection, United States; Robert M. Light, Santa Barbara; acquired in 1994 (D-F-57/ 1.1994.41)

Exhibitions: New York 1959, no. 51

Literature: Anon. 1932, cat. no. 3 (n.p.), repr.; Borenius 1933, p. 36; New York 1959, cat. no. 51 (n.p.), repr.; Roethlisberger 1968, vol. 1, cat. no. 167, p. 128, repr., vol. 2, fig. 167

Claude specialized in the creation of imaginary landscape paintings, which he executed in his Roman studio. He assimilated nature on walks in the countryside, making countless sketches. He was a passionate draftsman (some 1300 fine sheets survive), but he never took these nature studies directly into his paintings. Although the drawings reveal his innate sense of order and simplification, the media and composition of the paintings are usually both more complex and more composed.

Whereas his paintings have invariably darkened over time, his best-preserved drawings remain unchanged, and their unspoiled spontaneity of execution both delights the eye and makes them precious documents. The Horvitz *View of the Roman Campagna*, datable to about 1635–40 on account of its handling, is one of Claude's numerous drawings of nature. Created rapidly with a sharp pen and light wash, it offers a pleasing view of a calm landscape. The scenery is arranged into four successive levels: the largest is the empty foreground, going from a light tone across most of the bottom of the sheet to the drawing's darkest wash in the left corner. Next is an empty, light zone, followed by the slightly darker middleground, accentuated near the center by a

building and silhouetted trees, whose tiny shapes emphasize their remoteness. Finally, a flattened skyline and a light tone unify the distant hills. The large sky—over half of the sheet's height—along with the suggested depth and the lateral opening account for the impression of airy spaciousness. Clouds above the hills and behind the foliage dissolve toward the luminous center of the sky.

The left half of this composition clearly reveals the four levels, while the narrow bends of a river enliven the right half. The slender foreground trees in the left half serve as dark *contre-jour* foils; some trunks are vertical, but the largest bends inward, embracing the distant view. This trunk, the slanting foreground, and the open right side create a sense of movement from left to right. Thus the artist consciously staged and stylized even an apparently unassuming drawing. Throughout Claude's drawings and paintings, the scenery remains a remote world set out in parallel planes, without any road leading into it.

The hardly perceptible distant bridge with the tower above its north end can only be the Ponte Molle across the Tiber, just north of Rome. Claude executed the view studied here roughly a mile east of the bridge at Acqua Acetosa, a region he and his contemporaries favored for sketching, although he consistently altered the topographic features of this and other sights. As his later *View of the Acqua Acetosa* of about 1660–65 from the Wildenstein Album reveals, Claude drew the area repeatedly, nearby and from afar (fig. 1).[1] Comparable distant views recur in the background of many of his finished drawings and paintings, such as *Liber Veritatis* no. 42.[2] Today the Acqua Acetosa is largely overbuilt.

It seems that our *View of the Roman Campagna* was done on the spot, one indication being the irregularity of the autograph framing line, drawn freehand. A small album discovered in 1982, and now in the Nationalmuseum in Stockholm, contains some much scantier pen or chalk sketches by him undoubtedly done out-of-doors (fig. 2).[3] Several other sheets such as those in the Musée du Louvre, Paris; the Ashmolean Museum, Oxford; the Biblioteca Reale, Turin; and the British Museum, London, show open views comparable to this one, either with or without foreground trees.[4] The existence of similar views without trees—and the fact that the trees in the Horvitz drawing are distinctly drawn over the horizontal lines of the landscape and clouds—suggest that Claude may have drawn only the general view *in situ*, adding the trees later, in the studio, thereby changing the record of an excursion into a picturesque image. MR

1

2

LAURENT DE LA HYRE

Paris 1606–1656 Paris

12 *Scene from the* Cyropaedia: *Panthea Sending Word of the Threat of Araspes to Cyrus (?)*

Black chalk heightened with white gouache on light tan antique laid paper

292 × 405 mm.

Watermark: Laid down—none visible through mount

Inscriptions: In pen and brown ink on recto of mount, bottom center: *La Hyre (Laurent de) (Collection Mariette)*

Provenance: Private Collection, Paris; Galerie de Bayser, Paris; acquired in 1996 (D-F-340/ 1.1996.15)

Exhibitions: None

Literature: Unpublished

*E*arly in his career (c. 1624), La Hyre, like most of his French contemporaries, studied the works of masters of the Renaissance at the Château de Fontainebleau. His strong attraction to their methods led him to spend several months there.[1] Four early suites of twelve drawings each reveal his absorption of the particularized form of Mannerism developed by the two schools of artists who worked there, from the refined Emilian elegance of the early decorations by Primaticcio and Nicolo dell'Abate to the later and more robust Franco-Flemish works of Ambroise Dubois.[2] Each of La Hyre's suites depicts episodes in the lives of a pair of lovers drawn from antique and early modern novels and plays. The earliest suite illustrates the story of Rinaldo and Armida, and the second group depicts that of Tancred and Clorinda. Both of these pairs of characters were drawn from Tasso's *Gerusalemme Liberata*.[3] The last suite portrays the story of Alcestis and Admetus, from Euripides's ancient Greek drama *Alcestis*. The Horvitz La Hyre is from the third suite, which illustrates the story of Cyrus and Panthea, originally told in Xenophon's *Cyropaedia*.[4]

The *Cyropaedia* is a historical novel that chronicles the life of King Cyrus the Great, founder of the Persian Empire, with fictional additions to suit the moralizing goals of the author. The most diverting subplot in the extensive narrative is the story of Panthea, wife of King Abradatas of Susa. Panthea is treated with such courtesy and respect by the gallant Cyrus upon her capture that her husband surrenders his army and eventually dies courageously in battle for the future emperor.[5]

Initially, after the capture of Panthea, upon hearing of her beauty, Cyrus feared the potential for impropriety and placed his trusted companion, Araspes, in charge of the queen's house arrest. Araspes

soon fell in love with her. Panthea refused his advances and promised not to inform Cyrus. But later, when threatened with violation by Araspes, she was forced to tell the king. The exhibited sheet probably represents Panthea on the columned porch of her palace, giving her old servant a message to deliver to Cyrus, as the rejected Araspes withdraws up the stairs. Another drawing from the series in the Rijksprentenkabinet, Amsterdam, shows the servant delivering the message to the king (fig. 1).[6] And in one of the most poignant moments in the drama, seen in a drawing in the Hamburger Kunsthalle (fig. 2), both the servant and Panthea, in her distinctively draped costume, reappear when, after having been reunited for a short time with her husband, King Abradatas, she bids him farewell before he departs for his final battle.[7]

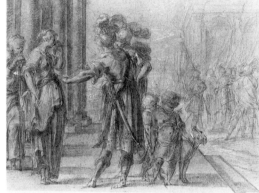

1

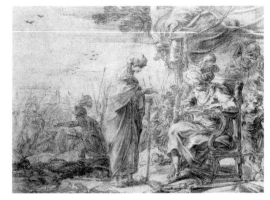

2

La Hyre executed these four early suites of drawings before reaching the age of twenty, and they reveal a personalized form of Fontainebleau Mannerism, replete with elongated figures and attenuated gestures. As the less fully realized protagonists in a drawing from the second suite, the *Combat between Tancred and Clorinda* in the Fogg Art Museum in Cambridge, demonstrate (fig. 3), La Hyre developed rapidly during the course of the four suites' execution.[8] He soon supplanted the decorative arabesques of the draperies in the second suite with an effort in the Amsterdam, Hamburg, and exhibited drawings to evoke the volumes of his foreground figures with a crisp and lively contour line and deeply shadowed draperies. These advances soon led to plastically conceived figures like those in his *Annunciation* of about 1630, also in the Fogg (fig. 4).[9] In the Horvitz sheet, the squared floor of the porch, the carefully planned columns and statues framing the balustrade, and the lightly rendered indications of the landscape also point to La Hyre's attempt to create a three-dimensional space for the action and visual clarity of the drama. Nonetheless, some of the most spontaneous and pleasing aspects of his earliest draftsmanship—the sketchily rendered soldiers in the heat of debate in the background and the two frisky dogs playing in the foreground—are also still evident. ALC

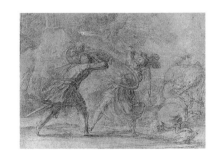

3

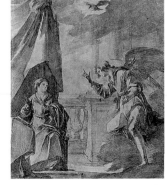

4

GRÉGOIRE HURET

Lyon c. 1606–1670 Paris

13　*Rest on the Flight into Egypt*

Black chalk extensively stumped, on cream antique laid paper

510 × 383 mm.

Watermark: Laid down—none visible through mount

Inscriptions: In pen and brown ink on recto of mount, bottom right: *Salviati*

Provenance: Private Collection, France; Galerie Eric Coatalem, Paris; acquired in 1995 (D-F-135/ 1.1995.8)

Exhibitions: None

Literature: Brugerolles and Guillet 1997, pp. 10 and 31

*H*uret, a prolific printmaker, was only the fourth member of that profession to enter the Académie. He was also a controversial and published scholar of perspective. As an artist, he gained as much notice for the force of his personality as for his enormous powers of invention.[1] His character as a draftsman has only emerged slowly during the last two decades and is based on a group of thirty-two late sheets in the Biblioteca Nacional in Madrid that are related to his *Théâtre de la Passion,* a suite of thirty-two original engravings presented as his reception piece to the Académie in 1664.[2] Scholarly attention was first drawn to these by Pierre Rosenberg in 1971.[3] More recently, Jean-François Méjanès published a *Flagellation* from the Musée des Beaux-Arts, Quimper, and Emmanuelle Brugerolles and David Guillet published an important group in the Ecole nationale supérieure des Beaux-Arts, Paris.[4] Like the elegant Horvitz *Rest on the Flight into Egypt,* the vast majority of these works are highly finished drawings or *modelli,* ready to be engraved.

In this sheet, the Virgin and St. Joseph take a much-deserved rest from their arduous journey, seated among classical ruins strewn across the foreground. They play with the Christ Child, personification of the new order, while lithe angels follow them through the gate of the crumbling city to lead their donkey to fresh water. Some of the angels pick fruit for the family's nourishment from the trees behind them. As this drawing reveals, Huret developed a highly personal and extravagant manner that often included large, buoyant, and slightly attenuated figures who never stand or sit firmly on flat surfaces. They seem to be a blend of those by late French Mannerists such as Claude Vignon and those of artists in the Vouet circle, and, as Huret's *Triumph of the Trinity* from the Musée du Louvre demonstrates, their oval

faces usually end in small pointed chins (fig. 1).[5] Although the largest part of his designs are his densely populated middlegrounds—which recede up the sheet to a small view into the distance—the strongest areas of his compositions are the foregrounds, where the figures appear at their most monumental, with heavily reinforced contours and extremely worked and tactile surfaces generated by a complex combination of hatching and stumping. This blend of techniques endows the figures with animated and volumetric draperies that set them apart from those in the middleground and displays the artist's enormous and carefully calculated range of tone. The *Noli me tangere* from Huret's *Théâtre de la Passion* in Madrid is a variant of this compositional system, with foliage replacing figures in the middleground (fig. 2).[6] Despite recent attempts to attribute drawings to him, the paucity of extant sheets from most periods of the artist's career makes dating individual works difficult.[7] However, the *Rest on the Flight into Egypt* probably dates from the early to mid-1650s, between the Louvre and Madrid drawings, which can be dated to the mid- to late 1640s and c. 1660, respectively.

Most of Huret's known drawings relate to his engravings, which as Maxime Préaud has noted, display highly coloristic burin work that eschews the growing popularity of restrained classicism among his contemporaries in favor of active surfaces that recall the printmakers in Rubens's atelier.[8] Although the Horvitz sheet does not appear to have been engraved, it relates in theme and design (for the monumental figures of the Holy Family in the foreground) to two of Huret's prints, in the Bibliothèque nationale de France, Paris (fig. 3),[9] after his own compositions representing the Holy Family without the assistance of angels. ALC

2

3

1

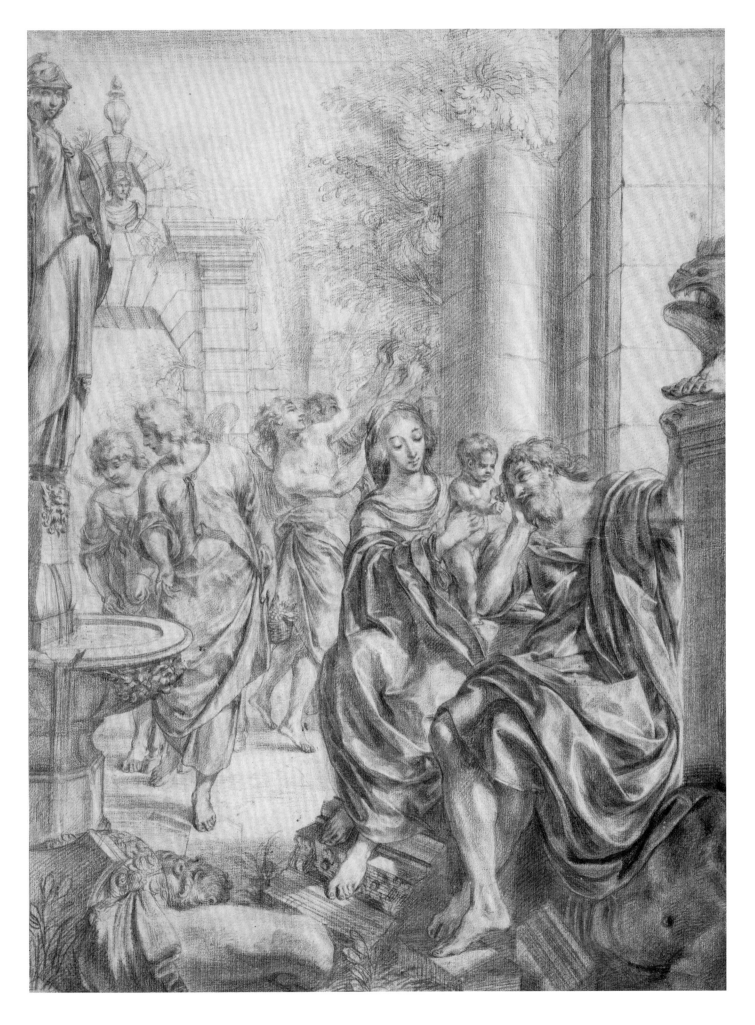

THOMAS BLANCHET

Paris 1614–1689 Lyon

14 *Portia*

Pen and brown ink with brush and brown and gray wash over traces of red chalk on off-white antique laid paper; squared in red chalk

190 × 112 mm.

Watermark: Laid down—none visible through mount

Inscriptions: In pen and brown ink on recto of mount, bottom right: *1623–1691*; in pen and black ink on verso of mount, across top: *Claude Lorrain / ll Moritz von Fries* (copy of mark) *Vienne dont parle Goethe / Lugt 2903 / Coll. Mariette* (copy of mark) *Lugt 1857* (7 superimposed with a 2) [*1852* in graphite] *Coll. W. Mayor, Londres / Coll. Arth Sambon* (copy of mark) *Paris / Filippe Lauri, Lucrèce*; in graphite on verso of mount, bottom right: *37* (encircled)/ *17 × 25½ h mn.*; in graphite on verso of mount, bottom left: *B. D. doré*

Provenance: Pierre-Jean Mariette, Paris (L. 1852, at bottom right); his sale, part 6, Paris, 1775, part of lot 1088; Count Moritz von Fries, Vienna (L. 2903, bottom left); consigned to W. Mellish, London; William Mayor, London (L. 2799, bottom left); Arthur Sambon, Paris (his mark, at bottom right, not in Lugt); Ian Woodner, New York; sale, Christie's, London, 2 July 1991, lot 144; Galerie Patrick Perrin, Paris; acquired in 1996 (D-F-360/ 1.1996.29)

Exhibitions: None

Literature: Galactéros-de Boissier 1991, D.42–47, p. 414

*B*y the middle of the eighteenth century, the noted collector and biographer, Antoine-Joseph Dézallier d'Argenville, complained that Blanchet—who eventually enjoyed a reputation distinguished enough to be referred to as the "Le Brun of Lyon"—was almost entirely forgotten.[1] Fortunately, due in large part to the efforts of Lucie Galactéros-de Boissier, this situation has been remedied within the last decade.[2] Thanks to the collector, dealer, and biographer Pierre-Jean Mariette, we know that after working with the sculptor Jacques Sarazin, Blanchet became a pupil of Simon Vouet (cats. 5 and 6), like his contemporaries Eustache Le Sueur (cat. 16) and Michel Dorigny (cat. 17). He then spent almost fifteen years in Italy, where the German artist and biographer Joachim von Sandrart tells us that he was known to be an associate of Poussin (cat. 8) and a student of Andrea Sacchi.[3] Although this information remains speculative, the Horvitz Blanchet demonstrates that the young artist, while in Rome, absorbed and developed aspects of the ornate Roman Baroque mode.

The exhibited sheet depicts the noblewoman Portia, daughter of the renowned Roman statesman Cato the younger, and wife of Marcus Brutus (one of the senators who conspired to murder Julius Caesar), about to swallow burning coals which she has just taken from the fire behind her. According to the Greek historian Plutarch in his *Lives of the Romans* (46:53), Portia took her own life in order to demonstrate her united conjugal and Republican loyalties after Brutus committed suicide because of his devastating defeat by the Imperial forces led by the *triumvirs* Octavian and Antony at Philippi in 42 B.C. Images of powerful women from the Bible and ancient literature and history performing acts of heroism or loyalty for their nation, religion, or spouse became increasingly fashionable at the end of the Middle Ages, and their popularity continued into the seventeenth century. Indeed, Blanchet's *Portia* recalls engravings by Abraham Bosse and Gilles Rousselet of *Portia* and *Lucretia* (figs. 1 and 2), after Claude Vignon's designs for illustrations to Père Pierre Le Moyne's *Galerie des Femmes Fortes* of 1647, appropriately dedicated to Anne of Austria, queen of France, and regent for the young Louis XIV.[4]

The combination of color, energy, and drama in Blanchet's depiction of the scene characterizes his mature drawings. As Mariette, a former owner of the present sheet, aptly suggested, the artist's manner of drawing was very sketchy, but well informed. Dézallier d'Argenville noted that when one finds a mixture of pen and ink—sometimes with strong hatching—along with brown wash and red chalk, used to generate active draperies in well-conceived compositions, one is in the presence of Blanchet's art.[5] Also, Hilliard Goldfarb correctly suggested that Pietro da Cortona and his circle probably constituted the original source of the artist's volumetric and dynamic figures. Blanchet would have become familiar with their paintings and drawings during his long stay in Italy.[6] Two other drawings by the artist dating between the late 1660s and c. 1680, his pen and ink *Justice Crushing Crime* in the Musée des Beaux-Arts, Angers (fig. 3, detail),[7] and his *Assumption of the Virgin* in the Musée du Louvre, Paris (fig. 4),[8] reveal the same squarish faces, rounded figures, dynamic poses, and animated draperies. Although unconnected with any known commission, the poignant Horvitz sheet should be dated to the same period.[9] ALC

1

2

3

4

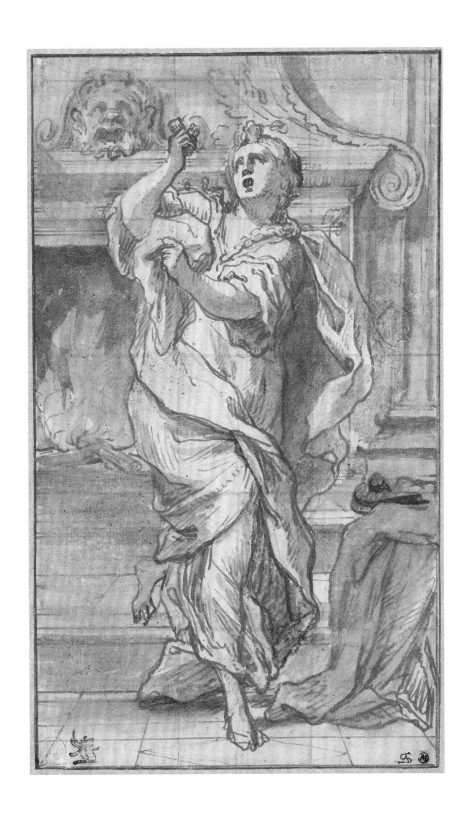

SÉBASTIEN BOURDON

Montpellier 1616–1671 Paris

15 *Banquet of Esther*

Verso: *Banquet of Esther*

Pen and brown ink with brush and brown and blue wash, heightened with white gouache, on light tan antique laid paper (recto); pen and brown ink, and brush with white and red oil paint on light tan antique laid paper prepared with brown oil wash (verso; not exhibited)

280 × 475 mm.

Watermark: Fleur-de-lys in a double circle

Inscriptions: In pen and brown ink on recto, top right: *position de salle de banque[t]*

Provenance: Collection Pascalis (?), Marseille (L. and L.s. 2707, at bottom, right of center, with his number: *203*); Private Collection, France; sale, Drouot, Paris, 7 June 1995, lot 65; W. M. Brady and Co., New York, and Thomas Williams Fine Art, Ltd., London (in 1995); Private Collection, United States; Michael Miller–Lucy Vivante Fine Art, Inc., New York; acquired in 1997 (D-F-501/ 1.1997.17)

Exhibitions: New York and London 1995b, no. 23

Literature: Thomas Williams and Julian Brooks in New York and London 1995b, cat. no. 23, pp. 56–57, repr.

*B*oth sides of this large late sheet by Sébastien Bourdon depict variations of banquet scenes against backgrounds of splendid palace architecture. Like the Vouet composition drawing (cat. 5), Bourdon's subject is probably taken from the Old Testament Book of Esther (7:1–6), where the biblical heroine provides a feast for her husband, King Ahasuerus of Persia, reveals her Jewish heritage, and successfully persuades him to prevent the slaughter of her people planned by the first minister Haman, who is subsequently hanged for his crimes. A final identification of the subject is hampered by the atypical characterization of the king—usually represented as a bearded older figure—who appears as a youthful monarch in both scenes; on the recto, he sits at the left end of the table, and on the verso, at the right end, encircled by his guests and musicians. In both scenes, Esther sits beside him, bringing forth her request in an affectionate manner. Haman, who appears only on the recto, is realized in a more conventional manner; a grim and shadowed figure, he stands just behind the royal couple. As he was baptized as a Huguenot (French Calvinist), Bourdon should have been familiar with the Old Testament. Nonetheless, his oeuvre contains several minor inconsistencies in its portrayal of biblical subjects.[1]

Bourdon's extraordinary stylistic mutability, as well as his dexterity at rapidly absorbing aspects of the work and techniques of other artists, has often made attributions difficult and the dating of certain works complicated.[2] Following the pattern of taste in the

French capital established by the sumptuous and decorative work of Jacques Blanchard and Simon Vouet, the paintings and drawings Bourdon executed in Paris from 1637/38 to 1645 after his return from Rome —where his works revealed the influence of the Bamboccianti—demonstrate his attraction to Venetian and north Italian artists such as Paolo Veronese, Jacopo Tintoretto, and Giovanni Benedetto Castiglione. This predilection can even be seen in works such as his *Study for the Martyrdom of St. Peter* of c. 1643 at the Fogg Art Museum, Cambridge (fig. 1), despite its connection with a well-known early composition by Poussin.[3] From the end of the 1640s through the 1650s, however, the later, severe classicism of Poussin becomes a more important component of Bourdon's compositions, as seen in such works as the *Baptism of Christ* in the Graphische Sammlung Albertina, Vienna, of c. 1655–60 (fig. 2).[4] The last decade of Bourdon's career reveals a painterly blend of these earlier influences, and the Horvitz drawing is a direct continuation of the complex figural style in the now-destroyed decorations of the Hôtel Bretonvilliers, which he painted between 1663 and 1665. Fortunately, many of his compositions from its Galerie de Phaeton, such as *La Peinture* (fig. 3), were engraved by Jacques-Antoine Friquet de Varouze.[5] Both the Bretonvilliers decorations and the exhibited drawing feature carefully posed, elongated, affected, and slightly contorted and classicizing figures wrapped in draperies replete with undulating folds. The spaciousness of Bourdon's setting in the drawing studied here, achieved by *repoussoir* figures in the foreground and a vanishing point in the distance, also suggests a late date in the artist's career.

The double-sided sheet exhibited here reveals two different levels of Bourdon's draftsmanship late in his career. The sketchy verso was presumably executed before the recto. Here, the generalized indications of

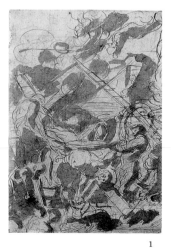

1

2

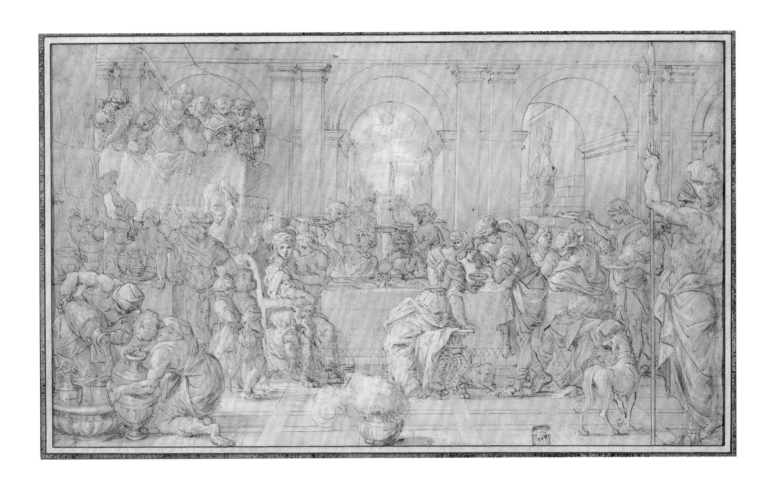

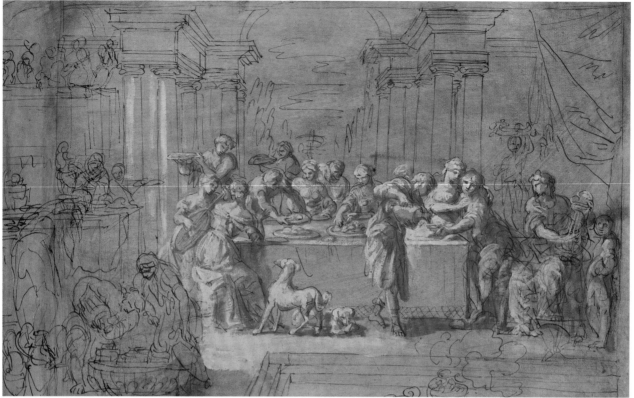

detail of cat. 15 verso

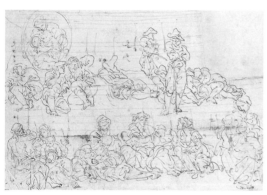

4

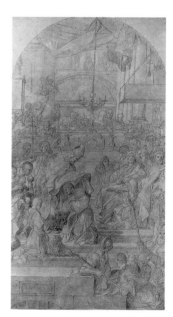

5

the setting and quickly executed contours of the figures are comparable to his *Sheet of Studies for an Adoration of the Shepherds* from the mid- to late 1650s in the Musée du Louvre, Paris (fig. 4).[6] The fluidly realized central group, which he accentuated with a combination of red oil paint and white gouache, reflects a Venetian approach to color and texture that anticipates the debate over color vs. line at the Académie in the last quarter of the century.[7] In contrast to the preliminary nature of the verso, the fastidious penwork on the recto, with its precise strokes, and the heightening with white gouache to evoke the plasticity of forms are reminiscent of his *Investiture of St. Peter Nolasco* of the late 1650s, also in the Albertina (fig. 5), where the high degree of finish points to a stage either directly before or just after the canvas.[8]

The Banquet of Esther is a relatively rare subject, but the artist was obviously less interested in the religious theme than he was in the splendor and luxury of the festive gathering. Given his continued predilection for Venetian models, banquet scenes by Veronese

may have served as an inspiration, and it seems plausible that Bourdon executed his *Banquet of Esther,* which dates stylistically to the mid-1660s, soon after the celebrated arrival of Veronese's *Banquet in the House of Simon* at Versailles (*in situ*) in 1664 as a gift to Louis XIV from the Republic of Venice.[9] The Horvitz drawing demonstrates that Bourdon skillfully mingled individual motifs from different banquet scenes by Veronese, such as the *Wedding Feast at Cana* (Musée du Louvre, Paris) and the *Feast in the House of Levi* (Galleria dell'Accademia, Venice), which he saw during his travels or knew through engravings,[10] and reveals that even in his late work, the artist remained true to his reputation of being an extremely talented *pasticheur.*[11] HW

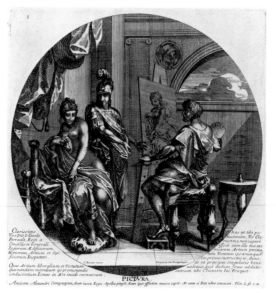

3

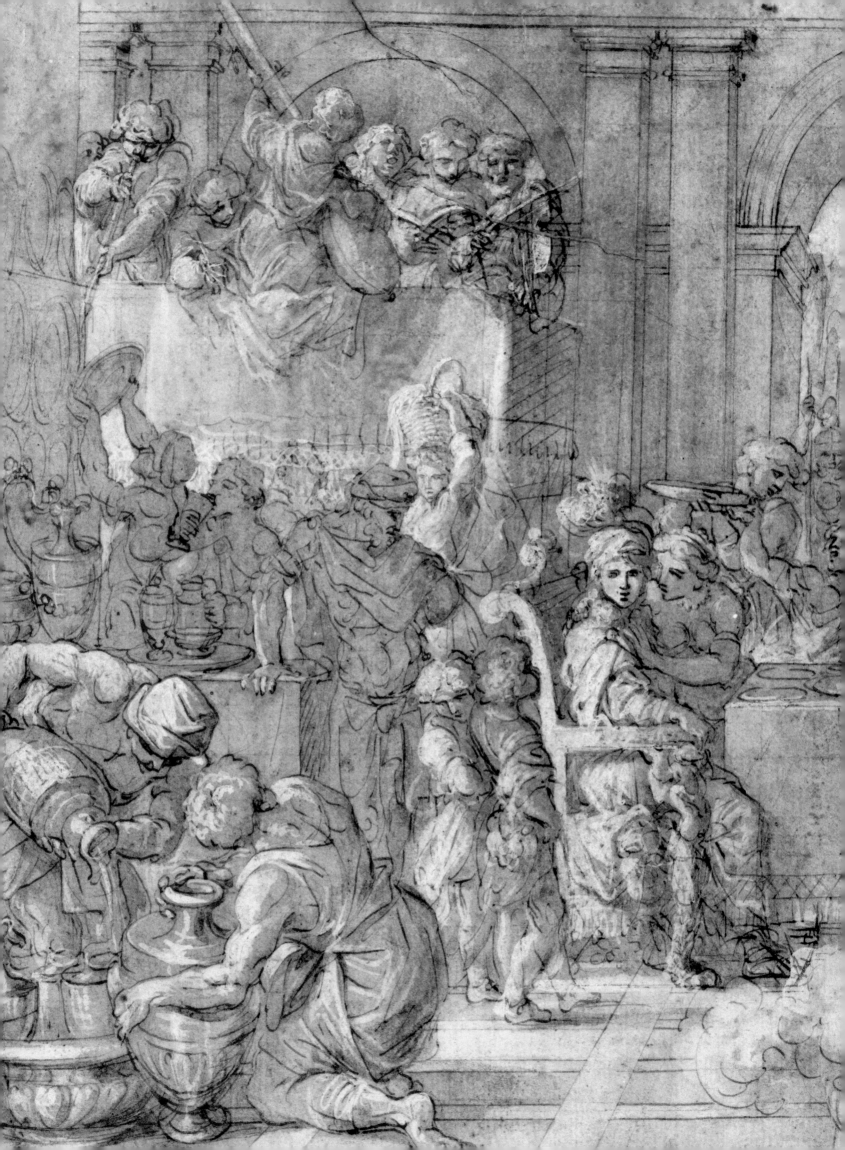

EUSTACHE LE SUEUR

Paris 1616–1655 Paris

16 *Kneeling Young Man Raising His Arm in Terror*

Black chalk heightened with white chalk on dark tan antique laid paper

345 × 256 mm.

Watermark: None

Inscriptions: In black chalk on recto of mount, bottom: *V. F. 10 – Le Sueur CMU-DSP*; in pen and brown ink on verso of mount, top: *no 112/ cette attribution est de la main de Philippe de Chennevières/ Anatole France*; in black chalk on verso of mount, bottom right: *Le Sueur*; in graphite on verso of mount, middle: *Le Sueur*; in pen and brown ink on verso of mount, middle: *Eust. Le Sueur*; in pen and black ink on verso of mount, middle: *1657*

Provenance: Charles-Philippe, marquis de Chennevières-Pointel, Paris (L. 2072, at bottom left); Anatole France, Paris; Private Collection, Paris; Galerie Jean-François Baroni, Paris; acquired in 1996 (D-F-346/ 1.1996.21)

Exhibitions: None

Literature: Chennevières 1894–97, vol. 2 (1894), p. 187; Mérot 1987, p. 391, cat. no. DM 83

2

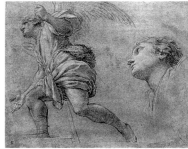

3

There is no doubt about the attribution of this vigorous study to Le Sueur. However, since it is not directly linked with any known painting by the artist, its specific purpose is not easily ascertained. Although the connections are not precise, both the style and pose of the figure in the Horvitz drawing are comparable to those in two known compositions for the now-dismantled Tobit cycle that Le Sueur painted for the Hôtel de Fieubet on the rue des Lions in Paris during 1646 and 1647. Only three of the paintings survive from the series, but fortunately several of the preparatory drawings are extant.[1] One is immediately struck by the similarity of the figure in the exhibited drawing with that of Tobias in the *Wedding Night of Tobias and Sara*, a painting now in the Banque Paribas Collection, Paris.[2] Several studies demonstrate that Le Sueur considered a number of alternatives for this canvas. One of these, a *Kneeling Man with Raised Arms* in the Musées royaux des Beaux-Arts, Brussels (fig. 1), reveals the same use of black chalk on dark paper, a comparable treatment of the drapery, and a similarly roughly sketched hand.[3] However, in the painting, he lifts his hands in front of his face as a small demon is thrown into the fireplace, while in the Brussels sheet, he only bends on one knee facing in the other direction, with both of his arms raised emphatically, in a manner that recalls a figure in the foreground of Raphael's *Death of Ananias* from the *Acts of the Apostles* tapestry series. A more convincing connection for the exhibited drawing can be found in the figure of the angel in the artist's study for the *Warrior Angel Chasing the Soldiers of Sennacherib* in the Louvre, Paris (fig. 2).[4] This finely executed composition, neatly squared for transfer, was probably for one of the paintings in the Tobit cycle heightened with gold in imitation of gilt-bronze bas-reliefs and accompanied by ornaments that decorated the spaces around the canvases in the Hôtel de Fieubet.[5] The poses of the soldier and the figure in the sheet catalogued here, both with their right arms raised in fear to protect themselves, are certainly analogous, and their differences can be understood by their disparate functions in Le Sueur's working process. The much stronger figure in the exhibited drawing is more solidly modeled and deliberately turned towards the spectator for dramatic effect, whereas Le Sueur has attenuated the figures for the illusionistic relief, and his line tends towards decorative arabesques in their draperies. This stylistic choice reflects the characteristics of what is often referred to as Parisian Atticism, a pseudo-classicism of pure linear elegance extremely popular in Paris during the regency of Anne of Austria.[6]

The robust and forthright graphic style of the *Kneeling Young Man Raising His Arm in Terror*—summary for the face and the hands, but much more highly developed for the drapery—is characteristic of Le Sueur's manner in the mid-1640s. At this time, he was completing his highly acclaimed St. Bruno cycle for the Chartreuse de Paris and was about to undertake the commission for the sumptuous decorations in the Cabinet de l'Amour of the Hôtel Lambert.[7] The Horvitz drawing and other sheets related to the Tobit cycle, such as the *Study for the Return of Tobias* in the Fogg Art Museum, Cambridge (fig. 3), bear witness to the importance Le Sueur placed on classicizing Raphaelesque models at this point in his career,[8] as he attempted to make his final break with the resplendent grace of the tempered Baroque mode of his teacher Simon Vouet.[9] AM

1

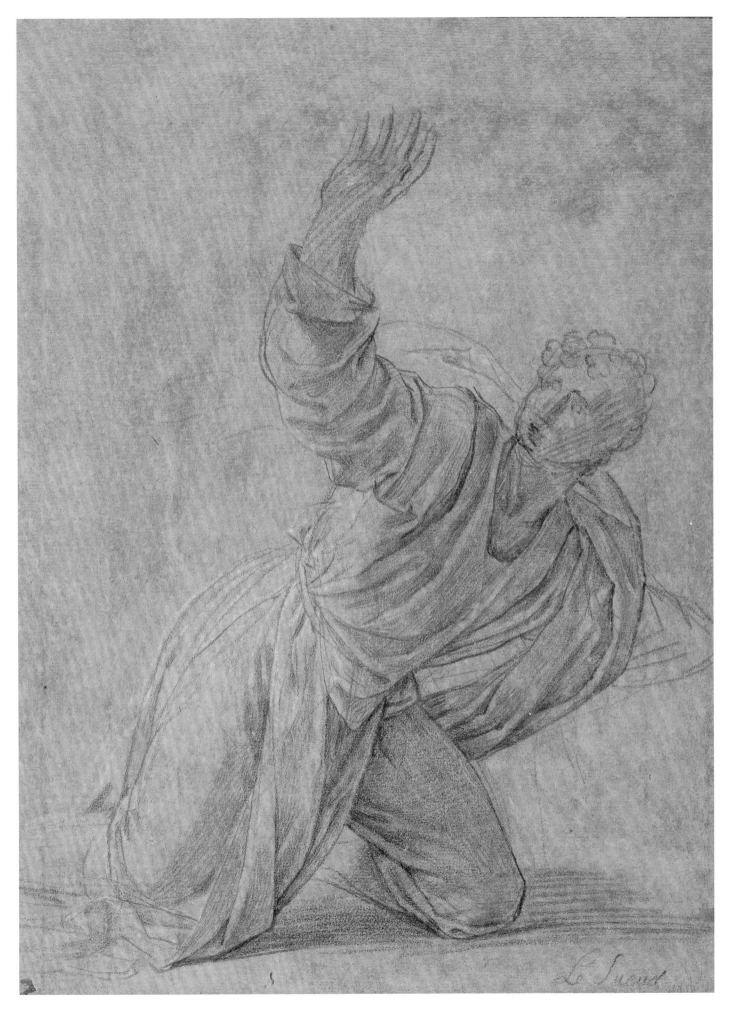

MICHEL DORIGNY

Saint-Quentin 1616–1665 Paris

17 *Massacre of Niobe's Children*

Black chalk on off-white antique laid paper (partially incised for transfer)

215 × 200 mm.

Watermark: None

Inscriptions: In pen and brown ink on verso, bottom right: *n 8*

Provenance: Jules Dupan, Geneva (L. 1440, at lower left, partially on sheet and partially on mount); his sale, Paris, 26–28 March 1840, lot 1439; Germain Seligman, New York and Paris; Private Collection, Switzerland; William Foucault, Paris (in 1991); Kate de Rothschild, London, and Galerie Didier Aaron, Paris, London, and New York (in 1993); acquired in 1993 (D-F-85/ 1.1994.5)

Exhibitions: Bern 1959, no. 191; Paris 1991b; New York et al. 1993, no. 7

Literature: Boris Lossky and J. M. Girard in Bern 1959, cat. no. 191 (n.p.) (as Vouet); Richardson 1979, cat. no. 88 (as Vouet); William Foucault in Paris 1991b, pp. 12–13, repr.; Kate de Rothschild and Alan Salz with Jill Dienst and Isabelle Mayer in New York et al. 1993, cat. no. 7 (n.p.)

Sometime in 1637, Michel Dorigny entered the atelier of Simon Vouet (cats. 5 and 6) who, as first painter to Louis XIII since his return to Paris late in 1627, was rapidly becoming the most important artist in the French capital. For twelve years, Dorigny would remain Vouet's most trusted assistant for large painted decorations and the most prolific printmaker after Vouet's celebrated compositions.[1]

This pristine Dorigny depicts a scene from Ovid's *Metamorphoses* (6:146–312), when Diana and Apollo kill the children of the boastful queen Niobe of Thebes.[2] The composition, based on one of the scenes designed by Vouet in the late 1640s for the now-destroyed lower gallery of the sumptuous *hôtel particulier* of chancellor Pierre Séguier, provides eloquent testimony as to why Vouet placed so much confidence in his young associate.[3] The high degree of finish suggests that Dorigny almost certainly executed this sheet after the completed canvas in preparation for his print of 1651 (fig. 1).[4] Three of his other composition drawings after Vouet's designs for this commission are in the Graphische Sammlung Albertina in Vienna (fig. 2),[5] and the Pierpont Morgan Library in New York (fig. 3).[6]

The Horvitz Collection also contains a study by Vouet for the head and torso of Niobe (fig. 4) that demonstrates the strong stylistic similarities between Vouet and his collaborators.[7] These affinities were reinforced by the fact that the senior assistants in his atelier became fluent in the general aspects of his manner by drawing after his compositions and participating in the actual painting of his designs for large decorative commissions.[8] Although the drawings of the senior artist and the various members of his atelier were often grouped under his name in the past, the research of Barbara Brejon de Lavergnée on the production of Vouet, Dorigny, and others has helped to identify their distinct graphic styles.[9] As the exhibited sheet reveals, Dorigny's figures have large, round, and deep-set eyes, rounded faces, hair with individually articulated strands, and heavily reinforced and curvilinear contours. In his late drawings, he also makes generous use of white heightening. In short, what Vouet often subtly suggested with his slow-moving and expansive protagonists, Dorigny translated emphatically, with crisp, hardened draperies and frozen gestures. He also had a tendency to use the pronounced short hatching strokes so dear to printmakers to create texture and to better define regions of light and shade. As the Horvitz drawing demonstrates, these skills enabled Dorigny to become an excellent general interpreter and systematic propagator of the elegance, grandeur, drama, color, and movement of Vouet's most celebrated Parisian works.

ALC

2

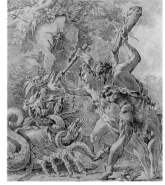

3

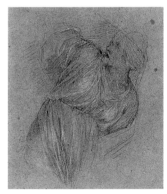

4

1

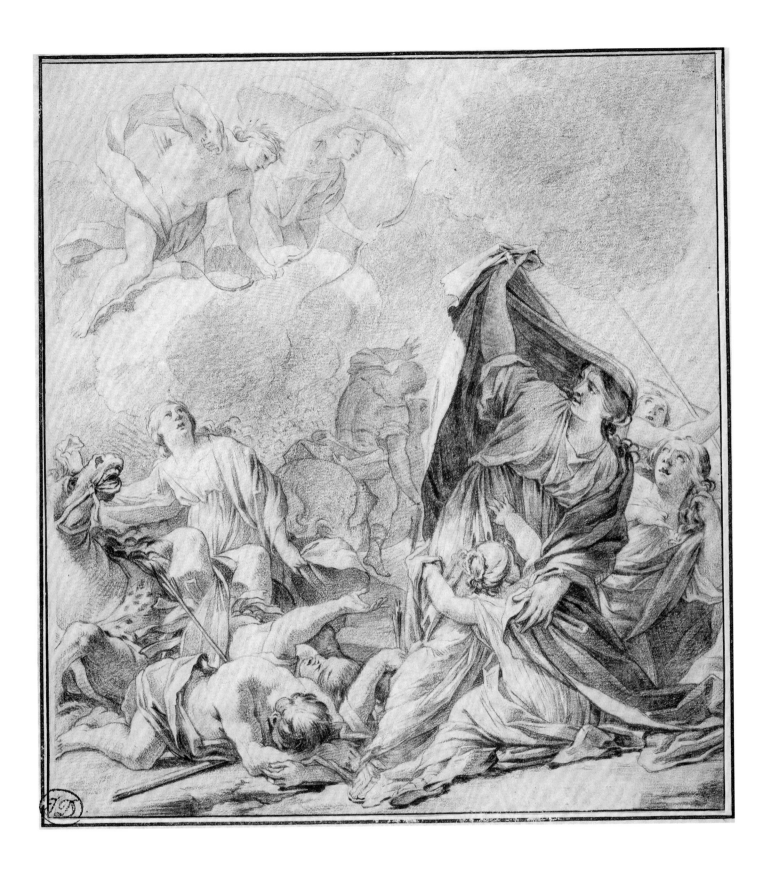

CHARLES LE BRUN

Paris 1619–1690 Paris

18 Return from Flanders

Black chalk with brush and gray wash on off-white antique laid paper; partially incised

344 × 505 mm.

Watermark: Laid down—none visible through mount

Inscriptions: None

Provenance: Jean-Denis Lempereur, Paris (L. 1740 at bottom center); Private Collection, Paris; Galerie Paul Prouté, S.A., Paris; acquired in 1996 (D-F-206/ 1.1996.38)

Exhibitions: Paris 1996b, no. 9

Literature: Hubert Prouté in Paris 1996b, cat. no. 9, pp. 20–21

Clearly cut from a larger sheet, this drawing is a study for the upper portion of a larger composition designed for the public display of the conclusions to the thesis defended at the Collège de Clermont by Jean-Baptiste Colbert, marquis de Seignelay, on 29 July 1668. An earlier, full design depicts Louis XIV—to whom the thesis was dedicated—returned from his victorious campaign in Flanders in a courtyard resembling that of the Louvre (Musée du Louvre, Paris, fig. 1).[1] Based on aspects of both drawings, as well as subsequent changes, the complete composition was engraved in reverse on two plates by François de Poilly (fig. 2).[2]

In the exhibited sheet at the left, only the hand of the man on the ladder has been cut off by the sheet's edge, while at the upper right, the end of a trumpet and the edge of the inscribed banner hanging from it show that Le Brun had originally included the figure of Fame. The top of the long scroll on which the conclusions of the thesis are written, here attached by a nail, is held in the print by the figure of Philosophy. The drawing studied here is also missing the detail of the ladders and scaffolding against the obelisk of the fountain, and the arms of the conquered provinces within the shields. In the finished design, the base of the obelisk would be simplified by the omission of the reliefs sketched here. The Louvre drawing (fig. 1), shows an early version of the same composition, with the upper part much less fully worked than the lower. The exhibited sheet has been cut so as to omit more of the right side, where the armed woman (Bellona?) ris-

ing high on the chariot would have been visible. This suggests that it may have been deliberately cut to an oval in order to remove her and to serve with only minor modifications as the final composition.

During the seventeenth century, the habit of printing the conclusions of theses with images honoring the dedicatee had developed from simple coats of arms to highly elaborate images, often designed by the most famous artists. In this case, the son of Colbert, the king's leading minister, could afford the king's *premier peintre.* In some of his earlier designs, Le Brun had broken with the tradition of enclosing the conclusions within a frame on the lower half, but only here does he succeed in incorporating them into a fully unified composition.[3]

By 1668 Le Brun was at the height of his power, enjoying the complete confidence of the king, whom he accompanied on his Flemish campaign. In 1667, after the rejection of Bernini's plans for the Louvre facade, Le Brun had been summoned by Colbert, together with the architects Claude and Charles Perrault and Louis Le Vau, to produce a new design. This facade forms the background of the drawing, while a detail of the porch and columns appears in the left foreground. In the center is the *Pyramide du Louvre,* which was to be surmounted by a bronze equestrian statue of the king by François Girardon.[4] The lower half of the larger design, as shown in the engraving, depicts Louis XIV dismounted from a chariot guided by Hercules (symbolizing Heroic Virtue), greeted by Victory and Wisdom, while an infant genius, crowned with laurel, and with a similar wreath slung on his arm, holds the bottom of the conclusions. Two putti in the foreground personify the arts of painting and sculpture, with the symbols of architecture and the products of the applied arts strewn on the ground before them.

In Le Brun's belief, drawing was the basis of all the visual arts, and the Horvitz sheet illustrates his domination of sculpture and (at least as he would have wished it) of architecture, as well as his power as a draftsman. He retains a liveliness in his line and a freedom in his application of the wash, without sacrificing the precision and clarity that would enable Poilly to copy the drawing with his burin. JM

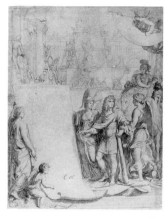

1

2

ROBERT NANTEUIL

Reims 1623–1678 Paris

19 *Rol. Burin*

Graphite on parchment

172 × 122 mm.

Inscriptions: In graphite on recto of mount, bottom: *Rob. Nanteuil Faciebat An.o 1650./ Sorori Amantissime Rol. Burin/ D. D. Dicatq./ 1650*

Provenance: Abel François Poisson, marquis de Vandières et Marigny (based on inscription on verso); Private Collection, Rouen; Frederick J. Cummings, New York; Zangrilli, Brady and Co., Ltd., New York; acquired in 1986 (D-F-206/ 1.1993.97)

Exhibitions: Cleveland et al. 1989, no. 103

Literature: Hilliard Goldfarb in Cleveland et al. 1989, cat. no. 103, pp. 201–203

*A*lthough most famous today as an indefatigable engraver of portraits, in the seventeenth century, Robert Nanteuil was also celebrated as a draftsman.[1] His early works, almost miniaturist in sensibility, reveal both his attention to Dutch and Flemish portraiture and the acute observations of an engraver. During these early years, it was fitting that he worked for Philippe de Champaigne and Abraham Bosse: he must have been in natural sympathy with their technical discipline and exactitude in rendering subjects. Executed in graphite on parchment—Nanteuil's standard combination of medium and support at this time—the exhibited drawing is at once a typical and innovative example of the artist's work during this period. His refined delicacy of draftsmanship appears in the lace trim of the shirt, more suggested than detailed; the subtly rendered border within the edge of the collar; and the fluid treatment of hair and eyes. Despite its early date, this portrait already reveals the artist's sensitivity to passing shadows and to the features of the face, as well as his habit of disciplining details of drapery and hair to the overall contour. Both of these characteristics anticipate his more mature portraits.

A certain stiffness lingers in this work from early in his career, when Nanteuil still drew portraits near the cemetery of the Innocents near the Sorbonne.[2] However, the composition is an innovative one. By this time, the artist had already established his convention of portraying bust-length figures (without hands) in an oval format, often later elaborated to include the illusion of a frame in his engravings. Here, though, as in other contemporary portrait drawings such as *John Evelyn* at Wooton House, Surrey, and *Bishop Félix Vialart* in the Musée des Beaux-Arts, Reims (fig. 1), Nanteuil depicts the bust-length figure in a three-quarter pose without recourse to the oval format.[3] All three portraits demonstrate a notable expansion of control, an increased sophistication in light effects, more naturalistic detailing, and a greater animation of the sitter than one commonly sees in earlier portraits like the *Old Woman* of 1648 in the Musée du Louvre, Paris (fig. 2).[4] Compared to the latter, the exhibited drawing, although small in scale, conveys far more of the sitter's individual personality. It also reveals Nanteuil's heightened perception of volumes, textures, and mass. The Louvre portrait looks back to prototypes such as Lagneau and the Dumonstier (cat. 3), whereas the works of 1650 come closer to the innovations of Claude Mellan.

The Horvitz Nanteuil, like many of the early portrait drawings, was not reproduced in a print, and the artist's inscription on the original mount is particularly interesting. A second version of this drawing, also on parchment—with the same dimensions, signature, date, and elegant dedication—is in the British Museum, London (fig. 3).[5] These two highly finished sheets were almost certainly commissioned by a man named Burin for each of his two sisters, as the *D.D. Dicatq.* that follows the dedicatory inscription to Burin's *Sorori Amantissime,* or "beloved sisters," confirms. Unfortunately, the fact that he had two sisters is all we know about him. HG

1

2

3

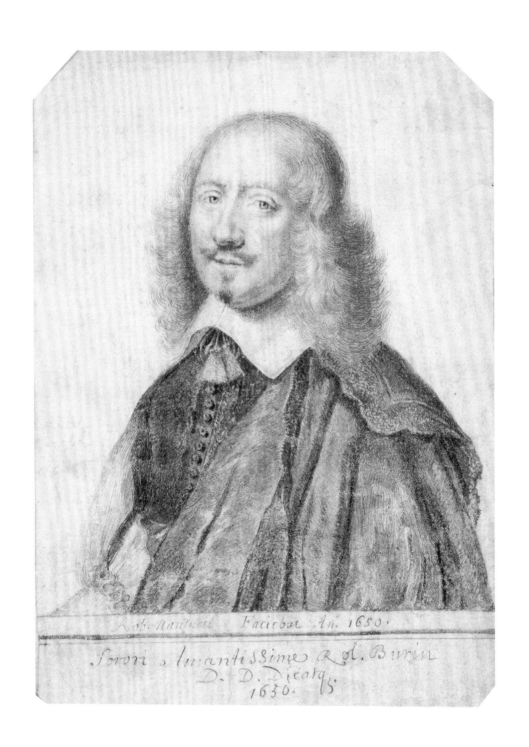

Rob. Nanteuil Faciebat An. 1650.

Sorori Amantissimæ R. N. Burin
D. D. Dicatq.
1656.

NOËL COYPEL

Paris 1628–1707 Paris

20 *Assumption of the Virgin*

Black chalk heightened with white chalk on blue antique laid paper

384 × 244 mm.

Watermark: None

Inscriptions: None

Provenance: Private Collection, Paris; Galerie Aaron-Terrades, Paris; acquired in 1989 (D-F-75/ 1.1993.66)

Exhibitions: None

Literature: Unpublished

*A*lthough Noël Coypel had an extremely distinguished career and became the founder of a dynasty of artists (see cats. 45–46), only a small number of his paintings and drawings have been identified.[1] He began his studies as a student of Pierre Poncet and Noël Quillerier, both of whom were students of Simon Vouet, but by the late 1650s, he had become the senior assistant to Charles Errard, the celebrated painter to the king who would be the first director of the French Academy in Rome. Errard's *Minerva Seated by a Cartouche with the Emblems of the Arts and Being Crowned by a Putto* (see MRC ess. frontispiece) in the Horvitz Collection reveals that he developed a severe, hard-edged, intense brand of classicism, one that was less Italianate than Poussin's and less Rubensian than Le Brun's. As this *Assumption* by Coypel demonstrates, Errard was undoubtedly a great influence on the young Noël during the pivotal years of his early maturity; Coypel gradually eschewed both the supple grace of the Vouet circle in which he was nurtured (cats. 5, 6, and 17) and the refinement of the Parisian Atticism that became popular during his youth (cat. 10).

In this scene of the Virgin being lifted into the heavens three days after her death, as recounted in Jacopo da Voragine's *Golden Legend*,[2] Coypel divided the pyramidal composition into two distinct zones that are linked only by the feet of the two lowest angels. In the upper part of the scene, the Madonna, having burst forth from her tomb, is seated on a tactile mass of clouds with her arms outstretched in ecstatic thanksgiving, as angels of every age and type sweep her heavenward. In the lower register, the twelve apostles and other early Christians standing around the tomb react with varying degrees of piety

and astonishment. Some have fallen to the ground; others have their mouths agape, and their large, long-fingered, squarish hands—one of Coypel's trademarks—are folded in prayer, lifted wide and open in praise, or thrown to the body in an effort to slow the racing of their hearts.

Although we do not know to which finished work this roughly sketched sheet relates, it can be connected with three very similar composition studies for the same subject, one in a private collection (fig. 1),[3] one in the Metropolitan Museum of Art, New York (fig. 2),[4] and one in the Marcel Puech Collection in Avignon.[5] Stylistically, the angular draperies and the voluminous figures evident in all four sheets point to Coypel's adoption of a dignified but often cumbersome form of classicism, analogous to the ponderous mode of the larger works produced by both Errard and Le Brun. This manner, which Coypel softened somewhat in his canvases, remained popular with many patrons through the last quarter of the seventeenth century. The Virgin in the upper register of all of the drawings relates to the artist's oil study for the ceiling of the sanctuary of the Invalides that was exhibited in the Salon of 1704 (Private Collection, Paris),[6] but its spandrel-shaped design makes a link with the exhibited sheet unlikely. However, perhaps it was the success of the now-destroyed Invalides composition that induced a commission for another *Assumption*, for which the Horvitz sheet and its related studies are preparatory. ALC

1

2

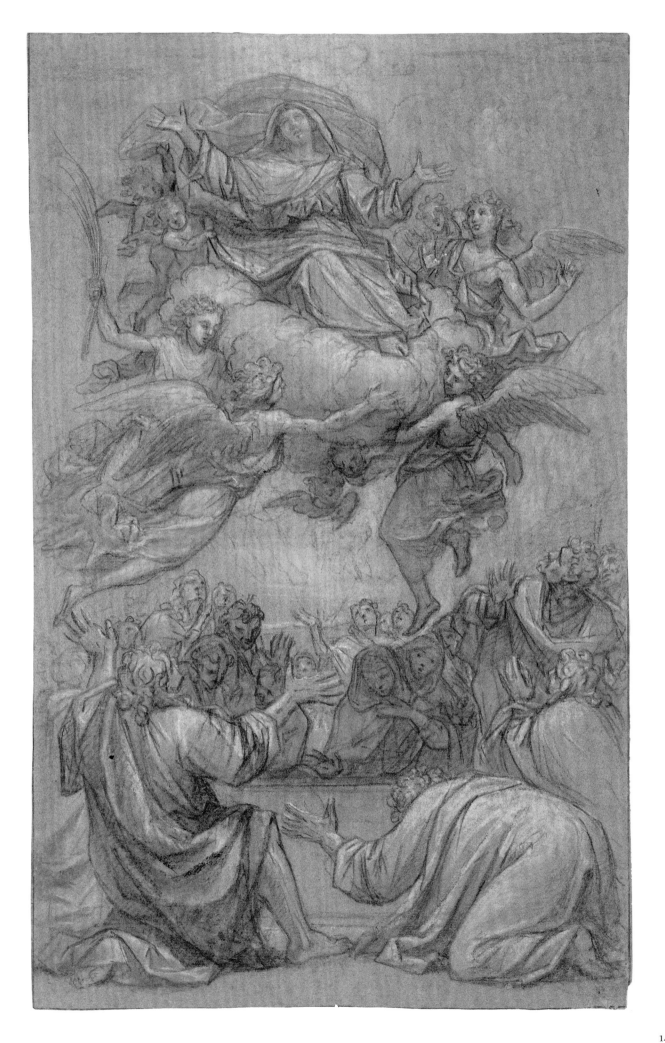

141

NICOLAS DE PLATTEMONTAGNE

Paris 1631–1706 Paris

21 *Studies for a Virgin and Child*

Red and black chalk heightened with white chalk on cream antique laid paper

184 × 273 mm.

Watermark: Laid down—none visible through mount

Inscriptions: None

Provenance: Richard Day, London; Galerie Patrick Perrin, Paris (in 1990); acquired in 1994 (D-F-244/ 1.1994.31)

Exhibitions: Paris 1990d, no. 5

Literature: Patrick Perrin in Paris 1990d, cat. no. 5 (n.p.); Prat 1991, p. 143; Narbaïts 1993, pp. 64–65

*L*ike Guillerot (cat. 22), Plattemontagne was a French artist active in the second half of the seventeenth century whose graphic oeuvre has been rediscovered in the past twenty years. Thanks to the donation made by Henri and Suzanne Baderou to the Musée des Beaux-Arts in Rouen, more than twenty of the artist's drawings that the two collectors reunited have remained together.[1] For Pierre Rosenberg and Nathalie Volle, who first published these sheets, they form "a homogeneous group that seems to have come from the atelier of the artist."[2] This seminal publication enabled us to extend our knowledge of Plattemontagne as a draftsman further than previously possible with his few known drawings, usually signed *Montagne* or *P. Montagne*.[3]

This sheet of studies reveals Plattemontagne's characteristic blend of black, red, and white chalk. He rapidly outlined the figure of Christ in the manger, who rests under the attentive eyes of Mary. However, for the Virgin, he turned to a more precise approach in which he modeled the folds of her drapery and, at the far right of the sheet, produced detailed, vigorous, realistic studies of the positions of her hands and arms. Other sheets where one can see a similar blend of media together with restudied figures and elements of a composition include the *Two Studies of a Woman Seated on the Ground Raising Her Left Hand* in the Polakovits Collection at the Ecole nationale supérieure des Beaux-Arts, Paris (fig. 1),[4] and the superb *Studies for "St. Paul in Prison"* recently acquired by the Metropolitan Museum of Art, New York (fig. 2).[5]

Although our understanding of Plattemontagne as a draftsman continues to grow, only five of his paintings are extant. This is barely one-tenth of those mentioned on the list of the artist's paintings given to the Académie in Paris by his family after the master's death.[6] This list describes only one painting with which the Horvitz drawing might be connected; there was "in 1700 and 1701, a large altarpiece for the nuns of the Visitation representing the Nativity of Our Saviour."[7] If the Horvitz study does indeed relate to this lost picture, we must see this sheet as a late work of the artist. Unfortunately, scholars have not yet determined a firm chronology of Plattemontagne's works that would enable us to give a more precise dating.

JFM

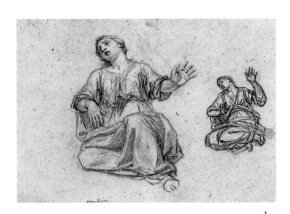

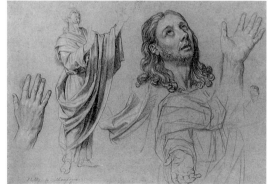

1

2

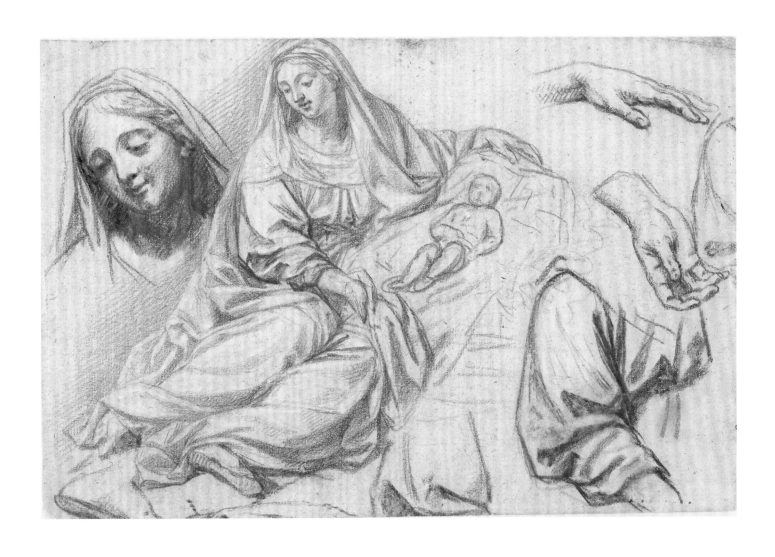

GUILLEROT

Active in Paris and Rome, second half of the seventeenth century

22 River Landscape with Dam and Floodgate

Pen and brown ink over traces of black chalk on off-white antique laid paper

204 × 283 mm.

Watermark: Laid down—none visible through mount

Inscriptions: In pen and black ink on recto of mount, bottom left: *No. 416. Guillerot fecit*; in pen and black ink on recto of mount, bottom right: *par Guillerot eleve de Bourdon*; in pen and brown ink on verso of mount, top left: *fecit*; in blue crayon on verso, top: GUILLEROT; in graphite on verso, bottom left: *45* (encircled) *I*; in pen and brown ink on verso at top right: GDBA *Avril 1975, p. 121*; in graphite on verso, across bottom: *Paysage à la plume/ Ecole française XVIIe siècle/ Collection Crozat no. 282/ Achété a la vente du peintre grenier (Janvier 1884) L4/0274 H-O 205 mm/ Le Louvre n'a pas de dessin de Guillerot qui fut un peintre de grande reputation par le livre de Papillion de La Ferté* (the rest, illegible)

Provenance: Antoine-Joseph Dézallier d'Argenville, Paris (L. 2951, with his numeration: *2802*, at left); his sale, Paris, 18–28 January 1779, part of lot 416; Claude-Jules Grenier, painter, Paris; his sale, Paris, 7–9 January 1884; Marcel Puech, Avignon, mark at bottom left; sale, Christie's, Monaco, 2 July 1993, lot 55; acquired at the sale (D-F-129/ 1.1993.185)

Exhibitions: None

Literature: Jean-François Méjanès in Paris 1993a, p. 274, under cat. no. 142; Labbé and Bicart-Sée, 1996, p. 310

*A*t first glance, this beautiful landscape appears to be a straightforward presentation of a rustic site: in the middle of a great forest, a dam has created a plane of water in a narrow valley.[1] At the right, a boat approaches, and in the center, a man prepares to close the sluice so that the eddies and currents will not overturn the small, fragile boat. This natural scene extends itself into the pastoral; in the distance, two shepherds converse not far from a herd dispersed over hilly fields crowned by immense buildings with towers. The appearance of the sea sprinkled with sailboats along the horizon at the right is unexpected.

It is only when one considers the sources of this work that one realizes how it was shaped by certain ideas. Landscapes such as the exhibited sheet evoke those conceived in sixteenth-century Venice around Giorgione, which were then developed further by Giulio and Domenico Campagnola. They are illustrations of a literary and poetic realm inspired by Jacopo Sannazaro's *Arcadia* of 1502. This ideal and harmonious world consists of elements observed in nature but restructured by the artist in his studio. The pastoral landscape tradition would continue into the beginning of the seventeenth century in Bologna with the Carracci and their circle. Although they continued the legacy of the composed landscape, the Carracci

and their students and collaborators introduced a bit more realism, and this synthesized version of the pastoral continued to the end of the seventeenth century with the works of Giovanni Francesco Grimaldi. Indeed, were it not for the inscription on the mount of this landscape, it would have been attributed to Grimaldi, as was a drawing in the Musée des Beaux-Arts, Dijon (fig. 1).[2] However, a fortuitous conjunction of recently published scholarship permits both of these sheets to be given to the hand of the mysterious Guillerot.

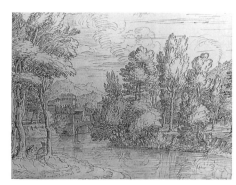

1

André Félibien, the first historian of French painting, recorded the family name—but not the Christian name—of this landscape painter whose oeuvre has slowly emerged only in the last twenty years. Félibien cited the artist in passing when he noted that "it was around this time, or a little after [the death of Jean Lemaire] that Fouquier also died; Bellin, who was his disciple, would die a little while afterwards, as would Guillerot, the landscapist who had worked under Bourdon."[3]

The collector, biographer, and art critic Antoine-Joseph Dézallier d'Argenville provided the clue to the rediscovery of the artist in the form of the inscriptions he wrote on the drawings in his collection. Next to the collector's paraph, the Horvitz sheet displays the number *2802*, which, in turn, corresponds to the number in the collector's inventory. Luckily, his system of inscriptions was identified recently by Jacqueline Labbé and Lise Bicart-Sée.[4] Their work also enables us to confirm that the *Guillerot fecit* and the *par Guillerot eleve de Bourdon*—undoubtedly information from Félibien—are also in the handwriting of Dézallier d'Argenville. We still do not know how the collector was able to bring together such a large group of the artist's drawings. The catalogue of the sale of Dézallier d'Argenville's collection that took place in 1779 cites these drawings as groups under lots 416 and 519.[5] Based on the inventory established by the collector himself, Labbé and Bicart-Sée found fourteen sheets attributed to Guillerot listed consecutively from numbers 2793 to 2807; four of these have appeared in the last eight years.[6]

Marcel Roethlisberger was the first to discover and publish material on Guillerot when he was in the midst of his monographic research on the drawings of Claude Lorrain (cat. 11). Based on the inscriptions and annotations, he has now extended the artist's oeuvre beyond the base established by those formerly in the collection of Dézallier d'Argenville.[7] JFM

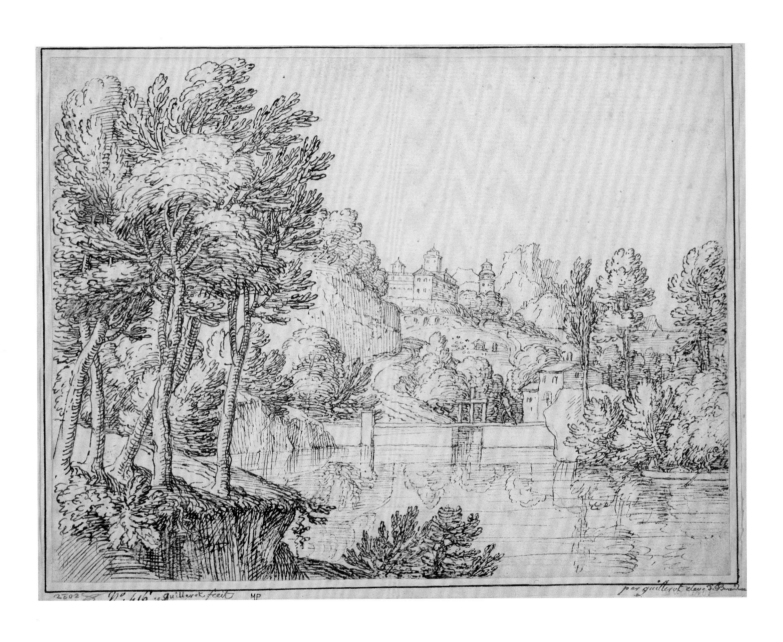

CHARLES DE LA FOSSE

Paris 1636–1716 Paris

23 *Three Female Nudes*

Verso: *Borghese Gladiator*

Red and black chalk heightened with white chalk on cream antique laid paper (recto); black chalk (verso, not exhibited)

426 × 263 mm. (top left corner made up)

Watermark: Variant of Gaudriault 959 (also see Heawood 2241 and 2289)

Inscriptions: None

Provenance: Sale, Christie's, London, 10 October 1979, lot 170; Private Collection, New York; Zangrilli, Brady and Co., Ltd., New York; acquired in 1986 (D-F-145/ 1.1993.72)

Exhibitions: New York 1986

Literature: W. M. Brady in New York 1986

This sheet of studies depicts three female nudes in elegant contrapposto poses viewed from below.[1] It is a typical example of La Fosse's preparation for complex, multifigure, mythological ceiling designs. Several of these studies have survived; in them, the artist often clusters more than one figure on the same sheet, either in compositionally related positions or, as here, in looser groupings.[2] Although they are often difficult to date, or to relate to a specific commission, the majority of these studies date from the artist's maturity (c. 1680 onward), when La Fosse became the foremost decorative painter in France following the fall from favor and eventual death of his teacher, Charles Le Brun (d. 1690), and the latter's aging rival, Pierre Mignard (d. 1695).

When this drawing first resurfaced, the figures were compared to the muses in La Fosse's *Apollo and the Muses*, his ceiling composition for Charles Perrault's Cabinet des Beaux-Arts. The ceiling was engraved twice: an overall view by Juan Dolivart and a detail view of the central composition by Louis de Chastillon (fig. 1).[3] The pose of the top figure on the present sheet resembles Melpomene, muse of tragedy, but here depicts Cybele, goddess of the earth, with her characteristic citadel-like headdress. When related to similar representations by La Fosse, the middle figure wearing a diadem may be identified as Juno, queen of the gods,[4] and the bottom left figure in profile may be compared to other depictions of Diana in the sketches and oil studies for the *Birth of Minerva* in the Musée des Arts Decoratifs in Paris, the Hessisches Landesmuseum in Darmstadt (fig. 2),[5] and private collections in France and London.[6] The poses of the figures on this sheet do not, however, correlate exactly to the

figures in any of these thematically related designs, and the similarities are too general to enable the present study to be attached definitively to any one specific scheme.

The immediacy of the poses of the foreshortened figures in the exhibited drawing probably results from a particular aspect of La Fosse's working process, as recorded by one of his anonymous biographers, who noted that La Fosse drew after clay figurines positioned above in the studio, rather than calculating the foreshortening according to the rules of optics and perspective.[7] The subsidiary study of the leg illustrates another tendency of the artist when drawing figures. One might speculate that when he was about to run out of paper, he included the missing part as a subsidiary sketch, as in the *Three Young Genies* in the Musée des Beaux-Arts, Dijon, and the *Sheet of Studies* in the Musée du Louvre, Paris (fig. 3).[8]

While the figures in the Horvitz sheet eschew the heavier manner that marks some of La Fosse's draftsmanship—a trait for which he was criticized by his contemporaries—they demonstrate his skill with the *trois-crayons* technique, the subtle blending of black, red, and white chalk to define volumes.[9] Inspired by the example of Rubens, La Fosse broke away from the linearity of the Poussinesque seventeenth-century ideal established by his teacher Le Brun at the Académie and focused on the expressive and formal potential of color. Commenting on his achievement, the renowned amateur Antoine-Joseph Dézallier d'Argenville noted that "La Fosse's drawings are full of color and have the same effect as his paintings."[10] The subtle *trois-crayons* technique helped to raise the status of drawing as an independent art form in France and prefigured the achievements of Watteau in the early eighteenth century. JH

1

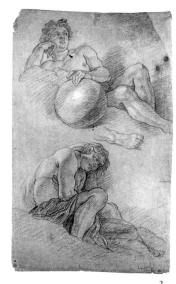

3

2

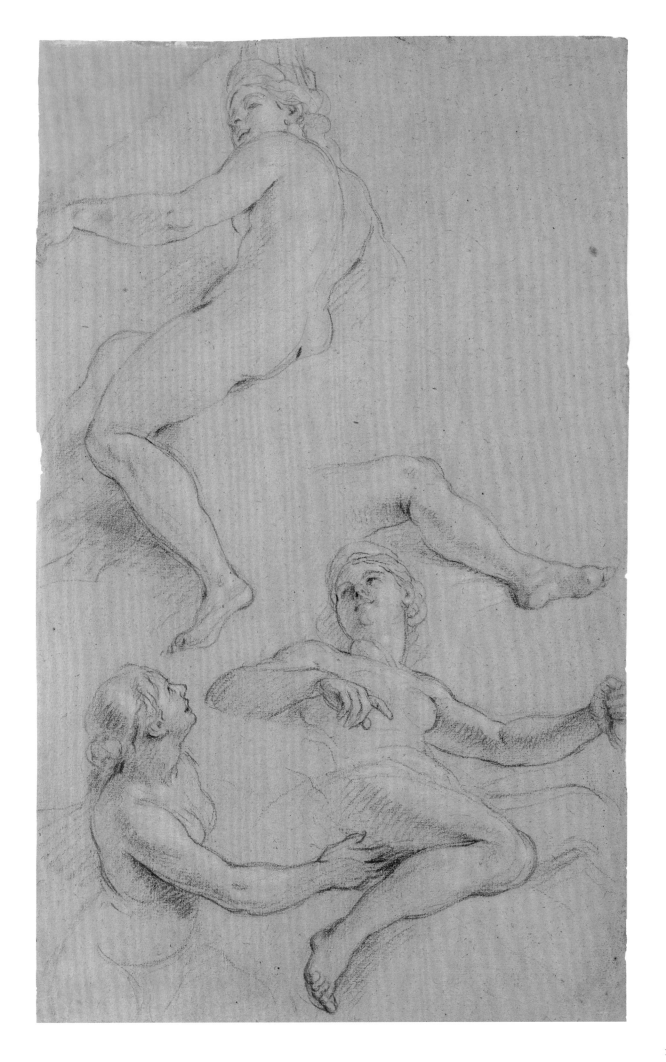

MICHEL II CORNEILLE

Paris 1642–1708 Paris

24 *Sheet of Studies*

Black chalk heightened with white chalk on lightly faded blue antique laid paper

305 × 269 mm.

Watermark: None

Inscriptions: None

Provenance: Pierre Guéraud, Paris (his mark at bottom left, not in Lugt); his sale, Drouot, Paris, 20 November 1977, lot 145; Private Collection, Paris; Galerie Emmanuel Moatti, Paris, in 1992; acquired in 1994 (D-F-68/ 1.1994.24)

Exhibitions: Paris 1992c, no. 4

Literature: Emmanuel Moatti in Paris 1992c, cat. no. 4 (n.p.)

Michel II Corneille was one of the most prolific and varied draftsmen of his generation (see cat. 25), making scores of drawings of all types in preparation for his own paintings, and hundreds of copies after the paintings and drawings of great Italian masters in preparation for prints.[1] This drawing is a particularly rich example of one type that has become associated with Corneille's name in recent years: the sheet overflowing with miscellaneous studies, mainly of heads and hands, through which he worked out details of pose and expression for his compositions.[2]

Some of these study sheets are quite refined in their execution and organization; others, like the exhibited drawing, are more spontaneous and have a charmingly unpremeditated quality to them. Here, Corneille seems to have begun with the largest study in the middle of the page, but the exact order of the succeeding sketches cannot be determined. He may have continued with the three quick jottings of the head of the angel facing to the left—possibly, but not certainly, alternate ideas for the same figure—before

drawing the three variations of the angel looking to the right in the upper left corner of the sheet. The two separate studies of eyes at the top of the page are also related to Corneille's work on the angels' heads, as are the five delightful studies of wings filling the corners at upper and lower right. Perhaps he then moved on to the apparently unrelated study of a sandaled foot and to the delineation of the head and hands of a bearded man.

We do not know whether all the studies on the exhibited drawing were made in preparation for a single composition or reflect instead Corneille's ideas for multiple works because, as with so many other sheets of this type, the present drawing has not yet been linked to any of his known projects. Its attribution to Corneille is secure, however, for it is closely comparable in every respect to sheets of studies in the Prat Collection, Paris (fig. 1),[3] the Musée du Louvre, Paris (fig. 2),[4] and the Musée Fabre, Montpellier (fig. 3).[5] The latter is connected to his designs for a tapestry depicting the *Judgment of Paris,* begun in 1684.[6] Based on the stylistic similarities, the Horvitz drawing may reasonably be dated to approximately the same period. MMG

1

2

3

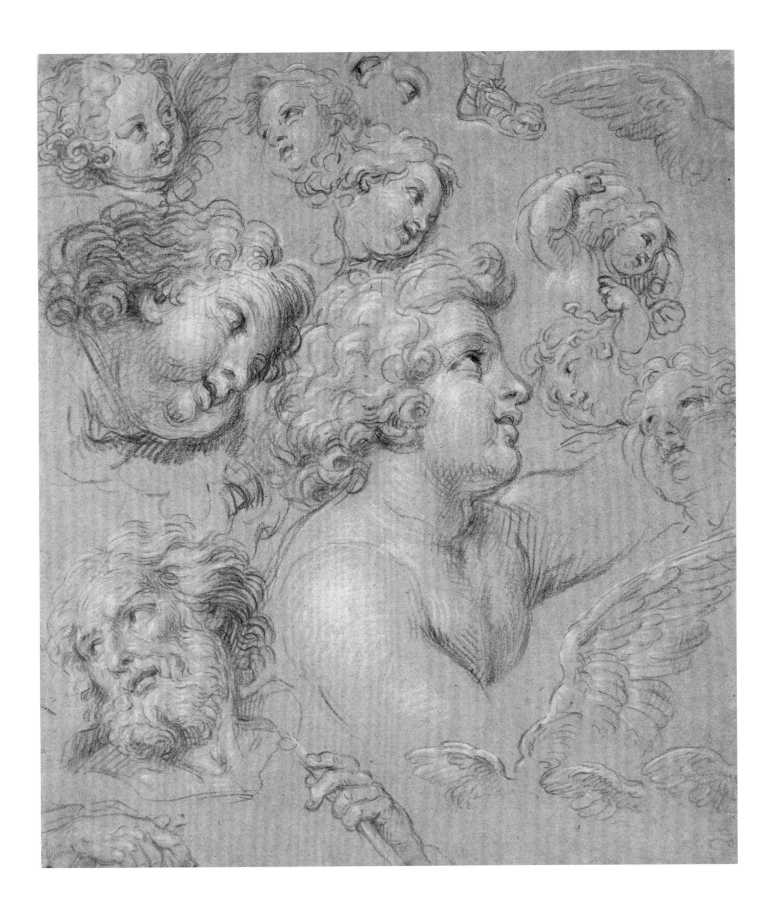

149

MICHEL II CORNEILLE

Paris 1642–1708 Paris

25 Arrival of Aesculapius in Rome

Pen and black and brown ink with brush and brown wash over black chalk on off-white antique laid paper

497 × 420 mm.

Watermark: Laid down—none visible through mount

Inscriptions: In graphite on verso of mount, top right: *1624*; in pen and brown ink on verso of mount, lower left: *B8*; in graphite on verso of mount, upper left: *G* (?) *107* (crossed out); in pen and brown ink on verso of mount, upper left, *Corneille*

Provenance: Sale, Christie's, New York, 30 January 1997, lot 126; acquired at the sale (D-F-505/ 1.1997.1)

Exhibitions: None

Literature: Unpublished

*T*he story of Aesculapius is told in Ovid's *Metamorphoses* (15:626–744).[1] When a deadly plague was decimating the Roman population, civic leaders sought help from the gods. After first consulting the oracle at Delphi—sacred to Apollo, god of healing—they were sent on to Epidaurus and the shrine of Apollo's son, Aesculapius, who was also worshipped as a healer. There, Aesculapius appeared to the Romans in a dream and declared that he would come in the form of an enormous serpent (or dragon) to help them.[2] Having then appeared at his shrine in that guise, he was transported to Rome by ship, resumed his normal form, and quickly restored the Roman people to health.

As this drawing demonstrates, Corneille was a gifted and accurate storyteller. He enriched the simple scene of Aesculapius's arrival with a number of descriptive details that help to identify its subject.[3] The composition shows Apollo presiding over the arrival of his dragon-son, who is escorted on the left by the Roman soldiers who went to seek his help, and greeted on the right by a woman personifying Rome. Some of the citizens surrounding the figure of Rome have been stricken by the plague, but others express their joy and relief at the arrival of their unusual savior. The odd, vaselike object visible behind the soldiers at left is the prow of the ship that transported Aesculapius from Epidaurus to Rome.

Whereas Corneille generally used chalk for his studies of heads and hands (cat. 24), for his composition studies he preferred to draw in ink and wash, often heightened with white gouache. His facility with both pen and brush is amply illustrated in the exhibited drawing, especially in the swift, calligraphic pen strokes that animate and characterize each of the figures. Early in his career, Corneille was deeply

influenced by the classicizing restraint of Poussin, Le Brun, and masters of the Italian Renaissance, resulting in an accomplished, yet somewhat cumbersome manner, as seen in highly finished sheets like his *Breaking Ground for the Erection of the Cross* in the Detroit Institute of Arts.[4] Perhaps influenced by the animated draftsmanship of his brother, Jean-Baptiste, he soon adopted a lighter touch and a livelier idiom, a development that to some extent prefigured the less ponderous tastes of the next century.[5] Stylistically, the unusual technique of the exhibited sheet, with its open penwork and bold brush strokes, relates to two large, unpublished drawings executed in the same media, *Christ Chasing the Merchants from the Temple* (?) in the Städelsches Kunstinstitut, Frankfurt (fig. 1, detail), and *Christ and the Woman of Samaria* in the Hessisches Landesmuseum, Darmstadt (fig. 2).[6] Together with the drawing studied here, they form a coherent group that combines elements of both the old and the new that seem to belong to the last years of the seventeenth century (c. 1690).

The story of Aesculapius is an uncommon one in art, and no other drawings or paintings of this subject by Corneille are known.[7] The fact that the same episode, differently interpreted, was illustrated in a 1676 edition of the *Metamorphoses* suggests that Corneille's drawing, too, may have been designed for book illustration, although its scale suggests a more lavish project.[8] The 1676 print, unsigned but probably designed and engraved by François Chauveau (fig. 3), may have been known to Corneille, for the dragonlike serpent is similar to the one in the Horvitz drawing, as is the strangely shaped ship's prow. If Corneille's composition was indeed made as an illustration for a new edition of Ovid, the project must have been abandoned, for no related print or book is known. MMG

1

2

3

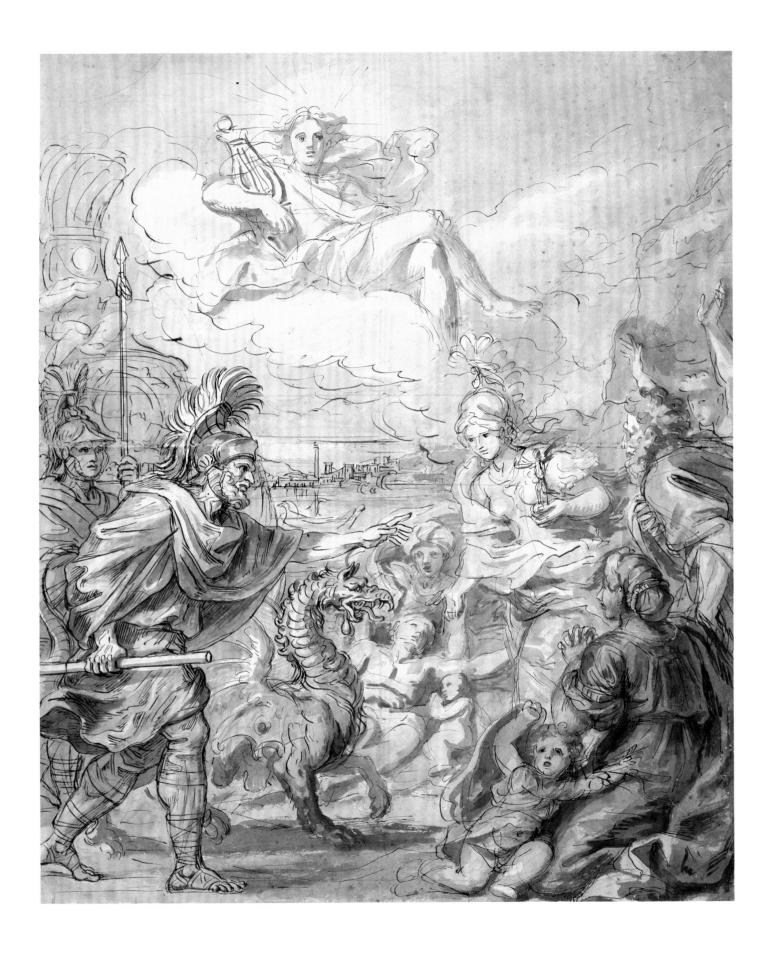

PIERRE-ANTOINE PATEL LE JEUNE

Paris 1648–1707 Paris

26 *Winter Landscape*

Gouache on parchment

155 × 267 mm.

Inscriptions: In white gouache on recto, signed bottom left: *AP/PATEL/1688*

Provenance: Private Collection; Colnaghi, New York; acquired in 1995 (D-F-228/ 1.1995.22)

Exhibitions: New York 1990, no. 17

Literature: Stephen Ongpin in New York 1990, pp. 79–83; Stephen Ongpin in New York and London 1998, under cat. no. 27 (n.p.)

*P*ierre-Antoine Patel le jeune, son of the landscapist Pierre Patel l'aîné, also specialized in landscape. This charming view by the younger Patel is characteristic of his singular approach to the depiction of nature late in his career, after the death of his father. Reflecting the trend toward the use of colored media at the end of the seventeenth century in France, which was influenced by the color vs. line debates at the Académie, Pierre-Antoine produced compact and highly detailed compositions elaborately finished with gouache on parchment. The preference for gouache differentiates the works of the younger Patel from those of his father, who always used chalk. A dozen of Pierre-Antoine's innovative works have resurfaced, all about the same size as the exhibited drawing; almost all are signed and dated from c. 1680 to c. 1695.[1] Compositionally, these gouaches are similar to his only known independent commission, a series of paintings representing the twelve months of the year that decorated one of the private rooms of the Jesuit church of Saint-Paul–Saint-Louis.[2]

When Pierre-Jean Mariette referred to the elder Patel as "the Claude of France," he also noted that people often confused the works of father and son.[3] The emergence of a group of chalk drawings has clarified their differences.[4] The elder Patel's comparatively heavy, undulating contours created large volumes in somewhat formulaic, open compositions with low horizon lines. However, when Pierre-Antoine used chalks, his lighter and more feathery touch generated compositions that rest on the surface of the sheet. His designs were usually more complex with higher horizon lines, and his thin line did not attempt to render the same massive volumes.[5] Some of these qualities can also be observed in his gouaches.

The Horvitz Patel reveals how Pierre-Antoine usually filled his mature gouaches with small, attenuated, and sketchily rendered figures dwarfed by the sky and a mixture of ruins and contemporary structures. In this composition and similar winter scenes in the National Gallery of Scotland, Edinburgh (fig. 1),[6] and in a private British collection (fig. 2)[7], where many of the compositional elements seen here are repeated, Patel carefully framed the composition with a *repoussoir* of ruins and foreground details, gracefully leading the eye up the sheet and into the distance. In terms of technique, he first used broad areas of deeply colored gouache as a base and then built the composition with thinner layers of lighter colors. Finally, he heightened the design with stretches of white gouache of varying density in order to evoke both the expanses of frost on the ice and the volumes of the deepest pockets of snow. For other areas, he used thin, wiry lines of white gouache to detail the effect of fragile ridges of snow resting in the cracks and on the edges of the buildings and vegetation. The result is an alluring view that rests between the idyllic and the fantastic. ALC

1

2

LOUIS DE BOULLOGNE

Paris 1654–1733 Paris

27 *Standing Male Nude with Raised Arm*

Black and white chalk on blue antique laid paper

433 × 319 mm.

Watermark: Laid down—none visible through mount

Inscriptions: In black chalk on recto, bottom center: *LB*; in graphite on recto, bottom center: *2 pendants, no. 1*

Provenance: Sale, Christie's, Monaco, 30 June 1995, lot 87; acquired at the sale (D-F-36/ 1.1995.88)

Exhibitions: None

Literature: Unpublished

*T*he letters *LB* written in black chalk at the bottom of the page immediately identify the author of this study as the younger Louis de Boullogne, who frequently signed his drawings in this way. Even without those initials, however, his authorship would have been clear, for the drawing is perfectly typical of his work in every way. The particular combination of media, for example—black and white chalk on blue paper—was his favorite, and he commonly used it for both figure studies and compositions.[1] Furthermore, the way the chalks are combined on the page, with strong, mobile strokes that ripple along the contours, tight black zigzags that mark the darkest shadows, and densely crosshatched patches of white that bathe the figure in light are all characteristic of the artist's hand.

Many of Boullogne's studies of the male nude were drawn as academic exercises when he was serving as professor at the Académie's life-drawing sessions between 1694 and 1715. Those formal nudes, or *académies,* present the entire figure from head to toe and are clearly complete, finished works in themselves. The figure exhibited here, by contrast, is drawn with considerable spontaneity and verve, and is shown in only three-quarter length. A number of pentimenti along the contours of the figure's back and left arm and visible changes in the position of the head suggest that Boullogne was searching here for just the right pose for a particular composition. Although the contrapposto stance and uplifted arm recall the kind of pose often given John the Baptist in

a Baptism of Christ, the closest comparison is actually a figure who appears in reverse in a preparatory study for a *Bacchus and Ariadne* of c. 1700 (Musée du Louvre, Paris, fig. 1).[2] However, no precise connection for the exhibited figure can be made with any of Boullogne's known paintings.

Since no systematic study has yet been published of either his paintings or drawings, other than those in the Louvre, dating an unconnected drawing like the one studied here can be problematic. Boullogne sometimes dated his *académies*—none before 1694 and none after 1715—during the years he served as a professor at the Académie, and other studies can sometimes be dated through connections with documented projects. The exhibited drawing has much in common with a study of an angel made by Boullogne in preparation for the decorations of the Invalides in about 1703–4 (Musée du Louvre, Paris, fig. 2)[3] and shares many characteristics with a *Double Académie,* dated 1710, now in the Museum of the Rhode Island School of Design, Providence (fig. 3).[4] A date for the Horvitz drawing in the first decade of the eighteenth century, when Boullogne was at the height of his powers as a draftsman, is likely. MMG

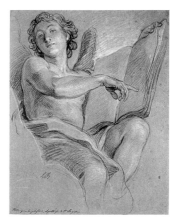

2

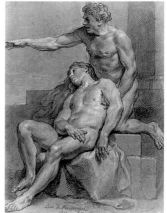

3

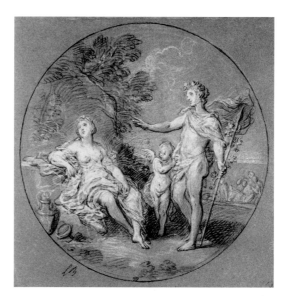

1

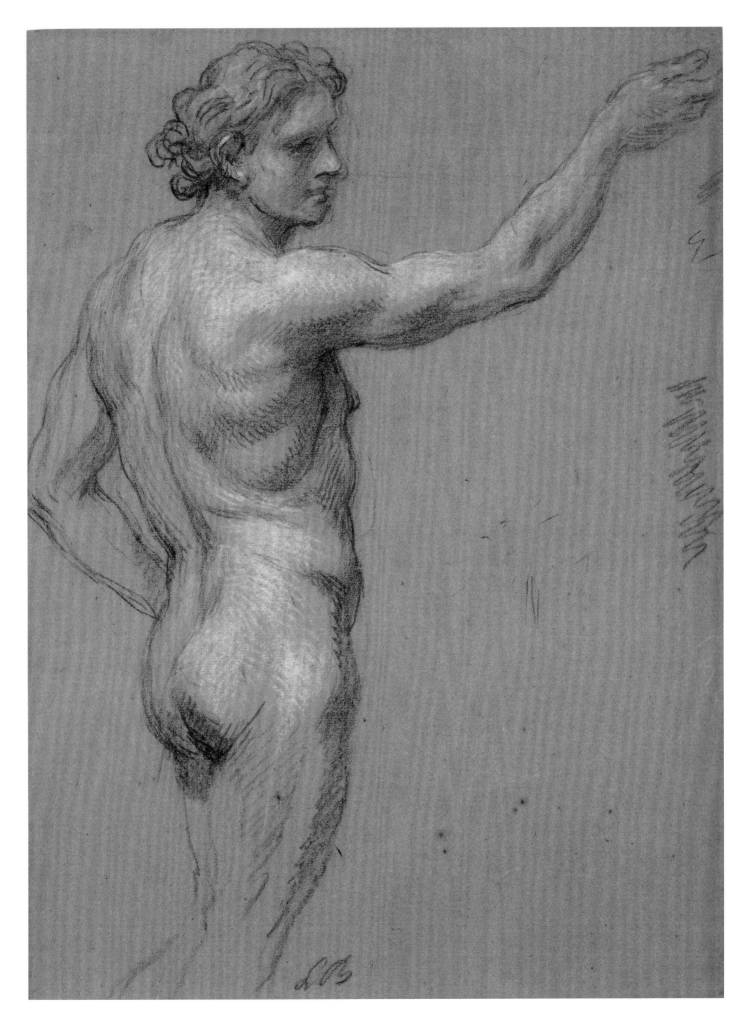

HYACINTHE RIGAUD & CHARLES VIENNOT (?)

Perpignan 1659–1743 Paris Active in Paris, c. 1700

28 *Portrait of a Lady*

Black chalk stumped and heightened with white gouache on faded blue antique laid paper

375 × 289 mm.

Watermark: Laid down—none visible through mount

Inscriptions: In graphite on verso of mount, top left: *6* / *NV 17747* / *25,000.* / *attr. to Largillière* / *268* (in a square stamp) *1*; in red crayon on verso of mount, bottom left: *67*; in graphite on verso of mount, center: *156*; in graphite on verso of mount, middle right: *Ch 4* (encircled)

Provenance: Private Collection, Paris; Galerie de Staël, Paris; acquired in 1989 (D-F-260/ 1.1993.152)

Exhibitions: None

Literature: Unpublished

*T*he highly finished portrait drawings on blue paper produced by Hyacinthe Rigaud and members of his studio were made for three principal reasons: as records of the paintings that were produced in Rigaud's atelier, forming a kind of *Liber veritatis;* as models for engravings; and as examples of stock poses and props from which prospective customers could choose the types of portraits they would like to have made for them. All were copies made after finished paintings; none were made as preparatory studies.

A few of the drawings, like the *Portrait of Samuel Bernard* at the Nelson-Atkins Museum (fig. 1), were certainly made by Rigaud himself, but most were produced by others.[1] Indeed, Rigaud's own account books list three separate payments for copy drawings: in 1700, Rigaud paid Charles Viennot for twenty-four drawings; in 1707 and 1708, he paid an artist named Monmorency for a total of twenty more drawings.[2] Rigaud himself may then have put the finishing touches on many of these drawings, for a will drawn up for him in 1731 makes mention of "a portfolio of drawings after the portraits made by the Testator and *which he retouched.*"[3]

The drawing exhibited here appears to be one of those that Rigaud retouched, for the elegant handling of the white gouache picks out details of lace and ornament in the lady's costume and delineates the petals of the various flowers in a particularly masterful way. This stands out against the handsome but more workmanlike treatment of the draperies. Rigaud may also have refined the treatment of the face by softening the shadows and adding the white highlights that give a spark of life to the image.

The costume and hairstyle of the unidentified sitter in the drawing studied here seem to be consistent with the prevailing fashions in the 1690s, suggesting that this could be one of the twenty-four copy portraits for which Viennot was paid in 1700. Viennot's drawing style is still hardly known, but many aspects of this drawing seem consistent with the small group that is beginning to be assembled under his name, including works such as the *Portrait of a Man,* in the Yale University Art Gallery, New Haven (fig. 2).[4]

Since Rigaud, like so many of his contemporaries, often repeated poses, costumes, and props in his portraits, it is not surprising that a painting by Rigaud—or his studio—in the Nelson-Atkins Museum of Art, Kansas City, shows a woman, wearing a similar costume, in the same pose as that seen in this drawing (fig. 3).[5] That woman, who bears no resemblance to the sitter in the portrait exhibited here, has been identified as the marquise d'Usson de Bonnac. Given the practices in Rigaud's studio and the fact that he kept drawings to show to prospective patrons, it is tempting to suggest that the marquise's decision to have herself portrayed in this particular way was made after she was shown what is now the Horvitz drawing.

MMG

1

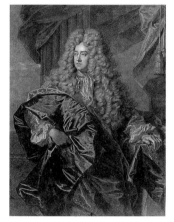

2

3

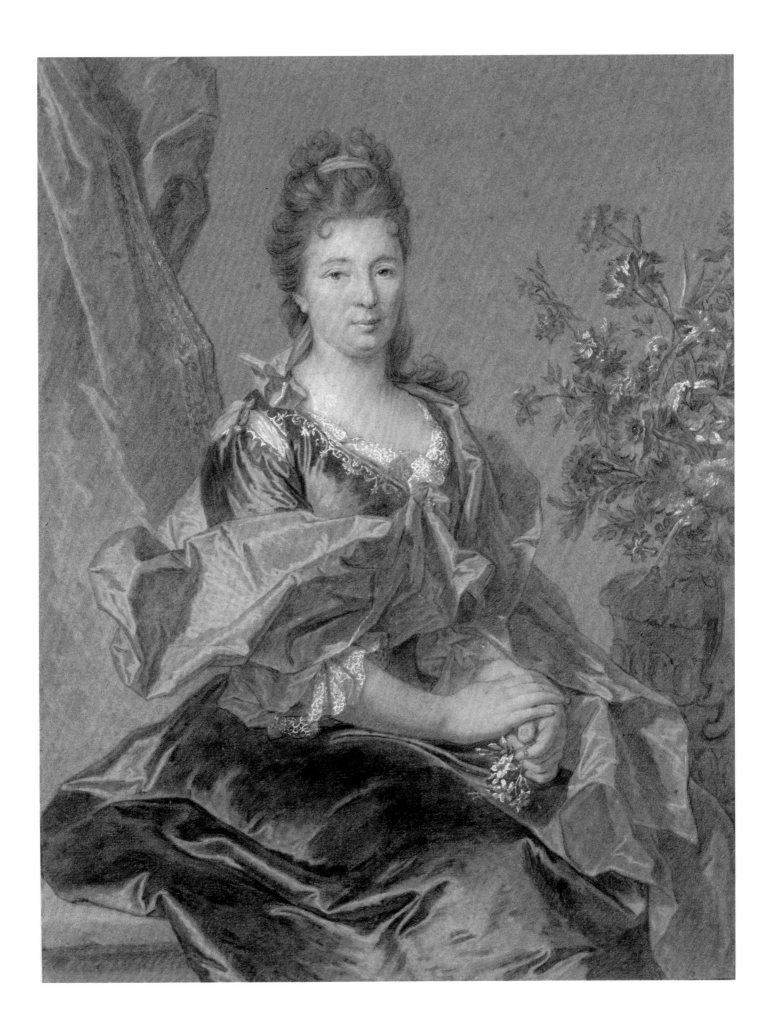

LOUIS CHÉRON

Paris 1660–1725 London (United Kingdom)

29 *Dorinda and Silvio*

Pen and brown ink with brush and brown wash, heightened with white gouache, on blue-green antique laid paper

250 × 245 mm. (circular)

Watermark: Laid down—none visible through mount

Inscriptions: In pen and brown ink on recto of mount, bottom center: *Luigi Cheron*; in pen and brown ink on verso of mount, bottom left: *Pastor Fido-act 2*

Provenance: Collection of the artist (?); his estate sale, 28 February 1726, perhaps part of lot 77 or 78; John Thane, London (L. 1544 and 2394, at lower left); Sir Thomas Lawrence, London (L. 2445, at bottom center); perhaps Mrs. E. E. Dakeyne, Granit Field, Dun Loaghaire, Dublin; C. R. Rudolf, London (L.s. 2811b); his sale, Sotheby's, London, 19 May 1977, lot 173; Hazlitt, Gooden and Fox, Ltd., London; acquired in 1994 (D-F-56/ 1.1994.42)

Exhibitions: None

Literature: Pierre Rosenberg in Paris 1989a, under cat. no. 55, pp. 150–51

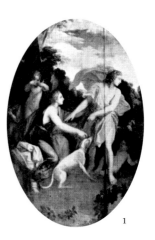

1

Although Chéron has long been neglected, the artist's hand is now easy to recognize. His finished drawings reveal strong but fluid contours in pen and ink, amply supplemented with wash and gouache. Often, he delineates subsidiary details of the figures with dashed lines. These are visible in *Dorinda and Silvio* on the hound's rib cage and on the legs and arms of the young hunter.[1] Chéron's manner and technique reveal him to be a typical artist of the Transition.[2] The heavy line and the classicizing features of his work recall his student years at the Académie under Le Brun (where he won the Prix de Rome in 1678) and his long sojourn in Italy (where he won first prize at the Accademia di San Luca, Rome). At the same time, the grace of his figures announces the refinements of early eighteenth-century talents like François Le Moyne (cats. 40–42).[3] Here, in the exhibited drawing, Chéron's use of his traditional media on blue paper adds a warmth and softness that evokes the *colore* of the work of north Italian artists, which he must have studied during his travels.[4] The Horvitz drawing illustrates that Chéron developed one of the most elegant styles of his generation. The suavity of his compositions was noted by Dézallier d'Argenville, who had an unabashed passion for Chéron's facility of invention and what he considered to be a level of taste rarely seen among his contemporaries.[5]

Although Chéron's chronology has not yet been established, this sheet is surely late in, or after, his stay in Italy.[6] It probably dates to his three decades in England, where he sought refuge in 1693 after the Revocation of the Edict of Nantes in 1685, since he refused to follow the path of his famous sister—the painter and poet Elisabeth-Sophie Chéron—and abjure the Protestant faith.[7] This drawing is comparable to finished sheets, bound into an album in the British Museum, London, related to commissions he received during his very successful English career.[8]

Although the event depicted here appears at first to be Venus delaying Adonis's departure for the hunt,[9] based on the relationship of the Horvitz sheet to other round drawings detailed in the sale catalogue of the artist's studio after his death,[10] the actual source must be the text of Giambattista Guarini's internationally celebrated pastoral tragicomedy, *Il Pastor Fido*.[11] Chéron was recorded as being paid for scenes based on this popular work for William, first duke of Devonshire, and the Horvitz sheet appears to be the *modello* for a composition executed for the Gallery at Chatsworth (fig. 1).[12] It almost certainly depicts Silvio, the hunter cherished by Dorinda; she is as devoted to him as he is contemptuous of her. Rendering an encounter between these two protagonists would naturally occasion similarities to famous works interpreting the story of Venus and Adonis, but Chéron's success with this composition lies in its original grouping of the figures in a manner appropriate to the particulars of this story, in which Silvio, who does not wish to stay, looks away and hastens to depart for the hunt.[13] Unlike Adonis, he is not torn between two desires. Another sheet from this series with the same provenance, *Shepherds Praying to the Goddess Diana*, is now in the Polakovits Collection in the Ecole nationale supérieure des Beaux-Arts, Paris (fig. 2).[14] As Pierre Rosenberg has noted, these drawings reveal that although Chéron may not always attempt to seduce, both his precision and his elegant *mise-en-page* deserve respect.[15] ALC

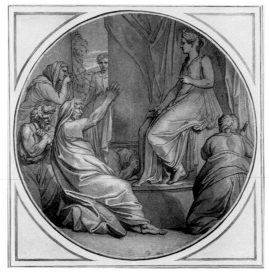

2

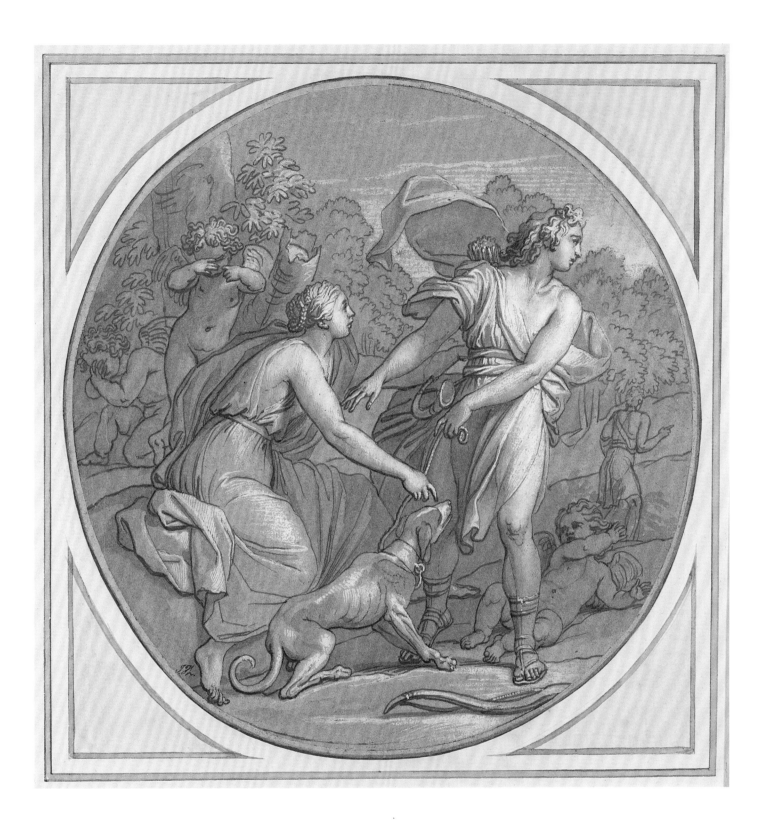

ANTOINE DIEU

Paris 1662–1727 Paris

30 *Triumph of Faith*

Red chalk with brush and red chalk wash on off-white antique laid paper; squared for transfer in black chalk

320 × 227 mm.

Watermark: Laid down—none visible through mount

Inscriptions: In graphite on recto of mount, bottom right: *Carlo Maratti*

Provenance: Sale, Christie's, New York, 30 January 1997, lot 131; acquired at the sale (D-F-390/ 1.1997.2)

Exhibitions: None

Literature: Unpublished

*P*ossibly designed for an engraving to accompany a thesis on a theological subject, this animated drawing presents an allegory of Faith triumphing over Evil. Faith herself, holding a chalice with the host, rides in a chariot surrounded by angels and Christian symbols, including the cross, the column, and the lion and eagle that are associated both with Evangelists and the resurrection of Christ. The roaring dragon on the ground represents sin and paganism, while the winged demons in the lower right corner are associated with earthly and heavenly evil.

A smaller but more densely worked drawing in the Pushkin Museum, Moscow, presents a variation on the same subject, though with marked differences in the composition (fig. 1);[1] it is possible that the two drawings belong to different moments in Dieu's preparations for the same project. Even though Dieu executed the exhibited drawing in a sketchy, open style that may belong to an early phase of his work, the squaring suggests that he regarded the design as complete enough to transfer it to a copper plate, or at

least to another stage in the genesis of the final design. No print after the drawing is known, however, and neither the date nor the origin of the project has been identified. An avenging angel whose pose and demeanor closely resemble the one near the center of the sheet studied here appears, in reverse, in another allegorical drawing by Dieu, a *Triumph of Justice* in the Wallraf-Richartz Museum, Cologne (fig. 2).[2] Although this other work shares a certain similarity in the character of the chalk strokes and the use of the washes with those in the exhibited sheet, it is otherwise unrelated.[3]

Dieu's drawing style reflects his roots in the art of the late seventeenth century, with hints of the influence of Charles Le Brun in the structure and character of the figures and in the way he combines the outlines and broad washes. These traits are particularly evident in his more typical and linear drawings executed in pen and black ink with gray wash, such as the *Adoration of the Golden Calf* (fig. 3),[4] also in the Horvitz Collection. However, in the exhibited drawing, these characterisitics are coupled not only with an unusually colorful combination of red chalk and pink washes but also with a lively touch and a broadly curving arrangement of the figures on the page, heralding the move toward a new, thoroughly eighteenth-century aesthetic.

In his notes about Dieu, the eighteenth-century collector Pierre-Jean Mariette made special mention of his "extreme facility" as a draftsman.[5] Drawings like the Horvitz *Triumph of Faith* bear out the truth of Mariette's description and may explain why Dieu's reputation as an artist has survived mainly through his drawings. MMG

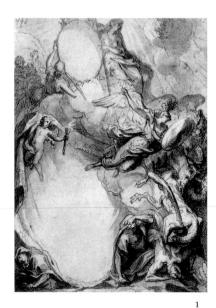

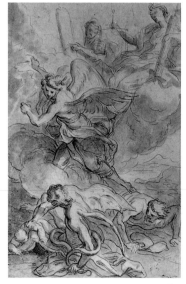

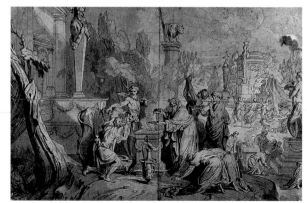

1

2

3

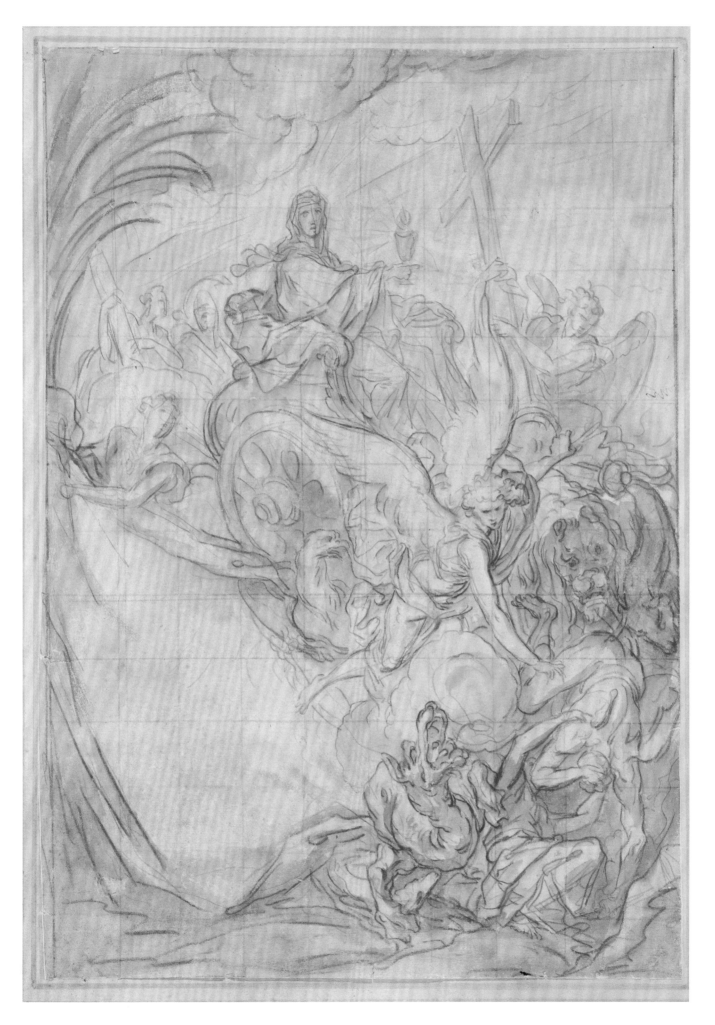

ANTOINE RIVALZ

Toulouse 1667–1735 Toulouse

31 *Expulsion of the Protestants from Toulouse*

Pen and black ink with brush and gray wash, heightened with white gouache, on blue-green antique laid paper

330 × 464 mm.

Watermark: Gaudriault 4120

Inscriptions: In black chalk on verso, bottom left: *Ant*; in pen and brown ink on verso, bottom left: *Rivalz*

Provenance: The artist's estate; Pierre Rivalz, his son, Toulouse; A. Finot, Paris (his mark, at bottom left, not in Lugt); sale, Christie's, New York, 11 January 1989, lot 123; Private Collection; Nicolas Joly at Galerie Yves Mikaeloff, Paris; acquired in 1997 (D-F-472/ 1.1997.11)

Exhibitions: Salon of the Académie royale de Peinture, Sculpture, et Architecture de Toulouse, 1766, no. 66

Literature: Rivalz 1735, cat. no. IV; Robert Mesuret in Toulouse 1953, p. 49; Mesuret 1972, p. 161, cat. no. 1452

\mathcal{A}s this superb drawing demonstrates, Rivalz was the most accomplished draftsman active in southern France in the first two decades of the eighteenth century. The rare scene depicted here is taken from one of the episodes in the history of Toulouse that Rivalz—official painter of the city after his return from Italy in 1701—was commissioned to paint for the municipal Gallery of Paintings. The related canvas is now in the Musée des Augustins in Toulouse (fig. 1).[1] Although situated in the south of France, where there were large Huguenot (French Protestant) communities, Toulouse remained ardently Catholic. When the city's Huguenots grew tired of two months of intense persecution ignited by a series of minor incidents, they seized the town hall on 17 May 1562. The vastly larger Catholic community eventually routed the Huguenots, and although the disarmed Protestants were promised safe passage from Toulouse, the crowds of angry Catholics grew riotous and chased them from the city, killing as many as they could in the process. Rivalz depicts the Catholics chasing the last Huguenots from a gate in one of the city's famous turreted walls. Hundreds of people died in one night, and the number rose into the thousands when the count extended to the entire two-month period of civic unrest. This astonishing display of intolerance was celebrated annually in Toulouse in one of the most enduring ceremonies of the ancien régime (1563–1791).[2]

The somewhat more vertical painting differs from the exhibited drawing in several ways: Rivalz made both the chiaroscuro and the progression into depth more emphatic; he excluded the figures in the drawing that were climbing up from the moat and added the figures on top of the wall throwing stones beneath an expanse of sky; and he emphasized the famous red bricks of Toulouse. There is one less Catholic man attacking a Protestant in the left foreground; and one of the fallen Huguenots on the bridge is now more upright, turning toward his attacker in horror.

A student of both his father and Raymond La Fage, Rivalz spent just over twelve years in Rome at the end of the seventeenth century, where he absorbed the salient aspects of the late Baroque from the works of contemporary artists like Carlo Maratta and Giacinto Brandi.[3] Followers of the tradition established by Giovanni Lanfranco and Pietro da Cortona, these Italian artists preferred large, dynamic, and complex compositions, replete with energetic and monumental figures fluidly united by painterly manipulations of intense colors and strong chiaroscuro. The Horvitz drawing demonstrates Rivalz's technical adaptations of this mode, especially his use of heightening with white gouache for his large, squarish figures, which provides a strong contrast with the colored paper and gray wash. He used this combination of media to similar effect in his *St. Peter Healing the Sick with His Shadow* (Prat Collection, Musée du Louvre, Paris, fig. 2).[4] The drama and ecstatic frenzy of battering, fleeing, and falling figures, which takes place across the exhibited sheet as in a frieze, is intensified by their extended limbs, distraught expressions, and exaggerated, semifrozen gestures. Rivalz was particularly adept at depicting masses of muscular fighting and falling figures in motion, most notably in drawings like his *Jupiter Expelling the Titans from Olympus* (Accademia di San Luca, Rome) and his *Fall of the Rebel Angels* (Musée Paul Dupuy, Toulouse).[5] ALC

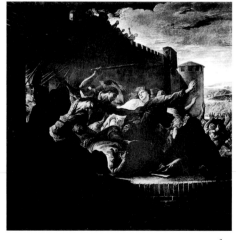

1

2

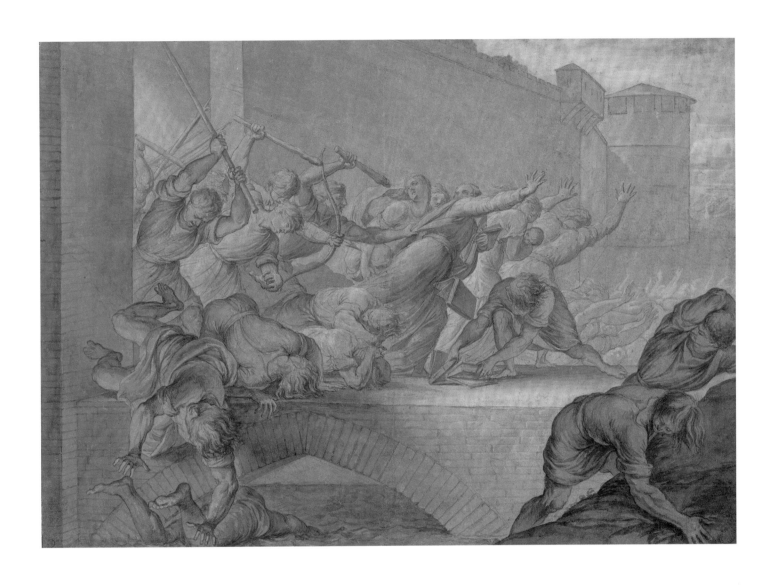

LOUIS GALLOCHE

Paris 1670–1761 Paris

32 *Seated Woman Holding a Tunic*

Black and red chalk heightened with white chalk on tan antique laid paper

522 × 401 mm.

Watermark: Close to Gaudriault 426

Inscriptions: In graphite on recto, top left: *#838*

Provenance: Duvivier Family, Paris; sale, Paris, Drouot, 29 October 1987, part of lot 60 (as circle of Antoine Coypel); sale, Christie's, London, 5 July 1988, lot 120; Private Collection; Galerie Emmanuel Moatti, Paris; acquired in 1995 (D-F-109/ 1.1995.56)

Exhibitions: None

Literature: Unpublished

*T*his drawing belongs to a group of studies by various artists gathered together in a portfolio in Paris at the end of the eighteenth century by the Duviviers, a family of medalists. The group was dispersed in 1987, and nine of the drawings by Galloche (including the one catalogued here) representing draped figures made in preparation for historical paintings resurfaced in 1988 with the correct attribution.[1]

The exhibited study depicts a seated woman holding up what appears to be a child's tunic. Despite Galloche's importance in the history of French art as a successful student of Louis de Boullogne (cat. 27) and the teacher of both François Le Moyne (cats. 40–42) and Charles-Joseph Natoire (cats. 55–58), no monograph has been published on him.[2] In the present state of our knowledge, this drawing cannot be connected with any of the compositions in his oeuvre. The only known painting by the artist that calls for a tunic held in such a demonstrative manner is the one that he successfully submitted to the Académie for the Prix de Rome in 1695, *Jacob Being Shown Joseph's Bloody Coat* (Ecole nationale supérieure des Beaux-Arts, Paris), but there is no figure in that composition that resembles the seated female figure in the drawing shown here. Whether she was drawn as a preparatory study for a St. Anne, a St. Elizabeth, or a Virgin holding the tunic of Christ in a depiction of the Holy Family in a domestic setting remains a question for the future.

In the Horvitz drawing and in the other eight studies mentioned above from the Duvivier group, two of which are now in a private collection in Paris (figs. 1 and 2), the artist focused primarily on the draperies.[3] Here, he rendered only sketchily the head, hands, and feet of the seated woman, whereas he executed the thin black chalk contours of her clothed form and the various folds of the fabric with meticulous detail and great sensitivity. He manipulated the black chalk by subtle stumping that, together with the delicate network of short hatchings, provides the fabric with a rich variation of tone and texture. Numerous spare touches of white chalk indicate the highlights and help to define the volumes, while red chalk serves to color significant parts of the tunic. The technique Galloche used for this sheet is similar to that found in six of his *académies,* or life drawing exercises (Ecole nationale supérieure des Beaux-Arts, Paris), dating from the late 1720s, when he taught drawing at the Académie.[4]

The Horvitz drawing demonstrates that Galloche did experiment, if infrequently, with the *trois-crayons* (three chalks) technique. However, his localized and virtually unblended application of the black, red, and white chalks reveals his hesitation; he never exploited the rich potential of the new procedure as fully as contemporary artists like Watteau. Nonetheless, his use of the technique places Galloche in the emerging colorist tradition so eloquently defended by the critic Roger de Piles.[5] This new trend attracted such late seventeenth-century artists as Galloche's teacher Boullogne (cat. 27)—with whom he shared a tendency to draw with black and white chalk on blue paper—Antoine Coypel, and Charles de La Fosse (cat. 23).[6] The reserve and refinement of Galloche's modestly draped *Seated Woman Holding a Tunic* recalls Florentine Madonnas of the Renaissance, a reminder that this eclectic artist assigned an important role in his teaching to the example of Raphael, whom Galloche claimed as a model for "the great art of drapery."[7] MCS

1

2

CLAUDE GILLOT

Langres 1673–1722 Paris

33 *Burial of a Satyr*

Verso: *Ornament Designs*

Pen and black ink over traces of red chalk on off-white antique laid paper (recto and verso)

220 × 334 mm.

Watermark: Gaudriault 182

Inscriptions: None

Provenance: Galerie Arnoldi-Livie, Munich; acquired in 1995 (D-F-115/ 1.1995.74a)

Exhibitions: None

Literature: Unpublished

*I*n contrast to Gillot's red chalk drawings, which are often confused with those of his star pupil, Jean-Antoine Watteau (cats. 34–36),[1] pen drawings like the one in the Horvitz Collection represent the purest expression of his unique draftsmanship and pose few attribution difficulties. Characteristic of Gillot's hand are the thin, wiry strokes that reflect his training as an etcher; the attenuated yet muscular figures that balance rather precariously on tiny hooves; the small, elongated heads with steeply slanted eyes, mouths, and jawlines; and the firmly constructed, geometric space that creates a sturdy framework for the lively figures moving within it.

The exhibited drawing was made in preparation for one print in a set of four representing key moments in the life of a satyr: birth, education, marriage, and funeral (fig. 1).[2] All four prints were etched in reverse by Gillot himself and were then completed with engraving by Jean Audran.[3] The plate measurements of *Les Obsèques* (218 × 334 mm.) are virtually identical to those of the exhibited drawing, but numerous differences between the drawing and the print—most notably in the foreground figures—suggest that this sheet represents an intermediate step on the way to the definitive composition.[4] The final model drawing is currently lost, but it would

undoubtedly have resembled in execution and appearance the two for *Birth* and *Marriage* (fig. 2), which are preserved in the Graphische Sammlung Albertina, Vienna.[5]

As the chronological development of Gillot's drawings and prints has never been studied, it is difficult to assign the exhibited sheet to a specific moment within his career. It is likely, however, that most of the satyr works preceded Gillot's contact with Watteau in the early 1700s, for by that time he was mainly occupied with theater subjects.[6] One small detail that seems to support a date no later than about 1700 is the arrangement of the hair of the female at the far left, behind the satyr holding a cane; her hair is styled in a *coiffure à l'effrontée* or a *coiffure en palissade.* This kind of tall headdress enjoyed its greatest popularity from 1680 to 1696 and was outmoded by about 1700.[7]

As the anonymous verses inscribed on the print indicate, Gillot's burial scene was intended to "satirize" the funeral customs of Man:

> For a dead Satyr, what good is all this mourning?
> Without pomp, could one not dig a grave?
> To render his memory famous, you say,
> He needs nothing more than a funeral oration.
> But is Man less insane? Why these heraldic plaques?
> These funerary affectations? These lamenting Virtues?
> And these Heralds camped out near your Mausoleums?
> Could one not rot without this ado?

The precise purpose of the border designs sketched on the verso of the Horvitz drawing is not known (fig. 3, detail), though Gillot's talents as a decorator were frequently tapped for a wide range of ornamental projects, including book bindings, chapter head- and tailpieces, arabesque borders, frames, and so on. Comparable pen sketches are found on the versos of other compositional studies by Gillot, including one in the Woodner Collection (on deposit at the National Gallery of Art, Washington) and another in the Kunstbibliothek, Berlin.[8] MMG

1

2

3

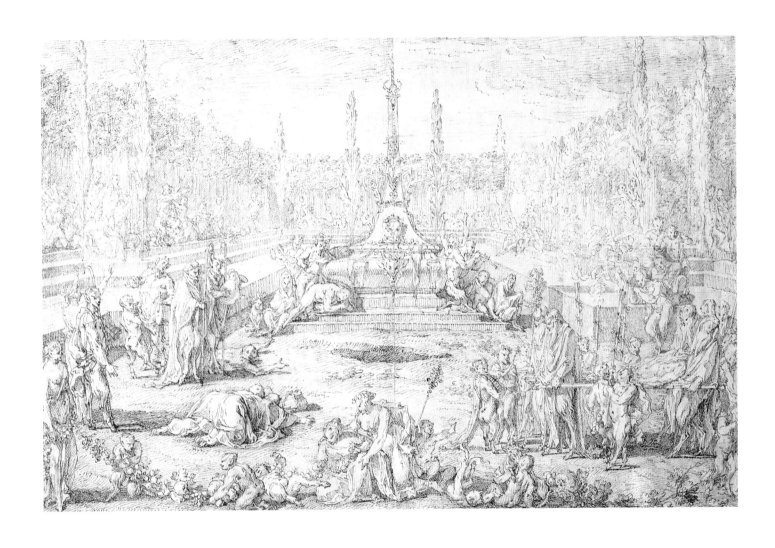

JEAN-ANTOINE WATTEAU

Valenciennes 1684–1721 Nogent-sur-Marne

34 *Standing Man in Persian Costume Seen from Behind*

Red chalk on cream antique laid paper

322 × 133 mm.

Watermark: Laid down—none visible through mount

Inscriptions: In brown ink on verso of mount, bottom left: *Watteau*

Provenance: General de la Villestreux (his *ex libris* on verso of old frame); A. Danlos in February of 1901 (inscription on verso of old frame); sale, Drouot, Paris, 15 April 1946, lot 119; Marcel Boussac, Paris; Boussac family, by descent; Didier Aaron, Inc., New York; acquired in 1995 (D-F-305/ 1.1995.46)

Exhibitions: None

Literature: Parker and Mathey 1957, vol. 2, cat. no. 580, p. 313; Roland Michel 1984, pp. 133–34; Margaret Morgan Grasselli in Washington et al. 1984, under cat. no. 49, p. 112, fig. 1; Grasselli 1988, p. 170; Rosenberg and Prat 1996, vol. 1, pp. 448–49, cat. no. 285

*F*ormerly thought to represent a woman seen from behind,[1] this drawing is actually connected to two other Watteau studies of gentlemen wearing the same unusual garb, one in the Thaw Collection, New York (fig. 1),[2] the other in the Victoria and Albert Museum, London (fig. 2).[3] Specific details of the costume depicted in these sheets—the fleece-lined hat with four triangular peaks on the crown; the sleeved cloak with a fleece collar; and the long, striped tunic worn underneath—are clearly the same and suggest that the model for the drawing here, even though seen from behind, was the same mustachioed gentleman who posed for the New York and London drawings. It is quite likely that all three studies were made in a single drawing session. Possibly also belonging to this group are two other drawings in which the model is clean-shaven but seems to be wearing the same costume; one of these is in the Fondation Custodia, Institut Néerlandais, Paris,[4] and the other is in the Achenbach Foundation for the Graphic Arts, San Francisco.[5]

The Persian origin of the costumes in these drawings, first proposed by Jacques Mathey in 1939, connected the studies to the presence in Paris of a Persian embassy in 1715.[6] The Persian ambassador made his official entry into Paris on 7 February and was granted an audience with Louis XIV at Versailles twelve days later. He and his entourage remained in Paris for six months, taking their leave of the king in a second audience on 13 August. They left Paris on 30 August. Both the ceremonial entrance into Paris and the first audience with Louis XIV were recorded in anonymous engravings, but none of the figures in either print clearly matches the model in the Horvitz drawing.[7] It is certainly possible that this model was not actually a member of the embassy but rather an actor or friend who had simply agreed to pose for Watteau in clothing like that worn by the Persians; however, some of the models for other drawings in the series do indeed seem to have been Persian.[8]

How and when Watteau gained access to the Persians to execute his drawings remain a mystery. The "exotic" subject matter would certainly have appealed to him, just as he had been attracted already by theatrical subjects, modern fashion, Savoyards, and so on, but he does not appear to have carried his interest in the Persians beyond the drawings. He never used them in any of his *fêtes galantes,* nor did he execute any painted portraits of them.

Because of the well-documented dates of the Persian ambassador's presence in Paris, Watteau's related drawings can be dated with unusual precision between February and August of 1715. Since Watteau never dated any of his paintings or drawings, making it particularly difficult to trace the chronological development of his art, datable works such as these provide critically important style markers along the course of his short career.

Watteau's studies of Persians show that in 1715, he was a bold draftsman, in full command of his chalks. Form and surface were of equal importance to him, and both were created through brilliantly engineered effects of light and shade over his figures. The Horvitz figure is the largest and most abstract of the group and is the least concerned with specific details of pose and costume. It is also the only one drawn solely in red chalk and has more the character of a casual jotting than the others. It may have been more swiftly and summarily drawn because of the simplicity of the back view and the overall lack of detail in the costume when seen from behind. Nevertheless, it is an arresting study and gives us more than a hint of Watteau's powerful and evocative draftsmanship at the moment when he achieved full mastery as an artist. MMG

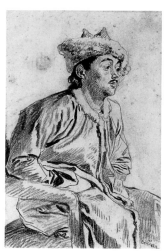

1

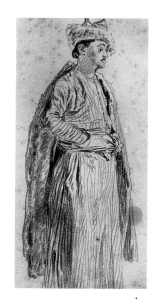

2

JEAN-ANTOINE WATTEAU

Valenciennes 1684–1721 Nogent-sur-Marne

35 *Couple Seated on the Ground*

Red chalk on cream antique laid paper

191 × 183 mm. (extended 21 mm. at top)

Watermark: Laid down—none visible through mount

Inscriptions: None

Provenance: Perhaps Jules-Robert Auguste, Paris;[1] perhaps his sale, Drouot, Paris, 28–31 May 1850—one of the undescribed lots of Watteau (lots 100–103); Baron Louis-Auguste de Schwiter, Paris (L. 1768, at bottom left); his sale, Drouot, Paris, 20–21 April 1883, lot 171; Henri-Michel Lévy, Paris; Louis Cartier; Claude Cartier, his son; his sale, Sotheby's, Monte Carlo, 26 November 1979, lot 519, repr.; Private Collection; sale, Sotheby's, New York, 10 January 1995, lot 124; acquired at the sale (D-F-304/ 1.1995.30)

Exhibitions: None

Literature: Grasselli 1993, p. 116, cat. no. 10, and p. 119, fig. 19; Rosenberg and Prat 1996, vol. 2, p. 784, cat. no. 470, repr.

*A*mong the hundreds of surviving drawings by Watteau, the great majority are studies of individual figures, often many such studies to a single page (see cat. 36). Only rarely did Watteau make studies of groups or couples like this one. His preference is directly related to the unusual way in which he constructed his paintings: instead of working up his compositions in the rather orderly manner followed by his fellow French artists—moving from compositional sketches through nude and clothed studies of the individual figures to the final model drawings and cartoons—Watteau tended to make his drawings without specific compositions in mind. He would then stockpile his studies in albums, and when it came time to compose a picture, he would leaf through the albums in search of appropriate staffage, bringing together entirely unrelated studies to create a new composition.[2]

On rare occasions, however, Watteau did make studies for specific paintings. These exceptions include some drawings of couples like the sheet exhibited here, which is connected to his *Pleasures of Love,* a painting now in the Gemäldegalerie, Dresden (fig. 1, detail). Watteau departed from his usual preparatory techniques by also making a compositional sketch for that painting; the sketch is now in the Art Institute of Chicago (fig. 2).[3] In the drawing studied here, Watteau reworked the two figures in the right foreground

of the Chicago sheet, changing slightly the poses of the figures and their placement in relation to each other. By the time Watteau finished the Dresden painting, both poses had been altered even more—especially that of the woman—so that the painted pair bears only a generic similarity to the one in the exhibited drawing.

Watteau's few studies of couples all date from the period between 1716 and 1718, when he was working on two of his most important paintings: *Pilgrimage to the Isle of Cythera* (Musée du Louvre, Paris), which he submitted in 1717 to the Académie as his reception piece; and his second version of that same composition, *Embarkation for the Isle of Cythera* (Schloss Charlottenburg, Berlin). *Pleasures of Love* is closely related to the latter through a number of details, including, most obviously, the sculpture at right. Both paintings can be dated to the period just after Watteau's admission to the Académie (1717–18),[4] the same moment to which the Horvitz sheet most likely belongs.[5]

Like the *Standing Man in Persian Costume Seen from Behind* (cat. 34), the *Couple Seated on the Ground* is drawn in a rather broad, summary manner, with just a few details of pose and costume picked out with sharper accents. Here, however, the chalk strokes have a softer, more crumbly texture that mutes the contrasts of light and shade and suggests a palpable atmosphere enveloping the figures. Those qualities, together with the somewhat pensive mood of the woman, are characteristic of many of Watteau's later drawings. MMG

1

2

JEAN-ANTOINE WATTEAU

Valenciennes 1684–1721 Nogent-sur-Marne

36 *Studies of a Seated Woman and a Hand*

Black and red chalk on off-white antique laid paper

158 × 116 mm.

Watermark: Laid down—none visible through mount

Inscriptions: At bottom right of mount, blind mark of mount maker E. Mans (L. 878b)

Provenance: Perhaps Jean de Jullienne, Paris; perhaps Francesco Maria Nicolò Gaburri, Florence; sale, Sotheby's, London, 27 April 1927, lot 53; sale, Charpentier, Paris, 8 December 1953, lot 28, repr.; Paul Cailleux, Paris; Galerie Cailleux, Paris (mark not in Lugt, at bottom right); acquired in 1984 (D-F-303/ 1.1993.136)

Exhibitions: Paris 1968, no. 50 (n.p.); Paris and Geneva 1978, no. 65

Literature: Parker and Mathey 1957, vol. 2, p. 314, cat. no. 595; Marianne Roland Michel in Paris and Geneva 1978, p. 95, cat. no. 65; Pierre Rosenberg in Washington et al. 1984, p. 357; Boerlin-Brodbeck 1987, p. 163, n. 2; Schreiber Jacoby 1987, pp. 257–58, n. 36; Rosenberg and Prat 1996, vol. 1, p. 526, cat. no. 328

Of the three Watteau drawings in this exhibition, this one conveys most clearly why his draftsmanship has long been admired.[1] First is the subject: no other artist has been so praised for his drawings of women and for the expressive beauty of his studies of hands. Second, the beautifully pictorial blend of red and black chalks in the study of the hand shows on a small scale why Watteau is considered the great master both of this technique and its extension to *trois crayons,* in which white highlights are also used. Next is the harmonious placement of disparate studies on a single page; and last, the precision and beauty of the execution, demonstrating that Watteau had few rivals in his mastery of both his medium and the human form.

It has been suggested that the study of the woman seated on the ground may be connected with similarly seated figures in four paintings by Watteau: *Deux Cousines* (Musée du Louvre, Paris), *La Contredanse* (Private Collection), *La Gamme d'amour* (National Gallery, London), and *Récréation galante* (Gemäldegalerie, Berlin; fig. 1, detail).[2] The drawn figure is closest to the woman holding a music book in the last two paintings (the same woman appears in both with only slight changes in costume), but in the end there are sufficient differences in pose and gesture, and in the arrangement of the draperies, to conclude that the study exhibited here was not the specific source for

that figure, nor for any of the figures in the paintings mentioned. More likely, this was one of those studies that Watteau made, as he most often did, with no specific composition in mind (see cat. 35).

As is often the case with the studies that Watteau brought together on a single page, these two are unrelated: the detail of the hand has no connection with the position of the right hand of the figure, nor does it seem to be an alternate idea for it. Since the exhibited sheet was likely cut from a larger page, it is possible that the hand study was originally connected with another figure sketch on the same page; but, given Watteau's tendency to execute a series of completely unrelated drawings on the same sheet, we should not assume a lost link. Indeed it is possible—and even probable—that the hand study was drawn at a different time from the figure. For other artists, the specificity of the gesture in the hand study would ordinarily indicate that it was made with a particular purpose in mind, but that is not necessarily the case with Watteau. As it happens, no connection has yet been established with any of his known paintings.

The drawing has been dated as early as 1715 and as late as 1718, the two dates that are suggested here for the other two Watteau drawings in the present exhibition.[3] *Studies of a Seated Woman and a Hand* is the tightest, most precise drawing of the three, but at the same time its forms are the most fully rounded and palpably three-dimensional. It certainly does not belong to 1715, the period of the man in a Persian costume (cat. 34), when Watteau's drawings are often larger and more expansive, but the forms beneath the draperies not as clearly defined. It is closer in spirit, though not in execution, to the *Couple Seated on the Ground* (cat. 35); the divergence in execution can be explained by the different purposes of the drawings and by the fact that for the study of the woman, Watteau surely had a posed model in front of him. Indeed, around 1717–18, Watteau made a number of compact, yet fully formed studies of women in similarly voluminous skirts and in equally animated poses, such as his *Two Studies of a Woman* in the British Museum, London (fig. 2).[4] The Horvitz sheet is more highly worked than these figures and has one of the few figures drawn only in red chalk at a time when Watteau was regularly mixing red not only with black chalk but also with graphite. Nonetheless, the quality of both the draftsmanship and the forms in the exhibited drawing ally it with that group. MMG

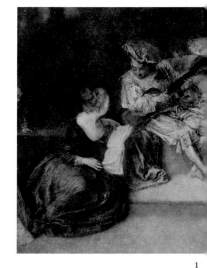

1

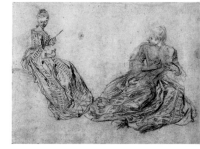

2

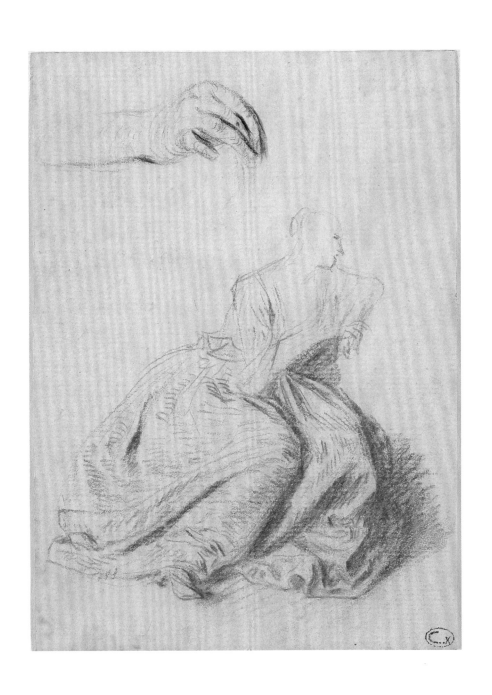

JEAN-BAPTISTE OUDRY

Paris 1686–1755 Beauvais

37 *Basilica Seen through Trees*

Black chalk heightened with white chalk on blue antique laid paper

318 × 496 mm.

Watermark: Laid down—none visible through mount

Inscriptions: In pen and brown ink on recto, bottom left: *Oudry*; in graphite on verso of mount, bottom center: *1883.*; in graphite on verso of mount, bottom right: *4*; in graphite on verso of mount, bottom right: *228548/13*

Provenance: Sale, Christie's, New York, 13 January 1989, lot 249; acquired at the sale (D-F-211/ 1.1993.101)

Exhibitions: None

Literature: Unpublished

*T*aking the empirical understanding of nature far more seriously than any of his contemporaries, Oudry demonstrated a lifelong fascination with the gentle countryside around Paris. His numerous drawings and oils of landscape motifs, often done directly *d'après nature* showed the way toward the experiencing of nature as a transformative artistic force, one that would elevate the genre to a central role in French painting of the next century.

Oudry never strayed far from Paris, but he often visited the immediate environs within a one-day radius of the city. His dismembered early landscape sketchbook in the Musée du Louvre, Paris, with a frontispiece dated 1714, consists of studies such as *Trees Bordering a River Bank with a Manor House in the Distance* (fig. 1).[1] He examined light and atmosphere in these drawings, which he executed primarily with a brush, combining ink with white heightening. Their unpretentious but convincing views of hills, river valleys, and workaday structures near Paris are too homely to be identifiable today.

The set of tapestries depicting the *Royal Hunts of Louis XV*, and the related commissions leading up to it beginning in 1728, brought Oudry out into the royal forests of Fontainebleau, Compiègne, and Saint-Germain where he sketched the kind of scenery found in the present drawing, in preparation for the landscape backgrounds of his tapestry designs.[2] Regular sojourns in Beauvais during his twenty-year tenure as entrepreneur of the tapestry manufactory there (1734–54) were the occasion for sketching trips in the Oise region. These studies led to paintings of picturesque dovecotes, stone bridges, and city gates that he exhibited in the Salons.

In the 1740s, Oudry was often a weekend guest in the suburban residences of friends and patrons at Arcueil, along the valley of the Bièvre south of Paris, and several paintings of local scenery resulted from these visits. But far more noteworthy were his sketch-ing trips to the park and gardens of the abandoned Château d'Arcueil, which attracted considerable attention in his day.[3] The exhibited *Basilica Seen through Trees* most resembles, in size and medium, his one hundred or more famous drawings of the gardens of Arcueil, executed from c. 1744 to 1747.[4] Like one of the sheets from this series at the Ecole nationale supérieure des Beaux-Arts, Paris—which depicts the garden wall and gates (fig. 2)—they are all impressive in scale, in mastery, and in their originality.[5] His vision is unique for its time—the art of the classical landscape designer slowly reverting to a natural state. These scenes are usually unpeopled; the emphasis rests with the individuality (and the rightness) of the perceptual moment, rather than on any particular human activity.

Does the Horvitz sheet belong with the Arcueil group or does it date to a slightly earlier moment of transition between those and the *Royal Hunts of Louis XV* tapestry drawings? The building—probably an abbey church outside Paris—has yet to be identified, though an identification ought to be possible: its Romanesque nave and transept, Gothic west facade and north tower, and south tower cupola of later date give it a distinctive personality. It is an important building, one that imposes its weighty history even on viewers such as ourselves who can no longer recognize it specifically (as Oudry no doubt would have expected of his contemporaries). In this sense, the drawing is quite unlike the famous garden series, whose message does not depend on associational par-ticularities. But the mood of the garden drawings carries over to this sheet, tempering the subject. The building, screened by trees, its facade brilliantly lighted by the afternoon sun, reminds one of nothing so much as Constable's Salisbury Cathedral seen across Bishop's Grounds, pointing both backward and forward in time, a meditation on the interplay between the natural and the human orders. HO

1

2

JEAN-BAPTISTE OUDRY

Paris 1686–1755 Beauvais

38 *Combat of Eagles and Swans*

Pen and black ink and brush with brown and gray wash, over an underdrawing in black chalk, extensively heightened with white gouache, on blue antique laid paper

305 × 542 mm.

Watermark: Laid down—none visible through mount

Inscriptions: None

Provenance: Collection of the artist; his sale, Paris, 7 July 1755; duc de Tallard, Paris; his sale, 22 March–13 May 1756, lot 462; sale, Paris, 21 March–29 April 1768, lot 686; Pierre-François Basan, Paris; his sale, 1–19 December 1798, lot 117; Collection Choffard; Collection Brochant; sale, Drouot, Paris, 12 April 1996, lot 28; Didier Aaron et Cie, Paris; acquired in 1996 (D-F-353/ 1.1996.92)

Exhibitions: Salon of 1753 (without a number)

Literature: Mariette 1750, vol. 4, pp. 65–66; Locquin 1912, cat. nos. 735 and 879; Opperman 1973, p. 60, cat. no. 10; Opperman 1977, vol. 2, cat. no. D660; Hal Opperman in Paris et al. 1982a, pp. 201–2, under cat. no. 108

*I*n 1751, Oudry proposed a series of tapestry designs representing Combats of Wild Animals, to be woven at the Gobelins.[1] His proposal lists twelve subjects, including one that matches the impressive Horvitz *Combat of Eagles and Swans*. This unsigned drawing was probably made in 1745. Several other very similar drawings whose subjects correspond to those of the tapestry proposal are signed and dated in that year. That they were all intended as presentation drawings no doubt accounts for their highly finished nature. Angling for the commission, which he never received, in the Salon of 1753 Oudry showed his *Combat of Eagles and Swans* and another drawing made for the series, *Combat of Leopards and Wild Horses*, now in the Graphische Sammlung Albertina, Vienna (fig. 1),[2] on an equal footing with his paintings.

For Oudry, drawings like the exhibited sheet—which depict the ferocity of the eagles' attack and the combination of fear, anger, and counterattack by the swans—grew out of many years of observing birds from a distance during his sketching trips in the countryside and examining them in more detail in the royal menagerie at Versailles. This research is revealed in dramatic drawings like the liberally sketched *Frightened Duck* in the Staatliches Museum, Schwerin (fig. 2);[3] these were later worked up in the studio, where he produced drawings of individual birds such as the *Angry Swan* at the Metropolitan Museum of Art, New York (fig. 3),[4] and full compositions—conceived more out of convention than from nature—like the *Bird of Prey Attacking Ducks* engraved by Tischbein (fig. 4).[5] Occasionally, Oudry would complete highly finished drawings that maximized the potential of heightening with gouache, as in the *Dog Attacking a Swan* at the Art Institute of Chicago (fig. 5)[6] and the sheet shown here. Some of the more formal elements of the Horvitz composition, such as the elegant stone fountain in the shape of a fish pouring forth water, appear in other works from the artist's mature years like *Dog Attacking a Swan beneath Trophies of the Hunt* engraved by Gabriel Huquier (fig. 6).[7]

Pierre-Jean Mariette—the great eighteenth-century collector, connoisseur of drawings, and biographer of artists—owned six of Oudry's Arcueil landscapes (see cat. 37) and knew the *Combat of Eagles and Swans*. He wrote dismissively of the very high price it brought in the sale after Oudry's death and the still higher one at the Tallard sale a year later. This price was due, he said, to mere fashion for such carefully finished drawings among a certain category of collectors, who were ignorant of the true nature of drawing.[8] Given his seemingly contradictory praise and passion for the precision of the finished drawings of artists such as

2

4

3

1

Edme Bouchardon (cats. 51–52), could Mariette's words hide a simple anger at being outbid? Or did he actually consider the only true drawings to be those that revealed the genius of the artist's mind and hand at work, and did he therefore prefer those drawings by Oudry where the fire of the artist's inspiration manifested itself in a more spontaneous way? In the case of the Horvitz sheet, no painting or other, more finished version was to be made, so the drawing stands in for the final product. Thus, Mariette missed the point in judging it *only* as a drawing. Its qualities reside in the meticulously planned and executed composition, the heightened illusionism, and a fully realized distribution of light and shadow. Oudry's purpose was to convey as much as possible of the design's potential for realization in a tapestry: that is, its decorative and rhetorical impact in a near-panoramic format twenty or more feet across, displayed in a monumental space as one of a large set.

Sumptuous and regal, tapestry was still the most prestigious medium for grand mural statements in the mid-eighteenth century, though with the passing of another generation, that would cease to be the case. Around 1745–50, Oudry was just completing the supervision of his final designs for the nine tapestries of the *Royal Hunts of Louis XV* woven on the looms of the Gobelins, a project that had brought him prominence and a handsome income for twenty years. Like the *Royal Hunts* before them, the projected series of designs for the Combats of Wild Animals unites the two great artifices, perceptual and emotional: the physical illusion of nature and the dramatic illusion of the stage. Oudry must naturally have hoped that they would provide him with a continuation of the royal beneficence.

As he had done so often in his career, and so successfully, Oudry chose to recast Rubensian subjects as modern opera-pantomime, right off the late Baroque stage. Why, then, was his initiative denied? Some of the opportunities provided to Oudry earlier in his career are a reflection of the influence of powerful protectors such as Louis Fagon, intendant des finances; Henri-Camille, marquis de Beringhen, premier écuyer du roi; and the duc d'Antin, when he was directeur des Bâtiments du roi. But in 1751, at age 65, without the influence of his early protectors, Oudry's ambitious proposal did not find favor with the tastemakers of the new artistic establishment. Perhaps, by mid-century, this was an idiom too grand even for the court. HO

5

6

CHARLES PARROCEL

Paris 1688–1752 Paris

39 *Soldiers at Rest*

Red chalk on cream antique laid paper

558 × 440 mm.

Watermark: Laid down—none visible through mount

Inscriptions: In red chalk on recto, bottom left: *CP;* in pen and brown ink on recto, bottom left: *Charles Parrocel f.*

Provenance: Jean-Denis Lempereur, Paris (L. 1740, at bottom right); Didier Aaron, Inc., New York; acquired in 1996 (D-F-427/ 1.1996.82)

Exhibitions: None

Literature: Unpublished

*T*he large red chalk drawings of soldiers, battles, and encampments by Charles Parrocel occupy a unique place in the art of his time. In contrast to the more refined and traditional drawings of many of his contemporaries, his are bold and brash—like the men he was sketching—and have an arresting physicality, a presence that commands instant attention.

Having himself served in the king's cavalry, Parrocel had an insider's understanding of military life, and his highly personal drawing style was well suited to capturing its character. As the exhibited sheet demonstrates, Parrocel wielded his chalk with an almost swaggering assurance, creating large, blocky forms with bold, well-defined outlines, and patterning the surfaces with strongly contrasted patches of light and shade. The facial features of Parrocel's soldiers are generally characterized by strongly chiseled jawlines and cheeks, and by long, narrow eyes that are set quite widely apart. Some of the details of pose, such as the ungainly twist of the central figure's head, are intentionally awkward, and although the overly large, knobby hands give them considerable emphasis here, the gestures of his figures are often rather formulaic.

Battles were the most common subjects in Parrocel's drawings, but slices of camp life were also a favorite theme. Johann Georg Wille made a suite of twelve etchings, *Reitres et Lansquenets*, after Parrocel's drawings of this type.[1] Most of Parrocel's camp scenes are smaller than the Horvitz drawing, but two that are comparable in both scale and subject are in the Städelsches Kunstinstitut, Frankfurt, and the Graphische Sammlung Albertina, Vienna; neither of the two, however, features the huge forms and crammed space of the exhibited sheet.[2] What must be one of Parrocel's largest sheets, also in the Horvitz Collection, *Soldiers Playing Cards before a Tavern* (fig. 1, detail of center and right side),[3] offers one of the most striking comparisons.

Given the grand monumentality of the figures in the exhibited drawing, it is not entirely surprising to discover that the central soldier—probably a cuirassier or a heavy cavalryman from the look of his armor—was strongly influenced by Michelangelo's enormous figures on the ceiling of the Sistine Chapel in Rome. His pose is in fact very similar to both the prophet Jonah and an *ignudo* above the Libyan Sibyl. It is even closer, though in reverse, to the Delphic Sibyl reproduced here in a print by Pierre II Biard (fig. 2).[4] The head, left arm, and legs of this Sibyl are in much the same position, and the drapery gives the same kind of rounded form to the Sibyl's back as the armor does to the soldier's. Parrocel certainly studied the Sistine ceiling during his several years at the French Academy in Rome (1712–21); he probably also knew it through the many prints that replicated the famous monument. Whether the Horvitz drawing was actually made when Parrocel was in Rome, however, cannot be determined without further study of the chronology and development of his draftsmanship.[5] MMG

1

2

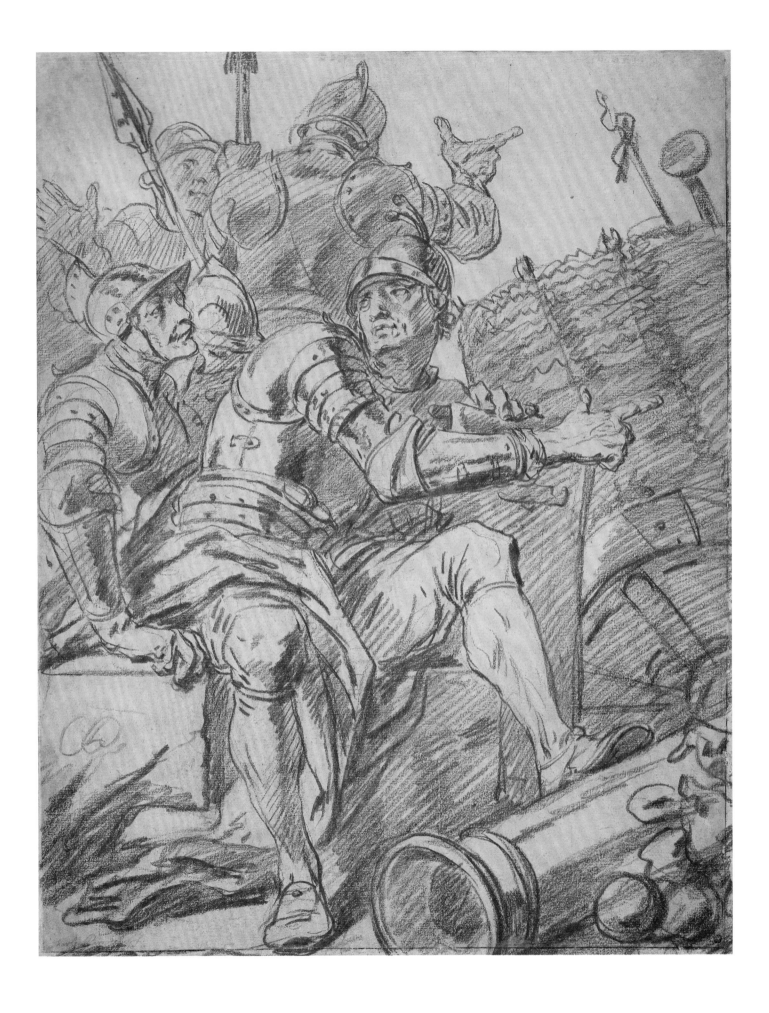

181

FRANÇOIS LE MOYNE

Paris 1688–1737 Paris

40 *Landscape with a Castle*

Red chalk on cream antique laid paper

230 × 385 mm.

Watermark: Gaudriault 960

Inscriptions: In pen and brown ink on recto, bottom left: *le Moyne*; in graphite on verso, top left: *941/ Le Moyne*; in pen and brown ink on verso, bottom left: *V*

Provenance: Collection Valpinçon, Normandy (until 1974); Mathias Polakovits (without his mark); art market, London; Mary-Kaye Bordeaux, Santa Monica and Paris; Colnaghi, New York and London (as of 1990); acquired in 1995 (D-F-336/ 1.1996.1)

Exhibitions: Northridge 1976, no. 28; New York 1990, no. 21; New York and London 1991, no. 44

Literature: Bjurström 1982, under cat. no. 1053 (n.p.); Bordeaux 1984, pp. 87, 149, cat. no. D38, fig. 165; Per Bjurström in New York and Edinburgh 1987, p. 132, under cat. no. 81; Stephen Ongpin in New York 1990, pp. 139–40, cat. no. 21; Riopelle 1991, pp. 554–55, fig. 79; Stephen Ongpin in New York and London 1991, cat. no. 34 (n.p.); Grasselli 1996, p. 368, fig. 3

*E*ighteenth-century writers such as Antoine-Joseph Dézallier d'Argenville and the comte de Caylus give precise accounts of how Louis Galloche (see cat. 32) took his student Le Moyne into the countryside around Paris to sketch from nature. These writers also report that Le Moyne drew landscapes frequently during his stay in Italy (1723–24).[1] The present landscape was the first to be exhibited under Le Moyne's name and is characteristic of the views he executed before his Italian trip. In his monograph on the artist, Jean-Luc Bordeaux dated the Horvitz sheet to 1721–22, close to Le Moyne's signed and dated painting, *Tancred and Clorinda* (Musée des Beaux-Arts, Besançon, fig. 1).[2] While the castle in this large canvas—the Château Landon, located in the Ile-de-France near Melun—resembles the fortress depicted in the drawing, the exhibited landscape seems to be an imaginary construction.

Recently, through a careful examination of the red chalk landscapes attributed to Jean-Antoine Watteau by Karl Theodore Parker and Jacques Mathey, Margaret Morgan Grasselli doubled the number of landscapes ascribed to Le Moyne.[3] A comparison of the present sheet, which was drawn in France, with views Le Moyne sketched soon after in Rome and Venice, led her to observe that all of the artist's earlier works—such as the contemporaneous *Landscape with Cottage and Riverbank* in the Pierpont Morgan Library, New York (fig. 2)[4]—share a common treatment of architecture and vegetation. Then, using the Fogg Art Museum's *View of Formia from Gaeta* (fig. 3)[5] as a point of departure for an analysis of Le Moyne's later, more precise manner, in which he is freer in his use of space and perspective, she was able to assemble a group of his mature landscapes. The two groups of drawings provide a perfectly coherent image of Le Moyne as a landscapist throughout his career.[6]

In addition to the systematic use of curves, feathered lines, egg shapes, stumping, and hasty sketching to evoke the rustic view of nature evident in the Horvitz drawing, Le Moyne increasingly employed parallel hatching to construct and shade the forms of his later, more classicizing landscapes. Despite the increased attention to structure, Le Moyne's concern for the unity of the whole composition did not prevent him from depicting the charm of the concavities in the roofs and the crenellations of Italy's undulating roof tiles in his later drawings. The recent catalogue raisonné of Watteau drawings by Pierre Rosenberg and Louis-Antoine Prat, in which landscapes previously given to the master are removed from his oeuvre, should enable scholars to discover still further views by Le Moyne. JFM

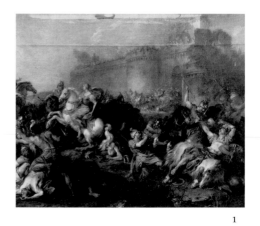

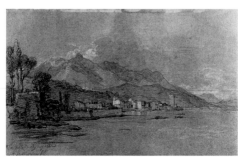

1 2 3

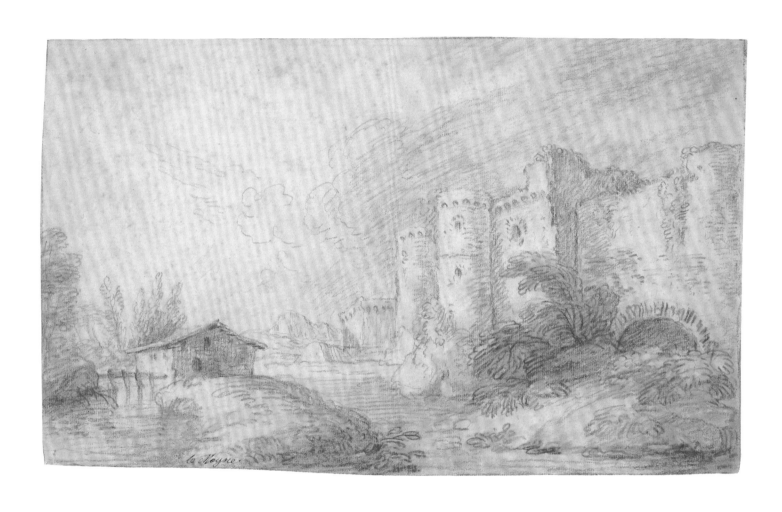

le Noyre.

FRANÇOIS LE MOYNE

Paris 1688–1737 Paris

41 *Seated Female Nude*

Black and red chalk, heightened with white chalk, on tan antique laid paper

334 × 205 mm.

Watermark: Laid down—none visible through mount

Inscriptions: In black chalk on verso of mount, bottom center: *g*

Provenance: Private Collection, London; Thos. Agnew and Sons, Ltd., London and New York; acquired in 1996 (D-F-453/ 1.1996.84)

Exhibitions: None

Literature: Colin Bailey in Paris et al. 1991, p. 255, under cat. no. 24, fig. 3

*T*his study of a seated female nude was made in preparation for the figure of Diana in Le Moyne's *Diana and Callisto* of about 1726 (Wengraf Collection, London, fig. 1).[1] Heightened in white chalk to accentuate her generous proportions, the figure conveys Le Moyne's ideal of feminine beauty. The graceful pose integrates the various parts of the body—the extended left arm and the right arm crossing the thighs, with the hand holding a drapery—all perfectly modeled in light and dark. Although Diana's face would be rendered with great delicacy in the painting, in the drawing Le Moyne avoided the potential distraction of facial expression, imparting the fullest significance to her gesture.

The story of Diana and Callisto is told by Ovid (*Metamorphoses,* 2:442–53). In the midst of her chaste maidens, Diana, virgin goddess of the hunt, points to Callisto, whom she discovers is pregnant. The goddess does not yet realize that Zeus had assumed her own form in order to gain Callisto's confidence and seduce her. Diana's surprise leads to anger, and she changes Callisto—who had been her favorite companion—into a bear and sets hounds upon her. Fortunately, Zeus intervenes at the last moment to save the future mother of Arcas, ancestor of the Arcadians.

The painting consists entirely of mature female figures set in a luxuriant landscape. Le Moyne based most of his nude studies on male models, but a group of drawings of female nudes, dated by Jean-Luc Bordeaux to the early to mid-1720s, reveals the artist's new practice of using women as models around the time he produced *Diana and Callisto.* These include the *Reclining Female Nude* in the Städelsches Kunstinstitut, Frankfurt (fig. 2),[2] and the *Standing Female Nude* in the Fogg Art Museum, Cambridge (fig. 3).[3] Like the Horvitz drawing, Le Moyne executed these two roughly contemporary sheets in *trois crayons,* a technique that lends itself to the rendering of soft flesh.

Although we know of no other extant drawing that can be linked to this composition, eighteenth- and early nineteenth-century sale catalogues list a study with several figures entitled *The Pregnancy of Callisto,* executed in black and white chalk on blue paper.[4]

JFM

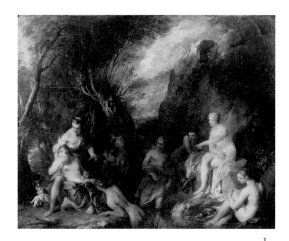

1

2

3

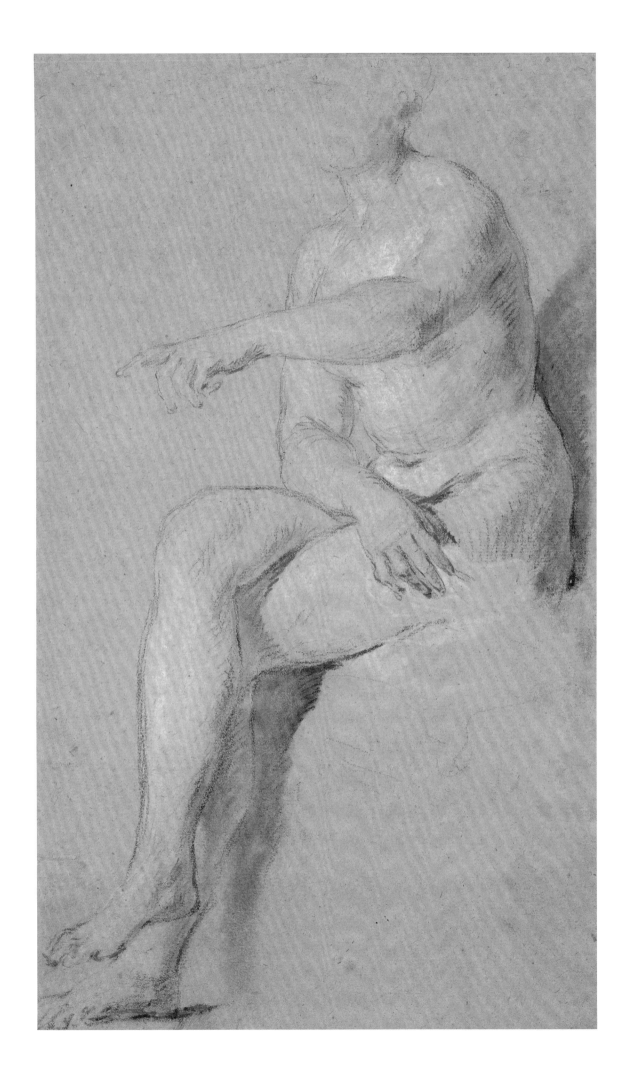

FRANÇOIS LE MOYNE

Paris 1688–1737 Paris

42 Mark Anthony Attempting to Crown Julius Caesar at the Lupercalian Festival

Black chalk heightened with white chalk on faded blue antique laid paper

280 × 480 mm.

Watermark: Laid down—none visible through mount

Inscriptions: In pen and black ink on recto of mount, bottom right: *Lemoine*; in black chalk on recto of mount, across bottom: *Collections Mariette, Legroy, Catalogue Lempereur, no. 501, Chennevières, no. 299, César couronné par des Romans dans une fête lupercale*

Provenance: Jean-Denis Lempereur, Paris (L. 1740, bottom right); his sale, Paris, 24 May–28 June 1773, part of lot 501; Charles-Philippe, marquis de Chennevières-Pointel, Paris (L. 2073, bottom left); his sale, Drouot, Paris, 4–7 April 1900, lot 299; sale, Sotheby's, London, 30 June 1986, lot 136; acquired at the sale (D-F-180/ 1.1993.85)

Exhibitions: None

Literature: Bordeaux 1984, p. 181 (as lost)

*A*lthough the mount of this important, unpublished drawing by Le Moyne bears a twentieth-century annotation that gives the correct provenance of the distinguished Lempereur and Chennevières collections, there is no mention of the sheet in the sale catalogues of the renowned collections of Pierre-Jean Mariette or Jean-Baptiste-Florentin-Gabriel, marquis de Lagoy (to whom the "Legroy" in the inscription probably refers). However, the title in the inscription and the further description provided by the Lempereur catalogue make it possible to determine the subject, which is taken from the "Life of Julius Caesar" and the "Life of Mark Anthony" in Plutarch's *Lives of the Romans* (9:61–62 and 13:12–13).

During the pagan festival of Lupercalia—held annually on 15 February to commemorate the she-wolf that suckled Romulus and Remus, the legendary founders of Rome—a group of priests sacrificed goats and a dog. Streaked with the blood from these oblations and wielding rawhide thongs made from the hides of the dead animals, the priests wandered through the *Roma quadrata* (the area surrounding the Palatine Hill), lashing women they encountered, which was believed to ensure their fecundity. This ritual signified a symbolic purification of the city and was thought to guarantee the fertility of the people, livestock, and fields. With the advent of official Christianity, the festival was suppressed in 494 A.D.

In 44 B.C., Mark Anthony participated in the Lupercalia as consul of Rome. Le Moyne's drawing depicts the moment that he approached the podium to crown Julius Caesar with a diadem twined with laurel, proclaiming him dictator for life. This was a designation that Caesar knew the majority of Roman

citizens opposed, and he declined. A month later, on the Ides of March, Marcus Junius Brutus and others, fearing Caesar's increasing power, assassinated him.

The collector Jean-Denis Lempereur owned the pendant to the Horvitz composition as well. It was described in the catalogue of his sale as follows: "the other drawing depicts Anthony addressing the people after the assassination of the emperor" [*sic*; Julius Caesar never held this title]. The missing pendant may also be identical to a sheet showing "the body of Caesar being borne in state on an ivory bier through a public square, while a Roman displays Caesar's bloody robe to the people," cited in 1762 by the collector and Le Moyne's biographer, Antoine-Joseph Dézallier d'Argenville, as one of a pair of drawings executed just before the artist's death.[1] Although the dimensions of this sheet are unrecorded, if they were the same as those of the exhibited drawing—and also divided in the foreground into distinct but linked zones of activity—it may well be the one listed with a slightly different description in the 1753 Lempereur catalogue as the pendant to the Horvitz composition.

In his poignant biography of Le Moyne, Dézallier d'Argenville wrote, "In the final six months of his life, he was attacked by a fever that left him few lucid intervals. . . . His friends made efforts to distract him. They read aloud to him from a history of Rome; and whenever some Roman was said to have killed himself out of nobility of spirit he would request that the passage be reread, and would exclaim, 'Now *that* was a good death!'"[2] The *Lives of the Romans* was undoubtedly the "history of Rome" read to Le Moyne to distract him from his suffering. The subjects of both the

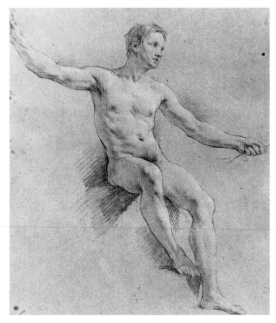

3

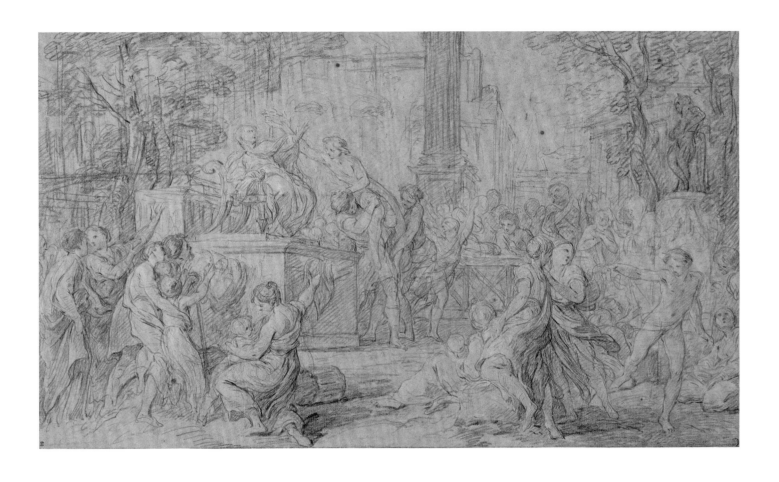

Horvitz drawing and its lost pendant were taken from Plutarch's account. The mournful themes of the two compositions, as well as the artist's remarks about "a good death," were prophetic, for Le Moyne committed suicide on 4 June 1737, soon after he completed the drawings.

Before he died, Le Moyne had also begun a painting commissioned by Philip V of Spain for the throne room at La Granja entitled *Alexander the Great Captures King Porus*, which depicted the battle of Hydaspes in 327 B.C. Unfinished at the artist's death, the work was completed by Carle Vanloo (see cats. 63–66). However, Le Moyne's preparatory design for this painting survives in two versions, one of which is in the Nationalmuseum, Stockholm (fig. 1).[3] Like the

Horvitz drawing, the Stockholm sheet is another large, complex, multifigure scene drawn from Greco-Roman history in which details are suppressed in favor of the overall rhythm of the fluid composition.

Two late figure studies in the Musée du Louvre, Paris, may also relate to either the present composition or the lost pendant.[4] *Drapery Study for a Female* (fig. 2)[5] recalls the figures of the dancing women at the right of the exhibited sheet, and the *Study of a Seated Male Nude* (fig. 3)[6] echoes the pose of Caesar. The artist's illness and the late date of execution may explain the hasty and rough style of the Horvitz drawing, in which the artist—as he rarely did elsewhere—incongruently combined a classical theme with a highly rocaille vision of an antique festival. JFM

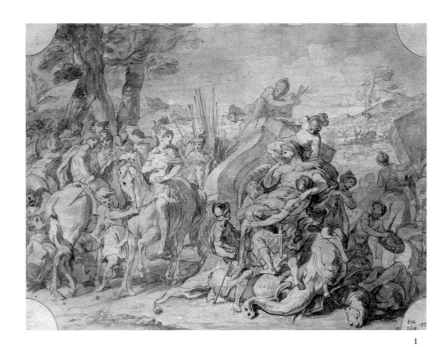

1

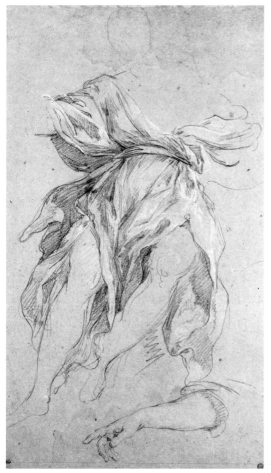

2

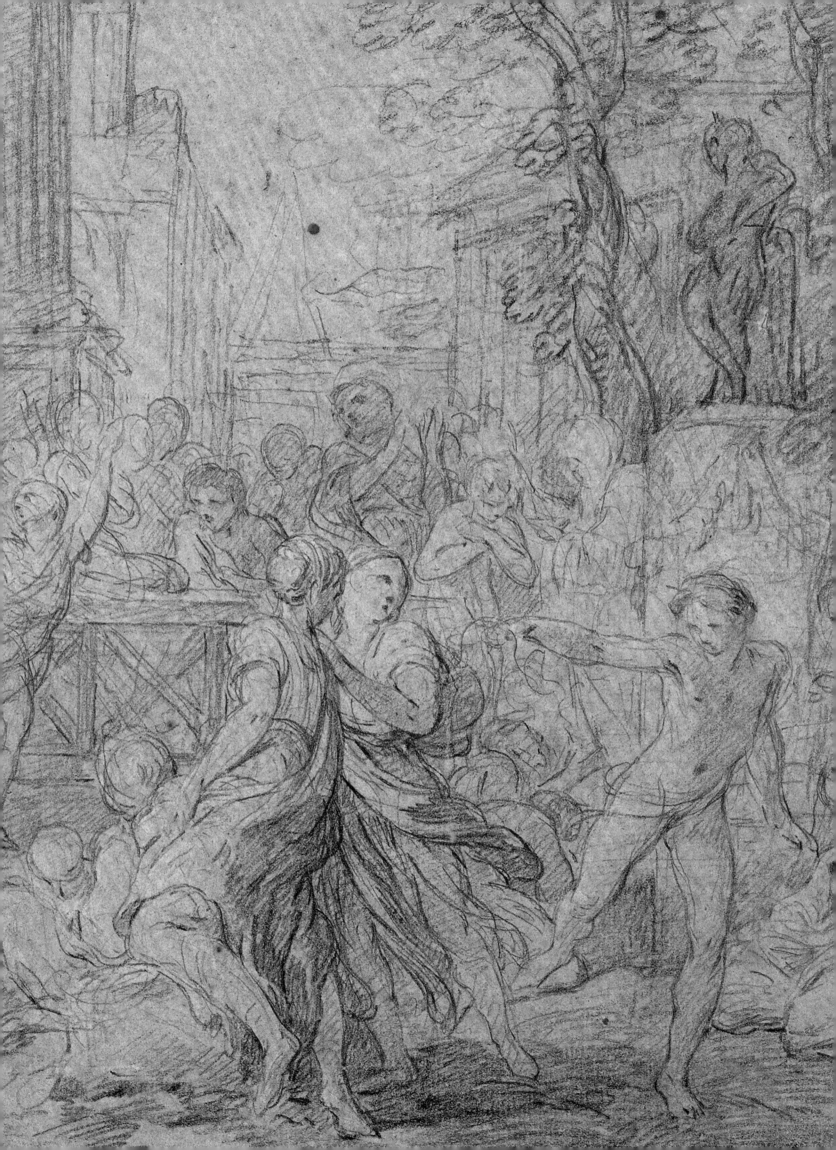

JEAN II RESTOUT

Rouen 1692–1768 Paris

43 *The Denial and Repentance of St. Peter*

Black and white chalk on two joined pieces of blue antique laid paper

446 × 327 mm.

Watermark: None

Inscriptions: None

Provenance: Nicolas Joly at Galerie Yves Mikaeloff, Paris; acquired in 1994 (D-F-259/ 1.1994.19)

Exhibitions: None

Literature: Unpublished

According to the Gospel of St. Mark (14:66–72), after his arrest in the Garden of Gethsemane, Christ was taken for questioning to the palace of the high priest Caiaphas. During this interrogation, St. Peter—prince of the apostles and eventual guardian of the keys of Heaven—joined a crowd that gathered in front of the palace. He attempted to remain anonymous, but one of the priest's maids recognized him and asked if he wasn't one of the members of Christ's entourage. As Jesus had prophesized, Peter denied this three times, even though, when he first heard the prediction, he had sworn to Christ that he would never do such a thing. In this drawing, Restout depicted the most frequently represented moment of the story, when St. Peter, realizing that Christ's prophecy has come true, is overcome with tears of repentance.

At the upper right of the composition, Restout shows Christ being led by two guards toward Caiaphas, who is enthroned on the columned porch of his palace at the upper left. The blue paper effectively translates the night's darkness, broken only by the lamplight on the porch above and—given that the foreground figures are lit from below—by what one assumes is a fire just beyond our view in the right foreground. St. Peter, overwhelmed with shame at his weakness, rushes away from the astonished maid and her equally astounded companions.

Although Restout's drawings numbered only about fifty when a monographic exhibition was organized in his native Rouen in 1970,[1] a large number of his sheets have resurfaced since that time.[2] As Pierre Rosenberg has noted, they reveal that Restout's typically angular and elongated figures with small heads were intentionally posed in slightly awkward positions for maximum visual and thematic effect.[3] He

often drew lightly and fluidly with black chalk to generate compositions in which figures with long, sweeping contours traverse the plane of the sheet with large, open gestures. The freshness of the exhibited drawing enables us to experience the artist's characteristically calculated use of heightening with white chalk to punctuate the drama of the scene.

Most of Restout's oeuvre consists of vast religious paintings that are notable for the emotional intensity of their compositions and their sober use of color and decorative effects. These ensured his reputation as one of the most celebrated artists of his generation.[4] Although it has not been possible to identify a related painting for the exhibited drawing, it can be compared to his *Procession of Monks* in the Metropolitan Museum of Art, New York (fig. 1),[5] and especially to his *St. Peter Healing a Lame Man before a Temple* in the Bibliothèque nationale de France, Paris (fig. 2).[6] The latter is one of four known drawings he made in preparation for one of his three extant canvases, detailing moments from the life of St. Peter, in Saint-Pierre-du-Martroi, Orléans (*in situ*), produced during the late 1730s.[7] The compelling similarities in technique and composition between the drawing shown here and the related studies for the paintings depicting the life of St. Peter suggest that the Horvitz sheet was preparatory for an unexecuted scene from the life of St. Peter for the same commission and should be dated to approximately the same moment.

ALC

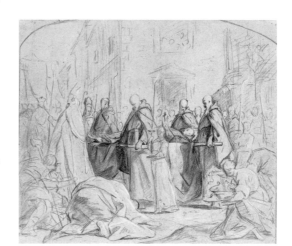

1

2

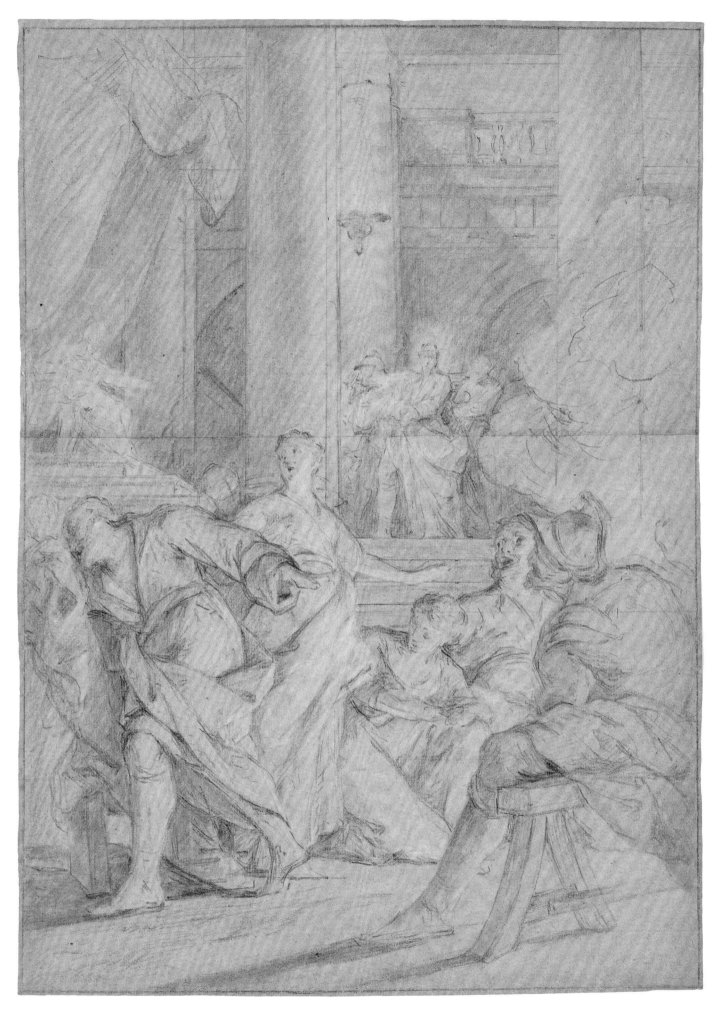

HYACINTHE COLLIN DE VERMONT
Versailles 1693–1761 Paris

44 *Feast of the Gods*

Red chalk and red chalk wash with traces of heightening in white chalk on cream antique laid paper

385 × 490 mm.

Watermark: Laid down—none visible through mount

Inscriptions: In pen and brown ink on recto, bottom left: *colin de vermont.;* in graphite on verso, upper right: *8263N*

Provenance: Private Collection, France; Jean-Christophe Baudequin at Galerie Ratton et Ladrière, Paris; Galerie Emmanuel Moatti, Paris; acquired in 1995 (D-F-65/ 1.1995.14)

Exhibitions: None

Literature: Unpublished

If one omits his academic figure studies, only twenty-four drawings by Collin de Vermont are known today.[1] These sheets are primarily composition studies executed in either pen and brown ink over black chalk with brown or gray wash, or in red chalk with touches of red chalk wash, like the exhibited *Feast of the Gods*. He often heightened his drawings with white chalk or white gouache, both to emphasize the dramatic aspects of the design and to intensify the effects of light. The exceptional dimensions of the Horvitz sheet make it the artist's largest known composition drawing. It must certainly be preparatory for a lost painting of the same subject that Collin de Vermont exhibited for the first time in the Salon of 1737, and again—following a practice that had become fashionable—in the Salon of 1753.[2]

The Horvitz composition depicts the feast given after the wedding of Peleus and Thetis. Although Peleus was the son of King Aeucus of Aegina and grandson of Zeus and the nymph Aegina, it was still considered a privilege for him, as a mortal, to marry the sea deity Thetis (future mother of their child Achilles). He was granted this extraordinary permission because he successfully met the challenge of wrestling his betrothed as she changed into various shapes. The gods who came to their wedding feast as depicted in Collin de Vermont's composition include, from left to right around the table, Venus and her son Cupid; Mars and Minerva in armor; Mercury in his winged hat; Pluto or Neptune with a long beard; Juno and Zeus with their diadems; and, in the foreground, Ganymede, performing his duties as cupbearer. Many of the gods brought gifts, as did Eris, goddess of strife, the only Olympian who was not invited to the event. Furious at having been left out, she threw a golden apple onto the table; the apple was inscribed, "for the most beautiful." It is this inscription that Mercury brings to the attention of the assembled guests. In the

drawing, Collin de Vermont has suggested the initial stages of the argument: Venus, goddess of love, points to herself as the obvious choice, while being counseled by her son and Mars, god of war; Minerva, goddess of wisdom and protectress of the arts, seems to dissent; and Juno, queen of Olympus, reaches for the apple as if it were undeniably hers. Thus began the dispute among the three goddesses that led to the Judgment of Paris and the Trojan War.

Collin de Vermont's *Feast of the Gods* probably dates to c. 1737, the year of the first Salon in which the lost painting was exhibited. The drawing displays many of the characteristic aspects of his style, including his heavy contours, his tendency to depict figures in profile, his very particular manner of shading to describe flesh, and his accentuation of the volumes and anatomical details of the figures with the subtle application of gouache and red chalk wash. One can also see many of these stylistic traits in the artist's *Rest after the Hunt* in the Musée du Louvre, Paris (fig. 1), another large, festive mythological sheet from the 1730s that he executed in red chalk.[3] In the Horvitz drawing, subsidiary studies—including a repetition of Minerva's forearm and hand—elegantly punctuate the bottom of the sheet. The other studies may not all be preparatory for this composition. They reveal another practice of the artist—the use of one sheet for studies destined for different works—that can be seen on the double-sided composition drawing for his *Gathering of Manna* in the Musée des Beaux-Arts, Angers, which also dates to the 1730s (figs. 2 and 3).[4] The recto, drawn with red chalk and squared for transfer, features numerous heavily contoured figures in profile, a servant kneeling in the foreground, and a large decorative anthropomorphic vase, all similar to those found in the Horvitz sheet. In addition to another black chalk study for the same composition, the verso of the Angers drawing also contains an unrelated study for the head of a woman. xs

2

3

1

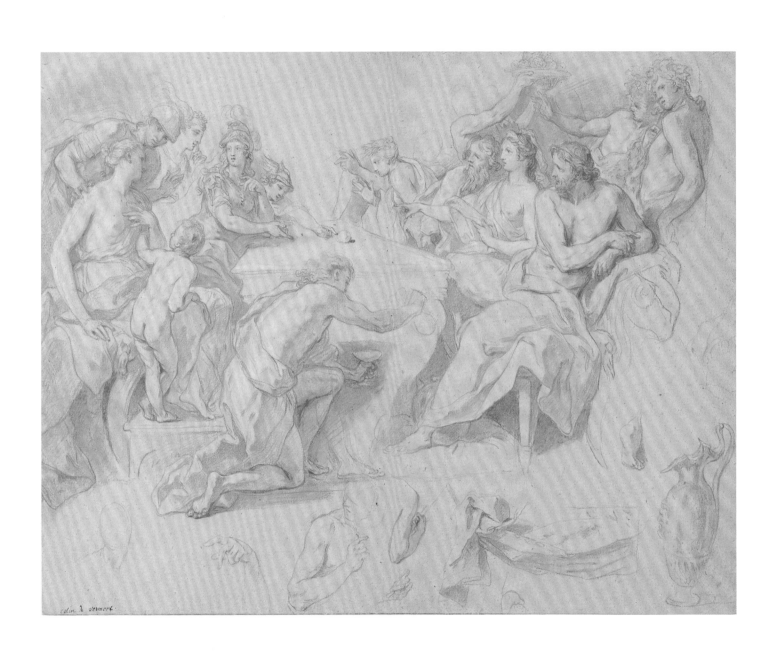

colin de vermont

CHARLES-ANTOINE COYPEL

Paris 1694–1752 Paris

45 Head of Potiphar's Wife

Black chalk and pastel on greenish-blue antique laid paper

310 × 242 mm.

Watermark: Laid down—none visible through mount

Inscriptions: In graphite on recto, across bottom: *Potiphar . . . de Joseph*

Provenance: Didier Aaron, Inc., New York (1993); acquired in 1994 (D-F-72/ 1.1994.4)

Exhibitions: New York et al. 1993, no. 17

Literature: Kate de Rothschild and Alan Salz with Jill Dienst and Isabelle Mayer in New York et al. 1993, cat. no. 17 (n.p.); Lefrançois 1994, p. 451, cat. no. D76

Coypel made this superb drawing in preparation for the head of Potiphar's wife in the lost *Joseph Accused by Potiphar's Wife* (fig. 1). Coypel executed the painting in 1737, and it was displayed the same year at the Salon, where it attracted favorable comment.[1] The renowned expert Pierre Rémy—who described the painting when it surfaced in 1778 at the estate sale of the widow of the fermier-général La Haye in Paris— called it "one of Coypel's finest works."[2]

It is quite possible that the present sheet, which displays extensive use of pastel, was one of two drawings mentioned in the catalogue of Coypel's estate sale of 1753: "Life studies in pastel—one for the head of Joseph and the other for that of Potiphar's wife—for a painting by M. Charles Coypel depicting Joseph accused by this shameless woman."[3] Unfortunately, the dimensions are not provided, but an annotation on a copy of this catalogue indicates that these studies were withdrawn from the sale by the painter's heirs. They do not, however, appear in the catalogue of the 1777 estate sale of his brother and heir, Philippe Coypel.[4]

The *Head of Potiphar's Wife* exemplifies Coypel's finest graphic work. Rapidity and sureness of line are combined with a smoothness of modeling that is enhanced by the generous use of pastel, a technique also evident in other examples such as the *Study for Adrienne Lecouvreur in a Dramatic Role* (Musée des Beaux-Arts, Mulhouse, fig. 2).[5] In both sheets, the treatment of the eyes—in which the eyeball is touched with white chalk to make it appear to protrude slightly from the face—is similar. Above all, the exaggerated expression, the anguished surprise conveyed by the gaze, and the rich pearl jewelry adorning the hair remind us of the important role that the theater played in the life of the artist, who was also a playwright in his spare time.

Most of Coypel's contemporaries took advantage of the licentiousness of this Old Testament subject— upon Potiphar's return home, his wife unjustly accused Joseph of having violated her (Genesis, 39:7–20)—as a pretext for the display of a charming female nude in an historicized *scène galante*. Coypel refused this facile alternative towards genre and turned instead, by way of an utterly theatrical interpretation, to a mode that aspired to the intensity of grand history painting. However, the recourse to excessively grandiloquent gestures undermined his aspirations for the lost painting, and here—as in several of his greatest and most dramatic canvases, such as *Athaliah Questioning Jehoash* (Musée des Beaux-Arts, Brest) and *Cleopatra Swallowing Poison* (Musée du Louvre, Paris)—he confused the realistic and the histrionic.[6]

If Coypel's painting was ultimately unsuccessful, the Horvitz drawing attests to both the sincerity of his efforts and to his powers as a draftsman. In addition to this magnificent sheet, two composition studies exist for the final canvas: one, a small drawing recently in the collection of Annamaria Edelstein (fig. 3),[7] and the other, a larger sheet that has been mentioned by Jean-Luc Bordeaux.[8] It is possible that a third study may yet be discovered; a "drawing blended with a bit of pastel" figured in the estate sale of the sculptor Jacques Saly in 1776.[9] TL

1

3

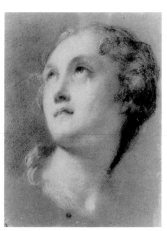

2

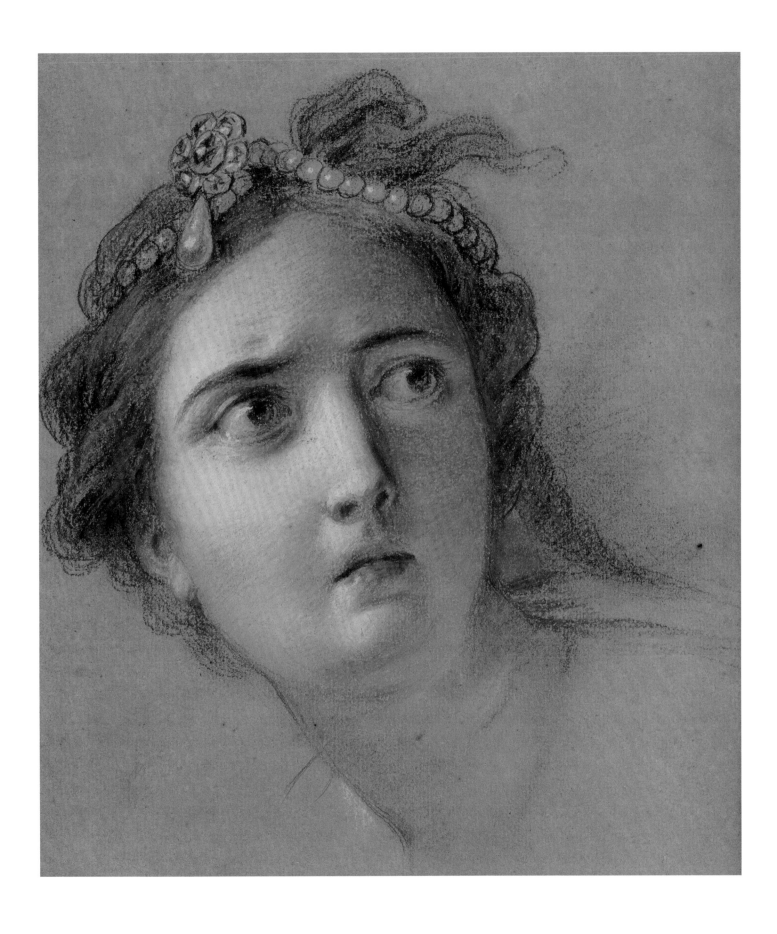

CHARLES-ANTOINE COYPEL

Paris 1694–1752 Paris

46a *Standing Male Nude with Outstretched Arms*
46b *Four Young Ladies*

46a: Black and white chalk with touches of red chalk on blue antique laid paper

435 × 260 mm.

46b: Black and white chalk with touches of red chalk on blue antique laid paper

440 × 330 mm.

Watermark: None

Inscriptions: None

Provenance: Private Collection, France; Galerie de Bayser, Paris; acquired in 1995 (D-F-73/ 1.1995.52 and D-F-74/ 1.1995.53, respectively)

Exhibitions: None

Literature: Unpublished

These two recently discovered drawings are studies for Admetus and the attendants of Alcestis in Coypel's *Hercules Brings Alcestis Back from the Underworld to Her Husband, Admetus*. The *modello* for this work was painted in 1750—only two years before the artist's death—for one of the so-called Dresden Tapestries. Later in the same year, Coypel executed the design in a larger format to serve as the cartoon (Musée des Beaux-Arts, Grenoble, fig. 1).[1]

Between 1733 and 1741, Coypel executed a series of four cartoons for tapestries inspired by the operatic works of Philippe Quinault.[2] On the occasion of the marriage of the dauphin, Louis, son of Louis XV, to Princess Maria Josepha of Saxony in 1747 (see cat. 70), the painter was asked to complement this series with four new compositions illustrating tragedies and comedies. The set became known as the Dresden Tapestries because it was sent as a gift by the dauphin to his new mother-in-law, Maria Josepha of Austria, queen of Poland, in Dresden (capital of the electorate of Saxony, whose elector was also king of Poland). The subjects chosen were *Psyche Abandoned by Cupid* from Jean-Baptiste Molière's *Psyche*; *Atalide and Roxanne* from Jean Racine's *Bajazet*; *Cleopatra Swallowing Poison* from Pierre Corneille's *Rodogune*; and *Hercules Brings Alcestis Back from the Underworld to Her Husband, Admetus* from Quinault's *Alcestis*.[3]

In these two studies, Coypel focused on the fervent passions of the protagonists in Quinault's play, which is based on a story with origins in Greek mythology, the most familiar version of which was Euripides's *Alcestis* of 438 B.C. At the wedding of Alcestis and Admetus, prince of Pherae in Thessaly, it was revealed that the prince was about to die. Through Apollo's intervention, Admetus was permitted to live on the condition that he could find a substitute to take his place in the underworld. In accordance with her spousal duty, Alcestis made the ultimate sacrifice.

Passing through Thessaly on his travels, Hercules learned of the tragic affair just after the queen's burial. He intercepted Death leading Alcestis to the underworld and restored her to her husband. Coypel depicted Admetus rushing toward his wife, overwhelmed with joy by her return. In Quinault's interpretation of the story, however, this joy is tinged with sadness, since Hercules, positioned between the two protagonists in the finished composition, rescued Alcestis from Hades so that he could enjoy her favors. As Coypel's depiction suggests, Alcestis's charming attendants are also overjoyed to see their mistress. This conventional eighteenth-century theatrical composition is enhanced by Coypel's supple contours, at once round and firm, which typify his late paintings.

Coypel's *Self-Portrait* of about 1746, also in the Horvitz Collection, depicts the artist at the height of his career (fig. 2).[4] Seated before an easel, he holds not paintbrushes, but chalk and a drawing board with paper attached. This testimonial to Coypel's commitment to the practice of drawing is underscored by the function of the two studies exhibited here. Following French academic tradition—reinforced in the middle of the eighteenth century by the revival of history painting and the eventual emergence of Neoclassicism—Coypel produced highly realized drawings of individual figures after making preliminary composition sketches (all of which are lost).[5] For the principal characters such as Admetus, the artist studied the live model in order to find the most expressive pose, then

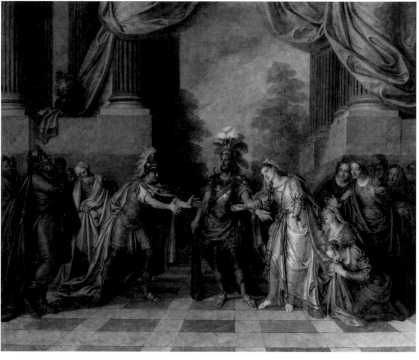

1

carefully squared the resulting sketch in black chalk for transfer. The Horvitz Collection also contains the nude study for Hercules (fig. 3).[6] Later, Coypel would draw the figures clothed, in order to elaborate details of their costume, as he began to do here with the attendants of Alcestis. If the attitudes and gestures seem uninspired, it is because later in the process the artist probably relied on mannequins posed on miniature stage sets, complete with scenery and lighting.[7] The dramatic poses undoubtedly reflect those of actors in contemporary French theater. Nonetheless, these drawings are extremely valuable for what they teach us about the complex process by which Coypel elaborated these theatrical compositions, which blend reality and fiction.

The study for the figure of Hercules, which offers an early alternative to the hero's pose in the final version, is drawn in a different technique on different paper. Here, the paper is cream colored instead of blue, and black chalk was used without white heightening. This sheet recalls the nude male figure studies routinely produced at the Académie, where Coypel was trained and later served as a professor. Of note is the substitution of a stick—commonly used by models to maintain their poses—for a club. In particular, the elegant technique, with its subtly rendered modeling and the treatment of the tousled hair, resembles his *Standing Male Nude* in the Rijksprentenkabinet, Amsterdam (fig. 4).[8] Although less painterly than his *Head of Potiphar's Wife* (cat. 45), here, at the end of his successful career, Coypel's drawings related to the prestigious Dresden Tapestry commission are no less characteristic of his great talent. TL

2

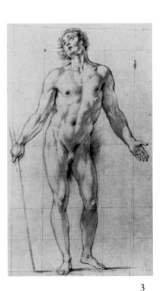

3

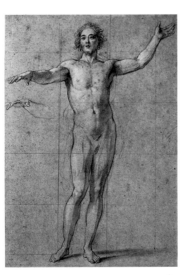

4

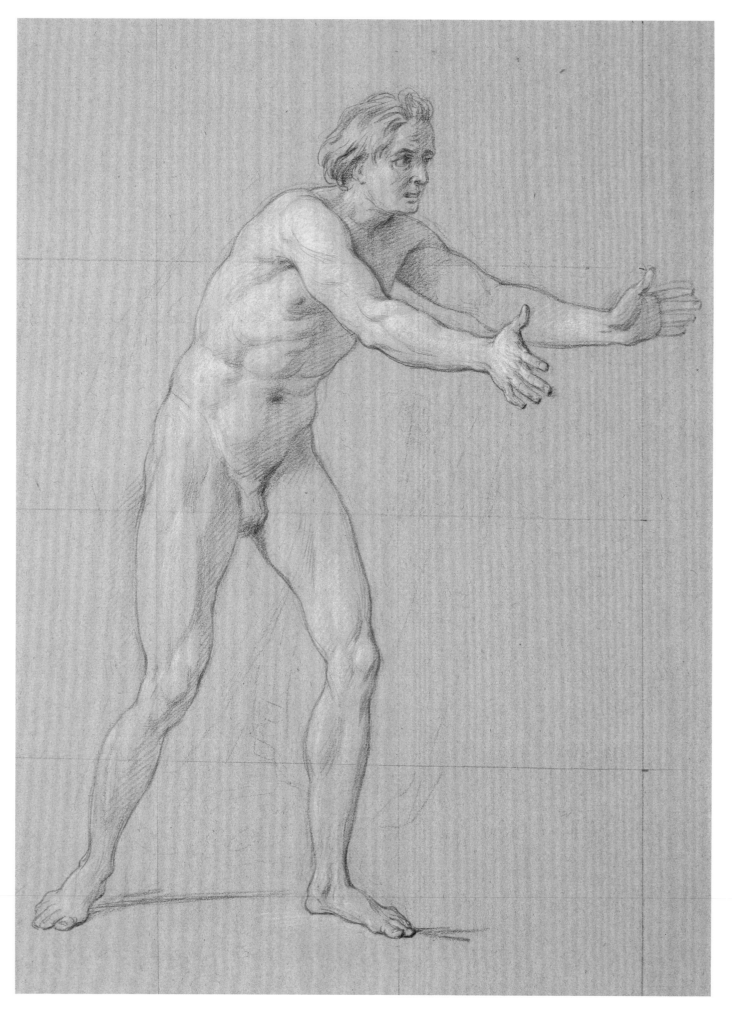

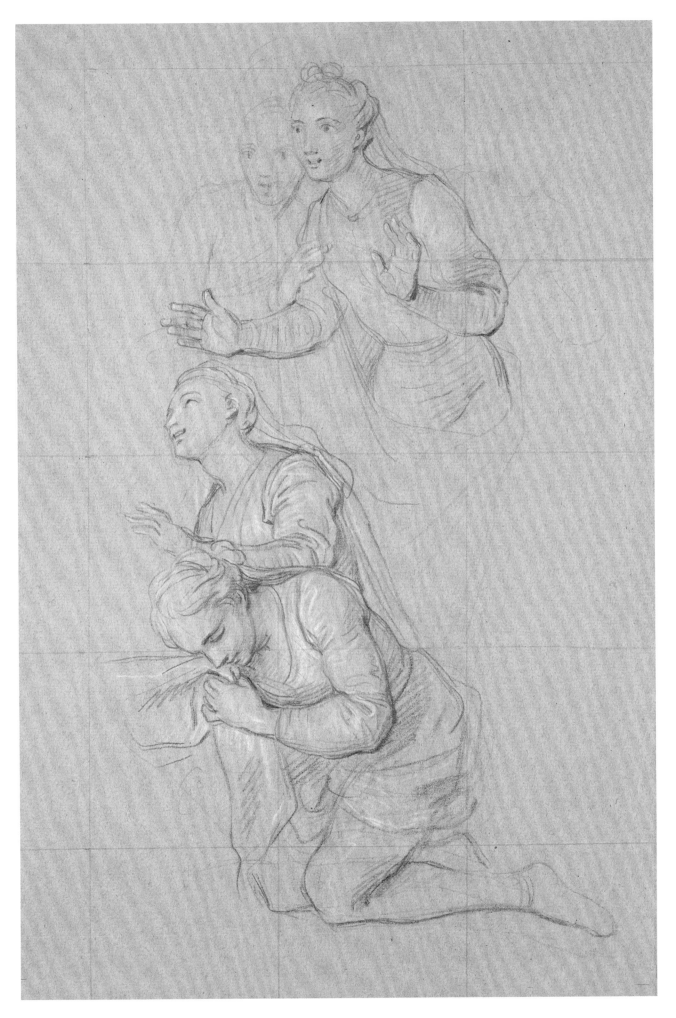

JEAN-BAPTISTE-JOSEPH PATER

Valenciennes 1695–1736 Paris

47 Seated Woman and Hand Studies

Red chalk on cream antique laid paper

174 × 218 mm.

Watermark: None

Inscriptions: None

Provenance: Galerie de Bayser, Paris; acquired in 1996 (D-F-370/ 1.1996.39)

Exhibitions: None

Literature: Unpublished

*P*ater holds a unique position as Jean-Antoine Watteau's only documented pupil and his most faithful imitator. It is not surprising, then, that his teacher's influence is abundantly plain in almost every aspect of his art, including such accomplished sheets as the one in the Horvitz Collection. The choice of subject, the *mise-en-page*, the quality of pose and gesture, and the choice of medium all derive from Pater's intimate knowledge of Watteau's drawings (cats. 34–36). In certain important respects, however, while following in his master's footsteps, Pater developed a personal idiom that was distinct from Watteau's and from those of other followers of the master, such as Lancret. As this sheet attests, in Pater's studies of women, contours tend to be more nervous and fluttery than Watteau's, and his rapid accents are often more decorative than functional. Both the drawing exhibited here and Pater's *Two Ladies* (Boijmans Van Beuningen Museum, Rotterdam, fig. 1)[1] demonstrate that, unlike Watteau, who was equally concerned with articulating underlying forms as with describing outer surfaces, Pater took special delight in the latter, emphasizing the ornamental aspects of the ladies' draperies through a lively interplay of line, light, and shade. For many of his drawings of men, however, Pater used a simpler, more sober style, with longer, smoother contours, somewhat weightier forms, and a less playful line. This is especially true of his studies of soldiers, like the *Standing Soldier with a Pipe* (Fondation Custodia, Paris, fig. 2),[2] which he made in preparation for his many paintings of camp scenes and marches.

A distinctive feature of all Pater's figure drawings, whether of gentlemen or ladies, is his treatment of the faces. The features of the woman studied here are typical. Her elongated eyelids and eyebrows slant diagonally upward toward the temples; her patrician nose is

quite long (lengthened in this case by the downward tilt of the head); her mouth is pursed and pinched at the corners; and her face, which tapers to a small pointed chin, is long and narrow. These are ingredients of what might be called the Pater "look": the strong family resemblance among his figures that, more readily than any other characteristic, identifies them as having been produced by Pater.

Unrelated to the figure of the lady in the exhibited sheet are two separate studies of hands. While Watteau was a master of expressive gesture and was known for the beauty of his hand studies, Pater usually paid little attention to them. In many instances, the hands of his figures are their clumsiest feature. The studies of hands on the drawing shown here, however, are among the finest Pater ever made, and in them he comes unusually close to the spirit and quality of Watteau's own (cat. 36).

Apart from a catalogue raisonné of his pictures published seventy years ago, very little has been written about Pater's paintings and drawings or about his development as an artist.[3] Under these circumstances, it is virtually impossible to assign a meaningful date to the present sheet, particularly since it has not yet been connected with a painting. Like Watteau, Pater often made drawings with no particular composition in mind, but kept them for possible use in later works. Many of them appear not to have been used in his extant corpus of paintings. That the Horvitz sheet belongs to a mature phase of Pater's career seems certain; the strong sense of his master's enduring influence narrows the likely date to the 1720s, within a few years after Watteau's death. MMG

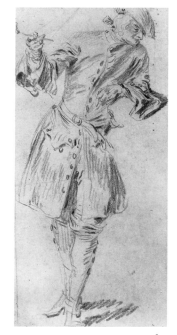

2

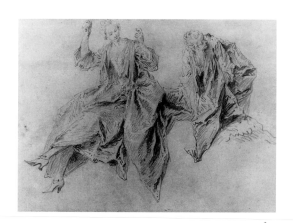

1

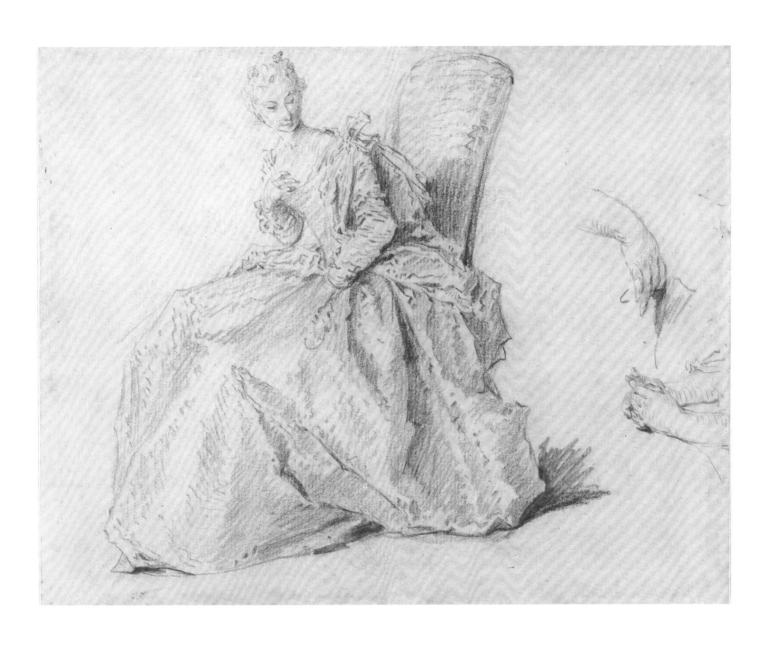

JACQUES-ANDRÉ PORTAIL

Brest 1695–1759 Versailles

48 *Young Girl Sewing in an Interior with a Cat*

Red and black chalk over graphite, lightly stumped and heightened with red chalk wash, on cream antique laid paper

329 × 278 mm.

Watermark: None

Inscriptions: None

Provenance: Sale, Bergerac, 21 September 1997; Galerie de Bayser, Paris; acquired in 1998 (D-F-552/ 1.1998.43)

Exhibitions: None

Literature: Unpublished

*T*hanks to the protection of Philibert Orry, directeur des Bâtiments du roi, Portail was named draftsman to Louis XV in 1738. In addition to numerous court positions, Portail found the time to produce charming and highly finished drawings, such as the one exhibited here. Their meticulous execution and unusual combination of colors elicited both the admiration of his peers and the esteem of the most knowledgeable connoisseurs. Intended to be framed, these sheets reveal the artist's predilection for the precious technique and visual quality of the miniature. Using quick, fine, multiple strokes, he liked to juxtapose red and black chalk, but without ever really blending them. Instead, he often preferred to use their individual strengths to highlight elements of the composition, such as an item of clothing or an anatomical detail. The contrast between the two colors, striking to the eye, was generally accentuated by the very way in which the artist used his chalks. Portail often brushed the red chalk across the surface of the paper and then gently stumped it, so as to render the flesh tones; in opposition to this, he usually manipulated the black chalk to produce fine hatching that served as a base of contrast. His slender line also created accents, alternating from darker and more intense to lighter and more diffuse.

This sheet from the Horvitz Collection displays a number of Portail's typical stylistic and technical features. The black chalk and graphite, which form a delicate network of hatching, are lightly stumped; they set off the red chalk used to render the flesh tints as well as the stripes of the dress, the ribbon from which the scissors are hung, the bow on the cap, the ribbon on the left sleeve, the work basket, and the cat's nose.

The subject of this drawing is also characteristic of the artist's work. Portail was especially fond of scenes depicting ladies and young women in the privacy of their homes. We know of a number of sheets in which the models, absorbed in their activities and sometimes accompanied by their pets, devote themselves to either literary, artistic, or domestic pursuits. All of these compositions portray human figures suspended in action, scenes that Portail intentionally treated as a kind of still life. These drawings include the *Presumed Portrait of Madame de Lalive de Jully Sketching at a Table* (Pierpont Morgan Library, New York—see MRM ess., fig. 16); *Young Girl Reading* (also in the Horvitz Collection, fig. 1),[1] *Woman Holding a Musical Score* (Fogg Art Museum, Cambridge, fig. 2),[2] *Woman Drawing a Mouse* (Private Collection, Switzerland),[3] and *Two Women Sewing* (Private Collection, fig. 3).[4] The artist produced works like these in many versions throughout his career; they often depict the same models and usually exhibit the same technique.[5] This practice makes it particularly difficult to date individual drawings. XS

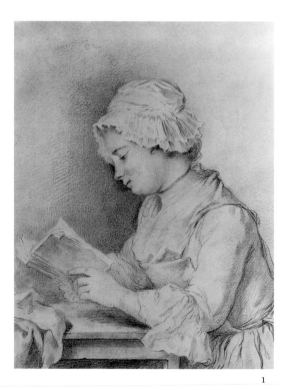

2

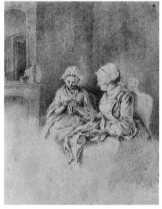

3

1

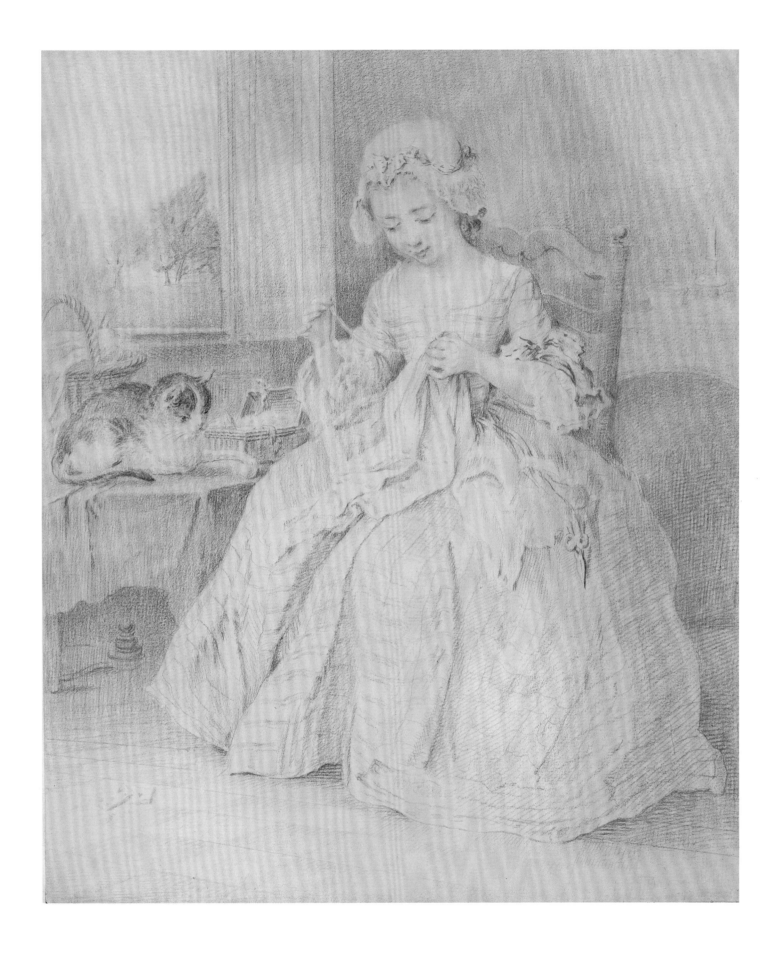

JACQUES-ANDRÉ PORTAIL

Brest 1695–1759 Versailles

49 *Seated Hunter with a Dead Hare*

Red and black chalk with touches of pen with black and brown ink, heightened with white chalk, on cream antique laid paper

426 × 364 mm.

Watermark: Laid down—none visible through mount

Inscriptions: In graphite on recto of mount, bottom center: *16/*

Provenance: Collection of Mlle Seheult, great-niece of the artist, Nantes (in 1855); Beaudenon de Lamaze Collection, Paris; his sale, Galerie Charpentier, Paris, 22 June 1938, lot 23; sale, Sotheby's, London, 30 June 1986, lot 164; acquired at the sale (D-F-249/ 1.1993.115)

Exhibitions: None

Literature: Salmon 1996, pp. 7, 21, 73, and 89, cat. no. 46

*T*his sensitive sheet is one of a group of drawings depicting the same model. The old man with a full beard and long hair in the drawing exhibited here reappears as a paterfamilias with a cane and a three-cornered hat in a lost work (fig. 1),[1] as St. Anthony the Hermit in a drawing recently acquired by the Château de Versailles (fig. 2),[2] and as St. Augustine in a third sheet in a private Parisian collection.[3] A nearly identical figure with a bald head is featured in other works by Portail, including a drawing in the Art Institute of Chicago (fig. 3),[4] in which he appears as a modern pilgrim next to a basket filled with fruits and vegetables, in the pendant to the Horvitz composition (Private Collection, Paris, fig. 4)[5] and in a drawing of St. Paul in another private collection that was conceived as a pendant to the *St. Augustine* mentioned above.[6] All of these works display Portail's characteristically subtle method of combining colored chalks to evoke an undisturbed atmosphere of quietude and reflection.

Perhaps these men were among the ordinary people who inhabited the neighborhood around Portail's home in the rue du Vieux-Versailles, which included a large number of inns and taverns. Their picturesque appearance obviously appealed to the artist's eye and to his most distinguished and celebrated patrons. Madame de Pompadour, mistress of Louis XV, owned the drawings of Sts. Anthony, Augustine, and Paul,[7] which were framed behind glass and undoubtedly displayed in one of the oratories or in one of her rooms at Versailles. These works had probably won her favor for their pensive calm and their highly accomplished technique, in which black and red chalk and black ink are blended with finesse and precision.

Though it lacks the distinction of Madame de Pompadour in its provenance, the Horvitz sheet was conceived in a similar spirit to those in her collection. Portail brilliantly combines chalks and ink to render the russet highlights of the fur of the dead hare lying beside the curious and enigmatic "hunter-philosopher" with his hand on a sphere. These techniques remind us that in his critical remarks on the artists of his day, the eighteenth-century connoisseur Louis Petit de Bachaumont emphasized Portail's remarkable ability to render tangibly the velvety surface of flower petals, the sheen of feathers, and the character and texture of hair.[8] His praise of Portail's still lifes—which display a broad range of media and techniques (chalk, wash, and paint with stippling and hatching)—helped to legitimate the admiration with which his contemporaries, as well as nineteenth- and twentieth-century collectors, viewed these remarkable works. xs

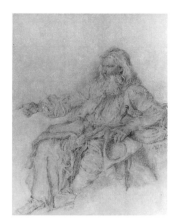

1

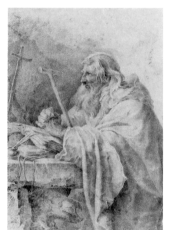

2

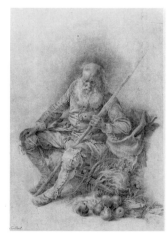

3

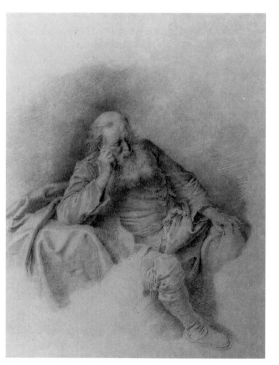

4

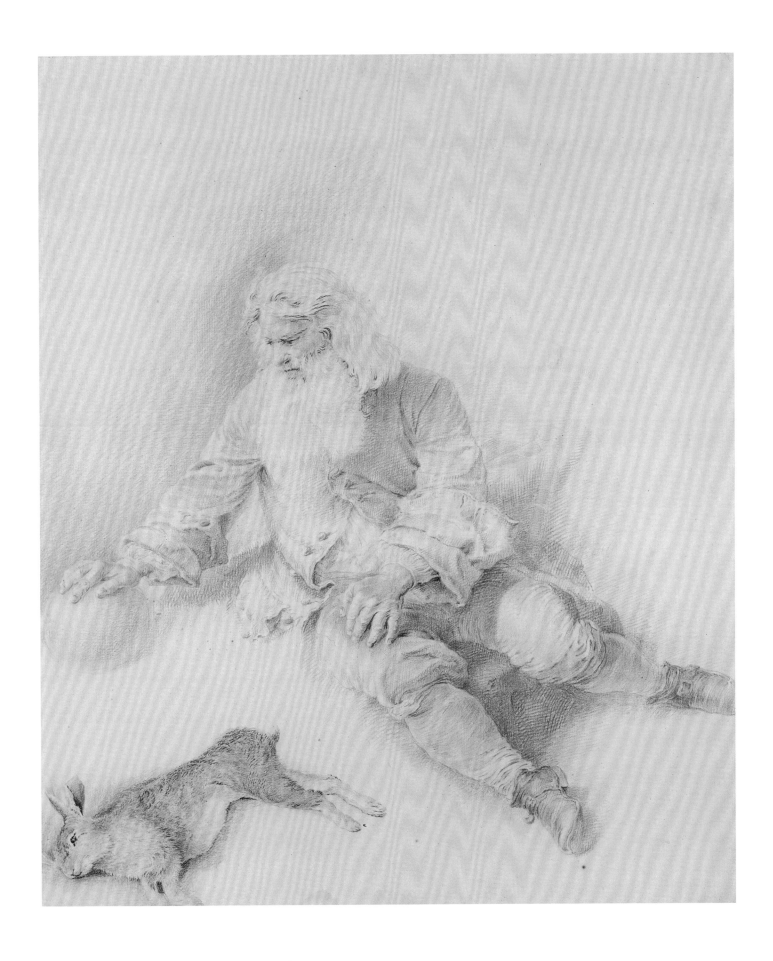

JUSTE-AURÈLE MEISSONNIER

Turin (Savoy) 1695–1750 Paris

50 *St. Aignan in Prayer before an Altar with Two Angels*

Black chalk, heightened with white chalk, on blue antique laid paper

453 × 312 mm.

Watermark: None

Inscriptions: None

Provenance: Collection Jullienne; his sale, 30 March 1767, lot 866; Kate Ganz, London; acquired in 1990 (D-F-196/ 1.1993.93)

Exhibitions: None

Literature: Kate Ganz in London 1989a, cat. no. 24 (n.p.)

*T*he subject and purpose of this exceptional drawing are identified in the caption of Pierre Chenu's print after Meissonnier's design: "St. Aignan, bishop of Orléans, bas-relief sculpted in silver, executed . . . for the reliquary of St. Aignan in Orléans" (fig. 1).[1] The official commission for a new reliquary for the highly esteemed relics of this saint—whose life was intertwined with the ancient Roman history of the city—followed soon after Bishop Fleuriau authorized the collecting of funds in 1725.[2] According to the contract, which enumerates the ornaments that should be included, Meissonnier agreed to complete the work by 1 May 1726.[3] Contrary to this commitment, however, the tomb-shaped reliquary was not delivered until November of 1730, when it was placed in the royal church of St. Aignan, for which Meissonnier had also designed an altar (fig. 2).[4] The exhibited drawing was probably completed just before the contract of 1725, but it remains possible that it was executed sometime during the span of four years that Meissonnier took to finish the work. A description of the reliquary published in the *Mercure de France* on the occasion of its installation supplies many of the details of the scenes depicted.[5] The drawing studied here portrays St. Aignan as bishop of Orléans at prayer, and the second bas-relief from the other side of the reliquary depicted Agrippa—friend and counselor of the administrator Augustus—being healed by St. Aignan. While the design is lost for this second composition, it was also reproduced in a print by Chenu (fig. 3).[6] Unfortunately, this impressive reliquary was destroyed in 1792.[7]

Meissonnier always made all of the drawings connected with his works, including the *modelli* for the prints made after his designs. Comprising a corpus of only ninety-five sheets, his oeuvre of drawings is relatively small when compared to those of his contemporaries.[8] His preliminary sketches reveal characteristic curvilinear contours in pen and ink or black chalk. He generally heightened his black chalk draw-

ings with white chalk to achieve greater volume, and he used colored washes as a supplement to his pen and ink studies to define the surface of his objects. Meissonnier also used gouache for effect, but this was usually restricted to rare, large preparatory compositions for paintings and firework displays.

The provenance of the St. Aignan sheet remains unclear, but its significance is certain.[9] It is unique in Meissonnier's oeuvre because of the visual impact of the figures. Although he was primarily famous for his designs for ornament and architecture, the exhibited drawing clearly demonstrates the artist's ability to manipulate complex figural compositions. It also reveals his debt to Gian Lorenzo Bernini and Pietro da Cortona. The choice of blue paper was not only dictated by the intended medium of silver for the finished work or his desire to heighten the volumes. It was also probably a reflection of Meissonnier's interest in the coloristic possibilities the paper offered when combined with black and white chalks. The resulting softness of the forms, which appear to emerge in an undulating rhythm from the surface of the sheet, was particularly fitting for the depiction of a bas-relief, and the white heightening suggests the reflection of light on its silver surface. These pictorial effects, and the artist's habitual avoidance of straight lines—which eventually won him great notoriety—recall a comment made by Charles-Nicolas Cochin le jeune in reference to his designs: "Meissonnier will destroy all of the correct lines that were traditionally used in favor of twists and turns . . . he will give these forms to everything."[10] PF

3

2

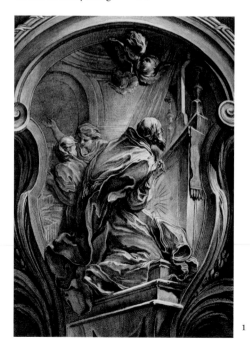

1

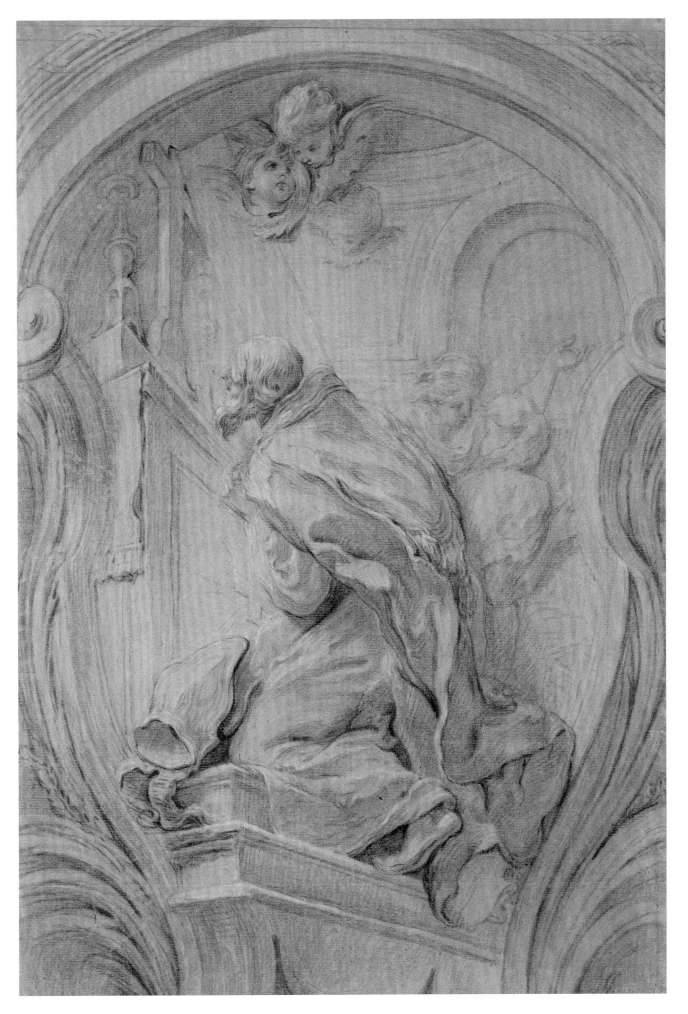

EDME BOUCHARDON

Chaumont-en-Bassigny 1698–1762 Paris

51 *Asia*

Red chalk on cream antique laid paper

262 × 324 mm.

Watermark: Churchill 368

Inscriptions: In red chalk in image on recto, bottom left: *L'asie*

Provenance: Galerie de Staël, Paris; acquired in 1994 (D-F-16/ 1.1994.17)

Exhibitions: None

Literature: Unpublished

*E*ighteenth-century collectors, biographers, critics, and even other artists esteemed Bouchardon as a brilliant draftsman. Pierre-Jean Mariette, a friend and an avid collector of Bouchardon's graphic production, noted that the artist's true genius was revealed in his drawings, which were worth their weight in gold,[1] and Michel-François Dandré-Bardon claimed that although Bouchardon's sculptures were the equivalent of the best works of antiquity, his drawings surpassed the ancients.[2] Given that he was a sculptor and not a painter, this level of appreciation was particularly rare. Although much of this unparalleled praise was due to the crisp draftsmanship of his later works, produced during his tenure as dessinateur de l'Académie des Inscriptions et Belles Lettres (cats. A.31–A.32), and for major sculptural projects (cat. 52), critics also admired the varied, supple line of drawings from the earlier part of his career, when, as a student in Paris and Rome, he often produced softer, more fluid sheets like *Asia*.

Given the large number of prints after Bouchardon's designs, one might speculate that he was keenly aware that, compared to a painter, a sculptor who worked with marble and therefore produced fewer works might receive less public attention. Although this important aspect of his career has never been thoroughly investigated, he may well have decided that a consistent campaign of having his inventions reproduced by printmakers would correct this imbalance. This process begins in the earliest part of his career.

A series of allegorical representations of the four continents was engraved after Bouchardon's designs by the German printmaker, Johann Justin Preissler, in the same direction as the originals (figs. 1–4).[3] The series is undated. However, since there is no evidence that Preissler ever visited Paris for an extended period of time, it is highly likely that these prints were made during his travels in Italy from 1724 to 1731, dates that coincided with Bouchardon's term as an artist-in-residence at the French Academy in Rome (1723–32).[4] *Asia,* exhibited here, and *America,* another sheet from the series in the Metropolitan Museum of Art, New York (fig. 5),[5] have resurfaced; the other two drawings remain lost. The graceful flow of the curving lines across the sheet, the subtle passages of stumping, and the elegant *mise-en-page* of the two extant drawings suggest a relatively early date of c. 1730, which accords with their probable date of reproduction.[6] All of the designs follow the standard iconographic prescriptions laid out by Cesare Ripa at the beginning of the seventeenth century.[7] Thus, even if the Horvitz drawing had not been inscribed, Bouchardon's *Asia* would be easily identified by her turban, earring, smoking censer, flowers, and camel. Given that each of these figures rests on a curved arc of moulding, it is tempting to speculate that they were designed either as ancillary figures for a large and complex fountain or tomb or as a set of *sopraporte* in a room with two doors. ALC

1

2

3

5

4

EDME BOUCHARDON

Chaumont-en-Bassigny 1698–1762 Paris

52 *Recumbent Putto with Raised Arms*

Red chalk on off-white antique laid paper

252 × 430 mm.

Watermark: Variant of Gaudriault ANG7.865/ ANG7.845

Inscriptions: In pen and brown ink on recto, bottom right: *Bouchardon*

Provenance: Sale, Drouot, Paris, 15 December 1993, lot 125; Thomas Williams Fine Art, Ltd., London; acquired in 1994 (D-F-19/ 1.1994.32)

Exhibitions: None

Literature: Anon., *L'Estampille-L'Objet d'art*, February 1994, p. 16

Since the beginning of the eighteenth century, the urgent need for a public source of clean water in the Faubourg Saint-Germain was a pressing concern for the Echevins, the public representatives of the city of Paris. Finally, in 1739, they chose a site and awarded Bouchardon the commission for what became the Fountain of the Four Seasons on the rue de Grenelle.[1] The fountain was completed in 1741. Still in place, and illustrated here in an elevation by an anonymous eighteenth-century engraver (fig. 1),[2] this large and impressive sculptural ensemble—which fits elegantly and functionally into this always-busy district—was one of the two most important and celebrated works of the artist's career.[3] Over the fountain proper, poised on a columned and pedimented porch, a soberly draped, seated woman representing the city of Paris is surrounded by personifications of the Seine and Marne rivers. This central group is flanked by four genii placed in niches, two on either side of the arc-shaped wall that serves as both a curved backdrop to the ensemble and a double-porticoed entrance to what was then the Convent of the Recollects behind the fountain. Each of the four genii represents one of the four seasons, as do the charming bas-reliefs of

cavorting putti and animals placed beneath them. The exhibited drawing is for one of the putti in the bas-relief *Autumn*, illustrated here by Bouchardon's related drawing, recently given to the Philadelphia Museum of Art with the McIlhenny Bequest (fig. 2).[4]

Following a time-honored tradition, Bouchardon's *Autumn* depicts putti eating and playing with grapes in a vaguely indicated landscape—a reference to the harvest season. Curiously, the artist also included a ram, which typically appears in scenes of spring.[5] Although the ram's presence is unusual, it adds to the delightful disorder and playfulness of the scene. At least two other drawings for *Autumn* are known: one for the charging ram in the Musée du Louvre, Paris (fig. 3);[6] and another in the Boijmans Van Beuningen Museum, Rotterdam (fig. 4),[7] for the putto who is eating grapes at the far right, seated in reverse to his position in the bas-relief.

In his memorial address to the Académie after Bouchardon's death, the comte de Caylus, a friend of the artist, suggested that Bouchardon's exceptional talent as a draftsman derived from the way he combined the best talents of sculptors, who understand the third dimension, and those of painters, who understand how to convey the third dimension with light and shadow on a two-dimensional surface.[8] The Horvitz study is one of a number of late drawings that justifies Caylus's praise. The putto sits in a tangibly three-dimensional space and he is convincingly realized with astoundingly sure contours. Bouchardon has enhanced these with a subtly nuanced chiaroscuro, achieved with a gentle system of hatching and stumping. Moreover, his additional attention to texture endowed the putto with palpably tactile hair, and skin that appears to cover real bone and muscle. These types of mature studies demonstrate the techniques that led Charles-Nicolas Cochin le jeune to proclaim that Bouchardon was one of the three greatest draftsmen of the eighteenth century.[9] ALC

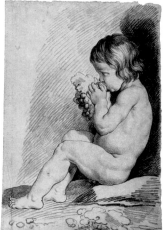

4

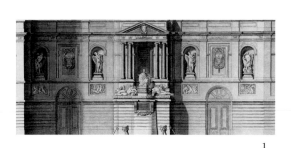

1

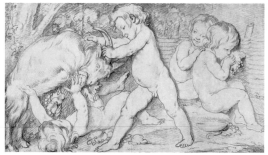

2

3

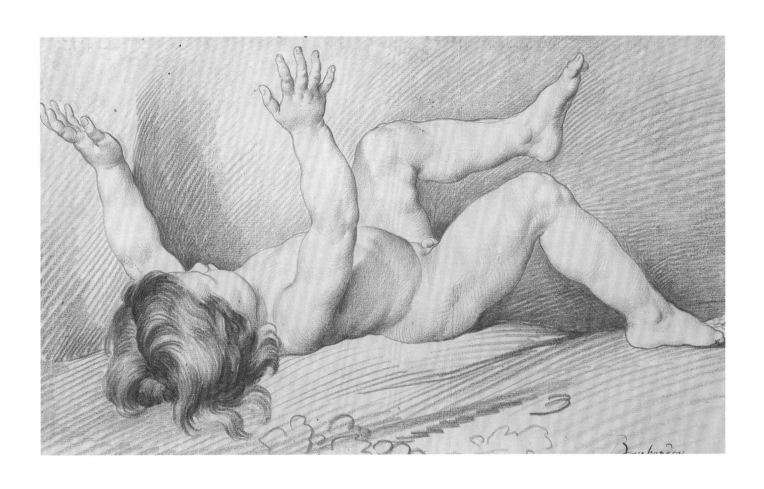

JEAN-BAPTISTE-SIMÉON CHARDIN

Paris 1699–1779 Paris

53 Bust of an Old Man

Pastel on blue paper adhered to canvas

449 × 370 mm.

Watermark: Laid down—none visible through mount

Inscriptions: Signed and dated in brown pastel, at lower right: *Chardin/ 1771*; signed and dated in brown pastel, at upper right: *C 1771 Char*

Provenance: Probably Salon of 1771, under no. 39; perhaps Jacquemin, jeweler to the king; his sale, 26 April 1773, lot 832; Laurent Laperlier; his sale, 11–13 April 1867, lot 58; sale, 19 June 1934, lot 6; sale, 19 June 1968, lot 1; sale, 30 May 1969, lot 3; Galerie Cailleux, Paris; acquired in 1984 (D-F-49/ 1.1993.32)

Exhibitions: Paris 1971, no. 1; Paris 1984d, no. 11

Literature: Bocher 1876, p. 116; Dayot and Vaillat 1907, under cat. no. 64; Goncourt 1909, p. 173; Wildenstein 1933, cat. no. 659; Wildenstein 1963, cat. no. 367; Wildenstein 1969, cat. no. 659, p. 224; Cailleux 1971, pp. iii–iv, fig. 2; Rosenberg in Paris et al. 1979, pp. 354 and 356, under cat. nos. 130 and 134; Rosenberg 1983, cat. no. 192; Rosenberg and McCullagh 1985, pp. 46, 49, 58, cat. no. 27, fig. 11; Rosenberg 1987, p. 116; Roland Michel 1996, pp. 96–98 and 224

*T*he reason that led Chardin to embrace pastel toward the end of his life is known: the technique of oil painting as practiced in his time actually burned his eyes.[1] Over time, with advancing age, they had become very delicate and sensitive.

But why, when Chardin chose to turn to pastel, did he only paint portraits? Certainly, he had already experimented with portraiture in 1746 and 1757, without achieving much success. Perhaps he wished to prove that he was still a viable talent. Did he think that pastel would enable him to avenge and obliterate the near-failures of the later forties and fifties?

To be sure, the Horvitz pastel is not a portrait in the strict sense of the word.[2] Chardin has chosen to present us with a bust-length view of an old man with long hair and a long beard who crosses his arms and appears to be sleeping. Inspired by Rembrandt, these

types of head studies from life were quite successful during the second half of the eighteenth century. One thinks immediately of the many by Greuze (cat. A.144; fig. 1). Here, Chardin was interested primarily in the burst of light—which strikes the head of the old man—and in the hair, which he boldly described with green and blue pastels.

Two other versions of questionable attribution have been discovered recently in private French collections. One is a more finished oval with variants that is of lesser quality (fig. 2),[3] and the other is very close to the original, but in poor condition (fig. 3).[4]

The Horvitz *Bust of an Old Man* seems to be one of the artist's earliest pastels—one of his first efforts in a new medium that would ensure his final triumphs—and it places Chardin among the greatest pastellists of his century. PR

1

2

3

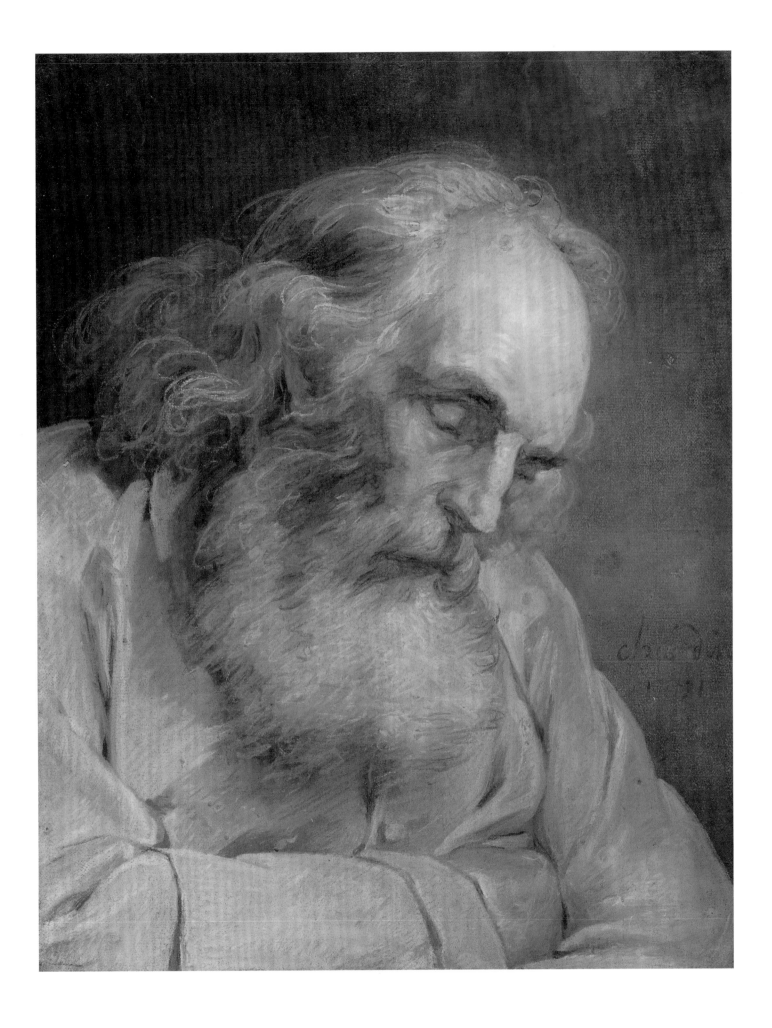

MICHEL-FRANÇOIS DANDRÉ-BARDON

Aix-en-Provence 1700–1783 Paris

54 *Adoration of the Shepherds*

Pen and brown ink with brush and brown wash, heightened with white gouache, over traces of black chalk on light tan antique laid paper

405 × 294 mm.

Watermark: Indecipherable

Inscriptions: None

Provenance: Jean-Christophe Baudequin at Galerie Ratton et Ladrière, Paris; acquired in 1995 (D-F-77/ 1.1995.97)

Exhibitions: None

Literature: Unpublished

Together with Bouchardon, Boucher, Chardin, Dumont le Romain, Natoire, Slodtz, Carle Vanloo, and others (cats. 51–53, 55–66), Dandré-Bardon was one of the prolific and enormously influential members of the so-called generation of 1700 who are well represented in the Horvitz Collection. Dandré-Bardon was one of the few members of this group to spend a significant portion of his mature career outside of Paris (1741–52).[1] This *Adoration of the Shepherds* is a particularly fine example of his draftsmanship during his early maturity in Paris (c. 1734–41), just after his return from Rome via Venice.[2] The significance of Venetian art for Dandré-Bardon and his contemporary compatriots has already been discussed by Pierre Rosenberg.[3] The exhibited drawing provides yet another example of this influence, as its composition must be indebted to a lost painting by Giambattista Piazzetta known through a reproductive etching by Francesco Bartolozzi (fig. 1).[4]

Although the figures in Dandré-Bardon's composition are similar to Piazzetta's, he has made them larger and more dramatic. Other differences present in Dandré-Bardon's version are the exclusion of the cherubim; the addition of a shepherd at the extreme left; and the turning of the middle shepherd, who is also seen mostly in profile and clasps his hands in thanksgiving. Further changes include the young boy who begins to take off his hat as a sign of respect, and the kneeling shepherd in the foreground who has his arms outstretched in astonishment and is seen completely from behind with his offering of a lamb to his left, and his gourd on the ground. Dandré-Bardon also diminished the role of St. Joseph. He is now in the corner reading. All of these changes enable the viewer to focus more attention on the Virgin and Christ child, who occupy the center of the scene.

The Horvitz study reveals that Dandré-Bardon's drawings share a number of characteristics with other artists working in Aix-en-Provence, such as Jean-Baptiste Vanloo and Jean-Baptiste Cellony (cats. A.340 and A.61–A.62). For example, instead of creating a logical recession into space in the manner preferred by the Académie—based on formulas established in central Italy—Dandré-Bardon used a combination of his febrile line and a liberal application of wash to create a pattern of diagonals through his compositions. Here, there are three zones of activity, all of which are squeezed onto the shallow plane of the sheet: the shepherds in varying tones of dark wash in the foreground; the Virgin and Christ in the middleground highlighted with white gouache; and St. Joseph in the shadowy background. In addition to his ability to capture rapidly the salient aspects of a figure, Dandré-Bardon's typically nervous line also generates active draperies. Nothing is ever still. At times, the effect he realizes with line and wash simulates the flickering quality achieved with the use of brush and brown wash on white paper by Venetian artists. One can also see many of these characteristics in his other drawings contemporary with the *Adoration of the Shepherds,* like the *Presentation in the Temple* of c. 1734 in the Musée du Louvre, Paris (fig. 2),[5] and the *Flight into Egypt* in the Bibliothèque municipale, Rouen (fig. 3).[6] These relatively early drawings reveal the unique and inventive aspects of color and movement that would continue to distinguish Dandré-Bardon's contribution to the art of his century. ALC

1

2

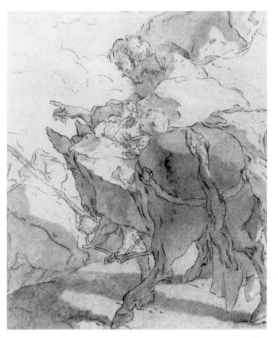

3

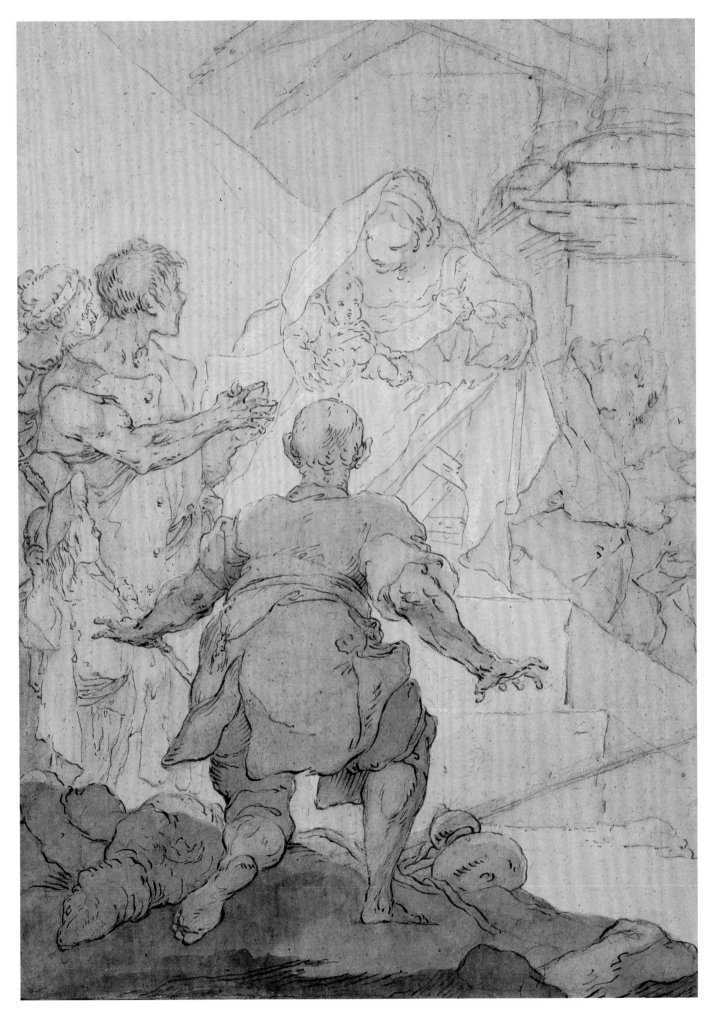

CHARLES-JOSEPH NATOIRE

Nîmes 1700–1777 Castel Gandolfo (Italy)

55 *Seated Female Nude Holding a Mirror, with a Subsidiary Study of a Hand*

Red and white chalk on light tan antique laid paper

334 × 243 mm.

Watermark: Laid down—none visible through mount

Inscriptions: None

Provenance: Sale, Bayeux, Calvados, 8 December 1981 (without catalogue, but reproduced in *La Gazette de l'Hôtel Drouot*, no. 41, 22 November 1981); Galerie Cailleux, Paris; acquired in 1987 (D-F-207/ 1.1993.98)

Exhibitions: None

Literature: Unpublished

*T*his graceful study is preparatory for the figure of Truth in Natoire's oval painting, *Time Revealing Truth*, now in the James A. Rothschild Collection at Waddesdon Manor (fig. 1).[1] A painted composition of the same subject, similar in shape and marginally smaller in size, was sold in 1796 with the collection of the fermier-général, Laurent de La Reynière, whose Paris mansion occupied the site where the United States Embassy now stands.[2] Although the estate sale catalogue of this luxury-loving collector makes no mention of a pendant to this composition, in 1880, without specifying its subject, Alice de Rothschild mentioned a painting in the collection of the duc de Noailles that might have been a pendant to the Waddesdon picture. Unfortunately, it has not been possible to locate this work.

The outdated catalogue of Natoire's oeuvre by Ferdinand Boyer mentions neither the Waddesdon picture nor any related drawing.[3] In addition to the present sheet, another study for the face of Truth recently appeared at auction (fig. 2),[4] where it was incorrectly identified as preparatory for the head of Hagar in Natoire's *Hagar and Ishmael in the Desert* of 1732.[5] However, both the exhibited drawing and the recently discovered sheet, as well as the Waddesdon canvas all appear to date to about 1737–40.

Like Le Moyne (cat. 41) and Pierre (cat. 69), Natoire excelled at studies of the female nude. The *mise-en-page*, accentuated here by a charming subsidiary study of Truth's hand holding the mirror, is always elegant, and his supple and rhythmic line generates graceful curves and generous contours. The crisp and sure red chalk line in the Horvitz drawing is not unlike that found in a slightly earlier sheet, now in the Graphische Sammlung Albertina, Vienna (fig. 3),[6] which is a preparatory study for his reception piece for the Académie in 1734.

Natoire's composition of *Time Revealing Truth* can be compared with an earlier treatment of this subject by François Le Moyne that also belonged to the La Reynière family (Wallace Collection, London).[7] In the Waddesdon canvas, Natoire borrowed many aspects of Le Moyne's figures (the face of Truth very clearly echoes the pose and expression that Le Moyne gave to this figure), but in order to adapt the image to the dimensions of his composition—the perspective clearly indicates that the work was conceived as an overdoor—Natoire modified their poses. Truth appears with Falsehood (or Deceit), who holds a mask that she is being forced to take off, and a putto helps Truth to support the mirror in which the unmasked face of Falsehood or Deceit is reflected. Natoire's painting may have been intended as a tribute to his former teacher, François Le Moyne (with whom he studied for two years after leaving the atelier of Louis Galloche), who had just committed suicide. JFM

2

3

1

216

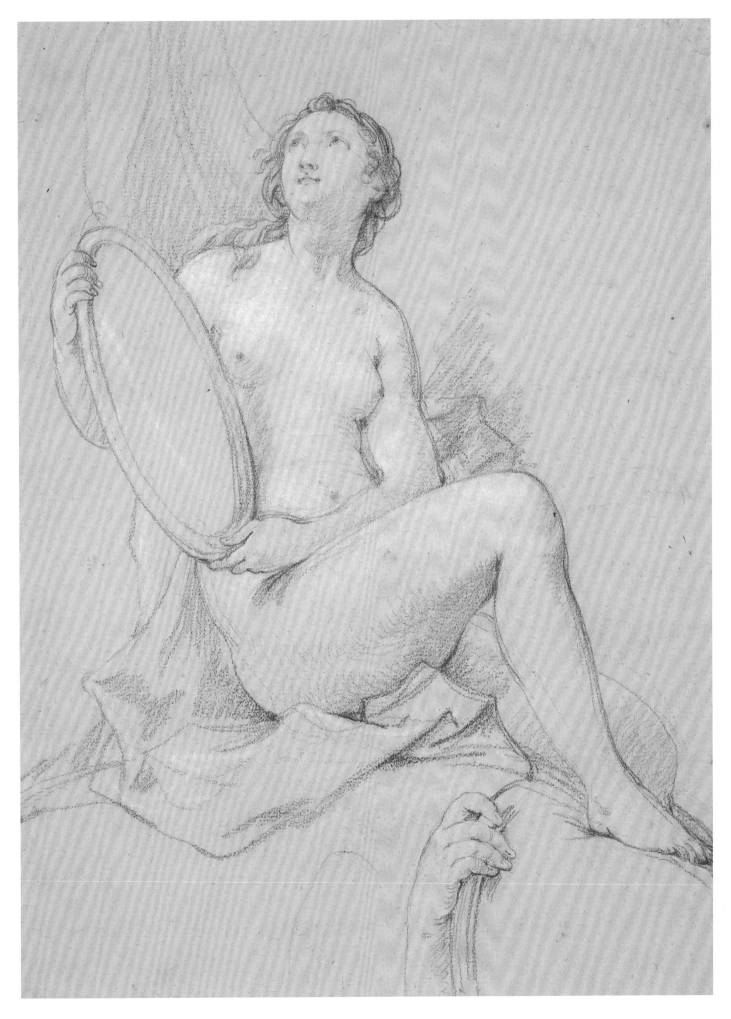

CHARLES-JOSEPH NATOIRE

Nîmes 1700–1777 Castel Gandolfo (Italy)

56 *Ceiling Study for a View of Heaven*

Black chalk with brush and brown wash, heightened with white gouache, on faded blue antique laid paper

890 × 559 mm. (irregular; arched at top and bottom)

Watermark: Laid down—none visible through mount

Inscriptions: None

Provenance: Galerie Emmanuel Moatti, Paris; acquired in 1993 (D-F-209/ 1.1993.98)

Exhibitions: None

Literature: Bull 1993, pp. 368–69, fig. 74

*A*lthough this exceptionally fine study is undoubt-edly the work of Natoire—his hand is apparent in each of its numerous figures, some of them scarcely distinguishable from the parted clouds—its precise subject and purpose remain a mystery. It seems that he wished to depict heaven in its entirety, open to the viewer's gaze. In the center is God the Father, flanked by the Virgin and their son, Jesus Christ. Below them and to their right, Moses holds the tablets of the Law, his forehead radiant with the holy light that touched him on Mount Sinai. Below and to either side of him are groups of figures that doubtless represent the Prophets. Beneath God the Father appear the Evange-

lists: St. John is in the center, next to the eagle; to his right is St. Matthew with the angel; the figure between Saints John and Matthew is probably St. Luke, since St. Mark with the lion is depicted in an inverted posi-tion along the right side of the composition. Within the semicircle at the bottom of the image on the left are St. Peter (seen from the back and surrounded by angels holding the keys to heaven's gates), a pontiff crowned with a papal tiara, and near him an angel holding the triple papal cross. On the right, St. Andrew with his ×-shaped cross sits above a Church Father. Saints George and Claire, various saints who founded orders, and other holy figures are grouped along the left edge of the drawing. They precede St. Catherine, shown with the wheel, and a number of other martyrs bearing palm fronds. In the semicircle at the top of the image, St. Louis, or perhaps Charle-magne, is wearing a crown and holding a sword and a globe. He is accompanied by St. Lawrence, who is depicted with the grill on which he was burned alive; St. Simplicius, patron saint of builders, who holds a column; and St. Dominic, who is accompanied by a dog holding a torch in its mouth. Music-making angels evoke the harmony and beauty of the heavenly realm.

No project that corresponds to this design is men-tioned in the documents pertaining to Natoire's career. The most important of his earlier religious commissions is the one he executed in 1750–51 to adorn the chapel of the well-known orphanage, Les Enfants Trouvés, located near Notre-Dame in Paris. This extraordinary work was destroyed in 1868, but it is known through the engravings of Etienne Fessard.[1] Natoire's highly original conception in that commis-sion, which included illusionistic buildings and ruins on the ceiling and walls, is inconsistent with the pro-ject shown here. Nevertheless, some of the figures in the exhibited drawing are similar to those executed

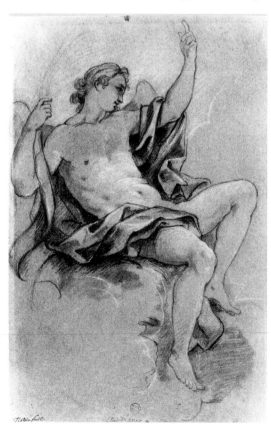

1

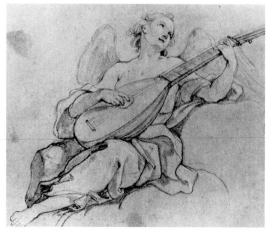

2

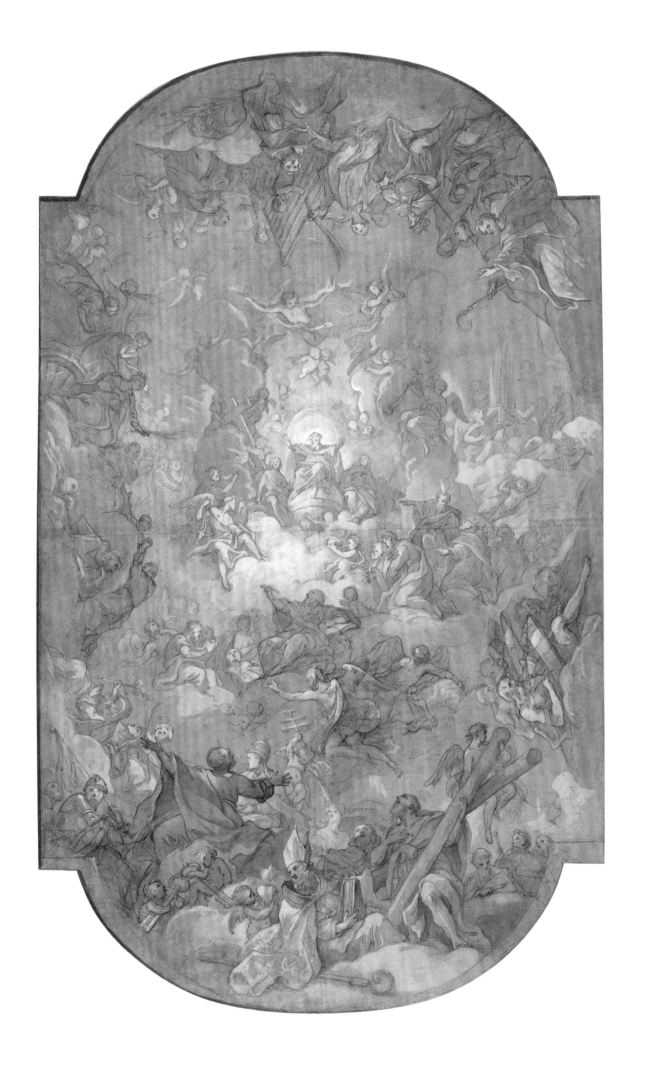

for that work. The preparatory study in the Musée Atger, Montpellier, for an angel holding a banderole in the chapel of Les Enfants Trouvés (fig. 1),[2] and the study for an angel playing a lute in the Musée des Beaux-Arts, Orléans (fig. 2),[3] echo some of the angels in the Horvitz project, such as the angel who holds a censer below and to the left of Christ and the one who plays a lute above and to the right of the Virgin.

The similarities between the exhibited drawing and preparatory studies for the chapel of Les Enfants Trouvés suggest that these projects must have been nearly contemporaneous. Natoire completed the decoration for the chapel just prior to his departure to assume the directorship of the French Academy in Rome. In 1753, he was commissioned to paint the ceiling of San Luigi dei Francesi, the national church of France in the Eternal City. Appropriately enough, the subject he chose was the apotheosis of St. Louis (*in situ*). The design for that composition, in the Musée Baron Martin, Gray (fig. 3),[4] like the one shown here, is semicircular at each end. Might the Horvitz draw-

ing, which probably includes the figure of St. Louis, have been Natoire's early plan for the ceiling of the French church in Rome? Its dimensions are wider than those of San Luigi dei Francesi, but the vaulting there was not completed until 1754.[5] Is it possible that Natoire envisaged a view of heaven that would simply include St. Louis before he turned to the final composition depicting this saint's apotheosis?

The Horvitz ceiling study and the *modello* in the Musée Baron Martin at Gray of the final ceiling design for San Luigi dei Francesi do not exist in isolation. Natoire drew another, more rectangular view of heaven that belonged to the marquis de Chennevières-Pointel,[6] and Jean-Louis Lempereur owned a large wash composition depicting the apotheosis of St. Charles Borromeo.[7] Two others are now in the Art Institute of Chicago (fig. 4)[8] and the Graphische Sammlung Albertina in Vienna (fig. 5).[9] Clearly, the realm of Natoire's major decorative painting—particularly his ceiling designs and the related studies that prepared them—remains to be discovered. JFM

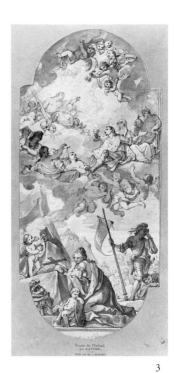

3

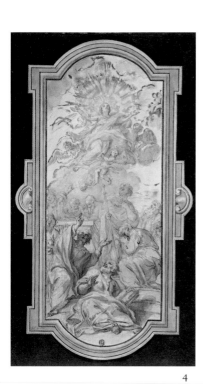

4

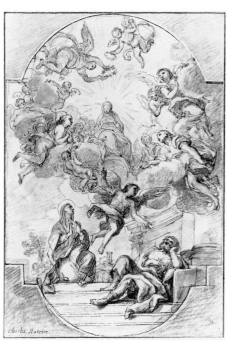

5

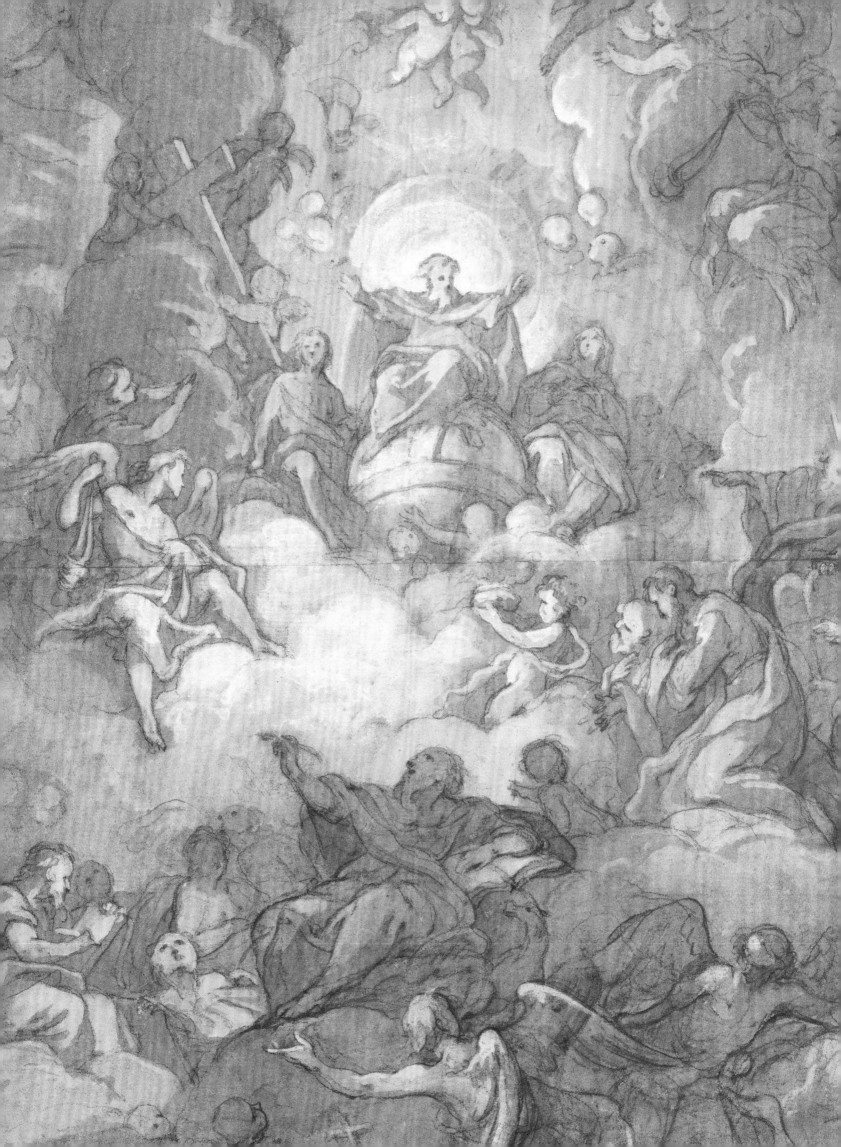

CHARLES-JOSEPH NATOIRE

Nîmes 1700–1777 Castel Gandolfo (Italy)

57 *Orpheus Charming the Nymphs*

Pen and brown ink and brush with light and dark brown wash, heightened with white gouache, over black chalk on off-white antique laid paper

299 × 438 mm.

Watermark: Laid down—none visible through mount

Inscriptions: In pen and brown ink of recto, bottom left: *C. Natoire/ f.*; in black chalk on verso of the mount, center: *C. Natoire F.*

Provenance: Sale, Paris, 26–27 May 1921, lot 358; Galerie Cailleux, Paris (as of 1983); acquired in 1987 (D-F-208/ 1.1993.99)

Exhibitions: Paris 1983b, no. 43

Literature: Boyer 1949, p. 87, cat. no. 473; Jean Cailleux and Marianne Roland Michel in Paris and Geneva 1986 (n.p.); Roland Michel 1987, p. 31, fig. 19

*T*his charming composition depicts the legendary poet Orpheus, famed for his skill with the lyre. So great was his gift that he could charm not only wild animals, but also trees and rocks, which would move of their own accord in order to follow the exquisite sound of his music (Ovid, *Metamorphoses*, Book 10).

In 1751, Natoire arrived to assume the directorship of the French Academy in Rome, then located in the Palazzo Mancini on the Corso. He devoted much of his first few years there to the ceiling of San Luigi dei Francesi (see the preceding entry) and to fulfilling commissions he had received in France. These projects were all completed by 1757, after which he seems to have followed his own inclinations. He often returned to the mythological themes that had brought him so much success in Paris.

Natoire executed at least three other drawings related to this composition: a study in the Musée du Louvre, Paris, for the figure of Orpheus (fig. 1),[1] and two for the entire design: one in the Musée Atger, Montpellier (fig. 2),[2] the other in the Robert Lehman Collection in the Metropolitan Museum of Art, New York (fig. 3).[3] The composition was conceived around 1757; this is the date inscribed on the Montpellier drawing, which is similar in most respects to the exhibited sheet. In the Montpellier version, Natoire perfected the arrangement of the figures and used a somewhat more complex technique: pen and brown ink with brush and brown wash and heightening in white gouache on blue paper. In contrast to the present drawing, in which the lines in black chalk are still visible, the Montpellier composition is more highly

finished, a kind of *bozzetto* reminiscent of a grisaille that prefigures the effects of light as the artist envisaged they would appear in the finished drawing.

It was probably at the advanced stage represented by the Montpellier version that Natoire began to make studies of the individual figures. The Louvre's *Orpheus* depicts the poet with his weight balanced on his right leg, and with hands that are more carefully detailed than they are in the Horvitz drawing. Despite the many extant drawings related to this composition, Natoire evidently did not execute a painting; none is mentioned in an eighteenth- or nineteenth-century source, and none has ever come to light.

During his period in Rome, especially in the 1770s toward the end of his life, Natoire often reworked or redrew his designs and then colored them with either watercolor or gouache. These were usually never intended to be executed as paintings. JFM

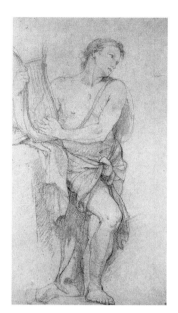

1

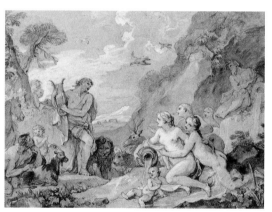

2

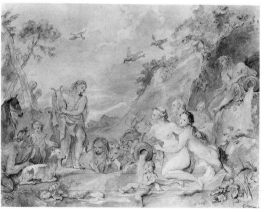

3

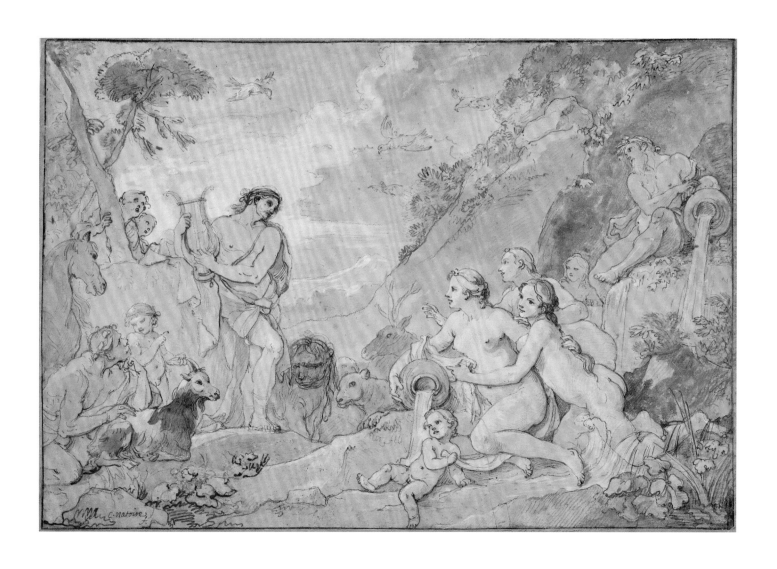

CHARLES-JOSEPH NATOIRE

Nîmes 1700–1777 Castel Gandolfo (Italy)

58 *Italian Landscape with the Ruins of the Villa Sacchetti*

Black chalk, pen and brown ink, brush with brown wash and watercolor, heightened with white gouache, on blue antique laid paper

323 × 460 mm.

Watermark: Laid down—none visible through mount

Inscriptions: Signed in pen and black ink, bottom right: *C. N* (letter reversed) *ATOIRE OCTob.e 1772*; in pen and black ink, bottom center: *Ruine DE LA Villa SACHETTI*

Provenance: Sale, Drouot, Paris, 22 March 1995, lot 108; acquired at the sale (D-F-338/ 1.1995.86)

Exhibitions: None

Literature: Unpublished

*W*hile attending the French Academy in Rome, Natoire was encouraged to draw landscapes by the director, Nicolas Vleughels. Years later, during his tenure as director of the same institution, Natoire, in turn, encouraged young students such as Fragonard and Robert to draw views of Rome and the surrounding *campagna* (cats. 86, 88, 90–91) and devoted his own free hours to the same endeavor. This landscape of the Villa Sacchetti, known as the Pignetto, is dated 1772, and thus belongs to the closing years of his life.

The Pignetto—one of several Sacchetti family villas surrounding Rome—was conceived by the renowned seventeenth-century painter and architect Pietro Berretini da Cortona.[1] Located northwest of Rome, between the Vatican and the Monte Mario, it was built around 1630 at the request of Cardinal Giulio Sacchetti or his brother Marcello, the marchese Sacchetti.[2] Cortona's design for the villa resulted in a type of building hitherto unknown in post-Renaissance architecture. As the view etched by Giuseppe Vasi reveals (fig. 1),[3] it combined the lofty elevations of classical Roman baths, unrealized plans first proposed by Andrea Palladio, and elements of the Vatican's monumental Belvedere, including an intricate system of curved stairways and multiple terraces. A number of engravings and blueprints—annotated by the eighteenth-century draftsman Pier Leone Ghezzi—preserve the appearance of this magnificent structure, which was demolished in the early nineteenth century.[4]

Natoire depicted the once-grand villa as it looked in 1772, when it had already lost its top story, along with the balustrades and statues that crowned it. The spectacular network of staircases and terraces have vanished. The only features still remaining beneath the enormous apse are the two Tritons adorning the main fountain. Yet Natoire renders them close to one another and off-center in relation to the main axis, as if the basins of the fountains had been modified and reduced during the period since seventeenth-century printmakers had depicted the villa.

Natoire relied mainly on black chalk in his endeavor to capture what remained of the magnificent villa. But, as he did with many late landscapes, he also added brown wash, watercolor, and gouache to create a colorful, idyllic, and picturesque blend of contemporary Italy and the crumbling remains of her glorious past. His *View of the Temple of Vesta from the Ruins of the Imperial Palace* in the Musée Atger, Montpellier (fig. 2), is another example of his work from 1772.[5]

The Horvitz landscape remained unknown until recently. It was not cited in the very long and precise list of the more than 160 landscape drawings by Natoire featured in the sale of his estate held in Paris in 1778. Thus, it might have been offered by the artist to one of his guests or to one of the many French notables who visited the Eternal City. Natoire occasionally returned to sketch sites that he had already drawn. Sometimes he would even copy a drawing he had made years before. His *View of the Campo Vaccino and Palatine Hill* (signed and dated 1773),[6] which reappeared at auction the same day as the exhibited sheet, is a later version of a drawing (signed and dated 1766) recently acquired by the Musée Bonnat in Bayonne as part of the bequest of Jacques Petithory.[7]

JFM

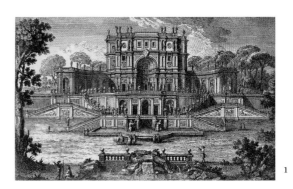

1

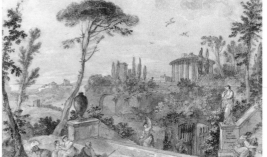

2

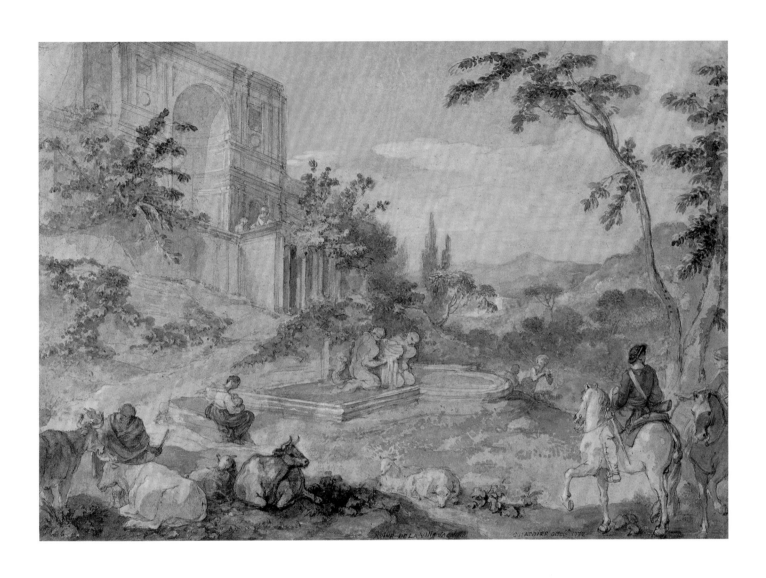

JACQUES or JEAN DUMONT, called DUMONT LE ROMAIN

Paris 1701–1781 Paris

59 Hercules or Bacchus Making a Request

Red chalk on off-white antique laid paper

272 × 390 mm.

Watermark: Variant of Gaudriault 730

Inscriptions: None

Provenance: Marie-Guillaume-Thérèse de Villenave; her sale, by Alliance des Arts, Paris (L. 61, twice at bottom left), 1–8 December 1842, lot 120 (as Sebastiano Conca); Jean-Luc Baroni, London; Douwes Fine Art, London; Private Collection, Paris; sale, Drouot, Paris, 28 March 1990, lot 4 (as Charles-Nicolas Cochin le jeune); Galerie Emmanuel Moatti, Paris (by 1992); acquired in 1995 (D-F-324/ 1.1995.89)

Exhibitions: London 1980, no. 25 (as Louis de Silvestre); Paris 1992c, no. 10 (as Dumont le Romain)

Literature: London 1980, cat. no. 25 (n.p.); Emmanuel Moatti in Paris 1992c, cat. no. 10 (n.p.)

*T*he subject of this charming drawing by Dumont le Romain is difficult to determine. The young hero in the center holds a club—albeit a meager one—which suggests that he is Hercules. However, Hercules is usually shown wearing a lion's skin,[1] whereas this figure is draped with the pelt of a panther, the traditional garb of Bacchus, whose presence would be supported by the important role that music and dance play in this composition. In the left foreground, a child strikes a pair of cymbals, and the woman seated on the ground in the right corner holds an ancient instrument known as a sistrum. In the background, in front of a structure resembling the Pantheon, women dance to the sound of a tambourine, and in the middleground on the right, at least two figures sit at a table and converse under what appears to be a vine-covered arbor. The distinctive central scene remains enigmatic: the hero leans toward a seated female figure who points to an elderly man and a shrouded woman. If this is indeed Hercules, it could scarcely be a portrayal of his choice between Vice and Virtue.[2] If the figure is Bacchus, could he be asking for directions to the underworld, where he will search for his mother, Semele?[3]

Although the subject remains a puzzle, the drawing has finally been assigned to the correct hand. Over the years, the many artists proposed included Sebastiano Conca, Charles-Nicolas Cochin le jeune, and both the elder and younger Louis de Silvestre, but none of these suggestions was very persuasive. Chantal Mauduit, who is completing her doctoral dissertation on Dumont le Romain, finally made the most recent and convincing attribution to her artist.

Dumont le Romain owes his sobriquet to the extended journey he made to Italy on foot (1720/

21–25) to familiarize himself with the works of its earlier and contemporary artists. He undoubtedly hoped that this would augment his education since he had been trained in a familial setting of sculptors and painters instead of the Académie, which excluded him from the competition for the Prix de Rome. At least four drawings he made after paintings by Benedetto Lutti in Italy are now in the Musée du Louvre, Paris. These include *The Magdalen at Christ's Feet*, now at Kedleston Hall, and *The Communion of the Magdalen*, after Luti's altarpiece in Sta. Caterina da Siena, Rome, which remains *in situ* (fig. 1).[4] Another drawing, *The Sacrifice of Manoah*, also probably a copy after an unidentified painting, is in the Metropolitan Museum of Art, New York (fig. 2).[5] These elegant and spirited copies, notable for their firm contours and flawless execution, belong to a homogenous group by Dumont, and they are often mounted identically. Could they all come from his atelier?

Dumont's focus on Luti's works may at first seem surprising. However, one may explain it by the major shift that occurred in the Roman art world during the decade or so after the death of Carlo Maratta in 1713, when the most talented members of the younger generation of painters working in the Eternal City—Luti from Florence, Francesco Trevisani from Venice, and Sebastiano Conca from Naples (to whom this sheet was first attributed)—became artists of central importance. Dumont's particular attention to Luti may also be related to the latter's death in 1724. The typically precise execution of the exhibited drawing, with loving attention given to every detail, suggests that it may also be after a contemporary Roman composition. JFM

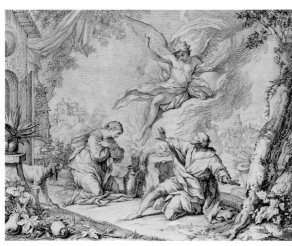

1

2

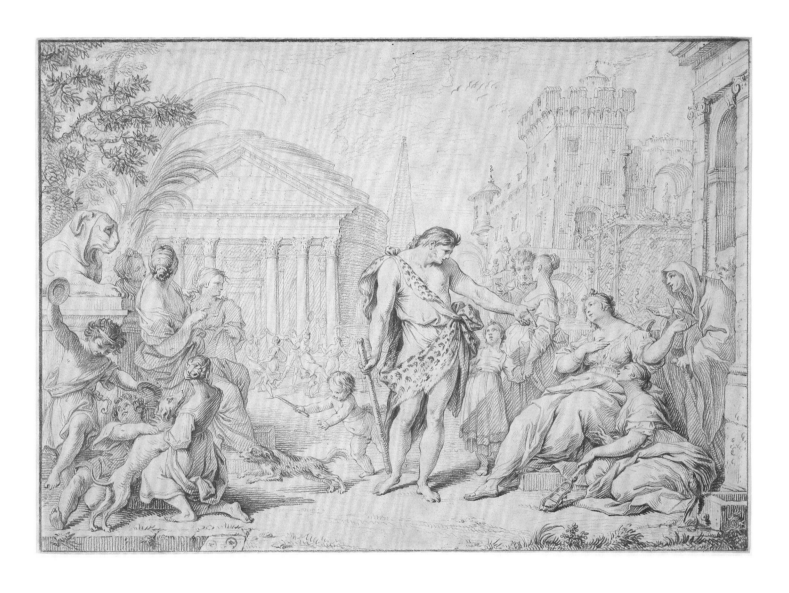

227

FRANÇOIS BOUCHER

Paris 1703–1770 Paris

60 *Seated Male Nude with Armor*

Red chalk on cream antique laid paper

487 × 354 mm.

Watermark: Churchill 515

Inscriptions: In pen and brown ink, bottom right: 55

Provenance: Private Collection, France; Thos. Agnew and Sons, Ltd., London; acquired in 1989 (D-F-23/ 1.1993.22)

Exhibitions: London 1986a, no. 25; London 1989b, no. 7

Literature: Gabrielle Naughton in London 1986a, pp. 44–45, cat. no. 25; Gabrielle Naughton in London 1989b, cat. no. 7 (n.p.)

*A*cadémies were, as their name indicates, one of the principal tools of academic art instruction in Europe in the eighteenth and nineteenth centuries. The master would choose the pose of the model for his pupils in a life class based on attitudes taken from celebrated paintings and sculptures or create one that might serve for one of his own compositions. The more advanced pupils, and sometimes even fully formed artists, would draw from life, while novices and amateurs—who began with easier, two-dimensional models—might copy *académies* taken from portfolios that contained a numbered selection of the most well-executed examples from the past.[1] A trap for the unwary is that the name or signature that often appears on these sheets may not be that of the draftsman. Instead, it may only indicate the master who drew the original or signify the approval of the professor who set the pose.

By the mid-eighteenth century, when drawings were a well-established category of collecting, many collectors avidly sought *académies* by the best masters. Boucher and Carle Vanloo, in particular, eagerly met the demands of this new market, both in the form of original "finished" drawings, sheets destined to be engraved, and counterproofs from them. Because of the usefulness of the poses, offsets were evidently almost as keenly sought after as their originals.[2] It was partly a result of their potential collectability that drawn, and sometimes painted, *académies* were supplemented—as in the case of the Boucher exhibited here—with indications of armor, urns, or other accessories, making it possible to interpret the figures as warriors, river gods, and even specific characters from mythology and literature.[3] The features of the nudes often differ little, even among artists, because the same regulars—always male until the late nineteenth century—were employed at the Académie, even into an advanced age.[4]

Boucher's *académies* reveal his preference for pensive poses in which the model supported his chin on one of his hands. This had the additional advantage of enabling the model to sustain the pose.[5] Although academic drawings are difficult to date, a fine seated *académie* in the Musée du Louvre, Paris—evidently of the same model seen in the exhibited drawing, where armor also appears as an accessory—provides an appropriate comparison with the exhibited drawing. The Louvre sheet is linked with a composition of 1747. This suggests that both the Louvre *académie* and the exhibited drawing might date to the late 1740s (fig. 1).[6] It would be a mistake to deduce from this any intended exploitation of the pose. Frequent though the association of armor with male nudes is in Boucher's oeuvre, his studies for paintings or cartoons employing such figures are more summary and patently functional. For example, his *Figure Study for Aeolus* from a private collection (fig. 2)[7] makes an instructive contrast with the artist's *académie* shown here. The figure study was made in preparation for a specific work in another medium (even though the *No. 54* inscribed on it suggests that it was later incorporated into the portfolio of some drawing school or academy), whereas the Louvre and Horvitz *académies* were executed as exercises or finished studies in their own right. AL

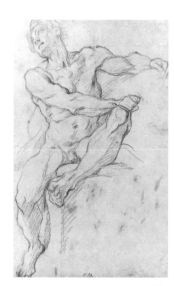

2

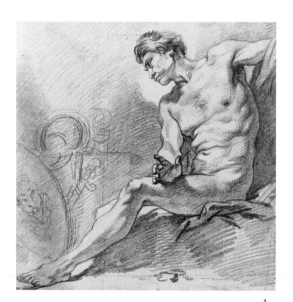

1

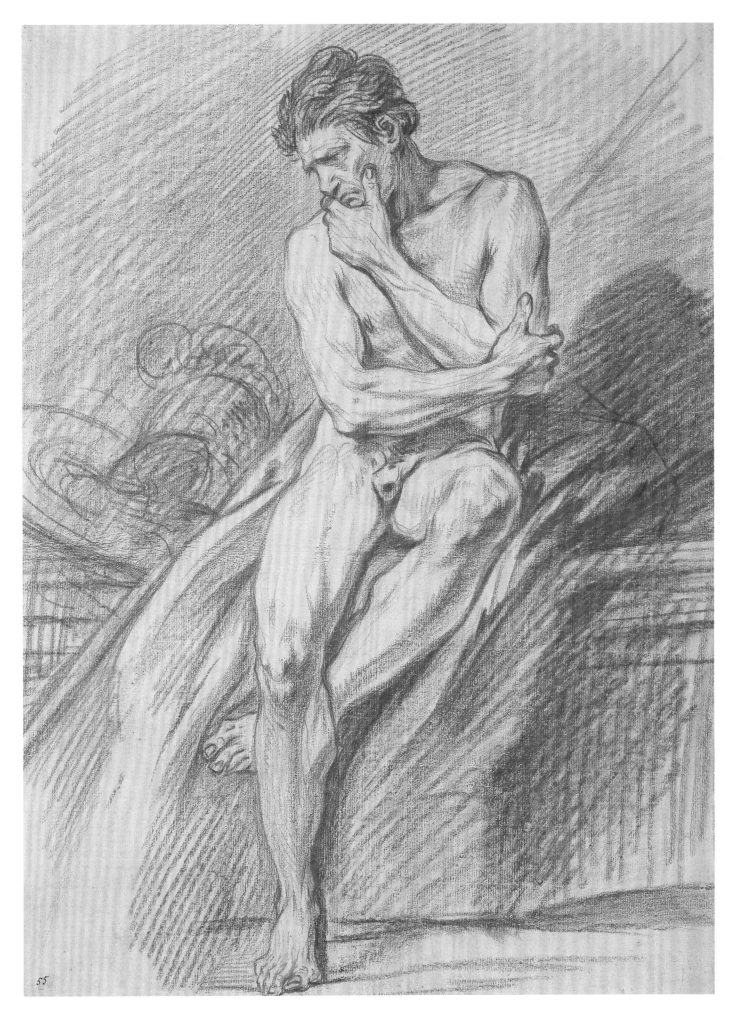

55

FRANÇOIS BOUCHER

Paris 1703–1770 Paris

61 *Juno Commanding Aeolus to Release the Storm Winds*

Pen and brown ink with brush and brown wash over black chalk on off-white antique laid paper

260 × 347 mm.

Watermark: Laid down—none visible through mount

Inscriptions: Signed in pen and brown ink, bottom right: *f Boucher/ 1753*; on mount, bottom right: blind stamp G (for the mount maker Glomy; L.1119)

Provenance: Probably Cayeux sale, Paris, 11 December 1776 and the following days, lot 205; probably Collet sale, Paris, 14 May 1787 and the following days, lot 140; probably sale, Paris, 31 May 1790 and the following days, lot 145; possibly sale, Paris, 15 March 1795 and the following days, lot 22; sale, Drouot, Paris, 27 March 1991, lot 46; sale, Sotheby's, London, 4 July 1994, lot 105, acquired at the sale (D-F-28/ 1.1994.60)

Exhibitions: None

Literature: Unpublished

*J*uno's request to King Aeolus to release the storm winds, so as to destroy the fleet of the detested Trojans under Aeneas, makes a dramatic opening to Virgil's *Aeneid* (1:50–86). Although the subject was not uncommon in seventeenth- and eighteenth-century French painting, Boucher himself only painted the subject once, so far as we know. Executed only a year before his death, it was one of the large upright canvases for a room in the Hôtel Bergeret de Frouville in Paris and is now in the Kimbell Art Museum, Fort Worth (fig. 1).[1] At first glance, the drawing exhibited here would appear to have been an early idea for this painting, since the figures of Aeolus and the foremost wind before his cave are strikingly similar.[2] But not only is the present composition oblong—when there never seems to have been any idea that the Bergeret de Frouville canvases should be anything but upright— it also lacks a number of elements of the painting, and it has others that relate it to two very similar, earlier chalk drawings of the subject now in private collections (fig. 2).[3]

If the relationship of Boucher's two earlier drawings of this theme to one another is somewhat uncertain, the composition they prepare is certainly that of the sheet shown here.[4] The seated figure of Juno and the adjacent winged figure of Iris are similar. However, in the exhibited drawing, Deiopeia, whom Juno offers to Aeolus as bride and bribe, is turned with her back to us, and Aeolus himself is raised from an aslant seated position—see the figure study for the original position (cat. 60, fig. 2)—to a standing one, where he looks back over his right shoulder in a manner very close to that seen in the Bergeret de Frouville painting.[5]

What was the purpose of the Horvitz version and when was it made? Unlike the two chalk drawings— which look like sketches for something else—in view of the signature and date, as well as the high degree of finish with successive layers of three tones of exquisitely applied brown washes, it seems probable that this sheet was made as an independent work.[6] Contrary to previous cataloguers, who were influenced perhaps by the connections between this sheet and the Bergeret de Frouville painting, I read the date here as 1753 and would propose a date in the late 1740s or early 1750s for the two chalk studies.[7] The existence of these two related studies as well as another recently discovered sheet (Private Collection, fig. 3),[8] suggests the importance of the composition for Boucher and makes it all the more curious and frustrating that we know nothing of the commission that must have given rise to them.

Boucher may have even gone so far as to have made an oil sketch related to the Horvitz composition. Chardin's estate sale contained an oil sketch ascribed to Boucher entitled *Venus, Irritated by the Contempt that Telemachus had Shown for Her Worship, Begs the Help of Aeolus.*[9] There is, however, no such episode in François de Salignac de la Mothe-Fénélon's *Les Aventures de Télémaque* of 1699—an amplification of Homer's *Odyssey*—and it is probable that the cataloguer, unfamiliar with the Latin *Aeneid*, had confused the Virgilian episode depicted in the oil sketch and the present sheet with one he imagined to be in the later Fénélon version of the story, with which he had only a vague familiarity. If this was so, he was displaying less learning than Boucher himself, who, even in his earliest sketches, recalled all of the essentials in the scene from the *Aeneid*, including such precise details as Juno's peacock and Iris's wings. These drawings are yet a further indication that Boucher was far from the unlettered boor misremembered by Jean-François Marmontel in his dotage.[10] AL

1

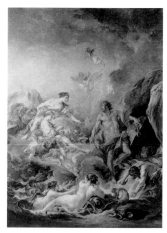

3

2

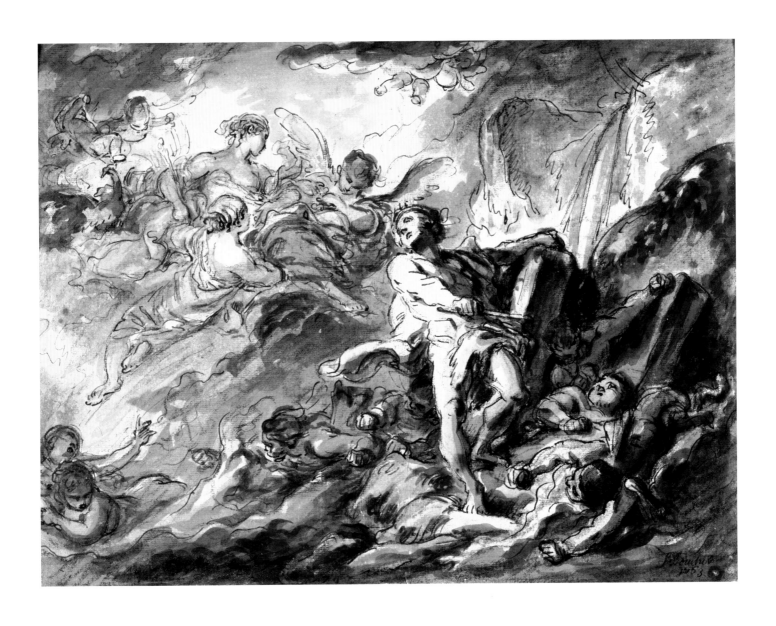

FRANÇOIS BOUCHER

Paris 1703–1770 Paris

62 *Lady Attended by a Handmaiden*

Black chalk heightened with white chalk on blue-green antique laid paper

360 × 275 mm.

Watermark: Laid down—none visible through mount

Inscriptions: Signed and dated in black chalk on recto, bottom left: *f. Boucher 1764*

Provenance: Sale, Drouot, Paris, 9 December 1992; Didier Aaron et Cie, Paris; acquired in 1995; (D-F-32/ 1.1995.82)

Exhibitions: None

Literature: Unpublished

*W*hen this drawing first appeared in 1986, it was entitled *Psyche Refusing Divine Honors.* This was probably because the pose of the main figure has a vague affinity to that of Psyche in Boucher's grisaille of this subject in the Musée du Château de Blois and because it seemed to contain an altar.[1] The chief protagonist here, however, is a woman of status, not a mere girl, and the supposed altar is more likely an incense-burner in the form of an *athénienne*. Before her is a cushion, seen at the lower left, the appearance of which is more likely a mark of her status than an indication of imminent use, and a kneeling handmaiden (or priestess?) holds what looks like a vessel for replenishing the incense on a tray enveloped by a cloth. The maid's hair is covered by a turban, while her mistress's hangs loose, partially wrapped by a shawl with striped borders. These details, and the sandaled feet of the standing lady, give this scene a faintly Middle Eastern flavor.

What can the actual subject be? It must immediately be admitted that there is no obvious answer: it corresponds to no known or recorded drawing or painting by Boucher.[2] However, it is tantalizingly evocative of Boucher's drawings for the frontispiece to Madame de Pompadour's privately printed edition of Jean-Baptiste Corneille's *Rodogune.*[3] Could this drawing also be for that project? The costumes, appearance, and attitude of the chief protagonist are similar and, like Boucher's studies for this project in

the Pierpont Morgan Library in New York (figs. 1–3),[4] it is executed in black and white chalk on blue paper of approximately the same size. The Morgan drawings for that composition were done in 1759, whereas the present drawing includes what appears to be a signature along with the date *1764*.[5]

It is a distinct possibility that this drawing might represent part of Boucher's response to Charles-Nicolas Cochin le jeune's attempt in that year, as secretary of the Académie, to elevate history painting in France by allocating four little-depicted subjects illustrating "generous and humane actions performed by good rulers for the good of their people" to four leading painters for the decoration of the Gallery of the royal Château de Choisy. Boucher was commissioned to paint *Titus Grieving over the Ruins of Jerusalem,* but Cochin's superior, the marquis de Marigny, then directeur des Bâtiments du roi, persuaded Cochin that this theme was too dour, and the subject was changed to *Titus Liberating More than Forty Thousand Prisoners and Their Families.* Boucher had not even begun this canvas before Louis XV—disgusted with such an open display of virtue after seeing the first three paintings—got Marigny to ask Boucher to paint four of his more characteristic and seductive pieces instead. Unfortunately, circumstances also combined to thwart this commission from reaching fruition.[6]

Although it would be difficult to see the Horvitz drawing as part of a composition depicting one of Cochin's two original "generous and humane" subjects, since Boucher never got to execute either painting, it is legitimate to speculate that he attempted to find another episode in the life of Titus that would have been more congenial for him to paint. Thus, it is tempting to suggest that what might be represented in this composition is the Jewish princess, Berenice, remonstrating with Titus for giving her up so as to devote himself wholeheartedly to the good of his subjects. As the pretext for plays by both Jean Racine and Corneille, the episode would have made a worthy successor to Boucher's frontispiece to the latter's *Rodogune,* and it would have fitted seamlessly into the original theme of the decorations for the gallery at Choisy. AL

1

2

3

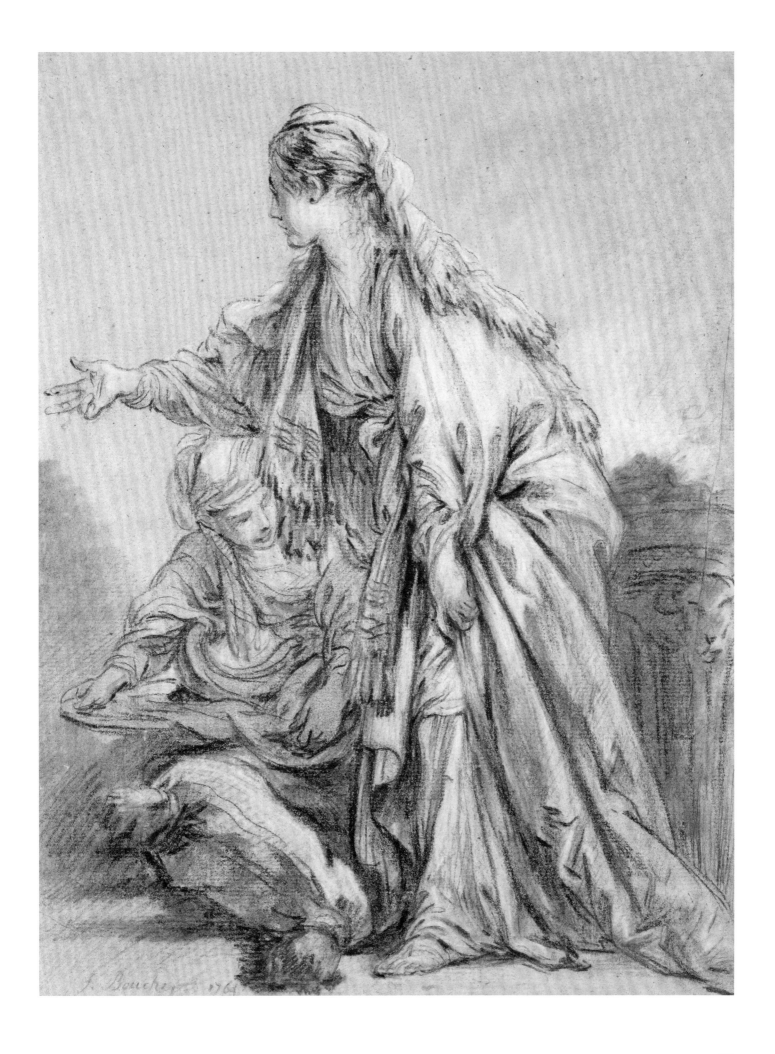

CHARLES-ANDRÉ, called CARLE VANLOO

Nice 1705–1765 Paris

63 *Fantasy Figure*

Brown chalk on cream antique laid paper

556 × 295 mm.

Watermark: Laid down—none visible through mount

Inscriptions: None

Provenance: Private collection, Paris; Nicolas Joly at Galerie Yves Mikaeloff, Paris; acquired in 1997 (D-F-510/ 1.1997.46)

Exhibitions: Paris 1996c, no. 11

Literature: Nicolas Joly in Paris 1996c, cat. no. 11, p. 28

*F*antasy figures are the pleasurable extension of a compulsory exercise for young artists who were admitted to the French Academy in Rome after they had won the Prix de Rome at the Académie in Paris. The prize enabled the finest painters, sculptors, and (more rarely) architects to travel to Italy at the expense of the crown and complete their education with firsthand exposure to Greco-Roman antiquities and to the works of the Renaissance masters and their successors.

Instruction at the Académie was founded on studies of the nude human figure in a great variety of poses. Nicolas Vleughels, then director of the French Academy in Rome, extended and completed this type of education by instituting the genre of the "draped academy figure." He wrote to the director of the Bâtiments du roi—at that time, the duc d'Antin—to whom the directors of both academies were subordinate:

It is an established custom at the Academy [in Rome] that models are never asked to pose between Easter and Pentecost . . . at that point, posing is resumed every morning at daylight. But in the interval, so as to keep the students occupied and not lose any time, we have found a way to occupy the evenings: we arrange draperies, and I borrow church ornaments to vary the setting and to create the illusion of reality, which is the soul of our profession. There is nothing that I will not do to set others on the right path, and people have never seemed reluctant to go along with my ideas. On the contrary.[1]

This use of draped models remained standard practice throughout the eighteenth century. The first group of artists to adopt this new practice was the "generation of 1700." Carle Vanloo was one of these. Apparently it was he who invented the "fantasy figure," which is a parodic form of the "draped *académie*": the classically inspired religious vestments and draperies that Vleughels introduced are replaced by masquerade costumes, some of which go as far as the burlesque, as in his *Seated Man with a Beard in an Enormous Cape* in the Musée du Louvre, Paris (fig. 1).[2] We have countless examples, many of which, like academic nudes, entail difficult problems of attribution,

given the young ages of the artists and the fact that they often executed these drawings in the same room at the same time.

A series of engravings published by Gabriel Huquier, and executed by Jacques-Philippe Le Bas and Simon-François Ier Ravenet, preserve the memory of some of those satirical images that Vanloo drew in Rome. But others were drawn, though not engraved, by some of his comrades of the same generation who were artists-in-residence with him at the French Academy in Rome: Michel-Ange Slodtz (cat. 67), Pierre Hubert Subleyras, and probably also Louis-Gabriel Blanchet, Pierre-Charles Trémolières and Antoine Boizot.[3]

In the Horvitz figure, the intensity of the hatching and the rounded modeling with heavy contours manipulated to create an enormous variety of folds and wrinkles in the drapery recall the ponderous weight of wet plaster—both techniques confirm the attribution to Vanloo. Although at first a drawing of this model by Subleyras appears to be the same hand as the Horvitz sheet (fig. 2),[4] Subleyras created a harsher light and used much simpler contours to create thinner and less volumetric folds, resulting in a figure more attached to the plane. JFM

1

2

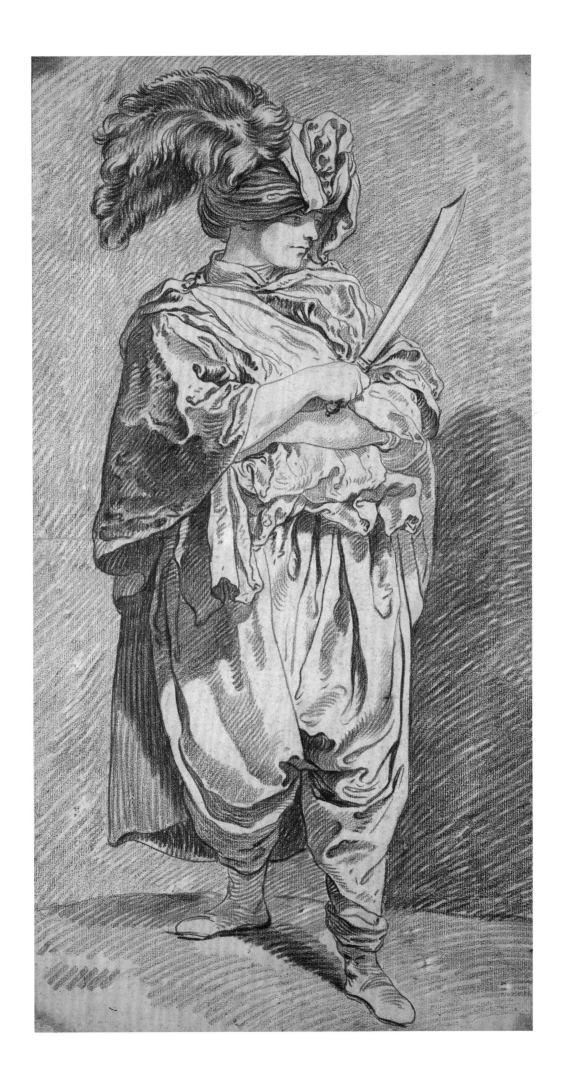

CHARLES-ANDRÉ, called CARLE VANLOO

Nice 1705–1765 Paris

64 *Portrait of the Artist's Son*

Black chalk heightened with in white chalk on tan antique laid paper

355 × 315 mm.

Watermark: Laid down—none visible through mount

Inscriptions: Signed in pen and black ink, bottom right: *Carle Vanloo*

Provenance: Sale, Paris, Drouot, 17 November 1950, lot 75; sale, Paris, Drouot, 12–13 November 1952, lot 61; Jean-Pierre Selz, Paris; acquired in 1987 (D-F-278/ 1.1993.129)

Exhibition: None

Literature: Marie-Catherine Sahut in Nice et al. 1977, p. 153, cat. nos. 482a and 482b (as lost, but known through an engraving)

*I*n 1733, Vanloo married the singer Christine Somis in Turin. Their union produced three sons and two daughters, one of whom died in childhood. This drawing belongs to a series of five portraits of children—all executed in black chalk with touches of white chalk on tan paper of approximately the same size—which are traditionally identified as portraits of the artist's children. Based on the approximate ages of the young sitters and the identical handwriting on all of the sheets in the group, it has often been surmised that they were executed at about the same time (c. 1746), when the children were between three and nine years old. Their round-cheeked faces can be glimpsed in some of the master's paintings, such as the *Preaching of St. Augustine*, executed in 1755 for Notre-Dame-des-Victoires in Paris and still *in situ*.[1] The late date suggests that Vanloo made their likenesses a permanent part of his figural repertory. Two years later, they are shown as adolescents in the large family portrait exhibited by Carle Vanloo's nephew, Louis-Michel Vanloo, at the Salon of 1757.[2] Now dispersed among various private collections, these drawings have never been examined side by side, which does not make it easy to confirm that they constitute a homogeneous series.[3]

The exhibited drawing could be the portrait of Jean-François Vanloo, born no later than July of 1740.[4] He would be at least six in the drawing, and his portrait may have been the second in Vanloo's series.[5] This child, about whom little is known, seems to have posed something of a disciplinary problem in subsequent years. According to archival documents, he lived like a great lord, idling away his time and "keeping company with good-for-nothings."[6] His father initially obtained an order for his confinement in Saint-Lazare prison, and then in 1763, he solicited the favor of having him sent to the penitentiary on the Ile de la Désirade.[7] This was apparently unsuccessful, as

there is evidence that Jean-François was once again present in Paris at important events that marked the Vanloos' family life.[8]

Whatever the precise date of these drawings, they were certainly executed in the middle of the artist's career, just before he received his most important commissions and acquired his reputation as a great painter. A series of small full-length portraits dating from 1743—hence, a few years prior to the supposed date of the children's portraits—proves that Vanloo worked frequently as a portraitist.[9] Michel-François Dandré-Bardon, his biographer, recalled that in his youth, before earning the funds to pay for his trip to Rome, Vanloo produced "the most exact likenesses" with "surprising facility," which "earned him a great deal of money."[10]

The Horvitz drawing exerts immense appeal through its rendering of childlike grace by way of a flawless technique that combined the softness of stumping, the vigor of crosshatching, and the freedom of the strokes of black chalk used for the hair and vest. Evoking the figures of the young that Chardin had popularized a few years earlier, it symbolizes perfectly the new place accorded children in eighteenth-century French society. The large number of engravings after this group of drawings—some made around 1757 by Charles Exchaw (one of Vanloo's students) and others by Louis-Marin Bonnet (fig. 1)[11]—demonstrate the success that these works enjoyed.

MCS

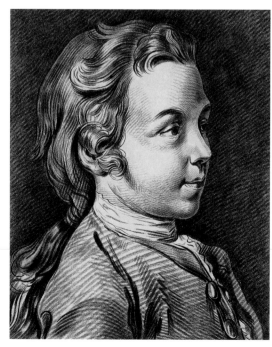

1

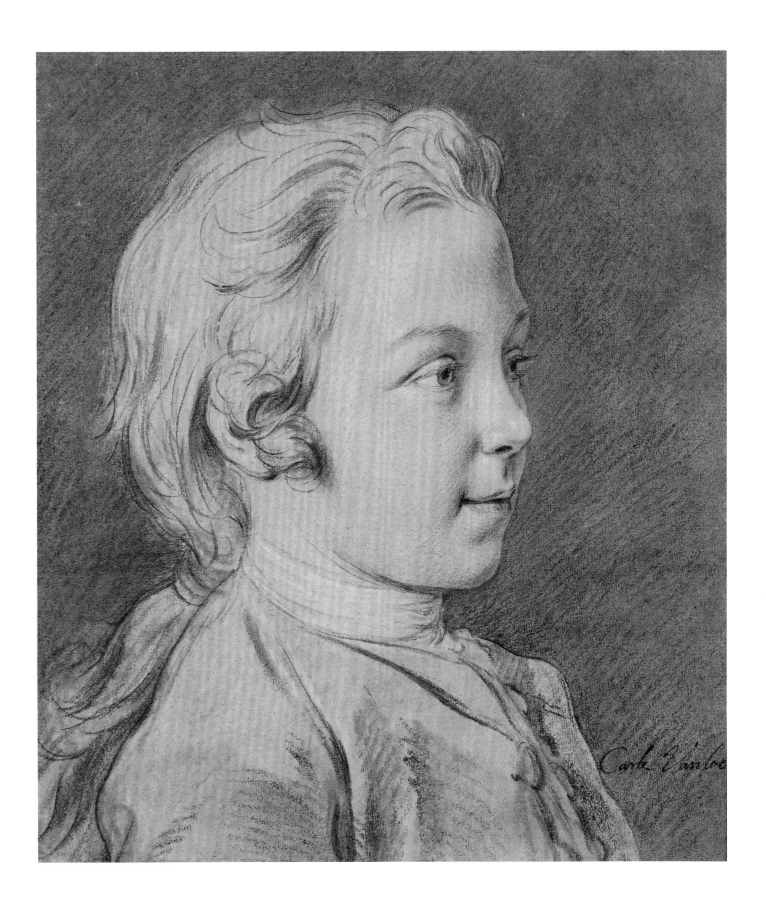

Carle Vanloo

237

CHARLES-ANDRÉ, called CARLE VANLOO

Nice 1705–1765 Paris

65 St. Clothilde Praying before the Tomb of St. Martin at Tours

Pen and brown ink, with brush and brown wash, heightened with white gouache, on off-white antique laid paper (artist's correction of head and torso of figure redrawn on two additional attached pieces of off-white antique laid paper)

385 × 236 mm.

Watermark: Laid down—none visible through mount

Inscriptions: In graphite on verso, top left: *1784*.

Provenance: Probably the drawing in the collection of Louis-François de Bourbon, prince de Conti; his sale, Paris, 8 April–6 June 1777, lot 1199; J. B. Lebrun, Paris; unidentified collector, mark in black ink at bottom right (close to L. 2902); Galerie de Staël, Paris; acquired in 1989 (D-F-279/ 1.1993.87)

Exhibitions: None

Literature: Marie-Catherine Sahut in Nice et al. 1977, p. 148, cat. no. 456 (as a lost drawing)

This drawing is a preparatory study for the painting of the same title that was presented at the Salon of 1753. Commissioned from Vanloo by the Bâtiments du roi in 1752 to adorn the high altar of the chapel of the Grand-Commun at the royal Château de Choisy, this canvas was so successful that it was considered by some critics to be the most important French religious painting of the eighteenth century.[1] The subject exalts the origins of the French monarchy, and it is typical of both the contemporary revival of interest in the history of France and the Bourbon tradition of linking its comparatively young dynasty with its distinguished predecessors.[2] The composition depicts St. Clothilde—the French queen venerated for converting her husband, King Clovis (and thus the entire Frankish nation), to Christianity—praying before the tomb of St. Martin at Tours, the town to which she withdrew from the court after the death of the king.[3]

The scratchy, angular penwork, generous application of wash, and patched correction—undoubtedly made to improve the pose of St. Clothilde—are all typical of Vanloo's drawings in this medium.[4] The composition is also quite close to that of the definitive painting for Choisy, now in the Musée des Beaux-Arts, Brest (fig. 1).[5] In addition to the heads of the cherubs, most of the clothing and accessories of the kneeling saint are already in place: the vaguely medieval tunic crowned by a braided coiffure, the open prayer book at the foot of St. Martin's tomb, and the attributes of royalty (the cloak on the saint's shoulder and, on the table to the right, the crown adorned with trefoils and the scepter with its fleur-de-lys).[6] The only differences are in the shape of the sarcophagus and the architectural setting. In the drawing, St. Clothilde prays in a constricted and columned alcove with a small window, and the tomb has a sinuous Baroque outline. In the definitive painting, the tomb is reduced to a simpler and more rectangular shape, and the setting around St. Clothilde takes the form of an immense Gothic interior inspired by Notre-Dame in Paris.[7]

The rediscovery of the Horvitz drawing enables us to reexamine the problems raised by the undated and reduced painting of this composition in the Musée des Beaux-Arts, Angers (fig. 2).[8] This small work of consummate delicacy reveals more details in the costume, especially the addition of the necklace and the sleeves, which extend beyond the wrists. The pose of the torso and the arms are now turned heavenward, and the arrangement of the royal emblems and prayer book have been reversed from their positions in the Brest painting and in the drawing shown here. However, the reduced version contains other details, such as the shape and position of the sarcophagus (which has returned to its Baroque exuberance), that appear only in the drawing. These changes are also reflected in the crayon-manner engraving executed after Vanloo's death by Louis-Marin Bonnet, which must be based on the exhibited sheet (fig. 3).[9] All of these considerations lead, with due caution, to the following probable order of execution: the Angers canvas is probably the first *modello*, and the Horvitz drawing, in which the saint's arms are lowered, may represent a stage prior to both the Angers *modello* and the definitive altarpiece. The drawing would have helped Vanloo to reposition the monarchical emblems and refine the saint's pose and expression, before other motivations—either symbolic or pictorial—may have led him to modify the architectural background in the definitive painting in Brest. MCS

1

2

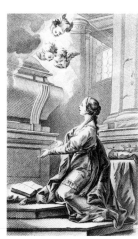

3

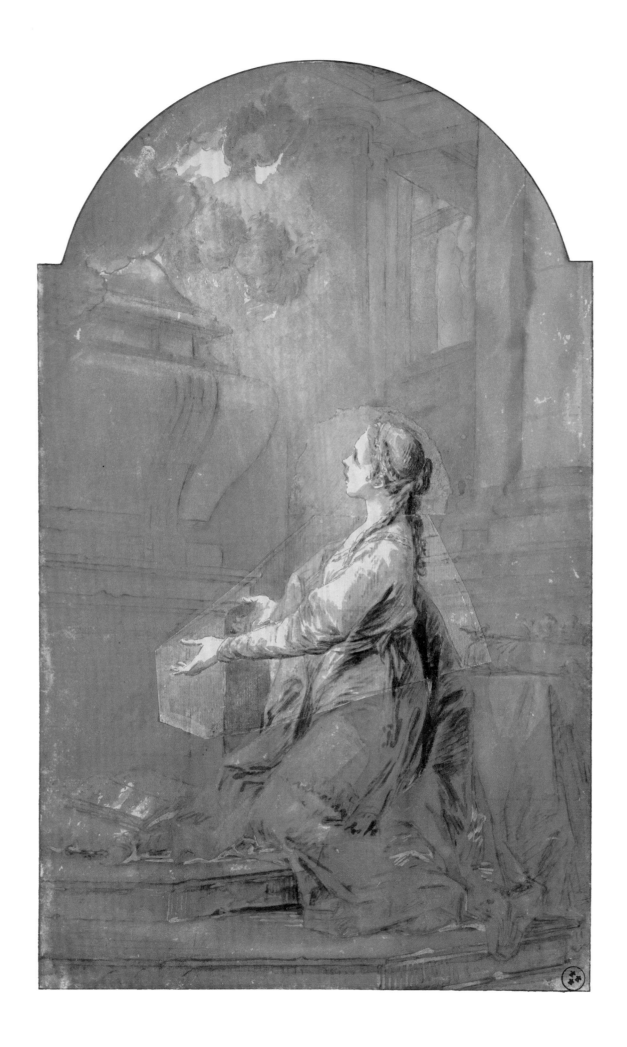

CHARLES-ANDRÉ, called CARLE VANLOO

Nice 1705–1765 Paris

66 *Mademoiselle Clairon as Medea Fleeing from Jason*

Pen and brown ink with brush and two tones of brown wash, heightened with white gouache, on tan antique laid paper

638 × 805 mm.

Watermark: Laid down—none visible through mount

Inscriptions: Signed in pen and brown ink on recto, bottom right: *Carle Vanloo*

Provenance: Jean-Claude-Gilles Colson, called Bellecourt, Paris (as of 1765); Collection Chevalier, Paris; sale, Paris, 26–27 November 1779, lot 46; Charles-Paul-Jean-Baptiste de Bougevin Vialart de Saint-Morys, Paris; his sale, Paris, 1–23 February 1786, lot 346; sale, Paris, 17–22 December 1787, lot 131; Gabriel Terrades at Galerie Grunspan, Paris (in 1996); Private Collection, London; Hazlitt, Gooden and Fox, Ltd., London (in 1997); acquired in 1997 (D-F-476/ 1.1997.15)

Exhibitions: Paris, Salon of 1757, no. 8; Paris 1996a

Literature: Fréron 1757, letter 15, 31 August 1757, p. 338; Anonymous 1757, p. 159; Dandré-Bardon 1765, p. 66; Réau 1938, p. 66; Diderot—Seznec—Adhémar 1967, vol. 1, p. 39; Marie-Catherine Sahut in Nice et al. 1977, p. 149, cat. no. 457a (as a lost drawing)

*T*his large and spectacular drawing was presented by Carle Vanloo as a gift to the famous actor known as Bellecourt immediately after it was exhibited at the Salon of 1757.[1] It later disappeared after being offered at a public sale in 1787. The drawing was a *modello* for the painting commissioned by Princess Ekaterina Dimitrievna Golitsyn (wife of a Russian diplomat to the French court, see cat. 75) as a gift for her friend, known as Mademoiselle Clairon, the renowned tragedienne of the Comédie Française.[2] The gift was an appropriate one, for Clarion was celebrated for playing Medea in Baron de Longepierre's modern version of the ancient Greek tragedy.[3]

In Greek mythology, Medea was the daughter of Aeëtes, king of Colchis, and like her aunt, Circe, she was an enchantress. Here, in a scene from the end of the Longepierre drama (act 5, scene 4), we see Medea armed with a magician's wand, leaving the palace of King Creon of Corinth, which she has just set ablaze. To avenge the infidelity of her husband, Jason—who abandoned her for Creon's daughter—she killed their two sons, whose bodies are strewn across the steps of the palace. Letting Jason live, she rises up in her chariot and pronounces that she loathes him too much to give him death. Jason, temporarily frozen with a murderous gesture by her powers, later commits suicide. This intense moment had also been depicted by two of Vanloo's predecessors: Charles-Antoine Coypel, who presented his version of the subject as his reception piece to the Académie in 1715, and Jean-François de Troy, who made it the theme of his final cartoon for the tapestry series based on the Story of Jason (c. 1746).[4]

Vanloo's oil sketch in the Musée des Beaux-Arts, Pau (fig. 1),[5] is nearly identical in size to the exhibited drawing. The fact that the figures occupy nearly the entire space in both works suggests that the Pau sketch is a link between the Horvitz drawing and the definitive painting, which was shown to Louis XV at Versailles in February of 1759, displayed at the Salon a few months after (Bildergalerie, Potsdam, fig. 2),[6] and later engraved (fig. 3).[7] In the Pau sketch, Medea is still turned toward the left, but Jason's pose is identical to his counterpart in the Potsdam canvas. The work is significantly different from the drawing catalogued here, which, according to one of the artist's relatives, depicted figures that were too small to make an effective painting.[8] We know that the Potsdam canvas had initially been executed with the figure of Jason seen from the back as in the drawing, but, sensitive to the criticism of visitors to his atelier, Vanloo revised the design, which became "larger and more picturesque."[9] The beautiful Medea in the drawing, who

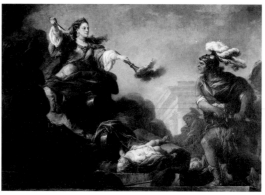

1

2

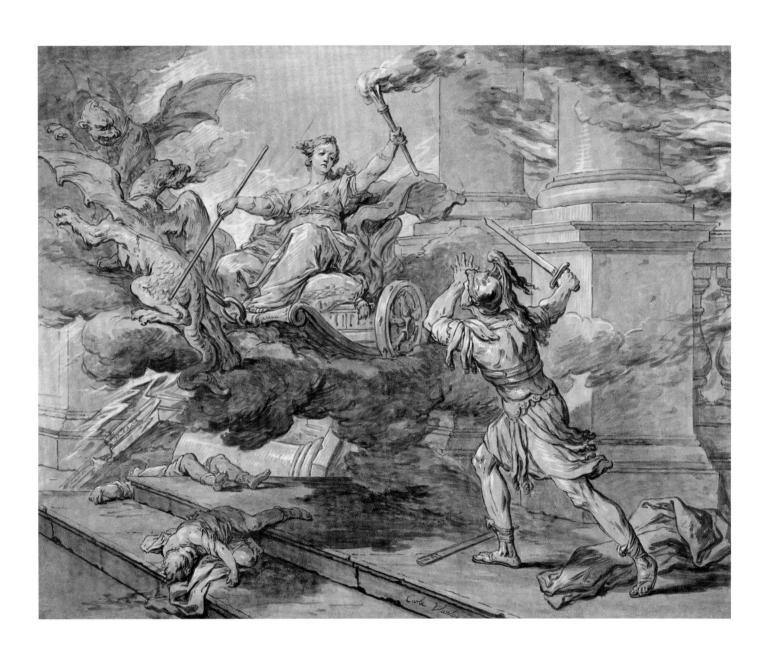

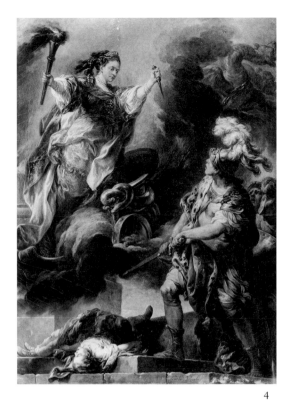

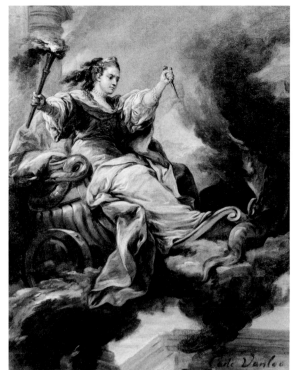

4

5

escapes triumphantly from the chaos she created, is transformed in the definitive Potsdam canvas to an avenger full of fury in a moving face-to-face encounter that focuses on the expression of the passions.[10] In short, the Potsdam picture becomes a history painting in the tradition of the *grand gout*, which Vanloo and officials at the Académie were intent upon reviving.[11] Some of this same rage can be seen in a vertical oil sketch by Vanloo in Schloss Sans Souci, Potsdam (fig. 4), and in a small oil study for the figure of Medea in her chariot (Private Collection, fig. 5).[12]

At the Salon of 1757, the drawing of *Mademoiselle Clairon as Medea Fleeing from Jason* and two other works displayed by Vanloo—a *Battle Scene* and a *Company of Soldiers*—attracted little comment com-

pared to his *Sacrifice of Iphigenia*, an ambitious painting commissioned by King Frederick II of Prussia (Neues Palais, Potsdam).[13] They were nevertheless considered to be "of the greatest beauty"[14] and "full of action, fire, and genius."[15] An enormous preparatory drawing on fourteen joined sheets for the *Sacrifice of Iphigenia*—even larger than the drawing exhibited here—is in the Metropolitan Museum of Art, New York (fig. 6).[16] Although it is somewhat less finished than the Horvitz *modello*, it serves as an example of another important large-scale eighteenth-century Salon drawing. In these works, Vanloo's "fire and genius" are well served by his impressive command of pen and brown wash with highlights in white gouache, a technique that he favored for his composition designs. MCS

3

6

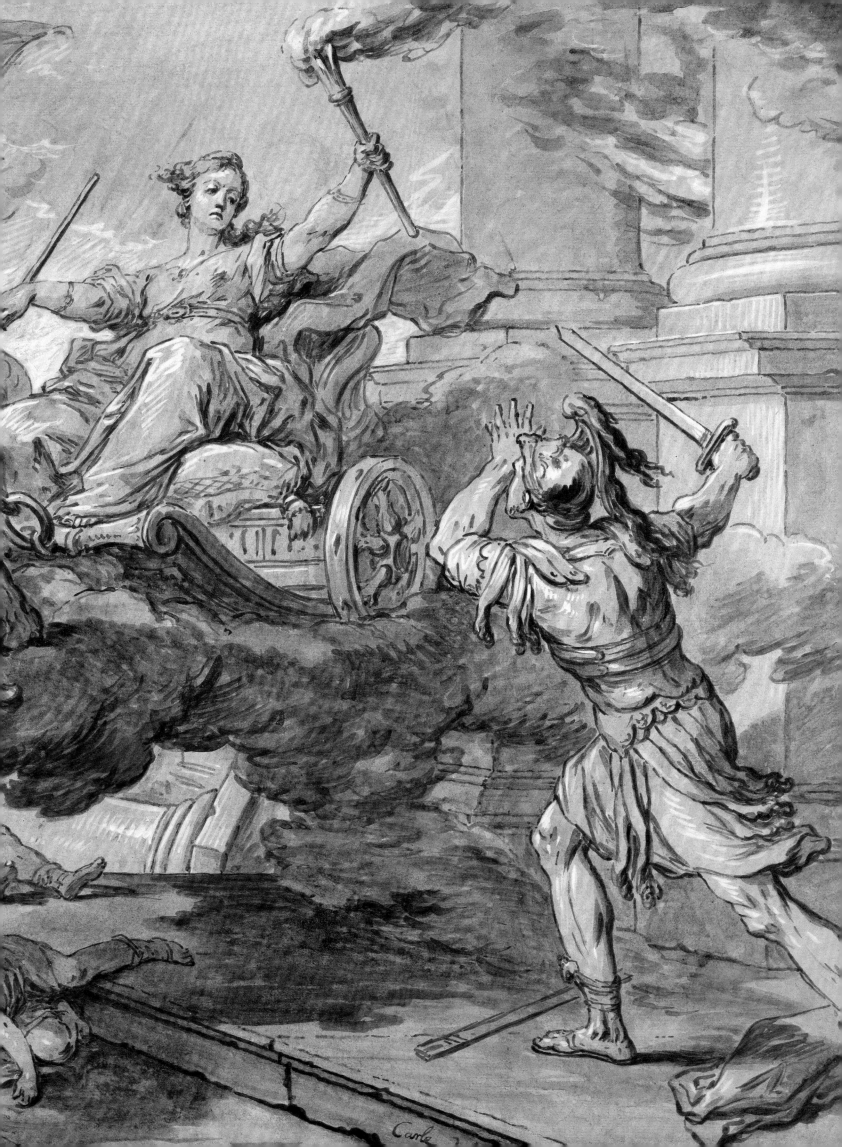

Carle

RENÉ-MICHEL, called MICHEL-ANGE SLODTZ

Paris 1705–1764 Paris

67 Monsieur Heurtault de Lienay

Red chalk on off-white antique laid paper

433 × 343 mm.

Watermark: Encircled Pascal lamb with a crucifix

Inscriptions: Signed in pen and black ink on verso, bottom left: *Mich. Ang. Slodtz F. Roma 1738/ Portrait au profil de/ M. de Lienay*

Provenance: Sale, Christie's, Monaco, 30 June 1995, lot 84; acquired at the sale (D-F-265/ 1.1995.92)

Exhibitions: None

Literature: Unpublished

*T*he profile portrait drawing, which originated in the Renaissance and was later associated with the art of engraving, for which it often served as a preparation, met with renewed success in the eighteenth century. Charles-Nicolas Cochin le jeune, who drew profile portraits of Slodtz and Charles III Bourbon of Spain (cat. 72), particularly favored this format.[1] The profile is also the pose characteristically preferred in portrait medallions. As the exhibited work attests, Slodtz, too, was an accomplished practitioner of this type of drawing, which he always used when portraying the friends and relations who posed for him in Italy.

Slodtz, a successful sculptor, was an artist-in-residence at the French Academy in Rome for an unusually long stay of eight years (1728–36). Having obtained commissions for other work, he remained in the city until 1744. His earliest known portrait drawing represents his friend, compatriot, and fellow artist-in-residence at the French Academy in Rome, the painter Pierre-Charles Trémolières (Musée du Louvre, Paris, fig. 1).[2] Executed before Trémolières left Rome in 1734, it bespeaks a familiarity with the sitter that is not apparent in the drawing shown here.

The sitter in the Horvitz portrait is identified by an inscription on the verso, where the sheet is also signed and dated *1738*. Heurtault is a common family name in France, particularly in the provinces of Berry and Brittany, but none of these families had Lienay as an estate name. Perhaps the sitter depicted in the exhibited drawing was an associate or distant relation of the duc de Saint-Aignan, France's ambassador to the Holy See (1734–40), who had ties to a prominent Berry family of that name.

The many profile portraits Slodtz sculpted in Rome must have been preceded by preliminary sketches, and the portrait drawings of Trémolières and Heurtault reveal that he was as adept with his chalk as he was with his chisel.[3] He surrounded Heurtault with a gentle and varied pattern of hatching, and by indicating a strong light emanating from the left, he was able to render his face with a combination of the white of the sheet and hatching that was at once modulated and directed. To maintain a hard-edged effect, he avoided stumping. He delineated the curls of the hair, the ribbons and lace at the neck, and the ribbon in the hair with crisp contours, and he further elaborated them with differentiated crosshatching. His combination of techniques resulted in a volumetric profile portrait of calculated brilliance. The high quality of this veritable bas-relief on paper should remind us that Charles-Nicolas Cochin le jeune considered Slodtz to be one of the best draftsmen of his century.[4] JFM/ALC

1

245

JEAN-LAURENT LEGEAY

Paris? c. 1710–after 1788 Rome (Italy)?

68 *Fantastic Landscape*

Red chalk on cream antique laid paper

420 × 597 mm.

Watermark: None

Inscriptions: Signed in pen and black ink, bottom right: *Le Geay invenit/ et fecit*

Provenance: Galerie Jean-François Baroni, Paris; acquired in 1995 (D-F-173/ 1.1995.20)

Exhibitions: None

Literature: Unpublished

A capriccio, or caprice, is a pure invention combining elements that seem to be rendered from life but may in fact be imaginary. Starting with an established vocabulary of forms grounded in nature, landscape motifs are brought together to evoke a myriad of impressions in the mind of the viewer.[1] This spirited architectural caprice tells us a great deal about the eccentric Legeay. Here, as in many of his drawings, massive classical structures—relics of the ancient past—are surrounded and even engulfed by untamed nature. Death and decay are also present among the trees, but unlike architecture, which cannot survive without being maintained by humans, nature is self-renewing and can find a foothold almost anywhere, even in the crannies of towering ruins. A similar approach to nature is evident in other large red chalk sheets such as the *Landscape with a Pyramid* (Kupferstichkabinett, Berlin, fig. 1),[2] and in the circular red chalk *Frontispiece for a Suite of Landscapes, Dense Woods, and Cascades* (Musée du Louvre, Paris, fig. 2),[3] which Legeay etched and published between 1756 and 1763. The Horvitz Collection also contains one of the ink drawings for his impressive suite of vases (see MRC essay, fig. 28).

The pessimism of Legeay's vision appears to be proportional to his own lofty, yet disappointed, ambitions. He had begun on a high note by winning the Prix de Rome in 1732 and spending five years in the Eternal City between 1737 and 1742. Thereafter, however, he had difficulty in working with his patrons, and even though Charles-Nicolas Cochin le jeune described him as "one of the greatest architectural geniuses who ever lived," he also wrote that Legeay "could never limit himself to the requests that were made of him, and even the Grand Mogul would not have been wealthy enough to erect the buildings that [Legeay] envisioned."[4]

During his tenure as a student at the French Academy in Rome, Legeay met Giovanni Battista Piranesi, who was ten years his junior but shared Legeay's fascination with antiquity and the incorporation of identifiable buildings and monuments into *capricci*. In fact, Legeay's role in the formation of a new vision of the antique and a new mode of the caprice—whether as leading innovator or Piranesi follower—has been the subject of some debate.[5] Whatever his artistic relationship with Piranesi may have been, Legeay was universally extolled by his contemporaries and the biographers of his students (of whom the most illustrious were Etienne-Charles Boullée and Charles de Wailly) as an especially inspired and innovative architect. Both his drawings and his prints show him to have been blessed with an imaginative mind as well as a precise hand. These talents are perhaps best combined in his red chalk drawings, where the coloristic qualities of the chalk and the varied weight of the strokes add both warmth and charm to the compositions. These works demonstrate why Legeay's creations have come to be called "architecture with a paintbrush."[6]

After a career full of disappointments and failures, the artist is said to have returned to Rome to die. Subsequently, a "trunk full of drawings by Legeay" passed into the hands of Piranesi's heirs; this may be the source of the many Legeay drawings that have since been dispersed throughout public and private collections.[7] The artist may have bequeathed the drawings directly to Piranesi, but it is also possible that Legeay gave them to Piranesi's sons in memory of the ties that he had established with their famous father early on in his career. JFM

1

2

JEAN-BAPTISTE-MARIE PIERRE

Paris 1714–1789 Paris

69 *Reclining Female Nude Asleep*

Red chalk heightened with white chalk on light tan antique laid paper

383 × 473 mm.

Watermark: Laid down—none visible through mount

Inscriptions: Signed in pen and black ink, bottom right: *Pierre*

Provenance: Private Collection, Paris; Jean-Pierre Selz, Paris and New York; acquired in 1990 (D-F-239/ 1.1993.11)

Exhibitions: None

Literature: Unpublished

*T*his study is remarkable for the rare naturalness and ease of the sitter's pose, which Pierre undoubtedly captured from life, rendering the sensual character of the model with great immediacy and delicacy. Among the countless female nudes drawn by French artists in the eighteenth century, such a subtle blend of grace and highly evocative realism is found only in the oeuvre of Jean-Antoine Watteau, speci-

fically in his seven studies of the same partially clothed model seated or lying on a chaise longue, which have been dated to about 1718.[1]

Following the practice of Watteau, Pierre sketched his model with her hair loose at least three times in the course of a single sitting. A drawing in the Musée du Louvre, Paris, depicts the young woman seated on cloth-draped cushions (fig. 1),[2] and another sheet in a private collection shows her in the same pose as the Horvitz study, but seen from the front (fig. 2).[3] These drawings must have been executed in the early 1740s, shortly after Pierre's return to Paris from his period as a pensionnaire at the French Academy in Rome (1735–40).[4]

This exhibition and catalogue enable us to make direct comparisons between nude studies in which the artist drew freely from a spontaneously posed model, as Pierre did here, and more typical examples—such as those by Le Moyne (cat. 41), Natoire (cat. 55), or another by Pierre from the Horvitz Collection (fig. 3)[5]—in which the models assumed predetermined poses designed to enhance the visual accuracy of the related compositions. JFM

1

2

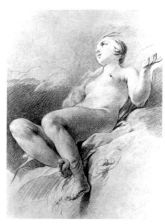

3

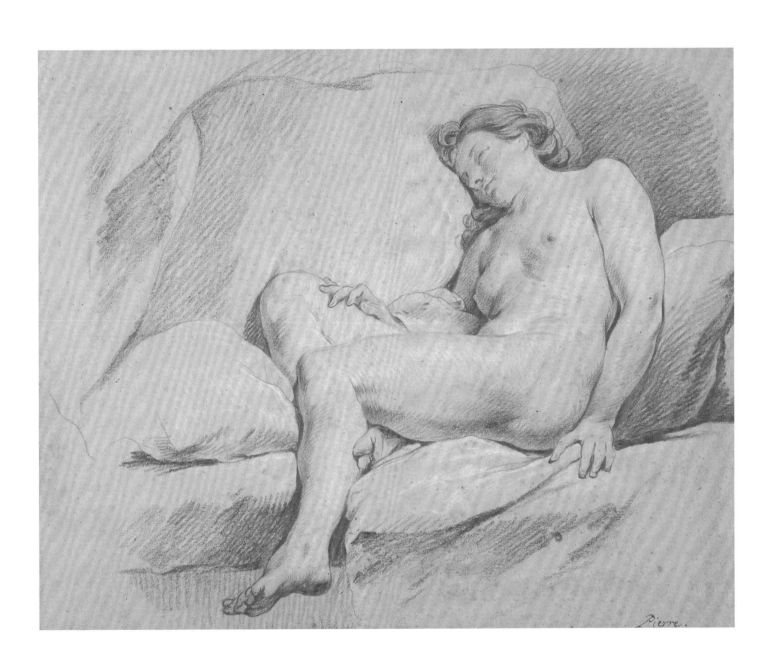

249

CHARLES-FRANÇOIS HUTIN

Paris 1715–1776 Dresden (Saxony)

70　*The Genius of France Leads the Dauphin Louis to the Temple of Hymen*

Black chalk, pen and brown ink, and brush with gray and brown wash and watercolor, heightened with white and yellow-gold gouache, on cream antique laid paper

503 × 346 mm.

Watermark: Laid down—none visible through mount

Inscriptions: In pen and dark brown ink, in foreground of image in open book, bottom right: DELR (the rest, indecipherable)

Provenance: Perhaps Gandouin Collection, Paris; his sale, Drouot, Paris, 23 May 1899; Galerie Cailleux, Paris; acquired in 1987 (D-F-136/ 1.1993.68)

Exhibitions: Perhaps the Salon of 1746

Literature: Unpublished

*H*utin's elaborately crafted sheet is either the presentation drawing or the *modello* for the allegorical frontispiece to the fete book commemorating the lavish public celebrations (23–26 February 1745) given by the city of Paris on the occasion of the marriage of Louis, son of Louis XV and dauphin (crown prince) of France, to infanta Maria Teresa Antonia Rafael, daughter of Philip V of Spain (title page, fig. 1).[1] Another sheet related to the design is in the Bibliothèque nationale de France, Paris,[2] and a probable preparatory study is in the Kunstmuseum, Basel (fig. 2).[3] Jacques-Philippe Le Bas reproduced the composition in a combination of etching and engraving (fig. 3),[4] and the complex imagery was described in detail in the ornately engraved preface.[5]

Crowned with flowers, and dressed in a brilliant blue tunic beneath a dazzling gold cloak, the dauphin appears as a young hero led by a large-winged Genius of France to the temple of Hymen. Hymen, the ancient Greek deity who presided over weddings, greets the dauphin on the steps of the temple in order to present him with a portrait of his betrothed. Hymen's aides also display the prince's crown and a banderole emblazoned with the couple's joined coats of arms, while the seated Graces, seen between Hymen and the dauphin, await the dauphin at the temple's door. Athena, goddess of war, maintaining a discreet distance, leads the prince's armed royal escort

in the background on the left. At the bottom right, Destiny directs Clio, muse of history, to inscribe the royal pair and their descendants into the book of immortality. Across from them, putti play with a sleeping lion—perhaps a reference to the future reign of the dauphin, who was admired for his prowess in battle—and prepare for the celebration by making garlands of flowers.[6]

Hutin, a student of Le Moyne (cats. 40–42) and Sébastien Slodtz, was a moderate talent who, as director of the new Academy in Dresden, later became one of the many French artists responsible for disseminating the decorative Rococo manner across Europe.[7] This sheet reveals his habitual lack of concern for rational spatial constructions, his characteristically delicate contours, and the elegance of his slight and typically elongated figures.[8] Despite the harsh criticism that Hutin received from critics like Denis Diderot, the exhibited drawing, which may be his masterpiece, is quite an accomplishment.[9] His great effort surely reflects the importance of the commission, and his success is related to both the figural and allegorical density of the composition and his calculated use of watercolor and gouache.

The court ceremony and the sumptuous royal celebrations at Versailles for the marriage were recorded in another fete book and four large prints by Charles-Nicolas Cochin le jeune (cat. 72).[10] However, the Parisian festivities were among the most notable galas in the French capital during the ancien régime. In addition to a ball for more than 12,000 ticketed guests at the Hôtel de Ville, seven enormous public pavilions were designed and decorated by artists for the large crowds. One of the most beautiful of these was a temple of Hymen erected in the Place Dauphine.[11] Unfortunately, the joy reflected in the Horvitz Hutin was fleeting in actuality; the dauphin adored his new wife, but she never became popular, and she died in July 1746 after giving birth to a girl who did not survive. In February 1747, the dauphin was remarried to Princess Maria Josepha of Saxony. This marriage, which produced eight children (see cat. 72), would be more successful for both the prince and the court, but the dauphin died before assuming the throne from which his son, Louis XVI, would be removed. ALC

1

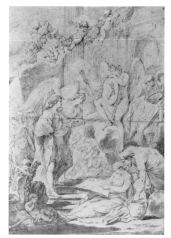

2

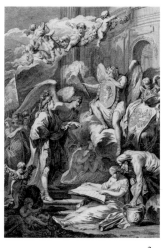

3

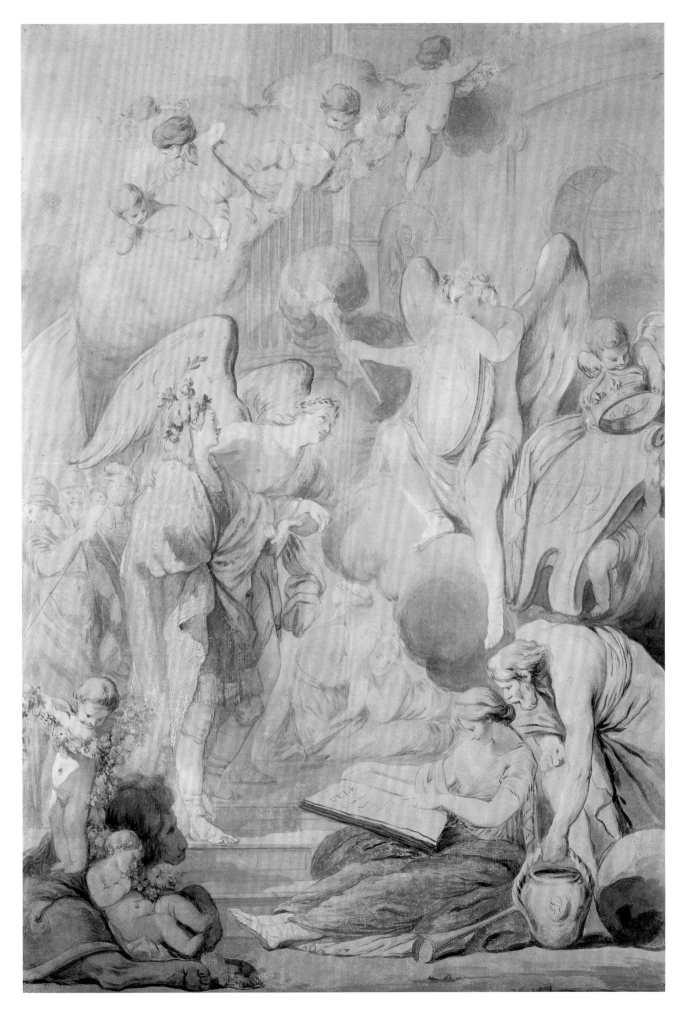

JEAN-BAPTISTE PERRONEAU

Paris 1715–1783 Amsterdam (The Netherlands)

71 Laurent Cars

Pastel on paper laid down on canvas

680 × 580 mm.

Watermark: Laid down—none visible through mount

Inscriptions: None

Provenance: Private Collection, Paris; Etienne Breton at Bureau Marc Blondeau, Paris; acquired in 1995 (D-F-230/ 1.1995.105)

Exhibitions: None

Literature: Monnier 1972, under cat. no. 95 (n.p.)

*P*erroneau portrayed his teacher, Laurent Cars (1699–1771), at least three times: once in oils and twice—in an original and a replica—in pastel.[1] The prime pastel version, exhibited at the Salon of 1759, and now in the Musée du Louvre, Paris, is a rectangular composition that depicts Cars in half-length, holding a sheaf of drawings and a *porte-crayon* in his right hand (fig. 1).[2] The exhibited portrait, made at an unknown later date, is a slightly smaller autograph replica, in which the format has been changed to an oval, and Cars's right hand and drawing paraphernalia have been omitted. A few slight differences in the expression of the mouth give Cars a somewhat more kindly demeanor in the Horvitz version, which also shows minor changes in the folds of the coat and neck cloth.

In 1777, Simon Charles Miger made an engraving, reversed and in an oval format, after Perroneau's portrait of Cars (fig. 2).[3] The rounded design and the omission of Cars's right hand suggest that the exhibited pastel might have served as Miger's model, but small differences in the details of the facial expression and the clothing indicate that Miger actually worked from the Louvre version. Miger's choice of the oval format is striking, however, suggesting that the version shown here was either known to Miger or that he at least knew that an oval replica existed.

Born in Lyon in 1699, Laurent was the son of the engraver Jean-François Cars. He first trained as a painter with a member of the Christophe family (probably Joseph) and later studied with François Le Moyne. However, he soon turned to engraving, and after some instruction from his father, he perfected his craft with Nicolas-Henri Tardieu. Cars was admitted to the Académie with the provisional status of *agréé* in 1729, and he was received as a full member in 1733. In 1757, he was appointed *conseiller* of the Académie, and in 1771, just days before his death, he was awarded a royal pension of 500 livres. Apparently, the engraver remained friends with his portraitist and former student even after Perroneau decided not to become a printmaker; Cars even served as a witness at Perroneau's wedding in 1754.

That Perroneau occasionally made autograph replicas of his own works is certain: he is known, for example, to have made two each after his portraits of *Jacob Boreel Jansz* and the Abbeville manufacturer *Abraham von Robais*, and one after his portrait of the daughter of another engraver, *Mademoiselle Huquier Holding a Kitten*.[4] Usually such replicas were made as gifts for family members or friends.[5] The specific reason for which Perroneau made the exhibited pastel is not known, though one might logically suppose that it was made for a member of the Cars family: Laurent had two daughters.

Perroneau's handling of the pastels in the Horvitz version is not identical to his technique in the first portrait, but, as one would expect in a replica, actually somewhat smoother and more practiced. The strokes of pure, unblended color lying over softly smudged tonal layers, however, are entirely typical of Perroneau's technique, as is the particular way in which highlights are applied to the end of the nose, on the lips, and at the corner of the eye. Also characteristic is the use of blue at the temples, in the shadows along the left side of the face, on the upper lip, and especially in the pendulous flesh of the double chin; Perroneau was occasionally criticized for overusing blue pastel in the flesh tones. Even though this was Perroneau's second rendering of his friend, he managed to keep the image fresh and to imbue it with some of the "lively spirit" and "natural goodness" that the biographer of artists, Pierre-Jean Mariette—who knew Cars—mentioned as defining traits of his character.[6] MMG

1

2

CHARLES-NICOLAS COCHIN LE JEUNE

Paris 1715–1790 Paris

72 *The Château de Versailles Decorated for the Celebration of the Birth of Louis-Joseph, Duc de Bourgogne, 30 December 1751*

Pen and black ink with brush and gray wash, over black chalk and traces of graphite, on cream antique laid paper

454 × 917 mm.

Watermark: Laid down—none visible through mount

Inscriptions: In black chalk, bottom right: *C. N. Cochin Perot invenit*

Provenance: Probably the unidentified collector D. de L.; his sale, Paris, 26 April 1873, probably lot 41; sale, Sardou, 27 April 1909, lot 62; sale, Paris, 1 April 1949, lot 36; Galerie Cailleux, Paris; acquired in 1987 (D-F-62/ 1.1993.39)

Exhibitions: None

Literature: *Mercure de France*, March 1752, pp. 207–14; Jombert 1770, no. 203; Chennevières 1886, vol. 3, pp. 25–29; Souchal 1967, p. 639, cat. no. 106; Michel 1993, p. 58

*T*his is the last fete drawing executed by Cochin for the Menus-plaisirs, the division of the royal household concerned with entertainment. Since 1735, Cochin had executed fourteen large and complex drawings, of which thirteen had been engraved by either himself or his father.[1] These include the festive *Masked Ball Given for the Marriage of Louis, Dauphin of France, to Infanta Maria Teresa Antonia Rafael of Spain on 9 February 1747* in the Musée du Louvre, Paris (fig. 1).[2] The design by Charles-François Hutin for the frontispiece to the fete book commemorating the Parisian celebration of that marriage is also in the Horvitz Collection (cat. 70). Although these works won Cochin great fame, the process of generating the final design and engraving it usually took almost two years. Perhaps this is one reason Cochin decided to give up this type of work, even though the exhibited sheet was the only one commissioned from him by the new contrôleur des Menus-plaisirs, his friend, Louis Bay de Curis, who Cochin claimed was "the only person who ever paid him adequately."[3] The Horvitz drawing was executed just after his trip to Italy (1749–51), a time when his artistic interests were also undergoing a radical change. He had entered the circle of Madame de Pompadour and had become the secretary of the Académie, where his contributions as an administrator and an art theorist would play a critical role in the development of French art.[4]

The relative lack of interest that Cochin took in this commission becomes clear when one realizes that in 1753 he had not even completed the drawing, that it was never displayed at the Salon, and that, when it was converted to a print, Cochin contented himself with engraving only the coat of arms at the bottom of the

plate. The bulk of the work on the enormous plate was left to Martin Marvie, who etched the architectural details in which he specialized, and to Cochin's student, Jean Ouvrier, who wielded the burin (fig. 2).[5]

Cochin's commission was to capture the extravagance of the extremely costly decorations, erected in six weeks in the late autumn and early winter of 1751 by a team under the direction of the Slodtz family of sculptors. For the first time, Michel-Ange Slodtz (see cat. 67), a friend of Cochin's, worked in conjunction with his brothers, Sébastien and Pierre-Ambroise Slodtz. The occasion was the long-awaited birth of the first son of Louis, the dauphin (crown prince), and his second wife, Maria Josepha of Saxony, whose wedding celebrations were also captured in another of Cochin's drawings for the Menus-plaisirs (fig. 3).[6] The new grandson of Louis XV, the potential heir to the French throne, was named Louis-Joseph, duc de Bourgogne.

To limit the task before him, Cochin chose to render neither the illuminations of 19 December nor the fireworks of 30 December. Instead, he focused on the ephemeral decorations designed by the Slodtz family that served as the background for the festivities. As was customary, the structures in the drawing are animated by a crowd of small figures drawn in graphite and black chalk. Huddled in cloaks and muffs, they evoke the extreme cold that gripped northern France throughout that December and January.

The drawing differs from the engraving in that the jets of water were replaced by groups of statues in the basins of the ornamental fountains. Perhaps, independent of his own studies drawn on site, Cochin made use of the Slodtzes' preparatory drawings to complete his own and forgot that the usual jets of water had been replaced by sculptural groups. The correction must have been requested by either the Slodtzes or Bay de Curis.

Cochin may have conceived his view of this celebratory scene as a pendant to another composition he designed for the Menus-plaisirs: *View of the Decorations Erected on the Terrace of the Château de Versailles*

1

2

for the Illuminations and Fireworks Held on the Occasion of the Marriage of Madame Louise-Elisabeth, 26 August 1739, which he also engraved (fig. 4).[7] If so, he did not simply repeat the same composition twice. Cochin transformed the crisp summer light to the cool, moody, and less changeable skies of northern French winters, which enabled him to reduce the chiaroscuro and create what were then referred to as "picturesque" effects. His point of view was higher, probably corresponding to that afforded by the chateau's gallery, the vantage point for which the decorative effects had been planned. This allowed him to reduce the dimensions of the figures so as to give a better idea of the enormous size of the Slodtzes' decorative monuments. Indeed, the structures extended for some 312 meters, and the triumphal arch, behind which was a Temple of Love, reached a height of nearly 13 meters. Given this order of magnitude, it is highly probable that the spectator could not encompass this entire panorama with one glance, and that despite the scale of the drawing, Cochin was forced to depict the event in a mode that combined the birdseye view with a perspectival rendering.

Sadly, the royal family's hopes for the young prince, whose birth is celebrated in the Horvitz Cochin, were premature. He died in 1761. CM

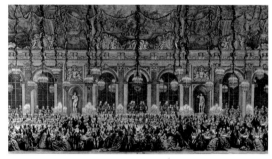

3

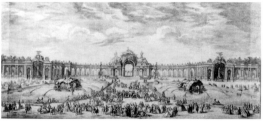

4

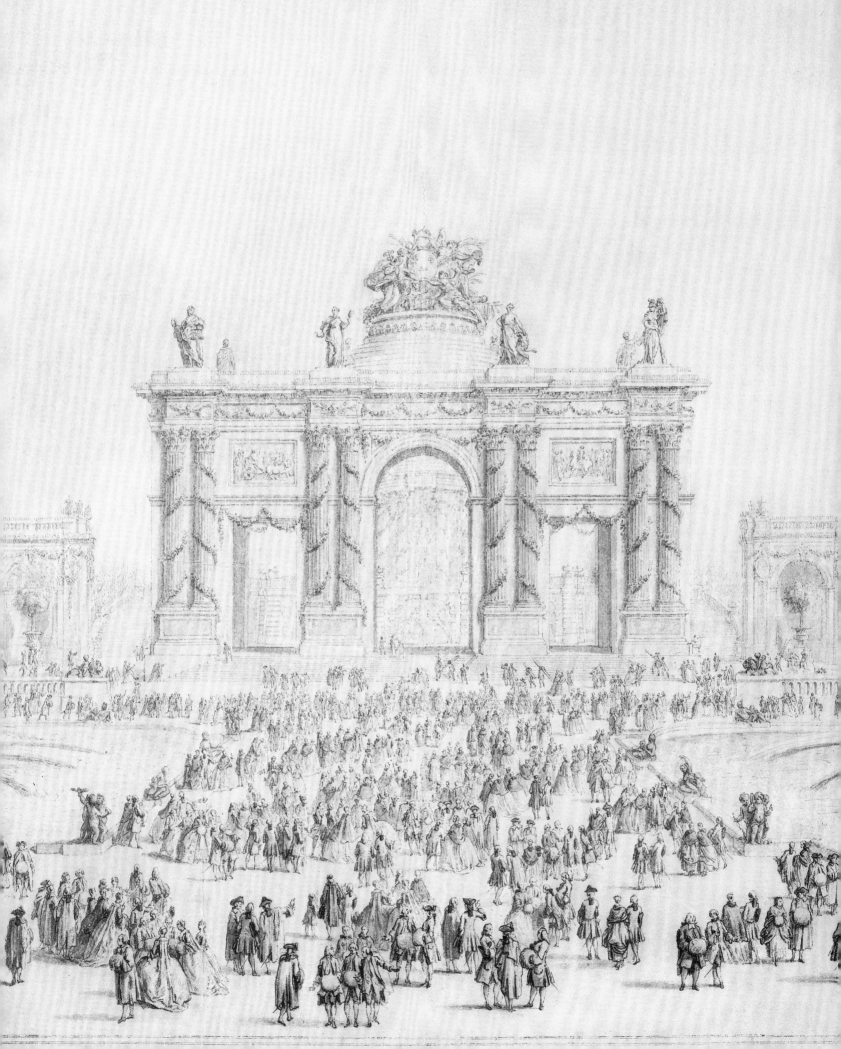

CHARLES-NICOLAS COCHIN LE JEUNE

Paris 1715–1790 Paris

73 *Allegory of the Glories of the Reign of Charles III Bourbon of Spain*

Red chalk over traces of black chalk on cream antique laid paper

238 × 167 mm.

Watermark: Laid down—none visible through mount

Inscriptions: All in reverse in red chalk on medallions and scrolls in descending order: *CAROLUS.III.PARENS. OPTIMUS; FOSSA.ARAG/ MADRIT./ E.T/ TURDET.; TABELLARIA NAVES; VIAE PUBLICAE; PORTICI; CASERTA; CAR. III./ REP/ NAT.ET.ART./ SUB UNO TECTO/ IN PUB.UTILIT./ CONSOCIAVIT; ANTICHITA D'HERCOLANO. . .(?); HORTUS BOTANICUS; CONDITAE URBIS NOVA GLORIA*; and signed in red chalk, beneath drawn border, bottom center: *C. N. Cochin f. del. 1777.*

Provenance: Perhaps R. Beraldi; Galerie Cailleux, Paris; acquired in 1994 (D-F-63/ 1.1995.5)

Exhibitions: None

Literature: Portalis 1877, p. 124; Michel 1993, p. 168

*T*his drawing is typical of the refined works produced during the last part of Cochin's career. Renowned as early as the 1740s for the fecundity and poetic genius of his inventions—as well as the quality and elegance of their execution—in 1753, he was awarded the commission to design a series of medals commemorating the life and achievements of Louis XV. One of his preparatory drawings for this project is also in the Horvitz Collection (fig. 1).[1] Though the French royal project was never completed, the process of generating the related drawings and engravings taught Cochin how to integrate allegorical and historical compositions with the medallion form in the most harmonious way imaginable. He also gained experience in this genre by executing other allegories exalting European monarchs: a drawing in 1761 for King Adolf Frederick of Sweden; another medallion drawing of Charles III, engraved in 1765 by Tomas Francisco Prieto; and in the late 1770s, two large allegories in honor of Empress Catherine II of Russia.[2] Thus, none of the iconographic features in the exhibited drawing were new for him.

In the Horvitz allegory of 1777 glorifying Charles III Bourbon of Spain (1716–1788) and the accomplishments of his reign,[3] the reversed composition and inscriptions suggest that the design was intended to

be engraved. The counterproof of the exhibited sheet was formerly in the collection of the Prince of Hesse, Rome (fig 2).[4] However, it would appear that the print was never executed. The circumstances of the commission can be inferred from the inscriptions. History, sitting on top of a vanquished Father Time in chains, places a diadem on the profile portrait of Charles III rendered inside the medallion in the center of the composition. Above, the Genius of Spain—crowned with the Tower of Castile and seated beside the Lion of Aragon—points toward the Temple of Glory hung with laurels at the upper left. Beneath these three figures, in the lower part of the drawing, dedicated to the king's cultural accomplishments and public works, cherubs support medallions that evoke the king as an enlightened monarch. Taking precedence over all of these is a medallion whose central position indicates its importance: "Charles III brought together under the same roof the republics of the natural sciences and the arts, for the benefit of the public."[5] At the very bottom of the drawing, in the background at right, the Indians of the Americas are liberated, and in the left foreground, a painter and a sculptor express their delight.

The presence of the artists and of the medallion relating to the arts suggests that this drawing may have been executed in a context associated with the Academia de San Fernando (the Spanish Academy of Fine Arts in Madrid). Indeed, on 24 July 1773, Charles III had purchased a building to house both this academy and his natural history collection.[6] Despite this link between historical fact and the present drawing and the knowledge that Cochin had depicted Charles III in an earlier composition, it is unlikely that this work was the result of any direct commission from the Spanish Academy. Moreover, the cultural achievements of Charles III date from an earlier period when he was still king of Naples.[7] We can, however, surmise that this commission was conveyed through Cochin's friend, the engraver, Pierre-Philippe Choffard, who had been named a Distinguished Academician of the Academia de San Fernando on 9 March 1777.[8] Their relationship is documented again two years later when Choffard commissioned Cochin to execute about thirty drawings to be engraved as illustrations to the works of Jean-Jacques Rousseau.[9] CM

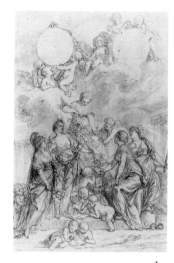

1

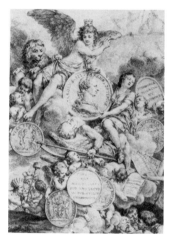

2

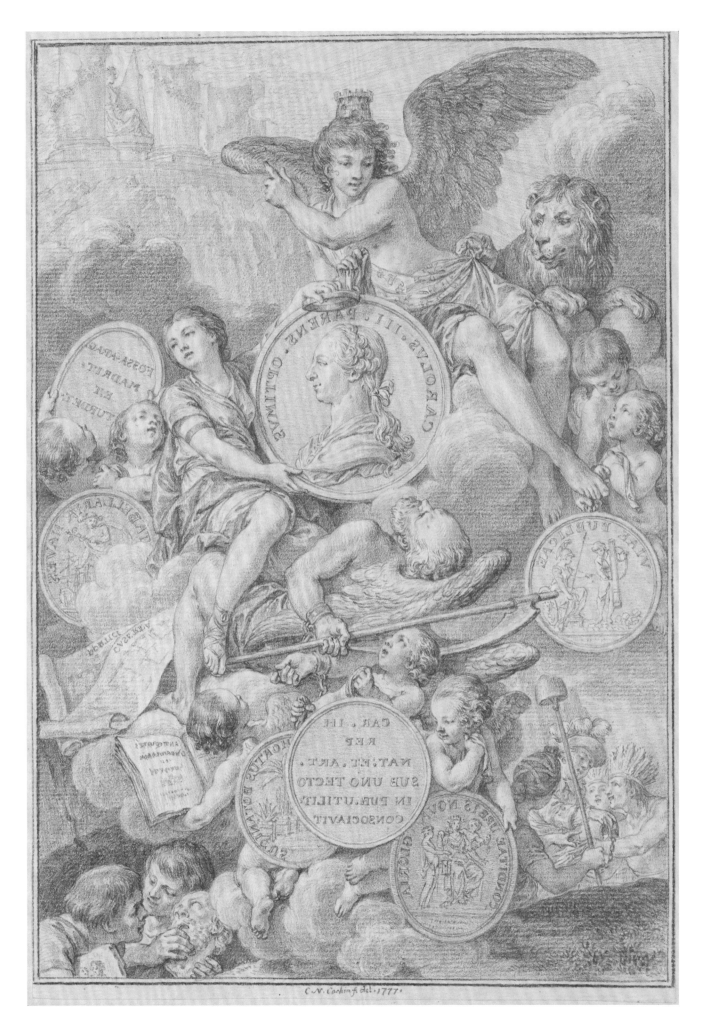

JOSEPH-MARIE VIEN

Montpellier 1716–1809 Paris

74 Bust of St. Eloi

Red chalk on off-white antique laid paper

535 × 415 mm.

Watermark: Laid down—none visible through mount

Inscriptions: None

Provenance: Galerie Cailleux, Paris; acquired in 1995 (D-F-286/ 1.1995.7)

Exhibitions: None

Literature: Unpublished

*I*n 1751, Madame de Pompadour, mistress of Louis XV, purchased the Château de Crécy, just north of Chartres. In addition to overseeing its refurbishment,[1] in the tradition of the concerned châtelaine, she also saw to the ornamentation of the church on her newly acquired lands and soon commissioned Vien to execute a painting representing one of the "holy mysteries" for the main altar. As it was eventually agreed that this would depict the Visitation,[2] to complement the altarpiece, Vien produced two flanking oval *sopraporte* (overdoor) paintings, "which would show only male figures."[3] Saint John, patron saint of Madame de Pompadour, whose Christian name was Jeanne-Antoinette, was chosen for the first, and St. Eloi, patron saint of the parish, was depicted in the second.[4] These remain *in situ* in the parish church of Crécy-en-Eure.[5] In the exhibited drawing, St. Eloi is shown in his mitre, his head turned to the left, his gaze cast heavenward, and his thick beard set off by an embroidered cloak. The drawing differs from the painting in only a few respects: in the painting, the seated saint is shown nearly full-length, while the drawing depicts him only bust-length; the crozier that St. Eloi holds in the painting is omitted; and the medallion of the Virgin embroidered on the cloak is in a slightly different position.

Vien may have referred to one of the studies of facial expressions he drew and painted as a student at the French Academy in Rome to render his drawing of St. Eloi. The model also appears as the bishop in his *Martyrdom of St. Martha*, one of six canvases he executed in Rome for the Church of St. Marthe in Tarascon (1748–49).[6] The present sheet is probably a later drawing by the artist, perhaps based on drawings related to the Tarascon commission. Although now lost, these early and presumably less finished drawings probably looked something like the *Head of a Bishop in Profile* from the late 1740s in the Musée Grobet-Labadié, Marseilles (fig. 1).[7] The exhibited drawing was certainly executed by 1772, for in that year, the *Mercure de France* announced the publication of the crayon-manner engraving by the renowned interpretive printmaker, Louis-Marin Bonnet (fig. 2).[8]

Several important differences are apparent when one compares the drawing with Bonnet's engraving. The size of the design was reduced, the shading was modified—which turned the full but soft beard into a solid mass—and the strength of the embroidery was diminished. The vitality, variety, and sureness of the painter's hand were attenuated by Bonnet's normative technique, which resulted in an interpretation that lacks the subtle dynamism of the drawing. While distinctions between elaborate original drawings for engravings by painters and precise copies by engravers prepared for prints can become blurred in the eighteenth century—when an industry developed around the reproduction of drawings—the vigorous Horvitz sheet cannot be a copy by Bonnet, whose print demonstrates his inability to capture all of the spirited qualities of the original, nor could it be a copy after the inferior engraving. Given that this drawing is in the same direction as the print, Bonnet's lost study, undoubtedly based on Vien's counterproof, would probably be in reverse. Moreover, the draftsmanship of the exhibited sheet displays all of the characteristics we would expect to see in a masterful presentation drawing that Vien intended for reproduction.

Another red chalk study by Vien that was engraved by Bonnet, the *Head of St. Germain* (fig. 3), is in the Horvitz Collection.[9] It is related to the head of St. Germain in *St. Germain, Bishop of Auxerre, and St. Vincent, Deacon of the Church of Saragossa* of 1755 (Musée Goya, Castres).[10] The technique utilized here is similar to that of his *Study for a Bishop's Cope* in the Metropolitan Museum of Art, New York, which Vien drew in preparation for the depiction of St. Germain's vestments in the Castres canvas.[11] JFM

1

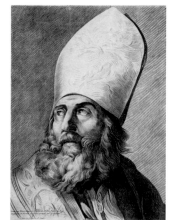

2

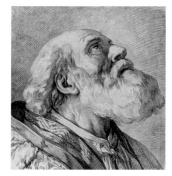

3

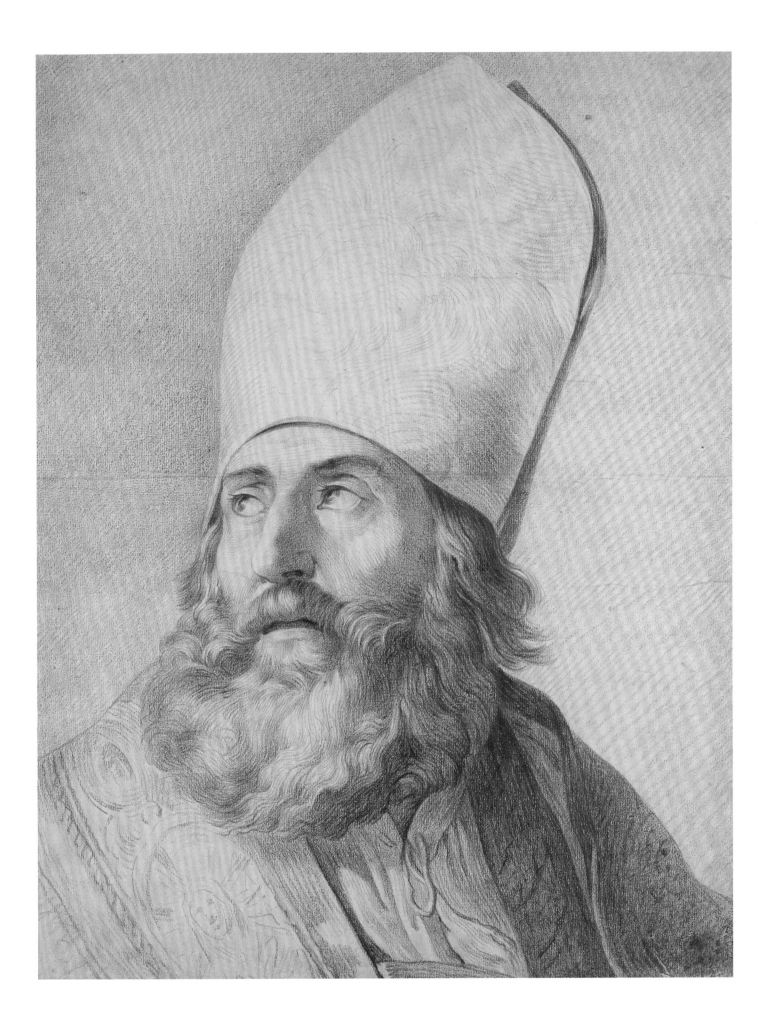

LOUIS-CLAUDE VASSÉ

Paris 1716–1772 Paris

75 *Funerary Monument for Princess Ekaterina Dimitrievna Golitsyn*

Red chalk on off-white antique laid paper

374 × 296 mm.

Watermark: Laid down—none visible through mount

Inscriptions: In red chalk on recto on the stone behind the figure in the image, top left: *PROH/ DOLOR*; in red chalk on recto on the entablature in the image, bottom: *HOS FRIGIDOS CINERES/ LACRUMIS FOVET/ MARITUS MOERENS*; in graphite on verso of mount, top left: *L. Trinquesse*; in graphite on verso of mount, middle left: *54*; in graphite on verso of mount, bottom left: *2*; in red crayon on verso of mount, bottom center: *2*; in pen and brown ink on verso of mount, bottom right: *Vassé*

Provenance: Atelier of the artist at his death; Galerie Cailleux, Paris (by 1988); acquired in 1989 (D-F-281/ 1.1993.132)

Exhibitions: Probably the Salon of 1763, no. 170

Literature: Guilhem Scherf in Paris 1989a, under cat. no. 95, p. 232; Black 1996, pp. 143–46

1

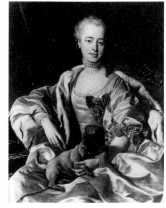

2

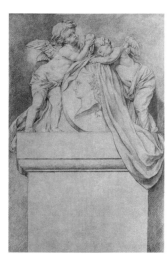

3

*P*rincess Ekaterina Dimitrievna Golitsyn was the daughter of Anastasia Ivanovna Troubetskoi and Prince Dimitri Cantemir of Moldavia; half-sister of Prince Anthiocus Cantemir (once Russian ambassador to France); and the wife of Prince Dimitri Mikhailovitch Golitsyn. She was a dame of honor to Empress Elisabeth I of Russia and was renowned for her beauty, learning, patronage, and works of charity. When her husband became the Russian minister plenipotentiary to France in 1757, the princess accompanied him to Versailles, where she became one of the most illustrious members of the French court until her early death in 1761. Her portrait was painted by Louis-Michel Vanloo (Pushkin Museum of Fine Arts, Moscow, fig. 1),[1] and she commissioned Carle Vanloo's *Mademoiselle Clairon as Medea Fleeing from Jason*—the drawn *modello* for which is now in the Horvitz Collection (cat. 66)—as a gift to the famous actress, who is depicted there in one of her most celebrated roles.[2]

This superb sheet by Vassé is associated with the marble tomb monument for the princess; he exhibited the unfinished sculpture at the Salon of 1763 with a drawing depicting the tomb in its entirety.[3] Pierre-Jean Mariette noted that the tomb was commissioned by General Betsky, uncle of the princess, through the comte de Caylus, who oversaw its progress.[4] After its completion, the sculpture was shipped to Russia,

where it was later depicted in an anonymous drawing in the Church of the Annunciation in St. Petersburg and in a medal by Joseph-Charles Roëttiers.[5]

Another drawing of the monument is in the Polakovits Bequest at the Ecole nationale supérieure des Beaux-Arts, Paris (fig. 2).[6] Executed in red chalk and red chalk wash, the Polakovits sheet renders the general lines of the final tomb, but it displays significant technical and compositional variations. The draped female, the urn, and the cypress-wreathed medallion are found in both works, but in the Polakovits drawing, the head is positioned differently, the left hand rests on a stack of books—an allusion to the princess's great learning—and the profile portrait of the deceased is reversed. One can also see that the Horvitz sheet is a highly finished work, whereas the Polakovits drawing, inscribed "idea for the tomb," betrays all the marks of a more rapid preparatory sketch.

Although one must be cautious about making a definitive statement, the drawing shown at the Salon is almost surely the sheet exhibited here. This conclusion agrees with that of Bernard Black, who cited similarities between this drawing and the monument depicted in both the anonymous drawing and the medal, where the inscriptions are repeated verbatim.[7] The Polakovits drawing was probably the sheet presented to the comte de Caylus and/or General Betsky for approval. Apart from their documentary interest, these two versions of this commission present us with two different aspects of Vassé's draftsmanship. The Polakovits sheet manifests a style of great purity, with close attention to line, sweetness of expression, and a poetic use of wash. Conversely, the exhibited drawing displays a trenchant approach that is almost severe, with very precise contours and a striking definition of the forms, which can be seen in other red chalk *ricordi* that Vassé executed from his completed sculptures, such as his *Monument to the Heart of Queen Maria Leczinska,* also in the Horvitz Collection (fig. 3).[8] This is why one might well think that the exhibited *Funerary Monument for Princess Ekaterina Dimitrievna Golitsyn* was executed after the sculpture or its plaster model, which, incidentally, Vassé kept all his life.[9] Displayed at the Salon along with the uncompleted statue, the Horvitz drawing gave the sculptor an opportunity to acquaint the public with his entire composition. GS

PIERRE-ANTOINE BAUDOUIN

Paris 1723–1769 Paris

76 Séance: A Visit to the Medium

Gouache on board

350 × 287 mm. (oval)

Watermark: None

Inscriptions: In pen and black ink, amidst symbols and illegible writing in the book in the image, lower left: *Deshays* (last two letters combined in a snakelike y)

Provenance: Perhaps Collection Delahaye, Paris; comtesse de Castrie (descendant of the Delahaye family); sale, Galliera, Paris, 30 March 1965, lot 2; Galerie Cailleux, Paris; Didier Aaron et Cie, Paris; acquired in 1985 (D-F-80/ 1.1993.2)

Exhibitions: New York 1984, no. 2

Literature: Olivier Aaron in Paris 1985f, pp. 62–63, cat. no. 56

1

2

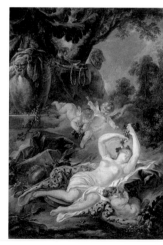

3

This remarkably fine drawing poses two problems. The first concerns its authorship. The traditional attribution to Baudouin appears to be the most plausible: the figural style, facture, coloration, and subject matter immediately recall the exquisite gouaches of this artist, who applied the technique to religious subjects as well as to a variety of genre scenes—such as *Morning* in the Metropolitan Museum of Art, New York (fig. 1)[1] or *The Honest Model* in the Woodner Collection at the National Gallery of Art, Washington (fig. 2)[2]—that were often popularized through engravings. The difficulty here stems from the clear inscription or "signature" of Jean-Baptiste Deshays embedded in the otherwise illegible melange of writing and symbols in the open book at the lower left. When considering its significance, we must remember that Deshays and Baudouin were both students of Boucher before becoming his sons-in-law, and that all three continued to follow and admire each other's work.[3] Thus, despite their independent artistic personalities, at specific moments in their careers, there was a certain homogeneity of manner that the current state of research on these three artists and on the larger subject of eighteenth-century French gouaches has not yet clarified.

In his genre studies, Baudouin customarily depicted two or three figures in a precisely rendered interior, such as the painter's atelier in *The Honest Model*, in which a painting clearly inspired by Boucher appears on an easel.[4] Moreover, as *Morning* in the Metropolitan Museum demonstrates, the majority of his compositions depict a curious man or woman in an attitude not unlike that of a voyeur.[5] In contrast, genre subjects appear only very rarely in the known oeuvre of Deshays,[6] and when they do, they are executed in either black chalk, bistre, or in oils. Like most of his contemporaries, Deshays (see cat. 84) used gouache to highlight forms and compositions, but his few genre works are never executed fully in gouache. However, the Horvitz Collection also contains a relatively large gouache of a mythological theme, *Erigone Vanquished* (fig. 3),[7] which is a slightly modified copy of a Deshays painting. The strength of the drawing and modeling, as well as its similarity to the painting, suggests that this may be the first gouache that can be attributed to Deshays. In any event, given the dearth of our documentation concerning Deshays and gouache, as well as the strong parallels of subject and manner between the exhibited work and Baudouin's oeuvre, the attribution of *Séance: A Visit to the Medium* to Baudouin should be confidently maintained.

The second problem posed by the present drawing is its subject. The setting is an alchemist's cabinet, full of preserved animal specimens hanging from the ceiling, vials and flasks, and scribbled formulas. The scene suggests the conjuring of a spirit; the young woman is surrounded by the signs of the zodiac, and the medium has lighted a stick of incense and a pair of torches that rest on caducei. The torches flank a mirror in which she summons the image of a smiling young man in a blue jacket adorned with a dark-colored sash. But who is the young man entering from the right? Although he also wears a blue jacket, he does not appear to be the same one reflected in the mirror. The fantastic decor and the costume of the medium—her embroidered veil, crescent-ornamented diadem, fur-trimmed cloak, and her strange slippers—suggest that the scene is taking place on the stage. A number of plays from this period used enchanted mirrors in which figures were made to appear.[8] Eventually, perhaps the scene represented here will be linked to a contemporary theatrical source. MRM

GABRIEL-JACQUES DE SAINT-AUBIN

Paris 1724–1780 Paris

77 King Solomon

Black and white chalk with touches of red chalk on cream antique laid paper

332 × 430 mm.

Watermark: Laid down—none visible through mount

Inscriptions: In black chalk on recto, lower left: *Gabriel de Saint-Aubin pinxit*

Provenance: Sale, Paris, 7 April 1899, lot 97; L. Coblentz; his sale, Paris, 16 December 1904, lot 84; Collection Cailleux, Paris (mark, at lower right, not in Lugt); Galerie Cailleux, Paris; acquired in 1985 (D-F-264/ 1.1993.125)

Exhibitions: Paris 1951, no. 196

Literature: Dacier 1931, vol. 2, p. 3, cat. no. 11; McCullagh 1981, vol. 1, pp. 167–69, and vol. 2, fig. 143

One of Saint-Aubin's largest and most sumptuous drawings, this pivotal sheet dates from a period in the artist's development between his early efforts to win the Prix de Rome at the Académie with similar historical or allegorical subjects and his later exploration of scenes of daily life. King Solomon, surrounded by young women, lounges on a bed as he examines the works of art that they present to him. Unlike Saint-Aubin's earlier depictions of historical themes, this drawing conveys a blend of intimacy and vitality, the feeling that Solomon is a "modern" magnate encircled by the lively ladies of his harem.

Two other drawings relate to the Horvitz Saint-Aubin. The first is a very rapidly sketched preliminary study in the Forsyth Wickes Collection in the Museum of Fine Arts, Boston (fig. 1).[1] The second and more complete sheet, signed and dated 1760, was first discussed by Emile Dacier as part of the Destailleur Collection (Musée du Louvre, Paris, fig. 2).[2] In addition to signaling the importance of the drawing shown here, Dacier noted that both sheets were inscribed *pinxit,* suggesting that Saint-Aubin executed this composition in preparation for a painting, which he also intended to reproduce as a print. Although no painting or print of this subject is known, the Destailleur drawing is traced with a stylus, rubbed on the back with red chalk in preparation for engraving, and contains a further inscription beneath the image in the form of a legend. It also includes a larger number of figures, greater figural characterization, and more architectural detail than the exhibited sheet. The other inscription on the Destailleur study, which illuminates this unusual biblical scene, is a quotation from Voltaire's *Defense of the Worldly or the Apology of Luxury* that describes Solomon as a great man, the likes of which could not be seen in Paris, Peking, or Rome— a rich wise man, a philosopher king, and a crowned

Plato—who understood everything from cedars to grass and who lived the most luxurious life ever seen.[3]

While it is difficult to determine with certainty which of the two fully developed Solomon compositions preceded the other, it is clear that one relates to Saint-Aubin's earlier work, whereas the other reflects his later creations. The elaboration of the Destailleur sheet evokes the etched and painted histories of 1752–53, such as the *Reconciliation of Absalom and David* and *Laban Searching for His Household Gods,* and his use of red chalk wash can be compared to his use of the same medium in *Judith and Holofernes* in the Musée du Louvre.[4] By contrast, Saint-Aubin's broad and sensuous use of the chalk in the drawing shown here relates to his most Boucher-influenced sheets, such as the *Conversation galante,* the large and extraordinary *Family* in the Musée Carnavalet in Paris, and the imposing *View of the Boulevard* of c. 1760, in the Fondation Custodia, Paris.[5] Like these and other contemporary chalk studies, the exhibited drawing emphasizes broadly and simply the luminous effects and idealized forms rather than the details of the scene. It reveals not only a new solidity and structure, but a greater naturalism and grace, combined with a feeling for daily life that would engage Saint-Aubin for the rest of his career. It is as though the Destailleur Solomon were drawn as an illustration for a book and the Horvitz Solomon observed from either the theater or some life experience, having less to do with biblical history than with contemporary mores. The love of this Maecenas for beautiful objects and beautiful women speaks to the collecting instinct that would become a dominant topic for Saint-Aubin in his documentation of the Salons and sales from the 1760s on. SFM

1

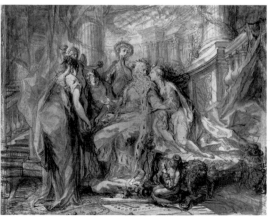

2

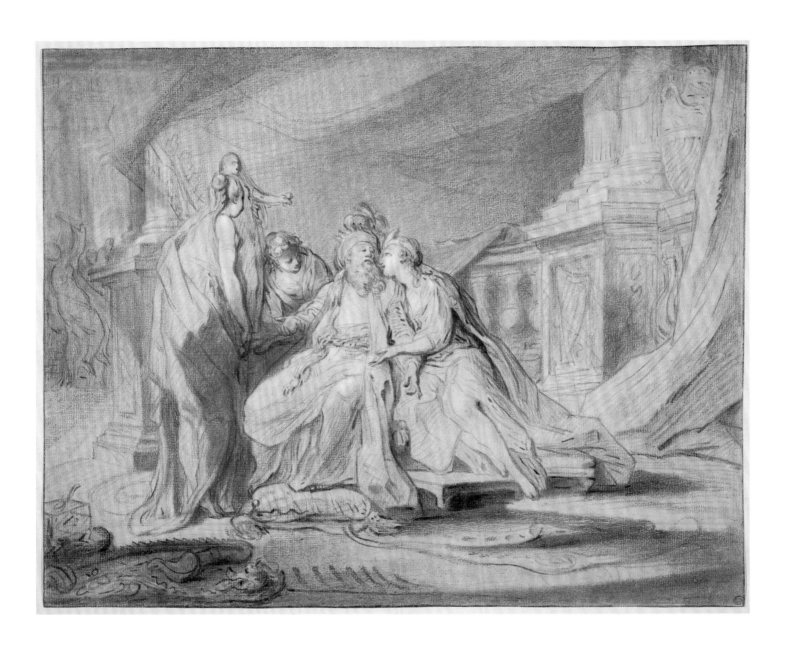

JEAN-BAPTISTE GREUZE

Tournus 1725–1805 Paris

78 *Head of a Woman in Profile*

Red chalk on cream antique laid paper

390 × 318 mm.

Watermark: Gaudriault 664

Inscriptions: None

Provenance: Galerie Cailleux, Paris; acquired in 1988 (D-F-120/ 1.1993.60)

Exhibitions: None

Literature: Unpublished

*T*his drawing is not a preparatory study for any known painting by Greuze, nor can it be considered a portrait. Rather, it resembles most closely the artist's studies of human expression, drawn after unknown models, which he published beginning in 1766 as four suites of engravings entitled *Cahiers de Têtes de différents caractères*. This masterful drawing must date from that period.

The inspiration for Greuze's publication venture was Charles Le Brun's *Conférence sur l'expression générale et particulière*, a lecture that the artist delivered to the Académie in the spring of 1668, illustrated with his own drawings.[1] On the basis of the engravings subsequently executed after Le Brun's studies, Greuze would sometimes modernize the earlier artist's subjects by including details of clothing and coiffures of his own time, but he always faithfully repeated the muscular distortions described and illustrated.[2] His boldly hatched *Head of an Angry Young Girl in a Fauchon*, also in the Horvitz Collection (fig. 1),[3] demonstrates Greuze's procedure even more obviously. The engravings after Greuze's drawings were intended to serve as visual models in the training of young artists, but they were also utilized by actors and singers. Copies executed after them continue to confound dealers, curators, and collectors.

The nearest parallel in Le Brun's series to Greuze's more elusive display of the passions in the sheet exhibited here would be *La Crainte* (*Fear*), as seen in Bernard Picart's engraving after Le Brun's drawing illustrating that emotion (fig. 2), based on a figure in his painting of the *Family of Darius before Alexander* (Musée national des Châteaux de Versailles et de Trianon). Le Brun's description of this emotional state reads: "The movements of Fear are expressed by the inner end of the eyebrow slightly raised; the pupil is bright, in restless movement, and situated in the mid-

dle of the eye; the mouth is open, drawn back, and the sides more open than the center, and the under lip drawn further back than the upper." As in the case of many of his other adaptations of Le Brun's exaggerated depiction, the present study by Greuze has a casual immediacy and subtlety of mood that make it seem almost like a cinematic freeze frame. And yet, his model must have managed to hold that enigmatic expression long enough for him to capture not only its evanescent quality—"attentive and almost incensed," in the words of Marianne Roland Michel[4]—but also to define the complex planes of the young woman's head and coiffure as well as the play of light and shade that gives this bust such a three-dimensional plasticity.

Oddly enough, no engraving of the Horvitz *Head of a Woman in Profile* appears in any of Greuze's *Cahiers*, but in the mid-1770s, he would develop the visual concept of the emotion of fear even more dramatically in a striking pastel (fig. 3), the first work by him in this medium to enter the collection of the Musée du Louvre, Paris.[5] In that work, the generalized draperies and flowing hair remove the subject to the timeless world of the ideal, as opposed to the specific here and now. EM

La Crainte

2

3

1

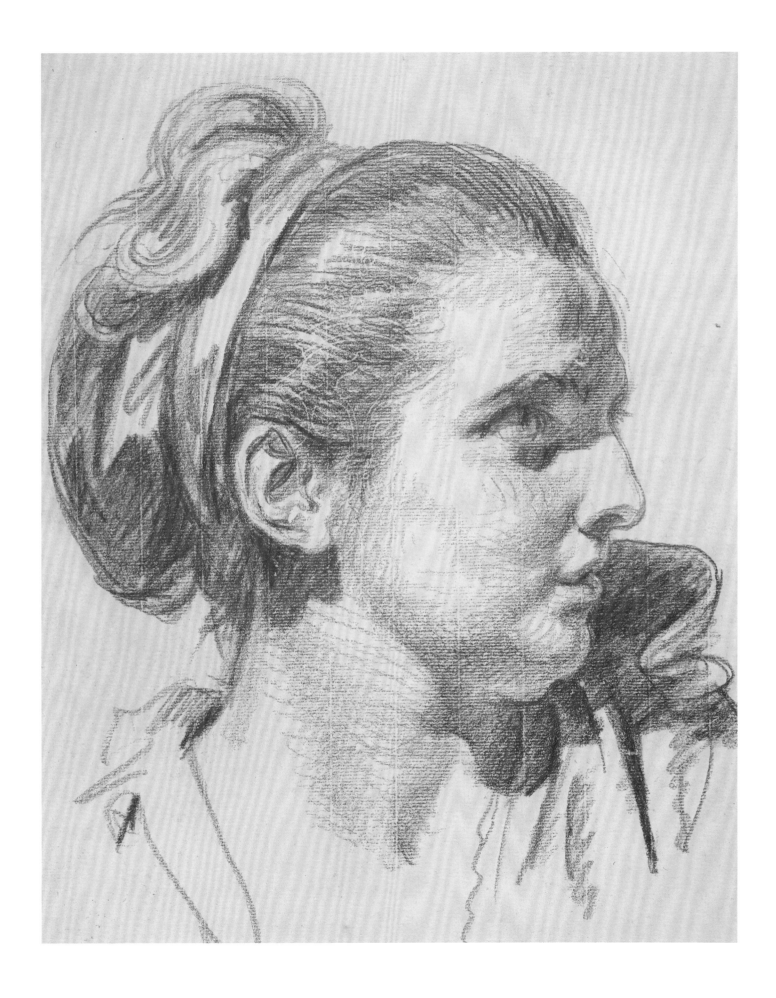

JEAN-BAPTISTE GREUZE

Tournus 1725–1805 Paris

79 *The Boat of Misfortune*

Brush and gray wash over graphite on off-white antique laid paper

646 × 529 mm.

Watermark: Gaudriault 664

Inscriptions: None

Provenance: W. M. Brady and Co., Inc., New York; acquired in 1995 (D-F-126/ 1.1995.35)

Exhibitions: New York 1994a, no. 4

Literature: Chennevières 1894–97, vol. 19, p. 184; Mauclair—Martin—Masson 1906, cat. no. 80; Edgar Munhall in Hartford et al. 1976, pp. 182–83, cat. nos. 89–90; Mark Brady in New York 1994a, cat. no. 4 (n.p.)

With this drawing and the related *Boat of Happiness* in the Boijmans Van Beuningen Museum, Rotterdam (fig. 1),[1] Greuze provided an allegorical but frank evocation of his marriage to Anne-Gabrielle Babuti, referring in the Rotterdam sheet to their early hopes of happiness and in the exhibited drawing to their subsequent disappointments. Married on 3 February 1759, their relationship seemed stable through most of the next decade, when three daughters were born to them.[2] However, by 1767, Diderot was describing Madame Greuze as "one of the most dangerous creatures on earth" and the couple's frequent squabbles as resembling a Punch and Judy show.[3] The drawing catalogued here dates from about a decade later.

Greuze seemed to thrive perversely on his wife's outrageous misbehavior, often utilizing examples of it as subjects for drawings such as *The Angry Woman* (Metropolitan Museum of Art, New York) and *The Reconciliation* (Phoenix Art Museum). The autobiographical note of the present drawing and its thematic pendant is stressed by the presence of the two children, who recall Greuze's own two surviving daughters. By 1785, the artist and his wife were living separately; around 1791–92, Greuze dictated a lengthy account of his marital woes; and on 4 August 1793, he was granted a divorce. The huge settlement accorded Anne-Gabrielle ruined him financially.

Madame de Valori, a pupil and early biographer of Greuze, may have been echoing the artist's own words in her early description of the present drawing and its symbolism:

In the second boat, how different the scene that passes is from the first! It no longer offers the image of happiness that we admired in the other. The billows against which it struggles have risen, clouds have piled up; the lightning that tears through them and the thunderbolt that has struck the temple of Happiness, of which we now see only the wreckage, announces the wrath of the heavens, which never protect a disunited couple. The winds and the unleashed waves push this unfortunate boat toward the precipice it had succeeded in avoiding. The husband alone makes vain efforts to prevent it from falling into the abyss; his weakened hands can hardly support the oars; the rudder is broken. The wife, seated opposite her unhappy husband, her head nonchalantly resting on one hand, seems insensitive to the danger that surrounds her, and while her children fight with each other and quarrel over a piece of bread, she stares at them without interest and does not even appear to dream of separating them, so much has her heart been frozen by the unconcern and frivolity of her character. Love, whose torch is extinguished, flies far away from this boat in which discord reigns, and which will soon disappear under the waves.[4]

A less finished and considerably smaller rendering of *The Boat of Misfortune* is in the Musée Greuze, Tournus (fig. 2).[5] The only known version of *The Boat of Happiness* is the Rotterdam drawing—roughly the same size as the Tournus sheet—which must also be considered the preliminary sketch of its subject. All three drawings were executed in grisaille, but the exhibited drawing contains the most violent contrasts of lights and darks. Charles-Philippe, marquis de Chennevières-Pointel, who owned the Tournus study, remembered being told by the marquis de Valori that Greuze had intended to treat its subject and *The Boat of Happiness* "in very large drawings or paintings."[6] The Horvitz sheet could be one of these. EM

1

2

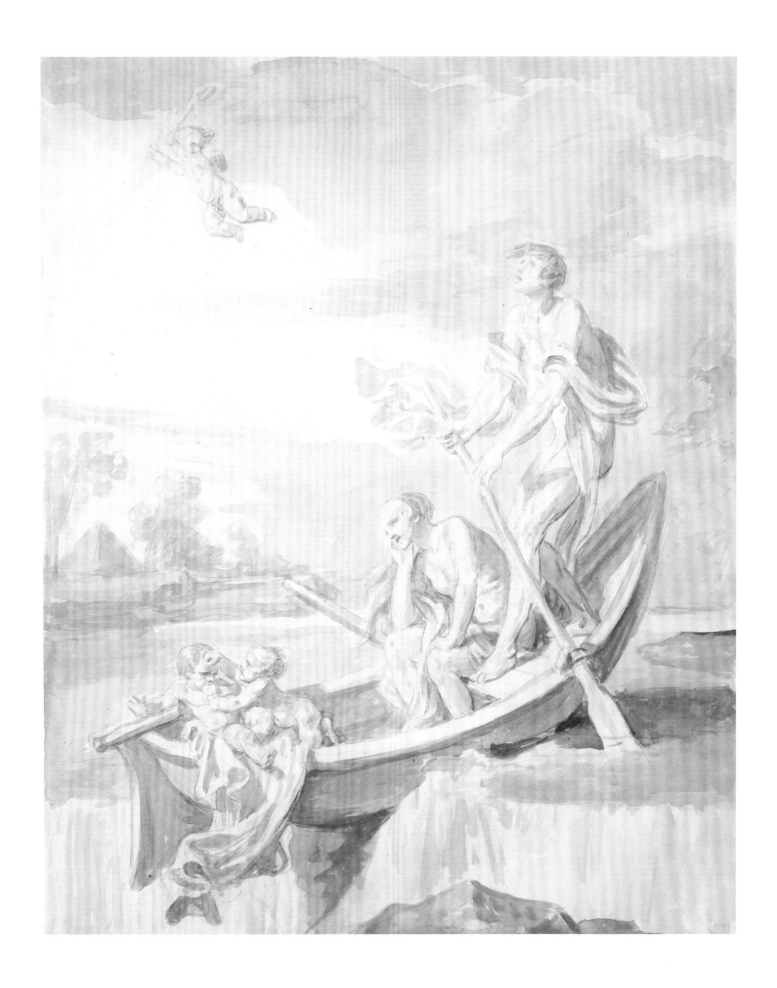

JEAN-BAPTISTE GREUZE

Tournus 1725–1805 Paris

80 *Psyche Crowning Cupid*

Pen and black ink with brush and gray wash, heightened with white gouache, over black chalk on tan laid paper

421 × 528 mm.

Watermark: Gaudriault 664

Inscriptions: None

Provenance: Baron Dominique-Vivant Denon (L. 779, at bottom right), Paris; his sale, Paris, 1 May 1826, probably lot 753; Galerie de Bayser, Paris; Private Collection; Hazlitt, Gooden and Fox, Ltd., London; acquired in 1997 (D-F-477/ 1.1997.16)

Exhibitions: None

Literature: Mauclair—Martin—Masson 1906, cat. nos. 41 and 85

*I*n treating the subject of Cupid and Psyche in this study and in the painting that resulted from it (Palais des Beaux-Arts, Lille, fig. 1),[1] Greuze characteristically eschewed the more frequently depicted episodes from the story of these mythical lovers united by Jupiter—either Psyche holding a candle to ascertain her husband's identity or the celebration of their nuptials amidst an assembly of the gods—in favor of this intimate crowning scene that is not described in any of the standard narrative sources for the story (such as Lucius Apuleius's *Golden Ass*) nor represented in any pictorial antecedent.

The meaning of Greuze's painting was most succinctly described in an early catalogue of the museum at Lille: "*Psyche Crowning Cupid:* Seated, Psyche is about to place the white Crown of Purity on the kneeling Cupid's head. Behind her, the figure of Modesty veils herself. In the background, an amor places two crowns of roses on the bed while another, at right, pours incense onto a perfume burner."[2] In contrast to the painting, in the drawing exhibited here, Greuze depicted Psyche and her attendant as more fully clothed, omitted the putti on the marriage bed and by the perfume burner, turned Psyche's ewer on its side, rendered Psyche's stool and the table behind her in a less elegant classical style, and depicted Cupid's left wing on a larger scale.

Since nothing is known about the circumstances that led to the creation of *Psyche Crowning Cupid*, its date remains problematic. In scale and style, it seems almost a pendant to the artist's *Innocence Carried Off*

by Cupid (Musée du Louvre, Paris), which is known to have left Greuze's studio around 1785, and thus it probably dates from the same period.[3]

A number of figure studies were recorded for this composition, but they have not been seen since the beginning of this century, and they were never reproduced.[4] Of the many extant sheets related to this important late drawing, those to be considered most closely include a study in a vertical format that probably predates it, which is also in the Palais des Beaux-Arts, Lille (fig. 2);[5] a *Young Woman Weeping by a Tomb* (location unknown),[6] whose pose and spirit are similar to Psyche's; a giddy depiction of *Cupid Crowning Psyche* in the Israel Museum in Jerusalem (fig. 3);[7] and, almost as though depicting an aftermath of the present scene, a *Sleeping Cupid Holding a Smoking Torch* (Private Collection, Paris).[8]

The presence of the mark of Baron Dominique-Vivant Denon at lower right suggests that the Horvitz *Psyche Crowning Cupid* may have been lot 753 in the estate sale of the collection of this great arts administrator, connoisseur, and artist, who owned a number of paintings and drawings by Greuze. In the catalogue of the sale, it is described as "*Faithful Love Crowned:* a wash drawing heightened in white, on colored paper, . . . a study for a painting." Denon made a comical drawing of Greuze in which he is shown with his hat under his arm, holding a huge muff, and looking nervously over his shoulder at a portrait of a woman (his wife?).[9] Greuze, in turn, is known to have drawn a portrait of Denon, represented in profile, holding a medal.[10] EM

3

2

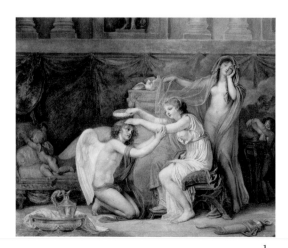

1

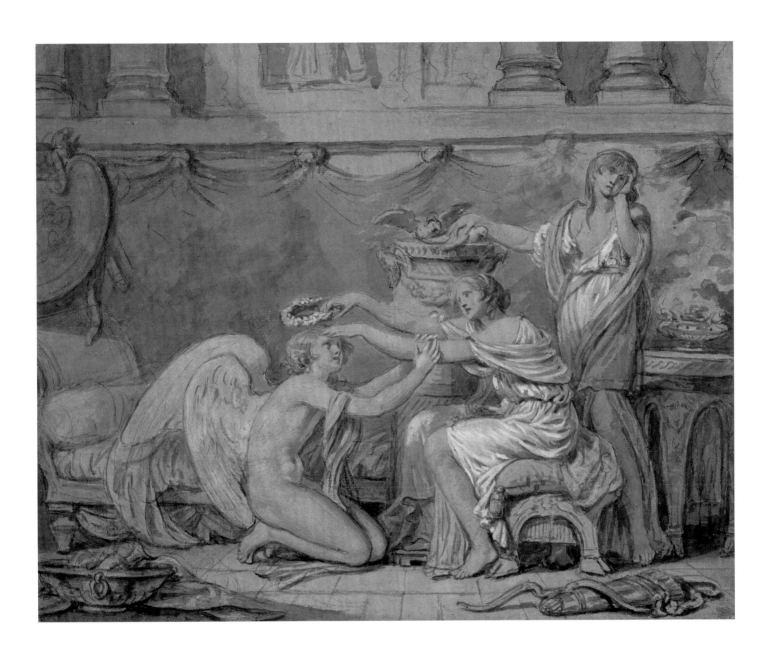

JEAN-BAPTISTE GREUZE

Tournus 1725–1805 Paris

81 *Philippe-François-Nazaire Fabre d'Eglantine*

Pastel on tan paper laid down on canvas

577 × 468 mm.

Watermark: Laid down—none visible through mount

Inscriptions: None

Provenance: Private Collection, Germany; Franco Zangrilli, New York; acquired in 1984 (D-F-119/ 1.1993.59)

Exhibitions: New York 1996b

Literature: Unpublished

This pastel portrait of the writer and revolutionary Fabre d'Eglantine (1750–1794) was executed by Greuze as a study for an oval version in oil of nearly identical dimensions that is now in the Musée du Louvre, Paris (fig. 1).[1] The sitter assumed his picturesque name "d'Eglantine" (meaning "sweetbrier," a wild rose with fragrant leaves and flowers) after winning a poetry competition sponsored by the Académie of Toulouse in 1771: the prize for his sonnet to the Virgin Mary was a silver rose.[2] His original surname, Fabre, was quite common in the south of France, where he was born at Carcassonne.

After many years of wandering through the provinces earning a meager existence as an actor, musician, poet, and painter, Fabre and his wife settled in Paris in 1787. As a playwright, he produced a string of failures but finally obtained success with *Le Philinte de Molière* in 1790. The following year, his five-act comedy in verse, *L'Intrigue épistolaire,* delighted Parisians with its depiction of an artist named Fougère, supposedly modeled on Greuze. Certainly the personage of Madame Fougère recalled the caustic Madame Greuze as she declaimed:

> Oh, paint our bourgeois, paint the devil himself,
> And thus line your pockets. What could it cost you?
> Does painting a portrait entail any risk?
> Just make each man handsome and each woman fair—
> And human folly will make you a millionaire.[3]

Though Greuze was separated from his wife at this point, Madame Fougère's declamation may not have been so different from the artist's own thoughts at the time he executed the present work, for he was painting few subject pictures—but numerous portraits—in the 1790s.

Swept up in the current of the Revolution—Fabre was president and secretary of the club of the Cordeliers—he was chosen to be the private secretary of Georges-Jacques Danton in 1792 and soon sat in the Convention Nationale. By then, the poverty that had haunted Fabre all his life mysteriously vanished, and

he was suddenly living sumptuously in the former residence of the duc d'Aumont on the rue Ville-l'Evêque. It was probably at this time that he had the means to commission this portrait from the celebrated Greuze. In all of Fabre's frantic revolutionary activities, which included voting for the death of the king, his most memorable accomplishment was naming the months of the revolutionary calendar that replaced the Gregorian one with such gems as "Prairial" and "Floréal" and such oddities as "Primidi" and "Duoda." On 12 January 1794, Fabre was arrested on charges of malversation of state funds and forgery. During his trial, he diverted the bystanders by singing the famous song he had composed in his youth, *Il pleut, il pleut, bergère, rentre tes blancs moutons,* and on the way to the guillotine on 5 April 1794, he was seen scattering manuscript poems to the crowd with his manacled hands.

Fabre's appearance, evidently flattered in Greuze's portrait of him, was evoked in these words by a contemporary: "Hair thrown back, eyes round and sunken beneath a heavy brow, rather strong nose hanging over his mouth, prominent jaw and cheekbones."[4]

This pastel entered the Horvitz Collection with a portrait of a woman reputed to be Madame Fabre d'Eglantine (fig. 2). Subsequent study of that pastel and its related version in oil in the Musée du Louvre, Paris, has revealed that they are works by Antoine Vestier, depicting his daughter, Marie-Nicole (b. 1767).[5]

EM

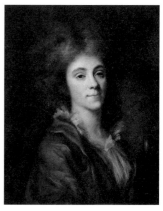

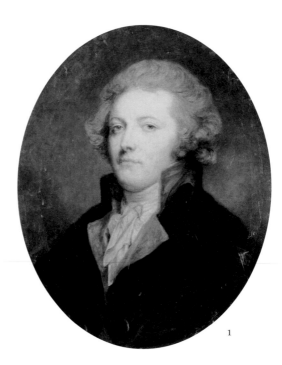

2

1

274

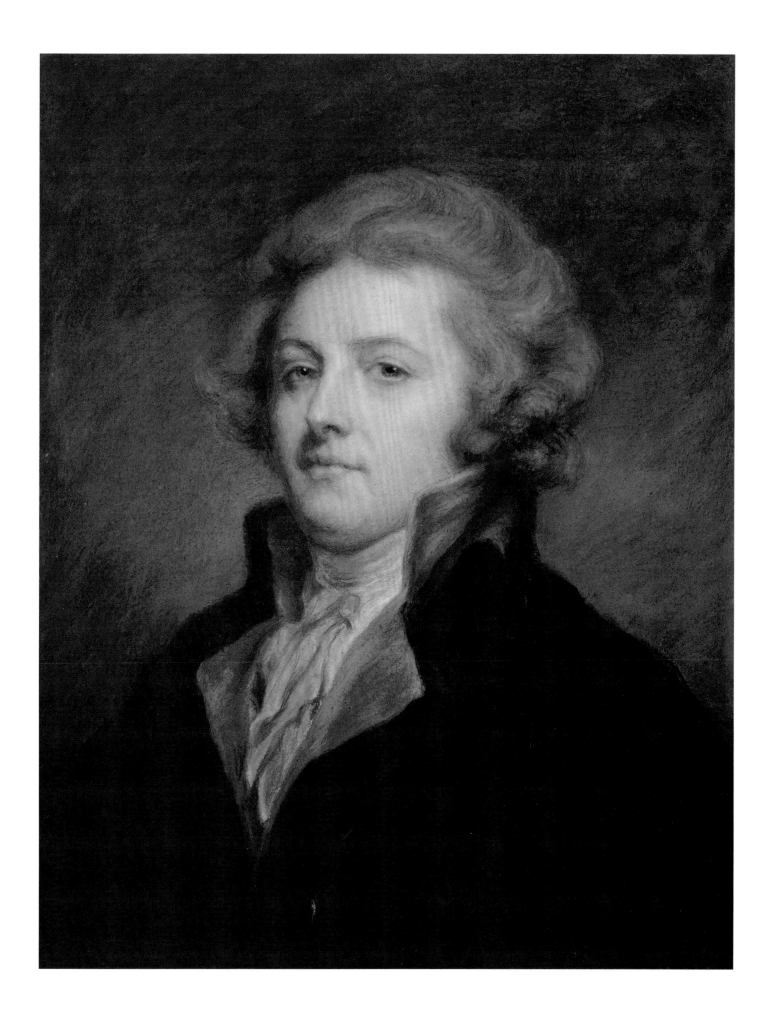

GABRIEL-FRANÇOIS DOYEN

Paris 1726–1806 St. Petersburg (Russia)

82 *Cybele Tormented by the Elements*

Pen with black and brown ink, and brush with brown, ochre, and gray wash, heightened with white gouache, on off-white laid paper

660 × 493 mm.

Watermark: Laid down—none visible through mount

Inscriptions: Signed and dated in pen and black ink on recto, bottom left: *Doyen/ 1778*

Provenance: Private Collection; Galerie Emmanuel Moatti, Paris; acquired in 1994 (D-F-86/ 1.1994.27)

Exhibitions: New York 1994b, no. 21

Literature: Carpentier 1809, p. 13; Stein 1888, p. 6; Sandoz 1959, pp. 85–86; Sandoz 1967, p. 113–16; Sandoz 1971, p. 153; Sandoz 1975, cat. no. 39, p. 45; Emmanuel Moatti in New York 1994b, cat. no. 21 (n.p.)

*T*his stunning and dramatic composition by Doyen probably illustrates the moment in the *Metamorphoses*—just after Jupiter had overthrown the Titans and installed himself as king of the gods—when Ovid informs us that Jove's wrath turned to the misdeeds of humanity, which he decided to punish by drowning the earth with water (1:262–69):

He wasted no time, but imprisoned the north wind in Aeolus's caves, together with all the gusts . . . and he let loose the south wind. On dripping wings the south wind flew. . . . His beard was heavy with rain, water streamed from his hoary locks, mists wreathed his brow, his robes . . . dripped with moisture. When he crushed the hanging clouds with his broad hand . . . sheets of rain poured down from heaven. . . . Neptune, god of the sea, lent him the assistance of his waves. He sent forth a summons to the rivers, . . . 'Fling wide your homes, . . . and give free course to your waters.' . . . Now sea and earth could no longer be distinguished . . . the human race was swallowed up.

Doyen portrayed the south wind as a figure aloft with outstretched arms, crushing clouds and dripping with water at the top of the drawing. In addition to his aides, on his right a winged river god with a snakelike tail and fin pours forth his waters. At the bottom left, from the cracks of the earth, Aeolus's gusts attempt to dispel the clouds, to no avail. In the center of the sheet, Doyen personified the suffering of humanity and the earth with a distraught Cybele, the great mother goddess, mistress of wild nature, who was responsible for both fertility and the well-being of humankind. She is depicted with a turreted or mural crown and the disgruntled lions that pull her now-destroyed chariot. Fortunately for the human race, the tumult soon ceased, and Cybele was able to restore and repopulate the earth with the assistance of Pyrrha and her husband Deucalion, son of Prometheus; Prometheus had warned them to build a boat. Once they reached safety, an oracle told them to "throw the bones of their great mother behind them." When they threw stones in the wet soil, humans began to form in the mud.[1]

A student of Carle Vanloo (cats. 63–66), Doyen was a pivotal figure in what is sometimes called the Reform (c. 1750–80), or the experimental phase between the Rococo period and Neoclassicism, when artists such as Vien (cat. 74), Greuze (cats. 78–81), and Deshays (cat. 84) searched for ways to revitalize the grand manner. Even Fragonard, usually considered to be firmly entrenched in the Rococo mode, occasionally executed works like his *River God* (Private Collection, fig. 1),[2] which is as "proto–Romantic" as the Doyen shown here. The critic Denis Diderot and others ranked Doyen as second only to Vien and considered him to be the potential "savior" of the French school.[3] Aspects of his talent that they admired must have included his powerful draftsmanship, with its febrile line and lavish brushwork; his evocative use of color; the density of his media; and his astute utilization of expression, gesture, and movement. In the exhibited drawing and in a few other sheets, such as his *Allegory of Fishery: Neptune and Amphitrite* (Metropolitan Museum of Art, New York, fig. 2)[4] and his *Martyrdom of St. Sebastian* (Musée des Beaux-Arts, Grenoble, fig. 3),[5] these facets combine to create exquisitely crafted, impassioned, and thespian schemes. Signed and dated *1778*, the Horvitz drawing reprises the subject of one of Doyen's most celebrated and sensational paintings (now lost), which had been commissioned by the duchesse de Choiseul as a gift for her husband and was shown at the Salon of 1773.[6]

A very linear, reversed copy of the Horvitz drawing is in the Nationalmuseum, Stockholm (fig. 4),[7] suggesting that Doyen intended to have the work engraved. ALC

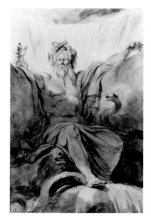

1

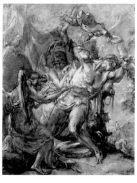

3

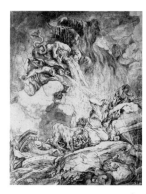

4

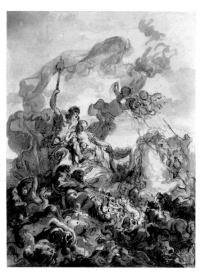

2

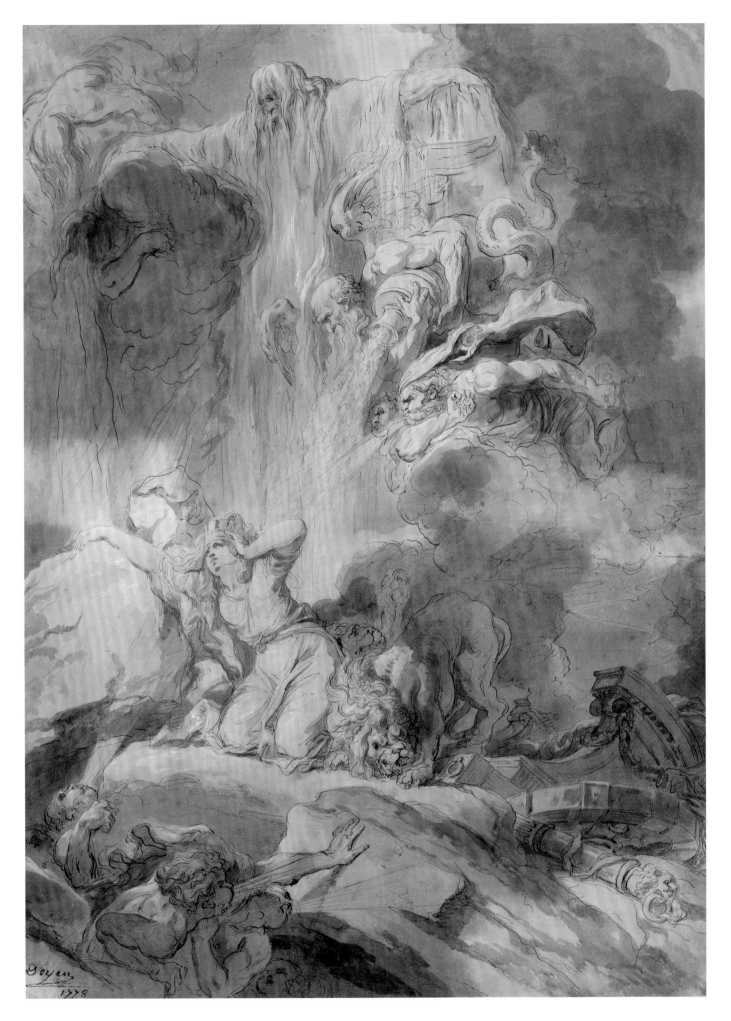

277

SIMON MATHURIN LANTARA

Oncy 1729–1778 Paris

83 *Nocturnal Landscape with a Church on a Hill above a River*

Charcoal and black chalk, extensively stumped, and lightly heightened with white chalk, on gray-blue laid paper

370 × 555 mm.

Watermark: Laid down—none visible through mount

Inscriptions: In black chalk, bottom left: *Lantara/ V.48*

Provenance: Christian Adrien, Neuilly (by 1990); Galerie Paul Prouté, S.A., Paris; acquired in 1996 (D-F-418/ 1.1996.70)

Exhibitions: Paris 1996b, no. 15

Literature: Hubert and Michèle Prouté in Paris 1996b, cat. no. 15, p. 32

This exceptionally large and atmospheric moonlight scene is entirely characteristic of the work of Lantara, who devoted himself to landscape beginning about 1760. Landscape appears to be the only genre in which he worked, and our knowledge of his production is limited to two decades (1760–78). His predilection for this genre coincided with the taste and conception of a number of artists and amateurs whose renewed appreciation of earlier Dutch and Flemish works led to their embrace of a new sensibility that celebrated naturalism and nature itself. Many aspects of this new trend were the result of the writings of Jean-Jacques Rousseau, who died in the same year as Lantara, and who championed nature, primitivism, and man in his natural state.[1]

Lantara was born in the country near the forest of Fontainebleau, where painters of the following generations would develop what we now refer to as Realism. His style, however, remained firmly rooted in eighteenth-century practice,[2] as exemplified in the exhibited sheet. Here, the view consists of elements observed in nature that were carefully reunited into a harmonious composition in the atelier. His goal was to depict a nocturnal landscape, in which moonlight pierces the clouds and illuminates the sleeping village dominated by a church on a hill, casts subtle reflections on the rippled surface of the river below, and dissolves the winding coastline into the distant horizon. In order to achieve his visual effects, Lantara suppressed line in favor of subtly stumped charcoal and black chalk, evoking a symphony of modulated tones of black and gray that he punctuated lightly with varying amounts of heightening in white chalk.

Lantara seldom represented specific sites, though there are rare exceptions, such as his *View of the Château de Chambord* in the Metropolitan Museum of Art, New York, which he executed using a different medium and technique.[3] For the most part, rather than choose a particular site, he delighted in rendering the nuances of the various seasons and the light at different times of the day in imaginary settings. The few extraordinary sheets by the artist that are as large as this and also depict nocturnal scenes include two versions of a *Moonlight Landscape with a Castle*, where the turreted roof resembles that of the Château de Vincennes—one in the Musée Girodet, Montargis; and one in the Musée des Beaux-Arts, Besançon (fig. 1)[4]—and *The Storm* in the Musée des Beaux-Arts, Chartres (fig. 2).[5] Although the atmospheric conditions differ, the composition of the latter drawing closely resembles that of the Horvitz sheet. JFM

1

2

JEAN-BAPTISTE DESHAYS
Colleville 1729–1765 Paris

84 Tobit Directing the Burial of the Dead

Black chalk, pen and black ink, and brush with light and dark brown wash, heightened with white gouache, on tan antique laid paper

328 × 354 mm.

Watermark: None

Inscriptions: In pen and black ink on recto, bottom right: *Deshyes*; in graphite on verso, upper center: *Deshayes*; in graphite on verso, lower center: *Deshayes*; in graphite on verso, bottom left: *f/ Deshayes/ 28*; in purple chalk on verso, top right: *Philippe Deshayes/ Paris* (illegible) *1665*

Provenance: Pierre-François Basan, Paris; his sale, Paris, 1–19 December 1798, lot 86; Wilhelm Koenig, Vienna and The Hague (L.s. 2653b); Private Collection, Paris; Galerie Cailleux, Paris (as of 1985); acquired in 1990; (D-F-79/ 1.1993.43)

Exhibitions: None

Literature: Sandoz 1958, p. 14, cat. no. 5; Sandoz 1977, p. 103, cat. no. 159 (as lost); Marianne Roland Michel in Paris 1985e, under cat. no. 10 (n.p.); Roland Michel 1987, p. 195; James Draper and Guilhem Scherf in Paris and New York 1997b, pp. 50–51, under cat. no. 15

During the captivity of the Israelites in Assyria, Sennacherib, king of Nineveh, decreed that their dead be thrown outside the walls of the city. Tobit, father of the young Tobias, was more fearful of divine law than of the unjust edicts of his temporal monarch, and so secretly, under the cover of night, he had the bodies of his fellow Hebrews buried. In addition to this specific event, in this moving composition, Deshays depicts what later became known as the seventh and final Act of Mercy.

Deshays's painted sketch of this subject, executed while he was an artist-in-residence at the French Academy in Rome, is signed and dated *1757* (Private Collection, fig. 1).[1] However, it is completely different in composition from this later drawing, in which the nocturnal scene required by the subject is illuminated only faintly by a brandished torch and a dim oil lamp suspended from the vaulted ceiling of the open tomb. In the drawing, these effects of lighting and the reduced number of figures enhance the secretive and tragic mood of the scene. Throughout his brief career—Deshays died when he was scarcely thirty-

five—he demonstrated a marked predilection for scenes in which such contrasts of light accentuate the dramatic character of the subject. His contemporaries at the French Academy in Rome, such as Gabriel-François Doyen (cat. 82) and Charles-François de La Traverse, also composed a number of scenes with sensational light effects.[2]

The exhibited drawing displays an expressive intensity even more striking than that of the painted sketch, and it can be effectively compared with only one or two other drawings: first, a study for the *Punishment of Korah* (Private Collection, fig. 2)[3] and, most importantly, the exceptional study for *The Resurrection of Lazarus*—which so impressed Diderot when he saw it at the Salon of 1763—that Charles-Nicolas Cochin le jeune acquired for the royal collection at the sale of Deshays's estate in 1765 (Musée du Louvre, Paris, fig. 3).[4] In both the Louvre sheet and the one catalogued here, by establishing a violent opposition between the white gouache and the various nuances of somber brown wash, the artist pushed the limits of chiaroscuro to the extreme. The exaggeration of form and the climactic intensity of the compositions in these two drawings indicate a date of 1763–64. They also reveal the significance of Deshays's brief and unique contribution during the period when the work of Joseph-Marie Vien (cat. 74) and the new restrained Neoclassical style were changing the course of French art. JFM

2

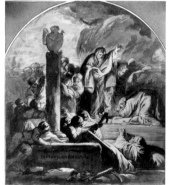

3

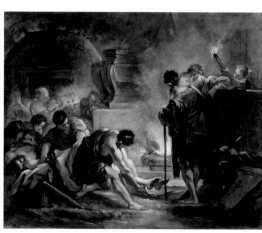

1

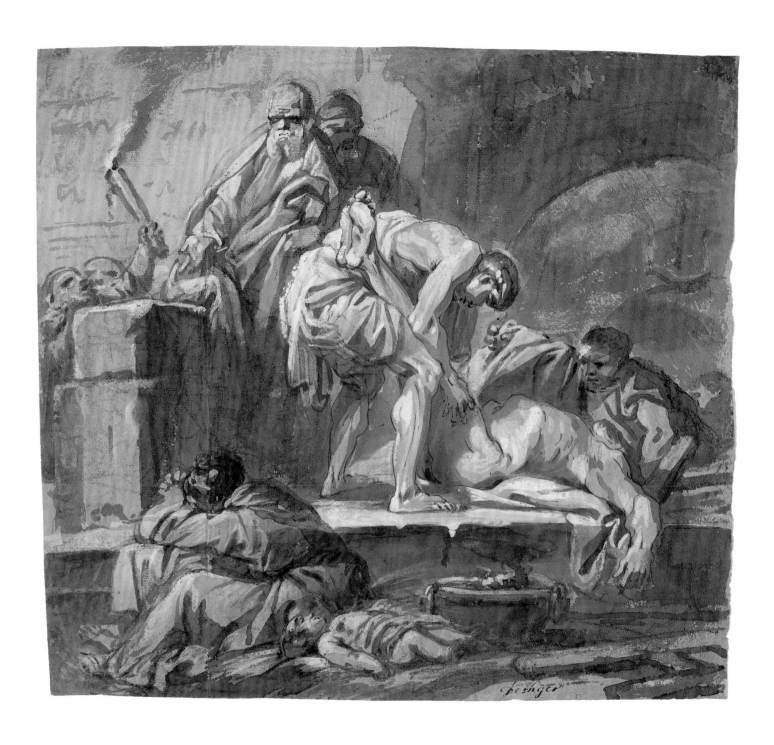

AUGUSTIN PAJOU

Paris 1730–1809 Paris

85 *Young Woman Holding a Cornucopia*

Verso: *Young Woman Holding a Cornucopia*

Red chalk with touches of black chalk on cream antique laid paper (recto); black chalk on cream antique laid paper (verso)

323 × 235 mm.

Watermark: None

Inscriptions: None

Provenance: Alain Latreille, Paris; acquired in 1990 (D-F-217/ 1.1993.103)

Exhibitions: None

Literature: Guilhem Scherf in Paris and New York 1997b, p. 237

*T*his superb red chalk drawing is generally acknowledged as one of the artist's finest sheets. It was executed in conjunction with a prestigious sculptural commission from the comtesse Du Barry —official mistress to Louis XV after the death of Madame de Pompadour—for Louveciennes, her pavilion near Saint-Germain-en-Laye. Like most structures of this type, Louveciennes was built as a pleasure palace for dinners and parties. Although now stripped of its early decoration, under Madame Du Barry's direction, Louveciennes became one of the most extravagant and sumptuously decorated garden pavilions of the later eighteenth century.[1] Pajou's sculpture was to be a "five-foot, four-inch white marble figure representing a young woman holding a cornucopia, which was designed to serve as a light source."[2] According to the critic Mathieu-François Pidansat de Mairobert, Madame Du Barry wanted this torchère and the three matching it by Pajou, Félix Lecomte, and undoubtedly, Martin-Claude Monot "to resemble her."[3] Pajou's torchère received a favorable reception when it was displayed at the Salon of 1773, and it was delivered to the comtesse in July 1774, at a cost of ten thousand *livres*, just two days prior to the onset of Louis XV's fatal illness.[4] Known only through the exhibited drawing, this sculpture provides an indication of the lost early Neoclassical decoration that graced Louveciennes, and it probably resembled its patron with the same idealization seen in Pajou's lost terra-cotta for an unexecuted marble of 1771 (fig. 1).[5]

We know that Pajou executed a number of red chalk drawings after his sculptures. These were usually based on either the definitive model or the completed work. As a group, they can be counted among his most important sheets. Compared to the sketches made during his period in Italy—which include sweeping landscapes and ambitious historical com-

positions—they constitute a personal gallery much like that recorded in the drawings of Louis-Claude Vassé (cat. 75). It is as if the artist endeavored to preserve images of his finest works on paper. On the verso of this sheet is a rough black chalk sketch of the figure seen on the recto (fig. 2).

This elegantly draped young woman, delicately supporting her cornucopia, is clearly a court image. Even if we are unsure whether the features of the lovely Du Barry are reflected in this rounded face, with its large eyes and small mouth, the highly ornate details of the coiffure banish all doubt, as it refers to the abundant iconography of the comtesse—Pajou's favorite subject—found throughout his work. Only a few years earlier (c. 1768), Pajou had designed an allegorical relief sculpture presumed to be for the royal opera at Versailles, a red chalk *modello* of which is also in the Horvitz Collection (fig. 3).[6] In this drawing, the broad planes of a frontally posed figure that was to be sculpted in relief predominate, while in the exhibited sheet, the complex contours and hatchings of the red chalk emphasize the elaborate effects of light and shade as they would have appeared in the drapery of a three-dimensional statue. Pajou's delicacy is particularly evident in the hands and feet, which are rendered with infinite lightness and precision, and he never lets us forget that the draperies are only a thin veil of fabric gently caressing a full and sensual female form.

GS

3

1

2

JEAN-HONORÉ FRAGONARD

Grasse 1732–1806 Paris

86 *Belvedere of the Villa d'Este at Tivoli Seen from the Fountain of Rome*

Red chalk over light indications in black chalk on off-white antique laid paper

355 × 493 mm.

Watermark: Laid down—none visible through mount

Inscriptions: In pen and brown ink on recto of mount, bottom center: *Robert ()*; in pen and brown ink on verso of mount, top left: *Robert*; in black crayon on verso of mount, top left: *villa d'Este*; in graphite on verso, bottom right: *431r=SFr*

Provenance: Perhaps the collection of Hubert Robert, Paris; perhaps his sale, Paris, 5 April 1809; Private Collection and by descent, Paris; Galerie Cailleux, Paris (1989); acquired in 1994 (D-F-104/ 1.1994.11)

Exhibitions: Rome 1990, no. 79 [as Fragonard(?) 1760(?)]; Paris 1991c, no. 59

Literature: Jean-Pierre Cuzin and Pierre Rosenberg in Rome 1990, p. 133; Marianne Roland Michel in Paris 1991c, cat. no. 59 (n.p.); Cara Dufour Denison in Montreal 1993, p. 169, under cat. no. 91, fig. 3

*F*ragonard's red chalk drawings of the Villa d'Este in Tivoli, made during the summer of 1760, are among his greatest achievements. Not only are they almost synonymous with his name, but they also influenced public perception of the famous villa.[1] They were intended neither as documentary views nor as preparatory studies. From the start, Fragonard considered them as autonomous works, and two drawings exhibited at his first Salon in 1765 received lavish praise.[2] The exact number of Tivoli views is unknown, but ten large sheets, including the *Temple of Vesta and the Temple of the Sibyl at Tivoli* in the Musée des Beaux-Arts, Besançon (fig. 1),[3] form a dateable core group against which other red chalk landscapes can be compared.[4] These drawings belonged first to the abbé de Saint-Non, who sponsored the trip, and then to the architect Pierre-Adrien Pâris, who bequeathed them to the library of his hometown.[5] The dimensions of the sheets are fairly consistent,[6] as is Fragonard's practice of beginning his composition with light indications in black chalk before taking up the indelible red chalk.

The view exhibited here conforms to the size and media of Fragonard's drawings in Besançon and, as in those, Fragonard takes artistic license with the specifics of the location. He looked up to the main buildings from a position near the celebrated Fountain of Rome, called the *Rometta*.[7] As he preferred to concentrate the viewer's attention on the intercepting walls and stairs, exploiting all of the possibilities of the eye's movement between diverse stretches of positive and negative space, he ignored one of the *Rometta's* most recognizable features: the stone boat

fountain (it would be on the right in the area Fragonard chose to fill with a crumbling stone wall). He also shifted the axes not only of the wall niches opposite, but of the buildings looming above.[8] Foliage, rendered in imprecise but vigorous and varied patterns, unifies the scene. In the opinion of Jean-Pierre Cuzin and Pierre Rosenberg, the exhibited drawing may be one of the earliest executed after Fragonard's arrival at the villa in July 1760.[9] Therefore, it would predate the landscapes at Besançon.

Old inscriptions on the mount of the Horvitz drawing have led to confusion about the attribution, inspired perhaps by the popular tradition that Hubert Robert had been at Tivoli with Fragonard and the abbé de Saint-Non.[10] Neither documents, letters, nor drawings of the garden by Robert can support this.[11] Stylistic analysis of the red chalk *graphisme* and compositional structure of the present sheet confirm the case for Fragonard's authorship. For this artist, formal concerns involved space and movement, whether in the interpretation of foliage or the description of a garden or a landscape. He invented a personal shorthand for the rendering of leaves and flowers, improvised and stylized but based on natural appearances. On close inspection, variations in the control of the chalk and the width of the strokes can be observed. They create paths of rhythmic movement suggestive of changing conditions of light and wind. Fragonard's treatment of space is never static; it is defined through in-and-out movements to avoid a continuous surface. And the result is a spatial complexity, viewed from a low vantage point, with as many penetrations into depth as there are projections into open areas. By contrast, Robert's landscapes are defined by a planar structure and by graphic patterns that respect the surface. He was rarely as daring as Fragonard, who, like a twentieth-century photographer, framed a scene mentally before shooting it. He exploited formal possibilities only to enhance his power to convince. EW

1

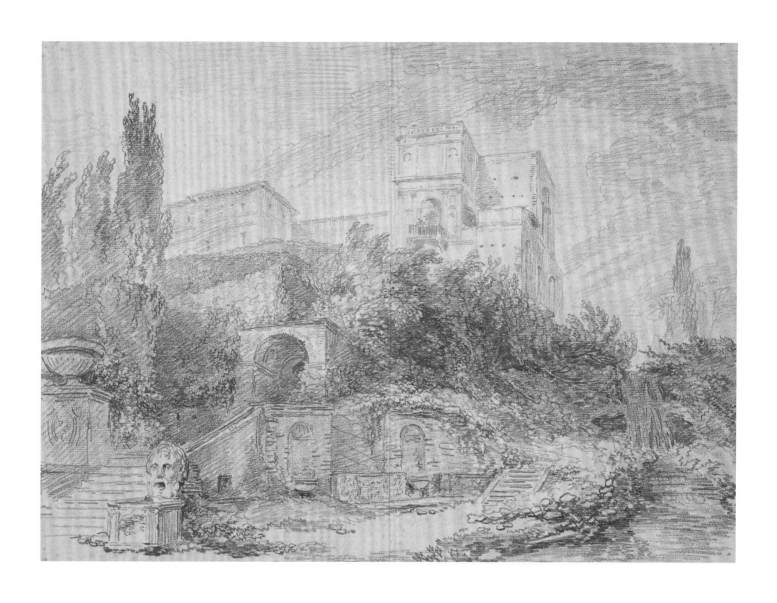

JEAN-HONORÉ FRAGONARD

Grasse 1732–1806 Paris

87 *The Satyr and the Peasant*

Black chalk and charcoal, extensively stumped and heightened with white chalk, on cream antique laid paper

548 × 454 mm.

Watermark: D & C BLAUW

Inscriptions: None

Provenance: Prince Serra di Cassana, Palermo, and his family, by descent; Professor de' Giovanni, Naples; Private Collection, United Kingdom; Mathiesen Fine Art, Ltd., London; acquired in 1989 (D-F-101/ 1.1993.52)

Exhibitions: Cambridge 1993, no. 16

Literature: Eunice Williams in Cambridge 1993, cat. no. 16 (n.p.)

*T*he subject of this drawing derives from the ancient *Fables* of Aesop, rewritten by Jean de La Fontaine in the late seventeenth century. In one of these, a wayfarer is invited inside from the cold night to take dinner with a satyr and his family. The peasant blows first on his hands to warm them, then on a bowl of hot soup to cool it. The satyr, confused and frightened by what he considers a demonstration of human inconstancy, tells him, "Be off! I won't have a guest who blows both hot and cold." Although this subject is rare in French art,[1] it was very popular with seventeenth-century Dutch and Flemish masters, who saw in the moral tale an opportunity to portray humble farmhouses filled with still-life and genre details. Paintings by Jan Steen and Jacob Jordaens established a pictorial tradition wherein the satyr became the guest of the farm family.[2]

Fragonard was probably attracted to the theme for the same reasons as the northern artists. In the absence of a French tradition, he might have turned to Dutch or Flemish precedents. However, great narrator that he was, he presented the essentials of the story in a setting of which he was already a master. In his own oeuvre, there are numerous examples of family genre scenes, both drawings and paintings of rustic interiors where several generations, along with various pets, gather informally around a table for a meal or entertainment. For example, compositions like *The Little Preacher* (National Gallery of Art, Washington) or *La Perruque brûlée* in the Fogg Art Museum (fig. 1)[3] contain many of the same models and types: a chubby child, an idealized father, a kindly older woman (perhaps a grandmother or nurse), and a gentle dog. The interiors carry these similarities further: a coherent stagelike space with a fireplace, improvised table and chairs, cooking utensils, and domestic objects stored on shelves. The familiar interior is Fragonard's idealized recreation of a Provençale kitchen, constructed of stone and terra-cotta, that served as the center of family life in an ancient *mas* or *grange*.

The leading actor in the drama of the exhibited composition is the satyr, who gestures emphatically after rising hastily—to the astonishment of his family and guest—to make his pronouncement. Fragonard frequently depicted satyrs of his own invention and copied them from earlier artists. This one derives from an obscure and hitherto unrecognized source, one with sufficient correspondence to be beyond coincidence. The satyr's gesture, his caught-in-action pose, and his muscular torso are almost a reprise, in reverse, of the satyr in Matthias Scheits's drawing of this subject in the Hamburger Kunsthalle (fig. 2).[4] In all probability, Fragonard knew not the drawing but the etching of 1677 made by Andreas Scheits after his father's composition.[5] The reversal of the printing process renders Scheits's satyr in an almost identical pose and expression as Fragonard's figure. We know that Fragonard was a print collector from his purchases at the posthumous sale of François Boucher's collection in 1771.[6]

The large dimensions of the sheet, close to the scale of many family genre paintings, is as unusual as his choice of media.[7] He appears to have explored the potential of charcoal on only one other occasion (c. 1770).[8] Given his broad handling of the media here and the northern European inspiration of the subject and composition, the Horvitz *Satyr and the Peasant* is probably from the late 1770s, after Fragonard's travels in central and northern Europe. EW

1

2

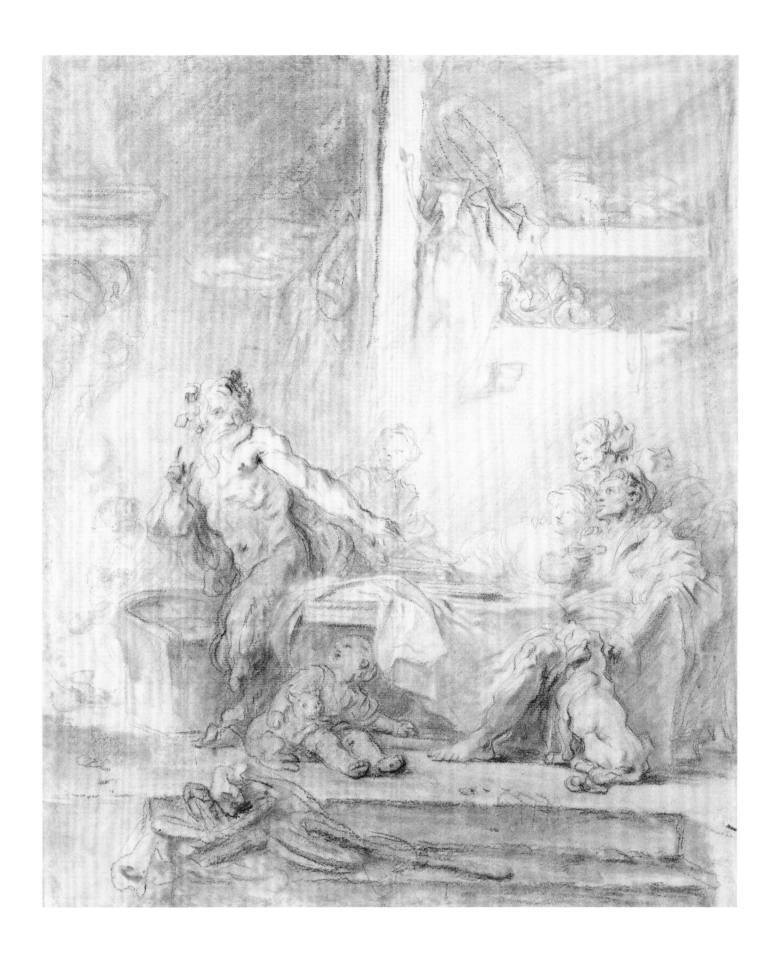

287

JEAN-HONORÉ FRAGONARD

Grasse 1732–1806 Paris

88 *Garden of an Italian Villa, with a Gardener and Two Children*

Brush and brown wash over traces of graphite on off-white antique laid paper

335 × 448 mm.

Watermark: Simple fleur-de-lys with the initial *I* at the right (similar to Heawood 1382)

Inscriptions: None

Provenance: Edouard Kahn (according to a label on the verso of the old frame); Robert Treat Paine II, Boston; by descent to Mrs. Thomas Card, Boston; sale, Sotheby's, New York, 13 January 1993, lot 65; acquired at the sale (D-F-103/ 1.1993.53)

Exhibitions: Cambridge 1934; Boston 1939, no. 165; Pittsburgh 1951; Cambridge 1993, no. 19

Literature: Mongan 1934, p. 8, fig. 2.; Boston 1939, pl. 86

*I*n the years following his return from his second trip to Italy in 1774, Fragonard continued to call on memories of the landscapes and sights he had experienced there. The journey renewed his interest in landscape, which he often drew with brush and wash. These drawings reveal a personal synthesis of style and technical practice that parallels his achievements in red chalk during his first Italian period (1756–61, see cat. 86). This sheet from the late 1770s proves how vivid the impressions had been.

The Horvitz drawing depicts an imaginary composition, a summation of all the features of an Italian park that a Parisian collector might desire in a drawing: brilliant sunlight that exaggerates the contrasts between light and shade; ancient sculptures, of which the *Crouching Venus* is the most immediately recognizable; towering parasol pines on the right and wild, overgrown vegetation on the left. An open gate, a gardener loading a wheelbarrow, and two children at play add narrative embellishment.[1] It is a theatrical landscape but one based on years of sensitive awareness of the natural world. To deal with the challenge of combining the many elements, Fragonard repeated a formal device found in one of his most celebrated paintings, *The Fête at Saint-Cloud,* also from the period between 1775 and 1780 (Banque de France, Paris).[2] In that monumental canvas, as in this drawing, a strong horizontal balustrade in the middle dis-

tance and a magical, atmospheric light connect two quasi-independent scenes.

One can also view the present drawing as having two distinct parts, not only in a botanical sense, but in the technique used to describe the setting. The foliage on the left is purely imaginary and generalized and is drawn in an exuberant manner: it is stagecraft. In contrast, to examine the right half of the sheet is to discover Fragonard's genius in interpreting nature. He draws and paints simultaneously with the point of the brush. Working quickly before the wash dries, he maps the complex pattern of forked branches that can be identified as forming separate trees. There is real depth and density within this stand of massive pines. Below them, a nervous pointillism suggests leafy vines or bushes shimmering in the sun. A comparable drawing, not only in subject but in style and date, is *The Umbrella Pines at a Villa near Rome* in the Rijksprentenkabinet, Amsterdam (fig. 1).[3] EW

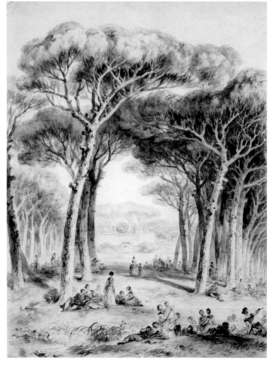

1

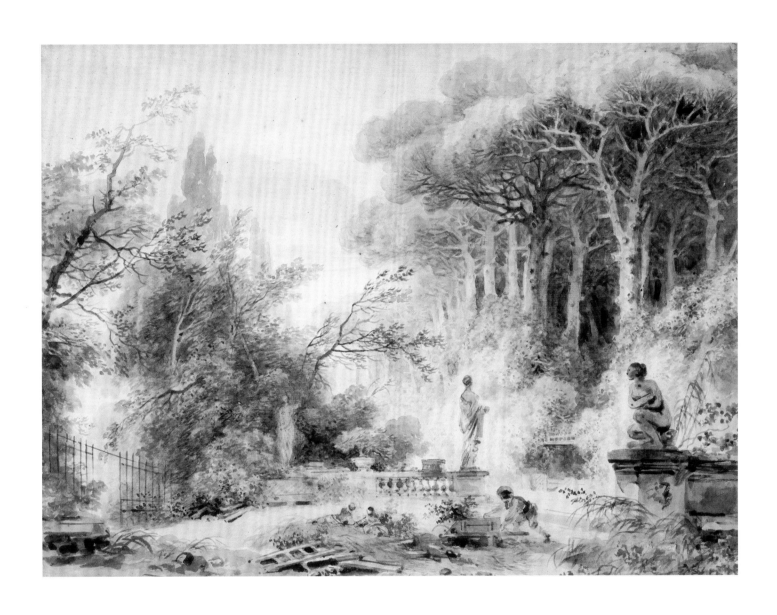

JEAN-HONORÉ FRAGONARD

Grasse 1732–1806 Paris

89 *The Angel Receives the Prayers of Charlemagne*

Black chalk and brush with brown and gray wash on off-white antique laid paper

382 × 245 mm.

Watermark: Initials *PF* (similar to Gaudriault 4258 and 4260); the rest indecipherable

Inscriptions: None

Provenance: One of a set of more than 150 drawings comprising the series of illustrations to Ariosto's *Orlando Furioso* in the collection of the artist at his death; Fragonard family, by descent; Hippolyte Walferdin; his sale, Paris, 12–16 April 1880, lot 228; Louis Roederer, Reims; Olry-Roederer, Reims; Dr. A. S. W. Rosenbach and the Rosenback Co., Philadelphia and New York; one of 100 drawings from the series acquired by Arthur Houghton in 1947; Thos. Agnew & Sons, Ltd., London; acquired in 1990 (D-F-102/ 1.1993.53)

Exhibitions: London 1989b, no. 17; Cambridge 1993 (omitted from checklist)

Literature: Mongan—Hofer—Seznec 1945, pl. 105; Cuzin 1988a

*T*his drawing is one of a set of approximately 150 sheets that Fragonard made during the 1780s as illustrations to Ludovico Ariosto's *Orlando Furioso*. The main plot of this sixteenth-century chivalric epic concerns the conflict between the Christians and the Saracens, but there is also a large number of diverting subplots focused on the amorous affairs of the protagonists. This series can be counted among Fragonard's boldest and most unrestrained works. The more exuberant drawings, like the example shown here, combine a restless flow of the black chalk and thin layers of wash juxtaposed with the reserved white of the paper to create dynamic scenes replete with energy and passion, while other sheets from this series, like *Ruggiero and Alcina Attend a Play in the Palace*—also in the Horvitz Collection (fig. 1)—utilize a more traditional, but particularly vigorous pen line to render the spirited contours. The exhibited drawing depicts Charlemagne kneeling at mass before battle. Above him flies an angel with upstretched arms, lifting the emperor's prayers to heaven. Diagonal beams descend from the upper left, bathing the upper torsos of Charlemagne and his celestial messenger in a divine light.[1]

The Ariosto drawings have been universally admired ever since they were first cited, but their pur-

pose has never been clarified.[2] Most scholars have assumed they were commissioned by an unidentified patron or publisher for an illustrated edition that never materialized, although it has also been said that Fragonard's spirited handling of chalk and wash made the sheets unsuitable models for engraving.[3] The general conclusion has been that Fragonard did not understand the technical requirements of commercial printmaking and, after depicting scenes from only the first half of the text, abandoned the project.[4] Unfortunately, none of these explanations is satisfactory. First, there is no evidence that a commission existed.[5] Second, the extraordinary quantity and large size of the sheets would have been unusual for any publishing project.[6] Third, even though tradition required the selection of one representative scene from each canto, Fragonard drew multiple scenes to create a continuous visual narrative that would capture the vibrant flow and dramatic tension of Ariosto's text.[7] His *St. Michael Finds Silence at the Gates of the House of Sleep* (Private Collection, fig. 2)[8] is one of eight additional drawings illustrating the same canto as the exhibited sheet.

Finally, it is noteworthy that Fragonard did not design these drawings in reverse, so that engravings made after them would appear in their proper orientation. Despite modern opinion, Fragonard was very familiar with technical procedures in preparing drawings for engravings, and printmakers, such as those for the abbé de Saint-Non's *Voyage pittoresque* and Jean de La Fontaine's *Contes et nouvelles*, successfully accommodated his style.[9] Appropriately, designs made for those projects were drawn in reverse; for example, noblemen wear swords on their right sides in the *Contes* drawings, whereas in the Horvitz sheet, Charlemagne's sword is properly placed at his left hip. Given these numerous departures from traditional book illustration practice, it would seem unlikely that the Ariosto drawings were intended for publication.[10]

Fragonard seems to have made these drawings for private use. Rather than mere amusement, their originality, size, and large quantity suggest a very serious purpose. Faced with the increasing popularity of Neoclassicism in the 1780s, Fragonard may have turned to dramatic literature like Ariosto's *Orlando Furioso* in order to develop a personal language that would offer an alternative and less austere interpretation of the grand manner.[11] AS

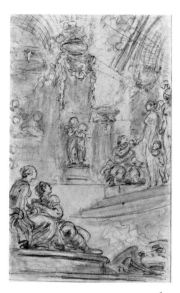

1

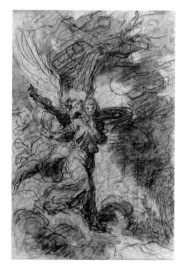

2

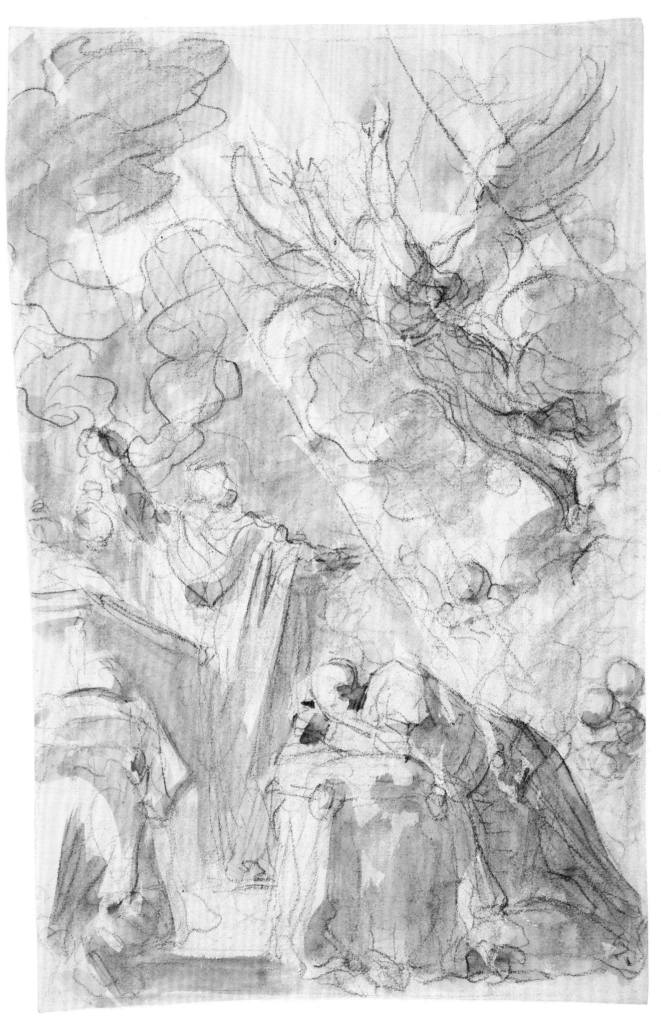

HUBERT ROBERT

Paris 1733–1808 Paris

90 *Roman Capriccio with the Pantheon and Ruins*

Pen and black ink with brush and watercolor over traces of black chalk on off-white antique laid paper

493 × 608 mm.

Watermark: Laid down—none visible through mount

Inscriptions: In pen and black ink, on base of pediment, upper left: *SPQR/ DIVO ANTIONINO DIVAE FA (?)/ DI CONSCE (?) NIA. CONSCLEA (?)/ H ROBERTI FECIT ROMAE 1760;* in pen and black ink, on base of right pedestal: *Roberti/ 1760 Roma*

Provenance: Sale, Drouot, Paris, 24 June 1981, lot 90 (as attributed to Hubert Robert); Didier Aaron, Inc., New York; acquired in 1984 (D-F-261/ 1.1993.123)

Exhibitions: New York 1984, no. 38

Literature: Alan Salz in New York 1984, cat. no. 38 (n.p.)

*T*his drawing is a typical Robert *capriccio* with references to celebrated Roman monuments from various locations juxtaposed to create a gracefully decorative oval composition. Two monumental sculptures of horses and their attendants are loosely based on the pairing seen in the *Dioscuri* on the Campidoglio, where the placement of each man and horse is reversed. These sculptures dominate the scene on the right, while behind them curves a colonnade probably inspired by Bernini's structure in the Piazza di San Pietro, although the fluted columns and Corinthian capitals are Robert's innovation. The columns and pediment at the near end of the colonnade recall the portico of the Pantheon, included here as a picturesque ruin. Robert depicts the remains of an Egyptian obelisk strewn across the immediate foreground as if to emphasize the temporality of human endeavors, while several figures go about their mundane tasks or pause for a moment amid the grandeur of ancient and modern Rome.

When Robert executed the exhibited watercolor in 1760, the broad outlines of his interests and his manner of working had already been formed. We do not know to what extent the artist's earliest training in Paris contributed to these, although several artists in the French capital had executed *capricci* of antique and modern architecture that were often influenced by the example of Piranesi or Panini.[1] Robert knew both Italian artists as a student at the French Academy in Rome, but it was Panini's art that most decisively oriented his development, as seen in such works as the present drawing. This influence is not surprising: for many years, Panini had close ties to the French Acad-

emy in Rome (in 1731, his sister-in-law married Nicolas Vleughels, then its director), and in 1732, he was elected to membership in the Académie in Paris, where several important patrons bought his pictures or gave him commissions. It is usually claimed that Panini taught perspective at the French Academy in Rome, although this has been questioned recently.[2] In any event, it was inevitable that Robert and Panini would meet during Robert's years as a student in Rome,[3] and later, Robert became a major collector of Panini's canvases.[4] Panini also drew highly finished watercolors, and works like his *Capriccio with the Forum, the Column of Marcus Aurelius, the Pantheon, and the Colosseum* (Musée du Louvre, Paris, fig. 1)[5] were of primary importance to Robert. One can clearly see Robert's indebtedness to the Italian artist in the interplay between transparent washes of color, the firmly drawn contours, and the manipulation of the liquid medium to suggest the dappled play of light over the worn surfaces of Rome's antiquities.

Despite the influence of Panini, Robert composed the Horvitz drawing with distinctive originality. The arc of the colonnade receding into space echoes the work's oval format, chosen by the artist to animate an otherwise static composition. His *Equestrian Statue of Hadrian,* in the Lehman Collection at the Metropolitan Museum of Art, New York (fig. 2),[6] is another contemporary oval watercolor. Denis Diderot, renowned critic and author of the *Encyclopédie,* expressed his century's fascination with these scenes of ruins most eloquently when he reviewed Robert's first submissions to the Salon of 1767: "The ideas aroused within me by ruins are lofty. Everything vanishes, everything perishes, everything passes away, the world alone remains, time alone continues. How old this world is! I walk between two eternities."[7] VC

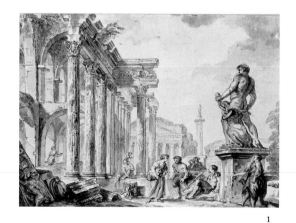

1

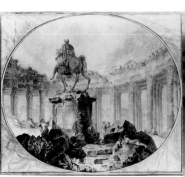

2

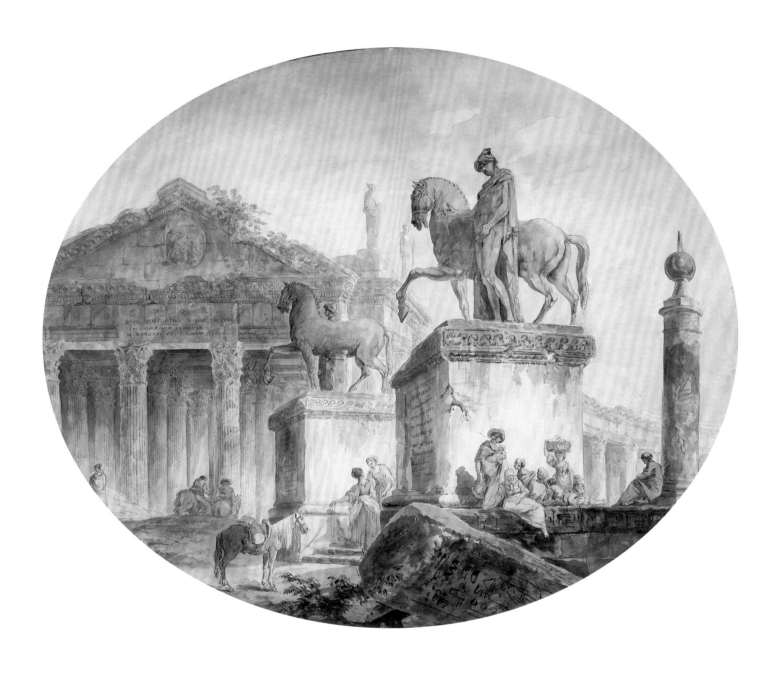

HUBERT ROBERT

Paris 1733–1808 Paris

91 *Steps Leading to S. Maria in Aracoeli, Rome*

Red chalk on cream antique laid paper

326 × 451 mm.

Watermark: None

Inscriptions: In red chalk, bottom right: *1762*

Provenance: Galerie Julius Böhler, Munich; Adolphe Stein, London; Galerie de Bayser, Paris; Private Collection; sale, Drouot, Paris, 20 October 1994, lot 90; Private Collection; Hazlitt, Gooden and Fox, Ltd., London; acquired in 1996 (D-F-358/ 1.1996.53)

Exhibitions: Munich 1982, no. 41; London 1986b, no. 57; Paris 1986, no. 26; Rome 1990, no. 106

Literature: Julius Böhler in Munich 1982, cat. no. 41; Adolphe Stein in London 1986, cat. no. 57; Bruno de Bayser in Paris 1986b, cat. no. 26 (n.p.); Cayeux 1985, under cat. no. 22, p. 128, fig. 30; Catherine Boulot and Jean-Pierre Cuzin in Rome 1990, cat. no. 106, pp. 163–64

During their student years in Italy, Robert and his compatriot, Jean-Honoré Fragonard, executed a large number of red chalk views of Rome and the surrounding countryside that rank among their finest achievements as draftsmen (see cat. 86). The warm tones of the natural red chalk, a commonplace material for artists, was ideally suited to convey the excitement of their responses to the Italian *campagna*. For some time, it had been part of the curriculum at the French Academy in Rome to make studies out-of-doors. This practice was encouraged by Charles-Joseph Natoire who was director of the institution when Robert and Fragonard were there together as students. But Natoire's own landscape drawings were overwhelmingly executed in watercolor on colored papers (see cat. 58), and no earlier precedents in French art can explain the type of drawing under consideration here. Evidently, Robert and Fragonard were among the first French artists to create important landscape drawings using red chalk, and certainly no subsequent artist working in this genre and medium ever surpassed their achievement. By 1760, each artist had found his own distinctive approach, on occasion drawing at the same location and, in all probability, at the same time.[1]

The exhibited drawing is a quite accurate view of the long flight of stairs leading up to the church of S. Maria in Aracoeli, to the left of the Campidoglio. Giovanni Battista Piranesi etched a panoramic view of this site with the steep flight of steps and the church seen here, which also includes the staircase leading up to the piazza of the Campidoglio with the two monumental statues of horse tamers known as the *Dioscuri* (fig. 1).[2] Variants of these statues are also seen in the Horvitz watercolor (cat. 90). In the sheet exhibited here, the only significant departure from actuality made by the artist is the introduction of the church cupola at the upper left, evidently added to give a sense of balance to the composition. Six other red chalk views of this site by Robert, such as the *Steps to the Campidoglio* (fig. 2), are in the museum at Valence.[3] All of these sheets are either dated or date-able to 1762, when it appears that Robert set about recording the sculpture and architecture of this site.[4]

None of Robert's drawings have the panoramic sweep of Piranesi's view but instead focus on some aspect of the architectural complex. In the Horvitz sheet, Robert created a surprisingly bold composition dominated by the upward sweep of the stairs leading to S. Maria in Aracoeli, flanked along their far side by modest buildings. In the foreground, the fountains of reclining lions spouting water into basins at the foot of the stairs and the vendor who has set up an impromptu shop underneath an awning add a note of anecdotal interest to this otherwise rather severe architectural view. Drawings such as this are the work of a painter, not a topographical artist, and they illustrate that by 1762, Robert had found a distinctive and mature style that he was never to surpass. VC

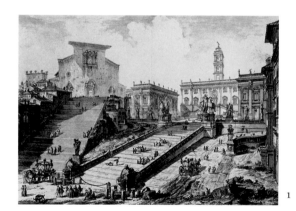

1

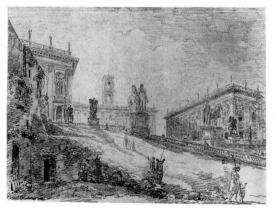

2

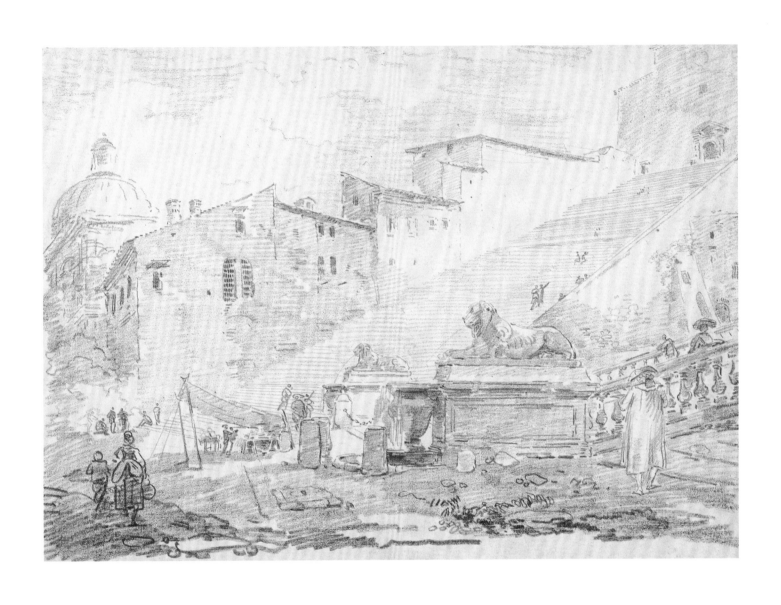

JACQUES GAMELIN

Carcassonne 1738–1803 Carcassonne

92 *Hector at the Palace of Paris*

Pen and black ink with brush and blue-green wash, heightened with white gouache, on prepared blue laid paper

345 × 494 mm.

Watermark: Laid down—none visible through mount

Inscriptions: In pen and black ink on recto of drawing, bottom right: *P. P. Prud'hon*; in pen and black ink on recto of mount, across bottom: *Hector montait au Palais que Paris avoit fait Batir, il le trouva qu'il preparait Ses armes; en le voyant il ne put retenir Sa Colere; helene etait assise au mileu de ses femmes, quelle employoit a des ouvrages d'une grande beauté . . . l'Iliade D'homer / Livre 6e*

Provenance: Heim Gallery, London (by 1975); Annamaria Edelstein, London (by 1984); acquired in 1985 (D-F-110/ 1.1993.56)

Exhibitions: London 1975, no. 35; London 1984, no. 15

Literature: Philip Conisbee in London 1975, cat. no. 35 (n.p.)

*A*n avid reader, Gamelin liked to use classical texts as the inspiration for many of his compositions, and he often cited his literary sources. These were usually Homer, Virgil, or the *Histoire ancienne* by Charles Rollin, whose work he greatly admired. We find examples of his readings in a letter of August 1784, in which he asked the chevalier de Fornier, a nobleman living near Narbonne, to lend him Suetonius's *Lives of the Twelve Caesars* and Lacombe's *Dictionnaire des Beaux-Arts*.[1]

As Gamelin informs us in the inscription on this drawing, the scene he depicted is taken from the sixth book of Homer's *Iliad* (6:321–69). The Trojan warrior Hector, angry over the delays that have kept his brother, Paris, away from the scene of battle, visits his house and urges him to finish his preparations quickly and to join the fight against the Achaeans who have surrounded their city. Upon entering, Hector finds his sister-in-law, Helen, amidst her maids and ladies-in-waiting, engaged in household tasks.

Gamelin's penchant for historical subjects often led to his choice of unusual themes like this one, for which the standard iconographic references cite only four previous examples, ones that Gamelin had probably never seen.[2] However, he might have recalled two other works: Michel-Ange Challe had displayed a painting on a similar subject at the Salon of 1765; and it is also possible that Gamelin knew the series of seven Beauvais tapestries depicting Homeric themes, one of which was devoted to Hector and Paris; his teacher, Jean-Baptiste Deshays, had painted cartoons for the tapestries prior to 1761.[3] The most striking aspect of the exhibited composition is its fidelity to Homer's text. Unlike any earlier depictions of this rarely illustrated moment in the famous drama, Gamelin oddly relegated the dispute between the two brothers to the left edge of the composition, where Paris sharpens his bow (6:322), and gave visual precedence to the gentle charm of Helen's life in the *gynaeceum*.

The exhibited drawing had a pendant in the same format, *The Grief of Achilles after the Death of Patroclus*, which paralleled its composition through a series of inverse symmetries (fig. 1).[4] For example, where the seated figure of Helen relaxes in the center of the drawing shown here, the collapsed Achilles in the pendant is in a state of extreme agitation. The frenzy and grief of this male-dominated camp scene contrasts with the calm and domestic bliss of the predominately female realm depicted in the interior of Paris's palace.

The Horvitz drawing exhibits the traits that Philip Conisbee singled out as "very typical of Gamelin's idiosyncratic style—quirky, expressionistic, with rather stocky figures, a bold technique, and a piercing light that accentuates the main characters and events."[5] It probably dates from the mid-1780s, when the painter, having settled in Narbonne and obtained important, but unprofitable ecclesiastical commissions, turned to drawing and painting a great number of small works to ensure himself a supplemental income from a clientele of moderately wealthy *amateurs*. But his style does not yet give the impression of sketchiness, an effect that he would use in the 1790s for a number of small, round drawings on classical themes.[6] OM

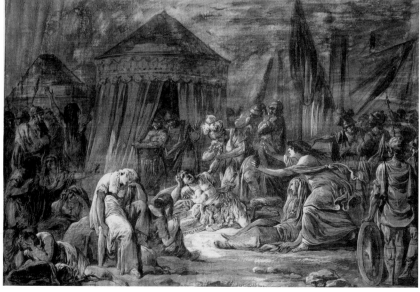

1

296

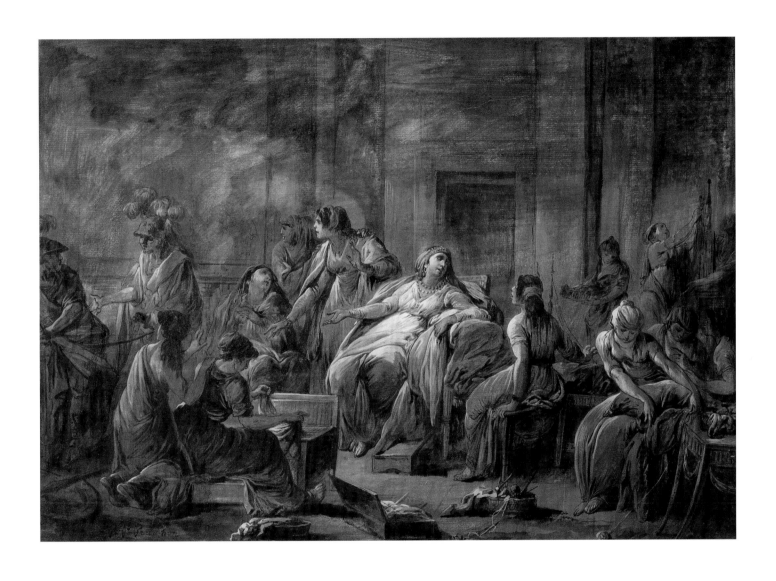

JOSEPH-BENOÎT SUVÉE

Bruges (Belgium) 1743–1807 Rome (Italy)

93 *Interior of the Colosseum*

Red chalk on four joined pieces of off-white laid paper

624 × 494 mm.

Watermark: Laid down—none visible through mount

Inscriptions: None

Provenance: Private Collection, Paris; Jacques Petithory, Paris (without his mark); Galerie Brame et Lorenceau, Paris (in 1983); Didier Aaron et Cie, Paris; acquired in 1995 (D-F-350/ 1.1996.19)

Exhibitions: None

Literature: Unpublished

*T*his previously unpublished sheet is one of Suvée's most important and beautifully drawn landscapes from his tenure as an artist-in-residence at the French Academy in Rome (1772–76). During his stay, which he extended until 1778 in order to complete commissions from the comte d'Orsay and a few other connoisseurs, he produced some of the finest landscape drawings of his age.[1] Suvée's accomplishment in this genre was so splendid that his only contemporary rivals were François-André Vincent (cats. 98–99), the now-almost-forgotten Jean-Simon Barthélemy Le Bouteux, and Pierre-Charles Jombert.[2] This generation of artists succeeded that of Jean-Honoré Fragonard (cats. 86–89) and Hubert Robert (cats. 90–91), and they adopted from their esteemed predecessors the custom of using red chalk for drawing landscapes.

Although this composition is executed in red chalk, when Joseph-Marie Vien (cat. 74) succeeded Charles-Joseph Natoire (cats. 55–58) in 1774 as director of the French Academy in Rome, it henceforth became the practice to draw landscapes with black chalk; Vien urged his students to revive this black chalk technique, which he and other members of his generation—the first French followers of Piranesi—had employed so effectively. Soon after his arrival, the innovative Charles Michel-Ange Challe, an artist-in-residence at the French Academy in Rome from 1742 to 1749, initiated the use of black chalk highlighted with white chalk on blue or gray paper to draw the Roman ruins that are so frequently associated with

his name. This technique accentuated contrasts of light and enabled artists, when sketching ruins, to render more effectively the succession of planes punctuated by shadows and the play of exterior light coming through the remaining archways and collapsed vaults.[3]

Suvée made many drawings of the Colosseum in both red and black chalk. These include one drawn in red chalk in the Musée des Beaux-Arts, Rouen (fig. 1),[4] and one primarily executed in black chalk in the Polakovits Collection at the Ecole nationale supérieure des Beaux-Arts, Paris (fig. 2).[5] In the Horvitz drawing, Suvée has used red chalk, and thus this sheet, like the one in Rouen, probably dates from 1774 or earlier. Attentive to the imposing monumentality of the Colosseum, he subtly expressed the feeling that it inspired in the sensibilities of the latter half of the eighteenth century by attempting to describe the texture of the stone, the play of the light, the surrounding vegetation, and the precise archaeological condition of the famous structure. He inserted the figures on the right to give a sense of scale and clothed them in Greco-Roman style to enhance the "antique" effect.

JFM

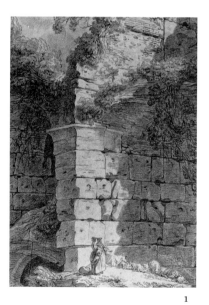

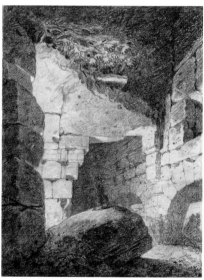

1

2

298

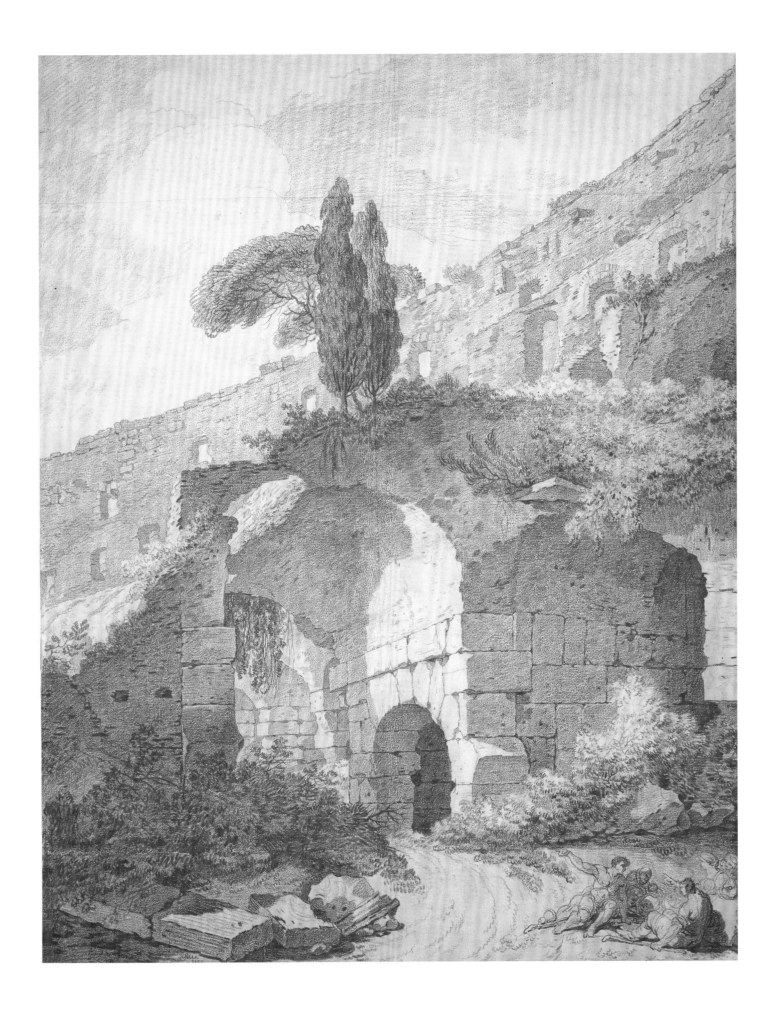

JOSEPH-BENOÎT SUVÉE

Bruges (Belgium) 1743–1807 Rome (Italy)

94 *Virgin and Child*

Black chalk, extensively stumped and heightened with white chalk, on tan laid paper

475 × 368 mm.

Watermark: Laid down—none visible through mount

Inscriptions: In black chalk, on old detached mount, bottom left: *Suvée inve. et pinx. 1798*; in black chalk, on old detached mount, across bottom: *J. B. SUVEE AU SOUVENIR RESPECTEUX DE G. DE PELICHY*

Provenance: Sale, Drouot, Paris, 27 November 1990, lot 147; W. M. Brady and Co., New York; acquired in 1994 (D-F-271/ 1.1994.6)

Exhibitions: None

Literature: Unpublished

*T*he technical rigor of this touching image is surprising. At first sight, this drawing does not appear to accord with the art that Suvée developed and produced throughout most of his career (see cat. 93). However, it is linked to specific intentions and circumstances.

In 1792, after a long and distinguished career during which Suvée demonstrated that he was a painter of the first rank, he was named director of the French Academy in Rome. This prestigious post was the culmination of his many important and successfully completed commissions—royal, private, and ecclesiastic (he was the last major religious painter of the eighteenth century)—and fitting recognition of his role as the master of a widely respected atelier that attracted a great many students. Although named to the post in 1792, Suvée was a victim of the upheavals of the Revolution, especially the vengeance of Jacques-Louis David (cat. 100), who never forgave Suvée for besting him when they had both participated in the Prix de Rome Competition of 1771. Rather than see the French Academy in Rome directed by his old rival, David instigated political measures that led to the suppression of the school. It was eventually reopened, and Suvée was finally able to take up his post in 1801. At that time, he initiated the purchase of the Villa Medici and moved the honored institution from the Palazzo Mancini into its new quarters, where it remains to this day.

Before leaving for Italy to assume the directorship, Suvée decided to draw copies of compositions that he had previously painted in order to present them as gifts to his dearest and most faithful friends. The drawing shown here is an excellent example of these works. Suvée dedicated it to one of his oldest friends, Gertrude de Pelichy (1743–1825), the daughter of an aristocratic family from Bruges, Suvée's birthplace. Pelichy was initially his fellow student in the Parisian atelier of the painter Jean-Jacques Bachelier, and later she became Suvée's student and collaborator. The Horvitz *Nativity* that Suvée dedicated to her reproduces a lost canvas originally painted for the maréchale de Noailles and displayed at the Salon of 1785. This Virgin presenting the Christ Child to God the Father reveals the great simplicity the artist sought in his compositions, the pains he took in rendering the draperies of his figures, and the purity and intensity of his religious feeling. Like his *Allegory of Temperance* in the Musée Fabre, Montpellier (fig. 1),[1] which was dedicated to the painter Joseph-Marie Vien (cat. 74), it demonstrates the way in which Suvée typically idealized young female faces. Often, in his multifigure compositions, he skillfully contrasted them with realistically detailed male faces.

So far, a number of Suvée's late gift drawings have been discovered. In addition to the exhibited sheet, another one is now in an American collection: Suvée's *Dibutade,* or *The Discovery of Drawing,* which was dedicated by the artist to the painter Gerard van Spaendonck, is now in the J. Paul Getty Museum, Los Angeles (fig. 2).[2] It is a copy of what is today his most famous painting in the Groeningemuseum, Bruges, which he displayed at the Salon of 1791. JFM

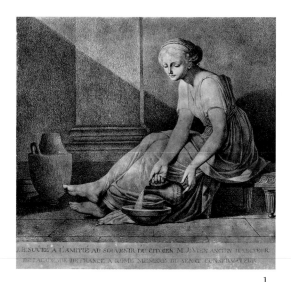

1

2

NICOLAS LE JEUNE

Active c. 1765–1804

95 *The Feast of Absalom*

Pen and black ink and brush with colored gouaches on heavy tan laid paper

710 × 865 mm.

Watermark: Laid down—none visible through mount

Inscriptions: In pen and black ink across mount, bottom: *PRIMO PREMIO. IL SIGNORE N.LO LE JEUNE, PARIGINO. 1771. IN ROMA.*

Provenance: Galerie Didier Aaron et Cie, Paris; acquired in 1996 (D-F-410/ 1.1996.67)

Exhibitions: Paris et al. 1992, no. 14

Literature: Jill Dienst, Michael Hall, Isabelle Mayer, and Alan Salz in Paris et al. 1992, cat. no. 14 (n.p.)

*T*his large, dramatic, and highly finished drawing depicts one of the most tragic episodes in the lives of the children of King David of Israel, as recounted in the second Book of Samuel (13:11–29). Amnon had raped his half-sister, the virgin Tamar, but the king refused to punish him. Taking retribution for his sister into his own hands during a sheep-shearing feast on his estate in Baal-Hazor where all of the king's sons were present, Absalom ordered his men to kill his half-brother, Amnon. As the dramatic expressions and impassioned gestures in the exhibited work suggest, the assembled brothers and their entourages were stunned by the murder, and many fled from the estate. Absalom hid in the neighboring land of Geshur for three years before he was eventually reunited with his father.

Le Jeune placed his violent scene in the middle of a vast, columned hall with an elaborately carved ceiling, all of which he described with a cool blue gouache. In the background, the cavernous room opens to glimpses of a landscape in the distance, with a few details highlighted in white gouache. On the right, a large canopy hangs high above one end of the table of David's sons, appropriate to their rank. Underneath it, one can see the care with which the household's plate has been arranged on open shelves for the feast. At the far right, behind this display, and thus unaware of the violence in the main part of the room, guests continue to converse. In the center of the composition, behind an immense round table with food and utensils in disarray, Absalom directs three of his men to continue stabbing Amnon, who has fallen to the floor on the right with the force of their thrusting knives. In order to dramatize the event, Le Jeune indicated a strong light emanating from the left and bathed most of the central middleground in white gouache, which is incrementally graduated from a cool bluish-white for Absalom in the distant middleground to a warm yellowish-white for Amnon toward the foreground. Only the main participants in the drama share this white zone (Absalom; Amnon; and, on the left, a seated, bearded figure who is probably Jonadab, the son of David's brother, who later informs the king about the sad event). Even the three murderers are rendered either in various levels of shadow or in colors corresponding to their placement. In the left foreground, which Le Jeune darkened to a warm yellow, three figures flee the scene around a column.

At the bottom of the original mount, the exhibited work is inscribed: *PRIMO PREMIO*. Despite this indication, it was actually Le Jeune's slightly smaller version of the same subject that won second prize (or *secondo premio*) in the senior class (or *prima classe*) at the Concorso Clementino of the Roman Accademia di San Luca in 1771; the Accademia assigned the theme and kept Le Jeune's second-prize winning sheet (fig. 1).[1] No first prize was awarded that year, and Marcello Leopardi di Potenza won the third prize (fig. 2).[2] The drawing shown here must be a revised enlargement of the first, more rectangular design, which has a lower ceiling and more detail on the left side. The fleeing woman with her arm wrapped around a column in the Horvitz variant was depicted in the left foreground of the Accademia di San Luca version walking toward the center of the composition, supporting a large silver wine vessel with her left arm, while with her right hand attempting to slow the pace of the pair of figures running toward her. Although Le Jeune used intense coloration in both works, he gave the colors in the Horvitz sheet more nuance and

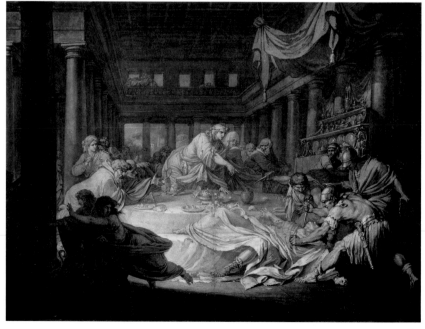

1

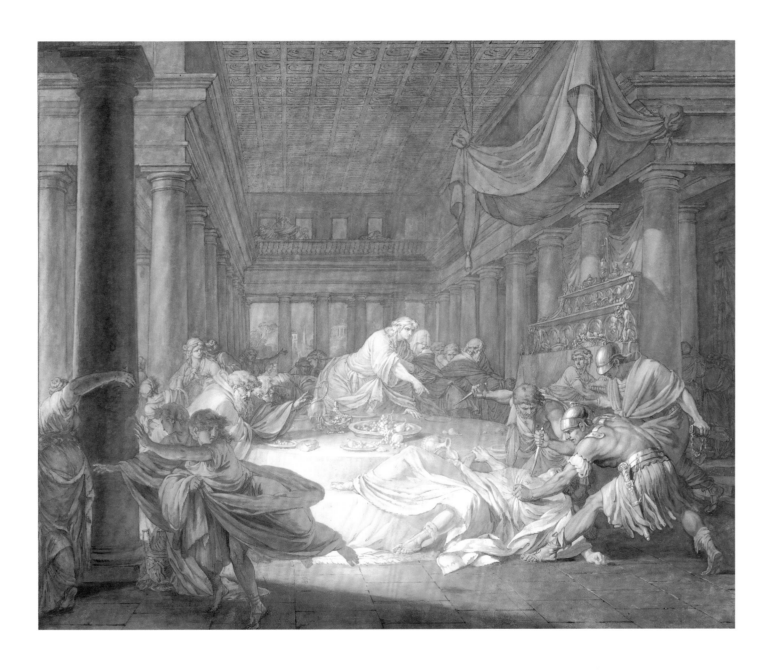

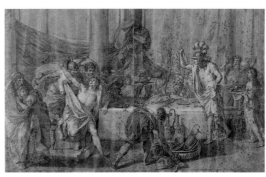

2

elaboration; he also rendered the draperies in the lat-ter with more volume and movement. For example, in the Accademia di San Luca version, the canopy hang-ing over the table is almost linear, and the slashed leather skirt of the soldier closest to the viewer hangs perfectly straight and motionless. In the exhibited version, we feel the weight of the canopy's drape, and the individual pieces of the soldier's slashed skirt rip-ple with motion.

Although it is astonishing that Leopardi won any prize at all, perhaps we should not be surprised to learn that Le Jeune's entry was not deemed worthy of first prize. While Le Jeune's original sheet is re-spectably designed and well colored, and he clearly delighted in manipulating the smooth textures of the gouache, his perspective grid on the ceiling and floor is a bit too pronounced, some of his figures are inap-propriately scaled within his own perspective sys-

3

tem—if Absalom stood erect he would reach the bal-cony—and many of his figures are somewhat awk-ward, with disproportionately small heads. A number of these faults remain in the exhibited drawing, but Le Jeune has amended many figural and composi-tional details, and his handling of the color and the sumptuous media has become even more fluid and subtle.

Le Jeune's theatrical interpretation of this rarely depicted biblical episode was undoubtedly influenced by the design and strong chiaroscuro of two dis-tinguished predecessors whose work he must have known: Gaspare Traversi's altarpiece in S. Paolo fuori le Mura in Rome, *in situ;*[3] and, most notably, Mattia Preti's canvas originally in the collection of the duke of San Severino in Naples (fig. 3):[4] a trip to Naples was considered obligatory for French artists traveling in Italy in the second half of the eighteenth century. The Preti canvas is now in the Museo di Capodimonte, Naples. Some of the ferocity of the attack on Amnon may have been inspired by Traversi's work, but the architectural background, the display of silver plate, the half-elevated figure of Absalom with the finger pointing from a delicate hand, and the very particular way in which the body of the dying Amnon falls back-wards, exposing the straining muscles of his neck and chest, all point to Preti's example.

Le Jeune had been a student at the Académie and later worked with Louis-Jean-François Lagrenée, called Lagrenée l'aîné. Indeed, Le Jeune's firm con-tours and volumetric draperies reflect those of his mentor. Sadly, these two versions of the *Feast of Absa-lom* are his only surviving drawings. We know of his presence in Rome because of a number of small etch-ings that he signed and dated *Rome 1771*. As Prosper de Baudicour has noted, these very rare prints also dis-play the artist's fluid draftsmanship.[5] Based on his description of one of these etchings, we can surmise that the Horvitz drawing was reproduced, but efforts to locate a surviving impression have not been suc-cessful. Le Jeune exhibited at the Salon from 1793 to 1804, and in 1793 he was listed as *peintre de l'Académie de Berlin,* suggesting that he had relocated to Ger-many.[6] Unfortunately, no trace of his presence has been identified in the former capital of the Prussian kingdom.[7] ALC

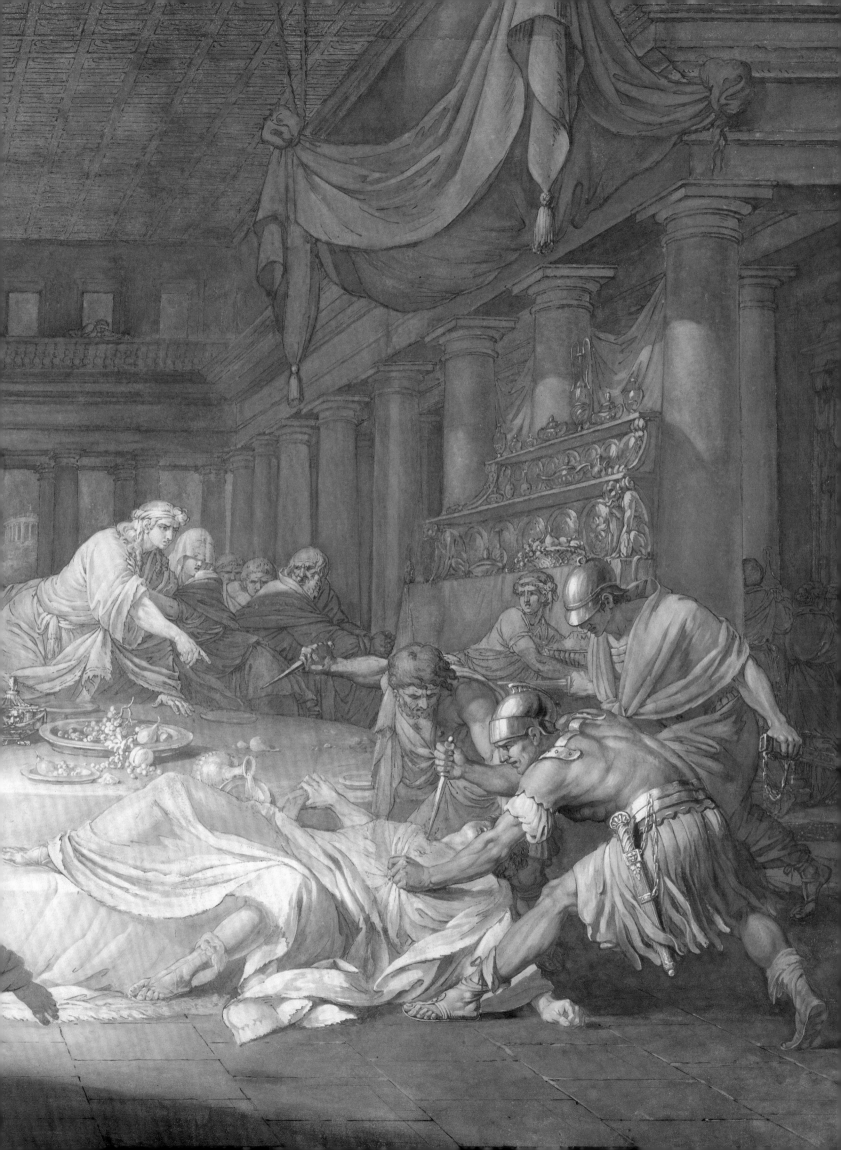

JEAN-FRANÇOIS-PIERRE PEYRON

Aix-en-Provence 1744–1814 Paris

96 Seated Male Nude

Black chalk on off-white laid paper

365 × 530 mm.

Watermark: Encircled fleur-de-lys (similar to Heawood 1592)

Inscriptions: In pen and black ink, lower left: *Peyron f. a Rome 1780*

Provenance: Private Collection, Germany; W. M. Brady and Co., New York; acquired in 1993 (D-F-233/ 1.1993.107)

Exhibitions: New York 1989, no. 12

Literature: Mark Brady in New York 1989, cat. no. 12 (n.p.); Rosenberg, forthcoming

*A*s this powerful *Seated Male Nude* demonstrates, Peyron was one of the most audacious talents of the first generation of Neoclassical artists. Although David (cat. 100), like Poussin (cat. 8), was a slow starter whose skills gradually grew to match the force of his vision, the brilliance and versatility of Peyron's talent as a draftsman were evident much earlier in his career. He won the Prix de Rome in 1773 while David unofficially placed second for the second time; Peyron then spent seven years as an artist-in-residence at the French Academy in Rome (1775–82).[1]

Discovered only a decade ago, this drawing remains Peyron's only known *académie*.[2] Based on the inscription, it was executed during his stay in Rome. The muscular figure was undoubtedly posed with strong, directed light coming from above and from the right.[3] Peyron outlined the figure with his typically fine and precise contours and then gently stumped those places where light did not reflect off the skin's surface. His characteristic economy of means enabled him to use the white of the sheet to render those areas where the light was most effulgent, resulting in a radiant contrast of lights and darks that described, in very sculptural terms, the flickering pattern of flesh rippled over bone and muscle throughout the figure. Peyron lightly reinforced the stumping with an open pattern of hatched lines to suggest the various directions in which the skin of the figure was being pulled; he also shaded the background with a combination of loose and tight hatching and crosshatching that followed the direction of the light and placed the figure in an even more pronounced relief. Finally, his unexpected addition of windblown hair heightened the implication of movement in the model, who already appeared as if he were about to rise up off the page. A small notebook sketch of an antique statue in the Museo Pio-Clementino in Rome, *Cincinnatus* or *Her-*

mes Fastening His Sandal, also dates from Peyron's Roman period (Bibliothèque nationale de France, Paris, fig. 1).[4] The only other known nude study by the artist, it reveals a similar system of hatching strokes and gives some indication of how the figure in the exhibited sheet appeared before being stumped to a careful finish.

Peyron seems to have recalled the pose of the figure in the Horvitz *académie* when he made his drawing for *Rhadamisthe and Zénobie* (fig. 2),[5] one of his illustrations to the *Oeuvres de Crébillon* (Works of Crébillon) of 1797. Except for the obvious differences of the hair and the uncrossed legs, the figure of the young male being propped up on a bier that stretches across the foreground of the composition is strikingly similar to the pose of the male nude in the exhibited sheet.

François-André Vincent's *Seated Male Nude* of 1772 (Ecole nationale supérieure des Beaux-Arts, Paris, fig. 3),[6] drawn with a blend of red and black chalk, is one of the few extant *académies* by one of Peyron's contemporaries that was executed relatively early in the artist's career and reveals a comparable level of mastery. Like Peyron, Vincent (cats. 98–99) proved himself to be a talented draftsman from the outset. Both sheets also demonstrate the gradual shift from red chalk—the preferred medium for this essential academic exercise in the first half of the century (see Boucher, cat. 60)—to either a mixture of red and black chalk or black chalk alone. ALC

3

2

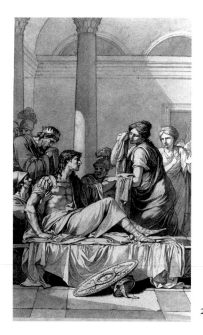

1

JEAN-FRANÇOIS-PIERRE PEYRON

Aix-en-Provence 1744–1814 Paris

97 *Minerva Debating with Father Time Concerning the Placement of the Portraits of Famous Artists in Her Temple*

Pen with brown and black ink and brush with brown wash over black chalk, heightened with white gouache, on tan laid paper

688 × 484 mm.

Watermark: Laid down—none visible through mount

Inscriptions: In pen and black ink in architectural moulding in image, top right: *AUX ARTISTES CELEB*; in pen and black ink on oval portraits of artists in the image, from top to bottom: *TITIEN, ANTOINE COREGE, JULE ROMAIN, VERONESE, CARACHE*; in pen and black ink at bottom left: *P. Peyron f. 1790*; in pen and brown ink across mount, bottom: *le tems et Minerve deliberent sur la place que doivent occuper les artistes celebres dans le temple de minerve*

Provenance: Private Collection; Galerie Emmanuel Moatti, Paris; acquired in 1994 (D-F-233/ 1.1995.15)

Exhibitions: Salon of 1791 (also called Salon de la Liberté), no. 118 in the Académie's official list (where the dimensions given reflect the drawing with its original mount and frame), and no. 473 in the additional list published as the Salon de la Liberté (where no dimensions were given); New York 1994b, no. 23

Literature: Collection Deloynes, vol. 18, cat. nos. 436 439; Bellier and Auvray 1885, vol. 2, p. 259; Rosenberg and van de Sandt 1983, cat. no. 140D (as lost), pp. 133–35; Paris 1989e, vol. 3, under cat. no. 1089, p. 867; Emmanuel Moatti in New York 1994b, cat. no. 23 (n.p.); Heim— Béraud—Heim 1989, p. 308; Rosenberg, forthcoming

*A*large-winged Father Time stands beside a bust of Raphael in front of the columned entrance to the impressive hall that Minerva, goddess of wisdom and protectress of the arts, has dedicated to the memory of famous artists in her temple. He holds a portrait medallion of Correggio with the aid of two putti and points to the hall behind him as he discusses which masters should be represented with the goddess, who is seated before him. Minerva, assisted by a standing putto, holds a portrait medallion of Titian, to which she also points. Beneath and in front of her, portrait medallions of Giulio Romano, Veronese, and Annibale Carracci are strewn across the foreground. Michelangelo, frequently considered in French art criticism since the seventeenth century to be inferior to Raphael as a painter, is conspicuously absent.[1]

Discovered only five years ago, this large and elegant allegorical drawing was exhibited at the Salon of 1791. In 1796, a reduced and slightly modified version of the composition served as the frontispiece to the third volume of Jean-Baptiste-Pierre Lebrun's *Galerie des Peintres flamands, hollandais, et allemands,* where it was inscribed *Allégorie à la Gloire des peintres de Genre* and the portrait medallions depicted famous

Dutch artists (fig. 1).[2] After winning second prize at the Concours de l'an III, which awarded the artist with a sum that enabled him to execute a painting of his choice, Peyron transferred a variation of this design onto a large canvas exhibited at the Salon of 1799 (Ministère de la Défense, Paris, fig. 2).[3]

Allegories are relatively rare in Peyron's oeuvre. Here, in an inscription across the bottom of the original mount, we are given the artist's precise subject. The only other allegorical composition of similar significance is his *Study Clarifies and Instructs Emulation* of 1800, which was commissioned to decorate the Salle des Antonins in the Louvre's Département des Antiquités Grecques et Romains *(in situ)* along with paintings by Prud'hon (cats. 101–4), Guillaume Guillon Lethière, and Philippe-Auguste Hennequin.[4]

Perhaps more satisfying than either of the two known later versions, the exhibited drawing manifests many of the hallmarks of Peyron's maturity, such as the classical austerity of the composition with its scrupulously manipulated perspective, the carefully wrought architectural details, the firm treatment of contours, and the weighty, solid approach to volumes. At the same time, it recalls the graceful *mise-en-page* and overall refinement of the three large finished sheets in the Hessisches Landesmuseum, Darmstadt (fig. 3); the Graphische Sammlung Albertina, Vienna; and the Musée des Beaux-Arts, Nancy; all three sheets are related to his *Hagar and the Angel* of 1779.[5] Although Peyron produced the Nancy drawing twelve years earlier than the Horvitz sheet, one sees the same large wings, gentle gestures, tender expressions of concern, and an analogous treatment of coloristic effects such as the luminous heightening used to accentuate the folds of the elegant draperies. ALC

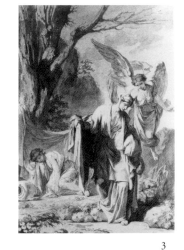

3

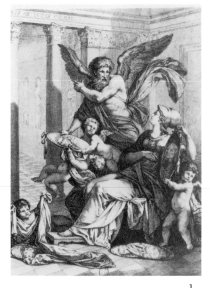

1

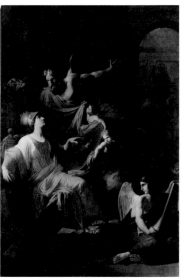

2

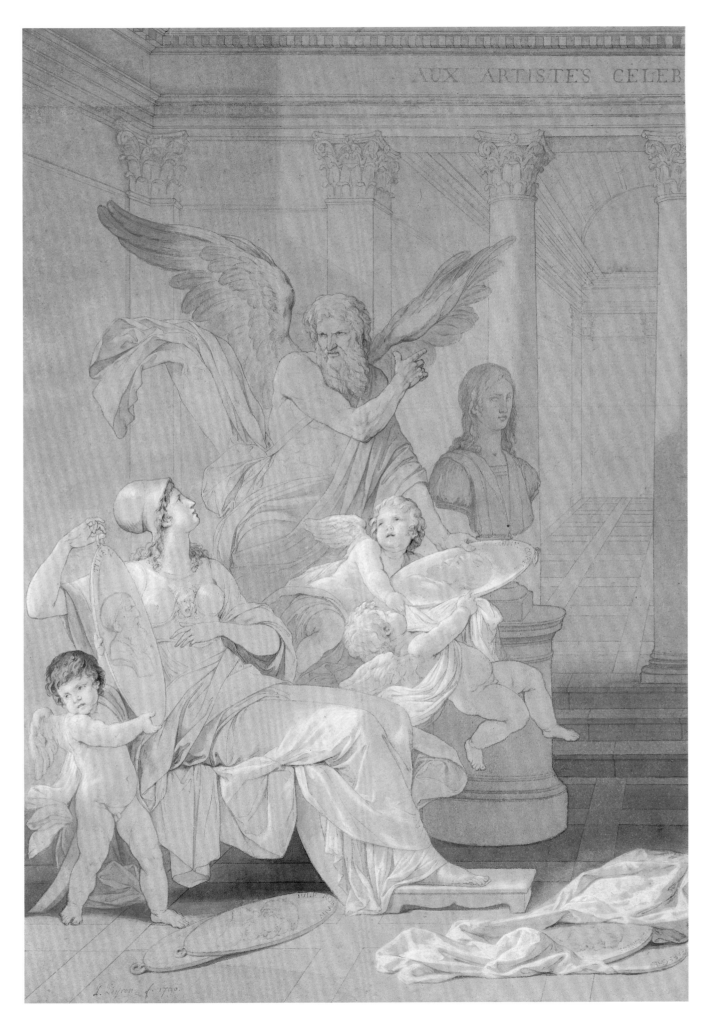

FRANÇOIS-ANDRÉ VINCENT

Paris 1746–1816 Paris

98 *Head of a Young Girl*

Black and red chalk heightened with white chalk on tan laid paper

390 × 310 mm.

Watermark: None

Inscriptions: None

Provenance: Private Collection; Galerie Emmanuel Moatti, Paris; acquired in 1995 (D-F-292/ 1.1995.16)

Exhibitions: None

Literature: Unpublished

*V*incent's abundant corpus of drawings, including ten in the Horvitz Collection, reveals that he was one of the most talented and prolific draftsmen of his generation. His elegant landscapes (MRM ess., fig. 31), amusing caricatures, and rigorous copies after Raphael and the antique executed during his residence at the French Academy in Rome from 1771 to 1775 (MRC ess., fig. 31);[1] his chalk studies and his ink and wash drawings in the manner of Fragonard produced just before and after his return to France (c. 1774–78);[2] his experiments with intense chiaroscuro in sheets elaborately heightened with white gouache beginning in the early 1780s (cat. 99); and the severe, linear manner seen in his mature compositions beginning in the late 1780s prove that he was one of the most multifaceted artists active in the last quarter of the eighteenth century.[3]

This charming *trois-crayons* study of the head of a young girl cannot be connected with any of Vincent's known paintings,[4] but its media and manner of execution resemble those found in the many head studies he produced in the late 1770s and early 1780s, like his *Head of a Young Woman in Profile* of 1780 in the Musée du Louvre, Paris (fig. 1).[5] The extensive stumping found in his *Presumed Portrait of Mademoiselle Capet* of c. 1790 in the Musée du Petit Palais, Paris,[6] precludes a late date for the sheet shown here. In fact, in the exhibited drawing, the less subtle blending of the three chalks, the individual treatment of each thick strand of hair that protrudes from the girl's turban in blocky clumps, and the careful rendering of the drapery folds across her chest and shoulders suggest a date even earlier than the Louvre work. Vincent probably produced this *Head of a Young Girl* sometime between the late 1760s and the early 1770s, that is, toward the end of his period in Vien's atelier

(1765–68), during his attendance at the Ecole royale des Elèves Protégés after winning the Prix de Rome in 1768 (1769–71), or just after his arrival in Rome (1771–72), when many aspects of his work continued to reflect the influence of Vien (cat. 74).[7] The small nose; thin, delicate lips; and gently rounded chin of this young girl certainly resemble the features seen in Vien's innumerable depictions of young ladies as allegories or as vestal virgins. In addition, Vincent executed this drawing with the tighter draftsmanship evident in his early copy after Raphael.

Despite the fact that the vast majority of surviving head studies by Vien date from c. 1780 onward, we know that Vincent began making them early in his career at the Académie. Indeed, in 1768, the year he won the Prix de Rome, he also won the prestigious Prix de l'Etude des Têtes et de l'Expression (or Competition in Head Studies and Expression). The enchanting Horvitz drawing, which demonstrates Vincent's knowledge of Charles Le Brun's fundamental treatise on expression (see the engraving of *Fear* by Bernard Picart after Le Brun, cat. 78, fig. 2),[8] undoubtedly reflects these early efforts. ALC

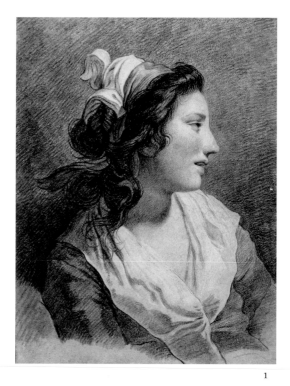

1

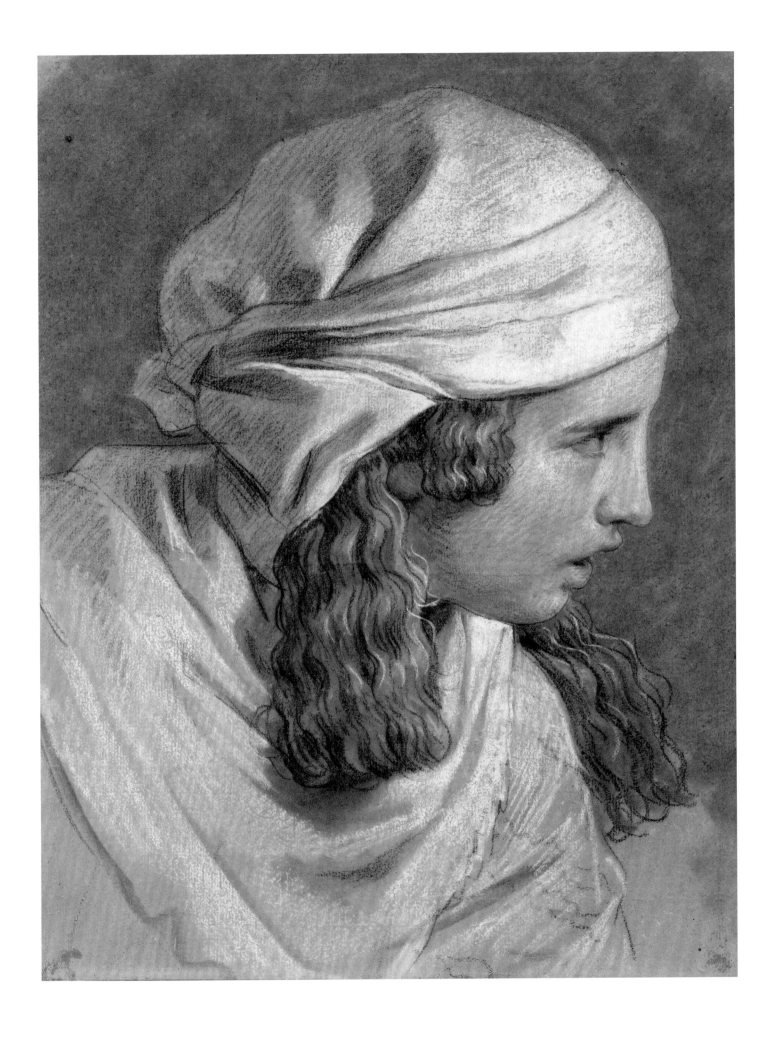

FRANÇOIS-ANDRÉ VINCENT

Paris 1746–1816 Paris

99 *Arria and Paetus*

Pen and dark brown ink with brush and gray wash, heightened with white gouache, over traces of red chalk on brown laid paper

530 × 426 mm.

Watermark: Laid down—none visible through mount

Inscriptions: In pen and brown ink on recto, bottom left: *Vincent F. 1784*; in graphite on verso of mount, bottom right: illegible / *no. 4*

Provenance: Private Collection, Paris; sale, Drouot, Paris, 13 March 1995, lot 233; acquired at the sale (D-F-297/ 1.1995.91)

Exhibitions: None

Literature: Cuzin 1988, cat. no. 41

*I*n this poignant drawing, Vincent depicted one of the lamentable results of a failed revolt against the Roman emperor Claudius led by Scribonianus at Illyricum, on the eastern coast of the Adriatic Sea. The story was first recounted in the *Letters* of the first-century Roman administrator, Gaius Plinius Caecilius Secundus, or Pliny the Younger. In a letter to his friend, Maecilius Nepos,[1] he states that after the defeat and capture of Scribonianus's followers, they were slated for execution. One of the captives was the senator Caecina Paetus, whose loyal wife, Arria, followed him on the journey back to Rome. In a memorable act of devotion and courage aimed at sustaining the resolve and inciting the bravery of her spouse, when she could not persuade the emperor to spare him, she twice attempted suicide. The first time, she was restrained by her son-in-law, so she simply banged her head against the nearest wall as hard as she could. On the second occasion, she plunged a dagger into her breast, pulled it out, handed it to her husband, and spoke her final words: "Paete, non dolet" (It doesn't hurt, Paetus). Vincent focused on the moment of her second selfless deed, which Pliny and later authors such as the second-century Roman historian, Cassius Dio, referred to as heroic and almost divine.[2] Vincent portrays a dim, vaulted cell, in which a single source of light centers on three figures whom he has elaborately heightened with white gouache. The tragic Arria, supported by a maidservant, pulls the knife from her body and attempts to hand it to her husband who, overcome with emotion, rushes to embrace his dying wife.

The exhibited drawing relates to Vincent's painting of the same subject in the Musée des Beaux-Arts, Amiens (fig. 1), one of two canvases on this theme that he exhibited at the Salon of 1785.[3] Two preparatory drawings in a private Paris collection relate to the two paintings. The first is a sheet of brush and wash sketches for the Amiens version that reveals the various ways in which Vincent considered grouping the figures before executing the exhibited drawing (fig. 2, detail).[4] The second study is a more finished and linear drawing for a second canvas (now lost) where Vincent treated the theme in a horizontal format; this second work depicted Arria pointing to the wound that developed from striking her head against the wall (fig. 3).[5]

During the two decades following his reception into the Académie in 1781, Vincent exhibited frequently at the Salon, often displaying large groups of his paintings and drawings in varying styles, which earned him a great reputation as a genius of invention and a master of several manners. He produced the drawing that shows the design for the lost, horizontal *Arria and Paetus* in what Régis Michel has aptly referred to as the "severe antique style."[6] Vincent would execute a number of other contemporary sheets that are equally remarkable for their restraint and linear control.[7] Although he did not always limit himself to the stern classicism of this mode, the exacting precision of his line underlies the strength of the more lyrical draftsmanship evident in the Horvitz version (which preceded the Amiens canvas), where he obviously enjoyed embellishing his depiction of the densely highlighted draperies in motion. *The Painter Apelles* of 1815 in the Fogg Art Museum, Cambridge (fig. 4),[8] provides another example of his use of white gouache against a dark background and demonstrates how the versatile Vincent could use this medium to reinforce the rigor of a more classicizing composition. ALC

4

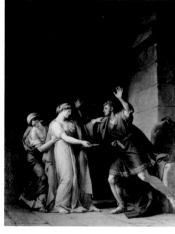

2

1

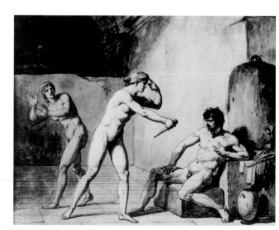

3

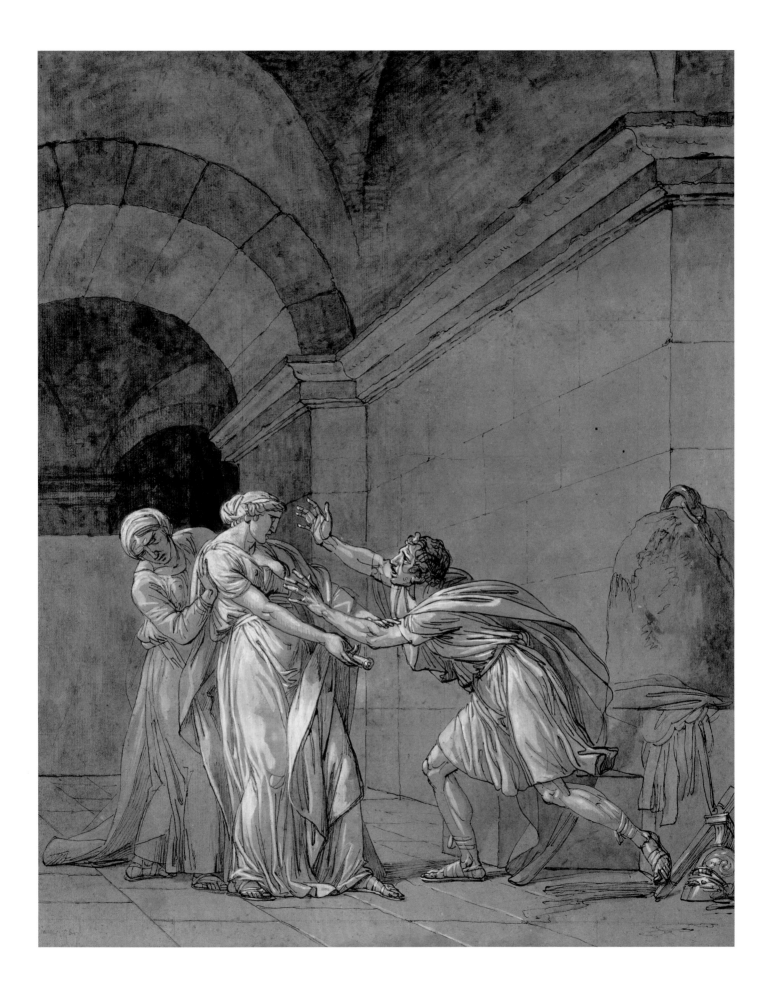

313

JACQUES-LOUIS DAVID

Paris 1748–1825 Brussels (Belgium)

100 *The Ghost of Lucius Septimius Severus Appearing after Caracalla's Murder of His Brother Geta*

Pen and brown ink with brush and blue-gray wash on tan wove paper

316 × 446 mm.

Watermark: None

Inscriptions: In pen and dark brown ink, bottom left: *David f./ 1783*

Provenance: Unidentified collector's mark at lower left; Anne-Louis Girodet de Roucy-Trioson, Paris; his sale, Paris, 11 April 1825, lot 48; L-J-A. Coutan, Paris; his sale, Paris, 9–10 March 1829, lot 93; A. Dumont, Paris; his sale, Paris, 13 February 1854, lot 120; T. Dumesnil, Paris (by 1884); Private Collection; Nicolas Joly at Galerie Yves Mikaeloff, Paris; acquired in 1996 (D-F-471/ 1.1997.10)

Exhibitions: Paris 1884, no. 155

Literature: David 1880, p. 653; Arlette Sérullaz in Paris and Versailles 1989, under cat. no. 46, p. 128

*L*ost for more than a century, this drawing is related to *Caracalla Murdering Geta in His Mother's Arms,* which was recently acquired by the Musée du Louvre, Paris (fig. 1).[1] In both cases, David's theme was inspired by Cassius Dio's *History of Rome,* which relates the episodes that bloodied the last years of the reign and family of the late Roman emperor Lucius Septimius Severus at the beginning of the third century.[2] P. Septimius Geta and Marcus Aurelius Antoninus Bassianus—who was known as "Caracalla" because he was fond of wearing a cloak of that name from Gaul—were the two sons of the emperor. Both of them were designated as successors to the throne, but since they each wanted sole power, a confrontation was inevitable. To achieve his ends, Caracalla murdered Geta in the arms of their mother, Julia Domna, and assassinated all of his other adversaries. He himself was killed in Syria in 217 by a rebellious officer. Upon hearing of the death of her second son, Julia Domna committed suicide.

After five years as an artist-in-residence at the French Academy in Rome (1775–80), David returned to Paris and was received into the Académie in 1783 upon the presentation of his *Grief of Andromache* (Ecole nationale supérieure des Beaux-Arts, Paris). Several of his drawings from the early 1780s are con-

cerned with the lamentable story of Caracalla and Geta. These include studies preliminary to the drawing in the Louvre at the Ecole nationale supérieure des Beaux-Arts, Paris; at the Boijmans Van Beuningen Museum, Rotterdam; as well as a number of other lost but recorded sheets.[3] David's focus on the story of Caracalla and Geta leads one to believe that he planned to execute a major painting on the subject. However, we have no additional or more precise information that would reveal why he gave up such a project, other than his simultaneous interest in various episodes in the story of the Horatii, resulting in his famous canvas, *The Oath of the Horatii,* of 1784 (Musée du Louvre, Paris).[4]

A lesson in the fatal consequences of tyrannical power, the drawing shown here attests to David's temporary predilection in the early 1780s for brutal and tragic scenes. It also exhibits one of his favorite compositional schemes: an austere architectural frame punctuated by large columns and illuminated by stark lateral lighting that accentuates the figures in the foreground. Like the Louvre drawing, this one holds the viewer's attention with the linear boldness of its angular draftsmanship and the emphatic quality of its expressive gestures, both of which underscore the violence of the image. In the Horvitz drawing, the ghost of Lucius Septimius Severus—to whom Caracalla responds with horror—also effectively presents a supernatural, visionary element that is quite unusual and significant for David. AS

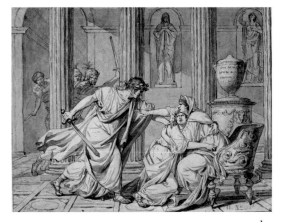

1

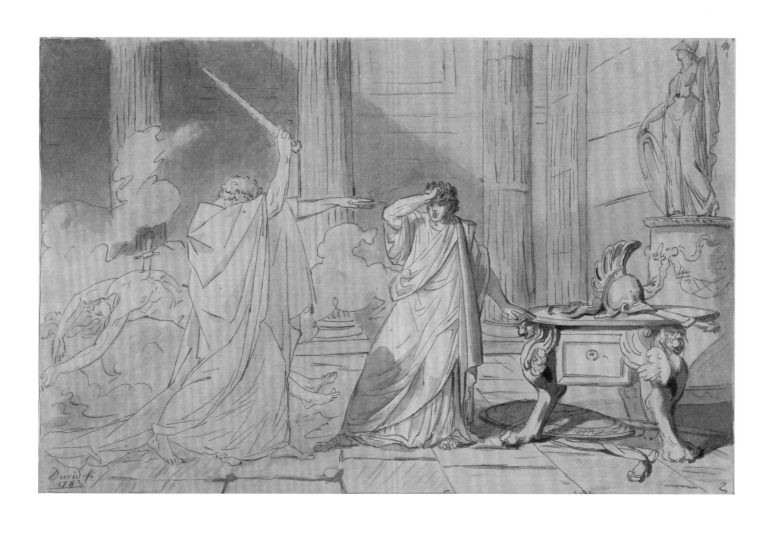

PIERRE-PAUL PRUD'HON

Cluny 1758–1823 Paris

101 *Walking Young Male Nude with Raised Arm*

Black chalk heightened with white chalk and pink pastel, extensively stumped, on blue wove paper

584 × 410 mm.

Watermark: Illegible

Inscriptions: None

Provenance: Charles-Pompée Le Boulanger de Boisfremont, Paris (L. 353, at bottom right); his daughter, Emilie Power, by descent; her sale, Paris, 15–16 April 1864, lot 84; sale, Drouot, Paris, 11 June 1990, lot 140; Colnaghi, London; acquired in 1990 (D-F-252/ 1.1993.116)

Exhibitions: Paris and New York 1997a, no. 40

Literature: Goncourt 1876, p. 144; Guiffrey 1924, cat. no. 13, p. 8; Sylvain Laveissière in Legrand 1997, under cat. nos. 2061–62, p. 560; Sylvain Laveissière in Paris and New York 1997a, pp. 84–85

This drawing has the double merit of being both a life study—akin to Prud'hon's many celebrated academic nudes—and a study for the figure of Love in one of the artist's major compositions, *Love Seduces Innocence, Pleasure Entraps, Remorse Follows*.[1] The precise date of the exhibited sheet is difficult to determine. Prud'hon conceived the design during his stay in Rome from 1784 to 1788 and began work on a large canvas in 1789, which he intended to use as his reception piece to the Académie. Related drawings for the composition include *Love* in the Musée Bonnat, Bayonne (fig. 1);[2] *Innocence* in the Pierpont Morgan Library, New York (fig. 2);[3] *Remorse* in the Nationalmuseum, Stockholm;[4] and *Love and Innocence* in the Musée du Louvre, Paris (fig. 3).[5] Prud'hon eventually abandoned his idea of executing the composition as a painting, but he did intend to have it engraved. He furnished his engraver, Barthélémy Roger, with drawings of the entire composition: these are now in the Musée du Louvre, Paris,[6] and in the Fogg Art Museum, Cambridge (fig. 4).[7] The print did not appear until 1812, but at some time around 1809, Prud'hon returned to the subject in oils on a medium-sized canvas for Empress Josephine (Private Collection, fig. 5).[8] Whether the Horvitz and Morgan studies were executed early in the 1790s, at the beginning of the project, or ten to twenty years later for the painting, remains a question for future research.[9]

As with all of his figure studies, whether they were destined to be integrated into compositions or drawn as academic exercises, Prud'hon used a large sheet of blue paper and imparted movement to the figure through a complex blend of black and white chalk, which he effaced, drew again, stumped to harmonize the areas of shading, and finished with finely worked parallel hatching. Both the exhibited drawing and the

Study for Innocence in the Pierpont Morgan Library contain faint highlights in pink pastel, unusual for this artist.

Prud'hon may have developed the pose for Love from a pen-and-ink sketch of a relief in the Vatican Logge that appears in one of his Roman notebooks.[10] Both the Horvitz and Bayonne studies for Love were in the Boisfremont Collection, which contained most of the works left in the artist's atelier at his death. They were also in the Boisfremont sale in 1864.[11] The sketchily rendered head in the exhibited sheet is depicted in greater detail in the Bayonne study, a drawing that seems to antedate the one presented here. One can find evidence for this supposition in a comparison between the two. In the Bayonne sheet, Prud'hon shows the left leg directly under the body, whereas in the Horvitz drawing, he has corrected this positioning to a pose that corresponds to the way the figure appears in the whole composition, in the drawn, engraved, and painted versions. SL

2

3

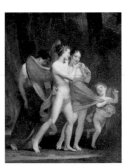

4

1

5

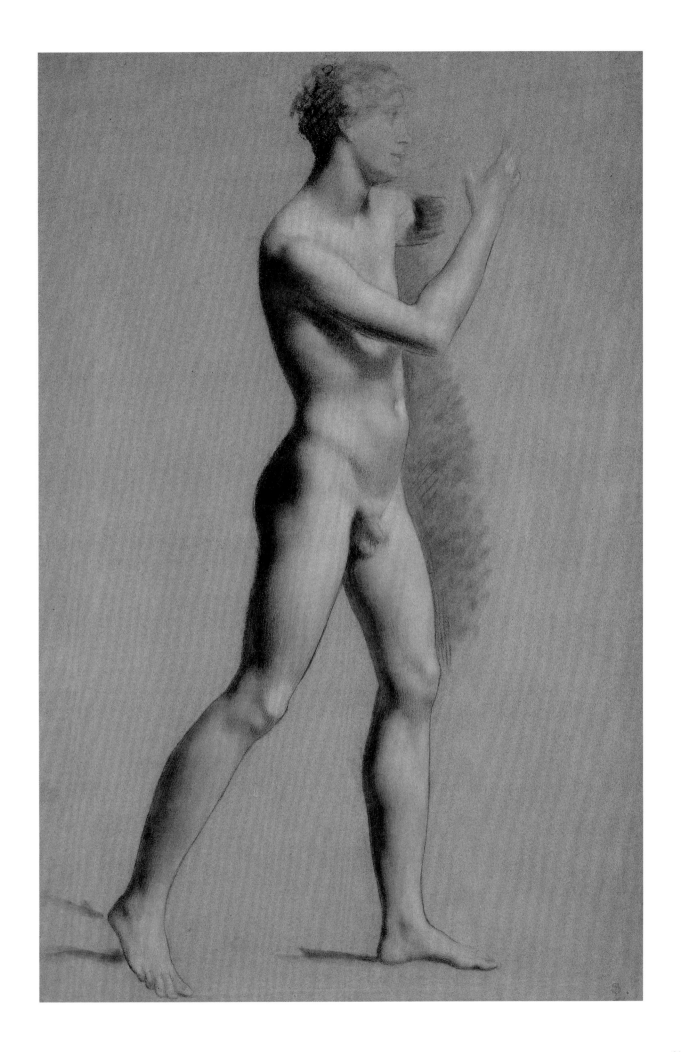

PIERRE-PAUL PRUD'HON

Cluny 1758–1823 Paris

102 *Paradise Lost: God Reproaching Adam and Eve after Their Misdeed*

Black chalk, extensively stumped, heightened with white chalk, on blue wove paper

330 × 490 mm.

Watermark: Illegible

Inscriptions: None

Provenance: Charles-Pompée Le Boulanger de Boisfremont, Paris (L. 353, at top and bottom right); his daughter, Emilie Power, by descent; her sale, 15–16 April 1864, lot 53; Eugène Lecomte; his sale, Drouot, Paris, 11–13 June 1906, lot 29; Gilbert Lévy, Paris; his sale, Drouot, Paris, 6 May 1987, lot 87; sale, Sotheby's, London, 15 June 1994, lot 50; Private Collection, France; Etienne Breton at Bureau Marc Blondeau, Paris; acquired in 1997 (D-F-522/ 1.1997.20)

Exhibitions: Paris 1874, no. 153

Literature: Goncourt 1876, p. 81; Guiffrey 1924, cat. no. 272, p. 98; Sylvain Laveissière in Paris 1986a, cat. no. 39a, pp. 66–67

*W*hile Prud'hon was studying in Dijon and Paris from 1774 to 1784, he made a number of drawings based on episodes from the Old Testament. He undoubtedly executed between 1780 and 1784 three drawings now in the Musée des Beaux-Arts, Dijon: *Moses Receiving the Tablets of the Law, The Sacrifice of Abraham,* and *God Reproaching Adam and Eve after Their Misdeed* (fig. 1).[1] He produced these either during his stay at the Académie in Paris (1780–83) or during the year he spent in Dijon to prepare for the Prix de Rome of the Province of Burgundy (1783–84). Originally in the Boisfremont Collection, the exhibited drawing reprises, at a much later date, the subject of God chastising Adam and Eve after their misdeed. A lost oil sketch, which was approximately the same size, composition, and date as the exhibited drawing, was also in the Boisfremont Collection.[2]

Prud'hon usually conceived and produced paintings of religious subjects only as commissions for churches or public places, but no early biography or document mentions a project that would include the subject of the exhibited sheet. Its broad style closely resembles that of *Justice and Divine Vengeance Pursuing Crime,* a large presentation drawing from late 1804 now in the Musée Condé, Chantilly.[3] The general arrangement of the two compositions is similar. God the Father occupies the place of Justice and Divine Vengeance, and the guilty Adam and Eve occupy the place of the criminal. Moreover, the sources on which Prud'hon modeled the figures are the same for both

compositions: the floating figures of God and his attendant spirits or angels in depictions of the Creation painted by Raphael in the Vatican Logge and by Michelangelo on the ceiling of the Sistine Chapel, which had inspired an oil sketch during his stay in Rome (Musée de Beaux-Arts, Dijon, fig. 2).

Curiously, we do not know if Prud'hon intended the Horvitz composition, which also deals with the theme of divine punishment, for the Palais de Justice in Paris or for a later project. During the Restoration, the years after 1815, Prud'hon painted several religious scenes: *The Assumption of the Virgin* for the royal chapel of the Tuileries Palace (1816–19)[4] and *Christ on the Cross* for the Strasbourg Cathedral (1820–22), both in the Musée du Louvre, Paris.[5] A drawing for the latter work, preserved in the Musée des Beaux-Arts, Dijon,[6] also shares several features with the exhibited sheet; in the Dijon drawing, the pose of the Magdalene weeping at the foot of the Cross resembles that of the repentant Eve. SL

1

2

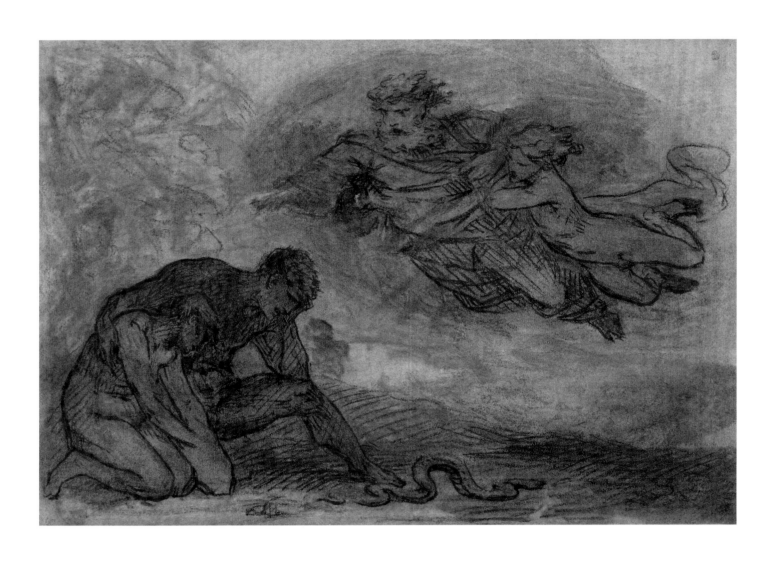

PIERRE-PAUL PRUD'HON

Cluny 1758–1823 Paris

103 *The Model*

Black chalk, extensively stumped, heightened with white chalk on faded blue wove paper

365 × 289 mm.

Watermark: Laid down—none visible through mount

Inscriptions: On recto of sheet in black chalk, bottom left: *Prud'hon*; in black chalk on recto of mount, bottom left: *69*; in graphite on verso of mount, across entire surface: *Bristol rapporti/ 71 × 61 verre/ avec filet & lore/ Parcilla au dessin de mathian/ A160 (Prud'hon)/ Cris presse*

Provenance: Baron Tonnes Christian Bruun Neergaard, Copenhagen; his sale, Paris, 29 August–7 September 1814, part of lot 316; Constantin, Paris; perhaps Allier de Hauterouche; perhaps his sale, Paris, 28 January–2 February 1828, lot 187; Camille Marcille; his sale, 6–7 March 1876, lot 124; Scheurer-Kestner Collection; David David-Weill, Paris; his sale, Sotheby's, London, 10 June 1959, lot 120; Duits, London; sale, Sotheby's, New York, 30 April 1982, lot 99; Galleria Carissimi, Milan, 1996; Michel Gierzod, Paris; acquired in 1997 (D-F-530/ 1.1997.58)

Exhibitions: Chartres 1858, no. 80; Paris 1874, no. 284; Paris 1889, no. 494

Literature: Goncourt 1876, p. 281; Guiffrey 1924, p. 282, cat. no. 761; Henriot 1929, vol. 2, p. 351; Sylvain Laveissière in Cuzin 1996, pp. 189–91; Eisler 1996, p. 726; Laveissière 1997, p. 119

*D*epictions of putti, or small children, with or in the guise of adults, are grounded in a tradition dating back to the Hellenistic era that was resumed during the Renaissance and Baroque periods, particularly in the work of artists such as Francesco Albani, François Duquesnoy, and Jacques Stella. They also have a special place in Prud'hon's oeuvre. With the naive sentiments of these mischievous and endearing figures, he expresses a microcosm of the attitudes and emotions of humanity. The exhibited drawing, formerly in the Bruun Neergaard collection with a lost pendant,[1] shows a small nude girl, seated on a pseudo-antique stool ornamented with the heads and paws of dogs, who rests her head in her hand and appears bored.[2] The reason for her expression is clarified when she is seen as the model posing for the young boy artist depicted in the lost pendant who has only managed to draw her headdress. She clearly finds that the whole process is taking a bit too much time.

The exhibited drawing and its pendant were engraved, in reverse, by the little-known Noel in 1804,[3] but their subject is related to Prud'hon's decorations for the Salon de la Richesse of the Hôtel de Lannoy in Paris produced between 1798 and 1801.[4] In the panels of this salon, beneath large allegorical figures representing the Arts, an imitation bronze bas-relief was described by Bruun Neergaard: "Under the Arts, one sees the genius of Painting, who paints little girls [sic] based on a model. A child who is developing a love of the arts makes critical remarks, while another blends colors."[5] This composition, painted on panel, was recently acquired by the Musée du Louvre;[6] the cartoon for this panel is now in a private collection in New York (fig. 1);[7] and a preparatory sketch depicting the faint bas-relief between masks of Mnemosyne and Apollo is in the Bibliothèque nationale de France.[8]

The first years of the nineteenth century marked the beginning of the public recognition of Prud'hon and his work, which would culminate in the Salon of 1808 where he exhibited two marvelous canvases: *Justice and Divine Vengeance Pursuing Crime* and *Psyche Carried Away by the Zephyrs.*[9] It is also about this time (1800–5) that a series of engravings was published that reproduced slightly modified details of his compositions from the last decade of the eighteenth century as models for drawing or as decorative prints. Aspects of the Hôtel de Lannoy decorations were engraved on eight plates.[10] His engravers were either supplied with fragments of his cartoons—which explains why sections of Prud'hon's cartoons for the main allegorical figures in the Musée du Louvre are missing—or sheets like the charming Horvitz drawing and its lost pendant were executed especially for this project.[11] SL

1

PIERRE-PAUL PRUD'HON

Cluny 1758–1823 Paris

104 *Female Nude with Raised Arms*

Black chalk, extensively stumped and heightened with white chalk and touches of pink pastel, on blue wove paper

585 × 452 mm.

Watermark: None

Inscriptions: None

Provenance: Charles-Pompée Le Boulanger de Boisfremont (L. 353, at bottom left); his daughter, Emilie Power, by descent; her sale, Paris, 15–16 April 1864, lot 91; Roger-Jourdain Collection; Pierre Jourdan; Emile Pereire, Paris (according to 1990 sale catalogue); sale, Drouot Paris, 5 April 1990, additional lot without number; Hazlitt, Gooden and Fox, Ltd., London (by 1990); acquired in 1993 (D-F-254/ 1.1993.171)

Exhibitions: Paris 1874, no. 214; London 1990, no. 3; Paris and New York 1997a, no. 219

Literature: Goncourt 1876, p. 171; Guiffrey 1924, cat. nos. 347 and 349, pp. 125 and 126; *Gazette de l'Hôtel Drouot*, 13 April 1990, cat. no. 15, p. 19; *L'Estampille*, June 1990, p. 35; Sylvain Laveissière in Cuzin 1996, pp. 194–96; Laveissière 1997, pp. 114–15; Paillat 1997, p. 68; Sylvain Laveissière in Paris and New York 1997a, pp. 310–12

*T*his admirable nude dates from the very end of Prud'hon's career. It is one of a series of at least ten drawings that he executed in preparation for his last major allegorical painting, *The Soul Breaking the Ties That Attach It to the Earth*, which was left incomplete at his death.[1] The artist, nearing his end, and worn down by a life full of difficulties and misfortunes—among them the suicide of his longtime companion, Constance Mayer, in 1821—was no longer thinking of anything but ultimate deliverance. He translated his feelings into a poetic winged nude female figure soaring into the air, glistening in a ray of light. The terrestrial world is evoked by a rocky shore pounded by hostile waves on which a serpent—a symbol of evil and envy—strives vainly to reach the soul, which is breaking free from its chains. His composition may have been inspired by the sixth verse of Psalm 55, which was inscribed on one of his early preparatory drawings: "Oh that I had wings like a dove! *for then* would I fly away, and be at rest."

Despite its unfinished state, Prud'hon's canvas, particularly its beautiful nude, was admired by artists such as Eugène Delacroix, and it was reproduced twice—in a lithograph of 1847 by Jules Boilly and in an engraving by Léon-Louis Chapon—both of which are in reverse to the original.[2] His preliminary oil sketch (now in the Musée du Louvre, Paris) was also reproduced in reverse in an engraving by Adrien Didier in 1874 (fig. 1).[3] Recently, one of Prud'hon's preparatory studies for the entire composition reappeared at auction in New York (fig. 2).[4] There, the figure is shown close to her pose in the painting but with a different coiffure and no drapery.

The Horvitz drawing was undoubtedly still unframed at the time of its sale in 1864, when the recorded dimensions corresponded to those of the entire sheet, but it was framed in the Jourdan collection, where Jean Guiffrey saw it and measured the interior dimensions of the window of the mat that, until 1990, concealed Boisfremont's mark.[5] SL

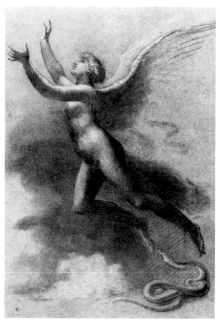

1

2

322

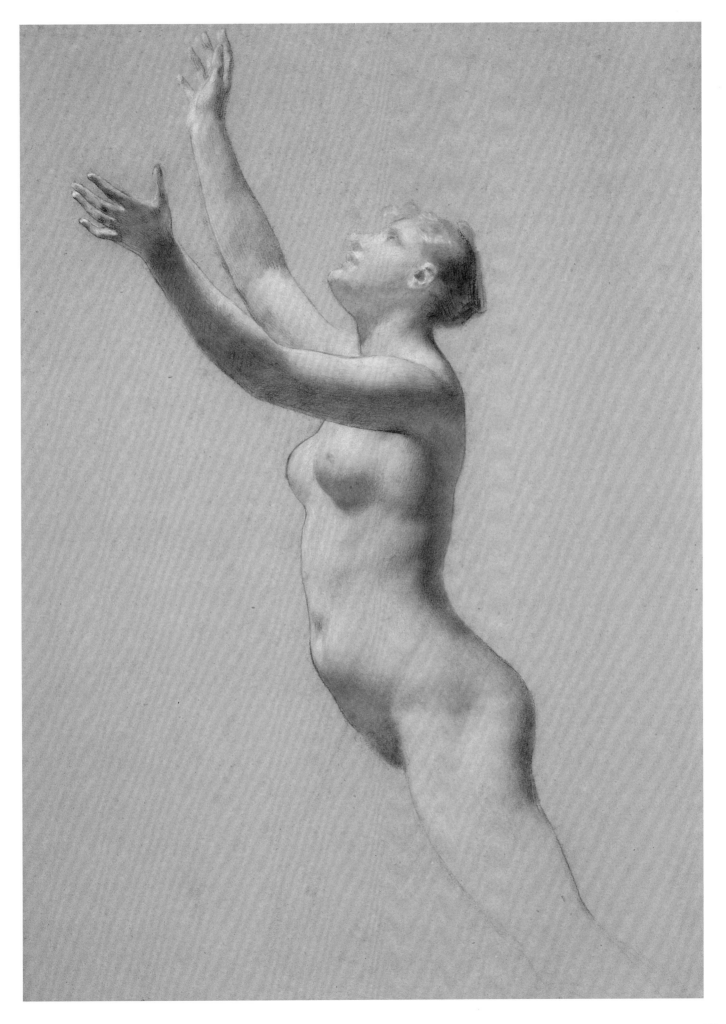

ETIENNE-BARTHÉLEMY GARNIER
Paris 1759–1849 Paris

105 *Banquet of Tereus*

Pen with black and brown ink and brush with brown wash, heightened with white gouache, on blue-green laid paper

355 × 517 mm.

Watermark: Laid down—none visible through mount

Inscriptions: In pen and black ink on base of statue, middle of image: MOZPOAL (the rest, indecipherable); in black chalk, at bottom left: *garnier*

Provenance: Nicolas Joly at Galerie Yves Mikaeloff, Paris; acquired in 1994 (D-F-111/ 1.1994.39)

Exhibitions: None

Literature: Unpublished

*A*lthough he had a long and successful career, only a handful of drawings can be ascribed to Garnier today. The exhibited sheet is one of the few drawings in the United States by the artist, and it is a ravishing example of his bold use of chiaroscuro on blue paper. Highly finished drawings such as this, executed with the same media, were made throughout Europe by artists working in the Neoclassical style. Indeed, without the signature, it would be difficult to attribute this sheet to Garnier, not only because of the paucity of extant works by him, but also because the finesse of execution in drawings like this, and his *Socrates and Alcibiades* in the Art Museum at Princeton (fig. 1),[1] sometimes obscures a distinctive personality at work.

The subject of the exhibited drawing, the banquet of Tereus, occurred only rarely in earlier European art, and the identification here is due to Maxime Préaud.[2] The best known source of this myth is Ovid's *Metamorphoses* (6:424–672), which was essential reading for students at the Académie. Procne, an Athenian princess, was married to Tereus, king of Thrace, who raped his sister-in-law, Philomela. Although he cut out her tongue and hid her in a fortress, Philomela managed to weave her plight into a tapestry that she sent to her sister. Procne arranged her sister's release and smuggled her into Tereus's palace. To take revenge on her husband, Procne killed their son Itys and had his flesh served up to her husband. After the meal, Philomela brought in the boy's severed head so that Tereus would realize the fate of his heir.

Garnier may have seen illustrated volumes of Ovid,[3] but his depiction of Philomela's outstretched arm holding Itys's head, at the center of the foreground, and of Tereus recoiling in horror, at the right, suggests that he probably knew Rubens's painting of the subject, now in the Museo del Prado, Madrid (fig. 2), which was engraved by Cornelis I Galle.[4] In the center of the composition, behind Itys's severed head, Garnier placed a statue loosely modeled on the Minerva Giustiniani with an unintelligible inscription in Greek letters, presumably added to convey an aura of classical learning.[5]

In the Horvitz drawing, Garnier transformed a recondite mythological story into a scene with topical significance. The artist had returned to Paris in 1793, driven from Rome by the anti–French riots there following news of the execution of Louis XVI earlier that year.[6] One of the most gruesome anti-royalist prints published in the wake of the Revolution is by the little-known Villeneuve. It shows an outstretched arm holding the king's severed head—in profile, dripping blood, and grasped by its hair (fig. 3).[7] Published shortly after Louis XVI's execution, this image would have been current when Garnier returned to Paris, and the severed head in the drawing exhibited here is strikingly similar to that of Louis XVI in the Villeneuve print. Evidently, Garnier found a parallel in the Tereus myth to the lust, misuse of power, and punishment of the French monarchy. It is not known whether he executed the drawing with a specific project or audience in mind.

The few surviving drawings made by Garnier in Rome also depict events from classical literature or history that evidence his considerable erudition. These works also treat such highly pitched emotions as horror or despair in a grandiloquent, theatrical manner, although there is no reason to suppose that the artist chose his subjects as a pretext for propounding a political message, as he so clearly did in the exhibited drawing.[8] VC

1

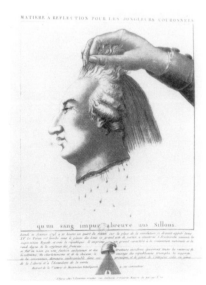

2

3

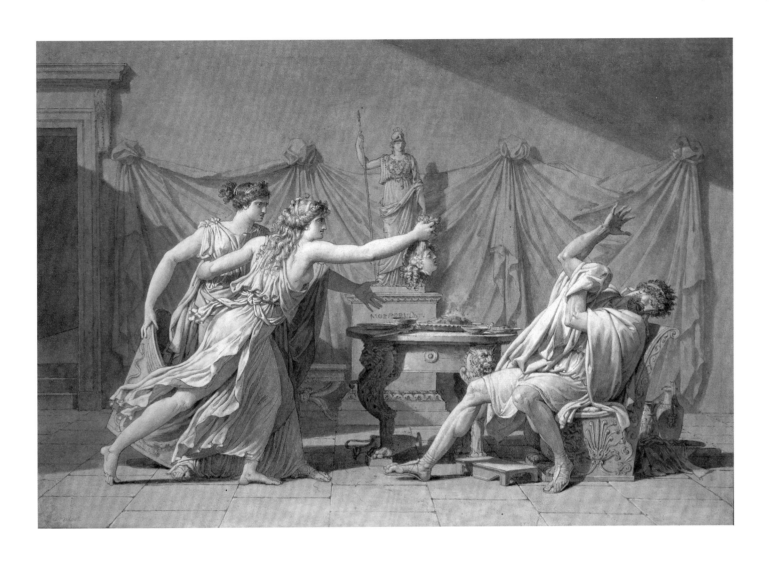

MARIE-GABRIELLE CAPET

Lyon 1761–1818 Paris

106 *Self-Portrait*

Black and red chalk heightened with white chalk on tan laid paper

340 × 294 mm.

Watermark: Laid down—none visible through mount

Inscriptions: In black ink, stamp on verso of mount: *Niodot*

Provenance: Niodot fils, Paris (L. 1944, dry stamp on recto of mount, bottom right); Galerie de Bayser, Paris; acquired in 1996 (D-F-429/ 1.1996.85)

Exhibitions: None

Literature: Unpublished

Capet is one of those unfortunate artists who, having enjoyed a goodly measure of success during her lifetime, quickly slipped into oblivion shortly after her death. For many years, she was more familiar as a model in the paintings and drawings of her teachers and friends, Madame Adélaïde Labille-Guiard and François-André Vincent (cats. 98–99), than for her own accomplishments as an artist. Labille-Guiard's works include a stunning drawing in a private collection in New York (fig. 1)[1] and an ambitious and admired painting, *Self-Portrait with Two Pupils, Mademoiselle Marie-Gabrielle Capet and Mademoiselle Carreaux de Rosemond* of 1785 (Metropolitan Museum of Art, New York; fig. 2, detail);[2] also noteworthy is Vincent's portrait drawing of the young Capet (Stanford University Museum of Art, Palo Alto, fig. 3).[3] In 1934, Capet's work as a portrait painter, pastellist, and miniaturist was finally given some measure of recognition with the publication of a monograph,[4] but her work as a draftsman remains unstudied. This is further complicated by the fact that none of her drawings has previously been published.

As this beguiling *Self-Portrait* attests, Capet was an accomplished draftsman with a deft, sensitive touch and an eye for both surface and color. The skill with which this work was executed indicates that drawing must have been a regular exercise for her, as it was for her contemporary French colleagues. Indeed, the portfolio on her lap in this *Self-Portrait* is filled with papers—presumably drawings—and Capet is known to have exhibited a painted portrait in 1783 of herself in the process of making a drawing.[5] She had also exhibited a *trois-crayons* study of an expressive head, which elicited positive comments, at the Exposition de Jeunesse on the Place Dauphine in June 1781.[6]

From the style of Capet's clothing and coiffure, the exhibited drawing can be dated to the early to mid-1790s. Although she had been trained by Labille-

Guiard very much in the eighteenth-century manner and had even portrayed herself in 1784 wearing a fetching hat and a sheer scarf over a low-cut dress,[7] Capet quickly abandoned those mid-century bourgeois trappings at the time of the Revolution. Here she shows herself as a simple *citoyenne*, wearing an unadorned black dress, seated on a plain wooden chair in an otherwise empty, undefined space. The starkness of the composition is relieved somewhat by the unruly tendrils of her hair, the uneven edges of the drawings in her portfolio, and the unaffected sincerity of her expression, but it is Capet's assured manipulation of the coloristic *trois-crayons* technique that gives this drawing its distinct visual appeal.

The skillful execution and unabashed charm of this drawing make it especially regrettable that Capet's other drawings are now so entirely unknown. Undoubtedly, others have survived, hidden under incorrect attributions because of our lack of knowledge about her draftsmanship. As the Horvitz sheet becomes better known, the chance that other drawings by the talented Capet will be recognized certainly improves. MMG

1

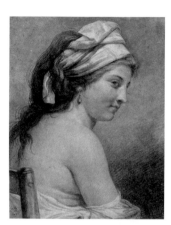

2

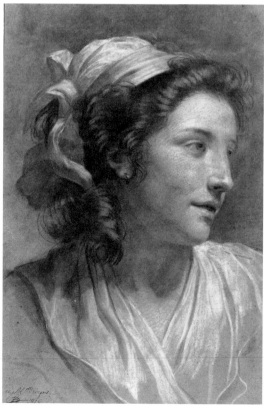

3

ARMAND-CHARLES CARAFFE

Paris 1762–1818/22 Paris

107 *Agis Restoring the Laws of Lycurgus to Sparta*

Pen and black ink with brush and gray wash, heightened with white gouache, on blue laid paper

341 × 631 mm.

Watermark: Laid down—none visible through mount

Inscriptions: In black ink on recto of drawing, bottom right: *David fecit/ Anno II*; in pen and black ink on recto of old mount, bottom: *Grand panneau décoratif pour la salle de l'Assemblé des représentants du peuple*

Provenance: W. M. Brady and Co., Inc., New York; acquired in 1995 (D-F-42/ 1.1995.36)

Exhibitions: Salon of 1793, no. 807

Literature: Unpublished

Standing on a platform beneath the trophies of war won by his renowned army, Agis IV, the second-century B.C. king of Sparta, addresses a large crowd of his subjects gathered before a statue of their legendary ancient leader Lycurgus, which is being wreathed with laurels. In his *Lives of the Noble Greeks and Romans,* the first-century Greek historian and biographer Plutarch informs us that it was the patrician statesman Lycurgus who overcame enormous obstacles to establish Sparta's *eunomia* (or "good order"), which ensured the equality of land, wealth, and status among its citizens; placed the common good above the individual; designed an austere ("spartan") lifestyle; and separated the sexes from each other until adulthood to ensure that young men focused on becoming strong soldiers, a practice that led to Sparta's military dominance of the Peloponnese. In the centuries following his death, the nation had reverted to some of the vices of pre–Lycurgian Sparta, and Agis IV endeavored to rectify the situation by returning to the shining example established by his ancient predecessor. Unfortunately, as Plutarch also informs us, the obstacles facing the idealistic king were overwhelming. The luxury-loving nobility would not be swayed, and they murdered Agis and his family in order to avoid relinquishing the privileges provided by their servants, slaves, hereditary lands, and titles.

Caraffe exhibited this large and striking drawing at the Salon of 1793. The scene is arranged in a friezelike manner across the foreground, so that all of the figures are pressed into a wide horizontal space before a wall pierced with arches through which we glimpse Sparta's palaces and temples in the background.[1] Beneath Agis, a scribe or keeper of records moves toward the middle of the foreground with a basket of laws created since the death of Lycurgus; there, they are burned by a kneeling figure borrowed from Eustache Le Sueur's well-known *St. Paul at Ephesus*.[2] Some of those listening—the young, those making music and dancing at the far right, and those with their arms ele-

vated in joy—are captivated by the king's proposals. But others—the men silhouetted behind the king; the older men in shadow between him and the statue of Lycurgus; the troubled man to the right of the fire with his finger in his mouth; and the patrician woman in the left corner who, fearing that her children might be contaminated by these ideas, pulls them away from a servant—are clearly disturbed by what they hear. The artist must have been proud of this composition, for it served as the design for his first print (fig. 1), which he etched with minor changes in the same direction and on the same scale but abandoned before completion.[3]

Like Nicolas Le Jeune (cat. 95), Caraffe was a student of Louis-Jean-François Lagrenée l'aîné,[4] but he may also have studied in David's atelier.[5] Criticisms of Caraffe's style began early in his career. While he was an artist-in-residence at the French Academy in Rome, its director, François-Guillaume Ménageot, referred to his manner as "an abuse of style."[6] Later, when a painted nude Caraffe sent from Rome was judged by professors at the Académie in 1788, he was criticized for working in a gigantesque style without harmony, which was considered to be an "abuse of the antique."[7] Certainly, Caraffe's style was not—as his superiors would have wished—formed by an observation of nature corrected by imitation of the antique and the masters of the High Renaissance. Instead, it may be an intentional modification. As one of his early *académies* in the Ecole nationale supérieure des Beaux-Arts in Paris demonstrates (fig. 2),[8] although he had not yet attained the mastery of a young François-André Vincent or Jean-François-Pierre Peyron (see cat. 96), he had a clear grasp of the basics of anatomy and he understood how to depict a figure in space. The same drawing also reveals that Caraffe was already an artist who liked extremes. The contour is overly exaggerated, and every muscle is described in such detail that, instead of blending together into a naturally elegant and idealized figure, the nude seems about to be pulled apart by the strain.

1

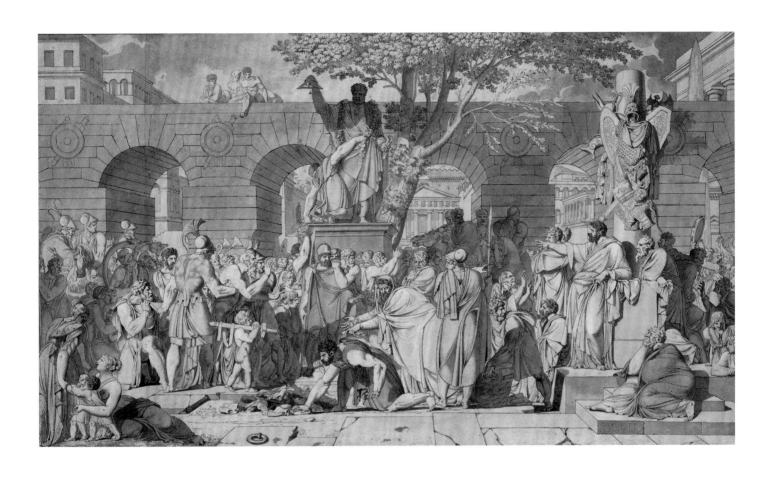

The idiosyncratic style that Caraffe evolved in the 1790s for compositions like the Horvitz drawing reveals the artist's preference for linear refinement and detail. The dimensionality of each of Caraffe's planar figures, like the soldier with his back to us just below Agis in the exhibited drawing, is evoked by a variety of distinct rhythmic patterns of calligraphic drapery folds shaded with wash to suggest greater or lesser levels of relief. This shading, combined with the emphatic contours of the draperies, creates a spatial tension between them and the figures or objects near them, which Caraffe orchestrates across his densely populated compositions. In addition, he delights in describing details like the bricks in the wall, the trophies above Agis, each leaf of the tree behind the statue of Lycurgus, the elaborately trimmed costumes, the extravagantly plumed helmets, and the fantastic shapes of the musical instruments. In this sheet, Caraffe's vision of the antique is not the beauty of ideal form but the conglomeration of ancient references.

The artist began to break away from this system in his slightly later *Consul Gaius Popillius Laenas Sent by the Romans to King Antiochus in Order to Request the Cessation of Battle* in the Graphische Sammlung Albertina, Vienna (fig. 3).[9] In that drawing, he opened up the background on the left and right by constructing clearly defined registers of relief and then created more three-dimensional figures by using a meticulously modulated system of washes to describe leather armor. But even in the Vienna sheet, the large tree in the center of the composition and the insistently planar horses in the foreground bring the viewer back to the surface. In these early, dense, and static drawings, was Caraffe—like Poussin nearly two centuries before him—so overwhelmed by the remains of ancient past that he was unable to see the totality of the use of the antique so embraced by his superiors?[10] Or was he

2

intentionally evolving a powerful and very personal manneristic interpretation of the Neoclassical mode? Only further research on this understudied artist will provide the answer.

If the style in which Caraffe crafted the exhibited drawing was atypical, his choice of subject was not. Such a display of *exemplum virtutis*, the type of theme depicting heroic acts of public virtue, was frequently chosen during the Revolutionary era for its political content.[11] Agis and Lycurgus were particularly popular subjects, for they were regarded as especially appropriate models for the reinforcement of the moral character of the citizens of the young French Republic. Caraffe drew a pendant, now lost, to the exhibited drawing, *Agesilaus Condemned to Death for Opposing the Laws of Lycurgus,* which he exhibited with the Horvitz drawing at the Salon of 1793. Vincent and Nicolas-André Monsiau also treated this theme in paintings and drawings,[12] and both Maximilien Robespierre and Louis-Antoine Saint-Just referred to the Spartan king and statesman often to justify their goals and policies.[13] ALC

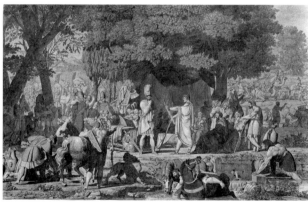

3

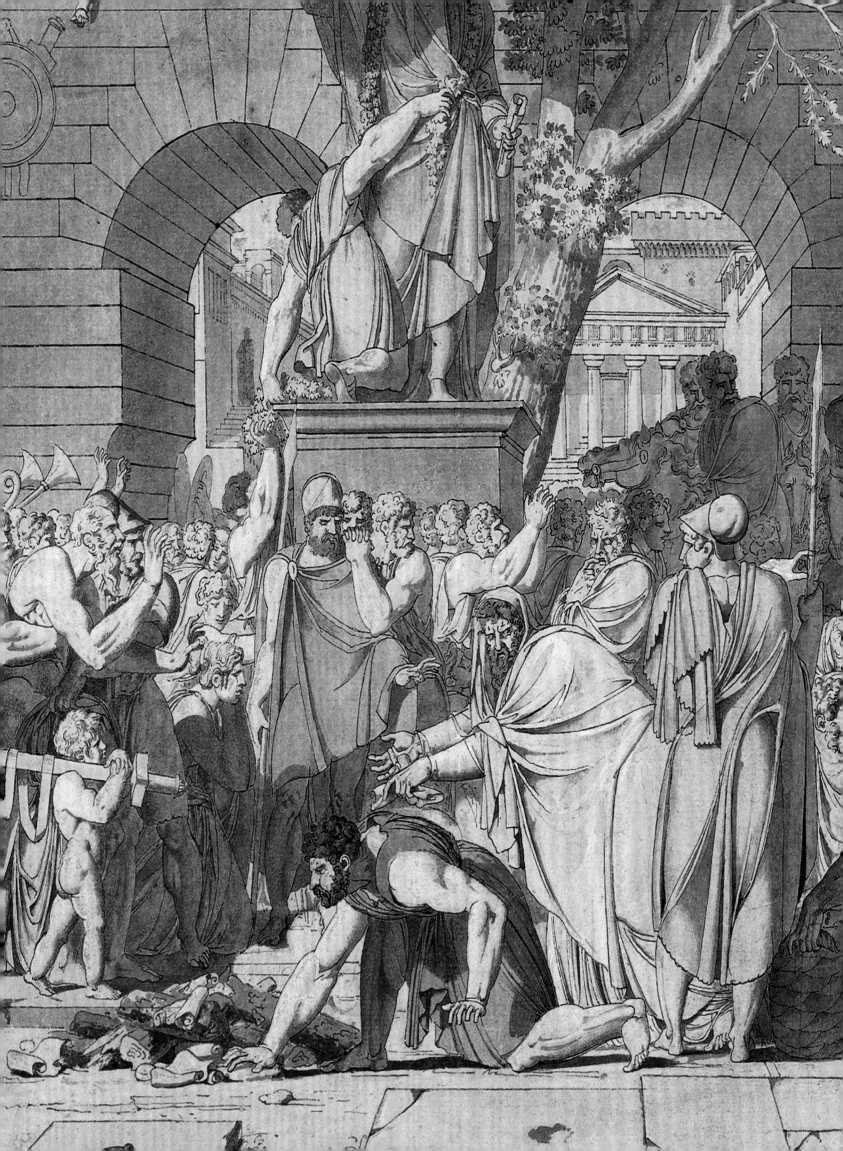

ANNE-LOUIS GIRODET DE ROUCY-TRIOSON

Montargis 1767–1824 Paris

108 *Head of a Young Woman with an "Antique" Coiffure*

Black chalk stumped and heightened with white chalk on off-white laid paper

448 × 406 mm.

Watermark: Illegible

Inscriptions: In black chalk, bottom right: *Girodet-Trioson/1799*

Provenance: In the artist's atelier at his death; perhaps his estate sale, 11–25 April 1825, lot 270; Private Collection, Paris; Frederick J. Cummings, New York; acquired in 1989 (D-F-116/ 1.1993.58)

Exhibitions: Rome 1959, no. 107; Montargis 1967, no. 65

Literature: Jacqueline Bouchot-Saupique in Rome 1959, cat. no. 107 (n.p.); Jacqueline Pruvost-Auzas in Montargis 1967, cat. no. 65 (n.p.)

*G*irodet described the study from life as "the living figure, model of models" in his didactic poem, *Les Veilles* (The Vigils).[1] In doing so, he situated himself and his art between the compilation of a learned iconographic repertoire and the time-honored artistic practice of the observation of nature. This portrait of a young woman in profile belongs to both of these categories. The coiffure, called "à la Flaminia," is in the Neoclassical style of the French Revolutionary era. It is akin to other contemporary hairstyles depicted in Girodet's *Mademoiselle Lange as Danaë*, a canvas in the Minneapolis Institute of Arts; in his *Danaë Gazing at Her Reflection in the Mirror Held Up by Love*, a canvas in the Museum der Bildenden Künste, Leipzig; and in another, much smaller head study in a private collection (fig. 1).[2] Both the Minneapolis and Leipzig canvases to which the exhibited drawing relates were dated by P. A. Coupin to 1798 and 1799, respectively.[3] Their dates corroborate the accuracy of the date of 1799 inscribed on the drawing. Shortly before his death in 1824, Girodet charged Alexis Nicolas Pérignon le jeune—one of his former students and the eventual author of the sale catalogue of Girodet's estate—with the classification of his teacher's works, as well as those by others in Girodet's collection.[4] It is possible that the artist affixed what appears to be his autograph signature, *Girodet-Trioson*, at that time, since this could not be contemporaneous with the drawing. Girodet was adopted by Dr. Trioson in 1809, and the family name of his tutor-turned-father does not appear before 1806. Furthermore, in 1799, the artist would have used the Revolutionary calendar, writing *l'an VII* or *l'an VIII*.

The features of the face of the young girl depicted here, with its blunt, upturned nose, and the artist's use of stumping to evoke the vividly sculptural coiffure —blurred like the shadow of the beloved face that

Dibutade strove to preserve on a wall in Pliny the Elder's description of the invention of drawing—are clearly drawn from life rather than from some idealized image.[5] They are the result of observation. Conversely, the contour of the profile does not impart volume: it is derived from the classification of the expressions that Le Brun described in an address to the Académie in 1668. Like the *Head of a Woman in Profile* by Jean-Baptiste Greuze (cat. 78), the dazed expression here is close to Charles Le Brun's "Surprise" and "Wonder" as Bernard Picart and Henri Testelin popularized them in their publications of Le Brun's study.[6]

Like Le Brun, Girodet also had a great interest in physiognomy. He compiled his own *Cahiers de principes* (Handbook of Principles) for instruction in his atelier; the volume contained an archetypal selection of eyes, noses, and ears that he described as "freely copied from the Ancients or from nature."[7] Thanks to his surrogate father, Dr. Trioson, who assisted him with his investigations, he was familiar with the medical and scientific "avant-garde" of the early nineteenth century. His *Deluge* of 1806–14, now in the Musée du Louvre, Paris, was engraved as an illustration in *Planches Physiologiques, Système de Lavater* (Physiological Plates: The System of Lavater),[8] and Girodet also owned Lavater's works. In *Les Veilles*, when referring to the celebrated pastels of the renowned portraitist Maurice-Quentin de La Tour, he also wrote: "Taking him as your example, paint the character this way. . . . The only painter of history is the king of the portrait."[9] Thus, in portraiture, as in all other genres, Girodet raised his subject and artistic practice to the level of moral and principle. SB

1

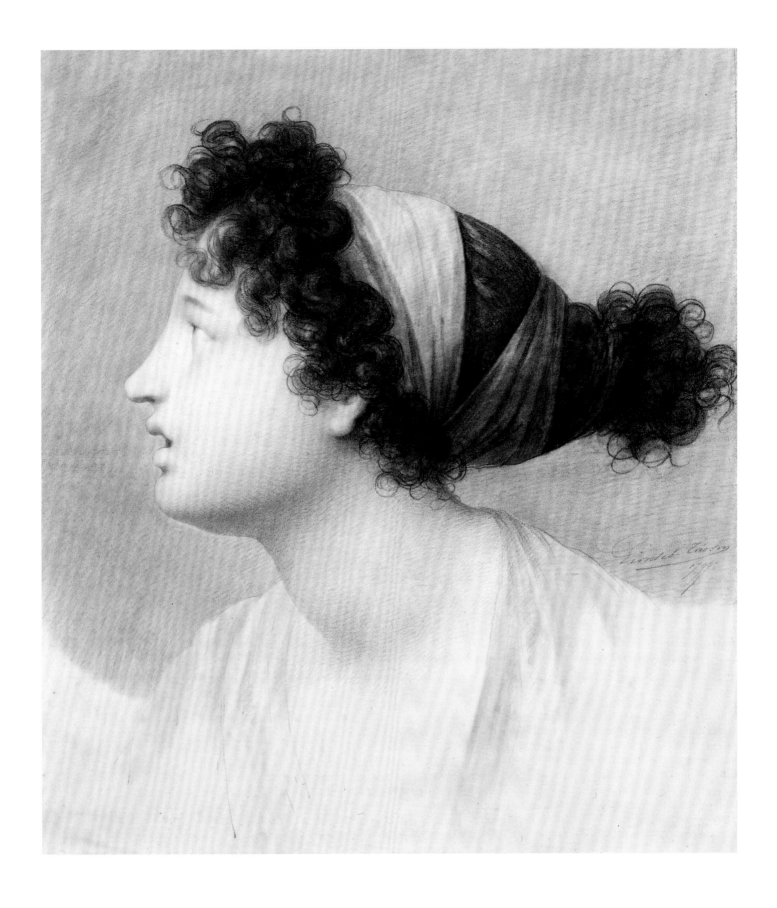

ANNE-LOUIS GIRODET DE ROUCY-TRIOSON

Montargis 1767–1824 Paris

109 *The Death of Phaedra*

Pen and brown ink, and brush with brown and gray wash, heightened with white gouache on off-white wove paper

325 × 225 mm.

Watermark: Laid down—none visible through mount

Inscriptions: In graphite beneath image, bottom left: GIRODET INV.; in pen and brown ink beneath image, bottom center: PHÈDRE./ DEJA JE NE VOIS PLUS QU'A TRAVERS UN NUAGE/ ET LE CIEL, ET L'EPOUX QUE MA PRESENCE OUTRAGE;/ ET LA MORT A MES YEUX DEROBANT SA CLARTÉ/ REND AU JOUR, QU'ILS SOUILLAIENT, TOUTE SA PURETE./ PANOPE./ ELLE EXPIRE, SEIGNEUR; in pen and brown ink across bottom of sheet: PHÈDRE ACTE V. SCÈNE DERN.E.; in pen and black ink with green watercolor across bottom of mount: DESSIN ORIGINAL DE GIRODET

Provenance: Firmin Didot, Paris; Private Collection; Galerie de Bayser, Paris; acquired in 1998 (D-F-600/ 1.1998.60)

Exhibitions: Salon of 1804, one of five drawings listed under no. 212

Literature: Osborne 1985, pp. 113–48 and p. 236

Drawings such as this impressive design for book illustration provide eloquent testimony to Girodet's passion for and knowledge of important works of literature, which was far more extensive than that of his contemporaries such as David and Ingres. In the words of Charles Baudelaire, Girodet "always dipped his brush in the most literary of sources."[1] In addition to composing poetry, he collaborated on several important publications and translations.[2] He also designed frontispieces and illustrations for a number of texts,[3] but none were as pivotal as those he provided for the lavish editions produced by Pierre and Firmin Didot, including the large three-volume folio edition of the *Oeuvres de Racine* (Works of Racine, 1801–4), for which the exhibited drawing served as an illustration. Referring to the high level of execution in these works, Girodet claimed, in a letter of c. 1806 to his friend, the future marquis de Pastoret, the same status for drawing as for history painting.[4]

The Didots published a series of beautiful volumes in the 1790s, and their *Oeuvres de Racine*, advertised as a masterpiece of Neoclassical editions, was to be a notable advance over their highly successful *Oeuvres de Virgile* (Works of Virgil) of 1798, for which Girodet provided the frontispiece (Musée des Beaux-Arts, Angers, fig. 1).[5] As before, the selection of the young artists to design the illustrations was left up to Jacques-Louis David.[6] As a collaborator who had already proved himself capable of the challenge with his drawings for the *Oeuvres de Virgile*, his student

Girodet was given the responsibility for illustrating *Phèdre* and *Andromache*.[7] However, the engraving by Jean-Baptiste-Raphaël-Urbain Massard after the sheet exhibited here reveals that, even though an effort was made to entrust the translation of the drawings to the finest printmakers, a great deal of subtlety was often lost in the transition (fig. 2).[8]

Illustrating one of the most famous scenes in French classical drama, Girodet's recently rediscovered *Death of Phaedra*[9] depicts the final scene of the last act of Racine's tragedy of 1677.[10] Here, we see Queen Phaedra—wife of King Theseus of Athens—who had conceived an illicit passion for her stepson Hippolytus during her husband's absence, dying in the arms of her servant Panope. The latter had replaced Phaedra's nurse Oenone, who drowned herself after accusing Hippolytus of attempting to seduce her lady. When Theseus forced Phaedra to defend or deny Oenone's accusation, she supported it in order to conceal her shameful and incestuous lust for Hippolytus, whom the enraged Theseus then banished and placed under one of the three curses promised to him by Neptune, god of the sea. As Hippolytus drove away in his chariot along the coastline, a sea monster emerged to frighten the horses and Hippolytus was dragged to his death. Finally, as we see here, upon learning of Hippolytus's demise, Phaedra drinks poison and dies, while admitting that Oenone's accusation was false and confessing her reasons for initially supporting it.

The expression of the passions in Neoclassical art derives from the theater; the emphatic gestures that Girodet has imparted to Theseus, who covers his face and his eyes because he cannot bear to watch what is happening—as well as those of Theramen, Hippolytus's tutor, who looks on in horror and clenches his fists—reveal the inner state of the actors as the tragedy unfolds. Neptune, Theseus's protector during his voyages, is invoked many times in the course of the play, and his presence in the background as a statue presiding over the scene incarnates Fate. As in all of Girodet's illustrations for this play, like *Phaedra Refusing the Embraces of Theseus* in the J. Paul Getty Museum, Los Angeles (fig. 3),[11] the tableau is set in an enclosed interior, for in Racinian drama, danger and death come from outside the tragic space. Thus, through the opening in the background of the exhibited drawing, soldiers take away the dead body of Hippolytus. His beloved, Aricie, is shown weeping by his side.

For each of his illustrations for the *Oeuvres de Racine*, Girodet made studies for both the figures and the compositions, just as he would have for a history painting. Although only four are extant, we know that more than thirty studies were made for this project.[12] One of the most poignant and exquisite of these

1

2

3

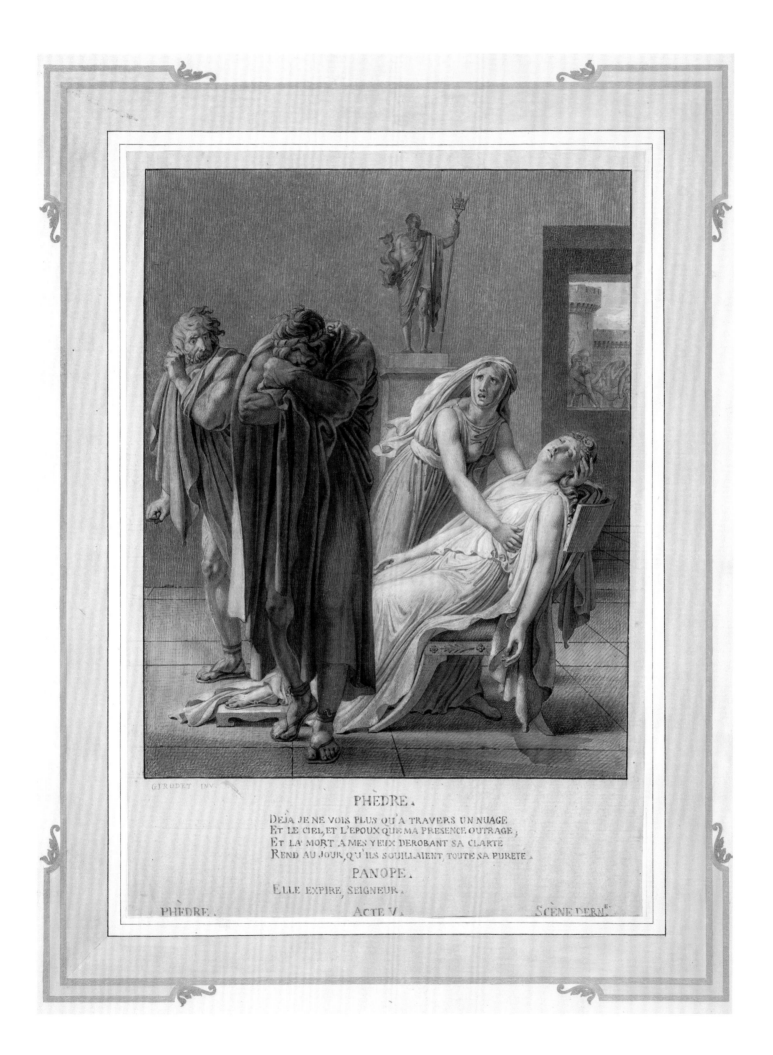

PHEDRE.

DEJA JE NE VOIS PLUS QU'A TRAVERS UN NUAGE
ET LE CIEL, ET L'EPOUX QUE MA PRESENCE OUTRAGE ;
ET LA MORT A MES YEUX DEROBANT SA CLARTE
REND AU JOUR, QU'ILS SOUILLAIENT, TOUTE SA PURETE.

PANOPE.

ELLE EXPIRE, SEIGNEUR.

PHEDRE. ACTE V. SCENE DERN.ᵉ

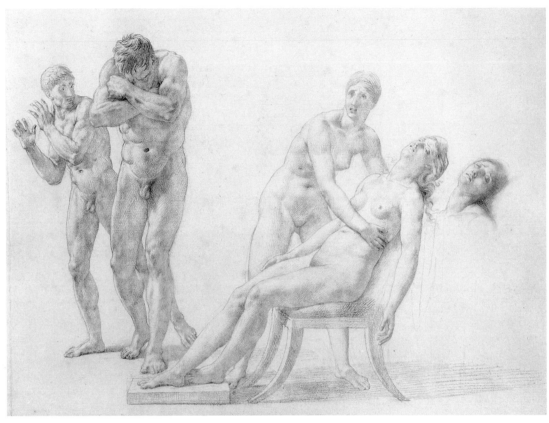

4

sheets is in the Musée du Louvre, Paris (fig. 4),[13] and it was made in preparation for the drawing exhibited here. The Louvre drawing reveals how Girodet placed the figures in perspectively correct positions similar to their appearance in the final composition and carefully drew each one in the nude. Their firm contours, and the combination of shading and stumping utilized to subtly render their flesh and musculature betrays his training as a student of David and demonstrates the base of academic study and control that was necessary to realize the bold, yet remarkably powerful and balanced illustrations.

At the Salon of 1804, Girodet displayed at least four portraits.[14] For an artist who adhered to the precepts of his teacher, David, and who had built a solid reputation as a history painter—the most exalted genre in the hierarchy of the arts—this plethora of portraits might have seemed a symptom of weakness or even a waste of his talents.[15] In fact, a number of critics leveled this charge at him.[16] Moreover, at this particular

Salon, Girodet confronted a daunting challenge from a formidable adversary: Baron Antoine-Jean Gros exhibited his stunning *Plague Victims of Jaffa* (Musée du Louvre, Paris), one of the greatest paintings of the first half of the nineteenth century. At the last minute, in the context of this rivalry with another of David's followers, Girodet added his five drawings for Racine's *Phèdre* to his entries at the Salon in order to reaffirm his mastery of invention in the genre of history painting. Critics of Girodet's time demanded that the history painter must synthesize in a single image the moment in which the action is implied in its totality and in which the meaning achieves its maximum coherence and effect.[17] In each of his drawings for the *Oeuvres de Racine*, Girodet rose to this challenge. He endeavored to create a richly connotative and fertile image for every act of the tragedy, and he realized in his illustrations a series of historical compositions that can only be fully understood in the context of their semantic interrelation. SB

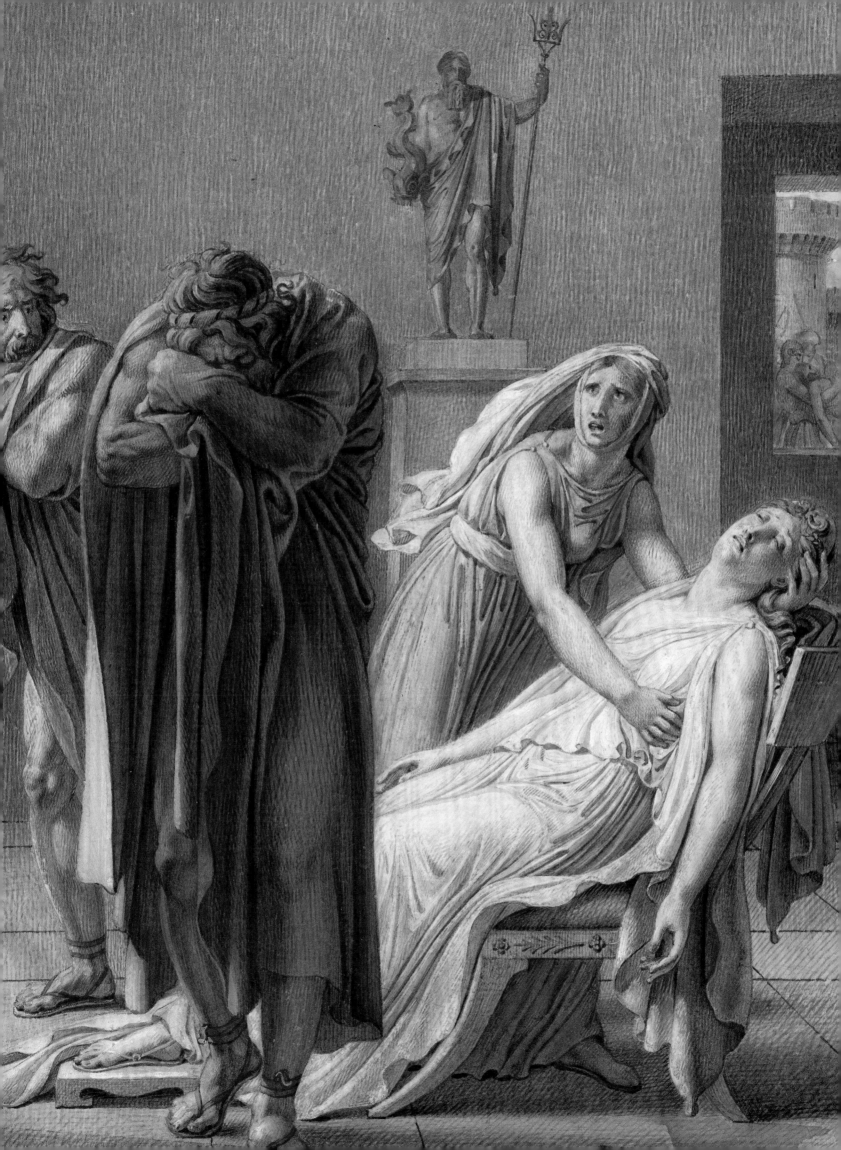

ANNE-LOUIS GIRODET DE ROUCY-TRIOSON

Montargis 1767–1824 Paris

110 *Aeneas Welcomed in Hades by the Shades of His Former Comrades*

Black chalk and graphite on two joined sheets of off-white wove paper

277 × 379 mm.

Watermark: Churchill 433

Inscriptions: In black chalk on recto, upper right, *no. 12*; in black chalk on verso, upper left: *(81)*; in black chalk on verso, bottom right: 22; in black chalk on verso, upper right: *58*

Provenance: Antoine-Claude Pannetier, Paris; Collection M. de la Bordes; his sale, Drouot, Paris, 15 April 1867, part of lot 11 (170 drawings by Girodet, compositions for the *Aeneid* and the *Georgics* of Virgil); Ambroise Firmin-Didot, Paris (the name of the Didot publishing family was hyphenated to Firmin-Didot in 1826); Firmin-Didot family, by descent; sale of 146 drawings by Girodet, Drouot, Paris, 17 November 1971, lot 58; Heim Gallery, London (until 1975); Private Collection, U.S.; W. M. Brady and Co., Inc., New York (by 1991); acquired in 1994 (D-F-117/ 1.1994.36)

Exhibitions: London 1975, no. 55; New York 1991b, no. 7

Literature: Boucher 1930; Philip Conisbee in London 1975, cat. no. 55 (n.p.); Mark Brady in New York 1991b, cat. no. 7 (n.p.); Philippe Ségéral in Montargis 1997, cat. no. 93, p. 54

*G*irodet attached great importance to his drawings for book illustration, especially those he designed for the editions produced before his death by Firmin Didot (see cat. 109). A comparison of these sheets with those published posthumously—*Anacreon* of 1825; *Sappho, Bion,* and *Moschus,* all in 1829; and especially the *Aeneid,* beginning in 1826—reveals that Girodet's artistic language gradually moved away from that of his teacher, David, toward foreign influences like the works of John Flaxman and Philipp Otto Runge. Here, the purity of line, which evoked antiquity for many of his contemporaries, reigned supreme.[1]

Perhaps initiated as early as 1811, the *Aeneid* illustrations remained incomplete at Girodet's death.[2] The exhibited sheet depicts a scene from the sixth book of the epic in which Aeneas—whose voyage of initiation has led to Hades—is reunited with the shades (ghosts) of his former comrades while his old enemies retreat. In place of the often elaborately crafted, heroic compositions for the *Oeuvres de Virgil* and the colored pathos of his designs for the *Oeuvres de Racine,* Girodet substituted an open and linear, but sensual Neoclassicism in black and white that, like the work of many followers of David, glorified the young male form.

Just as the quantity of Jean-Honoré Fragonard's drawings designed to illustrate Ariosto's *Orlando*

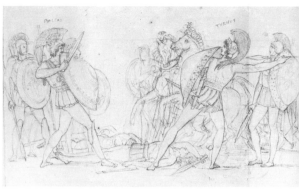

Furioso a generation earlier was uncommonly numerous (cat. 89), the number of Girodet's illustrations for the *Aeneid* was also unusually large. At his death, Girodet's project had resulted in 161 compositions. Of this number, only 76 were reproduced; at least 85 were never translated into illustrations.[3] The posthumous selection of illustrations seems to have been a matter of chance, although it may have depended on the varying state of completion of the drawings. Even though the general outlines of all the compositions are evident, some sheets, like the *Combat between Pallas and Turnus* for the tenth book of the *Aeneid* in the Fogg Art Museum, Cambridge (fig. 1),[4] are less finished than the Horvitz drawing. There is no doubt that the artist—so receptive to new ideas and exceedingly familiar with the text, which he himself had translated from Latin—had established a highly personal reading of Virgil's poem, whose structure is still debated by critics today. The vision that Girodet evolved for the *Aeneid* is a narrative in which image takes the place of text.[5] Like Flaxman's illustrations to Dante's *Inferno,* Girodet created a veritable comic strip, with the difference that his images, while following the sequence, can also stand alone.[6] Unlike his drawings for the *Oeuvres de Racine* (cat. 109), they are no longer restricted to climactic moments in the text. Instead, the emotion and the perception of the drama are diffused throughout a more extended visual chronicle. Following this logic, a large number of illustrations would have been crucial.

The atypically large number of Girodet's drawings demanded an economical means of reproduction, for engraving would have required an unfeasible expense and effort to illustrate the book. Lithography was the solution. Indeed, Girodet was fascinated with the medium ever since its discovery in 1798, and he darkened many of the lines in the majority of the *Aeneid* drawings in preparation for their translation. Curiously, although lithography is admired for its eloquent transcription of shadows and chiaroscuro, Girodet emphasized line, which traditionally belongs to the language of engraving. Is it to Girodet's credit, or to the initiative of his devoted students who proceeded with the production of the *Aeneid* after his death, that we should attribute this unique blend of the goals and techniques of Neoclassicism and Romanticism? In the end, the duality of Girodet's new figural and narrative language was most faithfully served. sb

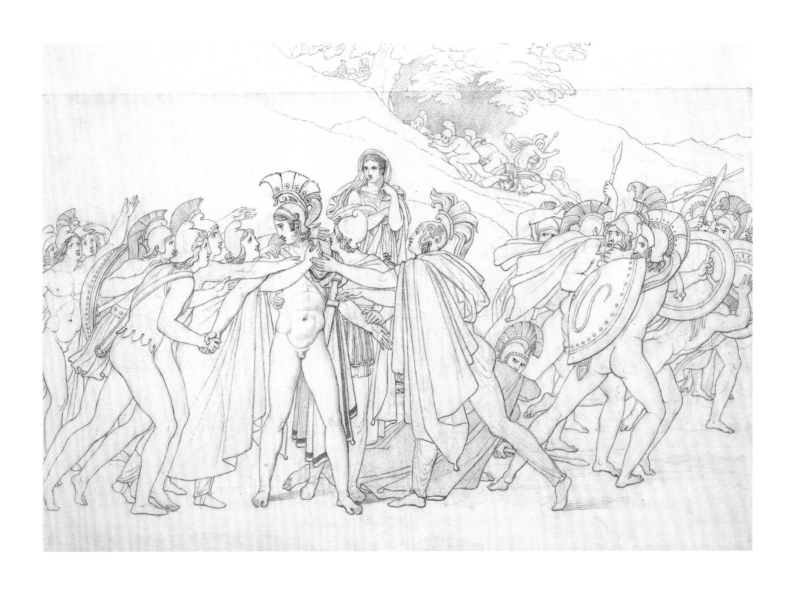

JEAN-VICTOR BERTIN

Paris 1775–1842 Paris

111 *Landscape with the Ruins of the Bridge of Augustus at Narni*

Black chalk on off-white wove paper

346 × 549 mm.

Watermark: None

Inscriptions: Signed and dated in black chalk, bottom right: *Bertin/ 1816*

Provenance: W. M. Brady and Co., Inc., New York; acquired in 1996 (D-F-426/ 1.1996.83)

Exhibitions: None

Literature: Unpublished

*I*n this large landscape, Bertin has drawn, or more precisely, redrawn, one of the central Italian sites he helped to make famous: the ruins of what is known as the Bridge of Augustus at Narni, near the border between Umbria and Latium. Approximately fifty miles north of Rome, the ancient bridge was constructed during the reign of Augustus, first emperor of Rome. This monumental structure—originally nearly 450 feet long and 80 feet high—enabled the Via Flaminia to cross the Nera, a tributary of the Tiber River. In Bertin's time, a few of the bridge's travertine-clad arches still stood.

One of the first artists to extol Narni as a useful place for artists to visit was the landscapist Pierre-Henri de Valenciennes, who succeeded Doyen (cat. 82) as Bertin's teacher at the Académie in 1788. Valenciennes had a thorough knowledge of Italy, where he had lived on two occasions (1777–81 and 1782–86).[1] In his *Réflexions et conseils à un élève sur la peinture et particulièrement sur le genre du paysage* (Reflections and Advice for a Student on Painting, and Particularly on the Genre of Landscape) of 1800,[2] Valenciennes recommended seeing "the classical ruins at Narni" firsthand and making numerous studies of them. Although Bertin did not travel to Italy until after 1800, and the details of his visit cannot be documented with certainty today, at the Salon of 1810, he displayed a painting (now lost) entitled *Scene in the Vicinity of Narni, Including a Bridge Built on the Nera*,[3] and at the Salon of 1814, he presented *View of Part of the Bridge of Augustus on the Nera at Narni*,[4] which is probably the same as one now in a private British collection.[5]

One might speculate that the exhibited drawing, dated 1816, is compositionally related to the painting shown in 1810. The depiction of the region is accurate in its essential details: on the right, the first arch of the ancient bridge is precisely rendered; in the background appears a second bridge—more recent, lower, and less imposing; and further toward the back, on the left, a fortified tower overlooks the newer bridge. This general disposition is also found in contemporary lithographs,[6] but those prints show that Bertin

reversed the position of the mountains commanding the valley between Narni and the point at which the Nera and Tiber rivers join. In the drawing shown here, we see the mountains upstream in relation to the bridge, whereas, in reality, they are downstream. Bertin also depicted the group of houses on the right farther downstream than their actual location (on the other side of the intact arch).

Bertin's draftsmanship is a model of controlled linear elegance. In contrast to artists like Lantara (cat. 83), who delighted in the depiction of nature untamed, Bertin's depiction of the Nera River and the area surrounding the Bridge of Augustus represents a domesticated nature. The ripples in the water and most of the shading that gently punctuate the composition and carry the eye across the sheet are achieved by scores of thin and carefully placed hatching lines. Two of the types of trees that appear in the exhibited landscape can be found in detailed studies prepared for Bertin's *Recueil d'études d'arbres* (Collection of Tree Studies) of 1816–24.[7] His *Study of a Plane Tree* (fig. 1)[8] and his *Landscape with a Poplar and Willow Tree at the Edge of a Pond* (fig. 2)[9] reveal the kind of methodical procedures underpinning this very academic approach. These studies resulted in impeccably finished sheets like the exhibited drawing and his *Classical Italian Landscape* (Musée des Beaux-Arts et d'Archéologie, Besançon, fig. 3),[10] which demonstrate how Bertin and many of his contemporaries preferred to depict a vision of nature and antiquity that was tranquil and ordered.[11]

Given the significance of the Bridge of Augustus at Narni for his teacher Valenciennes, it is not surprising that Bertin often returned to this theme. The first time may have been at the end of the second decade of the nineteenth century, when he was thinking about new decorations for the Château de Maisons. The

1

2

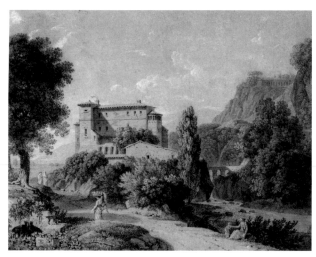

3

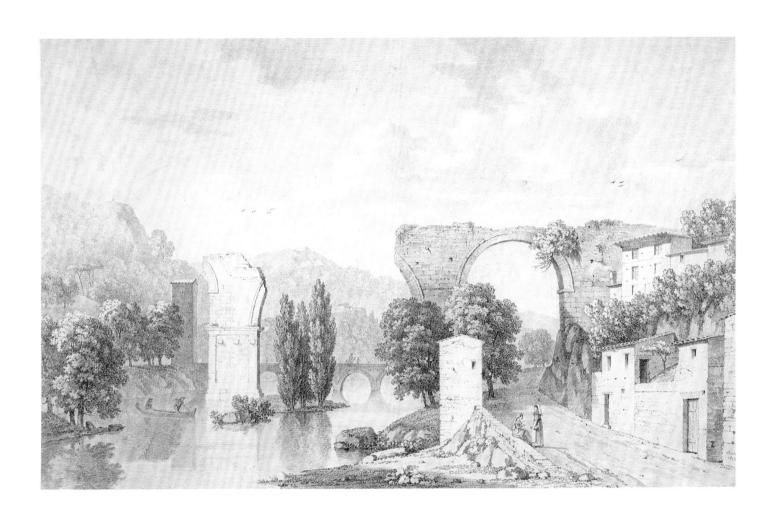

banker, Jacques Laffite, who had just purchased the chateau, wished to have the main Gallery redecorated and asked Bertin and Jean-Joseph-Xavier Bidauld, another follower of Valenciennes, to paint landscapes that evoked Italy.[12] Among other scenes he completed for this commission, Bertin depicted the ruins of the Bridge of Augustus in a canvas signed and dated *1819* that is now on deposit at the Musée du Louvre, Paris (fig. 4).[13] This painting portrays the bridge's principal arch surrounded by cascading waters, which are being crossed by a solitary horseman. Eight years later, at the Salon of 1827, he exhibited a canvas (now lost) entitled *View of the Town of Narni*.[14]

Valenciennes's insistence on the grandeur and importance of Narni influenced many of Bertin's contemporaries, as well as artists of the following generation. Jean-Thomas Thibault depicted the site in a drawing from the last decade of the eighteenth century (Fogg Art Museum, Cambridge, fig. 5),[15] and at the Salon of 1827, where Bertin exhibited his *View of the Town of Narni*, Jean-Baptiste Corot also displayed his impressive *Bridge at Narni* (National Gallery of Canada, Ottawa)—a work that was painted from the celebrated sketch in the Musée du Louvre (fig. 6).[16]

JFM

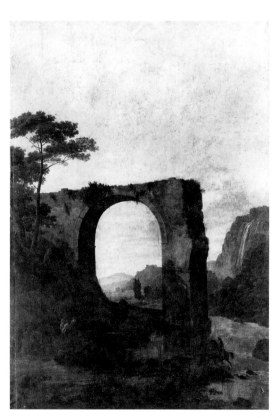

4

5

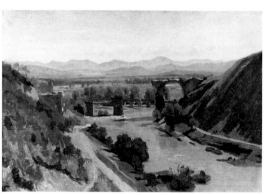

6

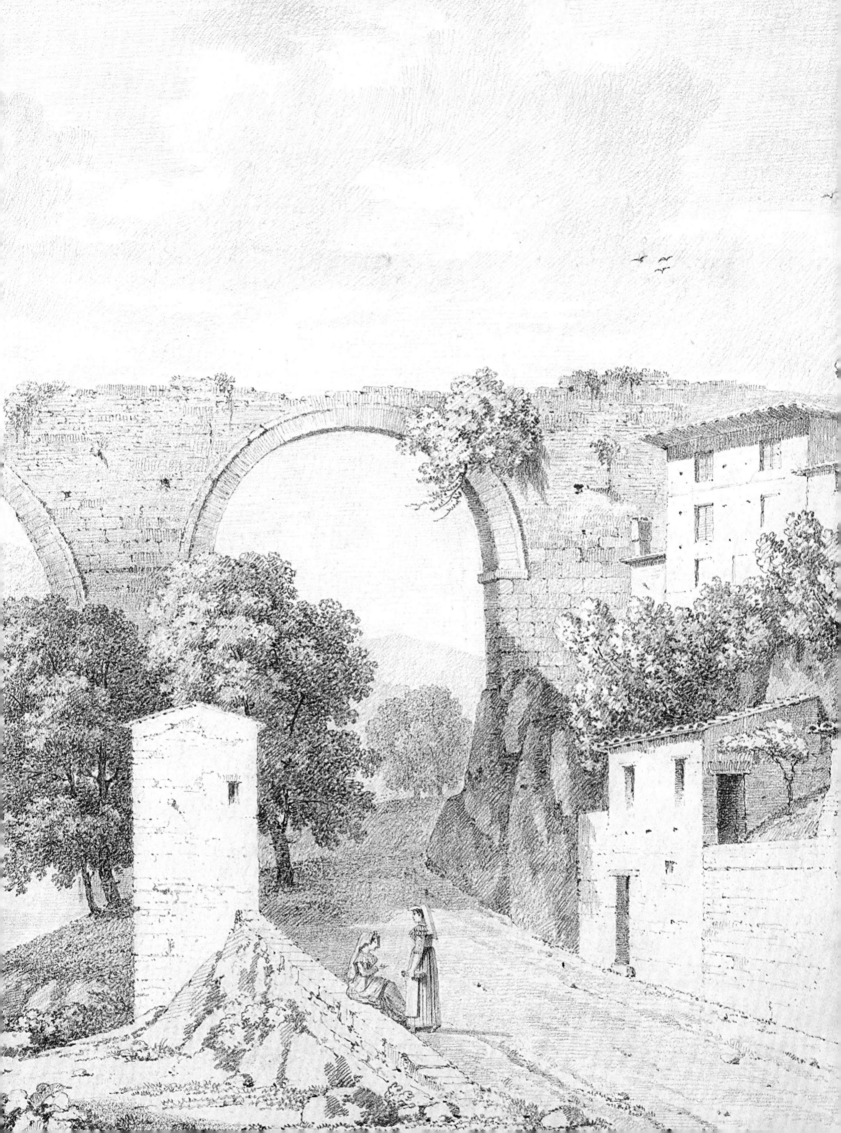

ALEXANDRE-EVARISTE FRAGONARD

Grasse 1780–1850 Paris

112 *Anacreon Warming Amor*

Black chalk and charcoal, extensively stumped, with pen and black ink and brush with brown and gray wash, heightened with white gouache and white chalk, on off-white wove paper

459 × 549 mm.

Watermark: Laid down—none visible through mount

Inscriptions: None

Provenance: Private Collection, France; sale, Sotheby's, Monaco, 22 February 1986, lot 11; acquired at the sale (D-F-99 / 1.1993.49)

Exhibitions: Paris, Salon of 1808, no. 220

Literature: Sylvie Brame, Isabelle Mayer, Althea Palmer, Kate de Rothschild, and Alan Salz in New York et al. 1996, under cat. no. 43 (n.p.)

Anacreon, a Greek lyric poet of the sixth century B.C., who served at the courts of Polycrates of Samos and Hipparchus of Athens, wrote chiefly about love and wine. Only fragments of his odes and hymns survive, but in the eighteenth century, his name was adopted to describe a cult of all things Greek. Anacreontism reached its height in the 1790s, a time when distinctions were made between the cultures of Republican Rome and the monarchies and city-states of ancient Greece,[1] and when new translations into French of works by Anacreon and other ancient poets inspired imitations in poetry, opera, and theatrical productions.[2] His influence was also felt in painting and sculpture, not only in subject matter but also in the proportions of idealized male figures, which became more graceful, serpentine, and androgynous.[3] The subject of the aged poet, his head wreathed with grapes, and Amor, the young god of love, became extremely popular in Neoclassical art. The theme could carry many meanings, from an allegory of Winter (an old man with a burning brazier) to homoerotic love (as in the mature Greek *erastos* and his younger *eromenos*).[4] This subject is depicted in a drawing of 1777 by the sculptor Augustin Pajou (see cat. 85), which is also in the Horvitz Collection (fig. 1).[5]

In the exhibited work by Evariste—son of Jean-Honoré Fragonard (cats. 86–89)—Amor is a child barely two or three years old; he is not even an idealized putto. The poet is portrayed as a sympathetic old man, his face characterized by intelligence and *gravitas.* This expression, together with the stylized treat-

1

ment of the beard as a mass of curls, connects it to the celebrated head of the Jupiter of Versailles (Musée du Louvre, Paris, fig. 2), a colossal fragment of a Roman monument that entered the royal collection in the late seventeenth century, when Louis XIV had it restored by Jean Droully and set up as a herm in the park at Versailles in 1685.[6] Such classical allusions would have come naturally to an artist who entered the studio of David (cat. 100) at the age of thirteen. If he had not seen the original Jupiter, he would surely have known a plaster cast of it.

In style as well as subject, the Horvitz drawing is typical of Evariste's early years, when he exhibited works in the Neoclassical style at the Salons (1793–1812). This sheet was shown in the Salon of 1808 along with his *Oedipus and His Daughters,* a drawing analogous in style and technique and also based on Greek literature.[7] As *Anacreon Warming Amor* demonstrates, Evariste is essentially a draftsman, which reflects his training with David more than the influence of his father, which appears in his later works.[8] Dramatic lighting, often from internal sources like the cauldron in this work, allows the artist to brilliantly exploit atmospheric effects in empty space while simultaneously developing a subtle chiaroscuro that models these palpable figures. This drawing and his *Psyche before Venus* of c. 1797 in the Musée du Louvre, Paris (fig. 3),[9] both demonstrate that the younger Fragonard was a master of stumping black chalk and blending it with other media to heighten volumes and produce a meticulous, polished finish. That the gifted and versatile Evariste was also a sculptor should come as no surprise.[10] EW

2

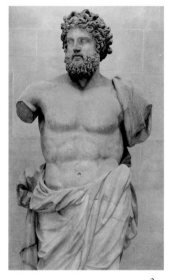

3

PHILIBERT-LOUIS DEBUCOURT

Paris 1755–1832 Paris

113a *Maternal Joys*
113b *Paternal Pleasures*

113a: Black chalk, stumped and heightened with white gouache, on off-white wove paper

450 × 360 mm.

113b: Black chalk, stumped and heightened with white gouache, on off-white wove paper

455 × 365 mm.

Watermark (113a and 113b): *J. Whatman*
(variant of Gaudriault 2062; also see Churchill, p. 54)

Inscriptions (113a): In black chalk, lower left: *D*

Inscriptions (113b): In black chalk, bottom right: *D B*

Provenance (113a): Probably Baron Franchetti; his sale, Paris, 8–9 May 1894, lot 171 (as *L'heureuse famille*); A. Lion; his sale, Paris, 18–19 November 1908, lot 19 (as *L'offrande au bébé*); repurchased by Lion; his sale, Paris 22–23 May 1919, lot 13 (as *L'offrande au bébé*); Marius Paulme, Paris (L. 1910, dry stamp at bottom right); his sale, 13 May 1929, lot 58 (as *Les joies maternelles*); Private Collection; Galerie Didier Aaron et Cie, Paris, and Kate de Rothschild, London (by 1993); acquired in 1996 (D-F-394/ 1.1996.63)

Provenance (113b): Adolphe Fould; his sale, Paris, 14 May 1875, lot 81 (as *Le Grand-père*); Private Collection; Galerie Didier Aaron et Cie, Paris, and Kate de Rothschild, London (by 1993); acquired in 1996 (D-F-393/ 1.1996.62)

Exhibitions (113a): Paris 1920, no. 33; Paris 1928, no. 135; New York et al. 1993, no. 38

Exhibitions (113b): New York et al. 1993, no. 39

Literature (113a): Paris 1920, p. 55; Jill Dienst, Isabelle Mayer, Kate de Rothschild, and Alan Salz in New York et al. 1993, cat. no. 38 (n.p.)

Literature (113b): Roux 1949, p. 97, under cat. no. 49; Jill Dienst, Isabelle Mayer, Kate de Rothschild, and Alan Salz in New York et al. 1993, cat. no. 39 (n.p.)

Maternal Joys and *Paternal Pleasures*, a pair of Debucourt's drawings celebrating the bliss of family life in France at the very end of the eighteenth century, were reunited in 1993 after being separated for more than a century. His *Paternal Pleasures*, in which the child is depicted as an infant, was engraved in reverse as a four-color print of the same title and is traditionally dated to 1796 (fig. 1).[1] The print differs from the exhibited sheet in many details of the costumes worn by the parents. In the drawing, they are depicted wearing clothes characteristic of a comfortably situated bourgeois family. The mother's elaborately beribboned cap cannot contain the luxuriant curls of her hair, which falls to her shoulders. A kerchief modestly covers her breasts, and a long, handsomely patterned shawl is draped across most of her

figure. The father is outfitted in the modish manner of an English country gentleman—replete with a hound leaning in his lap—in a high-collared coat, stylishly patterned waistcoat, tight-fitting breeches and boots, and a top hat casually lying on the ground beside him. The exposed hose and slippers of the perhaps more conservative grandfather playing with the baby suggest an interesting generational and political difference. In the color print, Debucourt altered several of these details. The mother is now more modestly attired, and only a few curls escape from her simpler mobcap. The father no longer sports a fancy waistcoat but instead wears a striped shirt very similar to those worn by the Jacobin supporters of the Revolutionary goals of 1789.[2] In the aftermath of the Revolution and the Reign of Terror that followed (1792–94), the artist evidently revised these details of costume to reflect his sympathies with the emerging social and political order that would, he must have hoped, be the potential market for his color print.

Debucourt's *Maternal Joys*, where the child has grown into a small boy, was also engraved in reverse, but the identity of the printmaker poses a question because the margins of the one known impression have been trimmed and thus any references to Debucourt as the creator of the image and to the identity of the engraver have been lost (fig. 2).[3] The color print is not listed in Fenaille's catalogue of Debucourt's work, but its dimensions correspond closely to the exhibited drawing, as well as to the engraving after *Paternal*

3

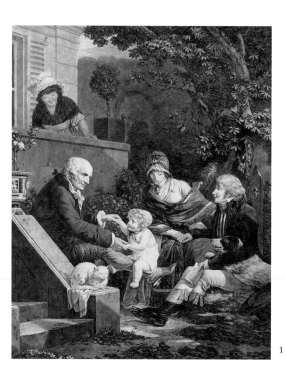

1

346

Pleasures.[4] The composition of this print also follows the drawing except for minor details.[5] In the engraving, the seated woman wears a blouse with a high neck and a pleated ruff, a barrow of flowers has been added to the lower right, and the grape vine across the upper part of the composition is more detailed. In the drawing, details of the women's dresses suggest that it too was created in the mid-1790s. In 1796, when inflation was rampant, the artist may have considered the times unpropitious to undertake the publication of another labor-consuming print.

Scenes extolling the pleasures of family life abound in Debucourt's oeuvre. One of his pre–Revolutionary prints, *Le compliment ou la matinée du Jour de l'An* of 1788 (fig. 3),[6] shows a young child surrounded by loving parents, a theme that can be found in works by other artists, such as Jean-Michel Moreau le jeune's designs for several engraved illustrations for his second *Monument du costume . . .* of 1789.[7] The happiness to be found in loving family relationships was also an important subject for such painters as Chardin (cat. 53) and Jean-Honoré Fragonard (cats. 86–89), to mention only the most celebrated names.[8] Both artists created compositions focusing on a child as the center of attention, a theme that was, at the time, far less commonplace in French genre imagery than might be supposed. The appearance of the child as an important, or often central, personage within the family may well reflect the contemporary writing of authors such as Jean-Jacques Rousseau, whose popular and influential novel, *Emile* (1762), urged that parents display greater love, tenderness, and understanding toward their children. Debucourt's prints mirror this view of family relationships, although in the wake of the Revolution, these scenes also had political implications. After the Reign of Terror, a time of mass executions and imprisonments, it became urgently necessary to secure peace before further political reforms could be enacted. Stable family relationships thus became an essential part of the reconstruction of society; the constitution adopted in 1795 declared: "We want to naturalize the family spirit in France. . . . No one is a good citizen if he is not a good son, good father, good husband."[9] This political message was not lost on Debucourt, who in 1795–96 made five other engravings, in addition to those exhibited and illustrated here, of subjects that celebrate familial happiness.[10]

Compared to his oeuvre of nearly six hundred prints, drawings by Debucourt are of great rarity. The only exhibition devoted to the artist, held in Paris in 1920, catalogued a mere twelve drawings (including *Maternal Joys*), with another eight listed as known only from references in the literature and sales catalogues.[11] One of the few drawings by the artist in a North American public collection is the Fogg Art Museum's watercolor, *Garden Party* (fig. 4).[12] One might expect the artist to have made carefully executed studies before embarking on the time-consuming production of a multicolor engraving; but in addition to the two drawings exhibited here, one can cite only the gouache study for the masterpiece among his color engravings, *La Promenade Publique* (1792), which is now in the Metropolitan Museum of Art, New York.[13] The dearth of our knowledge concerning Debucourt as a draftsman makes the recently reunited pendants in the Horvitz Collection all the more significant. Not only does their meticulous execution give us some insight into his working process as a printmaker, but this pair of drawings is a vision—idealized, to be sure—of French society at the beginning of a new era.

VC

4

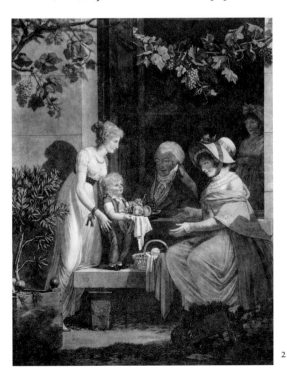

2

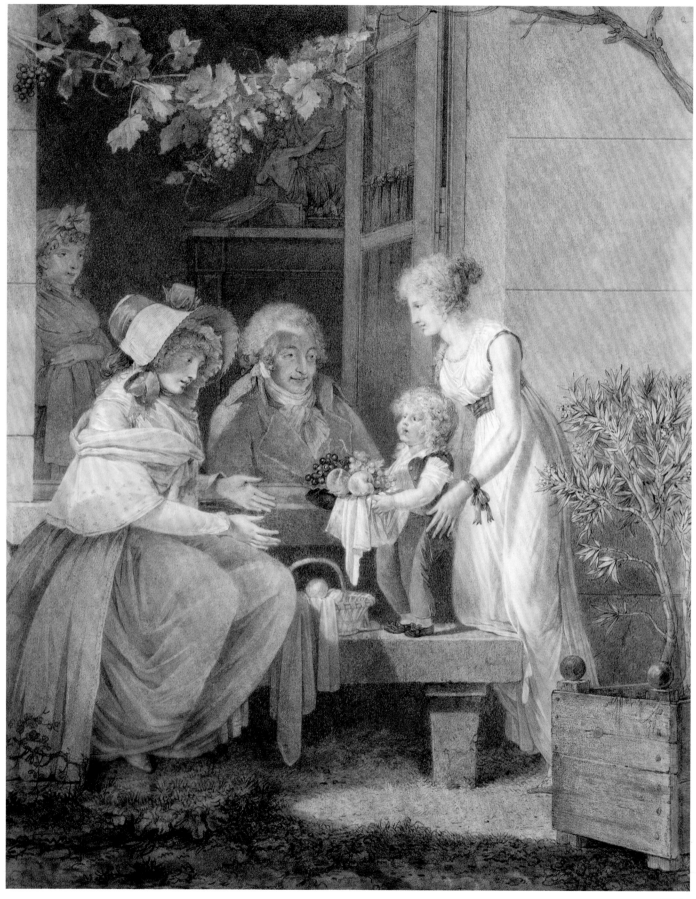

113a

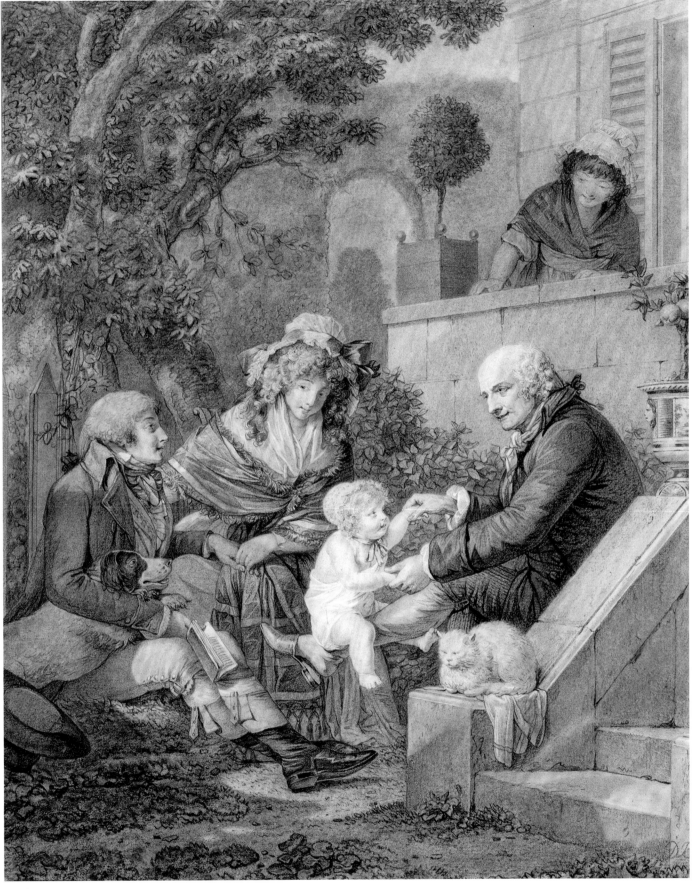

113b

JEAN-MICHEL MOREAU LE JEUNE

Paris 1741–1814 Paris

114 *Ball Given by the City of Paris on the Occasion of the Marriage of Emperor Napoleon to Archduchess Maria Luisa of Austria at the Hôtel de Ville, 10 June 1810*

Pen with brown ink and brush with brown wash, heightened with white gouache, over black chalk on cream laid paper

545 × 820 mm.

Watermark: None

Inscriptions: In pen and brown ink over black chalk, bottom left: *J. M. Moreau Le Jne.1810.*

Provenance: Baron Dominique-Vivant Denon, Paris; his sale, 1 May 1826, lot 839; Private Collection; Galerie Didier Aaron et Cie, Paris; acquired in 1996 (D-F-396/ 1.1996.66)

Exhibitions: Salon of 1810, no. 588; Tokyo 1994, no. 87

Literature: Mahérault 1880, cat. no. 489, p. 485; Moureau 1893, p. 132; Aaron 1975

On 10 June 1810, the city of Paris gave a ball to honor the marriage of Emperor Napoleon to Archduchess Maria Luisa of Austria. Shortly thereafter, Jean-Michel Moreau le jeune, who in earlier years had enjoyed considerable success documenting similar ceremonies and festivals at the royal courts of both Louis XV and Louis XVI (*Arrival of Marie-Antoinette at the Hôtel de Ville, Paris, 1782*, Private Collection, fig. 1),[1] recorded the imperial event in the exceptionally large and highly finished drawing exhibited here. Moreau, then age sixty-nine, made it and its pendant, *Reception for Emperor Napoleon at the Hôtel de Ville, Paris, in Celebration of the Peace in Vienna, 4 December 1809* (fig. 2),[2] in the hope of reviving his faltering career by winning favor and obtaining future commissions from the emperor and his court. Although the drawings won for Moreau a first-class medal at the Salon of 1810, where they were exhibited in August, he did not succeed in procuring further court patronage.

In these two drawings, Moreau combined his twin talents of observer and illustrator to capture the flavor of fashionable, formal gatherings at the height of the Napoleonic Empire. With minute touches of his pen and brush, he set down a multitude of individual figures, each one with distinctive dress, coiffure, gesture, pose, and expression. The guests are drawn with such precision that one would have expected them to be readily recognizable as specific members of the court. Napoleon himself is easily identifiable in both drawings: enthroned at left of center in the reception scene and—as he did not like to dance—seated in lonely splendor in the middle of a row of empty armchairs at the ball. Only his new wife's silk shawl, draped on the chair next to him, keeps him company while Maria Luisa dances at the center of the ballroom floor. But the facial features of most others in atten-

dance—including Napoleon's brothers and sisters and their spouses, as well as other prominent members of the court—are not sufficiently individualized to distinguish them with certainty.

The infinite care and precision with which Moreau drew the figures and their fashions continued into his rendering of the spaces in which the events took place, providing a remarkable record of the interior decoration of two large public rooms at the height of the Napoleonic era. Indeed, the settings share equal prominence with the figures, for in each drawing, Moreau has divided the composition horizontally, confining the crowds of figures to the lower half of the sheet while devoting the entire upper half to the architecture and the interior decor. For the clean lines and symmetrical forms of the Neoclassical architecture, Moreau used an elegant, neatly ruled drawing style that matched its crisp linearity and contrasts markedly with the more animated, rounded forms of the figures. He allowed his pen greater freedom in the delineation of the chandeliers, sconces, and torchères that illuminate the scenes, and he took special delight in a complex combination of gouache with silhouetted and light-dissolved forms to create the effect of glowing candles. Ironically, the chandeliers in the exhibited ball scene appear to be identical in form and details to the ones that Moreau had drawn nearly thirty years before, in 1782, when a *bal masqué* was held in the Hôtel de Ville—but not, apparently, in the same room unless it was greatly transformed—to celebrate the birth of the dauphin, heir to Louis XVI and Marie-Antoinette (engraving, fig. 3).[3]

1

2

The two drawings by Moreau le jeune in the Horvitz Collection belong to a grand tradition, begun in the Renaissance, of recording court and civic festivals and celebrations in drawings, prints, and paintings.[4] Two examples from the reign of Louis XV by Charles-François Hutin (cat. 70) and Charles-Nicolas Cochin le jeune (cat. 72) are also in the collection. Planned with great care, these events often included the construction of temporary structures—such as the huge sculptural embellishments above Napoleon's throne depicted in figure 2—and a new or completely refurbished interior decor that would be suitable to the style of the time and the personage being honored. In these works, Napoleon's personal symbols, the eagle and the bee, form part of the ornamental schemes, especially in the audience room, where they both have a place of prominence. The eagle appears less conspicuously in the ballroom, having been placed above the cornice, where it alternates with the double-headed eagle of the Hapsburgs, family of the new empress.

Napoleon himself was aware of the propaganda value of permanent records of certain official ceremonies and celebrations, and he was well served in this arena by Charles Percier and Pierre Fontaine, who not only designed and decorated some of his imperial residences but also orchestrated many official functions. They also made drawings of the events, which were then engraved and published in grand com-

memorative albums. Moreau probably knew the album they produced in 1807 of the coronation of Napoleon and Josephine (Maria Luisa's predecessor, whom Napoleon had divorced because of her inability to produce an heir), for several of those images strike a similar stylistic chord with those produced by Moreau. Indeed, by the time Moreau produced the exhibited drawing and its pendant, every vestige of his eighteenth-century artistic personality had given way to the new Neoclassical mode. He must have realized that if he wanted to rejoin the ranks of favored court artists, his art had to appeal to the current arbiters of taste. It is not surprising, therefore, that the two Horvitz drawings, which rank among Moreau's most ambitious and are the last he made of this type, conform so closely to the style of Percier and Fontaine, even to a similar elongation of the figures and the same emphasis on the architectural settings. Unfortunately, however, Percier and Fontaine produced their own album of prints recording the wedding of Napoleon and Maria Luisa (fig. 4),[5] and Moreau failed to achieve his goal of breaking into the rather closed artistic circles at Napoleon's court. His drawings were never engraved, and he had to be satisfied instead with the approbation of the director of the Musée Napoléon (precursor to the Louvre), baron Dominique-Vivant Denon, who acquired both drawings for his private collection. MMG

3

Cérémonie du Mariage Civil de S.M. l'Empereur Napoléon et de S.A.I. Marie-Louise d'Autriche, dans la Galerie du d'Ænsd.

4

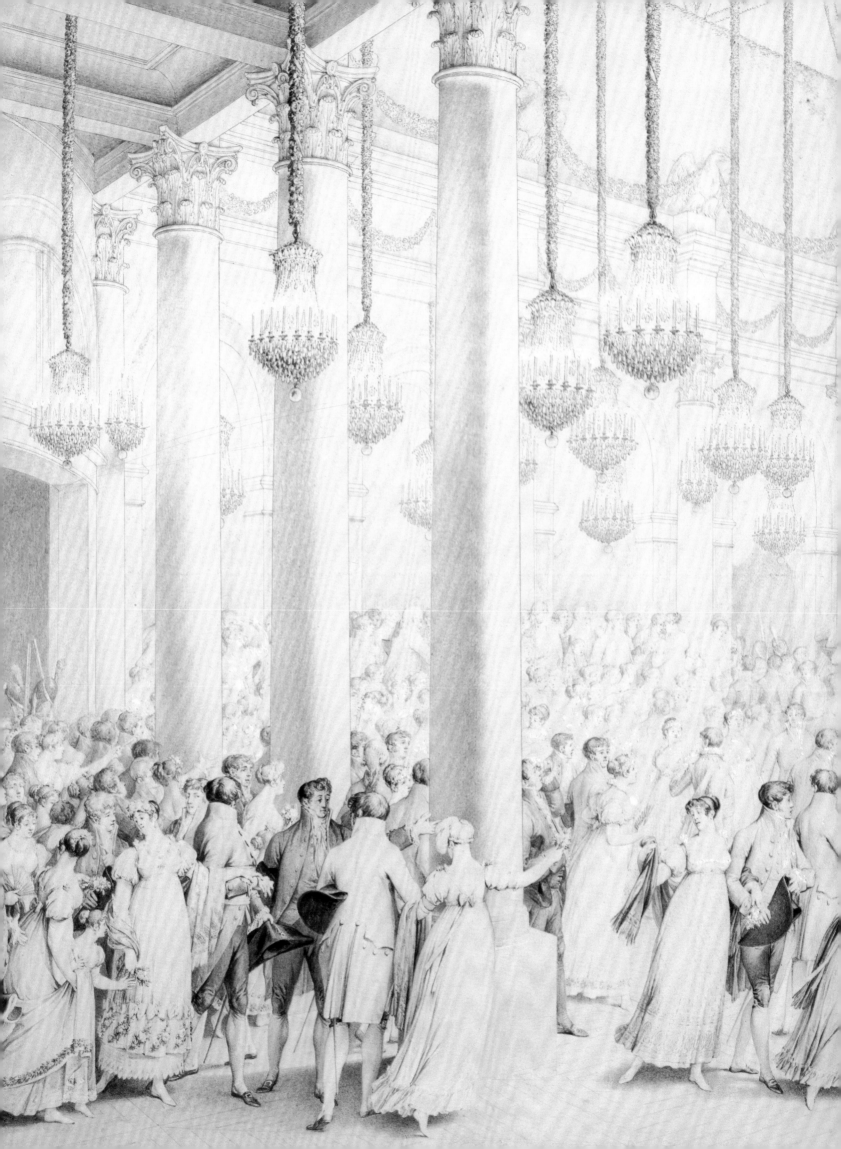

ANTOINE-CHARLES-HORACE, called CARLE VERNET

Bordeaux 1758–1836 Paris

115 *Scene of Combat in Egypt*

Black chalk, stumped, and brush with brown and gray wash, heightened with white gouache, on three joined sheets of off-white wove paper

718 × 970 mm.

Watermark: Laid down—none visible through mount

Inscriptions: In pen and black ink, bottom right: *Carle Vernet*

Provenance: Galerie Didier Aaron et Cie, Paris; acquired in 1993 (D-F-284/ 1.1993.164)

Exhibitions: None

Literature: Bull 1993

*T*he political turmoil in France from the beginning of the Revolution through the first twenty years of the nineteenth century was reflected in a multitude of subtle and overt ways in the work of artists active during those three decades. The Napoleonic era was particularly notable for the variety of its styles and themes.[1] One of the traditional genres that gained in importance during Napoleon's reign was battle painting, especially works that depicted or related to the military achievements of the emperor. This large, powerful, and finished drawing by Carle Vernet showing French and Egyptian soldiers in the midst of battle evokes the short-lived French conquest of Egypt.

In the late 1790s, the administration of the unstable Directory feared the popularity of Napoleon Bonaparte, then one of the most successful generals in the French army, and wanted to keep him away from Paris. It was decided that he should leave the capital on a military expedition aimed at checking the expansion of England's vast empire. Leaving his first wife, Josephine, and two of his brothers to look after his political interests, he departed France with more than 50,000 soldiers in May 1798. He avoided the powerful British fleet by sending out false intelligence about his mission. By early June, he had defeated the Knights of Malta, and by the end of July he had conquered both Cairo and Alexandria. Malta and Egypt were now French possessions. In addition to introducing a number of administrative reforms, Napoleon founded the Institute of Egypt and invited French and Egyptian scientists, archaeologists, and artists to explore the rich culture of the country. They recorded their findings in the twenty-four folio-sized volumes of the *Déscription de l'Egypt.* Their discoveries included the Rosetta Stone—a black basalt stone with the same text in three scripts (demotic, hieroglyphic, and Greek)—which enabled the first reliable translations of hieroglyphics. Newspapers subsidized by the future emperor gave lavish press coverage to these cultural and military triumphs. Napoleon's desire to advance

into the Middle East was thwarted by the devastating losses at Acre in Turkey and the cunning strategy of Admiral Nelson at sea. By May 1799, British and indigenous forces were chipping away at the new French conquests in Egypt and the Mediterranean, and by October, Napoleon returned to Europe at the request of the Directory in order to protect threatened French territories in Italy.

In the exhibited drawing, Vernet obviously delighted in portraying the elaborate white Hussard costumes of the French soldiers, the exotic dark costumes of the Mameluke warriors, and the agile forms of the Arabian horses. However, while this particular composition champions the heroism of the French soldiers fighting in Egypt, it does not glorify war. On the left, one Frenchman lies dead or dying from an arrow protruding from his chest, while four soldiers armed with rifles advance over him and fire at the invading Mamelukes. Two of the Mameluke cavalrymen have been felled in mid-charge, but others press forward in the foreground on foot and in the background on horseback, so the danger has not yet been averted. The Mameluke armed with a knife in the foreground, who was not shot in the first volley, is a particularly unnerving element in the composition. In an effort to prevent further incursions, a group of soldiers in the left background attempts to raise the drawbridge with a broken chain just as a mounted Mameluke attempts to charge across. Vernet excelled at the depiction of horses, and the combination of charging and rearing thoroughbreds is an essential component of this composition, adding an element of rapid movement, instability, and drama to the scene.

1

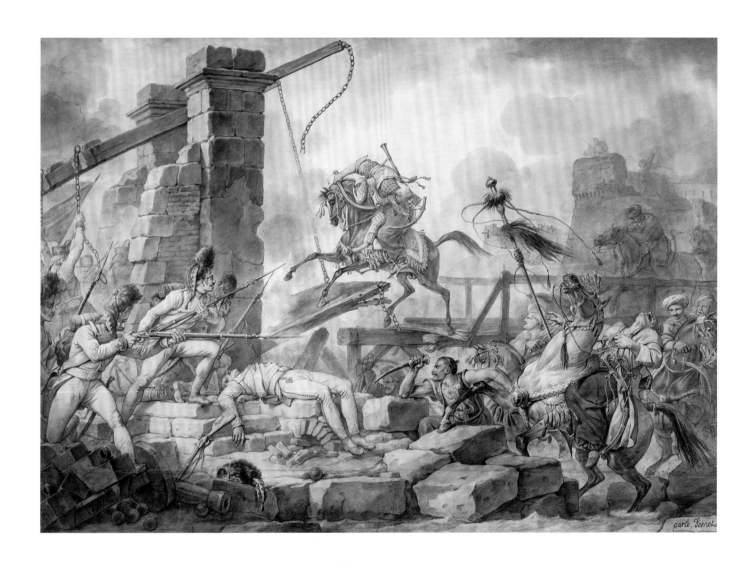

2

Vernet's seamless blend of stumped black chalk with gray and brown washes helps to define the various registers of the action and heightens the realism of the scene by evoking the smoke and dust of battle. His command of these techniques of rendering tone recalls his predilection for the new medium of lithography. However, Vernet himself did not execute a print after this composition. It was reproduced in an aquatint on the same large scale by Philibert-Louis Debucourt (fig. 1; also see cat. 113), who made more than one hundred prints after Vernet's works. Debucourt's print was exhibited in the Salon of 1819 with an aquatint pendant after Vernet's lost *Combat of a Hussard and a Mameluke* (fig. 2).[2] The inscription under the print after the Horvitz drawing reads: "Nine Frenchmen surprised by the Anglo-Turkish army take refuge in an old fort where they sustain the attack and after having lost two men obtain an honorable capit-

ulation."[3] A. Regnier also produced a lithograph after this celebrated drawing (fig. 3), and an engraving by Debucourt, *Charge of the Mamelukes* (fig. 4) records another lost composition on a similar theme by Vernet.[4]

When the artist was nearing death, he is reported to have mused about the resemblance of his life to that of the dauphin, son of Louis XVI. Just as the dauphin was the son of one king, father of another, but never king himself, Vernet lamented that he was the son of a great artist—the marine and landscape specialist Joseph Vernet—and father of another—the celebrated Salon painter Horace Vernet—but that he had failed to equal their achievements.[5] More than 160 years after his death, the lack of scholarly interest in his work suggests his prescience about his later reputation. Although Vernet was one of the most favored and honored talents of the Restoration, acknowledged as the most significant influence on the young Géricault,[6] and credited with bringing verisimilitude to battle painting in acclaimed works like the *Battle of Marengo* (1808) and the *Capture of Pamplona* (1824), there is no monograph or recent article focused on him.[7] This makes dating works like the popular Horvitz sheet quite difficult. To be sure, the subject attests that it was executed after Napoleon's invasion of Egypt in 1798, and it was completed before 1819, when Debucourt's aquatint was exhibited. The superb and highly finished execution, as well as the large scale of the figures in this impressive sheet—neither of which is evident in his drawing for the *Battle of Marengo*[8]—suggests that it probably dates to the second decade of the nineteenth century, close to the date of Debucourt's print. ALC

4

3

NOTES TO THE CATALOGUE

1. For a recent summary of Bellange's life and work, see the essay and entries by Jacques Thuillier and the biography by Michel Sylvestre in Nancy 1992b, esp. pp. 134–92, 312–15, and 382–88.

2. The sheet was skillfully removed from its mount by Anne Driesse in the Straus Center for Conservation at the Harvard University Art Museums. I would like to thank Alvin Clark and Hilliard Goldfarb for generously sharing their opinions on this drawing.

3. *Encyclopaedia Britannica*, 14th ed., 1938, p. 255; Réau 1955, vol. 3, pp. 1190–99.

4. For a history of the cult of St. Sebastian in Lorraine, see Philip Conisbee in Washington 1996, pp. 88–89; for a description of the church in Nancy, see Marot 1970, pp. 123–29.

5. About thirty extant paintings reveal that Constant was a capable but an uninspired painter, primarily of altarpieces. Although he worked for the cardinal of Lorraine, a member of the ducal family, court documents attest to the fact that the dukes preferred Bellange to do the interior decoration of the palace, the subjects of which were generally secular. On one occasion in 1606, the two artists worked together on decorations for the entry of Duchess Margherita Gonzaga of Mantua into Nancy. No evidence exists to indicate competition between the two artists; indeed, Bellange was godfather to Constant's son Jacques in 1612. See Michel Sylvestre in Nancy 1992b, pp. 366–74 and 390–93.

6. First identified by Michel Sylvestre in Nancy 1992b, p. 366; for von Aachen, see Kauffmann 1988, esp. chaps. 3 and 4, and pp. 133–63.

7. Jacques Bellange, *Martyred Saints Attest to Their Faith*, pen and brown ink with brush and brown wash over black chalk, 347 × 264 mm., Graphische Sammlung, Städelsches Kunstinstitut, Frankfurt, inv. no. 4360. This sheet—and the Louvre version of the composition (see below, n. 9)—were also based on an engraving by Cornelis Cort after Federico Zuccaro's *Coronation of the Virgin*; see Margret Stuffmann in Frankfurt 1986, cat. no. 7, pp. 13–14, and Jacques Thuillier in Nancy 1992b, pp. 138–39. The print is reproduced by E. James Mundy in Milwaukee and New York 1989, under cat. no. 60, p. 194.

8. For Bellange's *Raising of Lazarus* (Metropolitan Museum of Art, New York, inv. no. 1994.209), see de Montebello 1995, p. 33, and Jacques Thuillier in Nancy 1992b, cat. no. 8, p. 150, where the title is given as the *Lamentation of Christ*. The subject was recently correctly identified by Perrin Stein.

9. Jacques Bellange, *Martyred Saints Attest to Their Faith*, pen and brown ink with brush and brown wash over black chalk, 355 × 245 mm., Département des Arts Graphiques, Musée du Louvre, Paris, inv. no. 11537; see Jean-François Méjanès in Paris 1984a, cat. no. 18, pp. 23–25, and Jacques Thuillier in Nancy 1992b, under cat. no. 2, p. 138.

10. Jacques Bellange, *Entombment of Christ*, pen and brown ink with brush and brown wash over traces of underdrawing in black chalk, 190 × 275 mm., Cabinet des Dessins, Musée des Beaux-Arts, Dijon; see Jacques Thuillier in Nancy 1992b, cat. no. 3, pp. 140–41.

11. Jacques Bellange, *Cavalier Holding a Lance*, pen and brown ink with brush and brown wash, 312 × 228 mm., Donation Henri and Suzanne Baderou, Cabinet des Dessins, Musée des Beaux-Arts, Rouen, inv. no. 975.4.556; see Pierre Rosenberg in Washington et al. 1981, cat. no. 2, pp. 3–4 and p. 112, and Jacques Thuillier in Nancy 1992b, cat. no. 105, pp. 312–13. Jacques Thuillier dates the Louvre and Frankfurt versions of the *Martyred Saints Attest to Their Faith* at about 1600; he puts the Rouen sheet at 1600–5; and he places the Metropolitan Museum's drawing and its companion drawing, the *Adoration of the Shepherds*, in the Museum of Fine Arts, Boston, at 1606–8. For references to the individual sheets already cited, see notes 7 through 10 above; for the Boston work, see Nancy 1992b, cat. no. 9, p. 151.

12. Is this cavalier the emperor? His outstretched arms and the horse's arched neck are not dissimilar to the mounted Diocletian in the center distance of Muller's print. His lance may be the baton of a general, and his headdress—truncated by the edge of the sheet—may be an imperial crown.

13. On the Académie and drawing, see the essay by Alain Mérot and Sophie Raux-Carpentier in this catalogue.

1. Notable recent contributions include those by Denis Lavalle in Nancy 1992b, pp. 194–209; and Patrick Ramade in Meaux 1990, pp. 118–37.

2. Georges Lallemant, *River God*, black chalk and gray wash, 298 × 170 mm., Department of Drawings, Nationalmuseum, Stockholm (see Bjurström 1976, cat. no. 462, and Bjurström in New York and Edinburgh 1987, cat. no. 17, p. 43, repr.). It is worthy of note that the Nationalmuseum in Stockholm has sheets by Nicolo dell'Abate, Antoine Caron, and Jacques Bellange that are also cut to the contour (see Bjurström 1976, cat. nos. 8, 15–23, 117–20, all repr.; and Per Bjurström in New York and Edinburgh 1987, cat. nos. 8, 11, 12, 15, and 16, pp. 30–31, 34, and 41–43, all repr.). All share an early provenance that includes the collector Prince Victor-Amadée de Carignan (1680–1741). Could all of them, including the Horvitz sheet, have derived from a single collector who cropped his decorative figure drawings?

3. See Hilliard Goldfarb in Cleveland et al. 1989, cat. nos. 52–53, pp. 109–13. Another such drawing recently entered the market as circle of Georges Lallemant (*A Pilgrim: St. James the Greater*, sale, Christie's, London, 2 July 1996, lot 199).

4. For the Louvre *Warrior*, see Hilliard Goldfarb in Cleveland et al. 1989, p. 113, repr., fig. 53a, and for the Louvre *Holy Family*, pen and brown ink with brush and brown wash over traces of black chalk, oval, 290 × 212 mm., inv. no. 23713, see Nancy 1992b, pp. 206–7, cat. no. 54, repr. The other drawings mentioned include *Deposition*, pen and brown ink with brush and brown wash, retraced with black ink, 315 × 213 mm., Château-Musée, Nemours, inv. no. 975-4-633 (see Jean-François Méjanès in Paris 1993a, cat. no. 8, pp. 50–51, repr.); and *Man in a Plumed Hat*, red chalk, 174 × 135 mm., Musée des Beaux-Arts, Rouen, inv. no. 975-4-637 (see Denis Lavalle in Nancy 1992b, cat. no. 9, pp. 52–53, repr.).

5. Georges Lallemant, *Adoration of the Magi*, oil on canvas, Palais de Beaux-Arts, Lille. For this canvas and Lallemant's *Charity of St. Martin*, see Nancy 1992b, cat. nos. 49 and 51, pp. 198–99 and 202–3; and for the *Finding of Jesus in the Temple* and the *Abraham and Melchisedech*, see Meaux 1989, cat. nos. 31–32, pp. 126–27 and 130–31.

6. For the St. Petersburg version, see Nancy 1992b, cat. no. 50, pp. 200–1, repr.; and for the etching, see Cleveland et al. 1989, p. 111, repr., fig. 52a.

1. Dimier deplored the abundant and monotonous suites of late drawings with large, round eyes, harsh and realistic features, and dark shadows (see Dimier 1924, p. 193).

2. Adhémar 1970; see also Guiffrey and Marcel 1928, vol. 5, p. 52.

3. See Guiffrey and Marcel 1928, vol. 5, cat. nos. 3799–3827.

4. On the consolidation of royal power at the expense of the upper levels of the old nobility, *noblesse d'épée*, in preference to the minor nobility and the ennoblement of the haute bourgeoisie, see Bitton 1969, esp. chap. 3; and Schalk 1986, esp. chaps. 6 and 7.

5. Daniel Dumonstier, *François de La Grange d'Arquien, maréchal de Montigny*, c. 1608, colored chalks, Réserve du Cabinet des Estampes, Bibliothèque nationale de France, Paris. On the maréchal de Montigny, see Bluche 1990, p. 1059.

6. I would like to offer my thanks to Philippe Palasi and Frédéric Mathieu for their assistance with this biographical research.

7. I would like to thank Jean-Paul Leclercq for research on the costume. For more on court costume under Henri IV, which confirms his findings, see the brief discussion by Jacques Ruppert in Ruppert—Delpierre—Davray—Gourguet 1996, pp. 81–83.

1. Although 1562 is a commonly accepted date of commencement, the specific end date of the Wars of Religion in France is debated. I believe, however, that the Wars must be seen as an essential component of the first quarter of the seventeenth century; thus, I have used the dates suggested by Mack P.

Holt; see Holt 1995, pp. 1–7. On the destruction of works of art during this time and the resulting paucity of works of French art from the first quarter of the seventeenth century, see Thuillier 1975, and the extended essays by the same author, "Seventeenth-Century French Painting and Art History: Problems and Method," in Montreal et al. 1993, pp. 19–42, esp. pp. 23–27; and "La Peinture française du XVI siècle en province: un domaine archéologique?" in Dijon 1990, pp. 11–20.

2. See Chennevières 1850, pp. 85–120; for the drawings, see Jacques Thuillier in Bourges and Angers 1988 (the pivotal modern study of the artist), pp. 159–221.

3. Jean Boucher de Bourges, *Recumbent Male Nude with Elevated Left Arm*, black chalk heightened with white chalk on tan antique laid prepared paper, laid down on off-white antique laid paper, 123 × 301 mm., Cabinet des Dessins, Musée du Berry, Bourges, inv. no. 900.13.25; and *Frontal Standing Seminude Male Holding a Scythe*, black chalk heightened with white chalk on yellowish-red prepared antique laid paper laid down on off-white antique laid paper, 378 × 215 mm., Cabinet des Dessins, Musée du Berry, Bourges, inv. no. 900.13.15. This sheet is also inscribed in pen and ink at top right: *76*. See Jacques Thuillier in Bourges and Angers 1988, pp. 188 and 192–93.

4. Jacques Thuillier in Bourges and Angers 1988, pp. 161–68.

5. Hilliard Goldfarb in Cleveland et al. 1989, pp. 107–8.

6. For more on this impressive, large, and very personal work, which also includes portraits of the artist and his mother, and was later etched by the artist, see Jacques Thuillier in Bourges and Angers 1988, cat. nos. P.35 and G.7, pp. 130–35 and p. 265, all repr.

7. The vast majority of Boucher's extant drawings were brought together and published by Jacques Thuillier in Bourges and Angers 1988, pp. 159–221; for the drawings by students and assistants in his atelier, see pp. 223–46.

8. The dates of Boucher's travels have been established based on the inscriptions placed on his drawings (unless otherwise stated, the following references are to Jacques Thuillier in Bourges and Angers 1988). These dates suggest trips to Rome in 1596 (*boucher me fecit Romae 1596.*, cat. D.2); Rome again in 1600, after being documented in Bourges in 1598 and 1599 (*boucher me fecit Romae 1600*, cat. nos. D.3, D.4, and D.5); Fontainebleau in 1602, based on a sheet after a Raphael painting in the French royal collection placed in the chateau (*boucher me fecit 1602*, cat. no. D.6); reputedly in Rome again in 1621, according to the distinguished historian of Berry, G. Thaumas de la Thaumassière, who owned Boucher drawings and recorded seeing one inscribed *1621* (p. 39); the Low Countries, based on a dedication to Abraham Bloemaert inscribed on a drawing discovered and first published by Pierre Rosenberg in Washington et al. 1981, under cat. no. 6, p. 7 (cat. no. D.1–c. 1620s); and Rome once more in 1625, based on a recently discovered drawing after the *Torso Belvedere* inscribed *boucher me fecit Rome 1625* (Christie's, Monaco, 7 December 1990, lot 215). For this sheet and other publications on the artist since its discovery, see Thomas Le Claire in New York 1992b, cat. no. 24, pp. 52–53; Jean-Claude Boyer in Paris 1993a, pp. 56–59; and Emmanuel Brugerolles and David Guillet in Paris et al. 1994, pp. 276–81.

9. For a convenient general discussion of these artists and further bibliography, see Veronika Birke in Fort Worth and Los Angeles 1992, pp. 110–128, esp. pp. 126–27.

NOTES TO CAT. 5

1. Félibien 1688, vol. 3, Entretien 7, pp. 392–96.

2. Simon Vouet, *St. Peter Healing the Sick with His Shadow*, brush and brown wash over traces of black chalk, 362 × 220 mm., Department of Prints and Drawings, The Art Museum, Princeton, inv. no. 53–103; see Brejon 1987, cat. no. I, p. 42, repr., and Barbara Brejon de Lavergnée in Paris 1990a, p. 358, n. I. The drawing is preparatory for Vouet's altarpiece for one of the chapels in St. Peter's, Rome, and now in the Galleria degli Uffizi, Florence.

3. Simon Vouet, *Last Supper*, red and black chalk with brush and brown wash, 326 × 208 mm., Kupferstichkabinett, Berlin, inv. no. kdz 14375; see Brejon 1987, cat. no. III, p. 44, repr., and Barbara Brejon de Lavergnée in Paris 1990a, p. 358, n. I. The drawing is preparatory for an altarpiece executed in Paris in 1629–30 and now in the Palazzo Apostolico, Loreto.

4. Simon Vouet, *Apotheosis of St. Joseph(?)*, black chalk with brush and brown and gray wash, squared for transfer in black chalk, 300 × 228 mm., Private Collection, Paris; see Barbara Brejon de Lavergnée in Paris 1990a, cat. no. 68, pp. 364–65, repr.

5. Simon Vouet, *Assumption of the Virgin*, red chalk and brush with gray wash, squared for transfer in red chalk, 266 × 210 mm., Département des Arts Graphiques, Musée du Louvre, Paris, inv. no. 14270; see Brejon 1987, cat. no. 1,

pp. 42–44, repr., and Barbara Brejon de Lavergnée in Paris 1990a, cat. no. 69, pp. 366–67, repr. The drawing is preparatory for the signed and dated altarpiece of 1629 painted for St. Nicolas des Champs, Paris, *in situ*.

6. Simon Vouet, *Lot and His Daughters*, black chalk, squared in red chalk, 240 × 199 mm., Cabinet des Dessins, Musée des Beaux-Arts, Reims, inv. no. 795.I.3875; see Brejon 1987, cat. no. XXXV, p. 80, repr., and Barbara Brejon de Lavergnée in Paris 1990a, cat. no. 79, p. 381, repr. The study is preparatory for the painting of the same theme of 1633 in the Musée des Beaux-Arts in Strasbourg.

7. Simon Vouet, *Greeks at the Table of Circe*, black chalk heightened with white chalk on light beige antique laid paper, 326 × 431 mm., Department of Drawings, Fogg Art Museum, Harvard University Art Museums, Cambridge, inv. no. 1955.24.; see Brejon 1987, cat. no. XLI, pp. 85–86. The study is related to the cycle painted in 1634 for the now-destroyed Hôtel de Bullion; fortunately, the cycle was translated into a surviving tapestry cycle now in the Cour d'Appel, Riom. For the latter, see Denis Lavalle in Paris 1990a, p. 494, and Isabelle Denis in Loir-et-Cher 1996, pp. 156–59.

8. Simon Vouet, *St. Peter Delivered from Prison by an Angel*, red chalk with brush and brown wash, 206 × 195 mm., Cabinet des Dessins, Musée des Beaux-Arts, Rennes, inv. no. 794.I.2759; see Brejon 1987, cat. no. LXIV, repr., and Barbara Brejon de Lavergnée in Paris 1990a, cat. no. 103, pp. 418–19, repr. This sheet is preparatory for a painting executed for the private oratory in the Parisian hôtel of the chancelier Séguier and was etched by the artist's son-in-law, Michel Dorigny, in 1638.

9. Simon Vouet, *Assembly of the Gods*, black chalk with traces of heightening in white chalk, 247 × 486 mm., Cabinet des Dessins, Musée des Arts Décoratifs, Paris, inv. CD 462; see Brejon 1987, cat. no. CI, p. 141, repr., and Barbara Brejon de Lavergnée in Paris 1990a, cat. no. 86, pp. 392–93, repr. The composition is recorded in the inventory taken after the death of Vouet's first wife in 1639 and in the one taken before his remarriage in 1640. See Brière and Lamy 1953, p. 144, and Fleury 1969, p. 749.

10. Simon Vouet, *Virgin and Child with a Basket of Fruit*, black chalk, squared in black chalk, 174 × 136 mm., Cabinet des Dessins, Musée des Beaux-Arts, Besançon, inv. no. D.1814; see Brejon 1987, cat. no. XCI, p. 132, repr., and Barbara Brejon de Lavergnée in Paris 1990a, cat. no. 126, p. 459, repr. The sheet is preparatory for a painting now in the Musée des Beaux-Arts, Caen, that was engraved by Pierre Daret in 1642.

11. The composition is not recorded in the inventories of 1639 or 1640 (see n. 9 above) or in the unpublished inventory taken after the artist's death in 1649 (Paris, Minutier Central, L 30, 3 July 1649).

NOTES TO CAT. 6

1. Simon Vouet, *Artemisia Directing the Building of the Mausoleum*, oil on canvas, Nationalmuseum, Stockholm. The subject of the painting is taken from the ancient Roman historian Valerius Maximus's *De Factis Dictisque Memorabilibus...*, a diverse narrative providing brief accounts of good and bad conduct from the lives of notables. In 353 B.C., soon after the death of Mausolus, satrap of Caria in Asia Minor, his widow, Artemisia, commissioned the architect Pythius to construct a monument to her husband in the capital of Halicarnassus. Given the memorial nature of the subject, and the fact that the painting dates to the early to mid-1640s, it has often been assumed that it was commissioned by Anne of Austria after the death of Louis XIII. We know that Vouet proposed at least one other idea at this time; for more, see Grate 1988, p. 70; Jacques Thuillier in Paris 1990a, pp. 135–36, and cat. no. 58, p. 326; and Olaf Koester in Copenhagen 1992, cat. no. 26, p. 224.

2. Simon Vouet(?), *Turbaned Man Bending Forward with Arms Extended* (recto), *Standing Man with Staff* (verso), black and white chalk on tan paper (recto and verso), 359 × 276 mm., Graphische Sammlung, Städelsches Kunstinstitut, Frankfurt, inv. no. 4285. A reproduction and discussion of the recto of this sheet are curiously absent from Barbara Brejon's monograph of Vouet's drawings, where the verso is included (Brejon 1987, cat. no. CXXXV, pp. 202–3). Although the attribution of this study for the figure of the architect Pythius in the Stockholm painting has been questioned, at the very least it probably documents a lost original by Vouet and was most likely executed by a member of the artist's atelier. See Margret Stuffmann in Frankfurt 1986, pp. 21–22.

3. For an example, see Richard Harprath in Munich 1991, pp. 157–61.

4. Brejon 1987, p. 33.

5. I would suggest a date of c. 1644–45, which would still accord well with the memorial nature of the commission that may have been related to Louis XIII's death in 1643.

6. Simon Vouet, *Kneeling Draped Figure*, black chalk heightened with white chalk on tan paper, 283 × 335 mm., Bayerische Staatsbibliothek, Munich, inv. no. Cod. icon. 397b, fol. 29.; see Richard Harprath in Munich 1991, cat. no. 31, pp. 104–5.

7. It is tempting to think of this shift in style as a somewhat delayed reaction to Poussin's stay in Paris (1640–42) and the growing popularity for the pseudo-classical manner referred to as Parisian Atticism (see the essay by Alain Mérot and Sophie Raux-Carpentier in this catalogue and cat. nos. 9, 10, and 17).

8. For more on Mariette as a collector, and his mounts, see the essays by Frits Lugt and Roseline Bacou in Paris 1967, pp. 13–23, and James—Corrigan—Enshaian—Greca 1997, pp. 19–21.

NOTES TO CAT. 7

1. As of 1962, twelve of the drawings were divided among the Uffizi in Florence, the Graphische Sammlung Albertina in Vienna, the Nationalmuseum in Stockholm, and both the British Museum and the Victoria and Albert Museum in London (see Ternois 1962a, cat. nos. 25–36). Five others were published in Ternois 1973—one in the Kupferstichkabinett in Berlin, another in the Albertina, and three in private collections (of this group of three, one has recently entered the National Gallery in Washington, and another is the Horvitz sheet). Recently, three others entered the Getty Museum in Los Angeles, bringing the total to twenty. The three in the Getty Museum will be published in the forthcoming supplement to my catalogue of 1962 (see Ternois 1998). For the whole series, also see Ternois 1962b and Daniel Ternois in Nancy 1992a, pp. 157–61.

2. Jacques Callot, *Four Studies of a Horse, and the Head of a Horse*, pen and brown ink, 406 × 559 mm., Department of Prints and Drawings, National Gallery of Art, Washington, inv. no. 1981.51.1b. The Washington sheet is also the largest in the series; the other two sheets are in the Graphische Sammlung Albertina, Vienna (inv. no. 33.364—see Knab and Widauer 1993, pp. 262–63, cat. no. F140, repr.); and Private Collection, Switzerland (see Nancy 1992a, pp. 159–60, cat. no. 44).

3. Florence, 1590 (Bartsch 1803–21, vol. 7, cat. nos. 941–68, and Bartsch-Ill., vol. 36, pp. 184–212).

4. See Ternois 1962a, cat. nos. 27 recto, 31, and 34; Ternois 1973, cat. nos. 5 recto, and 6 recto.

5. Jacques Callot, *Horse among Figure Studies*, pen and brown ink, 243 × 339 mm., Department of Prints and Drawings, British Museum, London, inv. no. 5213; see Ternois 1962a, cat. no. 26, p. 47.

6. Jacques Callot, *Standing Male Nude Seen from Behind*, red chalk, 308 × 185 mm., Gabinetto dei Disegni, Galleria degli Uffizi, Florence, inv. no. 2476(F); see Ternois 1962a, cat. no. 60.

7. "… la gran facilità, ch'égli aveva in disegnare piccole figurine, con un modo pero ammanierato, e aggrotescato molto" (see Baldinucci 1686–1772 ed., vol. 13, pp. 31–34, and vol. 14, pp. 128–29).

8. Meaume 1860, cat. nos. 632–35; Lieure 1924–27, cat. nos. 169–172; and Daniel Ternois in Nancy 1992a, pp. 189–91.

NOTES TO CAT. 8

1. For the commission, see Hugh Macandrew in Edinburgh 1981, pp. 44–56, cat. nos. 18–26.

2. The paintings include the *Triumph of Bacchus*, Nelson-Atkins Museum, Kansas City, and the *Triumph of Pan* and the *Triumph of Silenus*, National Gallery, London. The *Triumph of Neptune*, Philadelphia Museum of Art, may have also been in this group. The related drawings include Rosenberg and Prat 1994, cat. nos. 83–88; also see Martin Clayton in London et al. 1995, pp. 102–11.

3. Pierre Rosenberg and Louis-Antoine Prat in Bayonne 1994, p. 36.

4. Nicolas Poussin, *Satyr Lifting a Nymph in the Presence of a Seated Nymph*, pen and brown ink, 93 × 168 mm., Musée Bonnat, Bayonne, inv. no. AI 1670-NI 45 (Rosenberg and Prat 1994, cat. no. 141); and *Nymph Seated beneath a Tree*, pen and brown ink, 158 × 112 mm., Royal Library, Windsor Castle, inv. no. RL 11922 (Rosenberg and Prat 1994, cat. no. 143). To these one might also consider adding *The Sorcerer Atlas Abducting Pinabello's Lady* (Metropolitan Museum of Art, New York; see Rosenberg and Prat 1994, cat. no. 117). Although usually placed before the Bacchanals, the redrawn contours and energetic figures appear closer to the Horvitz sheet.

5. Hugh Brigstocke has made the interesting suggestion that as a draftsman, Poussin needed to execute the passionate type of drawings we see for the Bacchanals in order to achieve the classical dramatic unity evident in the first

series of Sacraments that set the tone for the majority of the rest of his oeuvre. See the introduction to Oxford 1990 (n.p.).

6. For the relief-like compositions beginning with the Bacchanal series, and the use of boxes and models, see Blunt 1979, pp. 105–8; and most recently, see Avigdor Arika, "De la boîte, des figurines, et du mannequin," in Paris and London 1994, pp. 44–47.

7. On Poussin's efforts to heighten the clarity of his compositional structure so that the viewer could *read* his works in the context of the artistic circles of seicento Rome, see Marc Fumaroli, "Rome 1630: entrée en scène du spectateur," in Rome 1994, pp. 53–82.

NOTES TO CAT. 9

1. The fullest early account of Stella's stay in Italy is Félibien 1725, vol. 4, Entretien 10, pp. 204–14.

2. The best modern study of Stella's Italian period is section IV, "Monsu Stella Pittore e amico mio," in Thuillier 1960, pp. 96–112. The best-known drawings executed during this period were the series of illustrations for the life of St. Philip Neri, in the Yale University Art Gallery, New Haven; see Haverkamp-Begemann and Logan 1970, vol. 1, pp. 11–17, and Pierre Rosenberg in Toronto et al. 1972, under cat. no. 135, pp. 211–12. For Stella's small paintings, many of which were executed on marble, slate, or copper, as well as canvas, see Pierre Rosenberg in Paris et al. 1982b, cat. nos. 98 and 99, pp. 318–19.

3. The last digit of the signed and dated canvas is either a 5 or 7; see Thuillier 1961, p. 100, n. 112.

4. The most important comparative work that would have been influential for Stella's canvas is Annibale Carracci's *Assumption* in the Cerasi Chapel, St. Maria del Popolo, Rome; see Posner 1971, vol. 2, cat. no. 126, pp. 55–56, repr., pl. 126b. For Lanfranco's version in the chapel at Schloss Nymphenburg, Munich, see Bernini 1985, cat. no. 106, p. 277, repr.; and for Vouet's work, part of the ceiling of the Aleoni chapel in St. Lorenzo in Lucina, Rome, see Jacques Thuillier in Paris 1990a, pp. 212–15, repr.

5. Jacques Stella, *Assumption*, black chalk with brush and gray wash, and a subsidiary study in pen and brown ink, 356 × 275 mm., location unknown; see sale, Christie's, New York, 13 January 1987, lot 111, repr. For more on the *Life of the Virgin* series, see cat. 10.

6. See Chomer 1980.

7. Letter in Horvitz file from Chomer to Siegfried Billesberger, 29 May 1995, "… aux questions que vous me posez … le premier, *St. François de Paule et la Vierge de l'Assomption*, est, à mon avis, un magnifique dessin de Jacques Stella. Il devrait préparer un tableau point pour le couvent des Pères Minimes d'Abbeville, tableau aujourd'hui perdu mais cité par les sources." One of the early sources that mentions the canvas is Dézallier d'Argenville 1745, p. 45, where the painting is said to be located "au fond du choeur."

8. Famous for his healing powers, the Franciscan monk Francis of Paola was sent to France by Pope Sixtus IV to aid the dying King Louis XI. Although he arrived too late to help the dying monarch, he remained in France, where his followers became known as the Minimes (the least of their brethren). He was canonized in 1519. See Mâle and Chazal 1984, pp. 421–22, and 425–26; and Evans 1970, pp. 43–45.

9. Thuillier 1961, pp. 101–2.

10. Jacques Stella, *The Stabbing of Paolo de Bernardis*, pen and brown ink with brush and blue ink and blue wash, 204 × 148 mm., Department of Prints, Drawings, and Photographs, Yale University Art Gallery, New Haven, inv. no. 1965.65.83. See Haverkamp-Begemann and Logan 1970, vol. 1, cat. nos. 20 and 24, pp. 14–15, and 16–17. Also see the *Glorification of Virtue*, Cabinet des Dessins, Musée du Louvre, Paris (Jean-François Méjanès in Paris 1984a, cat. no. 66, pp. 56–57); and for another type of even more atmospheric wash drawing executed in 1633, see Emmanuelle Brugerolles in Paris 1981a, cat. no. 162, pp. 326–27, repr., and Brugerolles 1984, cat. no. 474, p. 287, repr.

11. Although the Horvitz drawing probably predates the Louvre *Glorification of Virtue*, given the northern Italian influences evident in both the composition and the handling of the media, this slightly extended dating does not preclude the possibility that Stella executed this drawing on his return trip to France, when we know that he stopped in Venice and other northern Italian cities (see Félibien 1725, vol. 4, Entretien 10, p. 410). It would certainly appear to predate the already classicizing *Adoration of the Angels*, a canvas of 1635 in the Musée des Beaux-Arts, Lyon, painted upon his return to France. Finally, the fact that the drawing probably predates his return to France does not exclude the possibility that it is for the lost Abbeville painting. It is a work so close in date to his return that the canvas could either have been painted in Rome upon the Minimes' approval of the drawing, and then sent to Abbeville—such long-distance commissions were already frequent in the seven-

teenth century, and Stella's fame by the early 1630s would have placed him among the group of artists entrusted with this type of responsibility—or it could have been painted just after he returned to France, based on the slightly earlier drawing.

NOTES TO CAT. 10

1. Stella traveled in the suite of the maréchal de Créquy as far as Venice and arrived in Paris in 1635 after a brief stay in his native Lyon; see Félibien 1725, vol. 4, Entretien 10, pp. 409–10. Charles, duc de Créquy, maréchal de France, and premier gentilhomme de la chambre du roi, was a distinguished collector and patron of contemporary artists; for more, see Boyer and Volf 1988.

2. For more on Stella and the Imprimérie Royale, see Thuillier 1960, p. 103, n. 121, and Thuillier 1987.

3. The smaller set of eight scenes depicting the Life of the Virgin is first mentioned in the sale catalogue of the Paignon-Dijonval Collection (see Bénard 1810, lot 2814). Another sheet from this series is in the Polakovits Collection at the Ecole nationale supérieure des Beaux-Arts in Paris (see Gilles Chomer in Paris 1989a, pp. 84–85).

4. This second series was first mentioned in the death inventory of the artist's niece Claudine Bouzonnet-Stella (1636–1697). See Guiffrey 1877, pp. 3–4 and 53–54. The drawings remained together in France, then Italy, and then the United Kingdom until 1986, when they were dispersed in two sales (Christie's, London, 9 December 1986, and Christie's, New York, 13 January 1987). Although it has often been remarked that the entire group was sold, given that this sheet was present (and reproduced) in both sales of eleven sheets each—unless there was an error—it would appear that only twenty-one were sold at auction. We might also question whether the drawings for the *Life of the Virgin* series weren't originally bequeathed to Antoinette, who engraved it, while her older sister, Claudine, might have been willed Stella's *Passion*, which she engraved. The *Life of the Virgin* series might only have entered Claudine's possession upon Antoinette's death. Two of the sheets from the *Life of the Virgin* series are now in the Musée des Beaux Arts, Lyon (see Jean-François Méjanès in Paris 1993a, cat. nos. 46 and 47, pp. 111–13) and another is in the Prat Collection, Paris (see Pierre Rosenberg in Paris et al. 1995, cat. no. 11, pp. 56–57).

5. It was incorrectly identified in the two auction catalogues (see provenance).

6. Francesco Polanzani after Jacques Stella, *Expulsion of Joachim and Anna from the Temple*, engraving, Gift of Margot Gordon, Fogg Art Museum. Apparently, Antoinette's prints were also reissued with a false attribution to Poussin as inventor. On this and Polanzani's falsifications, see Blunt 1974.

7. Undoubtedly because some of the scenes could not be reversed and still be read in an appropriate iconographic manner, the printmakers made a special effort to engrave a number of the sheets in the same sense; on Mochetti's continued falsification of the inventor, see Blunt 1974.

8. Most recently, for Poussin in Paris from 1640–42, see Pierre Rosenberg and Louis-Antoine Prat in Paris and London 1994, pp. 294–309.

9. For more on Parisian Atticism, see Alain Mérot in Dijon and Le Mans 1998.

10. Jacques Stella, *Noli me tangere*, graphite, brown ink, traces of red chalk, and white gouache on tan antique laid paper, 230 × 252 mm., signed and dated at lower left: *J. Stella fecit 1638*, The Melvin R. Seiden Fund and Louise Haskell Daly Fund, Department of Drawings, Fogg Art Museum, Harvard University Art Museums, Cambridge, inv. no. 1984.597; see Hilliard Goldfarb in Cleveland et al. 1989, under cat. no. 69, pp. 142–43.

11. Jacques Stella, *Christ at the Column*, black chalk, brown and gray wash, and white gouache on light gray antique laid paper, 250 × 197 mm., The Melvin R. Seiden Fund and Louise Haskell Daly Fund, Department of Drawings, Fogg Art Museum, Harvard University Art Museums, Cambridge, inv. no. 1984.595; see Hilliard Goldfarb in Cleveland et al. 1989, cat. no. 69, pp. 142–43, where the suggested date is c. 1640s.

12. Jacques Stella, *Birth of the Virgin*, brush and gray wash over black chalk on off-white antique laid paper, laid down to a second sheet extended at the bottom, 250 × 173 mm., Gift of Melvin R. Seiden, Department of Drawings, Fogg Art Museum, Harvard University Art Museums, Cambridge, inv. no. 1990.52; see Pierre Rosenberg in Paris et al. 1995, under cat. no. 11, p. 56, where it is suggested that very little time passed between the execution of this sheet and a drawing from the later series depicting the same event. However, I would suggest a difference of at least three to four years; Stella's mastery of his new approach may be a reflection of the technique he had perfected in an important series of genre drawings in the late 1630s and early 1640s. See Davidson 1975, and Hilliard Goldfarb in Cleveland et al. 1989, pp. 144–45.

NOTES TO CAT. 11

1. Claude, *View of the Acqua Acetosa,* pen and brown ink with brush and brown wash, 220 × 323 mm., Wildenstein Album no. 44, Private Collection, see Roethlisberger 1962, cat. no. 44; Roethlisberger 1968, cat. no. 875, p. 326; and for other views of the Acqua Acetosa, see cat. nos. 874 and 876.

2. The *Liber Veritatis* was the artist's record book of his compositions. His records took the form of carefully finished drawings, originally kept in a bound volume. Now dismembered, it is in the Department of Prints and Drawings at the British Museum. See Roethlisberger 1968, cat. no. 346, p. 166, and Kitson 1978, cat. no. 42, p. 78.

3. Claude, *Landscape with River and Hills,* black chalk, 185 × 129 mm., Department of Drawings, Nationalmuseum, Stockholm, inv. no. NM 268/1982, fol. 19v.; see Bjurström 1984, pp. 25–26.

4. For those with trees, see Roethlisberger 1968, cat. nos. 137, 323, and 355, and for those without, cat. nos. 26, 138r, 276r, 288r, and 353r.

NOTES TO CAT. 12

1. On the continued importance of Fontainebleau as a study center for young artists, see Thuillier 1975.

2. On the paintings and drawings of the two schools of Fontainebleau, particularly for Primaticcio, Nicolo dell'Abate, and Ambroise Dubois, see Sylvie Béguin in Paris and Ottawa 1972, pp. 5–21, 80–89, and 130–73.

3. Tasso's *Gerusalemme Liberata* was enormously popular in France and northern Europe at the beginning of the seventeenth century. See Stechow 1953 and Blunt 1957.

4. It is entirely possible that La Hyre used any of at least five different contemporary variations of the ancient Greek original. These are discussed by Pierre Rosenberg and Jacques Thuillier in Grenoble et al. 1988, p. 119.

5. For a recent discussion of the ancient author—who knew the young Cyrus—and his perception of the nobility of the young monarch's actions, see Higgins 1977, chap. 3.

6. Laurent de La Hyre, *Cyrus Receives a Letter from Panthea,* black chalk heightened with white chalk on gray paper, 297 × 405 mm., Rijksprentenkabinet, Amsterdam, inv. no. 1965.185. I disagree with the provisional title provided by Pierre Rosenberg and Jacques Thuillier in Grenoble et al. 1988, cat. no. 8, p. 118.

7. Laurent de la Hyre, *Abradatas Bidding Farewell to Panthea,* black chalk heightened with white chalk on gray paper, 293 × 396 mm., Hamburger Kunsthalle, inv. no. 59.080. Note that there is one further extant drawing from the series in the Réserve of the Cabinet des Estampes of the Bibliothèque nationale de France; see Pierre Rosenberg and Jacques Thuillier in Grenoble et al. 1988, cat. nos. 7 and 10, pp. 118–19.

8. Laurent de La Hyre, *Combat between Tancred and Clorinda,* black and white chalk on buff antique laid paper, laid down, 301 × 420 mm., Louise Haskell Daly Fund, and through the generosity of Melvin R. Seiden, Department of Drawings, Fogg Art Museum, Harvard University Art Museums, Cambridge, inv. no. 1991.26.; see Clark 1993a, pp. 181, 183, and 184, n. 4.

9. Laurent de La Hyre, *Annunciation,* black chalk, pen and black ink, and brush with gray and brown wash, heightened with white chalk, on off-white antique laid paper toned with brown wash, 255 × 222 mm., The Melvin R. Seiden Fund and Louis Haskell Daly Fund, Department of Drawings, Fogg Art Museum, Harvard University Art Museums, Cambridge, inv. no. 1984.605; see Hilliard Goldfarb in Cleveland et al. 1989, cat. no. 83, pp. 167–68.

NOTES TO CAT. 13

1. Huret's oeuvre of engravings numbers more than five hundred (see Weigert 1968, pp. 294–391). Both Pierre-Jean Mariette and Michel, Abbé de Marolles, noted the artist's fecundity of invention and his high opinion of his own talents (Mariette, *Notes Manuscrites,* as cited in Weigert 1968, p. 295, and Marolles 1673, p. 15). The artist's publication was entitled, *Optique de portraiture et peinture en deux parties, La Premiere est la Perspective Pratique Acomplie, pour representer les somptueuses Architectures des plus superbes, batimens en perspective par deux manières dont la premiere montre les moyens pour arriver à une precision acomplie, mais qui ne sont enseignez que pour donner connoissance à l'esprit & non pour estre pratiquez si on ne veut. Et en la seconde sont les plus briefs et faciles moyens qui ayent esté publiez jusques à present, pour estre generalement pratiquez, & le tout sans employer aucun point de distance ny plan geometral. La Deuxième Partie Contient la Perspective Speculative sçavoir les demonstrations & declarations des secrets fondamentaux des Regles ou moyens contenus en la premiere Partie. Ensemble les plus curieuses & considerables ques-*

tions qui ayant esté proposées jusques à present sur la Portraiture & Peinture, Paris, 1670. This conservative work was in direct opposition to Abraham Bosse's more controversial theories on perspective and thus won the artist some favor. After the dismissal of Bosse from the Académie by Charles Le Brun, Huret took his place as professor of perspective. For recent considerations of this work and Huret as an art theorist, see Helsdingen 1970, Helsdingen 1979, and Kemp 1990, pp. 125–26.

2. The full Latin title on the title page is given as *Theatrum Dolorum Jesu Christi Dei Hominis pro Hominibus Patienis,* and the French translation on the introductory page is given as *Théâtre de la Passion de Nostre Seigneur Jesus Christ.* This introduction provides descriptions and biblical references to each episode depicted and these are repeated in an abbreviated form in Latin at the bottom of each plate. See Weigert 1968, cat. nos. 407–38, pp. 383–84.

3. Rosenberg 1971, p. 90.

4. Paris 1993a, cat. no. 79, pp. 166–67, and Brugerolles and Guillet 1997; also see Clark, forthcoming.

5. Grégoire Huret, *Triumph of the Trinity,* black chalk, 340 × 455 mm., Département des Arts Graphiques, Musée du Louvre, Paris, inv. no. 27202.

6. Grégoire Huret, *Noli me tangere,* black chalk, 464 × 340 mm., Biblioteca Nacional, Madrid, inv. no. 9141.

7. For the first attempt at establishing a chronology, see Brugerolles and Guillet 1997.

8. Maxime Préaud in Paris 1989a, no. 26, pp. 92–93; and Alvin Clark in Boston et al. 1998, no. 95.

9. One is inscribed *Quasi pater in filio complacet. prouer. 12,* and the other (fig. 3) is inscribed *Veniat dilectus meus in bortum suum, et comedot fructum pomorum fuorum./ Cantieorum, 5.*

NOTES TO CAT. 14

1. Dézallier d'Argenville 1745, pp. 118–19.

2. Galactéros-de Boissier 1991, p. 49.

3. Sandrart 1675, pp. 339–40; also see Galactéros-de Boissier 1991, p. 266, where the accuracy of this assertion is questioned.

4. Abraham Bosse and Gilles Rousselet, *Portia* and *Lucretia,* etching and engraving, Département des Estampes, Bibliothèque nationale de France, Paris. Père Le Moyne was a Jesuit poet who taught philosophy at Dijon, and this was one of eight such publications dedicated to the regent. Although I once questioned the dual authorship of these prints (see Alvin Clark in New Haven 1987, pp. 35–36), it appears that Rousselet engraved the large figures in the foreground, and Bosse etched the landscape backgrounds. For the two prints after Vignon, and one related preparatory drawing, see Pacht Bassani 1992, cat. nos. 444G, 446, and 446G, pp. 442–43; except for their attributes, images depicting heroines like Lucretia and Cleopatra were interchangeable. Images of Portia should be added to this list. For more on the contemporary significance and background of these kinds of images, see Ramade 1980, Maclean 1977, and Pacht Bassani 1992, pp. 437–38; the essay by Bernadine Barnes, "Heroines and Worthy Women," in Washington 1990, pp. 29–35; and the sections "Femme Forte" and "Imagery of Strong Women," in Garrard 1989, chap. 2, pp. 154–79.

5. Dézallier d'Argenville 1745, p. 121.

6. Hilliard Goldfarb in Cleveland et al. 1989, p. 181.

7. Thomas Blanchet, *Justice Crushing Crime,* pen and brown ink on beige paper, 262 × 200 mm., Musée des Beaux-Arts, Angers, inv. no. MTC 5076. See Galactéros-de Boissier 1991, cat. no. D25, where it is suggested that the sheet was preparatory for a ceiling in the Chambre criminelle or Chambre de la Conseil and dates between 1660 and 1681.

8. Thomas Blanchet, *Assumption of the Virgin,* red chalk with brush and red chalk wash, heightened with white gouache, and squared with black chalk on gray paper, 336 × 255 mm., Département des Arts Graphiques, Musée du Louvre, Paris, inv. no. 23779 (also an ex-Mariette drawing). See Galactéros-de Boissier 1991, cat. no. D.81, p. 438, where it is placed between drawings dating from the late 1670s and c. 1680.

9. I would suggest a date almost exactly in between these two (the mid-1670s), especially when this sheet is compared to the Louvre's.

NOTES TO CAT. 15

1. See the discussions about Bourdon's *Departure of Jacob* (Museum of Fine Arts, Houston), its related print, and his *Landscape with a Ford* (Smith College Museum of Art, Northampton), by Pierre Rosenberg in Paris et al. 1982b, cat. nos. 8 and 9, pp. 227–29; and Alvin Clark in Boston et al. 1998, cat. no. 101.

2. This sheet was referred to as "Ecole bolonaise du XVIIIe siècle," at a Paris auction (Drouot, 7 June 1995, lot 65). Discussions of the problems of attribution in Bourdon's work include Pierre Rosenberg, as in n. 1; Clark 1993b; and Michel Hilaire in Paris 1993a, pp. 202–3.

3. Sébastien Bourdon, *Study for the Martyrdom of St. Peter,* pen and brown ink with brush and brown wash, 213 × 148 mm., The Melvin R. Seiden Fund and Louise Haskell Daly Fund, Department of Drawings, Fogg Art Museum, Harvard University Art Museums, Cambridge, inv. no. 1984.583. Perhaps inspired by Poussin's *Martyrdom of St. Erasmus,* this sheet is one of several studies for Bourdon's *May* painting for Notre-Dame de Paris in 1643; see Richardson 1979, cat. no. 6; Brigitte Scart in Paris 1984a, cat. no. 131; and for the *May* paintings, see Auzas 1949. Venetian influences are also evident in the artist's *Encounter of Alexander and Cleopatra,* a painting now in the Musée du Louvre, Paris (inv. RF 1979.57).

4. Sébastien Bourdon, *Baptism of Christ,* brush with white gouache over red and black chalk on brown prepared paper, 257 × 358 mm., Graphische Sammlung Albertina, Vienna, inv. no. 11.663; see Knab and Widauer 1993, cat. no. F.342, pp. 640–41.

5. Jacques-Antoine Friquet de Varouze, *La Peinture,* after Sébastien Bourdon, etching, Département des Estampes, Bibliothèque nationale de France, Paris. There are also sketches after Bourdon's decorations in the Musée Atger, Montpellier, by Michel II Corneille. For more on the Hôtel Bretonvilliers, see Wilhelm 1956, pp. 144–45, and p. 149, and Paris 1981b, esp. pp. 49–53.

6. Sébastien Bourdon, *Sheet of Studies for an Adoration of the Shepherds,* pen and brown ink, 208 × 304 mm., Département des Arts Graphiques, Musée du Louvre, Paris, inv. no. 25015; see Guiffrey and Marcel 1928, vol. 2, cat. no. 1635.

7. Another oil on paper, *Jason and the Golden Fleece* of c. 1645–50, is in the Musée des Beaux-Arts, Rouen (inv. no. 975-4-571); see Michel Hilaire in Paris 1993a, cat. no. 103, pp. 204–5. On the later debate over color vs. line, see the essay by Alain Mérot and Sophie Raux-Carpentier in this catalogue.

8. Sébastien Bourdon, *Investiture of St. Peter Nolasco,* black chalk with brush and brown wash heightened with white gouache, 624 × 348 mm., Graphische Sammlung Albertina, Vienna, inv. no. 15.220; see Knab and Widauer 1993, cat. no. F.338, pp. 632–34.

9. Pignatti 1976, vol. 1, cat. no. 176, p. 135, and vol. 2, fig. 454; and Brejon 1987, cat. no. 365, pp. 360–61; at the same time, there were discussions—that were finally abandoned—about the acquisition of Veronese's *Wedding Feast at Cana* from the Refectory of the Benedictine Convent at San Giorgio. The painting was brought to Paris by Napoleon in 1797. See Pignatti 1976, vol. 1, cat. no. 131, p. 126.

10. For example, the double columns on the verso point to the Louvre painting; the division of three arches as a backdrop to the composition on the recto of Bourdon's sheet probably reflects the Accademia canvas; and the figures pouring wine are found in the Louvre work. For prints after Veronese that could have been known by Bourdon, see Rome 1978, esp. cat. nos. 10 and 22, pp. 29–30 and 37–38.

NOTES TO CAT. 16

1. Mérot 1987, pp. 217–19.

2. See Mérot 1987, p. 219, cat. no. 66, fig. 220.

3. Eustache Le Sueur, *Kneeling Man with Raised Arms (Study for the Figure of Tobit),* black chalk heightened with white chalk on gray-brown paper, 216 × 363 mm., Département des Arts Graphiques, Musées royaux des Beaux-Arts, Brussels, inv. no. de Grez 2237; also see the composition drawing in the Nationalmuseum, Stockholm (Mérot 1987, p. 219, cat. no. D179, figs. 221).

4. Eustache Le Sueur, *Warrior Angel Chasing the Soldiers of Sennacherib,* black chalk, squared in black chalk, 275 × 282 mm., Département des Arts Graphiques, Musée du Louvre, Paris, inv. no. MI 1101; see Mérot 1987, p. 220, cat. no. D182, fig. 223.

5. Guillet de Saint-Georges 1690, vol. 1, p. 157.

6. For more on Parisian Atticism, see Alain Mérot in Dijon and Le Mans 1998.

7. See Paris 1972b.

8. Eustache Le Sueur, *Study for the Return of Tobias,* black chalk heightened with white chalk on tan antique laid paper, 226 × 289 mm., The Melvin R. Seiden Fund and Louise Haskell Daly Fund, Department of Drawings, Fogg Art Museum, Harvard University Art Museums, Cambridge, inv. no. 1984.591.

9. This is especially true for the tapestry designs for the *Death of Ananias* and the *Beheading of St. Stephen.* See Mérot 1987, pp. 78–80, and 236–40, cat. nos. 83–85. Also see Mérot in Paris 1983a, pp. 142–45; for the earlier influence of Vouet on Le Sueur, see Mérot 1987, pp. 54–56.

NOTES TO CAT. 17

1. See Jacques Thuillier in Paris 1990a, pp. 53–54, 124, and 141, and for more on Dorigny as a printmaker, see Robert-Dumesnil 1871, vol. 4, pp. 247–300, Duplessis 1871, pp. 79–82, and most recently, Alvin Clark in Boston et al. 1998, cat. nos. 102 and 124.

2. Niobe and her children are attacked by Apollo and Diana at the request of their mother, Leto, who was angry at Niobe for discouraging Theban women from worshiping at Leto's temple as Niobe boasted that she had bettered Leto by being both the granddaughter and daughter-in-law of Zeus, as well as the mother of seven strong sons and seven beautiful daughters.

3. Following Henri Sauval, Barbara Brejon de Lavergnée dates the decoration of the gallery of the Hôtel Séguier—which remained incomplete at the death of the artist—to the late 1640s. The paintings in the lower gallery symbolized or alluded to major events in the reign of Louis XIII. See Barbara Brejon in Paris 1990a, p. 472, and Sauval 1724, vol. 2, bk. 7, p. 197; in the preceding decade, Vouet and his collaborators had already decorated the chapel (c. 1635) and the library of the chancellor's residence (c. 1637–39). See Jacques Thuillier and Barbara Brejon de Lavergnée in Paris 1990a, pp. 121, 269–73, and 436, and Nexon 1983; for more on Séguier, see Mousnier 1964 and Nexon 1985a.

4. Michel Dorigny, *Massacre of Niobe's Children,* after Simon Vouet, etching with engraving, Département des Estampes, Bibliothèque nationale de France, Paris. After Vouet's death in 1649, Dorigny and his brother-in-law, François Tortebat—who also worked in Vouet's studio—obtained a royal privilege to remain the sole interpreters of Vouet's works. The prints reproducing the gallery of the Hôtel Séguier were produced in 1651. See Jacques Thuillier in Paris 1990a, pp. 80–81.

5. Michel Dorigny, *France Asks Jupiter and the Assembled Gods for a Minister,* black chalk (partially incised), 216 × 201 mm. Graphische Sammlung Albertina, Vienna, inv. no. 11.198; for this sheet, and one other, see Knab and Widauer 1993, cat. nos. F.128–29, pp. 238–41.

6. Michel Dorigny, *Hercules and Iolas Slaying the Hydra,* black chalk heightened with white chalk (incised for transfer with stylus), 221 × 193 mm., Pierpont Morgan Library, New York, inv. no. 1988.8; see Cara Dufour Denison in Paris and New York 1993, cat. no. 28, pp. 68–69.

7. Simon Vouet, *Niobe,* black chalk heightened with white chalk, 264 × 205 mm., Loan from the Collection of Jeffrey E. Horvitz, Department of Drawings, Fogg Art Museum, Harvard University Art Museums, Cambridge, inv. no. D-F-345/ 1.1996.5; other preparatory studies by Vouet for this commission include sheets in the Musées des Beaux-Arts in Besançon and Grenoble; the Musée du Louvre, Paris; the Bayerische Staatsbibliothek, Munich; and private collections. See Barbara Brejon in Paris 1990a, cat. nos. 34–37, pp. 472–77, Brejon 1987a, cat. nos. 156–58 and cxvi–cxviii, pp. 154–56, and Richard Harprath in Munich 1991, cat. nos. 33 and 71–73, pp. 108–109 and 187–93.

8. One of the many examples of this is Guillet de Saint-Georges's insistence that during an earlier commission (c. 1631), François Perrier—then in Dorigny's role as senior assistant—painted the ceiling of the chapel of the Château de Chilly based on the master's drawings. See Guillet de Saint-Georges 1690, pp. 129–30.

9. In addition to the fundamental study of Vouet's drawings (Brejon 1987a) and the drawings section of the pivotal Vouet exhibitions in Paris and Munich (Paris 1990a, pp. 355–485 and Munich 1991, pp. 38–206), see Brejon 1986 and Brejon 1987b. On Dorigny in particular, see Brejon 1981, and Barbara Brejon in Munich 1991, pp. 216–31, and for Dorigny as a painter, see Brejon 1984, and Brejon 1992.

NOTES TO CAT. 18

1. Charles Le Brun, *Return from Flanders,* black chalk with gray wash, 523 × 298 mm., Département des Arts Graphiques, Musée du Louvre, Paris, inv. no. 29423; see Guiffrey and Marcel 1928, vol. 8, cat. no. 6386, and Lydia Beauvais in Paris 1985a, p. 75, no. 93.

2. François de Poilly, *Return from Flanders,* after Charles Le Brun, engraving, Département des Estampes, Bibliothèque nationale de France, Paris; see Lothe 1994, cat. no. 365; Wildenstein 1965, cat. no. 294, p. 56.

3. In his earliest surviving thesis print, that of 1641 for Charles Girard, he had already inserted the inscription into a single composition; see Jouin 1896, p. 596.

4. This never got beyond the stage of a model. See Nivelon 1700, pp. 257–58.

NOTES TO CAT. 19

1. Nanteuil's corpus of 230 prints consists of 221 portraits. The standard reference for the artist's engravings remains Petitjean and Wickert 1925; and the most thorough treatment of the artist's work as a draftsman remains Metcalfe 1911 and Fromrich 1957.

2. Fromrich 1957, p. 210.

3. Robert Nanteuil, *Bishop Félix Vialart,* graphite on parchment, 140 × 115 mm., Musée des Beaux-Arts, Reims, inv. no. 978-10-79J, inscribed on mount at bottom center: *Robertus Nanteüil Faciebat Parisiis Jul [. . .] 1650;* see Barbara Brejon de Lavergnée in Paris 1993a, cat. no. 102, pp. 238–40. For the Wooton drawing, see Fromrich 1957, p. 211, repr., fig. 2, and Vallery-Radot 1954, p. 30.

4. Robert Nanteuil, *Old Woman,* graphite on parchment, 137 × 112 mm., Département des Arts Graphiques, Musée du Louvre, Paris, inv. no. RF 31370; see Duclaux 1975, pp. 15–16.

5. Robert Nanteuil, *Rol. Burin,* graphite on parchment, 172 × 122 mm., Phillips-Fenwick Collection, Department of Prints and Drawings, British Museum, London, inv. no. 1845-4-15-949.

NOTES TO CAT. 20

1. The largest concentration of the artist's works can be found in a private Parisian collection. See Roswitha Erbslöh in Rennes 1995, cat. nos. 30–38, pp. 48–83; and Schnapper 1977.

2. Her Assumption is celebrated on 15 August.

3. Noël Coypel, *Assumption of the Virgin,* black and white chalk on tan antique laid paper, 356 × 252 mm., Private Collection; it was recently sold at Christie's, New York, 30 January 1998, lot 220.

4. Noël Coypel, *Assumption of the Virgin,* black and white chalk on gray paper, 261 × 203 mm., Harry G. Sperling Fund, 1981, Department of Drawings and Prints, The Metropolitan Museum of Art, New York, inv. no. 1981.15.3; see Bean and Turčić 1986, cat. no. 85, p. 83.

5. Information provided verbally by Nicolas Schwed, who discovered the sheet under another attribution.

6. Roswitha Erbslöh in Rennes 1995, cat. no. 38, pp. 82–83.

NOTES TO CAT. 21

1. Between 1950 and 1980, Suzanne and Henri Baderou were among the most active Parisian collectors of drawings. See the introduction to Rosenberg and Bergot 1990.

2. Rosenberg and Volle 1980.

3. These abbreviations reflect the French version of the Flemish family name of Plattenberg.

4. Nicolas de Plattemontagne, *Two Studies of a Woman Seated on the Ground Raising Her Left Hand,* black and red chalk, 185 × 291 mm., Département des Arts Graphiques, Ecole nationale supérieure des Beaux-Arts, Paris, inv. no. PM 773. See Pierre Rosenberg in Paris 1989a, cat. no. 36, pp. 112–13.

5. Nicolas de Plattemontagne, *Studies for "St. Paul in Prison,"* black and red chalk partially heightened with white chalk on cream antique laid paper, 284 × 423 mm., Purchase—Charles and Jesse Price Gift, David L. Klein Memorial Foundation Gift, and Harry G. Sperling Fund, Department of Drawings and Prints, The Metropolitan Museum of Art, New York, inv. no. 1996.97.

6. Guillet de Saint-Georges 1690, vol. 1, pp. 350–52.

7. "En 1700 et 1701, un grand tableau d'autel pour les dames de la Visitation, représentant *La Nativité de Notre-Seigneur,*" Guillet de Saint-Georges, as in n. 6.

NOTES TO CAT. 22

1. In Paris 1993a (p. 274), this sheet was published as part of the collection of the Musée Calvet in Avignon. In fact, it was part of the Puech Collections in Avignon, some of which were given to the museum. In the end, this drawing was not a part of that donation.

2. Guillerot, *Landscape with a River Bordered by Trees and Divided by a Bridge and Fortifications,* pen and black ink, 275 × 273 mm., Cabinet des Dessins, Musée des Beaux-Arts, Dijon, inv. no. Ca.T.149; see Jean-François Méjanès in Paris 1993a, pp. 274–75, cat. no. 142.

3. For Jean Lemaire (1598–1659), see Fagilo dell'Arco 1996; for Jacques Fouquières (1590–1659), the Flemish landscapist charged with painting the cities of France in the Grand Galerie of the Louvre, see Stechow 1948; and for François Bellin (or Blin), who died in 1661, see Jacques Thuillier in Paris 1990a, pp. 42–43.

4. Labbé and Bicart-Sée 1987, and the introduction to Labbé and Bicart-Sée 1996.

5. These large groups, totaling forty-seven sheets, include the works of other artists.

6. See Labbé and Bicart-Sée 1996, p. 310, where they note that the numbers between 2807 and 2823 are blank. Could this suggest sixteen more by Guillerot, bringing the total to thirty?

7. Roethlisberger 1975.

NOTES TO CAT. 23

1. The black chalk study of *The Borghese Gladiator* on the verso does not appear to be by La Fosse.

2. A comparable study of *Three Female Nudes* was shown in Rennes 1995, pp. 90–91, cat. no. 42.

3. For more on the Cabinet des Beaux-Arts, see Stuffmann 1964, pp. 104–5, cat. no. 36.

4. For a similar characterization, see Le Havre 1987, cat. no. 116.

5. Charles de La Fosse, *Study for the "Birth of Minerva,"* oil on paper, 226 × 338 mm., Hessisches Landesmuseum, Darmstadt, inv. no. HZ 1759.

6. Stuffmann 1964, p. 107, cat. nos. 47–48. Others include an *Assembly of the Gods,* Private Collection, Paris, and *Pandora with the Gods of Olympus,* formerly called the *Triumph of Psyche,* which recently appeared on the market (sale, Sotheby's, Monaco, 8 February 1981, lot 92, repr.).

7. "Pour faire études de la coupole de l'église des Invalides, il fit modeler par son neveu les figures afin de les dessiner, à l'example des Corrège, pour être vues du bas en haut, méthode plus certaine que celle des règles de la perspective et de l'optique"; see this anonymous author in Guillet de Saint-Georges 1690, vol. 2, p. 7.

8. Charles de La Fosse, *Sheet of Studies,* black and red chalk heightened with white chalk on tan paper, Département des Arts Graphiques, Musée du Louvre, Paris, inv. RF 38516. For the Dijon drawing, see Jean-François Méjanès in Paris 1993a, cat. no. 132, pp. 256–57, repr.

9. Dézallier d'Argenville 1745, p. 194: "*une touche lourde, des draperies pesantes des figures un peu courtes sont les indices assurés de sa main.*"

10. "*Les desseins de la fosse sont pleins de couleur & font autant d'effet que ses tableaux*"; see Dézallier d'Argenville 1745, p. 194.

NOTES TO CAT. 24

1. The largest collection of drawings by Corneille is in the Département des Arts Graphiques, Musée du Louvre, Paris. See Guiffrey and Marcel 1928, vol. 3, cat. nos. 2320–680.

2. Several study sheets by Corneille are known, including examples in the Musée du Louvre, Paris (Guiffrey and Marcel 1928, cat. no. 2680); the Nationalmuseum, Stockholm (Bjurström 1976, cat. nos. 328–31); the Staatliche Graphische Sammlung, Munich (Rosenberg 1971, fig. 46); the National Gallery of Art, Washington (see sale, Christie's, London, 11–13 December 1985, lot 171, repr.); the Courtauld Institute, London (London 1991, cat. no. 10); Mr. and Mrs. Guy-Philippe L. de Montebello (Toronto et al. 1972, cat. no. 31, pl. 54); sale, Sotheby's, London, 1 December 1983, lots 208 and 209; and New York 1965, cat. no. 57.

3. Michel II Corneille, *Sheet of Studies: A Woman's Face and Heads of Women and Cherubs,* black and red chalk heightened with white chalk on tan paper, 315 × 270 mm., Collection of Louis-Antoine Prat, Paris; see Pierre Rosenberg in New York et al. 1990, cat. no. 27, pp. 88–89.

4. Michel II Corneille, *Studies of Heads and Hands,* black and red chalk heightened with white chalk on beige paper, 305 × 446 mm., Département des Arts Graphiques, Musée du Louvre, Paris, inv. no. 26651; see Jean-François Méjanès in Paris 1985a, cat. no. 130, pp. 102–3.

5. Michel II Corneille, *Studies of Female Heads,* black chalk heightened with white chalk on gray paper, 250 × 230 mm., Musée Fabre, Montpellier, inv. no. 870.1.36; see Jean-Claude Boyer in Paris 1993a, cat. no. 146, pp. 280–81.

6. See Boyer 1991, and Jean-Claude Boyer in Paris 1993a, cat. no. 146.

NOTES TO CAT. 25

1. For a good translation of Ovid's *Metamorphoses,* see the one by Rolfe Humphries, published by the Indiana University Press, Bloomington, 1958. The story of Aesculapius is recounted on pages 384–88.

2. In Latin, the word "draco" can be used interchangeably to mean both snake and dragon. See Hall 1994, p. 21; de Tervarent 1964, vol. 1, col. 49. A draw-

ing in the National Gallery of Art, Washington, by François Boitard of *Aesculapius Receiving the Roman Messengers* (inv. no. 1991.226.2) also shows the god in the form of a dragon very like the one in the Horvitz drawing.

3. The past suggestion that this drawing represented the *Foundation of Thebes* was not due to any lack of clarity on Corneille's part, but rather to modern unfamiliarity with the range of stories in which dragons could appear (see Sotheby's, New York, 30 January 1997, lot 126). A similar error was made in respect to the Boitard drawing depicting a scene from the story of Aesculapius mentioned in n. 2, previously thought to represent *Daniel and the Babylonian Dragon.*

4. Michel II Corneille, *Breaking Ground for the Erection of the Cross,* pen and brown ink with brush and brown wash, heightened with white gouache, on blue laid paper, squared for transfer in graphite, 72 × 283 mm., Gift of Mrs. James E. Scripps, Department of Drawings, Detroit Institute of Arts, inv. no. 1909.1 S-Dr.75a. See Sharp 1992, cat. no. 72. Two further highly finished composition drawings by the artist are also in the Detroit Institute of Arts. These sheets, which all appear to belong to an earlier phase of Corneille's career than the Horvitz sheet, are dated to c. 1680. See Sharp 1992, cat. nos. 73–74.

5. The highly idiosyncratic drawings of Corneille's nonconformist younger brother, Jean-Baptiste Corneille, surely played a role in the loosening of Michel's pen technique. Jean-Baptiste's drawings feature a wiry line and a rather quirky handling of faces and hair, but the free-flowing sense of line and the rapid suggestion of forms with several quick strokes of the pen are clearly echoed in Michel's drawings. Several drawings by Jean-Baptiste are reproduced in Picart 1987, pp. 90–97, cat. nos. 103–31.

6. Michel II Corneille, *Christ Chasing the Merchants from the Temple (?),* Graphische Sammlung, Städelsches Kunstinstitut, Frankfurt; and Michel II Corneille, *Christ and the Woman of Samaria,* Graphische Sammlung, Hessisches Landesmuseum, Darmstadt. The stylistic connection between these two drawings and the Horvitz sheet was made by Alvin Clark, who kindly brought the drawings to my attention.

7. See Davidson Reid and Rohmann 1993, pp. 234–35.

8. *Metamorphoses d'Ovide en Rondeaux.* This edition, published by the royal press and dedicated to the dauphin, was illustrated mainly by François Chauveau and Sebastien Le Clerc.

NOTES TO CAT. 26

1. In addition to the two works reproduced and discussed in this entry, one in a private British collection and the other in the National Gallery of Scotland, Edinburgh (see below nn. 6 and 7), there is another sheet in the National Gallery of Scotland (*Summer,* dated 1695; see Stephen Ongpin in New York 1990, pp. 79–83), one in the Metropolitan Museum of Art in New York (*Landscape with a Circular Temple on a Mountain,* dated 1693; see Bean and Turčić 1985, cat. no. 231), two in the Musée du Louvre, Paris (*Landscape with the Good Samaritan,* dated 1691, and *Landscape with Christ and the Samaritan,* dated 1692; see Jean-François Méjanès in Legrand 1997, cat. nos. 908–9, p. 223), one in the Musée Girodet, Montargis, dated 1693, and one in the Galleria nazionale di Palazzo Corsini in Rome (for this and the Montargis sheet, see the Larousse *Dictionnaire de la peinture française,* Paris, 1989, p. 373). In addition, one of his works is now on the art market in New York (dated 1679; sale, Christie's, London, 4 July 1995, lot 84); three others (dated 1693, 1688, and 1689) recently on the art market were cited by Stephen Ongpin in New York 1990, p. 82, nn. 2 and 3.

2. The paintings date from the last decade of the seventeenth and the first decade of the eighteenth century. They remained in the church (then called Saint-Louis-de-la-Culture)—where they were in a salon just off the garden—until the Revolution. The nine extant canvases are now split among the Musée du Louvre, Paris (January, April, August, and September), the Staatliches Museum, Schwerin (November and December), the Fine Arts Museums of San Francisco (October), and a private collection (February and June). See Beatrice Sarrazin in Paris 1985b, cat. nos. 45 and 46, pp. 50–52; Compin and Roquebert 1986, vol. 4, pp. 126–27; and Rosenberg and Stewart 1987, pp. 75–78.

3. Mariette 1750, vol. 4, pp. 88–90.

4. For a summarization of the draftsmanship and references to drawings by Pierre Patel l'aîné, see Jean-François Méjanès in Paris 1993a, cat. no. 72, pp. 154–55. For recent information on Patel le jeune, see Jean-François Méjanès in Paris 1993a, cat. no. 155, pp. 298–99. One sheet catalogued as attributed to the younger Patel, *Landscape with the Rest on the Flight into Egypt* (Musée du Louvre, Paris), is essentially executed in black chalk, but it is also heightened with pastel and touches of gouache and may indicate an early attempt at integrating color into his oeuvre (see Jean-François Méjanès in Legrand 1997, cat. no. 907).

5. Pierre-Antoine's touch is not unlike that seen in the etchings of the Patels' contemporary, Francisque Millet. For the etchings of Millet, see Alvin Clark in New Haven 1987, cat. no. 45.

6. Pierre-Antoine Patel, *Winter,* gouache on parchment, 161 × 274 mm., Department of Drawings, National Gallery of Scotland, Edinburgh, see Stephen Ongpin in New York 1990, pp. 79–83.

7. Pierre-Antoine Patel, *Winter Landscape with Ruins and Figures on a Frozen Lake,* gouache on vellum, 162 × 224 mm., Private Collection, United Kingdom; see Stephen Ongpin in New York and London 1998, cat. no. 27 (n.p.).

NOTES TO CAT. 27

1. Of the more than 160 drawings by Boullogne catalogued in Guiffrey and Marcel 1928 (cat. nos. 1437–1599) in the collection of the Musée du Louvre, Paris more than two-thirds are drawn in black and white chalk on blue paper, and most of the others are drawn in the same combination of media on non-white papers described as greenish, gray, or tan.

2. Louis de Boullogne, *Bacchus and Ariadne,* black and white chalk on blue paper, 255 × 257 mm., circular, Département des Arts Graphiques, Musée du Louvre, Paris, inv. no. 24902. See Schnapper and Guicharnaud 1986, cat. no. 14.

3. Louis de Boullogne, *Study of an Angel,* black and white chalk on blue paper, 354 × 288 mm., Département des Arts Graphiques, Musée du Louvre, Paris, inv. no. RF 24939. See Schnapper and Guicharnaud 1986, cat. no. 26.

4. Louis de Boullogne, *Double Académie,* 1710, black and white chalk on blue paper, 581 × 422 mm., Department of Prints and Drawings, Museum of Art, Rhode Island School of Design, Providence, RI, inv. no. 57.091. See Schnapper and Guicharnaud 1986, cat. no. 41.

NOTES TO CAT. 28

1. Hyacinthe Rigaud, *Portrait of Samuel Bernard,* signed and dated 1727, black and white chalk on blue paper, squared in black chalk, 559 × 412 mm., Department of Prints and Drawings, Nelson-Atkins Museum of Art, Kansas City, inv. no. 66-15. Rigaud was paid 200 livres for this drawing. See Eric Zafran in Atlanta 1983, p. 144, pl. 71; O'Neill 1984b; and Roger Ward in Tulsa et al. 1996, cat. no. 33, ppl 117–19.

2. Roman 1919, pp. 83, 84, 135, 136, 141, 142. Unfortunately, not all of Rigaud's account books have survived, making it impossible to know how many drawings were produced by members of his studio.

3. The emphasis has been added. Minutier Central des Notaires, Archives Nationales, Paris, Etude LIII, 256 (Billeheu), 11 February 1731; cited in Wildenstein 1966, p. 135. For a discussion of Rigaud's wills, see O'Neill 1984a, p. 191, n. 1. As O'Neill points out, the portfolio appears to have been passed on intact to Rigaud's godson and heir Hyacinthe Collin de Vermont and was probably included in the sale held after Collin de Vermont's death on 14 November 1761, lot 72. The portfolio was described as "un paquet de Dessins de Portraits très finis aux crayons noir et blanc & lavés par M. Rigaud, qui ont servi pour graver ses Tableaux."

4. Attributed to Charles Viennot, *Portrait of a Man,* black chalk and brush with dark gray wash heightened with white gouache and white chalk on blue-green paper, squared in black chalk, 374 × 287 mm., Gift of Edward B. Greene, B.A. 1900, Department of Prints, Drawings, and Photographs, Yale University Art Gallery, New Haven, inv. no. 1937.329. See Haverkamp-Begemann and Logan 1970, vol. 1, cat. no. 27, p. 18.

5. Hyacinthe Rigaud, *Portrait of the Marquise d'Usson de Bonnac,* oil on canvas, 54 × 42 in. (sight), Acquired through the Mary Runnells Fund, Department of Paintings, Nelson-Atkins Museum of Art, Kansas City, inv. no. F77-14.

NOTES TO CAT. 29

1. Chéron's use of color, and the strong contours, heavily muscled figures, and expressive faces in his mature works, were too forceful for his critics, and sometimes even for those who generally admired his production (see Mariette 1750, vol. 1, pp. 368–69; and Dézallier d'Argenville 1745, p. 329).

2. "The Transition" is used here to describe the art of the late seventeenth century and early eighteenth century (c. 1680–1720), when the work of a number of artists reveals a simultaneous link with a heavier brand of classicism from the middle of the century and the lighter and more colorful art of the Rococo period that matures in the first third of the eighteenth century.

3. Both Jean-François Méjanès and Louis-Antoine Prat have discussed Chéron's links with Le Brun, with whom his drawings have been confused in the past. See Paris 1993a, cat. no. 161, pp. 308–9; and Rennes 1995, cat. no. 57, pp. 119–20. After his many years in Italy (c. 1680–86), Chéron often referred to himself as a student of Raphael (see Dézallier d'Argenville 1745, pp. 329–30); for Chéron's prize-winning drawing at the Accademia di San Luca (*Judgment of Solomon*), see Cipriani and Valeriani 1988, vol. 1, pp. 79–81, repr.

4. For Chéron in northern Italy, particularly Venice—where he painted his *Christ Healing a Paralytic at the Pool of Bethesda* for San Pantaleone, Venice *(in situ)*—see Ivanoff 1962.

5. Dézallier d'Argenville 1745, p. 327; this author was the first to write an extensive biography of the artist.

6. Chéron probably returned to Paris by 1686 and executed two *Mays* for Notre-Dame in 1687 and 1690; this was an annual commission for the decoration of the chapels of this church by the Parisian Goldsmiths' Guild. For the *May* paintings in general, see Auzas 1949, Auzas 1953, and Auzas 1963; and for Chéron's paintings, see Auzas 1949, pp. 186–87 and 198.

7. Elisabeth-Sophie Chéron was one of the first women admitted to the Académie. On the Revocation of the Edict of Nantes, see Garrison 1985 and Phillips 1997, pp. 205–25. Although most French literature states that Chéron left for England in 1695, he is already recorded as a member of the Huguenot congregation at the Savoy Chapel in 1693 and lived at the Green Door, Little Piazza, Covent Garden, until his death in May of 1725. His major patron there was Ralph, first duke of Montagu, a former British ambassador to France and protector of many Huguenot artists and craftsmen. Chéron executed a number of painted ceilings and other decorations for Montagu's three houses (Boughton in Northamptonshire, Ditton Park in Buckinghamshire, and Montagu House in London—this last was later demolished to provide space for the construction of the British Museum). See Lindsay Stainton and Christopher White in London and New Haven 1987, pp. 217–19; Tessa Murdoch in London 1985, pp. 193–95; and Croft-Murray 1962, pp. 243–45.

8. Although rarely discussed, the drawings in this album—purchased from the artist's estate sale by the tenth earl of Derby in 1725 and acquired by the British Museum from the sale of the Derby Library from Knowsley in 1953—may date from various periods in the artist's career and should not be taken as a direct reflection of his English period alone. Indeed, there are many studies after details of works by Italian masters that remain *in situ* and a number of academic nudes whose different styles suggest connections with Chéron's work in France, Italy, and, of course, England, where he was one of the original participants in the first British Academy in Great Queen Street, Covent Garden, beginning in 1711 (see Lindsay Stainton and Christopher White in London and New Haven 1987, pp. 219–20).

9. Ovid, *Metamorphoses,* 10:519–59.

10. The sale took place on three days, 26 and 28 February, and 2 March 1726, and the drawings mentioned were sold on 28 February 1726, lots 77 and 78 (see Russell 1988, p. 467); "four highly finished roundels of subjects connected with the *Pastor Fido* subjects at Chatsworth" are also mentioned in the collection of Mrs. E. E. Dakeyne, Granit Field, Dun Loaghaire, Dublin (see Croft-Murray and Hulton 1960, p. 270).

11. Pierre Rosenberg in Paris 1989a, cat. no. 55, pp. 150–51. Begun in 1580, Guarini's *Il Pastor Fido* was first published in 1590. Although largely unread today, its enormous popularity led to translations into many languages, including French (by Rolland Brisset in 1593) and English (by Sir Richard Fanshawe, *The Faithful Shepherd* in 1647). Proclaimed a pastoral in the mode of a tragicomedy by its author—a new genre that blended a tragic plot with a happy ending—its form and its frank eroticism led to one of the most important early modern literary debates, extending into the beginning of the nineteenth century (see Perella 1973).

12. The Chatsworth decorations included at least six scenes based on *Il Pastor Fido.* They were painted in the Gallery and the Little Dining Room in c. 1699–1700. Chéron was paid a total of 110 pounds for his work there and in the Bowling House. By 1827, the Gallery was transformed into the present-day Library, and some of the scenes were deinstalled for use in the new Theater (see Croft-Murray and Hulton 1960, p. 269, and Thompson 1949, pp. 163–69 and 200, repr., plates 76–77).

13. This work probably represents Act 2, Scene 3.

14. Louis Chéron, *Shepherds Praying to the Goddess Diana,* pen and brown ink with brush and brown wash, heightened with white gouache, 244 mm. diameter, Polakovits Collection, Département des Arts Graphiques, Ecole nationale supérieure des Beaux-Arts, Paris, inv. no. PM 1167; see Pierre Rosenberg in Paris 1989a, cat. no. 55, pp. 150–51.

15. Rosenberg as in n. 14.

NOTES TO CAT. 30

1. Antoine Dieu, *Triumph of Faith,* pen and ink with brush and wash, 270 × 195 mm., Pushkin Museum of Fine Arts, Moscow, inv. no. Box 81-8, 1025; see Rosenberg 1979, p. 167, and Moscow 1978, cat. no. 66.

2. Antoine Dieu, *Triumph of Justice,* black and red chalk with brush and brown wash, 240 × 157 mm., Graphische Sammlung, Wallraf-Richartz Museum, Cologne, inv. no. Z.2227. See Rosenberg 1979, p. 166, pl. 35a, and Robels 1967, p. 119.

3. Like the Horvitz drawing, it does not appear to have been engraved.

4. Antoine Dieu, *Adoration of the Golden Calf,* pen and black ink with brush and gray wash over red chalk on off-white antique laid paper, 300 × 441 mm., Loan from the Collection of Jeffrey E. Horvitz, Department of Drawings, Fogg Art Museum, Harvard University Art Museums, Cambridge, inv. no. D-F-598/ 1.1998.62.

5. Mariette 1750, vol. 10, p. 112; the text is cited verbatim in Rosenberg 1979, p. 163.

NOTES TO CAT. 31

1. See Georges 1864, no. 266, p. 206.

2. For the 1562 expulsion of the Huguenots, see Greengrass 1983, and Schneider 1989, pp. 90–96. The Catholic victory made Toulouse the stronghold of the ultra-Catholic Holy League in southern France for decades (for Toulouse and the Holy League, see Schneider 1989, pp. 96–100 and Holt 1995, pp. 90–93 and 142–45).

3. At least two early biographers note that Rivalz had just begun to assist Maratta on an important ecclesiastic commission before he was forced to return to Toulouse upon receiving the news of his father's stroke. See Dézallier d'Argenville 1745, vol. 4, p. 356, and Mariette 1750, vol. 4, p. 403, where he notes that the date of Rivalz's return to Toulouse was 1702 instead of 1701.

4. Antoine Rivalz, *St. Peter Healing the Sick with His Shadow,* black chalk and brush with brown wash, heightened with white gouache, on six joined sheets of tan paper, 582 × 730 mm., Gift of Louis-Antoine and Véronique Prat, Département des Arts Graphiques, Musée du Louvre, Paris, inv. no. RF44326; see Pierre Rosenberg in Paris et al. 1995, cat. no. 33, p. 100.

5. See Jean Penent—who is preparing a monograph on the artist—in Toulouse 1992, pp. 144–47.

NOTES TO CAT. 32

1. Three of Galloche's drawings from this group are linked to well-known works. One is a study for the central figure in Galloche's painting of *St. Vincent de Paul Urging the Institution of the Foundlings' Home* of 1732 (Eglise Sainte-Marguerite, Paris); see sale catalogue, Christie's, London, 5 July 1988, lot 119, resold 7 July 1992, lot 227. The two others are studies for Volumnia, kneeling and accompanied by a child (now in the Pierpont Morgan Library, New York), and for Coriolanus in Galloche's *Coriolanus in the Camp of the Volscians* in the Musée des Beaux-Arts, Orléans, which was entered in the competition of the Direction des Bâtiments in 1747; see sale catalogue, Christie's, London, 5 July 1988, lot 118, and 4 July 1989, lot 119. For the five other sheets—*Draped Man Holding a Globe in His Left Hand* (now in the Metropolitan Museum of Art, New York), a *Kneeling Man,* a *Man Bowing,* and two studies for a *Seated Woman* (all unconnected to known compositions)—see Laurence Strapélias in Paris 1988e, cat. nos. 16–18; sale, Christie's, London, 4 July 1989, lots 120–121; and sale, Christie's, London, 2 July 1996, lots 219–220.

2. The only recent study is an unpublished one by Marie-Catherine Sahut, *Le peintre Louis Galloche (1670–1761),* mémoire de maîtrise, Université de Paris IV-Sorbonne, 1973.

3. The *Two Draped Men* is a study for *Pentecost* in the Musée des Beaux-Arts, Nantes, and the *Drapery Study for a Male Figure* is unconnected at this time.

4. In 1720, Galloche was elevated to the rank of one of the twelve professors at the Académie who taught in rotation, and from 1722 to 1738, he taught there every January. Four of the six unpublished *académies* at the Ecole nationale supérieure des Beaux-Arts in Paris are dated 1725, 1726, 1727, and 1729.

5. See the essay by Alain Mérot and Sophie Raux-Carpentier in this catalogue.

6. For a drawing by Galloche executed with black and white chalk on blue paper in the manner of Louis de Boullogne, see Jean-François Méjanès in Paris 1987d, cat. no. 66, pp. 50–51.

7. It is notable that the pose of the figure here resembles that of the Virgin in Raphael's *Large Holy Family* (or the *Holy Family of François Ier,* Musée du Louvre, Paris) in reverse, as she appears in an engraving by Gérard Edelinck (see Martine Vasselin in Paris 1983a, cat. no. 288). For Galloche's reference to Raphael, see "Remarks on the Great Masters," the third part of his unpublished treatise on painting, which was based on the *conférence* he delivered to the Académie on 7 April 1753 (Ecole nationale supérieure des Beaux-Arts, Paris, manuscript no. 203, fol. 6).

NOTES TO CAT. 33

1. Dézallier d'Argenville 1745, vol. 2, p. 420, where the author noted that the pupil quickly equaled the master and "one could hardly tell their works apart"; reprinted in Pierre Rosenberg, *Vies anciennes de Watteau,* Paris, 1984, p. 47.

2. The print reproduced here and related to this drawing is also in the Horvitz Collection.

3. See Populus 1930, pp. 79–82, cat. nos. 5–8.

4. The woman standing at the left in the drawing, for example, is kneeling in the print, and the artist has added a child-satyr between the two children holding the garland of fruit next to her. A male satyr replaces the child in the trio of figures in the center foreground, and the poses of all three have changed. The two children playing with the goat to the right of that central group have been replaced by a basket and fruit; the space between the two child-satyrs leading the burial procession is wider in the print, and the poses of the weeping couple at the far right in the drawing show greater emotion. At the center of the composition, the shape of the grave dug in the ground has been clarified in the print, with a spade, a few satyr bones, and a small pile of dirt added around it.

5. Claude Gillot, *Birth,* pen and black ink with brush and sanguine wash, heightened with white on paper prepared with red chalk (incised for transfer), Graphische Sammlung Albertina, Vienna, inv. no. 11965; and *Marriage,* pen and black ink with brush and sanguine wash, heightened with white on paper prepared with red chalk (incised for transfer), inv. no. 11966; see Benesch 1967, p. 214.

6. The comte de Caylus, who knew Watteau personally, indicates that Gillot had worked in a number of different genres (bacchanales, fantasy, ornament, fashion and history) before immersing himself in the theater at about the time of Watteau's arrival in his studio. See his "La vie d'Antoine Watteau, Peintre de figures et de paysages, sujets galants et modernes," read at a session of the Académie on 3 February 1748 (reprinted in Rosenberg 1984, p. 59).

7. See Ruppert—Delpierre—Davray—Gorguet 1996, pp. 119–21. This coiffure was omitted in the final print.

8. See Margaret Morgan Grasselli in Washington 1995a, cat. no. 77, p. 283; and the Gernsheim Corpus of Drawings, no. 73-860.

NOTES TO CAT. 34

1. Parker and Mathey 1957, cat. no. 580. The connection of this sheet with Watteau's studies of Persians was made separately in two publications that appeared in the same year. See Roland Michel 1984, pp. 133–34; and Margaret Morgan Grasselli, in Washington et al. 1984, p. 116, fig. 1.

2. Jean-Antoine Watteau, *Standing Man in Persian Costume Facing Right in Three-Quarter View,* red and black chalk, 293 × 145 mm., Collection of Clare and Eugene Victor Thaw, New York, on loan to the Pierpont Morgan Library, New York; see Rosenberg and Prat 1996, cat. no. 284.

3. Jean-Antoine Watteau, *Seated Man in Persian Costume Facing Right,* red and black chalk, 294 × 196 mm., Department of Prints and Drawings, Victoria and Albert Museum, London, inv. no. Dyce 593; see Rosenberg and Prat 1996, cat. no. 283.

4. Rosenberg and Prat 1996, cat. no. 286.

5. Rosenberg and Prat 1996, cat. no. 287.

6. Mathey 1939, pp. 158–59; prior to 1939, the drawings were thought to represent Turks who visited Paris in 1721.

7. The anonymous prints are in the Bibliothèque nationale, Paris, and are reproduced in Mathey 1939, p. 158.

8. Rosenberg and Prat 1996, cat. nos. 281, 282.

NOTES TO CAT. 35

1. According to Edmond and Jules de Goncourt, "une partie de ces dessins à été acquise par le baron Schwiter après le décès de M. Auguste, le sculpteur, dont la vente en mai 1850 . . . fut si extraordinairement malheureuse" (Goncourt 1875, p. 366).

2. Watteau's method of composing his paintings was described by his

friend, the comte de Caylus, in the biography of Watteau he read to the Académie on 3 February 1748; see Rosenberg 1984, pp. 78–79.

3. Jean-Antoine Watteau, *Study for "Pleasures of Love,"* red chalk and graphite, 196 × 265 mm., Gift of the Regenstein Foundation, Mrs. Henry C. Woods, and the Wirt D. Walker Fund, Department of Prints and Drawings, The Art Institute of Chicago, inv. no. 1975.343; see Rosenberg and Prat 1996, cat. no. 599.

4. The execution dates for all three paintings are discussed at length in Grasselli 1988, pp. 263–71 and 347–52.

5. In Rosenberg and Prat 1996, under cat. no. 470, a slightly earlier date of "c. 1716?" is proposed, but the logical position of the Horvitz drawing between the Chicago compositional study and the Dresden painting indicates that it was probably made no earlier than 1717.

NOTES TO CAT. 36

1. See Schreiber Jacoby 1987, pp. 257–58, where it is suggested that this was one of the drawings given to Francesco Gaburri by Jean de Jullienne.

2. Relevant details from these paintings are reproduced in Rosenberg and Prat 1996, cat. no. 328.

3. In 1968, Marianne Roland Michel suggested a date around 1716 (Paris 1968, cat. no. 50), but some years later, in Roland Michel 1984 (p. 136), she revised the date to about 1718. In 1996, Rosenberg and Prat (cat. no. 328) suggested a date around 1715 for the figure and perhaps a little later for the study of a hand.

4. Jean-Antoine Watteau, *Two Studies of a Woman,* red and black chalk, 144 × 192 mm., Department of Prints and Drawings, British Museum, London, inv. no. 1846-11-14-25 (see Rosenberg and Prat 1996, cat. no. 528, and Parker and Mathey 1957, cat. no. 602); see also Rosenberg and Prat 1996, cat. nos. 527, 529–31, and 587, among others.

NOTES TO CAT. 37

1. Jean-Baptiste Oudry, *Trees Bordering a River Bank with a Manor House in the Distance,* brush and brown wash with pen and brown ink heightened with white gouache on blue paper, 198 × 256 mm., Département des Arts Graphiques, Musée du Louvre, Paris, inv. no. RF14952; see Hal Opperman in Paris et al. 1982a, p. 70, cat. no. 24; Duclaux 1975, cat no. 266, pp. 149–50.

2. These were executed from the late 1720s through the 1730s. See Hal Opperman in Paris et al. 1982a, cat. nos. 60–62.

3. The abbé Gougenot, Oudry's official biographer, describes how students accompanied Oudry in the gardens of Arcueil, where he willingly taught them the mysteries of light and shade (see Gougenot 1761, p. 378).

4. See Hal Opperman in Paris et al. 1982a, pp. 232–44, cat. nos. 129–38.

5. Jean-Baptiste Oudry, *Garden Wall with Gate at Arcueil,* black and white chalk on blue paper, 308 × 530 mm., Donation Armand-Valton, Cabinet des Dessins, Ecole nationale supérieure des Beaux-Arts, Paris, inv. no. 1382 (see Brugerolles 1984, p. 275, cat. no. 443).

NOTES TO CAT. 38

1. For the history of this proposal, see Hal Opperman in Paris et al. 1982a, cat. nos. 107–9; and Opperman 1977, vol. 1, pp. 111–12, and vol. 2, pp. 749–59 and 956–58.

2. Jean-Baptiste Oudry, *Combat of Leopards and Wild Horses,* pen and black and brown ink, and brush with brown and and gray wash, heightened with white gouache, on blue antique laid paper, 319 × 546 mm., signed and dated 1745, Graphische Sammlung Albertina, Vienna, inv. no. 12.015; see Hal Opperman in Paris et al. 1982a, cat. no. 108.

3. Jean-Baptiste Oudry, *Frightened Duck,* black and white chalk on blue paper, 555 × 640 mm., Graphische Sammlung, Staatliches Museum, Schwerin, inv. no. 1178-Hz; see Hal Opperman in Paris et al. 1982a, cat. no. 101.

4. Jean-Baptiste Oudry, *Angry Swan,* black chalk heightened with white chalk on blue-green paper, 247 × 380 mm., The Mr. and Mrs. Henry Ittleson Purchase Fund, 1970, Department of Drawings and Prints, The Metropolitan Museum of Art, New York, inv. no. 1970.133.

5. Johann Heinrich Tischbein the Younger, after Jean-Baptiste Oudry, *Bird of Prey Attacking Ducks,* engraving, Graphische Sammlung Albertina, Vienna; see Hal Opperman in Paris et al. 1982a, cat. no. 102.

6. Jean-Baptiste Oudry, *Dog Attacking a Swan,* pen and black ink and brush with black and gray wash, heightened with white gouache, on blue paper, 319 × 411 mm., Helen Regenstein Collection, Department of Drawings, The Art

Institute of Chicago, inv. no. 1966.351; see Hal Opperman in Paris et al. 1982a, cat. no. 105.

7. Gabriel Huquier, after Jean-Baptiste Oudry, engraving, Graphische Sammlung Albertina, Vienna; see Hal Opperman in Paris et al. 1982a, cat. no. 115.

8. See Mariette 1750, vol. 4, pp. 65–66.

NOTES TO CAT. 39

1. Le Blanc 1890, vol. 4, cat. nos. 121–32. Some of the Parrocel drawings that served as Wille's models are in the Metropolitan Museum, New York (inv. 07.282.8; see Bean and Turčić 1986, cat. no. 228); the Royal Print Room, Copenhagen (Tu 24,1; Tu 24,2; Tu 24,3); and the British Museum, London (1943-11-13-81).

2. For the Frankfurt drawing, see Margret Stuffmann in Frankfurt 1986, cat. no. 62; for two other smaller examples of this type, see Antoine Schnapper in Paris 1989a, pp. 188–89. Two slightly smaller drawings of standing officers, signed and dated 1718, and executed in red chalk, also offer similarities that may help to fix the Horvitz drawing in the earlier part of Parrocel's career. These are reproduced in New York et al. 1988, cat. nos. 18 and 19.

3. Charles Parrocel, *Soldiers Playing Cards before a Tavern,* red chalk on two joined pieces of cream antique laid paper, 710 × 334 mm., Loan from the Collection of Jeffrey E. Horvitz, Department of Drawings, Fogg Art Museum, Harvard University Art Museums, Cambridge, inv. no. D-F-223/ 1.1995.84.

4. Dèpartement des Estampes, Bibliothèque national de France, Paris.

5. Very little has been published on Parrocel and even less on the chronology of his drawings. J. Crosby Schuman's doctoral dissertation, *Charles Parrocel,* submitted to the University of Washington in 1979, has not been published and is not generally available for consultation.

NOTES TO CAT. 40

1. Dézallier d'Argenville 1762, pp. 419–20; Caylus 1765, pp. 43–44.

2. Bordeaux 1984, cat. no. 33.

3. The Horvitz sheet, on which Grasselli based her new attributions, was one of seven published by Jean-Luc Bordeaux (five bear the annotation *Le Moyne*). See Parker and Mathey 1957; Bordeaux 1984; and Morgan Grasselli 1996.

4. François Le Moyne, *Landscape with Cottage and Riverbank,* red chalk, 215 × 330 mm., Department of Drawings and Prints, Pierpont Morgan Library, New York, inv. no. I, 281; Morgan Grasselli 1996, p. 370, fig. 6.

5. François Le Moyne, *View of Formia from Gaeta,* black and white chalk on blue antique laid paper, 224 × 339 mm., Bequest of Frances L. Hofer, Department of Drawings, Fogg Art Museum, Harvard University Art Museums, Cambridge, inv. no. 1979.74.

6. Although it resembles the others in the group, the *View of the Church of S. Stefano Rotundo* (Musée du Louvre, Paris) is not by Le Moyne. See Jean-François Méjanès in Paris 1987d, pp. 96–97, cat. no. 128.

NOTES TO CAT. 41

1. See Bordeaux 1984, cat. no. 60 and Colin Bailey in Paris et al. 1991, cat. no. 24. The Wengraf painting is considered to be the original. The comte de Caylus stated this as early as 1748 (see Caylus 1765, p. 65), and the picture was engraved in London in 1767. However, there was at least one other autograph version. It appeared in the second sale of the prince de Conti (March 1779, lot 82), where it was sketched by Gabriel de Saint-Aubin in the margins of his copy of the sale catalogue (Dacier 1919, p. 69). It should be noted that Charles-Joseph Natoire, one of Le Moyne's students, made a copy of *Diana and Callisto.* This copy, which was the same size as the original, was offered at the estate sale of the painter Nicolas-Louis Barbier, a member of the Academy of St. Luke in Paris (Paris, 19 July 1779, lot 4). Other replicas—or old copies—have reappeared on the art market during the past three decades.

2. François Le Moyne, *Reclining Female Nude,* black and red chalk on tan antique laid paper, 230 × 371 mm., Graphische Sammlung, Städelsches Kunstinstitut, Frankfurt, inv. no. 1276; see Bordeaux 1984, cat. no. 82, and Margret Stuffmann in Frankfurt 1986, cat. no. 76.

3. François Le Moyne, *Standing Female Nude,* black and red chalk with touches of white chalk on beige antique laid paper, 420 × 278 mm., Gift of Charles E. Dunlap, Department of Drawings, Fogg Art Museum, Harvard University Art Museums, Cambridge, inv. no. 1954.114; see Bordeaux 1984, cat. no. 81.

4. This study appeared at the Boileau sale (Paris, 4 March 1782, lot 141); at the sale of "part of the cabinet of an artist" (Paris, 22 January 1787, lot 302); and at the estate sale of the painter Jacques-Augustin de Silvestre (Paris, 29 February–25 March 1811, lot 381).

NOTES TO CAT. 42

1. Dézallier d'Argenville 1762, pp. 424–25.

2. Ibid.

3. François Le Moyne, *Alexander the Great Captures King Porus,* pen and gray ink with brush and brown wash over a faint sketch in black chalk, 310 × 437 mm., Department of Prints and Drawings, Nationalmuseum, Stockholm, inv. no. NM2734/1863; see Bjurström 1982, cat. no. 1057. For the other, more finished version, in the Metropolitan Museum, New York, see Bean and Turčić 1986, cat. no. 170.

4. The connection was first suggested by Alvin Clark.

5. François Le Moyne, *Drapery Study for a Female,* black chalk heightened with white chalk on gray paper, 390 × 226 mm., Département des Arts Graphiques, Musée du Louvre, Paris, inv. no. 30520; see Bordeaux 1984, cat. no. 112.

6. François Le Moyne, S*tudy of a Seated Male Nude,* black chalk heightened with white chalk on gray paper, 306 × 268 mm., Département des Arts Graphiques, Musée du Louvre, Paris, inv. no. 30558; see Bordeaux 1984, cat. no. 174.

NOTES TO CAT. 43

1. See Pierre Rosenberg and Antoine Schnapper in Rouen 1970, pp. 12 and 71–90.

2. See Rosenberg and Schnapper 1977; Rosenberg and Geissler 1980; Rosenberg 1982; and Rosenberg 1996.

3. Rosenberg and Schnapper 1977, pp. 166–67; and Pierre Rosenberg in New York et al. 1990, cat. no. 43, p. 120.

4. Recently, a consideration of the Restout family's leanings toward a French sect of Catholicism known as Jansenism (which emphasized the intense internal conflict for the eternal life of the soul) has been offered as one possible reason for the *gravitas,* intense spirituality, and—compared to his contemporaries—earnest approach to religious compositions. See Goodman 1995, pp. 74–78.

5. Jean II Restout, *A Procession of Monks,* black chalk heightened with white chalk on light tan antique laid paper, 337 × 402 mm., Harry G. Sperling Fund, 1993, Department of Drawings and Prints, Metropolitan Museum of Art, New York, inv. no. 1993.200; see Marianne Roland Michel in Paris 1991c, cat. no. 22 (n.p.).

6. Jean II Restout, *St. Peter Healing a Lame Man before a Temple,* black and white chalk on light tan paper, 386 × 252 mm., Réserve du Département des Estampes, Bibliothèque nationale de France, Paris (recueil B6a); see Rosenberg and Schnapper in Rouen 1970, cat. no. D19, pp. 79–80.

7. The painting of *St. Peter Healing a Lame Man* was exhibited at the Salon of 1738. For more on the ensemble of paintings depicting scenes in the life of St. Peter for Saint-Pierre-de-Martroi (also called Saint-Pierre-Ensentelée) and the related drawings, see Rosenberg and Schnapper in Rouen 1970, cat. nos. P24 and D17–19, pp. 55, 79–80, and 195, all repr.; Rosenberg and Schapper 1977, p. 166, pl. 26; Rosenberg and Geissler 1980, pp. 133–35, fig. 2.

NOTES TO CAT. 44

1. These sheets are essentially conserved in a few major European museums such as the Musée du Louvre, Paris; the Kupferstich-Kabinett, Dresden; the National Gallery of Scotland, Edinburgh; the Ashmolean Museum, Oxford; the Graphische Sammlung Albertina, Vienna; and a small number of private collections; for the academic drawings, see Salmon 1994a.

2. Collin de Vermont's *Peleus and Thetis* was listed in the *livret* of the Salon of 1737 (p. 27). It was exhibited on the third pier under the cornice, on the side of the room in the Louvre closest to the Seine, near paintings by Pierre Dulin and Jean-Baptiste Massé. It was listed also as cat. no. 15 in the *livret* of the Salon of 1753 (p. 28); it measured 144 × 97.5 cm.

3. Hyacinthe Collin de Vermont, *Rest after the Hunt,* red chalk heightened with white gouache, 349 × 476 mm., Département des Arts Graphiques, Musée du Louvre, Paris, inv. no. 25261; see Jean-François Méjanès in Paris 1987a, cat. no. 144, pp. 108–9; and Labbé and Bicart-Sée 1987, vol. 1, p. 488. For other complex compositions by the artist, see Salmon 1994b.

4. Hyacinthe Collin de Vermont, *Gathering of Manna,* red chalk (recto),

black and red chalk (verso), 360 × 283 mm., Saint-Genys Bequest (1915), Cabinet des Dessins, Musée des Beaux-Arts, Angers, inv. no. MTC 4825; see Salmon 1991.

NOTES TO CAT. 45

1. Lefrançois 1994, pp. 298–99, cat. no. P182, oil on canvas, 100 × 133 cm.

2. Sale, Hôtel Lambert, Paris, 1 December 1778, lot 29.

3. Sale, Paris, 27 March 1753, lot 288. The works in the sale were catalogued by Pierre-Jean Mariette.

4. Collection Doucet, Bibliothèque nationale de France, Paris, inv. no. 1737/ 4d.

5. Charles-Antoine Coypel, *Study for Adrienne Lecouvreur in a Dramatic Role,* before c. 1730, pastel, 344 × 272 mm., Musée des Beaux-Arts, Mulhouse, inv. no. 85-2-3; see Lefrançois 1994, pp. 236–37, cat. no. P118.

6. The Brest canvas was painted in 1741, the Louvre painting in 1749. See Lefrançois 1994, pp. 316–18, cat. no. P206, and pp. 362–65, cat. no. P265, respectively.

7. Charles-Antoine Coypel, *Joseph Accused by Potiphar's Wife,* black chalk, pen and black ink with brush and brown wash, heightened with white gouache, 140 × 185 mm., Private Collection; Lefrançois 1994, pp. 450–51, cat. no. D73.

8. Lefrançois 1994, p. 451, cat. no. D74.

9. Lefrançois 1994, p. 451, cat. no. D75.

NOTES TO CAT. 46

1. Charles-Antoine Coypel, *Hercules Brings Alcestis Back from the Underworld to Her Husband Admetus,* oil on canvas, Musée des Beaux-Arts, Grenoble. The *modello* is now in the Musée des Beaux-Arts, Nevers (inv. no. N.P.203); see Lefrançois 1994, pp. 366–69, cat. nos. P273, P274. The tapestries were woven a number of times at the Gobelins factory between 1750 and 1776. One set is in the Musée du Louvre, Paris (inv. no. OA 3989).

2. The series was entitled *Tapestries on Operatic Themes;* see Lefrançois 1994, pp. 284–320, cat. nos. P152, P166, P187, P207.

3. See Lefrançois 1994, pp. 350–51.

4. Charles-Antoine Coypel, *Self-Portrait,* c. 1746, black chalk with touches of red chalk on tan antique laid paper, 339 × 273 mm., Loan from the Collection of Jeffrey E. Horvitz, Department of Drawings, Fogg Art Museum, Harvard University Art Museums, Cambridge, inv. no. D-F-482/ 1.1997.29; see Lefrançois 1994, p. 110, cat. no. I.7, and pp. 138–39 for the related painting exhibited at the Salon in 1746.

5. One drawing mentioned in Mariette's catalogue of the artist's estate sale (27 March and on the following days in 1753) could have been of this type.

6. Charles-Antoine Coypel, *Hercules,* black and red chalk on cream antique laid paper, squared in graphite, 435 × 260 mm., Loan from the Collection of Jeffrey E. Horvitz, Department of Drawings, Fogg Art Museum, Harvard University Art Museums, Cambridge, inv. no. D-F-73/ 82.1995.

7. Lefrançois 1994, p. 80.

8. Charles-Antoine Coypel, *Standing Male Nude,* black chalk on brown paper, squared in black chalk, 405 × 290 mm., Rijksprentenkabinet, Rijksmuseum, Amsterdam, inv. no. 1954.202; see Lefrançois 1994, pp. 463–64, cat. no. D105.

NOTES TO CAT. 47

1. Jean-Baptiste-Joseph Pater, *Two Ladies,* red chalk, 181 × 248 mm., Department of Prints and Drawings, Boijmans Van Beuningen Museum, Rotterdam; Carlos van Hasselt in Paris and Amsterdam 1964, vol. 2, cat. no. 64.

2. Jean-Baptiste-Joseph Pater, *Standing Soldier with a Pipe,* red chalk, 187 × 92 mm., Fondation Custodia, Collection Frits Lugt, Institut Néerlandais, Paris; Carlos van Hasselt in Paris and Amsterdam 1964, cat. no. 63.

3. For the catalogue of Pater's paintings, see Ingersoll-Smouse 1928. For discussions of some of his drawings and problems of attribution within the Watteau school, see Parker 1933; Mathey 1936; Mathey 1948; Morgan 1975, pp. 91–94; and Morgan Grasselli 1986 (pp. 378–80 specifically address the distinctions between the drawings of Pater and Lancret). Discussions of individual drawings by Pater can often be found in catalogues of exhibitions of French eighteenth-century drawings and in collection catalogues of various museums in the United States and Europe. The most extensive collection of Pater's drawings is in the Musée du Louvre, Paris, and these have been recently reproduced and catalogued by Jean-François Méjanès in Legrand 1997, pp. 223–27, cat. nos. 910–20.

1. Jacques-André Portail, *Young Girl Reading*, red and black chalk on cream antique laid paper, 310 × 208 mm., Loan from the Collection of Jeffrey E. Horvitz, Department of Drawings, Fogg Art Museum, Harvard University Art Museums, Cambridge, inv. no. D-F-248/ 1.1993.114; see Salmon 1996, cat. no. 15.

2. Jacques-André Portail, *Woman Holding a Musical Score*, watercolor, white gouache, red and black chalk, and gray ink over graphite on cream antique laid paper, 349 × 278 mm. (sight), Gift of Charles E. Dunlap, Department of Drawings, Fogg Art Museum, Harvard University Art Museums, Cambridge, inv. no. 1954.114; see Salmon 1996, cat. no. 12.

3. See Salmon 1996, cat. no. 22.

4. Sold in Paris on 13 June 1975.

5. Portail also drew compositions of individual young men, especially musicians, engaged in various activities. See Salmon 1996, cat. nos. 33–37.

NOTES TO CAT. 49

1. Jacques-André Portail, S*eated Old Man with Raised Arm*, red and black chalk, 370 × 300 mm.; location unknown, formerly with Galerie Cailleux, Paris; see Salmon 1996, cat. no. 44.

2. Jacques-André Portail, *St. Anthony the Hermit*, red and black chalk with pen and black ink, heightened with watercolor, 400 × 290 mm., Cabinet des Arts Graphiques, Musée national des Châteaux de Versailles et du Trianon, inv. no. MV8962; see Salmon 1996, cat. no. 45.

3. Jacques-Antoine Portail, *St. Augustine*, black and red chalk with pen and black ink, heightened with brush and red chalk wash, on cream antique laid paper, 429 × 338 mm., Paris, Private Collection (Provenance: Madame de Pompadour, Versailles; Marquis de Marigny, her brother; his sale, Paris, February 1782, lot 340 [sold to Péra with the *St. Paul* at 71 *livres*]; Nicos Dikheos Collection, Lyon; Galerie de Bayser, Paris, late 1996).

4. Jacques-André Portail, *Old Man with a Basket of Fruit*, black and red chalk with graphite, 425 × 310 mm., Gift of Mr. William H. Schab with the David Adler Fund, The Art Institute, Chicago, inv. no. 1972.26. See Salmon 1996, cat. no. 43.

5. Jacques-André Portail, *Seated Old Man: The Philosophe*, black and red chalk, 431 × 358 mm., Paris, Private Collection; see Salmon 1996, cat. no. 47.

6. Jacques-André Portail, *St. Paul*, black and red chalk with pen and black ink, on cream paper, 424 × 339 mm., Paris, Private Collection; also see note 3 above.

7. Salmon 1996, p. 84.

8. See Bachaumont 1780.

NOTES TO CAT. 50

1. Chenu's etching—published as plate 111 of the *Oeuvre de Juste-Aurèle Meissonnier*, Paris, Gabriel Huquier, n.d. (c. 1738–48)—has nearly the same measurements as the drawing (470 × 318 mm.). The subject of the print was mentioned earlier, together with that of a second bas-relief and the altar for the same church, in Meissonnier's application for a general privilege to have his designs engraved and published, dating from 17 November 1733: "deux Bas-reliefs de S. Aignan d'Orléans—avec l'autel," see Fuhring 1986, pp. 19–33 and Nyberg 1994. However, the three prints, all in reverse to the drawings, were made much later, probably after 1738, when Huquier took over the organization of the publication of the artist's designs from Marguerite Caillou, widow of François I Chereau, and decided to publish the prints in a folio-size book in the form of an *Oeuvre*. See Fuhring 1992 for a discussion of Huquier's role in publishing the artist's oeuvre.

2. Louis-Gaston Fleuriau, then bishop of Orléans, asked Aignan Tripault, canon of St. Aignan, to find an arrangement with a "habile ouvrier de la capitale" for the making of such a work. See Lottin 1837, part 1, vol. II, pp. 270–71, where the names of Tripault and Meissonnier do not figure in the index. The dates of the commission are mentioned in Brault and Bottinau 1959, but their source, undoubtedly Lottin, is not cited. The contract for the reliquary was drawn up in Paris on 30 May 1725: "sous seings privés," between Aignan Tripault, chanoine député, and Juste-Aurèle Meissonnier (transcribed in Lottin 1837, note 5, pp. 272–74). The original contract and other related documents did not survive the nineteenth-century fire at the archives in Orléans.

3. Although he had been active in Paris since 1714 and had already worked for several prestigious clients—including the first minister of the kingdom, the duc de Bourbon; his mother, the duchesse de Bourbon; and the duc de Mortemart, premier gentilhomme de la Chambre du roi—it was only shortly before, on 6 February 1725, that Meissonnier was officially accepted as one of the members of the Parisian Goldsmiths' Guild. We are not informed about the circumstances of the choice of Meissonnier for the St. Aignan commission, but several connections with the court might have played a role. The duc d'Antin, surintendant des Bâtiments, was governor of the province of Orléans. He had played a role in obtaining Meissonnier's *brevet*, appointing him as a royal goldsmith, dating from 28 September 1724. But one could also think of Joseph-Jean-Baptiste Fleuriau, garde de Sceaux, brother of the bishop of Orléans, who might have informed his brother about Meissonnier's exceptional talents. The goldsmiths did not have to apply for an authorization from the king for the making of important works in silver because such works were excluded from the prohibited works in the royal declaration of 1721 (see Le Roy 1734, p. 137 and the *Recueil général des anciennes lois françaises*, Paris, n.d., vol. 21, cat. no. 340). In the text of the contract, all the details are enumerated as are all the ornaments that should be made "au marteau, bien ciselés, recherchés et finis" (with the hammer, well-chased, selected, and finished). All the separate parts had to be assembled on a frame made out of Dutch oak. For the execution, Meissonnier received 150 *marcs* of silver in advance, and after delivery, he was to be paid 3,000 *livres*. The latter sum included making (*façon*) the wooden frame and the drawings and models as well as the locksmith work, transport by carriage, and Meissonnier's trip to Orléans. In a document listing all the costs of the different stages in making the reliquary, Meissonnier used an extra 12 *marcs* of silver, paid by the church, and the fee for the "*controle*" and the costs of the trip were paid separately, as well as 500 *livres* of "gratifications." Thus, the total cost for the reliquary mounted to 12,373 *livres*.

4. Because of space considerations, the possible reasons for Meissonnier's delay in completing the commission are not given. The royal church of St. Aignan was part of the appanage of the ducs d'Orléans. Along with Notre-Dame de Cléry, it was the most popular sanctuary in the city. See Toussaint du Plessis 1736, pp. 43–45. Both churches profited from the funds put at their disposal by Louis XV and from those of the cathedral. See Chenesseau 1921, vol. 2, p. 64. Meissonnier also designed an altar for St. Aignan, depicted by an unknown printmaker in Huquier's *Oeuvres*. In the *Mercure de France*, one finds a lengthy description of this altar on which the reliquary was to be placed. However, this altar was never executed, and in the caption of the print it is referred to as a "project." It is very likely that Meissonnier was invited to design more pieces of silver for St. Aignan. In the thirteenth series of the engraved *Oeuvre* published by Huquier, one finds an altar cross (pl. N79) and a chandelier (pl. N81). Both of these are also depicted in the large print showing the altar. To this group could be added a censer (pl. N82), an incense box, a church lamp (pl. N83), and a monstrance (pl. N80). The captions of the prints do not mention their destination nor whether they were executed.

5. The measurements were as follows: height 1.62 m., length 1.45 m., and depth 0.81 m. The height of the bas-reliefs was 0.54 m., and the height of the principal figures was 0.40 m. The reliquary was melted down in 1793. Strangely, no discussion of the subjects selected by Meissonnier for the plaques, taken from the long history of the city of Orléans, was offered. The contract stipulates clearly that the two bas-reliefs are the most important part of its decoration. The frame of both bas-reliefs has an oval shape and is composed of a succession of convex and concave bands in relief. When one looks at the front of the reliquary, as one can see it in the engraving showing the main altar, one realizes that the central bas-relief oversteps the lower border of the reliquary as well as the entablature, thus creating an effect of motion and tension. At the bottom, feet in the shape of volutes bend, and at the summit, leaves spring out and link the counter movement of the borders of the bas-relief. At the top, the curved part of the frame goes beyond the entablature crowning the tomb. The two scenes for the bas-reliefs are drawn with the vanishing point placed very low and outside the composition, making them easier to read for passersby who see them placed above the altar. One sees that already, in 1725, Meissonnier opened the space and that several elements—such as the staircase—reach out beyond the traditionally limiting frame, the costumes of the principal persons, and the heads of the cherubim. Bas-relief that stretches out over the supporting elements originated in interior decoration. It was to become a common element both in the field of ornament and interior decor late in the of reign of Louis XV.

6. On both extremities of the reliquary one found the arms of the bishop of Orléans and the coadjutor, Monsieur de Paris, and on the other side the arms of the city of Orléans and of the Chapter.

7. In October 1792, the administration of the district of Orléans sent a letter to the *conseil général* of the community with a request of the citizens who asked to preserve the reliquary. They offered to open a subscription to hand over to the nation the equivalent of the price of the silver covering the reliquary. This request was not honored, and on 28 January 1793, the deposition

of the relics was ordered to be put in a simple, silvered wooden reliquary, and the silver plaques were to be sent to the mint. On 28 March 1793, after Easter, this finally happened. See Lottin 1838, part 2, vol. 2, pp. 50, 428–29, and 453.

8. It should be noted that fifty of these are extremely small sketches.

9. A large quantity of Meissonnier's drawings are documented in the former collection of his engraver, Gabriel Huquier. They are listed on several sheets with figures either after or in the manner of Bernini. The mention of Bernini's name clearly points to the contemporary awareness of one of Meissonnier's sources of inspiration. To this one should add the work of Pietro da Cortona. A related drawing was part of the collection of de Jullienne in 1767 (his sale, Paris, 30 March 1767, cat. no. 866): "Deux Desseins au crayon blanc & à la plume noire sure papier bleu, de 17 pouces 6 lignes de haut, sur 11 pouces 9 lignes, par Juste-Aurele Maissonier; l'un représente un Saint en prière & l'autre un Pape qui fait un miracle." The size of the drawings in modern measurements corresponds to about 472 × 317 mm. Could the Horvitz drawing be one of these? A red chalk drawing, most likely related to the second bas-relief, showing St. Aignan, bishop of Orléans, is today only known by a description in an auction catalogue of 1864 (*Catalogue d'Estampes anciennes et modernes, plans & vues de Paris, collection d'Ornements et compositions dessinés & gravés se rapportant à l'Architecture, à l'Ameublement, au Costume; Décorations Théâtrales, etc.*, par Vignères, Paris, 18–19 November 1864, cat. no. 377: "Evêque agenouillé entouré d'anges. Magnifique dessin à la sanguine"). Meissonnier executed several other drawings in black chalk with white heightening on blue paper. The most important is a large sheet showing two sides of one of the famous Kingston tureens with a centerpiece in the middle (Paris, Bibliothèque nationale de France, Réserve du Département des Estampes, inv. no. B. 11. rés., p. 4). See Hawley 1978, pp. 312–352, fig. 8. The second is a portrait depicting the bust of Henri de la Tour d'Auvergne, vicomte de Turenne, depicted within an oval frame, preparatory for the engraving by Nicolas IV de Larmessin. The print was used as a frontispiece to the chevalier Andrew Michael Ramsay's *Histoire du vicomte de Turenne, maréchal général des armées du roy*, Paris, 1735. A lost pastel drawing for the altar of St. Aignan was also executed on blue paper (Huquier sale, Paris, 1771, lot 37, framed) as was the project for a tomb from 1733 (Huquier sale, Amsterdam, 1761, lot 3415).

10. "Meissonnier commença à détruire toutes les lignes droites qui étoient du vieil usage; il tourna & fit bomber les corniches de toutes façons, il les ceintra en haut & en bas, en devant, en arrière, donna des formes à tout, même aux moulures qui en paroissent les moins susceptibles." Charles-Nicolas Cochin le jeune, "Supplication aux orfèvres, ciseleurs, sculpteurs en bois pour les appartements et autres par un société d'artistes," *Mercure de France*, December 1754, pp. 178–87.

NOTES TO CAT. 51

1. Mariette 1750, vol. 1, p. 164.
2. Dandré-Bardon 1765, vol. 2, p. 198.
3. Le Blanc 1854, vol. 3, p. 245.
4. Bean and Turčić 1986, p. 27.
5. Edme Bouchardon, *America*, red chalk on beige paper, 257 × 345 mm., Gift of the Estate of James Hazen Hyde, 1959, Department of Drawings and Prints, Metropolitan Museum of Art, New York, inv. no. 59.208.91; see Bean and Turčić 1986, cat. no. 13, p. 27.
6. For a comparable early use of red chalk, see the artist's presumed self-portrait from one of his Roman sketchbooks in the Pierpont Morgan Library, New York (Cara Dufour Denison in Paris and New York 1993, cat. no. 45, pp. 104–6, repr.). This softer approach to the medium continues through the 1730s in Paris with drawings like the project for a tomb of c. 1736–38 in the Musée du Louvre, Paris (see Lise Duclaux in Paris 1973, cat. no. 4, p. 12, repr., pl. 2).
7. Ripa 1603, pp. 332, 334–35, and 338.

NOTES TO CAT. 52

1. See Roserot 1902; Roserot 1910, chap. 4; Weber 1969; and Paris 1980, pp. 43–45.
2. *Elévation géométrale de la fontaine érigée rue de Grenelle: par les soins et pendant la 5e prévoté de M. Turgot, Conseiller d'Etat*, anonymous eighteenth-century engraving, Musée Carnavalet, Paris, inv. no. Topo P.C., 116E.
3. The success of the fountain won him great fame and fortune (a pension from the city of Paris). The other great project was an equestrian statue of Louis XV (destroyed). See Lise Duclaux in Paris 1973, esp. pp. 25–38.
4. Edme Bouchardon, *Autumn*, red chalk on beige laid paper, 12⅝ × 21¹⁵⁄₁₆ in., The Henry P. McIlhenny Collection in memory of Frances P. McIlhenny, Philadelphia Museum of Art, inv. no. 1986-26-319.

5. Ripa's original edition of the *Iconologia* does not offer satisfactory individual images of the seasons. See the augmented French 1643 edition of Cesare Ripa's *Iconologia* by Jacques de Bie and Jean Baudoin (Ripa—de Bie—Baudoin 1643, part 2, pp. 34–39), where the descriptions place the ram with spring.
6. Edme Bouchardon, *Charging Ram*, red chalk on tan paper, 430 × 540 mm., Département des Arts Graphiques, Musée du Louvre, Paris, inv. no. 24686; see Guiffrey and Marcel 1927, vol. 2, p. 12. Other drawings for the fountain are also in the Musée de Louvre, Paris; see Guiffrey and Marcel 1928, vol. 2, pp. 11–13.
7. Edme Bouchardon, *Seated Putto Eating Grapes*, red chalk on off-white paper, 432 × 300 mm., Boijmans Van Beuningen Museum, Rotterdam, inv. no. MB1992/T-1; see Marianne Roland Michel in Paris 1991c, cat. no. 17 (n.p.).
8. Caylus 1765, p. 78.
9. The other two were Slodtz (cat. 67) and Boucher (cats. 60–62); see Michel 1993, p. 406.

NOTES TO CAT. 53

1. A good description of the effects of lead pigments used by painters through the nineteenth century can be found in Tardieu 1862, vol. 3; also see Edizel 1995, where the author cites Bernardini Ramazzini's *Morbis Artificium* and discusses this issue.
2. In the Salon of 1771, this pastel would have been one of the three listed under no. 39; it was perhaps lot 832 in the Jacquemin sale, "un buste de veillard de grandeur naturelle"; and it was acquired before 1864 from an architect related to Chardin—together with three other works by the artist—by Laurent Laperlier, who was assisted in the acquisition by Bonvin (see the letter from Laperlier to the Goncourt brothers in Pierre Rosenberg in Paris et al. 1979). In Wildenstein 1963 (cat. no. 367) and 1969 (cat. no. 659), the author identified the Horvitz pastel with one of those exhibited in the Salon of 1777. The drawing by Gabriel de Saint-Aubin in the margins of the salon catalogue reproduced in Rosenberg 1983 (fig. 200a) proves that Wildenstein's identification is not correct.
3. Jean-Baptiste-Siméon Chardin (?), *Head of an Old Man*, pastel, 540 × 440 mm., Private Collection, Paris.
4. Jean-Baptiste-Siméon Chardin (?), *Head of an Old Man*, pastel, 400 × 320 mm., Private Collection, Paris.

NOTES TO CAT. 54

1. D'Ageville, an early biographer, insists that this period lasted only nine years; see Rosenberg 1974, p. 138.
2. The artist spent at least six months in Venice on his return from Rome, where he had resided for almost six years (1726–31). He was in his native Aix from 1732 to 1734. See Chol 1987, pp. 19–22 and 24–29.
3. As Pierre Rosenberg has noted, many members of this generation were influenced by the works of northern Italian artists, specifically those from Venice. Some of these Venetian artists, like Sebastiano Ricci, Giovanni Battista Pittoni, and Rosalba Carriera, actually visited Paris while the artists of the generation of 1700 were students in the French capital before they traveled to Italy. See Pierre Rosenberg in New York et al. 1986, p. 49, and in Toledo et al. 1975, p. 13.
4. De Vesme and Calabi 1928, cat. no. 12. I would like to thank Jean-Christophe Baudequin, who first recognized the specific link between this drawing and Piazzetta's *Adoration of the Magi*. Dandre-Bardon must have known the original by Piazzetta.
5. Michel-François Dandré-Bardon, *Presentation in the Temple*, pen with brown ink and brush with brown wash, heightened with white gouache, 400 × 278 mm., Département des Arts Graphiques, Musée du Louvre, Paris, inv. no. 26071; see Chol 1987, cat. no. 89, p. 97.
6. Michel-François Dandré-Bardon, *Flight into Egypt,* pen and brown ink heightened with white gouache, 393 × 281 mm., Hedou Bequest, Bibliothèque municipale, Rouen; see Chol 1987, cat. no. 94, p. 98.

NOTES TO CAT. 55

1. Waterhouse 1967, p. 264, cat. no. 121.
2. It was of slightly smaller dimensions. The sale took place from 7 to 17 September 1796.
3. See Boyer 1949.
4. Charles-Joseph Natoire, *Study for the Head of Truth*, black, red, and white chalk on blue paper, 200 × 165 mm., sale, Christie's, New York, 13 January 1993, lot 90.

5. This study was identified in the Christie's sale catalogue (see n. 4) as a preparation for the head of Hagar in the painting *Hagar and Ishmael in the Desert*. Commissioned by the duc d'Antin, directeur des Bâtiments du Roi, for his own chateau and paid for by the king in December 1732, this painting is now in the Louvre (Compin and Roquebert 1986, vol. IV, p. 120). Although the pose and expression in the drawing sold in London are different from those in *Hagar and Ishmael in the Desert*, they are identical to those in the study for Truth shown here and to those of the figure as Natoire painted it in the Waddesdon Manor canvas.

6. Charles-Joseph Natoire, *Seated Female Nude*, red and white chalk on tan antique laid paper, 360 × 250 mm., Graphische Sammlung Albertina, Vienna, inv. no. 12073; see Duclaux 1991, cat. no. 10. This sheet was preparatory for his *Venus Commanding Vulcan to Make the Armor of Aeneas*, oil on canvas (Musée Fabre, Montpellier). It should also be mentioned that there is another female nude study by Natoire in the Horvitz Collection from nearly a decade earlier. It is for *Eve* in *Adam and Eve Expelled from Paradise* (The Metropolitan Museum of Art, New York). See cat. A.247.

7. See Bordeaux 1984, pp. 125–26, cat. no. 97, fig. 91; and Ingamells 1989, vol. 2, p. 392.

NOTES TO CAT. 56

1. See Duclaux 1971.

2. Charles-Joseph Natoire, *Angel Holding a Banderole*, black and red chalk, and touches of white chalk on gray-blue paper, 431 × 290 mm., Gift of Xavier Atger, 1826, Musée Atger, Montpellier, inv. no. Album M-43F; see Lise Duclaux in Troyes et al. 1977, cat. no. 45, p. 83.

3. Charles-Joseph Natoire, *Angel Playing a Lute*, black chalk heightened with white chalk, 300 × 354 mm., Bequest of Léon Cogniet and Mlle Thévenin, his sister, 1890–92, Musée des Beaux-Arts, Orléans, inv. no. 917D; see Lise Duclaux in Troyes et al. 1977, cat. no. 46, p. 83.

4. Charles-Joseph Natoire, *Apotheosis of St. Louis*, pen and brown ink with brush and brown wash, 530 × 260 mm., Maciet Collection, Musée Baron Martin, Gray, inv. no. 332. See Georges Brunel in Troyes et al. 1977, cat. no. 70, p. 101.

5. See Georges Brunel, as in n. 4, pp. 97–99.

6. It was subsequently exhibited in Paris, in 1981 (Galerie de Bayser, *Dessins de maîtres anciens,* cat. no. 34) and later reappeared at a public sale (Paris, Drouot, 8 December 1994, lot 55).

7. Sale, Paris, 24–28 June 1773, lot 570, "a large ceiling composition executed in wash and heightened with white chalk." Lempereur also owned the large Le Moyne in the Horvitz Collection, cat. 42.

8. Charles-Joseph Natoire, *Ceiling Study*, black chalk, pen and brown ink and brush with brown and gray wash, heightened with white wash on cream laid paper, 474 × 195 mm., Department of Prints and Drawings, The Art Institute of Chicago, inv. no. 1976.344. This sheet may also be a preliminary study connected with San Luigi dei Francesi.

9. Charles-Joseph Natoire, *Ceiling Study*, black chalk, pen and brown ink with brush and brown wash, Graphische Sammlung Albertina, Vienna. This sheet was brought to my attention by Alvin L. Clark.

NOTES TO CAT. 57

1. Charles-Joseph Natoire, *Orpheus*, black chalk, Département des Arts Graphiques, Musée du Louvre, Paris, inv. no. 31392; see Duclaux 1975, pp. 26–28, cat. no. 34, where it is mistakenly classified among the works executed in 1737.

2. Charles-Joseph Natoire, *Orpheus Charming the Nymphs*, pen and brown ink with brush and brown wash, heightened with white gouache, on blue paper, 321 × 430 mm., Musée Atger, Montpellier, inv. no. Album M. 43, f. 38; see Duclaux in Troyes et al. 1977, p. 101, cat. no. 71; Roland Michel 1987, pp. 31 and 38, fig. 21, color repr.

3. Charles-Joseph Natoire, *Orpheus Charming the Nymphs*, pen and brown ink with brush and brown wash and watercolor, 368 × 475 mm., Robert Lehman Collection, Metropolitan Museum of Art, New York, inv. no. 1975-1-676; see Roland Michel 1987, pp. 30 and 38, fig. 20, color repr.

NOTES TO CAT. 58

1. See Wittkower 1982, pp. 232–34; Blunt 1982b, pp. 220–24; and Variano 1986, pp. 106–8.

2. It is not clear who initiated the project. The account given in Specchi 1699, text accompanying pl. 44, differs from that given in Vasi 1761, text accompanying pl. 183.

3. Giuseppe Vasi, *View of the Villa Sacchetti*, etching, Houghton Library, Harvard University, Cambridge; see Vasi 1761, pl. 183.

4. Wittkower 1982, p. 233, pls. 139–40.

5. Charles-Joseph Natoire, *View of the Temple of Vesta from the Ruins of the Imperial Palace*, black chalk with brush and brown wash, watercolor, and gouache, 325 × 491 mm., Musée Atger, Montpellier, inv. no. M43–f27; see Lise Duclaux in Troyes et al. 1977, p. 107, cat. no. 76.

6. Sale, Drouot, Paris, 22 March 1995, lot 109.

7. See Jean-François Méjanès in Paris 1997c, p. 185, cat. no. 191.

NOTES TO CAT. 59

1. The familiar myth by Apollodorus of Athens tells us that after killing the Nemean lion in the first of his twelve labors, Hercules dressed himself in its hide.

2. The Choice of Hercules is attributed to the ancient Greek Sophist Prodicus, a friend of Socrates and Plato, and was first published by Xenophon in his *Memorabilia*. The event took place in the wilderness, on Mt. Cithaeron, where Hercules began to wonder what future course he should choose. He saw two women appear before him. One offered him a life of pleasure and the other a life of heroic deeds and glory. His choice of virtue would lead him to deification at the end of his life, when he joined the gods on Mt. Olympus.

3. The story of Bacchus's journey to Hades to seek his mother Semele is recounted by Pausanias (*Description of Greece*, II, 37:5).

4. J. Dumont le Romain, *The Communion of the Magdalen,* after Benedetto Luti, red chalk on cream antique laid paper, 312 × 206 mm., Département des Arts Graphiques, Musée du Louvre, Paris, inv. no. 18196. The other, inv. no. 211, reproduces the version of Luti's *The Magdalen at Christ's Feet* in Kedleston Hall, and not the one in the Accademia di San Luca, Rome (see Dowley 1962, figs. 3 and 4).

5. J. Dumont le Romain, *The Sacrifice of Manoah,* red chalk on cream antique laid paper, 288 × 368 mm., Gift of the David L. Klein, Jr. Memorial Foundation, Department of Drawings and Prints, Metropolitan Museum of Art, New York, inv. no. 1982.173. See Bean and Turčić, 1986, cat. no. 283, p. 249, where it is catalogued as Louis de Silvestre.

NOTES TO CAT. 60

1. The best study of the function of *académies* in France is James Henry Rubin in Princeton 1977. Other studies for later time periods and other Western countries include Nottingham and Kenwood 1991, Binghamton et al. 1974, and Cambridge 1994.

2. See Jean-Richard 1978 for several individual examples engraved by Louis-Marin Bonnet (cat. nos. 370–72), Gilles Demarteau (cat. no. 598), and Henningsen (cat. no. 1074). However, only ten of the twelve etched by Louis-Félix de La Rue and published by Gabriel Huquier as the *Livre d'Académies dessinés d'Apres le naturel Par François Boucher* (cat. nos. 1257–66) can be found there, and the frontispiece to Huquier's *Livre de Diverses Figures d'Académies Dessinées d'après le naturel par les différents Professeurs de l'Académie Royalle*— after another Boucher *académie*—is also absent. A complete set of both of these is in the former library of Baron Ferdinand de Rothschild at Waddesdon Manor, Buckinghamshire.

3. Painted *académies* were executed only at the most advanced stages of a student's career. In the French academic tradition, the students who had won the Prix de Rome at the Académie in Paris sent their painted works to the professors in Paris during their residence at the French Academy in Rome as an annual demonstration of their progress. Two of the finest examples of this are Nicolas-Guy Brenet's *Endymion* of 1756 in the Worcester Art Museum (see Toledo et al. 1975, cat. no. 12, p. 25, pl. 86) and *The Morpheus*, plausibly identified with Jean-Bernard Restout (see Sandoz 1979, cat. no. 8, p. 78, pl. 14, fig. 5). *Wounded Achilles*, which has been through several auctions since the Paul Delaroff sale (Galerie Petit, Paris, 23–24 April 1914, lot 57) with an incorrect attribution to Boucher, must be by an artist of a later generation.

4. The most celebrated model was Deschamps, or Descamps, whose eagerness to serve the Académie was such that, having functioned as a model for twenty-five years, he sold the institution his bones for use as a skeleton for 100 *écus*, paid to him in advance! See Mannlich 1948, pp. 264–65. For more on Descamps, see James Henry Rubin in Princeton 1977, p. 22, in which the illustrated *académie* of 30 October 1763, which supposedly depicts the famous model (cat. no. 38) and is also inscribed with his name, is more likely to be a work by the amateur artist and historiographer Jean-Baptiste Descamps— hence the use of "M" (signifying Monsieur) before the name. The attribution of this sheet to Hubert Robert by Marianne Roland Michel cannot be sus-

tained, as he was by that date in Rome, where students usually graduated to painted *académies* (Roland Michel 1987, p. 63, fig. 49). If it had been intended as a gift to Descamps, it would say so.

5. Other examples of this include an *académie* of a *Seated Male Nude* in red chalk, 464 × 323 mm., first recorded in the Michel-Lévy sale, Paris, 12–13 May 1919, lot 55—its further provenance includes the Leverton Harris sale, Sotheby's, London, 22 May 1928, lot 97, bought by Richard Owen; Archibald Russell, CVO, Lancaster Herald (Lugt 2770a); Colnaghi's, London (see London 1949, cat. no. 44); Slatkin Gallery, New York (see New York 1957, cat. no. 25); and Mr. and Mrs. Gerald Bronfman (see Ananoff 1966, pp. 147–48, cat. no. 531, and Washington and Chicago 1973, cat. no. 25)—and the *académie* of a *Seated Nude Male Leaning on an Urn-Fountain*, red chalk, 320 × 445 mm. The provenance of this sheet includes Galerie Cailleux, Paris (see Paris 1964, cat. no. 66, not illus.); Cora Kavanagh, Buenos Aires; Sotheby's, New York, 12 January 1992, added as lot 87A. The Horvitz *académie* also seems to have inspired one by another artist, of which only the top half survives (black and white chalk, 172 × 157 mm.; sale, Paul Renard, Drouot, Paris, 18 March 1987, lot 27).

6. François Boucher, *Académie*, red chalk, 355 × 346 mm., inscribed in red chalk: *Boucher*, Département des Arts Graphiques, Musée du Louvre, Paris, inv. no. RF 24756 (Guiffrey and Marcel 1928, vol. 2, cat. no. 1376, and James Henry Rubin in Princeton 1977, p. 96, fig. 30, where it is dated to the 1730s). There are affinities of pose, in reverse, with that of Jupiter in the *Apotheosis of Aeneas*, signed and dated 1747, and recently recovered for Marly-le-Roi (see *Louveciennes Echos*, no. 22, June 1991).

7. François Boucher, *Study for the Figure of Aeolus*, media, dimensions, and location unknown (Witt Library negative 405/70).

NOTES TO CAT. 61

1. In addition to pictures by François Perrier, Louis de Boullogne, Antoine Coypel, and Jean II Restout (Pigler 1974, vol. 2, p. 285), Michel II Corneille used the theme for an important ceiling in the Hôtel Hardouin-Mansart in 1683 (see Denis Lavalle in Paris 1987c, pp. 194–96; a preparatory drawing for this composition is in the Victoria and Albert Museum, London; a *modello* or *ricordo* with watercolor was recently at auction, Paris, Drouot, Ader-Picard-Tajan, 12 Dec. 1988, lot 11), and it is the subject of a rare painting by Jean-Baptiste Massé in the Musée des Beaux-Arts, Nancy (Nancy Catalogue 1909, p. 176, cat. no. 489). Boucher's canvas was removed from the Hôtel Bergeret de Frouville in 1882 and was acquired by the Kimbell in 1972 (see Alastair Laing in New York et al. 1986, cat. no. 84, pp. 318–24).

2. Further details on the provenance for this sheet include the following: in the Cayeux sale catalogue, the sheet is described as "Junon qui commande à Eole de mettre la flotte d'Enée en desordre; Dessein distingué, à la plume, lavé de bistre" (no dimensions were given). It was purchased by La Combe for 211 *louis*; the Collet sale was incorrectly entitled the Rohan-Chabot sale by Soullié and Masson, and the drawing was listed as "un charmant Dessein représantant Junon qui vient prier Eole de déchaîner les vents. Ce Dieu est vu auprès d'un rocher dont il ouvre l'entrée, les vents en sortent avec impétuosité. Cette composition à la plume est lavée à l'encre de la Chine sur papier blanc. Hauteur 8 pouces, largeur 13." It was purchased by Constantin for 11 *louis*. In the Le Brun and Constantin sale, it was listed as "Junon ordonnne à Eole de dechainer les vents, pour tourmenter la flotte des Troyens; à la plume, lavé de bistre: Hauteur 11 pouces, largeur 15 pouces" (the larger measurement could suggest that it included the mount). The 1795 sale was the sale of the cabinet of Cit[oyen] and it appeared as one of a lot of three Boucher drawings listed as "Junon priant Eole de déchaîner les Vents contre la Flotte d'Enée." In the 1991 sale, the catalogue quoted the present author, who only knew the drawing by photograph at that time, to the effect that the date should be read as 1763 rather than 1768.

3. François Boucher, *Juno Commanding Aeolus to Release the Storm Winds*, red chalk, 255 × 325 mm., sale, Drouot, Paris, 29 October 1980, lot 67, as a "sujet mythologique"; and sale, Christie's, London, 3 April 1984, lot 81 and 3 April 1986, lot 88—each time as attributed to Boucher (illustrated in this entry as our fig. 1). For the other drawing, which we have not illustrated (black chalk, 226 × 293 mm.), see the A. Mos and Dr. J. Nieuwenhuizen Collection sale, R. W. P. de Vries, Amsterdam, 2 November 1928, lot 117; sale, Christie's, London, 6 July 1977, lot 93; and New York 1981, cat. no. 59.

4. The unillustrated black chalk drawing (see n. 3) may be a contemporary copy.

5. Aeolus's altered position in the Horvitz sheet is very close to his pose in Coypel's version of the theme. His painting occupied one of the ends of the vault in the Gallery of the Palais-Royal in Paris and was destroyed with the rest

of the Gallery in 1781. However, his related oil sketch, which was probably in the posthumous sale of his son, Charles-Antoine Coypel, in—significantly—1753, is now in the Musée Réattu, Arles (Garnier 1989, p. 152, cat. no. 91, fig. 253 and pl. 21). There is a fine nude study by Boucher that represents precisely the mid-point between these two poses in a private British collection, in which it is incorrectly ascribed to Chiari (cat. 60, fig. 2). Though neither dimensions nor medium are given, it is evidently executed in chalk and inscribed in ink: *No 54* (Witt Library neg. no. 405/70; unfortunately, the owner's name has been lost). Although Aeolus's position in the Horvitz drawing is close to his pose in the Fort Worth painting, another drawing (black and white chalk on buff paper, 292 × 200 mm., exhibited in New York 1968, cat. no. 91; see also Ananoff and Wildenstein 1976, vol. 2, cat. no. 674/8, fig. 1757, p. 302) appears to have been produced for that work, in which the mermaid and nereid—only suggested at the bottom left here—form a prominent part of the foreground, as in the painting.

6. Or perhaps Boucher's abandonment of the composition as represented in the two earlier drawings for use in any other media led to his decision to use it for a finished drawing. At no point, however, can a tapestry have been contemplated—as was first asserted in the 1991 Drouot sale—since Juno and Aeolus always hold their scepters in their right hands and not in their left, as one would expect in designs for cartoons that would have been reversed in weaving. No such project is recorded at the Gobelins.

7. The date was read as 1763 or 1768 by the cataloguers of this drawing in the Paris and London sales of 1991 and 1994. The pen and brown ink drawing with grayish blue wash, 242 × 335 mm., acquired in 1975 by the Smith College Museum of Art, Northampton, that would appear to be a studio repetition of the present drawing (although after seeing them side by side, Alvin Clark believes that its authenticity should be reconsidered) is listed by Ananoff and Wildenstein as a preparatory drawing for the 1769 Fort Worth painting (see Paris 1964, cat. no. 53 and Ananoff and Wildenstein, vol. 2, cat. no. 674/6, fig. 1756, p. 302).

8. In addition to the drawings mentioned in the notes above, just as this text was submitted, Galerie de Bayser, Paris, acquired a sheet (now in a private collection) that represents yet another link in the chain of Boucher's successive studies for this composition. It should probably be placed between the chalk studies and the Horvitz sheet, for the artist has sharpened the confrontation between Juno and Aeolus—almost to the point of caricature—and omitted the figure of Deiopeia. Moreover, for Aeolus, he has adopted the pose of his figure study for the turn of the head and the torso, but he has already shifted from this for the lower part of the body, where he opts for a less contrived position. The storm wind in the bottom right corner has the pose of the one seen in the chalk study, but he has changed from an adolescent to a fierce adult, and putti, rather than nymphs, still occupy the lower left corner.

9. Sale, Paris, Hôtel d'Aligre, Paris, 6 March 1780, lot 12: "Vénus irrité du mépris que Télémaque avoit témoigné pour son culte, implore le secours d'Eole, belle Esquisse, par le même [Boucher]. Hauteur 26 pouces, largeur 30 pouces. Toile." What may have been the same sketch, but only referred to as "Eole," was one of seven by Boucher forming lot 8 in the posthumous sale of Batailhe de Francès de Montval, at the nadir of Boucher's critical *fortuna* on 8 January 1828 and the following days.

10. Marmontel 1792, vol. 1, p. 168.

NOTES TO CAT. 62

1. See Alastair Laing in New York et al. 1986, cat. no. 36, where the related etching by Philippe Louis Parizeau is also reproduced (fig. 136).

2. This theme does not appear to correspond to any of the obscure subjects in Anton Pigler's *Barockthemen* (see Pigler 1974).

3. In Corneille's play, Cleopatra, evil queen of Syria, murders her husband the king, who wants to set her aside in order to marry Rodogune, princess of Parthia. But in the play, the villainous—and Boucher's drawings leave no doubt that she is so—Cleopatra is attended by her maid Laonice during the scene in which she and Rodogune accuse each other of the king's murder.

4. François Boucher, *Designs for the Frontispiece to Corneille's "Rodogune"* (figs. 1 and 2), black chalk heightened with white chalk on blue paper, two drawings mounted together, on the left 300 × 214 mm., on the right 304 × 214 mm., Department of Drawings, Pierpont Morgan Library, New York, inv. no. III, 104a (see Regina Slatkin in Washington and Chicago 1973, pp. 103–4, cat. no. 80) and François Boucher, *Young Woman in Classical Dress* (fig. 3), black chalk heightened with white chalk on blue antique laid paper, 348 × 222 mm., Martha Crawford von Bulow Memorial Fund, Department of Drawings, Pierpont Morgan Library, New York, inv. no. 1983.1 (see Cara Dufour Denison in

Paris and New York 1993, pp. 126–27, cat. no. 55). In addition, a two-sided preliminary study for Cleopatra from Charles Jourdeuil's collection was offered for sale by Sotheby's, London, 7 December 1987, lot 180 and in New York, 13–14 January 1989, lot 149. The actual ink and wash drawing for the whole composition, which was etched by Madame de Pompadour, is in the Bibliothèque nationale de France (see Ananoff and Wildenstein 1976, cat. no. 9, vol. 1, p. 88, figs. 126, 127. Curiously, the etching is much smaller than the drawings. For the fullest account of the etching and the related drawings, see Jean-Richard 1978, p. 364, cat. no. 1514.

5. It should not be excluded that the "signatures" on these sheets may not be autograph, but rather inscriptions applied later with incorrect dates.

6. Boucher's son-in-law, Jean-Baptiste Deshays, was also involved with the project. He was commissioned to paint *Trajan Descending from His Horse to Give Justice to a Female Petitioner.* However, Deshays died before painting his picture. For a useful summary, see Locquin 1912, pp. 23–26.

NOTES TO CAT. 63

1. Correspondance, vol. 7, p. 324, letter of 21 April 1732.

2. Carle Vanloo, *Fantasy Figure: Seated Man with a Beard in an Enormous Cape*, red chalk, 461 × 372 mm., Collection d'Orsay, Département des Arts Graphiques, Musée du Louvre, Paris, inv. no. 34927; see Jean-François Méjanès in Paris 1983a, cat. no. 118.

3. For most of these fantasy figures, see Marie-Catherine Sahut in Nice et al. 1977, pp. 164–68; and Jean-François Méjanès in Paris 1983b, pp. 84–86, 113–14, 130–32, and cat. nos. Ors. 573, 575–614, 665–76, and 849.

4. Pierre Hubert Subleyras, *Fantasy Figure: Standing Draped and Bearded Man in a Turban, Turned to the Left*, red chalk, 540 × 410 mm., Collection d'Orsay, Département des Arts Graphiques, Musée du Louvre, Paris, inv. no. 35032; see Jean-François Méjanès in Paris 1983a, cat. no. 579, p. 174.

NOTES TO CAT. 64

1. See Marie-Catherine Sahut in Nice et al. 1977, cat. no. 152, repr.

2. This painting is now in the Ecole nationale supérieure des Beaux-Arts, Paris.

3. With the aid of what we know about the appearance of the Vanloo children from the two paintings mentioned, we can cautiously venture to identify the children depicted in the other four drawings, which are known in the following order: [a] *Little Girl Wearing a Fichu* could be the portrait of the oldest daughter, who was born probably around 1737 and who died in childhood. She would have been nine years old in the drawing, if it indeed dates from about 1746 (see Marie-Catherine Sahut in Nice et al. 1977, cat. no. 401, and *Galerie françoise, ou portraits des hommes et des femmes célèbres qui ont paru en France . . .*, Paris 1771, p. 6). This is certainly she and not her sister who is represented in a painting at the Salon of 1740 (no. 8), described as "*Un petit ovale, représentant le Portrait de la fille de M. Carlo Van Loo, âgée d'environ trois ans*" (now in Drottingholm Castle, Sweden; see Marie-Catherine Sahut in Nice et al. 1977, cat. no. 74, repr.). [b] *Little Girl Sleeping* probably depicts Marie-Rosalie Vanloo, who was born, at the latest, in March 1741 and was married to Benoît Bron in 1758. She died in 1762 of complications following the birth of her second child (see Marie-Catherine Sahut in Nice et al. 1977, cat. no. 400, repr., and p. 22). She would have been five years old in the drawing. [c] The child shown in *Round-Cheeked Boy* would have been the painter Charles Vanloo (1742–1769) at the age of four, who died of consumption on 24 May 1769 (see Marie-Catherine Sahut in Nice et al. 1977, cat. no. 402, repr.). [d] The model in *Boy with Merry Eyes* would have been the landscape painter Jules-César-Denis Vanloo (1743–1821) at the age of three (see Marie-Catherine Sahut in Nice et al. 1977, cat. no. 403, repr.). Finally, the portrait of Vanloo's wife in the Département des Arts Graphiques, Musée du Louvre, Paris, should probably be added to this group. Although it is similar to the others in technique, signature, and spirit, it was executed on a significantly larger sheet. See Marie-Catherine Sahut in Nice et al. 1977, cat. no. 397.

4. See Marie-Catherine Sahut in Nice et al. 1977, cat. no. 482.

5. For information on the approximate date of Jean-François's birth, see note 8. It is possible that the sequence described in note 4 is incorrect. If so, the Horvitz drawing could just as easily represent one of the two younger boys, Charles or Jules-César-Denis Vanloo, and would then—if we assume the child was six or seven—date from about 1749.

6. Based on research in the Archives de la Marine (see Jal 1867, p. 797).

7. Jal 1867, p. 797.

8. At the death of his father, Jean-François Vanloo was referred to as having obtained his majority, but he was still living with his mother in Paris, on the Place du Vieux Louvre, in the parish of St. Germain-l'Auxerrois. At this time, the age of majority was twenty-five; thus, Jean-François was born before 24 July 1740 (see the "Death Inventory of Carle Vanloo, 24 July–5 August 1765," Archives nationales, Minutier central, Etude 56, 122). In 1766, at the moment when his father's estate was divided among the various family members, Jean-François was living in the same parish on the rue Fromenteau (Archives nationales, Minutier central, Etude 56, 128, 24 December 1766). In 1771, when dividing the goods of his brother Charles in favor of his mother, he was living in Paris on the rue des Deux-Ecus in the parish of St. Eustache (Archives nationales, Minutier central, Etude 56, 166, 11 June 1771). And in 1785, at his mother's death, he was living in Paris on the rue de Cléry, in the parish of Notre-Dame-de-Bonne-Nouvelle (Archives nationales, Minutier central, Etude 56, 312, 9 July 1785). I would like to thank Jean Chatelus for providing me with details from his research at the Archives nationales.

9. For portrait drawings by Vanloo in the Société Historique et Littéraire Polonaise, Paris; the Nelson-Atkins Museum of Art, Kansas City; the Pierpont Morgan Library, New York; and others in private collections, see Marie-Catherine Sahut in Nice et al. 1977, cat. nos. 404–9. To these, one could also add three drawings of the Berthelin de Neuville family that entered the collection of the Département des Arts Graphiques, Musée du Louvre, Paris, as gifts from the Société des Amis du Louvre in 1981 (see Jean-François Méjanès in Paris 1997a, cat. nos. 314–16, pp. 283–84).

10. Dandré-Bardon 1765, pp. 13–14.

11. Louis-Marin Bonnet, *Portrait of a Son of Carle Vanloo*, crayon-manner engraving, Collection Doucet, Bibliothèque nationale de France, Paris, inv. no. 100139. In the prints published by Bonnet, the Horvitz portrait and another engraving after a drawing of one of Vanloo's daughters were considered pendants. The drawing related to the pendant, which may be a copy after Vanloo, is in the Metropolitan Museum of Art, New York. See Marie-Catherine Sahut in Nice et al. 1977, cat. no. 399.

NOTES TO CAT. 65

1. See Vilain 1972, and Marie-Catherine Sahut in Nice et al. 1977, cat. no. 130.

2. On medievalism in the eighteenth century, see Pupil 1985, esp. pp. 83, 345–46, 379–80. Another example of this medievalism involving St. Clothilde is Charles-Antoine Coypel's painting of *France Giving Thanks to Heaven for the Healing of Louis XV* (Eglise de Clairvaux), originally painted for the Grand Cabinet de la Reine at Versailles in 1744. There, this painting may have been understood as a subtle reference to Queen Maria Leczinska praying for the conversion of her husband to a more Christian lifestyle (see Pupil 1985, pp. 209–10).

3. Given the rarity of this subject, Vanloo drew inspiration for his composition from Charles-Antoine Coypel's *St. Louis Kneeling before the Crown of Thorns*, which depicted the saint with Louis XV's features and was intended for the chapel of the Château de Trianon in 1751. The original is lost, but it is known by a copy. See Lefrançois 1994, pp. 371–72, cat. no. P279.

4. See Marie-Catherine Sahut in Nice et al. 1977, cat. nos. 339, 379, 388.

5. The painting (oil on canvas) measures 278 × 173 cm.

6. The crown resembles those on the statues of King Clovis, St. Clothilde, and their children that decorated the portal of St. Germain-des-Prés before the Revolution. Fortunately, they were engraved (see Montfaucon 1733, vol. 1, p. 53 and pls. 2 and 7).

7. First suggested by Christophe Henry, who is preparing a study on the representation of architecture in eighteenth-century French painting (also see Henry 1997). The anachronism of a fleur-de-lys on the scepter and the choice of a late-Gothic interior for a saint who lived in the middle of the sixth century was criticized by the abbé Laugier (see Laugier 1753).

8. The small oil on canvas measures 77 × 43 cm. It is interesting to note that, like the drawing, this small canvas also belonged to the prince de Conti, who purchased it in 1772 at the estate sale of Louis-Michel Vanloo, Carle Vanloo's nephew.

9. Louis-Marin Bonnet, after Carle Vanloo, *St. Clothilde Praying before the Tomb of St. Martin at Tours*, crayon-manner engraving, Bibliothèque nationale de France, Paris. Bonnet's inscription notes that his engraving is "after a study for" the deceased Vanloo's painting for the king's chapel.

1. Bellecourt was actually Jean-Claude-Gilles Colson, son of the painter Jean-Gilles Colson, and one of Vanloo's former students. The Horvitz drawing is identified by a sketch by Gabriel-Jacques de Saint-Aubin in the margins of the Chevalier sale catalogue (see Provenance) in the John G. Johnson Collection at the Philadelphia Museum of Art.

2. Claire Josèphe Hippolyte Léris de La Tude, called Mademoiselle Clairon, was noted for having introduced to the stage a more natural style of declamation and greater historical accuracy in costuming. See Schmidt-von Essen 1994.

3. As Medea, Mademoiselle Clairon usually played opposite the famous Le Kain in the role of Jason (on at least three occasions in 1752). In the mid-eighteenth century, the preferred version of the drama was the Baron de Longepierre's tragedy *Médée*—presented for the first time at the Comédie Française in 1694 and played for 171 performances until 1813—which must have served as the source for this scene. I would like to thank Odile Faliu, conservateur de la bibliothèque-musée de la Comédie-Française, as well as Mme Levoyet and Mlle Laplace for their assistance with the history and details of the theater in the eighteenth century that appear throughout this text.

4. The painting by Coypel is in Schloss Charlottenburg, Berlin, and the tapestry cartoon by de Troy is in the Musée du Louvre, Paris (see Lefrançois 1994, pp. 144–47, cat. no. P7). Curiously, when Vanloo borrows from de Troy for the figure of Jason (depicted with his face in profile and his torso seen frontally, as he prepares to unsheathe his sword rather than brandishing it) and from Coypel for the figure of Medea (thereafter facing Jason and holding a dagger rather than the wand), he transforms the spirit of his composition for the definitive Potsdam canvas. The connections between these compositions were first made by Antoine Schnapper (see Schnapper 1968, pp. 252–64). See also Goldstein 1967, pp. 328–29.

5. Marie-Catherine Sahut in Nice et al. 1977, cat. no. 167.

6. The enormous oil on canvas measures 230 × 328 cm.; see Marie-Catherine Sahut in Nice et al. 1977, cat. no. 166. For the critical reception of the work, see Henry 1995, vol. 1, pp. 39–41 and 133–41.

7. See Marie-Catherine Sahut in Nice et al. 1977, cat. no. 169. This version was engraved, with some variations, by Laurent Cars and Jacques-Firmin Beauvarlet in 1764. Print reproduced from the Bibliothèque nationale de France, Paris.

8. Manuscript of Le Brun, nephew of Carle Vanloo, in *Recueil des manuscrits divers* of Michel-François Dandré-Bardon, Paris, Bibliothèque nationale de France, Départment des Manuscrits, Fonds Français, no. 13081, folio 272 verso.

9. Fréron 1757, part 5, p. 218.

10. Medea's head in the Potsdam work, which was considered to be an accurate likeness, closely resembles Vanloo's *Portrait Study of Mademoiselle Clairon* in the Musée de la Comédie-Française, Paris. See Marie-Catherine Sahut in Nice et al. 1977, cat. no. 366.

11. See the essay by Alain Mérot and Sophie Raux-Carpentier in this catalogue.

12. Marie-Catherine Sahut in Nice et al. 1977, cat. no. 168.

13. Marie-Catherine Sahut in Nice et al. 1977, cat. no. 158.

14. "Observations sur les tableaux exposés au Louvre, par MM. de. l'Academie royale de Peinture et de Sculpture," *Mercure de France*, October 1757, vol. 2, pp. 155–70, esp. p. 159.

15. Fréron 1757, p. 338.

16. Carle Vanloo, *Sacrifice of Iphigenia*, pen and brown ink with brush and brown, blue, red, and pale yellow wash, heightened with white gouache, over traces of black chalk, on fourteen pieces of brown prepared paper, 752 × 934 mm., Rogers Fund, 1953, Department of Drawings and Prints, Metropolitan Museum of Art, New York, inv. no. 53.121. Like the Horvitz drawing, this large work may also have been presented as a gift by the artist (to Lorenzo Somis, his brother-in-law; however, it was eventually returned to Vanloo's widow). See Marie-Catherine Sahut in Nice et al. 1977, cat. no. 363, and Bean and Turčić 1986, cat. no. 295.

1. For Cochin's portrait of Slodtz, see Souchal 1967, pl. 1c. It should also be noted that Augustin de Saint-Aubin and Jean-Michel Moreau le jeune both produced very fine portrait drawings in the medallion format.

2. René-Michel, called Michel-Ange Slodtz, *Pierre-Charles Trémolières*, red chalk on cream paper, 430 × 332 mm., Départment des Arts Graphiques, Musée du Louvre, Paris, inv. no. 32850; see Souchal 1967, p. 704, cat. no. 1, and

Jean-François Méjanès's monographic study of Trémolières in Cholet 1973, p. 59.

3. The sculptures include one of Monseigneur de Lacroix-Laval, who purchased a bust from him and commissioned its pendant in 1738 (see Souchal 1967, cat. no. 35, pp. 658–59, and p. 709, pl. 91). In that same year, Slodtz also sculpted the tomb in San Luigi dei Francesi of Nicolas Vleughels, former director of the French Academy in Rome, and in 1746, he finished the mausoleum of the marchese Capponi in San Giovanni dei Fiorentini. Each of these two works, which remain *in situ* in Rome, were adorned with profile portraits that must have been preceded by drawings. See Souchal 1967, cat. no. 153, pp. 662–63 and cat. no. 164, pp. 675–76.

4. See Michel 1993, p. 406.

1. See the introduction by Georges Brunel in Rome et al. 1976.

2. Jean-Laurent Legeay, *Landscape with a Pyramid,* red chalk, 420 × 595 mm., Staatliche Museen Preussischer Kulturbesitz, Kupferstichkabinett, Berlin, inv. no. 14911.

3. Jean-Laurent Legeay, *Frontispiece for a Suite of Landscapes, Dense Woods, and Cascades,* red chalk, 350 mm., diameter, inscribed *VARIE INVENTIONE/ DI PAESE BOSCI/ ET CASCADE/ DI GIOVANNI LORENSO LE GEAY/ PRIMO ARCHITETTO DEL/ RE ET INTAGLIATE DA/ LUI STESSO,* purchase, 1972, Départment des Arts Graphiques, Musée du Louvre, Paris, inv. no. RF35517. Legeay inscribed that he was architect of the king because he left Rome to work for Duke Christian II of Mecklenburg-Schwerrin and was later summoned to Berlin by Frederick II of Prussia.

4. Cochin 1791, pp. 140–41.

5. See Kaufmann 1952 and Harris 1967. Also see Gilbert Erouart in Brunel 1978, and Myra Nan Rosenfeld in Montreal 1993, pp. 148–51.

6. Gilbert Erouart, the biographer of this architect, appropriately entitled his study *L'Architecture au pinceau: Jean-Laurent Legeay, Un Piranésien Français dans l'Europe des Lumières* (Architecture with a Paintbrush: Jean-Laurent Legeay, A French Piranesian in Enlightenment Europe). See Erouart 1982.

7. Cochin 1791, as in n. 4.

1. Margaret Morgan Grasselli (in Washington et al. 1984, cat. nos. 272–76 and 280) believes they were done in 1718–19. More recently, in Rosenberg and Prat 1996, cat. nos. 578–585, a slightly earlier date was suggested (1717–18).

2. Jean-Baptiste-Marie Pierre, S*eated Female Nude,* red chalk heightened with white chalk on tan laid paper, 466 × 325 mm., Collection Saint-Morys, Départment des Arts Graphiques, Musée du Louvre, Paris, inv. 32398; see Aaron 1993, p. 16, cat. no. 36, pl. 76, and Jean-François Méjanès in Legrand 1997, pp. 328–29, cat. no. 1305.

3. Jean-Baptiste-Marie Pierre, *Seated Female Nude Asleep,* red and white chalk on tan paper, 492 × 410 mm., Private Collection. This third sheet was included in London 1975 (cat. no. 22), where it was attributed to François Boucher, because of an old inscription: *Bouché* is visible in the lower left corner. The reappearance of the Horvitz drawing, which is signed by Pierre, and the publication of the one in the Louvre, which is also signed, have made it possible to credit Pierre with the sheet displayed in London in 1975.

4. These may be usefully compared with a study of the same type and similar technique now in a private collection in France (Aaron 1993, p. 16, cat. no. 37, fig. 37, dated "circa 1750"). This figure can also be seen—depicted down to the hands and in the same pose, but facing in the opposite direction—in the artist's painting *Antiope with Jupiter in the Guise of a Satyr* (sale, Paris, Drouot, 15 May 1941, lot 20, repr., pl. 3) in the characteristic form of an overdoor. This model posed for two other equally realistic compositions dealing with the loves of Jupiter (*Leda and the Swan* and *Danaë and the Shower of Gold*), paintings that are almost identical in size to *Antiope with Jupiter in the Guise of a Satyr,* but oval in shape (sale, Paris, Drouot, 27 November 1969, lot 28, and at Sotheby's, London, 24 June 1970, lot 72). The same model seems also to have posed—or else Pierre reused earlier drawings—for two paintings now in the Prado in Madrid: *Diana and Callisto* and *Jupiter and Antiope* (the latter is dated to 1745–49).

5. Jean-Baptiste-Marie Pierre, *Seated Female Nude Aloft,* red chalk heightened with white gouache on tan antique laid paper, 451 × 333 mm., Loan from the Collection of Jeffrey E. Horvitz, Department of Drawings, Fogg Art Museum, Harvard University Art Museums, Cambridge, inv. no. D-F-325/ 1.1995.90.

1. The Horvitz sheet was first attributed to Hutin by Christian Michel. The title page to the fete book (*FETES PUBLIQUES DONNEES PAR LA VILLE DE PARIS a l'occasion de Mariage DE MONSEIGNEUR LE DAUPHIN, les 23 et 26 Fevrier, M.DCC.XLV,* folio) was engraved by Charles Eisen, and except for the frontispiece (see below), all of the other prints were engraved by Charles-Nicolas Cochin l'aîné after the drawings of Charles-Nicolas Cochin le jeune.

2. Charles-François Hutin, *The Genius of France Leads the Dauphin Louis to the Temple of Hymen,* Département des Estampes, Bibliothèque nationale de France, Paris. This rather dry sheet is bound into one of the three copies of the fete book in this collection. It is noticeably less spirited in its handling than the Horvitz version and was primarily drawn with gouache. It is perhaps a copy of the exhibited sheet executed (by an assistant of the artist?) in preparation for the print.

3. Charles-François Hutin, *The Genius of France Leads the Dauphin Louis to the Temple of Hymen,* black chalk heightened with white chalk, 516 × 351 mm., inscribed *Cochin. Del. Et Invenit.,* Kupferstichkabinett, Kunstmuseum, Basel, inv. no. Bi.385.26; see Basel 1978, cat. no. 145 (as Charles-Nicolas Cochin le jeune), pp. 73–74. Marianne Roland Michel first identified the Basel drawing, hiding under a doubtful attribution to Cochin. Although Hutin and Cochin were exact contemporaries and their works share several general stylistic traits, this somewhat awkward sheet could not be by Cochin, who was a superior draftsman. It is almost certainly a preparatory study for either the exhibited drawing or the print.

4. Département des Estampes, Bibliothèque nationale de France, Paris.

5. "CE FRONTISPIECE/ représente/ MONSEIGNEUR LE DAUPHIN./ Sous la figure d'un jeune Héro qui simplement couronné/ de fleurs, marche au Temple de l'Himen conduit par le Génie/ tutelaire de la France, reconnoissable, a la tige de Lire/ qu'il tient de la main droite./ Le Dieu de l'Himenée vient au-devant d'eux avec le/ Portrait de l'Infante qu'il leur présente, et il est suivi de/ deux Génies chargés d'une banderole aux Armes du/ PRINCE & de la PRINCESSE pour le prochain/ accomplissement d'une union si desirée./ La Déesse Pallas, qui ne perd pas le PRINCE de vuë, le/ suit a une certaine distance, avec une troupe de Guerriers/ qui portent les habits militaires dont il doit se revêtir après/ la Cérémonie./ Au bas du Perron du Temple de l'Himen on voit la Muse héroïque à qui le Destin laisse lire dans le Livre des/ Tems, le détail des Exploits qui doivent immortaliser dans/ l'histoire le nom du PRINCE, & celui de ses Descendans./ Divers petits Amours, dont les uns voltigent dans les airs,/ et les autres joüent avec un Lion Samilier suv le passage du/ PRINCE, s'occupent à faire des Couronnes et des Guirlandes/ de Fleurs, pour la célébration de la Fête./ Les Ris, les Graces et les Jeux attendent le PRINCE/ à la porte du Temple."

6. The dauphin's daring as a soldier was most effectively revealed at the Battle of Fontenoy in May 1745. The laudatory reports of his performance caused Louis XV to refuse to let him see arduous battle again. It is speculated that this was either because of his fear of losing the heir to the throne, or his fear that his son's popularity would outshine his own. See Viguerie 1995, pp. 1133–34. The frontispiece, which was probably designed after the wedding, may be contemporary with the dauphin's victory. Placed in a deep shadow, the lion is noticeably less prominent in the print.

7. On Hutin and his activities in Dresden, see Baudicour 1861, vol. 2, pp. 114–34; Harold Marx in *Deutsche Biographie,* vol. 10, pp. 95–96; and Marx 1977.

8. The contours are strengthened, volumes increased, and both the foreground space and that between the prince and Athena in the left background are enlarged in Le Bas's print. Although only two Graces are visible in Hutin's drawing, squeezed between the dauphin and Hymen, the third appears clearly in Le Bas's print.

9. Diderot's comments were in reference to a genre painting that Hutin sent to the Salon of 1769; for more, see Marie-Catherine Sahut in Paris 1984b, pp. 277–79. For other genre paintings, see Luna 1979. Most of Hutin's drawings are quick sketches in red chalk for draped figures (Ecole nationale supérieure des Beaux-Arts, Paris), precise studies in preparation for the prints reproduced in *Receuil d'estampes d'après les plus célèbres tableaux de la Galerie Royale de Dresde,* 1753–57 (Kupferstichkabinett, Dresden), or rough composition studies for the decorative paintings he executed during his stay in Dresden (Kupferstichkabinett, Museum der Bildenden Künste, Leipzig).

10. In addition to the wedding itself, the celebrations at Versailles consisted of a masked ball—where Louis XV, dressed as a yew tree, first met Madame de Pompadour, dressed as Diana—and a comedy-ballet with text by Voltaire and music by Rameau (François-Marie Arouet, called Voltaire, and Jean-Philippe Rameau, *La Princesse de Navarre, comédie-ballet. Feste donnée par le Roy en sa château de Versailles le mardi 23 février 1745,* with a frontispiece by Pierre-Antoine Baudoin); see Versailles 1997, pp. 29–30 and 69–73. For Cochin's prints, *Cérémonie du mariage . . . dans la chapelle du Château de Versailles, Décoration de la Salle de Spectacle . . . , Décoration du bal paré . . . ,* and *Bal masqué . . . dans la Grande Galerie de Versailles,* see Michel 1993, p. 57.

11. Each of the other six pavilions had themes, and all of them contained musicians, four enormous buffets, and several fountains flowing with wine. Many commentators noted that it was impossible to get a carriage through the streets of central Paris because of festivities involving tens of thousands of Parisians. On these events, and the oversold masked ball at the Hôtel de Ville, which was too crowded to allow dancing, see Héron de Villefosse 1980, pp. 261–63; and Versailles 1997, pp. 70–71.

NOTES TO CAT. 71

1. A third pastel, described as being "dans le même attitude que celui du Louvre," 595 × 495 mm., is mentioned in Monnier 1972, under cat. no. 95. She specifically avoids calling it a replica and leaves open the question of authorship. The oil painting, formerly in the collection of David David-Weill, is reproduced in Vaillat and Ratouis de Limay 1908, pl. 25. It was sold at Sotheby's, London, on 10 June 1959, lot 118.

2. Jean-Baptiste Perroneau, *Laurent Cars,* pastel on gray-blue paper, laid down on canvas, 600 × 505 mm., Département des Arts Graphiques, Musée du Louvre, Paris, inv. no. 32.350.

3. Simon Charles Miger, after Jean-Baptiste Perroneau, *Laurent Cars,* Department of Prints and Drawings, National Gallery of Art, Washington, D.C. The copper plate was exhibited at the Salon of 1779 (no. 276). It is now in the Chalcographie du Louvre, Paris, inv. no. 2123.

4. For the portrait of Mademoiselle Huquier, see Vaillat and Ratouis de Limay 1908, pp. 87–88, cat. nos. 17–18, pl. 59; for that of M. von Robais, see p. 102, cat. nos. 114–16, pl. 32; and for the portrait of Boreel Jansz, see pp. 106–7, cat. nos. 140–41 and 153, pl. 38 (Boreel Jansz). Versions of the first two are in the Louvre (see Monnier 1972, cat. nos. 91 *bis* and 96).

5. Vaillat and Ratouis de Limay 1908, p. 102, cat. no. 114. Two of the portraits of Boreel Jansz were still in the possession of members of the Boreel family when they were catalogued by Vaillat and Ratouis de Limay 1908 (nos. 140 and 153).

6. Pierre-Jean Mariette's thumbnail description of Cars's personality is included in his *Notes manuscrites,* quoted verbatim by Vaillat and Ratouis de Limay 1908, pp. 36–37.

NOTES TO CAT. 72

1. For a list of these sheets, see Michel 1993, pp. 56–61.

2. Charles-Nicolas Cochin le jeune, *Masked Ball Given for the Marriage of Louis, Dauphin of France, to Infanta Maria Teresa Antonia Rafael of Spain on 9 February 1747,* pen and black ink with brush and gray wash, over black chalk, 456 × 760 mm., Département des Arts Graphiques, Musée du Louvre, Paris, inv. no. 25253.

3. Cochin 1790, p. 138.

4. See Michel 1993, parts 2 and 3.

5. The plate for the large print is in the Chalcographie du Louvre, Paris, a division of the Département des Arts Graphiques. See Angoulvent 1926, no. 4035.

6. Charles-Nicolas Cochin le jeune, *Illuminations of the Stables at Versailles in Celebration of the Second Marriage of Louis, Dauphin of France, to Maria Josepha of Saxony, 25 February 1745,* pen and black ink with brush and gray wash, over black chalk, 440 × 900 mm., Cabinet des Arts Graphiques, Musée national des Châteaux de Versailles et du Trianon, Versailles, inv. no. MVD.704 8132. The dauphin's first wife had died soon after childbirth in 1746 (see cat. 70).

7. Charles-Nicolas Cochin le jeune, *View of the Decorations Erected on the Terrace of the Château de Versailles for the Illuminations and Fireworks Held on the Occasion of the Marriage of Madame Louis-Elisabeth, 26 August 1739,* engraving, Département des Estampes, Bibliothèque nationale de France, Paris. The drawing is lost.

NOTES TO CAT. 73

1. Charles-Nicolas Cochin le jeune, *Allegory of Free Instruction,* black chalk, extensively stumped, squared in black chalk, on cream antique laid paper, 325 × 214 mm., Loan from the Collection of Jeffrey E. Horvitz, Department of Drawings, Fogg Art Museum, Harvard University Art Museums, Cambridge, inv. no. D-F-385/ 1.1996.54.

2. For the prints of the monarchs of Sweden and Russia, see Michel 1993, p. 158, and Bjurström 1982, cat. no. 912, respectively. The other print of Charles III was engraved in commemoration of the marriage of the prince of Asturias. Prieto's name was added to the counterproof. It also appears with the inscription *Carolus III Parens Optimus.*

3. Charles III Bourbon of Spain (1716–1788) was the second son of Philip V Bourbon, duc d'Anjou and king of Spain, and his second wife, Elisabetta Farnese, heiress to the duchies of Parma and Piacenza. Philip V was himself the grandson of Louis XIV—through whose Spanish wife, together with other ancient claims (and the victory of the War of the Spanish Succession)—the Bourbons inherited the Spanish throne. Through his Farnese mother, the future Charles III soon inherited the duchies of Parma and Piacenza in 1731. He was also named heir to the Medici grand duchy of Tuscany. In 1734, as a result of his victorious invasion of Naples, he assumed the kingdom of Naples and Sicily, which was ratified by the Treaty of Vienna in 1738, when he agreed to cede Parma and Piacenza to his younger brother and to cede Tuscany to Austria (ruled by Duke Francis of Lorraine). The ratification took place only a year after his marriage, in 1737, to Maria Amalia of Saxony-Poland (daughter of Augustus III, elector of Saxony and king of Poland). Charles remained in Naples until the deaths of his father (1746) and his childless elder brother (1759), when he departed to assume the Spanish throne.

4. The counterproof (which is signed again next to the counterproofed signature) was once in the collection of the prince of Hesse in Rome. See Marina Causa-Picone in Detroit and Chicago 1981, pp. 276–77, cat. no. 97, repr.

5. The inscriptions indicate Charles III aiding commerce through the construction of roads (*VIAE PUBLICAE*), canals (*FOSSA.ARAG/ MADRIT./ E.T/ TURDET.*), and the institution of maritime laws (*TABELLARIA NAVES*). His contributions to the arts and architecture include the construction of Caserta and Portici (for which the plans are titled and reproduced); the archaeological excavations in Campania; the creation of the Accademia Ercolanense (a volume of their *Antichità d'Ercolano esposte,* [Antiquity of Herculaneum Revealed], is depicted lying open); the founding of cities (*CONDITAE URBIS NOVA GLORIA*); the creation of the botanical gardens of Madrid (*HORTUS BOTANICUS*); and the king's public works (*CAR. III./ REP/ NAT.ET.ART./ SUB UNO TECTO/ IN PUB.UTILIT./ CONSOCIAVIT*).

6. The installation of the collections took place in October 1774, and the new building was visited by the king in December 1775; see Bedat 1974, pp. 84–92.

7. The royal villa at Portici, the royal palace of Caserta, and the publications concerning archaeological excavations (books that Cochin owned) all date to the time during which Charles was king of Naples and Sicily (see n. 3).

8. Bedat 1974, p. 256.

9. As a gesture of thanks, Choffard may have considered sending his engravings of Cochin's drawings to his new Spanish colleagues at the Academia de San Fernando. Instead, he sent a set of his previously engraved works.

NOTES TO CAT. 74

1. The carved wood paneling adorned with canvases painted by François Boucher from the Château de Crécy is now in the Frick Collection in New York.

2. *The Visitation* disappeared sometime before 1876, but Vien's preparatory sketch for it is preserved in the Musée des Beaux-Arts of Rouen; see Gaehtgens and Lugand 1988, cat. no. P74.

3. Letter from Jean-Bernard Lépicié to the marquis de Vandières, director of the Bâtiments du roi and brother of Madame de Pompadour, 25 July 1752; see Furcy-Raynaud 1903, pp. 17 and 19.

4. He is also the patron saint of goldsmiths.

5. Gaehtgens and Lugand 1988, cat. nos. P72–P73.

6. Completed by another artist in 1751, this extraordinary series of religious paintings can still be seen *in situ* (Gaehtgens and Lugand 1988, cat. nos. P29–P34 and P60).

7. Joseph-Marie Vien, *Head of a Bishop in Profile*, black and white chalk on tan paper, 335 × 250 mm., Musée Grobet-Labadié, Marseilles, inv. G 2001; see Gaehtgens and Lugand 1988, p. 238, cat. no. D51.

8. Louis-Marin Bonnet after Joseph-Marie Vien, *Bust of St. Eloi*, crayon-manner engraving, Cabinet des Estampes, Bibliothèque nationale de France, Paris; Vien was undoubtedly interested in the print because it would make his well-received but somewhat isolated painting better known to a larger audience. The print is inscribed "after the Drawing by Mr. Vien, Painter to the King, Professor and Director of the Students under His Majesty's Protection." See Hérold 1935, p. 96, cat. no. 85.

9. Joseph-Marie Vien, *Head of St. Germain*, red chalk on cream laid paper, 329 × 314 mm., Loan from the Collection of Jeffrey E. Horvitz, Department of Drawings, Fogg Art Museum, Harvard University Art Museums, Cambridge, inv. no. D-F-354/1.1996.11.

10. A replica painted by the artist for the Church of St. Germain l'Auxerrois in Paris is still *in situ* (see Gaehtgens and Lugand 1988, cat. nos. P121 and P123). There is also a further head study in the Horvitz Collection (inv. no. D-F-287/ 1.1995.55). It corresponds to the painting *Bearded Old Man Looking toward His Left* (Musée des Beaux-Arts, Rouen), a head study that was executed in 1748 using the same model and was likewise preparatory for a painting in the cycle painted for the Church of St. Marthe in Tarascon (see Gaehtgens and Lugand 1988, cat. no. P40). The same model posed for *St. John the Baptist in the Desert,* a canvas painted around the same time for the monks of the Order of Mercy in Montpellier; today it is in the collection of the Musée Fabre, Montpellier (Gaehtgens and Lugand 1988, cat. no. 23). His face can also be seen in *The Sleeping Hermit*, a canvas signed by the artist and dated *Romae 1750* (Musée du Louvre, Paris). It was exhibited at the Salon of 1753, where it enjoyed immense success (Gaehtgens and Lugand 1988, cat. no. P51).

11. This study is in the Metropolitan Museum of Art, New York; see Bean and Turčić 1986, cat. no. 309.

NOTES TO CAT. 75

1. For the Moscow portrait of 1759 by Louis-Michel Vanloo, which has a pendant portrait of the prince by François-Hubert Drouais le jeune, and for more on the princess, see Paris 1986c, cat. no. 270, pp. 176–77. The princess, who died at age forty-one, was frequently ill. She left a large bequest for medical research in Russia.

2. This commission may have been, at least in part, because Elisabeth I of Russia was attempting to persuade the actress to travel to St. Petersburg.

3. The unfinished sculpture was cat. no. 166 in the Salon's catalogue: "A female figure reclining on a square base, weeping over an urn which she covers with the folds of her garment. This figure, executed in marble and four feet six inches high, is part of the tomb of Madame the Princess Golitsyn." The drawing was cat. no. 170 in the Salon's catalogue: "A drawing of the monument for the tomb of Madame the Princess Golitsyn in its entirety."

4. Mariette 1750, vol. 6, p. 42.

5. Based on information provided by Sergei Androssov, curator of sculpture at the Hermitage Museum, Bernard Black has shown that the completed sculpture was shipped to Russia. Indeed, he has found several allusions to it in old guidebooks to St. Petersburg, including a sketch depicting the tomb when it was located in the Church of the Annunciation in St. Petersburg (Alexander Nevsky Cloisters; reproduced in Black 1996, fig. 5) and a copy of a medal by Roëttiers that bears the statue's silhouette (Black 1996, fig. 6). A comparison of these documents with the Horvitz drawing leaves no room for doubt: they all refer to the same monument.

6. Louis-Claude Vassé, *Study for the "Monument to Princess Ekaterina Dimitrievna Golitsyn,"* red chalk with red chalk wash, 366 × 303 mm., inscribed in pen and brown ink *pensée du tombeau Vassé,* Bequest of Mathias Polakovits, Ecole nationale supérieure des Beaux-Arts, Paris, inv. no. PM 2138. Other related drawings include another study in red chalk in the Rijksprentenkabinet, Amsterdam, with a very different composition; and a sheet executed in black chalk that reproduces the figure seen at the top of the Horvitz version (formerly Galerie Cailleux, Paris). For all of these, see Guilhem Scherf in Paris 1989a, cat. no. 95, pp. 230–33.

7. See Black 1996, p. 145, where the author inclines toward the Horvitz drawing: in his opinion, Vassé could not have exhibited a study, since the Salon's catalogue specifies that the work on display depicted the tomb "in its entirety." I concur with this reasoning. Although the Polakovits drawing also shows the monument "in its entirety," it contains the variations that we noted above, which would doubtless have been remarked on by the visitor; furthermore, the artist's quite prominent signature and the indication of scale prove that the Polakovits sheet was a plan presented to General Betsky and destined to be reworked subsequently.

8. Louis-Claude Vassé, *Design for the Monument to the Heart of Queen Maria Leczinska*, red chalk over graphite on off-white antique laid paper, 449 × 296 mm., Loan from the Collection of Jeffrey E. Horvitz, Department of Drawings, Fogg Art Museum, Harvard University Art Museums, Cambridge, inv. no. D-F-282/ 1.1993.133; see Réau 1930, esp. p. 48, and Coural 1978, esp. p. 205, cat. no. 39. Other *ricordi* include the *Tomb of Paul-Esprit Feydeau de Brou* (Musée Carnavalet, Paris); *Study for the "Tomb of the Princess Anastasia Ivanovna Troubetskoi"* (Rijksprentenkabinet, Amsterdam); and *Comedy; Seat-*

ed *Amor Assembling the Spokes of Venus's Chariot;* and *Venus Teaching Cupid to Use His Bow* (after three marbles in the collection of Madame Du Barry). For the first two in this latter group, see Nicolas Joly in *Galerie Yves Mikaeloff, 15th Biennale des Antiquaires, 1990,* cat. nos. 16–17, repr., and for the third, now in the Metropolitan Museum of Art, New York, see Bean and Turčić 1986, cat. no. 302, p. 268, repr.

9. Coural 1978, p. 208, cat. no. 173.

NOTES TO CAT. 76

1. Pierre-Antoine Baudouin, *Morning,* gouache over traces of graphite on paper mounted onto board, 260 × 200 mm., Gift of Anne Payne Blumenthal, 1943, Department of Drawings, Metropolitan Museum of Art, New York, inv. no. 43.163.19; see Bean and Turčić 1986, cat. no. 5, pp. 21–22.

2. Pierre-Antoine Baudouin, *The Honest Model,* gouache with touches of graphite on vellum, 406 × 357 mm., Gift of Ian Woodner, Department of Drawings, National Gallery of Art, Washington, D.C., inv. no. 1983.100.1; see Margaret Morgan Grasselli in Washington 1995a, cat. no. 92, pp. 324–27.

3. Their mutual admiration is evident when one examines the estate sale that took place after Baudouin's death in 1769: his collection proved to contain numerous works by his brother-in-law, Deshays, who died at an early age. The same phenomenon can be observed in the estate sale after Boucher's death: he had survived his two sons-in-law and owned many of their drawings.

4. It is close to Boucher's *Cupid Caressing His Mother* (Private Collection, New York), *Venus Crowned by Paris* (E. de Rothschild Collection), or *Venus on the Waters* (J. Paul Getty Museum, Los Angeles).

5. These observations are equally sound for other works by Baudouin, such as the boudoir in *The Toilette,* in which a man observes a young woman gazing at herself in the mirror, and the bedchamber in *The Awakening.* For both works, see sale catalogue, Sotheby's, London, 1 July 1991, lots 40 and 41.

6. Titles such as *The Hurried Lover, Interior Scene, The Young Mother of the Village, The Young Reader,* and *The Bride Preparing for Bed* have been noted in the catalogues of the sale of his collection after his death and in those of contemporary collections. See Sandoz 1977, pp. 58, 59, and 123.

7. Jean-Baptiste Deshays, *Erigone Vanquished,* gouache on off-white antique laid paper, 438 × 298 mm., Loan from the Collection of Jeffrey E. Horvitz, Department of Drawings, Fogg Art Museum, Harvard University Art Museums, Cambridge, inv. no. D-F-80/ 1.1993.44. The related painting (Private Collection, New York) was exhibited in the Salon of 1761 under the title *Erigone et Bacchus en raisin.* Given the very finished nature of this work, it must have been executed after the painting—as if the popular reception of the subject led some patrons to request another version, and he found it easier and quicker to execute it in gouache—in the same way that the rare gouaches of Fragonard were. For an example, see Fragonard's *Island of Love,* also called the *Fête at Rambouillet* (John H. Straus Collection, New York); see Pierre Rosenberg in Paris and New York 1987, cat. nos. 168–69, pp. 355–58.

8. For instance, Marmontel and Grétry's *Zemira and Azor,* presented two years after Baudouin's death, offered a perfect example of a magical scene presented simultaneously to both the audience and the actors. This scene was depicted by Jean Touzé in a drawing now in the the University of Michigan Museum of Art, Ann Arbor; see Pierre Rosenberg in Toronto et al. 1972, p. 215, repr., pl. 129. It should be noted that my interpretation of the scene depicted in the Horvitz drawing differs from that given by Olivier Aaron (see Paris 1985f, pp. 62–63).

NOTES TO CAT. 77

1. Gabriel-Jacques de Saint-Aubin, *Entretien galante* (recto), *King Solomon and Other Studies* (verso), pen with brown and black ink and brush with gray wash over graphite (recto and verso), 200 × 131 mm., Forsyth Wickes Collection, Department of Prints and Drawings, Museum of Fine Arts, Boston, inv. no. 65.2604; see Eric Zafran in Munger 1992, cat. no. 91, pp. 142–43.

2. Gabriel-Jacques de Saint-Aubin, *King Solomon,* pen and black ink with brush and rose wash, 170 × 200 mm., Loan to the Département des Arts Graphiques, Musée du Louvre, Paris, inv. no. CP357 fol. 72. The entire inscription reads: *Gabriel de St. Aubin pinxit. 1760.* This sheet entered the literature on Saint-Aubin without being seen (see Dacier 1931, vol. 1, pl. 19; vol. 2, p. 2, cat. no. 12). It was first documented in the 1899 sale catalogue of the Destailleur collection. The sheet is actually bound into the *Livre des Saint-Aubin;* the entire album is now on deposit in the Louvre.

3. "Je veux icy vous parler d'un grant homme/ Tel que n'en vit Paris,/ Pékin ni Romme,/ C'est Salomon, le sage fortuné,/ Roi philosophe et Platon cou-

ronné/ Qui connoissoit du cèdre jusqu'à l'herbe./ Vit-on jamais un luxe plus superbe." François Marie Arouet Voltaire, *La Défense du mondain ou l'Apologie du luxe,* Paris, 1736. The visual and iconographic tradition for Saint-Aubin's composition can be traced to seventeenth-century depictions of the idolatry of Solomon—particularly by Goltzius and his circle—in which the concubines try to get Solomon to worship false gods. There, the works of art offered by the concubines were depicted as statues of other gods.

4. McCullagh 1981, vol. 2., figs. 113–17.

5. McCullagh 1981, vol. 2, figs. 127 and 146; Dacier 1931, vol. 1, pl. 6.

NOTES TO CAT. 78

1. For the fullest analysis of Le Brun's seminal lecture, see Montagu 1994.

2. For Greuze's adaptations of Le Brun's studies of expression, see Edgar Munhall in Hartford et al. 1976, pp. 14 and 174.

3. Jean-Baptiste Greuze, *Head of an Angry Young Girl in a Fauchon,* red chalk heightened with white chalk on cream antique laid paper, 296 × 248 mm., Loan from the Collection of Jeffrey E. Horvitz, Department of Drawings, Fogg Art Museum, Harvard University Art Museums, Cambridge, inv. no. D-F-123/ 1.1993.63; see Marianne Roland Michel in Paris and Geneva 1978, p. 44, cat. no. 18.

4. On the information sheet provided by Galerie Cailleux at the time of sale.

5. Jean-Baptiste Greuze, *Fear,* pastel, 400 × 300 mm., Département des Arts Graphiques, Musée du Louvre, Paris, inv. no. RF 41.293. See "Acquisitions," *La Revue du Louvre,* cat. no. 3, 1987, p. 208, fig. 4; and Régis Michel in Paris 1989b, cat. no. 118, p. 83.

NOTES TO CAT. 79

1. Jean-Baptiste Greuze, *The Boat of Happiness,* late 1770s, brush and gray wash over graphite on white paper, 219 × 358 mm., Prentenkabinet, Boijmans Van Beuningen Museum, Rotterdam. See Edgar Munhall in Hartford et al. 1976, cat. no. 89, p. 182.

2. The three daughters were Marie-Anne Claudine (1759–?), Anne-Geneviève, called Caroline (1762–1842), and Louise-Gabrielle (1764–1812).

3. Diderot—Dieckmann—et al. 1975, vol. 8, p. 104.

4. Valori 1813, pp. 373–74. The theme of Greuze's pendants was later taken up by Constance Mayer and Pierre-Paul Prud'hon. See Guffy 1996.

5. Jean-Baptiste Greuze, *The Boat of Misfortune,* late 1770s, brush and gray wash over graphite on white paper, 370 × 230 mm., Musée Greuze, Tournus, inv. no. 31. See Edgar Munhall in Hartford et al. 1976, cat. no. 90, p. 183.

6. Chennevières 1894–97, vol. 19, p. 184.

NOTES TO CAT. 80

1. Jean-Baptiste Greuze, *Psyche Crowning Cupid,* c. 1785, oil on canvas, Palais des Beaux-Arts, Lille. For the most complete study of Greuze's painting, see Colin B. Bailey in Paris et al. 1991, cat. no. 65, pp. 522–27.

2. Lille 1893, cat. no. 358, p. 127.

3. Also known as the *Triumph of Hymen.* See Compin and Roquebert 1986, vol. 3, p. 289 (inv. no. RF 2154).

4. These were cited in Mauclair—Martin—Masson 1906, cat. nos. 1414, 1415, 1430, and 1433.

5. Jean-Baptiste Greuze, *Psyche Crowning Cupid,* brush with brown and gray wash over graphite on yellow paper, 364 × 257 mm., Palais des Beaux-Arts, Lille. See Annie Scottez in Lille and Rome 1983, cat. no. 104, p. 136, and Raux 1995, cat. no. 30, pp. 110–11.

6. Jean-Baptiste Greuze, *Young Woman Weeping by a Tomb,* brush and gray wash on paper (dimensions and location unknown). See Paris 1951, cat. no. 64.

7. Jean-Baptiste Greuze, *Psyche Crowning Cupid,* pen and black ink with brush and gray wash, 288 × 230 mm., Israel Museum, Jerusalem.

8. Exhibited in New York 1986, no. 16, no cat. (Private Collection, Paris).

9. Sale, Christie's, London, 4 July 1988, lot 170, repr.

10. Recorded in the catalogue of the Denon sale, Paris, 1 March 1826, lot 156.

NOTES TO CAT. 81

1. Mauclair—Martin—Masson 1906, cat. no. 1115; Rosenberg—Reynaud—Compin 1974, vol. 1, p. 274, cat. no. 326; and Compin and Roquebert 1986, vol. 3, p. 288, La Caze Bequest, inv. no. M.I.1070 (600 × 495 mm.).

2. Jacob 1946, p. 17.

3. "Eh! Peins, peins nos bourgeois, et peins plutôt le diable,/ Et gagne de l'argent. Que t'en coûteroit-il?/ A peindre le portrait est-il quelque péril?/ On fait les hommes beaux, et les femmes jolies,/ Et l'on profite ainsi de toutes les folies." See Fabre d'Eglantine 1822, p. 156.

4. Jacob 1946, p. 22.

5. Antoine Vestier, *Marie-Nicole, Daughter of the Artist*, pastel on paper laid down on canvas, 575 × 468 mm., Loan of Jeffrey E. Horvitz, Department of Drawings, Fogg Art Museum, Harvard University Art Museums, Cambridge, inv. no. D-F-122/ 1.1993.62. This work was shown as the pendant to the portrait of *Fabre d'Eglantine* in New York 1996b. How these two portraits came to be paired—as well as the two related ones in the Musée du Louvre (both bequeathed with the La Caze Collection)—remains unclear. For the related canvas by Vestier, see Compin and Roquebert 1986, vol. 4, p. 313, in which it is listed as anonymous (inv. no. M1118).

NOTES TO CAT. 82

1. Even in antiquity, Cybele, whose cult originated in Anatolia and later centered in Phrygia, was often confused and amalgamated with Gaia, or Earth (mother of the Titans). I would like to thank Jennifer Montagu, emeritus curator of the Photograph Collection, Warburg Institute, University of London, for her assistance with the iconography.

2. Jean-Honoré Fragonard, *River God,* brush and bister wash over black chalk on off-white paper, 320 × 220 mm., Private Collection. See Pierre Rosenberg in Paris and New York 1987, cat. no. 252, p. 503, where it is placed among works from the end of the 1770s (a date contemporary with the Doyen exhibited here).

3. See Diderot's comments on Doyen in the Salon of 1767 (Diderot—Goodman 1995, vol. 2, pp. 142–57 and 298); and Nathalie Volle in Paris 1984b, pp. 179–89.

4. Gabriel-François Doyen, *Allegory of Fishery: Neptune and Amphitrite*, pen and brown ink with brush and brown wash, with touches of white wash, over graphite, 288 × 217 mm., Harry G. Sperling Fund, 1981, Department of Drawings and Prints, Metropolitan Museum of Art, New York, inv. no. 1981.129; see Bean and Turčić 1986, cat. no. 103, p. 100.

5. Gabriel-François Doyen, *Martyrdom of St. Sebastian*, pen and brown ink with brush and brown wash, heightened with white gouache, on blue paper, 442 × 353 mm., Cabinet des Dessins, Musée des Beaux-Arts, Grenoble, inv. no. D953.

6. There is little doubt that this was one of Doyen's most famous compositions. It is depicted on an easel behind him in his portrait by Antoine Vestier (Musée du Louvre, Paris) that was exhibited at the Salon of 1787. It was described in the *livret* of the Salon in a manner different than that offered above—"Cybèle mère des Dieux, représente la Terre avec ses attributs. Sur un rocher glacé, les vents rassemblent tous les frimats et attaquent la mère des Dieux; son char est brisé; ses lions effrayés, se pressent autour d'elle pour la défendre; les vents souterrains, en combattant contre eux, ébranlent le rocher sur lequel la terre est renversée; au même instant Jupiter pluvieux arrive avec les enfants des nuées pour apaiser les vents et délivrer Cybèle." Later, one of Doyen's student's referred to it as an *Allegory of Winter*. For more on these changes, different titles, and the original commission, see Sandoz 1975, p. 45.

7. Gabriel-François Doyen (?), *Cybele Tormented by the Elements*, pen and brown ink with brush and brown wash, Department of Drawings, Nationalmuseum, Stockholm, inv. no. NM-H-113/1966. The awkward draftsmanship evident in this damaged sheet, discovered by the present author, suggests that it is a copy; however, there are notable minor alterations to the composition. Another version of this design, formerly in the collection of Germain Seligman, is now in a private collection in New York, and William Griswold has indicated that another version exists in a Russian palace museum outside Moscow. This is not surprising: Doyen died in St. Petersburg.

NOTES TO CAT. 83

1. Two of Rousseau's most notable and influential works concerned with man, nature, and the natural state of man were *Emile* and *Rêveries du promeneur solitaire.*

2. See Levitine 1975.

3. Simon Mathurin Lantara, *View of the Château de Chambord*, pen and gray ink with watercolor over traces of graphite, Department of Drawings and Prints, The Metropolitan Museum of Art, New York, inv. no. 1985.104.3. See Bean and Turčić 1986, cat. no. 154, p. 143.

4. Simon Mathurin Lantara, *Moonlight Landscape with a Castle*, black chalk and charcoal, extensively stumped, and lightly heightened with white chalk, 385 × 517 mm., Cabinet des Dessins, Musée des Beaux-Arts, Besançon, inv. no. D.2888.

5. Simon Mathurin Lantara, *The Storm*, black chalk and charcoal, extensively stumped, and lightly heightened with white chalk, 205 × 305 mm., Cabinet des Dessins, Musée des Beaux-Arts, Chartres, inv. no. 6986.

NOTES TO CAT. 84

1. See Marianne Roland Michel in Paris 1985e, cat. no. 10 (n.p.).

2. The Musée des Beaux-Arts in Besançon had some spectacular examples in its collection (Cornillot 1957, cat. nos. 100 and 101) even before it acquired an entire album of studies La Traverse executed in Italy (see Méjanès 1972, cat. nos. 1 and 2).

3. Jean-Baptiste Deshays, *The Punishment of Korah*, black chalk with brush and brown wash, heightened with white gouache, on tan laid paper, 537 × 435 mm., Private Collection.

4. Jean-Baptiste Deshays, *The Resurrection of Lazarus*, pen and brown ink and brush with brown wash, heightened with white gouache, over black chalk, 487 × 420 mm., Département des Arts Graphiques, Musée du Louvre, Paris, inv. no. 26200. Although Diderot mentions this work in the Salon of 1763, it does not appear in the catalogue of the Salon; see Diderot—Seznec—Adhémar 1967, pp. 218–20.

NOTES TO CAT. 85

1. See Marly 1992 and DeLorme 1996, pp. 157–65.

2. Document cited in Pichon 1856, pp. 285–86.

3. The quote continues, "One can see . . . to what extent these are representations of the Graces, rather than torchères." See Pidansat de Mairobert, p. 44.

4. It was no. 200 in the catalogue of the Salon. The suite of four sculptures was described by the critic Luc-Vincent de Thiéry as they appeared in the vestibule of the pavilion (Thiéry 1788, p. 459). In an inventory taken during the Revolution, they are listed as being in the "dining room." See Christian Baulez in Marly 1992, p. 69.

5. This torchère was notably different from another that Pajou conceived in 1769 for the royal Château de Versailles that was executed in wood by the *menuisier* Babel. See Beaulieu 1981, p. 163, fig. 10. For the lost sculpture by Pajou, formerly in the Flameng and David-Weill Collections, see Guilhem Scherf in Paris and New York 1997b, p. 237.

6. Augustin Pajou, *Allegory of Music*, red chalk on cream antique laid paper, 306 × 204 mm., Loan from the Collection of Jeffery E. Horvitz, Department of Drawings, Fogg Art Museum, Harvard University Art Museums, Cambridge, inv. no. D-F-218/ 1.1993.104; see Guilhem Scherf in Paris and New York 1997b, cat. no. 48, pp. 123–24.

NOTES TO CAT. 86

1. The Villa d'Este was constructed in the sixteenth century for Cardinal Ippolito d'Este; in the eighteenth century, it belonged to the Este duke of Modena. It was already in disrepair when the abbé de Saint-Non rented it and applied to Natoire, then director of the French Academy in Rome, for permission to have the young Fragonard join him. The previous year, in June 1759, Natoire had spent two weeks in Tivoli drawing *en plein air*, a practice that he made a regular part of instruction during his tenure as director. He was, therefore, a catalytic influence in discovering and encouraging his pupil's talent.

2. Pierre-Jean Mariette wrote about "their spirited execution, where a great intelligence reigns" (Mariette 1750, p. 263).

3. Jean-Honoré Fragonard, *Temple of Vesta and the Temple of the Sibyl at Tivoli*, red chalk over light indications in black chalk, 500 × 570 mm., Pâris Bequest, Musée des Beaux-Arts et d'Archéologie, Besançon, inv. no. D.2839; see Pierre Rosenberg and Jean-Pierre Cuzin in Rome 1990, cat. no. 63, pp. 112–13.

4. See Cornillot 1957, cat. nos. 32–41. The chronology of Fragonard's works, both drawn and painted, is extremely difficult, as he rarely signed or dated them.

5. Part of the collection was transferred from the library in Besançon to the Musée des Beaux-Arts et d'Archéologie. See the brief introduction to Cornillot 1957.

6. The average size is approximately 357 × 495 mm.

7. See Dernie and Carew-Cox 1996, pp. 88–91.

8. See the beautiful photograph reproduced in Dernie and Carew-Cox 1996, p. 88, which shows the present-day appearance of the *Rometta*, allowing us to see Fragonard's fidelity to the scene as well as his *invenzioni*.

9. Jean-Pierre Cuzin and Pierre Rosenberg in Rome 1990, p. 133, cat. no. 79.

10. Robert typically signed his drawings discreetly within the composition, using the same media. It is significant that the inscription on the recto is followed by an empty pair of parentheses intended for the artist's dates. On the verso, the name *Robert* is very close to the artist's signature, which is a strong indication of his ownership.

11. See Victor Carlson in Washington 1978, pp. 20, 39ff., and cat. no. 6, in which this controversy is examined. Natoire's letters to Marigny in Paris do not indicate that Robert was absent from Rome at the time. However, in April of 1760, Robert had joined the abbé de Saint-Non for a trip to Naples.

NOTES TO CAT. 87

1. Fragonard's composition was unknown to Pigler, whose fundamental *Barockthemen* lists no depictions of the story by French artists. See Pigler 1974, vol. 2, pp. 339–341.

2. For example, Jan Steen's *The Satyr and the Peasant Family*, c. 1660–62 (J. Paul Getty Museum, Los Angeles), illustrated and discussed by John Walsh in connection with another Steen belonging to the Getty, *The Drawing Lesson*; see Walsh 1996, fig. 11, p. 15ff. Also illustrated in the same work is Jacob Jordaens's composition from the Staatliche Kunstsammlungen in Kassel, where it has hung since 1769. Fragonard visited Kassel with Pierre-Jacques Onesyme Bergeret de Grancourt in 1774 after his second trip to Italy. Although not a source of formal influence, the subject may have appealed to Fragonard and his patron.

3. Jean-Honoré Fragonard, *La Perruque brûlée* (or *Comical Scene with Two Card Players*), brush and brown wash over black chalk on tan paper, 351 × 462 mm., Gift of Charles E. Dunlap, Department of Drawings, Fogg Art Museum, Harvard University Art Museums, Cambridge, inv. no. 1954.107; see Pierre Rosenberg in Paris and New York 1987, cat. no. 215, p. 446. For *The Little Preacher*, see Pierre Rosenberg in Paris and New York 1987, cat. no. 227, pp. 465–66.

4. Matthias Scheits, *The Satyr and the Peasant*, pen and brown ink with brush and brown wash, 190 × 262 mm., Kupferstichkabinett, Hamburger Kunsthalle, inv. no. 30717.

5. Leblanc 1854–90, vol. 3, cat. no. 6.

6. See Pierre Rosenberg in New York and Paris 1987, p. 300.

7. In addition to the drawing entitled *The Little Preacher* cited in note 3, Fragonard painted the same composition, now in a Parisian private collection. It measures 540 × 650 mm. (see Cuzin 1988, cat. no. 351, where it is dated to c. 1780).

8. This is the *Education of the Virgin*, which is executed in brush and wash with charcoal, extensively stumped, 548 × 445 mm. This sheet bears the stamp of the engraver, Gabriel Huquier (L. 1285), which establishes a date before the latter's death in 1772. See Ananoff 1968, vol. 3, cat. no. 1770, fig. 440. This sheet is now with Artemis, London.

NOTES TO CAT. 88

1. Roger de Portalis lists a drawing with similar figures: "Un dessin au bistre, représent la vue d'un jardin des environs d'Italie, orné de figures sur different plans; on remarque sur le devant un jeune homme roulant une brouette. Ce marceau piquant offre un site des plus agréable; 9 pouces h; 14 pouces l.; 48 livres 1 sou à Constantini." See Portalis 1889, vol. 2, p. 304. This description comes from the catalogue for the sale of the Collet collection (present location unknown) in Paris, 14 May 1787. That this is a different sheet is confirmed by translating the pouce measurements into metric, approximately 243 × 379 mm., making the Collet drawing considerably smaller than the Horvitz sheet. The Collet drawing was catalogued in Ananoff 1970, vol. 2, cat. no. 900.

2. Fragonard made two preparatory oil sketches in order to work out the complexities of *The Fête at Saint-Cloud*. See Pierre Rosenberg in Paris and New York 1987, cat. no. 161, illus. His discussion includes the chronology and history of the painting, as well as the two preparatory oil sketches.

3. Jean-Honoré Fragonard, *The Umbrella Pines at a Villa near Rome*, brush and brown wash over traces of black chalk, 447 × 337 mm., Rijksprentenkabinet, Amsterdam, inv. no. 53.206. See Pierre Rosenberg in Paris and New York 1987, cat. no. 184. Numerous other landscapes include umbrella pines, which Fragonard took pleasure in studying as he depicted their intricate structure.

For an example of one of his *en plein-air* studies, see Ananoff 1963, vol. 1, cat. no. 339, illus. in vol. 3, fig. 509.

NOTES TO CAT. 89

1. In Seznec—Mongan—Hofer 1945, the Horvitz drawing is identified as a depiction of canto 14, verses 69–73. Lines 68–73 read as follows: "The day before the eve of battle, the Emperor Charlemagne ordained that throughout Paris masses and offices were to be celebrated by priests and friars and that everyone was to be shriven, so as to escape the hands of the infernal spirits, and then to receive communion—just as though they were all to die the next day. With his barons and paladins, princes and prelates, he repaired to the cathedral and most devoutly raising his eyes to heaven, he prayed: 'Lord, though I am wicked and sinful, in your goodness suffer not your faithful people to be afflicted on account of my faults.' Thus prayed the pious emperor, humble and contrite of heart; other prayers too, he added, and a vow suitable to the magnitude of the need and lofty splendour of his office. His urgent entreaties were not without effect, for his tutelary spirit, his angel, took his prayers and, shaping his flight heavenwards, bore them up to the Saviour." Quoted from Ludovico Ariosto, *Orlando Furioso*, trans. and introd. by Guido Waldman, Oxford and New York, 1983, 145–46.

2. Blanc 1862, vol. 2, p. 14, Goncourt 1912, 3d ed., vol. 10, p. 243.

3. Réau 1956, p. 100; also see Kimerly Rorschach in Philadelphia and Houston 1985, p. 14; and Marianne Roland Michel in Paris 1987e, cat nos. 78, 79 (n.p.).

4. More recently, however, it has been argued that the book publishing market was already saturated with editions of Ariosto's works. See Michel 1987, pp. 144–45.

5. It should be noted that the lack of any documentation of a commission is not in itself evidence that one did not exist, but it does increase suspicion that there may not have been a formal arrangement.

6. The most famous editions of Ariosto's *Orlando Furioso* during the later eighteenth century were those issued by the Baskerville firm in 1773 and the Brunet firm in 1783. They contained far fewer plates, and these were half the size of Fragonard's drawings. Both of these editions contained forty-six plates for the entire text, compared with Fragonard's 140 designs for only the first half. Fragonard's drawings averaged 395 × 240 mm. The plates for the Baskerville edition, after Charles Eisen, Giovanni Battista Cipriani, Jean-Michel Moreau le jeune, Charles Monnet, Jean-Baptiste Greuze, and Charles-Nicolas Cochin le jeune, measured approximately 240 × 150 mm. Those after Cochin le jeune for the 1783 Brunet edition were approximately 265 × 195 mm. These are described in further detail in Ray 1986, cat nos. 10 and 64.

7. Fragonard followed this practice for his earlier folio-sized illustrations to La Fontaine's *Contes et nouvelles*, making one illustration for each tale. Engraved beginning in the late 1780s by Jean-Baptiste Tillard, Augustin de Saint-Aubin, and Jean-Baptiste Delafosse, these prints measured approximately 205 × 128 mm.

8. Jean-Honoré Fragonard, *St. Michael Finds Silence at the Gates of the House of Sleep*, black chalk and brown wash, approximately 380 × 240 mm., Private Collection.

9. When Fragonard prepared a design to be engraved, as in the preparatory drawings for the *Contes et nouvelles* and the *Voyage pittoresque* (the latter—including its title page, now in the Fogg Art Museum—also dates to the 1780s), he prepared the image in reverse, sometimes by making a counterproof of a preliminary design in black chalk that was in the proper direction. He would then finish the mirror-image version with wash to enhance the light and shadow for the engravers. The printmakers would prepare their plates from the reversed image, often making an intermediary copy to clarify the lines. When the engravings were printed, the image would be reversed once again, thus back in its proper orientation.

10. I will elaborate on this issue in a forthcoming article, which will include a discussion of the possible purpose of many of the subjects of Fragonard's illustrations.

11. Painted works of this period, such as the *Invocation to Love*, combined this dynamic style with the passionate excesses of Ariosto's subjects to create a new category of contemporary poetic drama that can be seen in several aspects of Fragonard's production in the 1780s. Indeed, the importance of the sixteenth-century chivalric epic for Fragonard was recognized in his own time. One of his eulogists wrote in 1806 that Ariosto had been a major "inspiration." See Le Carpentier 1806, p. 4.

NOTES TO CAT. 90

1. For Piranesi and French art, see Rome et al. 1976. For a summary of the connection between Panini and France, see Paris 1992d, pp. 19–22.

2. Because the extensive correspondence between the various directors and their superiors in Paris does not specifically refer to the appointment, it has been doubted; see Michel 1996, pp. 88–90.

3. Robert and Panini must also have met socially because they were members of the "Arcadia," a Roman literary society composed of both Italians and foreigners residing in or visiting Rome. See Michel 1996, pp. 95–107.

4. The sales after Robert's death in 1808, and after the death of his widow in 1826, contained more than twenty-five of Panini's canvases. The relevant sale catalogue data is reprinted in Gabillot 1895, pp. 257–59, lots 9–24; pp. 249–50, lots 226–27; and p. 253, lots 275–77.

5. Giovanni Panini, *Roman Capriccio with the Forum, the Column of Marcus Aurelius, the Pantheon, and the Colosseum*, pen and brown ink with brush, brown wash, and watercolor, over black chalk, 251 × 356 mm., Département des Arts Graphiques, Musée du Louvre, Paris, inv. no. 6723; see Micheal Kiene in Paris 1992d, cat. no. 46.

6. Hubert Robert, *Equestrian Statue of Hadrian,* watercolor over traces of black chalk, 484 × 584 mm., Robert Lehman Collection, The Metropolitan Museum of Art, New York; see Victor Carlson in Washington 1978, cat. no. 2, pp. 30–31.

7. Translated by this author from Diderot—Seznec—Adhémar 1967, vol. 3, Salon of 1767, pp. 228–29.

NOTES TO CAT. 91

1. The chronology of the two artists' work in Rome and the reciprocal interaction between them has recently been studied by Catherine Boulot, "E Roma Creò Hubert Robert," in Rome 1990, pp. 31–49.

2. Giovanni Battista Piranesi, *View of the Capitoline Hill with the Steps to the Church of S. Maria Aracoeli,* before 1761, etching, Gift of David Keppel, Department of Prints, National Gallery of Art, Washington, D.C., inv. no. 1943.10.66.(B-2545)/PR.; see Hind 1922, cat. no. 38, and Wilton-Ely 1994, vol. 1, cat. no. 147.

3. Hubert Robert, *Steps to the Campidoglio,* red chalk, 335 × 450 mm., Cabinet des Dessins, Musée des Beaux-Arts, Valence, inv. no. D.94; see Cayeux 1985, cat. no. 22, pp. 128–29.

4. The Musée des Beaux-Arts, Valence, has the most important public collection of Robert's drawings (see Cayeux 1985, cat. nos. 22–27). Several other sheets can be cited in private collections. To the drawings mentioned by Cayeux and Boulot (as in n. 1) may be added: *View of the Capital and the Dioscuri,* dated 1762, red chalk, 310 × 445 mm. (ex coll. Prince Argoutinsky-Dolgoroukoff, L. 2602d), sale, Paris, Drouot, 26 June 1987, lot 196, repr. There is also a *View of the Campidoglio, Rome,* in the Pierpont Morgan Library, New York; see Cara Dufour Denison in Montreal 1993, p. 179, cat. no. 100, repr.

NOTES TO CAT. 92

1. Hahn 1971.

2. Anton Pigler's compendium, *Barockthemen,* lists only four works. The only two works that Gamelin had the remotest possibility of knowing were a painting of 1770 by Angelika Kauffmann that was engraved in 1788 and a canvas by Jacques Berger de Chambery painted in Rome in 1787. Gamelin left Rome in the mid-1770s. See Pigler 1974, p. 318; G. S. and I. G. Facius in Düsseldorf 1979, p. 56, cat. no. 102; and the *Giornale delle Belle arti,* vol. 4, cat. no. 21, p. 159 (26 May 1787).

3. The painting by Challe has been lost, but Diderot provides a very critical description of it in his *Salons* (Challe depicted the moment at which Hector interrupts the sacrifice being offered by Helen and Paris, after the latter has escaped the fury of Menelaus with the help of Minerva). Gamelin lived in Paris from 1761 until early 1765. Might he have seen this work in Challe's studio? Also, he might have seen the sketches for Deshays's tapestry cartoons in his teacher's studio. See Sandoz 1977, cat. no. 70-2, pp. 84 and 134, repr., pl. 6.

4. Jacques Gamelin, *The Grief of Achilles after the Death of Patroclus,* pen and gray ink with gray and blue wash, heightened with white gouache, on prepared paper, 340 × 485 mm., location unknown; see Philip Conisbee in London 1975, cat. no. 36.

5. Philip Conisbee in London 1975, under cat. nos. 35–36 (n.p.).

6. Olivier Michel and Joseph Hahn in Carcassonne 1990, pp. 68–76, cat. nos. 44–63.

NOTES TO CAT. 93

1. Jean-François Méjanès in London 1977, cat. no. 123; and in Paris 1983b, pp. 139–42, cats. 130–35.

2. Suvée would outdistance Vincent when François-Guillaume Ménageot assumed the directorship of the French Academy in Rome. Le Bouteux dropped from sight after a stay in Rome that ended in 1775.

3. Jean-François Méjanès in Rome et al. 1976, pp. 69–72, cat. no. 20, and in London 1977, p. 49, cat. no. 56.

4. Joseph-Benoît Suvée, *Landscape with the Colosseum and Two Women, a Shepherd, and His Flock,* red chalk on white paper, 404 × 288 mm., Cabinet des Dessins, Musée des Beaux-Arts, Rouen, inv. no. 868.5.20; see François Bergot and Pierre Rosenberg in Washington et al. 1981, pp. 86–87, cat. no. 110.

5. Joseph-Benoît Suvée, *Interior of the Colosseum,* black chalk heightened with white chalk over traces of red chalk on gray-beige paper, 476 × 355 mm., Polakovits Bequest, Cabinet des Dessins, Ecole nationale supérieure des Beaux-Arts, Paris, inv. no. EBA1441; see Jean-François Méjanès in Paris 1989a, cat. no. 115, p. 272.

NOTES TO CAT. 94

1. Joseph-Benoît Suvée, *Allegory of Temperance,* black and white chalk on tan paper, Cabinet des Dessins, Musée Fabre, Montpellier, inv. 64.9.3, inscribed *J.B. SUVEE A L'AMITE AU SOUVENIR DU CITOYEN M.J. VIEN ANCIEN DIRECTEUR DE LACADEMIE DE FRANCE A ROME MEMBRE DU SENAT CONSERVATEUR DE LA REPUBLIQUE FRANCAISE;* for the related painting, see Jean-François Méjanès in Brussels 1985, pp. 100–1, cat. no. 62.

2. Joseph-Benoît Suvée, *Dibutade (The Discovery of Drawing),* black and white chalk on brown paper, 546 × 355 mm., Department of Drawings, J. Paul Getty Museum, Los Angeles, inv. no. 87. GB.145, inscribed *J.B. SUVEE. A SON AMI VAN SPAENDONCK MEMBRE DE L'INSTITUT NATIONAL;* see Goldner and Hendrix 1992, p. 208, cat. no. 87; and Victor Carlson in Los Angeles et al. 1993, p. 172, cat. no. 30.

NOTES TO CAT. 95

1. Nicolas Le Jeune, *The Feast of Absalom,* pen and brown ink and brush with watercolor and gouache, 645 × 910 mm., Gabinetto dei Disegni, Accademia Nazionale di San Luca, Rome; see Cipriani and Valeriani 1991, vol. 3, pp. 75–78.

2. Marcello Leopardi di Potenza, *The Feast of Absalom,* black chalk heightened with white, 510 × 810 mm., Gabinetto dei Disegni, Accademia Nazionale di San Luca, Rome. The young Antonio Cavallucci won the first prize in the junior class; for both, see Cipriani and Valeriani 1991, as in n. 1.

3. See Moir 1967, vol. 2, pl. 229.

4. See Maria Utili in London and Washington 1982, cat. no. 106, pp. 213–15; and Spike 1979.

5. Baudicour 1861, vol. 1, cat. no. 2, p. 301.

6. Baudicour 1861, vol. 1, p. 300.

7. I would like to thank Holm Bevers in the Kupferstichkabinett, Berlin, and Erich Schleier in the Gemäldegalerie, Berlin, for their assistance.

NOTES TO CAT. 96

1. David placed second in 1771 when Suvée won the Prix de Rome (see cat. 94). One could not win second place twice, but it was admitted that he was the best candidate (see the excerpt from a letter of 1771 from Jean-Baptiste-Marie Pierre to the abbé Terray in Rosenberg and van de Sandt 1983, p. 22). Apparently, even David later recognized the superiority of Peyron's talent early in their careers, for at Peyron's funeral, David noted that the artist had "opened his eyes" (see Rosenberg and van de Sandt 1983, p. 22).

2. This is the most basic and essential kind of drawing produced by students at the Académie, where the figurative and narrative character of the most esteemed genres of painting at the time—historical, religious, and mythological—made it imperative for the students to be capable figure draftsmen. Because such drawings were inseparable from the institutions at which they were produced, they were called *académies.* For more, see Alvin Clark in Cambridge 1994; James H. Rubin and David Levine in Princeton 1977; and Albert Boime in Binghamton et al. 1974.

3. Early composition studies, such as his *Funeral of Miltiades* (drawing, Musée des Beaux-Arts, Alençon; see Rosenberg and van de Sandt 1983, cat. no. 64) reveal the occasional awkwardness of Peyron's idealized male figures in motion. His large-boned males—like the one in the middle background sup-

porting the front end of Miltiades's bier with enormously broad shoulders that flow into squarishly muscular upper arms, thick forearms, and big hands—can barely turn their small heads to see past their shoulders. Wisely, Peyron would learn to temper the proportions of his males without sacrificing their virility. His male figures always provided a stark contrast to the smooth, curved, and delicate features of his females and his elegant draped figures.

4. Jean-François-Pierre Peyron, *Cincinnatus* or *Hermes Fastening His Sandal,* red chalk, 163 × 97 mm., Fondation Jacques Doucet, Collection Bibliothèque d'Art et d'Archéologie, now housed in the Bibliothèque nationale de France, Paris, inv. no. MS38-fol. 1 r.; see Rosenberg and van de Sandt 1983, cat. no. 96, pp. 110–13.

5. Jean-François-Pierre Peyron, *Rhadamisthe and Zénobie,* pen with black and brown ink and brush with brown wash, heightened with white gouache, 139 × 89 mm., Donation Dutuit, Cabinet des Dessins, Musée du Petit Palais, Paris; see Rosenberg and van de Sandt 1983, cat. no. 149-5, pp. 140–41.

6. François-André Vincent, *Seated Male Nude,* red and black chalk, stumped and heightened with white chalk, on tan paper, 541 × 422 mm., Ecole nationale supérieure des Beaux-Arts, Paris, inv. no. 3268; see Cuzin 1988b, cat. no. 5.

NOTES TO CAT. 97

1. Michelangelo was considered the unparalleled genius of sculpture, but the dominant vein of classicism in French art and art criticism, from Poussin and Le Sueur through Ingres, consistently ranked Raphael as the superior painter. See Jacques Thuillier in Paris 1983a, pp. 11–36, and Thuillier 1957.

2. See Rosenberg and van de Sandt 1983, under cat. no. 141D, p. 135.

3. See Rosenberg and van de Sandt 1983, cat. no. 137, pp. 133–34.

4. Rosenberg and van de Sandt 1983, cat. nos. 152 and 153, pp. 142–43.

5. Jean-François-Pierre Peyron, *Study for "Hagar and the Angel,"* pen and black ink with brush and gray wash, heightened with white gouache, on blue paper, 546 × 375 mm., Kupferstichkabinett, Hessisches Landesmuseum, Darmstadt, inv. no. HZ 2543; see Rosenberg and van de Sandt 1983, cat. no. 40, p. 91.

NOTES TO CAT. 98

1. François-André Vincent, after Raphael, *Head of a Woman,* red chalk over traces of black chalk on cream antique laid paper, 526 × 412 mm., Loan from the Collection of Jeffrey E. Horvitz, Department of Drawings, Fogg Art Museum, Harvard University Art Museums, Cambridge, inv. no. D-F-290/1.1993.134.

2. See Jean-Pierre Cuzin in Rome 1990, cat. nos. 169–78, pp. 230–51.

3. For a survey of Vincent's draftsmanship, see Cuzin 1988b, pp. 5–9.

4. I would like to thank Jean-Pierre Cuzin for taking the time to correspond and discuss this sheet with me.

5. François-André Vincent, *Head of a Young Woman in Profile,* black and red chalk heightened with white chalk on tinted paper, 535 × 412 mm., Département des Arts Graphiques, Musée du Louvre, Paris, inv. no. 32282; see Cuzin 1988b, cat. no. 36. A number of Vincent's head studies from c. 1780 were reproduced in engravings by Gilles Demarteau.

6. See Cuzin 1988b, cat. no. 56, and José-Luis de Los Llanos in Paris 1992a, cat. no. 49, pp. 98–99.

7. For an early work in the manner of Vien, see Pierre Rosenberg in Toledo et al. 1975, p. 82, cat. no. 116, pl. 118.

8. See Montagu 1994, esp. appendix 4, pp. 163–70.

NOTES TO CAT. 99

1. Plutarch, *Letters,* vol. 3, no. 16.

2. Cassius Dio, *History of Rome,* 49:16.

3. These were listed as nos. 67 and 68 in the Salon of 1785.

4. François-André Vincent, *Studies for "Arria and Paetus,"* brush and brown wash (nine drawings grouped on one mount), 277 × 421 mm., Private Collection, Paris; see Cuzin 1988b, cat. no. 42.

5. François-André Vincent, *Arria and Paetus,* pen and brown ink, 415 × 505 mm., Private Collection, Paris; see Cuzin 1988b, cat. no. 43.

6. See Régis Michel in Paris 1989, p. 89.

7. These include *Young Pyrrhus at the Court of Glaucus* in the Musée du Louvre, Paris (see Régis Michel in Paris 1989b, fig. 52, p. 90); *Melancholy* in the Prat Collection, Paris (see Cuzin 1988b, cat. no. 63); three studies for the *Clemency of Augustus*—two in the Metropolitan Museum of Art, New York, and one in the Horvitz Collection (see Cuzin 1988b, cat. nos. 46 and 47, and the

appendix to this catalogue); and two composition studies for *Zeuxis Choosing His Models from the Women of Croton*—one in the Musée Atger, Montpellier, and one in the Horvitz Collection (see Cuzin 1988b, cat. no. 46, and the appendix to this catalogue).

8. François-André Vincent, *The Painter Apelles,* pen and black ink with brush and white gouache on brown laid paper, 349 × 470 mm., Purchase—The Melvin R. Seiden Fund, Louise Haskell Daly Fund, and the Paul J. Sachs Memorial Fund, Department of Drawings, Fogg Art Museum, Harvard University Art Museums, Cambridge, inv. no. 1985.50; see Cuzin 1988b, cat. no. 66.

NOTES TO CAT. 100

1. Jacques-Louis David, *Caracalla Murdering Geta in His Mother's Arms,* pen and brown ink with brush and gray wash, lightly heightened with white gouache, over traces of black chalk on tan paper, 223 × 292 mm., signed: *L. David inv. 1782* (ex coll. Flury-Hérard), Gift of the Société des Amis du Louvre in 1995, Département des Arts Graphiques, Musée du Louvre, Paris, inv. no. RF 49923. See Arlette Sérullaz in Paris 1997a, cat. no. 380, p. 300. This subject was also treated by Simon Julien, called Julien de Parme, in drawings now in the Musée Granet in Aix-en-Provence, and the Nationalmuseum, Stockholm.

2. The work of the ancient Greek historian Cassius Dio was translated into Italian and French in the fifteenth century by Armand and Charles Les Angeliers. Parts of his work appeared again in French in 1610, by the Parisian publisher Richier (*L'Histoire de Dion Cassius de Nycare contenant la vie des 26 empereurs qui ont régné depuis Jules Caesar jusqu'a Alexandre, revue par Antoine de Bandhole . . .*).

3. For the sheets in Rotterdam and in the Ecole nationale supérieure des Beaux-Arts, Paris, as well as other works that have been lost, see Arlette Sérullaz in Paris and Versailles 1989, cat. no. 46, p. 128, repr.

4. For two contemporary drawings (1783–84) inspired by the story of the Horatii, see Arlette Sérullaz in Paris and Versailles 1989, cat. no. 52, repr.; and Sérullaz 1991, cat. no. 191, repr.

NOTES TO CAT. 101

1. The full title in French reads: *L'Amour séduit l'Innocence, le Plaisir l'entraîne, le Repentir suit.*

2. Pierre-Paul Prud'hon, *Study for Love,* black chalk, stumped, heightened with white chalk, on blue wove paper, 592 × 360 mm., Musée Bonnat, Bayonne, inv. no. 1141.

3. Pierre-Paul Prud'hon, *Study for Innocence,* black chalk, stumped, heightened with pink pastel, on blue wove paper, 588 × 317 mm., Pierpont Morgan Library, New York, inv. no. 1974.71; see Sylvain Laveissière in Paris and New York 1997a, cat. no. 41, p. 86.

4. Pierre-Paul Prud'hon, *Remorse,* black chalk, stumped, heightened with white chalk on white wove paper, 320 × 160 mm., Nationalmuseum, Stockholm, inv. no. 274/1972. See Sylvain Laveissière in Paris and New York 1997a, cat. no. 39, p. 84.

5. Pierre-Paul Prud'hon, *Love and Innocence,* black chalk, stumped, heightened with white chalk, on blue wove paper, 375 × 252 mm., Donation Pereire, Département des Arts Graphiques, Musée du Louvre, Paris, inv. no. RF29743; see Sylvain Laveissière in Paris and New York 1997a, cat. no. 42, pp. 86–87.

6. See Sylvain Laveissière in Paris and New York 1997a, cat. no. 38, pp. 82–83.

7. Pierre-Paul Prud'hon, *Love Seduces Innocence, Pleasure Entraps, Remorse Follows,* graphite and pen and black ink with brush and gray wash on cream antique laid paper, 503 × 395 mm., Bequest of Grenville L. Winthrop, Department of Drawings, Fogg Art Museum, Harvard University Art Museums, Cambridge, inv. no. 1943.891. Prud'hon also gave Roger the studies in the Louvre (*Love* and *Innocence*) and Stockholm (*Remorse*). See Laveissière 1977, p. 26.

8. See Sylvain Laveissière in Paris and New York 1997a, cat. no. 44, pp. 88–89.

9. The models are said to have been Julien and Marguerite (family names unknown), who posed for a number of Prud'hon's academic drawings on unspecified dates.

10. See Sylvain Laveissière in Paris and New York 1997a, cat. no. 14, p. 55, repr., fig. 14b.

11. The Bayonne drawing was lot 84 in the Boisfremont sale.

NOTES TO CAT. 102

1. Pierre-Paul Prud'hon, *God Reproaching Adam and Eve after Their Misdeed,* black chalk and charcoal heightened with white chalk on blue wove

paper, 236 × 300 mm., Cabinet des Dessins, Musée des Beaux-Arts, Dijon, inv. no. CA-704.

2. It was sold by that collector's daughter to Laurent Laperlier and resurfaced at the sale held after his death. It subsequently passed into the Dugléré, Rouart, and Baudrier collections. This latter collector lent it to the Prud'hon exhibition of 1922, after which it disappeared from view.

3. Pierre-Paul Prud'hon, *Justice and Divine Vengeance Pursuing Crime*, black chalk, stumped, heightened with white chalk, on blue wove paper, 402 × 504 mm. (sight), Cabinet des Dessins, Musée Condé, Chantilly, inv. no. 485. For this drawing and the related works, see Sylvain Laveissière in Paris and New York 1997a, pp. 226–35, esp. cat. no. 165.

4. See Sylvain Laveissière in Paris and New York 1997a, cat. nos. 207–210, pp. 291–95, repr., p. 295.

5. See Sylvain Laveissière in Paris and New York 1997a, cat. no. 211, pp. 294–97, repr., p. 297.

6. See Sylvain Laveissière in Paris and New York 1997a, under cat. no. 211, repr., fig. 211b, p. 296.

NOTES TO CAT. 103

1. Bruun Neergaard, chamberlin to the king of Denmark, was a naturalist, traveler, and an avid collector of contemporary French art. He was particularly fond of Prud'hon, built the first major collection of the artist's drawings, and published descriptions of the artist's work. See Laveissière 1997, pp. 116–19.

2. It is this expression—a bit sullen—and an error concerning the sex of the figure, that led to the Horvitz drawing being entitled *The Little Crier (Le Petit Pleureur)* in the 1889 exhibition. The lost pendant is listed in Guiffrey 1924, cat. no. 760, pp. 281–82. The dimensions, based on those given in the sale of 1814, are erroneous. It is clear that this is the pendant to the Horvitz drawing, and it must be of similar dimensions.

3. The two prints were inscribed with their titles, LE DESSINATEUR and LE MODELE, and further inscribed, *15 september 1804* and *Dessiné par P::P::Prudon et gravé par Noel/ A Paris chez Bance, Rue St. Denis, No 175, près celle aux Ours.* See Goncourt 1876, cat. nos. 165–66, pp. 280–81.

4. See Laveissière 1988; and Sylvain Laveissière in Paris and New York 1997a, pp. 137–49.

5. Bruun Neergaard 1801, p. 125.

6. See Sylvain Laveissière in Cuzin 1996, pp. 189–91.

7. Pierre-Paul Prud'hon, *Allegorical Representation of Painting* (La Génie de la Peinture), black chalk heightened with white chalk on blue wove paper, Private Collection, New York; see Eisler 1996, pp. 71–74.

8. See Laveissière 1988, pp. 16, 18, and 20, cat. nos. D.8–10. A more finished drawing (Guiffrey 1924, cat. no. 927, p. 348) was sold in Paris (Drouot, 22 June 1978, lot 109, repr.).

9. See Sylvain Laveissière in Paris and New York 1997a, pp. 222–43.

10. Laveissière 1988, p. 23.

11. For two others made specifically for this project, *Clotho* and *Lachesis*, see Sylvain Laveissière in Chantilly 1997, cat. nos. 14–15.

NOTES TO CAT. 104

1. See Sylvain Laveissière in Cuzin 1996, pp. 194–96, where many of the preparatory drawings are reproduced; and in Paris and New York 1997a, cat. no. 219, pp. 310–12.

2. Delacroix 1846, pp. 449–50.

3. Adrien Didier after Pierre-Paul Prud'hon, *The Soul Breaking the Ties That Attach It to the Earth*, engraving, Bibliothèque nationale de France, Paris.

4. Pierre-Paul Prud'hon, *The Soul Breaking the Ties That Attach It to the Earth*, black chalk, extensively stumped, heightened with white chalk, on blue wove paper, 483 × 343 mm., Private Collection (from the Boisfremont, Power, Desvosges, and Dupin collections); see sale, Sotheby's, New York, 28 January 1998, lot 200. See Sylvain Laveissière in Cuzin 1996, p. 195, fig. k.

5. Guiffrey's measurements were 530 × 380 mm.

NOTES TO CAT. 105

1. Etienne-Barthélemy Garnier, *Socrates and Alcibiades*, pen and black ink with brush and gray wash, heightened with white gouache, faintly squared in white chalk, 305 × 447 mm., Gift of Mrs. Rensaleer W. Lee, Mrs. David H. McAlpin, and Mrs. Hibbin Ziesing, Department of Prints and Drawings, The Art Museum, Princeton University, inv. no. 1978-6. For this and another drawing by Garnier at Princeton, *Anacreon with His Mistress and the Young Bathyl-*

los, see Ross 1983, pp. 20–21; and Victor Carlson in Los Angeles et al. 1993, cat. no. 50, pp. 206–7.

2. See Pigler 1974, vol. 2, p. 239; and Davidson Reid and Rohmann 1993, vol. 2, pp. 895–98.

3. See Henkel 1930, the major study on illustrated editions of Ovid's *Metamorphoses*.

4. For the Rubens painting, see Alpers 1971, cat. no. 57, pp. 262–63; and for the Galle engraving, see Hollstein (DF), cat. no. 278.

5. Haskell and Penny 1981, cat. no. 63, fig. 140, pp. 269–71. I am indebted to Dr. Sara Morris, Department of Classics, University of California at Los Angeles, for her help with the Greek inscription.

6. The decapitation of Louis XVI took place on 21 January 1793.

7. For more on the Villeneuve etching, see James Cuno in Los Angeles 1988, cat. no. 90, p. 194.

8. *The Emperor Maurice, Dethroned by the Usurper Phocas, Is Executed by Lictors after Witnessing the Murder of His Five Sons*, 1790, and *The Consternation of Priam's Family after the Death of Hector*, c. 1792, are both in the Musée des Beaux-Arts, Quimper (see Nathalie Volle in Paris 1974a, cat. nos. 49–50, pp. 57–59, repr.).

NOTES TO CAT. 106

1. Adélaïde Labille-Guiard, *Portrait of Marie-Gabrielle Capet*, red and black chalk heightened with white chalk, 501 × 403 mm., Private Collection, New York; see Emmanuel Moatti in New York 1994b, cat. no. 28.

2. Adélaïde Labille-Guiard, *Self-Portrait with Two Pupils, Mademoiselle Marie-Gabrielle Capet and Mademoiselle Carreaux de Rosemond*, 1785, oil on canvas, 210.8 × 151.1 cm., Gift of Julia A. Berwind, Metropolitan Museum of Art, New York, inv. no. 1953.225.5.

3. François-André Vincent, *Portrait of Marie-Gabrielle Capet*, black and white chalk on tan paper, 454 × 307 mm., Purchased with funds given by Anne B. Dickinson, Department of Drawings, Stanford University Museum of Art, Palo Alto, inv. no. 1982.137.

4. Doria 1934.

5. This *Self-Portrait*—which was probably executed in oils—is mentioned in two of the reviews written at the time of the Exposition de Jeunesse. See Doria 1934, pp. 52–53.

6. Doria 1934, p. 51.

7. Reproduced in Doria 1934, fig. 2.

NOTES TO CAT. 107

1. In the *livret* of the Salon, it was described as: "Agis rétablissant à Sparte les lois de Lycurge, et faisant brûler dans la place publique, tous les actes tendans à détruire l'Egalité, un vieux soldat Spartiale porte par ses enfants sur un bouclier, rends grace aux Dieux de la regeneration de sons pays. La statue de Lycurge est ornée de guirlande de chêne . . . Dessin."

2. See Mérot 1987, cat. no. 85, pp. 237–41.

3. Armand-Charles Caraffe, *Agis Restoring the Laws of Lycurgus to Sparta*, etching, Bibliothèque nationale de France, Paris. This rare impression is inscribed: *1ère eau-forte de Caraffe. planche détruite après avoir été retouchée. unique.*

4. Lagrenée recommended Caraffe as his student in a letter to Joseph-Marie Vien (see Montaiglon and Guiffrey 1902, vol. 14, p. 6).

5. J. L. J. David, as quoted by Antoine Schnapper in Paris et al. 1974, p. 344.

6. Montaiglon and Guiffrey 1902, vol. 15, p. 245.

7. Montaiglon 1889, p. 387.

8. Armand-Charles Caraffe, *Académie: Standing Male Nude Seen from Behind*, black and red chalk, Département des Arts Graphiques, Ecole nationale supérieure des Beaux-Arts, Paris, inv. no. 2791.

9. Armand-Charles Caraffe, *The Consul Gaius Popillius Laenas Sent by the Romans to King Antiochus in Order to Request the Cessation of Battle*, pen and black ink with brush and brown wash heightened with white gouache on blue wove paper, 485 × 743 mm., Graphische Sammlung Albertina, Vienna, inv. no. 15352.

10. See two of Poussin's early efforts, both antique battle scenes (Hermitage, St. Petersburg and Pushkin Museum of Fine Arts, Moscow), from his first year in Rome (Pierre Rosenberg in Paris 1994a, cat. nos. 6–7, pp. 134–37).

11. See the chapter on *exemplum virtutis* in Rosenblum 1967, pp. 50–106, esp. p. 79 and n. 101.

12. Charles-Nicolas Cochin le jeune also treated this composition in a drawing presented as his reception piece to the Académie in 1760 (Musée du

Louvre, Paris). For this, and Vincent's drawing in the Art Gallery of Ontario, Toronto, see Pierre Rosenberg in Toronto et al. 1972, cat. no. 146, p. 221, repr., pl. 126; and for Monsiau's canvas from the Salon of 1789 in the Musée du Petit Palais, Paris, see Heim—Béraud—Heim 1989, p. 290.

13. See chap. 13, "Solon or Lycurgus," in Parker 1937, pp. 146–70.

NOTES TO CAT. 108

1. First published in Coupin 1829, vol. 1, p. 353.

2. Anne-Louis Girodet de Roucy-Trioson, *Head of a Woman in a Turban,* black chalk, 133 × 109 mm., Private Collection; see Philip Conisbee in London 1975, cat. no. 46 (n.p.). For the Minneapolis painting, see Clark 1971, cat. no. 94, repr.; and for the Leipzig painting, see Winkler and Heiland 1979, cat. no. 93, p. 68, repr., pl. 291.

3. Coupin 1829, vol. 1, pp. lvi–lvii.

4. See Perignon 1824, p. 3.

5. See Pliny the Elder, *Natural History,* 35:151.

6. For a complete study of Le Brun's crucial *conférence,* and the role and publications of Bernard Picart and Henri Testelin in popularizing them, see Montagu 1994; also see Testelin 1680.

7. A rare extant edition of this publication is in the Bibliothèque nationale de France, Paris, inv. no. DC48. The original drawings for this publication are in an album in the Musée Girodet, Montargis, inv. no. D.77-1; see Jacqueline Boutet-Loyer in Montargis 1983, cat. nos. 99–137.

8. See Jean Clair in Paris 1993c, p. 225, repr.

9. Coupin 1829, vol. 1, p. 396.

NOTES TO CAT. 109

1. Baudelaire, *Musée classique du bazar Bonne-Nouvelle,* in *Curiosités esthetiques,* Paris, 1990, p. 91.

2. He collaborated on François Noël's important *Dictionnaire de la fable, ou mythologie universelle à l'usage des artistes* (Paris, 1801). On p. xxvii, n. 2, of the second edition of Noël's *Dictionnaire de la fable* (1803), the editor thanks Girodet for his assistance with the text. In addition, Girodet pursued his involvement with literature to such an extent that he devoted a large part of his time and energy to composing long didactic poems in the descriptive style of Jacques-Henri Bernardin de Saint-Pierre and Jacques Delille. Much of it is published in Coupin 1829. He also translated into French from the original Greek and Latin works by ancient authors such as Anacreon, Sappho, and Virgil. Girodet was also familiar with the works of the most significant modern and contemporary authors such as Dante, Milton, James MacPherson (*Ossian*), and François-Auguste-René vicomte de Chateaubriand (*Atala*).

3. These include Noël's *Dictionnaire de la fable* (1803), Jacques-Henri Bernardin de Saint-Pierre's *Paul et Virginie* (1806), abbé Jacques Delille's *La Conversation* (1812), and Julie Candeille's *Bathilde, Reine des Gauls* (1814).

4. "It is an injustice for drawings to be nothing but drawings while they demand the same composition as and nearly the same studies as a history painting." Coupin 1829, vol. 2, p. 338.

5. Anne-Louis Girodet de Roucy-Trioson, *Frontispiece for the "Oeuvres de Virgile,"* pen and black ink with brush and gray wash, over traces of black chalk, 210 × 150 mm., Turpin de Crissé Bequest (1859), Musée des Beaux-Arts, Angers, inv. no. MTC90; see Jean Lacambre in Paris 1974a, cat. no. 62, pp. 69–70.

6. In the prospectus for the *Oeuvres de Virgile* in 1797, Didot announced the participation of David: "Je fis part de mon projet à David, le premier peintre de la France et peut-être de l'Europe. Il l'accueilit avec enthousiasme et s'offrit à faire les dessins lui-même ou du moins si ses occupations ne lui permettaient pas d'y mettre assez de suite, il se proposa d'en confier quelques uns à deux de ses élèves qu'il jugea capables de travailler concurremment avec lui."

7. There were a total of ten drawings, one for each of the five acts in the two plays. Didot wished to retain Prud'hon for *Andromache,* but he was eventually replaced by Girodet; see Bellenger, forthcoming.

8. Massard engraved all of the illustrations for *Phèdre* except for that designed for the fourth scene, which was engraved by Louis de Chatillon. Both were students of Girodet.

9. The five drawings for Racine's *Phèdre* disappeared from view for many years. At an early date, they were incorporated by the publisher into a unique volume printed on vellum. Van Praet, director of the French royal library, noted in 1824 that this volume was then in the Firmin Didot Collection. When the book was acquired by the French royal library sometime between 1828 and about 1840, it no longer contained the original drawings, which had been replaced by engravings. The five drawings, with their provenances after leav-

ing the Firmin-Didot Collection, were *Phaedra Reveals Her Passion for Hippolytus* (I:3/ once in the Schubert-Coutan-Auguet Collection and acquired by the Pierpont Morgan Library, New York, from W. M. Brady and Co., Inc., New York, in 1997); *Phaedra, after Revealing Her Passion for Hippolytus, Attempts to Kill Herself with His Sword* (II:10/ also once in the Schubert-Coutan-Auguet Collection and acquired by the Art Institute of Chicago from W. M. Brady and Co., Inc., New York, in 1997); *Phaedra Refusing the Embraces of Theseus* (III:10/ acquired by the J. Paul Getty Museum, Los Angeles, in 1985 from the Heim Gallery, London); *Theseus Rejecting Hippolytus after Oenone Accuses His Son of Attempting to Seduce Phaedra* (IV:2/ acquired by the Musée Dobrée, Nantes, in 1975 from the Heim Gallery, London); and the exhibited sheet in the Horvitz Collection (V:5).

10. Although it contains notable aberrations, Racine's drama is based on Euripides's *Hippolytus* and Seneca's *Phaedra.*

11. Anne-Louis Girodet de Roucy-Trioson, *Phaedra Refusing the Embraces of Theseus,* graphite, pen and brown ink, and brush with brown wash, heightened with white gouache, 335 × 226 mm., J. Paul Getty Museum, Los Angeles, inv. no. 85.GG.209; see Goldner and Hendrix 1988, cat. no. 71, pp. 162–63.

12. These were included in the sale of the artist's estate; see Sylvain Bellenger in Los Angeles et al. 1993, under cat. no. 55, p. 216.

13. Anne-Louis Girodet de Roucy-Trioson, *Sheet of Studies for "The Death of Phaedra,"* black chalk, 265 × 368 mm. (ex coll. His de La Salle), Département des Arts Graphiques, Musée du Louvre, Paris, inv. no. 26780; see Régis Michel in Paris 1989b, cat. no. 55, pp. 93–94, and p. 153.

14. These four portraits were: no. 208, *Portrait of the Deceased M. Bonaparte, Father of His Imperial Majesty* (now in the Musée national des Châteaux de Versailles et du Trianon); no. 209, *Portrait of Baron Dr. Jean-Dominique Larrey, Former Chief Surgeon of the French Forces during the Egyptian Campaign* (now in the Musée du Louvre, Paris); no. 210, *Portrait of Katchef Dahout, Christian Mameluke of Georgia* (now in the Art Institute of Chicago); and no. 211, *Portrait of Dr. Trioson, M.D., Giving a Geography Lesson to His Son* (lost). These are listed in "Explication des ouvrages de peinture, sculpture, architecture, des artistes vivants, exposés au Musée Napoléon, le 2ème jour complémentaire, an XII de la République Française (12 Septembre 1804)," manuscript in the Collection Deloynes, Bibliothèque nationale de France, Paris, doc. 864.

15. The paintings that helped Girodet establish his reputation as a leading practitioner of history painting included: *The Sleeping Endymion,* from the Salon of 1791 (Musée du Louvre, Paris); *Hippocrates Refusing the Gifts of Artaxerxes,* Salon of 1792 (Faculté de Médecine, Paris); and *Ossian Meeting the Shades of Former French Heroes,* Salon of 1802 (Musée national du Château de Malmaison).

16. Anonymous, "Si j'avais produit le beau tableau d'Esculape méprisant les richesses, l'Apothéose des généraux français, je ne réduirais pas mon génie au seul genre du portrait," in *Arlequin au Museum ou critique des tableaux en Vaudevilles, Exposition de l'an XII, no. 1,* published pamphlet in the Collection Deloynes, Bibliothèque nationale de France, Paris, 1804, doc. 865.

17. In *Laocoön,* Gotthold Lessing defined the principle of the "fertile moment," and Henry Fuseli used the phrase "critical moment," but the concept is the same.

NOTES TO CAT. 110

1. See Sylvain Bellenger in Los Angeles et al. 1993, cat. no. 60, pp. 225–26.

2. See Coupin 1829, vol. 2, pp. 309–10 (there may be reason to doubt this early date). The drawings were dispersed after Girodet's death, but they were gathered together again in the collection of Ambroise Firmin-Didot.

3. This calculation is based on the assumption that the Firmin-Didot collection had gathered all of the drawings Girodet had made in connection with this project.

4. Anne-Louis Girodet de Roucy-Trioson, *The Combat Between Pallas and Turnus,* black chalk on off-white antique laid paper, 237 × 400 mm., Purchase—Paul Geier Fund, Department of Drawings, Fogg Art Museum, Harvard University Art Museums, Cambridge, inv. no. 1989.63.

5. Lamentably, when the complication of finished vs. unfinished drawings is combined with their first dispersal, presumed regathering, and subsequent redispersal (before they were all photographed), it becomes nearly impossible to determine with any real certainty the sequence that Girodet intended.

6. Some of them may have even been used as preliminary drawings for oil sketches. See Jacqueline Boutet-Loyer in Montargis 1983, cat. nos. 53–85.

NOTES TO CAT. 111

1. Apparently, Valenciennes traveled to the Far East between his two stays in Italy.

2. Valenciennes 1800, pp. 600–1.

3. This was no. 71 in the Salon's catalogue.

4. This was no. 84 in the Salon's catalogue.

5. John Lishawa Collection; see London 1988, cat. no. 19.

6. Lithographs of the site were made by Isidore-Laurent Deroy and Karl Johan Billmark.

7. Printed by the comte de Lasteyrie and G. Engelmann.

8. Jean-Victor Bertin, *Study of a Plane Tree*, black chalk, 536 × 390 mm., Private Collection; see Mark Brady in New York 1992c, cat. no. 5 (n.p.).

9. Jean-Victor Bertin, *Landscape with a Poplar and Willow Tree at the Edge of a Pond*, black chalk, 492 × 360 mm., Department of Drawings and Prints, Metropolitan Museum of Art, New York; see Mark Brady in New York 1991b, cat. no. 6 (n.p.).

10. Jean-Victor Bertin, *Classical Italian Landscape*, black chalk on off-white paper, 336 × 513 mm., Cabinet des Dessins, Musée des Beaux-Arts, et d'Archéologie, Besançon, inv. no. D1064.

11. See Peter Galassi, "The Nineteenth Century: Valenciennes to Corot," in New York 1990, p. 235.

12. Bidauld was not a student of Valenciennes, but he was "in many ways his artistic inheritor"; see Peter Galassi, as in n. 11.

13. See Gutwirth 1974, p. 352, cat. no. 97.

14. This was no. 78 in the Salon's catalogue.

15. Jean-Thomas Thibault, *The Ponte di Augusto at Narni*, 1788–92, brown wash and graphite on cream modern laid paper, 139 × 224 mm., Gift of Mrs. Jacob M. Kaplan, Department of Drawings, Fogg Art Museum, Harvard University Art Museums, Cambridge, inv. no. 1965.21.56.

16. This was no. 221 in the Salon's catalogue.

NOTES TO CAT. 112

1. See Solomon-Godeau 1997, pp. 103–114; and Schneider 1916.

2. For example, *La Lyre d'Anacréon* (1798) contained arias based on Anacreontic poetry, and at least two operas dealt with Anacreon: André Modeste Grétry's *Anacreon chez Policrate* (1799), which contained a libretto by Jean-Henri Guy; and Cherubini's *Anacreon, ou l'amour fugitif* (1803), which was written during his tenure as director of the Conservatoire de Paris.

3. Solomon-Godeau 1997, pp. 99–116; and Régis Michel in Paris 1989b, pp. 97–99 and 126–129.

4. Bertel Thorvaldsen's 1823 rendering of the subject portrays an ephebic Amor (see Solomon-Godeau 1997, p. 112).

5. Augustin Pajou, *Anacreon and Amor*, red chalk over black chalk on cream antique laid paper, 302 × 450 mm., Loan from the Collection of Jeffrey E. Horvitz, Department of Drawings, Fogg Art Museum, Harvard University Art Museums, Cambridge, inv. no. D-F-220/ 1.1995.112; see Guilhem Scherf in Paris and New York 1997b, pp. 205–6, under cat. no. 80.

6. Inv. no. MA 78; see Bober and Rubinstein 1986, p. 52.

7. See Sylvie Brame, Isabelle Mayer, Althea Palmer, Kate de Rothschild, and Alan Salz in New York et al. 1996, cat. 43 (n.p.), repr.

8. The influence of the elder Fragonard became more obvious in Evariste's troubadour paintings, beginning with the Salon entries of 1819. See New Orleans et al. 1996, esp. Guy Stair Sainty and Nadia Tscherny, pp. 55–57 and 154–57.

9. Alexandre-Evariste Fragonard, *Psyche before Venus*, black chalk, stumped, heightened with white chalk, 550 × 890 mm., Département des Arts Graphiques, Musée du Louvre, Paris, inv. no. RF 31041; see Régis Michel in Paris 1989b, cat. no. 59, pp. 98–99 and 151.

10. See the brief biography by Marie-Claude Chaudonneret in *The Dictionary of Art*, vol. 11, London and New York, 1996, pp. 370–72. For example, Evariste sculpted the pediment of the Palais Bourbon in Paris; it was later destroyed in the Revolution of 1830.

NOTES TO CAT. 113

1. Philibert-Louis Debucourt, *Paternal Pleasures*, color engraving, Graphic Arts Council Fund, Department of Prints and Drawings, Los Angeles County Museum of Art, inv. no. M.72.78; see Fenaille 1899, cat. no. 56. For more on Debucourt's graphic work, see other entries in Fenaille 1899; and Roux 1949, vol. 6, pp. 162–91. There is only one known and undescribed first state of his four color engravings of *Paternal Pleasures* (present location unknown) that

corresponds exactly to the drawing; it first appeared in London 1974, cat. 159, repr., pl. 48. For the date of the print, see Roux 1949, vol. 6, p. 162.

2. See Riberio 1988 for a recent and very helpful study of costume in Revolutionary France. The father's costume in the exhibited drawing may be compared to that worn by Pierre Sériziat in Jacques-Louis David's 1795 portrait of his brother-in-law or to François Gérard's *Jean-Baptiste Isabey and His Daughter* (1795) (both in the Musée du Louvre, Paris); see Riberio 1988, p. 119, pl. 6, and fig. 77, respectively. In the published state of the print, the father's striped shirt is similar to those worn by Jacobins or other supporters of the Revolution. See *Les Tricoteuses . . . (un) Jacobin . . . Le Bonnet Rouge* or *Planting the Tree of Liberty* (both works are undated gouaches attributed to Pierre-Étienne Le Sueur in the Musée Carnavalet, Paris); see Riberio 1988, fig. 51 and pl. 4, respectively. David's portrait of his sister-in-law *Mme Emilie Sériziat* (Musée du Louvre, Paris) shows the sitter wearing a bonnet virtually identical to that worn by the mother in the drawing; however, this dress can be found in both pre- and post–Revolutionary portraits (Riberio 1988, fig 79, p. 121). In the drawing, the young lady at the right behind the standing boy wears a high-waisted chemise gown inspired by the flowing draperies of classical sculpture, a style that became fashionable during the winter of 1794–95 (Riberio 1988, pp. 124–31).

3. Attributed to Philibert-Louis Debucourt, *Maternal Joys*, color engraving, Private Collection, Philadelphia.

4. 18½ × 14½ in., or approximately 470 × 370 mm.

5. It is a pleasure to thank John Ittmann, curator of prints, Philadelphia Museum of Art, for bringing this work to my attention.

6. Philibert-Louis Debucourt, *Le compliment ou la matinée du jour de l'An*, engraving, Collection Rothschild, Département des Arts Graphiques, Musée du Louvre, Paris. Fenaille 1899, cat. nos. 11–12.

7. *Monument du costume physique et morale de la fin du dix-huitième siècle*, Paris, 1789. Fenaille 1899, cat. nos. 15 and 16; see Pierrette Jean-Richard in Paris 1985f, cat. no. 134, pp. 105–6, and cat. no. 137, pp. 106–7. For the earlier *Monument du costume* of 1776, see MRM ess., fig. 18.

8. For Moreau le jeune, *Les Délices de la Maternité* (1777) or *Le vrai Bonheur* (1782) are characteristic (see Paris 1985f, cat. no. 74, pp. 66–67, and cat. no. 98, pp. 78–79). Genre subjects featuring the care and education of children abound in paintings and drawings by Jean-Honoré Fragonard; among the best known themes are: *L'Heureuse Fécondité* (known also in reproductive engravings; a drawing in the Musée Cognacq-Jay, Paris; and a watercolor); *The Little Preacher* (known in a painting; a reproductive engraving; and a drawing in the National Gallery of Art, Washington); and *The First Riding Lesson* (a drawing known in at least two versions—in the Brooklyn Museum, New York, and in the Muzeum Narodowe, Warsaw—as well as an etching by the artist's sister-in-law Marguerite Gérard); see Pierre Rosenberg in Paris and New York 1987, cat. nos. 222–23, pp. 456–60; cat. no. 227, pp. 465–66; and cat. no. 243, pp. 492–93, respectively. There are also two paintings, both in the Fogg Art Museum, executed jointly by Fragonard and his student Marguerite Gérard (*Le Premier Pas de l'enfance* and *L'Enfant chéri*); see Pierre Rosenberg in Paris and New York 1987, cat. no. 303, pp. 573–75; and figs. 1–6, p. 573, for other related works. Earlier instances of these themes are to be found in the work of artists such as Chardin, *The Diligent Mother* (*La Mère laborieuse*), Salon of 1740; *Saying Grace* (*La Bénédicté*), Salon of 1740; *The Right Education (La Bonne Education)*, Salon of 1753 (see Pierre Rosenberg in Paris et al. 1979, cat. no. 84, pp. 263–64; cat. no. 94, pp. 266–71; and cat. no. 95, pp. 291–93, respectively).

9. Quoted in Hunt 1992, p. 163.

10. The other family scenes produced by Debucourt in 1795–96 were: *La Bénédiction paternelle ou le Départ de la Mariée* (1795) (Fenaille 1899, cat. no. 50); *Jouis tendre Mère* (n.d.) (Fenaille 1899, cat. no. 58); *Ils sont heureux* (n.d.) (Fenaille 1899, cat. no. 59); *Oui, son arrivée fera notre bonheur* (1796) (Fenaille 1899, cat. no. 60); and *L'Heureuse Famille* (1796) (Fenaille 1899, cat. no. 61).

11. Paris 1920, cat. nos. 29–40, pp. 63–64.

12. Philibert-Louis Debucourt, *Garden Party*, watercolor, white gouache, black ink, and graphite on cream antique laid paper, 309 × 205 mm. (sight), Gift of Charles E. Dunlap, Department of Drawings, Fogg Art Museum, Harvard University Art Museums, Cambridge, inv. no. 1959.183.

13. Philibert-Louis Debucourt, *La Promenade Publique*, gouache, 355 × 580 mm., Bequest of Emma A. Sheafer, The Lesley and Emma Sheafer Collection, Metropolitan Museum of Art, New York, inv. no. 1974.356.50; see Paris 1920, cat. no. 31, p. 53. Another gouache (present collection unknown) is closely related to Debucourt's color engraving *Annette et Lubin* (1789) (Fenaille 1899, cat. no. 22), although it is impossible to decide whether the work is preparatory to or a replica after the print (265 × 230 mm.), ex coll. George Blumenthal (see Rubinstein 1930, vol. 5, pl. 13; and sale catalogue, Sotheby's, London, 26 November 1970, lot 92).

1. Jean-Michel Moreau le jeune, *Arrival of Marie-Antoinette at the Hôtel de Ville, Paris, 1782,* pen and brown ink with brush and brown wash on cream antique laid paper, 480 × 683 mm., Private Collection, formerly with Galerie Emmanuel Moatti, Paris (in 1998).

2. Jean-Michel Moreau le jeune, *Reception for Emperor Napoleon I at the Hôtel de Ville, Paris, in Celebration of the Peace of Vienna, Paris, 4 December 1809,* pen and black ink with brush and brown wash over black chalk on cream wove paper, 540 × 814 mm., Loan from the Collection of Jeffrey E. Horvitz, Department of Drawings, Fogg Art Museum, Harvard University Art Museums, Cambridge, inv. no. D-F-397/ 1.1996.65.

3. Jean-Michel Moreau le jeune, *Le Bal masqué,* engraving and etching, Widener Collection, Department of Prints and Drawings, National Gallery of Art, Washington, D.C., inv. no. 1942.9.2161/PR.

4. See Providence 1979; Strong 1973; and Gruber 1972.

5. Charles Percier and Pierre Fontaine, *Description des cérémonies et des fêtes qui ont eu lieu pour le couronnement de Leurs Majestés Napoléon . . . et Joséphine d'après les dessins sous la conduite de C. Percier et P. F. L. Fontaine,* Paris, 1810, copy in the Houghton Library, Harvard University; also see Schnapper 1980, text and figs. 123–25.

1. See Robert Rosenblum in Paris et al. 1974, p. 173.

2. Impressions of both prints reproduced are from the Réserve of the Cabinet des Estampes, Bibliothèque nationale de France, Paris; for more on these two works, see Dayot 1925, cat. nos. 86 a and b, pp. 119–20.

3. "Neuf français surpris par l'armée anglo-turque se réfugient dans un vieux fort d'ou ils soutiennent l'attaque et après avoir perdue deux hommes obtiennent une capitulation honorable."

4. Impressions of both prints reproduced are from the Réserve of the Cabinet des Estampes, Bibliothèque nationale de France, Paris.

5. See Isabella Julia in Paris et al. 1974, p. 649.

6. See Chiego 1974.

7. Dayot 1925, the only focused study on the artist, is a catalogue of one extensive collection of prints after Vernet's works.

8. Vernet's preparatory composition drawing for the *Battle of Marengo,* at the Snite Museum of Art, University of Notre Dame, South Bend, is illustrated in the *Dictionary of Art,* vol. 32, p. 334, fig. 1.

BIOGRAPHIES OF ARTISTS
IN THE EXHIBITION

Pierre-Antoine Baudouin (Paris 1723–1769 Paris)

The son of an engraver, Baudouin began his studies with Boucher, whose younger daughter he married in 1758. He was received into the Académie in 1763 and continued to exhibit there until his death. Gouache miniatures of contemporary and often libertine subjects form the core of his oeuvre. Although Baudouin tempered Boucher's pastorals with morality and careful attention to detail, both the critic Denis Diderot and the archbishop of Paris accused him of indecency in his paintings. Critics generally considered him to be a purveyor of bad morals by way of contrast with Greuze, who painted wholesome family scenes.

Baudouin's official commissions attest to a wider range than his genre scenes: two portraits for the king in 1766; a series of the Life of the Virgin for Madame Du Barry; and religious projects for the Royal Chapel at the Château de Versailles. Nonetheless, his gouaches, in which he adapted the language of oil painting to a completely different medium and scale—sometimes at the risk of preciosity—made his reputation. Both his paintings and the prints after them were enormously popular during his lifetime. Unfortunately, there has been no recent study of his oeuvre.

REFERENCE: Marie-Catherine Sahut in Paris 1984b

Jacques-Charles Bellange (Active in Lorraine, 1595–1616)

Little is known about the origins of Bellange, yet his technical brilliance and idiosyncratic approach to traditional themes in his graphic works has continued to attract scores of admirers since his death.

From 1602 until his death in 1616, Bellange was court painter in Nancy to Charles III and Henri II, dukes of Lorraine; his oeuvre reflects an exuberant late Mannerist style influenced by artworks produced in the major centers of Antwerp, Florence, the Ile-de-France, and Prague. He would have known these works via prints and from visits of major artists and their students to Nancy on missions related to the court of the small, but cosmopolitan and well-connected, duchy of Lorraine. He also traveled to France for study in 1608, where he must have visited the Château de Fontainebleau. Although just over eighty-five drawings and forty-five etchings can be securely attributed to his hand, the vast majority of Bellange's portraits, altarpieces, and court decorations are now destroyed. His students included his ward or nephew, Thierry Bellange, and Claude Deruet, who succeeded him as court painter.

REFERENCES: Walch 1971; Sue Welsh Reed and Amy Worthen in Des Moines et al. 1975; Jacques Thuillier in Nancy 1992b; Sue Welsh Reed in Los Angeles et al. 1994; Antony Griffiths and Craig Hartley in London 1997; Sue Welsh Reed in Boston et al. 1998

Jean-Victor Bertin (Paris 1775–1842 Paris)

Bertin's training at the Académie began in 1785, first with Doyen, and then with the landscapist Pierre-Henri de Valenciennes. Although his Salon debut came late (1793), he contributed regularly from then until his death. Although he never won a Prix de Rome, he may have visited Italy between 1806 and 1808, judging by the precise locations that he later painted. With the gradual shift from Neoclassicism to Romanticism and Realism, his idealized Italianate landscapes drew many critics. However, the decorative quality of his works found favor with the successive governmental regimes, which often purchased them.

Bertin's best compositions are considered to date from 1810 to 1830, when he shed some of the mechanical correctness of his earlier works for a greater delicacy and grace of execution, particularly in lateral lighting effects. In 1817, the Académie instituted an idea that he had first suggested sixteen years earlier—a Prix de Rome for historical landscape painting—and his pupil Achille Michallon won the first competition. Although the late works of Bertin are considered less successful, he published two lithographic series on the teaching of landscape painting; received official recognition of his contributions in 1822 when he was elected to the Légion d'Honneur; and left a substantial legacy as the teacher of the next generation of landscape painters: Michallon, Camille-Joseph-Étienne Roqueplan, Jules Coignet, and most notably Jean-Baptiste-Camille Corot. Indeed, Corot credited Bertin with teaching him how to transpose a study made directly from nature for use in the studio.

REFERENCES: Pierre Rosenberg in Paris et al. 1974; Gutwirth 1974

Thomas Blanchet (Paris 1614–1689 Lyon)

Little is known about the early career of Blanchet. According to the biographer Pierre-Jean Mariette, he spent time in Vouet's atelier in Paris, although he may have been, more specifically, the student of the sculptor Jacques Sarazin, who was a frequent collaborator with Vouet. He was in Rome from 1647–53, where the German artist and biographer Joachim von Sandrart noted that he was influenced by the works of artists such as Alessandro Algardi, Andrea Sacchi, and Nicolas Poussin. In 1655, Blanchet settled in Lyon, where he collaborated with the city's official painter, Germain Panthot, on the Hôtel de Ville. He was comissioned to paint a *May* for Notre-Dame in Paris in 1663, succeeded Panthot as official painter of Lyon (1675), and was received into the Académie in 1681. Blanchet's surviving paintings and drawings reveal that he remained attached to elements of the Italianate Baroque throughout his highly successful career. His virtual domination of commissions in Lyon eventually led to his being called the "Le Brun of Lyon."

REFERENCE: Galactéros-de Boissier 1991

Edme Bouchardon
(Chaumont-en-Bassigny 1698–1762 Paris)

The most renowned French sculptor of the eighteenth century, Bouchardon began his studies with his father (an architect, sculptor, and gilder) and continued his training with the sculptor Guillaume Coustou. He won the Prix de Rome in 1722 and traveled to Italy in 1723 with the sculptor Lambert-Sigismond Adam. Bouchardon received a num-

ber of private commissions from the papal court and expatriate communities. He returned to Paris in 1733 and was received into the Académie in 1745.

Bouchardon worked in an extremely painstaking manner, with the result that relatively few commissions occupied him for many years. His *Cupid Cutting a Bow out of Hercules's Club* for the Salon d'Hercule at Versailles was commissioned in 1740 but took a decade to complete. Although Bouchardon's most important extant work is the Fountain of the Four Seasons in the rue de Grenelle, Paris, completed in 1745, his most prestigious commission (and probably his masterpiece) was the equestrian statue of Louis XV for the Place Louis XV (now the Place de la Concorde), which was destroyed during the French Revolution. The project was commissioned in 1749 but was still incomplete at his death. Jean-Baptiste Pigalle finished the statue in time for its inauguration in 1763.

Bouchardon abstained from the Salons of 1749 and 1751 in protest of the art criticism of Etienne La Font de Saint-Yenne, who was not an admirer of his style. However, other critics, such as the comte de Caylus, Pierre-Jean Mariette, and Denis Diderot had nothing but effusive praise for his work. Despite his own sensitivity to criticism, Bouchardon was sometimes considered hostile toward his fellow sculptors—whom he accused of being too pleasing and picturesque—and dismissive of his former teacher Coustou.

In addition to his role as a professor at the Académie, in 1736, Bouchardon was appointed as draftsman to l'Académie des Inscriptions et Belles-Lettres, for which he produced designs for medals and tokens. On the basis of these sheets, as well as those copied after earlier masters during his years in Italy and those made in preparation for his sculpted works, Charles-Nicolas Cochin le jeune considered Bouchardon to be the greatest sculptor and draftsman of his century. He is certainly the sculptor we know best as a draftsman. Virtually his entire corpus of more than a thousand extant sheets was executed in red chalk. His enormous oeuvre reveals that he gradually replaced the gentle and rhythmic poetry of his early works with the hard-edged precision and masterful economy of means evident in his mature drawings—a stylistic transition so admired by his contemporaries that it led to his consideration as one of the most significant precursors of Neoclassicism.

REFERENCES: Roserot 1910; Guiffrey and Marcel 1928b, vols. 2 and 3; Weber 1969; Lise Duclaux in Paris 1973; Ames 1975

François Boucher (Paris 1703–1770 Paris)

One of the most prolific and talented painters of the eighteenth century, Boucher was the son of a minor painter in the Académie de Saint-Luc. He studied with François Le Moyne and won the Prix de Rome in 1723. However, as there was purportedly no space for him at the French Academy in Rome, he did not receive the funds to go. Instead, for the next five years, Boucher worked for the engraver and publisher Jean-François Cars, made etchings after Watteau for Jean de Jullienne, and drew the illustrations for the third edition of Père Daniel's *Histoire de France*. This experience—essentially, the constant production of drawings—provided the young artist with the foundation of his skills as a superb draftsman. With funds earned from these activities, Boucher went to Italy in 1728 with Carle Vanloo.

He returned to Paris in 1731 and was received into the Académie in 1734. Boucher received a number of royal commissions and became one of the favorite artists of Madame de Pompadour, who preferred his intimate genre works and whom he taught to etch. He also generated a number of compositions for tapestry cartoons and other decorative arts for Beauvais, the Gobelins, Sèvres, and innumerable printmakers.

Although the range of Boucher's talent as both a painter and a draftsman was vast—*académies*; figure studies; mythological, historical, and religious compositions; drawings for book illustration; and landscapes—he became known above all for his sensuous treatment of the nude female form as seen in his numerous drawings executed in red chalk and *trois crayons*.

In 1765, Boucher was appointed premier peintre du roi and succeeded Carle Vanloo as director of the Académie. He continued to paint actively, although by the 1760s, the Salon viewed his works as outmoded. His numerous students included his two sons-in-law, Pierre-Antoine Baudouin and Jean-Baptiste Deshays, as well as Gabriel-Jacques de Saint-Aubin, Charles-François de La Traverse, Jean-Baptiste Le Prince, Nicolas-Guy Brenet, and François-Guillaume Menageot.

REFERENCES: Regina Shoolman Slatkin in Washington and Chicago 1973; Jean-Richard 1978; Alastair Laing in New York et al. 1986; Schreiber Jacoby 1986

Jean Boucher de Bourges (Bourges c. 1575–c. 1633 Bourges)

Boucher is known to have traveled to Rome several times (in 1596, 1600, 1621, and 1625) and possibly once to the Low Countries. By the beginning of the seventeenth century, he was established as the most important painter in Bourges—capital of the duchy of Berry—where he painted altarpieces and decorations and produced a dozen etchings. His busy studio attracted such talents as Pierre Mignard, who was later successor to the post of premier peintre du roi after the death of Charles Le Brun.

Unlike many of his contemporaries working in the first quarter of the seventeenth century, Boucher's extant oeuvre includes a relatively even balance of works in all media. These paintings, drawings, and prints reveal that he eschewed the typical current of late Mannerism for a new brand of Counter-Reform or proto–Baroque naturalism that is seen at its best in a number of life studies—the earliest known drawings of this type by a French artist—executed in his atelier.

REFERENCE: Jacques Thuillier in Bourges and Angers 1988

Louis de Boullogne (Paris 1654–1733 Paris)

A member of the second generation of an important French dynasty of painters, Louis de Boullogne was taught by his father, who had been one of the founders of the Académie in 1648. He won the Prix de Rome in 1673 and was enrolled at the French Academy in Rome by 1695, just as his older brother Bon was returning to France. Some of the copies after earlier masters that Louis made in Rome were used as cartoons for tapestries woven at the Gobelins. While he was in the Eternal City, Boullogne also distinguished himself by winning a prize for drawing at the Accademia di San Luca.

After returning to France in 1679, Boullogne produced mythological and historical paintings for the royal family at Versailles, and religious works for the Royal Chapel, the Chapel in the Convent of St. Cyr, and Notre-Dame in Paris. He and his brother Bon—who often collaborated on commissions—helped to decorate the Grand Trianon at Versailles. Boullogne's most prolific period began just before the turn of the century, and he exhibited fourteen paintings in the Salon of 1699 and eighteen in the Salon of 1704. During the same period, he also participated in the decoration of the royal chateaus of Marly, Meudon, and Fontainebleau. In addition, he received commissions for mythological and religious paintings in and around Paris, which included projects at the Hôtel de Ville in Paris and at the Château de Rambouillet.

Boullogne was received by the Académie in 1681 and was chosen for a number of positions, including professor (1694), rector (1717), and eventually director (1722). He was also admitted to the Order of St. Michael—one of the first artists to receive this honor—and further ennobled by Louis XV. In 1725, he was invited to fill the post of premier peintre du roi, which had been left vacant for three years after the death of Antoine Coypel.

Reflecting the trend toward *colore* at the end of the seventeenth and the beginning of the eighteenth century, as a draftsman, Boullogne is well known for his smooth and seamless blend of black and white chalks on blue paper.

REFERENCES: Schnapper 1967; Schnapper and Guicharnaud 1986

Sébastien Bourdon (Montpellier 1616–1671 Paris)

Bourdon began his career with his father, Marin, and the little-known Barthélemy in Paris. By 1634, he had arrived in Rome. Although he supported himself by copying paintings by other other artists, his own work there revealed his attraction to northern European genre painters known as the *Bamboccianti*. His adherence to Protestantism forced him to leave Rome in 1637, and he returned to Paris via Venice.

Bourdon achieved notoriety in the French capital with his very Baroque *May* of 1643 for Notre-Dame (*in situ*) but, by the late 1640s, he abandoned both his early genre works and his elegant Baroque mode for the fashionable Poussinesque classicism known as Atticism, which became his most celebrated style. He was a founding member of the Académie, and, ever peripetetic, he accepted an invitation to Sweden from Queen Christina in 1652. On his return to Paris in 1654, he executed his most famous work, the *Galerie de Phaeton,* in the Hôtel Bretonvilliers (destroyed, but known through prints by his pupil, Friquet de Varouze) and gave an important series of *conférences* at the Académie. Bourdon's exceptional stylistic mutability, and his rapid absorption and original use of the techniques of others, have made the attribution and dating of his works difficult, but a few key elements—luminosity, highly keyed colors, a reflective mood, and a pliant and vigorous line that facets as much as it models (especially in his many prints)—remain fairly consistent.

REFERENCES: Ponsonhaille 1886; Fowle 1970; Pierre Rosenberg in Paris et al. 1982b; Michel Hilaire in Paris 1993a and in Montreal et al. 1993; Clark 1993; Knab and Widauer 1993; Alvin Clark in Boston et al. 1998

Jacques Callot (Nancy, Lorraine 1592–1635 Nancy, Lorraine)

Son of a herald-at-arms at the court of Lorraine, Callot studied with the little-known painter Claude Henriet and the goldsmith Demange Crocq. He departed for Italy in 1608, where he continued his studies with the painter and printmaker Antonio Tempesta. Callot moved to Florence in 1614, where he became an artist at the Medici court under Grand Duke Cosimo II. Callot remained in Florence for seven years and established a great reputation through his many prints recording events at the ducal court.

Callot returned to Lorraine in 1621, and in 1623, he was appointed an artist at the court of Henri II, duke of Lorraine, at Nancy. Callot's production included etchings recording the horrors of the Thirty Years War, religion, genre scenes, and court events, as well as two enormous military sieges. He visited Paris often between 1628 and 1631 and established a professional relationship with Israël Henriet—a print publisher and the son of his former teacher—who inherited and purchased hundreds of Callot's copper plates, which he continued to publish after the artist's death.

Callot was certainly one of the most internationally famous, productive, influential, and innovative printmakers of the seventeenth century. He etched more than 1,400 prints and developed technical procedures that became industry standards. Hundreds of his drawings in chalks and in pen and ink survive. Usually small in format, they are all executed in a well-informed, late Mannerist style that reveals the same curving and swelling line so often found in his prints.

REFERENCE: Daniel Ternois in Nancy 1992a (with extensive bibliography)

Marie-Gabrielle Capet (Lyon 1761–1818 Paris)

We know very little about Capet's life and work. It is not certain how or exactly when she came to Paris to study painting and drawing, but by 1781, she was already part of the atelier of Adélaïde Labille-Guiard, with whom Capet would maintain a close relationship throughout her life. In 1781, she exhibited at the Exposition de la Jeunesse with a *trois-crayons Tête d'expression,* and she submitted entries to that exhibition for the following four years. Her first Salon was in 1791, and Capet continued to exhibit there approximately every two years through 1814. During most of these two decades, she confined her production to portraits (drawings, oils, pastels, and miniatures).

REFERENCE: Doria 1934

Armand-Charles Caraffe (Paris 1762–1818/22 Paris)

A student of L-J-F. Lagrenée l'aîné and David, Caraffe traveled to Italy at his own expense in the late 1780s, but in 1788, he took the place of the recently deceased Jean-Germain Drouais at the French Academy in Rome. Before returning to France in 1793, Caraffe appears to have traveled to Greece and Constantinople, because his subject matter included scenes of that area and a portrait of Selim III. He first exhibited at the Salon of 1793 with three drawings depicting scenes from ancient history, and he continued to show historical and allegorical paintings and drawings as well as portraits at the Salon until 1802.

He was imprisoned for a short time (c. 1794) because he remained a Jacobin after the fall of Robespierre and because of his illicit affair with the wife of a fellow artist. In 1800, he obtained a commission to paint the ceiling in the Hall of Anatomy of the Ecole de Médicine. In most of his early works, Caraffe was severely censured for his use of a caricatural and bizarre Neoclassical manner that his critics referred to as barbarous and elephantine. Soon after 1802, he went to Russia, where he was engaged as a painter at the court. However, his health gradually deteriorated there, and he returned to Paris in 1812. Nothing is known about his last years.

REFERENCES: Renouvrier 1863; Antoine Schnapper in Paris et al. 1974

Jean-Baptiste-Siméon Chardin (Paris 1699–1779 Paris)

Chardin was a student of two well-known academicians, Pierre-Jacques Cazes and Noël-Nicolas Coypel, but despite his formal training in Paris, he never traveled to Italy and he chose to focus his skills on still lifes, genre scenes, and, occasionally, portraiture. Chardin's earliest still lifes were simple compositions of food and utensils, although he gradually incorporated a greater variety of objects in his paintings. He was received into the Académie in 1728, although in the eyes of most of his new colleagues, still life was the humblest genre, so Chardin began to attempt figure painting. His genre scenes won praise at the Salon and were widely engraved to meet the demand of the public. Having nearly abandoned still life during the late 1730s and 1740s, he resumed his preferred genre in 1751 and dispensed with figure painting. The finer quality of the objects represented in his second still-life period is generally attributed to Chardin's second wife, whom he married in 1744. She was a wealthy widow who apparently (according to inventories) enabled Chardin to own most of the objects he painted. Although his works were enormously popular with the public, because of Chardin's field of specialization, he received few official commissions and mainly catered to private collectors. However, he did produce successful sets of large-scale decorative overdoor paintings for two royal chateaus.

A loyal member of the Académie, Chardin served as its treasurer from 1755 to 1774 and exhibited frequently at the Salon—which he often organized—through the year of his death. His son Jean-Pierre was also a painter and won the Prix de Rome in 1754. Only a handful

of drawings remains by Chardin, but in the 1770s, when he encountered problems with his eyes (which the fumes from contemporary oil paint seemed to exacerbate), he began working in pastel. Just over a dozen of these impressive works are extant.

REFERENCES: Pierre Rosenberg in Paris et al. 1979; Rosenberg and McCullagh 1985; Rosenberg 1987; Roland Michel 1996

Louis Chéron (Paris 1660–1725 London, United Kingdom)

Chéron was the son of the miniaturist and engraver Henri—who was probably his first teacher—and brother of the painter and printmaker Elisabeth-Sophie. Chéron continued his education under Le Brun at the Académie, and after winning the Prix de Rome in 1676 and 1678, he traveled to Italy, where he is known to have had a particular preference for the works of Raphael during his stay in Rome. He also spent time in Venice before he returned to France.

Upon his return to Paris, Chéron received a number of commissions, the most important of which were his two *Mays* for Notre-Dame (1687 and 1690). However, as a Huguenot (French Protestant), he found the climate inhospitable in France after the Revocation of the Edict of Nantes, and he departed for England around 1693, where he joined a growing and prosperous Huguenot community. In 1710, Chéron was naturalized as a British citizen.

Chéron's most important British commissions include his decorations at Montagu House, Boughton House, and Ditton Park for Ralph, first duke of Montagu—former British ambassador to France—who became his most important patron. He also worked at Barleigh and Chatsworth. In addition to his own work, he taught drawing at Kneller's Academy starting in 1711 and later at St. Martin's Lane Academy, a rival institution that he helped to found. He also executed a number of book illustrations.

The large number of his extant finished composition drawings reveals that Chéron utilized firm but fluid contours in pen and ink, amply supplemented with various tones of wash and heightened with white gouache. These sheets reflect his study under Le Brun and his circle in Paris, as well as his efforts to switch to a somewhat lighter and more colorful idiom, like most of his contemporaries, at the beginning of the eighteenth century.

REFERENCES: Croft-Murray 1962; Pierre Rosenberg in Paris 1989a; and Jean-François Méjanès in Paris 1993a

Charles-Nicolas Cochin le jeune (Paris 1715–1790 Paris)

Cochin began his studies with his parents, both of whom were engravers. He also trained with Jean II Restout and at the Académie. Based on the success of his early works, in 1737 he was employed by the Menus-plaisirs du roi. Compared to his contemporaries, Cochin's career was an unusual one. He did not travel to Italy until relatively late in life, when he and his protector—the future marquis de Marigny, brother of Madame de Pompadour—spent two years visiting the most important cities and sites (1749–51). Cochin was as interested in recent archaeological excavations as he was in the old masters; his copious notes were later published as a book (*Voyage d'Italie*, 1758).

After their return to France, Cochin was received into the Académie in 1751, and Marigny helped him to secure a number of important posts: garde des dessins du roi (1752), which included lodgings in the Louvre; secrétaire perpétuel de l'Académie (1755), which included the responsibility of serving as the administrator of the arts; and chevalier of the Order of St. Michael (1757).

Cochin won many official commissions for engravings. For most works executed after the mid-1750s, he drew and lightly etched the plates, leaving the actual engraving to others. His oeuvre includes a number of accomplished drawings and prints, such as enormous compositions exhibited at the Salons; large and complex fete drawings

for the Menus-plaisirs; the frontispiece to the *Encyclopédie*; the *Ports de France* in collaboration with Jean-Philippe Le Bas after Joseph Vernet; and book illustrations for Tasso, Ariosto, and Hénault's *Histoire de France*. He is most celebrated for his densely populated red chalk compositions, where each figure is rendered with crisp and ample contours.

In addition to his renown as a draftsman, Cochin is remembered as a prolific author. His writings included descriptions of the recently excavated Herculaneum frescos, defenses of various artists at the Académie, and a number of artist biographies that served as extended obituaries at the time of their deaths. His influential *Lettres à un jeune artiste peintre* (c. 1774) brought about perceptible changes in contemporary painting, and Diderot sought his counsel regarding art criticism. Cochin's influence gradually diminished after the loss of his post as administrator of the arts in 1770, and especially after Marigny's retirement in 1773. His *Mémoires* and letters reveal increasing financial concerns in his late years.

REFERENCES: Michel 1987; Michel 1993

Hyacinthe Collin de Vermont (Versailles 1693–1761 Paris)

Although Collin de Vermont received his training from Jean-Baptiste Jouvenet, his most influential teacher was Hyacinthe Rigaud, his godfather and protector. Collin de Vermont was also Rigaud's heir and later inherited a fine collection of drawings. In 1715, Collin de Vermont won second place in the Prix de Rome competition and received a scholarship to the French Academy in Rome. After overcoming a minor illness, he caught the attention of its director, Charles Poerson, who acclaimed him as one of the best students he had seen in twelve years. He returned to France via Venice in 1721.

Collin de Vermont's personal qualities, coupled with Rigaud's protection, ensured his successful academic career. After being received at the Académie in 1725, he became an assistant professor in 1733, professor in 1740, and assistant rector in 1754. As a connoisseur and advisor, he was often consulted on the hanging of the Salon. Collin de Vermont exhibited religious paintings at the Salons of 1737, 1738, 1740, 1743, and 1759. However, his history paintings did not garner notable attention at the painting competitions of 1727 and 1747. His thirty-three oil sketches that chronicled the Life of Cyrus were shown in two sets, at the Salons of 1737 and 1751, respectively. Collin de Vermont owed one of his most distinguished commissions, the *Presentation in the Temple* (1755) for the high altar at Versailles, to the overworked Carle Vanloo.

The relatively small number of extant drawings by Collin de Vermont that has survived reveals him to be an artist who preferred the medium of red chalk to realize the solid contours of his elongated figures with small heads. He sometimes accentuated these sheets with red chalk wash, and white chalk or gouache. Ever loyal to the Académie, he left the institution some of the works in his collection at his death.

REFERENCES: Salmon 1991; Salmon 1994a; Salmon 1994b

Michel II Corneille (Paris 1642–1708 Paris)

The son and brother of successful painters, Corneille began his studies with his father and completed his education with Charles Le Brun and Pierre Mignard. In 1659, a special prize from the Académie enabled him to go to Italy (the Prix de Rome had not yet been established). Corneille enjoyed copying the Italian masters, especially the Carracci; this activity prepared him perfectly for his later work of copying and etching the Italian drawings in the collection of Everard Jabach, a wealthy collector whose drawings were purchased *en bloc* by the crown. This truly impressive group established the basis of the French royal collection, which is today housed in the Musée du Louvre, Paris. Corneille's brother Jean-Baptiste also collaborated on this

project. Corneille's extensive output also included numerous religious works, including scenes for a Life of St. Gregory in the Invalides (replaced with canvases by Doyen in the eighteenth century), as well as decorative paintings for the Grand Trianon and the royal chateaus at Meudon, Fontainebleau, and Versailles.

Of the three painters in the Corneille family, Michel was most highly regarded during his own time. He was a particularly prolific draftsman. In addition to the hundreds of sheets after drawings in the Jabach Collection, there are hundreds more drawn in preparation for his own works. They reveal an accomplished talent that gradually displaced the heavy classicism inspired by a blend of Rubens and Poussin that he had absorbed in Le Brun's atelier; his later works displayed a tendency toward a lighter and more colorful manner that looked ahead to the next century.

REFERENCES: Goguel 1988; Boyer 1991; Jean-Claude Boyer in Paris 1993a

Charles-Antoine Coypel (Paris 1694–1752 Paris)

Charles-Antoine Coypel was born into a dynasty of important painters. His most significant influence was undoubtedly his father Antoine, who became premier peintre du roi in 1716. The Académie received the precocious Charles-Antoine as a member in 1715, even though he had never studied in Italy, the typical destination for students of history painting.

One of Charles-Antoine's earliest commissions was a series of tapestry cartoons to illustrate *Don Quixote* (in 1716). He first undertook a parallel career as a playwright, which he abandoned in the 1720s. Nonetheless, a dramatic flair persisted in his art. Four tapestry cartoons that he executed for the Gobelins (1733–41) are based on the operas of Jean-Baptiste-Maurice Quinault. Upon his father's death, Coypel succeeded him as first painter to Philippe II, duc d'Orléans, and as the king's garde des tableaux; by 1747, he also became premier peintre du roi. In addition, he joined the crusade led by the Bâtiments du roi to revive history painting; in this vein, he helped to found the Ecole royale des Elèves Protégés.

The handling of gesture and expression in Coypel's paintings evidently owes a great deal to Poussin and Le Brun, and the latter also influenced Coypel's later theoretical writings. Despite his success as a history painter, the genre scenes to which Coypel later turned made his reputation. He is also renowned for his satirical engravings. His numerous drawings and pastels reveal that he was a talented draftsman who utilized and preferred fluid contours and a lightness of touch.

REFERENCE: Lefrançois 1994

Noël Coypel (Paris 1628–1707 Paris)

Founder of an illustrious dynasty of painters, Coypel began his training with Pierre Poncet and Noël Quillerier, both of whom were former students of Simon Vouet. He then became an assistant of Charles Errard—later the first director of the French Academy in Rome—with whom he collaborated on a number of decorations for royal residences. He painted the *May* for Notre-Dame in 1661 and he was received into the Académie in 1663. During the ensuing twenty years, Coypel painted a number of important altarpieces at Saint-Germain and the Invalides, as well as major secular decorations at Versailles, the Tuileries Palace, the Grand Trianon, and the Chambre of the Parlement at Rennes. He succeeded Errard as director of the French Academy in Rome and became director of the Académie in Paris in 1695.

The small extant oeuvre of paintings and drawings by Coypel reveals that he abandoned the Vouetesque manner in which he was trained for a heavy, angular brand of classicism influenced by both Le Brun and Errard.

REFERENCE: Roswitha Erbslöh in Rennes 1995

Michel-François Dandré-Bardon
(Aix-en-Provence 1700–1783 Paris)

Scion of a distinguished family of lawyers in Aix, Dandré-Bardon came to Paris in 1720 intending to study law but soon turned to painting. He trained with Jean-Baptiste Vanloo, Jean-François de Troy, and at the Académie. In the Prix de Rome competition of 1725, Dandré-Bardon won second prize and financed his own trip to Italy. He had lodgings at the French Academy in Rome and later won a stipend, but he was never officially enrolled. Dandré-Bardon spent five years in Rome before returning to Paris after a six-month detour to Venice.

Upon his return to France, Dandré-Bardon worked on decorations for the Hôtel de Ville in Aix for two years (1731–33). He returned to Paris in 1734 and was received into the Académie in 1737. Soon afterward, he left the French capital again for more than a decade. During this time (1741–52), he worked in Marseille, where he helped to found the municipal Academy. Upon François Boucher's appointment as premier peintre du roi in 1752, Dandré-Bardon returned to Paris and assumed his post as a professor at the Académie. Later in life, as Dandré-Bardon's career turned toward administration, he produced a number of publications: a two-volume *Traité de peinture . . . suivi d'un catalogue des artistes le plus fameux de l'Ecole française* (1765); a three-volume *Histoire universelle traitée relativement aux Arts de Peinture et de Sculpture . . .* (1769); and a three-volume *Costumes des Anciens Peuples* (1772).

Dandré-Bardon was a prolific draftsman. Because of his frequent contact with artistic currents in the south of France throughout his career, one of the recognizable characteristics of his oeuvre is its distinctly regional flavor. He favored compositions organized around strong diagonals, and his typically nervous line, occasionally combined with an exuberant application of wash, generates active figures and draperies and often simulates the flicker of Venetian drawings. The partial paralysis that Dandré-Bardon suffered in 1770 effectively ended his painting career, but he did not cease drawing.

REFERENCE: Chol 1987

Jacques-Louis David (Paris 1748–1825 Brussels, Belgium)

This towering figure of French Neoclassicism studied with Joseph-Marie Vien and enrolled at the Académie in 1766. He won the Prix de Rome on his fifth try in 1775. The obstacles he encountered, which even led to a suicide attempt in 1773, laid the foundation for David's grievances against the Académie. From October 1775 to July 1780, David was in Rome with Vien, the new director of the French Academy there. Although he drew after the antique out of duty, he reserved his true enthusiasm for seventeenth-century painters such as Poussin, Caravaggio, Reni, and the Carracci. Like Poussin, David worked constantly in his drawings to reduce a composition to its most essential and forceful elements. He was admitted (agréé) to the Académie in 1781 with his *Belisarius Receiving Alms* and became a full member in 1783 with his *Sadness of Andromache by the Body of Hector*. About this time, he began his distinguished career as a teacher; his students included Girodet, Caraffe, Drouais, Alexandre-Evariste Fragonard, baron Gros, Ingres, and many others.

In 1784, he painted his austere and linear *Oath of the Horatii*, which ushered in a new approach to composition and inspired an entire generation of painters. In 1793, he helped to abolish the Académie, and he became an inaugural member of the Institut des Beaux-Arts (now the Ecole nationale supérieure des Beaux-Arts) that replaced it. David is well known for his other activities during the Revolution: joining the Jacobin Club, supporting Robespierre (which cost David two prison terms), voting for the death of Louis XVI in 1793, painting three Revolutionary martyrs (including Marat), and organizing festivals and pageants.

After sitting briefly for portraits in 1798, Napoleon became his avowed hero and patron. David was elected a Chevalier of the Légion

d'Honneur in 1803, and he became Napoleon's first painter immediately after the emperor's coronation in December 1804. Soon, however, because of David's excessive monetary demands, the choicest commissions were diverted to his former pupils, especially baron Gros. After Napoleon's defeat, David was not safe in Paris under the Bourbons during the Restoration; he fled to Belgium in January 1816 and turned over his students to Gros. David's Belgian paintings—which he considered his best, although critics have disagreed—were primarily portraits and mythological subjects. At his death, he was denied burial in France.

REFERENCES: Antoine Schnapper and Arlette Sérullaz in Paris and Versailles 1989; Sérullaz 1991

Philibert-Louis Debucourt (Paris 1755–1832 Paris)

Philibert-Louis Debucourt was a student of Joseph-Marie Vien, whose atelier he abandoned after only a short time to pursue his taste for genre painting. On the strength of these efforts, he was approved (agréé) as a member of the Académie in 1781 and exhibited at the Salons of that year, 1783, and 1785. Known principally as an engraver, in the 1780s Debucourt perfected his color printing techniques, which culminated in his two greatest successes: *The Palais Royal Gallery's Walk* and *The Public Promenade*. Until 1800, Debucourt engraved after his own paintings—genre scenes, portraits and patriotic scenes—which tended toward a comic, caricatural style. During this period, he continued to experiment with many different color printing techniques, but after 1800, his engravings mainly reproduced the work of other artists.

Debucourt married and obtained an apartment in the Louvre in 1781, but his wife died only 15 months later, shortly after the birth of their son. It seems that Debucourt's anxiety about providing for his son motivated him to favor the production of aquatints over painting, since more profit could be garnered from a single design. Soon after the Revolution forced him to leave the Louvre, Debucourt's son died. He remarried in 1803. To the extent that Debucourt made prints after the works of fashionable artists such as Carle Vernet, he was associated with their success and thus ensured his own livelihood. However, his situation was far from carefree. Though he exhibited his paintings at the Salons of 1810, 1814, 1817, and 1824, he died nearly penniless, dependent on the resources of his nephew and pupil, Jean-Pierre-Marie Jazet.

REFERENCES: Fenaille 1899; Dacier 1923; and Emile Dacier, Albert Vuaflart, and Jacques Hérold in Paris 1920

Jean-Baptiste Deshays (Colleville 1729–1765 Paris)

Deshays trained first with his father and then briefly at Jean-Baptiste Descamps's Ecole Gratuite de Dessin in Rouen. In about 1748, he continued his studies in Paris with Collin de Vermont, who was instrumental in the formation of Deshays's masterful draftsmanship. In 1749, he joined the studio of his uncle, Jean II Restout (the nephew and student of Jouvenet), which created a formidable lineage of Norman painters. Deshays won the Prix de Rome in 1751. During his three years at the Ecole royale des Elèves Protégés, the teaching of Carle Vanloo softened the influence of the severe style of Restout. In Rome (1754–58), he copied Raphael, Domenichino, Guercino, and the Carracci and produced a number of gouache drawings on dark paper that were celebrated for their emphatic chiaroscuro.

Upon his return to Paris, Deshays married Boucher's daughter, Elisabeth-Victoire. In the Salon of 1759, the year he was received as a full academician, Deshays exhibited his *St. Andrew Refusing to Worship Idols*. Diderot called it a "horrible butchery" but simultaneously hailed Deshays as heir to Le Brun and Le Sueur, and the most important painter in the nation. Deshays's historical and mythological compositions—such as his scenes of Homer's *Iliad* for a set of tapestries now

in Madrid—betray the influence of Boucher but are also more athletic and monumental. The mortal illness that he contracted in 1764 is thought to have been tuberculosis. His posthumous entry in the Salon of 1765 showed that his powers had clearly waned. Nonetheless, Deshays's vision of history painting reigned supreme in France until David defined a new direction two decades later. The volume and quality of his oeuvre are all the more impressive when one considers that his period of maturity lasted a mere six years.

REFERENCES: Sandoz 1977; Nathalie Volle in Paris 1984b

Antoine Dieu (Paris 1662–1727 Paris)

This pupil of Charles Le Brun won the Prix de Rome in 1686. In the first decade of the eighteenth century, Dieu collaborated on decorations for the Ménagerie and the Chapel at the Château de Versailles. He was received by the Académie late in life (1722) but was swiftly elevated to the rank of professor (1724). Three years later, he entered the painting competition organized by the Batiments du roi, but he died two months before the prizes were given.

Most of Dieu's painted oeuvre has disappeared, but many of his drawings have resurfaced. They reveal a great variety of styles, media, and subject matter (including allegories, historical and biblical scenes, and decorative frontispieces). His first works reflected the heavier mode established by Le Brun; however, by the beginning of the eighteenth century, he had shifted to a lighter, proto–Rococo manner with a thin, wiry, but active line often supplemented with wash. Many consider that the artist's best works arose when he abandoned depictions of reality for the fantastic.

Although a number of artists earned extra income by working privately as part-time dealers for their most important patrons, Dieu can be distinguished among his contemporaries who engaged in this activity because he actually maintained a gallery in Paris from 1699 to 1714. After 1714, the gallery passed into the hands of Edmé-François Gersaint, a great friend and patron of Jean-Antoine Watteau.

REFERENCES: Rosenberg 1979; Pierre Rosenberg in Paris 1989a; Pierre Rosenberg in Paris et al. 1995

Michel Dorigny (Saint-Quentin 1616–1665 Paris)

Michel Dorigny began his career (1630–35) as an apprentice to Georges Lallemant, but the most important influence on his artistic formation was his work with Simon Vouet, which began about 1636–37. Although he never traveled to Italy, he soon became an essential member of Vouet's busy Parisian atelier as both a painter and a printmaker. His more than one hundred interpretive prints after Vouet and members of his studio, as well twenty etchings after his own designs, remain the work for which he is best known. In 1640, he signed a contract promising his services to Vouet for six years; in 1648, he married Vouet's second daughter; and at Vouet's death in 1649, he and his brother-in-law, François Tortebat, obtained an exclusive royal privilege to reproduce the works of his deceased father-in-law.

Dorigny carried Vouet's somewhat outmoded, but elegant decorative mode well into the third quarter of the century with a new career as a painter in his own right; his work at that time included a cycle of the Four Seasons in the Château de Colombes; the ceiling for the Pavillon de la Reine at the Château de Vincennes; and decorations in the Hôtels Lauzun, Hesselin, and Tubeuf-Mazarin. The lively and brightly colored compositions of his later, more independent style, were in opposition to the pseudoclassical Atticism then in vogue. Few of his paintings survive, but his abundant oeuvre of prints and drawings provides some indication of his talent. He became a member of the Académie in 1663, only two years before his death.

REFERENCES: Brejon 1981; Brejon 1984; Brejon 1992; Barbara Brejon in Munich 1991; Sue Welsh Reed and Alvin Clark in Boston et al. 1998

Gabriel-François Doyen
(Paris 1726–1806 St. Petersburg, Russia)

After winning second place in the Prix de Rome competition of 1748, Doyen became the first pupil to enroll at the Ecole royale des Elèves Protégés, where he studied with Carle Vanloo. Upon his arrival in Rome in 1752, Doyen steeped himself in the works of Raphael and numerous painters of the early Baroque. He also visited Parma, Bologna, Venice, and Turin before returning to France in 1756. At the Salon of 1759, Doyen exhibited his enormous *Death of Virginia*, which established his success with both the critics and the Académie (agréé in 1759 and full membership in 1761). For the next twenty years, Doyen produced huge, dramatic, and media-rich drawings and canvases. His *St. Geneviève and the Miracle of the Victims of Burning-Sickness* (1767) is recognized not only for its stylistic boldness but also for its methods; Doyen made studies of dying patients in hospices, a practice that Géricault and Gros adopted half a century later.

Doyen was chosen to finish the decoration of the church of the Invalides in Paris after the death of Vanloo, who had not progressed beyond preliminary plans. His work there was completed in 1772 with seven scenes from the Life of St. Gregory, which is often considered to be the decorative masterpiece of the period. In 1773, Doyen was appointed first painter to the comte d'Artois (later Charles X), and in 1775, he received the same appointment from the comte de Provence (later Louis XVIII). He produced decorations for the city of Reims in honor of Louis XVI's coronation in 1774, and in 1776, he became a professor at the Académie. Doyen began the salvaging of art works endangered by the Revolution in 1791–92 with his pupil Alexandre Lenoir, but this was interrupted by his departure to accept an appointment from Empress Catherine II of Russia as a professor at the Imperial Academy of Fine Arts in St. Petersburg. He remained in that city for the last fourteen years of his life.

REFERENCE: Sandoz 1975

Daniel Dumonstier (Paris 1574–1646 Paris)

The last well-known member of a dynasty of painters, manuscript illuminators, and portraitists active in France since the beginning of the sixteenth century, Daniel was the illegitimate son of Cosme Dumonstier, a painter in the service of Marguerite de Navarre, and later a peintre du roi at the French court. Daniel was legitimized in 1577 and probably began his studies in his field of specialization—portrait drawings in the tradition of the Clouets—with his father. Although the quality of his oeuvre is uneven, he became a great success and was renowned for his naturalism and the sincerity of his expression. He was named peintre du dauphin in 1601, peintre et valet de chambre du roi in 1602, and was also a well-known collector of curiosities.

REFERENCES: Dimier 1925; Emmanuelle Brugerolles in Paris et al. 1994

Jacques or Jean Dumont, called Dumont le Romain
(Paris 1701–1781 Paris)

Son of a sculptor and brother of an architect, Dumont le Romain began his studies with the landscapist Antoine Lebel. He left France before the age of twenty to study in Italy and returned approximately five years later. He was received into the Académie in 1728, where he gradually won appointments throughout his career: professor (1736), rector (1752), and chancellor (1768). Louis XV named Dumont governor of the newly founded Ecole royale des Elèves Protégés in 1748—a post in which he was succeeded after only three months by Carle Vanloo—and in 1763 he was named honorary director of the Académie, a post he retained until his death.

Dumont exhibited at the Salon eight times from 1737 to 1761. At the Salon of 1761, Diderot led the resoundingly favorable critical response to his work. Although only a small number of his paintings are known, his numerous drawings—usually red chalk copies after Italian masters drawn with a spirited precision—reveal his commitment to a sober, classicizing grand manner. There is no monograph on the artist.

REFERENCE: Jean-François Méjanès in Paris 1983b

Alexandre-Evariste Fragonard (Grasse 1780–1850 Paris)

This painter, sculptor, and draftsman trained first with his father, Jean-Honoré Fragonard, and then with David. His early drawings—inspired by Prud'hon and often compared in quality and style to those of Jean-Baptiste Isabey—were frequently reproduced in prints. He debuted at the Salon of 1793 with a drawing, *Timoleon Sacrificing His Brother*. Many of his sheets from the Consulate and Empire are Neoclassical friezes notable for their dramatic lighting effects. During the Empire, Fragonard began an official career as a painter and sculptor. He received commissions for the Palais Bourbon and worked for the Sèvres porcelain factory. In 1817, he was elected a Chevalier of the Légion d'Honneur.

Around 1820, Fragonard painted architectural interiors and views of ruined castles and churches populated with characters in medieval or Renaissance costume. These troubador scenes presaged his shift toward history painting—usually the history of the French monarchy—although his broad, lively style distinguishes his works from those of other members of this movement. Fragonard's style is further characterized by artificial, strongly contrasted lighting, where foreground figures are silhouetted against a bright background. Fragonard continued to exhibit at the Salon until 1842. He managed to perpetuate his career with history paintings and drawings for lithography, despite diminished commissions after 1830. There is no record in the literature of travel to Rome or elsewhere.

REFERENCES: Guy Stair Sainty and Nadia Tscherny in New Orleans et al. 1996

Jean-Honoré Fragonard (Grasse 1732–1806 Paris)

When Fragonard's family moved to Paris in 1738, Jean-Honoré began his studies with Chardin and later entered Boucher's atelier (c. 1749). He remained there for only a year, but he continued to assist Boucher with large commissions. Although Fragonard was not enrolled at the Académie, he won the Prix de Rome in 1752. After studying under Carle Vanloo at the Ecole royale des Elèves Protégés, Fragonard arrived in Rome in 1756. In addition to his numerous copies after antique sculpture and modern masters, during his tenure at the French Academy in Rome, he produced numerous brilliant red chalk landscape drawings for which he (along with his colleague, Robert) became justifiably famous. They were encouraged in this endeavor by Natoire, who was then director of the institution.

After returning to Paris in 1761, Fragonard was received into the Académie (agréé) with his *Coresus and Callirhoë* (Salon of 1765). This work excited hopes that he was the heir to the great history painter Deshays, but he was never received as a full academician. Instead, he shifted to genre painting and shunned the official Salon in favor of the unofficial Salon de la Correspondance. His greatest work may be the four-panel series *The Progress of Love* (1770–73; Frick Collection, New York), painted for Madame Du Barry's pavilion at Louveciennes. In 1773–74, he traveled with the financier Pierre-Jacques-Onesyme Bergeret de Grancourt on a second journey to Italy, which was extended to Vienna, Prague, and the southern German states. This was a period of prolific drawing. In the 1780s, Fragonard produced mythological compositions and scenes of family life; he also made drawings, noted for their extravagance and rapid execution, for book illustration.

Fragonard resettled in Grasse for three years, and after his permanent return to Paris in 1792, he apparently did not paint again. Instead, he took on administrative tasks such as the direction of the new Louvre museum. His only pupils of note were his son Alexandre-Evariste and his sister-in-law Marguerite Gérard.

REFERENCES: Rosenberg and Brejon de Lavergnée 1986; Pierre Rosenberg in Paris and New York 1987; Cuzin 1988; Rosenberg 1989; Catherine Boulot, Jean-Pierre Cuzin, and Pierre Rosenberg in Rome 1990

Louis Galloche (Paris 1670–1761 Paris)

After foregoing his studies for the priesthood at the Collège Louis-le-Grand and later abandoning his preparation as a notary, Galloche's parents recognized his love for the arts. He was placed in the atelier of Louis de Boullogne and won the Prix de Rome in 1695. As no royal stipend was provided, Galloche paid his own expenses during the two years he spent in Rome.

After his return to Paris, Galloche worked primarily for churches and monasteries. He was received into the Académie in 1711, exhibited in the Salons from 1737 to 1751, participated in both of the competitions held by the Batiments du roi in 1727 and 1747, and held several posts at the Académie. His secular commissions included canvases and decorations for the Salle des Machines in the Tuileries Palace, the Hôtel du Grand Maître at Versailles, the Grand Trianon, and the Château de Fontainebleau.

Galloche's most successful students included François Le Moyne and Charles-Joseph Natoire. Toward the end of his life, he gave an important series of lectures at the Académie in which he noted that although he did not deplore copying from the antique, such studies should be combined with studies from life.

REFERENCE: Sahut 1973

Jacques Gamelin (Carcassonne 1738–1803 Carcassonne)

Baron de Puymarin, for whom Gamelin worked as a bookkeeper in Toulouse, was sufficiently impressed with his employee's drawings to underwrite his study of art: first with Pierre Rivalz in Toulouse, then with Deshays in Paris, and finally in Italy, when Gamelin twice failed to win the Prix de Rome. He studied there with French and Italian painters, traveled to Naples in 1770, and became particularly noted for his battle paintings. In 1774, upon his return to France, Gamelin received a number of ecclesiastic commissions in and around Toulouse and Narbonne, and in 1779, he designed the plates for a handbook of anatomy for artists. However, the book's commercial failure was the beginning of his financial difficulties.

Gamelin served as director of the Académie in Montpellier from 1780 to 1783 and then settled in Narbonne, where he remained until 1796. There, he produced works for the cathedral and local churches, portraits, Flemish-style genre paintings, battle paintings, and scenes from the history of ancient Rome; the latter included a large series of drawings on papers prepared with wash, which reveals aspects of the chiaroscuro and idiosyncratic figural style of Deshays. He also organized Revolutionary celebrations. After resettling in his birthplace, Gamelin taught at its Ecole Centrale and helped to found its museum, which houses much of his oeuvre.

REFERENCES: Joseph Hahn and Olivier Michel in Carcassonne 1990

Etienne-Barthélemy Garnier (Paris 1759–1849 Paris)

Garnier was educated to become a magistrate and only later turned to painting as his career. He trained with Louis-Jacques Durameau, Doyen, and Vien. Although he resisted the pervasive influence of David, he succeeded in competitions with that master's students, winning second place in the Prix de Rome competition of 1787 and first prize the following year. He remained in Italy through 1793, where he often produced elaborately finished drawings heightened with gouache. While there, he also began work on his masterpiece, *The Family of Priam*, which he was given a government grant to finish. Exhibited at the Salon of 1800, this enormous painting established his reputation and was said to have influenced David's *Leonidas at Thermopylae*.

Garnier exhibited regularly at the Salon from 1795 onward, and he also received important commissions under the Empire, collaborating with Prud'hon and Jean-François Léonor Mérimée on the ceiling of the Salle de Diane in the Louvre, and with Charles Meynier and baron Gros (among others) on the sacristy in the church of Saint-Denis. In 1808, he painted *Napoleon Studying the Map of Europe in His Study*, and Louis XVIII bought his *Eponina and Sabinus* of 1810. Garnier's commissions (many religious) continued under the Restoration, although he had fallen somewhat out of fashion. He was elected to the Institut de France in 1816, and in 1829, Charles X awarded him the Légion d'Honneur and a pension. Garnier also became president of the Académie des Beaux-Arts. His last Salon entry, *Christ Falling under the Weight of His Cross* (1848), illustrates how outmoded his style had become by the end of his long life. By the time of his death, he was already somewhat forgotten, and he remains so today. Several of his paintings now hang at Versailles.

REFERENCES: Renouvrier 1863; Jean-Pierre Cuzin in Paris et al. 1974; Victor Carlson in Los Angeles et al. 1993

Claude Gellée, called le Lorrain
(Chamagne, Lorraine 1600–1682 Rome, Italy)

When Claude's parents died in 1612, he was sent from the then-independent duchy of Lorraine to Freiburg-im-Breisgau to live with his brother, who was a maker of intarsia and probably his first teacher. Soon afterward, Claude traveled to Italy with an older relative, and except for a brief return to Lorraine (1625–27), he remained there for the rest of his life.

In Italy, Claude trained with the Italian landscape painter Agostino Tassi (Rome, 1613–15) and with the German landscapist Godfredo Wals (Naples, 1618–22). Thus, it is not surprising that by the time he settled definitively in Rome in 1626–27, Claude decided to specialize in idyllic and classical landscape painting. He gradually became one of the greatest masters of the genre in history. He was so successful during his lifetime that he became one of the most expensive and highly sought painters in the Eternal City, with commissions from noble members of the papal court, the city's international community of diplomats and expatriate aristocrats, royal courts from abroad, and visitors to Rome. He was also a significant and respected graphic artist whose prints and drawings were avidly collected. He became a member of the Accademia di San Luca in 1633, was offered (but declined) the post of "first rector" in 1654, and accepted the request to be in charge of all resident foreign members in 1669.

Claude's surviving oeuvre of drawings includes a full range of works from simple black chalk sketches executed *en plein air*, to more advanced studies embellished with wash, to highly elaborate finished drawings heightened with white gouache in his *Liber Veritatis* (British Museum, London); the latter, like his paintings, depict the subtlety and majesty of light and nature in a sumptuous and highly acclaimed manner.

REFERENCES: Roethlisberger 1961; Roethlisberger 1968; H. Diane Russell in Washington 1982b; Mannocci 1988; Kitson 1990

Claude Gillot (Langres 1673–1722 Paris)

Gillot first trained with his father, an embroiderer and ornament painter, and then with Jean-Baptiste Corneille (c. 1690), with whom he trained as both a painter and a printmaker. He was received into the Académie in 1715. Although he was received as a history painter and produced religious works, his passion was the theater, particularly the Commedia dell'Arte, a standard feature at Paris street fairs. In addition to making drawings and prints of theatrical subjects, Gillot is also reputed to have managed a puppet theater, authored plays, and designed operatic costumes and sets.

Gillot's love of the theater can be seen in the work of his most famous pupil, Jean-Antoine Watteau, whose early drawings are sometimes confused with those of Gillot. Indeed, Gillot sowed the seeds for the *fête galante* that Watteau later perfected. Gillot's other students include Nicolas Lancret and François Joullain.

The inventory of Gillot's studio taken after his death listed thirty-three paintings, but few are known today except through engravings. However, a significant number of his drawings in all media are preserved. They reveal his numerous projects for illustrations to almanacs, ballets, operatic libretti, poetry, and other literature. His most prolific work was for two editions of Houdard de La Motte's *Fables nouvelles* (1719) and a Life of Christ composed of 60 drawings that were translated into print by Gabriel Huquier. Despite his varied and imaginative designs, Gillot died in poverty.

REFERENCE: Populus 1930

Anne-Louis Girodet de Roucy-Trioson
(Montargis 1767–1824 Paris)

Girodet trained as a draftsman and as an architect before becoming a student in David's studio in 1783–84. His emulation of David's style is clear from his entries for the Prix de Rome, which he won in 1789 on his fourth try. The Revolution further delayed Girodet's eventual departure for Italy, but once there, he managed to stay from 1790 to 1795. His earliest success was his *Sleep of Endymion*, which initiated his gradual move away from David's artistic precepts. After his return to Paris, Girodet illustrated the Didot editions of Virgil (1798) and Racine (1801) and achieved a reputation as a portraitist. His definitive break with David came just after 1800 with his *Ossian and the French Generals*, a dense, multifigure painting of pseudo–Baroque complexity. This was the first of several nocturnal paintings lit artificially, which anticipated Romanticism (although he became a reactionary critic of this movement in his later years).

From 1808 to 1821, Girodet worked sporadically on decorative, allegorical, and mythological paintings for Empress Josephine at the Château de Compiègne, but after collecting a large inheritance in 1815 upon the death of his adoptive father, Dr. Trioson, Girodet's oeuvre dwindled in both quantity and quality. Although he was not a particularly successful teacher, his students reproduced his illustrations to Virgil's *Aeneid* with the new technique of lithography. An important component of his extant oeuvre, including a number of his outstanding preparatory drawings, is now in the Musée Girodet, Montargis.

REFERENCES: Jacqueline Auzas in Montargis 1967; Bernier 1975; Jacqueline Boutet-Loyer in Montargis 1983; Montargis 1989; Sylvain Bellenger in Los Angeles et al. 1993; Philippe Ségéral in Montargis 1997

Jean-Baptiste Greuze (Tournus 1725–1805 Paris)

After probably receiving some artistic training in Tournus, Greuze began his documented studies in the late 1740s with the painter Charles Grandon in Lyon, whom he most likely accompanied to Paris around 1750. There, Greuze studied drawing at the Académie with Charles-Joseph Natoire. Greuze supported himself in the French capital by painting small genre works, which gained him the protection of the sculptor Jean-Baptiste Pigalle and the painter Louis de Silvestre. With their assistance, he was permitted to exhibit at the Salon of 1755 and was provisionally accepted to the Académie (agréé). In the same year, Greuze traveled to Italy as the guest of Louis Gougenot, abbé de Chezal-Benoît, to whom he may have been introduced by Pigalle. Gougenot probably covered his expenses as they toured throughout the country, although Greuze claimed that he had paid his own way. Like Fragonard and Hubert Robert, Greuze became as interested in scenes of contemporary life as he was in ancient monuments or in the work of Renaissance and later masters.

Greuze returned to Paris in 1757 and exhibited canvases at the Salon executed during his travels in Italy. These works elicited the praise of contemporary critics like the baron Grimm and Denis Diderot, who felt an affinity for Greuze early in the artist's career. During the end of the 1750s and most of the 1760s, Greuze's production consisted primarily of the genre paintings and portraits for which he remains so well known. One of the most significant peaks of Greuze's fame was the *Marriage Contract* (Musée du Louvre, Paris), which was a tremendous success in 1761.

By the mid-1760s, Greuze's friendship with Diderot had deteriorated to such a point that in 1767, Diderot blocked Catherine II's invitation to the artist. Moreover, a sudden shift to history painting at the end of the 1760s brought about his humiliation at the Académie, which disapproved of his reception piece, *Septimius Severus Reproaching Caracalla* (1769) and received him as a genre painter instead of a history painter as he had hoped. When public criticism seemed to agree with that of the Académie, Greuze left Paris for Tournus and did not exhibit again at the Salon of the Académie until 1800.

Greuze amassed a significant fortune with engravings that other artists made after his works, but he lost much of it in the 1792 divorce settlement with his wife, Anne-Gabrielle Babuti, who had caused a number of incidents and scandals. Greuze's achievements were given official recognition in 1777, when he received a patent of nobility from Emperor Joseph II, and in 1792, when he received a royal pension from Louis XVI.

As a draftsman, Greuze is remembered, above all, for his bold and deft manipulation of red chalk where his mastery is revealed in numerous examples that range from all parts of his career. But he was equally skillful with studies prepared in pen and ink with wash, the media in which the compositions for his moralizing genre works—which he elevated to the level of history painting—were most frequently executed.

REFERENCES: Brookner 1972; Edgar Munhall in Hartford et al. 1976; Edgar Munhall in Paris 1984b

Guillerot (Active in Paris and Rome, second half of the seventeenth century)

Little is known about Guillerot. Indeed, we do not even know his Christian name. He specialized in landscape and may have been a pupil of Jacques Fouquières. According to André Félibien, he worked with Sébastien Bourdon at the Tuileries Palace (1667–71). His oeuvre of drawings, which numbers about twenty, has been reconstituted from those of Claude and Giovanni Battista Grimaldi during the last two decades.

REFERENCES: Félibien 1725, *Entretien* X; Roethlisberger 1975; Roethlisberger 1987; Jean-François Méjanès in Paris 1993a

Grégoire Huret (Lyon c. 1606–1670 Paris)

Although he was a prolific draftsman and printmaker, little is known concerning the training or early artistic career of Huret. He may have been a student of the little-known Horace Le Blanc, who was the leading artist of his time in Lyon. After a decade of printmaking in Lyon, Huret settled definitively in Paris, where he must have arrived by the mid-1630s. By the mid-1640s, he had become a draftsman and printmaker to the king. He was only the fourth printmaker to be admitted to the Académie; for his reception piece, he presented his sumptuously engraved *Théâtre de la Passion* in thirty-two plates.

In 1670, shortly before his death, Huret published his study of perspective, the *Optique de portraiture*, which had interested him for several years. In his hundreds of drawings, prints, and book illustrations, Huret developed one of the most lavish and idiosyncratic styles of his day. His sheets featured slightly elongated and massive figures, rendered with extensive stumping and heavy contours, crowding the foregrounds of detailed compositions that were as remarkable for their texture and tonal subtlety as they were for their density.

REFERENCES: Weigert 1954; van Helsdingen 1970; van Helsdingen 1978; Brugerolles and Guillet 1997; Alvin Clark in Boston et al. 1998

Charles-François Hutin (Paris 1715–1776 Dresden, Saxony)

The son and brother of artists, Hutin studied in the atelier of François Le Moyne. He won the Prix de Rome in 1735, and during the seven years he spent in Italy, he turned from painting to sculpture under the tutelage of Sébastien Slodtz. Upon his return to France, he was received into the Académie as a sculptor in 1747. Hutin can certainly be considered as one of Le Moyne's most successful students, one whose draftsmanship reveals that he inherited aspects of his teacher's light and rhythmic contours.

Hutin departed France with his brother for Dresden, where they both entered the service of Augustus III, king of Poland and elector of Saxony. They were undoubtedly recommended by their cousin, the painter Louis de Silvestre, who was Augustus's premier peintre. Hutin's posts included guardian of the king's paintings, professor, and eventually director (1764) of Dresden's new Academy of Fine Arts.

In addition to sculpture, Hutin returned to painting, prepared a number of drawings for the monumental *Recueil d'Estampes d'après les plus célèbres tableaux de la Galerie Royale de Dresde*, produced two suites of etchings, and occasionally sent paintings to the Salon in Paris. Regrettably, there is no monograph on the artist.

REFERENCES: Marx 1974; Marx 1977; Marie-Catherine Sahut in Paris 1984b

Charles de La Fosse (Paris 1636–1716 Paris)

The son of a goldsmith, La Fosse received his training with Charles Le Brun and the engraver François Chauveau. A precocious talent, at nineteen he was already assisting Le Brun with the ceiling of the St. Sulpice seminary. He arrived in Rome in 1658 (eight years before the founding of the French Academy there), where he remained for two years. In addition to the antique and Raphael, La Fosse paid particular attention to the exuberant Baroque works of Pietro da Cortona and his circle. From 1660 to 1663, he was in Venice on a royal grant, where he favored the works of Titian and Veronese, and he returned to France via Parma.

Upon his return to Paris, Le Brun and Jean-Baptiste Colbert served as his protectors. His early commissions included decorations for a chapel in St. Eustache (1665), the Louvre (1666), and the ceiling at the Tuileries Palace (1670). La Fosse was received into the Académie in 1673, and he continued to win religious, royal, and private commissions, including decorations for the church of the Assumption in the rue Saint-Honoré (1676) and at Versailles throughout the 1670s. From 1688 to 1701, he was employed at the Grand Trianon and the chateaus

of Marly and Meudon. He was also called to London to decorate Montagu House (the site of the present British Museum), home of the former British ambassador to France. He returned from London in 1692 to assist with the decoration of the just-completed Dôme des Invalides. Throughout the 1670s and 1680s, La Fosse also painted several altarpieces for religious communities. From 1704 to 1707, the artist was employed to decorate the *hôtel particulier* of the renowned collector Pierre Crozat in the rue de Richelieu—an intellectual and artistic center where La Fosse and his wife also lived—and he later performed the same service at Crozat's country house in Montmorency. In short, La Fosse became the most important decorative painter of the generation following Le Brun. He was equally noted for his drawings, which, more than any other media, reveal his shift away from Le Brun's classicism towards a softer approach inspired by Rubens and Venetian artists.

Although he became director of the Académie in 1699, La Fosse probably regretted never becoming premier peintre du roi, a post that stood empty between the tenures of Mignard (d. 1695) and Antoine Coypel (appointed in 1716, the year of La Fosse's death).

REFERENCE: Stuffmann 1964

Laurent de La Hyre (Paris 1606–1656 Paris)

La Hyre was the son of a minor painter, Etienne, who was his first teacher. He continued his studies with an extended trip to Fontainebleau and a year in the studio of Georges Lallemant (1625). It is notable that La Hyre did not travel to Italy. Indeed, he probably never left the Ile-de-France.

By the early 1630s, La Hyre was established as a leading painter, equally adept at religious, historical, and mythological compositions. He was deeply interested in perspective (one of his many children became a noted mathematician), and in 1648, he became a founding member of the Académie. La Hyre painted two *Mays* for Notre-Dame (1635 and 1637) and a number of elegant decorations, including his renowned series of the Liberal Arts for the Hôtel Tallemant des Reaux. He was also a talented printmaker, who produced more than thirty etchings. In the 1640s, La Hyre was one of the most significant proponents of Parisian Atticism, the refined and classicizing style that was considered to be a viable alternative to the more Baroque manner of Vouet and his circle.

La Hyre was a subtle and gifted draftsman, and his surviving corpus of drawings—recently separated from those produced by his brothers, sisters, and children, who were also artists—demonstrates his continued preference for black and white chalk. They also reveal his gradual transition from a Fontainebleau-inspired form of late Mannerism in the 1620s, to the Baroque exuberance of the 1630s and the Atticism of the 1640s and 1650s. His most successful student was François Chauveau.

REFERENCE: Pierre Rosenberg and Jacques Thuillier in Grenoble et al. 1988

Georges Lallemant (Nancy, Lorraine c. 1575–1636 Paris)

Other than the fact that he was an almost exact contemporary of Jacques-Charles Bellange, nothing is known of Lallemant's early training in Lorraine. He arrived in Paris in 1601 and received his first major commission in 1611 to paint the group portrait of the Echevins of Paris. From that success until his death, his atelier was one of the two or three most important in the French capital. His students and assistants included Michel Dorigny, Laurent de La Hyre, Nicolas Poussin, and Philippe de Champaigne.

Lallemant worked in a lively late Mannerist style that was occasionally blended with a type of realism resembling that later seen in the works of the Le Nain brothers. His limited corpus of drawings is still disputed, but his collaboration with Ludolph Büsinck, who pro-

duced a small group of chiaroscuro woodcuts after Lallemant's drawings (1623–29), provides a solid base of attribution for his late works.

REFERENCES: Patrick Ramade in Meaux 1988; Michel Sylvestre and Denis Lavalle in Nancy 1992b; Jean-François Méjanès in Paris 1993a

Simon Mathurin Lantara (Oncy 1729–1778 Paris)

At the age of eight, Lantara's sketches attracted attention at the Château de la Renoumière, where he tended the animals. He was sent to study art at Versailles with an unknown teacher, but after a brief stay, he went on to Paris and worked for another unidentified painter in exchange for art lessons. It is not known if he ever traveled to Italy or elsewhere outside France. He established himself in the rue Saint-Denis and married a fruit seller named Jacquelin who lived in the same house. Lantara sold his landscape paintings and drawings to dealers for nearly nothing. It has been suggested that the dealers then hired other painters, such as Joseph Vernet, to add figures to the landscapes to make them more salable. From what is known of Lantara, he was eminently capable of adding figures himself but refused to bow to the demands of the market.

Lantara often employed an atmospheric landscape style in his compositions to evoke different times of the day or year. Many of his drawings, especially his moonlit scenes, have an imaginary, misty quality. He exhibited at the Salon de la Jeunesse in the Place Dauphine (1771 and 1773), and his works were also shown posthumously at the Salon de la Correspondance in 1783. After his death in a charity hospital, his works were engraved. Lantara is credited for bringing realism to landscape, and his best drawings have been compared to those of Théodore Rousseau. Three vaudeville plays based on his life portray him as the archetypal bohemian.

REFERENCES: Levitine 1975; Jean-François Méjanès in London 1977

Charles Le Brun (Paris 1619–1690 Paris)

After working briefly with François Perrier, Le Brun became a pupil of Simon Vouet. His earliest known works reveal a talent precocious enough to win the praise of Poussin, whom Le Brun joined in 1642 on a trip to Rome, where he was supported for three years by Chancellor Séguier. On his return, he became one of the king's painters and one of the founders of the Académie. Le Brun executed canvases and large decorative commissions for Parisian *hôtels particuliers* and religious organizations throughout the 1650s. The deaths of Perrier, Vouet, and Le Sueur (in 1649 to 1655)—combined with the success of his ceiling in the Galerie d'Hercule of the Hôtel Lambert—made him the unrivaled French painter of his day. A royal order of 1656 forbidding the reproduction of his works without permission provides a measure of his reputation.

In 1658, Le Brun began the decorations for Nicolas Fouquet, minister of finance, at Château Vaux-le-Vicomte, where the tasks included overall direction of the embellishment of the chateau and its gardens. When Louis XIV imprisoned Fouquet for embezzlement of state funds, the king quickly employed Le Brun to work at Versailles. The transformation of this former hunting lodge into the premier palace of Europe included supervising and supplying designs to an enormous team of painters, sculptors, gardeners, and decorative artists, as well as executing vast stretches of painted surfaces glorifying his royal patron. Commissions soon expanded to the Louvre and other royal residences.

Le Brun's brilliant success as an artist and administrator led to his appointment as premier peintre du roi (1664), a post that grew to entail advising the king on his collection, setting up the Gobelins (1663), and assuming the directorship of the Académie (1683). Le Brun's role as an educator was pivotal. He oversaw the founding of the French Academy in Rome, and beginning in 1667, his *conférences* at the Académie in Paris—including the one on the expression—quickly became French standards. Between his royal commissions and his role at the Académie, Le Brun trained an entire generation of artists (La Fosse, Jouvenet, Corneille, Chéron) in the energetic, but heavy, pseudoclassical blend of Rubens and Poussin that had earned him such success.

REFERENCES: Jennifer Montagu and Jacques Thuillier in Versailles 1963; Lydia Beauvais and Jean-François Méjanès in Paris 1985a; Brejon 1987; Jennifer Montagu et al. in London 1990b; Claire Constans, Jean-Pierre Babelon et al. in Versailles 1991; Gareau 1992; Montagu 1994

Jean-Laurent Legeay (? Paris c. 1710–after 1788 Rome, Italy?)

Legeay received his art training at the Académie royale d'Architecture in Paris. Winner of the Prix de Rome in 1732, he spent five years at the Eternal City (1737–42). Piranesi arrived in Rome in 1740, and the two artists influenced each other's drawings and prints after ancient Roman monuments and collaborated with other engravers on illustrations for guidebooks of Rome.

When Legeay returned to Paris in 1742, he was appointed professor at the Académie royale d'Architecture, but he did not stay long. In 1745, he was in Berlin working on plans for a Catholic church, and he made garden and palace designs for the court at Mecklenburg-Schwerin from 1748 to the mid-1750s. By 1756, he was on the move again, this time to Potsdam, where he worked on the Neues Palais at Sans Souci for Frederick II, king of Prussia. Despite a quarrel with the king, he produced the first Neoclassical palaces in Prussia. Legeay left Prussia in 1763 and was recorded in England in 1766 to 1768. He seems to have returned to France to publish a series of prints around 1770. The last record of him is a request that he sent to the Duke of Mecklenburg from the south of France for a pension that would permit him to live out his days in Rome, where it is presumed that he died.

Legeay's drawings of monumental and often fantastic Neoclassical schemes were executed with equal precision in both red chalk and pen and ink. These works so influenced his pupils at the Académie and his compatriots in Rome that Charles-Nicolas Cochin le jeune did not hesitate to consider him one of the most significant architectural geniuses of all time.

REFERENCE: Erouart 1982

Nicolas Le Jeune (Active c. 1765–1804)

Little is known about the elusive Le Jeune, except that he was a pupil at the Académie and later worked with Louis-Jean-François Lagrenée l'aîné. We know that Le Jeune traveled to Rome because we have a number of rare, small etchings that he signed and dated *Rome 1771*. He exhibited at the Salon from 1793 to 1804, and in 1793 he was listed as "peintre de l'Académie de Berlin," suggesting that he had relocated to Germany. Unfortunately, no trace of Le Jeune's presence there has been identified.

REFERENCES: Baudicour 1861, vol. 1; Cipriani and Valeriani 1991, vol. 3

François Le Moyne (Paris 1688–1737 Paris)

In 1701, Le Moyne entered the studio of Louis Galloche, where he remained for the next twelve years. During this period, he also studied at the Académie. He won the Prix de Rome in 1711, but no stipend was available to travel to Italy, and he continued his work in Paris. Le Moyne was received into the Académie in 1718. By this time, he had a number of commissions for mythological and religious paintings. He taught both Natoire and Boucher from 1719 to 1720. Shortly after this, the financier François Berger became Le Moyne's patron and com-

missioned a painting of *Tancred and Clorinda*. In 1723, he invited the artist to accompany him on a trip to Italy that lasted several months.

In 1727, Le Moyne shared first prize with Jean-François de Troy in the competition in history painting organized by the Bâtiments du roi. This initiated a rivalry between the two artists and catapulted Le Moyne to an important royal commission, *Louis XV Giving Peace to Europe* (1729) for the Salon de la Paix at the Château de Versailles. Success followed on success in the 1730s. These included his appointment as a professor at the Académie, his ceiling for St. Sulpice, and his *Apotheosis of Hercules* for the ceiling of the Salon d'Hercule at Versailles. These events led to his appointment as premier peintre du roi in 1736. Only a year later, the Parisian art community was devastated by the news that Le Moyne had committed suicide.

Le Moyne was a prolific draftsman who was renowned for his sinuous and rhythmic use of line. His oeuvre reflects the combined influences of La Fosse, Galloche, and contemporary Italian masters with those of Rubens and Correggio. The result was a lighter mode of decoration that merged the late seventeenth-century French grand manner with the lighter taste of the court of Louis XV.

REFERENCE: Bordeaux 1984

Eustache Le Sueur (Paris 1616–1655 Paris)

In the eyes of many critics for several generations, Le Sueur was the equal of Poussin in the French classical tradition. A precocious child, he was admitted into Vouet's prestigious studio in about 1632. He remained there for a decade, collaborating with the master on several large commissions. Le Sueur chose not to travel to Italy, but he studied prints after Raphael and absorbed a great deal from Poussin during the latter's stay in Paris in 1640–42. In 1644, he married Geneviève Goussé, with whom he had eight children. Soon after his marriage, he began an enormous cycle of twenty-two paintings on the Life of St. Bruno (Musée du Louvre, Paris) for the cloister of the Chartreuse de Vauvert. In the late 1640s, Le Sueur became one of the king's painters and began to teach at the Académie (1649), supplied the *May* for Notre-Dame de Paris (*St. Paul at Ephesus*, 1649), and initiated his decorations for the Cabinet de l'Amour and the Cabinet des Muses of the Hôtel Lambert. His last major project was a series of six tapestry cartoons on the lives of saints Gervase and Protase. He would finish only one of these before his death, but it is a supreme achievement (Musée du Louvre, Paris).

Although Le Sueur began in the lyrical mode of Vouet, he became increasingly attached to a reserved manner that he developed into a rarified and exquisite form of classicism—often referred to as Parisian Atticism. This style was as grounded in his understanding of the masters of the French and Italian Renaissance as it was in the results of his confrontation with the works of Poussin.

REFERENCE: Mérot 1987

Juste-Aurèle Meissonnier (Turin, Savoy 1695–1750 Paris)

After training with his father Etienne, a sculptor and silversmith, Juste-Aurèle came to Paris in 1714, where he joined the metalworkers' guild. His work seems to have included design, watchcase making, and especially chasing. However, only one piece signed with his mark is known to survive. He also worked for ten years at the Gobelins. In September 1724, Meissonnier received a royal appointment as master of the Corporation des Marchands-Orfèvres-Joailliers. Two years later, he succeeded Jean Berain le jeune as dessinateur de la Chambre et du Cabinet du Roi, a post charged with designing all court celebrations.

Meissonnier's autograph drawings are rather rare. Some engravings of his designs were made while he was alive, and Gabriel Huquier published a nearly complete set after his death. Represented in the engravings are designs for tableware (such as tureens and candlesticks), altar furnishings, architectural projects, and some furniture.

Above all, Meissonnier is remembered for the technical brilliance that enabled him to make an enormous contribution to the exuberant Rococo manner. In his completed works, silver seems as malleable as terracotta. His rare large drawings, often executed with black and white chalk on blue paper, reveal some of the sources of his inspiration—Bernini and Pietro da Cortona—and demonstrate the enormous skill of the artist as a draftsman.

REFERENCES: Hawley 1978; Fuhring, forthcoming

Jean-Michel Moreau le jeune (Paris 1741–1814 Paris)

Moreau le jeune's training was as notable for its brevity as it was for its location. He accompanied his teacher, the sculptor Louis-Joseph Le Lorrain, to Russia, where Moreau gained an appointment as a professor of drawing at the Academy of Fine Arts in St. Petersburg. However, this sojourn ended abruptly with Le Lorrain's unexpected death in 1760, and subsequently, Moreau never returned to painting.

Upon his return to Paris, he entered the workshop of the engraver Jacques-Philippe Lebas and produced drawings after contemporary artists and old masters, contributed designs to be engraved for the *Encyclopédie*, and participated in the engraving of illustrations for an edition of Ovid's *Metamorphoses*. In 1770, Moreau succeeded Charles-Nicolas Cochin le jeune as dessinateur des Menus-plaisirs du roi. By this time, he abandoned printmaking to devote himself to drawings that he employed others to reproduce. As dessinateur et graveur du Cabinet du Roi (1781), Moreau's subject matter focused on court manners, dress, and festivities on the eve of the Revolution (designs in honor of the birth of the Dauphin in 1782; and for the *Histoire de Moeurs et du Costume* …, published in 1776 and 1783).

Moreau le jeune made a brief trip to Italy in 1785 and was received as a member of the Académie in 1789. The Revolution led to the loss of both his Louvre lodgings and his royal post, but he salvaged his career by shifting the subject matter of his illustrations to Republican events and personalities and by teaching at the Ecoles Centrales de la Ville in Paris, where his grandson, Horace Vernet was a student. He was reinstated as graveur du Cabinet du Roi shortly before his death in 1814.

REFERENCES: Mahérault 1880; Hind 1913; Schefer 1915

Robert Nanteuil (Reims 1623–1678 Paris)

Nanteuil studied philosophy at the Jesuit College of Reims, but his artistic aspirations were revealed when he engraved the headpiece for his thesis in 1645. He trained with Nicolas Regnesson, whose sister he married in 1646. A year later, he arrived in Paris. His early work consists of portraits, drawn in graphite on parchment. His principal influences were Philippe de Champaigne, Claude Mellan, Jean Morin, and Abraham Bosse, in whose studio Nanteuil worked. In 1658, Nanteuil was named dessinateur et graveur ordinaire du roi. His engraved portrait busts gradually increased to life size by 1664. His goal in portraiture was always to capture the character of his sitters, who were usually members of the court.

Nanteuil's efforts helped to secure the Edict of St. Jean-de-Luz (1660), which elevated engraving to the status of the liberal arts. Nanteuil shone in the medium of pastel portraits, which are notable for their refinement and technical skill. But it was in realm of portrait-engraving that he was, and remains, best known, and his influence on that genre in France endured through the end of the eighteenth century.

REFERENCES: Petitjean and Wickert 1925; Fromrich 1957; Duclaux 1975; Hilliard Goldfarb in Cleveland et al. 1989; and Barbara Brejon de Lavergnée in Paris 1993a

Charles-Joseph Natoire
(Nîmes 1700–1777 Castel Gandolfo, Italy)

Son of a sculptor and the exact contemporary of Boucher, Natoire was a prodigious talent. He initiated his studies with his father and then worked in Paris with Louis Galloche and François Le Moyne. Natoire won the Prix de Rome in 1721 and arrived in the Eternal City two years later. He distinguished himself in drawing, winning first prize at the Accademia di San Luca. At the end of 1728, he went to northern Italy, where he spent more than a year. In 1730, Natoire returned to Paris, where he was received into the Académie in 1734.

Natoire's first royal commission, an allegory for the Chambre de la Reine at Versailles, was soon followed by paintings for several royal chateaus and the Bibliothèque Royale. His highly successful decorative series executed during the 1730s depicting the Story of Clovis was unusual for its use of national history as subject matter. At the end of the 1730s, Natoire collaborated on the restoration of the Hôtel de Soubise (now the Archives Nationales). His eight paintings on the Story of Psyche had to be adapted to the intricately curved spandrels designed by the architect, Germain Boffrand. Paintings for another of Boffrand's projects, the chapel of the orphanage known as Les Enfants Trouvés, absorbed Natoire during the 1740s and quickly became one of his most celebrated works. A prolific artist—who was also the teacher of Joseph-Marie Vien and Jean-Baptiste-Marie Pierre—Natoire became known above all for fluidly unified and elegantly finished compositions, replete with graceful, pliant figures.

After his appointment as director of the French Academy in Rome, Natoire never returned to France. Although he was not a successful administrator, he developed a strong interest in landscape during his later years in Italy and produced a great number of sheets that evoke the light and atmosphere of the Italian campagna in the same harmonious manner that characterized his large multifigure Parisian compositions. Natoire encouraged plein-air landscape drawing and painting by his students in Rome—Hubert Robert and Jean-Honoré Fragonard—and he often joined them on drawing trips to sites in Rome, Frascati, and Tivoli.

REFERENCES: Boyer 1949; Troyes et al. 1977; Duclaux 1991

Jean-Baptiste Oudry (Paris 1686–1755 Beauvais)

The son of a painter and art dealer, Jean-Baptiste Oudry was a pupil of Michel Serre by 1704 and then spent five years as an apprentice to Nicolas de Largillière. During this time, he took drawing courses at both the Académie and the Academy of St. Luke. He became a master in the latter institution in 1708, during his father's tenure as president.

The early years of Oudry's career were devoted mainly to portraiture and still life. We know these works through his two-volume *Livre de raison* of 1713, which recorded all of his works for five or six years in wash drawings. He was received into the Académie in 1719, but he continued his relations with the Academy of St. Luke, where he was elected professor. He began to make a name for himself in the early 1720s by exhibiting at the Exposition de la Jeunesse in the Place Dauphine, but his major accomplishment during this decade was unseating Alexandre-François Desportes as the predominant painter of hunt scenes and animals. The year of 1725 was perhaps the turning point: Oudry obtained lodgings at the Tuileries, won various royal commissions for hunt scenes, and exhibited more paintings than any other artist. The following year, by order of the king, he presented the entire contents of his studio (twenty-six paintings) at Versailles.

In 1726, Oudry entered the employ of the royal tapestry works at Beauvais. He began by designing tapestries—such as the nine *Royal Hunts of Louis XV* (eventually woven at the Gobelins factory)—and in 1734, he became the director, where he presided over that institution's most profitable years and recruited Boucher as a designer. Oudry also served as Inspector at the Gobelins beginning in 1748. When the Salon

was reinstated in 1737, Oudry returned to easel paintings of animals, still lifes, and bucolic landscapes. Besides the king, Oudry's most distinguished collectors included count Carl Gustav Tessin, the Swedish ambassador; the marquis de Beringhen; and Friedrich, crown prince of Mecklenburg-Schwerin. Oudry became a professor at the Académie in 1743 and founded a free drawing school at Beauvais in 1750.

Oudry was a prolific draftsman throughout his career. In addition to the drawings in his *Livre de raison* and other drawings related to his later royal commissions, he produced more than 270 sheets for an edition of the *Fables* of La Fontaine, 38 drawings for Scarron's *Roman comique*, and a series of stunning views of the park of the abandoned Château d'Arcueil.

REFERENCES: Opperman 1977; Hal Opperman in Paris et al. 1982a

Augustin Pajou (Paris 1730–1809 Paris)

The son of a minor sculptor, Pajou began his studies with Jean-Baptiste Lemoyne in Paris at age fourteen. As the winner of the Prix de Rome in 1748, he enrolled at the Ecole royale des Elèves Protégés before his four-year residence at the French Academy in Rome. He became agréé at the Académie in 1759 and was received as a full academician a year later. In addition to religious sculpture, Pajou produced decorative reliefs for the opera house at Versailles and for the Palais Royal in Paris. He went on to make additions to the sixteenth-century Fontaine des Innocents by Jean Goujon, which was being moved to a new site and rebuilt. He was also acclaimed for his lifelike portrait busts.

Pajou's drawings, including his many sketches after the antique in Rome in pen and ink, and his preparatory studies and *modelli* for major projects in red chalk, reveal an exceptional technical mastery. He was named garde des antiques du roi in 1777, and in 1792 he began taking inventories of statues for the commission charged with the conservation of monuments. That year, he was also appointed rector at the Académie.

Pajou sat out the Terror (1793–94) in Montpellier, and toward the end of his life, he gave up artistic activities (soon after the Revolution forced him to abandon his lodgings in the Louvre), and paralysis gradually engulfed him. His son Jacques-Augustin Pajou was a portrait painter, and his daughter Flora married the sculptor Clodion.

REFERENCES: Stein 1912; Guilhem Scherf and James David Draper in Paris and New York 1997b

Charles Parrocel (Paris 1688–1752 Paris)

This scion of a dynasty of painters and engravers studied first with his father Joseph—a noted painter of military scenes—until Joseph's death in 1704. Charles's training then continued with Bon de Boullogne and Charles de La Fosse. He served for just one year in the cavalry, where he observed at close range the horses and military accessories that appear in his paintings. Despite competing unsuccessfully for the Prix de Rome in 1709, Parrocel arrived in Italy in 1712 and stayed there for nearly a decade. In 1713, after sending his painting *Moses Saved from the Waters* back to Paris, he was named a pensionnaire of the king at the French Academy in Rome. He then lived in Venice for four years after traveling throughout Italy.

Upon returning to Paris in 1721, Parrocel was received into the Académie and completed two paintings commemorating the visit to France of the Turkish ambassador Mehemet Effendi. Commissioned by the duc d'Antin on behalf of the king, these canvases were woven into tapestries at the Gobelins and still remain *in situ* at Versailles, as does Parrocel's equestrian portrait of Louis XV. However, Parrocel's favored subjects were battles and hunts. He accompanied the king on the military campaigns of the mid-1740s (the War of the Austrian Succession) and sketched some of the battle scenes in the field. In addi-

tion to these adventures, Parrocel pursued a conventional academic career—exhibiting at the Salons of 1737, 1738, 1745, and 1746 and becoming professor at the Académie in 1745. Poor health overtook him before he could complete a projected ten-canvas cycle for the gallery in the chateau of Choisy.

Parrocel is also noted for his prints, which betray the influence of Salvator Rosa and include eighteen scenes for François de la Guérinière's *Ecole de cavalerie* (1733). He had lodgings at the Gobelins factory and a royal pension and is said to have spent each evening drawing. His prodigious oeuvre reveals his preference for large, squarish, and hastily sketched figures in red chalk or in pen and ink with wash. His pupils included the battle painter Philibert-Benoît de La Rue.

REFERENCES: Crosby Schuman 1979; Xavier Salmon in Versailles and Amiens 1995

Pierre-Antoine Patel le jeune (Paris 1648–1707 Paris)

Patel's training and frequent collaboration with his father, the landscape painter Pierre Patel l'aîné (a former student of Simon Vouet), probably accounts for the resemblance of their styles. Whereas no Italian travel is documented for Pierre-Antoine, his father had traveled to Rome, where he absorbed many of the motifs he later used in his landscapes. Rather than taking the traditional route through the Académie, Pierre-Antoine Patel joined the Parisian guild—renamed the Academy of Saint Luke—in 1677 (in 1651, his father had signed a contract designed to join the two institutions, but this would not take place for many years).

Patel's first signed work dates from 1673, and only about fifty paintings and a dozen gouaches from late in his career survive. Many of these works are related to the landscape series of the twelve months he painted for the Jesuit church of Saint-Paul–Saint-Louis in Paris. He also produced decorations in the Louvre and was a printmaker. Both Pierre-Antoine and his father were considered excellent imitators of the style of Claude.

REFERENCES: Jean-François Méjanès in Paris 1993a; Jean-François Méjanès in Le Grand 1997

Jean-Baptiste-Joseph Pater (Valenciennes 1695–1736 Paris)

After studying with his father Antoine (a sculptor), in 1704, Pater entered an apprenticeship with another local artist, Jean-Baptiste Guidé, who died when Pater was about fifteen. It was then that Pater began his studies in Valenciennes and Paris with Jean-Antoine Watteau, who was also a native of Valenciennes. Although it would be of lifelong importance for Pater, their early experience was inauspicious: the younger man found it necessary to flee his master's difficult, impatient disposition. Thus ensued a turbulent period: Pater retreated to Valenciennes in 1715 or 1716 but then went back to Paris in 1718 after some legal troubles at home.

Pater soon found employment with some of Watteau's dealers and clients. When Watteau was near death at Nogent, Pater reconciled with him and apparently received some artistic instruction as well. He later said to Gersaint that "he owed all that he knew to that little time that he had put to good use" during those crucial weeks. Pater inherited commissions that Watteau was not well enough to complete, as well as some of his mentor's most distinguished admirers and collectors (such as Frederick the Great).

Pater was received into the Académie in 1728 as a painter of *fêtes galantes*, the category that had been invented for Watteau. His prolific output is comprised of pleasing scenes of outdoor gatherings, female bathers, and drawings for book illustrations. Watteau's influence is also evident in Pater's manner of sketching figures in red chalk. His reputation waned after his death, and he is still often considered to be an uninspired and repetitive follower of Watteau who was more concerned with earning money than he was for creating important works of art.

REFERENCE: Nicole Parmentier in Washington et al. 1984

Jean-Baptiste Perroneau
(Paris 1715–1783 Amsterdam, The Netherlands)

Although Perroneau began his studies with the engraver Laurent Cars, he did not produce engravings after the 1730s. His other teachers included Charles-Joseph Natoire and the portrait painter Hubert Drouais. He was received into the Académie in 1753.

For much of his career, Perroneau was overshadowed by his rival Maurice-Quentin de La Tour, who dominated noble portrait commissions. Although La Tour often worked for François Boucher, the competition meant that Perroneau had to cast a wider net for business. In 1754 he married, and his voyage to Holland in the same year initiated a series of travels that lasted throughout his remaining years.

Perroneau's portrait subjects were usually bourgeois, often from the provinces, and frequently other artists. Examples from the last category include portraits of Gabriel Huquier (1747), Hubert Drouais (1756), and Laurent Cars (1759). He exhibited both oils and pastels at the Salon throughout his career; however, the critics were not as enamored of Perroneau's later work, largely because of its increasingly sober color palette, which moved toward grays and blacks. His widely dispersed oeuvre lay forgotten during the nineteenth century, when certain writers even thought he was two separate artists—one a painter and pastellist, the other an engraver. This confusion has since been clarified, but there is no recent study of the artist.

REFERENCES: Vaillat and Ratouis de Limay 1923; Monnier 1972

Jean-François-Pierre Peyron
(Aix-en-Provence 1744–1814 Paris)

Family opposition delayed Peyron's study of art until the death of his father in 1765, when he became the pupil of Dandré-Bardon at the Ecole de Dessin in Aix. In 1767, he moved to Paris, where he studied with L-J-F. Lagrenée l'aîné and at the Académie. From the outset, the firm contours, subtle brush strokes, and spatial clarity of Peyron's drawings revealed him to be a superb draftsman, in contrast to the young David. In 1773, he won the Prix de Rome over David, who won it the following year. Both of them went to Italy in 1775 with Vien, the new director of the French Academy in Rome, and Peyron remained there for seven years. During this time, he gravitated toward the sober clarity of Poussin, which provided the base for his Neoclassical style. Peyron was first received as agréé at the Académie in 1783, and he was accepted as a full academician in June 1787. The comte d'Angiviller, directeur des Bâtiments du roi, became a significant patron who promoted Peyron over David and appointed him Inspecteur Général of the Gobelins in 1785.

The rivalry with David continued at the Salon of 1787 when Peyron's *Death of Socrates* was hung next to David's version of the same subject. The triumph of David's canvas dealt a serious blow to Peyron's career. Ill health and slow methods of working set him back further, and his post at the Gobelins was abolished in 1792. Thereafter, Peyron limited his production to small-scale works and drawings for book illustration. Although he continued to exhibit at the Salon and received a few official commissions, he became a somewhat marginal figure. Nonetheless, his contribution to the early stages of the Neoclassical movement was significant. At Peyron's funeral, David confessed that as a student, his rival had "opened my eyes."

REFERENCE: Rosenberg and van de Sandt 1983

Jean-Baptiste-Marie Pierre (Paris 1714–1789 Paris)

Pierre, the son of a wealthy jeweler, began his training with Charles-Joseph Natoire. He won the Prix de Rome in 1734, and during the five years he spent in Italy, he produced the expected large-scale figure compositions as well as genre scenes depicting Italian peasants. He would continue to produce genre works at intervals throughout his career. Pierre returned to Paris in 1740 and was received into the Académie in 1742.

A prolific painter and draftsman, Pierre was noted for developing an eclectic range of styles, but his mature works always carefully mitigated the distance between Rococo decoration and the more sober grand manner. Despite criticism from Denis Diderot, who went so far as to claim that Pierre was "the most insipid of our artists," Pierre received a number of prestigious royal, semiroyal, and private commissions (the cupola of St. Roch, a ceiling in the Palais Royal, a *Descent from the Cross* for the Cathedral in Versailles, paintings for Madame de Pompadour, and decorations for the *hôtel particulier* of the duc d'Orléans).

Pierre received a number of distinguished appointments: professor at the Académie (1748); premier peintre du duc d'Orléans (1752); l'Ordre de St. Michel (1761); premier peintre du roi, upon the death of Boucher (1770); director of the Académie (1770); and garde des tableaux du roi (1777). After the mid-1760s, Pierre ceased to paint and exhibit with any regularity, except for a few works executed in his role as premier peintre. The culmination of his career was the two appointments he received in 1770. In these two positions, he helped his friend, the comte d'Angivillier—then directeur des Bâtiments du roi—to promote the reform of the grand manner towards a less decorative and a more didactic direction. Their efforts—which included the suppression of the Ecole royale des Eléves Protégés—have been viewed by some later historians as conservative and authoritarian.

REFERENCES: Marie-Catherine Sahut in Paris 1984b; Aaron 1993

Nicolas de Plattemontagne (Paris 1631–1706 Paris)

Son of the painter Mathieu de Plattemontagne (or Plattenberg), Nicolas received his artistic training from Philippe de Champaigne, Charles Le Brun, and his uncle, Jean Morin, with whom he lived. Perhaps the strongest of these influences was Champaigne, whose nephew and disciple, Jean-Baptiste, was born the same year as his student. When both young artists worked in the master's studio, they completed a double portrait in which each painted the other.

Plattemontagne was received into the Académie in 1663 and exhibited in the Salons of 1673, 1699, and 1704. He became an associate professor at the Académie in 1679 and a professor in 1681. Although he painted both historical compositions (including the Tuileries Palace decorations, 1683–84) and portraits, a large part of his production appears to have been religious. He received a *May* for Notre-Dame (*Conversion of St. Paul*, 1666) and executed paintings for St. Sulpice.

Plattemontagne was also a printmaker. His oeuvre includes landscapes and religious subjects after Champaigne, as well as vignettes and portraits after his own drawings and those of others. His small corpus of drawings reveals a predilection for angular contours and heavy, deeply shadowed draperies in varying mixtures of black, red, and white chalk.

REFERENCE: Rosenberg and Volle 1980

Jacques-André Portail (Brest 1695–1759 Versailles)

Portail's first employment was with his father, an architectural engineer from Nantes. Jacques-André embarked on the same career but enjoyed sketching black chalk scenes of Brittany between projects. By 1738, he had been appointed dessinateur du roi. It is unclear how his acquaintance was formed with Philibert Orry, comte de Vignory—then directeur des Batiments du roi—who brought him to Versailles.

In 1740, Portail received additional official responsibilities, when he was appointed garde des tableaux. This meant that he was in charge of the periodic rotation of works of art at Versailles for the enjoyment of the royal family. He also supervised the copying studio, which reproduced portraits of the king's family to send abroad and enriched the royal art collection with copies of famous paintings. That same year, he was dismissed with a pension but remained in the employ of Orry.

In 1743, Portail began the time-consuming task of producing an inventory of paintings in the royal collection. Three years later, at the behest of Lenormant de Tournehem during his tenure as directeur des Bâtiments, Portail established a studio of draftsmen to make albums of views of the royal chateaus and gardens. This work took four years to complete. Portail also decorated public rooms in the Louvre, for which the Académie rewarded him with the title "painter of flowers and fruits" upon his acceptance. However, very few of his still lifes and landscapes survive. Instead, the basis of his fame is his drawings—all executed with the refined sensibility of a miniaturist—of landscapes, still lifes, and, above all, his depictions of courtly and bourgeois ladies and gentlemen pursuing their daily activities.

REFERENCE: Salmon 1995

Nicolas Poussin (Les Andelys 1594–1665 Rome, Italy)

Poussin was convinced that he wanted to study painting when Quentin Varin visited Les Andelys in 1612. He trained with Georges Lallemant in Paris, and after meeting the poet Giambattista Marino, he traveled to Italy in the spring of 1624, where, after having visited Venice, Marino introduced him to Cardinal Francesco Barberini and his circle in Rome. Except for a brief return to Paris (1640–42), he remained in the Eternal City for the rest of his life.

Poussin established his reputation with his splendid *Death of Germanicus* (1627) and soon received a papal commission for St. Peter's (*Death of St. Erasmus*, 1629). After losing the commission to decorate a chapel in S. Luigi dei Francesi—the French church in Rome—Poussin abandoned his ambitions to paint grand decorations and turned instead to smaller cabinet pictures, which he continued to produce for a limited group of *amateurs* in Rome and abroad for the rest of his career. During this time, Poussin also became increasingly attached to an ascetic way of life and a rigorously disciplined, central Italian approach to art and art theory. These tendencies reveal themselves in his work, where, eschewing the attraction of north Italianate *colore* evident in varying degrees in his earlier Italian works, he turned to a more sober and refined form of classicism that became increasingly distilled and cerebral throughout his maturity. This can be seen at its best in his two series of the Seven Sacraments.

Poussin's surviving oeuvre of drawings represents the opposite of that of his counterpart, the court painter Simon Vouet, as most of Poussin's extant oeuvre consists of composition studies. Primarily executed in pen and ink with wash, Poussin's drawings revealed that he used them to slowly elaborate upon his evolving ideas for compositions with the aid of props to examine the play of light and the appropriateness of gestures. His painstaking process resulted in mature and late drawings that were not traditionally charming or beautiful but were striking for their expressive intensity. His art and theories formed the doctrinal foundation of the new Académie, which he declined the offer to direct.

REFERENCES: Blunt 1966; Blunt 1967; Blunt 1979; Mérot 1990; Pierre Rosenberg and Louis-Antoine Prat in Paris and London 1994; Rosenberg and Prat 1994

Pierre-Paul Prud'hon (Cluny 1758–1823 Paris)

Prud'hon is best known for his allegorical paintings and portraits dating from the Revolution and the Empire. With their charm and sentimental appeal, his works are softer and more lyrical than those produced by David and his circle and sometimes verge on Romanticism. His training began at the Académie in Dijon, one of the best French art schools outside Paris. From 1780, he studied at the Académie in Paris, where he met Greuze and Wille before winning the Prix de Rome from the Etats de Bourgogne in 1784. During his Italian sojourn, from 1784 to 1788, Prud'hon copied from the antique and claimed Leonardo as "my master and my hero." These influences are betrayed in his first Salon entry (1791), a drawing entitled *Liberty Looking to Wisdom for Support* (Fogg Art Museum, Cambridge).

Prud'hon was exiled for two years to his native Franche-Comté following the execution in 1794 of Robespierre, with whom he had sympathized. However, during this period, Prud'hon painted some of his best portraits—usually of people outdoors in relaxed poses—and produced book illustrations for the publisher Pierre Didot. Upon his return to Paris in 1796, he began work on large decorative projects, including two ceilings for the Louvre, where much of his oeuvre resides today. After his wife's mental breakdown in 1802, Constance Mayer became Prud'hon's pupil and mistress. She not only helped to raise his five children but also became his artistic collaborator.

During the Empire, Prud'hon solidified his reputation as a history painter and portraitist. His style led contemporaries to refer to him as "the French Correggio." In 1808, the year he was awarded the Légion d'Honneur, his Salon entry was *Justice and Divine Vengeance Pursuing Crime*, which later inspired artists such as Géricault, Daumier, and Picasso. Napoleon's second wife, Maria Luisa of Austria, studied drawing with Prud'hon after his completion of commissions related to their marriage celebrations. He was less enthusiastic about commissions from the Bourbon government during the Restoration, and he only bothered to complete one of them. Prud'hon's last years were marred by financial worries and Constance Mayer's suicide in 1821.

REFERENCE: Sylvain Laveissière in Paris and New York 1997a

Jean II Restout (Rouen 1692–1768 Paris)

By the time that Jean II Restout was ten years old, his mother and father had died. He was left in the care of two uncles, both of whom were members of the Restout dynasty of artists. Another uncle by marriage, Jean-Baptiste Jouvenet, took over the role of artistic mentor for the young artist in Paris, where Restout had arrived by 1707. He made the acquaintance of Jouvenet's friends at the Académie, although he appears never to have been a student there and did not compete for the Prix de Rome.

Jouvenet died in 1717, and Restout was received into the Académie in 1720, the same year in which he married the daughter of the painter Claude-Guy Hallé. By 1734, Restout was a full professor at the Académie. Although he was capable of richly colored historical and mythological canvases that ranged from the serious to the lighthearted, Restout focused most of his efforts on major religious paintings. He received and completed a number of commissions for monasteries and churches in a reserved, but increasingly lyrical manner. His inspiration for working in this mode may have been his demonstrable Jansenist leanings (a religious sect that was banned in 1737). For a number of critics, Restout was considered one of the foremost painters of the eighteenth century.

Research over the last three decades has revealed that Restout was a prolific draftsman. Usually drawn with black chalk and heightened with white chalk, the broad contours of his elongated figures with small heads sweep across the surface of his sheets. His drawings demonstrate the same intentional restraint and avoidance of decorative effects, and some of the gestures and poses of his figures may have been intentionally awkward.

REFERENCES: Pierre Rosenberg and Antoine Schnapper in Rouen 1970; Rosenberg and Schnapper 1977; Rosenberg and Geissler 1980; Rosenberg 1982; Goodman 1995; and Rosenberg 1997

Hyacinthe Rigaud (Perpignan 1659–1743 Paris)

Hiacinto Francisco Honorat Matias Pere-Martir Andreu Joan Rigau y Ros was born in Perpignan, close to the Spanish border, and later changed his Spanish name to the more familiar French form of Hyacinthe Rigaud. He trained in Montpellier with the little-known Paul Pezet and Antoine Ranc and spent some time in Lyon in the late 1670s. By 1681, Rigaud had arrived in Paris, where he attended classes at the Académie. He won the Prix de Rome in 1682, but Charles Le Brun, recognizing his special talent as a portraitist, advised him to decline the scholarship and concentrate exclusively on portraiture. Rigaud followed Le Brun's advice, worked with Nicolas de Largillière and François de Troy—whose talents he later either matched or surpassed—and was received by the Académie in 1700.

By the late 1680s, Rigaud's work had met with such success that it became the exclusive province of the court, from the royal family and the French aristocracy to foreign princes and diplomats. His most famous portrait is that of Louis XIV (Musée du Louvre, Paris, 1701), which has been called the most Baroque representation of a king of France up to that time. It became an emblem of the Bourbon monarchy, established a new standard for royal portraiture across Europe, and led to Rigaud's international acclaim. His reputation was further enhanced by the scores of prints after his works that were engraved by Pierre Drevet and Gérard Edelinck. After the death of Louis XIV, the Regent, Philippe II, duc d'Orléans—whose portrait Rigaud had painted in 1689—became an important patron and protector who assured the artist's future. However, by this time, Rigaud was also rich enough not to have to paint except when he wanted to. The summit of his career came in 1733, when he was appointed director of the Académie.

Many of the more than four hundred portraits that Rigaud painted are recorded in his *Livre de raison* (Bibliothèque de l'Institut). Rigaud's efforts as a draftsman remain understudied, but only a small handful of the sheets attributed to him are actually considered to be authentic. In our present state of research, this conclusion seems to agree with his *Livre de raison,* which also records the artist's payments to assistants and other artists for drawings. He may, however, have retouched a number of these sheets.

REFERENCES: Roman 1919; Blunt 1982; Mary O'Neill in Montreal 1982; O'Neill 1984a; O'Neill 1984b

Antoine Rivalz (Toulouse 1667–1735 Toulouse)

Rivalz's first teacher was his father, the architect and painter Jean-Pierre Rivalz, whose studio brought the younger Rivalz into contact with the draftsman Raymond La Fage. In 1685 Rivalz went to Paris, where he attended classes at the Académie and painted a number of portraits. Two years later, he made his way to Rome, where he would remain for fifteen years. There, he was associated with the studios of Carlo Cignani, Giacinto Brandi, Ciro Ferri, and Carlo Maratta. After he won a prize for drawing at the Accademia di San Luca in 1694, Cardinal Albani (later Pope Clement XI) became a patron and protector.

Rivalz returned to Toulouse in 1702 and became peintre de la ville in 1703, a post he retained until his death. His interest in developing an institution in Toulouse for the study of art—one that would be independent of the powerful Académie in Paris—led him to found the successively named Ecole de Dessin, Société des Beaux-Arts, and finally (shortly after his death), the Académie royale de Peinture et de Sculpture de Toulouse. His commissions included a number of altarpieces, historical and allegorical decorations in municipal buildings, and portraits. He also produced a number of prints.

Rivalz was a brilliant draftsman, whose exuberant Baroque man-

ner informed by La Fage, Le Brun, and Maratta is at its best in highly worked, finished drawings with dense and dramatic compositions. The numerous students trained in his atelier include his son Jean-Pierre le jeune, his nephew Barthélemy, and Pierre Hubert Subleyras.

REFERENCES: Robert Mesuret in Toulouse 1953; Jean Penent in Toulouse 1992

Hubert Robert (Paris 1733–1808 Paris)

Robert studied with Michel-Ange Slodtz and in 1754 traveled to Italy in the entourage accompanying his protector, the comte de Stainville, French ambassador to the Holy See, who ensured that Robert studied at the French Academy in Rome without having won the Prix de Rome. During his eleven years there, Robert became fascinated with the architectural ruins that figure in so much of his work. He traveled to Naples in 1760 with the abbé de Saint-Non, and later he worked at Tivoli with Fragonard, where they produced the luminous red chalk landscapes for which they both became famous. Both Giovanni Paolo Panini (view painter and professor of perspective) and Giovanni Battista Piranesi (draftsman and etcher of Roman views) were significant influences.

Robert was received into the Académie in July 1766, where he exhibited consistently until 1798. His appointment in 1778 as dessinateur des jardins du roi (for which he received lodging at the Louvre) led to commissions for a grotto at Versailles, as well as a dairy and English gardens for Louis XVI's chateau at Rambouillet. In 1784, Robert was appointed garde des tableaux for the Louvre, but during the Revolution, his post was abolished and he was imprisoned in 1793–94. He received many royal and private commissions for gardens and decorative paintings throughout his career, especially from Empress Catherine II of Russia and various members of her court, which explains why the Hermitage (along with the Musée des Beaux-Arts, Valence) has the world's richest collection of his work. Elisabeth-Louise Vigée-LeBrun said that Robert died "brush in hand." Despite the artist's popularity during his lifetime, Diderot and others later criticized him for overproduction and negligence.

REFERENCES: Victor Carlson in Washington 1978; Cayeux 1985; Catherine Boulot, Jean-Pierre Cuzin, and Pierre Rosenberg in Rome 1990

Gabriel-Jacques de Saint-Aubin (Paris 1724–1780 Paris)

This inveterate chronicler of eighteenth-century Parisian life was one of seven children of the royal embroiderer, each of whom pursued careers in the visual arts. Gabriel studied with Etienne Jeurat and Hyacinthe Collin de Vermont, but after three failed attempts to win the Prix de Rome, he ceased his efforts at the Académie and turned to the rival Academy of St. Luke, where he devoted himself to drawing and etching. He fluidly blended chalk, graphite, wash, ink, and watercolor to great effect with a style that combined elegance with journalistic flair.

Saint-Aubin always carried a sketchbook and noted the dates and times of the incidents he recorded, such as fires, political events, auctions, and exhibitions. His documentation filled one hundred notebooks at the time of his death. Saint-Aubin's views of exhibitions and his scribbled illustrations to sale catalogues are important documents for understanding the art world of eighteenth-century Paris. The banker Pierre Crozat is said to have owned thousands of his drawings and prints. In contrast to this prodigious graphic output, however, only a dozen or so paintings exist (of which he sold only two in his lifetime). In addition to his compulsive drawing, Saint-Aubin found time to teach at Jacques-François Blondel's Ecole des Arts (from 1747) and the Academy of St. Luke (which was dissolved in 1776). Unfortunately, he was doomed to critical mockery by a number of his contemporaries, for whom even his allegorical compositions fell too low on the scale of genres.

REFERENCES: Ellen D'Oench, Richard S. Field, and Victor Carlson in Middletown and Baltimore 1975; McCullagh 1981

René-Michel, called Michel-Ange Slodtz (Paris 1705–1764 Paris)

Slodtz was born into a family of artists and began his studies with his father. He won second prize in the Prix de Rome competition in both 1724 and 1726, and he departed for the French Academy in Rome in 1728. Slodtz was an artist-in-residence for the unusually long period of eight years. He remained in the Eternal City after leaving the French Academy, set up his own studio, and became a fashionable sculptor. For nearly a decade, Slodtz produced portrait busts, as well as mythological and religious bas-reliefs. Two of his most important commissions, executed around 1740, were funerary monuments for Cardinal de la Tour d'Auvergne and Archbishop Montmorin (for the cathedral at Vienne) and a colossal *St. Bruno* in marble for St. Peter's.

In 1746, when he returned to France, Slodtz quickly found that his Baroque tendencies conflicted with the classicizing aims of the powerful comte de Caylus. Slodtz was admitted as agréé by the Académie in 1749 but he was never received as a full academician. Caylus seems to have delayed Slodtz's official favor (and may have prevented the artist from receiving the commission to redecorate the choir at St. Germain-l'Auxerrois). Ironically, however, once he received royal commissions—a park project for the Bâtiments du roi and a *Cupid* for Madame de Pompadour—Slodtz failed to complete them. He received less distinguished projects at St. Sulpice, Notre-Dame, the Place Louis XV (now the Place de la Concorde), and the Cathedral at Bourges.

The tide turned in favor of Slodtz when his friend Charles-Nicolas Cochin le jeune succeeded Nicolas-Bernard Lépicié as administrator of the arts. Cochin saw to it that Slodtz was granted a generous annual pension. Thus, in his last years, most of Slodtz's activities were in the service of the Menus-plaisirs du roi. He succeeded his brother as dessinateur du Cabinet du roi in 1758. His most well-known students were the sculptor Jean-Antoine Houdon and the painters Jean-Baptiste-Siméon Chardin and Hubert Robert.

REFERENCE: Souchal 1967

Jacques Stella (Lyon 1596–1657 Paris)

Stella was the son of a Flemish painter (Frans Stellaert), with whom he probably initiated his training. He continued his studies in Lyon with that city's leading painter, Horace Le Blanc, and then left France for Italy in 1616, where he traveled extensively and lived in Florence (1616–22) and Rome (1622–34). During Stella's extended stay in Italy, he gained a distinguished reputation for his involvement with printmaking; his small paintings on copper, marble, and semiprecious stones; the several commissions he received from the Grand Duke of Tuscany in Florence and the Barberini circle in Rome; and his well-known and lifelong friendship with Nicolas Poussin. He returned to Paris in 1634, where he was a favorite of Cardinal Richelieu and received a number of commissions for altarpieces and cabinet paintings. He became a peintre du roi and received the Order of St. Michael in 1644.

Although they await monographic study, a number of Stella's works survive in all media. Perhaps influenced by Poussin, Stella's drawings reveal a talented draftsman who gradually displaced his attraction to the ebullient Baroque mode, which he encountered in Italy, for the more restrained and sober pseudoclassicism referred to as Parisian Atticism, that became popular in Paris in the 1640s and 1650s.

REFERENCES: Thuillier 1960; Davidson 1975

Joseph-Benoît Suvée
(Bruges, Belgium 1743/47–1807 Rome, Italy)

This precocious painter entered the Belgian Royal Academy in Bruges at the age of eight as a pupil of Mathias de Visch, and about five years later he came under the influence of Jan Antoon Garemijn. While at school, Suvée won three prizes: two for life drawing and one for architecture. In 1764, a year after arriving in Paris, Suvée began his study at the Académie with Jean-Jacques Bachelier who had founded the Ecole Gratuite de Dessin, where Suvée was appointed professor in 1766. He won the Prix de Rome on his third attempt with a painting that reflected the influence of Rubens and Lemoyne. David, who came in second, maintained that Suvée had won through the good offices of Vien and other academicians. Before leaving for Rome, he studied at the Ecole royale des Elèves Protégés and produced a number of religious works.

From 1772 to 1778, Suvée was in Rome, where he copied classical seventeenth-century Italian masters and made picturesque yet archaeologically correct landscape drawings in red and black chalk. Upon his return to Paris, he was agréé at the Académie in 1779 and was received as a full academician in 1780, and he taught and exhibited regularly until 1795. The animosity between David and Suvée continued throughout their careers. In 1792, David closed the French Academy in Rome soon after Suvée was chosen for the directorship (assumed in 1801) and may have caused his imprisonment in 1794, during which time Suvée painted portraits of great psychological depth. Suvée is credited with anticipating the primitivism of the first two decades of the nineteenth century with his austere and archaizing later paintings and drawings. Unfortunately, his output dwindled after 1795.

REFERENCE: Jean-François Méjanès in Brussels 1985

Charles-André, called Carle Vanloo (Nice 1705–1765 Paris)

This most illustrious member of a distinguished dynasty of artists joined his brother Jean-Baptiste (his first teacher) in Turin upon the death of their father in 1712. When the brothers moved to Rome two years later, Carle studied drawing with the painter Benedetto Luti. Around 1720, the brothers returned to France and worked together in and around Paris on such projects as the restoration of the Galerie François Ier at the Château de Fontainebleau. Carle also continued his studies at the Académie and won the Prix de Rome in 1724. He left for Italy in 1727, at the same time as Boucher. Vanloo remained there until he departed for Turin in 1732, where he worked for Charles-Emanuel III, duke of Savoy and king of Sardinia. His eleven decorative canvases based on Tasso for the Palazzo Reale enjoyed a wide reputation through engravings. He was married in Turin before his definitive return to Paris in 1734, where he was received into the Académie in 1735.

Vanloo's royal commissions included hunt scenes, mythological and allegorical paintings, and portraits. He also painted Rococo works inspired by Boucher for Parisian clients. Some of his most renowned paintings include seven scenes for the Life of St. Augustine, executed between 1746 and 1755 for the choir of Notre-Dame-des-Victoires, Paris; *St. Clothilde Praying before the Tomb of St. Martin at Tours* (Brest), which was hailed by some critics as the most important religious canvas of the eighteenth century; and his *Mademoiselle Clairon as Medea fleeing from Jason* (Potsdam). Throughout his career, Vanloo was also considered a superb draftsman in all media. Like his painted work, this part of his oeuvre is marked by heavy contours and energetic but somewhat classicizing compositions that always retain a measured distance from the decorative excesses of the Rococo.

Vanloo received numerous appointments: professor at the Académie (1737); director of the Ecole royale des Elèves Protégés (1749); premier peintre du roi (1762); and finally, director of the Académie (1763). The list of his successful students—Jean-Honoré Fragonard, Gabriel-François Doyen, Nicolas-Bernard Lépicié, and

Louis-Jean-François Lagrenée l'aîné—is an impressive one that provides a measure of the high level of his success.

REFERENCES: Marie-Catherine Sahut in Nice et al. 1977; Marie-Catherine Sahut in Paris 1984b

Louis-Claude Vassé (Paris 1716–1772 Paris)

This sculptor trained first with his father, who was also a sculptor, and later became one of the favorite students of Edme Bouchardon, with whom he completed his studies. Vassé won the Prix de Rome in 1739, and during the years he spent in Rome (1740–45), his studies focused on Bernini and the antique. Vassé was admitted to the Académie in 1751, and he became a professor there ten years later. He also succeeded his former professor as dessinateur de l'Académie des Inscriptions et Belles-Lettres.

The collector and antiquarian Anne-Claude, comte de Caylus, became Vassé's friend and protector and encouraged his predilection for a classicizing style. Jealous and critical contemporaries, such as Charles-Nicolas Cochin le jeune, Pierre-Jean Mariette, and Denis Diderot saw Vassé as opportunistic and shamelessly ambitious—no less so because his refined and erotic marble sculptures appealed strongly to collectors—and criticized his style as too severe. Cochin went so far as to accuse Vassé of bad faith and copying the ideas of others.

Vassé's large and varied oeuvre includes mythological, allegorical, and religious subjects; funerary monuments; and portrait sculptures. His major commissions include decorations for Madame de Pompadour's dairy at Crécy, the choir at St. Germain-l'Auxerrois, the cathedrals of Auxerre and Bourges, and the tombs of the comte de Caylus and the princess Golitzyn.

REFERENCES: Réau 1930; Jean-René Gaborit in Paris 1984b

Antoine-Charles-Horace Vernet, called Carle Vernet
(Bordeaux 1758–1836 Paris)

Although the fame of Carle's father, Joseph, and his son, Horace, eventually overhadowed his own, Carle's election to the Légion d'Honneur (1808) and the Institut de France (1815) reveal the high level of his own achievements as a painter. His greatest passion was horses, which he portrayed as lithe, exalted creatures in works that influenced such later artists as Géricault, Delacroix, and Degas. He trained with his father and Nicolas-Bernard Lépicié and won the Prix de Rome in 1782 (the year after he earned second place to David), but an unexplained "mystical" crisis caused him to return from Rome to Paris after scarcely six months.

In 1799, he exhibited drawings of Napoleon's Italian campaign. Large contemporary battle scenes—along with witty caricatures of fashionable Parisian society—were his favored genres during this period. After the fall of Napoleon, Vernet's special attraction to horses led him to devote an increasing amount of time to scenes of hunting and racing that he produced as paintings, large drawings, and lithographs (he was one of the earliest French artists to explore the potential of the new medium). A celebrated equestrian portrait of the duc de Berry (Salon of 1814) helped win him the special favor of the Restoration government.

REFERENCES: Colin 1923; Isabelle Julia in Paris et al. 1974

Joseph-Marie Vien (Montpellier 1716–1809 Paris)

In his youth, Vien was employed as an assistant to Jacques Giral, a painter of faience. In 1740, he began his studies in Paris as a history painter with Charles-Joseph Natoire and won the Prix de Rome three years later. During his six years at the French Academy in Rome, Vien was particularly attracted to Raphael, Michelangelo, and seventeenth-

century Bolognese painters. He also made drawings and etchings of the Carnival of 1748 and a number of costume designs.

After his return to France, Vien was received into the Académie in 1754. The Bâtiments du roi gave him a commission at the church of Crécy in 1752. His success there was followed by a number of other commissions, including one for a Danish patron in 1754–56 and a tapestry cartoon for the Gobelins factory in 1757. At the end of the decade, Vien became a professor at the Académie.

Inspired by the archaeological findings at Herculaneum, Vien experimented with wax encaustic techniques presumed to be of Greek origin, and by the mid-1750s, he turned away from the Rococo toward a more sober style. One of his most successful decorations in this vein was his four decorative panels, *The Progress of Love in the Hearts of Young Girls* (1773–74), which replaced Fragonard's series in Madame Du Barry's pavilion at Louveciennes.

Vien was named director of the Ecole royale des Elèves Protégés in 1771 and became director of the French Academy in Rome four years later. He departed for Rome with the young Jacques-Louis David. Vien remained at his post in Rome for six years, during which time he remained a strong proponent of Neoclassicism. Despite critical discouragement, he continued to attempt monumental paintings based on antique themes. He did not exhibit at the Salon after 1793.

In addition to his leading role in the stylistic shift from the Rococo to the more sober works of the Reform, and eventually, Neoclassicism, Vien is remembered, above all, for his influential role as a teacher—in both Paris and Rome—to such great Neoclassical artists as David, Peyron, Suvée, and Regnault, who revered him as the restorer of the French school. Toward the end of his noted career, he received a number of official honors: premier peintre du roi (1789); senator (1799); commander of the Légion d'Honneur (1804); and elevation to the nobility by Napoleon (1808). At the end of his long life, he compiled his *Mémoires*.

REFERENCE: Gaehtgens and Lugand 1988

Charles Viennot (Active in Paris, c. 1700)

Little is known about this draftsman and painter, except that he was one of the studio assistants of Hyacinthe Rigaud, who is recorded as paying him and others for drawings.

REFERENCE: Roman 1919

François-André Vincent (Paris 1746–1816 Paris)

Vincent began his studies with his father, the miniaturist François-Elie, and later continued with Vien at the Académie. He won the Prix de Rome in 1768, and after three years at the Ecole royale des Elèves Protégés, he departed for Italy in 1771. Vincent was to spend more than four years in Rome. His drawings from that period represent a variety of techniques, styles, and genres, including amusing caricatures of his fellow students. The influence of Jean-Honoré Fragonard—during the latter's trip to Italy from December 1773 to June 1774—is also evident in Vincent's paintings and drawings from that time.

In the autumn of 1775, Vincent returned to France. He was received as a member of the Académie in 1782 and exhibited regularly at the Salon. His works included religious commissions and secular Neoclassical themes inspired by Greek and Roman history and literature, but his scenes of French history were particularly successful; examples include *President Molé and the Insurgents* (Salon of 1779) and six tapestry cartoons for a Life of Henry IV (1783–87). Vincent held various official posts in the 1790s and turned increasingly to portraiture. Although he was beset by poor health in his last years, his atelier continued to rank in popularity with those of David and Jean-Baptiste Regnault. His marriage to the portrait painter Adélaïde Labille-Guiard in 1800 was cut short by her death three years later. Vincent

joined the Institut in 1795 and won the Légion d'Honnée in 1805.

One of the most prolific and talented artists of his generation, Vincent is remembered, above all, for his strength and astounding versatility as a draftsman. His large oeuvre of extant sheets encompasses a broad range of subjects (landscapes, portraits, *académies*, figure and composition studies), styles (Rococo, Neoclassicism, Romanticism), and media (chalks, pen and ink, brush and wash, and gouache on dark grounds), all executed with consummate skill.

REFERENCE: Cuzin 1988b

Simon Vouet (Paris 1590–1649 Paris)

Since the late seventeenth century, many historians of French art have considered Vouet to be the founder of the early modern school of French painting. The son of a minor court painter and grandson of the Master of the King's Falcons, Vouet was a child prodigy who was perfectly situated to receive the best possible exposure to great works of art, and the best training, which probably began with his father. At the age of fourteen, he was already recognized as a successful portraitist, and at the age of twenty-two, he was selected by the crown to travel to Constantinople with the French Ambassador to paint portraits of important foreign dignitaries.

After traveling in Italy, Vouet settled in Rome, where he painted in a refined Caravaggesque mode. He achieved so much success there that he became the first non–Italian director, or *principe,* of the Accademia di San Luca, where his insistence on a solid grounding in the principles of good draftsmanship was greatly admired. Richelieu and Louis XIII kept a close watch on this precocious talent by supporting him in Rome, and in 1626, he was offered a *brevet du roi,* accompanied by a lucrative pension and suitably noble housing in the Louvre for himself, his family, and his atelier.

Knowing that Caravaggism was never really appreciated in the French capital, upon his return to Paris late in 1627, Vouet gradually altered his manner. His four-month stop in Venice on his return journey from Rome was probably intentionally designed to inform his heavy Roman chiaroscuro with the grace, fluidity, and *colore* of northern Italian painting. As a result, Vouet became unequaled in Paris for grand decorative painting marked by the power of his forceful draftsmanship and the genius of his elegant inventions, where slightly elongated monumental figures with swirling draperies slowly float across the surfaces of his large canvases. His manner was an astute blend of the gentle art of Fontainebleau, the later Romano–Bolognese classicism of the Carracci, the naturalism of Caravaggio, and the extravagant color, lively facture, and dazzling light of Venetian artists. He received numerous ecclesiastic commissions for altarpieces (Saint Nicolas-des-Champs, Saint Eustache, and the Novitiate of the Jesuits), and an even greater number of royal and private commissions for both religious and secular decorations in the Louvre, the Palais Royal, the Palais du Luxembourg, the Hôtel Seguier, and the chateaus at Chilly, Chessy, Fontainebleau, Poitou, Rueil, Saint-Germain, and Wideville.

Vouet's extraordinarily busy atelier trained and influenced more than a generation of painters and printmakers. These artists included François Perrier, Charles Le Brun, Nicolas Chaperon, Charles Poerson, Pierre Daret, Michel I Corneille, Noël Quillerier, François Bellin, Pierre Patel l'aîné, Eustache Le Sueur, and both Michel Dorigny and François Tortebat, who became his sons-in-law. Once they matured, many of these artists actively participated in Vouet's vast decorative campaigns.

A large number of Vouet's drawings survive, but most of them are elegant figure studies. Only a small number of extant composition studies enable us to comprehend the genesis of his designs.

REFERENCE: Jacques Thuillier, Barbara Brejon de Lavergnée, and Denis Lavalle in Paris 1990a (with extensive bibliography)

Jean-Antoine Watteau
(Valenciennes 1684–1721 Nogent-sur-Marne)

Few biographical facts are known about this pivotal artist. In Valenciennes, Watteau was apprenticed to the painter Jacques-Albert Gérin. Soon after that artist's death in 1702, Watteau arrived in Paris. By 1705, he is recorded in the atelier of Claude Gillot, where he produced scenes of the Commedia dell'Arte; a standard feature of Paris street fairs. Watteau left Gillot's workshop around 1708, and worked briefly with Claude III Audran, a fashionable painter of arabesques.

In 1709, Watteau was invited to compete for the Prix de Rome and received second prize. Disenchanted at losing this opportunity to study in Italy, Watteau retreated to his native Valenciennes for nearly a year before bringing his pupil Jean-Baptiste Pater back to Paris with him. During this period, Watteau produced a number of small military scenes. On his return to Paris, he was admitted to the Académie as agréé in 1712. After five years and three official reminders to submit his *morceau de reception*, he was received as a full member in 1717 upon the presentation of the *Pilgrimage to the Island of Cythera* with the title of *peintre des fêtes galantes*.

Although Watteau never studied in Rome, he had the opportunity to copy Italian art in the collection of Pierre Crozat, a wealthy patron for whom Watteau painted a cycle of *Four Seasons*. In 1719, he traveled to London, where he made two paintings for Richard Mead, a doctor and collector. Severely ill, he returned to Paris in 1720 and lived with his friend, the art dealer Edmé-François Gersaint. He then left for Nogent-sur-Marne, near Vincennes, where he lived at the country house of Monsieur Le Febvre, administrator of the Menus-plaisirs, until his death a few months later.

In addition to the *fête galante*, Watteau's most significant and enduring legacy is his skill as a draftsman. The lightness of his touch, the elegance of his *mise-en-page*, the delicacy of his contours, and the exquisite refinement of his *trois-crayons* technique were already recognized during his own lifetime. He is universally recognized as one of the most important draftsmen of the French school.

REFERENCES: Margaret Morgan Grasselli and Pierre Rosenberg in Washington et al. 1984; Rosenberg and Prat 1996

APPENDIX

List of Works in the Horvitz Collection Not Included in the Exhibition
(French Artists Born before 1780)

A.1
Jacques-François **Amand**
(Paris 1730–1769 Paris)
View of the Palatine Hill in Rome with the Belvedere of a Palace
Red chalk on off-white antique laid paper
380 × 510 mm.
Provenance: Galerie de Bayser, Paris; acquired in 1997, D-F-550/ 1.1998.10

A.2
Attributed to Jean-Paul d'André, called **Frère André** (Active in Grenoble, seventeenth century)
St. Peter
Pen and brown ink with brush and brown wash over black chalk, heightened with gold and white gouache, on tan antique laid paper
290 × 189 mm.
Provenance: Sale, Christie's, New York, 30 January 1998, lot 228; acquired at the sale, D-F-558/ 1.1998.19

A.3
Jean (?) Robert (?) **Ango**
(?–after 1773 Rome)
St. Martha in Glory
After Giovanni Battista Gaulli (1639–1709)
Red chalk on off-white antique laid paper
275 × 275 mm.
Provenance: Galerie Cailleux, Paris; acquired in 1997, D-F-486/ 1.1997.33

A.4
Jean **Audran** (Lyon 1667–1756 Paris)
Jacob Pleading with Laban for the Hand of Rachel
After Antoine Coypel (1661–1722)
Red chalk, squared in black chalk, on cream antique laid paper
435 × 535 mm.
Provenance: Paul Weis, New York; acquired in 1990, D-F-1/ 1.1993.1

A.5
Victor **Auger** (c. 1760–?)
Fainting Young Girl
After Jacques-Louis David (1748–1825)
Black chalk heightened with white gouache on light tan laid paper
480 × 340 mm.

Provenance: David and Constance Yates, New York; acquired in 1986, D-F-423/ 1.1996.79

A.6
Jean-Jacques **Bachelier**
(Paris 1724–1806 Paris)
Catherine-Etienne Crispier d'Aury Le Franc
Black and red chalk over graphite on tan antique laid paper [mark of mounter, J. B. Glomy, L. 1119]
130 mm. diameter
Provenance: Richard Lion, Paris; sale, Drouot, Paris, 3 April 1886, lot 1; sale, Galliera, Paris, 7 March 1972, lot 101; sale, Christie's, New York, 11 January 1994, lot 329; acquired at the sale, D-F-2/ 1.1994.2

A.7
Jacques **Barraband** (? 1767/8–1809 ?)
Bird Study: Rufous-Capped Motmot
(Baryphthengus Ruficapillus)
Watercolor and gouache over traces of black chalk on off-white paper
520 × 380 mm.
Provenance: Sale, Sotheby's, London, 13 December 1996, lot 123; acquired at the sale, D-F-470/ 1.1997.9

A.8
Dominique **Barrière**
(Marseille c. 1620–1678 Rome)
Mediterranean Sea Battle
Pen and black and gray ink on off-white antique laid paper
163 × 254 mm.
Provenance: Sale, Sotheby's, London, 3 July 1995, lot 202; acquired at the sale, D-F-3/ 1.1995.104
[Repr.: this page]

A.8

A.9
Jacques-Firmin **Beauvarlet**
(Abbeville 1731–1797 Abbeville)
Rinaldo and Armida
After François de Troy (1645–1730)
Black chalk, pen and brown ink, and brush with gray wash and white gouache on blue-green antique laid paper
460 × 579 mm., sight
Provenance: Jean-Pierre Selz, Paris and New York; acquired in 1990, D-F-5/ 1.1993.3

A.10
Thierry **Bellange** (Nancy, Lorraine 1594–1638 Nancy, Lorraine)
Lamentation
Colored chalk heightened with gold on parchment
273 × 378 mm.
Provenance: Galerie de Bayser, Paris; acquired in 1998, D-F-584/ 1.1998.45
[Repr.: this page]

A.10

A.11
Alexis-Simon **Belle** (Paris 1674–1734 Paris)
Portrait of a Seated Lady
Red chalk over traces of black chalk on off-white antique laid paper
315 × 258 mm.
Provenance: Gabriel Terrades at Galerie Grunspan, Paris; acquired in 1998, D-F-586/ 1.1998.47

A.12

Jean-Simon **Berthélemy**
(Laon 1743–1811 Paris)
*Man Formed by Prometheus and Animated
by Minerva*
Graphite on off-white wove paper
155 × 212 mm.
Provenance: Charles de Jonghe (mark not in
Lugt); Neal Fiertag, Paris and New York;
acquired in 1995, D-F-6/ 1.1995.77

A.13

Jean-Victor **Bertin** (Paris 1775–1842 Paris)
Classical Landscape
Black chalk on off-white antique laid paper
594 × 791 mm.
Provenance: Galerie Cailleux, Paris;
acquired in 1985, D-F-7/ 1.1993.4

A.14

Thomas **Blanchet** (Paris 1619–1689 Lyon)
Christ Bearing the Cross
Pen and brown ink with brush and brown
wash, squared in red chalk, on light tan
antique laid paper
128 × 86 mm.
Provenance: Michel Gierzod, Paris; acquired
in 1998, D-F-585/ 1.1998.46
[Repr.: this page]

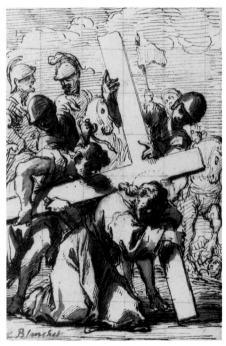

A.14

A.15

Death of the Virgin
Pen and brown ink over red chalk and
traces of black chalk on cream antique
laid paper
151 × 209 mm.
Provenance: Charles-Philippe, marquis de
Chennevières-Pointel, Paris (L. 2072);
Charles de Jonghe (mark not in Lugt);
A. Finot, Paris (mark not in Lugt); sale,
Drouot, Paris, 6 December 1982, lot 88;

Private Collection, France; Michel
Gierzod, Paris; acquired in 1995,
D-F-9/ 1.1995.50

A.16

Louis-Nicolas van **Blarenberghe**
(Lille 1716–1794 Fontainebleau)
Pastoral Landscape with a Cottage
Gouache on paper
165 × 228 mm.
Provenance: Nicolas Joly at Galerie Yves
Mikaeloff, Paris; acquired in 1998,
D-F-588/ 1.1998.49

A.17

Louis-Léopold **Boilly**
(La Bassée 1761–1845 Paris)
Café Scene, 1808 (recto); *Study for a Café
Scene* (verso)
Pen and black ink with brush and gray wash
on off-white laid paper (recto); black
chalk on off-white laid paper (verso)
252 × 438 mm.
Provenance: General de la Villestreux; his
sale, Paris, 5 April 1872, lot 346; Private
Collection, Paris; Etienne Breton at
Bureau Marc Blondeau, Paris; acquired
in 1996, D-F-407/ 1.1996.87

A.18

The Happy Family
Oil on tan wove paper
235 × 295 mm., sight
Provenance: Collection G. Danyau (L. 720);
Jacques Petithory, Paris; Private
Collection, Paris; Etienne Breton at
Bureau Marc Blondeau, Paris; acquired
in 1998, D-F-587/ 1.1998.48

A.19

Standing Young Woman with a Chair
Black and white chalk on blue wove paper
264 × 153 mm.
Provenance: Galerie de la Scala, Paris;
acquired in 1996, D-F-430/ 1.1996.101

A.20

Young Woman Artist
Black chalk heightened with white chalk on
tan wove paper
240 × 189 mm.
Provenance: Gabriel Terrades at Galerie
Grunspan, Paris; acquired in 1998,
D-F-622/ 1.1998.74

A.21

Jean-Jacques de **Boissieu**
(Lyon 1736–1810 Lyon)
Artist Painting a Portrait of an Old Man
Pen and black ink with brush and gray wash
on off-white wove paper
249 × 340 mm.
Provenance: Gabriel Terrades at Galerie
Grunspan, Paris; acquired in 1997,
D-F-547/ 1.1998.14

A.22

A Concert
Graphite on off-white antique laid paper
100 mm. diameter
Provenance: Comte de la Ferrère, Paris; his
sale, Paris, 2 December 1912, lot 3; Marius
Paulme, Paris (L. 1910); his sale, Galerie
Petit, Paris, 13 May 1929, lot 14; sale,
Sotheby's, New York, 11 January 1994, lot
331; acquired at the sale, D-F-11/ 1.1994.1

A.23

Landscape with a Mill, 1794
Brush with gray wash heightened with
white gouache on off-white laid paper
269 × 390 mm.
Provenance: Galerie Fischer-Kiener, Paris;
acquired in 1993, D-F-12/ 1.1993.168

A.24

Attributed to André **Boisson** (Aix-en-
Provence 1643–1733 Aix-en-Provence)
Minerva, Cadmus, and the Dragon
Pen and black and brown ink with brush
and brown wash, heightened with gold,
on tan antique laid paper
225 × 174 mm.
Provenance: Galerie Moatti, Paris; acquired
in 1984, D-F-13/ 1.1993.7

A.25

François **Boitard** (? 1670–1715 The Hague)
*Christ Revealing the Prophets of the Old
Testament to the Virgin,* 1692
Pen and black ink with brush and gray wash
on parchment
225 × 293 mm.
Provenance: Thomas Williams Fine Art,
Ltd., London; acquired in 1996,
D-F-362/ 1.1996.31

A.26

The Incredulity of St. Thomas
Pen and black ink with brush and gray wash
on parchment
231 × 289 mm.
Provenance: Thomas Williams Fine Art,
Ltd., London; acquired in 1996,
D-F-361/ 1.1996.30

A.27

*Virgin and Child with Sts. Elisabeth, Michael,
and John the Baptist*
Pen and black ink on off-white antique laid
paper
526 × 383 mm.
Provenance: Galerie Eric Coatalem, Paris;
acquired in 1995, D-F-14/ 1.1995.60

A.28

Jean **Bonvoisin** (Paris 1752–1837 Paris)
Death of Geta
Pen and black, brown, and gray ink with
brush and brown and gray wash, squared
in black chalk, on off-white wove paper
499 × 699 mm.

Provenance: Didier Aaron et Cie, Paris; acquired in 1996, D-F-436/1.1996.93

A.29

Jean-François **Bosio**

(Monaco 1764–1827 Paris)

Parisians Shopping

Pen and brown ink with brush and brown wash on off-white wove paper

138 × 201 mm.

Provenance: Galerie Emmanuel Moatti, Paris; acquired in 1998, D-F-614/ TL36356.03

A.30

Edme **Bouchardon**

(Chaumont 1698–1752 Paris)

Allegory of Hearing

Red chalk on cream antique laid paper

327 × 225 mm.

Provenance: Sale, Sotheby's, New York, 29 January 1997, lot 218; acquired at the sale, D-F-460/ 1.1997.3

A.31

Medal Design for the Chambre aux Deniers in 1742: FRUGES ET CEREREM FERANT

Red chalk on cream antique laid paper

217 mm. diameter, sight

Provenance: Didier Aaron et Cie, Paris; acquired in 1997, D-F-540/ 1.1998.5

A.32

Medal Design for the Maison de la Reine in 1740: TOTO SPARGET IN ORBE

Red chalk on cream antique laid paper

216 mm. diameter, sight

Provenance: Didier Aaron et Cie, Paris; acquired in 1997, D-F-539/ 1.1998.4

[Repr.: MRC ess., fig. 25]

A.33

Seated Male Nude

Red chalk on cream antique laid paper

486 × 390 mm.

Provenance: Private Collection, New York; W. M. Brady and Co., New York; acquired in 1998, D-F-625/ 1.1998.71

A.34

Standing Male Nude with Folded Arms

Red chalk on cream antique laid paper

364 × 205 mm.

Provenance: Baron Roger Portalis, Paris (L. 2232); sale, Christie's, New York, 10 January 1990, lot 147 (as J-B-M. Pierre); sale, Christie's, New York, 10 January 1996, lot 238; acquired at the sale, D-F-341/ 1.1996.8

A.35

Study for the Tomb of Cardinal Hercule de Fleury (1653–1743)

Red chalk on light tan antique laid paper

440 × 315 mm.

Provenance: Pierre-Jean Mariette, Paris (L. 1852); his sale, Paris, 15 November 1775–30 January 1776, part of lot 1120; M. de Bourguignon de Fabregoules, Aix-en-Provence; Charles-Joseph Barthelemi Giraud; Collection Flury-Hérard, Paris (L. 1015); Private Collection; sale, Christie's, London, 4 July 1995, lot 131; acquired at the sale, D-F-18/ 1.1995.109

A.36

François **Boucher** (Paris 1703–1770 Paris)

Belshazzar's Feast

Pen and brown ink with brush and brown wash over black chalk, partially squared in black chalk, on off-white antique laid paper

281 × 424 mm.

Provenance: Sale, Sotheby's, New York, 10 January 1995, lot 172 (as Dandré-Bardon); acquired at the sale, D-F-31/ 1.1995.32

A.37

Courtyard of a Farm with Two Children

Black chalk with traces of white chalk on faded blue antique laid paper

256 × 369 mm.

Provenance: Perhaps Blondel d'Azaincourt, Paris; Private Collection, Switzerland; sale, Lucerne, 28 June 1934, lot 50; Katrin Bellinger, Munich; acquired in 1991, D-F-20/ 1.1993.16

A.38

Design for a Carriage Door Decoration(?): Crowned Rocaille Escutcheon with Putti and the Order of the Golden Fleece

Black chalk heightened with white chalk on tan antique laid paper (pricked for transfer)

523 × 417 mm.

Provenance: N. Shelton; sale, Sotheby's, London, 10 December 1968, lot 76; Thos. Agnew and Sons, Ltd., London (as of 1975); Lodewijk and Bernard Houthakker, Amsterdam; Hazlitt, Gooden and Fox, Ltd., London; acquired in 1993, D-F-27/ 1.1993.170

A.39

Hippolytus Thrown from His Chariot

Red chalk on light tan antique laid paper

262 × 382 mm.

Provenance: Alain Latreille, Paris; acquired in 1989, D-F-22/ 1.1993.20

A.40

Large Family before a Farmstead with Animals (recto); *Counterproof of a Standing Female Nude* (verso)

Black and white chalk on light tan antique laid paper (recto); red chalk on light tan antique laid paper (verso)

278 × 366 mm.

Provenance: Galerie de Bayser, Paris; acquired in 1995, D-F-29/ 1.1995.1

A.41

Large Family Gathered around a Baby in a Cradle (recto); *Garden Scene and Ornamental Studies* (verso)

Pen and brown ink with brush and brown wash on off-white antique laid paper (recto and verso)

159 × 174 mm.

Provenance: Unidentified collector's mark; Kate de Rothschild, London; sale, Christie's, New York, 19 January 1995, lot 98; acquired at the sale, D-F-30/ 1.1995.25

[Repr.: recto, this page]

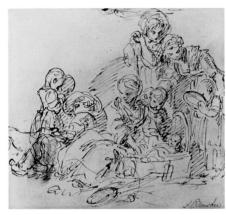

A.41r

A.42

Peasants and Animals in a Landscape

Brownish-red chalk on cream antique laid paper

269 × 367 mm.

Provenance: Paul Weis, New York; acquired in 1990, D-F-25/ 1.1993.24

A.43

Putto

Red chalk heightened with white chalk on light tan antique laid paper

387 × 242 mm.

Provenance: Private Collection, Paris; Alain Latreille, Paris; acquired in 1989, D-F-19/ 1.1993.13

A.44

Two Girls and a Dog in a Landscape

Black chalk heightened with white chalk on faded blue antique laid paper

352 × 252 mm.

Provenance: Perhaps collection of the artist at his death; perhaps his sale, Paris, 18 February 1771, lot 383; M. de Sireul, Paris; his sale, Paris, 3 December 1781, lot 103; Didier Aaron et Cie, Paris; acquired in 1984, D-F-24/ 1.1993.23

[Repr.: opposite Dedication]

A.45
Young Boy Seated beside a Jug
Black, red, and white chalk on tan antique
 laid paper
307 × 230 mm.
Provenance: Jan Baptiste de Graaf,
 Amsterdam (L. 1120); Private Collection,
 France; Etienne Breton at Bureau Marc
 Blondeau, Paris; acquired in 1995,
 D-F-335/ 1.1996.16

A.46
Counterproof of François **Boucher**
 (Paris 1703–1770 Paris)
Reclining Female Nude
Red chalk heightened with white chalk on
 light tan antique laid paper
260 × 352 mm.
Provenance: Alain Latreille, Paris; acquired
 in 1990, D-F-26/ 1.1993.19
[Repr.: this page]

A.46

A.47
Attributed to François **Boucher**
 (Paris 1703–1770 Paris)
Study for an Execution (?)
Pen and brown ink on off-white antique
 laid paper
138 × 97 mm.
Provenance: Alain Latreille, Paris; acquired
 in 1990, D-F-33/ 1.1993.11

A.48
Bon de **Boullogne** (Paris 1649–1717 Paris)
Venus and Mars (?) (recto)*; Head and Torso
 of a Male Nude Seen from Behind* (verso)
Black chalk heightened with white chalk on
 blue antique laid paper (recto); black
 chalk with touches of white and red
 chalk on blue antique laid paper (verso)

A.48r

157 × 216 mm.
Provenance: Michel Gierzod, Paris; acquired
 in 1995, D-F-35/ 1.1995.13
[Repr.: recto, this page]

A.49
Antoine **Bouzonnet-Stella**
 (Lyon 1637–1682 Paris)
Dispute in the Temple (recto); *Architectural
 Design* (verso)
Black chalk heightened with white gouache
 on blue antique laid paper (recto and
 verso)
201 × 261 mm.
Provenance: Jean Lavit, Paris; acquired in
 1991, D-F-37/ 1.1993.91

A.50
Ursule **Boze** (Active in Paris, last quarter of
 the eighteenth century)
*Portrait of the Artist's Father, Joseph Boze
 (1744–1826)*
Black chalk and charcoal with brush and
 gray wash, heightened with white
 gouache, on dark tan laid paper
460 × 367 mm.
Provenance: Didier Aaron et Cie, Paris;
 acquired in 1995, D-F-38/ 1.1995.61

A.51
Nicolas-Guy **Brenet** (Paris 1728–1792 Paris)
Standing Male Nude Holding a Staff
Red chalk on off-white laid paper
590 × 402 mm.
Provenance: Frederick J. Cummings,
 New York; sale, Sotheby's, New York,
 29 January 1997, lot 253; acquired at the
 sale, D-F-38/ 1.1997.4

A.52
Antoine-François **Callet**
 (Paris 1741–1823 Paris)
Allegory of the Concordat
Pastel on paper
552 × 824 mm.
Provenance: Nicolas Joly at Galerie Yves
 Mikaeloff, Paris; acquired in 1998,
 D-F-611/ TL36292.13

A.53
Head of a Woman in Distress
Pastel and charcoal(?) on tan laid paper
432 × 379 mm.
Provenance: Renaud Jouslin de Noray, Paris;
 acquired in 1996, D-F-352/ 1.1996.25

A.54
Venus and Adonis
Black chalk with brush and brown wash,
 heightened with white gouache and
 white chalk, on dark tan wove paper
446 × 591 mm.
Provenance: Didier Aaron Inc., New York;
 acquired in 1984, D-F-40/ 1.1993.28

A.55
Marie-Gabrielle **Capet**
 (Lyon 1761–1818 Paris)
Young Lady Sketching (recto); *Study of a
 Young Lady Supporting Her Head with
 Her Hand* (verso)
Black and red chalk heightened with white
 chalk on tan laid paper (recto); black
 chalk on tan laid paper (verso)
440 × 360 mm.
Provenance: Galerie de Bayser, Paris;
 acquired in 1998, D-F-580/ 1.1998.41

A.56
Armand-Charles **Caraffe**
 (Paris 1762–1822 Paris)
*Three Gauls Approaching a Seated Roman
 Consul* (recto); *Figure Studies* (verso)
Black chalk, pen and black ink, and brush
 and gray wash on light tan wove paper
 (recto); black chalk on light tan wove
 paper (verso)
251 × 379 mm.
Provenance: Sale, Christie's, Monaco, 2 July
 1993, lot 123; acquired at the sale,
 D-F-42/ 1.1993.178

A.57
Jacques-Philippe **Caresme**
 (Paris 1734–1796 Paris)
Peasants in a Tavern, 1780
Pen and brown ink, brush with brown wash
 and watercolor, heightened with white
 gouache, on tan laid paper
201 × 245 mm.
Provenance: Sale, Drouot, Paris, 22 March
 1995, lot 18; acquired at the sale,
 D-F-45/ 1.1995.87

A.58
Louis-François **Cassas**
 (Azay-le-Ferron 1756–1827 Versailles)
*Shepherds and an Artist Sketching in a Rustic
 Landscape,* 1778
Pen and gray ink with brush and gray wash
 on off-white laid paper
266 × 420 mm.
Provenance: Kate de Rothschild, London;
 acquired in 1996, D-F-406/ 1.1996.80

A.59
Temple of Aesculapius in Spalato, Dalmatia
Pen and black ink with brush and gray
 wash, heightened with white gouache,
 on blue laid paper
402 × 275 mm.
Provenance: Othmar Brioschi; Private
 Collection, Austria; Didier Aaron et Cie,
 Paris; acquired in 1997, D-F-542/ 1.1998.7

A.60
*Two Temples and a Palace in Spalato,
 Dalmatia*
Pen and black ink with brush and gray
 wash, heightened with white gouache, on
 blue laid paper

285 × 401 mm.
Provenance: Othmar Brioschi; Private Collection, Austria; Didier Aaron et Cie, Paris; acquired in 1997, D-F-541/ 1.1998.8

A.61
Joseph II **Cellony** (Aix-en-Provence 1730–1786 Aix-en-Provence?)
Death of Sophonisba
Pen and black ink with brush and brown wash, heightened with white gouache, over red chalk on off-white antique laid paper
355 × 255 mm.
Provenance: Daniel Katz, London; acquired in 1996, D-F-420/ 1.1996.76

A.62
Moses and the Brazen Serpent
Pen and dark brown ink with brush and brown wash, heightened with white gouache, on cream antique laid paper
395 × 494 mm.
Provenance: Galerie Cailleux, Paris; acquired in 1996, D-F-431/ 1.1996.89
[Repr.: this page]

A.62

A.63
Louis **Chaix** (Marseille c. 1740–1811 Paris)
Ruins of the Temple of Serapis at Pozzuoli
Black chalk on off-white laid paper
332 × 474 mm.
Provenance: W. M. Brady and Co., New York; acquired in 1996, D-F-363/ 1.1996.32

A.64
Jérome-François **Chantereau**
(Paris 1710–1757 Paris)
Study of Two Young Men (Puppeteers?)
Black and red chalk with traces of heightening in white chalk on light tan antique laid paper
203 × 315 mm.
Provenance: Charles-Philippe, marquis de Chennevières-Pointel, Paris (L. 2073); W. M. Brady and Co., New York; acquired in 1994, D-F-47/ 1.1994.63

A.65
Young Woman on a Donkey Followed by a Shepherd
Black chalk heightened with white chalk on tan antique laid paper
219 × 353 mm.
Provenance: Galerie Eric Coatalem, Paris; acquired in 1995, D-F-48/ 1.1995.67

A.66
Claude-Louis **Chatelet**
(Paris 1752–1794 Paris)
Cascade at Tivoli
Pen and black ink, brush with gray and black wash, heightened with white gouache, on blue laid paper
267 × 199 mm.
Provenance: Jean-Luc Baroni at Colnaghi, London; acquired in 1989, D-F-50/ 1.1993.33

A.67
Mountain Landscape with Volcano
Brush with gray and black wash heightened with white gouache on blue laid paper
218 × 280 mm.
Provenance: Hazlitt, Gooden and Fox, Ltd., London; acquired in 1994, D-F-52/ 1.1994.51

A.68
Mountain Landscape with Waterfall
Brush with gray and black wash heightened with white gouache on blue laid paper
217 × 284 mm.
Provenance: Hazlitt, Gooden and Fox, Ltd., London; acquired in 1994, D-F-51/ 1.1994.50

A.69
Jean **Chaufourier**
(Paris 1679–1757 Saint-Germain-en-Laye)
Hilly Landscape with the Town of Vauhallon in the Distance
Pen and black ink with brush and brown wash, heightened with white gouache, on blue laid paper
249 × 320 mm.
Provenance: Michel Gierzod, Paris; acquired in 1998, D-F-595/ 1.1998.57

A.70
Royal Hunting Trail near Bièvre
Pen and black ink and black chalk, heightened with white chalk, on blue laid paper
250 × 412 mm.
Provenance: Galerie de Bayser, Paris; acquired in 1997, D-F-491/ 1.1997.37

A.71
Louis **Chéron** (Paris 1660–1725 London)
Elisha and the Shunammite Woman
Pen and brown ink heightened with white gouache on off-white antique laid paper
370 × 508 mm.

Provenance: Giuseppe Vallardi, Milan (L. 1223); Galerie de Staël, Paris; acquired in 1993, D-F-54/ 1.1993.165
[Repr.: this page]

A.71

A.72
Hercules Wrestling with Acheolus
Pen and brown ink heightened with gouache on tan antique laid paper
388 × 519 mm.
Provenance: Giuseppe Vallardi, Milan (L. 1223); Galerie de Staël, Paris; acquired in 1993, D-F-55/ 1.1993.166

A.73
Seated Female Nude
Black chalk with traces of heightening in white chalk on tan antique laid paper
600 × 445 mm.
Provenance: Paul Weis, New York; acquired in 1998, D-F-573/ 1.1998.29

A.74
Seated Female Nude in Profile with a Vase
Black chalk heightened with white chalk on tan antique laid paper
615 × 445 mm.
Provenance: Paul Weis, New York; acquired in 1998, D-F-574/ 1.1998.30

A.75
Jean-François **Clermont**
(Paris 1717–1807 Reims)
Three Seated Children
Red chalk on cream antique laid paper
225 × 322 mm.
Provenance: Michel Gierzod, Paris; acquired in 1996, D-F-437/ 1.1996.94

A.76
The Clodion Hand (Active in Paris, third quarter of the eighteenth century)
Associated with Claude Michel, called Clodion (Nancy, Lorraine 1738–1814 Paris)
Two Putti with Grapes and an Overturned Pitcher
Black and white chalk on dark tan antique laid paper
318 × 318 mm.
Provenance: Alain Latreille, Paris; acquired in 1990, D-F-59/ 1.1993.34

A.77
Charles-Nicolas **Cochin le jeune**
(Paris 1715–1790 Paris)
Allegory of Free Instruction
Black chalk, extensively stumped, squared in
 black chalk, on cream antique laid paper
325 × 214 mm.
Provenance: Michel Gierzod, Paris; acquired
 in 1996, D-F-385/ 1.1996.54
[Repr.: cat. 73, fig. 1, and Appendix frontispiece]

A.78
The Angel and Zacharias, 1782
Brown chalk over traces of graphite on
 off-white antique laid paper
131 × 158 mm.
Provenance: M. Guyot de Villeneuve, Paris;
 his sale, Paris, 28 May 1900; Galerie
 Cailleux, Paris; acquired in 1984,
 D-F-60/ 1.1993.35

A.79
*Partially Standing Female Nude with Arm
 Extended*
Black chalk on cream antique laid paper
340 × 210 mm.
Provenance: The unidentified Toulouse
 collector (L. 2917); Galerie de Bayser,
 Paris; acquired in 1995, D-F-334/ 1.1996.12

A.80
Priam Returning the Body of Hector to Troy,
 1775
Red chalk over traces of black chalk on
 off-white antique laid paper
226 × 140 mm.
Provenance: Galerie Cailleux, Paris;
 acquired in 1996, D-F-328/ 1.1996.17

A.81
St. Peter Preaching to the Jews, 1782
Reworked counterproof: brown chalk on
 off-white antique laid paper
112 × 214 mm.
Provenance: M. Guyot de Villeneuve, Paris;
 his sale, Paris, 28 May 1900; Galerie
 Cailleux, Paris; acquired in 1984,
 D-F-61/ 1.1993.38

A.82
Jean-Antoine **Constantin** (La Loutbière
 1756–1844 Aix-en-Provence)
Classical Landscape
Pen and black ink with brush and gray
 wash, heightened with white gouache,
 on off-white laid paper
467 × 358 mm.
Provenance: Galerie Cailleux, Paris;
 acquired in 1990, D-F-67/ 1.1993.169

A.83
John the Baptist Preaching in a Landscape
Pen and black ink with brush and gray wash
 on off-white laid paper
468 × 360 mm.
Provenance: Annamaria Edelstein, London;
 acquired in 1985, D-F-66/ 1.1993.161

A.84
Penitent Magdalen in an Extensive Landscape
Pen and black ink with brush and gray,
 black, and rose wash on off-white laid
 paper
597 × 448 mm.
Provenance: Galerie Cailleux, Paris;
 acquired in 1997, D-F-485/ 1.1997.32

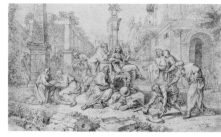

A.85

A.85
Michel II **Corneille** (Paris 1642–1708 Paris)
Aspasia Debating with Greek Philosophers
Black chalk with traces of heightening in
 white chalk on blue antique laid paper
305 × 529 mm.
Provenance: Galerie de Bayser, Paris;
 acquired in 1996, D-F-453/ 1.1996.99
[Repr.: this page]

A.86
Attributed to Jean Cousin, called **Cousin
 le jeune** (Sens 1522–1594 Paris)
Design for a Table Ornament
Pen and brown ink and watercolor over
 black chalk on off-white antique laid
 paper
134 × 190 mm.
Provenance: Giovanni Piancastelli, Rome;
 Kate de Rothschild, London; acquired
 in 1995, D-F-70/ 1.1995.47

A.87
Antoine **Coypel** (Paris 1661–1722 Paris)
Perseus and Andromeda
Black chalk heightened with white chalk
 on light gray antique laid paper
172 × 162 mm.

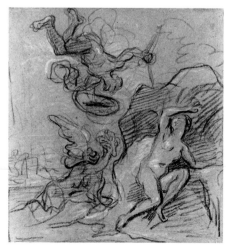

A.87

Provenance: Louis-Antoine Prat, Paris
 (mark not in Lugt); Michel Gierzod,
 Paris; acquired in 1996,
 D-F-438/ 166.1996
[Repr.: this page]

A.88
Seated Female Nude with Raised Arms
Red chalk over traces of black chalk
 heightened with white chalk on tan
 antique laid paper
205 × 234 mm.
Provenance: Sale, Phillips, London,
 6 July 1994, lot 172; acquired at the sale,
 D-F-71/ 1.1994.61

A.89
Sheet of Studies with Three Bearded Men
Black chalk with traces of heightening in
 white chalk on tan antique laid paper
330 × 268 mm.
Provenance: Sale, Christie's, London,
 2 July 1996, lot 210; acquired at the sale,
 D-F-403/ 1.1996.72
[Repr.: this page]

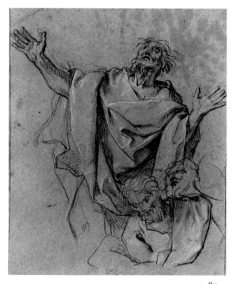

A.89

A.90
Charles-Antoine **Coypel**
 (Paris 1694–1752 Paris)
Hercules
Black and red chalk, squared in graphite,
 on cream antique laid paper
435 × 260 mm.
Provenance: Galerie de Bayser, Paris;
 acquired in 1995, D-F-73/ 82.1995
[Repr.: cat. 46, fig. 3]

A.91
Self-Portrait, c. 1746
Black chalk with touches of red chalk on tan
 antique laid paper
339 × 273 mm.
Provenance: Hazlitt, Gooden and Fox,
 Ltd., London; acquired in 1997,
 D-F-482/ 1.1997.29
[Repr.: cat. 46, fig. 2]

A.92

Michel-François **Dandré-Bardon**
(Aix-en-Provence 1700–1783 Paris)
Parnassus
Pen and brown ink with brush and brown
wash over traces of black chalk on two
joined pieces of off-white antique laid
paper
198 × 490 mm.
Provenance: Edmond and Jules de
Goncourt, Paris; their sale, Paris,
15 February 1897, lot 59; Galerie Paul
Prouté, S.A., Paris; Private Collection,
United States; Galerie Emmanuel Moatti,
Paris, and Jack Kilgore, New York;
acquired in 1995, D-F-339/ 1.1995.108

A.93

Seated Cleric
Black chalk heightened with white chalk on
buff antique laid paper
168 × 176 mm.
Provenance: Jean-Christophe Baudequin
at Galerie Ratton et Ladrière, Paris;
acquired in 1996, D-F-388/ 1.1996.57

A.94

Seated Male Nude with Clasped Hands
Black and white chalk on tan laid paper
498 × 312 mm.
Provenance: Marcel Puech, Avignon (at
bottom right, mark not in Lugt); sale,
Christie's, Monaco, 2 July 1993, lot 74;
acquired at the sale, D-F-76/ 1.1993.181

A.95

Henri-Pierre **Danloux**
(Paris 1752–1809 Paris)
Portrait of a Woman (Wife of the Artist?)
Black chalk and charcoal (?), extensively
stumped, on off-white laid paper
267 × 217 mm.
Provenance: Hazlitt, Gooden and Fox,
Ltd., London; acquired in 1997,
D-F-481/ 1.1997.28

A.96

Jacques-Louis **David**
(Paris 1748–1825 Brussels)
*Daughter of Niobe, after the Medici Niobe
Group*
Pen and black ink with brush and gray wash
on off-white laid paper
212 × 144 mm.
Provenance: Galerie de Bayser, Paris;
acquired in 1997, D-F-488/ 1.1997.35

A.97

Head and Expression Studies, 1821
Black chalk on tan laid paper
134 × 180 mm.
Provenance: James Mackinnon, London;
acquired in 1995, D-F-330/ 1.1996.9

A.98

Jean-Charles **Delafosse** (? 1734–1789 ?)
*Design for a Moulding with a Dense Mixture
of Foliage and Flowers*
Black chalk on off-white laid paper
440 × 288 mm.
Provenance: Galerie de Bayser, Paris;
acquired in 1997, D-F-527/ 1.1997.25

A.99

Dominique-Vivant, baron **Denon**
(Givry 1747–1825 Paris)
Street Scene with Five Figures and a Dog
Pen and brown ink with brush and brown
wash over traces of graphite on off-white
laid paper
104 × 169 mm.
Provenance: Jean-Pierre Selz, Paris
and New York; acquired in 1990,
D-F-298/ 1.1993.135

A.100

Jean-Baptiste-Marc-Antoine **Descamps**
(Rouen 1742–1836 Rouen)
*Head of an Antique Male Statue Seen from
Below,* 1761
Red chalk on tan antique laid paper
526 × 420 mm.
Provenance: Galerie de Bayser, Paris;
acquired in 1996, D-F-382/ 1.1996.51

A.101

Aignan-Thomas **Desfriches**
(Orléans 1715–1800 Orléans)
*Rustic Landscape with Figures and Buildings
beside a Lake*
Black chalk with brush and gray wash on
cream laid paper
538 × 680 mm.
Provenance: Galerie Cailleux, Paris;
acquired in 1996, D-F-395/ 1.1996.64

A.102

Jean-Baptiste **Deshays**
(Rouen 1729–1765 Paris)
Belisarius Receiving Alms (recto)*; Nymph
and Satyr and a Bust of a Man* (verso)
Black and red chalk with brush and brown
wash with traces of heightening in white
gouache on light tan antique laid paper
(recto); black chalk with touches of red
chalk on light tan antique laid paper
(verso)
300 × 390 mm.
Provenance: Jean-Luc Baroni at Colnaghi,
London and New York; acquired in 1987,
D-F-78/ 1.1993.42

A.103

Erigone Vanquished
Gouache on off-white antique laid paper
438 × 298 mm.
Provenance: Ronald L. Winokur,
Los Angeles; acquired in 1985,
D-F-80/ 1.1993.44
[Repr.: cat. 76, fig. 3]

A.104

Priest with Outstretched Arms
Black chalk heightened with white gouache
on tan laid paper
580 × 380 mm.
Provenance: Galerie de Bayser, Paris;
acquired in 1997, D-F-490/ 1.1997.36

A.105

Laurent **Desmarets** (Lyon? c. 1635–? Lyon?)
St. Paul
Pen and dark brown ink with brush and
brown wash, heightened with white
gouache, on tan antique laid paper
256 × 170 mm.
Provenance: Jean-Christophe Baudequin
at Galerie Ratton et Ladrière, Paris;
acquired in 1996, D-F-381/ 1.1996.50

A.106

Alexandre-François **Desportes**
(Champigneulle 1661–1743 Paris)
America (Seated Woman with Hunters)
Black chalk with touches of red chalk on
light tan antique laid paper
303 × 196 mm.
Provenance: Galerie de Bayser, Paris;
acquired in 1997, D-F-493/ 1.1997.39

A.107

*Asia (Prelate Carried by Two Servants with
Animals)*
Black and red chalk, squared in pen and
brown ink, on light tan antique laid
paper
298 × 205 mm.
Provenance: Galerie de Bayser, Paris;
acquired in 1997, D-F-492/ 1.1997.38

A.108

Claude-Louis **Desrais** (Paris 1746–1816
Paris)
St. Peter in Prison
Pen and brown ink with brush and brown
wash on cream antique laid paper
265 × 197 mm.
Provenance: Galerie de Bayser, Paris;
acquired in 1998, D-F-593/ 1.1998.55

A.109

François **de Troy** (Toulouse 1645–1730 Paris)
Seated Woman (recto); *Legs of a Standing
Man* (verso)
Red chalk heightened with white chalk on
light tan antique laid paper (recto); black
chalk on light tan antique laid paper
(verso)
345 × 225 mm.
Provenance: Sale, Sotheby's, Monaco,
13 June 1982, lot 131; Galerie Cailleux,
Paris; acquired in 1986, D-F-81/ 1.1993.45

A.110
Jean-François **de Troy**
 (Paris 1679–1752 Rome, Italy)
Study of a Standing Soldier in Distress
Red chalk, extensively stumped, on blue
 antique laid paper
470 × 345 mm.
Provenance: Sale, Sotheby's, London,
 8 July 1998, lot 244; acquired at the sale,
 D-F-626/ 1.1998.75

A.111
Antoine **Dieu** (Paris 1662–1727 Paris)
Adoration of the Golden Calf
Pen and black ink with brush and gray wash
 over red chalk on off-white antique laid
 paper
300 × 441 mm.
Provenance: Perhaps Marcel Louis Guérin,
 Paris (close to L.s. 1872b); Nicos Dhikeos,
 Lyon (mark not in Lugt); Galerie Eric
 Coatalem, Paris; acquired in 1998,
 D-F-598/ 1.1998.62
[Repr.: cat. 30, fig. 3]

A.112
St. Paul Throwing the Serpent into the Fire
Pen and black ink with brush and gray
 wash, heightened with white gouache, on
 blue antique laid paper
224 × 179 mm.
Provenance: Annamaria Edelstein, London;
 acquired in 1985, D-F-83/ 1.1994.33

A.113
Michel **Dorigny**
 (Saint-Quentin 1617–1665 Paris)
Study for an Atlante with Garland
Black chalk with traces of heightening in
 white chalk on tan antique paper
206 × 155 mm.
Provenance: Sale, Christie's, London,
 2 July 1993, lot 96; acquired at the sale,
 D-F-84/ 1.1993.182
[Repr.: this page]

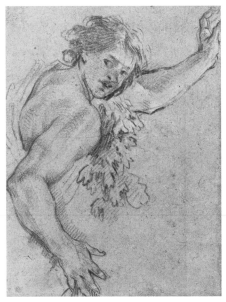

A.113

A.114
Unidentified Design Representing a Warrior
 Angel Chasing Two Winged Figures and a
 Harpy
Pen and brown ink over traces of black
 chalk, squared in pen and brown ink,
 on cream antique laid paper
177 × 189 mm.
Provenance: Galerie de Bayser, Paris;
 acquired in 1997, D-F-523/ 1.1997.21
[Repr.: this page]

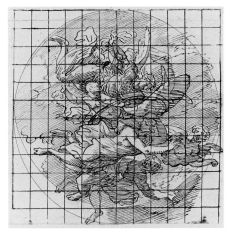

A.114

A.115
François-Hubert **Drouais**
 (Paris 1763–1788 Rome)
Sheet of Studies for Marius à Minturnes
Red chalk on off-white laid paper (recto and
 verso)
194 × 150 mm.
Provenance: Galerie de Staël, Paris; acquired
 in 1994, D-F-88/ 1.1994.18

A.116
Gaspard **Dughet** (Rome 1615–1675 Rome)
Landscape with the Apparition of the Angel to
 Elijah (recto); *Apparition of the Virgin to*
 a Female Saint (verso)
Pen and black ink with brush and colored
 washes over red chalk on cream antique
 laid paper (recto); pen and brown ink
 over red chalk on cream antique laid
 paper (verso)
123 × 274 mm.
Provenance: Galerie de Bayser, Paris;
 acquired in 1996, D-F-387/ 1.1996.56

A.117
Pierre II **Dumonstier** (Paris 1565–1656 Paris)
Study of a Hand Holding a Handkerchief,
 1627
Black and red chalk heightened with white
 chalk on cream antique laid paper
245 × 190 mm.
Provenance: Catherine Doubs, Paris;
 acquired in 1997, D-F-512/ 1.1997.47
[Repr.: this page]

A.117

A.118
Jacques or Jean Dumont, called **Dumont**
 le Romain (Paris 1701–1781 Paris)
Inverted Male Nude Lying on His Back
Red chalk on off-white antique laid paper
354 × 465 mm.
Provenance: David Daniels, New York; his
 sale, Sotheby's, New York, 25 April 1978,
 lot 76; Private Collection; sale, Sotheby's,
 London, 18 April 1996, lot 104; acquired
 at the sale, D-F-412/ 1.1996.69

A.119
Male Nude Collapsing under a Tree
Red chalk on cream antique laid paper
425 × 527 mm.
Provenance: Sale, Phillips, London,
 28 October 1997, lot 197; acquired at the
 sale, D-F-531/ 1.1997.59

A.120
Michel-Hamon **Duplessis**
 (Active in Paris, 1790–1799)
The Boarding of a Ferry
Pen and black ink with brush and gray
 wash, heightened with white gouache,
 on green prepared antique laid paper
325 × 432 mm.
Provenance: Marcel Puech, Avignon (mark
 not in Lugt); sale, Christie's, Monaco,
 2 July 1993, lot 81; acquired at the sale,
 D-F-91/ 1.1993.183

A.121
Louis **Durameau** (Paris 1733–1796 Versailles)
Angel Holding a Lily
Red chalk heightened with white chalk,
 squared in red chalk, on dark tan antique
 laid paper
165 × 143 mm.
Provenance: Aldega-Gordon, New York;
 acquired in 1995, D-F-93/ 1.1995.40

A.122
St. Helen
Red chalk heightened with white chalk,
 squared in red chalk, on dark tan antique
 laid paper
168 × 142 mm.
Provenance: Aldega-Gordon, New York;
 acquired in 1995, D-F-92/ 1.1995.39

A.123
Ignaz **Duvivier** (Rians or Marseille 1758–
 1832 Paris or Reims)
Standing Male Nude
Red chalk on tan laid paper
459 × 276 mm.
Provenance: Galerie Fischer-Kiener, Paris;
 acquired in 1997, D-F-497/ 1.1997.41

A.124
Charles **Eisen**
 (Valenciennes 1720–1778 Brussels)
Dying Male Nude with Extended Left Arm
Red chalk on off-white antique laid paper
280 × 470 mm.
Provenance: Sale, Christie's, South
 Kensington, 19 April 1996, lot 172;
 acquired at the sale, D-F-411/ 1.1996.68

A.125
Four Soldiers Aiming Their Rifles
Red chalk over traces of black chalk on
 cream antique laid paper
220 × 148 mm.
Provenance: Thomas Le Claire,
 Kunsthandel, Hamburg; acquired in
 1995, D-F-94/ 1.1995.75
[Repr.: this page]

A.125

A.126
François **Eisen** (Brussels 1695–1788 Paris)
Child Playing a Small Wind Instrument
Pen and black ink with brush and gray wash
 on off-white antique laid paper
178 mm. diameter
Provenance: Sale, Galliera, Paris, 30 March
 1965, lot 13; sale, Versailles, 20 June 1971,
 lot 28; Alain Latreille, Paris; acquired
 in 1990 [as J-M. Moreau le jeune],
 D-F-95/ 1.1993.96

A.127
Charles **Errard** (Nantes 1606–1689 Rome)
*Minerva Seated by a Cartouche with the
 Emblems of the Arts and Being Crowned
 by a Putto*
Pen and brown ink with brush and brown
 wash, heightened with white gouache,
 on tan antique laid paper
243 × 192 mm.
Provenance: Sale, Christie's, New York,
 19 January 1995, lot 165; acquired at the
 sale, D-F-96/ 1.1995.27
[Repr.: MRC ess. frontispiece]

A.128

A.128
Henri-Antoine de **Favanne**
 (London 1668–1752 Paris)
*Fainting Female Nude, with Subsidiary
 Studies of Hands and Feet*
Black chalk heightened with white chalk
 on tan antique laid paper
253 × 350 mm.
Provenance: Sale, Christie's, Monaco,
 30 June 1995, lot 41; acquired at the sale,
 D-F-97/ 1.1995.94
[Repr.: this page]

A.129
*Seated Woman Holding a Shield and Staff,
 with Subsidiary Study of a Leg* (recto);
 Leg Studies (verso)
Black chalk heightened with white chalk on
 tan antique laid paper (recto); black
 chalk on tan antique laid paper (verso)
274 × 360 mm.
Provenance: Sale, Christie's, Monaco,
 30 June 1995, lot 52; acquired at the sale,
 D-F-98/ 1.1995.95

A.130
School of Fontainebleau
Sacrifice to Juno
Pen and brown ink with brush and gray and
 brown wash over black chalk on light tan
 antique laid paper
315 × 380 mm.
Provenance: Jean-Pierre Selz, Paris and New
 York; acquired in 1988, D-F-183/ 1.1993.55

A.131
Jean-Honoré **Fragonard**
 (Grasse 1732–1806 Paris)
Joseph-Jérôme Le Français de Lalande
Red chalk on off-white antique laid paper
449 × 370 mm.
Provenance: René Fribourg; sale, Sotheby's,
 London, 16 October 1963, lot 533; Thos.
 Agnew and Sons, Ltd., London; sale,
 Christie's, London, 4 July 1995, lot 134;
 acquired after the sale, D-F-106/ 1.1995.111

A.132
*Ruggiero and Alcina Attend a Play in the
 Palace*
Black chalk with brush and brown wash on
 off-white antique laid paper
396 × 242 mm.
Provenance: One of a set of approximately
 150 drawings in the collection of the
 artist at his death; Fragonard family, by
 descent; Hippolyte Walferdin; his sale,
 Paris, 12–16 April 1880, lot 228; Louis
 Roederer, Reims; Olry-Roederer, Reims
 (until 1923); Dr. A. S. W. Rosenbach and
 the Rosenbach Co., Philadelphia and
 New York; one of 100 drawings from the
 series acquired by Arthur Houghton;
 Thos. Agnew and Sons, Ltd., London;
 Private Collection; sale, Sotheby's, New
 York, 9 January 1996, lot 61; acquired at
 the sale, D-F-344/ 1.1996.2
[Repr.: cat. 89, fig. 1]

A.133
Frolicking Putti
Red chalk on off-white antique laid paper
304 × 244 mm.
Provenance: Sale, Paris, 28–29 April 1911,
 lot 324; Marius Paulme, Paris (L. 1910);
 his sale, Paris, Galerie Georges Petit,
 13–14 May 1929, lot 76; Casimir Stralem;
 Donald S. Stralem, New York; sale,
 Sotheby's, New York, 9 January 1996, lot
 78; acquired at the sale, D-F-343/ 1.1996.3
[Repr.: MRM ess. frontispiece]

A.134
Standing Young Woman, Seen from Behind
Black chalk on off-white antique laid paper
380 × 258 mm.
Provenance: Jean Dubois, Paris; Earl of
 Pembroke, United Kingdom; K. E.
 Maison; H. Schuake; sale, Christie's, 2
 4 March 1964, lot 145; Private Collection;
 sale, Christie's, London, 5 July 1994, lot
 94; acquired at the sale, D-F-105/ 1.1994.58
[Repr.: next page]

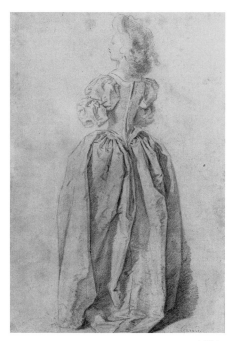

A.134

A.135
Bargellini Madonna
After Lodovico Carracci (1555–1619)
Black chalk on off-white antique laid paper
293 × 204 mm.
Provenance: Sale, Drouot, Paris, 18 March 1889, lot 286; Galerie Cailleux, Paris; acquired in 1996, D-F-432/ 1.1996.88
[Repr.: MRC ess., fig. 27]

A.136
Jean-Martial **Frédou** (Fontenay-le-Père c. 1711–1795 Versailles)
Portrait of a Young Man
Black and red chalk on cream antique laid paper
400 × 316 mm.
Provenance: Alain Latreille, Paris; acquired in 1990, D-F-107/ 1.1993.130

A.137
Bénigne **Gagneraux**
(Dijon 1756–1795 Florence)
Education of Achilles
Pen and dark brown ink with brush and light and dark brown wash on cream wove paper
555 × 445 mm.
Provenance: Private Collection, Switzerland; Galerie Eric Coatalem, Paris; acquired in 1995, D-F-108/ 1.1995.81

A.138
François-Pascal-Simon, baron **Gérard**
(Rome 1770–1837 Paris)
Figure Studies for "The Tenth of August 1792" (recto and verso)
Black chalk on off-white laid paper (recto); black chalk with brush and gray wash on off-white laid paper (verso)
215 × 172 mm.

Provenance: Nicolas Joly at Galerie Yves Mikaeloff, Paris; acquired in 1994, D-F-112/ 1.1995.10

A.139
Scene from "Bajazet" by Racine (V:11): "Bajazet était mort. Nous l'avons rencontré / De morts et de mourants noblement entouré . . ."
Pen and brown ink with brush and brown wash on off-white laid paper
308 × 210 mm.
Provenance: Galerie de Bayser, Paris; acquired in 1998, D-F-599/ 1.1998.59

A.140
Attributed to François-Pascal-Simon, baron **Gérard** (Rome 1770–1837 Paris)
Ugolino and His Children in Prison
Pen and black ink with brush and gray wash, heightened with white gouache, over traces of black chalk on tan laid paper
470 × 320 mm.
Provenance: Sale, Christie's, Monaco, 2 July 1993, lot 87; acquired at the sale, D-F-113/ 1.1993.177

A.141
Anne-Louis **Girodet** de Roucy-Trioson (Montargis 1767–1824 Paris)
Birth of Venus
Black chalk, extensively stumped, on off-white wove paper
243 × 173 mm.
Provenance: Galerie Emmanuel Moatti, Paris; acquired in 1997, D-F-519/ 1.1997.56

A.142
St. Louis Welcoming Louis XVI into Heaven
Black chalk, extensively stumped, heightened with white chalk on tan wove paper
290 × 245 mm.
Provenance: Galerie de Bayser, Paris; acquired in 1997, D-F-545/ 1.1998.11

A.143
Jean-Baptiste **Greuze**
(Tournus 1725–1805 Paris)
Head of an Angry Young Girl in a Fauchon
Red chalk heightened with white chalk on cream antique laid paper
296 × 248 mm.
Provenance: Galerie Cailleux, Paris; acquired in 1984, D-F-123/ 1.1993.63
[Repr.: cat. 78, fig. 1]

A.144
Head of an Old Man
Black, red, and white chalk on light tan laid paper
500 × 375 mm.
Provenance: Jean-François Heim, Paris; acquired in 1997, D-F-516/ 1.1997.52
[Repr.: cat. 53, fig.1]

A.145
Head of a Woman in Distress
Red chalk on cream antique laid paper
401 × 311 mm.
Provenance: Unidentified collector's mark (MM); Baron Louis-Auguste de Schwiter, Paris (L. 1768); his sale, Paris, 20–21 April 1883; Kurt Meissner, Zurich; Thomas Le Claire, Kunsthandel, Hamburg; acquired in 1990, D-F-124/ 1.1993.64

A.146
Seated Female Nude
Red chalk on off-white antique laid paper
444 × 305 mm.
Provenance: Sale, Christie's, Monaco, 20 June 1994, lot 97; acquired at the sale, D-F-125/ 1.1994.54

A.147
Jean-Urbain **Guérin**
(Strasbourg 1760–1836 Obernai)
General Bruneteau de Sainte-Suzanne
Black chalk heightened with white gouache on off-white wove paper
191 × 158 mm.
Provenance: Charles-Philippe, marquis de Chennevières-Pointel, Paris (L. 2073); Nicolas Joly at Galerie Yves Mikaeloff, Paris; acquired in 1995, D-F-127/ 1.1995.63

A.148
Pierre-Narcisse **Guérin**
(Paris 1774–1833 Rome)
Aurora and Cephalus
Black chalk heightened with gouache on light tan wove paper
570 × 430 mm.
Provenance: Didier Aaron Inc., New York; acquired in 1985, D-F-128/ 1.1993.65

A.149
General Henri Duverger, Comte de la Rochejaquelein, Leading French Troops during the Vendean Insurrection
Black chalk heightened with white chalk on green wove paper
615 × 460 mm.
Provenance: Didier Aaron et Cie, Paris; acquired in 1997, D-F-571/ 1.1998.27

A.150
Standing Man Holding a Tablet and Inkwell: Study for the Robes of a Parisian Magistrate
Black chalk on cream laid paper
288 × 199 mm.
Provenance: Galerie de Bayser, Paris; acquired in 1997, D-F-524/ 1.1997.22

A.151
Standing Man in a Plumed Hat: Study for the Robes of a Parisian Magistrate
Black chalk on cream laid paper
282 × 200 mm.

Provenance: Galerie de Bayser, Paris; acquired in 1997, D-F-525/ 1.1997.23

A.152
Philippe-Auguste **Hennequin**
(Lyon 1763–1833 Leuze)
Allegory of Birth
Pen and black ink with brush and brown wash on off-white laid paper
400 × 570 mm.
Provenance: Galerie de Staël, Paris; acquired in 1994, D-F-131/ 1.1994.16
[Repr.: MRC ess.]

A.153
Annunciation, 1821
Pen and black ink with brush and gray wash on off-white wove paper
659 × 870 mm.
Provenance: Galerie Jean-François Baroni, Paris; acquired in 1997, D-F-474/ 1.1997.13

A.154
Claude-Jean-Baptiste **Hoin**
(Dijon 1750–1817 Dijon)
Seated Male Nude
Brown chalk heightened with white chalk over traces of black chalk on tan laid paper
492 × 338 mm.
Provenance: Didier Aaron et Cie, Paris; acquired in 1995, D-F-132/ 1.1995.58

A.155
Jean-Pierre-Louis-Laurent **Houel**
(Rouen 1735–1813 Paris)
Entrance to the Grotto of Caumont, near Rouen
Pen and brown ink with brush and brown and gray wash, heightened with white gouache, on blue-green laid paper
314 × 264 mm.
Provenance: Nicolas Joly at Galerie Yves Mikaeloff, Paris; acquired in 1996, D-F-375/ 1.1996.44

A.156
Jean-Baptiste **Huet** (Paris 1745–1811 Paris)
Acanthus Plant (recto); *Plant Studies* (verso)
Red and white chalk on blue antique laid paper (recto and verso)
465 × 337 mm.
Provenance: Frederick J. Cummings, New York; acquired in 1990, D-F-133/ 1.1993.67

A.157
Flowering Branches
Red and white chalk on tan antique laid paper
480 × 375 mm.
Provenance: Sale, Christie's, New York, 10 January 1996, lot 245; acquired at the sale, D-F-342/ 1.1996.6

A.158
Patch of Foliage
Red chalk on off-white laid paper
477 × 365 mm.
Provenance: Galerie Paul Prouté, S.A., Paris; Private Collection, France; Neal Fiertag, Paris and New York; acquired in 1998, D-F-602/ 1.1998.64

A.159
Rustic Landscape with a Fallen Tree and Two Figures, 1769
Black chalk heightened with white gouache on faded blue antique laid paper
442 × 357 mm.
Provenance: W. M. Brady and Co., New York; acquired in 1995, D-F-134/ 1.1995.34

A.160
Grégoire **Huret** (Lyon 1606–1670 Paris)
Allegory of Faith
Black chalk on cream antique laid paper
336 × 467 mm.
Provenance: Galerie de Bayser, Paris; acquired in 1998, D-F-544/ 1.1998.9

A.161
Flagellation of Christ
Pen and brown ink with brush and brown wash, heightened with white gouache, on tan antique laid paper
478 × 358 mm.
Provenance: Jean-Christophe Baudequin at Galerie Ratton et Ladrière, Paris; acquired in 1996, D-F-433/ 1.1996.90

A.162
Funeral Scene (recto)*; Studies of Falling Devils* (verso)
Black chalk heightened with white chalk on light tan antique laid paper (recto); black chalk on light tan antique laid paper (verso)
223 × 394 mm.
Provenance: Nicolas Joly at Galerie Yves Mikaeloff, Paris; acquired in 1996, D-F-378/ 1.1996.47

A.163
Charles-François **Hutin**
(Paris 1715–1776 Dresden)
St. Cecilia Distributing Alms
Red chalk on off-white antique laid paper
222 × 163 mm.
Provenance: Unidentified collector's mark; Galerie Eric Coatalem, Paris; acquired in 1996, D-F-434/ 1.1996.91

A.164
Saxon Pulling a Wheelbarrow
Black and white chalk on two joined pieces of tan laid paper
504 × 340 mm.
Provenance: M. Chanlaire, Versailles; Charles-Philippe, marquis de Chennevières-Pointel, Paris (L. 2072);

Louis-Antoine Prat, Paris (mark not in Lugt); sale, Christie's, New York, 30 January 1998, lot 188; acquired at the sale, D-F-555/ 1.1998.21

A.165
Jean-Baptiste **Isabey**
(Nancy 1767–1855 Paris)
Clytemnestra Receiving the News of Iphigenia's Impending Sacrifice, 1791
Black chalk and charcoal (?), extensively stumped, on off-white wove paper
222 × 267 mm.
Provenance: Paul Weis, New York; acquired in 1998, D-F-560/ 1.1998.17

A.166
Etienne **Jeurat** (Paris 1699–1789 Versailles)
Two Female Nudes Bathing
Red chalk heightened with white chalk on tan antique laid paper
388 × 268 mm.
Provenance: Marcel Puech, Avignon (mark not in Lugt); sale, Christie's, Monaco, 2 July 1993, lot 72; acquired at the sale, D-F-138/ 1.1993.186

A.167
Pierre **Jollain** (Paris 1720–after 1762 ?)
Seated Male Nude
Black chalk with pen and brown ink on tan antique laid paper
396 × 518 mm.
Provenance: Alain Latreille, Paris; acquired in 1990, D-F-137/ 1.1993.69

A.168
Jean-Baptiste **Jouvenet**
(Rouen 1644–1717 Paris)
Man Bending Forward to Grasp Handles, and Head of a Bearded Man
Black chalk with traces of white chalk on tan antique laid paper
360 × 226 mm.
Provenance: Amédée-Paul-Emile Gasc, Paris (L. 1131); Charles Gasc, Paris (L. 543); Colnaghi, London (in 1969); Felton L. Gibbons, New Jersey; Jean-Luc Baroni at Colnaghi, London; acquired in 1991, D-F-139/ 1.1993.155
[Repr.: next page]

A.169
Marriage of the Virgin
Pen and black ink with brush and gray wash, heightened with white gouache, on blue antique laid paper
269 × 210 mm.
Provenance: Louis-Antoine Prat, Paris (mark not in Lugt); Galerie Paul Prouté, S.A., Paris; acquired in 1996, D-F-377/ 1.1996.46

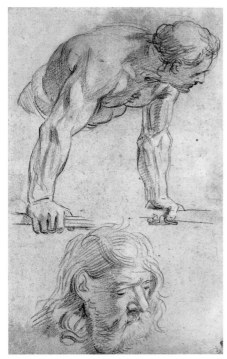

A.168

A.170
Seated Male Nude
Red chalk on light tan antique laid paper
503 × 308 mm.
Provenance: Galerie Cailleux, Paris;
acquired in 1993, D-F-140/ 1.1994.14
[Repr.: MRC ess., fig. 15]

A.171
Simon Julien, called **Julien de Parme**
(Toulon 1735–1798 Paris)
Virgil Reading the Aeneid
Pen and black ink with brush and brown
wash, heightened with white gouache,
on brown prepared laid paper
288 × 364 mm.
Provenance: Gabriel Terrades at Galerie
Grunspan, Paris; acquired in 1996,
D-F-443/ 1.1996.104

A.172
Nicolas-Raymond de **La Fage**
(Lisle-en-Albigeois 1656–1684 Lyon)
Army Attacked by Flying Snakes
Pen and black ink with brush and gray wash
on parchment
248 × 329 mm.
Provenance: Annamaria Edelstein, London;
acquired in 1985, D-F-143/ 1.1993.71

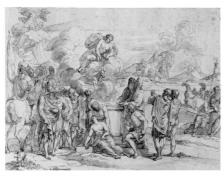

A.173

A.173
Sacrifice of Iphigenia
Pen and brown ink with brush and gray-
blue wash on light tan antique laid paper
442 × 618 mm.
Provenance: Sale, Christie's, New York,
10 January 1996, lot 178; acquired at
the sale, D-F-352/ 1.1996.7
[Repr.: this page]

A.174
Louis **Lafitte** (Paris 1770–1828 Paris)
*Allegory of the Regime of the French
Revolution*
Pen and black ink with brush and gray wash
on off-white wove paper
287 × 446 mm.
Provenance: Edmondo di Robilant, London;
acquired in 1997, D-F-513/ 1.1997.51

A.175
Charles de **La Fosse** (Paris 1636–1716 Paris)
*Aeneas Rescuing His Father Anchises from
Burning Troy*
Black and red chalk heightened with white
chalk, squared in red chalk, on gray
antique laid paper
245 × 198 mm.
Provenance: Gabriel Terrades at Galerie
Grunspan, Paris; acquired in 1998,
D-F-594/ 1.1998.56
[Repr.: this page]

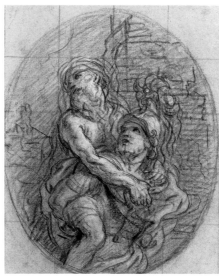

A.175

A.176
Attributed to Charles de **La Fosse**
(Paris 1636–1716 Paris)
Fall of the Damned
Pen and dark brown ink over black chalk
with traces of heightening in white
chalk, squared in black chalk, on tan
antique laid paper
367 × 217 mm.
Provenance: Nicolas Joly at Galerie Yves
Mikaeloff, Paris; acquired in 1994,
D-F-146/ 1.1994.20

A.177
Nicolas **Lagneau** (Active in Paris, first half
of the eighteenth century)
Head of an Old Man
Black, white, and red chalk with brush and
watercolor and gouache on off-white
antique laid paper
331 × 262 mm.
Provenance: Jean-Pierre Selz, Paris and New
York; acquired in 1988, D-F-147/ 1.1993.73

A.178
Jean-Jacques Lagrenée, called **Lagrenée
le jeune** (Paris 1739–1821 Paris)
The Finding of Moses
Pen and brown ink with brush and brown
wash on cream laid paper
613 × 489 mm.
Provenance: Galerie Cailleux, Paris;
acquired in 1985, D-F-148/ 1.1993.74

A.179
Pastoral Landscape
Gouache on paper
573 × 410 mm.
Provenance: Ney, prince de la Moscova;
Annamaria Edelstein, London; acquired
in 1987, D-F-149/ 1.1993.75

A.180
The Plague
Pen and brown ink with brush and brown
and gray wash over traces of black chalk
on cream laid paper
470 × 675 mm.
Provenance: Galerie Cailleux, Paris;
acquired in 1985 (as L-J-F. Lagrenée
l'aîné), D-F-150/ 1.1993.76

A.181
Louis-Jean-François Lagrenée, called
Lagrenée l'aîné (Paris 1725–1805 Paris)
Seated Male Nude
Red chalk on off-white antique laid paper
375 × 517 mm.
Provenance: Private Collection, Paris;
Michel Gierzod, Paris; acquired in 1995,
D-F-151/ 1.1995.54

A.182
Jacques de **Lajoüe** (Paris 1687–1761 Paris)
Garden with Fantastic Architecture
Pen and black ink with brush and gray
wash, heightened with white gouache,
on cream antique laid paper
332 × 212 mm.
Provenance: Alain Latreille, Paris; acquired
in 1990, D-F-152/ 1.1993.77
[Repr.: MRC ess., fig. 17]

A.183
Nicolas **Lancret** (Paris 1690–1743 Paris)
Standing Woman
Red chalk heightened with white chalk on
blue-gray antique laid paper

229 × 170 mm.
Provenance: Galerie Cailleux, Paris;
 acquired in 1996, D-F-371/ 1.1996.40
[Repr.: MRC ess., fig. 18]

A.184
Woman Kneeling
Red chalk with touches of black chalk on
 light tan antique laid paper
119 × 168 mm.
Provenance: Michel Gierzod, Paris; acquired
 in 1995, D-F-155/ 1.1995.49A

A.185
Woman Leaning with Right Arm Raised
Red chalk on cream antique laid paper
165 × 135 mm.
Provenance: Eugène Rodrigues, Paris
 (L. 897); Galerie Jean-François Baroni,
 Paris; acquired in 1994, D-F-154/ 1.1994.7

A.186
Charles-Paul **Landon**
 (Nonant 1760–1826 Paris)
Allegory of the Union of the Arts and Truth
Black chalk with brush and blue wash on
 white wove paper
370 × 248 mm.
Provenance: James Mackinnon, London;
 acquired in 1996, D-F-331/ 1.1996.10

A.187
Louis-Félix de **La Rue** (Paris 1731–1765 Paris)
March of Silenus
Pen and brown ink with black and red chalk
 on cream antique laid paper
410 × 602 mm.
Provenance: Galerie Cailleux, Paris;
 acquired in 1987, D-F-157/ 1.1993.78
[Repr.: Interview, fig. 12]

A.188
Martyrdom of St. Bartholomew
Pen and black ink with brush and brown
 wash over traces of black chalk on cream
 antique laid paper
500 × 329 mm.
Provenance: Sale, Christie's, London, 4 July
 1995, lot 273 with cat. A.189; acquired at
 the sale, D-F-159/ 1.1995.110

A.189
Putti Festooning an Eagle
Pen and brown ink with brush and brown
 wash on cream antique laid paper
119 × 160 mm.
Provenance: As in cat. A.188;
 D-F-160/ 1.1995.106

A.190
Maurice-Quentin de **La Tour** (Saint-
 Quentin 1704–1788 Saint-Quentin)
Portrait of the Painter, Jean Restout
Pastel on paper
387 × 306 mm., sight
Provenance: Jean-Luc Baroni at Colnaghi,

London and New York; acquired in 1988,
D-F-161/ 1.1993.79

A.191
Charles de **La Traverse**
 (Paris 1727–1787 Paris)
*Design for a Fountain with Leda and the
 Swan above a Reclining River God*
Pen and brown ink with brush and brown
 wash over traces of red and black chalk
 on off-white antique laid paper
389 × 283 mm.
Provenance: Galerie Moatti, Paris; acquired
 in 1987, D-F-162/ 1.1993.80

A.192
Two Satyrs Observing Two Sleeping Nymphs
Pen and brown ink with brush and brown
 and gray wash over traces of black chalk
 on cream antique paper
337 × 230 mm.
Provenance: Comte Rey de Villette (L.s.
 2200a); sale, Christie's, London, 7 July
 1987, lot 155; acquired at the sale,
 D-F-163/ 1.1993.82

A.193
Etienne de **Lavallée-Poussin**
 (Rouen 1733–1793 Paris)
Children Playing
Pen and black ink with brush and brown
 wash on light tan antique laid paper
173 × 256 mm.
Provenance: Paul Weis, New York; acquired
 in 1993, D-F-165/ 1.1993.159

A.194
Jean-Jacques-François Le Barbier, called **Le
 Barbier l'aîné** (Rouen 1736–1826 Paris)
*The Chevalier Désilles Presented to Henri IV
 by Minerva in the Elysian Fields*
Pen and black ink with brush and brown
 wash on off-white laid paper
240 × 335 mm.
Provenance: Nicolas Joly at Galerie Yves
 Mikaeloff, Paris; acquired in 1998,
 D-F-546/ 1.1998.16

A.195
Man Lunging Forward
Black chalk heightened with white chalk
 on blue laid paper
404 × 506 mm.
Provenance: Didier Aaron et Cie, Paris;
 acquired in 1997, D-F-543/ 1.1998.6

A.196
Jacques-Philippe **Le Bas**
 (Paris 1707–1783 Paris)
Scène galante
Red chalk on cream antique laid paper
222 × 328 mm.
Provenance: Matthias Polakovits, Paris
 (mark not in Lugt); Galerie Cailleux,
 Paris; acquired in 1996, D-F-383/ 1.1996.52
[Repr.: MRC ess., fig. 20]

A.197
André **Le Brun** (Paris 1737–1811 Wilna)
Tobias Burying the Dead (?)
Pen and brown ink with brush and brown
 wash over traces of black chalk on
 off-white antique laid paper
338 × 495 mm.
Provenance: Galerie Eric Coatalem, Paris;
 acquired in 1995, D-F-166/ 1.1995.71

A.198
Charles **Le Brun** (Paris 1619–1695 Paris)
*Allegory of Architecture: Two Putti Working a
 Block of Stone in Front of the Louvre*
Red and black chalk on cream antique laid
 paper
338 × 191 mm.
Provenance: Galerie Patrick Perrin, Paris;
 acquired in 1995, D-F-168/ 1.1995.18
[Repr.: this page]

A.198

A.199
Seated Male Saint in Ecstasy
Red chalk heightened with white chalk
 on tan antique laid paper
409 × 282 mm.
Provenance: Sale, Christie's, New York,
 30 January 1998, lot 217; acquired after
 the sale, D-F-559/ 1.1998.18
[Repr.: next page]

A.199

A.200
Young Satyr Holding the Tail of a Scorpion
Black chalk and traces of red chalk on tan
 antique laid paper
272 × 191 mm.
Provenance: Sale, Christie's, Monaco,
 2 July 1993, lot 59; acquired at the sale,
 D-F-167/ 1.1993.187

A.201
Circle of Charles **Le Brun**
*Man Supporting a Woman: Study for "Moses
 and the Brazen Serpent"*
Red chalk heightened with white chalk on
 tan antique laid paper
303 × 206 mm.
Provenance: Eugène David, Paris (L. 839);
 British Rail Pension Fund, London; their
 sale, Sotheby's, New York, 8 January 1991,
 lot 110; sale, Sotheby's, London, 3 July
 1995, lot 124; acquired at the sale,
 D-F-169/ 1.1995.103

A.202
Félix **Le Comte** (Paris 1737–1817 Paris)
Religion and the Virtues, 1788
Red chalk on cream laid paper
355 × 932 mm.
Provenance: Galerie Patrice Bellenger, Paris;
 acquired in 1997, D-F-549/ 1.1998.13

A.203
Jeanne **Ledoux** (Paris 1767–1840 Belleville)
Portrait of a Young Woman
Black chalk, extensively stumped,
 heightened with white chalk, on
 off-white laid paper
520 × 440 mm.
Provenance: Neal Fiertag, Paris and
 New York; acquired in 1994,
 D-F-170/ 1.1994.64

A.204
Hilaire **Le Dru** (Oppy 1769–1840 Paris)
Portrait of a Seated Man
Black chalk and charcoal (?) on off-white
 wove paper
470 × 360 mm.
Provenance: W. M. Brady and Co., New
 York; acquired in 1995, D-F-171/ 1.1995.37

A.205
Jean-Laurent **Legeay** (Paris 1710?–1786)
Fantastic Landscape with a Vase
Pen and black ink on off-white antique
 laid paper
316 × 238 mm.
Provenance: Galerie Jean-François
 Baroni, Paris; acquired in 1996,
 D-F-379/ 1.1996.48
[Repr.: MRC ess., fig. 28]

A.206
Pierre **Lelu** (Paris 1741–1810 Paris)
Saul and the Witch of Endor
Pen and brown ink with brush and gray
 wash, heightened with white gouache,
 on tan laid paper
595 × 460 mm.
Provenance: Sale, Sotheby's, New York,
 10 January 1995, lot 121; acquired at
 the sale, D-F-174/ 1.1995.29

A.207
Jacques-Antoine-Marie **Lemoine**
 (Rouen 1751–1824 Paris)
Portrait of a Young Man in Profile, 1797
Black chalk and charcoal on off-white
 wove paper
291 × 251 mm.
Provenance: Sale, Sotheby's, New York,
 8 January 1991, lot 81; acquired at the
 sale, D-F-178/ 1.1993.83

A.208
*Woman and Child Seated beside a Lake with
 a Chateau in the Distance*
Black chalk and charcoal, extensively
 stumped, on off-white laid paper
526 × 418 mm.
Provenance: Michel Gierzod, Paris; acquired
 in 1996, D-F-439/ 1.1996.100

A.209
Anicet-Charles-Gabriel **Lemonnier**
 (Rouen 1743–1814 Paris)
Artist at Work
Black chalk heightened with white chalk on
 green prepared laid paper
244 × 176 mm.
Provenance: Michel Gierzod, Paris; acquired
 in 1997, D-F-508/ 1.1997.44

A.210
Draped Female Figure
Black chalk heightened with white gouache
 on gray-green prepared paper
521 × 331 mm.

Provenance: Galerie de Bayser, Paris;
 acquired in 1994, D-F-176/ 1.1994.37

A.211
Seated Roman Senators in Debate
Black, red, and white chalk, squared in
 graphite, on light tan wove paper
356 × 393 mm.
Provenance: Galerie de Bayser, Paris;
 acquired in 1994, D-F-177/ 1.1994.38

A.212
Standing Man in a Surplice
Black chalk heightened with white chalk on
 gray prepared wove paper
375 × 246 mm.
Provenance: Galerie Jean-François Baroni,
 Paris; acquired in 1994, D-F-175/ 1.1994.8

A.213
François **Le Moyne** (Paris 1688–1737 Paris)
Nude Study for St. Cyril of Alexandria
Black chalk heightened with white chalk on
 light tan antique laid paper
322 × 234 mm.
Provenance: Perhaps Antoine-Joseph
 Dézallier d'Argenville, Paris (L. 2951);
 perhaps his sale, Paris, 18 January 1779,
 lot 422; W. M. Brady and Co., New York;
 acquired in 1986, D-F-179/ 1.1993.84

A.214
Nicolas-Bernard **Lépicié**
 (Paris 1735–1784 Paris)
Head of a Bearded Man
Black and red chalk with traces of
 heightening in white chalk on
 cream laid paper
354 × 279 mm.
Provenance: Collection of the artist until
 his death; his sale, Paris, 10 February
 1785; Anne-Louis Girodet de Roucy-
 Trioson, Paris; family of Girodet, by
 descent; Galerie Moatti, Paris (as of
 1981); Jacques Petithory, Paris; acquired
 in 1989, D-F-192/ 1.1993.89

A.215
Kneeling Boy
Pen and black ink with brush and gray wash
 with touches of red chalk on off-white
 laid paper
185 × 215 mm.
Provenance: Neal Fiertag, Paris and New
 York; acquired in 1998, D-F-591/ 1.1998.53
[Repr.: MRC essay, fig. 19]

A.216
Marriage of the Virgin
Pen and black ink with brush and gray wash
 over traces of black chalk on off-white
 laid paper
420 × 395 mm.
Provenance: Collection of the artist until his
 death; his sale, Paris, 10 February 1785;
 Anne-Louis Girodet de Roucy-Trioson;

family of Girodet, by descent; Galerie Moatti, Paris (as of 1981); acquired in 1989, D-F-190/ 1.1993.86

A.217
Standing Male Nude Holding a Bow
Brown chalk on cream laid paper
556 × 304 mm.
Provenance: As in cat. A.216;
D-F-193/ 1.1993.90

A.218
Standing Male Nude with His Hands on His Head
Brown chalk on cream antique laid paper
565 × 358 mm.
Provenance: As in cat. A.216;
D-F-191/ 1.1993.88

A.219
John-Baptiste **Le Prince**
(Metz 1734–1781 Saint-Denis-du-Port)
Clearing in a Landscape with Soldiers, 1777
Pen and brown ink with brush and brown wash over graphite on off-white laid paper
277 × 375 mm.
Provenance: Renaud Jouslin de Noray, Paris; acquired in 1996, D-F-408/ 1.1996.96

A.220
Louis-Nicolas de **Lespinasse**
(Pouilly 1734–1808 Paris)
View of Bordeaux
Pen and black ink, black chalk, and brush and gray and blue wash on cream wove paper
485 × 1285 mm., sight
Provenance: Nicolas Joly at Galerie Yves Mikaeloff, Paris; acquired in 1997, D-F-511/ TL36005.28

A.225

A.221
Eustache **Le Sueur** (Paris 1616–1655 Paris)
Baptism of Christ
Pen and brown ink with brush and grayish-brown wash over black chalk, squared in black chalk, on cream antique laid paper
[mark of mounter, L. 1045]
255 × 208 mm.
Provenance: Hubert Marignane, Paris (L.s. 1343a); Louis-Antoine Prat, Paris (mark not in Lugt); sale, Christie's, London, 2 July 1996, lot 202; acquired at the sale, D-F-402/ 1.1996.74

A.222
Standing Woman in Profile, with a Reclining River God Behind
Black chalk with traces of heightening in white chalk on tan antique laid paper
388 × 267 mm.
Provenance: Charles-Philippe, marquis de Chennevières-Pointel, Paris (L. 2073); Anatole France, Paris; Galerie Jean-François Baroni, Paris; acquired in 1996, D-F-347/ 1.1996.22

A.223
Jacques-Philippe II de **Loutherbourg**
(Strasbourg 1740–1812 London)
Adoration of the Shepherds
Red chalk with brush and brown, gray, and red chalk wash, heightened with white gouache, on tan laid paper
485 × 790 mm., sight
Provenance: Galerie Cailleux, Paris; acquired in 1985, D-F-194/ 1.1993.92

A.224
Nicolas **Maréchal** (? –1803 ?)
Study of an Elaborately Feathered Bird, 1793
Watercolor on off-white laid paper
212 × 150 mm.
Provenance: Galerie Jean-François Baroni, Paris; acquired in 1994, D-F-195/ 1.1994.9

A.225
Claude **Mellan** (Abbeville 1598–1688 Paris)
Portrait of a Young Man
Red chalk on cream antique laid paper
127 × 105 mm.
Provenance: Margot Gordon, New York; acquired in 1996, D-F-368/ 1.1996.37
[Repr.: this page]

A.226
Charles **Mellin**
(Nancy, Lorraine 1597?–1649 Rome)
Annunciation with God the Father
Pen and brown ink with brush and brown wash on cream antique laid paper
245 × 153 mm.
Provenance: Galerie Paul Prouté, S.A., Paris; acquired in 1997, D-F-502/ 1.1997.43

A.227

A.227
Transfiguration
Pen and brown ink with brush and brown wash over traces of black chalk on off-white antique laid paper
157 × 98 mm.
Provenance: Nicolas Joly at Galerie Yves Mikaeloff, Paris; acquired in 1994, D-F-197/ 1.1995.11
[Repr.: this page]

A.228
François-Guillaume **Ménageot**
(London 1744–1816 Paris)
Seated Woman in Distress Holding a Dead Child (recto); *Two Male Head Studies* (verso)
Black chalk heightened with white gouache on blue laid paper (recto); red chalk on blue laid paper (verso)
333 × 568 mm.
Provenance: Private Collection, France; Galerie de Bayser, Paris; acquired in 1998, D-F-579/ 1.1998.40

A.229
Charles **Meynier** (Paris 1768–1832 Paris)
Apotheosis of Henri IV
Pen and black ink with brush and brown wash, heightened with white gouache over black chalk, squared in black chalk, on six joined pieces of tan laid paper
447 × 872 mm.
Provenance: Galerie Talabardon, Paris; acquired in 1996, D-F-409/ 1.1996.102

A.230

Entry of Napoleon into Berlin

Pen and black ink with brush and gray
wash, heightened with white gouache,
over black chalk on two joined pieces
of off-white laid paper

449 × 682 mm.

Provenance: Didier Aaron et Cie, Paris;
Private Collection, Switzerland; Galerie
de Bayser, Paris; acquired in 1996,
D-F-389/ 1.1996.58

A.231

Nicolas Mignard, called **Mignard d'Avignon**
(Troyes 1606–1668 Paris)

Head of a Young Man Looking Down (recto);
Head and Torso of a Man with a Book
(verso)

Red chalk over traces of black chalk with
traces of heightening in white chalk on
light tan laid paper (recto); red chalk on
light tan laid paper (verso)

295 × 218 mm.

Provenance: Nicolas Joly at Galerie Yves
Mikaeloff, Paris; acquired in 1995,
D-F-200/ 1.1995.65

[Repr.: recto and verso, this page]

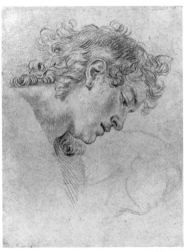

A.231 r

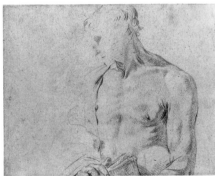

A.231 v

A.232

Head of the Virgin

Red and black chalk on light tan antique
laid paper

415 × 280 mm.

Provenance: Michael Miller and Lucy
Vivante Fine Art, New York; acquired in
1997, D-F-520/ 1.1997.18

A.233

Upturned Head of a Man (recto); *Clasped
Hands* (verso)

Red chalk heightened with white chalk on
tan antique laid paper (recto and verso)

293 × 221 mm.

Provenance: Jean-François Baroni, Paris;
acquired in 1993, D-F-199/ 1.1993.167

[Repr.: recto and verso, this page]

A.234

Pierre **Mignard** (Troyes 1612–1695 Paris)

Bacchantes and Satyr with a Herm

Black chalk heightened with white chalk on
tan antique laid paper

244 × 616 mm.

Provenance: Private Collection, France;
Galerie Eric Coatalem, Paris; acquired in
1998, D-F-617/ 1.1998.69

A.235

Alexandre **Moitte** (Paris 1750–1828 Paris)

Portrait of a Woman, 1773

Graphite on off-white antique laid paper

245 × 172 mm.

Provenance: Eugène Rodrigues, Paris
(L. 897); his sale, Drouot, Paris,
28–29 November 1928, lot 163; Neal
Fiertag, Paris and New York; acquired
in 1995, D-F-202/ 1.1995.76

A.236

Jean-Guillaume **Moitte**
(Paris 1746–1810 Paris)

Bacchante with an Infant Faun

Pen and brown ink with brush and brown
and gray wash, heightened with white
gouache, over underdrawing in red
chalk, on tan paper

360 × 221 mm.

Provenance: Alain Latreille, Paris; acquired
in 1990, D-F-203/ 1.1993.95

A.237

David Beseeching God to Stop the Plague

Pen and black and brown ink with brush
and brown wash over traces of black
chalk on cream laid paper

325 × 430 mm.

Provenance: Sale, Christie's, London,
2 July 1996, lot 287; acquired at the sale,
D-F-419/ 1.1996.73

A.238

*Scene from "La Thébaïde" by Racine (V:6):
"Creon—Ah! c'est m'assassiner que me
sauver la vie. / Amour, rage, transports,
venez à mon secours"*

Pen and black ink with brush and gray wash
on off-white laid paper

300 × 188 mm.

Provenance: Galerie de Bayser, Paris;
acquired in 1998, D-F-601/ 1.1998.63

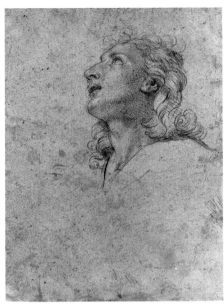

A.233 r

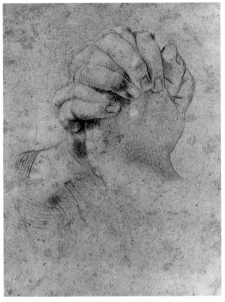

A.233 v

A.239

Charles **Monnet** (Paris 1732–1808 Paris)

Anacreon and Amor

Pen and black ink with brush and gray wash
on off-white wove paper

211 × 162 mm.

Provenance: Michel Gierzod, Paris; acquired
in 1997, D-F-509/ 1.1997.45

A.240

The Arts Paying Homage to Napoleon

Pen and ink with brush and gray wash on
cream wove paper

198 × 155 mm.

Provenance: Michel Gierzod, Paris; acquired
in 1998, D-F-554/ 1.1998.3

A.241

Nicolas-André **Monsiau**
(Paris 1754–1837 Paris)

Aspasia Visited by Socrates and Alcibiades

Black chalk, pen and brown ink, and brush
and brown wash on cream wove paper
220 × 287 mm., sight
Provenance: Louis Maudet, Paris
(mark not in Lugt); Nicos Dhikeos,
Lyon (mark not in Lugt); sale, Christie's,
London, 21 November 1996, lot 8;
acquired at the sale, D-F-452/ 1.1996.107

A.242
Death of Phocion
Pen and black ink with brush and brown
wash on cream laid paper
269 × 357 mm.
Provenance: Galerie Cailleux, Paris;
acquired in 1993, D-F-204/ 1.1994.13

A.243
Jean-Michel Moreau, called **Moreau
le jeune** (Paris 1741–1814 Paris)
Death of Antiochus, 1803
Pen and brown ink with brush and brown
wash over graphite on cream wove paper
182 × 265 mm.
Provenance: Germain Seligman, New York
and Paris; Galerie Cailleux, Paris;
acquired in 1996, D-F-372/ 1.1996.41

A.244
Festive Gathering in a Park
Pen and brown ink with brush and brown
wash on off-white antique laid paper
125 × 82 mm.
Provenance: Galerie de Bayser, Paris;
acquired in 1997, D-F-528/ 1.1997.26

A.245
*Reception for Emperor Napoleon I at the
Hôtel de Ville, Paris, in Celebration of the
Peace of Vienna, 4 December 1809*
Pen and black ink with brush and brown
wash over black chalk on cream wove
paper
540 × 814 mm.
Provenance: Dominique-Vivant, baron
Denon, Paris; his sale, Paris, 1 May 1826,
lot 839; Didier Aaron et Cie, Paris;
acquired in 1996, D-F-397/ 1.1996.65

A.246
*Tullia Driving Her Chariot over the Body of
Her Father*
Pen and gray-black ink with brush and
brown wash on light tan laid paper
261 × 383 mm.
Provenance: Private Collection, France;
Etienne Breton at Bureau Marc
Blondeau, Paris; acquired in 1995,
D-F-156/ 1.1995.83A

A.247
Charles-Joseph **Natoire**
(Nîmes 1700–1777 Castel Gandolfo, Italy)
Eve
Red chalk with traces of heightening in
white chalk on light tan antique laid
paper

355 × 253 mm.
Provenance: Galerie Jean-François Baroni,
Paris; acquired in 1995, D-F-333/ 1.1996.23

A.248
Repentance of St. Peter
Pen and brown ink, red chalk, and brush
and brown wash, heightened with white
gouache, on cream antique laid paper
396 × 248 mm.
Provenance: Van Parijs, Brussels (L. 2531);
B. Jolles, Dresden and Vienna (L.s. 381a);
Galerie de Bayser, Paris; acquired in 1998,
D-F-597/ 1.1998.61

A.249
Sacrifice of Iphigenia, 1737
Pen and brown ink with brush and gray
wash and traces of heightening in white
chalk over black chalk on blue antique
laid paper
254 × 377 mm.
Provenance: Nicolas Joly at Galerie Yves
Mikaeloff, Paris; acquired in 1996,
D-F-386/ 1.1996.55

A.250
Miracle of St. Vincent Ferrer
After Giuseppe Passeri (1654–1714)
Pen and brown ink with brush and brown
wash, heightened with white gouache, on
light tan antique laid paper
315 × 214 mm.
Provenance: Michael Miller and Lucy
Vivante Fine Art, New York; acquired in
1997, D-F-521/ 1.1997.19

A.251
Jean-Marc **Nattier** (Paris 1685–1766 Paris)
*Kneeling Nude Man in a Helmet Seen from
Behind*
Black chalk with touches of red and white
chalk on cream antique laid paper
441 × 306 mm.
Provenance: Galerie de Bayser, Paris;
acquired in 1997, D-F-496/ 1.1997.40

A.252
Victor Jean **Nicolle** (Paris 1754–1826 Paris)
Roman Ruins
Pen and brown ink with brush and brown
wash and watercolor on cream laid paper
244 × 163 mm.
Provenance: Galerie Eric Coatalem, Paris;
acquired in 1998, D-F-590/ 1.1998.52

A.253
Woman at the Well
Pen and black ink with brush and gray wash
on off-white wove paper
121 × 188 mm.
Provenance: Galerie de Bayser, Paris;
acquired in 1998, D-F-589/ 1.1998.50

A.254
Alexandre Jean **Noël**
(Brie-Comte-Robert 1752–1834 Paris)
Ruins of a Castle on a Cliff by the Sea
Watercolor over traces of black chalk on
off-white wove paper
312 × 399 mm.
Provenance: Nicolas Joly at Galerie Yves
Mikaeloff, Paris; acquired in 1998,
D-F-575/ 1.1998.36

A.255
Jean-Pierre **Norblin de la Gourdaine**
(Misy-Fault-Yonne 1745–1830 Paris)
Belisarius
Red chalk on cream laid paper
232 × 178 mm.
Provenance: W. M. Brady and Co., New
York; acquired in 1998, D-F-618/ 1.1998.70

A.256
Michel-Barthélemy **Ollivier**
(Marseille 1712–1784 Paris)
Seated Young Woman
Black and red chalk heightened with white
chalk on off-white antique laid paper
147 × 194 mm.
Provenance: Jean Masson, Paris (L.s. 1494a);
Galerie de Bayser, Paris; acquired in 1998,
D-F-592/ 1.1998.54
[Repr.: this page]

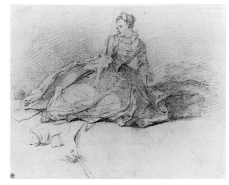

A.256

A.257
Gilles-Marie **Oppenord**
(Paris 1672–1742 Paris)
Architectural Caprice in a Landscape
Pen and black ink with brush and gray wash
on off-white antique laid paper
427 × 560 mm.
Provenance: Galerie Cailleux, Paris;
acquired in 1994, D-F-210/ 1.1995.33

A.258
Jean-Baptiste **Oudry**
(Paris 1686–1755 Beauvais)
Fighting Wolves
Pen and black ink with brush and gray
wash, heightened with white gouache,
over traces of black chalk on blue
antique laid paper
314 × 547 mm.
Provenance: Galerie de Bayser, Paris;
acquired in 1998, D-F-583/ 1.1998.44

A.259
Heron in a Landscape
Pen and gray ink with watercolor on
off-white antique laid paper
320 × 246 mm.
Provenance: Alain Latreille, Paris; acquired
in 1990, D-F-215/ 1.1993.100

A.260
The Power of Fables, 1731
Brush with black ink and gray wash,
heightened with white gouache, with a
frame in blue wash on blue antique laid
paper
310 × 260 mm.
Provenance: One of a series of drawings for
illustrations to the *Fables* of Jean de La
Fontaine bound in two albums sold by
the artist to M. de Montenault, c. 1751;
de Bure brothers, Paris (by 1828); sale of
J. J. de Bure, Paris, 1–18 December 1853,
lot 344; Comte Adolphe-Narcisse
Thibaudeau, Paris; sale to Félix Solar
in 1856; his sale, Paris, 19 November–
8 December 1860, lot 627; Baron Isidore
Taylor, Paris; sale to Morgand and
Fatout, booksellers, Paris (c. 1876); sale
to Emile Pereire, Paris; sale to Louis
Olry-Roederer, Reims; his family, by
descent; Dr. A. S. W. Rosenbach and the
Rosenbach Co., Philadelphia and New
York (in 1923); sale to Raphael Esmerian,
New York (c. 1946); his sale, Galliera,
Paris, 6 June 1973, part 3, lot 46; one
album to the British Rail Pension Fund,
London, and one album dismembered;
Private Collection; Clovis Whitfield Fine
Art Ltd., London; acquired in 1998,
D-F-626/ 1.1998.76

A.261
The Shepherd and the King, 1732
Brush with black ink and gray wash,
heightened with white gouache, with
a frame in blue wash on blue antique
laid paper
310 × 260 mm.
Provenance: As in cat. A.260;
D-F-627/ 1.1998.77

A.262
*Woman in a Garden with Figures Seated
under a Trellis in the Distance*
Pen and brown ink with brush and brown
wash, heightened with white gouache, on
blue antique laid paper
200 × 200 mm.
Provenance: Sale, Drouot, Paris, 13
December 1963, lot 33 (as Netscher);
Geneviève Aymonier-Férault (as of
1964); Collection Cailleux (mark not in
Lugt); sale, Christie's, London, 4 July
1995, lot 129; acquired at the sale,
D-F-213/ 1.1995.100

A.263
Jean-Baptiste **Oudry** and studio
(Paris 1686–1755 Beauvais)
Scene of Debauchery
Pen and black ink, black chalk, and brush
and gray wash, heightened with white
gouache, on tan antique laid paper
314 × 450 mm.
Provenance: Sale, Christie's, Monaco,
30 June 1995, lot 104; acquired at the
sale, D-F-214/ 1.1995.85

A.264
Study of a Pumpkin Vine
Black chalk heightened with white chalk on
blue antique laid paper
314 × 479 mm.
Provenance: Unidentified collector's mark;
Jean-Luc Baroni at Colnaghi, London
and New York; acquired in 1984,
D-F-212/ 1.1993.102

A.265
Antoine **Paillet** (Paris 1626–1701 Paris)
*Allegorical Portrait of a Man and Two
Women in a Chariot*
Pen and dark brown ink with brush and
brown wash, heightened with white
gouache, over black chalk on light tan
prepared antique laid paper
375 × 281 mm.
Provenance: Galerie Emmanuel Moatti,
Paris; acquired in 1994, D-F-216/ 1.1994.23

A.266
Augustin **Pajou** (Paris 1730–1809 Paris)
Allegory of Music
Red chalk on cream antique laid paper
306 × 204 mm.
Provenance: Alain Latreille, Paris; acquired
in 1990, D-F-218/ 1.1993.104
[Repr.: cat. 85, fig. 3]

A.267
Anacreon and Amor, 1777
Red chalk over black chalk on cream
antique laid paper
302 × 451 mm.
Provenance: Sale, Christie's, London,
4 July 1995, lot 273 (as French School
18th century); acquired at the sale,
D-F-220/ 1.1995.112
[Repr.: cat. 112, fig. 1]

A.268
*Antique Statue of a Standing Female in the
Villa Medici, Rome*
Pen and brown ink with brush and brown
wash on off-white laid paper
276 × 151 mm.
Provenance: From a sketchbook in the
collection of the artist at his death; Pajou
family, by descent; Private Collection;
Galerie Cailleux, Paris; acquired in 1996,
D-F-374/ 1.1996.43

A.269
Gate and Garden of the Villa Negroni, Rome
Black chalk on cream antique laid paper
134 × 192 mm.
Provenance: As in cat. A.268,
D-F-373/ 1.1996.42

A.270
Plant Study (recto)*; Studies of Putti* (verso)
Black chalk on cream antique laid paper
(recto and verso)
189 × 125 mm.
Provenance: As in cat. A.268;
D-F-391/ 1.1996.60

A.271
*Study for a Monument to a Naval
Commander*
Pen and brown ink with brush and brown
wash over black chalk on light tan laid
paper
492 × 326 mm.
Provenance: Arthur M. Sackler, New York;
sale, Christie's, New York, 12 January
1995, lot 183; acquired at the sale,
D-F-219/ 1.1995.28

A.272
Philippe Louis **Parizeau**
(Paris 1740–1801 Paris)
Portrait of an Older Man, 1775
Red chalk on light tan laid paper
490 × 387 mm.
Provenance: Galerie de Bayser, Paris;
acquired in 1997, D-F-526/ 1.1997.24

A.273
Scene of Military Capture
Red chalk over traces of black chalk on
cream laid paper
514 × 700 mm.
Provenance: Nicolas Joly at Galerie Yves
Mikaeloff, Paris; acquired in 1996,
D-F-446/ 1.1996.97

A.274
Soldiers in Discussion before a Building
Red chalk on off-white laid paper
332 × 235 mm.
Provenance: Sale, Christie's, New York,
30 January 1998, lot 288; acquired after
the sale, D-F-557/ 1.1998.20

A.275
Charles **Parrocel** (Paris 1688–1752 Paris)
Soldiers on the March
Pen and brown ink with brush and gray
wash over black chalk on off-white
antique laid paper
548 × 408 mm.
Provenance: Baron Dr. ver Hayden
de Lancey; Jean-Luc Baroni at
Colnaghi, London; acquired in 1986,
D-F-222/ 1.1993.105

A.276

Soldiers Playing Cards before a Tavern
Red chalk on two joined pieces of cream
 antique laid paper
710 × 334 mm.
Provenance: Sale, Christie's, Monaco,
 30 June 1995, lot 94; acquired at the
 sale, D-F-223/ 1.1995.84
[Repr.: cat. 39, fig. 1]

A.277

Etienne Parrocel, called **Parrocel le Romain**
 (Avignon 1696–1776 Rouen)
Studies of a Bearded Man in Profile (recto)*;*
Studies of a Seated Cardinal, a Young
Man, an Arm and Hands (verso)
Red chalk heightened with white chalk on
 light tan antique laid paper (recto and
 verso)
391 × 256 mm.
Provenance: Nicolas Joly at Galerie Yves
 Mikaeloff, Paris; acquired in 1995,
 D-F-224/ 1.1995.68

A.278

Joseph-François **Parrocel**
 (Avignon 1704–1781 Paris)
God the Father
Black chalk heightened with white chalk on
 tan antique laid paper
334 × 292 mm.
Provenance: W. M. Brady and Co.,
 New York; acquired in 1993,
 D-F-225/ 1.1993.106

A.279

The Virgin Ascending: Study for an
 Assumption
Black and white chalk on grayish-tan
 antique laid paper
476 × 389 mm.
Provenance: Alain Latreille, Paris; acquired
 in 1990, D-F-226/ 1.1993.15

A.280

Pierre **Parrocel** (Avignon 1670–1739 Paris)
Christ Healing the Mother-in-Law of Simon
Black chalk heightened with white chalk on
 light tan antique laid paper
211 × 357 mm., sight
Provenance: W. M. Brady and Co.,
 New York; acquired in 1994,
 D-F-227/ 1.1994.62

A.281

Laurent **Pécheux** (Lyon 1729–Turin 1821)
Sadness of Achilles
Brush and brown wash with extensive
 heightening in white gouache over black
 chalk on green prepared laid paper
252 × 335 mm.
Provenance: Sale, Christie's, New York,
 19 January 1995, lot 112, acquired at the
 sale, D-F-229/ 1.1995.26

A.282

A.282

Gabriel **Perelle**
 (Vernon-sur-Seine 1603–1677 Paris)
Piazza Colonna, Rome
Pen and brown ink on light tan antique laid
 paper
141 × 258 mm.
Provenance: Galerie Patrick Perrin, Paris;
 acquired in 1997, D-F-141/ 1.1997.14
[Repr.: this page]

A.283

François **Perrier** (Pontarlier, Franche-
 Comté 1594–1649 Paris)
Allegory of Glory (recto); *Standing Putto*
 with Elevated Arms (verso)
Black chalk with traces of white chalk on
 light tan antique laid paper (recto); red
 chalk on light tan antique laid paper
 (verso)
173 mm. diameter
Provenance: Hazlitt, Gooden and Fox,
 Ltd., London; acquired in 1997,
 D-F-480/ 1.1997.27
[Repr.: this page]

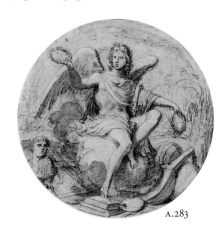

A.283

A.284

Jean-Baptiste **Perroneau**
 (Paris 1715–1783 Amsterdam)
Presumed Portrait of Madame Jean-Baptiste
 Chevotet, 1748
Pastel on parchment
525 × 425 mm.
Provenance: Perhaps gift of the artist to his
 grandson; M. Roux, Tours; his sale, Paris,
 17–20 February 1868, lot 480; Alfred
 Mame, Paris; his sale, Paris, 26 April
 1904, lot 64; Armand Mame, Paris; his

sale, Drouot, Paris, 14 June 1960, lot 17;
 Galerie Cailleux, Paris; sale, Christie's,
 New York, 30 January 1998, lot 252;
 acquired at the sale, D-F-556/ 1.1998.65

A.285

Jean-François-Pierre **Peyron**
 (Aix-en-Provence 1744–1814 Paris)
Lucius Sergius Catalina Inciting Insurrection
Pen and gray ink with brush and gray wash
 on cream laid paper
255 × 189 mm.
Provenance: Marcel Puech, Avignon (mark
 not in Lugt); sale, Christie's, Monaco,
 2 July 1993, lot 86; acquired at the sale,
 D-F-232/ 1.1993.189
[Repr.: MRC ess., fig. 33]

A.286

Bernard **Picart** (Paris 1673–1733 Amsterdam)
Christ Led Away from Pilate
Pen and black ink with brush and gray wash
 and touches of brown wash on off-white
 antique laid paper
323 × 212 mm.
Provenance: Galerie Jean-François Baroni,
 Paris; acquired in 1995, D-F-348/ 1.1996.24

A.287

Attributed to Bernard **Picart**
 (Paris 1673–1733 Amsterdam)
Seated Lion with a Bridle
Red chalk on cream antique laid paper
240 × 399 mm.
Provenance: L. S. Adam, Paris (L. 4); Galerie
 Patrick Perrin, Paris; acquired in 1996,
 D-F-359/ 1.1996.28

A.288

Jean-Baptiste-Marie **Pierre**
 (Paris 1714–1789 Paris)
Discovery of Moses
Black chalk heightened with white chalk on
 tan antique laid paper
419 × 323 mm.
Provenance: Nicolas Joly at Galerie Yves
 Mikaeloff, Paris; acquired in 1998,
 D-F-578/ 1.1998.39

A.289

Jupiter and Juno
Red chalk on off-white antique laid paper
210 × 260 mm.
Provenance: Jean Lavit, Paris; acquired in
 1991, D-F-238/ 1.1993.110

A.290

Penitent Magdalen in a Landscape
Pen and black ink with brush and gray wash
 on off-white antique laid paper
312 × 222 mm.
Provenance: Didier Aaron et Cie, Paris;
 acquired in 1984, D-F-236/ 1.1993.108

A.291

St. Jerome in a Landscape
Pen and black ink with brush and gray wash
on off-white antique laid paper
315 × 222 mm.
Provenance: Didier Aaron et Cie, Paris;
acquired in 1984, D-F-235/ 1.1993.112

A.292

Seated Female Nude Aloft
Red chalk heightened with white gouache
on tan antique laid paper
451 × 333 mm.
Provenance: Galerie Emmanuel Moatti,
Paris; acquired in 1995, D-F-325/ 1.1995.90
[Repr.: cat. 69, fig. 3]

A.293

Seated Male Nude Playing a Flute
Red chalk heightened with white gouache
on tan antique laid paper
443 × 420 mm.
Provenance: Thomas Le Claire,
Kunsthandel, Hamburg; acquired in
1996, D-F-365/ 1.1996.34

A.294

Unidentified Biblical Scene
Pen and black ink with brush and gray wash
on off-white antique laid paper
336 × 540 mm.
Provenance: Unidentified collector;
A. Finot, Paris (mark not in Lugt);
Galerie Eric Coatalem, Paris; acquired in
1998, D-F-577/ 1.1998.37

A.295

*Vulcan Presents Venus with the Arms of
Aeneas*
Red chalk, squared with stylus, on cream
antique laid paper
365 × 470 mm.
Provenance: Jean Lavit, Paris; acquired in
1991, D-F-237/ 1.1993.109
[Repr.: MRC ess., fig. 30]

A.296

Jean-Baptiste **Pillement**
(Lyon 1728–1808 Lyon)
*Mountainous Landscape with Peasants
Herding Cattle*
Colored gouache on paper, laid down
on canvas
530 × 770 mm.
Provenance: Jean-Pierre Selz, Paris
and New York; acquired in 1993,
D-F-242/ 1.1993.175

A.297

*Mountainous Landscape with Peasants
Herding Sheep*
Colored gouache on paper, laid down on
canvas
528 × 767 mm.
Provenance: Jean-Pierre Selz, Paris
and New York; acquired in 1993,
D-F-241/ 1.1993.176

A.298

*Peasant Boy Seen from Behind, Holding a
Basket of Flowers*
Black and red chalk on off-white antique
laid paper
230 × 160 mm.
Provenance: Hazlitt, Gooden and Fox,
Ltd., London; acquired in 1994,
D-F-243/ 1.1994.52

A.299

Rustic Landscape
Black chalk on off-white antique laid paper
364 × 503 mm.
Provenance: Jean-Luc Baroni at
Colnaghi, London; acquired in 1984,
D-F-240/ 1.1993.113

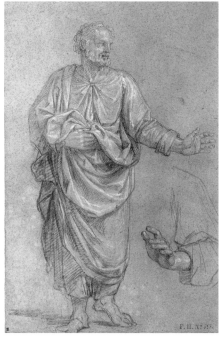

A.300

A.300

Nicolas de **Plattemontagne**
(Paris 1631–1706 Paris)
*Bearded Man in Classical Dress Walking
Forward, with Subsidiary Study of a Hand
and an Arm*
Black chalk heightened with white chalk on
tan antique laid paper
388 × 254 mm.
Provenance: Collection Flury-Hérard, Paris
(L. 1015, his no. 625); Charles-Philippe,
marquis de Chennevières-Pointel, Paris
(L. 2072); Private Collection, France;
Galerie de Bayser, Paris; acquired in 1994,
D-F-245/ 1.1995.3
[Repr.: this page]

A.301

Two Women Surprised
Red chalk heightened with white chalk on
tan antique laid paper
200 × 266 mm.

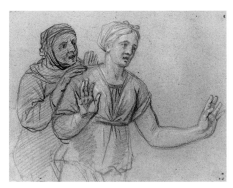

A.301

Provenance: Galerie de Bayser, Paris;
acquired in 1995, D-F-246/ 1.1995.51
[Repr.: this page]

A.302

Charles-François **Poerson**
(Vic-sur-Seille 1609–1667 Paris)
Presentation of Helen to Priam
Black chalk heightened with white chalk on
tan antique laid paper
204 mm. diameter
Provenance: Galerie de Staël, Paris; acquired
in 1994, D-F-247/ 1.1994.15
[Repr.: this page]

A.303

Jacques-André **Portail**
(Brest 1695–1759 Versailles)
View of the Cour Carrée of the Louvre
Black chalk on off-white antique laid paper
254 × 378 mm.
Provenance: Charles-Philippe, marquis de
Chennevières-Pointel, Paris (L. 2073);
sale, Sotheby's, New York, 10 January
1995, lot 131; acquired at the sale,
D-F-250/ 1.1995.31

A.304

Young Girl Reading
Red and black chalk on cream antique
laid paper
284 × 216 mm.
Provenance: Jean-Pierre Selz, Paris
and New York; acquired in 1987,
D-F-248/ 1.1993.114
[Repr.: cat. 48, fig. 1]

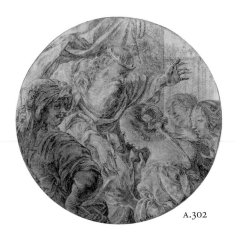

A.302

A.305
Pierre-Paul **Prud'hon**
(Cluny 1758–1823 Paris)
Seated Female Nude
Black chalk heightened with white chalk on
faded blue antique laid paper
424 × 283 mm.
Provenance: Sale, Férault, Paris,
28 November–21 December 1929,
lot 121; Galerie Cailleux, Paris (mark
at bottom right); acquired in 1983,
D-F-253/ 1.1993.117
[Repr.: Interview, fig. 1]

A.306
*Torso of a Female Nude Silhouetted by
Drapery*
Black chalk, extensively stumped,
heightened with white chalk, on blue
wove paper
297 × 455 mm.
Provenance: Galerie Emmanuel Moatti,
Paris; acquired in 1997, D-F-518/ 1.1997.55

A.307
François **Quesnel**
(Edinburgh 1544–1616 Paris)
*Charles de Neuville, Sieur de Villeroy et
d'Alincourt*
Black and red chalk heightened with white
chalk on off-white antique laid paper
308 × 235 mm.
Provenance: Sale, Galerie Georges Petit,
Paris, 3 May 1909, lot 39; Jean-Pierre Selz,
Paris and New York; acquired in 1992,
D-F-255/ 1.1993.118
[Repr.: this page]

A.308
Daniel **Rabel** and studio
(Paris 1578–1637 Paris)
Costume Design for a Huntsman
Pen and brown ink with watercolor,
heightened with gold, over black chalk
on off-white antique laid paper
310 × 208 mm.
Provenance: Sale, Sotheby's, New York,
9 January 1996, lot 102; acquired at the
sale, D-F-353/ 1.1996.4

A.309
Jean-Baptiste, baron **Regnault**
(Paris 1754–1829 Paris)
Judgment of Paris
Pen and black ink with brush and gray-
brown wash over traces of black chalk
on off-white wove paper
184 × 141 mm.
Provenance: Alain Latreille, Paris; acquired
in 1990, D-F-256/ 1.1993.119

A.310
Jupiter and Io
Black and white chalk, extensively stumped,
on off-white antique laid paper
312 × 268 mm.

Provenance: Paul Weis, New York; acquired
in 1991, D-F-257/ 1.1993.120

A.311
Seated Female Nude
Black chalk on cream laid paper
354 × 221 mm.
Provenance: Galerie Jean-François Baroni,
Paris; acquired in 1997, D-F-538/ 1.1998.1

A.312
Jean-Augustin **Rénard**
(Paris 1744–1807 Paris)
*Densely Wooded Landscape with a Fountain
and Ruins*
Pen and brown ink with brush and gray and
three tones of brown wash, heightened
with white and colored gouache, over
graphite on light tan laid paper
412 × 556 mm.
Provenance: Nicolas Joly at Galerie Yves
Mikaeloff, Paris; acquired in 1996,
D-F-473/ 1.1997.12

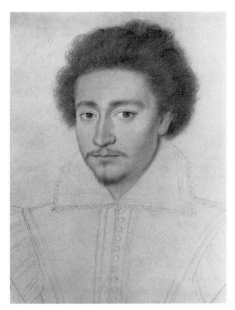
A.307

A.313
Jean II **Restout** (Rouen 1692–1768 Paris)
Head of a Man
Black chalk heightened with white chalk on
light tan antique laid paper
232 × 189 mm.
Provenance: Perhaps André Hippolyte
Lemmonier, Rouen and Paris (close to
L.s. 1330a); Jean-Christophe Baudequin
at Galerie Ratton et Ladrière, Paris;
acquired in 1996, D-F-376/ 1.1996.45
[Repr.: bibliography frontispiece]

A.314
*Seated Male Nude Supporting the Upper
Body of a Collapsed Male Nude*
Black and red chalk heightened with white
chalk on tan antique laid paper

388 × 498 mm.
Provenance: Frederick J. Cummings,
New York; acquired in 1990,
D-F-258/ 1.1993.121

A.315
Pierre **Révoil** (Lyon 1776–1842 Paris)
Musicians at a Virginal
Pen and brown ink with brush and gray and
brown washes on off-white wove paper
336 × 238 mm.
Provenance: Stair Sainty-Mathiesen,
New York; acquired in 1996,
D-F-466/ TL35787.12

A.316
Antoine **Rivalz**
(Toulouse 1667–1735 Toulouse)
Man Leaning on a Staff, Seen from Behind
(recto)*; Running Woman and Seated Man*
(verso)
Black chalk heightened with white chalk on
light tan antique laid paper (recto); black
chalk on light tan antique laid paper
(verso)
474 × 370 mm.
Provenance: Pierre Gaubert, Paris; Galerie
de Bayser, Paris; acquired in 1995,
D-F-351/ 1.1995.98

A.317
Hubert **Robert** (Paris 1733–1808 Paris)
Kneeling Man in Middle Eastern Costume
Red chalk on off-white antique laid paper
400 × 543 mm.
Provenance: Eugène Rodrigues, Paris
(L. 897); Galerie de Bayser, Paris;
acquired in 1996, D-F-384/ 1.1996.53

A.318
Shelter and a Well amidst Ruins
Red chalk on off-white antique laid paper
415 × 554 mm.
Provenance: Jacques-Auguste Boussac
(L.s. 729b); Galerie Cailleux, Paris;
acquired in 1997, D-F-484/ 1.1997.31

A.319
Follower of Hubert **Robert**
(Paris 1733–1808 Paris)
Study of Trees
Red chalk on off-white laid paper
530 × 400 mm.
Provenance: Christian Humann, New York;
sale, Sotheby's, New York, 21 January
1983, lot 183; Richard Day, London;
acquired in 1984, D-F-262/ 1.1993.124

A.320
Nicolas **Robert** (Langres 1614–1685 Paris)
Albino Turkey (Meleagris Gallopavo)
Watercolor and gouache on parchment
369 × 291 mm.
Provenance: Marcel Jeanson; his sale,
Sotheby's, Monaco, 16 June 1988, lot 83;
Kate de Rothschild, London; acquired in
1996, D-F-405/ 1.1996.81

A.321

Nicolas **Robert** and studio
 (Langres 1614–1685 Paris)
Bird Study: Jackdaw (Corvus Monedula)
Watercolor and gouache over traces of black
 chalk on parchment
378 × 340 mm.
Provenance: Sale, Sotheby's, London,
 13 December 1996, lot 51; acquired at
 the sale, D-F-469/ 1.1997.8

A.322

Bird Study: Male Variable Seedeater
 (Sporophila Americana)
Watercolor and gouache over traces of black
 chalk on parchment
334 × 252 mm.
Provenance: Sale, Sotheby's, London,
 13 December 1996, lot 32; acquired
 at the sale, D-F-468/ 1.1997.7

A.323

Bird Study: South American Troupial
 (Icterus Icterus)
Watercolor and gouache over traces of black
 chalk on parchment
350 × 302 mm.
Provenance: Sale, Sotheby's, London,
 13 December 1996, lot 14; acquired
 at the sale, D-F-467/ 1.1997.6

A.324

François **Roëttiers**
 (London 1685–1745 Vienna)
Moses Striking the Rock
Pen and brown ink on light tan antique
 laid paper
420 × 567 mm.
Provenance: Sale, Sotheby's, New York,
 13 January 1988, lot 241; acquired at
 the sale, D-F-263/ 1.1993.8

A.325

Attributed to Joseph Charles **Roëttiers**
 (Paris 1692–1779 Paris)
Allegory of Winter (?)
Pen and brown ink with brush and gray
 wash on off-white antique laid paper
229 × 360 mm.
Provenance: Galerie Eric Coatalem, Paris;
 acquired in 1998, D-F-596/ 1.1998.58

A.326

Jacques **Rousseau** (Paris 1630–1693 London)
Rustic Landscape with Two Figures
Red chalk on off-white antique laid paper
138 × 189 mm.
Provenance: Sir Thomas Lawrence, London
 (L. 2445); the 2nd Lord Ashburton;
 Simon Dickinson, Inc., London; Galerie
 Cailleux, Paris; acquired in 1996,
 D-F-329/ 1.1996.18

A.327

Augustin de **Saint-Aubin**
 (Paris 1736–1807 Paris)
Portrait of a Young Man
Black chalk, extensively stumped, on white
 wove paper
266 × 214 mm.
Provenance: Neal Fiertag, Paris and New
 York; acquired in 1996, D-F-366/ 1.1996.35

A.328

David **Sambin**
 (Active in Dijon and Paris, c. 1560–1585)
*Two Studies after a Headless Antique
 Sculpture of a Seated Female*
Pen and brown ink on cream antique laid
 paper
215 × 256 mm.
Provenance: Galerie de Bayser, Paris;
 acquired in 1997, D-F-494/ 1.1997.48

A.329

Nicolas Charles de **Silvestre**
 (Versailles 1699–1767 Valenton)
Tree in an Open Landscape
Brown chalk on off-white antique laid paper
310 × 210 mm.
Provenance: Thomas Le Claire,
 Kunsthandel, Hamburg; acquired in
 1997, D-F-462/ 1.1997.5

A.330

René Michel Slodtz, called Michel-Ange
 Slodtz (Paris 1705–1764 Paris)
Study of a Dog Looking Upwards
After Annibale Carracci (1560–1609)
Red chalk on cream antique laid paper
451 × 350 mm.
Provenance: Chevalier de Damery, Paris
 (L. 2862); Collection L. Berger (mark not
 in Lugt); Galerie Cailleux, Paris; acquired
 in 1994, D-F-266/ 1.1995.6

A.331

Pierre Hubert **Subleyras**
 (Saint-Gilles-du-Gard 1699–1749 Rome)
Moses and the Brazen Serpent
Black chalk on blue antique laid paper
351 × 459 mm.
Provenance: Charles Gasc, Paris (L. 543);
 Galerie Emmanuel Moatti, Paris;
 acquired in 1994, D-F-270/ 1.1994.28

A.332

Kneeling Ecclesiastic
After Benedetto Luti (1666–1724)
Black chalk heightened with traces of white
 chalk on off-white antique laid paper
356 × 249 mm.
Provenance: Jean-Denis Lempereur, Paris
 (L. 1740); sale, Drouot, Paris, 24 January
 1980, lot 295; Galerie Heim, Paris;
 Private Collection, Avignon; sale, Paris,
 16 July 1987, lot 9; Frederick J.
 Cummings, New York; acquired in
 1990, D-F-269/ 1.1993.126

A.333

Joseph-Benoît **Suvée**
 (Bruges 1743–1807 Rome)
*Standing Man in Voluminous Drapery, with
 Outstretched Arms*
Black chalk and traces of white chalk on
 blue laid paper
557 × 394 mm.
Provenance: Galerie Paul Prouté, S.A., Paris;
 acquired in 1996, D-F-380/ 1.1996.49

A.334

Jean-Joseph **Taillasson**
 (Bordeaux 1745–1809 Paris)
Danaë and Perseus Adrift in a Chest
Black chalk on off-white laid paper
315 × 436 mm.
Provenance: Gabriel Terrades at Galerie
 Grunspan, Paris; acquired in 1996,
 D-F-444/ 1.1996.103

A.335

Louis Gustave **Taraval**
 (Stockholm 1738–1794 Paris)
The Visitation
Pen and black and brown ink with brush
 and gray wash, heightened with white
 gouache, squared in black chalk, on
 faded blue antique laid paper
570 × 420 mm.
Provenance: Nicolas Joly at Galerie Yves
 Mikaeloff, Paris; acquired in 1997,
 D-F-572/ 1.1998.28

A.336

Nicolas Antoine **Taunay**
 (Paris 1755–1830 Paris)
Classical Landscape with Two Lovers
Black chalk, extensively stumped, on
 off-white wove paper
315 × 387 mm.
Provenance: W. M. Brady and Co.,
 New York; acquired in 1996,
 D-F-414/ TL35470.14

A.337

Jean-Thomas **Thibault**
 (Moutier-en-Der 1757–1826 Paris)
Classical Landscape
Black chalk with brush and brown wash,
 heightened with white gouache, squared
 in black chalk, on tan wove paper
485 × 216 mm.
Provenance: Galerie Cailleux, Paris;
 acquired in 1997, D-F-561/ 1.1998.22

A.338

Luc Vincent **Thiery de St. Colombe**
 (Paris 1734–after 1811 Paris)
*Temple on a Hill above a River with Figures
 Arriving in a Boat*, 1785
Pen and black ink with brush and
 watercolor and white gouache on
 off-white wove paper
166 × 245 mm.
Provenance: Hazlitt, Gooden and Fox,

Ltd., London; acquired in 1994,
D-F-274/ 1.1994.53

A.339
Jean **Touzé** (Paris 1747–1809 Paris)
The Charlatan
Black chalk on off-white laid paper
218 × 271 mm.
Provenance: Edmond and Jules de
 Goncourt, Paris; Didier Aaron et Cie,
 Paris, acquired in 1995, D-F-277/ 1.1995.69

A.340
Jean-Baptiste **Vanloo** (Aix-en-Provence
 1684–1745 Aix-en-Provence)
Ascension of Christ
Pen and brown ink with brush and brown
 wash, heightened with white gouache, on
 tan antique laid paper
323 × 238 mm.
Provenance: W. M. Brady and Co., New
 York (as J. II Cellony); acquired in 1993,
 D-F-46/ 1.1993.160

A.341
Jules-César-Denis Vanloo, called Jules-César
 Vanloo (Paris 1743–1821 Paris)
Landscape with a Temple on a Hill
Brush and brown wash over black chalk on
 cream laid paper
349 × 509 mm.
Provenance: Charles-Philippe, marquis de
 Chennevières-Pointel, Paris (L. 2073);
 Louis Deglatigny, Rouen (L.s. 1768a);
 Jacques Petithory, Paris (mark not
 in Lugt); acquired in 1989,
 D-F-280/ 1.1993.131

A.342
Louis-Claude **Vassé** (Paris 1716–1772 Paris)
Crouching Venus
Red chalk on cream antique laid paper
487 × 317 mm.
Provenance: Sale, Christie's, London,
 1 July 1997, lot 142 (as French school,
 18th century); acquired at the sale,
 D-F-515/ 1.1997.50

A.343
*Design for the Monument to the Heart of
 Queen Maria Leczinska*
Red chalk over graphite on off-white
 antique laid paper
449 × 296 mm.
Provenance: Collection of the artist at his
 death; his family, by descent; Jean-Pierre
 Selz, Paris and New York; acquired in
 1989, D-F-282/ 1.1993.133
[Repr.: cat. 75, fig. 3]

A.344
St. Cecilia (?)
Red chalk on off-white laid paper
174 × 249 mm.
Provenance: Gabriel Terrades at Galerie
 Grunspan, Paris; acquired in 1997,
 D-F-500/ 1.1997.42

A.345
Antoine Laurent Thomas **Vaudoyer**
 (Paris 1756–1846 Paris)
Landscape with Hills in the Distance
Black chalk heightened with white chalk on
 blue laid paper
225 × 300 mm.
Provenance: Kate de Rothschild, London;
 acquired in 1996, D-F-455/ 1.1996.109

A.346
François **Verdier** (Paris 1651–1730 Paris)
Seated Woman Holding onto a Column
Red chalk heightened with white chalk on
 tan antique laid paper
284 × 198 mm.
Provenance: Jean-Christophe Baudequin
 at Galerie Ratton et Ladrière, Paris;
 acquired in 1994, D-F-283/ 1.1995.19
[Repr.: this page]

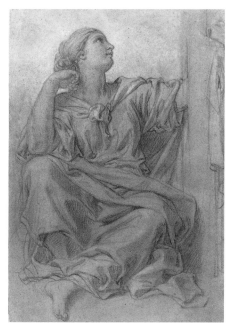

A.346

A.347
Antoine-Charles-Horace, called Carle
 Vernet (Bordeaux 1758–1836 Paris)
Horse Tamers, 1832
Watercolor on off-white wove paper
185 × 257 mm.
Provenance: Galerie Emmanuel Moatti,
 Paris; acquired in 1997, D-F-517/ 1.1997.54

A.348
Claude-Joseph Vernet, called Joseph **Vernet**
 (Avignon 1714–1789 Paris)
*Coastal Scene near Naples with Boats and
 Workers*, 1755 (?)
Pen and brown ink with brush and brown
 wash on off-white paper
261 × 420 mm.
Provenance: Jean Masson, Paris (L.s. 1494a);
 Galerie de Bayser, Paris; acquired in 1995,
 D-F-285/ 1.1995.70

A.349
River Landscape
Black chalk, pen and brown ink, and brush
 and brown and gray wash on light tan
 laid paper
295 × 434 mm.
Provenance: Renaud Jouslin de Noray, Paris;
 acquired in 1996, D-F-440/ 1.1996.95

A.350
Antoine **Vestier** (Avallon 1740–1824 Paris)
Marie-Nicole, Daughter of the Artist
Pastel on paper adhered to canvas
575 × 468 mm.
Provenance: Private Collection, Germany;
 Franco Zangrilli, New York; acquired in
 1984, D-F-122/ 1.1993.62
[Repr.: cat. 81, fig. 2]

A.351
Joseph-Marie **Vien**
 (Montpellier 1716–1809 Paris)
Head of a Bearded Man
Red chalk on cream laid paper
497 × 400 mm.
Provenance: Gabriel Terrades at Galerie
 Grunspan, Paris; acquired in 1995,
 D-F-287/ 1.1995.55

A.352
Head of St. Germain
Red chalk on cream laid paper
329 × 314 mm.
Provenance: Michel Gierzod, Paris; acquired
 in 1996, D-F-354/ 1.1996.11
[Repr.: cat. 74, fig. 3]

A.353
Love Giving the Prize
Pen and black ink with brush and brown
 wash on off-white laid paper
195 × 277 mm.
Provenance: Galerie Cailleux, Paris;
 acquired in 1997, D-F-487/ 1.1997.34

A.354
View of Rome with the Villa Malta (recto);
 Standing Draped Man (verso)
Black chalk heightened with white chalk on
 blue laid paper (recto); black chalk on
 blue laid paper (verso)
415 × 267 mm.
Provenance: Gabriel Terrades at Galerie
 Grunspan, Paris; acquired in 1996,
 D-F-457/ 1.1996.105

A.355
Marie-Louise Elizabeth **Vigée-Lebrun**
 (Paris 1755–1842 Paris)
*Study for a Portrait of the Countess
 Skavronsky*
Graphite on off-white antique laid paper
203 × 186 mm.
Provenance: Galerie Eric Coatalem, Paris;
 acquired in 1995, D-F-288/ 1.1995.64
[Repr.: next page]

A.355

A.356
François-André **Vincent**
 (Paris 1746–1816 Paris)
Antique Male Bust
Red chalk on cream antique laid paper
540 × 385 mm.
Provenance: Private Collection, Belgium;
 Renaud Jouslin de Noray, Paris; acquired
 in 1995, D-F-296/ 1.1995.57
[Repr.: MRC ess., fig. 32]

A.357
Clemency of Augustus
Pen and brown ink with brush and brown
 wash over traces of red chalk on cream
 laid paper
338 × 382 mm.
Provenance: Galerie Patrick Perrin, Paris;
 acquired in 1994, D-F-291/ 1.1994.30

A.358
Foot Studies
Red chalk on off-white laid paper
173 × 250 mm.
Provenance: Nicolas Joly at Galerie Yves
 Mikaeloff, Paris; acquired in 1994,
 D-F-295/ 1.1995.48

A.359
Gate and Garden of the Villa Negroni, Rome
Black chalk on off-white laid paper
249 × 174 mm.
Provenance: Nicolas Joly at Galerie Yves
 Mikaeloff, Paris; acquired in 1994,
 D-F-293/ 1.1995.12

A.360
Kneeling Woman with Outstretched Arm
 (recto); *Two Male Figures* (verso)
Pen and black ink with brush and gray wash
 over red chalk on off-white laid paper
 (recto); black chalk on off-white laid
 paper (verso)
200 × 215 mm.
Provenance: Thomas Le Claire,
 Kunsthandel, Hamburg; acquired in
 1995, D-F-294/ 1.1995.38

A.361
Roman Landscape
Black chalk on cream laid paper
303 × 466 mm.
Provenance: W. M. Brady and Co., New
 York; acquired in 1997, D-F-529/ 1.1997.57

A.362
Zeuxis Choosing His Models from the Women
 of Croton
Pen and black ink over traces of graphite,
 partially squared in black chalk, on
 off-white laid paper
410 × 532 mm.
Provenance: Unidentified collector's mark;
 E. Calando, Paris (L. 837); Private
 Collection, France; Didier Aaron et Cie,
 Paris; acquired in 1998, D-F-620/ 1.1998.72

A.363
Head of a Woman
After Raphael (1483–1520)
Red chalk over traces of black chalk on
 cream antique laid paper
526 × 412 mm. (irregular; corners trimmed)
Provenance: Louis Deglatigny, Rouen (L.s.
 1768a); W. M. Brady and Co., New York;
 acquired in 1989, D-F-290/ 1.1993.134
[Repr.: MRC ess., fig. 31]

A.364
Simon **Vouet** (Paris 1590–1649 Paris)
Niobe
Black chalk heightened with white chalk on
 light tan antique laid paper
264 × 205 mm.
Provenance: Eugène Fromentin, Paris; sale,
 Sotheby's, New York, 9 January 1996, lot
 40; acquired at the sale, D-F-345/ 1.1996.5
[Repr.: cat. 17, fig. 4]

A.365
Simon **Vouet** or his circle
 (Paris 1590–1649 Paris)
Head of Christ (recto); *Seated Man in a*
 Large Hat with Raised Right Arm (verso)
Black chalk with traces of heightening in
 white chalk on light tan antique laid
 paper (recto); red chalk on light tan
 antique laid paper (verso)
174 × 141 mm.
Provenance: Jean-Christophe Baudequin
 at Galerie Ratton et Ladrière, Paris;
 acquired in 1995, D-F-300/ 1.1995.93
[Repr.: this page]

A.366
Arnould de **Vuez**
 (Hautpont 1664–1720 Lille)
Expulsion of the Merchants from the Temple
Pen and black ink with brush and gray wash
 on off-white antique laid paper
209 × 411 mm.
Provenance: Nicolas de Joly at Galerie Yves
 Mikaeloff, Paris; acquired in 1995,
 D-F-301/ 1.1995.59
[Repr.: this page]

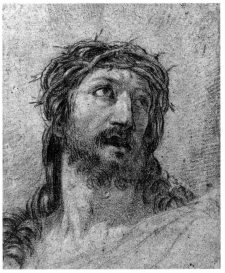

A.365

A.367
François-Louis-Joseph Watteau,
 called **Watteau de Lille**
 (Valenciennes 1758–1823 Lille)
Blindman's Bluff
Red and black chalk on off-white antique
 laid paper
352 × 451 mm.
Provenance: W. M. Brady and Co., New
 York; acquired in 1994, D-F-306/ 81.1995
[Repr.: MRC ess., fig. 21]

A.368
Village Carnival at Night
Red and black chalk heightened with white
 gouache on off-white laid paper
346 × 452 mm.
Provenance: W. M. Brady and Co.,
 New York; acquired in 1994,
 D-F-307/ 1.1994.34
[Repr.: MRC ess., fig. 22]

A.369
Jean-Antoine **Watteau** (Valenciennes 1684–
 1721 Nogent-sur-Marne)
Woman Holding Her Skirt
Red chalk on off-white antique laid paper
164 × 90 mm.
Provenance: Sale, Sotheby's, London,
 4 July 1994, lot 68; acquired at the sale,
 D-F-303/ 1.1994.59
[Repr.: next page]

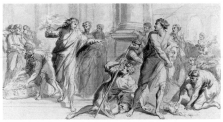

A.366

A.369

A.370

Jean-Baptiste-Joseph **Wicar**
 (Lille 1762–1834 Rome)
*Drapery Study for a Standing Man in
 Classical Dress*
Black chalk heightened with white gouache
 on tan laid paper
399 × 259 mm.
Provenance: Collection of the artist;
 Antonio Bianchi, his student; Bianchi
 family, by descent; Aldega-Gordon, New
 York; acquired in 1995, D-F-308/ 1.1995.42

A.371

Standing Man in a Toga Holding a Scroll
 (recto); *Study of Legs* (verso)
Black and white chalk, squared in black
 chalk, on light blue laid paper (recto);
 black and white chalk on light blue laid
 paper (verso)
224 × 134 mm.
Provenance: As in cat. A.370;
 D-F-309/ 1.1995.43

A.372

Pierre Alexandre **Wille**
 (Paris 1748–1821 Paris)
Card Party in an Elegant Interior, 1768
Pen and black ink with brush and brown
 wash, watercolor, and white gouache on
 off-white laid paper
385 × 328 mm.
Provenance: Comenos Gallery, Boston;
 acquired in 1997, D-F-537/ 1.1997.60

A.373

Head of an Old Woman Screaming, 1774
Brush and brown wash heightened with
 white gouache on brown laid paper
 [François Renaud, mounter, Paris
 (L. 1042)]
194 × 150 mm.
Provenance: Friedrich Quiring, Berlin
 (L.s. 1041c); D-F-310/ 1.1993.137

A.374

Old Man Accosting a Young Woman, 1774
Pen and black ink with brush and brown
 wash on light tan antique laid paper
307 × 253 mm.
Provenance: Nicolas Joly at Galerie Yves
 Mikaeloff, Paris; acquired in 1994,
 D-F-311/ 1.1994.21

A.375

Seated Man Asleep
Red chalk on off-white laid paper
499 × 372 mm.
Provenance: Guy and Christiane d'Aldecoa,
 Paris; acquired in 1997, D-F-581/ 1.1998.42

A.376

Village Wedding
Colored chalks with wash on off-white wove
 paper
670 × 990 mm.
Provenance: Collection Pelieveau, Paris;
 Didier Aaron et Cie, Paris; acquired in
 1998, D-F-621/ 1.1998.73

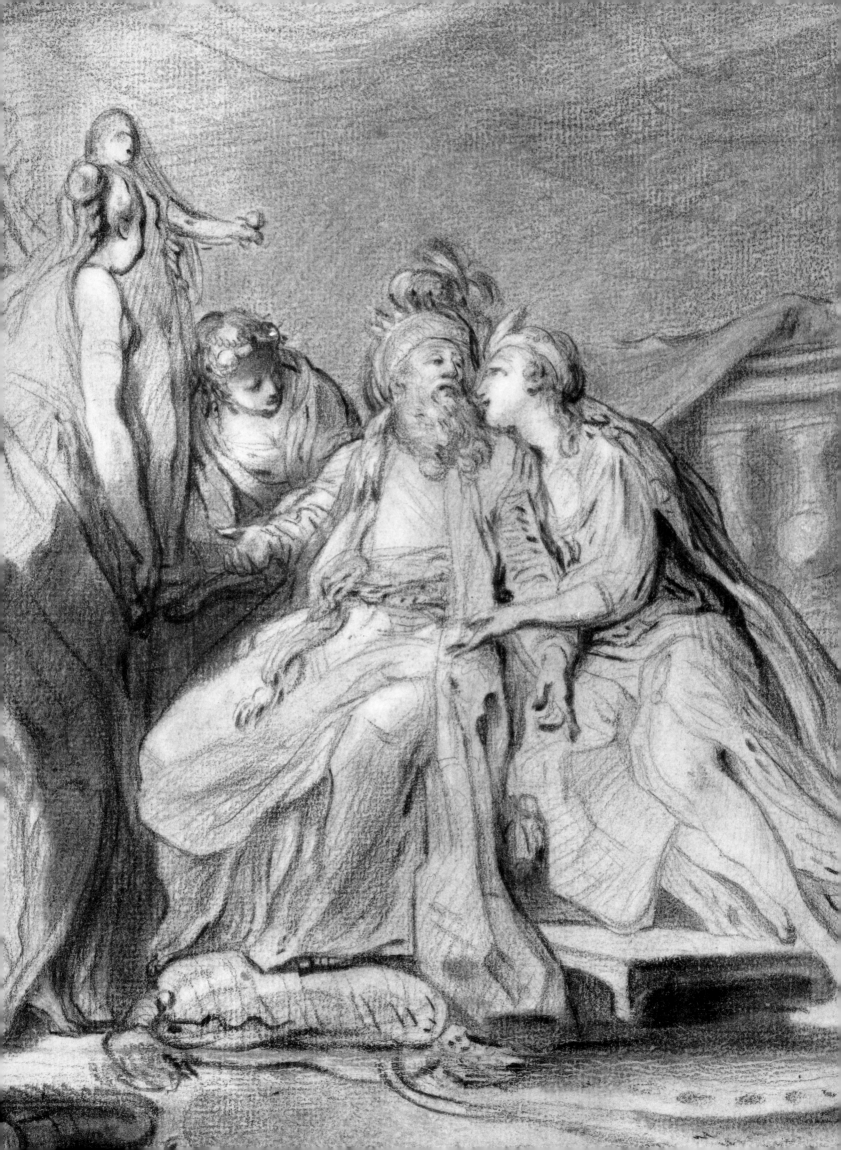

INDEX OF FORMER OWNERS

Standalone numbers refer to catalogue entries.
Numbers preceded by A refer to drawings in the Horvitz Collection
that are catalogued in the Appendix.

Galerie **Aaron-Terrades**, Paris: N. Coypel (20)

L. S. **Adam**, Paris [L. 4]: B. Picart (A.287)

Christian **Adrien**, Neuilly: S. M. Lantara (83)

Thos. **Agnew** and Sons, Ltd., London: F. Boucher (60); F. Boucher (A.38); J-H. Fragonard (89); J-H. Fragonard (A.131); J-H. Fragonard (A.132); F. Le Moyne (41); N. Poussin (8)

Guy and Christiane d'**Aldecoa**, Paris: P. A. Wille (A.375)

Aldega-Gordon, New York: L. Durameau (A.121); L. Durameau (A.122); J-B-J. Wicar (A.370); J-B-J. Wicar (A.371)

Galerie **Arnoldi-Livie**, Munich: C. Gillot (33)

The 2nd Lord **Ashburton**: J. Rousseau (A.326)

Jules-Robert **Auguste**, Paris: J-A. Watteau (35)

Geneviève **Aymonier-Férault**: J-B. Oudry (A.262)

Galerie Jean-François **Baroni**, Paris: P-A. Hennequin (A.153); N. Lancret (A.185); J-L. Legeay (68); J-L. Legeay (A.205); A-C-G. Lemonnier (A.212); E. Le Sueur (16); E. Le Sueur (A.222); N. Maréchal (A.224); C-J. Natoire (A.247); B. Picart (A.286); J-B. Regnault (A.311)

Jean-Luc **Baroni**, London: J. Dumont le Romain (59); also see Colnaghi, London

Pierre-François **Basan**, Paris: J-B. Deshays (84); J-B. Oudry (38)

Jean-Christophe **Baudequin** at Galerie Ratton and Ladrière, Paris: H. Collin de Vermont (44); M-F. Dandré-Bardon (54); M-F. Dandré-Bardon (A.93); L. Desmarets (A.105); G. Huret (A.161); J. II Restout (A.313); F. Verdier (A.346); S. Vouet (A.365)

Galerie de **Bayser**, Paris: J-F. Amand (A.1); T. Bellange (A.10); F. Boucher (A.40); M-G. Capet (106); M-G. Capet (A.55); J. Chaufourier (A.70); C-N. Cochin le jeune (A.79); M. II Corneille (A.85); C-A. Coypel (46); C-A. Coypel (A.90); J-L. David (A.96); J-C. Delafosse (A.98); J-B-M-A. Descamps (A.100); J-B. Deshays (A.104); A-F. Desportes (A.106); A-F. Desportes (A.107); C-L. Desrais (A.108); M. Dorigny (A.114); G. Dughet (A.116); F-P-S. Gérard (A.139); A-L. Girodet (109); A-L. Girodet (A.142); J-B. Greuze (80); P-N. Guérin (A.150); P-N. Guérin (A.151); G. Huret (A.160); L. de La Hyre (12); A-C-G. Lemonnier (A.210); A-C-G. Lemonnier (A.211); F-G. Ménageot (A.228); C. Meynier (A.230); J-G. Moitte (A.238); J-M. Moreau le jeune (A.244); C-J. Natoire (A.248); J-M. Nattier (A.251); V. J. Nicolle (A.253); M-B. Ollivier (A.256); J-B. Oudry (A.258); P. L. Parizeau (A.272); J-B-J. Pater (47); N. de Plattemontagne (A.300);

N. de Plattemontagne (A.301); J-A. Portail (48); N. Poussin (8); A. Rivalz (A.316); H. Robert (91); H. Robert (A.317); D. Sambin (A.328); J. Vernet (A.348)

Collection **Beaudenon** de Lamaze, Paris: J-A. Portail (49)

Jean-Claude-Gilles Colson, called **Bellecourt**, Paris: C. Vanloo (66)

Galerie Patrice **Bellenger**, Paris: F. Le Comte (A.202)

Katrin **Bellinger**, Munich: F. Boucher (A.37)

R. **Beraldi**: C-N. Cochin le jeune (73)

Collection L. **Berger**: M-A. Slodtz (A.330)

Lady **Beythswood**, Penrice Castle, Glamorgan, United Kingdom: J. Stella (10)

Antonio **Bianchi**: J-B-J. Wicar (A.370); J-B-J. Wicar (A.371)

Galerie Siegfried **Billesberger**, Munich: J. Stella (9)

Blondel d'Azaincourt, Paris: F. Boucher (A.37)

Stichting P. and N. De **Boer**, Amsterdam: J. Callot (7)

Galerie Julius **Böhler**, Munich: H. Robert (91)

Charles-Pompée Le Boulanger de **Boisfremont**, Paris [L. 353]: P-P. Prud'hon (101); P-P. Prud'hon (102); P-P. Prud'hon (104)

Mary-Kaye **Bordeaux**, Santa Monica and Paris: F. Le Moyne (40)

Collection M. de la **Bordes**: A-L. Girodet (110)

M. de **Bourguignon de Fabregoules**, Aix-en-Provence: E. Bouchardon (A.35)

Jacques-Auguste **Boussac** [L.s. 729b]: H. Robert (A.318)

Marcel **Boussac**, Paris: J-A. Watteau (34)

Claudine **Bouzonnet**-Stella, Paris: J. Stella (10)

W. M. **Brady** and Co., New York: J-V. Bertin (111); E. Bouchardon (A.33); J. Boucher de Bourges (4); S. Bourdon (15); A-C. Caraffe (107); L. Chaix (A.63); J-F. Chantereau (A.64); A-L. Girodet (110); J-B. Greuze (79); J-B. Huet (A.159); H. Le Dru (A.204); F. Le Moyne (A.213); R. Nanteuil (19); J-P. Norblin de la Gourdaine (A.255); J-F. Parrocel (A.278); P. Parrocel (A.280); J-F-P. Peyron (96); J-B. Suvée (94); N. A. Taunay (A.336); J-B. Vanloo (A.340); F-A. Vincent (A.361); F-A. Vincent (A.363); F-L-J. Watteau de Lille (A.367); F-L-J. Watteau de Lille (A.368)

Galerie **Brame et Lorenceau**, Paris: J-B. Suvée (93)

Etienne **Breton** at Bureau Marc Blondeau, Paris: L-L. Boilly (A.17); L-L. Boilly (A.18); F. Boucher (A.45); J-M. Moreau le jeune (A.246); J-B. Perroneau (71); P-P. Prud'hon (102)

Othmar **Brioschi**: L-F. Cassas (A.59); L-F. Cassas (A.60)

British Rail Pension Fund, London: Circle of C. Le Brun (A.201); J-B. Oudry (A.260); J-B. Oudry (A.261); S. Vouet (6)

Collection **Brochant**: J-B. Oudry (38)

Tonnes Christian Bruun, baron **Neergaard**, Copenhagen: P-P. Prud'hon (103)

de **Bure** brothers, Paris: J-B. Oudry (A.260); J-B. Oudry (A.261)

Galerie and Collection **Cailleux**, Paris: J. R. Ango (A.3); P-A. Baudouin (76); J-V. Bertin (A.13); J. II Cellony (A.62); J-B-S. Chardin (53); C-N. Cochin le jeune (72); C-N. Cochin le jeune (73); C-N. Cochin le jeune (A.78); C-N. Cochin le jeune (A.80); C-N. Cochin le jeune (A.81); J-A. Constantin (A.82); J-A. Constantin (A.84); A-T. Desfriches (A.101); J-B. Deshays (84); F. de Troy (A.109); J-H. Fragonard (86); J-H. Fragonard (A.135); J-B. Greuze (78); J-B. Greuze (A.143); C-F. Hutin (70); J-B. Jouvenet (A.170); J-J. Lagrenée le jeune (A.178); J-J. Lagrenée le jeune (A.180); N. Lancret (A.183); L-F. de La Rue (A.187); J-P. Le Bas (A.196); J-P. II de Loutherbourg (A.223); N-A. Monsiau (A.242); J-M. Moreau le jeune (A.243); C-J. Natoire (55); C-J. Natoire (57); G-M. Oppenord (A.257); J-B. Oudry (A.262); A. Pajou (A.268); A. Pajou (A.269); A. Pajou (A.270); J-B. Perroneau (A.284); P-P. Prud'hon (A.305); H. Robert (A.318); J. Rousseau (A.326); G-J. de Saint-Aubin (77); M-A. Slodtz (A.330); J-T. Thibault (A.337); L-C. Vassé (75); J-M. Vien (74); J-M. Vien (A.353); J-A. Watteau (36)

E. **Calando**, Paris [L. 837]: F-A. Vincent (A.362)

Mrs. Thomas **Card**, Boston: J-H. Fragonard (88)

Galleria **Carissimi**, Milan: P-P. Prud'hon (103)

Claude **Cartier**: J-A. Watteau (35)

Louis **Cartier**: J-A. Watteau (35)

Comtesse de **Castrie**: P-A. Baudouin (76)

M. **Chanlaire**, Versailles: C-F. Hutin (A.164)

Charles-Philippe, marquis de **Chennevières**-Pointel, Paris [L. 2072 and 2073]: T. Blanchet (A.15); J-F. Chantereau (A.64); J-U. Guérin (A.147); C-F. Hutin (A.164); F. Le Moyne (42); E. Le Sueur (16); E. Le Sueur (A.222); N. de Plattemontagne (A.300); J-A. Portail (A.303); J-C. Vanloo (A.341)

Collection **Chevalier**, Paris: C. Vanloo (66)

Collection **Choffard**: J-B. Oudry (38)

Galerie Eric **Coatalem**, Paris: F. Boitard (A.27); J-F. Chantereau (A.65); A. Dieu (A.111); B. Gagneraux (A.137); G. Huret (13); C-F. Hutin (A.163); A. Le Brun (A.197); P. Mignard (A.234); V. J. Nicolle (A.252); J-B-M. Pierre (A.294); J. C. Roëttiers (A.325); M-L. E. Vigée-Lebrun (A.355)

L. **Coblentz**: G-J. de Saint-Aubin (77)

Colnaghi, London and New York (Jean-Luc Baroni): C-L. Chatelet (A.66); J-B. Deshays (A.102); J-B. Jouvenet (A.168); M-Q. de La Tour (A.190); F. Le Moyne (40); J-B. Oudry and studio (A.264); C. Parrocel (A.275); P-A. Patel le jeune (26); J-B. Pillement (A.299); P-P. Prud'hon (101)

Commenos Gallery, Boston: P. A. Wille (A.372)

Constantin, Paris: P-P. Prud'hon (103)

Louis-François de Bourbon, prince de **Conti**: C. Vanloo (65)

L-J-A. **Coutan**, Paris: J-L. David (100)

Frederick J. **Cummings**, New York: N-G. Brenet (A.51); A-L. Girodet (108); J-B. Huet (A.156); R. Nanteuil (19); J. II Restout (A.314); P. H. Subleyras (A.332)

Mrs. E. E. **Dakeyne**, Granit Field, Dun Loaghaire, Dublin: L. Chéron (29)

Chevalier de **Damery**, Paris [L. 2862]: M-A. Slodtz (A.330)

David **Daniels**, New York: J. Dumont le Romain (A.118)

A. **Danlos**: J-A. Watteau (34)

Collection G. **Danyau** [L. 720]: L-L. Boilly (A.18)

Eugène **David**, Paris [L.839]: Circle of C. Le Brun (A.201)

Richard **Day**, London: N. de Plattemontagne (21); Follower of H. Robert (A.319)

Professor **de' Giovanni**, Naples: J-H. Fragonard (87)

Louis **Deglatigny**, Rouen [L.s. 1768a]: J-C. Vanloo (A.341); F-A. Vincent (A.363)

Collection **Delahaye**: P-A. Baudouin (76)

Dominique-Vivant, baron **Denon**, Paris [L. 779]: J-B. Greuze (80); J-M. Moreau le jeune (114); J-M. Moreau le jeune (A.245)

Antoine-Joseph **Dézallier d'Argenville**, Paris [L. 2951]: Guillerot (22); F. Le Moyne (A.213)

Nicos **Dhikeos**, Lyon: A. Dieu (A.111); N-A. Monsiau (A.241)

Simon **Dickinson**, Inc., London: J. Rousseau (A.326)

Galerie **Didier Aaron**, Paris, London, and New York: P-A. Baudouin (76); J. Bonvoisin (A.28); E. Bouchardon (A.31); E. Bouchardon (A.32); F. Boucher (62); F. Boucher (A.44); U. Boze (A.50); A-F. Callet (A.54); L-F. Cassas (A.59); L-F. Cassas (A.60); C-A. Coypel (45); P-L. Debucourt (113a-b); M. Dorigny (17); P-N. Guérin (A.148); P-N. Guérin (A.149); C-J-B. Hoin (A.154); J-J-F. Le Barbier l'aîné (A.195); N. Le Jeune (95); C. Meynier (A.230); J-M. Moreau le jeune (114); J-M. Moreau le jeune (A.245); J-B. Oudry (38); C. Parrocel (39); J-B-M. Pierre (A.290); J-B-M. Pierre (A.291); H. Robert (90); J-B. Suvée (93); J. Touzé (A.339); A-C-H. Vernet (115); F-A. Vincent (A.362); J-A. Watteau (34); P. A. Wille (A.376)

Catherine **Doubs**, Paris: P. II Dumonstier (A.117)

Douwes Fine Art, London: J. Dumont le Romain (59)

Jean **Dubois**, Paris: J-H. Fragonard (A.134)

Duits, London: P-P. Prud'hon (103)

T. **Dumesnil**, Paris: J-L. David (100)

A. **Dumont**, Paris: J-L. David (100)

Jules **Dupan**, Geneva [L. 1440]: M. Dorigny (17)

Duvivier Family, Paris: L. Galloche (32)

Annamaria **Edelstein**, London: J-A. Constantin (A.83); A. Dieu (A.112); J. Gamelin (92); N-R. de La Fage (A.172)

Raphael **Esmerian**, New York: J-B. Oudry (A.260); J-B. Oudry (A.261)

Comte de la **Ferrière**, Paris: J-J. de Boissieu (A.22)

Neal **Fiertag**, Paris and New York: J-S. Berthélemy (A.12); J-B. Huet (A.158); J. Ledoux (A.203); N-B. Lépicié (A.215); A. Moitte (A.235); A. de Saint-Aubin (A.327)

A. **Finot**, Paris: T. Blanchet (A.15); J-B-M. Pierre (A.294); A. Rivalz (31)

Firmin-Didot family, Paris: A-L. Girodet (109); A-L. Girodet (110)

Galerie **Fischer-Kiener**, Paris: J-J. de Boissieu (A.23); I. Duvivier (A.123)

Collection **Flury-Hérard**, Paris [L. 1015]: E. Bouchardon (A.35); N. de Plattemontagne (A.300)

Galerie William **Foucault**, Paris: M. Dorigny (17)

Adolphe **Fould**: P-L. Debucourt (113b)

Anatole **France**, Paris: E. Le Sueur (16); E. Le Sueur (A.222)

Baron **Franchetti**: P-L. Debucourt (113a)

René **Fribourg**: J-H. Fragonard (A.131)

Count Moritz von **Fries**, Vienna [L. 2903]: T. Blanchet (14)

Eugène **Fromentin**, Paris: S. Vouet (A.364)

Francesco Maria Nicolò **Gaburri**, Florence: J-A. Watteau (36)

Gandouin Collection, Paris: C-F. Hutin (70)

Kate **Ganz**, London: J-A. Meissonnier (50)

Amédée-Paul-Emile **Gasc**, Paris [L. 1131]: J-B. Jouvenet (A.168)

Charles **Gasc**, Paris [L. 543]: J-B. Jouvenet (A.168); P. H. Subleyras (A.331)

Pierre **Gaubert**, Paris: A. Rivalz (A.316)

Felton L. **Gibbons**, New Jersey: J-B. Jouvenet (A.168)

Michel **Gierzod**, Paris: T. Blanchet (A.14); T. Blanchet (A.15); B. de Boullogne (A.48); J. Chaufourier (A.69); J-F. Clermont (A.75); C-N. Cochin le jeune (A.77); A. Coypel (A.87); L-J-F. Lagrenée l'aîné (A.181); N. Lancret (A.184); J-A-M. Lemoine (A.208); A-C-G. Lemonnier (A.209); C. Monnet (A.239); C. Monnet (A.240); P-P. Prud'hon (103); J-M. Vien (A.352)

Charles-Joseph Barthelemi **Giraud**: E. Bouchardon (A.35)

Anne-Louis **Girodet** de Roucy-Trioson, Paris: J-L. David (100); N-B. Lépicié (A.214); N-B. Lépicié (A.216); N-B. Lépicié (A.217); N-B. Lépicié (A.218)

Edmond and Jules de **Goncourt**, Paris: M-F. Dandré-Bardon (A.92); J. Touzé (A.339)

Margot **Gordon**, New York: C. Mellan (A.225)

Jan Baptiste de **Graaf**, Amsterdam [L. 1120]: F. Boucher (A.45)

Claude-Jules **Grenier**, Paris: Guillerot (22)

Pierre **Guéraud**, Paris: M. II Corneille (24)

Marcel Louis **Guérin**, Paris [close to L.s. 1872b]: A. Dieu (A.111)

M. **Guyot** de Villeneuve, Paris: C-N. Cochin le jeune (A.78); C-N. Cochin le jeune (A.81)

Allier de **Hauterouche**: P-P. Prud'hon (103)

Baron Dr. ver **Hayden** de Lancey: C. Parrocel (A.275)

Hazlitt, Gooden and Fox, Ltd., London: F. Boucher (A.38); C-L. Chatelet (A.67); C-L. Chatelet (A.68); L. Chéron (29); C-A. Coypel (A.91); H-P. Danloux (A.95); J-B. Greuze (80); F. Perrier (A.283); J-B. Pillement (A.298); P-P. Prud'hon (104); H. Robert (91); L. V. Thiery de St. Colombe (A.338); C. Vanloo (66)

Heim Gallery, London: J. Gamelin (92); A-L. Girodet (110)

Galerie **Heim**, Paris: P. H. Subleyras (A.332)

Jean-François **Heim**, Paris: J-B. Greuze (A.144)

Nathaniel **Hone**, London [L. 2793]: J. Callot (7)

Arthur **Houghton**: J-H. Fragonard (89); J-H. Fragonard (A.132)

Lodewijk and Bernard **Houthakker**, Amsterdam: F. Boucher (A.38); J. Callot (7)

Hugh **Howard**, London: Claude (11)

Christian **Humann**, New York: Follower of H. Robert (A.319)

Jacquemin, jeweler to the king: J-B-S. Chardin (53)

Marcel **Jeanson**: N. Robert (A.320)

B. **Jolles**, Dresden and Vienna [L.s. 381a]: C-J. Natoire (A.248)

Nicolas **Joly** at Galerie Yves Mikaeloff, Paris: L-N. van Blarenberghe (A.16); A-F. Callet (A.52); J-L. David (100); E-B. Garnier (105); F-P-S. Gérard (A.138); J-U. Guérin (A.147); J-P-L-L. Houel (A.155); G. Huret (A.162); C. de La Fosse (A.176); J-J-F. Le Barbier l'aîné (A.194);

L-N. de Lespinasse (A.220); C. Mellin (A.227); N. Mignard (A.231); N. Mignard (A.233); C-J. Natoire (A.249); A. J. Noël (A.254); P. L. Parizeau (A.273); E. Parrocel (A.277); J-B-M. Pierre (A.288); J-A. Rénard (A.312); J. II Restout (43); A. Rivalz (31); L. G. Taraval (A.335); C. Vanloo (63); F-A. Vincent (A.358); F-A. Vincent (A.359); A. de Vuez (A.366); P. A. Wille (A.374)

Charles de **Jonghe**: J-S. Berthélemy (A.12); T. Blanchet (A.15)

Pierre **Jourdan**: P-P. Prud'hon (104)

Renaud **Jouslin** de Noray, Paris: A-F. Callet (A.53); D. Dumonstier (3); J-B. Le Prince (A.219); J. Vernet (A.349); F-A. Vincent (A.356)

Jean de **Jullienne**, Paris: J-A. Watteau (36); J-A. Meissonnier (50)

Edouard **Kahn**: J-H. Fragonard (88)

Daniel **Katz**, London: J. II Cellony (A.61)

Jack **Kilgore**, New York: M-F. Dandré-Bardon (A.92)

Knoedler Gallery, New York: Claude (11)

Wilhelm **Koenig**, Vienna and The Hague [L.s. 2653b]: J-B. Deshays (84)

Laurent **Laperlier**: J-B-S. Chardin (53)

Galerie de **La Scala**, Paris: L-L. Boilly (A.19)

Alain **Latreille**, Paris: F. Boucher (A.39); F. Boucher (A.43); F. Boucher (A.46); F. Boucher (A.47); Clodion Hand (A.76); J-H. Fragonard (A.136); P. Jollain (A.167); J. de Lajoüe (A.182); J-G. Moitte (A.236); J-B. Oudry (A.259); A. Pajou (85); A. Pajou (A.266); J-F. Parrocel (A.279); J-B. Regnault (A.309)

Jean **Lavit**, Paris: A. Bouzonnet-Stella (A.49); J-B-M. Pierre (A.295)

Sir Thomas **Lawrence**, London [L. 2445]: L. Chéron (29); J. Rousseau (A.326)

J. B. **Lebrun**, Paris: C. Vanloo (65)

Thomas **Le Claire**, Kunsthandel, Hamburg: C. Eisen (A.125); J-B. Greuze (A.145); J-B-M. Pierre (A.293); N. C. de Silvestre (A.329); F-A. Vincent (A.360)

Eugène **Lecomte**: P-P. Prud'hon (102)

André Hippolyte **Lemmonier**, Rouen and Paris [L.s. 1330a]: J. II Restout (A.313)

Jean-Denis **Lempereur**, Paris [L. 1740]: C. Le Brun (18); F. Le Moyne (42); C. Parrocel (39); P. H. Subleyras (A.332)

Gilbert **Lévy**, Paris: P-P. Prud'hon (102)

Henri-Michel **Lévy**, Paris: J-A. Watteau (35)

Robert M. **Light**, Santa Barbara: Claude (11)

A. **Lion**: P-L. Debucourt (113a)

Richard **Lion**, Paris: J-J. Bachelier (A.6)

James **Mackinnon**, London: J-L. David (A.97); C-P. Landon (A.186)

K. E. **Maison**: J-H. Fragonard (A.134)

Alfred **Mame**, Paris: J-B. Perroneau (A.284)

Armand **Mame**, Paris: J-B. Perroneau (A.284)

Camille **Marcille**: P-P. Prud'hon (103)

Pierre-Jean **Mariette**, Paris [L. 1852]: T. Blanchet (14); E. Bouchardon (A.35); S. Vouet (6)

Hubert **Marignane**, Paris [L.s. 1343a]: E. Le Sueur (A.221)

Abel François Poisson, marquis de Vandières et **Marigny**: R. Nanteuil (19)

Michel de **Maso**, Paris: J. Stella (10)

Jean **Masson**, Paris [L.s. 1494a]: M-B. Ollivier (A.256); J. Vernet (A.348)

Mathiesen Fine Art, Ltd., London: J-H. Fragonard (87)

Louis **Maudet**, Paris: N-A. Monsiau (A.241)

William **Mayor**, London [L. 2799]: T. Blanchet (14)

Kurt **Meissner**, Zurich: J-B. Greuze (A.145)

W. **Mellish**, London: T. Blanchet (14)

Christopher **Methuen**-Campbell, Penrice Castle, Glamorgan, United Kingdom: J. Stella (10)

Michael **Miller and** Lucy **Vivante** Fine Art, New York: S. Bourdon (15); N. Mignard (A.232); C-J. Natoire (A.250)

Gaetano **Minossi**, Rome: J. Stella (10)

Galerie Emmanuel **Moatti**, Paris: J-F. Bosio (A.29); H. Collin de Vermont (44); M. II Corneille (24); M-F. Dandré-Bardon (A.92); G-F. Doyen (82); J. Dumont le Romain (59); L. Galloche (32); A-L. Girodet (A.141); C-J. Natoire (56); A. Paillet (A.265); J-F-P. Peyron (95); J-F-P. Peyron (97); J-B-M. Pierre (A.292); P-P. Prud'hon (A.306); P. H. Subleyras (A.331); C. Vernet (A.347); F-A. Vincent (98)

Galerie **Moatti**, Paris: A. Boisson (A.24); C. de La Traverse (A.191); N-B. Lépicié (A.214); N-B. Lépicié (A.216); N-B. Lépicié (A.217); N-B. Lépicié (A.218); S. Vouet (5); S. Vouet (6)

M. de **Montenault**: J-B. Oudry (A.260); J-B. Oudry (A.261)

Morgand and Fatout, booksellers, Paris: J-B. Oudry (A.260); J-B. Oudry (A.261)

Niodot fils, Paris [L. 1944]: M-G. Capet (106)

Olry-Roederer, Reims: J-H. Fragonard (89); J-H. Fragonard (A.132); J-B. Oudry (A.260); J-B. Oudry (A.261)

Robert Treat **Paine** II, Boston: J-H. Fragonard (88)

Antoine-Claude **Pannetier**, Paris: A-L. Girodet (110)

Van **Parijs**, Brussels [L. 2531]: C-J. Natoire (A.248)

Collection **Pascalis** (?), Marseilles [L. 2707 and L.s. 2707a]:
S. Bourdon (15)

Marius **Paulme**, Paris [L. 1910]: J-J. de Boissieu (A.22);
P-L. Debucourt (113a); J-H. Fragonard (A.133)

Gertrude de **Pelichy**, Brussels: J-B. Suvée (94)

Collection **Pelieveau**, Paris: P. A. Wille (A.376)

Earl of **Pembroke**, United Kingdom: J-H. Fragonard (A.134)

Emile **Pereire**, Paris: J-B. Oudry (A.260); J-B. Oudry (A.261);
P-P. Prud'hon (104)

Galerie Patrick **Perrin**, Paris: T. Blanchet (14); C. Le Brun (A.198);
G. Perelle (A.282); B. Picart (A.287); N. de Plattemontagne (21);
F-A. Vincent (A.357)

Jacques **Petithory**, Paris: L-L. Boilly (A.18); G. Lallemant (2);
N-B. Lépicié (A.214); J-B. Suvée (93); J-C. Vanloo (A.341); S. Vouet (6)

Giovanni **Piancastelli**, Rome: J. Cousin le jeune (A.86)

Mathias **Polakovits**, Paris: J-P. Le Bas (A.196); F. Le Moyne (40)

Baron Roger **Portalis**, Paris [L. 2232]: E. Bouchardon (A.34)

Emilie **Power**: P-P. Prud'hon (101); P-P. Prud'hon (102);
P-P. Prud'hon (104)

Louis-Antoine **Prat**, Paris: A. Coypel (A.87); C-F. Hutin (A.164);
J-B. Jouvenet (A.169); E. Le Sueur (A.221)

Galerie Paul **Prouté**, S.A., Paris: M-F. Dandré-Bardon (A.92);
J-B. Huet (A.158); J-B. Jouvenet (A.169); S. M. Lantara (83);
C. Le Brun (18); C. Mellin (A.226); J-B. Suvée (A.333)

Marcel **Puech**, Avignon: M-F. Dandré-Bardon (A.94);
M-H. Duplessis (A.120); Guillerot (22); E. Jeurat (A.166);
J-F-P. Peyron (A.285)

Friedrich **Quiring**, Berlin [L.s. 1041c]: P. A. Wille (A.373)

Comte **Rey** de Villette [L.s. 2200a]: C. de La Traverse (A.192)

Pierre **Rivalz**, Toulouse: A. Rivalz (31)

Hubert **Robert**, Paris: J-H. Fragonard (86)

Edmondo di **Robilant**, London: L. Lafitte (A.174)

Eugène **Rodrigues**, Paris [L. 897]: N. Lancret (A.185); A. Moitte
(A.235); H. Robert (A.317)

Louis **Roederer**, Reims: J-H. Fragonard (89); J-H. Fragonard (A.132)

Roger-Jourdain Collection: P-P. Prud'hon (104)

Dr. A. S. W. **Rosenbach** and the Rosenbach Co., Philadelphia and
New York: J-H. Fragonard (89); J-H. Fragonard (A.132); J-B. Oudry
(A.260); J-B. Oudry (A.261)

Kate de **Rothschild**, London: F. Boucher (A.41); L-F. Cassas (A.58);
J. Cousin le jeune (A.86); P-L. Debucourt (113a-b); M. Dorigny (17);
N. Robert (A.320); A. L. T. Vaudoyer (A.345)

M. **Roux**, Tours: J-B. Perroneau (A.284)

C. R. **Rudolf**, London [L. 2811b]: L. Chéron (29)

Arthur M. **Sackler**, New York: A. Pajou (A.271)

Charles-Paul-Jean-Baptiste de Bougevin Vialart de **Saint-Morys**,
Paris: C. Vanloo (66)

Arthur **Sambon**, Paris: T. Blanchet (14)

Scheurer-Kestner Collection: P-P. Prud'hon (103)

H. **Schuake**: J-H. Fragonard (A.134)

Baron Louis-Auguste de **Schwiter**, Paris [L. 1768]: J-B. Greuze
(A.145); J-A. Watteau (35)

Collection Mlle **Seheult**, Nantes: J-A. Portail (49)

Germain **Seligman**, New York and Paris: M. Dorigny (17);
J-M. Moreau le jeune (A.243)

Jean-Pierre **Selz**, Paris and New York: J-F. Beauvarlet (A.9);
D-V. Denon (A.99); School of Fontainebleau (A.130); N. Lagneau
(A.177); J-B-M. Pierre (69); J-B-M. Pierre (A.289); J-B. Pillement
(A.296); J-B. Pillement (A.297); J-A. Portail (A.304); F. Quesnel
(A.307); C. Vanloo (64); L-C. Vassé (A.343)

Prince **Serra** di Cassana, Palermo: J-H. Fragonard (87)

N. **Shelton**: F. Boucher (A.38)

M. de **Sireul**, Paris: F. Boucher (A.44)

Félix **Solar**: J-B. Oudry (A.260); J-B. Oudry (A.261)

Galerie de **Staël**, Paris: E. Bouchardon (51); L. Chéron (A.71);
L. Chéron (A.72); F-H. Drouais (A.115); P-A. Hennequin (A.152);
C-F. Poerson (A.302); H. Rigaud and C. Viennot (?) (28);
C. Vanloo (65)

Stair Sainty-Mathiesen, New York: P. Révoil (A.315)

Adolphe **Stein**, London: H. Robert (91)

Casimir **Stralem**: J-H. Fragonard (A.133)

Donald S. **Stralem**, New York: J-H. Fragonard (A.133)

A. **Strölin**, Lausanne: N. Poussin (8)

Galerie **Talabardon**, Paris: C. Meynier (A.229)

Thomas **Talbot**, Margam Abbey, United Kingdom: J. Stella (10)

Duc de **Tallard**, Paris: J-B. Oudry (38)

Yvonne **Tan Bunzl**, London: J. Stella (10)

Baron Isidore **Taylor**, Paris: J-B. Oudry (A.260); J-B. Oudry (A.261)

Gabriel **Terrades** at Galerie Grunspan, Paris: A-S. Belle (A.11); L-L. Boilly (A.20); J-J. de Boissieu (A.21); Julien de Parme (A.171); C. de La Fosse (A.175); J-J. Taillasson (A.334); C. Vanloo (66); L-C. Vassé (A.344); J-M. Vien (A.351); J-M. Vien (A.354)

John **Thane**, London [L. 1544 and 2394]: J. Callot (7); L. Chéron (29)

Eugene Victor **Thaw**, New York: N. Poussin (8)

Comte Adolphe-Narcisse **Thibaudeau**, Paris: J-B. Oudry (A.260); J-B. Oudry (A.261)

Unidentified collector (close to L. 2902): C. Vanloo (65)

Unidentified collector D. de L.: C-N. Cochin le jeune (72)

Unidentified collector JB [L. 2736]: J. Callot (7)

Unidentified Toulouse collector [L. 2917]: C-N. Cochin le jeune (A.79)

Giuseppe **Vallardi**, Milan [L. 1223]: L. Chéron (A.71); L. Chéron (A.72)

Collection **Valpinçon**, Normandy: F. Le Moyne (40)

Marie-Guillaume-Thérèse de **Villenave**: J. Dumont le Romain (59)

General de la **Villestreux**: L-L. Boilly (A.17); J-A. Watteau (34)

Hippolyte **Walferdin**: J-H. Fragonard (89); J-H. Fragonard (A.132)

David **Weill**, Paris: P-P. Prud'hon (103)

Paul **Weis**, New York: J. Audran (A.4); F. Boucher (A.42); L. Chéron (A.73); L. Chéron (A.74); J-B. Isabey (A.165); E. de Lavallée-Poussin (A.193); J-B. Regnault (A.310)

Clovis **Whitfield** Fine Art Ltd., London: J-B. Oudry (A.260); J-B. Oudry (A.261)

Thomas **Williams** Fine Art, Ltd., London: F. Boitard (A.25); F. Boitard (A.26); E. Bouchardon (52); S. Bourdon (15)

Ronald **Winoker**, Los Angeles: J-B. Deshays (A.103)

Ian **Woodner**, New York: T. Blanchet (14)

David and Constance **Yates**, New York: V. Auger (A.5)

Franco **Zangrilli**, New York: J-B. Greuze (81); A. Vestier (A.350)

Zangrilli, Brady and Co., Ltd., New York: C. de La Fosse (23); R. Nanteuil (19)

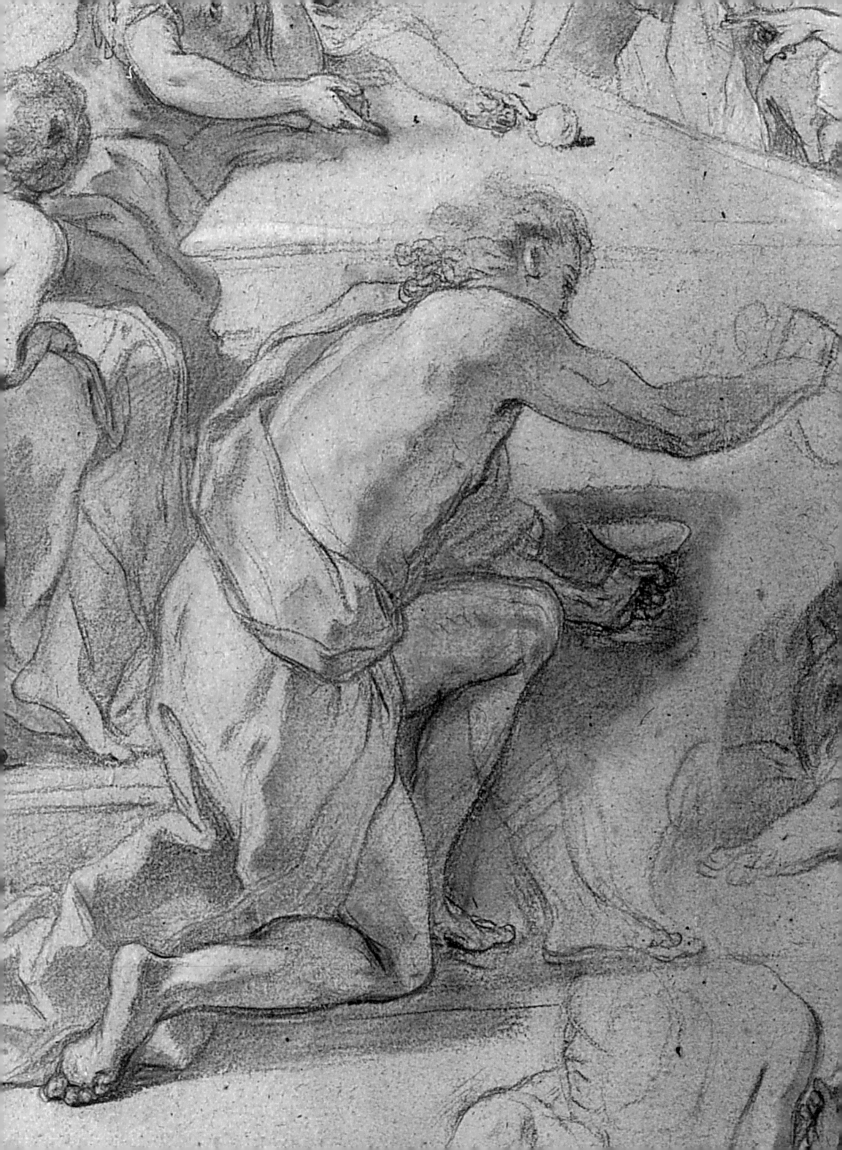

INDEX OF SUBJECTS

Standalone numbers refer to catalogue entries.
Numbers preceded by A refer to drawings in the Horvitz Collection that are catalogued in the Appendix.
Index restricted to drawings in the Horvitz Collection (by artists born before 1780).

XVII. HEAD STUDIES

XVIII. BODY PARTS

XIX. BOOK ILLUSTRATION

Christ Led Away from Pilate (B. Picart, A.286)

Death of Phaedra (A-L. Girodet, 109)

Figure Studies for "The Tenth of August 1792" (F-P-S. Gérard, A.138)

Four Soldiers Aiming Their Rifles (C. Eisen, A.125)

The Power of Fables (J-B. Oudry, A.260)

Priam Returning the Body of Hector to Troy (C-N. Cochin le jeune, A.80)

St. Peter Preaching to the Jews (C-N. Cochin le jeune, A.81)

Scene from "Bajazet" by Racine (V:11): "Bajazet était mort. Nous l'avons rencontré / De morts et de mourants noblement entouré . . ." (F-P-S. Gérard, A.139)

Scene from "La Thébaïde" by Racine (V:6): "Creon—Ah! c'est m'assassiner que me sauver la vie. / Amour, rage, transports, venez à mon secours" (J-G. Moitte, A.238)

The Shepherd and the King (J-B. Oudry, A.261)

XX. DRAWINGS RELATED TO ARCHITECTURE, SCULPTURE, MEDALS, ORNAMENT, AND THE DECORATIVE ARTS

Allegory of Architecture: Two Putti Working a Block of Stone in Front of the Louvre (C. Le Brun, A.198)

Allegory of Music (A. Pajou, A.266)

Architectural Design (A. Bouzonnet-Stella, A.49 verso)

Ceiling Study for a View of Heaven (C-J. Natoire, 56)

Costume Design for a Huntsman (D. Rabel and studio, A.308)

Design for a Carriage Door Decoration(?): Crowned Rocaille Escutcheon with Putti and the Order of the Golden Fleece (F. Boucher, A.38)

Design for a Fountain with Leda and the Swan above a Reclining River God (C. de La Traverse, A.191)

Design for a Moulding with a Dense Mixture of Foliage and Flowers (J-C. Delafosse, A.98)

Design for a Table Ornament (J. Cousin le jeune, A.86)

Design for the Monument to the Heart of Queen Maria Leczinska (L-C. Vassé, A.343)

Design Studies (C. Gillot, 33 verso)

Funeral Monument for Princess Ekaterina Dimitrievna Golitsyn (L-C. Vassé, 75)

Garden with Fantastic Architecture (J. de Lajoüe, A.182)

Medal Design for the Chambre aux Deniers in 1742: FRUGES ET CEREREM FERANT (E. Bouchardon, A.31)

Medal Design for the Maison de la Reine in 1740: TOTO SPARGET IN ORBE (E. Bouchardon, A.32)

Religion and the Virtues (F. Le Comte, A.202)

St. Cecilia (?) (L-C. Vassé, A.344)

Study for a Monument to a Naval Commander (A. Pajou, A.271)

Study for the Tomb of Cardinal Hercule de Fleury (1653–1743) (E. Bouchardon, A.35)

Two Putti with Grapes and an Overturned Pitcher (Clodion Hand, A.76)

View of the Cour Carrée of the Louvre (J-A. Portail, A.303)

Young Woman Holding a Cornucopia (A. Pajou, 85)

INDEX OF CITED DRAWINGS

Citations with an asterisk (*) are illustrated.

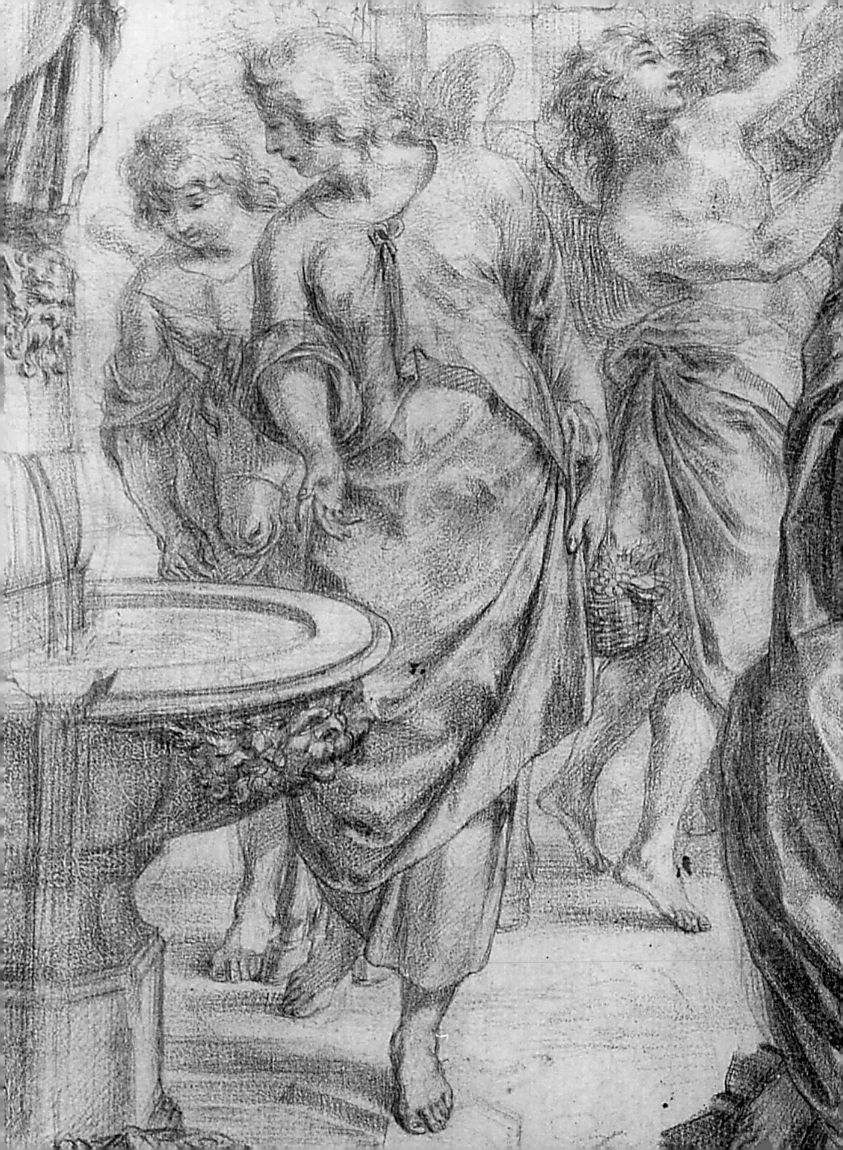

INDEX OF ARTISTS

Standalone numbers refer to catalogue entries.
Numbers preceded by A refer to drawings in the Horvitz Collection that are catalogued in the Appendix.
Index restricted to drawings in the Horvitz Collection.

BIBLIOGRAPHY

EXHIBITIONS

Alençon 1981
Alençon, Musée des Beaux-Arts et de la Dentelle, *Dessins du Musée d'Alençon du XVIe au XIXe siècle*, 1981, cat. by Philippe Durey and Jean-François Méjanès with Louis-Antoine Prat, Udo van de Sandt, Antoine Schnapper, and Françoise Viatte

Amiens and Versailles 1995
Amiens, Musée de Picardie—Versailles, Musée national du Château de Versailles, *Versailles: Les chasses exotiques de Louis XV*, 1995–96, cat. by Xavier Salmon

Amsterdam 1966
Amsterdam, Galerie Houtthaker, *Master Drawings*, 1966, cat. by Bernard Houtthaker

Atlanta 1983
Atlanta, The High Museum of Art, *The Rococo Age: French Masterpieces of the Eighteenth Century*, 1983, cat. ed. by Eric Zafran

Avignon 1979
Avignon, Palais des Papes, *Nicolas Mignard d'Avignon (1606–1668)*, 1979, cat. by Antoine Schnapper

Baltimore et al. 1984
Baltimore, The Baltimore Museum of Art—Boston, Museum of Fine Arts, Boston—Minneapolis, The Minneapolis Institute of Arts, *From Regency to Empire: French Printmaking, 1715–1814*, 1984–85, org. and ed. by Victor Carlson and John Ittmann

Basel 1978
Basel, Kunstmuseum, *Zeichnungen des 18. Jahrhunderts aus dem Basler Kupferstichkabinett*, 1978–79

Bayonne 1994
Bayonne, Musée Bonnat, *Nicolas Poussin: La Collection du Musée Bonnat à Bayonne*, 1994–95, cat. by Pierre Rosenberg and Louis-Antoine Prat

Bern 1959
Bern, Kunstmuseum, *Das Siebzehnte Jahrhundert in der französischen Malerei*, 1959, cat. by Boris Lossky

Besançon 1984
Besançon, Musée des Beaux-Arts, *Simon Vouet–Eustache Le Sueur: Dessins du Musée de Besançon*, Collections du Musée no. 5, 1984, cat. by Barbara Brejon de Lavergnée and Alain Mérot

Binghamton et al. 1974
Binghamton, State University of New York, Art Gallery—New York, Finch College Museum of Art—Williamstown, Sterling and Francine Clark Art Institute, *Strictly Academic: Life Drawing in the Nineteenth Century*, 1974, cat. by Albert Boime

Bois-le-duc and Strasbourg 1991
Bois-le-duc, Noordbrabants Museum—Strasbourg, Musées de la Ville, *Theodoor van Thulden: Un Peintre baroque du cercle de Rubens*, 1991, cat. by Alain Roy with Jacques Foucart and Sylvie Béguin

Bologna et al. 1988
Bologna, Pinacoteca Nazionale—Los Angeles, Los Angeles County Museum of Art—Fort Worth, Kimbell Art Museum, *Guido Reni, 1575–1642*, 1988–89, cat. by D. Stephen Pepper et al. (all refs. to English edition)

Bordeaux 1958
Bordeaux, Musée des Beaux-Arts, *Paris et les ateliers provinciaux au XVIIIe siècle*, 1958, cat. by Gilberte Martin-Méry

Boston 1939
Boston, Museum of Fine Arts, Boston, *Paintings, Drawings, Prints from Private Collections in New England*, 1939

Boston et al. 1998
Boston, Museum of Fine Arts, Boston—Ottawa, National Gallery of Canada—Paris, The Mona Bismarck Foundation, *French Prints from the Age of the Musketeers*, 1998–99, cat. by Sue Welsh Reed with Alvin L. Clark, Jr., Carl Goldstein, Marianne Grivel, Graham Larkin, Maxime Préaud, and H. Diane Russell

Bourges and Angers 1988
Bourges, Musée du Berry—Angers, Musée des Beaux-Arts, *Jean Boucher de Bourges, ca. 1575–ca. 1633*, 1988, cat. by Jacques Thuillier

Brou 1967
Brou, Musée de l'Ain, Salle Capitulaire, *Jean-Jacques de Boissieu, 1736–1810*, 1967, cat. by Françoise Baudson

Brussels 1985
Brussels, Musée communal des Beaux-Arts d'Ixelles, *1770–1830, Autour du néo-classicisme en Belgique*, 1985–86, cat. ed. by Denis Coekelberghs and Pierre Loze

Cambridge 1934
Cambridge, Fogg Art Museum, Harvard University Art Museums, *French Drawings and Prints of the Eighteenth Century*, 1934, org. by Agnes Mongan

Cambridge and New York 1965
Cambridge, Fogg Art Museum, Harvard University Art Museums—New York, Museum of Modern Art, *Memorial Exhibition: Works of Art from the Collection of Paul J. Sachs [1878–1965], Given or Bequeathed to the Fogg Art Museum, Harvard University, Cambridge, Massachusetts*, 1965–67, cat. by Agnes Mongan with Mary Lee Bennett

Cambridge 1968
Cambridge, Fogg Art Museum, Harvard University Art Museums, *Drawings from the Daniels Collection*, 1968, cat. ed. by Agnes Mongan with Mary Lee Bennett

Cambridge 1969
Cambridge, Fogg Art Museum, Harvard University Art Museums, *Grenville L. Winthrop: Retrospective for a Collector*, 1969, cat. ed. by Agnes Mongan with Gridley McKim, Dorothy Gillerman, and Joan Mertens

Cambridge 1971
Cambridge, Fogg Art Museum, Harvard University Art Museums, *Selections from the Collection of Freddy and Regina T. Homburger*, 1971, cat. ed. by Agnes Mongan

Cambridge 1977a
Cambridge, Fogg Art Museum, Harvard University Art Museums, *Wash and Gouache: A Study of the Development of the Materials of Watercolor*, 1977, cat. by Marjorie B. Cohn and Rachel Rosenfeld

Cambridge 1977b
Cambridge, Fogg Art Museum, Harvard University Art Museums, *Renaissance and Baroque Drawings from the Collections of John and Alice Steiner*, 1977–78, cat. ed. by Konrad Oberhuber

Cambridge 1979
Cambridge, Fogg Art Museum, Harvard University Art Museums, *Old Master Drawings: Selections from the Charles A. Loeser Bequest*, 1979, cat. ed. by Konrad Oberhuber

Cambridge 1980a
Cambridge, Fogg Art Museum, Harvard University Art Museums, *Louis XIII to Louis XVI: French Drawings from a Private Collection*, 1980, cat. ed. by Konrad Oberhuber and Beverly Schreiber Jacoby

Cambridge 1980b
Cambridge, Houghton Library, Harvard University, *Drawings for Book Illustration*, 1980, cat. by David P. Becker

Cambridge and Tampa 1984
Cambridge, Fogg Art Museum, Harvard University Art Museums—Tampa, The Tampa Museum, *Master Drawings and Watercolors: The Hofer Collection*, 1984, cat. by Konrad Oberhuber and William W. Robinson

Cambridge 1993
Cambridge, Fogg Art Museum, Harvard University Art Museums, *"Gens, Honorez Fragonard": Works from the Collection of Harvard University and Harvard Friends*, HUAM Gallery series no. 4, 1993, cat. by Eunice Williams

Cambridge 1994
Cambridge, Fogg Art Museum, Harvard University Art Museums, *Drawing on Tradition: The Lost Legacy of Academic Figure Studies*, HUAM Gallery series no. 12, 1994–95, cat. by Alvin L. Clark, Jr.

Carcassonne 1990
Carcassonne, Musée des Beaux-Arts, *Jacques Gamelin, 1738–1803*, 1990, cat. by Olivier Michel and Joseph Hahn

Chantilly 1997
Chantilly, Musée Condé, *Pierre-Paul Prud'hon (1788–1823) dans les collections du Musée Condé: Dessins et peintures*, 1997, cat. by Sylvain Laveissière

Charlotte et al. 1994
Charlotte, Mint Museum of Art—Palm Beach, Society for the Four Arts—Little Rock, The Arkansas Art Center—Atlanta, Michael C. Carlos Museum, Emory University, *French Oil Sketches and the Academic Tradition*, 1994, cat. by Peter Walch, Joanna Barnes, J. Patrice Marandel, Alastair Laing, and Alain Latreille

Chartres 1858
Chartres, *Exposition archéologique*, 1858

Chicago et al. 1976
Chicago, The Art Institute of Chicago—Paris, Musée du Louvre—Frankfurt, Städelsches Kunstinstitut, *French Drawings from the Art Institute of Chicago*, 1976–77, cat. by Harold Joachim with Suzanne Folds McCullagh

Cholet 1973
Cholet, Musée des Beaux-Arts, *Pierre-Charles Trémolières, Cholet 1703–Paris 1739*, 1973, cat. by Jean-François Méjanès

Cleveland et al. 1989
Cleveland, Cleveland Museum of Art—Cambridge, Fogg Art Museum, Harvard University Art Museums—Ottawa, National Gallery of Canada, *From Fontainebleau to the Louvre: French Drawing from the Seventeenth Century*, 1989, cat. by Hilliard T. Goldfarb

Cologne et al. 1987
Cologne, Wallraf-Richartz Museum—Zurich, Kunsthaus—Lyon, Musée des Beaux-Arts, *Triomphe et mort du héros: La Peinture d'histoire en Europe de Rubens à Manet*, 1987–88, cat. ed. by Ekkehard Mai, Anke Repp-Eckert, Guy Cogeval, and Philippe Durey (all refs. to French edition)

Copenhagen 1992
Copenhagen, Statens Museum for Kunst, *Fransk Guldalder: Poussin og Claude og maleriet i det 17.arhundredes Frankrig*, 1992, cat. by Humphrey Wine and Olaf Koester

Coutances and Le Mans 1996
Coutances, Musée Quesnel-Morinière—Le Mans, Musée de Tessé, *Autour de Simon Vouet*, 1996–97, cat. by Barbara Brejon de Lavergnée, Françoise Chaserant, Marianne Cabane, Denis Lavalle, and Ivonne Papin-Drastik

Des Moines et al. 1975
Des Moines, Des Moines Art Center—Boston, Museum of Fine Arts, Boston—New York, The Metropolitan Museum of Art, *The Etchings of Jacques Bellange*, 1975, cat. by Amy Worthen and Sue Welsh Reed

Detroit 1965
Detroit, The Detroit Institute of Arts, *The John S. Newberry Collection*, 1965, cat. ed. by Charles H. Elam

Detroit and Chicago 1981
Detroit, The Detroit Institute of Arts—Chicago, The Art Institute of Chicago, *The Golden Age of Naples: Art and Civilization under the Bourbons, 1734–1805*, 2 vols., 1981–82

Dijon 1977
Dijon, Musée Magnin, *Dessins français du XVIIIe siècle*, 1977, cat. ed. by Arnauld Brejon de Lavergnée and Pierre Quarré

Dijon 1990
Dijon, Musée des Beaux-Arts, *La Peinture en Bourgogne au XVIe siècle*, 1990, cat. by Marguerite Guillaume

Dijon and Paris 1992
Dijon, Musée des Beaux-Arts—Paris, Fondation Custodia, Institut Néerlandais, *Chefs-d'oeuvre de la peinture française des musées néerlandais, XVIIe–XVIIIe siècles*, 1992, cat. by Pierre Rosenberg, Guido Jansen, and Jeroen Giltaij

Dijon and Le Mans 1998
Dijon, Musée Magnin—Le Mans, Musée de Tessé, *Eloge de la clarté: Un Courant artistique au temps de Mazarin, 1640–1660*, 1998, cat. by Alain Mérot, Emmanuel Starcky, Françoise Chaserant, et al.

Dublin 1985
Dublin, National Gallery of Ireland, *Le Classicisme Français: Masterpieces of French Seventeenth-Century Painting*, 1985, cat. by Sylvain Laveissière

Dunkirk et al. 1980
Dunkirk, Musée des Beaux-Arts—Valenciennes, Musée des Beaux-Arts—Lille, Musée des Beaux-Arts, *Trésors des Musées du nord de la France IV: La Peinture française aux XVIIe et XVIIIe siècles*, 1980, org. by Hervé Oursel and Jacques Kuhnmunch

Düsseldorf 1979
Düsseldorf, C. G. Boerner, *Angelika Kauffmann und ihre Zeit,* 1979

Edinburgh 1981
Edinburgh, National Gallery of Scotland, *Poussin, Sacraments and Bacchanals: Paintings and Drawings on Sacred and Profane Themes by Nicolas Poussin, 1594–1665,* 1981, cat. by Hugh Brigstocke

Ferrara 1985
Ferrara, Palazzo Castello Estense, Casa Romei, *Torquato Tasso, tra letteratura, musica, teatro, e arti figurative,* 1985, cat. ed. by Andrea Buzzoni and Laura Laureati et al.

Fort Worth and Los Angeles 1992
Fort Worth, Kimbell Art Museum—Los Angeles, Los Angeles County Museum of Art, *Italian Drawings, 1350–1800: Masterworks from the Albertina,* 1992, cat. by Veronika Birke

Frankfurt 1986
Frankfurt, Städtische Galerie im Städelschen Kunstinstitut, *Französische Zeichnungen im Städelschen Kunstinstitut, 1500 bis 1800,* 1986, cat. by Margret Stuffmann and Hildegard Bauereisen

Frankfurt 1988
Frankfurt, Schirn Kunsthalle, *Guido Reni und Europe: Ruhm und Nachruhm,* 1988, cat. by Sybille Ebert-Schifferer, Andrea Emiliani, and Erich Schleier

Grenoble et al. 1988
Grenoble, Musée des Beaux-Arts—Rennes, Musée des Beaux-Arts—Bordeaux, Musée des Beaux-Arts, *Laurent de La Hyre, 1606–1656: L'Homme et l'oeuvre,* 1989–90, cat. by Pierre Rosenberg and Jacques Thuillier

Hartford et al. 1976
Hartford, Wadsworth Atheneum—San Francisco, Palace of the Legion of Honor—Dijon, Musée des Beaux-Arts, *Jean-Baptiste Greuze, 1725–1805,* 1976–77, cat. by Edgar Munhall

Helsinki 1994
Helsinki, Museum of Foreign Art–Sinebrychoff, *Seventeenth-Century French Paintings from the Museum of Fine Arts, Budapest,* 1994, cat. by Agnes Szigethi

's-Hertogenbosch 1992
's-Hertogenbosch, Noordbrabants Museum, *Van Boucher tot Boudin: Honderd jaar Franse schilderkunst, 1750–1850, uit de collectie van het Musée des Beaux-Arts te Quimper,* 1992, cat. by André Cariou, Sophie Barthélémy, and Bernard Vermet

Le Havre 1987
Le Havre, Maison de la Culture, *Le Dessin XVIe–XXe siècle à travers une collection Havraise,* 1987

Lille 1893
Lille, Musée des Beaux-Arts, *Catalogue des tableaux du Musée de Lille,* 1893

Lille 1968
Lille, Palais des Beaux-Arts, *Au Temps du roi soleil: Les Peintres de Louis XIV (1660–1715),* 1968, cat. by Antoine Schnapper, Jacques Thuillier, Sylvie de Langlade, Georges de Lastic, Albert Chatelet, and Geneviève Becquart

Lille and Rome 1983
Lille, Palais des Beaux-Arts—Rome, Palazzo Braschi, Centre Culturel Français, *Autour de David: Dessins néoclassiques du musée des Beaux-Arts de Lille,* 1983–84, cat. by Arlette Sérullaz, Jean-François Méjanès, et al.

Lille 1985
Lille, Palais des Beaux-Arts, *Au Temps de Watteau, Fragonard et Chardin: Le Pays-Bas et les peintres français du XVIIIe siècle,* 1985, cat. by Hervé Oursel, Catherine Louboutin, and Annie Scottez

Loir-et-Cher 1996
Loir-et-Cher, Château de Chambord, *Lisses et délices: Chefs-d'oeuvre de la tapisserie de Henri IV à Louis XIV,* 1996, cat. by Bruno Saunier et al.

London 1949
London, Colnaghi Galleries, *Old Master Drawings,* 1949

London 1955
London, Wildenstein, *Artists in Seventeenth-Century Rome,* 1955, cat. by Denis Mahon

London 1972
London, Royal Academy and the Victoria and Albert Museum, *The Age of Neo-Classicism,* 1972, chief org. and ed., Sir John Pope Hennessy

London 1974
London, Colnaghi Galleries, *Old Master Prints,* 1974

London 1975
London, Heim Gallery, *French Drawings, Neo-Classicism,* 1975, cat. by Philip Conisbee

London 1977
London, British Museum, Department of Prints and Drawings, *French Landscape Drawings and Sketches of the Eighteenth Century,* 1977, cat. by Roseline Bacou, Lise Duclaux, and Jean-François Méjanès

London et al. 1977
London, Heim Gallery—Liverpool, Walker Art Gallery—Dublin, National Gallery of Ireland—Birmingham, City Museum and Art Gallery, *The Finest Drawings from the Museum of Angers,* 1977, cat. by Viviane Huchard, Alastair Laing, et al.

London 1980
London, Baroni Gallery, *Master Drawings,* 1980, cat. by Jean-Luc Baroni

London and Washington 1982
London, Royal Academy of Arts—Washington, National Gallery of Art, *Painting in Naples 1606–1705: From Caravaggio to Giordano,* 1982, cat. ed. by Clovis Whitefield and Jane Martineau

London 1984
London, Robin Symes, Ltd., *Annamaria Edelstein: Master Drawings,* 1984

London 1985
London, Museum of London with the Huguenot Society, *The Quiet Conquest: The Huguenots, 1685–1985,* 1985, cat. ed. by Tessa Murdoch

London 1986a
London, Thos. Agnew and Sons, Ltd., *From Claude to Géricault: The Arts in France, 1630–1830,* 1986

London 1986b
London, Adolphe Stein, *Master Drawings,* 1986

London and New Haven 1987
London, The British Museum—New Haven, The Yale Center for British Art, *Drawing in England from Hilliard to Hogarth,* 1987, cat. by Lindsay Stainton and Christopher White

London 1988
London, Crawley and Asquith Gallery, *The Art of the Landscape: Classical, Neoclassical and "en Plein Air,"* 1988, cat. by John Lishawa

London 1989a
London, Kate Ganz, *Master Drawings,* 1989

London 1989b
London, Thos. Agnew and Sons, Ltd., *Master Drawings,* 1989, cat. by Gabrielle Naughton

London 1990a
London, Hazlitt, Gooden and Fox, Ltd., *Nineteenth-Century French Drawings*, 1990

London 1990b
London, Dulwich Picture Gallery, *Courage and Cruelty: Le Brun's "Horatius Cocles" and "The Massacre of the Innocents,"* 1990–91, cat. by Jennifer Montagu, Helen Glanville, Richard Wrigley, et al.

London 1991
London, Somerset House, Courtauld Institute Galleries, *French Drawings, Fourteenth to Nineteenth Centuries*, 1991, cat. by Gillian Kennedy and Anne Thackray

London 1994
London, Yvonne Tan Bunzl, *Master Drawings*, 1994

London et al. 1995
London, Dulwich Picture Gallery—Houston, Museum of Fine Arts—Cleveland, Cleveland Museum of Art—New York, The Metropolitan Museum of Art, *Poussin: Works on Paper, Drawings from the Collection of Her Majesty Queen Elizabeth II*, 1995–96, cat. by Martin Clayton

London 1997
London, British Museum, *Jacques Bellange, ca. 1575–1616*, 1997, cat. by Anthony Griffiths and Craig Hartley

Los Angeles 1988
Los Angeles, University of California, Grunwald Center for the Graphic Arts, *French Caricature and the French Revolution*, 1988, cat. ed. by James Cuno

Los Angeles et al. 1993
Los Angeles, Los Angeles County Museum of Art—Philadelphia, Philadelphia Museum of Art—Minneapolis, The Minneapolis Institute of Arts, *Visions of Antiquity: Neoclassical Figure Drawings*, 1993–94, cat. by Richard Campbell, Victor Carlson, et al.

Los Angeles et al. 1994
Los Angeles, University of California, Grunwald Center for the Graphic Arts and the Armand Hammer Museum of Art and Cultural Center—New York, The Metropolitan Museum of Art—Paris, Bibliothèque Nationale de France, *The French Renaissance in Prints from the Bibliothèque Nationale de France*, 1994–95, cat. ed. by Cynthia Burlingham and Marianne Grivel

Marly 1992
Marly-le-Roi, Musée-Promenade, *Madame Du Barry: De Versailles à Louveciennes*, 1992, cat. by Christian Baulez

Marseille 1978
Marseille, Musée des Beaux-Arts, Palais Longchamp, *La Peinture en Provence au XVIIe siècle*, 1978, cat. by Henri Wytenhove

Marseille and Genoa 1994
Marseille, Centre de la Vieille Charité and the Musée des Beaux-Arts—Genoa, Palazzo Ducale, *Pierre Puget: Peintre, sculpteur, architecte, 1620–1694*, 1994, cat. ed. by Marie-Paul Vial and Luc Georget

Meaux 1990
Meaux, Musée Bossuet, *De Niccolo dell'Abate à Nicolas Poussin: Aux Sources du classicisme, 1550–1650*, 1990, cat. ed. by Jean-Pierre Changeaux and Blanche Grinbaum

Middlebury 1975
Middlebury, Middlebury College, *Architectural, Ornament, Landscape, and Figure Drawings Collected by Richard Wunder*, 1975

Middletown and Baltimore 1975
Middletown, Wesleyan University, Davison Art Center—Baltimore, The Baltimore Museum of Art, *Prints and Drawings by Gabriel de Saint-Aubin, 1724–1780*, 1975, cat. by Victor Carlson, Ellen D'Oench, and Richard S. Field

Milwaukee and New York 1989
Milwaukee, Milwaukee Art Museum—New York, National Academy of Design, *Renaissance into Baroque: Italian Master Drawings by the Zuccarri, 1550–1600*, 1989, cat. by James Mundy

Minneapolis et al. 1968
Minneapolis, The Minneapolis Institute of Arts—Chicago, The Art Institute of Chicago—Kansas City, Nelson-Atkins Museum of Art—Cambridge, Fogg Art Museum, Harvard University Art Museums, *Loan Exhibition: Selections from the Drawing Collection of David Daniels*, 1968, cat. by Agnes Mongan

Montargis 1967
Montargis, Musée Girodet, *Girodet, 1767–1824*, 1967, cat. by Jacqueline Provost-Auzas

Montargis 1983
Montargis, Musée Girodet, *Girodet: Dessins du musée*, 1983, cat. by Jacqueline Boutet-Loyer

Montargis 1989
Montargis, Musée Girodet, *La Legende d'Ossian illustrée par Girodet*, 1989

Montargis 1997
Montargis, Musée Girodet, *Dessiner L'Eneide*, 1997, cat. by Philippe Ségéral

Montpellier 1996
Montpellier, Musée Fabre, *Paysages de Poussin à Courbet dans les collections du musée Fabre*, 1996, cat. by Michel Hilaire and Olivier Zeder

Montreal 1982
Montreal, Musée des Beaux-Arts, *Largillière: Portraitist du dix-huitième siècle*, 1981–82, cat. by Myra Nan Rosenfeld et al.

Montreal 1993
Montreal, Canadian Centre for Architecture, *Exploring Rome: Piranesi and His Contemporaries*, 1993–94, cat. by Cara D. Denison, Myra Nan Rosenfeld, and Stephanie Wiles

Montreal et al. 1993
Montreal, Museum of Fine Arts—Rennes, Musée des Beaux-Arts—Montpellier, Musée des Beaux-Arts, *Century of Splendor: Seventeenth-Century French Painting in French Public Collections*, 1993, cat. by Michel Hilaire and Patrick Ramade

Moscow 1978
Moscow, Pushkin Museum of Fine Arts, *French Drawings*, 1978

Munich 1982
Munich, Julius Böhler, *Gemälde, Handzeichnungen, Plastiken*, 1982

Munich 1991
Munich, Staatliche Graphischen Sammlung and Nueun Pinakothek München, *Simon Vouet, 100 neuendeckte Zeichnungen aus den Beständen der Bayerischen Staatsbibliothek*, 1991, cat. by Richard Harprath, Barbara Brejon de Lavergnée, Helge Siefert, and Laurentius Koch

Nancy 1992a
Nancy, Musée historique lorrain, *Jacques Callot, 1592–1635*, 1992, cat. by Daniel Ternois and Paulette Choné

Nancy 1992b
Nancy, Musée des Beaux-Arts, *L'Art en Lorraine au temps de Jacques Callot*, 1992, cat. by Jacques Thuillier, Claude Petry, et al.

New Haven 1984
New Haven, Yale University Art Gallery, *French Drawings: Acquisitions 1970–1984*, 1984, cat ed. by Richard S. Field

New Haven 1987
New Haven, Yale University Art Gallery, *From Mannerism to Classicism: Printmaking in France, 1600–1660*, 1987–88, cat. by Alvin L. Clark, Jr.

New Orleans et al. 1996
New Orleans, New Orleans Museum of Art—New York, Stair Sainty-Mathiesen—Cincinnati, The Taft Museum, *Romance and Chivalry: History and Literature Reflected in Early Nineteenth-Century French Painting*, 1996–97, cat. by Guy Stair Sainty, Marie Claude Chaudonneret, Nadia Tscherny et al.

New York 1957
New York, Slatkin Gallery, *Master Drawings*, 1957

New York 1959
New York, Knoedler Gallery, *Great Master Drawings of Seven Centuries*, 1959

New York 1962
New York, The Metropolitan Museum of Art, *Master Drawings in the Collection of Walter C. Baker*, 1962, cat. by Claus Virch

New York 1965
New York, Shickmann Gallery, *Old Master Drawings*, 1965

New York 1968
New York, Shickmann Gallery, *Old Master Drawings*, 1968

New York 1969
New York, Wildenstein, *Gods and Heroes: Baroque Images of Antiquity*, 1969, cat. by Eunice Williams

New York 1975
New York, The Pierpont Morgan Library, *Drawings from the Collection of Mr. and Mrs. Eugene V. Thaw*, 1975

New York 1979
New York, National Academy of Design, *Eighteenth-Century French Drawings from the Musée Carnavalet*, 1979, cat. by Bernard de Montgolfier

New York 1980
New York, The Metropolitan Museum of Art, *Seventeenth- and Eighteenth-Century French Drawings from the Robert Lehman Collection*, 1980, cat. by George Szabó

New York 1981
New York, Spencer Samuels and Co., *Master Drawings*, 1981

New York 1984
New York, Didier Aaron, Inc., *French Master Drawings*, 1984, cat. by Hervé Aaron and Alan Salz

New York 1985a
New York, The Pierpont Morgan Library, *Drawings from the Collection of Mr. and Mrs. Eugene V. Thaw—II*, 1985

New York 1985b
New York, Richard L. Feigen and Co., *Landscape Painting in Rome, 1595–1675*, 1985, cat. by Anne Sutherland Harris

New York et al. 1985
New York, Stair Sainty-Mathiesen—New Orleans, New Orleans Museum of Art—Columbus, Columbus Museum of Art, *The First Painters of the King: French Royal Taste from Louis XIV to the Revolution*, 1985–86, cat. by Colin Bailey

New York 1986
New York, Zangrilli, Brady and Co., *French and English Drawings, 1700–1875*, 1986, cat. by W. Mark Brady

New York et al. 1986
New York, The Metropolitan Museum of Art—Detroit, The Detroit Institute of Arts—Paris, Galeries Nationales du Grand Palais, *François Boucher, 1703–1770*, 1986, org. and cat. by Alastair Laing, J. Patrice Marandel, Pierre Rosenberg, and Edith Standen

New York and Edinburgh 1987
New York, The Drawing Center—Edinburgh, National Gallery of Scotland, *The Art of Drawing in France, 1400–1900*, 1987, cat. by Per Bjurström

New York 1988
New York, The Drawing Center, *Creative Copies: Interpretative Drawings from Michelangelo to Picasso*, 1988, cat. ed. by Egbert Haverkamp-Begeman and Carolyn Logan

New York et al. 1988
New York—Paris—London—Galeries Didier Aaron, *Master Drawings*, 1988, cat. by Hervé Aaron, Alan Salz, and Kate de Rothschild

New York 1989
New York, Colnaghi Galleries, *1789: French Art during the Revolution*, 1989, cat. ed. by Alan Wintermute

New York 1990
New York, Colnaghi Galleries, *Claude to Corot: The Development of Landscape Painting in France*, 1990, cat. ed. by Alan Wintermute

New York et al. 1990
New York, National Academy of Design—Fort Worth, Kimbell Art Museum—Ottawa, National Gallery of Canada, *Masterful Studies: Three Centuries of French Drawings from the Prat Collection*, 1990, cat. by Pierre Rosenberg

New York 1991a
New York, The Metropolitan Museum of Art, *French Architectural and Ornament Drawings of the Eighteenth Century*, 1991–92, cat. by Mary L. Myers

New York 1991b
New York, W. M. Brady and Co., Inc., *Nineteenth-Century French Drawings and Oil Sketches*, 1991, cat. ed. by Mark Brady

New York and Fort Worth 1991
New York, The Frick Collection—Fort Worth, Kimbell Art Museum, *Nicolas Lancret, 1690–1743*, 1991, cat. by Mary Tavener Holmes

New York and London 1991
New York—London, Colnaghi Galleries, *An Exhibition of Old Master Drawings Presented by Jean-Luc Baroni*, 1991, cat. by Stephen Ongpin

New York 1992a
New York, The Pierpont Morgan Library, *Drawings from the Collection of Mr. and Mrs. Eugene V. Thaw—III*, 1992

New York 1992b
New York, W. M. Brady and Co., Inc., *Thomas Le Claire, Kunsthandel, Master Drawings*, 1992

New York 1992c
New York, W. M. Brady and Co., Inc., *French Drawings, 1770–1880*, 1992, cat. by Mark Brady

New York 1993
New York, W. M. Brady and Co., Inc., *Nineteenth-Century Drawings and Oil Sketches*, 1993, cat. ed. by Mark Brady

New York et al. 1993
New York—Paris—London, Galeries Didier Aaron with Kate de Rothschild, *Master Drawings 1993*, 1993, cat. by Alan Salz and Kate de Rothschild with Jill Dienst and Isabelle Mayer

New York 1994a
New York, W. M. Brady and Co., Inc., *Master Drawings, 1760–1890*, 1994, cat. ed. by Mark Brady

New York 1994b
New York, Emmanuel Moatti at Jack Kilgore and Co., Inc., *Old Master Drawings*, 1994, cat. by Emmanuel Moatti

New York 1995a
New York, The Pierpont Morgan Library, *Fantasy and Reality: Drawings from the Sunny Crawford von Bülow Collection*, 1995–96, cat. by Cara Dufour Denison with Stephanie Wiles and Ruth S. Kraemer

New York 1995b
New York, W. M. Brady and Co., Inc., *Master Drawings 1790–1900: A Selection of Recent Acquisitions*, 1995, cat. ed. by Mark Brady

New York and London 1995a
New York—London, Colnaghi Galleries, *An Exhibition of Old Master Drawings Presented by Jean-Luc Baroni*, 1995, cat. by Stephen Ongpin

New York and London 1995b
New York, W. M. Brady and Co., Inc.—London, Thomas Williams Fine Art, Ltd., at Daniel Katz, Ltd., *Old Master Drawings*, 1995, cat. by Thomas Williams with Julian Brookes

New York 1996a
New York, W. M. Brady and Co., Inc., *Drawings and Pictures, 1790–1890*, 1996, cat. ed. by Mark Brady

New York 1996b
New York, The Frick Collection, *Greuze, A Portraitist for the '90s*, 1996, org. by Edgar Munhall, no catalogue

New York et al. 1996
New York—Paris—London, Galeries Didier Aaron with Kate de Rothschild and Galerie Brame and Lorenceau, *Master Drawings 1996*, 1996, cat. by Kate de Rothschild, Alan Salz, Sylvie Brame, Althea Palmer, and Isabelle Mayer

New York and London 1998
New York—London, Colnaghi Galleries, *An Exhibition of Old Master Drawings Presented by Jean-Luc Baroni*, 1998, cat. by Stephen Ongpin

Nice 1976
Nice, Musée National Message Biblique Marc Chagall, *Trente peintres du XVIIe siècle français: Tableaux d'inspiration religieuse des musées de province*, 1976

Nice et al. 1977
Nice, Musée des Beaux-Arts—Clermont-Ferrand, Musée Bargoin—Nancy, Musée des Beaux-Arts, *Carle Vanloo, premier peintre du roi (Nice, 1705–Paris, 1765)*, 1977, cat. by Marie-Catherine Sahut with Pierre Rosenberg

Norwich 1987
Norwich, Norwich Castle Museum, *The Northern Eye*, 1987, no catalogue

Nottingham and Kenwood 1991
Nottingham, University Art Gallery—Kenwood, the Iveagh Bequest, *The Artist's Model*, 1991, cat. by Ilaria Bignamini and Martin Postle

Noyons 1992
Noyons, Musée du Noyonnais, *Jacques Sarazin: Sculpteur du Roi, 1592–1660*, 1992, cat. by Geneviève Bresc-Bautier, Françoise de La Moureyre, and Barbara Brejon de Lavergnée

Oberlin et al. 1991
Oberlin, Oberlin College, Allen Memorial Art Museum—New Brunswick, Bowdoin College Museum of Art—Hanover, Hood Museum, Dartmouth College, *From Studio to Studiolo: Florentine Draftsmanship under the First Medici Grand Dukes*, 1991–92, cat. by Larry J. Fineberg, with Karen Edis-Barzman

Orléans 1975
Orléans, Musée des Beaux-Arts, *Dessins français du XVIe au XVIIIe siècle*, 1975, cat. by David Ojalvo

Ottawa 1982
Ottawa, National Gallery of Canada, *Bolognese Drawings in North American Collections, 1500–1800*, 1982, cat. by Mimi Cazort and Catherine Johnston

Ottawa 1994
Ottawa, National Gallery of Canada, *The Ingenious Machine of Nature: Four Centuries of Art and Anatomy*, 1994, cat. by Mimi Cazort, Monique Kornell, and K. B. Roberts

Oxford 1990
Oxford, Ashmolean Museum, *A Loan Exhibition of Drawings by Nicolas Poussin from British Collections*, 1990–91, cat. by Hugh Brigstocke

Paris 1874
Paris, Ecole des Beaux-Arts, *Exposition des oeuvres de Prud'hon au profit de sa fille*, 1874

Paris 1884
Paris, Ecole des Beaux-Arts, *Catalog des dessins de l'Ecole moderne exposé a l'Ecole nationale des Beaux-Arts au profit de la caisse de secours de l'association des artistes peintres, sculpteurs, architectes, graveurs, et dessinateurs*, 1884

Paris 1889
Paris, Exposition universelle. Beaux-Arts. *Exposition centenale de la Français (1789–1889)*, 1889

Paris 1920
Paris, Musée des Arts Decoratifs, *Exposition Debucourt, catalogue des tableaux, dessins, gravures*, 1920

Paris 1928
Paris, Musée Carnavalet, *La Vie Parisienne au XVIIIe siècle*, 1928

Paris 1934
Paris, Musée de l'Orangerie, *Les Peintres de la realité en France au XVIIe siècle*, 1934, cat. by Charles Sterling

Paris 1951
Paris, Galerie Cailleux, *Le Dessin français de Watteau à Prud'hon*, 1951, cat. by Jean Cailleux

Paris et al. 1958
Paris, Musée de l'Orangerie—Rotterdam, Boijmans van Beuningen Museum—New York, The Metropolitan Museum of Art, *French Drawings from American Collections, Clouet to Matisse*, 1958–59, cat. by Agnes Mongan

Paris 1961
Paris, Hôtel de Rohan, *Les Français à Rome: Résidents et voyageurs dans la Ville Eternelle de la Renaissance aux débuts du Romantisme*, 1961, org. by André Chamson

Paris 1964
Paris, Galerie Cailleux, *François Boucher*, 1964, cat. by Jean Cailleux

Paris and Amsterdam 1964
Paris, Institut Néerlandais—Amsterdam, Rijksmuseum, Rijksprentenkabinet, *Le Dessin français de Claude à Cezanne dans les Collections Hollandaises complété d'un choix d'autographes des artistes exposées*, 1964, cat. by Frits Lugt

Paris 1967
Paris, Musée du Louvre, Galerie Mollien, Cabinet des Dessins, *Le Cabinet d'un grand amateur, P.-J. Mariette, 1694–1774*, 1967, org. by Roseline Bacou, Françoise Viatte, and Sylviane d'Origny

Paris 1968
Paris, Galerie Cailleux, *Watteau et Sa Generation*, 1968, cat. by Marianne Roland Michel

Paris 1971
Paris, Galerie Cailleux, *Trente pastels, gouaches et aquarelles du XVIIIe siècle*, 1971, cat. by Jean Cailleux

Paris 1972a
Paris, Musée du Louvre, Cabinet des Dessins (exh. no. 50), *Dessins français de 1750 à 1825 dans les collections du Musée du Louvre: Le Neoclassicisme*, 1972, cat. by Arlette Sérullaz

Paris 1972b
Paris, Musée du Louvre, Département des Peintures (dossier no. 3), *Le Cabinet de l'amour de l'Hôtel Lambert*, 1972, cat. by Jean-Pierre Babelon, Georges de Lastic, Pierre Rosenberg, and Antoine Schnapper

Paris and Ottawa 1972
Paris, Galeries Nationales du Grand Palais—Ottawa, National Gallery of Canada, *L'Ecole de Fontainebleau*, 1972, org. by Sylvie Béguin (all refs. to French edition)

Paris 1973
Paris, Musée du Louvre, Cabinet des Dessins (exh. no. 52), *Le statue équestre de Louis XV: Dessins de Bouchardon, sculpteur du Roi, dans les collections du Musée du Louvre*, 1973, cat. by Lise Duclaux

Paris 1974a
Paris, Galeries Nationales du Grand Palais, *Le Néo-classicisme français, Dessins des Musées de Province*, 1974–75, cat. by Jean Lacambre, Arlette Sérullaz, Jacques Villain, and Nathalie Volle

Paris 1974b
Paris, Galeries Nationales du Grand Palais, *Valentin et les Caravagesques français*, 1974, org. by Jean-Pierre Cuzin and Arnauld Brejon de Lavergnée

Paris et al. 1974
Paris, Galeries Nationales du Grand Palais—Detroit, The Detroit Institute of Arts—New York, The Metropolitan Museum of Art, *French Painting 1774–1830: The Age of Revolution*, 1974–75, org. by Frederick J. Cummings, Pierre Rosenberg, and Robert Rosenblum

Paris 1976
Paris, Musée du Louvre, Cabinet des Dessins (exh. no. 62), *Dessins français de l'Art Institute de Chicago de Watteau à Picasso*, 1976–77, cat. by Harold Joachim and Suzanne Folds McCullagh, trans. by Geneviève Monnier

Paris et al. 1976
Paris, Galerie Heim—Lille, Palais des Beaux-Arts—Strasbourg, Musée des Beaux-Arts, *Cent Dessins du Fitzwilliam Museum, Cambridge*, 1976, cat. by Michael Jaffé

Paris 1977
Paris, Galeries Nationales du Grand Palais, *Le Siècle de Rubens dans les collections publiques françaises*, 1977, org. by Jacques Foucart and Jean Lacambre

Paris and Geneva 1978
Paris—Geneva, Galeries Cailleux, *Sanguines: Dessins français du dix-huitième siècle*, 1978, cat. by Marianne Roland Michel, Jean Cailleux, and Annette Rambaud

Paris et al. 1979
Paris, Galeries Nationales du Grand Palais—Cleveland, Cleveland Museum of Art—Boston, Museum of Fine Arts, Boston, *Chardin, 1699–1779*, 1979, cat. by Pierre Rosenberg

Paris 1980
Paris, Galerie de la SEITA, *Le Faubourg Saint-Germain: La rue de Grenelle*, 1980

Paris and Geneva 1980
Paris—Geneva, Galeries Cailleux, *Des Monts et des eaux: Paysages de 1715–1850*, 1980–81, cat. by Marianne Roland Michel and Jean Cailleux

Paris 1981a
Paris, Ecole nationale supérieure des Beaux-Arts, *De Michel-Ange à Géricault: Dessins de la donation Armand Valton*, 1981, cat. by Emmanuelle Brugerolles

Paris 1981b
Paris, Musée Carnavalet, *Ile Saint-Louis*, 1981, org. by Françoise Reynaud

Paris 1982a
Paris, Musée du Petit Palais, *L'Art du XVIIe siècle dans les Carmels de France*, 1982, cat. ed. by Yves Rocher and Gilles Chazal

Paris 1982b
Paris, Mairie du 5e Arrondissement, *Le Grand Siècle au Quartier Latin*, 1982, org. by Bernard de Montgolfier

Paris et al. 1982a
Paris, Galeries Nationales du Grand Palais—Fort Worth, Kimbell Art Museum—Kansas City, Nelson-Atkins Museum of Art, *Jean-Baptiste Oudry, 1686–1755*, 1982–83, cat. by Hal Opperman (all refs. to French edition)

Paris et al. 1982b
Paris, Galeries Nationales du Grand Palais—New York, The Metropolitan Museum of Art—Chicago, The Art Institute of Chicago, *France in the Golden Age*, 1982, cat. by Pierre Rosenberg

Paris 1983a
Paris, Grand Palais, *Hommage à Raphael: Raphael et l'art français*, 1983, org. by Jean-Pierre Cuzin and Dominique Cordellier

Paris 1983b
Paris, Musée du Louvre, Pavillon de Flore, Cabinet des Dessins, *Les Collections du comte d'Orsay: Dessins du Musée du Louvre*, 1983, cat. by Jean-François Méjanès

Paris 1983c
Paris, Galerie Cailleux, *Rome 1760–1770: Fragonard, Hubert Robert, et leurs amis*, 1983, cat. by Jean Cailleux and Marianne Roland Michel

Paris 1983d
Paris, Hôtel de la Monnaie, *Jean-Baptiste Colbert, 1619–1683*, 1983

Paris 1984a
Paris, Musée du Louvre, Cabinet des Dessins (exh. no. 83), *Dessins français du XVIIe siècle*, 1984–85, cat. by Roseline Bacou et al.

Paris 1984b
Paris, Hôtel de la Monnaie, *Diderot et l'art de Boucher à David, les Salons: 1759–1781*, 1984–85, cat. by Nathalie Volle and Marie-Catherine Sahut

Paris 1984c
Paris, Musée du Louvre, Cabinet des Dessins (exh. no. 81), *Acquisitions du Cabinet des Dessins, 1973–1983*, 1984, org. and ed. by Roseline Bacou

Paris 1984d
Paris, Galerie Cailleux, *Le Dessin en couleurs, aquarelles, gouaches, pastels*, 1984, cat. by Marianne Roland Michel

Paris 1985a
Paris, Musée du Louvre, Cabinet des Dessins (exh. no. 85), *Le Brun à Versailles*, 1985–86, cat. by Lydia Beauvais and Jean-François Méjanès

Paris 1985b
Paris, Musée Carnavalet, *Saint-Paul–Saint-Louis: Les Jésuites à Paris*, 1985, org. by Jean-Pierre Willesme

Paris 1985c
Paris, Sorbonne, *Richelieu et le monde de l'esprit*, 1985, cat. ed. by André Tuilier

Paris 1985d
Paris, Hôtel de Marle, Institut Culturel Suédois, *Versailles à Stockholm; Dessins de Nationalmuseum, peintures, meubles, et arts decoratifs des collections Suédois et Danoises*, 1985, cat. by Guy Walton

Paris 1985e
Paris, Galerie Cailleux, *Oeuvres de Jeunesse de Watteau à Ingres*, 1985, cat. by Marianne Roland Michel

Paris 1985f
Paris, Galerie Didier Aaron, *Dessins insolites*, 1985, cat. by Olivier Aaron

Paris 1985g
Paris, Musée du Louvre, Collection Edmond de Rothschild, *Graveurs français de la seconde moitié du XVIIIe siècle*, 1985

Paris 1986a
Paris, Musée du Louvre, Pavillon de Flore, Département des Peintures (dossier no. 32), *Prud'hon: La Justice et la Vengeance divine poursuivant le Crime*, 1986, cat. by Sylvain Laveissière

Paris 1986b
Paris, Musée Carnavalet, *Les Cisterciens à Paris*, 1986, org. by Jean-Pierre Willesme

Paris 1986c
Paris, Galerie de Bayser, *Dessins anciens*, 1986, cat. by Bruno and Thèrese de Bayser

Paris and Geneva 1986
Paris—Geneva, Galeries Cailleux, *Artistes en voyage au XVIIIe siècle*, 1986, cat. by Marianne Roland Michel

Paris 1987a
Paris, Musée Carnavalet, *La Chartreuse de Paris*, 1987, org. by Jean-Pierre Willesme

Paris 1987b
Paris, Bibliothèque Nationale de France, *L'Estampe en France du XVIe au XIXe siècle*, 1987, org. by Madeleine Barbin

Paris 1987c
Paris, Hôtel de Sully, *Le Marais: Mythe et Realité*, 1987, org. by Jean-Pierre Babelon and Claude Malécot

Paris 1987d
Paris, Musée du Louvre, Cabinet des Dessins (exh. no. 89), *Dessins français du XVIIIe siècle de Watteau à Le Moyne*, 1987, cat. by Roseline Bacou, Lise Duclaux, Hélène Guicharnaud, and Jean-François Méjanès

Paris 1987e
Paris, Galerie Cailleux, *Aspects de Fragonard: Peintures, Dessins, Estampes*, 1987

Paris and New York 1987
Paris, Galeries Nationales du Grand Palais—New York, The Metropolitan Museum of Art, *Fragonard*, 1988, cat. by Pierre Rosenberg

Paris and Rome 1987
Paris, Musée du Luxembourg—Rome, Villa Medici, Académie de France, *Subleyras, 1699–1749*, 1987, cat. by Pierre Rosenberg with Olivier Michel and Philippe Morel

Paris 1988a
Paris, Galeries Nationales du Grand Palais, *Seicento: Le siècle de Caravage dans les collections françaises*, 1988, org. by Arnauld Brejon de Lavergnée

Paris 1988b
Paris, Musée du Louvre, Cabinet des Dessins (exh. no. 91), *Le dessin à Rome au XVIIe siècle*, 1988, cat. by Roseline Bacou and Jacob Bean

Paris 1988c
Paris, Bibliothèque Nationale de France, *L'Oeil d'or Claude Mellan, 1598–1688*, 1988, cat. by Maxime Préaud and Barbara Brejon de Lavergnée

Paris 1988d
Paris, Mairie du 5e Arrondissement, *Trésors d'art sacré à L'Ombre du Val de Grâce*, 1988, org. by Jacques Charles and the Délégation à l'Action Artistique de la Ville de Paris

Paris 1988e
Paris, Galerie del Borgo, *Dessins anciens*, 1988, cat. by Lawrence D. Strapélias

Paris 1989a
Paris, Ecole national supérieure des Beaux-Arts, *Dessins de la donation Mathias Polakovits à l'Ecole des Beaux-Arts*, 1989, org. by Natalie Coural

Paris 1989b
Paris, Musée du Louvre, Cabinet des Dessins (exh. no. 94), *Le beau idéal, ou l'art du concept*, 1989, cat. by Régis Michel

Paris 1989c
Paris, Musée du Louvre, Département des Peintures (dossier no. 37), *Le Peintre, le roi, le héros: l'Andromède de Pierre Mignard*, 1989, cat. by Jean-Claude Boyer

Paris 1989d
Paris, Galerie Cailleux, *Les Etapes de la Creation: Esquisses et dessins de Boucher à Isabey*, 1989, cat. by Marianne Roland Michel

Paris 1989e
Paris, Galeries Nationales du Grand Palais, *La Revolution française et L'Europe, 1789–1799*, 1989, 3 vols.

Paris and Versailles 1989
Paris, Musée du Louvre—Versailles, Musée national du Château de Versailles, *Jacques-Louis David, 1748–1825*, 1989–90, cat. by Antoine Schnapper and Arlette Sérullaz

Paris 1990a
Paris, Galeries Nationales du Grand Palais, *Vouet*, 1990–91, cat. by Jacques Thuillier, Barbara Brejon de Lavergnée, and Denis Lavalle

Paris 1990b
Paris, Musée du Louvre, Département des Arts Graphiques (exh. no. 95), *Le Paysage en Europe du XVIe au XVIIIe siècle*, 1990, cat. by Catherine Legrand, Jean-François Méjanès, and Emmanuel Starcky

Paris 1990c
Paris, Musée du Louvre, Pavillon de Flore, Département des Peintures (dossier no. 38), *Le Guerchin en France*, 1990, cat. by Stéphane Loire

Paris 1990d
Paris, Galerie Patrick Perrin, *De Callot à Tiepolo*, 1990, cat. by Patrick Perrin, Marie-Thérèse Gudot, and Nathalie Tachon

Paris 1991a
Paris, Musée du Luxembourg, *Marie de Medicis et le Palais du Luxembourg*, 1991, org. and cat. ed. by M.-N. Baudouin-Matuszek

Paris 1991b
Paris, William Foucault, *Dessins anciens*, 1991

Paris 1991c
Paris, Galerie Cailleux, *Le Rouge et le noir: Cent dessins français de 1700 à 1850*, 1991, cat. by Marianne Roland Michel

Paris et al. 1991
Paris, Galeries Nationales du Grand Palais—Philadelphia, Philadelphia Museum of Art—Fort Worth, Kimbell Art Museum, *The Loves of the Gods: Mythological Painting from Watteau to David*, 1992–93, cat. by Colin A. Bailey with Carrie A. Hamilton (all refs. to English edition)

Paris 1992a
Paris, Musée du Petit Palais, *Fragonard et le dessin français au XVIIIe siècle*, 1992–93, cat. by José-Luis de Los Llanos

Paris 1992b
Paris, Musée du Louvre, Département des Sculptures, *Clodion, 1738–1814*, 1992, cat. by Anne Poulet and Guilhem Scherf

Paris 1992c
Paris, Galerie Moatti, *Dessins anciens*, 1992, cat. by Emmanuel Moatti

Paris 1992d
Paris, Musée du Louvre, Département des Peintures (dossier no. 41), *Panini*, 1992–93, cat. by Michael Kiene

Paris et al. 1992
Paris—London—New York, Galeries Didier Aaron, *Catalogue*, 1992, cat. by Jill Hoffer Dienst, Michael Hall, Isabelle Mayer, and Alan Salz

Paris 1993a
Paris, Musée du Louvre, Département des Arts Graphiques, *Dessins français du XVIIe siècle dans les collections publiques françaises*, 1993, cat. by Jean-Claude Boyer, Barbara Brejon de Lavergnée, Michel Hilaire, and Jean-François Méjanès

Paris 1993b
Paris, Bibliothèque Nationale de France, *Les Manuscrits à peintures en France, 1440–1520*, 1993–94, cat. by François Avril and Nicole Reynaud

Paris 1993c
Paris, Galeries Nationales du Grand Palais, *L'Ame au corps, arts, et sciences, 1793–1993*, 1993–94, cat. by Jean Clair et al.

Paris and New York 1993
Paris, Musée du Louvre—New York, The Pierpont Morgan Library, *French Master Drawings from the Pierpont Morgan Library*, 1993–94, cat. by Cara Dufour Denison

Paris 1994a
Paris, Musée du Louvre, Département des Peintures (dossier no. 45), *Autour de Poussin*, 1994–95, cat. by Sylvain Laveissière and Gilles Chomer

Paris 1994b
Paris, Hôtel Georges V, Association du dessin, *Salon du Dessin*, 1994

Paris 1994c
Paris, Galerie Eric Coatalem, *Lubin Baugin, Oeuvres religieuses et mythologiques provenant de collections privées*, 1994, cat. by Eric Coatalem and Nathalie Delosme

Paris and London 1994
Paris, Galeries Nationales du Grand Palais—London, National Gallery, *Nicolas Poussin, 1594–1665*, 1994–95, cat. by Pierre Rosenberg and Louis-Antoine Prat

Paris et al. 1994
Paris, Ecole nationale supérieure des Beaux-Arts—Cambridge, Fogg Art Museum, Harvard University Art Museums—New York, The Metropolitan Museum of Art, *The Renaissance in France: Drawings from the Ecole des Beaux-Arts, Paris*, 1994–95, cat. by Emmanuelle Brugerolles and David Guillet

Paris 1995
Paris, Hôtel Georges V, Association du dessin, *Salon du Dessin*, 1995

Paris et al. 1995
Paris, Musée du Louvre—Edinburgh, National Gallery of Scotland—Oxford, Ashmolean Museum, *Dessins français de la Collection Prat, XVIIe–XVIIIe–XIXe siècles*, 1995, cat. by Pierre Rosenberg

Paris 1996a
Paris, Hôtel Georges V, Association du dessin, *Salon du Dessin*, 1996

Paris 1996b
Paris, Galerie Paul Prouté, S.A., *Catalogue Veronèse*, 1996, cat. ed. by Michèle Prouté and Hubert Prouté

Paris 1996c
Paris, Galerie Yves Mikaeloff, *Dessins et peintures anciens*, 1996, cat. by Nicolas Joly

Paris 1997a
Paris, Musée du Louvre, *Des Mécènes par milliers: Un Siècle de dons par les Amis du Louvre*, 1997, org. and ed. by Pierre Rosenberg and Marie-Anne Dupuy

Paris 1997b
Paris, Hôtel Georges V, Association du dessin, *Salon du Dessin*, 1997

Paris 1997c
Paris, Musée du Luxembourg, *La Donation Jacques Petithory au Musée Bonnat, Bayonne: Objets d'art, sculptures, peintures, dessins*, 1997, cat. ed. by Pierre Rosenberg

Paris and New York 1997a
Paris, Galeries Nationales du Grand Palais—New York, The Metropolitan Museum of Art, *Prud'hon ou le rêve de bonheur*, 1997–98, cat. by Sylvain Laveissière

Paris and New York 1997b
Paris, Musée du Louvre, Département des Sculptures—New York, The Metropolitan Museum of Art, *Pajou, sculpteur du Roi*, 1997–98, cat. by Guilhem Scherf

Pau and Paris 1989
Pau, Musée National du Château de Pau—Paris, Hotel du Rohan, Archives Nationales, *Henri IV et la reconstruction du Royaume*, 1989, cat. ed. by Jean-Daniel Pariset and Patrick Dupont

Philadelphia and Houston 1985
Philadelphia, Rosenbach Museum and Library—Houston, Museum of Fine Arts, *Eighteenth-Century French Book Illustration: Drawings by Fragonard and Gravelot from the Rosenbach Museum and Library*, 1985, cat. by Kimerly Rorschach

Philadelphia et al. 1986
Philadelphia, Rosenbach Museum and Library—Pittsburgh, Frick Art Museum—New York, The Frick Collection, *Drawings by Jean-Baptiste Le Prince, for the "Voyage en Sibérie,"* 1986–87, cat. by Kimerly Rorschach

Philadelphia 1987
Philadelphia, Philadelphia Museum of Art, *The Henry P. McIlhenny Collection*, 1987, cat. by Joseph Rishel et al.

Pittsburgh 1951
Pittsburgh, Carnegie Institute, *French Painting, 1100–1900*, 1951, no catalogue

Princeton 1977
Princeton, The Art Museum, *Eighteenth-Century French Life-Drawings*, 1977, cat. by James Henry Rubin

Princeton 1991
Princeton, The Art Museum, *Old Master Drawings from the Collection of Joseph F. McCrindle*, 1991, cat. by F. A. Den Broeder

Providence 1975
Providence, Bell Gallery, List Art Center, Brown University, *Rubenism*, 1975, cat. ed. by Mary Crawford Volk

Providence 1979
Providence, List Art Center, Brown University, *Festivities, Ceremonies and Celebrations in Western Europe, 1500–1790*, 1979

Providence et al. 1983
Providence, Museum of Art, Rhode Island School of Design—Minneapolis, The Minneapolis Institute of Arts—Toledo, Toledo Museum of Art—Coral Gables, Lowe Art Museum, University of Miami—Toronto, Art Gallery of Ontario—Baltimore, The Baltimore Museum of Art—Hanover, Hood Museum, Dartmouth College, *Old Master Drawings from the Museum of Art, Rhode Island School of Design*, 1983–84, cat. ed. by Deborah J. Johnson

Providence 1984
Providence, Bell Gallery, List Art Center, Brown University, *Children of Mercury: The Education of Artists in the Sixteenth and Seventeenth Centuries*, 1984, org. by Jeffrey Muller

Rennes 1965
Rennes, Musée des Beaux-Arts, *Peinture classique du XVIIe siècle français et italien du Musée du Louvre*, 1965, cat. by Germain Bazin

Rennes 1980
Rennes, Musée des Beaux-Arts, *Correspondances: Dessins et gravures du XVIIe siècle français, Collections du Musée des Beaux-Arts de Rennes*, 1980, cat. by Patrick Ramade

Rennes 1995
Rennes, Musée des Beaux-Arts, *XVIIe siècle: La Passion d'un amateur*, 1995, org. by François Coulon

Rochester et al. 1987
Rochester, The Memorial Art Gallery of the University of Rochester—New Brunswick, Rutgers University, Jane Voorhees Zimmerli Art Museum—Atlanta, The High Art Museum at Georgia-Pacific Center, *"La Grande Manière": Historical and Religious Painting in France, 1700–1800*, 1987–88, cat. by Donald A. Rosenthal

Rome 1956
Rome, Palazzo delle Esposizioni, *Il seicento europeo: realismo, classicismo, barocco*, 1956, org. by Mario Salmi, Luigi Salerno, Charles Sterling, et al.

Rome 1959
Rome, Palazzo Venezia, *Il disegno francese de Fouquet à Toulouse-Lautrec*, 1959, cat. by Jacqueline Bouchot-Saupique

Rome et al. 1976
Rome, Villa Medici, Académie de France—Dijon, Palais des Etats de Bourgogne (Musée des Beaux-Arts)—Paris, Hôtel de Sully, *Piranèse et les Français, 1740–1790*, 1976, cat. by Georges Brunel, Jean-François Méjanès, Marianne Roland Michel, et al.

Rome 1978
Rome, Istituto Nazionale per la Grafica, Gabinetto Nazionale delle stampe, *Immagini dal Veronese: Incisioni dal secolo XVI al XIX dalle Collezioni del Gabinetto Nazionale delle stampe*, 1978, cat. ed. by Paolo Ticozzi

Rome and Nancy 1982
Rome, Villa Medici, Académie de France—Nancy, Musée des Beaux-Arts, *Claude Lorrain e i pittori lorenesi in Italia nel XVII secolo*, 1982, cat. by Jacques Thuillier

Rome 1985
Rome, Istituto Nazionale per la Grafica, Gabinetto Nazionale delle stampe, *Raphael Invenit: stampe da Raffaello nelle collezioni dell'istituto Nazionale per la grafica*, 1985, cat. by Grazia Bernini Pezzini, Stefania Massari, and Simonetta Prosperi Valenti Rodinò

Rome 1987
Rome, Istituto Nazionale per la Grafica, Gabinetto Nazionale delle stampe, *Vestigi delle antichità di Roma . . . et altri luochi: momenti dell'elaborazione di un'immagine*, 1987, cat. by Anna Grelle

Rome 1989
Rome, Istituto Nazionale per la Grafica, Gabinetto Nazionale delle stampe, *Claude Mellan, gli anni romani: un incisore tra Vouet e Bernini*, 1989, cat. by Luigi Ficacci

Rome 1990
Rome, Villa Medici, Académie de France, *J. H. Fragonard e H. Robert a Roma*, 1990–91, cat. by Jean-Pierre Cuzin and Pierre Rosenberg

Rome 1994
Rome, Villa Medici, Académie de France, *Roma 1630, il trionfo del pennello*, 1994–95, cat. by Olivier Bonfait

Rouen 1961
Rouen, Musée des Beaux-Arts, *Nicolas Poussin et son temps: Le Classicisme français et italien contemporain de Poussin*, 1961, cat. by Pierre Rosenberg

Rouen 1970
Rouen, Musée des Beaux-Arts, *Jean Restout (1692–1768)*, 1970, cat. by Pierre Rosenberg and Antoine Schnapper

Rouen 1984
Rouen, Eglise Sant-Ouen, *La Peinture d'inspiration religieuse au temps de Pierre Corneille, 1606–1684*, 1984, org. by Pierre Rosenberg, Denis Lavalle, and François Bergot

San Francisco 1989
San Francisco, Museums of Fine Arts, *Works of Art from the Collection of Mr. and Mrs. John Jay Ide*, 1989, cat. by Robert Flynn Johnson

Stockholm and Paris 1993
Stockholm, Nationalmuseum—Paris, Galeries Nationales du Grand Palais, *Le Soleil et l'Etoile du Nord: la France et la Suède au XVIIIe siècle*, 1993–94, cat. by Pontus Grate, Pierre Lemoine, Colombe Samouyault-Verlet, and Béatrix Saule

Tokyo 1994
Tokyo, Musée Fuji, *L'Empreinte et la gloire de Napoléon*, 1994

Toledo et al. 1975
Toledo, Toledo Museum of Art—Chicago, The Art Institute of Chicago—Ottawa, National Gallery of Canada, *The Age of Louis XV: French Painting, 1710–1774*, 1975–76, cat. by Pierre Rosenberg

Toronto et al. 1972
Toronto, Art Gallery of Ontario—Ottawa, National Gallery of Canada—San Francisco, California Palace of the Legion of Honor—New York, The New York Cultural Center in association with Farleigh-Dickinson University, *French Master Drawings of the Seventeenth and Eighteenth Centuries in North American Collections*, 1972–73, cat. by Pierre Rosenberg, trans. by Catherine Johnston

Toulouse 1953
Toulouse, Musée Paul Dupuy, *Le Dessin toulousain de 1610–1730*, 1953, cat. by Robert Mesuret

Toulouse 1992
Toulouse, Musée Paul Dupuy, *Le Dessin baroque en Languedoc et en Provence*, 1992, cat. ed. by J. Penent

Troyes et al. 1977
Troyes, Musée des Beaux-Arts—Nîmes, Musée des Beaux-Arts—Rome, Villa Medici, Académie de France, *Charles-Joseph Natoire (Nîmes 1700–Castel Gandolfo 1777): Peintures, dessins, estampes, et tapisseries des collections publiques françaises*, 1977, cat. by Lise Duclaux, Isabella Julia, Pierre Rosenberg, et al.

Tulsa et al. 1996
Tulsa, Philbrook Academy of Art—Jacksonville, The Cummer Museum of Art and Gardens—Hanover, Dartmouth College, Hood Museum, *Durer to Matisse: Master Drawings from the Nelson-Atkins Museum of Art*, 1996–97, cat. by Roger Ward

University Park et al. 1979
University Park, Museum of Art, Pennsylvania State University—New Brunswick, Rutgers University Art Gallery—Utica, Museum of Art, Munson-Williams-Proctor Institute, *French Drawings from European Collections: The Former Armand Gobiet Collection*, 1979–80, cat. by Olga K. Preisner

Versailles 1963
Versailles, Musée national du Château de Versailles, *Charles Le Brun, 1619–1690, peintre et dessinateur*, 1963, cat. by Jacques Thuillier and Jennifer Montagu

Versailles 1991
Versailles, Musée national du Château de Versailles, *Charles Le Brun 1619–1690: Le Décor de l'escalier des Ambassadeurs à Versailles*, 1991, cat. by Lydia Beauvais and Laure C. Starcky

Versailles and Amiens 1995
Versailles, Musée national du Château de Versailles—Amiens, Musée de Picardie, *Les chasses exotiques de Louis XV*, 1995, cat. by Xavier Salmon

Versailles 1997
Versailles, Bibliothèque de Versailles, *Plaisirs de rois: Fêtes royales de Louis XIV à Louis XVI*, 1997, cat. ed. by Claire Caucheteux

Washington and Chicago 1973
Washington, D.C., National Gallery of Art—Chicago, The Art Institute of Chicago, *François Boucher in North American Collections: One Hundred Drawings*, 1973–74, cat. by Regina Shoolman Slatkin

Washington 1978
Washington, D.C., National Gallery of Art, *Drawings by Hubert Robert, 1733–1808*, 1978, cat. by Victor Carlson

Washington et al. 1978
Washington, D.C., National Gallery of Art—Cambridge, Fogg Art Museum, Harvard University Art Museums—New York, The Frick Collection, *Drawings by Fragonard in North American Collections*, 1978–79, cat. by Eunice Williams

Washington et al. 1981
Washington, D.C., National Gallery of Art—New York, National Academy of Design—Minneapolis, The Minneapolis Institute of Arts—Malibu, J. Paul Getty Museum, *French Master Drawings from the Rouen Museum from Caron to Delacroix*, 1981–82, cat. by Pierre Rosenberg and François Bergot

Washington 1982a
Washington, D.C., National Gallery of Art, *Eighteenth-Century Drawings from the Collection of Mrs. Gertrude Laughlin Chanler*, 1982, cat. by Margaret Morgan Grasselli

Washington 1982b
Washington, D.C., National Gallery of Art, *Claude Lorrain, 1600–1682*, 1982, cat. by H. Diane Russell

Washington 1982c
Washington, D.C., National Gallery of Art, *Lessing J. Rosenwald: Tribute to a Collector*, 1982, cat. by Ruth E. Fine

Washington et al. 1984
Washington, D.C., National Gallery of Art—Paris, Galeries Nationales du Grand Palais—Berlin, Schloss Charlottenberg, *Antoine Watteau, 1684–1721*, 1984–85, cat. by Margaret Morgan Grasselli and Pierre Rosenberg with Nicole Parmantier

Washington et al. 1985
Washington, D.C., National Gallery of Art—Indianapolis, Indianapolis Museum of Art—Sarasota, The John and Mable Ringling Museum of Art—Atlanta, The High Museum of Art—Baltimore, The Walters Art Gallery—Los Angeles, University of California, Frederick Wight Gallery, *Master Drawings from Titian to Picasso: The Curtis O. Baer Collection*, 1985, cat. by Eric Zafran

Washington 1987
Washington, D.C., National Gallery of Art, *Master Drawings from the Armand Hammer Collection*, 1987, cat. ed. by Jane Sweeney

Washington 1988a
Washington, D.C., The Philipps Collection in association with the National Gallery of Art, *Places of Delight: The Pastoral Landscape*, 1988–89, cat. by Robert C. Cafritz, Lawrence Gowing, and David Rosand

Washington 1988b
Washington, D.C., National Gallery of Art, *Rosso Fiorentino: Drawings, Prints, and Decorative Arts*, 1988, cat. by Eugene A. Carrol

Washington 1990
Washington, D.C., National Gallery of Art, *Eva/Ave: Women in Renaissance and Baroque Prints*, 1990, cat. by H. Diane Russell and Bernadine Barnes

Washington 1993
Washington, D.C., National Gallery of Art, *Drawings from the O'Neal Collection*, 1993, cat. by Margaret Morgan Grasselli

Washington 1995a
Washington, D.C., National Gallery of Art, *The Touch of the Artist: Master Drawings from the Woodner Collections*, 1995, cat. ed. by Margaret Morgan Grasselli

Washington 1995b
Washington, D.C., Library of Congress, *Creating French Culture: Treasures from the Bibliothèque Nationale de France*, 1995, org. & ed. by Emmanuel Le Roy Ladurie, Marie-Hélène Tesnière, and Prosser Gifford

Washington 1996
Washington, D.C., National Gallery of Art, *Georges de La Tour and His World*, 1996, cat. by Philip Conisbee et al.

BOOKS AND ARTICLES

Publications in exhibition catalogues by contributors to this volume are cross-referenced here as **author's name §.**

Aaron 1993
Olivier Aaron, *Jean-Baptiste-Marie Pierre*, Cahiers du dessin français, no. 9, Paris [1993]

Adhémar 1954
Jean Adhémar, *Le Dessin français au XVIe siècle*, Lausanne, 1954

Adhémar 1970
Jean Adhémar, "Les dessins de Daniel Dumonstier du Cabinet des Estampes," *Gazette des Beaux-Arts*, 6th ser., (1970): 129–50

Alpers 1971
Svetlana Alpers, *The Decoration of the Torre de la Parada (Corpus Rubenianum Ludwig Burchard)*, London and New York, 1971

D'Amat 1970
Roman D'Amat, ed., *Dictionnaire de biographie française*, 20 vols., Paris, 1970

Ananoff 1966
Alexandre Ananoff, *L'Oeuvre dessiné de François Boucher (1703–1770): Catalogue raisonné*, Paris, 1966

Ananoff 1970
Alexandre Ananoff, *L'Oeuvre dessiné de Fragonard*, 4 vols., Paris, 1961–70

Ananoff and Wildenstein 1976
Alexandre Ananoff and Daniel Wildenstein, *François Boucher*, 2 vols., Lausanne and Paris, 1976

Angoulvent 1926
Paul-Joseph Angoulvent, *La Chalcographie du Louvre: Histoire et description des collections*, Paris, 1926

Arquié—Labbé—Bicart 1987
Françoise Arquié-Bruley, Jacqueline Labbé, and Lise Bicart-Sée, *La Collection Saint-Morys au Cabinet des Dessins du Musée du Louvre*, 2 vols., Notes et Documents des Musées de France, no. 19, Paris, 1987

Audin and Vial 1918
Marius Audin and Eugene Vial, *Dictionnaire des artistes et ouvriers d'art de la France Lyonnais*, Paris, 1918

Audran 1683
Gérard Audran, *Les Proportions du corps humains mesurées sur les plus belles figures de l'antiquité à Paris*, Paris, 1683

Auzas 1949
Pierre-Marie Auzas, "Les Grands 'Mays' de Notre-Dame de Paris," *Gazette des Beaux-Arts*, 6th ser., 2 (Oct.–Dec. 1949): 177–200

Auzas 1954
Pierre-Marie Auzas, "Précisions nouvelles sur les 'Mays' de Notre-Dame de Paris," *Bulletin de la Société de l'Histoire de l'Art Français*, 1954, 40–44

Auzas 1963
Pierre-Marie Auzas, "La Décoration intérieure de Notre-Dame de Paris au dix-septième siècle," *Art de France* 3 (1963): 124–34

Babelon 1991
Jean-Pierre Babelon, *Demeures parisiennes sous Henri IV et Louis XIII*, Paris, 1991

Babelon 1992
Jean-Pierre Babelon, "Quels étaient les goûts d'Henri IV en matière d'art?" *Avenement d'Henri IV–Quatrième Centenaire*, Colloque V: Les Arts au Temps d'Henri IV (1989), L'Association Henri IV, Pau, 1992, 41–62

Baccheschi 1989
E. Baccheschi, "Vincenzo Giustiniani collezionista d'arte e la sua Galleria di stampe," in *La Galleria Giustiniana: sculture antiche e incisioni secentesche* (Quaderni del Museo dell'Accademia Ligustica di Belle Arti, no. 10), Genoa, 1989

Bachaumont 1780
Louis Petit de Bachaumont, *Lettres sur les peintures, sculptures et gravures de Mssrs. de l'Académie royale: exposées au Salon du Louvre depuis 1767 jusqu'en 1779—commencées par feu M. de Bachaumont, depuis sa mort continuées par un homme de lettres célèbre*, London, 1780

Bailly and Engerand 1709–10
L. Bailly, *Inventaire des tableaux commandés et achetés par la direction des batiments du roi (1709–1792)*, 2 vols., ed. F. Engerand, Paris, 1901

Baldinucci 1686
Filippo Baldinucci, *Cominciamento e progresso dell'arte dell'intagliare in reme, colle vite di molti de'piu eccelenti maestri della stessa professione* (1686), Florence, 1772

Baldinucci 1728
Filippo Baldinucci, *Notizie de' professori del disegno da Cimabue in qua*, Florence, 1681–1728

Ballot de Savot 1743
Ballot de Savot, *Eloge de Nicolas Lancret peintre du roi*, Paris, 1743

Bardon 1974
Françoise Bardon, *Le Portrait mythologique à la cour de France sous Henri IV et Louis XIII, mythologie et politique*, Paris, 1974

Bartsch 1803–21
Adam Bartsch, *Le peintre-graveur*, 21 vols., Vienna, 1803–21

Bartsch-Illustrated 1978–87
The Illustrated Bartsch, 50 vols., New York, 1978–87

Basan 1789
F. Basan, *Dictionnaire des graveurs anciens et modernes depuis l'origine de la gravure . . .* , 2d ed., 2 vols., Paris, 1789

Baudicour 1861
Prosper de Baudicour, *Le Peintre-graveur continuée ou catalogue raisonné des estampes gravées par les peintres et les dessinateurs de l'école française nés dans le XVIIIe siècle—ouvrage faisant suite au peintre-graveur français de M. Robert-Dumesnil*, 2 vols., Paris, 1859–61

Bayard 1989
Françoise Bayard, "Manière d'habiter des financiers de la première moitié du XVIIe siècle," in *L'Hôtel Parisien au XVIIe siècle*, special issue of *XVIIe Siècle* 41, no. 162 (Jan.–Mar. 1989): 81–84

Bean and Turčić 1986
Jacob Bean with Lawrence Turčić, *Fifteenth- to Eighteenth-Century French Drawings in the Metropolitan Museum of Art*, New York, 1986

Beaulieu 1981
Michèle Beaulieu, "Oeuvres inédites et procédés de travail d'un sculpteur de la seconde moitié du XVIIIème siècle: Augustin Pajou," *Bulletin de la Société de l'Histoire de l'Art Français*, 1981, 161–65

Bedat 1974
Claude Bedat, *L'Académie des Beaux-Arts de Madrid*, Toulouse, 1974

Béguin 1960
Sylvie Béguin, *L'Ecole de Fontainebleau, le maniérisme à la cour de France*, Paris, 1960

Béguin 1970
Sylvie Béguin, *Il cinquecento francese*, vol. 5 of I disegni dei maestri, Milan, 1970

Béguin 1977
Sylvie Béguin, "La galerie du Connetable de Montmorency à l'Hôtel de la rue Sainte-Avoye: le décor de Nicolo dell'Abate," *Bulletin de la Société de l'Histoire de l'Art Français*, 1977, 47–66

Béguin—Guillaume—Roy 1985
Sylvie Béguin, Jean Guillaume, and Alain Roy, with Guillaume Roy, *La Galerie d'Ulysse à Fontainebleau*, Paris, 1985

Bellenger §
Sylvain Bellenger—see Los Angeles et al. 1993

Bellier and Auvray 1885
Emile Bellier de La Chavignerie and Louis Auvray, *Dictionnaire des artistes de l'école française depuis l'origine des arts du dessin jusqu'à nos jours*, Paris, 1882–87

Bellori 1672
Giovanni Pietro Bellori, *Le Vite de'pittori, scultori, ed architetti moderni*, Rome, 1672 (all refs. to Evelina Borea edition, Turin, 1976)

Benesch 1967
Otto Benesch with Eva Benesch, *Master Drawings in the Albertina: European Drawings from the Fifteenth to the Eighteenth Century*, Greenwich, 1967

Bernard and Thuillier 1994
Maurice Bernard and Jacques Thuillier, eds., *Poussin et la peinture française du XVIIe siècle*, TECHNE: La Science au service de l'histoire de l'art et des civilizations, no. 1, 1994

Bernini 1985
Giovanni Pietro Bernini, *Giovanni Lanfranco (1582–1647)*, 2d ed., Terenzo, 1985

Bitton 1969
Davis Bitton, *The French Nobility in Crisis*, Stanford, 1969

Bjurström 1971
Per Bjurström, "F. J. Chantereau, dessinateur," *Revue de l'Art* 14 (1971): 80–85

Bjurström 1976
Per Bjurström, *French Drawings in Swedish Public Collections: Sixteenth and Seventeenth Centuries*, Drawings in Swedish Public Collections, no. 1, Nationalmuseum, Stockholm, 1976

Bjurström 1982
Per Bjurström, *French Drawings in Swedish Public Collections: Eighteenth Century*, Drawings in Swedish Public Collections, no. 4, Nationalmuseum, Stockholm, 1982

Bjurström 1984
Per Bjurström, *Claude Lorrain, Sketchbook Owned by the National Museum, Stockholm*, Nationalmusei Skriftserie, n.s., no. 1, Stockholm, 1984

Black 1996
Bernard Black, "Vassé's Tombs for Two Russian Princesses—The Troubetskoy–Galitzin Monuments: New Discoveries and an Old Mystery," *Gazette des Beaux-Arts*, 6th ser., 128 (Oct. 1996): 141–54

Blanc 1862–63
Charles Blanc, "Fragonard," in *Histoire des peintres de toutes les écoles depuis la Renaissance jusqu'à nos jours, école française*, vols. 1–3, ed. C. Blanc, Paris, 1862–63

Bluche 1990
François Bluche, ed., *Dictionnaire du Grand Siècle*, Paris, 1990

Blunt 1944
Anthony Blunt, "The Early Work of Charles Le Brun," *The Burlington Magazine* 1 (1944): 165–73 and 2 (1944): 186–94

Blunt 1957
Anthony Blunt, "The Précieux and French Art," in *Fritz Saxl, 1890–1948: A Volume of Memorial Essays from His Friends in England*, ed. D. J. Gordon, London, 1957, 326–38

Blunt 1958
Anthony Blunt, "The Legend of Raphael in Italy and France," *Italian Studies* 8 (1958): 2–21

Blunt 1967
Anthony Blunt, ed., *Entretiens sur les vies et sur les ouvrages des plus excellens peintres anciens et modernes* (1685–88), by André Félibien, Geneva, 1967

Blunt 1974
Anthony Blunt, "Jacques Stella, the de Masso Family, and Falsifications of Poussin," *The Burlington Magazine* 861 (Nov. 1974): 745–51

Blunt 1979
Anthony Blunt, *The Drawings of Poussin*, New Haven and London, 1979

Blunt 1982a
Anthony Blunt, *Art and Architecture in France, 1500–1700*, rev. ed., Harmondsworth, 1982

Blunt 1982b
Anthony Blunt, *Guide to Baroque Rome*, New York, 1982

Bober and Rubinstein 1986
Phyllis Pray Bober and Ruth Rubinstein, *Renaissance Artists and Antique Sculpture*, New York, 1986

Bocher 1876
Emmanuel Bocher, *Jean-Baptiste-Siméon Chardin* (1876), vol. 3 of *Les gravures françaises du XVIIIe siècle*, Paris, 1875–82

Boerlin-Brodbeck 1987
Yvonne Boerlin-Brodbeck, "La Figure assise dans un paysage," in *Antoine Watteau (1684–1721), le peintre, son temps, et sa légende*, ed. François Moreau and Margaret Morgan Grasselli, Paris and Geneva, 1987, 163–71

Bonnaffé 1873
Edmond Bonnaffé, *Dictionnaire des amateurs français au XVIIe siècle*, Paris, 1873

Bordeaux 1984
Jean-Luc Bordeaux, *François Le Moyne (1688–1737) and His Generation*, Neuilly-sur-Seine, 1984

Borenius 1933
Tancred Borenius, "Zwei Claude Lorrain-zeichnungen," *Pantheon* 11 (Jan. 1933): 36–38

Bosse 1649
Abraham Bosse, *Sentimens sur la distinction des diverses manières de peinture, dessein et graveure . . .* (1649), ed. R.-A. Weigert, Paris, 1964

Bosse 1667
Abraham Bosse, *Le peintre converty aux précises et universelles règles de son art, avec un raissonement abrégé au sujet des tableaux, bas reliefs et autres ornemens que l'on peut faire sur les diverses superficies des batimens, et quelques avertissements contre les erreurs que des nouveaux écrivans veulent introduire dans la pratique de ces arts* (1667), ed. R.-A. Weigert, Paris, 1964

Bottari 1822
Giovanni Bottari and Stefano Ticozzi, *Raccolte di lettere sulla pittura, scultura, ed architettura*, 8 vols., Milan, 1822

Boucher 1930
Henri Boucher, "Girodet illustrateur, a propos des dessins inédits sur L'Eneide," *Gazette des Beaux-Arts*, 6th ser., 4 (1930): 304–19

Bousquet 1975
Jacques Bousquet, "Les Artistes français à Rome au XVIIe siècle à travers quelques examples Lyonnais," *L'Art Baroque à Lyon: Actes du colloque* (Université Lyon II, Institut d'Histoire de l'Art), Centre National de la Recherche Scientifique, Lyon, 1975

Bousquet 1980
Jacques Bousquet, *Recherches sur le séjour les peintres français à Rome au XVIIe siècle*, Montpellier, 1980

Boyer 1949
Ferdinand Boyer, "Catalogue raisonné de l'oeuvre de Charles Natoire," *Archives de l'Art Français*, n.s., 21 (1949): 31–107

Boyer 1969
Ferdinand Boyer, *Le Monde des arts en Italie et la France de la Révolution et de l'Empire: Etudes et recherches*, Biblioteca di studi francesi, no. 4, Turin, 1969

Boyer 1985
Jean-Claude Boyer, "Le Mécènat officiel et l'Italie," in *L'Age d'or du mécènat (1598–1661)*, actes du colloque international, ed. Roland Mousnier and Jacques Mesnard, Centre National de la Recherche Scientifique, Paris, 1985, 15–24

Boyer 1986
Jean-Claude Boyer, "Le Discours sur la peinture en France au XVIIe siècle: De subordination à l'autonomie," in *Storiografia della critica francese nel seicento*, ed. E. Balmas, vol. 7 of Quaderni del seicento francese, 1986, 253–66

Boyer 1991
Jean-Claude Boyer, "Le 'Jugement de Paris' de Michel Corneille," *Bulletin des musées et monuments Lyonnais* 1 (1991): 30–37

Boyer and Brejon 1980
Jean-Claude Boyer and Arnauld Brejon de Lavergnée, "Un Commande à des artistes français et italiens à Rome en 1639," *La Revue du Louvre et des Musées de France* 4 (1980): 231–39

Boyer and Volf 1988
Jean-Claude Boyer and Isabelle Volf, "Rome à Paris: Les tableaux du maréchal de Créquy (1638)," *Revue de l'Art* 79 (1988): 22–41

Brault and Bottinau 1959
S. Brault and Y. Bottinau, *L'Orfèvrerie française du XVIIIe siècle*, Paris, 1959

Brejon 1981
Barbara Brejon de Lavergnée, "New Light on Michel Dorigny," *Master Drawings* 4, no. 4 (1981): 445–55

Brejon 1984
Barbara Brejon de Lavergnée, "Contribution à la connaissance des décors peints à Paris et en Ile-de-France au XVIIe siècle: Le cas de Michel Dorigny," *Bulletin de la Société de l'Histoire de l'Art Français*, 1984, 69–83

Brejon 1986
Barbara Brejon de Lavergnée, "New Attributions around Simon Vouet," *Master Drawings* 13–14, no. 3 (autumn 1986): 347–51

Brejon 1987a
Barbara Brejon de Lavergnée, *Dessins de Simon Vouet*, Inventaire général des dessins, Ecole Française, Cabinet des Dessins, Musée du Louvre, Paris, 1987

Brejon 1987b
Barbara Brejon de Lavergnée, *Claude Mellan 1598–1688*, Cahiers du dessin français, no. 3, Paris, 1987

Brejon 1992
Arnauld Brejon de Lavergnée, "Nouveaux tableaux de chevalet de Michel Dorigny," in *Simon Vouet: Actes du colloque international*, ed. Stéphane Loire, Rencontres de l'Ecole du Louvre, La Documentation Française, Paris, 1992, 417–34

Brejon 1996
Barbara Brejon de Lavergnée, "Un Lillois retrouvé: Arnauld de Vuez dessinateur," in *Hommage au dessin: Mélanges offerts à Roseline Bacou*, ed. Maria Teresa Caracciolo, Rimini, 1996, 399–405

Brejon §
Barbara Brejon de Lavergnée—see Besançon 1984; Paris 1988c; Paris 1990a; Munich 1991; Noyons 1992; Paris 1993a; Coutances and Le Mans 1996

Brejon—Sainte Fare Garnot—Reyniès 1997
Barbara Brejon de Lavergnée, Nicolas Sainte Fare Garnot, and Nicole de Reyniès, *Charles Poerson, 1609–1667*, Paris, 1997

Bresc-Bautier 1992
Geneviève Bresc-Bautier, "Simon Vouet et le milieu des sculpteurs parisiens," in *Simon Vouet: Actes du colloque international*, ed. Stéphane Loire, Rencontres de l'Ecole du Louvre, La Documentation Française, Paris, 1992, 545–55

Breuille 1989
Jean-Philippe Breuille, ed., *Dictionnaire de la peinture française*, Paris, 1989

Brière and Lamy 1953
Gaston Brière and Marguerite Lamy, "Inventaires du logis de Simon Vouet dans la grande galerie du Louvre (1639–40)" (1951), *Mémoires de la Fédération des sociétés historiques et archéologiques de Paris et de l'Ile-de-France* 3 (1953): 117–72

Briggs 1977
Robin Briggs, *Early Modern France, 1560–1715*, Oxford, 1977

Brigstocke 1990
Hugh Brigstocke, "Poussin et ses amis en Italie," in *Seicento: La peinture italienne du XVIIe siècle et la France*, actes du colloque, ed. Jean-Claude Boyer, Rencontres de l'Ecole du Louvre, La Documentation Française, Paris, 1990, 215–30

Briquet 1923
Charles-Moise Briquet, *Dictionnaire historique des marques du papier*, Leipzig, 1923

Brugerolles 1984
Emmanuelle Brugerolles, *Les Dessins de la collection Armand-Valton: La Donation d'un grand collectionneur du XIXe siècle à l'Ecole des Beaux-Arts, Inventaire général*, Paris, 1984

Brugerolles §
Emmanuelle Brugerolles—see Paris 1981a; Paris et al. 1994

Brugerolles and Guillet 1997
Emmanuelle Brugerolles and David Guillet, "Grégoire Huret, dessinateur et graveur," *Revue de l'Art* 117 (1997): 9–35

Brune 1912
L'Abbé Paul Brune, *Dictionnaire des artistes et ouvriers d'art de la Franche-Comté*, Paris, 1912

Brunel 1978
Georges Brunel, ed., *Piranèse et les Français: Actes du colloque*, Paris, 1978

Bruun Neergaard 1801
Tonnes Christian Bruun, Baron Neergaard, *Sur la situation des Beaux-Arts en France ou Lettres d'un Danois à son ami*, Paris, 1801

Bull 1993
Duncan Bull, "Review: Salon du Dessin de Collection," *The Burlington Magazine* 135 (May 1993): 367–69

Cabane 1992
Marie Cabane, "Précisions et hypothèses sur l'oeuvre de Simon Vouet, exécuté pour le roi Louis XIII et la reine Anne d'Autriche, de 1627 à 1643," in *Simon Vouet: Actes du colloque international*, ed. Stéphane Loire, Rencontres de l'Ecole du Louvre, La Documentation Française, Paris, 1992, 255–90

Cailleux 1971
Jean Cailleux, "Three Portraits in Pastel and Their History," *L'Art du dix-huitième siècle*, supplement in *The Burlington Magazine* 27 (Nov. 1971): ii–vi

Caracciolo 1996
Maria Teresa Caracciolo, ed., *Hommage au dessin: Mélanges offerts à Roseline Bacou*, Rimini, 1996

Carlson 1996
Victor Carlson, "Jacques Gamelin," *Master Drawings* 34, no. 4 (winter 1996): 414–17

Carlson §
Victor Carlson—see Middletown and Baltimore 1975; Washington 1978; Baltimore et al. 1984; Los Angeles et al. 1993

Cayeux 1985
Jean de Cayeux, *Les Hubert Robert de la Collection Veyrenc au Musée de Valence*, Valence, 1985

Caylus 1765
Anne Claude Philippe de Pestels de Lévis de Tubières-Grimoard, comte de Caylus, *Vie d'artistes du XVIIIe siècle . . .* (written ca. 1730–65), ed. André Fontaine, Paris, 1910

Chantelou 1665
Paul Fréart de Chantelou, *Diary of the Cavaliere Bernini's Visit to France* (c. 1665), ed. Anthony Blunt, trans. Margery Corbett, London, 1986

Chastel 1981
André Chastel, "French Renaissance Art in a European Context," *Sixteenth-Century Journal* 12, no. 4 (1981): 77–103

Chenesseau 1921
George Louis Chenesseau, *Sainte-Croix d'Orleans, histoire d'une cathédrale gothique réédifiée par les Bourbons, 1599–1829*, 2 vols., Paris, 1921

Chennevières 1886
Philippe, marquis de Chennevières-Pointel, "Sébastien-René, Paul-Ambroise et René-Michel Slodtz, Dumont le Romain, et François Boucher," *Nouvelles Archives de l'Art Français* 3 (1886): 25–9

Chennevières 1894–97
Philippe, marquis de Chennevières-Pointel, "Une Collection de dessins d'artistes français," *L'Artiste,* Aug. 1894–Dec. 1897

Chiego 1974
William J. Chiego, "The Influence of Carle and Horace Vernet on the Art of Theodore Gericault," Ph.D. diss., Case-Western Reserve University, 1974

Chol 1987
Daniel Chol, *Michel-François Dandré-Bardon ou l'apogée de la peinture en Provence au XVIIIe siècle*, Aix-en-Provence, 1987

Chomer 1980
Gilles Chomer, "Jacques Stella: 'pictor lugdunesis,'" *Revue de l'Art* 47 (1980): 85–89

Chomer 1989
Gilles Chomer, "Une gravure de Michel Demasso d'après un dessin de Jacques Stella," *Travaux de l'Institut d'histoire de l'art a Lyon* 12 (1989): 67–74

Chomer 1992
Gilles Chomer, "Les Perrier à Lyon: nouvelles donées," in *Simon Vouet: Actes du colloque international*, ed. Stéphane Loire, Rencontres de l'Ecole du Louvre, La Documentation Française, Paris, 1992, 509–30

Chomer and Foucart 1987
Gilles Chomer and Jacques Foucart, "Horace LeBlanc vers 1580–1637," *Bulletin des musées et monuments Lyonnais*, special issue, 1987

Church 1975
William F. Church, "France," in *National Consciousness, History, and Political Culture in Early Modern Europe*, ed. O. Ranum, The Johns Hopkins Symposia in Comparative History, 5 (1975): 43–66

Churchill 1935
W. A. Churchill, *Watermarks in Paper in Holland, England, France, etc., in the Seventeenth and Eighteenth Centuries and Their Interconnection* (Amsterdam, 1935), 2d ed., Nieuwkoop, 1990

Cipriani and Valeriani 1988
Angela Cipriani and Enrico Valeriani, *I disegni di figura nell'Archivio storico dell'Academia nazionale di San Luca*, 3 vols., Rome, 1988

Clark 1971
Anthony M. Clark, *European Paintings from the Minneapolis Institute of Arts*, New York, 1971

Clark 1993a
Alvin L. Clark, Jr., review of *Laurent de La Hyre, l'homme et l'oeuvre* (exh. cat., 1989–90), by Pierre Rosenberg and Jacques Thuillier, *Master Drawings* 31, no. 2 (summer 1993): 179–84

Clark 1993b
Alvin L. Clark, Jr., "On the Significance of the Yale Bourdon," *Yale University Art Gallery Bulletin,* 1993, 86–94

Clark 1994
Alvin L. Clark, Jr., "Vouet and Printmaking in Seventeenth-Century France," review of *Vouet* (exh. cat., Grand Palais, Paris, 1990), by Jacques Thuillier, Barbara Brejon de Lavergnée, and Denis Lavalle, and *Simon Vouet: Actes du colloque international*, ed. Stéphane Loire (Rencontres de l'Ecole du Louvre, La Documentation Française, Paris, 1992), *Print Quarterly* 11 (March 1994): 69–71

Clark 1995
Alvin L. Clark, Jr., review of *Jacques Sarazin Sculpteur du Roi, 1592–1660* (exh. cat., Noyons, Musée Noyonais, 1992), by Barbara Brejon de Lavergnée, Geneviève Bresc-Bautier, and Françoise de La Moureyre, *Master Drawings* 33, no. 1 (1995): 69–70

Clark 1996
Alvin L. Clark, Jr., "Agnes Mongan's Flourishing Legacy: A New La Fosse for the Fogg in Honor of Her Ninetieth Birthday," *Drawing* 17, nos. 4–6 (Nov. 1995–Mar. 1996): 97–98

Clark §
Alvin L. Clark, Jr.—see New Haven 1987; Cambridge 1994; Boston et al. 1998

Cochin 1774
Charles-Nicolas Cochin le jeune, *Mémoires inédits sur le comte de Caylus, Bouchardon, les Slodtz* (ca. 1774), ed. Charles Henry, Paris, 1880

Cochin 1791
Charles-Nicolas Cochin le jeune, *Mémoires inédits* (1791), ed. Charles Henry, Paris, 1880

Compin and Roquebert 1986
Isabelle Compin and Anne Roquebert with Jacques Foucart and Elisabeth Foucart-Walter, *Catalogue sommaire illustré des peintures du Musée du Louvre et du Musée d'Orsay*, vols. 3–5 of summary catalogue, Paris, 1986

Cordellier 1988
Dominique Cordellier, "Martin Fréminet, 'Aussi scavants que judicieux': A propos des *modelli* retrouvé pour la Chapelle de la Trinité à Fontainebleau," *Revue de l'Art* 81 (1988): 57–72

Cordellier 1992
Dominique Cordellier, "Ambroise Dubois: Quelques feuilles inédites au Cabinet des Dessins du Musée du Louvre," *Avenement d'Henri IV– Quatrième Centenaire*, Colloque V: Les Arts au Temps d'Henri IV (1989), L'Association Henri IV, Pau, 1992, 139–56

Cornillot 1957
Marie-Lucie Cornillot, *Collection Pierre-Adrien Paris, Besançon*, Inventaire général des dessins des musées de province, no. 1, Paris, 1957

Cotté 1985
Sabine Cotté, "Inventaire après décès de Louis de la Vrillière," *Archives de l'Art Français*, n.s., 26 (1985): 89–100

Coupin 1826
Pierre-Alexandre Coupin, ed., *Oeuvres posthumes de Girodet-Trioson, peintre d'histoire; suivies de sa correspondence; précédés d'une notice historique*, Paris, 1826

Courajod 1874
Louis Courajod, *Histoire de l'Ecole des Beaux-Arts au XVIIIe siècle: L'Ecole des Elèves Protégés*, Paris, 1874

Coural 1978
Jean Coural, "Note sur le tombeau de Paul-Esprit Feydeau de Brou par Louis-Claude Vassé," *Revue de l'Art* 40–41 (1978): 203–8

Crelly 1962
William Crelly, *The Paintings of Simon Vouet*, New Haven, 1962

Croft-Murray 1962
Edward Croft-Murray, *Decorative Painting in England, 1537–1837*, London, 1962

Croft-Murray and Hulton 1960
Edward Croft-Murray and Paul Hope Hulton, *Catalogue of the British Drawings*, 2 vols., London, 1960

Cuno et al. 1996
James Cuno et al., *Harvard's Art Museums: One Hundred Years of Collecting*, Cambridge, 1996

Cuno §
James Cuno—see Los Angeles 1988

Cuzin 1988a
Jean-Pierre Cuzin, *Jean-Honoré Fragonard*, New York, 1988

Cuzin 1988b
Jean-Pierre Cuzin, *François-André Vincent, 1746–1816*, Cahiers du dessin français, no. 4, Paris, 1988

Cuzin 1996
Jean-Pierre Cuzin, ed., *Nouvelles acquisitions du département des peintures, 1991–1995*, Paris, 1996

Dacier 1909–21
Emile Dacier, *Catalogue de ventes et livrets de salons illustrés par Gabriel de Saint-Aubin*, 11 vols., Paris, 1909–21

Dacier 1931
Emile Dacier, *Gabriel de Saint-Aubin: Peintre, dessinateur et graveur (1724–80)*, 2 vols., Paris, 1929–31

Dandré-Bardon 1765
Michel-François Dandré-Bardon, *Essai sur la sculpture, suivi d'un catalogue des artistes les plus fameux de l'école française*, 2 vols., Paris, 1765

David 1880
J. L. Jules David, *Le peintre Louis David, 1748–1825*, vol. 1, Souvenirs et documents, Paris, 1880

Davidson 1975
Gail S. Davidson, "Some Genre Drawings by Jacques Stella: Notes on an Attribution," *Master Drawings* 13, no. 2 (1975): 147–57

Davidson 1990
Gail S. Davidson, "Nicolas Poussin, Jacques Stella, and the Classical Style in 1640: The Altar Paintings for the Chapel of Saint Louis at Saint-Germain-en Laye," in *The French Academy: Classicism and Its Antagonists*, ed. J. Hargrove, Newark, London, and Toronto, 1990

Davidson Reid and Rohmann 1993
Jane Davidson Reid with Chris Rohmann, *The Oxford Guide to Classical Mythology in the Arts, 1300–1990s*, New York, 1993

Dayot 1925
Armand Dayot, *Carle Vernet: Etude sur l'artiste, suivi d'un catalogue de l'oeuvre gravé et lithographie et du catalogue de l'exposition retrospective de 1925*, Paris, 1925

Dayot and Vaillat 1907
Armand Dayot and Léandre Vaillat, *L'Oeuvre de J. B. S. Chardin et J. H. Fragonard*, Paris, 1907

Delacroix 1846
Eugène Delacroix, "Peintres et sculpteurs modernes. II. Prud'hon," *Revue des deux Mondes* 16, pt. 4 (1846): 432–51

DeLorme 1996
Eleanor DeLorme, *Garden Pavilions and the Eighteenth-Century French Court*, London, 1996

Démoris 1990
René Démoris, "L'Ecole de Bologne sous le regard de la critique d'art classique en France," in *Seicento: La peinture italienne du XVIIe siècle et la France*, actes du colloque, ed. Jean-Claude Boyer, Rencontres de l'Ecole du Louvre, La Documentation Française, Paris, 1990, 257–72

Dempsey 1989
Charles Dempsey, "The Carracci Academy," in *Academies of Art between Renaissance and Romanticism*, vols. 5–6 (1986–87) of *Leids Kunsthistorisch Jaarboek*, ed. A. Boschloo et al., s'-Gravenhage, 1989, 33–43

Dennis 1986
Michael Dennis, *Court and Garden: From the French Hôtel to the City of Modern Architecture*, Cambridge, 1986

Dernie and Carew-Cox 1996
D. Dernie and Alastair Carew-Cox, *The Villa d'Este at Tivoli*, London, 1996

De Vesme and Calabi 1928
Count Alessandro Baudi de Vesme and Augusto Calabi, *Francesco Bartolozzi: Catalogue des estampes et notice biographique*, Milan, 1928

Dézallier d'Argenville 1745/1762
Antoine-Joseph Dézallier d'Argenville, *Abrégé de la vie des plus fameux peintres, avec leurs portraits gravés en taille douce, les indications de leurs principaux ouvrages, quelques reflexions sur leurs caractères, et la manière de connoitre les desseins des grandes maîtres*, 2 vols., Paris, 1745 (all refs. to 2d rev. edition, 4 vols., Paris, 1762)

Diderot—Seznec—Adhémar 1967
Denis Diderot, *Salons*, 4 vols., ed. Jean Seznec and Jean Adhémar, Oxford, 1957–67

Diderot—Dieckmann—et al. 1975
Herbert Dieckmann, Jean Fabre, Jacques Proust, and Jean Verloot, *Denis Diderot: Oeuvres completes*, 25 vols. to date, Paris, 1975–present

Diderot—Goodman 1995
Denis Diderot, *Salon of 1765*, *Salon of 1767*, and *Notes on Painting*, 2 vols., trans. and ed. John Goodman, New Haven and London, 1995

Dimier 1905
Louis Dimier, "L'Art français et l'établissement difficile d'une tradition" (1905), in *Louis Dimier: L'art français*, ed. Henri Zerner, Paris, 1972, 62–95

Dimier 1924
Louis Dimier, *Histoire de la peinture de portrait en France au XVIe siècle*, Paris, 1924

Dimier 1926
Louis Dimier, *L'Histoire de la peinture française de retour de Vouet à la mort de Le Brun, 1627–1690*, Paris, 1926

Doria 1934
Count Arnauld Doria, *Gabrielle Capet*, Paris, 1934

Dorival 1976
Bernard Dorival, *Philippe de Champaigne, 1602–1674: La vie, l'oeuvre, et le catalogue raisonné de l'oeuvre*, 2 vols., Paris, 1976, and supplement, Paris, 1992

Dowley 1962
Francis H. Dowley, "Some Drawings by Benedetto Luti," *The Art Bulletin* 44, no. 3 (1962): 219–36

Duclaux 1971
Lise Duclaux, "La Décoration de la chapelle de l'hospice des Enfants Trouvés," *Revue de l'Art* 14 (1971): 45–50

Duclaux 1975
Lise Duclaux, Musée du Louvre, *Inventaire général des dessins*, Ecole Française, 12, Paris, 1975 (for other volumes in the series, see Guiffrey and Marcel 1928, Rouchés and Huyghe 1938, and Legrand 1997)

Duclaux 1991
Lise Duclaux, *Charles Natoire*, Cahiers du dessin français, Paris, 1991

Dufresnoy 1667
Charles-Alphonse Dufresnoy, *De Arte Grafica*, ed. Roger de Piles, Paris, 1667

Duplessis 1871
Georges Duplessis, *Le Peintre-graveur français, ou catalogue raisonné des estampes gravées par les peintres et les dessinateurs de l'école française. Ouvrage faisant suite au peintre-graveur de M. Bartsch, 11, Supplement aux dix volumes du Peintre-graveur de M. Robert-Dumesnil*, Paris, 1871

Edizel 1995
Gerar Edizel, "Jean-Siméon Chardin: Seeing, Playing, Forgetting, and the Practice of Modern Imitation," Ph.D. diss., Cornell University, 1995

Ehrmann 1986
Jean Ehrmann, *Antoine Caron: Peintre des fêtes et des massacres*, Paris, 1986

Eidelberg 1981
Martin P. Eidelberg, "Quilliard as Draughtsman," *Master Drawings* 19, no. 1 (1981): 27–39

Eisler 1996
Colin Eisler, "Three Rediscovered Prud'hon Cartoons for the Salon de la Richesse at the Hôtel de Lannoy," *Drawing* 18, no. 3 (1996–97): 71–74

Erouart 1982
Gilbert Erouart, *L'Architecture au pinceau: Jean-Laurent Legeay—Un Piranésian français dans l'Europe des Lumières*, Paris, 1982

Evans 1970
Joan Evans, *Monastic Iconography in France from the Renaissance to the Revolution*, Cambridge, 1970

Fabre d'Eglantine 1822
Philippe-François-Nazaire Fabre d'Eglantine, *Chefs d'oeuvre dramatiques de Fabre d'Eglantine*, Paris, 1822

Fagiolo dell'Arco 1996
Maurizio Fagiolo dell'Arco, *Jean Lemaire pittore "antiquario,"* Rome, 1996

Félibien 1725
André Félibien, *Entretiens sur les vies et sur les ouvrages des plus excellens peintres anciens et modernes* (ca. 1675–90) (all refs. to first integrated edition by Trévoux, 1725)

Fenaille 1899
Maurice Fenaille, *L'oeuvre gravé de P.-L. Debucourt (1755–1832) . . . accompagné d'une preface et de notes de Maurice Vaucaire, avec des gravures sur bois de A. Leveille . . .* , Paris, 1899

Ficacci 1992
Luigi Ficacci, "La Renomenée de Vouet à Rome pendant le pontificat d'Urbain VIII," in *Simon Vouet: Actes du colloque international*, ed. Stéphane Loire, Rencontres de l'Ecole du Louvre, La Documentation Française, Paris, 1992, 573–82

Fleury 1969
Marie-Antoinette Fleury, *Documents du Minutier Central concernant les peintres, les sculpteurs, et les graveurs au XVIIe siècle, 1600–1650*, Paris, 1969

Fontaine 1903
André Fontaine, *Conférences de l'Académie royale de Peinture et de Sculpture*, Paris, 1903

Fontaine 1909
André Fontaine, *Les doctrines d'art en France: De Poussin à Diderot*, Paris, 1909

Fontaine 1910
André Fontaine, *Les Collections de l'Académie royale de Peinture et de Sculpture*, Paris, 1910

Fontaine 1914
André Fontaine, *Académiciens d'autrefois*, Paris, 1914

Foster 1994
Carter E. Foster, "Charles-Nicolas Cochin the Younger: The Philadelphia Portfolio," *Philadelphia Museum of Art Bulletin* 90, no. 381 (summer 1994): 1–28

Fréron 1757
Elie-Catherine Fréron, "Exposition des ouvrages de peinture, de sculpture et de gravure," *L'Année Litteraire* 15 (31 August 1757): 333–52

Fromich 1957
Yane Fromich, "Robert Nanteuil, dessinateur et pastelliste," *Gazette des Beaux-Arts*, 6th ser., 49 (April 1957): 209–17

Fuhring 1985
Peter Fuhring, "The Print Privilege in Eighteenth-Century France–I" *Print Quarterly* 2 (1985): 174–93

Fuhring 1986
Peter Fuhring, "The Print Privilege in Eighteenth-Century France–II" *Print Quarterly* 2 (1986): 19–33

Fuhring 1992
Peter Fuhring, "Two Title Page Designs by Gilles-Marie Oppenord for His Engraved Oeuvre," *Drawing* 14, no. 3 (1992): 49–52

Fuhring §
Peter Fuhring—see Los Angeles et al. 1994

Fumaroli 1994
Marc Fumaroli, *L'Ecole de silence: Le sentiment des images au XVIIe siècle*, Paris, 1994

Furcy-Raynaud 1903
Marc Furcy-Raynaud, "Correspondance de M. Marigny avec Coypel, Lépicié, et Cochin" (1903), *Nouvelles Archives de l'Art Français* 20, no. 1 (1904): 1–302

Gabillot 1895
Claude Gabillot, *Hubert Robert et son temps*, Paris, 1895

Gaehtgens 1990
Thomas Gaehtgens, "The Tradition of Anti-Academicism in Eighteenth-Century French Art," in *The French Academy: Classicism and Its Antagonists*, ed. J. Hargrove, Newark, London, and Toronto, 1990

Gaehtgens and Lugand 1988
Thomas Gaehtgens and Jacques Lugand, *Joseph-Marie Vien, 1716–1809*, Paris, 1988

Galactéros 1975
Lucie Galactéros, "Les dessins Thomas Blanchet dans les collections publiques françaises," *La Revue du Louvre et des Musées de France* 5–6 (1975): 323–32

Galactéros-de Boissier 1991
Lucie Galactéros-de Boissier, *Thomas Blanchet (1614–1689)*, Paris, 1991

Garnier 1989
Nicole Garnier, *Antoine Coypel*, Paris, 1989

Garrard 1989
Mary D. Garrard, *Artemisia Gentileschi: The Image of the Female Hero in Italian Baroque Art*, Princeton, 1989

Garrison 1985
Janine Garrison, *L'Edit de Nantes et sa révocation: Histoire d'une intolérance*, Paris, 1985

Gaudriault 1995
Raymond Gaudriault with Thérèse Gaudriault, *Filigranes et autres caractéristiques des papiers fabriqués en France aux XVIIe et XVIIIe siècles*, Paris, 1995

Gault de Saint-Germain 1808
Pierre-Marie Gault de Saint-Germain, *Les Trois siècles de la peinture en France, ou Galerie des peintures français depuis François Ier jusqu'au règne de Napoleon . . .* , Paris, 1808

Georges 1864
M. Georges, *Catalogue: Musée des Augustins*, Toulouse, 1864

Goldfarb §
Hilliard Goldfarb—see Cleveland et al. 1989

Goldner—Hendrix—Williams 1988
George Goldner with Lee Hendrix and G. Williams, *European Drawings 1: Catalogue of the Collections, The J. Paul Getty Museum*, Malibu, 1988

Goldner—Hendrix—Pask 1992
George Goldner and Lee Hendrix with G. Pask, *European Drawings 2: Catalogue of the Collections, The J. Paul Getty Museum*, Malibu, 1992

Goldstein 1967
Carl Goldstein, "Louis XIV and Jason," *The Art Bulletin* 46 (1967): 328–29

Goldstein 1971
Carl Goldstein, "Forms and Attitudes towards Caravaggio in Seventeenth-Century France," *Art Quarterly* (1971): 345–56

Goldstein 1986
Carl Goldstein, "The Platonic Beginnings of the Academy of Painting and Sculpture in Paris," in *Academies of Art between Renaissance and Romanticism*, vols. 5–6 (1986–87) of *Leids Kunsthistorisch Jaarboek*, ed. A. Boschloo et al., s'-Gravenhage, 1989, 186–202

Goldstein 1989
Carl Goldstein, "A New Role for the Antique in Academies," in *Antiken-rezeption im Hochbarock* (Schriften des Leibieghauses, Museum Alter Plastik, Frankfurt, 1988), colloquium proceedings, ed. Herbert Beck and Sabine Schulze, Berlin, 1989

Goncourt 1864
Edmond and Jules de Goncourt, *L'Art du dix-huitième siècle*, Paris, 1864

Goncourt 1875
Edmond and Jules de Goncourt, *L'Art du dix-huitième siècle*, 2d ed., Paris, 1875

Goncourt 1876
Edmond de Goncourt, *Catalogue raisonné de l'oeuvre peint, dessiné, et gravé de Pierre-Paul Prud'hon*, Paris, 1876

Goncourt 1909
Edmond and Jules de Goncourt, *L'Art du dix-huitième siècle*, 9th ed., Paris, 1909

Goncourt 1912
Edmond and Jules de Goncourt, *L'Art du dix-huitième siècle*, 3 vols., Paris, 1912

Goodman 1995
John Goodman, "Jansenism, Parlementaire Politics, and Dissidence in the Art World of Eighteenth-Century Paris: The Case of the Restout Family," *Oxford Art Journal* 18, no. 1 (1995): 74–95

Gougenot 1761
L'Abbé Gougenot, in *Mémoires inédits sur la vie et les ouvrages des membres de l'Académie royale de Peinture et de Sculpture* (written ca. 1761), 2 vols., ed. Louis Dussieux, Edouard Soulié, Philippe de Chennevières, Paul Mantz, and Anatole de Montaiglon, Paris, 1854

Gould 1982
Cecil Gould, *Bernini in France: An Episode in Seventeenth-Century History*, Princeton, 1982

Grate 1988
Pontus Grate, *French Paintings, The Seventeenth Century*, Stockholm, 1988

Greengrass 1983
Mark Greengrass, "The Anatomy of a Religious Riot in Toulouse, May 1562," *Journal of Ecclesiastical History* 34 (1983): 367–92

Gruber 1972
Alain Charles Gruber, *Grandes fêtes et leurs décors à l'époque de Louis XVI*, Geneva, 1972

Guerin 1715
M. Guerin, *Description de l'Académie Royale des Arts de Peinture et de Sculpture*, Paris, 1715

Guffy 1996
Elizabeth Guffy, "Prud'hon, Mayer, and 'The Dream of Happiness,'" *Master Drawings* 34, no. 4 (1996): 390–99

Guiffrey 1877
Jules-Joseph Guiffrey, "Testament et Inventaire des biens, tableaux, dessins, planches de cuivre, bijoux, etc., de Claudine Bouzonnet-Stella redigé et écrits par elle-même, 1693–97," *Nouvelles Archives de l'Art Français* (1877): 1–113

Guiffrey 1924
Jean Guiffrey, *L'Oeuvre de Pierre-Paul Prud'hon*, Paris, 1924

Guiffrey and Marcel 1928
Jean Guiffrey and Pierre Marcel, *Inventaire général des dessins du Musée du Louvre et du Musée de Versailles*, Ecole Française, 10 vols. (vol. 10 with G. Rouchés), Paris, 1907–28 (for the continuation of the series, see Rouchés and Huyghe 1938, Duclaux 1975, and Legrand 1997)

Guillaume 1984
Marguerite Guillaume, "Un Flammand Italianisant en Bourgogne: Nicolas De Hoey," in vol. 1 of *Scritti di storia dell'arte in onore di Federico Zeri*, Milan, 1984, 472–94

Guillet de Saint Georges 1690
Georges Guillet, called Guillet de Saint Georges, in *Mémoires inédits sur la vie et les ouvrages des membres de l'Académie royale de Peinture et de Sculpture* (written ca. 1690), 2 vols., ed. Louis Dussieux, Edouard Soulié, Philippe de Chennevières, Paul Mantz, and Anatole de Montaiglon, Paris, 1854

Gutwirth 1974
Suzanne Gutwirth, "Jean-Victor Bertin, un paysagiste néo-classique (1746–1842)," *Gazette des Beaux-Arts*, 6th ser., 83 (1974): 336–58

Hahn 1971
Joseph Hahn, "Correspondance entre Jacques Gamelin, Jean Pillement, et le Chevalier de Fornier," *Art et Curiosité*, Nov.–Dec. 1971, 29–39

Hall 1994
James Hall, *Illustrated Dictionary of Symbols in Eastern and Western Art*, London, 1994

Hall 1996
James Hall, *Dictionary of Subjects and Symbols*, 2d rev. ed., Cambridge, 1996

Hammond and Scullard 1973
N. G. L. Hammond and H. H. Scullard, eds., *The Oxford Classical Dictionary*, 2d ed., Oxford, 1973

Harris 1967
John Harris, "Legeay, Piranesi, and International Neoclassicism in Rome (1740–1750)," in *Essays in the History of Architecture*, 1967, 189–96

Haskell and Penny 1981
Francis Haskell and Nicholas Penny, *Taste and the Antique: The Lure of Classical Sculpture, 1500–1900*, New Haven and London, 1981

Haverkamp-Begeman and Logan 1970
Egbert Haverkamp-Begeman and Anne-Marie Logan, *European Drawings and Watercolors in Yale University Art Gallery*, New Haven and London, 1970

Hawley 1978
H. Hawley, "Meissonnier's Silver for the Duke of Kingston," *Bulletin of the Cleveland Museum of Art* 65, no. 10 (1978): 312–52

Heawood 1950
Edward Heawood, *Watermarks, Mainly of the Seventeenth and Eighteenth Centuries*, vol. 1 of Monumenta chartae papyraceae historiam illustrantia, Hilversum, 1950

Heim—Béraud—Heim 1989
Jean-François Heim, Claire Béraud, and Philippe Heim, *Les Salons de peinture de la Révolution Française (1789–1799)*, Paris, 1989

Helsdingen 1970
H. W. van Helsdingen, "Grégoire Huret's 'Optique de Portraiture,'" in *Opstellen voor H. van de Waal*, Amsterdam and Leiden, 1970, 90–100

Helsdingen 1978–79
H. W. van Helsdingen, "Laocoön in the Seventeenth Century," *Simiolus* 10, nos. 3–4 (1978–79): 127–41

Henkel 1930
M. D. Henkel, "Illustrierte Ausgaben von Ovide *Metamorphosen* in XV, XVI, und XVII Jahrhunderten," *Vörtrage der Bibliothek Warburg*, (1926–27), 1930, 58–144

Henriot 1928
Gabriel Henriot, *Collection David-Weill*, 3 vols., Paris, 1926–28

Henry 1995
Christophe Henry, "Carle Vanloo (1705–1765): Etat de la question et fortune critique," Ph.D. diss., Université de Paris I–Sorbonne, 1995

Hérold 1935
Jacques Hérold, *Louis-Marin Bonnet, 1736–1793: Catalogue de l'oeuvre gravé*, Paris, 1935

Héron de Villefosse 1980
René Héron de Villefosse, *Solennités, fêtes, et réjouissances parisiennes*, Nouvelles histoires de Paris, Paris, 1980

Higgins 1977
William Edward Higgins, *Xenophon the Athenian: The Problem of the Individual and the Society of the Polis*, Albany, 1977

Hind 1922
Arthur Magyar Hind, *Giovanni Battista Piranesi: A Critical Study, with a List of His Published Works and Detailed Catalogues of the Prisons and the Views of Rome*, London, 1922

Hollstein (DF)
F. W. H. Hollstein, *Dutch and Flemish Etchings, Engravings, and Woodcuts, 1450–1700*, Amsterdam, 1949–present

Hollstein (G)
F. W. H. Hollstein, *German Engravings, Etchings, and Woodcuts, ca. 1400–1700*, Amsterdam, 1949–present

Holt 1996
Mack P. Holt, *The French Wars of Religion, 1562–1629*, Cambridge, 1995

Hornblower and Spawforth 1995
Simon Hornblower and Anthony Spawforth, eds., *The Oxford Classical Dictionary*, 3d ed., Oxford, 1995

Hunt 1992
Lynn Hunt, *The Family Romance of the French Revolution*, Berkeley and Los Angeles, 1992

Huppert 1977
George Huppert, *Les Bourgeois Gentilshommes: An Essay on the Definition of Elites in Renaissance France*, Chicago, 1977

Ingamells 1989
John Ingamells, *The Wallace Collection: Catalogue of Pictures*, London, 1989

Ingersoll-Smouse 1928
Florence Ingersoll-Smouse, *Pater: Biographie et catalogues critiques, l'oeuvre complete de l'artiste reproduite en deux cent treize héliogravures*, Paris, 1928

Ivanoff 1962
Nicola Ivanoff, "La Piscina probatica di Louis Cheron nelle chiesa di San Pantaleone a Venezia," *Arte Veneta* 16 (1962): 174–76

Jacob 1946
Louis Jacob, *Fabre d'Eglantine: Chef des "Frippons,"* Paris, 1946

Jal 1867
Augustin Jal, *Dictionnaire critique de biographie et d'histoire: Errata et supplement pour tous les dictionnaires historiques d'après des documents authentiques inédits*, Paris, 1867

Janneau 1965
Guillaume Janneau, *La Peinture française au XVIIe siècle*, Geneva, 1965

Jean-Richard 1978
Pierrette Jean-Richard, *L'Oeuvre gravé de François Boucher dans la Collection Edmond de Rothschild*, Musée du Louvre, Paris, 1978

Jestaz 1963
Bertrand Jestaz, "L'Exportation des marbres de Rome de 1535 à 1571," *Mélanges d'Archéologie et d'Histoire* 75 (1963): 415–66

Jombert 1770
Charles-Antoine Jombert, *Catalogue de l'oeuvre de M. Charles-Nicolas Cochin le fils*, Paris, 1770

Joubert 1821
François-Etienne Joubert, *Manuel de l'amateur d'estampes faisant suite au manuel du libraire . . .* , Paris, 1821

Jouin 1880–83
Henry Jouin, *Conférences de l'Académie royale de Peinture et de Sculpture, recueillies, annotées et précédées d'une etude sur les artistes écrivains*, Paris, 1883

Jouin 1896
Henry Jouin, *Charles Le Brun et les arts sous Louis XIV*, Paris, 1896

Jullienne 1726
Jean de Jullienne, *Figures de différents caractères, de Paysages, et d'Etudes dessinés d'après Nature par Antoine Watteau*, 2 vols., Paris, 1726

Kaufmann 1952
Emil Kaufmann, *Three Revolutionary Architects: Boullée, Ledoux, and Lequeu*, in Transactions of the American Philosophical Society, n.s., 42, pt. 3, Philadelphia, 1952

Kaufmann 1988
Thomas DaCosta Kaufmann, *The School of Prague: Painting at the Court of Rudolf II*, Chicago, 1988

Kemp 1990
Martin Kemp, *The Science of Art: Optical Themes in Western Art from Brunelleschi to Seurat*, New Haven and London, 1990

Kerspern 1989
Sylvain Kerspern, "'Jésus retrouvé par ses parents dans le temple' (1654) par Jacques Stella (Provins, église Saint-Ayoul)," *Gazette des Beaux-Arts*, 6th ser., 114 (1989): 1–10

Kitson 1978
Michael Kitson, *Claude Lorrain: Liber Veritatis*, London, 1978

Knab and Widauer 1993
Eckhart Knab and Heinz Widauer, *Die Zeichnungen der Französischen Schule von Clouet bis Le Brun*, vol. 8 of Beschreibender Katalog der Handzeichnungen in der graphischen Sammlung Albertina, Vienna, 1993

Labbé and Bicart-Sée 1987
Jacqueline Labbé and Lise Bicart-Sée, "Antoine-Joseph Dézallier d'Argenville as a Collector of Drawings," *Master Drawings* 25, no. 3 (1987): 276–81

Labbé and Bicart-Sée 1996
Jacqueline Labbé and Lise Bicart-Sée, *La Collection de dessins d'Antoine-Joseph Dézallier d'Argenville reconstituée d'après son "Abrégé de la vie des plus fameux peintres," edition de 1762*, Notes et Documents des Musées de France, no. 27, Paris, 1996

La Blanchardière 1973
N. de La Blanchardière, "Simon Vouet, prince de l'Académie de Saint Luc," *Bulletin de la Société de l'Histoire de l'Art Français*, 1973, 79–84

Lacombe 1759
Jacques Lacombe, *Dictionnaire portatif des Beaux-Arts, ou abrégé de ce qui concerne l'architecture, la sculpture, la peinture, la gravure, la poésie et la musique . . .* , 2d ed., 2 vols., Paris, 1759

La Font de Saint-Yenne 1747
Etienne La Font de Saint-Yenne, *Reflexions sur quelques causes de l'état présent de la peinture en France avec un examen des principaux ouvrages exposés au Louvre, le mois d'août 1746*, Paris, 1747

La Font de Saint-Yenne 1754
Etienne La Font de Saint-Yenne, *Sentimens sur quelques ouvrages de la peinture, sculpture et gravure écrits à un particulier en province*, Paris, 1754

Laing §
Alastair Laing—see London et al. 1977; New York et al. 1986; Charlotte et al. 1994

Laugier 1753
Abbé Marc Antoine Laugier, *Jugement d'un amateur sur l'exposition des tableaux: Lettre à M. le marquis de V***[ence]*, Paris, 1753

Launay 1991
Elisabeth Launay, *Les frères Goncourt, collectionneurs de dessins*, Paris, 1991

Laurain-Portemer 1985
Madeleine Laurain-Portemer, "Un Mécènat ministériel: L'exemple de Mazarin," in *L'Age d'or du mécènat (1598–1661)*, actes du colloque international, ed. Roland Mousnier and Jean Mesnard, Centre National de la Recherche Scientifique, Paris, 1985, 89–106

Laveissière 1988
Sylvain Laveissière, "Prud'hon à l'hôtel de Lannoy," *Antologia di Belli Arti* 33–34 (1988): 2–23

Laveissière 1997
Sylvain Laveissière, *Le Cabinet des dessins: Prud'hon*, Paris, 1997

Laveissière §
Sylvain Laveissière—see Dublin 1985; Paris 1986a; Paris 1994a; Chantilly 1997; Paris and New York 1997a

Le Blanc 1890
Charles Le Blanc, *Manuel de l'amateur d'estampes*, Paris, 1854–90

Le Blant 1981
Roger Le Blant, "Collaborateurs de Charles Le Brun: I. François Perrier," in *105e Congrès des Sociétés savantes, Caen, 1980, Archéologie et histoire de l'art*, Paris, 1981

Le Carpentier 1806
Charles Le Carpentier, "Notice sur Fragonard" (1806), reprinted in Charles Le Carpentier, *Galerie des peintres célèbres, avec des remarques sur le genre de chaque maître*, Paris, 2 (1821): 279–83

Le Comte 1699
Florent Le Comte, *Cabinet des singularitez d'architecture, peinture et sculpture*, Paris, 1699

Lefrançois 1994
Thierry Lefrançois, *Charles Coypel, peintre du roi*, Paris, 1994

Legrand 1997
Catherine Legrand et al., *Inventaire général des dessins—Ecole Française—XIII: De Pagnest à Puvis de Chavannes*, Département des Arts Graphiques, Musée du Louvre et Musée d'Orsay, Paris, 1997 (for other volumes in the series, see Guiffrey and Marcel 1928; Rouchés and Huyghe 1938; and Duclaux 1975)

Le Jeune 1864
Théodore Le Jeune, *Guide théorique et pratique de l'amateur de tableaux . . .*, Paris, 1864

Le Moel 1990
Michel Le Moel, *L'Architecture privée à Paris au Grand Siècle*, Paris, 1990

Le Roy 1734
Pierre Le Roy, *Statuts et privileges du corps des marchands orfèvres-joyailliers de la Ville de Paris . . .*, Paris, 1734

Levey 1993
Michael Levey, *Painting and Sculpture in France, 1700–1789*, New Haven and London, 1993

Levi 1987
Honor Levi, "Richelieu collectionneur," in *Richelieu et la Culture*, actes du colloque international en Sorbonne (1985), ed. Roland Mousnier, Centre National de la Recherche Scientifique, Paris, 1987

Levitine 1975
Georges Levitine, "Les Origines du mythe de l'artiste bohème en France: Lantara," *Gazette des Beaux-Arts*, 6th ser., 86 (Sept. 1975): 49–60

Lichtenstein 1995
Jacqueline Lichtenstein, *La Peinture*, Paris, 1995

Lieure 1924–27
Jules Lieure, *Jacques Callot*, 3 vols., Paris, 1924–27

Lille 1893
Lille, Musée des Beaux-Arts, *Catalogue des tableaux du Musée de Lille*, 1893

Locquin 1912
Jean Locquin, *La Peinture d'histoire en France de 1747 à 1785*, Paris, 1912

Locquin 1978
Jean Locquin, *La Peinture d'histoire en France de 1747 à 1785*, 2d ed., Paris, 1978

Loire 1992
Stéphane Loire, "François Tortebat," in *Simon Vouet: Actes du colloque international*, ed. Stéphane Loire, Rencontres de l'Ecole du Louvre, La Documentation Française, Paris, 1992, 435–54

Lothe 1994
José Lothe, *L'Oeuvre gravée de François et Nicolas de Poilly d'Abbeville*, Paris, 1994

Lottin 1836–38
Denis Lottin, *Recherches historiques sur la ville d'Orleans: Depuis Aurelien, l'an 274, jusqu'en 1789*, 2 vols., Orleans, 1836–38

Lugt 1921 (L.)
Frits Lugt, *Les Marques de collections de dessins et d'estampes: Marques estampillées et écrites de collections particulières et publiques, marques de marchands, de monteurs et d'imprimeurs, cachets de vente d'artistes décédés, marques de graveurs apposées apres le tirage des planches, timbres d'edition, etc., avec des notices historiques sur les collectionneurs, les collections, les ventes, les marchands, et éditeurs, etc.*, Amsterdam, 1921

Lugt 1956 (L.s.)
Frits Lugt, *Les Marques de collections de dessins et d'estampes: Marques estampillées et écrites de collections particulières et publiques, marques de marchands, de monteurs et d'imprimeurs, cachets de vente d'artistes décédés, marques de graveurs apposées apres le tirage des planches, timbres d'edition, etc., avec des notices historiques sur les collectionneurs, les collections, les ventes, les marchands, et éditeurs, etc.*, Supplement, The Hague, 1956

Luna 1979
Juan J. Luna, "Dos pinturas de Charles-François Hutin en el Museo del Prado," *Archivio Español de Arte* 205 (1979): 81–83

Maclean 1977
Ian Maclean, *Women Triumphant: Feminism in French Literature, 1610–1652*, Oxford, 1977

Mahérault 1880
Marie-Joseph-François Mahérault, *L'Oeuvre de Moreau le jeune; catalogue raisonné et descriptif, avec notes iconographiques et bibliographiques . . .*, Paris, 1880

Mâle 1930
Emile Mâle, *L'Art religieux après le Concile de Trente*, Paris, 1930

Mâle and Chazal 1984
Emile Mâle, *L'Art religieux du XVIIe siècle*, 2d rev. ed. by Gilles Chazal, Paris, 1984

Malvasia 1678
Carlo Cesare Malvasia, *Felsina Pittrice, vite de' pittori bolognese*, Bologna, 1678 (all refs. to Giampetrino Zanotti edition, 2 vols., Bologna, 1841)

Mandowsky 1953
Erna Mandowsky, "Some Notes on the Early History of the Medicean 'Niobides,'" *Gazette des Beaux-Arts*, 6th ser., 41 (1953): 251–64

Mannlich 1948
Johann Christian von Mannlich, *Histoire de ma vie: Mémoires de Johann Christian von Mannlich*, ed. Delage, Paris, 1948

Mariette 1741
Pierre-Jean Mariette, *Description sommaire des Desseins des grands maîtres d'Italie, des Pays-Bas, et de France du Cabinet de feu M. Crozat, avec des reflexions sur la manière de dessiner des principaux maîtres*, Paris, 1741

Mariette 1750
Pierre-Jean Mariette, *Abécédario de P. J. Mariette et autres notes inédits de cet amateur* (ca. 1750), pub. posthumously as five volumes of the *Archives de l'Art Français*, vols. 2 (1), 4 (2), 6 (3), 8 (4), and 10 (5), ed. Philippe de Chennevières and Anatole de Montaiglon, Paris, 1851–60

Marmontel 1792
Jean François Marmontel, *Mémoires* (1792), ed. John Renwick, Clermont-Ferrand, 1972

Marolles 1666
Michel de Marolles, Abbé de Villeloin, *Catalogue de livres d'estampes et figures en taille douce . . .*, Paris, 1666

Marolles 1673
Michel de Marolles, Abbé de Villeloin, *Le Livre des peintres et graveurs*, Paris, ca. 1673

Marot 1970
Pierre Marot, *Le Vieux Nancy*, Nancy, 1970

Marrow 1982
Deborah Marrow, *The Art Patronage of Maria De' Medici*, Ann Arbor, 1982

Marx 1977
Harold Marx, "Zu fünf Gemälden von Charles Hutin," *Sächsische Heimatblätter* 4 (1977): 147–51

Mathey 1936
Jacques Mathey, "Quelques confusions entre les dessins de Watteau et ceux de son école," *Revue de l'Art ancien et moderne* 70, no. 372 (July 1936): 3–18

Mathey 1948
Jacques Mathey, "Deux dessins de J. B. Pater," *Gazette des Beaux-Arts,* 6th ser., 34 (1948): 133–36

Mathey 1949
Jacques Mathey, "Remarques sur la chronologie des peintures et dessins de Jean-Antoine Watteau," *Bulletin de la Société de l'Histoire de l'Art Français*, 1949, 158–65

Mauclair—Martin—Masson 1906
Charles Mauclair, Jean Martin, and Charles Masson, *Jean-Baptiste Greuze: Catalogue raisonné de l'oeuvre peint de J-B. Greuze,* Paris, 1906

McCullagh 1981
Suzanne Folds McCullagh, "The Development of Gabriel de Saint-Aubin (1724–1780) as a Draughtsman," 2 vols., Ph.D. diss., Harvard University, 1981

McCullagh §
Suzanne Folds McCullagh—see Chicago et al. 1976; Paris 1976

Meaume 1860
Edouard Meaume, *Recherches sur la vie et les ouvrages de Jacques Callot, suite au peintre-graveur français de M. Robert-Dumesnil*, Paris, 1860

Meder 1978
Joseph Meder, *The Mastery of Drawing*, trans. and rev. Winslow Ames, New York, 1978

Méjanès 1972
Jean-François Méjanès, "Musée des Beaux-Arts de Besançon. II. Un album de dessins de La Traverse," *La Revue du Louvre et des Musées de France* 22, nos. 4–5 (1972): 381–87

Méjanès 1976
Jean-François Méjanès, "A Spontaneous Feeling for Nature: French Eighteenth-Century Landscape Drawings," *Apollo* 104 (Nov. 1976): 396–404

Méjanès §
Jean-François Méjanès—see Cholet 1973; Rome et al. 1976; London 1977; Alençon 1981; Lille and Rome 1983; Paris 1983b; Paris 1984a; Paris 1984c; Rome 1984; Brussels 1985; Paris 1985a; Paris 1987d; Paris 1989a; Paris 1990b; Paris 1993a; Legrand 1997; Paris 1997a; Paris 1997c

Mengs 1762
Anton Raphael Mengs, *Gedanken uber die Schonheit und den Geschmack in der Mahlerey*, Zurich, 1762

Mérot 1983
Alain Mérot, "La place des sujets mythologiques et leur signification dans les décor peinte à Paris dans le première moitié du XVIIe siècle," in *La Mythologie au XVIIe siècle* (1981), actes du colloque, Nice, 1983, 219–24

Mérot 1985
Alain Mérot, "Les paroisses parisiennes et les peintres dans la première moitié du XVIIe siècle: Le rôle des fabriques," in *L'Age d'or du mécènat (1598–1661)*, actes du colloque international, ed. Roland Mousnier and Jean Mesnard, Centre National de la Recherche Scientifique, Paris, 1985

Mérot 1986
Alain Mérot, "Decors pour le Louvre de Louis XIV (1653–1660): La mythologie politique à la fin du Fronde," in *La Monarchie absolutiste et l'histoire en France*, actes du colloque, Sorbonne, Paris, 1986

Mérot 1987
Alain Mérot, *Eustache Le Sueur*, Paris, 1987

Mérot 1989
Alain Mérot, "Le Cabinet, décor et espace d'illusion," in *L'Hôtel Parisien au XVIIe siècle*, special issue of *XVIIe Siècle*, 41, no. 162 (Jan.–Mar. 1989): 81–84

Mérot 1990
Alain Mérot, *Poussin*, Paris, 1990

Mérot 1992
Alain Mérot, "Simon Vouet et la grotesque: Un langage ornemental," in *Simon Vouet: Actes du colloque international*, ed. Stéphane Loire, Rencontres de l'Ecole du Louvre, La Documentation Française, Paris, 1992, 563–72

Mérot 1994
Alain Mérot, "Le dessin français au XVIIe siècle: Vingt ans de recherche, *Revue de l'Art* 105 (1994): 43–50

Mérot 1995
Alain Mérot, *French Painting in the Seventeenth Century*, trans. Caroline Beamish, New Haven and London, 1995

Mérot 1996
Alain Mérot, ed., *Les Conférences de l'Académie royale de Peinture et de Sculpture au XVIIe siècle*, Paris, 1996

Mérot §
Alain Mérot—see Besançon 1984; Dijon and Le Mans 1998

Mesuret 1972
Robert Mesuret, *Les Expositions de l'Académie royale de Toulouse de 1751 à 1791*, Toulouse, 1972

Metcalfe 1911
Louis R. Metcalfe, "Robert Nanteuil," *Print Collector's Quarterly* 1, no. 5 (1911)

Michel 1987
Christian Michel, *Charles-Nicolas Cochin et le livre illustré au XVIII siècle*, Geneva, 1987

Michel 1992
Christian Michel, "L'Enseignement à l'Ecole royale des Elèves Protégés," in *Le Progrès des Arts Réunis* (1989), actes du colloque, Bordeaux, 1992, 83–90

Michel 1993
Christian Michel, *Charles-Nicolas Cochin et l'art des lumières*, Rome, 1993

Michel 1996
Olivier Michel, *Vivre et peindre à Rome*, Rome, 1996

Michel 1997
Christian Michel, "Les conférences académiques: Enjeux théoriques et pratiques," in *La Naissance de la théorie de l'art en France, 1640–1720*, special issue of *Revue d'Esthétique* 31/32 (1997): 71–82

Michel §
Olivier Michel—see Paris and Rome 1987; Carcassonne 1990

Mignot 1983
Claude Mignot, "Henri Sauval entre l'erudition et l'histoire de l'art," *XVIIe Siècle* 138 (1983): 51–66

Mirimonde 1975
Albert Pomme de Mirimonde, *L'Iconographie musicale sous les rois Bourbon: La musique dans les arts plastiques (XVII et XVIII siècles)*, 2 vols., Paris, 1975

Moir 1967
Alfred Moir, *The Italian Followers of Caravaggio*, 2 vols., Cambridge, MA, 1969

Monbeig-Goguel 1990
Catherine Monbeig-Goguel, "L'intérêt pour la peinture florentine contemporaine en France au XVIIe siècle," in *Seicento: La peinture italienne du XVIIe siècle et la France*, actes du colloque, ed. Jean-Claude Boyer, Rencontres de l'Ecole du Louvre, La Documentation Française, Paris, 1990, 231–56

Monnier 1972
Genevieve Monnier, *Pastels: Musée du Louvre, Cabinet des Dessins*, Paris, 1972

Montagu 1963
Jennifer Montagu, "The Unknown Charles Le Brun: Some Newly Attributed Drawings," *Master Drawings* 1, no. 2 (1963): 40–47

Montagu 1980
Jennifer Montagu, "Oeuvres de Charles Le Brun," in *La Donation Suzanne et Henri Baderou au Musée de Rouen: Peintures et dessins de l'Ecole Française*, vol. 1 of Etudes de La Revue du Louvre et des Musées de France, Paris, 1980, 41–44

Montagu 1992
Jennifer Montagu, "Les oeuvres de jeunesse de Charles Le Brun: L'influence de Simon Vouet et d'autres," in *Simon Vouet: Actes du colloque international*, ed. Stéphane Loire, Rencontres de l'Ecole du Louvre, La Documentation Française, Paris, 1992, 531–44

Montagu 1994
Jennifer Montagu, *The Expression of the Passions: The Origin and Influence of Charles Le Brun's "Conférence sur l'expression générale et particulière,"* London, 1994

Montagu §
Jennifer Montagu—see Versailles 1963; London 1990b

Montaiglon 1875–92
Anatole de Montaiglon, ed., *Procès verbaux de l'Académie royale de Peinture et de Sculpture (1648–1792)*, 10 vols., Paris, 1875–92

Montaiglon and Guiffrey 1887–1912
Anatole de Montaiglon and Jules Guiffrey, *Correspondance des directeurs de l'Académie de France à Rome*, 18 vols., Paris, 1887–1912

Montebello 1995
Philippe de Montebello, "New Accessions," *Metropolitan Museum of Art Bulletin* 53, no. 2, fall 1995

Montfaucon 1733
Bernard de Montfaucon, *Les monumens de la monarchie françoise, qui comprennant l'histoire de France, avec les figures de chaque regne que l'injure des tems à epargnées*, Paris, 1729–33

Moreau and Morgan Grasselli 1987
François Moreau and Margaret Morgan Grasselli, eds., *Antoine Watteau (1684–1721), le peintre, son temps, et sa légende* (1984), actes du colloque, Paris and Geneva, 1987

Morgan 1975
Margaret Morgan, "Autour de Watteau: Nouvelles attributions à Pater et à Quillard," *La Revue du Louvre et des Musées de France* (1975): 91–94

Morgan Grasselli 1986
Margaret Morgan Grasselli, "Eleven New Drawings by Nicolas Lancret," *Master Drawings* 23–24, no. 3 (autumn 1986): 377–88

Morgan Grasselli 1987a
Margaret Morgan Grasselli, "The Drawings of Antoine Watteau: Stylistic Development and Problems of Chronology," Ph.D. diss., Harvard University, 1987

Morgan Grasselli 1987b
Margaret Morgan Grasselli, "Watteau's Use of the *Trois-Crayons* Technique," in *Drawings Defined*, ed. Konrad Oberhuber, Walter Strauss, and Tracie Felker, New York, 1987

Morgan Graselli 1988
Margaret Morgan Grasselli, "A New Drawing by Jean-Baptiste Nattier," *Master Drawings* 26, no. 4 (1988): 356–57

Morgan Grasselli 1993
Margaret Morgan Grasselli, "Eighteen New Drawings by Antoine Watteau: A Chronological Study," *Master Drawings* 31, no. 2 (1993): 103–27

Morgan Grasselli 1996
Margaret Morgan Grasselli, "Landscape Drawings by François Le Moyne: Some Old, Some New," *Master Drawings* 34, no. 4 (1996): 365–74

Morgan Grasselli §
Margaret Morgan Grasselli—see Washington 1982a; Washington et al. 1984; Washington 1993; Washington 1995a

Moureau 1893
Adrien Moureau, *Les Moreau*, Paris, 1893

Mousnier 1964
Roland Mousnier, ed., *Lettres et mémoires adressés au chancelier Séguier (1633–1649)*, 2 vols., Paris, 1964

Mousnier 1984
Roland Mousnier, *The Institutions of France under the Absolute Monarchy 1589–1789*, trans. A. Goldhammer and B. Pearce, Chicago, 1979–84

Mousnier 1985
Roland Mousnier, ed., *Un Nouveau Colbert*, actes du colloque pour le tricentenaire de la mort de Colbert . . . , Paris, 1985

Munger et al. 1992
Jeffrey Munger et al., *The Forsyth Wickes Collection, Museum of Fine Arts, Boston*, Boston, 1992

Munhall §
Edgar Munhall—see Hartford et al. 1976; New York 1996b

Narbaïts 1993
Xavier Narbaïts, "Salon du dessin, vive le collage," *L'Oeil* 449 (March 1993): 62–67

Nexon 1983
Yannick Nexon, "L'Hôtel Séguier: Contribution à l'etude d'un hôtel parisien au XVIIe siècle," *Bulletin Archéologique du Comité des Travaux Historiques et Scientifiques* 16 (1983): 143–77

Nexon 1985a
Yannick Nexon, "La Collection de tableaux du chancelier Séguier," *Bibliothèque de l'Ecole des Chartes* 140 (1985): 189–215

Nexon 1985b
Yannick Nexon, "Le Mécènat du chancelier Séguier," in *L'Age d'or du mécènat (1598–1661)*, actes du colloque international, ed. Roland Mousnier and Jean Mesnard, Centre National de la Recherche Scientifique, Paris, 1985, 49–58

Nivelon 1700
Claude Nivelon, "Vie de Charles Le Brun et description detaillée de ses ouvrages," Bibliothèque Nationale, manuscript no. 12987, ca. 1700, 257–58

Nybert 1969
D. Nybert, ed., *Oeuvre de Juste-Aurèle Meissonnier* (facsimile), New York, 1969

Oberhuber 1988
Konrad Oberhuber, *Poussin, the Early Years in Rome: The Origins of French Classicism*, New York, 1988

Oberhuber—Strauss—Felker 1987
Konrad Oberhuber, Walter Strauss, and Tracie Felker, *Drawings Defined*, New York, 1987

O'Neill 1984a
Mary O'Neill, "Hyacinthe Rigaud's Drawings for His Engravers," *The Burlington Magazine* 980 (Nov. 1984): 674–83

O'Neill 1984b
Mary O'Neill, "Three Drawings in American Collections after Portraits by Rigaud," *Master Drawings* 22, no. 2 (1984): 186–94

Opperman 1973
Hal N. Opperman, "Oudry aux Gobelins," *Revue de l'Art* 22 (1973): 60

Opperman 1977
Hal N. Opperman, *Jean-Baptiste Oudry*, 2 vols., New York and London, 1977

Opperman §
Hal N. Opperman—see Paris et al. 1982a

Osborne 1985
Carol Margot Osborne, *Pierre Didot the Elder and French Book Illustration, 1789–1822*, New York, 1985

Pace 1981
Claire Pace, *Félibien's "Life of Poussin,"* London, 1981

Pacht Bassani 1992
Paola Pacht Bassani, *Claude Vignon, 1593–1670*, Paris, 1992

Pader 1658
Hilaire Pader, *La Peinture Parlant . . .* , Toulouse, 1657–58

Paignon-Dijonval and Bénard 1810
M. Paignon-Dijonval and M. Bénard, *Cabinet de M. Paignon-Dijonval, état détaillé et raisonné des dessins et estampes dont il est composé*, Paris, 1810

Paillat 1997
Edith Paillat, "Chronology," *Pierre-Paul Prud'hon*, special issue of *Connaissance des Arts*, 1997, 64–68

Papillion 1776
M. Papillion de La Ferté, *Extraits des differens ouvrages publiées sur la vie des peintres*, 2 vols., Paris, 1776

Parker 1933
Karl Theodore Parker, "An Etching and a Drawing by Antoine Watteau," *British Museum Quarterly* 8 (1932–33): 1–3

Parker 1937
Harold Talbot Parker, *The Cult of Antiquity and the French Revolutionaries: A Study in the Development of the Revolutionary Spirit*, Chicago, 1937

Parker and Mathey 1957
Karl Theodore Parker and Jacques Mathey, *Antoine Watteau, catalogue complet de son oeuvre dessiné*, 2 vols., Paris, 1957

Pascoli 1736
Lione Pascoli, *Vite de'pittori, scultori ed architetti moderni*, 2 vols., Rome, 1736 (all refs. to A. Marabottini et al. edition, Perugia, 1992)

Passeri 1772
Giambattista Passeri, *Vite de'pittori, scultori, ed architetti che anno lavorato in Roma, morti dal 1641 fino al 1673*, Rome, 1772 (all refs. to Jacob Hess edition, Leipzig and Vienna, 1934)

Perella 1973
Nicola Perella, *The Critical Fortune of Battista Guarini's "Il Pastor Fido,"* Florence, 1973

Pérignon 1824
Alexis Nicolas Pérignon, *Catalogue des tableaux, dessins et croquis de M. Girodet-Trioson*, Paris, 1824

Petitjean and Wickert 1925
Charles Petitjean and Charles Wickert, *Catalogue de l'oeuvre gravé de Robert Nanteuil*, Paris, 1925

Pevsner 1940
Nikolaus Pevsner, *Academies and Art, Past and Present*, Cambridge, 1940

Phillips 1997
Henry Phillips, *Church and Culture in Seventeenth-Century France*, Cambridge, 1997

Picart 1982
Yves Picart, *Aubin Vouet, 1591–1641: Un cadet bien oublié*, Paris, 1982

Picart 1987
Yves Picart, *Jean-Baptiste Corneille, 1649–1695: Une âme violente et tourmentée*, Lyon, 1987

Pichon 1856
Jérôme Pichon, "Mémoires de Pajou et de Drouais pour Mme Du Barry," in *Mélanges de littérature et d'histoire recueillis et publiés par la Société des Biblophiles François*, Paris, 1856

Pidansat de Mairobert 1776
Mathieu-François Pidansat de Mairobert, *Anecdotes sur Mme la comtesse Dubarri*, London, 1776

Pigler 1974
Andor Pigler, *Barockthemen: Eine Auswahl von Verzeichnissen zur Ikonographie des 17. und 18. Jahrhunderts*, Budapest, 1974

Pignatti 1976
Terisio Pignatti, *Veronese*, 2 vols., Venice, 1976

de Piles 1667
Roger de Piles, *Abrégé d'Anatomie accomodé aux arts de Peinture et de Sculpture*, with François Tortebat, Paris, 1667/68

de Piles 1673
Roger de Piles, *Dialogue sur le coloris*, Paris, 1673

de Piles 1676
Roger de Piles, *Abrégé de la vie de Rubens*, Paris, 1676

de Piles 1677
Roger de Piles, *Conversations sur la connoissance de la peinture*, Paris, 1677

de Piles 1694
Roger de Piles, *Les Premiers elémens de la peinture pratique*, Paris, 1694

de Piles 1699
Roger de Piles, *Abrégé de la vie des peintres avec des reflexions sur leurs ouvrages, et un traité du peintre parfait . . .* , Paris, 1699

de Piles 1708
Roger de Piles, *Cours de peinture par principes*, Paris, 1708

Populus 1930
Bernard Populus, *Claude Gillot (1673–1722), Catalogue de l'oeuvre gravé*, Paris, 1930

Portalis 1877
Baron Roger Portalis, *Les Dessinateurs d'illustrations au XVIIIe siècle*, Paris, 1877

Posner 1971
Donald Posner, *Annibale Carracci: A Study in the Reform of Italian Painting*, 2 vols., London, 1971

Posner 1993
Donald Posner, "Concerning the 'Mechanical' Parts of Painting and the Artistic Culture of Seventeenth-Century France," *Art Bulletin* 75, no. 4 (Dec. 1993): 583–98

Prat 1977
Louis-Antoine Prat, "Une Collection de dessins d'artistes français par Philippe de Chennevières, Index," *Bulletin de la Société de l'Histoire de l'Art Français*, 1977, 275–95

Prat 1991
Véronique Prat, "Salon du dessin de collection," *Le Figaro Magazine*, 6 April 1991, 143

Préaud 1989
Maxime Préaud, "L'Hôtel idéal selon Jean Lepautre," in *L'Hôtel Parisien au XVIIe siècle*, special issue of *XVIIe Siècle*, 41, no. 162 (Jan.–Mar. 1989): 81–84

Prestwich 1985
Menna Prestwich, "Patronage and the Protestants in France (1598–1661): Architects and Painters," in *L'Age d'or du mécénat (1598–1661)*, actes du colloque international, ed. Roland Mousnier and Jean Mesnard, Centre National de la Recherche Scientifique, Paris, 1985, 77–88

Pupil 1985
François Pupil, *Le style troubadour ou la nostalgie du bon vieux temps*, Nancy, 1985

Puttfarken 1985
Thomas Puttfarken, *Roger de Piles' Theory of Art*, New Haven and London, 1985

Quarré-Reybourbon 1904
Louis Quarré-Reybourbon, *Arnould de Vuez peintre lilois*, Lille, 1904

Quatremère de Quincy 1791
Antoine Chrysostome Quatremère de Quincy, *Recueil de notices historiques lues dans l'Académie royale des Beaux-Arts à l'Institut*, Paris, 1834

Quinchon-Adam 1993
Laurence Quinchon-Adam, "Arnould de Vuez (1644–1720)," *Bulletin de la Société de l'Histoire de l'Art Français*, 1993, 69–81

Ramade 1980
Patrick Ramade, *Correspondances: Dessins et gravures du XVIIe siècle français dans les collections du Musée des Beaux-Arts, Rennes*, Rennes, 1980

Ranum 1963
Orest Ranum, *Richelieu and the Councilors of Louis XIII: A Study of the Secretaries of State and Superintendants of Finance in the Ministry of Richelieu, 1635–1642*, Oxford, 1963

Ranum 1968
Orest Ranum, *Paris in the Age of Absolutism*, New York, 1968

Raux 1995
Sophie Raux, *Catalogue des dessins français du XVIIIe siècle de Claude Gillot à Hubert Robert*, Paris, 1995

Ray 1986
Gordon N. Ray, *Art of the French Illustrated Book, 1700–1914*, 2d ed., New York, 1986

Réau 1930
Louis Réau, "Un sculpteur oublié du XVIII siècle: Louis-Claude Vassé (1716–1772)," *Gazette des Beaux-Arts*, 6th ser., 4 (1930): 31–56

Réau 1938
Louis Réau, "Carle Vanloo (1705–1765)," *Archives de l'Art Français* 19 (1938): 7–96

Réau 1955–59
Louis Réau, *Iconographie de l'art Chrétien*, 6 vols., Paris, 1955–59

Réau 1956
Louis Réau, *Fragonard*, Brussels, 1956

Reed 1993
Sue Welsh Reed, "Après Bellange et Callot: La diffusion du maniérisme lorrain chez les graveurs français du XVIIe siècle," in *Jacques Callot (1592–1635): Actes du colloque*, Paris, 1993, 511–32

Reed §
Sue Welsh Reed—see Des Moines et al. 1975; Boston et al. 1998

Ribeiro 1988
Aileen Ribeiro, *Fashion in the French Revolution*, New York, 1988

Richardson 1979
John Richardson, *The Collection of Germain Seligman: Paintings, Drawings, and Works of Art*, New York, 1979

Riopelle 1991
Christopher Riopelle, "New York, Colnaghi/ French Landscape Painting," Exhibition Reviews II, *The Burlington Magazine* 133, no. 1054 (Jan. 1991): 54–55

Ripa 1603
Cesare Ripa, *Iconologia, overo descrittione di diverse imagini cavate dall'antichita, & di propria inventione, Di nuovo revista . . . trovate, & dichiarate da Cesare Ripa*, 3d ed., Rome, 1603

Ripa—de Bie—Baudoin 1643
Cesare Ripa, *Iconologie, ou, Les principales choses qui peuvent tomber dans la pensée touchant les vices sont représentées sous diverses figures gravée en cuivre par Jacques de Bie et moralement expliquées par Isaac Baudoin*, Paris, 1643

Rishel and Lefton 1987
Joseph J. Rishel with Alice Lefton, *The Henry P. McIlhenny Bequest, The Philadelphia Museum of Art*, Philadelphia, 1987

Rivalz 1735
Chevalier Pierre Rivalz, *Catalogue de la collection laissée par Antoine au chevalier Pierre Rivalz . . .* , Toulouse, 1735

Robels 1967
Hella Robels, *Katalog ausghewahlter Handzeichnungen und Aquarelle im Wallraf-Richartz-Museum*, Cologne, 1967

Robinson §
William W. Robinson—see Cambridge and Tampa 1984

Robert-Dumesnil 1871
A. P. F. Robert-Dumesnil, *Le Peintre-graveur français, ou catalogue raisonné des estampes gravées par les peintres et les dessinateurs de l'école française. Ouvrage faisant suite au peintre-graveur de M. Bartsch*, 11 vols. (vols. 9–10, with G. Duplessis; vol. 11, G. Duplessis), Paris, 1835–71

Roethlisberger 1962
Marcel Roethlisberger, *Claude Lorrain: L'Album Wildenstein*, Paris, 1962

Roethlisberger 1968
Marcel Roethlisberger, *Claude Lorrain: The Drawings*, 2 vols., Berkeley and Los Angeles, 1968

Roethlisberger 1975
Marcel Roethlisberger, "Guillerot," *Gazette des Beaux-Arts*, 6th ser., 85 (April 1975): 120–28

Roethlisberger 1981
Marcel Roethlisberger, *Claude Lorrain: The Paintings*, 2d ed., 2 vols., New York, 1981

Roethlisberger 1987
Marcel Roethlisberger, "Dessins de Barrière et Guillerot," *Gazette des Beaux-Arts*, 6th ser., 109 (April 1987): 139–51

Roland Michel 1984
Marianne Roland Michel, *Watteau: An Artist of the Eighteenth Century*, London, 1984

Roland Michel 1987
Marianne Roland Michel, *Le Dessin français du XVIIIe siècle*, Paris, 1987

Roland Michel 1996
Marianne Roland Michel, *Chardin*, New York, 1996

Roland Michel §
Marianne Roland Michel—see Paris 1968; Rome et al. 1976; Paris and Geneva 1978; Paris and Geneva 1980; Paris 1983c; Paris 1985e; Paris and Geneva 1986; Paris 1989d; Paris 1991c

Roman 1919
Joseph Roman, ed., *Le Livre de raison du peintre Hyacinthe Rigaud*, Paris, 1919

Rosenberg 1969
Pierre Rosenberg, "A propos d'un dessin Charles Mellin," *La Revue du Louvre et des Musées de France* 19, nos. 4–5 (1969): 223–26

Rosenberg 1971
Pierre Rosenberg, *Il seicento francese*, vol. 11 of I disegni dei maestri, ed. W. Vitzthum, Milan, 1971

Rosenberg 1974
Pierre Rosenberg, "Dandré-Bardon as a Draughtsman: A Group of Drawings at Stuttgart," *Master Drawings* 12, no. 2 (summer 1974): 137–50

Rosenberg 1975
Pierre Rosenberg, "Quelques nouveaux Blanchard," *Etudes d'art offertes à Charles Sterling*, Paris, 1975, 217–25

Rosenberg 1979
Pierre Rosenberg, "Dieu as a Draftsman," *Master Drawings* 17, no. 2 (1979): 161–69

Rosenberg 1981
Pierre Rosenberg, "Un Perrier à Varsovie," in *Ars Aureo Prior: Studia Ioanni Bialostocki Sexagenario Dicata*, Warsaw, 1981, 423–27

Rosenberg 1982
Pierre Rosenberg, "Notes on Some French Seventeenth-Century Drawings: Saint-Igny, Vignon, Mellin, Millet, and Others," *The Burlington Magazine* 124, no. 956 (1982): 694–98

Rosenberg 1983
Pierre Rosenberg, *Chardin: Tout l'oeuvre peint*, Milan and Paris, 1983

Rosenberg 1984
Pierre Rosenberg, "France in the Golden Age: A Postscript," *Metropolitan Museum Journal* 17 (1984): 23–46

Rosenberg 1987
Pierre Rosenberg, "Chardin Studies," review of *Chardin* (Paris, 1985 and London, 1986), by Phillip Conisbee, *The Burlington Magazine* 129, no. 1007 (Feb. 1987): 116–18

Rosenberg 1991
Pierre Rosenberg, review of *A Loan Exhibition of Poussin Drawings from British Collections* (exh. cat., Oxford, Ashmoleon Museum, 1990–91), *The Burlington Magazine* 133, no. 1056 (1991): 210–13

Rosenberg 1996
Pierre Rosenberg, "Un dessin de Restout à Athènes," in *Hommage au dessin: Mélanges offerts à Roseline Bacou*, ed. Maria Teresa Caracciolo, Rimini, 1996, 411–17

Rosenberg §
Pierre Rosenberg—see Rouen 1961; Rouen 1970; Paris 1972b; Toronto et al. 1972; Paris et al. 1974; Toledo et al. 1975; Nice et al. 1977; Troyes et al. 1977; Paris et al. 1979; Washington et al. 1981; Paris et al. 1982b; Rouen 1984; Washington et al. 1984; New York et al. 1986; Paris and New York 1987; Paris and Rome 1987; Grenoble et al. 1988; New York et al. 1990; Rome 1990; Dijon and Paris 1992; Bayonne 1994; Paris and London 1994; Paris et al. 1995; Paris 1997a; Paris 1997c

Rosenberg—Reynaud—Compin 1974
Pierre Rosenberg, Nicole Reynaud, and Isabelle Compin, *Musée du Louvre, Catalogue Illustré des Peintures, Ecole française, XVIIe et XVIIIe siècles*, 2 vols., Paris, 1974

Rosenberg and Schnapper 1977
Pierre Rosenberg and Antoine Schnapper, "Some New Restout Drawings," *Master Drawings* 15, no. 2 (1977): 166–73

Rosenberg and Bergot 1980
Pierre Rosenberg and François Bergot, eds., with François Avril et al., *La Donation Suzanne et Henri Baderou au Musée de Rouen: Peintures et dessins de l'Ecole Française*, vol. 1 of Etudes de La Revue du Louvre et des Musées de France, Paris, 1980

Rosenberg and Geissler 1980
Pierre Rosenberg and Heinrich Geissler, "Un nouveau groupe de dessins de Jean Restout (1692–1768) au musée de Stuttgart," *Jahrbuch der Staatlichen Kunstsammlungen in Baden-Wurttenberg* 17 (1980): 133–54

Rosenberg and Volle 1980
Pierre Rosenberg and Nathalie Volle, "Nicolas de Plattemontagne dessinateur," in *La Donation Suzanne et Henri Baderou au Musée de Rouen: Peintures et dessins de l'Ecole Française*, vol. 1 of Etudes de La Revue du Louvre et des Musées de France, Paris, 1980, 46–53

Rosenberg and van de Sandt 1983
Pierre Rosenberg and Udo van de Sandt, *Pierre Peyron (1744–1814)*, Paris, 1983

Rosenberg and McCullagh 1985
Pierre Rosenberg and Suzanne Folds McCullagh, "The Supreme Triumph of the Old Painter: Chardin's Final Work in Pastel," *The Art Institute of Chicago's Museum Studies* 12, no. 1 (1985): 43–59

Rosenberg and Thuillier 1985
Pierre Rosenberg and Jacques Thuillier, *Laurent de La Hyre, 1606–1656*, Cahiers du dessin français, no. 1, Paris, 1985

Rosenberg and Brejon 1986
Pierre Rosenberg and Barbara Brejon de Lavergnée, *Panopticon Italiano: Un diario di viaggio ritrovato, 1759–61*, Rome, 1986

Rosenberg and Stewart 1987
Pierre Rosenberg and Marion C. Stewart with Thierry Lefrançois, *French Paintings 1500–1825: The Fine Arts Museums of San Francisco*, San Francisco, 1987

Rosenberg and Prat 1994
Pierre Rosenberg and Louis-Antoine Prat, *Nicolas Poussin, 1594–1665: Catalogue raisonné des dessins*, 2 vols., Milan, 1994

Rosenberg and Prat 1996
Pierre Rosenberg and Louis-Antoine Prat, *Jean-Antoine Watteau: Catalogue raisonné des dessins*, 2 vols., Milan, 1996

Rosenblum 1967
Robert Rosenblum, *Transformations in Late Eighteenth-Century Art*, 2d ed., Princeton, 1967

Roserot 1902
Alphonse Roserot, "La Fontaine de la rue de Grenelle à Paris," *Gazette des Beaux-Arts*, 3d ser., 28 (1902): 353–72

Roserot 1910
Alphonse Roserot, *Edme Bouchardon*, Les Grand Sculpteurs Français du XVIIIe Siècle, Paris, 1910

Ross 1983
Barbara T. Ross, "Notes on Selected French Drawings from the Permanent Collection," *Record of the Art Museum, Princeton University* 42, no. 1 (1983): 4–42

Rouchés and Huyghe 1938
G. Rouchés and René Huyghe, *Inventaire général des dessins du Musée du Louvre et du Musée de Versailles*, Ecole Française, vol. 11, Paris, 1938 (for other volumes in the series, see Guiffrey and Marcel 1928, Duclaux 1975, and Legrand 1997)

Roux 1949
Marcel Roux, *Inventaire du fonds français, graveurs du XVIIIe siècle*, Bibliothèque nationale de France, vol. 6, Paris, 1949

Rubinstein 1930
Stella Rubinstein, *Catalogue of the Collection of George Blumenthal*, 5 vols., Paris, 1930

Ruppert—Delpierre—Davray—Gorguet 1996
Jacques Ruppert, Madeleine Delpierre, Renée Davray-Piékolek, and Pascale Gorguet-Ballesteros, *Le Costume français guide historique*, 2d ed., Paris, 1996

Sabatier 1986
Gérard Sabatier, "Politique, histoire, et mythologie: La galerie en France et en Italie pendant la première moitié du XVIIe siècle," in *La France et l'Italie au temps de Mazarin*, actes du colloque, Grenoble, 1986, 283–301

Sachs 1961
Paul J. Sachs, *Pocket Book of Great Drawings*, 2d ed., New York, 1961

Sahut §
Marie-Catherine Sahut—see Nice et al. 1977; Paris 1984b; Paris 1984d

Salmon 1990
Xavier Salmon, "Le décor disparu de la chapelle Saint-Grégoire au dome des Invalides: Dessins préparatoires de Charles de La Fosse et Michel II Corneille, *Revue de la Société des Amis du Musée de l'Armée* 100 (Dec. 1990): 28–41

Salmon 1994a
Xavier Salmon, "Hyacinthe Collin de Vermont et l'Estampe," *Nouvelles de l'Estampe* 133 (1994): 47–55

Salmon 1994b
Xavier Salmon, "La *Cyropaedie* de Hyacinthe Collin de Vermont (1693–1761)," *Gazette des Beaux-Arts*, 6th ser., 124 (Dec. 1994): 243–66

Salmon 1996
Xavier Salmon, *Jacques-André Portail (1695–1759)*, Cahiers du dessin français, no. 10, Paris, 1996

Salmon §
Xavier Salmon—see Versailles and Amiens 1995

Sandoz 1959
Marc Sandoz, "Gabriel-François Doyen: Peintre d'histoire (1726–1806)," *Bulletin de la Société de l'Histoire de l'Art Français*, 1959, 75–88

Sandoz 1967
Marc Sandoz, "Tableaux retrouvés de Jean-Baptiste Deshays, Gabriel Doyen et Louis Lagrenée (l'aîné)," *Bulletin de la Société de l'Histoire de l'Art Français*, 1967, 109–22

Sandoz 1969
Marc Sandoz, "Les oeuvres de G. F. Doyen exécutées ou actuellement conservées en Russie," *Acts of the XXII International Congress on the History of Art*, Budapest, 1969

Sandoz 1971
Marc Sandoz, "The Drawings of Gabriel-François Doyen (1726–1806)," *Art Quarterly* 34, no. 2 (1971): 149–78

Sandoz 1975
Marc Sandoz, *Gabriel-François Doyen, 1726–1806*, Paris, 1975

Sandoz 1977
Marc Sandoz, *Jean-Baptiste Deshays, 1729–1765*, Paris, 1977

Sandoz 1979
Marc Sandoz, *Nicolas-Guy Brenet, 1728–1792*, Paris, 1979

Sandrart 1675
Joachim von Sandrart, *Academie der Bau-, Bild-, und Mahlerey-Kunste von 1675. Leben der beruhmten Maler, Bildhauer und Baumeister*, 1675 (all refs. to A. R. Peltzer edition, Munich, 1925)

Sauval 1724
M. Sauval, *Histoire et recherches des antiquités de la ville de Paris*, 3 vols., written by 1650, pub. posthumously, Paris, 1724–33

Schalk 1986
Ellery Schalk, *From Valor to Pedigree: Ideas of Nobility in France in the Sixteenth and Seventeenth Centuries*, Princeton, 1986

Scherf §
Guilhem Scherf—see Paris 1992b; Paris and New York 1997b

Schmidt-von Essen 1994
Maren Isabelle Schmidt-von Essen, *Mademoiselle Clairon, Verwandlungen einer Schauspielerin*, Frankfurt-am-Main, 1994

Schnapper 1967
Antoine Schnapper, *Tableaux pour le Trianon de marbre*, Paris and The Hague, 1967

Schnapper 1968
Antoine Schnapper, "Musées de Lille et de Brest—A propos de deux nouvelles acquisitions: 'le chef d'oeuvre d'un muet' ou la tentative de Charles Coypel," *La Revue du Louvre et des Musées de France* 4–5 (1968): 253–64

Schnapper 1974
Antoine Schnapper, *Jean Jouvenet et la peinture d'histoire à Paris (1644–1717)*, Paris, 1974

Schnapper 1977
Antoine Schnapper, "Noël Coypel et le grand décor peint des années 1660," *Antologia di Belle Arti* 1 (1977): 7–17

Schnapper 1980
Antoine Schnapper, *David, temoin de son temps*, Paris, 1980

Schnapper 1989
Antoine Schnapper, *Le Géant, la licorne, la tulipe: Collections et Collectionneurs dans la France au XVIIe siècle. I. Histoire et histoire naturelle*, Paris, 1989

Schnapper 1990
Antoine Schnapper, "The Debut of the Royal Academy of Painting and Sculpture," in *The French Academy: Classicism and Its Antagonists*, ed. J. Hargrove, Newark, London, and Toronto, 1990

Schnapper 1994
Antoine Schnapper, *Curieux du Grand Siècle: Collections et Collectionneurs dans la France du XVIIe siècle. II. Oeuvres d'art*, Paris, 1994

Schnapper and Guicharnaud 1986
Antoine Schnapper and Hélène Guicharnaud, *Louis de Boullogne (1654–1733)*, Cahiers du dessin français, no. 2, Paris [1986]

Schneider 1916
René Schneider, "L'Art anacréontique et alexandrine sous l'Empire," *Revue des Etudes Napoléoniennes,* vol. 2, 1916

Schneider 1989
Robert A. Schneider, *Public Life in Toulouse: From Municipal Republic to Cosmopolitan City,* Ithaca, 1989

Schreiber Jacoby 1987
Beverly Schreiber Jacoby, "Watteau and Gabburri," in *Antoine Watteau (1684–1721), le peintre, son temps, et sa légende,* ed. François Moreau and Margaret Morgan Grasselli, Paris and Geneva, 1987

Sérullaz 1991
Arlette Sérullaz, *Dessins de Jacques-Louis David (1748–1825),* Inventaire Général des Dessins Français, Ecole Française, Cabinet des Dessins, Musée du Louvre, Paris, 1991

Sérullaz §
Arlette Sérullaz—see Paris 1972a; Paris 1974a; Lille and Rome 1983; Paris and Versailles 1989

Seznec—Mongan—Hofer 1945
Jean Seznec, Elizabeth Mongan, and Philip Hofer, *Fragonard Drawings for Ariosto,* Cambridge, 1945

Sharp et al. 1992
Ellen Sharp et al., *Italian, French, English, and Spanish Drawings and Watercolors: Sixteenth through Eighteenth Centuries,* Detroit and New York, 1992

Shoolman and Slatkin 1950
Regina Shoolman and Charles E. Slatkin, *Six Centuries of French Master Drawings in America,* Oxford, 1950

Solomon-Godeau 1997
Abigail Solomon-Godeau, *Male Trouble: A Crisis in Representation,* New York, 1997

Souchal 1967
François Souchal, *Les Slodtz: Sculpteurs et décorateurs du roi (1685–1764),* Paris, 1967

Spear 1982
Richard Spear, *Domenichino,* 2 vols., New Haven and London, 1982

Specchi 1699
Alessandro Specchi, *Quatro libro del nuovo teatro . . . di Roma,* Rome, 1699

Spike 1979
John Spike, "The 'Feast of Absalom' by Mattia Preti," *Annual Bulletin, National Gallery of Canada,* 1979

Stechow 1948
Wolfgang Stechow, "Drawings and Etchings by Jacques Fouquier," *Gazette des Beaux-Arts,* 6th ser., 34 (1948): 419–34

Stechow 1953
Wolfgang Stechow, "*Heliodorus Aethiopica* in Art," *Journal of the Warburg and Courtauld Institutes* 16 (1953): 144–52

Stein 1888
Henri Stein, *Le peintre Doyen et l'origine du musée des monuments français,* Réunion Société des Beaux-Arts des départements, Paris, 1888

Strong 1973
Roy Strong, *Splendor at Court: Renaissance Spectacle and the Theatre of Power,* Boston, 1973

Stuffmann 1964
Margret Stuffmann, "Charles de La Fosse et sa position dans la peinture française à la fin du XVIIe siècle," *Gazette des Beaux-Arts,* 6th ser., 64 (July–Aug. 1964): 3–121

Sue 1788
Jean-Joseph Sue, *Elémens d'anatomie à l'usage des peintres, des sculpteurs, et des amateurs, ornés de quatorze planches en taille-douce représentant tout les os de l'adulte et ceux de l'enfant du premier age, avec leur explication,* Paris, 1788

Szabó 1975
George Szabó, *The Robert Lehman Collection, The Metropolitan Museum of Art,* New York, 1975

Szabó 1980
George Szabó, *Seventeenth- and Eighteenth-Century French Drawings from the Robert Lehman Collection,* New York, 1980

Szigheti 1975
Agnes Szigheti, *Museum of Fine Arts Budapest—French Paintings of the Seventeenth and Eighteenth Centuries,* Budapest, 1975

Tardieu 1862
Ambroise Tardieu, *Dictionnaire d'hygiène publique et de salubrité; ou, Repertoire de toutes les questions relatives à la santé publique considerées dans leurs rapports avec les subsistances, les épidémies, les professions, les etablissements et institutions . . . ,* 4 vols. (all refs. to vol. 3), 2nd rev. ed., Paris, 1862

Ternois 1962a
Daniel Ternois, *Jacques Callot, Catalogue complet de son oeuvre dessiné,* Paris, 1962

Ternois 1962b
Daniel Ternois, *L'Art de Jacques Callot,* Paris, 1962

Ternois 1973
Daniel Ternois, "Callot et ses temps: Dix ans de recherches (1962–1972)," *Le Pays Lorrain; Journal de la Société d'archéologique lorraine et du Musée historique lorrain* 4 (1973): 211–48

Ternois 1993
Daniel Ternois, "Dessins de Jacques Callot, Quelques attributions récentes et leurs enseignements: Ses méthodes de travail, son atelier, ses continuateurs," in *Jacques Callot (1592–1635): Actes du colloque,* Paris, 1993, 357–422

Ternois 1998
Daniel Ternois, Supplement to Ternois 1962a, 1998–99, forthcoming

Ternois §
Daniel Ternois—see Nancy 1992a

Tervarent 1964
Guy de Tervarent, *Attributes et symboles dans l'art profane 1450–1600,* 2 vols., Geneva, 1958–64

Testelin 1680
Henri Testelin, *Sentimens des plus habiles peintres sur la pratique de la peinture et sculpture: mis en tables de préceptes, avec plusieurs discours académiques, ou conférences tenus en l'Académie royale desdits arts . . . ,* Paris, 1680

Teyssèdre 1957
Bernard Teyssèdre, *Roger de Piles et les débats sur le coloris au siècle de Louis XIV,* Paris, 1957

Teyssèdre 1964
Bernard Teyssèdre, *L'Histoire de l'art vue du Grand Siècle,* Paris, 1964

Teyssèdre 1965
Bernard Teyssèdre, *Roger de Piles et les débats sur le coloris au siècle de Louis XIV*, 2d ed., Paris, 1965

Théveniaud 1984
V. Théveniaud, "Michel Dorigny (1617–1665), Approaches biographiques," *Bulletin de la Société de l'Histoire de l'Art Français*, 1984, 43–67

Thiéry 1788
Luc-Vincent Thiéry, *Guide des amateurs et étrangers voyageurs . . . aux environs de Paris*, Paris, 1788

Thompson 1949
Francis G. Thompson, *A History of Chatsworth, Being a Supplement to the Sixth Duke of Devonshire's Handbook*, London, 1949

Thuillier 1957
Jacques Thuillier, "Polémiques autour de Michel-Ange au XVIIe siècle," *XVIIe siècle* 36–37 (1957): 353–91

Thuillier 1960
Jacques Thuillier, "Poussin et ses premiers compagnons français à Rome," in *Colloque Poussin* (1958), Centre National de la Recherche Scientifique, Paris, 1960, 71–112

Thuillier 1964
Jacques Thuillier, "Académie et classicisme en France: Les débuts de l'Académie royale de Peinture et de Sculpture: 1648–1663," in *Il mito del classicismo nel seicento*, ed. Stefano Bottari, Messina, 1964, 181–209

Thuillier 1965
Jacques Thuillier, "Les 'Observations sur la peinture' de Charles-Alphonse Du Fresnoy," in *Walter Friedlaender zum 90. Geburtstag*, Berlin, 1965, 193–210

Thuillier 1967a
Jacques Thuillier, "Le Brun and Rubens," *Bulletin de Musées Royaux des Beaux-Arts de Belgique*, 1967, 247–68

Thuillier 1967b
Jacques Thuillier, "Temps et tableau: 'La théorie des péripéties' dans la peinture française du XVIIe siècle," in *Stil und Uberlieferung in der Kunst des Abendlandes. III. Theorien und Problem* (Bonn, 1964), colloquium proceedings, Berlin, 1967, 191–207

Thuillier 1968a
Jacques Thuillier, "Doctrines et querelles artistiques en France au XVIIe siècle: Quelques textes oubliés ou inédits," *Archives de l'Art Français* 23 (1968): 125–217

Thuillier 1968b
Jacques Thuillier, "Claude Mellan, peintre," *Bulletin de la Société d'Emulation Historique et Litteraire d'Abbeville*, 1968, 285–96

Thuillier 1974
Jacques Thuillier, "Les débuts de l'histoire de l'art en France et Vasari," in *Il Vasari storiografo e artistica: Atti del congresso internazionale nel IV centenario della morte*, Florence, 1974

Thuillier 1975
Jacques Thuillier, "Fontainebleau et la peinture française du XVIIe siècle," in *Actes du colloque international sur l'art de Fontainebleau*, ed. André Chastel, Centre National de la Recherche Scientifique, Paris, 1975, 249–66

Thuillier 1978a
Jacques Thuillier, "Documents sur Jacques Blanchard," *Bulletin de la Société de l'Histoire de l'Art Français*, 1976–78, 162–67

Thuillier 1978b
Jacques Thuillier, "Propositions pour: I. Charles Errard, peintre," *Revue de l'Art* 40–41 (1978): 151–72

Thuillier 1983a
Jacques Thuillier, "Propositions pour: II. Charles-Alphonse Du Fresnoy, peintre," *Revue de l'Art* 61 (1983): 29–52

Thuillier 1983b
Jacques Thuillier, "La Théorie de l'art au XVIIe siècle: André Félibien," *Annuaire du Collège de France 1982–1983, Résumé des Cours et Travaux*, Paris, 83 (1983): 704–13

Thuillier 1984
Jacques Thuillier, "Les voyages des artistes français du XVIIe siècle," in *Voyages, récits, et imaginaire*, actes du colloque, Paris, Seattle, and Tübingen, 1984

Thuillier 1985
Jacques Thuillier, "Reflexions sur la politique artistique de Colbert," in *Un nouveau Colbert*, Paris, 1985, 275–86

Thuillier 1987
Jacques Thuillier, "Richelieu, son action sur l'Imprimerie royale," in *Richelieu et la Culture*, actes du colloque international en Sorbonne (1985), ed. R. Mousnier, Centre National de la Recherche Scientifique, Paris, 1987

Thuillier 1988a
Jacques Thuillier, "L'Influence des Carrache en France: Pour un premier bilan," *Actes du Colloque*, Ecole Française de Rome (1986), Rome, 1988, 421–55

Thuillier 1988b
Jacques Thuillier, "'Il se rendit en Italie . . .' Notes sur le voyage à Rome des artistes français au XVIIe siècle," in *"Il se rendit en Italie": Etudes offertes à André Chastel*, Paris, 1988

Thuillier 1996
Jacques Thuillier, "Pierre Brébiette dessinateur: Essai de chronologie," in *Hommage au dessin: Mélanges offerts à Roseline Bacou*, ed. Maria Teresa Caracciolo, Rimini, 1996, 275–323

Toussaint du Plessis 1736
Dom Toussaint du Plessis, *Description de la ville et des environs d'Orleans, avec des remarques historiques*, Orleans, 1736

Tulard 1989
Jean Tulard, *Dictionnaire Napoleon*, Paris, 1989

Turner—Hendrix—Plazotta 1997
Nicholas Turner, Lee Hendrix, and Carol Plazotta, *European Drawings 3: Catalogue of the Collections*, The J. Paul Getty Museum, Los Angeles, 1997

Valenciennes 1800
Pierre-Henri de Valenciennes, *Eléméns de perspective praqtique à l'usage des artistes suivis de reflexions et conseils à une élève sur la peinture, et particulièrement sur le genre du paysage*, Paris, 1800

Vallery-Radot 1953
Jean Vallery-Radot, *Le Dessin français au XVIIe siècle*, Lausanne, 1953

Vallery-Radot 1954
Jean Vallery-Radot, "Dessins de Mellan et de Nanteuil appartenant à des collections particulières d'Angleterre," *Bulletin de la Société de l'Histoire de l'Art Français*, 1954, 25–31

Vallery-Radot 1964
Jean Vallery-Radot, *French Drawings from the Fifteenth Century through Géricault*, Drawings of the Masters, New York, 1964

Valori 1813
C. de Valori, "Notice sur Greuze et ses ouvrages," in *Greuze ou l'acordée de village*, Paris, 1813 (repr., Anatole de Montaiglon, ed., *Revue Universelle des Arts* 9 [1860]: 373–74)

Varriano 1986
John Varriano, *Italian Baroque and Rococo Architecture*, Oxford, 1986

Vasi 1761
Giorgio Vasi, *Delle magnificenze di Roma antica e moderna*, Rome, 1747–61

Vigurie 1995
Jean de Vigurie, *Histoire et dictionnaire du temps des lumières*, Paris, 1995

Vilain 1972
Jacques Vilain, "Musée des Beaux-Arts de Brest, Un nouveau tableau de Carle Van Loo," *La Revue du Louvre et des Musées de France* 4–5 (1972): 367–70

Vitet 1861
Ludovic Vitet, *L'Académie royale de Peinture et de Sculpture*, Paris, 1861

Voragine 1900
Jacopo da Voragine, *The Golden Legend; Or, Lives of the Saints*, 7 vols., trans. and ed. J. M. Dent, London, 1900

Walsh 1996
John Walsh, *Jan Steen: The Drawing Lesson*, J. Paul Getty Museum Studies on Art, Los Angeles, 1996

Watelet and Levesque 1792
Claude Henri Watelet and Pierre Charles Levesque, *Dictionnaire des arts de peinture, sculpture et gravure*, 2 vols., Paris, 1792

Waterhouse 1948
Ellis K. Waterhouse, "Tasso and the Visual Arts," *Italian Studies* 3 (1947–48): 146–62

Waterhouse 1967
Ellis K. Waterhouse, *The James A. de Rothschild Collection at Waddesdon Manor: Paintings*, London, 1967

Weber 1969
Gerold Weber, "Dessins et maquettes d'Edme Bouchardon," *Revue de l'Art* 6 (1969): 39–50

Weigert 1968
Roger-Armand Weigert, *Inventaire du fonds français, graveurs du XVIIe siècle*, Bibliothèque nationale de France, vol. 5, Paris, 1968

Whitehead 1992
John Whitehead, *The French Interior in the Eighteenth Century*, New York, 1992

Wildenstein 1933
Georges Wildenstein, *Chardin*, Paris, 1933

Wildenstein 1963
Georges Wildenstein, *Chardin*, 2d ed., Zurich, 1963

Wildenstein 1965
Daniel Wildenstein, "Les Oeuvres de Charles Le Brun d'après les gravures de son temps," *Gazette des Beaux-Arts*, 6th ser., 2 (1965): 1–58

Wildenstein 1966
Daniel Wildenstein, *Documents inédits sur les artistes français du XVIIIe siècle conservés au Minutier Central des Notaires de la Seine, aux Archives Nationales et publiés avec le concours de la Fondation Wildenstein de New York*, Paris, 1966

Wildenstein 1969
Georges Wildenstein, *Chardin*, 3d rev. and aug. ed. by Daniel Wildenstein, Zurich, 1969

Wildenstein and Wildenstein 1973
Daniel and Guy Wildenstein, *Documents complémentaires au catalogue de l'oeuvre de Louis David*, Paris, 1973

Wilhelm 1956
Jacques Wilhelm, "La Galerie de l'Hôtel Bretonvilliers" (1956), *Bulletin de la Société de l'Histoire de l'Art Français*, 1957, 137–50

Williams §
Eunice Williams—see New York 1969; Washington et al. 1978; Cambridge 1993

Wilton-Ely 1994
John Wilton-Ely, *Giovanni Battista Piranesi: The Complete Etchings*, 2 vols., San Francisco, 1994

Winckelmann 1755
Johann Joachim Winckelmann, *Gedanken über die Nachahmung der griechischen Werke in der Malerei und Bildhauerkunst*, Dresden, 1755

Winckelmann 1764
Johann Joachim Winckelmann, *Geschichte der Kunst des Alterthums*, Dresden, 1764

Winkler and Heiland 1979
Gerhard Winkler and Susanne Heiland, *Museum der bildendenkünste— Katalog der Gemälde*, Leipzig, 1979

Wittkower 1982
Rudolf Wittkower, *Art and Architecture in Italy, 1600–1750*, Harmondsworth, 1982

Wright 1986
Christopher Wright, *The French Painters of the Seventeenth Century*, London, 1986

Yates 1947
Frances Yates, *The French Academies of the Sixteenth Century*, London, 1947

Zerner 1969
Henri Zerner, *L'Ecole de Fontainebleau: Etchings and Engravings*, London, 1969

ILLUSTRATION CREDITS

Numbers preceded by an A. refer to drawings in the Horvitz Collection that are catalogued in the Appendix.

DETAILS OF COLOR AND BLACK-AND-WHITE BLEEDS

Frontispiece: F. Boucher, cat. 61

Opposite Dedication: F. Boucher, cat. A.44

Opposite beginning of Director's Foreword: A. Rivalz, cat. 31

Opposite end of Director's Foreword: E-B. Garnier, cat. 105

Opposite beginning of Foreword: N. Poussin, cat. 8

Opposite end of Foreword: J-H. Fragonard, cat. 88

Opposite Preface: P-P. Prud'hon, cat. 102

Opposite List of Contributors: C. Le Brun, cat. 18

Opposite Mérot and Raux-Carpentier Essay: C. Errard, cat. A.127

Opposite Roland Michel Essay: J-H. Fragonard, cat. A.133

Opposite Interview: J-H. Fragonard, cat. 87

Opposite Note to the Reader: J-F-P. Peyron, cat. 97

Opposite beginning of Biographies of Artists: A-L. Girodet, cat. 110

Opposite end of Biographies of Artists: A-L. Girodet, cat. 110

Opposite Appendix: C-N. Cochin le jeune, cat. A.77

Opposite beginning of Index of Former Owners: G-J. de Saint-Aubin, cat. 77

Opposite end of Index of Former Owners: J-H. Fragonard, cat. A.131

Opposite Index of Subjects: H. Collin de Vermont, cat. 44

PHOTOGRAPHIC CREDITS

Amiens, Musée des Beaux-Arts (David Rosenfeld): 99-1

Amsterdam, Rijksmuseum-Stichting: 12-1, 46-4, 88-1

Angers, Musée des Beaux-Arts: 14-3, 44-2, 44-3, 65-2

Aylesbury, Bucks, Waddesdon Manor (The National Trust): 50-2, 55-1

Basel, Kunstmuseum: 70-2

Bayonne, Musée Bonnat (Réunion des musées nationaux)—R. B. Ojeda: 8-1, 101-1

Berlin, Gemäldegalerie (Walter Steinkopf): 36-1

Berlin, Kupferstichkabinett, Staatliche Museen zu Berlin-Preussischer Kulturbesitz: 68-1

Besançon, Musée des Beaux-Arts et d'Archéologie (Charles Choffet): 40-1, 83-1, 86-1, 111-3

Boston, Museum of Fine Arts: MRM ess., figs. 4, 5; cat. 77-1

Bourges, Musée du Berry: 4-1, 4-2, 4-3

Brussels, Musées royaux des Beaux-Arts: 16-1

Cambridge, Harvard University Art Museums (David Mathews, Michael Nedzweski, Rick Stafford): All color photography; MRC ess., frontispiece and figs. 2, 11, 13–15, 17–23, 25–28, 30–34; MRM ess., frontispiece and figs. 1, 6–9, 11, 12, 21, 22; Interview, all figs.; cats. 5-2, 10-1, 10-2, 10-3, 10-4, 12-3, 12-4, 15-1, 16-3, 17-4, 30-3, 33-1, 33-3, 39-1, 40-3, 41-3, 46-2, 46-3, 48-1, 48-2, 69-3, 73-2, 74-3, 75-3, 75-4, 76-3, 78-1, 81-2, 85-2, 85-3, 87-1, 89-1, 98-1, 99-4, 101-4, 106-4, 107-4, 110-1, 111-5, 112-1, 113-4, 114-2; Appendix, all figs.

Cambridge, Houghton Library, Harvard University: MRM ess., fig. 10; cats. 58-1, 70-1, 70-4, 109-2, 114-4

Chantilly, Musée Condé: 102-3

Chartres, Musée des Beaux-Arts: 83-2

Chicago, The Art Institute of Chicago: MRM ess., figs. 24–28; cats. 35-2, 38-5, 49-3, 56-4

Cologne, Rheinisches Bildarchiv: 30-2

Darmstadt, Hessisches Landesmuseum: 23-2, 25-2, 97-3

Dijon, Musée des Beaux-Arts: 1-4, 22-1, 102-1, 102-2

Dresden, Staatliche Kunstsammlungen: 35-1

Edinburgh, National Galleries of Scotland: 26-1

Fort Worth, Kimbell Art Museum: 61-1

Frankfurt, Städelsches Kunstinstitut (Ursula Edelmann): 1-3, 6-2, 25-1, 41-2

Gray, Musée Baron Martin: 56-3

Grenoble, Musée des Beaux-Arts: 46-1, 82-3

Hamburg, Kunsthalle, Fotowerkstatt (Elke Walford): 12-2, 87-2

Ivry-sur-Seine, Etablissement Cinémato-graphique et Photographique des Armées: 97-2

Jerusalem, Israel Museum: 80-3

Kansas City, Nelson-Atkins Museum of Art: 28-1, 28-3

Lille, Musée des Beaux-Arts (Réunion des musées nationaux)—P. Bernard, Quecq d'Henripret: MRC ess.: figs. 1, 29; cats. 2-2, 80-1, 80-2

London, Thos. Agnew & Sons, Ltd.: 89-2

London, British Museum: 7-4, 19-3, 36-2

London, Courtauld Gallery: MRC ess., fig. 6

London, Courtauld Institute of Art, Witt Library Photographic Survey of Private British Collections: 55-1, 60-2

London, Prudence Cuming Associates Limited: 26-2, 84-2

London, Victoria & Albert Museum (Picture Library): 34-2

London, Warburg Institute, University of London: 78-2

London, Alex Wengraf: 41-1

Los Angeles, County Museum of Art: 113-1

Los Angeles, J. Paul Getty Museum: MRM ess., fig. 18; cats. 94-2, 109-3

Madrid, Biblioteca Nacional: 13-2

Madrid, Museo del Prado: 105-2

Marseilles, Musée Grobet-Labadie: 74-1

Montpellier, Musée Atger: 56-1, 57-2, 58-2

Montpellier, Musée Fabre (Frédéric Jaulmes): 24-3, 94-1

Moscow, Pushkin Museum of Fine Arts: 30-1

Mulhouse, Musée des Beaux-Arts: 45-2

Munich, Bayerische Staatsbibliothek (E. Seehuber, A. Wanner): 6-3

Nancy, Musée historique lorrain: 1-1

Nantes, Musée des Beaux-Arts (Madec): 9-1

New Haven, Yale University Art Gallery: MRC ess., fig. 16; cats. 9-2, 28-2

New York, Christie's Images: 9-3, 20-1, 55-2, 61-2

New York, Cooper-Hewitt Museum, National Museum of Design, Smithsonian Institution/Art Resource: MRM ess., fig. 37

New York, Allan Finkelman: 111-2

New York, Metropolitan Museum of Art: MRM ess., figs. 2, 3, 13, 36, 38; cats. 20-2, 21-2, 38-3, 43-1, 51-4, 57-3, 59-2, 64-1, 76-1, 82-2, 90-2, 106-2

New York, Pierpont Morgan Library (David A. Loggie): MRM ess., figs. 14–17; cats. 17-3, 34-1, 40-2, 62-1, 62-2, 62-3, 101-3

New York, Rosenberg & Stiebel: 66-6

New York, Sotheby's: 104-2

Orléans, Musée des Beaux-Arts: 56-2

Palo Alto, Stanford University Museum of Art: 106-3

Paris, Galerie de Bayser: 53-2, 61-3

Paris, Bibliothèque nationale de France: 1-2, 3-1, 13-3, 14-1, 14-2, 14-4, 15-3, 18-1, 23-1, 39-2, 43-2, 50-1, 50-3, 51-1, 51-2, 51-3, 54-1, 66-5, 70-3, 72-2, 103-1, 103-2, 104-1, 107-1, 115-1, 115-2, 115-3, 115-4

Paris, Bibliothèque nationale de France (Institut d'Art) Collection Doucet: 64-2, 65-3, 74-2

Paris, Galerie Cailleux: 84-1

Paris, Musée Carnavalet (Photothèque des Musées de la Ville de Paris)—Joffre: 52-1

Paris, Jean-Loup Charmet: 49-4

Paris, Ecole nationale supérieure des Beaux-Arts: 21-1, 29-2, 37-2, 75-2, 93-2, 107-2

Paris, Fondation Custodia, Collection Frits Lugt, Institut Néerlandais: 47-2

Paris, Musée du Louvre (Réunion des musées nationaux): MRC ess., figs. 4, 5, 7–10, 24; cats. 13-1, 14-4, 15-4, 16-2, 18-2, 19-2, 23-3, 24-2, 27-1, 27-2, 31-2, 37-1, 42-2, 42-3, 44-1, 52-3, 54-2, 57-1, 59-1, 60-1, 63-1, 63-2, 67-1, 68-2, 69-1, 71-1, 72-2, 77-2, 78-3, 81-1, 84-3, 90-1, 98-2, 100-1, 101-2, 103-3, 109-4, 109-5, 111-4, 111-6, 112-2, 112-3, 113-3, 113-4

Paris, Galerie Emmanuel Moatti: 106-1, 114-1

Paris, Musée du Petit Palais (Photothèque des Musées de la Ville de Paris)—Pierrain: 96-2, 98-3